SCULPTURE OF BRITAIN VOLU

Public Sculpture of Glasgow

Public Monuments and Sculpture Association
National Recording Project

PMSA

Already published in this series

PUBLIC SCULPTURE OF LIVERPOOL
by Terry Cavanagh

PUBLIC SCULPTURE OF BIRMINGHAM
by George T. Noszlopy, edited by Jeremy Beach

PUBLIC SCULPTURE OF NORTH-EAST ENGLAND
by Paul Usherwood, Jeremy Beach and Catherine Morris

PUBLIC SCULPTURE OF LEICESTERSHIRE AND RUTLAND
by Terry Cavanagh, with an Introduction by Alison Yarrington

In preparation

PUBLIC SCULPTURE OF WARWICKSHIRE, COVENTRY AND SOLIHULL
by George T. Noszlopy

PUBLIC SCULPTURE OF OUTER WEST LONDON AND SURREY
by Fran Lloyd, Helen Potkin and Davina Thackara

PUBLIC SCULPTURE OF GREATER MANCHESTER
by Terry Wyke, assisted by Diana Donald and Harry Cocks

PUBLIC SCULPTURE OF EAST LONDON
by Jane Riches, edited by Penelope Reed

PUBLIC SCULPTURE OF BRISTOL
by Douglas Merritt and Janet Margrie

PUBLIC SCULPTURE OF THE CITY OF LONDON
by Philip Ward-Jackson

PUBLIC SCULPTURE OF CHESHIRE AND MERSEYSIDE
(EXCLUDING LIVERPOOL)
by Anne MacPhee

PUBLIC SCULPTURE OF NOTTINGHAMSHIRE
by Stuart Burch and Neville Stankley

PUBLIC SCULPTURE OF WALES
by Angela Gaffney

PUBLIC SCULPTURE OF EDINBURGH
by Dianne King

PUBLIC SCULPTURE OF SOUTH LONDON
by Terry Cavanagh

PUBLIC SCULPTURE OF STAFFORDSHIRE AND
THE BLACK COUNTRY
by George T. Noszlopy

Public Sculpture of Britain Volume Five

PUBLIC SCULPTURE OF GLASGOW

Ray McKenzie

WITH CONTRIBUTIONS
BY GARY NISBET

LIVERPOOL UNIVERSITY PRESS

First published 2002 by LIVERPOOL UNIVERSITY PRESS,
Liverpool, L69 7ZU

HERITAGE LOTTERY FUND

The National Recording Project is supported by the
National Lottery through the Heritage Lottery Fund

Copyright © 2002
Public Monuments and Sculpture Association

The right of Ray McKenzie to be identified
as the author of this work has been
asserted by him in accordance with the
Copyright, Design and Patents Act 1988

Scottish Enterprise
Glasgow

British Library Cataloguing-in-Publication Data
A British Library CIP record is available

ISBN 0-85323-927-4 (cased)
ISBN 0-85323-937-1 (paper)

Design and production, Janet Allan

Typeset in 9/11pt Stempel Garamond
by XL Publishing Services, Tiverton, Devon
Originated, printed and bound in Great Britain by
Henry Ling Ltd, Dorchester

Preface

The *Public Sculpture of Britain* is a series of volumes illustrating and cataloguing in great detail sculpture in Britain available to the public. It includes notable sculptures in public buildings as well as open air sculpture, and the only exclusions are works in museum and ecclesiastical buildings which have their own cataloguing procedures. The series is produced by the Public Monuments and Sculpture Association, which was founded in 1991 to encourage the appreciation, study and conservation of public sculpture, and it will eventually cover the whole of Britain. This is the fifth and perhaps the most ambitious volume so far.

Most of the greatest British and even some continental sculptors are represented in this volume with important sculptures – John Flaxman, J.H. Foley, John Gibson, Francis Chantrey, Carlo Marochetti, Auguste-Nicolas Cain, Hamo Thornycroft, George Frampton and many others. Glasgow was never provincial. Its trade and manufactures were international, and as early as the late eighteenth century in town planning it rivalled many European capitals. At the same time Glasgow has always resisted artistic centralization based on London. Elsewhere public sculpture has largely represented provincial excursions by London sculptors. It may have been commissioned locally but it was designed and executed in London. Edinburgh of course had its own sculptors, some of whom worked in Glasgow, but it lacked both Glasgow's wealth and international links. Liverpool did have eminent sculptors but they lived mainly in Rome. Thomas Banks, Chantrey, Foley, Goscombe John, Albert Toft and many others were born and educated outside London but the lure of the London art schools and studios soon enticed them to the capital. Only in Glasgow, and perhaps also in Edinburgh, were there significant local workshops, often family based, training dynasties of native sculptors. These workshops themselves depended on another great Glasgow specialism, architectural sculpture. Local architects naturally looked to local sculptors for the sculpture intended to enhance the beauty, proclaim the importance and explain the purpose of their buildings. Sir John Burnet, one of the most successful Edwardian architects, was born in Glasgow, trained in Paris, worked in Glasgow and so generally employed Glasgow sculptors – even on some of his London buildings after he moved there late in his career.

The study of architectural sculpture, falling between the history of art and the history of architecture, has been until very recently generally neglected – even by that great pioneer, Rupert Gunnis. Ray McKenzie has in this volume for the first time demonstrated the importance of Glasgow's architectural sculpture and explained its function with a wealth of superbly arranged and carefully marshalled detail. He began work on this volume in 1995 and has over the years employed five part-time research assistants and supervised a number of volunteers gathering material on Glasgow sculpture. This volume is therefore not only a triumph for his innovative research and synthesis in a new and very significant field but also a great achievement in the management of research. Scientists often blame students of the humanities for an individualistic reluctance to work in teams. Here is the refutation. Ray McKenzie and the other authors working on this series are creating a new school of historians of sculpture firmly wedded to original archival and printed sources.

Glasgow School of Art, where he teaches art history, has always strongly supported the project, with, in particular, a substantial contribution from its Research Fund. At a time when many universities are finding it difficult to support demanding long term research projects in the humanities and when many art colleges are retreating from the serious study of art history, it is immensely encouraging to find an art school willing to commit its resources and its staff to a major historical project. Glasgow City Council, which has played a large part in the transformation of the city into a major centre of culture and tourism, provided a substantial initial grant. Additional generous awards and grants came from the Paul Mellon Centre for Studies in British Art, from the Arts and Humanities Research Board, from the N.S. Macfarlane Charitable Trust, from Scottish Enterprise Glasgow and from the Henry Moore Foundation, which has committed itself to the support of every volume in this series. In 1999 Ray McKenzie's guidebook, *Sculpture in Glasgow*, was published thanks to the support of the Glasgow Revealed Trust and Neil Baxter Associates, and all the income from the sales of this guidebook has been used to assist the production of this volume. Lastly the Public Monuments and Sculpture Association have received a grant from the Heritage Lottery Fund of £470,000 towards the cost of research into public sculpture throughout Britain and of the compilation of a computerised database recording this research. The Association is therefore publishing its material in two forms – by means of these volumes with their detailed account of important sculptures and by means of the database recording briefer details of a much wider range of public monuments and sculpture.

As always we are deeply indebted to our courageous publisher, Robin Bloxsidge, and to our designer, Janet Allan, who has always done so much more than design.

EDWARD MORRIS
Chairman of the Editorial Board

Contents

Preface v

Map viii

Introduction ix

Abbreviations xxi

Acknowledgements xxii

Sources of Illustrations xxiii

CATALOGUE OF PUBLIC SCULPTURE OF
GLASGOW I

APPENDIX A Lost Works 431
 by GARY NISBET, *edited by* RAY MCKENZIE

APPENDIX B Minor Works 447

APPENDIX C Coats of Arms 461

Glossary 469

Selected Biographies 476
 by GARY NISBET, *edited by* RAY MCKENZIE

Bibliography 503

Index 509

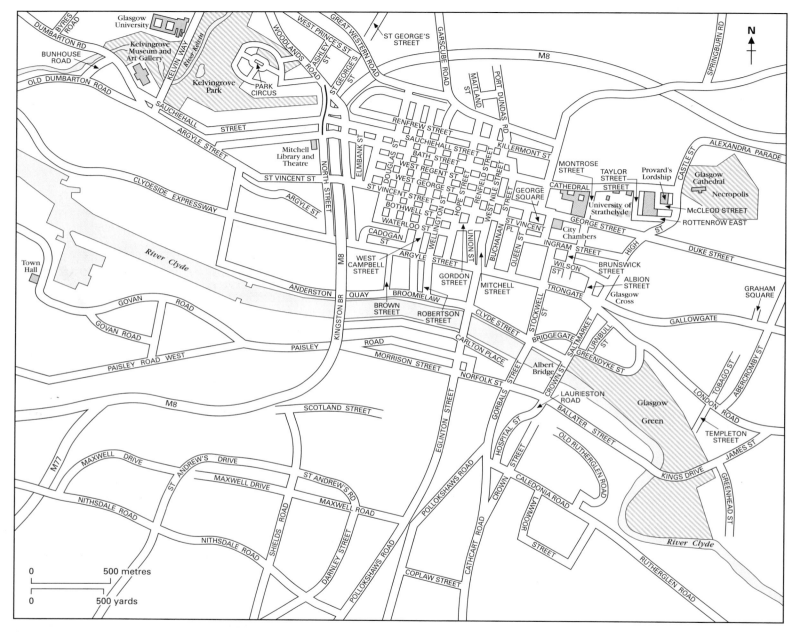

GLASGOW

Introduction

The city of Glasgow lies at the western end of the Scottish lowlands, at the point where the River Clyde begins to widen into an estuary. Like Rome it is built on a cluster of hills, known locally as 'drumlins', which were formed by the retreating glaciers of the last ice age. One of the most geologically well-placed cities in Britain, its prosperity was guaranteed by the rich seams of coal that lay all around, while the equally abundant deposits of carboniferous sandstone provided the material from which much its historic fabric came to be built. By world standards Glasgow is not a large city; one could cycle round its perimeter comfortably in a few hours. But what it lacks in size it makes up for in the diversity of the social cultures it embraces, and the extraordinary richness of its history.

Everyone who lives or works in Glasgow, or who has spent time in it as a visitor, will have their own idea of what makes it special. Even those who have never set foot in the place will often have a clearly defined mental image of what the 'real' Glasgow is like. To its more sympathetic historians it will always be the descendant of the medieval settlement known by the Celtic name of Glas Ghu, the 'dear green place' of fondly remembered folklore, and they can rightly point to the tree in the middle of its coat of arms to confirm the enduring relevance of such a view. More widespread, and more grimly realistic, is the perception of Glasgow as the 'second city of the empire', the epitome of those historic contradictions associated with the Industrial Revolution, in which extremes of prosperity and squalor coexisted as two sides of the same *laissez-faire* coin. From this emerged the image of Glasgow that was to persist for most of the twentieth century: the city of razor gangs, endemic unemployment and the worst health statistics in the United Kingdom. Coming to terms with the collective trauma of its post-industrial decline was a concern for everyone who cared about the city at this time, and in the late 1970s a renewed effort was made to shake off once and for all its reputation as the epicentre of everything that was bad about modern British urban life. In the early part of the following decade the transformation became official, even though the banner draped across the façade of the City Chambers announcing that Glasgow was 'Miles Better' merely served to provoke the cynical rejoinder: ' Aye, than Paisley!'. By 1990, however, when it had achieved the status of European City of Culture, it was felt that the time was right to take stock of the situation, and in a flagship exhibition entitled, with disarming simplicity, 'Glasgow's Glasgow', one final attempt was made to separate the myths from the facts. It was not a great success. True to form, the city remained frustratingly resistant to neat categorisation. The myths, and many of the problems, have refused to go away.

In embarking on a book devoted to one aspect of a great city's history, the writer cannot but be aware of the difficulties that lie ahead, and must be prepared to negotiate the hazards strewn across a terrain that has been crossed by so many better equipped travellers in the past, and in which so many pre-formed opinions have already taken root. And yet a comprehensive review of the city's sculptural heritage is urgently needed. In the vast body of literature that has been generated by the study of Glasgow, it is astonishing how little attention has been paid to this aspect of its historic culture. This is all the more surprising when one considers how well architecture has been served by the veritable publication boom that has occurred in recent years. Since the appearance of Gomme and Walker's *Architecture of Glasgow* in 1968[1] the output of books dealing with the city's buildings has grown into a minor publishing industry in its own right. The result is almost an embarrassment of riches, in which the interested reader can now choose from an array of guide books, monographs on different architects and even entire volumes devoted to individual buildings. By contrast, the number of publications dealing in any depth with the sculpture of Glasgow can be counted on the fingers of one hand. Ben Read led the way with his magisterial overview, *Victorian Sculpture*, of 1982, in which the achievements of Glasgow's sculptors were placed for the first time in a national context.[2] Shortly after came his collaboration with Philip Ward-Jackson on one of the Courtauld Institute's *Illustration Archives* series, providing an invaluable photographic record of more than a score of Glasgow's key monuments.[3] In 1988 the publication of *Glasgow Revealed* widened the scope of the photographic coverage, and two years later Gary Nisbet published the first fruits of his own private research in a short article in *The Scots Magazine*.[4] More recently Gary Nisbet and I, together with Tracy Smith, collaborated on the production of a small guide book to the sculptures concentrated in the city centre as a contribution to the 1999 Festival of Architecture and Design.[5] Taken together, these various contributions certainly add up to a significant body of literature, and show that the subject has not been entirely ignored, and yet it is remarkable that until now no publication has attempted to tackle the city as a whole, or to provide a detailed critical scrutiny of every known work.

In many ways this oversight is difficult to explain. Despite its prolonged neglect by the academic community, a very different sense of the value attached to sculpture in Glasgow emerges when it is looked at in the context of popular culture, and there is much evidence to suggest that

to the true Glaswegian the statues and carvings found on the streets are as crucial to the experience of the city as any of its more celebrated buildings. As long ago as 1866, a commentator writing in the *Builder* tried to suggest the passage of historical time by imagining how it might have been perceived from on high by the equestrian *Monument to King William III*, at that time located in the congested centre of urban life in the Trongate.

> If it were miraculously endowed with the gift of speech, what tales could it tell of stirring events and strange vicissitudes! It had already been fully ten years in existence when 'Bonnie Prince Charlie' and his army arrived in Glasgow in such a bedraggled condition after the futile expedition to Derby. It witnessed almost the earliest signs of our coming phenomenal greatness as an industrial and trading community.[6]

Monument to King William III in the Trongate, c.1868. Photograph by Thomas Annan, from *The Old Closes and Streets of Glasgow*, 1871. [MLG]

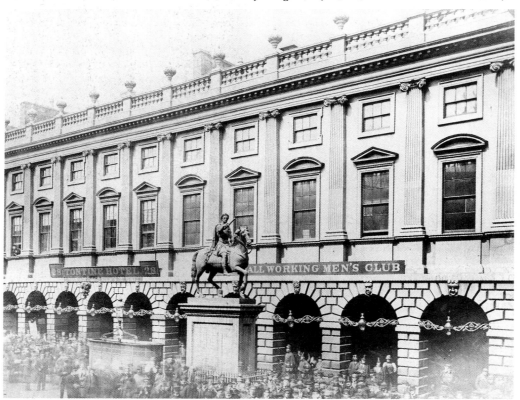

More recently, statues have proved useful in a variety of other ways when an immediately recognisable reference point has been needed to evoke the character of the city. In their short 1950s film *Broken Images*, Eddie McConnell and Laurence Henson included a scene in which a drunkard falls into a futile remonstration with the statues in George Square: one familiar Glasgow stereotype played off against another.[7] Bill Forsyth turned the device to even more brilliant effect in his early comic masterpiece *That Sinking Feeling*, which features an unemployed youth peering over the railing of the *Monument to Earl Roberts* to read the inscription on the pedestal, haughtily pointing out that there are not too many 'O Levels' on his list of achievements.[8] This sort of ribald reflection on our monuments is not confined merely to literature and film. In 1996, a group of anti-pollution campaigners placed green masks over the mouths of the *Reverend Norman Macleod* and his bronze companions in Cathedral Square in one of the most imaginative examples of direct action that has been seen on the streets of Glasgow for some time. Less political, but no less effective, is the now well-established custom of fitting a traffic cone to the head of Marochetti's monument to the Duke of Wellington in Royal Exchange Square. Nobody quite knows when – still less why – this dubious practice started, but it has become sufficiently familiar to provide a local newspaper with material for an entire advertising campaign.[9] Such affectionate irreverence towards the symbols of authority is itself an eminently Glaswegian trait, of course, but the regularity with which it manifests itself in this way suggests that statues have assumed a special place in the popular imagination. Little wonder, then, that when the city council recently proposed clearing George Square of all its historic monuments, the overwhelming response of the people of Glasgow, mediated through the pages of the *Evening Times*, was an unequivocal: 'Leave our statues alone'.[10] The mere fact that it was necessary for the general public to rise in opposition to a proposal so out of tune with popular feeling suggests that there are serious shortcomings in the management of the city's sculptural heritage, and this is a matter that will have to be addressed later in these pages. For the moment, it is enough to note the general fondness with which statuary is regarded, and the prominence it has as an aspect of the city's popular culture.

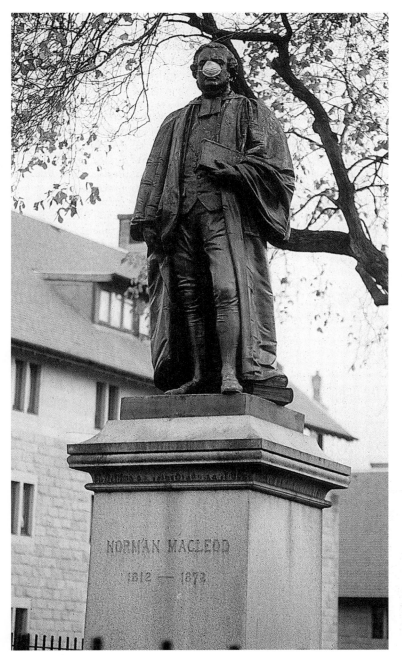

As this is the first attempt to provide a comprehensive overview of the subject, it has been necessary to make a number of strategic decisions with regard to the contents of the book and how they are arranged, and it is important that these are explained at the outset, if only to avoid creating unrealistic expectations in the reader's mind. Firstly, and most importantly, this is not a *history* of sculpture in Glasgow, but a catalogue of what that history happens to have thrown up. No attempt is made here to trace a single narrative thread through the pattern of development in which sculptural practices are embedded, or to explain the historical forces that made that development possible. The structure is not chronological but alphabetical, with the main body of the text laid out as a gazetteer, and with each work discussed methodically on a street by street basis. Clearly, questions of historical development and interpretation will arise in the course of discussing individual pieces, and these are addressed as and when they are relevant; but the primary

(left) John Mossman, *Monument to the Reverend Dr Norman Macleod* **taking part in an anti-pollution protest. Photograph, 1996.** [RM]

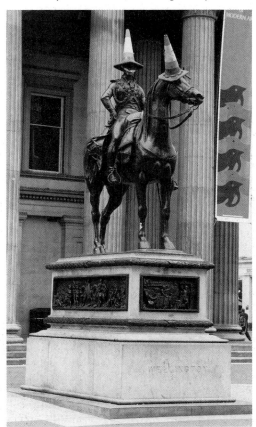

(right) Carlo Marochetti, *Monument to the Duke of Wellington* **in traditional headgear. Photograph, 1996.** [RM]

commitment here is to the identification and documentation of what exists, and the presentation of related bodies of factual information. A book that has been compiled as much as written, it does not attempt to provide a sculptural counterpart to Gomme and Walker's chronicle of the city's architecture. Such a book undoubtedly needs to be written, and it is to be hoped that the present work will prove to be of value when that task comes to be done, but it is not the book that is being presented here.

At the same time it is important to acknowledge that no work of art – least of all a work of public art – is made in a cultural vacuum, and it may be helpful at this point to offer a brief sketch of the historical trends that have shaped the production of sculpture in Glasgow over the past two or three centuries. Broadly, it is possible to divide our subject into four more or less distinct periods, each of which corresponds to a different phase in the city's evolution, and thus presents the researcher with a different sort of challenge. The main periods are:

(i) from the earliest extant examples in the seventeenth century to the beginning of the Victorian period,

(ii) from the 1830s to the First World War,

(iii) the modernist period, from the 1920s to the 1980s,

(iv) from c.1980 to the present day.

I am very aware of the problems associated with such crude historical periodisation, and in distinguishing between these phases I do not mean to suggest that they are anything other than a very rudimentary guide. With that caveat in mind, each phase will now be discussed briefly as a prelude to the more detailed examination of individual pieces which follows in the catalogue.

The seventeenth and eighteenth centuries

In all its most important aspects, the pattern of historical evolution of sculpture in Glasgow does not differ significantly from what one would expect to find in any British city of comparable size, and the material assembled here will be found to have much in common with the contents of the two previous volumes in this series which are devoted to individual cities.[11] As with Liverpool and Birmingham, there is very little extant work in Glasgow dating from before the turn of the nineteenth century, and among those pieces which have survived, very few were works of public art in the strict sense. If we discount the small amount of late medieval work on Glasgow Cathedral, and the remarkable collection of sarcophagi and stone crosses housed in Govan Parish Church[12] – two bodies of work which fall outside the purview of this study – the earliest surviving pieces are the twin portraits of Thomas and George Hutcheson, carved by James Colquhoun c.1649. Although these are now exposed to

view on the main façade of the former Hutchesons' Hall on Ingram Street, they were in fact made for the garden front of an altogether different building and were never intended for unregulated access by the general public. The same is true of the only other important pieces which have survived from the seventeenth century, the Lion and Unicorn group on the staircase salvaged from the inner quadrangle of the Old College when it was demolished in the 1860s (see University of Glasgow). Unfortunately very little is known about James Riddell, the carver of these two fine heraldic beasts, except that, like Colquhoun, he was a mason as well as a sculptor. Both men may well have produced many other statues that were once a familiar sight in Glasgow, but which have since disappeared. On the evidence of what remains, however, it cannot be said that there was a major tradition of public sculpture in Glasgow in the seventeenth century. It was to continue thus for the next hundred years or so, the only notable exceptions being the *Monument to King William III* (Cathedral Square Gardens) – a landmark work in every sense – together with the 'Tontine Faces', rescued from the old Town Hall (St Nicholas Garden, Castle Street), and the small amount of exterior architectural decoration associated with the late work of Robert and James Adam (McLennan Arch, Glasgow Green; Trades House, Glassford Street). These are all immensely interesting and important pieces, certainly, but as the isolated products of nearly two centuries of urban development they can hardly be said to constitute a settled tradition. We may reasonably conclude, therefore, that secular sculpture was not a central aspect of urban culture in pre-Victorian Glasgow.

The Victorian period

It was not until the second quarter of the nineteenth century, during the city's second and most dramatic phase of expansion, that secular monuments began to appear on the streets of Glasgow on anything like a regular basis. The organisers of the Sir John Moore memorial fund made the first move in 1809, and their choice of John Flaxman as the artist to produce the first public monument in Glasgow for nearly a century set an appropriately high standard for later artists to measure themselves against. At the same time, the tortuous process of debate and consultation that was necessary before they felt able to decide what form the memorial should take suggests that the whole process of commissioning statues was so unfamiliar, indeed so alien to them, that it had to be re-invented more or less from scratch. Nor should we forget the ferocious opposition they encountered from the local residents when it came to securing the statue a home in George Square. It is clear from this case that even in the early nineteenth century, the city still had some way to go before it would be ready to embrace public sculpture as a natural extension of its urban identity.

This was soon to change, however, and by the 1840s major statues were not only becoming a familiar part of the streetscape, but the events surrounding their production and reception were to play an important part in the development of urban culture in a more general sense. Once again, the story in Glasgow is much the same as in many other major cities that prospered during the industrial boom of the nineteenth century, and the pattern of development here will be found to correspond closely to the contemporary situation described by Terry Cavanagh in his earlier study of Liverpool.[13] In the period of just less than a century between the inauguration of the John Moore monument in 1819 and the completion of the memorial to Earl Roberts in 1916, a total of thirty free-standing statues was erected in Glasgow: an average of roughly one statue every three-and-a-half years. In almost every case the choice of the individual to be commemorated was enthusiastically endorsed by the large mass of the local community, and in several cases positive steps were taken to ensure the widest possible participation in the fund-raising process. This could be done either by limiting the subscription to a shilling, as in the case of the Burns monument (George Square), or by organising related events such as flag days. As in Liverpool, the inauguration ceremonies tended to be among the most spectacular events of the entire year, with attendances frequently requiring the sort of crowd control measures that would not be out of place in a rock concert today. Fortunately, the press coverage of these occasions tended to be very thorough, often providing a blow-by-blow account of the entire sequence of events from the erection of the barriers on the streets the night before, to the final departure, usually by train from Queen Street station, of whatever aristocratic celebrity had been invited to perform the unveiling. With the almost military precision of their timetables, their trade processions, their surging crowds of flag-waving onlookers and their occasional outbreaks of public disorder, these were a vital part of the culture of mass entertainment in the nineteenth century, a fact which is easy to overlook today when studying the monuments as purely sculptural objects.

The tradition of the free-standing commemoration of exceptional individuals represents only one aspect of the exponential growth of sculpture in the Victorian period, and in many ways an equally, if not more fertile breeding ground for significant work was in the related field of architectural decoration. It is here that the imagination and technical skill of our sculptors found most scope for development, encouraged by the challenge of finding new ways of fulfilling the multiplicity of tasks sculpture was required to perform on a building. The diversity of building types that were generated by the architectural fancy dress parade known as the 'Battle of the Styles' also acted as an important stimulus. Among the categories of practice associated with architecture, the most relevant in this context are portraiture, allegorical figure work and

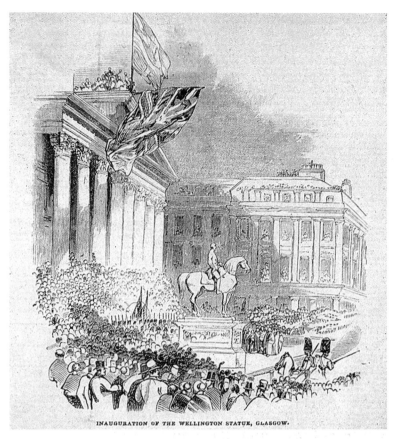

INAUGURATION OF THE WELLINGTON STATUE, GLASGOW.

Inauguration of the *Monument to the Duke of Wellington*, **1844, from the** *Illustrated London News*, **26 October, 1844** [MLG]

ornamental carving, each of which gives us a different kind of insight into the cultural purposes Victorian buildings served beyond their obvious utilitarian function. Portraiture is of particular interest because in a rational world the exterior surface of a building is surely the last place one would expect to find portrait artists practising their craft. Yet the streets of Glasgow are replete with images of recognisable individuals, who can be seen strutting on entablatures, protruding from roundels or joining the crowds in various forms of extended narrative frieze. Historical figures, from Homer to James Watt, are regular performers in this alfresco, if strictly unofficial extension of the Scottish National Portrait Gallery. There are also legions of other less well known contemporary characters,

usually those who played a part in bringing the building into existence, such as the commissioner, or his professional associates, and even, in one or two cases, the architect himself. Occasionally realistic portraiture becomes so entangled with allegorical symbolism that it is difficult to tell the difference between the two, as when David Bell cast his wife in the role of Minerva on the north façade of his fashionable West End concert hall, the Queen's Rooms (La Belle Place), or when Jack Mortimer provided an insurance firm with a symbolic mariner whom nobody in the sculptural profession at that time will have failed to recognise as a portrait of his teacher Archibald Dawson (200 St Vincent Street). Part of the vitality of such work is its lack of deference towards conventional art historical boundaries, and the sheer insouciance with which sculptors took the inherited allegorical forms of the past and reworked them to suit the needs of their own time. It is not surprising, therefore, that anachronisms abound. On the roof of the Clydeport Building (Robertson Street), a resplendent *Amphitrite* commands her sea horses with a trident in one hand and a massive industrial cog wheel in the other. Thundering towards us in the pediment of the former North British Locomotive Building in Springburn (Flemington Street) we see not a quadriga but a steam engine, complete with sawn-off sections of railway track and a pair of block and tackle assemblies doing service for a traditional floral festoon.

Looking back on this work from the standpoint of the early twenty-first century, when public art is struggling once again to find its way, we can only marvel at the skill and confidence of the artists who produced it. But we should not assume that all of it was universally appreciated at the

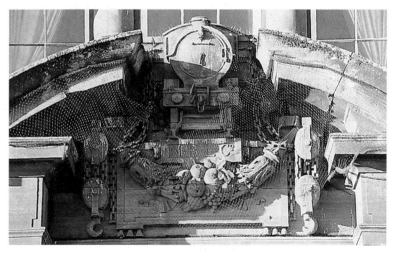

Albert Hemstock Hodge (attrib.), 110–36 Flemington Street (detail) [RM]

time, or that opinions over the value of public art were any less divided then than they are today. Certainly there was a general consensus that public sculpture was a good thing for a city to have, but there were many dissenting voices as well. Indeed, the critical reception of sculpture in the mid- and late-nineteenth century was often anything but benign. The difficulties encountered by the subscribers of the John Moore statue in finding a site have been noted already, but these were trivial compared to the dog-fights generated by the campaign to erect Marochetti's equestrian statue of the Duke of Wellington in Royal Exchange Square. For the most part the disquiet was focused on the fact that the commission had been awarded to a flamboyant Italian with an exotic reputation but no discernible track record for making satisfactory work in Britain, but even after it had been successfully completed, the attacks on the statue continued unabated. One critic described his monuments generally as 'more like toys on a large scale than genuine productions of masculine talent',[14] while another, with an enviable disregard for the constraints of logic, dismissed this particular specimen as 'too much like a real man on horseback'.[15] Architectural sculpture was also a regular target of hostile criticism, some of which came perilously close to outright abuse. What to the modern eye is a perfectly satisfactory representation of *Atlas* labouring under the weight of the world on the roof of the Standard Buildings on Hope Street was, in the view of one contemporary critic, 'something that might be removed to the cellars with advantage perhaps', while Birnie Rhind's masterpiece on Charing Cross Mansions was nothing but so much 'insane wriggling and convolution'.[16] John Ure, the Lord Provost of Glasgow in 1881, was no doubt right when he said that 'nothing so readily strikes a stranger as an evidence of refinement and taste in any community as beautiful statuary in their public places',[17] but difficulties are clearly bound to arise when those tastes are not shared by everyone, or when fashions begin to change. This is no doubt what was nagging in the mind of Augustine Birrel MP when he made his extraordinary speech at the unveiling of the *Monument to Lord Kelvin* in Kelvingrove Park in 1913. 'Statues', he claimed,

> … are often doubtful joys, and some day orators might be employed to go about the country, not unveiling but veiling old statues, and delivering speeches not in appreciation but in depreciation [*sic*] of their subjects, and showing cause why their effigies should no longer be allowed to thrust themselves upon public attention.[18]

The jest worked, as the 'laughter and cheers' noted in the press report indicate. But one cannot help suspecting that beneath the surface banter a much more ominous sea-change in public taste was under way, and that for the two great staples of the Victorian tradition – the commemorative monument and the heroic architectural sculpture programme – the writing was already very clearly on the wall.

Public sculpture after the First World War

The general pattern of decline that characterises the fate of monumental and architectural sculpture in Glasgow after around 1920 is no doubt echoed in the experiences of major cities in many other parts of the country, although in Glasgow the difficulties were clearly exacerbated by an economic depression that hit harder and penetrated more deeply than anywhere else in the British Isles. The change did not occur overnight, and throughout the 1920s and 1930s artists like Benno Schotz and Archibald Dawson continued to produce architectural work of immense vitality and freshness. Church building was also to remain a significant source of sculptural patronage until well into the 1950s, but by the middle of the century it was clear that the slow process of atrophy that had set in after the First World War had become irreversible. With the drying up of opportunities for sculptors to make work, and the consequent loss of many traditional skills, there also came a hardening of attitudes towards what had been done in the past. Traditional public art came to be viewed with the same contempt as Victorian academic painting: ugly, pretentious, boring, it was dismissed as the epitome of everything that was out of touch with the modern view of the world. Stung into action by the remark of a friend that the statues of George Square should be disposed of because 'no-one cares about them', the Director of Glasgow School of Art, Douglas Percy Bliss, wrote a spirited article in the *Glasgow Herald* in 1954, lamenting what he saw as the increasingly philistine fashion for 'debunking' monuments of great men. At that time two of Paul Raphael

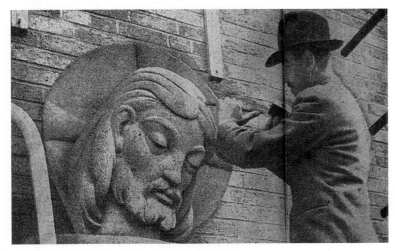

Edward Graham at work on *The Good Shepherd*. From the *Bulletin*, 10 November 1954.

Montford's figure groups from the Kelvin Way Bridge were still lying in the River Kelvin, having been toppled from their pedestals in a German bombing raid in 1941. Bliss describes how he had 'often regarded them down in the river bed and moralised inwardly on the decline and fall of sculpture in our city'.[19]

It was not only the 'philistines' who no longer cared: by this time such disdain for historic sculpture had become the orthodox position of anyone actively involved in the promotion of Modernism. In their post-war 'cautionary guide' to Scottish architecture, *Building Scotland*, Alan Reiach and Robert Hurd devote a page to the question of street furniture, illustrating their case with a cherub fountain by Cruikshank & Co., identical to one of the very first works discussed in this catalogue (see Alexandra Parade).[20] After rightly pointing out that such 'humble things as these can make or mar a street', they go on to express the view that: 'The lamp standards, kiosks and fountains in our towns are usually fussy and pretentious, unsuited in design for the simple jobs they have to perform.' Then comes the killer blow: 'As for our public monuments …!' (see illustration overleaf). It is more than anything the sheer casualness with which an entire tradition of public art is reduced to an ellipsis and an exclamation mark that reveals the depth to which it had sunk in the public's estimation, by this time. One is reminded of Ludwig Wittgenstein's famous dictum: 'Whereof we cannot speak we must pass over in silence.'

If traditional work was so unspeakably bad, what, we might ask, was the Modernist alternative? By and large the solution was left entirely to the artists themselves, and the answer they came up with was simply to treat public art as a continuation of their studio practices by other means. Richard Coley's untitled abstract design on the Stakis Hotel at 197–201 Ingram Street is a fine example of the strictly 'clip-on' approach to architectural sculpture in which the artist's personal agenda as a creative individual takes precedence over any form of shared public meaning. The controversy surrounding Paul Zunterstein's imposition of a naked mother and child on the gable end of a primary school on Ashgill Road provides an even more striking illustration of the widespread belief at that time that if a work of public art fails to please the public, then it must be the public, not the work, that is at fault.[21] Yet here is a work that was so out of keeping with the taste of the community it was meant to serve that it was necessary to cover it with a drape during the inauguration of the school (see illustration overfleaf), and it was only through an eloquent intervention by Douglas Percy Bliss that it was not taken down and destroyed immediately afterwards. Ignored, unloved and largely concealed by a strategically placed tree, it is, ironically, in far worse condition now than much of the 'traditional' Victorian work that was being so vehemently derided at the time it was made.

STREET FURNITURE

Such humble things as these can make or mar a street. The lamp standards, kiosks and fountains in our towns are usually fussy and pretentious, unsuited in design for the simple jobs they have to perform. As for our public monuments . . . !

Anywhere Newcraighall Craigmillar

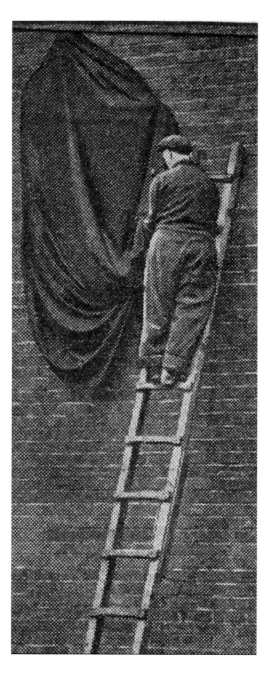

Page from *Building Scotland: a cautionary Guide*

(right) Paul Zunterstein, *Mother and Child* under canvas. *Scottish Daily Express*, 23 October 1953.

Public art in the later twentieth century

A detailed account of the vicissitudes of public sculpture as it laboured under and eventually liberated itself from the sterile dispensation of Modernism is beyond the scope of this short introduction. Suffice it to say that Glasgow, like many other British cities, has begun to embrace the full range of creative practices that constitute public art today, with new works appearing on the streets that are clearly informed by the lively theoretical debate in which those practices are now embedded. The concept of site-specificity has become a crucial concern here, shifting the focus of interest away from conventional questions of aesthetic 'quality' in the evaluation of individual pieces, to a more sophisticated appreciation of the requirements of the place in which it is located. The very notion of 'place' has itself been subjected to an extraordinary process of critical interrogation, and has now come to signify much more than the physical attributes of a location, but encompasses the subjective experience of the communities with which its identity is historically and demographically bound up. The recent removal from Buchanan Street of the egregious *Concept of Kentigern* (q.v., Appendix A, Lost Works) – a text-book example of the 1970s policy of arbitrarily 'parachuting' studio work into an alien context – provides evidence that the new thinking has begun to filter up into the more elevated regions of municipal decision-making.[22] In addition, a powerful independent infrastructure has begun to establish itself, with agencies such as Visual Art Projects and the Bulkhead public art prize in Glasgow, as well as the Edinburgh-based Art in Partnership, bringing a new level of critical self-awareness to the commissioning process which will help ensure that the blunders of the 1970s will remain firmly a thing of the past.

These developments are undoubtedly to be welcomed as changes for the better, but they bring certain difficulties with them as well, not least for a book such as this, which is committed to making a documentary record. Two problems are of particular concern here. To begin with the definition of what constitutes sculpture is now much more problematic than it was in the past, with no clear boundaries to enable us to distinguish easily between a work of sculpture and the products of that diverse range of practices denoted by the more general term 'public art'. The difficulty is especially acute in the case of works produced in conformity with what Susanne Lacey has defined as 'new genre public art', part of the purpose of which is to repudiate the conventional idea of a sculpture as a discrete physical object, fixed both in time and space.[23] Superficially, Douglas Gordon's *Empire* would appear to be both of these things, and a glance at the appropriate entry in the catalogue will confirm both its physical dimensions and the exact date on which it was installed in Brunswick Lane. However, as a mirror-reversed, semi-dysfunctional surrogate of a sign for a hotel that does not exist except in a 1950s film,

screenings of which may (or may not) occur from time to time in the pub on the opposite side of the lane … Such a work typifies the current trend in public art towards the use of what appear to be conventional sculptural processes to create something which is in fact very different. The *content* of the work, if such an old-fashioned term has any relevance here, is not its physical form but the pattern of interference it creates in the 'psycho-geography' of its immediate surroundings, including the puzzled responses of passers-by momentarily at a loss to know why a hotel sign has been erected on the windowless rear wall of a bank. To describe this technological will-o'-the-wisp as a work of 'sculpture' is tantamount to making what philosophers call a 'category mistake', and its inclusion in a publication which takes a bronze and marble statue of a Victorian worthy as its central paradigm will never be anything other than problematic.

The second difficulty concerns the question of transience, and the growing tendency among public artists to make work which has a deliberately limited life-cycle. There is a profound irony – and perhaps a certain sadness – in the fact that arguably the finest work of sculpture to have been produced in Scotland in the last twenty years was made specifically to be destroyed. In 1987, as part of the Mayfest celebrations of that year, George Wyllie was commissioned by TWSA-3D to make a forty-foot sculpture entitled *The Straw Locomotive*. Working with a team of retired engineers in the abandoned Hyde Park worksheds in Springburn, Wyllie hammered and bent and welded a mass of steel rods into a credible semblance of one of the great steam engines that until 1962 were manufactured in quantity in Glasgow and were exported to every part of the civilised world. In the event, a steel cage stuffed with straw turned out to be an object of remarkable beauty, combining formal elegance with an exceptional sensitivity to the nuances of structure. Above all it possessed the quality that all traditional sculpture strives to achieve: an unforgettable physical presence. Like his Scottish contemporary David Mach, Wyllie is aware of the profound satisfaction to be had from the contemplation of machines, and like Mach has developed a practice in which the aesthetic power of familiar objects is intensified through their transposition into an incongruous material. But in this case the fabrication of the object was only the first stage of a more complex process. On completion, *The Straw Locomotive* was paraded through the streets of Glasgow, and like the real engines of the city's industrial heyday, was delivered with a ceremonial flourish to the foot of another masterwork of ready-made industrial art, the monumental hammerhead crane that towers over the River Clyde at Finnieston.[24] Unlike its iron predecessors, however, Wyllie's locomotive was not hoisted onto a ship for delivery to a client in some other part of the globe: it was left to turn aimlessly in the wind, a forlorn reminder of the decline of Glasgow's historic industrial base. Two weeks later it was brought back to the ground and, in a spectacular finale, set ablaze. Within less than

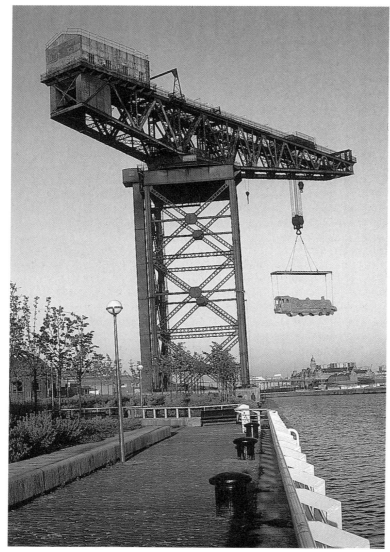

George Wyllie, *The Straw Locomotive*, 1987 [SS]

twenty minutes all that was left was a smouldering carcass, in the centre of which loomed an enormous question mark, the familiar calling card of Wyllie's practice as a Scotland's foremost 'scul?tor'.

The Straw Locomotive is only one of a number of works that have been produced in recent years in Glasgow which radically question the basis of traditional art practices while at the same time suggesting how they might be transformed to meet the very different cultural needs of a modern, post-industrial society. In 1972 Lawrence Alloway wrote that the predicament of contemporary public sculpture was that it had abandoned a tradition of monument-making that had served from classical times to the end of the Victorian era, but had failed to create a new tradition to take its place.[25] It would be premature to claim that such a new tradition has now finally been established. But the healthy climate of critical debate, together with the quality of much of the work that is now appearing in Glasgow, suggests that the prospects are not nearly as bleak as they once seemed. By providing a detailed documentary record of the best work from the past, along with a sympathetic acknowledgement of what is being produced today, it is hoped that the present book will make a small contribution to this vital and necessary debate.

The Catalogue

General

For the purposes of this study, the three terms used in the title are defined as follows:

Glasgow – the geographical area contained within the political boundary of the city indicated on the Ward Map issued by Glasgow City Council;

sculpture – free-standing commemorative monuments, architectural carvings including bas-reliefs and statues attached to buildings, drinking fountains, war memorials, columns and other independent structures, provided they incorporate portraits, allegorical figures or decorative work of exceptional quality; with some exceptions, sculptures in churches, churchyards and cemeteries are excluded;

public – existing in unregulated urban spaces and therefore freely accessible at all times; important works which have restricted access (mostly inside buildings) are also included.

Materials

The information relating to materials used for each item is as specific as possible. However, in those cases where the work is not physically accessible and the material is not identified in contemporary sources,

generic terms such as 'granite' or 'sandstone' (or more rarely 'stone') have been used.

Dimensions
Wherever possible monuments have been measured by hand. In the case of exceptionally large works the dimensions are usually known from contemporary documentation; otherwise an estimate, indicated by the abbreviation 'approx.', has been used. Certain types of work, such as reclining or crouching figures, are difficult to measure precisely, and in many cases a notional indication of their scale is given by the use of descriptive terms such as 'life-size' (approximately 1.75m high when standing), 'larger than life-size' (significantly larger than an average person) and 'colossal' (one and a half times life-size or larger). All measurements are given in the metric scale, with height preceding width and depth, though in some cases, in order to avoid ambiguity, the axis referred to in the measurement is specified.

Listed status
This information is taken from the *Street Index of Buildings of Special Architectural or Historic Interest*, published by Glasgow City Council in October 1998, and which includes free-standing monuments as well as buildings. Sculptures housed within or attached to listed buildings, or which appear within a designated area (such as the Necropolis), automatically assume the listed status of the building or area. In Scotland there are three categories, defined as follows:

Category A works of national or international importance;

Category B works of regional or local importance;

Category C(S) works of more modest historical or artistic interest.

The C(S) category replaces the former Category C, which was non-statutory.

Ownership
The term 'owner' is used here to encompass not only the individuals and organisations who are literally the owners of specific pieces, and to whom the work may be legally ascribed as property, but also those who might more properly be designated as custodians. The principal concern is to establish the body in whom duty of care resides. In the vast majority of cases, free-standing monuments are commissioned by private or public subscription and later accepted into the care of the local authority. The rules governing this process are, however, far from clear, and there are several recent works listed below which were commissioned by bodies that no longer exist, but for which the council has not so far formally acknowledged stewardship. Architectural sculpture also frequently presents difficulties, particularly those schemes which extend across large buildings with multiple occupants and more than one feu holder. The main source of information here is the city council's eleven-volume commercial Valuation Roll, which lists the names of property owners as registered on 1 April 2000. Unfortunately, not every property falling within the purview of the catalogue is listed in this document, and in a small number of cases the owner of the building has proved impossible to identify.

Condition
This section is not intended as a technical evaluation, but merely a record of the visual appearance of the particular item at the time of viewing. Whenever relevant, a brief account of the repair, maintenance and conservation work that has been carried out on the monument in the past is also included.

Sources
This section lists all known sources of information of any significance relating to the work, even when such information has not been made use of directly in the catalogue entry itself, and therefore does not appear in a footnote. Items are listed in chronological order. As a rule, a detailed citation is given for all articles in newspapers and periodicals, including page (but not column) references, though it should be noted that this has not always been possible when the article has been sourced from a clipping. In the case of very brief or minor references, citations are given in an abbreviated form, as are those in the Appendices. For brevity, books cited on a regular basis, both in the sources section and in the footnotes, are usually referred to by the name(s) of the author(s) as they appear in the Bibliography.

Selected Biographies
Detailed biographical profiles are provided only for makers whose works appear in the main catalogue. Artists whose contributions were peripheral or relatively slight (such as assistants) have usually been excluded, as have those about whom no significant information has been found. For artists mentioned in the Appendices, dates and other brief biographical details are given at the point where their names arise.

Notes
1. Andor Gomme and David Walker, *Architecture of Glasgow*, London, 1968.
2. Benedict Read, *Victorian Sculpture*, Yale, 1982.
3. Benedict Read and Philip Ward-Jackson, *Courtauld Institute Illustration Archives: Archive 4, Late 18th and 19th Century Sculpture in the British Isles, Part II, Glasgow*, London, 1984.
4. Harry Teggin, Ian Samuel, Alan Stewart and David Leslie, *Glasgow Revealed: a Celebration of Glasgow's Architectural Carving and Sculpture*, Glasgow, 1988;

Gary Nisbet, 'Gary Nisbet's City of Sculpture', *The Scots Magazine*, August 1990, pp.520–5.

5. Ray McKenzie, *Sculpture in Glasgow: an illustrated handbook*, with research by Gary Nisbet and Tracy Smith, Glasgow, 1999.

6. Anon., 'King William's Statue, the life-story of its donor', GH, 17 February 1894.

7. David Bruce, *Scotland the Movie*, Edinburgh, 1996, p.144.

8. *Ibid.*, p.120.

9. See, for example, *Sunday Herald*, 27 February 2000, p.9.

10. Josie Saunders, 'Leave our statues alone', ET, 26 July 2000, pp.8–9.

11. Terry Cavanagh, *Public Sculpture of Liverpool*, Liverpool, 1997; George T. Noszlopy, edited by Jeremy Beach, *Public Sculpture of Birmingham*, Liverpool, 1998.

12. Anna Ritchie, *Govan and its carved stones*, Forfar, 1999.

13. Cavanagh, *op. cit.*, pp.xiv–xvii.

14. *Edinburgh Evening Post*, quoted in Anon., 'Marochetti's statue of the Queen', ILN, 16 September 1854, p.50.

15. Quoted in Philip Ward-Jackson, 'Carlo Marochetti and the Glasgow Wellington memorial', *Burlington Magazine*, vol.132, no.1053, December 1990, p.861.

16. Tubal-Cain, 'Notable New Buildings in Glasgow', BI, 16 June 1890, p.58.

17. Anon., *Unveiling of the statue of Dr. Macleod 1881*, Glasgow, 1881, p.17.

18. *Glasgow Weekly Herald*, 11 October 1913, p.9.

19. Douglas Percy Bliss, 'Sculpture in Glasgow', GH, 20 February, 1954, p.3.

20. Alan Reiach and Robert Hurd, *Building Scotland, Past and Future: a cautionary guide*, Glasgow, n.d. (c.1950), n.p.

21. William Turnbull: 'the problem with public sculpture is largely with the public – not with the sculpture'. Quoted in Lawrence Alloway, 'The public sculpture problem', *Studio International* (184), October 1972, p.123.

22. For a fuller discussion, see Catherine Deveney, 'I don't know much about art, but I know what I like', *Scotland on Sunday*, 5 March 2000, pp.10–15 (incl. ills).

23. Suzanne Lacey (ed.), *Mapping the Terrain: New Genre Public Art*, Seattle, 1995, p.19. See also David Harding (ed.), *Decadent: Public Art: Contentius Term and Contested Practice*, pp.9–19.

24. See Heather Lyall, *Vanishing Glasgow*, Aberdeen, 1991, pp.92–3; Andrew Patrizio, *Contemporary Sculpture in Scotland*, Sydney, 1999, pp.138–9.

25. Alloway, *op. cit.*, p.123.

Abbreviations

A — *The Architect*
AA — *Academy Architecture*
ABJ — *The Architects' and Builders' Journal*
ACGB — Arts Council of Great Britain
ACR — *Architect and Contract Reporter*
AJ — *Architects' Journal*
B — *Builder*
BA — *British Architect*
BC — *Building Chronicle*
BI — *Building Industries and Scottish Architect*
BJ — *Builders' Journal*
BJAE — *Builders' Journal and Architectural Engineer*
BN — *Building News*
CI — *Calendar of Confirmations and Inventories* (MLG)
EB — *New Encyclopædia Britannica*
EC — *Evening Citizen*
ECA — Edinburgh College of Art
ET — *The Evening Times*
GAGM — Glasgow Art Gallery and Museum
GAPC — *Glasgow Advertiser and Property Circular*
GCA — Glasgow City Archive
GCC — Glasgow City Council
GCCJ — *Glasgow Chamber of Commerce Journal*

GDA — Glasgow Development Agency (now Scottish Enterprise Glasgow)
GG — *Glasgow Gazette*
GH — *Glasgow Herald*
GP — *Govan Press*
GSA — Glasgow School of Art
GSS — Glasgow Sculpture Studios
GUABRC — Glasgow University Archive and Business Record Centre
GWH — *Glasgow Weekly Herald*
H — *The Herald*
HAG — Hunterian Art Gallery
ILN — *Illustrated London News*
LBI — Listed Buildings Index. ('Buildings of Special Architectural or Historic Interest. Combined Statutory and Descriptive List', compiled by Historic Scotland)
MLG — Mitchell Library, Glasgow
NATS — National Art Training School, South Kensington (after 1896 the Royal College of Art)
NBDM — *North British Daily Mail*
NGS — National Galleries of Scotland
NLG — *The Northern Looking Glass*
NMRS — National Monuments Record of Scotland
NPG — National Portrait Gallery, London

POD — *Post Office Glasgow Directory* (MLG)
RA — Royal Academy of Art
RBS — Royal Society of British Sculptors
RGIFA — Royal Glasgow Institute of Fine Arts
RIBA — Royal Institute of British Architects
RIBAJ — RIBA *Journal*
RSA — Royal Scottish Academy of Art
SAC — Scottish Arts Council
SAR — *Scottish Art Review*
SLTAS — South London Technical Art School (est. 1879 as Lambeth School of Art)
SNGMA — Scottish National Gallery of Modern Art, Edinburgh
SNMR — Scottish National Monuments Record
SNPG — Scottish National Portrait Gallery, Edinburgh
V&A — Victoria and Albert Museum, London
VM — Virtual Mitchell (Mitchell Library online picture catalogue)

Acknowledgements

The research for this book was carried out between 1995 and 2000, during which time Glasgow School of Art provided accommodation and institutional support for the research team. I wish to record my gratitude to those members of the management and senior academic staff who authorised the use of the School's facilities in this way: Jimmy Cosgrove, former Depute Director; Steve Mulrine and Jane Allan, successive Heads of the Department of Historical and Critical Studies. I am also indebted to my immediate colleagues in the Department of Historical and Critical Studies, who generously allowed me the opportunity to devote a period of sabbatical leave to the project at a critical time, and whose encouragement throughout has been invaluable. In addition, I received regular assistance from a number of individual members of School staff, among whom I must acknowledge the following: Liz Arthur, Adele Ashley-Smith, Ross Birrell, Kathleen Chambers, Paul Cosgrove, David Harding, Ian Johnstone, Juliet Kinchin, Nicholas Oddy, George Rawson, Susannah Thompson and Peter Trowles. Sincere thanks are due to the members of the research team, without whose detective work this book could never have been written; these include Rob Close, Alexia Holt, Tracy Smith and Mathew Withey, all of whom participated in the project at various times, and Gary Nisbet, whose wide-ranging knowledge and experience of the subject proved essential in bringing the work to completion. Among my colleagues in the Public Monuments and Sculpture Association I must thank the members of the editorial board – Jo Darke, Ian Leith, Edward Morris, George Noszlopy, Benedict Read and Alison Yarrington – for their careful scrutiny of the text and the many valuable improvements they suggested. I would also like to extend my warmest thanks to the staff of Liverpool University Press, particularly Janet Allan, whose sympathy, understanding and patience proved impervious to the multitude of problems that arose during the production process.

My collaborators and I were greatly assisted by the cooperation of many artists whose work is recorded here, and their readiness to provide biographical information is much appreciated. Our thanks go to the following: Michael Dan Archer, Stan Bonnar, Michele de Bruin, Jim Buckley, Doug Cocker, Richard Coley, John Creed, Alan Dawson, Helen Denerley, Jules Gosse, Edward Graham, Paul Grime, Sybille von Halem, Kenny Hunter, Robert Hutchison, Brian Kelly, Jake Kempsell, Shona Kinloch, Rick Kirby, Russell Lamb, John McArthur, Hector McGarva, Andy Scott, William Scott, Callum Sinclair, Stephen Skrynka, Jack Sloan, Alexander Stoddart and Sean Taylor.

Similarly, we would like thank the many other individuals and organisations who responded to our requests for information: Art in Partnership; Neil Baxter, Neil Baxter Associates; Dr Gilbert Bell and Andrew Stewart, Springburn Museum; Calum Black, Peter Downing, Lucille Furie, Bert de Jong, Tom McAllister, Fiona McDermott, Iain Paterson and Andrew Pollock, Glasgow City Council; David Bruce; Lucy Byatt, Visual Art Projects; Hamish Dawson; Michael Donnelly; Harry Dunlop, the People's Palace Museum; James Durward, Glasgow Institute of Architects; John Ferry, Arts and Cultural Development Office, Castlemilk; Mathew J. Finkle, Castlemilk Environment Trust; Katharine Gibson; Andrew Guest, the Scottish Sculpture Trust; Laura Hamilton, the Collins Gallery; Ian Harrison; Giles Havergal, the Citizens' Theatre; David Hogg, Turner & Townsend Project Management; Andrew Jackson, Alison Gardiner, Irene O'Brien, Robert Urquhart and Edmund Wyatt, Glasgow City Archives; Stefan King, King City Leisure; Maurice Lim; Tom Macartney, Director, Crown Street Regeneration Project; Ewan MacBeth, the Merchants' House of Glasgow; Ian McConnochie, Department of Civil Engineering, University of Glasgow; Dr Jim McGrath, Strathclyde University Archive; David McLaughlin; Neil McLeish, Hugh Martin Partnership; Rory McLeod, Railtrack plc; the staff of the Glasgow Room, the Mitchell Library, Glasgow; Chris Mummery, Chris Simmons, David Page and David Park, Page & Park, Architects; Helen Redmond-Cooper, the Bank of Scotland; Alison Robertson and Christine McAllister, Scottish Mutual Association plc; Pamela Robertson and Anne Dulau, the Hunterian Art Gallery; Johny Rodger; Dr Ingrid Roscoe; Graham Roxburgh, Roxburgh & Partners, Civil Engineers; Stewart Shaw; Beverley Ballin Smith, Glasgow University Archaeological Research Division; George Fairfull Smith; Hugh Stevenson, Glasgow Museum and Art Gallery, Kelvingrove; Fraser Stewart, New Gorbals Housing Association; Professor Nigel Thorp, Centre for Whistler Studies; Alma Topen and Kate Hutcheson, Glasgow University Archive and Business Record Centre; David Ward; Philip Ward-Jackson, Courtauld Institute of Art; Vicki Wilkinson, the Royal Bank of Scotland; Lucy Wood; Graeme Woolaston and Lorraine Wilson, Glasgow Sculpture Studios.

Thanks are due to the numerous sponsoring organisations and their representatives who have contributed to the funding of the project: Glasgow School of Art Research Fund; Glasgow City Council; the Paul Mellon Centre for Studies in British Art; the Arts and

Humanities Research Board; David Leslie, Ian Samuel and Alan Stewart of the Glasgow Revealed Trust, whose sponsorship of the earlier publication *Sculpture in Glasgow: an illustrated handbook* contributed indirectly to the present project; Scottish Enterprise Glasgow, whose generous subvention was made in compliance with their mission to work with others to make Glasgow one of the great cities of Europe for the benefit of all its citizens; the N.S. Macfarlane Charitable Trust.

Last but not least, I wish to thank my wife Lorraine, and our two daughters Lucy and Kerry for their unflagging support throughout the long and often stressful process of writing this book.

Picture Credits

The majority of the photographs in this book were made by Allan Crumlish. Other photographers and sources are identified as follows: AL – Andrew Lee; AP – Art in Partnership; BB – Bill Brown; CIA – Courtauld Institute of Art; CS – Callum Sinclair; GAGM – Glasgow Art Gallery and Museum; GN – Gary Nisbet; GSA – Glasgow School of Art; HAG – Hunterian Art Gallery; JK – Juliet Kinchin; MLG – Mitchell Library, Glasgow; RJ – Robert Johnstone; RM – Ray McKenzie; SS – Stuart Shaw; ST – Susannah Thompson. The publishers are grateful to all the above for granting permission to reproduce their work.

RAY McKENZIE
Glasgow School of Art

Glasgow City Council Departments of Architecture and Related Services, 18–58 Albion Street / 20–46 Trongate

Pediment Group and Associated Decorative Carving

Sculptors: Holmes & Jackson

Architects: Thomson & Sandilands
Builders: Ebenezar McMorran (Trongate);
 McKissock & Gardner (Albion Street)
Date: *c*.1901–5
Material: red sandstone
Dimensions: figures larger than life-size
Inscription: on an escrol in the attic pediment –
 LET GLASGOW FLOURISH
Listed status: category B (15 December 1970)
Owner: Glasgow City Council

Description: Combined tenement and warehouse in an Edwardian 'freestyle' idiom, with a Renaissance palace frontage on Albion Street and a more Baroque accent introduced by the domed tower on the corner of the Trongate. The most substantial carving is concentrated on the central bays of the Albion Street façade, which is dominated by a series of vertically aligned pediments of various designs. Above the door is a pair of semi-naked female figures emblematic of *Justice* (left, holding scales) and *Law* (right, holding a sword) reclining on inverted cornucopias on either side of a shield bearing a cross of St George, and with a crown above. The theme of the home countries is developed in the storeys above, with Ireland represented by a panel containing shamrocks on the second floor, and Scotland by a cartouche decorated with thistles on the third. This part of the scheme is completed by a Glasgow coat of arms, richly ornamented with floral motifs and ribbons in the attic. Minor work elsewhere on

Holmes & Jackson, *Pediment Group*

the building includes a series of panels containing more emblematic flowers (thistle, rose and shamrock) below the giant Ionic pilasters on the main storeys, and a number of decorative features on the corner tower, including snarling lion masks, swags and festoons.

Discussion: The building was erected in two stages by the City Improvement Department (formerly Trust), and formed part of a comprehensive redevelopment of the area bounded by Trongate, Nelson (now Albion) Street, Bell Street and High Street.[1] A later phase of the scheme (1911–14) involved the demolition of the former Tontine Hotel, from which the celebrated keystone masks known as the 'Tontine Faces' (now in St Nicholas Garden, Castle Street, q.v.) had been removed some years earlier. Holmes & Jackson are recorded as having been paid £259 8s. in

December 1901, for their carvings on the 'corner of Nelson Street and Bell Street',[2] but it is unclear whether or not this included the figurative work in the central pediment. In view of the fact that William Morgan & Young were paid £307 13s. for the much more modest programme of decorative work on the similar building on the opposite side of Albion Street two years later,[3] it seems likely that the figurative work was paid for separately.

Condition: Good.

Notes
[1] GH, 18 January 1902, p.9. [2] GCA, C1/3/29, 'Sub-Committee on Northern District Properties', p.129. [3] GCA, C1/3/31, p.488, 25 February 1904.

Other sources
BI, 15 November 1901, supplement pp.iv, 125, 16 December 1903, p.141, 16 December 1914, p.139; B, 25 March 1905, p.331; BJ, 28 November 1906, pp. 265 (ill.), 273; GCA, C1/3/31, p.382; McKean *et al.*, p.29; Williamson *et al.*, pp.169, 180.

Alexandra Parade DENNISTOUN

At the entrance to Alexandra Park
Drinking Fountain with Cherub
Sculptor: not known

Founders: Cruikshank & Co. Ltd (attrib.)
Date: *c.*1880
Material: cast iron
Dimensions: canopy approx. 3m high × 90cm
 square at base; cherub 67cm high
Listed status: category B (17 June 1992)
Owner: Glasgow City Council

Anon., *Cherub Fountain* [RM]

Description: A standard late-nineteenth-century public drinking fountain, enclosed in a canopy consisting of an ornate dome raised on four slender stanchions. The drinking bowl is supported by a squat, fluted pillar, with a cherub rising from the centre. Naked except for a cape thrown over his shoulder, the cherub is seated on a tilted pitcher and leans on a paddle.

Discussion: No manufacturer's name is visible on the work, but the similarity of certain details – including the cherub, the inverted crocodiles on the ribs inside the dome and the drop tracery in the arches – to those on the *John Aitken Memorial Fountain* (q.v., Govan Cross, Appendix B., Minor Works) strongly suggest Cruikshank & Co. as the makers. The cherub is a particularly interesting feature, as figures of apparently identical size and design were also used on the outer bowl of the *Stewart Memorial Fountain* in Kelvingrove Park (q.v.). This raises important questions of attribution. For many years it was assumed that the Kelvingrove cherubs were modelled by John Mossman as part of his contribution to the bronze components of the scheme. If this is the case, the probability is that Mossman sold the design to Cruikshank for mass production. A more likely alternative is that the cherub was a standard item in the Cruikshank catalogue, available for purchase independently of their own ornamental works. Unfortunately, the Cruikshank company records have been lost, and it has not been possible to confirm this.

The fountain originally stood immediately in front of the railings, a few yards north-east of its present location. It is no longer functional.

Related work: Other examples of the use of the cherub in ornamental drinking fountains include Middleton-in-Teesdale, Co. Durham (1879), St Botolph's, Aldgate (1903) and Newcraighall, Scotland (n.d.).[1]

Condition: Heavily coated with green, black and gold paint, with some damage to the base plate.

Note
[1] Philip Davies, *Troughs and Drinking Fountains*, ('Chatto Curiosities of the British Street'), pp.93, 111 (incl. ills); Reiach and Hurd, n.p.

Other sources
LBI, Wards 23/24, p.2; Williamson *et al.*, p.447; Stuart (1995), p.11 (ill.).

In the centre of Alexandra Park
Saracen Fountain
Sculptor: David Watson Stevenson

Founder: Walter Macfarlane & Co.
Date: 1901
Re-erected: 1914
Material: cast iron
Dimensions: fountain 11.2m high; basin 12.2m
 diameter; figures life-size
Inscriptions: on shields attached to the front
 faces of three of the lower pedestals –
 WALTER MACFARLANE & CO /
 ARCHITECTURAL / SANITARY & ARTISTIC /
 IRONFOUNDERS / SARACEN FOUNDRY /
 GLASGOW
Listed status: category A (17 June 1992)
Owner: Glasgow City Council

Description: Elaborate three-stage ornamental fountain in the centre of a wide circular pool. At the base is a series of four rectangular buttresses projecting outwards in a cruciform arrangement from an arched octagonal chamber. The buttresses also function as pedestals for a set of four classically draped allegorical female figures which may be identified, clockwise from the north-west, as: *Science* (holding a retort); *Literature* (with a book open on her lap); *Commerce* (seated on a miniature ship with entwined sea monsters on the stern); *Art* (with a theatrical mask and a lyre at her feet). The middle stage is in the form of a

David Watson Stevenson, *Saracen Fountain* [RM]

circular peristyle of the Composite order, closely modelled on the choragic Monument of Lysicrates (334 BC, Athens). The octagonal drum on which it sits carries a series of relief panels illustrating the signs of the Zodiac and the months of the year, while the entablature provides support for an intermediary water basin decorated with wave patterns, bunches of fruit and eight sea urchins blowing pipes. The

topmost stage of the structure consists of a third water container, in this case in the form of a quatrefoil bowl supported by the entwined tails of inverted sea monsters. Additional decorative features include friezes of shells and other natural forms in the cornices of the pedestals and in the voussoirs of the central arches, lion masks projecting from the central chamber and further wave patterns under the rim of the lower basin. The overall design of the structure allows water to descend from the rim of the upper bowl and from the mouths of the sea monsters

into the middle basin, and to enter the main pool through the mouths of the lion masks and the pipes of the urchins above the peristyle.

Discussion: The fountain was originally erected in Kelvingrove Park in 1901 as part of the Glasgow International Exhibition. Situated near the Rockery Bandstand a short distance north of the Kelvin Way Bridge, it was one of the exhibition's chief attractions, and became a 'focal point of evening entertainments'.[1] At the conclusion of the exhibition Walter Macfarlane offered the fountain for sale to Glasgow Corporation, but the Town Clerk replied that the finance sub-committee was unable to recommend purchasing the work 'at the price offered'.[2] In January 1902, Macfarlane wrote again, this time offering the fountain to the city as a gift. This was accepted,[3] but there was a delay of several years before any action was taken. A photograph of Kelvingrove Park taken on 19 July 1905 from the tower of Glasgow University shows the fountain still *in situ*, a short distance north of the bridge over the River Kelvin, and it was not until plans were drawn up for the replacement of the bridge in 1912, and the creation of Kelvin Way, that serious consideration was given to the question of its location (see Kelvin Way Bridge, Kelvingrove Park).[4] Macfarlane himself offered to dismantle and re-erect the fountain in another part of Kelvingrove Park for £150, with an additional charge of £50 for preparing the foundations.[5] Two locations were considered, including a site immediately to the west of Kelvingrove Museum, but neither proved satisfactory, and in January 1914, after many months of discussion, Macfarlane agreed to move the fountain to Alexandra Park 'on the same terms and conditions specified' in his offer of 1912.[6]

Related work: Identical copies of the fountain were erected in Town Hall Park, Warrington, Cheshire, and in the Sammy Marks Zoological Gardens in Pretoria, South Africa. The Warrington fountain was destroyed in 1942 as a 'patriotic gesture ... for the war effort', but

is survived by a model in the Warrington Borough Council's silver collection.[7] The Pretoria version is still extant.

Condition: The fountain was painted in August 2000, but it is not known how closely the current blue, indigo and gold colour scheme corresponds to the fountain's original appearance. Structurally, the work is sound, though some of the gold paint on the figures is flaking and there is some surface rust.

Notes
[1] Kinchin and Kinchin, p.86. [2] GCA, C1/3/29, p.191. [3] *Ibid.*, p.282. [4] *Ibid.*, C1/3/47, p.2755. [5] *Ibid.*, C1/3/48, p.275. [6] *Ibid.*, C1/3/49, p.2629, C1/3/50, pp.305, 526, 803. [7] Information provided by Mary Griffiths, Co-ordinator, Merseyside and Cheshire Regional Archive Centre.]

Other sources
GCA, AGN 2006/7, miscellaneous documents; 'Glasgow's Victorian heritage of fountains', GH, 23 March 1953; LBI, Wards 23/24, p.2; Williamson *et al.*, p.447, **87**; Stuart (1995), p.13 (incl. ill.).

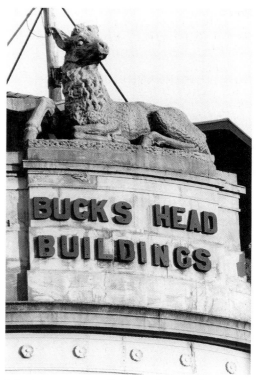

John Mossman (attrib.), *Couchant Buck*

Argyle Street MERCHANT CITY

Buck's Head Building, 63 Argyle Street / 3–11 Dunlop Street

Couchant Buck

Sculptor: John Mossman (attrib.)

Architect: Alexander Thomson
Date: 1863–64
Material: yellow sandstone
Dimensions: larger than life-size
Inscription: in raised lettering below buck –
 BUCK[']S HEAD / BUILDING
Listed status: category A (15 December 1970)
Owner: not known

Description: The buck is an acroterion on the curved attic on the Dunlop Street corner, and is shown couchant on a roughly carved plinth with one foreleg raised and head slightly tilted back. It is carved from a single block, and the sculptor has made a crude attempt to suggest the surface texture of the animal's coat and mane. The remainder of the building is decorated with a variety of Greek ornamental details, including anthemion and acanthus motifs in both cast iron and stone.

Discussion: The building was designed as a warehouse by Alexander 'Greek' Thomson, and takes its name from the Buck's Head Hotel, which had earlier occupied the site. It is of interest as one of the earliest examples in Europe of the use of structural cast iron exposed on the exterior, and as the only executed work by this important architect incorporating animal sculpture. In 1910, the architect Lionel Budden criticised the building for what he regarded as its 'excessive ornament', stating that the 'whole of the carving on this deplorable front is said to have cost a little under 300*l*'. He also makes the interesting observation that due to the disappearance of the 'old school of stonemasons, trained in the Classic traditions', Thomson had to

> ... make complete drawings himself of every individual piece of detail and insist on them being literally followed out to measure. Whilst this arrangement involved great additional labour ... it resulted in considerable economy.[1]

Whether this included the design of the buck is unclear. A more recent, and more sympathetic analysis is offered by Alexander Stoddart, who suggests that the

> ... eponymous Buck ... is firmly composed and cut, and conveys something of its species' *nerve* as it surveys Argyle Street from the cast-iron glade of its lower structure. But as a work of sculpture it has significance, since Thomson was to design for this class of work rather extensively, though mainly for unexecuted projects ... Mossman's hand can be presumed, although he is not well known as an *animalier*. The various representations of cattle on Carrick's later Meat Market (*c.*1875) [see Graham Square] bear resemblances to the handling of the buck, but they, too, are undocumented.[2]

Condition: Good, though slightly weathered.

Notes
[1] Lionel B. Budden, 'The Work of Alexander Thomson', B, 31 December 1910, p.187. [2] Stoddart (1994) p.84.

Other sources
Young and Doak, no.40 (incl. ill.); Gomme and Walker, pp.145–52 (incl. ill.); Ronald McFadzean, *The Life and Work of Alexander Thomson*, London, 1979, pp.143–6 (incl. ills); Williamson *et al.*, p.170; McKean *et al.*, p.64.

Commercial block, 116–20 Argyle Street

Eight Keystone Masks

Sculptor: Archibald Macfarlane Shannan (attrib.)

Architect: William Spence
Date: 1873
Material: yellow sandstone
Dimensions: approx. 36cm high
Listed status: category B (4 September 1989)
Owner: Prudential Assurance Co. Ltd

Description: The masks are located in the arches of the second-floor windows, with six bearded males and two females grouped in a 3–2–3 sequence.

Discussion: The building originally extended through to Buchanan Street, as part of Fraser & McLaren's warehouse, built at a total cost of £20,000.[1] This included a courtyard in which the arches were decorated with a series of keystone masks salvaged from the former Tontine Hotel on the Trongate by the builder Peter Shannan. It is believed that he commissioned his son, the sculptor Archibald

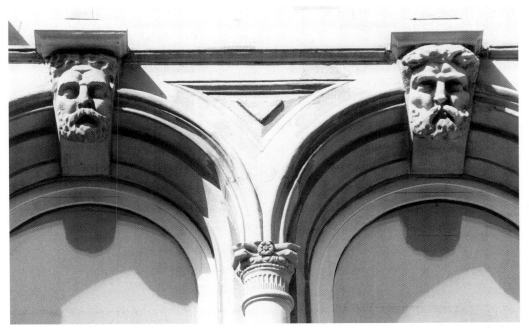

Macfarlane Shannan to complement the series with a number of new masks, possibly including the eight on this façade. The Buchanan Street courtyard was burnt down in October 1888[2] and the Argyle Street frontage is the only surviving part of the scheme. The quality of the carving in the masks is not especially high, but they are of interest because of their possible connection with the 'Tontine Faces'. (For a full discussion of the masks, see St Nicholas Garden, Castle Street.)

Condition: Very worn.

Archibald Macfarlane Shannan (attrib.),
Keystone Masks

Notes
[1] BN, 19 September 1873, p.325. [2] GH, 16 October 1888, quoted in Cowan, p.402.

Other sources
LBI, Ward 25, p.8; Gomme and Walker (1987), p.305; Williamson *et al.*, p.171.

Fraser's Department Store, 134–56 Argyle Street/1–19 Buchanan Street/Mitchell Street

Pair of Atlantes, Narrative Tympanum and Decorative Masks

Sculptor: William Vickers

Architect: Horatio Kelson Bromhead
Masons: P. & W. Anderson
Date: *c*.1899–1903
Materials: granite (atlantes) and yellow sandstone
Dimensions: atlantes 2.75m high; pediment figures life-size
Inscription: on the 4th floor of the Argyle Street frontage – STEWART; MCDONALD
Listed status: category B (15 December 1970)
Owner: House of Fraser Ltd

Description: This six-storey building in the Renaissance style occupies the entire north side of Argyle Street between Buchanan and Mitchell Streets, and has one of the most extensive frontages of any commercial building in Glasgow. The atlantes are located in the western section of the Argyle Street façade, flanking the main entrance and acting as supports for the large, curvaceous balcony projecting from the floor above. Conceived as stooped giants, with frowning expressions and exaggerated musculature, they provide an appropriately monumental introduction to a building estimated at the time to be 'the largest warehouse of its kind in Britain'.[1] Stylistically they make an interesting comparison with William Mossman's earlier Atlantes on the Mitchell Theatre (Granville Street, q.v.), the only doorcase figures in Glasgow of equal scale and grandeur. Like Mossman's figures, they are naked apart from a knee-length skirt overlaid

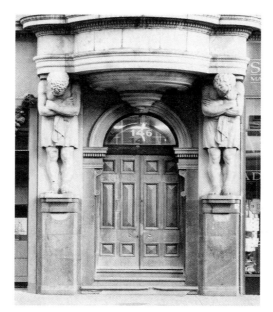

William Vickers, *Atlantes* [RM]

with a length of knotted cloth suspended from the waist. Vickers' figures, however, are much more static in their posture, with their weight borne equally by both legs and the superstructure resting directly on their shoulders. They are also identical in design, with the exception of their arms, which are folded in reverse directions, and minor differences in the treatment of their hair and beards. In popular folklore, they were known in the past as 'Stewart and McDonald', after the inscription on the frieze on the fourth floor.[2] Above them, in the attic, is a pediment with groups of allegorical figures ranged on either side of an oculus. Those of the left are classically dressed females, one of whom is accompanied by a bull (Europa?) while another

carries a trident; those on the right are oriental, and include an Egyptian, an Indian (with an elephant), an African and a Chinaman.

All three frontages have decorative masks and medallions in the friezes between the second- and third-storey windows, with thirteen on Buchanan Street, nine on Argyle Street and three on Mitchell Street. Those on Buchanan Street are all bearded male masks, apart from a clean-shaven youth shown in profile in the southernmost bay. The remainder are variously male or female, young or old, frontal or profile, with no apparent consistency in their arrangement.

Discussion: The building was designed as a warehouse for the wholesale drapery merchants Messrs Stewart & McDonald, a company whose extensive international trading activities are reflected in the global references in the pediment. The construction, which was completed in several stages, involved the demolition of their existing warehouse on Argyle Street, as well as the widening and straightening of the lower section of Buchanan Street.[3] The western half of the Argyle Street section was built first, so it is fair to assume that the sculpture programme was completed well before 1903, although this cannot be confirmed by the surviving documentation. A published version of Bromhead's proposal shows a standing figure at first-floor level on the corner with Buchanan Street.[4] This was not executed, and in the final scheme its place was taken by a balcony.

The entire block, together with Stewart & McDonald's original premises at 21–31 Buchanan Street, built by William Spence *c*.1879, were amalgamated into a single department store in 1975.

Condition: The granite atlantes are in excellent condition, though there is some wear on the sandstone parts of the scheme. The cartouches which originally decorated the pedestals under the atlantes have been removed.

Notes
[1] GAPC, 18 April 1899, n.p. [2] Cowan, pp.166–7 (incl. ill.). [3] GAPC, 17 May 1898, n.p., 18 April 1899, n.p. [4] *Ibid.*, 17 May 1898, n.p.

Other sources
GCA, TD13009/A204; A, 3 July 1903, p.7 (incl. ill.); Gomme and Walker, p.112 (ill.); Jack House, 'Ask Jack', ET, 17 May 1978, 13 June 1979; Michael Moss and Alison Turton, *A Legend of Retailing: House of Fraser*, 1989, p.33; McKean *et al*, p.69; Williamson *et al.*, 171; McKenzie, pp.64 (ill.), 65.

Argyle Street ANDERSTON

Former Anderston Savings Bank, 752–6 Argyle Street / 3–7 Shaftesbury Street

Figurines, Angels and Associated Decorative Carving

Sculptor: Albert Hemstock Hodge

Architects: James Salmon Junior and John Gaff Gillespie
Mason: John Kirkwood
Date: 1899–1902
Material: red Dumfriesshire sandstone
Dimensions: figurines 80cm high; angels approx. 1.2m high
Inscriptions: on the entrance arch in raised gilded letters – SAVINGS BANK OF GLASGOW; coat of arms, left capital – NEMO ME IMPUNE LACESSIT (trans.: 'no-one provokes me with impunity'); coat of arms, right capital – LET GLASGOW FLOURISH ; in entrance mosaic – ANNO DOMINI MDCCCC; on money bag – £10; on two tower panels – ANDERSTON BRANCH; in raised numerals on shield below dome – A / D / 1 / 9 / 00
Listed status: category A (15 December 1970)
Owner: Glasgow City Council

Description: A combined commercial and domestic block of five storeys in the Glasgow Style, with carved decoration concentrated on the main door and the domed corner tower. Flanking the arched entrance are groups of plain pilasters *in antis*, with capitals occupied by tight clusters of male and female figurines. Each capital has two figures facing outwards and acting as supporters for a coat of arms (left: Scottish, held by soldier and winged female figure; right: Glasgow, held by medieval maiden and soldier), with Saints Andrew and Mungo tucked behind in the respective re-entrant angles. Above the door is a semi-circular tympanum with a peacock mosaic by the British & Italian Mosaic Company.[1] This is divided in the centre by a miniature tabernacle composed of spiralling tendrils and clusters of stylised leaves. The springing of the outer arch is marked by a pair of roundels containing sleeping babies, while the keystone is filled with a child holding a knife and a chalice. Directly above the first-floor window in this bay a larger roundel shows Henry Duncan, the founder of

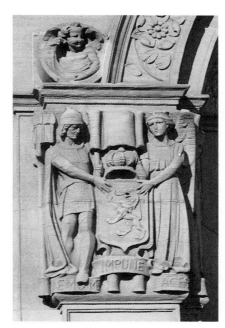

Albert Hemstock Hodge, *Figurines* [GN]

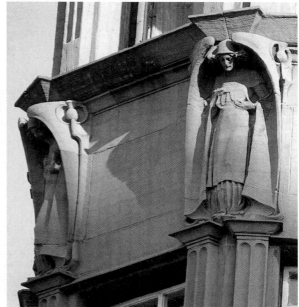

Albert Hemstock Hodge, *Angels* [GN]

the Savings Bank Movement, holding a money-bag and tapping his forehead in a gesture recommending financial prudence.[2] The elliptical border from which his head protrudes is inscribed with circles which may represent coins.

In the lower section of the corner tower is a pair of inscription panels, with letterforms in the distinctive Glasgow Art Nouveau manner, and the surrounding flora stylised into neatly symmetrical branches with spoon-like petals. On the second storey, the exposed faces of the tower are divided by a series of full-length angels. These have their heads lowered and their wings folded about them to form stylised canopies.

Minor details include a pair of unconventional capitals in the colonnettes in the entrance arch, floral motifs in the lower voussoirs of the arch above and groups of stylised tendrils on the corbels carrying the first-floor balcony. There is also some interior work by Hodge, including a carved chimney-piece. The wrought iron gates are by George Adam & Son.[3]

Discussion: Widely admired as one of the finest examples of Art Nouveau architecture in Glasgow, the building confirms James Salmon Junior's belief in the importance of carver work in bringing a façade to life. It also typifies the tendency among Glasgow Style designers to eschew the rhetoric associated with grand figurative programmes by confining the carving to small but subtle details, thus allowing free play to the sculptor's inventiveness and sense of humour. The tendency towards eccentricity in this approach to design won the guarded approval of the correspondent of the *Builders' Journal*, who commented on the building in detail soon after it was erected. 'We cannot say', he wrote,

> … that we like it unreservedly, because it has several features which strike us as being carried to excess, but there are many new

motifs in it which are the outcome of considerable thought and ability: the entrance, for example, where the carving is by Mr. Albert Hodge. Considering work of this kind, one must always remember that it is a great deal easier to be conventional than to be fresh. For our own part, however, we vastly prefer a building which shows some attempt at individual treatment – even though it may be strange – than one of those 'safe classic' designs which are the stock-in-trade of several well-known architects. Let some of the 'correct' detailing on buildings of the latter class, 'eminently respectable', be compared with the detailing on a building like this bank at Anderston. It will be evident how much superior the latter is.[4]

According to McKean *et al.*, the sculpture was produced jointly by Hodge and Johan Keller,[5] but a contemporary review states clearly that 'the carving work has been carried out by Mr Albert Hodge from the architects' designs'.[6]

Related work: Salmon's drawing of the building was exhibited at the RGIFA in the summer of 1900 (no.511).[7]

Condition: The building has recently been cleaned but is now empty. Apart from some erosion in the details the sculptures are generally sound.

Notes
[1] BI, 16 May 1901, p.29. [2] Jack House, 'Moneybag hint', ET, 28 August 1990. [3] 'New Buildings in Glasgow', BJ, 28 November 1906, p.254. [4] *Ibid.* [5] McKean *et al.*, p.172. [6] BN, 28 September 1900, p.431 (incl. ill.). [7] *Ibid.*; Billcliffe, vol.4.

Other sources
GCA, B4/12/1/7340; B, 21 March 1903, p.310 (incl. ill.); BJ, 28 November 1906, p.254; Young and Doak, no.159; Gomme and Walker, pp.220 (ills), 222; Worsdall (1982), p.72 (incl. ill.); Bowes, pp.12–13; Teggin *et al.*, pp.74–5 (ills); Williamson *et al.*, pp.293–4.

Ashgill Road MILTON

Chirnsyde Primary School, 228 Ashgill Road

Mother and Child
Sculptor: Paul Zunterstein

Architect: Ninian Johnstone
Date: 1953
Inaugurated: 22 October 1953
Material: cement reinforced with steel rods
Dimensions: 1.8m × 1.1m
Listed status: building listed category B (6 April 1992)
Owner: Glasgow City Council

Description: The sculpture is attached to the north wall of the school, beside the visitor entrance, and shows 'a young mother and child romping happily together', symbolising youth.[1] Both figures are naked, but the treatment of the anatomy is very simplified, and an effect of quasi-balletic lightness is achieved by the slight distortion in the proportions of the limbs.

Discussion: The choice of a pair of naked figures as decoration for a primary school was regarded as somewhat *risqué*, and prompted a lively public debate on whether or not the work should be retained. It would appear that the architect had commissioned the sculpture without consulting the council's Education Committee, and it was not until literally a matter of hours before the building's inauguration that the Lord Provost Tom Kerr was informed of its existence. The statue was immediately draped with a sheet of canvas (see illustration, p.xvi).[2] An inadvertent premonition of the work of the Bulgarian artist Christo, the sculpture was to remain under wraps for four weeks while the Education Committee deliberated on its fate. Amid allegations that the statue was 'pornographic'[3] the Director of

Glasgow School of Art, Douglas Percy Bliss, made a personal plea to the committee, defending the use of nudity as entirely suitable for a school building and citing the frequent use of such work on modern school buildings in Scandanavia and Italy. He also pointed out that Thomas Whalen's mother and child group on Prestonfield School in Edinburgh had caused no such objection. Describing Zunterstein as 'one of the best students they had had at the school of art for years', he went on to praise the work's 'fine lyrical feeling' and 'flowing curvilinear movement' as providing a foil to the modernist severity of the building. The main thrust of his argument, however, was that it was integral to the site:

> Mr Bliss suggested that, as the group at Chirnsyde School had been designed for a particular place on a particular building, its removal would impoverish the present building, while the chance of using it effectively elsewhere would be small.[4]

The Education Committee was divided in its response to Bliss's intervention, and after the convener proposed appointing a sub-committee with the Education Department's Superintendent of Art, Andrew Nairn, as advisor, one council member pointed out that on the matter of whether this was a suitable statue to erect on a school wall 'they did not need art directors or art advisers'.[5] The response of the general public to the 'Controversy in Concrete' was also very mixed, though for some the central issue was not the quality of the sculpture but the ineptitude of the council in their management of the affair. A correspondent to the *Glasgow Herald*, for example, remarked scornfully that 'politicians, and local politicians especially, are notoriously devoid of artistic sensibility', and that if they were so exercised over the question of 'suitability' they would do well to consider the Doulton Fountain on Glasgow Green (q.v.), 'where the most respectable of Queens presides over a mixed band of decidedly questionable characters'.[6] Perhaps the most surprising contribution to the debate, however, came from the Rev. John D. McLennan, who argued for the educational value of statues of nudes for teaching 'the facts of life'. It was time, he believed, to overcome 'the repressive prudery of the Victorian age'.[7] In the event the sub-committee voted 23 to 16 in favour of retaining the statue,[8] but the general climate of hostility towards public sculpture which the episode exposed appears to have prompted Bliss to write his extended defence of Glasgow sculpture in the *Glasgow Herald* a few months later.[9]

Condition: Overall very distressed; the feet of both figures have been broken off, exposing steel reinforcing rods.

Notes
[1] 'Mother and Child Group May Be Reprieved', GH, 31 October 1953, p.6. [2] 'School nude draped for bailies', *Scottish Daily Express*, 23 October 1953. [3] 'Nude statue stays on wall', *Glasgow Bulletin*, 28 November 1953. [4] GH, 31 October 1953, p.6. [5] *Ibid.* [6] *Ibid.*, 26 October 1953, p.6. [7] *Glasgow Bulletin*, 28 November 1953. [8] *Ibid.* [9] Douglas Percy Bliss, 'Sculpture in Glasgow', GH, 20 February 1954, p.3.

Other sources
GSA Press Cuttings, 1953, pp.35, 37, 39, 42; Williamson *et al.*, p.418.

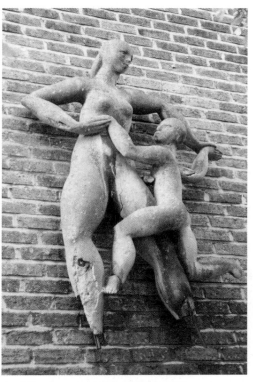

Paul Zunterstein, *Mother and Child* [ST]

Ashley Street WOODLANDS

On the west and south walls of 20 Ashley Street

Untitled (Woodlands Men)

Sculptor: Sean Taylor

Architects: McGurn, Logan, Duncan & Opfer
Date: 1991
Materials: cast copper (figures); cast brass (bell)
Dimensions: average height of figures approx.
 1.8m; figures attached at heights of 3m, 5.4m
 and 6m.
Listed status: not listed
Owner: Woodlands Community Development
 Trust Ltd

Description: The work consists of four
stylised figures mounted on the brick exterior
walls of a contemporary housing development;
three of the figures form a group on Ashley
Street, while the fourth is isolated on an
adjacent wall on Carnarvon Street. Composed
of clusters of copper oak leaves, the figures are
in extrovert postures suggestive of Bacchanalian
celebration, with the Ashley Street group
reaching towards a bell hanging above them.
They are fastened to the wall with copper nuts
and bolts and a resin glue.

Discussion: In 1989 Sean Taylor was engaged
by Woodlands Community Development Trust
(WCDT) as an artist in residence to develop an
arts programme in collaboration with the local
community. The contract was initially for six
months, but eventually ran until 1993. The
project described here was developed in
consultation with Woodlands residents (mostly
Asian), the board of the WCDT and the
architects. Recent documentation provided by
GCC refers to the figures as 'Woodlands Men',
relating the name of the area to the folk
tradition of the 'Green Man'. The artist,
however, did not envisage the figures as having
any specific gender. Part of the purpose of the
work was to celebrate the regeneration of
Woodlands as a residential area, connecting this
with a reference to the symbols of the Glasgow
arms, and using the familiar bell of St Mungo as
a metaphor of what the figures are striving to
achieve. The isolated figure on Carnarvon Street

Sean Taylor, *Untitled (Woodlands Men)*

is intended to represent the 'dreaming artist'. As
an extension of the theme of natural and
personal development, Taylor planned to allow
Virginia Creeper gradually to grow over the
surface of the wall and entwine with the cast
leaves of the figures, thereby emphasising that
all aspirations must be properly 'grounded'.
This proposal does not appear to have been put
into effect, however. The cost of the
commission was approximately £3,000.

Condition: Good. The leaf forms are not
patinated or protected with varnish, allowing
them to change colour naturally over time.

Sources
Unpublished GCC information sheet 'Percentage for
Art in Glasgow: Summary of Developments to
Incorporate Artwork'; letters from Sean Taylor to the
author, 15 October 2000 and 22 January 2001.

Gaelic Primary School, 44 Ashley Street / Grant Street

Dante, Homer and Decorative Masks

Sculptor: not known

Architects: H. & D. Barclay
Date: *c.* 1875
Material: yellow sandstone
Dimensions: portraits approx. 46cm high in
 97cm-diameter roundels; masks approx.
 23cm high
Listed status: category B (15 December 1970)
Owner: Glasgow City Council

Description: The portrait heads are carved
fully in the round, and project from roundels
inserted between the first-floor windows on
either side of the main entrance. Dante is on the
left and Homer on the right. A total of twelve
additional masks are in the capitals of the
pilasters dividing the first-floor windows on
Grant Street (× 5), Ashley Street (× 4) and on
the south front facing the playground (× 3).
These are variously male and female, with no
discernible pattern in their distribution, and are

shown wearing military helmets and other forms of headgear. The repetition of their features, particularly the male mask with the moustache, suggests that they are not intended as portraits of individuals.

Discussion: The building was designed as the Albany Academy. After lying unused for many years it was refurbished in 1999 and converted for use as a Gaelic Primary School.

Related work: Other academic buildings in Glasgow featuring similar portrait roundels are Abbotsford School, 129–31 Abbotsford Place (q.v., Appendix B, Minor Works), and the former Ladywell School, 94 Duke Street (q.v.).

Condition: There is some erosion on the head of Dante, and many of the smaller masks have lost their noses.

Sources
Gomme and Walker (1968), p.284; Williamson *et al.*, p.281; LBI, Ward 16, pp.2–3.

Anon., *Dante*

Atlas Square SPRINGBURN

In landscaped area, facing Springburn Public Library and Museum

Springburn Heritage and Hope
Sculptor: Vincent Butler

Founders: Burleighfield Foundry, High Wycombe
Date: 1988–9
Material: patinated bronze
Dimensions: figures life-size; plinth 1.01m × 42cm; pedestal 1.23m high × 1.53m × 92cm
Inscription: on a bronze plaque attached to the front of the pedestal – SPRINGBURN / HERITAGE AND / HOPE – 1989
Signed: in cursive script on the upper surface of the plinth – VINCENT BUTLER / 1988; at the rear edge of the plinth – BURLEIGHFIELD
Listed status: not listed
Owner: Glasgow City Council(?)

Description: A young girl is shown running with her arms outstretched, assisted and encouraged by a man trotting slightly less energetically behind her. The girl is dressed in a short skirt and has her hair tied in a ponytail; the man wears a peaked cap, dungarees and an open shirt with rolled sleeves. In both cases, the treatment of the draperies is strongly suggestive of forward motion. The statue has a shallow plinth and is mounted on a plain ashlar pedestal.

Discussion: The work was commissioned jointly by the Balgrayhill, Wallacewell, Central Springburn and Petershill Community Councils, with funding from Glasgow District (now City) Council. A commemorative leaflet explains the symbolism of the statue in the following terms:

The man is a worker from one of Springburn's steam locomotive works. He symbolises the area's pride in its rich

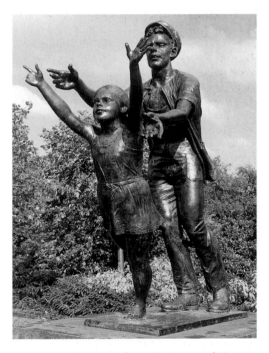

Vincent Butler, *Springburn Heritage and Hope*
[RM]

industrial heritage. The girl represents the community's hope in the future, as well as the importance of women's work both inside and outside the home.

The sculptor made casts from live, naked models in the preparation of the preliminary model, and used lengths of real cloth soaked in wet clay for some parts of the draperies. The figures were solid-cast in several sections, using sand moulds hardened with carbon dioxide, and subsequently welded together. An early maquette shows the two figures in a slightly more dance-like relationship, with the man holding the girl's wrists; in the finished piece the girl has been released entirely from his grip.

Condition: Good, though with some staining on the side of the man's face.

Source
Scott; leaflet, n.d., published by Springburn Museum Trust.

Barlanark Road BARLANARK

In landscaped area at sharp bend opposite 44 Barlanark Road

Calvay Milestone
Sculptor: Stephen Skrynka

Date: 1995
Material: copper sheeting on a concrete core
Dimensions: 2.2m diameter × approx. 6.7m high
Listed status: not listed
Owner: Calvay Housing Co-operative

Description: Stephen Skrynka describes the work as follows:

Protruding from the landscape as a large onion shape which tapers to a point, the form has echoes of onion domes found gracing churches in Eastern Europe. It implies by its presence that there is a church buried below.[1]

He goes on to note that the shape is also reminiscent of a potstill, which provides a 'contrasting point of reference'. The connection in this case is with the whisky-making practices associated with Calvay, on the Hebridean island of South Uist, from which this small part of Barlanark, as well as the work itself, derives its name.

Discussion: The work was commissioned as part of the 'Glasgow Milestones' scheme, initiated by Glasgow Sculpture Studios in 1990 in response to the city's designation that year as European City of Culture. The purpose of the scheme, which received start-up funding from the Henry Moore Foundation, was to enable local communities to develop public sculpture projects relevant to their own needs, with the studio providing guidance and support on matters of finance and administration, but otherwise encouraging commissioning groups

to work on their own initiative. According to the artist Peter Bevan, the original intention was to create a series of sculptures 'set at a distance of one mile in a circle from Glasgow's Tolbooth to mark trading, commercial and historical links'.[2] Although in the event the locations were rather more randomly distributed, Bevan insisted that the change in the geographical aspect of the plan did not compromise its 'essence'. Unlike much traditional post-war public sculpture, the Milestones were intended to express the collective aspirations of the community rather than the purely aesthetic concerns of the artist:

What makes a Milestone different from other types of public sculpture is that it is commissioned by local people who choose the location, the theme, the artist and the winning design, through a process of discussion and research. A Milestone is not a piece of sculpture which is landed on a community without their consent – it can only happen if people want it to happen and bring it about by working together at every stage of the process, from the initial idea to the launch of the finished work.[3]

The commissioning group in this case was Young Calvay Milestones, supported by Calvay Housing Co-operative. In a statement published after the inauguration, a spokesperson for the Co-operative referred to their belief that

… the enthusiasm, pride and energy of this area are expressed through this work and that the sense of welcome and community being established through the Co-op will find expression. The Milestone is for the people of Calvay.[4]

In all, seven Milestones were created in

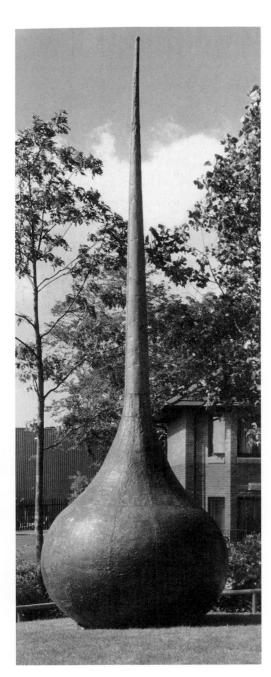

Glasgow between 1991 and 1995 (see below), with two additional pieces erected in Edinburgh and East Kilbride.

The work was made by first forming the outer copper casing on a fibreglass mould, transporting the empty shell to the site and filling the core *in situ* with poured concrete for stability. It cost about £7,000 to make.

Related work: The other works in the 'Milestones' series are *Milestone* (Cromwell Court), *Dennistoun Milestone* (Duke Street), *Rosebud* (East Garscadden Road), *Govan Milestone* (Govan Road), *The Works* (Springburn Way), *As the Crow Flies* (West Princes Street).

Condition: Fair.

Notes
[1] Rae and Woolaston, p.33. [2] Clare Henry, 'So you can see the join', GH, 16 July 1994, p.6. [3] Rae and Woolaston, *op. cit.*, p.3. [4] *Ibid.*, p.33.

Other sources
Location map, *Milestones*, Glasgow Milestones, n.d. (1994); information provided by Stephen Skrynka.

Stephen Skrynka, *Calvay Milestone* [RM]

Bath Street CHARING CROSS

On the King's Theatre, 335 Bath Street / Elmbank Street

Five Profile Portrait Medallions, Heraldic Lion and Associated Decorative Carving

Sculptor: not known

Architect: Frank Matcham
Builders: Morrison & Mason
Date: 1903–4
Building opened: 12 September 1904
Material: red Locharbriggs sandstone
Dimensions: medallions 50cm high
Inscriptions: in raised letters on the Bath Street
 attic – THE KINGS [*sic*] THEATRE; below the
 upper pediment on Elmbank Street – KING'S
 THEATRE; on the lion's shield – K / T
Listed status: category A (15 December 1970)
Owner: Glasgow City Council

Description: The building is in an Edwardian Mannerist style, combining Diocletian windows on the ground floor with a complex, and not altogether harmonious arrangement of flowing balustrades and dome-capped pillars ascending to a pair of large recessed pediments in the upper storey. The axis of the auditorium runs parallel to the main façade on Bath Street, with the entrance lobby and ancillary rooms grouped along its northern flank. The Elmbank Street façade, which is asymmetrical, is linked to the Bath Street frontage by a domed corner feature, capped by a lion sejant. The portrait medallions are grouped in two pairs in the channelled ashlar pillars at first-floor level, and are arranged to face each other across the Diocletian windows. Each is enclosed by a wreath with a margent below, and the subjects, from the left, are as follows: *Shakespeare* facing *Sir Walter Scott* (but see below); *Beethoven* facing *Mozart*. The fifth medallion is unidentified and is in a cartouche in the right-hand pediment. Additional minor carvings include a series of inverted cornucopias in the scrolls flanking the second-storey windows on Bath Street and on the corner bay; on Elmbank Street there is a pair of cartouches in the two

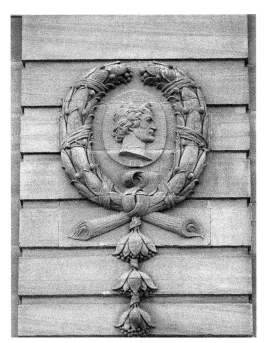

Anon., *Beethoven* [GN]

pediments, with some grotesque work in the spandrels of the arched windows. There is also a pair of cast iron lion masks attached to the wall at first floor-level at the north end of Bath Street, which appear to have been used to support an awning.

The interior plaster-work is by McGilvray & Ferris,[1] and includes four life-size caryatids in the ceiling of the entrance foyer and a pair of gilded putti holding an escutcheon above the proscenium arch.

Discussion: The building was erected for Howard & Wyndham Ltd at a cost of £50,000, and was taken over by Glasgow Corporation in 1967.[2] As originally built, the exterior included 'life size emblematical figures' on the two recessed pediments and a free-standing Imperial coat of arms in the centre of the attic.[3] The

pediment figures can be seen clearly in a photograph of c.1920, though the coat of arms appears to have been removed by this time.[4] A perspective line drawing published at the time the building was opened also suggests that the architect may also have intended to include standing figures in niches above the medallions.[5] It is interesting to note, however, that his own drawing of the north elevation preserved in the City Archive indicates no figurative sculpture whatever, and that the building is referred to as 'His Majesty's Theatre'.[6]

The identity of the portrait in the second medallion from the left has been the subject of some speculation. One popular notion was that the left-hand pair represent Howard and Wyndham, the entrepreneurs who commissioned the building, but this may be discounted on the grounds that one is quite clearly a portrait of Shakespeare. The actor David Garrick has also been suggested as a possible subject. However, as the journalist Jack House has pointed out, dramatised versions of Walter Scott's novels were performed regularly at the time the theatre was built, and it seems likely that the image of Shakespeare would have been balanced by a Scottish literary figure.[7]

Condition: The medallions are weatherworn, and the lion is painted white.

Notes
[1] GH, 10 September 1904, p. 3. [2] Brian Walker (ed.), *Frank Matcham, Theatre Architect*, Belfast, 1980, pp.25, 145–5. [3] BI, 15 September 1904, pp.88–9 (incl. ill.). [4] NMRS, Box 110/GW/1776. [5] ET, 8 September 1904, p.2. [6] GCA, TD1309/b/327. [7] ET, Jack House, 'Ask Jack: Can Anyone Solve the King's Mystery', 26 April 1978.

Other sources
B, 29 August 1903, p.232, 17 September 1904, p.298; LBI, Ward 18, pp.16–17; Williamson *et al.*, p.208; McKean *et al.*, p.121; McKenzie, p.79.

Battle Place LANGSIDE

In centre of a traffic island at the confluence of Langside Avenue and Langside Road

Langside Battlefield Memorial
Sculptor: James Young

Architect: Alexander Skirving
Builders: Morrison & Mason
Date: 1887–8
Material: grey Binnie sandstone
Dimensions: 16.3m high
Inscriptions: in raised letters on cornice of the pedestal – LANGSIDE (south face); BATTLEFIELD (east); MEMORIAL (north); 13 MAY 1568 (west); in incised lettering on the base of the pedestal – ERECTED AD 1887 (west face); ALEXANDER SKIRVING F.R.I.B.A. / ARCHITECT (south face); in raised letters on a modern plaque on the east face – THE BATTLE OF LANGSIDE WAS FOUGHT / ON THIS GROUND ON 13 MAY 1568 BETWEEN / THE FORCES OF MARY QUEEN OF SCOTS / AND THE REGENT MORAY, AND MARKED / THE QUEEN'S FINAL DEFEAT IN SCOTLAND / THIS MONUMENT WAS ERECTED IN 1887
Listed status: category B (15 December 1970)
Owner: Glasgow City Council

Description: The memorial stands on the prow of a hill overlooking the site of the battle it commemorates. It consists of a Corinthian column decorated variously with diaper patterns and strapwork intertwined with thistles, roses and fleurs-de-lis, and with a series of panels at the base carved with bagpipes, cannon, swords and shields. The capital, which has thistles in place of acanthus leaves, supports a lion sejant with its right paw resting on a cannonball, and the channelled ashlar pedestal on which the column is mounted has its corners carved with eagles.

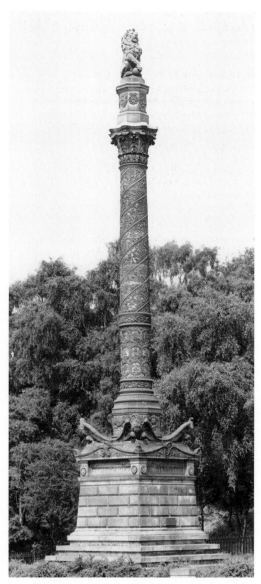

James Young, *Langside Battlefield Memorial*

Discussion: The Battle of Langside took place eleven days after Queen Mary's escape from Loch Leven Castle and marks the final collapse of her attempt to re-establish herself as a Roman Catholic sovereign. Routed by the forces of the Regent Moray, who lost very few of his 4,000 men, Mary was forced to flee to England where she was captured by Elizabeth I, imprisoned in Fotheringay Castle and executed 18 years later.[1]

The monument, which recalls the style of some old Scottish mercat crosses as well as the Classical tradition of the victory column, was erected by public subscription, and was timed to coincide with the 300th anniversary of Mary's death. Skirving's design was selected in a competition in which twelve architects, all of whom had subscribed to the memorial fund, were invited to submit proposals 'for the sake of honour'.[2] The foundation stone was laid on 13 May 1887, and a number of historical memorabilia were placed in the foundations, including a copy of Sir Walter Scott's novel *The Abbot* (1820), which deals sympathetically with the events surrounding the escape from Loch Leven, a selection of coins and newspapers of the day and the plans of the monument itself.[3] According to a contemporary press report, the sculptor James Young 'did his part of the work most cheerfully without a penny profit'.[4] Custody of the monument was undertaken by the trustees of Hutchesons' Hospital until April 1892, when responsibility for its upkeep was taken over by Glasgow Corporation.[5]

The historical events surrounding the battle were echoed in a number of other local events in the late nineteenth century. The Victoria Infirmary (q.v., 517 Langside Road) which occupies much of the land to the east, was opened in 1890 by the Duke of Argyle, a descendant of Mary's military commander. Four years later, the 15th Earl of Moray, descendant of her principal adversary the Regent Moray, laid the foundation stone of Langside Free Church, which stands behind the monument. This was also the work of Skirving, whose design included an unexecuted pediment sculpture of John Knox berating the Queen for her adherence to the Church of Rome.[6]

Condition: The monument was restored by the Cathcart Society and others in 1988 as part of Glasgow's 'Adopt a Monument' scheme, and is in good condition.

Related work: A mural painting *The Battle of Langside* (1919) by Maurice Greiffenhagen is in the Children's Department of Langside Library.

Notes
[1] Robert L. Mackie, *A Short History of Scotland*, London, 1931, p.252; Aileen Smart, *Villages of Glasgow*, vol.2, Edinburgh, 1996, pp.142-4. [2] GH, 12 May 1887, p.4. [3] *Ibid.*, 14 May 1887, p.9. [4] *Ibid.*, 12 May 1887, p.4. [5] Margaret Greene, *From Langside to Battlefield*, Glasgow, n.d. (c.1993), n.p. (p.4). [6] Smart, *op. cit.*, pp.143-4.

Bellshaugh Road KIRKLEE

On the perimeter wall and south façade of Kelvinside Academy, 20 Bellshaugh Road

Profile Reliefs of Athena

Sculptor: not known

Architect: James Sellars
Date: *c*.1878
Materials: bronze; yellow Wishaw freestone
Dimensions: inner disc of bronze medallion 28cm diameter; stone panels approx. 60cm × 45cm
Inscriptions: in raised letters on bronze medallion – KELVINSIDE ACADEMY / FOUNDED 1878; in bronze Greek letters attached to wall below medallion – AIEN APISTEVEIN (trans.: 'Always try to be the best')
Listed status: category A (6 July 1977)
Owner: Kelvinside Academy War Memorial Trust

Description: The carved part of the scheme consists of a triptych above the main entrance on the south façade, with a bust of *Athena* in the centre, flanked by olive branches in the outer panels. Athena, the patron of learning and the arts, is shown in profile wearing an armoured breastplate and a plumed helmet decorated with a tiny sphinx. The image of Athena is repeated almost identically, but on a smaller scale in the bronze medallion attached to the wall at the junction of Bellshaugh and Kirklee Roads. In this case the olive branches are used to form a wreath enclosing the medallion. Additional decorative work associated with the building includes a pair of ornate cast iron lamp standards flanking the entrance and a set of wrought iron gates and railings in the perimeter wall, all of which were manufactured by the Saracen Foundry to designs by James Sellars. The lamp standards are identical to those used on the same architect's Mitchell Theatre (q.v., Granville Street).

Discussion: The Academy was founded in 1878 by the Kelvinside Academy Company. The building was erected in ten months at a cost of £21,698, and was opened on 2 September 1878.

Condition: Good.

Sources
Groome, vol. 3, p.151; Worsdall (1982), p.44; Williamson *et al.*, p.318; Gary Nisbet, *St Luke's Greek Orthodox Cathedral and James Sellars 1843–1888*, ('Doors Open Day' leaflet), September 1993.

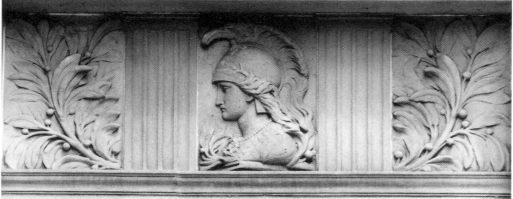

Anon., *Athena*

Lucinda Wilkinson and Jamie Burroughs, *Surf City* [RM]

Bilsland Drive RUCHILL

In landscaped area in front of Hazlitt Gardens

Surf City

Sculptors: Lucinda Wilkinson and Jamie Burroughs

Date: 1999
Inaugurated: 8 October 1999
Materials: red and yellow sandstone
Dimensions: 1.94m high × 1.96m × 1.98m
Inscription: on perspex plaque at bottom left of
 base – "SURF CITY" / BY L.C. WILKINSON &
 J.R.W. BURROUGHS / WITH BARNES ROAD
 ACTION GROUP / FUNDED BY: GLASGOW 1999,
 NATIONAL LOTTERY, / BAIRD & STEVENSON
 LTD, SCOTTISH HOMES, SHACT, GLASGOW CITY
 COUNCIL, PETER WALKER GROUP LTD /
 MARYHILL HOUSING ASSOCIATION.
Listed status: not listed
Owner: Maryhill Housing Association

Description: An abstract arrangement of interlocking geometric blocks, mostly cubic but with several more curvaceous forms suggestive of waves. In the lower part of the work, the stones are assembled in courses reminiscent of ashlar masonry familiar from traditional Glasgow tenements, while the upper part resembles, albeit in a simplified form, the massing of a group of modernist skyscrapers. A number of the surfaces are incised with geometric markings and recessed planes, and some are roughly tooled.

Discussion: The commission came about as a result of a chance meeting in 1998 between the Director of the Maryhill Housing Association and Lucinda Wilkinson, who had recently been awarded a grant by the Glasgow 1999 Festival Partnership Fund to make a work in an unspecified location. After a short period of consultation, her proposal was enthusiastically taken up by the Association, who identified an appropriate site adjacent to the Parkhill housing estate, then nearing completion. Meetings with members of the local community were arranged, and a group of residents, including a number of children, was formed to contribute ideas and assist the sculptors in making the work. In addition to the grant provided by the 1999 Festival, further funding was provided by the National Lottery and other sources, the total cost of the work eventually amounting to approximately £12,000. Sponsorship in kind was also provided by Baird & Stevenson, who donated the stone from their quarry in Dumfries. The inauguration of the sculpture was attended by the Scottish Executive Housing Minister, Calum McDonald MP.

Condition: Good, but there is some light graffiti.

Sources
Maryhill Housing Association *21st Annual Report*, 1997/8, p.12; information provided verbally by Maryhill Housing Assocation; 'Artist & Housing Association Partnership', project booklet, Glasgow, 1999.

Botanic Gardens NORTH KELVINSIDE

Kibble Palace

Interior sculptures by various artists

Originally known as the Kibble Crystal Art Palace and Conservatory, Glasgow's most imposing iron and glass structure was built in 1863 by John Kibble in the grounds of his home in Coulport. The architect was probably James Cousland, and it is likely that Kibble himself played a part in the design.[1] Kibble was an engineer and amateur photographer, whose negatives were exposed in a horse-drawn camera[2] and are believed to have been the largest glass plates produced in the Victorian era. In 1871 he gifted the conservatory to the city of Glasgow, and, after transporting it by water from Coulport via Loch and the River Clyde, arranged for it to be re-erected in enlarged form in the Botanic Gardens. The Botanic Gardens themselves were acquired by the Glasgow Corporation in 1891, after their directors had become bankrupt. A popular west end venue for concerts and other forms of public entertainment, the Kibble Palace was also used for cultural and political meetings, such as the inauguration of the British Association in 1876, and the addresses of two of Glasgow University's most distinguished rectors, Benjamin Disraeli (1878) and William Ewart Gladstone (1879) (see *Monument to William Ewart Gladstone*, George Square).[3] The interior was originally decorated with a collection of 39 plaster casts, including copies of *The Three Graces* by Antonio Canova, *The Greek Slave* by Hiram Powers and versions of

Eve by both John Gibson and Bertel Thorwaldsen, as well as a selection of antique and Italian Renaissance works.[4] These were removed in 1881 when the venue officially became the 'Winter Garden', and a greater emphasis was placed on its horticultural contents.[5] In 1941, however, a new selection of marble statues was brought from the GAGM collection as part of its re-organisation of the Sculpture Gallery after Kelvingrove Museum had been damaged by an air raid. In his autobiography, the then Director of Kelvingrove, Tom Honeyman later recalled that at the time the museum had

> … quite a number of largish marble ladies who had originally come out of Italy – a survival of the days when Glasgow merchants did the Grand Tour and came back with Eves, Satyrs and Nymphs to decorate their grand glass conservatories. And they looked not too bad in these very necessary extensions to the large mansions of Kelvinside, Dowanhill and Maxwell Park. At least the setting was appropriate enough.
>
> The next generation had no use for them and they found a home in the Art Gallery. I thought I knew a better home, and with the co-operation of the Director of Parks, we had them placed in the glass house known as the Kibble Palace in the Botanic Gardens.[6]

He goes on to note that although the move was generally approved, Professor John Walton, of the Department of Botany in Glasgow University, complained that the addition of the statues 'spoiled the overall vegetation climate' of the conservatory, turning it into a 'cheap imitation of a Palm Court, Grand Hotel type of presentation'.[7] Eric Curtis, a former curator of the Botanic Gardens, has noted that 'the humid atmosphere is not ideal for the statues', and that their surfaces are prone to algal growth if they are not regularly cleaned.[8]

The sculptures, which are still part of the GAGM collection, are listed here in the order in which they are encountered on an anti-clockwise perambulation of the building. It should be noted, however, that at the time of writing the Kibble Palace is due to be closed for an indefinite period while renovation work is carried out. In the meantime the Friends of Glasgow West Society have initiated a plan to commission a public sculpture to be placed in front of the entrance when the building is eventually re-opened to the public.

Notes
[1] McKean *et al.*, p.197. Williamson *et al.* attribute the design to Boucher & Cousland, as does Eric Curtis, *Kibble's Palace*, Glendaruel, 1999, p.20.
[2] William Buchanan, 'Photography comes to Glasgow: a survey of the fifteen years 1839–1854', *Scottish Photography Bulletin*, Spring 1988, p.12.
[3] Cowan, p.135. [4] The full list, published by John Tweed in 1874, is reproduced in Curtis, p.32. See also photograph of interior on pp.26–7. [5] Curtis, p.56.
[6] Honeyman, pp.74–5. [7] *Ibid.* [8] Curtis, *op. cit.*, p.66.

Other sources
Stevenson (1914), pp.172–3 (incl. ill.); Doublas Percy Bliss, 'Glasgow's garden home for aged statues', GH, 15 May 1953; Worsdall (1988), p.66 (incl. ill.); Lyall, p.140 (incl. ill.); McKenzie, pp.92 (ill.), 96.

To the left of the entrance

Cain

Sculptor: Edwin Roscoe Mullins

Date: 1899
Materials: marble statue on an octagonal brick base
Dimensions: statue 99.5cm high; base 1.12m high
Signature: in cursive script on rear of plinth – E. Roscoe Mullins 1899
GAGM reference: S.78

Seated male nude in a dejected posture. Also known by the title *My punishment is greater than I can bear* (Genesis 4: 13), the sculpture was purchased from the Glasgow International

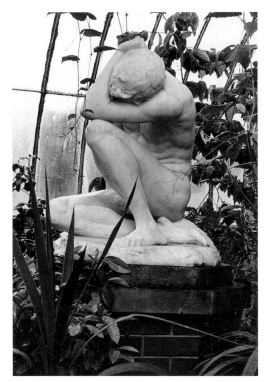

Edwin Roscoe Mullins, *Cain* [RM]

Exhibition, 1901 (see Kelvingrove Art Gallery and Museum, Kelvingrove Park, below) at a cost of £300. A plaster model was exhibited at the New Gallery, London, in 1896.

Condition: Good, but with brown surface staining.

Sources
International Exhibition Glasgow 1901, Official Catalogue of the Fine Art Section, Glasgow, 1901, p.111; GCA, C1/3/29, p.109; Stevenson (n.d.); Curtis, *op. cit.*, p.64 (ill.).

To the right of the entrance

King Robert of Sicily
Sculptor: George Henry Paulin

Date: *c.*1927
Materials: marble statue on a square brick base
Dimensions: statue 1.54m high; base 58cm high
Signature: none visible
GAGM reference: S.177

Naked male figure seated on a jester's costume, with a small monkey on his knee. The subject is taken from 'The Sicilian's Tale' in *Tales of a Wayside Inn* by H.W. Longfellow, and refers to an arrogant king who is deposed by an 'angelic' emissary and is forced to assume the role of king's jester. It was purchased in 1927, and exhibited at the RSA in the same year (cat.57) and the RGIFA in 1929 (cat.9).

Condition: Good, but with some brown staining and much surface grime.

Sources
Laperierre; Billcliffe; Stevenson (n.d.); Curtis, *op. cit.*, p.81 (ill.).

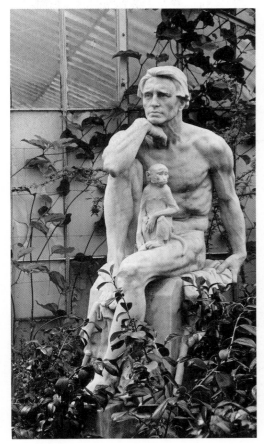

George Henry Paulin, *King Robert of Sicily* [RM]

Scipione Tadolini, *Eve* [RM]

At the junction of the 'aisle' and the main rotunda

Eve
Sculptor: Scipione Tadolini

Date: not known (*c.*1880)
Material: marble statue and pedestal
Dimensions: statue and pedestal 1.11m high ; reliefs 42.5cm × 47cm
Signature: none visible
GAGM reference: S.206

Naked female figure seated on a knoll covered with flora, and with her right hand raised to her cheek. The statue is based on a plaster model in the Palazzo Braschi, Rome, and was presented to the museum by Dr Douglas White of Overtoun in 1936. On the pedestal are reliefs depicting *The First Family* (front) and *The Expulsion from the Garden of Eden* (rear).
Condition: Good but with brown surface stains. The rear relief is particularly grimy.

Source
Stevenson (n.d.).

On the south side of the main rotunda

Ruth
Sculptor: Giovanni Ciniselli

Date: not known
Materials: marble figure on cylindrical red marble pedestal
Dimensions: statue 1.17m high; pedestal 84cm high
Signature: none visible
GAGM reference: S.171

Draped female figure seated in contemplative posture on a tree stump with wheatsheaves in her hand and on her lap. The sculpture was loaned to the International Exhibition, Glasgow, in 1888, by Leonard Gow, Esq., and presented to the museum by his family in 1927.

Giovanni Ciniselli, *Ruth* [RM]

Condition: There is some damage to the face and the surface is stained.

Source
Stevenson (n.d.).

On the south side of the main rotunda

The Nubian Slave
Sculptor: Antonio Rossetti

Date: not known (after 1858)
Material: marble statue and pedestal
Dimensions: figure 1.03m high; pedestal 82.5cm
 high; reliefs 27cm × 30cm
Signature: none visible
GAGM reference: S.43

Female figure, naked apart from a turban, seated on a stone covered with rush matting. A

Antonio Rossetti, *The Nubian Slave* [RM]

replica by Rossetti of his original work of 1858 (private collection), the statue was bequeathed to the museum by William Colvin in 1881. The four reliefs on the pedestal depict scenes of slavery.

 Condition: The left hand has a broken finger and the nose is chipped. There is also a small amount of surface staining.

Source
Stevenson (n.d.).

On the east side of the main rotunda

The Elf
Sculptor: William Goscombe John

Date: 1899
Materials: marble statue on a brick base
Dimensions: statue 1.04m high; base 1.21m high
Signature: in cursive script on left side of base –
 W Goscombe John / London 1899
GAGM reference: S.77

Naked female figure in a crouching posture. The statue is a marble copy of a bronze original, editions of which are in the National Museum of Wales, Cardiff, and the RA Diploma Collections. The plaster model was exhibited at the RA in 1898, and later in Paris, Rome and Venice; this version was shown at the RA in 1899 and at the Glasgow International Exhibition of 1901, where it was purchased by the city for £525. Presented by John as his Diploma piece at the RA in 1898, the work evidently meant much to him, and an outline of the figure is incised on the wooden base of his *Self Portrait* of 1942 (National Museum of Wales).
 Condition: Good.

Sources
International Exhibition Glasgow 1901, Official Catalogue of the Fine Art Section, Glasgow, 1901, p.111; GCA, C1/3/29, p.109; Fiona Pearson, *Goscombe John at the National Museum of Wales*, (ex. cat.), Cardiff, 1979, pp13, 35; Stevenson (n.d.).

William Goscombe John, *The Elf* [RM]

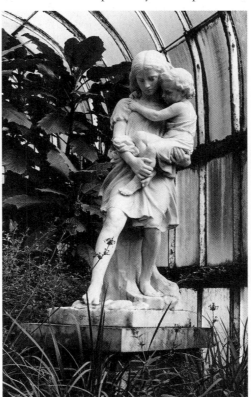

William Hamo Thornycroft, *Stepping Stones* [RM]

On the east side of the main rotunda

Stepping Stones

Sculptor: William Hamo Thornycroft

Date: 1878
Materials: marble statue on a brick base
Dimensions: statue 1.46m high; base 82cm high
Signature: on left side of plinth – HAMO
 THORNYCROFT / SCULPSIT 1878
Inscription: on front of plinth – STEPPING STONES
GAGM reference: S.140

Female figure carrying an infant across a brook. The statue was exhibited at the RA in 1879 (cat.1514) and at the RGIFA in 1880 (cat.759), where it was accompanied by the couplet:

'Pausing with reluctant feet / where the stream and river meet'. It was presented to the museum by Captain Wallace in 1919.
 Condition: Good.

Sources
Graves; Manning, pp.66 (ill.), 67–70; Billcliffe; Stevenson (n.d.).

On the north side of the main rotunda

Sisters of Bethany

Sculptor: John Warrington Wood

Date: 1871
Material: marble statue and pedestal
Dimensions: statue 1.48m high; pedestal 78cm high

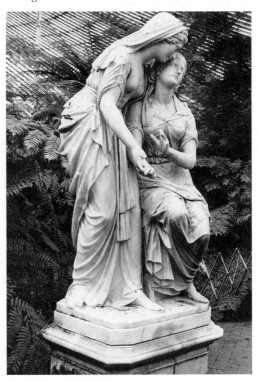

John Warrington Wood, *Sisters of Bethany* [RM]

Signature: in cursive script on rear of chair – J. WARRINGTON WOOD Sculp Rome 1871
Inscription: on front of plinth – THE SISTERS OF BETHANY / "THE MASTER IS COME AND CALLETH FOR THEE"
GAGM reference: S.207

A pair of draped female figures, one standing and one rising from a sitting position. The subject is derived from the Gospel of St John (12.1–7), in which Martha serves supper to Christ and Lazarus in Bethany, and her sister Mary wipes the feet of Christ with her hair after anointing them with spikenard. Exhibited at the RA in 1879, the statue was presented to the museum by Dr Douglas White of Overtoun in 1936.

Condition: Good, but with heavy brown staining.

Source
Stevenson (n.d.).

Bothwell Street CITY CENTRE

Former Commercial Bank of Scotland, 30 Bothwell Street / 100 Wellington Street

Six Allegorical Relief Panels
Sculptor: Gilbert Bayes

Architect: James Miller
Date: 1934–5
Material: Portland stone
Dimensions: each panel approx. 1.8m square
Inscriptions: one word per panel, from the left on Wellington Street – JUSTICE; WISDOM; CONTENTMENT; PRUDENCE; on Bothwell Street – INDUSTRY; COMMERCE; in winged orb above entrance – CBS (entwined)
Listed status: category B (15 December 1970)
Owner: Cromwell Properties

Description: A typical example of inter-war Neo-classicism, the building dispenses with historicist detail in all except the pair of giant Corinthian columns *in antis* which dominate the main frontage, and the vestigial pilasters on Wellington Street. The relief panels are inserted between the windows below the attic cornice, each consisting of a narrative figure group exemplifying one of the 'six qualities of man in modern society'.[1] The carving is very shallow, with almost no modelling, and the slightly mechanised treatment of the figures is consistent with the severity of the building as a whole. Decorative details in bronze include grille panels with anthemion cresting on the main door and flanking windows, and a winged solar orb in a panel above the entrance.

Discussion: The model for *Commerce* was exhibited at the RA in 1936, prompting the following observation from the *Builder*:

Gilbert Bayes is still outstanding in his treatment of low decorative relief, and in this field there is probably no sculptor to-day who can equal the standard of his work. Its affinity to the building is its outstanding quality, but the underlying motive is well handled; and the particular panel which is displayed at the Academy – namely,

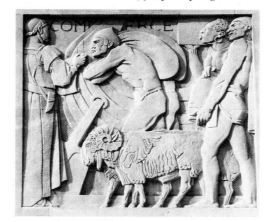

Gilbert Bayes, *Commerce*

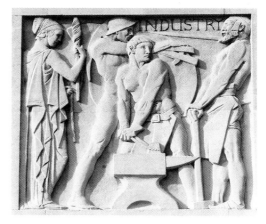

Gilbert Bayes, *Industry*

'Commerce' – well exemplifies its title in the general feeling of the mass and in the treatment of individual parts. I feel at each of these Royal Academy Exhibitions that Gilbert Bayes receives far too little recognition from his fellow-sculptors.[2]

According to Sloan and Murray, the bank was 'effectively Miller's last commercial commission', and the 'culmination of that strand of Glaswegian commercial architecture which had flowered from the mid-1890s until the war scares of 1938'. They also claim that the panels were carved by Joseph Armitage, although they are alone among contemporary commentators in holding this view.[3]

Related work: The panels of *Wisdom* and *Contentment* were exhibited at the RA in 1935, and *Commerce* in the following year. *Contentment* was also shown in the Palace of Arts at the Empire Exhibition, Glasgow, in 1938 (no.696; see Appendix A, Lost Works, Bellahouston Park).[4] The plaster model of *Commerce* has survived, and is in a private collection, while Bayes' original drawings are in the collection of the Bayes Trust.[5]

Condition: Good.

Notes
[1] Sloan and Murray, p.52. [2] B, 22 May 1898, p.1017. [3] Sloan and Murray, p.52. [4] Anon., *Illustrated Souvenir of the Palace of Arts*, Glasgow, 1938, p.90. [5] Irvine and Atterbury, p.165.

Other sources
GCA, B4/12/1934/190 (Miller's plans, 1934); Williamson *et al.*, p.216; Teggin *et al.*, p.53 (incl. ills); McKean *et al.*, p.134 (incl. ill.); Brian Frew, 'The commercial architecture of James Miller', unpublished dissertation, GSA, 1998, n.p.; Irvine and Atterbury, pp.66 (incl. ill.), 164–5 (incl. ills); McKenzie, pp.72, 73 (ill.).

Mercantile Chambers, 35–69 Bothwell Street

Mercury, Allegorical Figures of Industry, Prudence, Prosperity and Fortune and Associated Decorative Carving

Sculptors: Francis Derwent Wood (modeller), James Young, McGilvray & Ferris (carvers)

Architects: James Salmon & Son
Mason: P. & W. Anderson
Date: 1897–8
Material: red sandstone
Dimensions: figures approx. life-size
Inscriptions: see below
Listed status: category A (15 December 1970)
Owner: SM PH LP (per Richard Ellis St Quinton)

Description: The building was designed for the Mercantile Chambers Company as a combined shop and office block, and has six storeys plus an attic, with a depressed arcade on the ground floor, a complex pattern of oriel windows and projecting balconies in the middle storeys and end bays capped by gables. Widely regarded as one of the most distinctive Glasgow buildings of its period (Young and Doak describe it as pervaded by a 'kind of *fin-de-siècle* Beardsley feeling'[1]), it is of interest more for the eccentricity of its carved details than its overall design, which is in fact quite conventional.

There are five full-size figures, all of which were modelled by Derwent Wood and carved by James Young.[2] *Mercury* is the most prominently sited and perhaps also the most lyrically conceived. Seated in a projecting *baldacchino* directly above the main entrance, he is portrayed in a realistic style which breaks radically with the idealised treatment normally reserved for mythological figures attached to buildings. This was noted by a commentator in

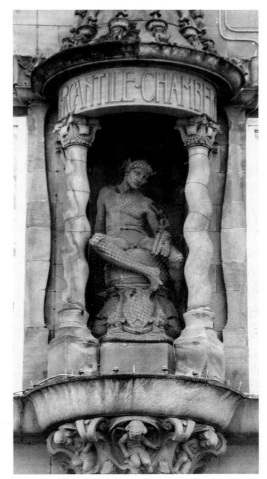

Francis Derwent Wood, *Mercury*

the *Builder*, who observed that: 'Poor Mercury, in his sentry box over the door, seems to have collapsed after the fatigues of some long journey'.[3] The *baldacchino* itself is a *tour de force* of imaginative thinking, with barley sugar columns supporting an ogee dome and a trio of levitating putti providing support from below, each involved in a co-ordinated process of

spinning, unwinding and cutting a length of ribbon. Inside the *baldacchino*, a globe embedded in a spherical arrangement of sailing ships and sea monsters provides a seat for *Mercury*, with more sailing ships appearing in the capitals. The curved entablature carries the inscription 'MERCANTILE CHAMBERS'.

The four standing allegorical figures are on the second storey, cradled within the recesses formed by a series of tall brackets supporting the balcony above. They are identified by their attributes and the inscriptions on the bases and represent, from the left: PROSPERITY (holding a money-bag, enclosed by oak branches); PRUDENCE (contemplating an hourglass); INDUSTRY (holding a distaff); FORTUNE (winged, holding a female figurine with the prow of a ship and a wheel of fortune at her feet). By their spacing they fall naturally into two groups of two, and it is interesting that each pair is stylistically different. Those on the left are fully clothed, with a heavy vertical accent in their draperies and a Pre-Raphaelite modesty in their demeanour. On the right the figures are semi-naked, and with their sinuous poses and raised elbows are closer to the conventions of mainstream academic Classicism.

The remainder of the relief carving was designed and carved by McGilvray & Ferris,[4] and as with much of their work in the City Centre (see, for example, 36–62 Bothwell Street, below), the imagery has a programmatic element. Between the columns on the second floor is a pair of roundels with heads representing oriental and occidental culture: a bearded male in a turban surrounded by entwined sea snakes (left) and a crowned female enclosed by birds. Above the first-floor windows on the outer oriels are pairs of brackets framing emblems of the four elements.[5] The order runs, from the left: *Earth* (lions and trees); *Air* (eagle and stars); *Fire* (dragon and torches); *Water* (fish and shells). Most distinctive of all is the sequence of decorative reliefs extending over the central

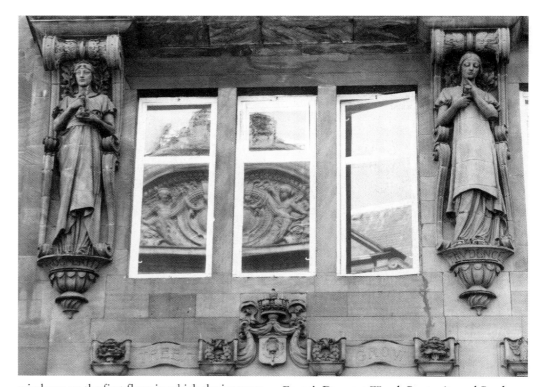

Francis Derwent Wood, *Prosperity* and *Prudence*

windows on the first floor in which the imagery of the Glasgow coat of arms is reconfigured as an elaborate visual conceit. This consists of an undulating ribbon, interrupted by a series of identical royal crests, and inscribed with references to the famous nursery rhyme associated with the legend of St Mungo and the Glasgow arms, thus: 'TREES GROW', 'BIRDS FLY', 'FISH SWIM', 'BELLS RING'.[6] Each section of the ribbon is terminated with the appropriate object.

The cunning and inventiveness of the decoration extends through a multitude of minor details. At the main entrance the capitals are carved as ship prows with winged female figureheads framed by cornucopias spilling coins (left) and sickles entwined with fruit garlands. A pair of cartouches inscribed with the number '53' is inserted at an angle into the

voussoirs of the arch above, and the keystone is decorated with a richly carved margent. The capitals on all the remaining ground-floor arches are carved variously with grotesques, birds, swords, guns and a wealth of related objects, while the grotesques in the keystones in the outer arches repeat the references to the four elements. A datestone inscribed '1898' and the monogram 'JS & S' appear in corbels at the extreme ends of the building, below the ground-floor entablature, and there are grotesques in all degrees of snarling ugliness in capitals and on brackets at various other points on the façade.

Finally, it should be noted that there is an arched panel, approximately 90cm × 75cm on

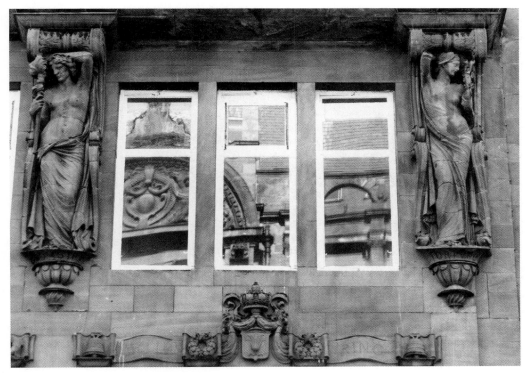

Francis Derwent Wood, *Industry* and *Fortune*

the rear of the building, in Bothwell Lane. This is inscribed 'THE / MERCANTILE / CHAMBERS' in Glasgow Style lettering and is decorated with an Art Nouveau tree.

Related work: Salmon & Son's drawing of the building was exhibited at the RGIFA in 1898 (no.266).[7]

Condition: Good.

Notes
[1] Young and Doak, no.156. [2] GAPC, 10 May 1898, n.p. [3] B, 9 July 1898, p.24. [4] GAPC, 10 May 1898, n.p. [5] *Ibid.* [6] The original rhyme runs: 'This is the bird that never flew,/This is the tree that never grew,/This is the bell that never rang,/This is the fish that never swam. [7] Billcliffe, vol.4.

Other sources
GAPC, 6 December 1898, n.p. (ill.); W.K. West, 'The Work of F. Derwent Wood', *The Studio*, vol.33, 1905, p.300 (incl. ill.); Gomme and Walker (1968), pp.218 (ill.), 222; Bowes, pp.8–10; Teggin *et al.*, pp.50–3 (incl. ills); McKean *et al.*, pp.134–5 (incl. ill.); McKenzie, pp.70 (ill.), 71.

Commercial building, 36–62 Bothwell Street / 87 Wellington Street / West Campbell Street

Profile heads of Athena and Mercury, Masks Representing Different Nations and Associated Decorative Carving
Sculptors: McGilvray & Ferris

Architects: H. & D. Barclay
Masons: Morrison & Mason
Dates: 1891, 1898 and 1901
Material: red sandstone
Dimensions: heads larger than life-size
Listed status: category B (5 September 1979)
Owner: Britannia Life Assurance Ltd

Description: This extensive commercial block was built in three stages, beginning with the east (Wellington Street) end. Although a broadly similar architectural and sculptural vocabulary is used throughout, the various stages are easily distinguished by clear differences in their treatment. On the eastern section (nos 36–44) the design is dominated by repeated rows of aedicule windows on the three main floors and the trio of substantial gables above them. The windows themselves are punctuated by vertical sequences of carved panels inserted into the bays aligned with the chimney-stacks rising between the gables. In ascending order, these take the form of heraldic escutcheons (first floor); square panels containing profile heads of *Athena* (left) and *Mercury* (both contained within larger rectangles decorated with arabesques and griffins); roundels with a shamrock (left) and a thistle. Each of the gables has a square panel containing frontal heads symbolising different regions of the world, including, from the left, a crowned female (Europe?), a bearded male with a turban and a pharoahic head framed by papyrus plants. The main pilasters of the central gable are in the form of female herms.

On the Wellington Street frontage, there are only two profile heads at second-floor level, both male and possibly representing figures from Scottish history, and the single gable panel is devoted to an American Indian in full head-dress. The floral roundels this time contain a rose and a thistle, thus complementing the references to the home countries on the south frontage. In the minor decorative work, a particularly inventive use is made of birds'

McGilvray & Ferris, *Decorative Mask*

wings, which feature in the brackets under the shell niches of the aedicule windows and as substitutes for Ionic volutes in the capitals of the third-floor pilasters. The lion masks in the first-floor pilasters have alternating open and closed mouths.

The central section of the building (nos 48–52) is known as Britannia Court. Here the principal architectural elements are much the same as the earlier block, but with the ground floor opened up by granite columns and lengths of balustrade dividing the attic storeys from the main façade. There have also been some modifications in the design of the gables, which now have segmental lunettes filled with amorini stretching swags across a central blind cartouche. There are lion masks at either end of the attic cornice.

The final section (nos 58–62) reverts to a pattern closer to the 1891 block, though with some significant modifications in the detailing, including the replacement of the aedicules with sets of two-light windows framed by Ionic colonettes and capped by scrolls. The gables are also more ornate, but with the portrait panels omitted, the only figurative work being a single winged cherub in the centre. The coats of arms, profile heads and national flowers have also been dispensed with, though a variation on the English rose appears in the volutes of the second-floor capitals. Another significant variation occurs on the West Campbell Street frontage, which has a series of empty niches which may have been intended to contain statues.

Discussion: H. & D. Barclay's design, described as 'Later Renaissance' in style, and 'richly treated as regards detail'[1] was the winner in a competiton which included an equally ostentatious submission in the Scottish Baronial manner by John Burnet, Son & Campbell.[2] A notice in *Building Industries* in 1891 states the projected cost of the entire block as £20,000, though it is likely that the eventual cost was higher.[3] The attribution to McGilvray & Ferris has only been confirmed in relation to the 1898 extension, but the consistency of the style throughout all three sections suggests that they were responsible for the whole scheme. The interior plasterwork is also by McGilvray & Ferris.[4]

Condition: Good.

Notes
[1] GAPC, 20 December 1898, n.p. [2] AA, 1891, p.75. [3] BI, 15 June 1891, p.45. [4] GAPC, 20 December 1898, n.p.

Other sources
AA, 1891, p.75 ; BI, 16 March 1901, p.189; Williamson *et al.*, p.217; McKenzie, pp.70 (ill.), 72.

Scottish Legal Life Assurance Society Building, 81–107 Bothwell Street / 80 Blythswood Street / 89 West Campbell Street

Relief Panels of Virtues, Royal Arms of Scotland and Associated Decorative Carving

Sculptors: Archibald Dawson and James A. Young

Architect: E.G. Wylie of Wylie, Wright & Wylie
Masons: Thaw & Campbell
Date: 1928–31
Material: Blaxter stone
Dimensions: panels approx. 1.8m × 1.2m
Inscriptions: in gilded letters on balcony above entrance – SCOTTISH LEGAL LIFE ASSURANCE SOCIETY; on coat of arms – PRUDENCE AND THRIFT
Listed status: category B (15 December 1970)
Owner: Scottish Legal Life Assurance Society

Description: American-inspired street block with eleven-bay modernist curtain wall embedded in a conventional framework of rusticated basement, banded quoins and massive classical entablature. The main component of the sculpture programme comprises a set of four figurative panels between the first-floor windows illustrating the moral aspirations of the insurance industry. Art Deco in style, and carved with a minimum of modelling, the figures are all depicted in crouching postures tightly contained within the frame, their subjects indicated by their activities and emblems as follows:

Industry – male figure with machine components, model boat and calibrated measuring instrument;
Prudence – semi-naked female with hour-glass and stylised plant;
Thrift – naked female with money bag and

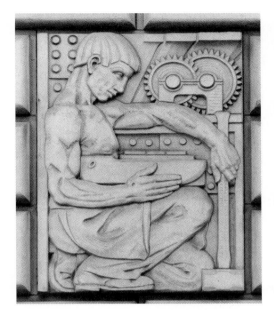

Archibald Dawson and James A. Young,
Industry

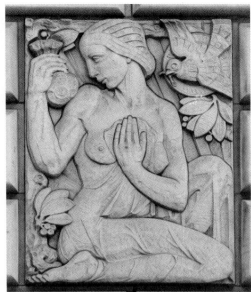

Archibald Dawson and James A. Young, *Thrift*

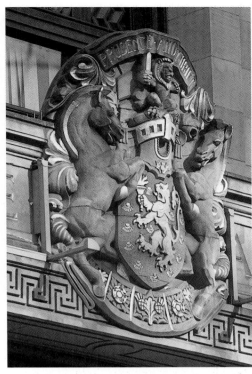

Archibald Dawson and James A. Young, *Royal
Arms of Scotland*

bird building a nest;
Courage – male warrior with sword and
scroll.

In the curtain wall the windows are divided
by rows of cast iron panels combining a
decorative zigzag motif with various symbolic
references. Ascending from the second floor,
these include: lions rampant flanking a torch;
rearing horses flanking a sword; a medieval
helmet inscribed with a stylised thistle. (A
modified version of the thistle appears in the
bronze cresting on the cornice above.) The
capitals on the pilasters are designed in the form
of various still life and naturalistic objects, in
most cases extending the references of the main
relief cases: a set of scales, a sword, a hand

grasping a snake, a cornucopia, a beehive and an
hourglass. An even more precisely encoded set
of references to the company appears in the
granite capitals on the first-floor windows of
the West Campbell and Blythswood Street
façades. Reading from the left as a lion rampant,
a judge's wig, a fountain and a castle, these form
a rebus based on the four words of the
company name.

Other decorative features include a
conventional royal coat of arms over the main
entrance, a series of lion masks in the main
cornice, pulvinated rolls on the inside faces of
the entrance arches, decorative bronze doors by
the Birmingham Guild and several lengths of
anthemion cresting by Charles Henshaw. There

is also a wooden version of the coat of arms in
the Board Room.[1]
Condition: Good.

Note
[1] AJ, 7 October 1931, p.462.

Other sources
AJ, 7 October 1931, pp.458–62, 480; Young and
Doak, no. 173 (incl. ill.); McKean *et al.*, pp.134–5
(incl. ill.); Williamson *et al.*, pp.217–8; McKenzie,
pp.70 (ill.), 71.

Bank of Scotland, 1–3 Bridge Street / 87 Carlton Place

Arms of the Bank of Scotland
Sculptor: John Crawford

Architect: John Burnet
Date: *c*.1857
Material: yellow sandstone
Dimensions: figures approx. 2.1m high
Inscriptions: below shield – TANTO UBERIOR (trans.: 'sustained growth')
Listed status: category B (15 December 1970)
Owner: Bank of Scotland

Description: The arms are located at attic level on the north-west corner of the building, and comprise a pair of standing female figures flanking a Bank of Scotland shield, with thistles and an inscription ribbon below and a horizontal cornucopia spilling coins above. The figures, both of which wear variations on the classical chiton, are symbolic of *Abundance* (left, holding an inverted cornucopia, left hand raised to breast) and *Justice* (holding scales, right hand resting on shield). The scales of *Justice* are attached directly to her body, rather than suspended on chains. There is a blindfold mask in the tympanum above the door.

Discussion: This is the earliest surviving example in Glasgow of a Bank of Scotland escutcheon with full-size supporters, and the most important of John Crawford's surviving works. A relatively late manifestation of Neo-classicism, it also forms a striking contrast with later interpretations of the same imagery, such as William Mossman's pediment group at 1 St Vincent Place (q.v.), which tend to be less idealised in their treatment of faces and draperies.

The design of the arms derives from the bank's early offices on Lawnmarket, Edinburgh, dating from 1700, when it was normal practice for business premises to be identified by signboards rather than street numbers. In conformity with this custom,

> … the Directors of the Bank applied for and obtained from the Lyon King of Arms their coat of arms, showing a silver saltire on an azure field with four golden bezants[1] having as supporters two women, 'she on the dexter representing Abundance holding in her hand a cornucopia, and that on the sinister representing Justice holding in her hand a balance: the motto *Tanto Uberior*'.[2]

Related work: A particularly splendid sculpted version of the arms was carved by John Marshall on the Bank's main office on the

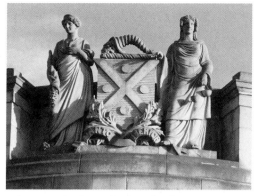

John Crawford, *Bank of Scotland Arms* [SS]

Mound, Edinburgh, in 1806.[3] Other branches in Glasgow displaying the full escutcheon with flanking figures are at 93 St Vincent Street (1924–6) and 255 Sauchiehall Street (1929–31). See also Appendix C, Coats of Arms.

Condition: Good.

Notes
[1] Besant, Bezant or Byzant: a gold coin (more properly *solidus*) issued in late Roman times at Byzantium. [2] Charles A. Malcolm, *The Bank of Scotland 1694–1945*, Edinburgh, n.d. (*c*.1945), p.205. See also frontispiece. [3] *Ibid*., p.214.

Other sources
Anon., 'The Late John Crawford, Sculptor' (obit.), GH, 13 February 1861, p.4; Williamson *et al*., p.520; McKenzie, pp.31 (ill.), 32.

Brown Street ANDERSTON

On the former Seamen's Institute, 9 Brown Street / Broomielaw

Nautical Reliefs
Sculptor: not known

Architects: R.A. Bryden & Robertson
Date: *c*.1927
Material: yellow sandstone
Dimensions: main images approx. 90cm high
Inscriptions: in separate panels above the corner
 entrance – GLASGOW / SEAMEN'S / INSTITUTE;
 in entwined numerals in escutcheons
 flanking the main entrance – 1822 (south);
 1927 (east)

Listed status: not listed
Owner: AA Brothers Ltd

Description: The main part of the decorative scheme on this building is a pair of relief panels carved with contrasting images of ships. Directly above the entrance is a contemporary ocean liner, the scale of the vessel accentuated by the low angle of view; at attic level at the east end of the Brown Street façade is a traditional sailing ship in full sail under a midday sun. The link between contemporary and historical references is echoed in the datestones flanking the main entrance, which give the year in which the Glasgow Seamen's Institute was founded and the date the present building was erected. Other carved work includes a pair of shields above the entrance displaying the emblems of the White Star and Anchor Line shipping companies (a star and an anchor respectively); a group of three wreaths (entwined with olive branches and nautical symbols) on the wall head below the corner dome. The main inscriptions are also superimposed on olive branches.

Discussion: The Glasgow Seamen's Institute was established on the Broomielaw to cater for the spiritual and material needs of seamen arriving and residing in Glasgow's then bustling, but now largely vanished docklands.

Related work: The present building formerly adjoined the demolished Seamen's Chapel, erected 1860–1, which included a figure of *Hope* by John Crawford.[1] (See Seamen's Chapel, 9 Brown Street, Appendix A, Lost Work.)

Condition: The reliefs are in good condition, but the building, used recently as a nightclub under various managements, is now empty and boarded up, and has an uncertain future.

Note
[1] Anon., 'The Late John Crawford' (obit.), GH, 13 February 1861, p.4.

Additional source
Williamson *et al.*, p.257.

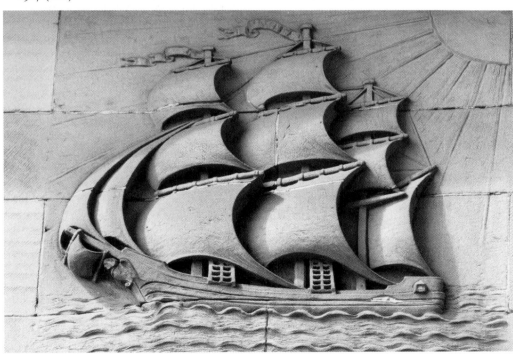

Anon., *Nautical Relief*

Kentigern House

The Symbols of St Kentigern
Sculptor: William Scott

Architects: Property Services Agency
Date: 1985–6
Material: lead
Dimensions: approx. 3.6m high × 1.5m wide
Listed status: not listed
Owner: Ministry of Defence

Description: Located over the Brown Street entrance, the sculpture is composed of five discrete forms, including a stylised representation of the sea with a fish and a ring

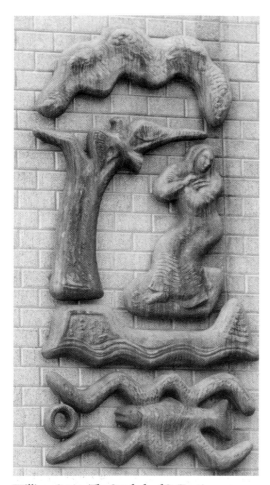

William Scott, *The Symbols of St Kentigern*

inserted in the waves, a tree supporting a bird, a hooded figure in a tragic pose and a cloud. As well as making a general reference to the landscape (see below), the forms are also intended to evoke the elements of the Glasgow arms, with a specific emphasis on the legend of St Kentigern (or Mungo), the patron saint of Glasgow. (For a discussion of the imagery of the arms see Appendix C, Coats of Arms.)

Discussion: Scott's design was one of two winning entries in a competition announced in December 1984 by the Property Services Agency (PSA; now defunct), who were seeking wall sculptures for two important public buildings then under construction: Kentigern House, for the Ministry of Defence, and the Sheriff Court of Glasgow and Strathkelvin on Carlton Place (q.v.), both by Keppie Henderson & Partners. A budget of £25,000 was allocated to each commission. The competition, though initiated by the PSA, was managed by William Buchanan, Head of Fine Art at Glasgow School of Art, and was limited to ten Scottish sculptors, who were invited to submit drawings and maquettes for an exhibition in the School's Newbery Gallery in April 1985. The nine other invited artists were Barry Atherton, Clifford Bowen, Fred Bushe, Jake Harvey, Jake Kempsell, Gerald Laing, Peter Reeve, Arthur Watson and Ainslie Yule, each of whom (with the exception of Fred Bushe, who did not submit) was paid an exhibiting fee of £200. A judging panel consisting of John Williams (Assistant Director (New Works) of the PSA), the painter Alberto Morrocco and the sculptor Gareth Fisher, were appointed on the advice of the SAC and the Fine Art Commission, and the winning entries were announced by the Right Hon. Viscount Muirsheil at the opening of the exhibition on 18 April 1985. The winner of the commission for the Sheriff Court work was Jake Kempsell.

The practice of appointing sculptors to create work intended to enhance the appearance of buildings that were not only already fully designed but also nearly completed conforms to the general approach to architectural sculpture in Scotland in the 1980s. There were also a number of issues connected to the commission that are relevant to the way in which the role of public sculpture was perceived at the time. In a letter to John Yellowlees, the Director of the PSA, Buchanan expressed his anxiety that the occupants of Kentigern House might wish to arrogate to themselves the power to 'act as

official judges' and veto the winning entry if it was not to their liking. Some delicate diplomacy appears to have been necessary to avert what may have produced, in Buchanan's words, 'lots of fireworks' at the opening of the exhibition.[1] Disquiet of a different kind was expressed by the students of Glasgow School of Art, many of whom regarded the School's involvement with the project as tantamount to a collaboration with the Ministry of Defence. In response to student demand, an open seminar was organised by the staff of the Department of Historical and Critical Studies to discuss the commission and the role of public art in relation to the Cold War. A report on the discussion was submitted by Buchanan to the PSA.

For his part, William Scott has explained that his approach to the commission was to proceed on the assumption that 'the one main point of any defence intention is to be aware of that which you wish to protect', which in this case led directly to a consideration of 'landscape, inhabited by a human figure, seen as a set of layers, sky, land and water and elements within the layers'.[2] He states that the competition brief demanded that there should be 'a definite and strong focus on the Glasgow symbols', and that by chance these had an affinity with a series of drawings and prints he had recently made in which he sought to 'clarify the elements of the landscape as a set of interactive organic forms'. The resulting design was an attempt to 'find a kind of badge shape which would read strongly from a distance against the wall' and which would also be 'the right scale for the building'.

Condition: Good.

Notes
[1] GSA Archive, copy of letter from William Buchanan to John Yellowlees, 29 March 1985. [2] Letter from William Scott to the author, 3 November 2000.

Other sources
GSA Archive, miscellaneous correspondence, School of Fine Art, 12 November 1984 to 17 June 1985; Williamson *et al.*, p.211.

Brunswick Lane MERCHANT CITY

North entrance to Brunswick Lane, on rear wall of Clydesdale Bank, 154–64 Trongate

Empire

Sculptor: Douglas Gordon

Fabricator: Lofthus Signs
Date: 1997
Inaugurated: 23 January 1998
Material: stainless steel, fluorescent tubing
Dimensions: 5m high
Inscriptions: on both sides – EMPIRE (reversed letters)
Owner: Merchant City Civic Society

Description: Wall-mounted neon sign with letters arranged vertically and in reverse, but reading correctly in the image reflected from the polished back plate. The electrical circuitry is designed to cause the letter 'I' on both sides to flicker, as if faulty.

Discussion: Commissioned by Visual Art Projects (VAP) on behalf of the Merchant City Civic Society, *Empire* was intended to form part of a projected series of 'Urban Icons', defined as 'deliberately non-grandiose artworks for public sites around the Merchant City'.[1] The site on Brunswick Lane has been described by Gordon as 'atypical of Glasgow', and a place that reminds him 'of other cities, with its odd juxtaposition of low and high buildings and … cinematic atmosphere'. He has also stated that the phrase 'a conspiracy of circumstances' was used frequently in his discussion of the proposal with the VAP, prompting a desire to make a work that would combine contradictory references to urban history with a critical reflection on various aspects of contemporary popular culture. In nominal terms, *Empire* is bound up with the political and economic history of the area in which it is located,

particularly the tobacco trade which formed the basis of Glasgow's mercantile prosperity in the eighteenth century. Overlaid with this is a specific reference to the scene in Alfred Hitchcock's film *Vertigo* (1956) in which Kim Novak is watched by James Stewart as she enters the Empire Hotel, and is later seen at an upstairs window beside the hotel's own neon sign. In his analysis of the commercial sign as a paradigm of the contemporary urban spectacle, and the problems this poses for contemporary public art practice, the critic John Calcutt has provided the following commentary on *Empire*:

> Tucked away in a narrow lane off Argyle Street, it's easily overlooked. (Camouflage allows works of art, as well as soldiers and animals, to infiltrate effectively.) Less so at night when its vertical strip of reversed, green neon letters glows in the dark. Despite its puzzling mirrored letter forms it could still be mistaken for an authentic commercial sign: a hotel, a bar, a club, a restaurant, a shop perhaps. 'Empire': what does it mean, what does it do? There is the faint atmosphere of history here because we are in Glasgow's Merchant City, former dense spot of commercial wealth, mighty neighbourhood of commercial warehouses. That's less than a memory now. Today it's more hip, more street. Today it's cool-arama, style-a-go-go. Those invisible ghosts of the Empire's mercantile past, slavery and exploitation, are now exorcised, hermetically sealed beneath a lick of pastel paint, a sheet of polished steel, a beech laminate surface, an endowment policy mortgage. Display is now the key concept. Sheets of glass replace masonry walls as the boundaries between the insides and outsides of buildings collapse. Architecture shrinks to a framing device for

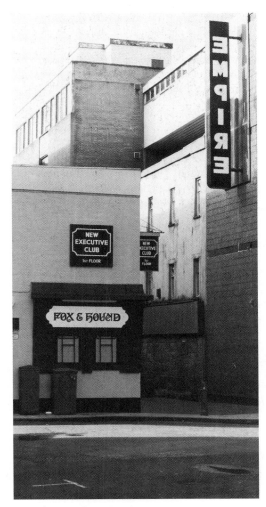

Douglas Gordon, *Empire* [RM]

> the public performances of eating, drinking, buying, all those loosely scripted acts of sociable life. In fact, this kind of architecture aspires increasingly to the condition of the movie screen: both aim to simultaneously provide a ground onto/into which vivid fantasies may be projected but also

contained; both act as amplifiers of glamorous illusions. Film and architecture, sister arts of distraction. It is therefore entirely appropriate that the visual source of Douglas Gordon's 'Empire' lies in a shot of the Hotel Empire from Hitchcock's 'Vertigo'. Significant also, perhaps, that the reversed letter forms are only 'righted' by means of their projected reflection in the sculpture's mirror back-plate. As in a movie, the projected image appears more real than the real itself. The abstract forces of art, film and the spectacularised city are condensed in this dissimulating sign, a sign in which historical memory and present forgetfulness are made to switch to and fro like the pulse of its winking letter.[2]

Gordon himself confirms that his intention was to

... make an artwork that would not look like

an artwork. I could make an object which was a copy of something that does not actually exist except in fiction, and the only way you can read it properly is to look in a mirror which is a place that does not really exist either.[3]

The work cost approximately £30,000 to produce, and was made with financial support from the SAC (Heritage Lottery Fund), the GDA (Merchant City fund), GCA (1996 Year of Visual Art fund) and a number of commercial sponsors. The electrical supply which powers the neon light is provided by the Trongate branch of the Clydesdale Bank, which also contributed to the installation costs. The unveiling was performed by Ross Hunter, Chairman of the Merchant City Civic Society, after which a reception was held in the neighbouring Mitre Bar, which undertook to 'run *Vertigo* on its video from time to time, so that the fictional sign on the screen and the real

sign shining through the pub window will meet in eerie juxtaposition'.[4]

Related work: Kenny Hunter's *Cherub/Skull* on the Tron Theatre (20–46 Trongate, q.v.) was also commissioned as a Merchant City 'Urban Icon'.

Condition: Good.

Notes
[1] Nicola White, 'A city of dreams reflected in bright neon', H, 29 December 1997. [2] John Calcutt, 'looking a bit distracted', SM, no.7, March 2000, pp.12–13. [3] White, *op. cit.* [4] *Ibid.*

Other sources
Thomas Lawson & Russell Fergusson, 'empire: a public work by douglas gordon', information leaflet and poster, VAP, Glasgow, n.d. (1998); 'Empire for Merchant City', H, 24 January 1998, p.4; Phil Miller, 'Backward art attack', *Glaswegian*, 12 March 1998, p.11; 'Hitchcock revisited', *Blueprint*, March 1998, p.16; Elisabeth Mahoney, 'Flickering sign of the times', *Scotsman*, 26 January 1998; McKenzie, pp.42 (ill.), 45.

Buchanan Street CITY CENTRE

Commercial building, 2–8 Buchanan Street / 122–32 Argyle Street

Abstract and Ornamental Panels

Sculptor: not known

Architects: Harry Wilson, R.I. Pierce and N. Martin
Date: 1929 (altered 1938 by Pierce and Martin)
Materials: cast iron; Portland stone
Dimensions: main (eagle) panels approx. 60cm high × 2.3m
Listed status: category B (4 September 1989)
Owner: Prudential Assurance Co. Ltd

The building is on the north-east corner of

Buchanan and Argyle Streets and was designed originally as a retail store for Montague Burton Ltd, the 'Tailor of Taste'.[1] The iron panels, which combine geometric motifs with quasi-anthemion designs, stylised eagles and abstract wave patterns, are inserted between the main Portland stone pilasters to divide the first, second and third floors. The Art Deco style of the designs, which were originally painted blue, conforms to the 'house style' adopted by Burton's in all their shop developments in the 1930s, and were probably designed by the company's own architect, N. Martin.[2] In the curved recess on the north-west corner and in the cavetto cornice of the north elevation there

are large stone cartouches containing designs based on stylised wings.

Related work: Burton's store, The Cross, Paisley.[3]

Condition: Good. The panels are painted brown.

Notes
[1] GCA, B4/12/1929/665. [2] McKean, p.96–7. [3] *Ibid.*, p.97 (ill.); Frank Arneil Walker, *The South Clyde Estuary*, Edinburgh, 1986, p.13 (ill.).

Other sources
LBI Ward 25, p.9; McKean *et al.*, p.92; Williamson *et al.*, p.171.

Anon., *Ornamental Panel*

Anon., *Youth*

Commercial building, 16 Buchanan Street

Statues of Youths and Associated Decorative Carving

Sculptor: not known

Architects: James Thomson and possibly others
Builder: Morrison & Mason
Date: *c*.1910
Material: red sandstone
Dimensions: figures approx. life-size
Listed status: category B (September 1989)
Owner: Prudential Assurance Co. Ltd

Description: The main sculptural feature on this seven-storey building in a simplified Venetian Renaissance style is a pair of free-standing statues of male youths on the upper balustrade, one (left) holding a shield and a cornucopia, the other a model ship. Decorative carving includes a cartouche in the upper pediment containing a thistle, a rose, a fleur-de-lis and a shamrock.

Discussion: The building has a complex history, and is the product of a number of alterations and changes of use at various times. Designed originally by William Spence, *c*.1873, it was built as part of Fraser & McLaren's warehouse. It was at this time that a group of four 'Tontine Faces' came into the possession of Mr Fraser (some believe illegally) after they had been removed from the Tontine Hotel (originally the Town Hall, later demolished) on the Trongate. These were cleaned and inserted into the keystones of the windows on the upper floor of the south and west faces of the warehouse by the builder Peter Shannan,[1] with some of them possibly extending to this part of the block. After a serious fire in 1888 it was rebuilt by Morrison & Mason for Brown, Smith & Co. and Fraser, Sons & Co. to a design by James Thomson.[2] The 'Tontine Faces' were subsequently removed, and a speculative outline of their subsequent history is given below. (See St Nicholas Garden, Castle Street. See also 116–20 Argyle Street.) The upper storeys were added *c*.1910,[3] and the statues of the youths presumably date from this time.

Condition: Apparently good, but the excessive height of the building makes inspection of the statues difficult.

Notes
[1] Cowan, pp.402–3; McKean *et al.*, p.93. [2] *Ibid.*; Michael Moss and Alison Turton, *A Legend of Retailing: House of Fraser*, London, 1989, pp.47–50. [3] LBI, Ward 25, p.25.

Other sources
BN, 19 September 1873, p.325; Gomme and Walker (1987), p.261.

Argyll Chambers, 28–32 Buchanan Street

Pair of Allegorical Female Figures
Sculptor: James M. Sherriff (attrib.)

Architect: Colin Menzies
Masons: Thaw & Campbell
Date: 1903–4
Material: red sandstone
Dimensions: figures approx. 2.3m high
Inscriptions: in raised letters on the central
 balcony – ARGYLL CHAMBERS; divided
 between two shields on the fourth floor – 19
 / 04; in the lunette on the central window of
 the third storey – SC
Listed status: category B (4 September 1989)
Owner: Royal Liver Assurance Ltd and
 Prudential Assurance Co. Ltd

Description: The style of this six-storey
commercial block has been described variously
as 'Edwardian Baroque',[1] 'free "French
Renaissance"'[2] and 'florid Franco-Flemish'.[3] It
has also been described as 'swaggeringly
sculptured',[4] although in fact the sculpture is
confined to the two standing female figures
which flank the balustraded central bay above
the entrance. The figure on the left is a
personification of *Industry*, and is shown
holding a distaff with part of a spinning wheel
protruding from her niche; her companion
holds a caduceus and has bales of goods
(possibly tea) at her feet, and may therefore be
identified as *Commerce*. Each is enclosed in an
elaborate *baldacchino* decorated with large
bosses suspended from miniature flattened
arches and capped by an octagonal ogee dome.

Discussion: The monogram 'SC' refers to
Stuart Cranston, a wealthy tea importer and the
brother of Catherine Cranston, whose joint
promotion of tea-drinking in Glasgow
revolutionised the city's social life in the late
nineteenth century (see 91 Buchanan Street,
below). In 1892 he opened a tea room in the
Argyle Arcade, a nineteenth-century shopping

James M. Sherriff (attrib.), *Industry*

James M. Sherriff (attrib.), *Commerce*

mall connecting Buchanan Street with Argyle Street, and which at that time was entered on Buchanan Street through a converted eighteenth-century villa.[5] In 1894 he bought the entire block, and by the beginning of the twentieth century had amassed sufficient capital to replace it with the present much more grandiose structure, in the process demolishing 'the last remaining representative of the old private houses which had marked the west end of the city in the early nineteenth century'.[6] His obstinate preference for the eccentric spelling 'Argyll' – in defiance of the customary 'Argyle' – has been described as indicating 'a touch of monomania in his character'.[7]

The architect's plan preserved in the City Archive shows the *baldacchini* but omits the statues.[8] A perspective drawing of the building published in *Academy Architecture* before it was built, however, shows the statues very clearly.[9] Their execution is ascribed here to James M. Sherriff on the basis of their stylistic similarity to the allegorical female figures on the former Springburn Halls (11 Millarbank Street, q.v.), one of which also has a wheel protruding from her niche.

Notes
[1] LBI, Ward 25, p.20. [2] Kinchin, p.64.
[3] Williamson *et al.*, p. 21. [4] McKean *et al.*, p.93].
[5] Kinchin, pp.48, 63 (ill.). [6] *Ibid.*, p.64. [7] *Ibid*,
p.48. [8] GCA, B4/12/1/9383. [9] AA, 1902, I, p.90.

Other sources
Daniel Frazer, *The Story of the Making of Buchanan Street*, Glasgow, 1885, pp.17, 68–9; Allan Fullarton, 'House Nos. 26–32 Buchanan Street', *The Regality Club* (Third Series), 1899, pp.114–23; BI, 15 April 1903, p.13; Margaret MacKeith, *Shopping Arcades: a Gazeteer of Extant British Arcades, 1817–1939*, London, 1985, pp.48–9; Pamela Robertson, 'Catherine Cranston', *Journal of the Decorative Arts Society*, no.10, 1986, p.10; McKenzie, pp.64 (ill.), 65.

Princes Square, 34–56 Buchanan Street

Peacock, Gates, Balustrades and Associated Decorative Ironwork
Sculptor: Alan Dawson

Fabricators: Shepley Dawson Architectural Engineering Ltd
Architects: Hugh Martin Partnership
Date: 1985–7, with additions 1990 and alterations 1997–8
Materials: forged iron; aluminium, stainless steel and bronze (peacock)
Dimensions: peacock 10m high × 20m wide
Listed status: building listed category B (15 December 1970)
Owner: Princes Square Consortium

Description: The work consists of an integrated programme of hand-forged iron

sculptures, extending from the five-storey Buchanan Street frontage to the glass-roofed public space of the galleried shopping mall within. Individual components differ in their scale and treatment, and in the variety of decorative and functional roles they perform. However, the use of a consistent pattern of imagery throughout, as well as a candid dependence on Art Nouveau precedents in the style, enables the scheme to be read as a visually and conceptually unified whole.

On the Buchanan Street façade the main feature is the colossal open-work peacock perched on an iron ring projecting from the centre of the attic balustrade. With its outspread tail of bronze-tipped aluminium rods, this provides an eye-catching climax to the exterior part of the scheme, and a dominant landmark on the southern section of Buchanan Street. At ground-floor level, and connected to the perch

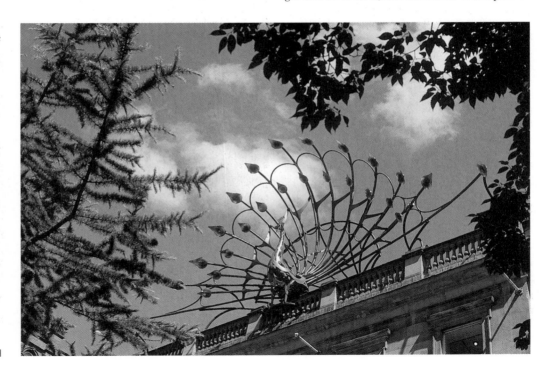

Alan Dawson, *Peacock* [RM]

by a cluster of descending cables, there is a curvaceous canopy suspended from wall-mounted brackets decorated with stylised references to the 'eye' motif in the peacock's tail. Extending across the nine central bays, the canopy forms a unifying device to connect the mouths of the three pends which provide access to the interior court. The peacock imagery is further elaborated in the fanlights above the entrances, in which forged and polished stainless steel outlines of the bird are finished with iridescent favrille-style glass inlays by John Ditchfield. The gates on the outer two pends are designed to illustrate the theme of the 'Tree of Life', with the iron-work combining tangled roots, twisted stems and tightly coiled buds with Art Nouveau whiplash forms, and with tendrils from the side posts extending into the lintels and spandrels of the fanlights.

Variations of the 'Tree of Life' theme are explored extensively in the interior, in many cases further enriched with symbolic references to the related theme of the 'Spring of Knowledge'. The principal elements here are the 350 metres of balustrading on the balconies on the three main floors, the helical staircase at the east side and the 220 lamp fittings of various designs distributed throughout the building. The plant forms in the balcony panels suggest a progressive development from bud to bloom as they ascend from floor to floor, while the treatment of the balustrades on the staircase is intended to create an overall impression of flowing downward movement. Additional decorative features, all of which have a 'family resemblance' to the main design, include the domical canopy on the lift cage, the bench seats, telephone supports, menu stands and litter bins employed on all three floors, and the shoe-shine stand on the ground floor.

Discussion: The scheme was commissioned as part of a comprehensive redevelopment of the Prince of Wales Buildings, which were designed in 1854 by John Baird I as a hotel and later converted to business premises, but which

by the mid-1980s, despite their listed status, had become semi-derelict. Following their successful conversion of Covent Garden Market in London, Teesland Developments undertook to transform the building into a distinctive retail and leisure centre for the building's owners, Guardian Royal Exchange. From the beginning the intention was that it would be a 'place to take the whole family to browse, eat and drink, and watch other people', and that it should avoid a 'sterile modernist style' by aiming to achieve a 'fashionable "hand made" look'.[1] In 1985, preliminary meetings were arranged between the architects Hugh Martin & Partners and Alan Dawson, who by this time had formed a partnership with the Workington firm Shepley Engineering in order to undertake large-scale architectural work. Despite some initial scepticism on the part of the developers that such an extensive programme of decorative work could be produced economically and on time by traditional artist-blacksmiths, the commission was approved and in April 1987 the complex process of simultaneously designing and producing the vast number of hand-forged components began. Because of the scale of the undertaking, and the repetitive nature of many of the individual pieces, it was necessary to employ a team of blacksmiths, who produced most of the sculptures off-site under Dawson's supervision. Innovative techniques were developed, including the installation of the main carcasses of the balustrading at an early stage, thus allowing the infill sections, including etched glass panels by Maria McClafferty, to be installed without impeding the work of other tradesmen. The efficiency of the process enabled the entire programme to be completed by October – a mere six months after it was started – and comfortably within its £500,000 budget. The Square itself was formally opened on 29 April 1988 by Prince Charles, the Prince of Wales, who later praised it as a 'welcome return of craftsmanship and the art nouveau

traditions of turn-of-the-century Glasgow'.[2]

The main exterior peacock was added in 1990, in part as a contribution to the City of Culture Festival in Glasgow that year. In 1997 a number of further alterations were made in preparation for the sale of the building by Guardian Royal Exchange. These included the removal of the three ground-floor canopies which originally projected from the pends onto the pavement on Buchanan Street and their replacement with the larger single canopy that exists today. The purpose of this was to give the Buchanan Street façade a greater impact and a more unified identity. Other alterations included the installation of a series of column lamps in the two outer pends, as part of their general re-design. In 1998 the building was sold to Hermes and Clerical Medical, who added the Glasshouse extension to the north-east corner the following year.[3] This included the commission of Shona Kinloch's *As Proud As …* in Springfield Court (q.v.).

Related work: The theme of the 'Tree of Life' is used by Alan Dawson on his later work at 131 St Vincent Street (q.v.).

Condition: Good.

Notes
[1] Paul Margetts, 'Alan Dawson and his work at Princes Square, Glasgow', unpublished research paper, Birmingham Polytechnic, 1989/90, p.8. [2] HRH The Prince of Wales, *A Vision of Britain: a Personal View of Architecture*, London, New York, Toronto, Sydney, Auckland, 1989, p.129. [3] GH, Property Supplement, 22 January 1998, p.1.

Other sources
Alan Dawson, 'The Princes Square metalwork: or iron comes of age', unpublished information pack, Shepley Dawson Architectural Engineering, n.d. (1988); S. Pollitzer, 'Craft is King in Princes Square', *Designweek*, 5 February 1988, p.13; Various contributors, 'Building Dossier: Princes Square, Glasgow', *Building*, 12 August 1988, pp.30–6; M. Crummy, 'Princes Square, Glasgow', *British Blacksmith*, no.50, December 1988, pp 7–12; Williamson *et al.*, p.221; McKean *et al.*, p.94; LBI, Ward 25, p.21; McKenzie, pp.62–4 (incl. ill.).

Fraser's Department Store, 45 Buchanan Street

Winged Female Figures and Imperial Arms

Sculptor: not known

Architects: Campbell Douglas & Sellars
Builder: Alexander Eadie
Date: 1884–5
Material: terracotta
Dimensions: figures life-size
Inscriptions: on coat of arms – DIEU ET MON
 DROIT (trans.: 'God and my right'); on
 cartouche below pediment – W & L LTD
 (entwined); on bracket above ground-floor
 pilaster, north end – 1884
Listed status: category A (23 March 1977)
Owner: House of Fraser Ltd

Description: The figures are located in the
broken scroll pediment above the main entrance
of this five-storey, Renaissance-style
commercial building. Seated on either side of a
decorative pedestal supporting the imperial
arms, they carry attributes identifying them as
allegories of *Art* (left, holding a palette and
brushes) and *Industry* (distaff). Although the
figures are exact mirror images of each other in
their poses, there are noticeable differences in
the treatment of their draperies, and it may be
significant that the figure representing Art has a
sensuously exposed shoulder. There is no other
figurative work on the building, but the
remainder of the façade is characterised by a
rich vocabulary of decorative relief work, which
is employed extensively on structural features
such as pilasters, cornices, entablatures and
colonettes. There is also a pair of carved
mahogany dolphins at the base of the stair
inside the main entrance.

Discussion: The building was commissioned
by the firm of upholsterers and cabinet makers
Wylie & Lochhead, and was praised at the time
as an 'admirable addition to the street

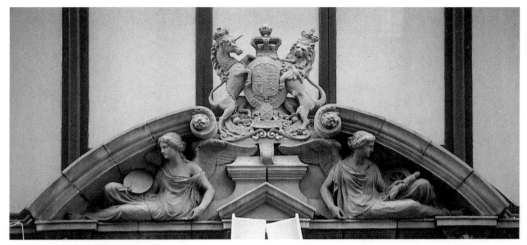

Anon., *Winged Female Figures* [RM]

architecture of Glasgow'.[1] An anonymous
writer in the *British Architect* commented on
the comparative scarcity of terracotta buildings
in Glasgow;[2] another correspondent noted that
the adoption of the Italian Renaissance style
'permitted the architects to take full advantage
of the facilities afforded for ornamenting the
terra cotta when in a plastic state'.[3] The building
has been described more recently as '"one huge
window" attractively complimented by an
ornamental doorway'.[4]

The identity of the sculptor, or sculptors,
responsible for modelling the figures and
carving the dolphins is not known, but it is
worth noting that the 'building of the terra
cotta, and the carpenter and joiner work' were
all ascribed by the *British Architect* to
Alexander Eadie.[5]

Condition: Good.

Notes
[1] BA, 21 May 1886, p.522. [2] *Ibid.*, 5 February
1886, p.111. [3] *Ibid.*, 1 May 1885, p.215. [4] Michael
Moss and Alison Turton, *A Legend of Retailing:
House of Fraser*, London, 1989, p.54. [5] BA, 1 May
1885, p.215.

Other sources
LBI, Ward 18, pp.40–1; GUABRC (Wylie and
Lochead press cuttings; private ledgers of Fraser &
McLaren and Fraser & Co.); McKean *et al.*, p 92;
Williamson *et al.*, p.219; McKenzie, pp.64 (ill.), 65.

Commercial building, 60–2 Buchanan Street

Allegorical Figures

Sculptor: not known

Architect: Robert Thomson
Masons: Robert McCord & Son
Date: 1894–6
Material: red sandstone
Dimensions: figures approx. 2.3m high
Listed status: category A (15 December 1970)
Owner: Jaeger Company's Shops Ltd

Description: The sculpture on this narrow,
seven-storey elevator building in a *fin de siècle*
Baroque style is concentrated on the fourth
storey, and consists chiefly of a pair of free-
standing allegorical female figures in canopied
niches on the side piers. On the left, *Justice*
holds a sword and a pair of scales; the figure on
the right holds a mirror and appears to have
removed a blindfold from her eyes and

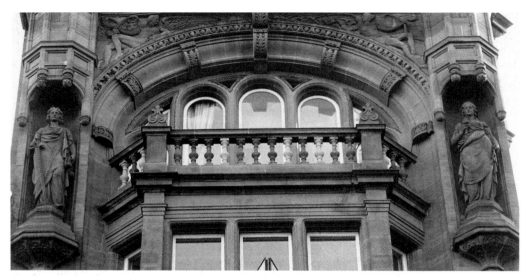

Anon., *Allegorical Figures*

therefore represents *Truth*. The canopies above them are in the form of two-stage octagonal turrets capped by domes and finished below with shafts terminating in variously carved bosses. In the spandrels over the central arch there are two reclining winged *Victories* carved in relief, including a male figure (left) holding an open book, and a female with a cylinder(?) propped on her left knee; the corners of the spandrels are occupied by an owl (left) and a crescent moon. Additional details include a frieze of winged griffins above the first-floor windows and foliage in the voussoirs of the main arch.

Discussion: The building was erected for the North British Rubber Company Ltd on a site so narrow that the architect was required to adopt a 'cantilever principle of construction, thus dispensing with the usual columns supporting the lintels'.[1] As a result the masonry jambs into which the statues are inserted appeared to be 'supported on an inadequate surface of plate glass'.[2] The correspondent of

the *Builders' Journal* found this arrangement 'much to be regretted, the more so as the rest of the building is designed on the right lines for a site of this kind'.[3] Stylistically, the building and the figures are very similar to Colin Menzies' slightly later Argyll Chambers, on the same side of Buchanan Street a few blocks to the south.

Condition: Good.

Notes
[1] BJ, 18 June 1895, p.301. [2] *Ibid.* [3] *Ibid.*

Other sources
GCA, B4/12/1/3255; B, 9 July 1898, p.23; GAPC, 22 November 1898, n.p. (incl. ill. of drawing by Thomson's assistant Andrew Wilson); Gomme and Walker (1987), pp.260 (ill.), 261; McKean *et al.*, p.94; Williamson *et al.*, p.221; McKenzie, pp.62, 64 (ill.); LBI, Ward 25, pp.21–2.

Former Glasgow Herald Building, 63–9 Buchanan Street

Statues of Caxton and Gutenberg, Narrative Relief Panels and Associated Decorative Carving

Sculptors: Charles Grassby (reliefs); John Mossman (statues)

Architect: James Sellars
Mason: John Morrison
Date: 1879–80
Material: yellow sandstone
Dimensions: Caxton and Gutenberg approx. 2.3m high; putti approx. 1.8m high
Inscription: on the coat of arms – LET GLASGOW FLOURISH
Listed status: category B (15 December 1970)
Owner: Scottish Widows Fund and Life Assurance Society

Description: This tall, narrow commercial building has a Corinthian order in the middle storeys, a pair of shallow oriel windows in the outer bays and a barrel-vaulted entrance; it was described at the time it was built as being a 'Classic design of dignified proportion and massing, and refined detail'.[1] There are four vertical relief panels in the pilastrade on the ground-floor mezzanine, with naked putti performing a variety of activities associated with newspaper production. From the left, they show: a weeping putto being consoled (a tragic news event?); putti carrying a bed of type; putti working a press; a putto conducting an interview.

The statues of Caxton and Gutenberg are on pedestals inserted in the balustrade on the third storey, in front of the recessed central bay, with Caxton on the left.

William Caxton (1422–91), pioneer English publisher and translator whose work as a publisher and translator had a decisive influence on English literature. He was a prosperous wool merchant in Bruges for thirty years and in

1463 became 'Governor of the English Nation of Merchant Adventurers' in the Low Countries. In 1469 he began to translate Raoul Le Fèvre's *Recueil de histoires de Troye*, but after his 'pen became worn, his hand weary, his eye dimmed' with the task, he turned to the more efficient process of printing, setting up his own press in 1474. Three years later he produced *Dictes and Sayenges of the Phylosophers*, the earliest dated book printed in English. Among the 100 or so publications he produced were devotional books, Chaucer's *Canterbury Tales* and Malory's *Morte Darthur*, catering for the entire literate public of his day.[2] He is represented here in contemporary dress with his right arm placed on his chest and an unidentified object in each hand.

Johannes Gutenberg (c.1398–1468), inventor of movable metal type, which revolutionised book production and remains one of the landmarks in the development of printed literature. Born in Mainz, Germany, he began his career as a goldsmith in Strasbourg in 1434. Soon afterwards he formed a partnership with a group of craftsmen to develop a refined printing process, though the key elements of the new

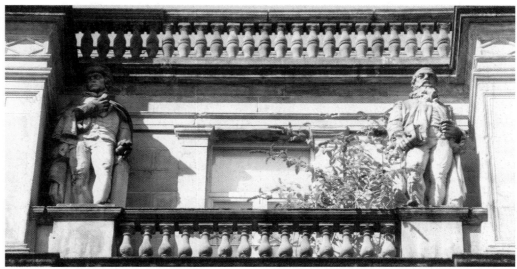

method were invented in secret by Gutenberg alone. During the period in which he brought his process to perfection he became involved in a disastrous legal dispute which led to the loss of his equipment and the publication rights of his first two printed masterpieces, the '42–line' Bible and a decorated Psalter. Though destitute

John Mossman, *Caxton* and *Gutenberg*

and nearly blind at the time of his death, his invention spread rapidly, and before the end of the fifteenth century there were more than 1,000 printers in Europe, including Caxton.[3] Here Mossman represents him in the costume of a prosperous fifteenth-century merchant, with a lace ruff and ample cloak, and with a bible in his right hand.

Additional sculpted work includes: a keystone mask of *Mercury* in the main entrance arch, with tree branches in low relief in the adjacent spandrels; a Glasgow coat of arms flanked by two further naked putti above the central window on the first floor; a variety of naturalistic forms in lintels, friezes and entablatures throughout the building, and on the oculi above the side entrances.

Discussion: The building was designed as the head office of the *Glasgow Herald*, then approaching its centenary as a leading Scottish broadsheet newspaper. One of a number of prestigious newspaper buildings erected in Glasgow in the last quarter of the nineteenth

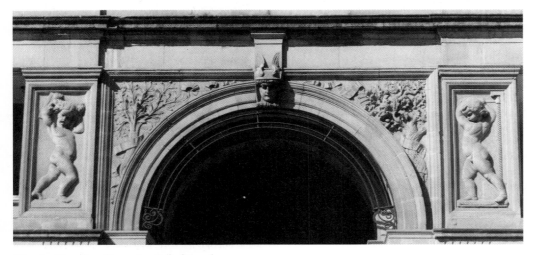

Charles Grassby, *Narrative Relief Panels*

century, it was part of what the *British Architect* described as a 'fashion for wealthy journals to build their own special premises'. The article goes on to observe that this practice was a 'privilege to be highly valued, not only in respect to the value of the accommodation only to be so obtained, but also as to the setting before the public the dignity and importance of newspaper literature now-a-days'.[4] The incorporation of portraits of Caxton and Gutenberg is clearly consistent with this aim, though it should be noted that the reference to the former has a particular relevance, as the earliest editions of the paper were printed on 'one of the old wooden screw presses which had been in exclusive use since the days of Caxton'.[5]

Related work: There are masks of Caxton and Gutenberg on the former Govan Press Building, 577–81 Govan Road (q.v.).

Condition: Good, apart from some minor chipping on the relief panels and some spalling on the main figures. Caxton has also lost his nose.

Notes
[1] BA, 27 August 1880, p.96. [2] EB, vol.II, p.660. [3] *Ibid.*, vol.8, pp.505–6. [4] BA, 27 August 1880, p.96. [5] *Ibid.*

Other sources
B, 9 July 1898, p.23; Gomme and Walker, p.286; McKean *et al.*, p.94; Williamson *et al.*, p.220; GH, 19 December 1994, p.9; LBI, Ward 18, p.42; McKenzie, pp.64 (ill.), 65.

Commercial building, 91 Buchanan Street

Relief Panels with Putti and Associated Decorative Carving

Sculptor: not known

Architect: George Washington Browne
Date: 1896–7
Building opened: 5 May 1897
Material: red Locharbriggs sandstone

Anon., *Putti Reliefs* [RM]

Dimensions: putti approx. 60cm high
Inscription: on keystone over ground-floor window – C
Listed status: category A (15 December 1970)
Owner: Bradford and Bingley Building Society

Description: There is no major sculpture on this four-storey commercial building, but the groups of putti seated among garlands and vases of fruit in the two panels below the first-floor oriel windows and in the pediment above are a natural extension of the ornate 'Pont Street Dutch' style of the façade,[1] which is further enlivened by alternating bands of red and cream (Prudhoe) sandstone. Additional decorations include: floral bosses on the brackets supporting the oriel; cartouches of various designs and deeply cut garlands above the windows of the first and second storeys; a Glasgow coat of arms flanked by particularly sinuous salmon in the gable; flowers in the voussoirs of the arched window on the ground floor. The first floor is also decorated with a wrought iron balcony in a complex Viennese Art Nouveau style (possibly the work of William Kellock Brown).

Discussion: The monogram 'C' in the keystone refers to Catherine Cranston, who commissioned the building as a suite of 'tea and luncheon rooms',[2] and who, together with her brother Stuart (see Argyll Chambers, above), was the leader of the 'temperance refreshment' movement which dominated social life in Glasgow at the end of the nineteenth century.[3] She also made an important contribution to the development of the artistic life of the city, using her restaurants as an opportunity to commission new work by a number of progressive local designers. In this case she chose to combine a safely conventional exterior by an established architect known for his banks and prestigious public buildings, with a radically experimental interior in the emergent 'Glasgow Style', including design work by George Walton and the still relatively young Charles Rennie Mackintosh. On the whole, the critics were impressed by the building, describing it variously as 'picturesque' and 'charmingly detailed in a very refined manner',[4]

although one writer did note that there were 'two styles … observable: that of the architect of the building, and that of Mr. Charles R. Mackintosh, who, together with Mr. George Walton, is responsible for the decoration and furnishing'.[5] Gleeson White, the editor of the progressive magazine the *Studio*, was more direct in his criticism of the incongruity of the two different styles, and complained of the

> … 'extremely irritating' ornamental features deriving from the architect (whom he tactfully declined to name) – things like stone coats-of-arms balanced on the banisters, or a carved Rococo cartouche slap in the middle of the gable end of the smoking gallery, a costly and superfluous 'eyesore' against the rarefied lines of Mackintosh's curious decorations.[6]

In her last and most famous venture, the Willow Tea Rooms on Sauchiehall Street, Miss Cranston solved the problem by commissioning Mackintosh to design the entire scheme.

A photograph of the ground floor during construction shows the two relief panels over the entrance and the decorative voussoirs in the window arch in their uncarved state.[7]

Condition: The exterior is in good condition. The interior work by Mackintosh and Walton has all been stripped out, and the building is now occupied by a building society.

Notes
[1] Gomme and Walker, p.198 n.3. [2] BA, 28 February 1896, p.148. [3] 'Men you know – No.2023', *The Bailie*, no.2023, 26 July 1911, p.1; Pamela Robertson, 'Catherine Cranston', *Journal of the Decorative Arts Society*, No.10, 1986, pp.10–17. [4] B, 9 July 1898, p.23. [5] BJ, 15 April 1903, p.127. [6] Kinchin, p.88. [7] *Ibid.*, p.85.

Other sources
BJ, 18 June 1895, p.301, 15 April 1903, pp.127–7; *Bailie*, 5 May 1897, p.6; Howarth, p.125; Worsdall (1988), p.52; McKean *et al.*, p.94; Williamson *et al.*, p.220; Karen Moon, *George Walton, Designer and Architect*, Oxford, 1993, p.51 ff. (incl. ill.); LBI, Ward 18, pp.43–4; McKenzie, pp.62, 63 (ill.).

Commercial building, 113 Buchanan Street

Decorative Carving
Sculptor: not known

Architect: A. Sydney Mitchell
Date: 1886–8
Material: yellow sandstone
Dimensions: roundels 51cm diameter; lunettes in entrance vestibule 1.83m wide
Inscription: on the central interior lunette – DITAT SERVATA FIDES (trans.: 'tried fidelity enriches'); in wrought iron lunettes above the entrance gates – CBS (entwined)
Listed status: category A (15 December 1970)
Owner: Burford Investment Co. Ltd

Description: Situated on the north-west corner of Buchanan Street and Gordon Street, the building is four storeys high, with a tall, domed corner turret in the French Renaissance style. On the Buchanan Street frontage there are four roundels in the ground-floor window spandrels containing, from the left: a camel; a winged bishop; a coat of arms supported by lions and including two masks; a coat of arms with a female figure, an anchor and a pair of unicorns. There is also some complex decorative work on the capitals of the giant pilasters, the frieze above the second-floor windows and the attic order.

Two further roundels appear in the spandrels of ground-floor arches on the Gordon Street façade, containing: a pair of griffins supporting a shield carved with an Agnus Dei; two dragons with entwined tails supporting a floral shield. The remainder of the spandrels on this façade are filled with plant forms. The capitals and friezes on the upper storeys are similar to those on Buchanan Street, with the addition of a group of garlands above the attic order. On the drum below the corner dome there are four panels carved with the Glasgow arms surmounted by double cornucopias. The corner also has projecting balconies with their undersides carved with acanthus leaves.

In the entrance vestibule there are five lunettes carved in relief, the central one containing a female figure, perhaps symbolising *Commerce*, seated against a background of trees, ships, cargo, etc., and an inscription (see above). The four outer lunettes contain blank panels decorated with swags, and there is a continuous Vitruvian frieze running below all five.

Discussion: Formerly a branch of the Royal Bank of Scotland, the building was designed as an extension to the Glasgow head office of the Commercial Bank of Scotland at 2–16 Gordon Street (q.v.). According to the *Building News*:

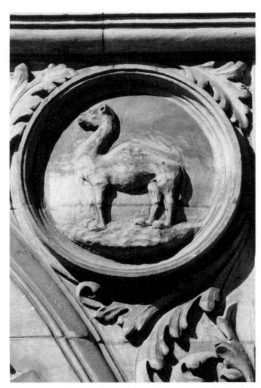

Anon., *Decorative Roundel*

'The purpose of these additions is to give the bank an entrance from Buchanan Street, the present entrance being on Gordon-street, and therefore somewhat wanting in dignity.'[1]

The relevance to banking of much of the imagery – particularly, the winged bishop and the Agnus Dei – remains unclear, though the camel is presumably intended to signify the prudent laying up of resources. It is worth noting, however, that in the perspective drawing published in the *Building News* the roundels are shown as floral decoration.[2]

Condition: Good.

Notes
[1] BN, 3 June 1887, p.832. [2] *Ibid.*, n.p.

Other sources
BA, 31 August 1888, p.149 (incl. ill.); BJ, 28 September 1898, pp.115–17 (incl. ill.); Williamson *et al.*, p.225; McKenzie, p.62.

In the pedestrian precinct, immediately south of St Vincent Street

Topographical Relief Map
Sculptor: Kathleen Chambers

Date: 1990
Materials: bronze on a base of concrete faced with polished granite
Dimensions: bronze relief 1.28m wide × 90cm; base 90cm high × 1.4m × 1.3m
Inscription: various street names and locations
Owner: Glasgow City Council

Description: Free-standing relief map of the centre of Glasgow, covering the area between Glasgow Green and the M8 motorway (east-west) and from the River Clyde to Cowcaddens, with architectural landmarks shown in a simplified form, and the River Clyde represented as a shallow channel designed to trap rainwater. Street names are given in both Roman script and braille, and the base incorporates a recessed pedestal to accommodate wheelchair access.

Discussion: Chambers was awarded the commission after being invited by representatives from Glasgow District (now City) Council, Strathclyde Regional Council (including Catherine Simpson of the SRC Services for the Blind) and Glasgow Building Preservation Trust to submit a proposal. A small-scale wax model was presented initially for approval, and during the production process the Services for the Blind Department, together with a group of VIPs (Visually Impaired People) were consulted on a regular basis. The braille inscriptions were made on rubber strips by William Douglas & Co. at the Centre for the Blind, and subsequently cast onto the work. The cost of the finished piece, which received an EEC-supported Helios Award for access and availability of information, was approximately £20,000.

Related work: Relief map of the west end of

Kathleen Chambers, *Topographical Relief Map* (detail) [RM]

Glasgow in Kelvingrove Park (q.v.), also by Chambers.

Condition: Good. The sculpture was removed in 1999 to allow improvements to be made in Buchanan Street and reinstated in the summer of 2000. The base was repaired while it was in store.

Source
Information provided by the artist.

Former Stock Exchange, 159 Buchanan Street / Nelson Mandela Place

Allegorical Statues, Roundels and Capital Figures
Sculptor: John Mossman (attrib.)

Architect: John Burnet
Builders: Morrison & Mason
Date: 1875–7
Material: yellow sandstone
Dimensions: main figures approx. life-size
Inscriptions: in raised letters below allegorical
 busts – SCIENCE; ART; BUILDING;
 ENGINEERING; MINING
Listed status: category A (12 December 1970)
Owner: Scottish Metropolitan Property plc

Description: The sculpture scheme of this three-storey Venetian Gothic building consists of three main figurative elements, augmented by a number of armorial reliefs. In the spandrels between the ground-floor arches there is a series of five roundels with projecting busts

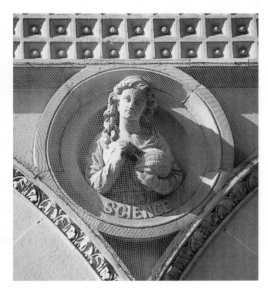

John Mossman (attrib.), *Science* [GN]

identified by their inscriptions and attributes as symbols of, from the left on Buchanan Street: *Science* (female, with globe and dividers); *Art* (female, with palette and brushes); *Building* (male, with mallet and chisel), *Engineering* (female, with cog wheel); and *Mining* (male, with pick axe). The entrance at the south end of Buchanan Street is flanked by capitals carved with projecting figures 'representing the natives of the four quarters of the globe, in appropriate costumes'[1]: on the left these are European and Chinese, shown with their arms entwined and divided by a bunch of lilies; on the right an African and an Asian reach across a large central poppy to offer each other fruit and olive branches. The balcony projecting over the entrance is supported by corbels decorated with curved shields bearing the insignia of Glasgow and Scotland. Attached to the wall at first-storey level below the cornice are three full-length allegorical figures on projecting corbels, with simple Gothic canopies above them. At the south end of Buchanan Street is *Industry* (male, with hammer and anvil), while *Commerce* (female, with bales at her feet and documents in her hand) and *Agriculture* (female, with rake and sheaf of corn) flank the corner at Nelson Mandela Place. On the same level there is a series of five roundels filled with rosettes, and, at the extreme ends of the two façades, two groups of shields emblazoned with the arms of England, Scotland and Ireland (south end), as well as Glasgow, Edinburgh and Dublin (west end).

Discussion: Designed as the Stock Exchange, the building is a rare example of a secular Gothic Revival work in Glasgow. Indeed, the introduction of a building so 'antagonistic to the general surroundings' prompted a curious line of speculation from the correspondent of the *Building News*. 'I know as little', he confessed,

> ... of the history as of the mystery of the art and science of stockjobbing, and it may be

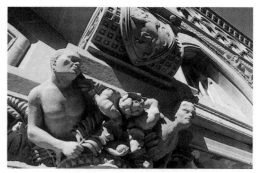

John Mossman (attrib.), *Figurative Capital*

that the association of ideas requires that a Stock Exchange should be girt about with Mediævalry; or, it is possible that our moneyed men, having subscribed largely towards the University, are – as bought wit is the best wit – most sweetly in love with the style that they have most deeply paid for, and therefore must have Gothic.[2]

A more serious matter was raised by E.W. Godwin, the editor of the *British Architect*. In an article entitled 'Architectural poaching', he accused Burnet of plagiarising his design from William Burges' London Law Courts, accompanying his text with a drawing of both buildings to support his allegation.[3] From these it can be seen that Burnet has used a much reduced sculpture programme, omitting the figures in the triforium and on the colonettes flanking the attic gables, while retaining the allegorical roundels in the ground-floor spandrels. Burges himself took up the issue, submitting photographs of the two buildings to the professional practice committee of the RIBA, who in fact eventually ruled that no breach of professional conduct had been committed. Burges graciously accepted their verdict. 'I need scarcely say', he concluded, 'that I feel very flattered that so veteran an architect as Mr. Burnet should have done me

the honour of selecting my work [for copying].'[4]

In 1967 the Glasgow Stock Exchange Association sold the building to the Scottish Metropolitan Property Company,[5] who demolished and re-designed the interior in one of the first redevelopments in the city to be subject to a façade retention order.[6] The Stock Exchange continued to occupy part of the property as tenants until July 1977, when the company was dissolved, and in 1999 the building was emptied for redevelopment. At the time of writing it is unoccupied.

The attribution of the sculpture to John Mossman is based on secondary sources only,[7] and has not been corroborated by contemporary documentation.

Condition: The nose on *Mining* has been chipped off and *Art* has lost the tips of her brushes.

Notes

[1] B, 17 February 1877, p.148. [2] 'Gossip from Glasgow', BN, 5 June 1874, p.611. [3] E.W. Godwin, 'Architectural poaching', BA, 13 July 1877, pp.16–17. [4] W. Burges, 'Architectural poaching', BA, 27 July 1877, p.40. [5] Anon., 'Centenary of Stock Exchange', *Glasgow Chamber of Commerce Journal*, May 1977, p.85. [6] Stewart McIntosh, 'Exchange building set to see its stock soar', GH, 6 November 1997, p.5. [7] McKean *et al.*, p.96.

Other sources

GCA, TD 1309/A488–89; BN, 2 March 1877, p.229; BJ, 28 November 1906, p.259; Cowan, p.167; Young and Doak, no.65 (ill.); Gomme and Walker, p.178 n.9; Worsdall (1982) p.145, (1988) p.44; Williamson *et al.*, p.222; Read and Ward-Jackson, 4/11/79–89 (ills); Teggin *et al.*, p.30 (incl. ills); McKenzie, pp.58, 59 (ill.); LBI, Ward 18, p.112.

Former Athenæum Theatre, 179 Buchanan Street

Pallas Athena, Muses, Wind Gods and Putti

Sculptor: William Kellock Brown

Architect: John James Burnet
Builders: Anderson & Henderson
Date: 1891–3
Materials: yellow sandstone; lead
Dimensions: Athena approx. 2.3m high; seated figures approx. 1.7m high; putti approx. 1.5m high
Inscriptions: in gilded letters incised on tablet above entrance – ATHENÆUM; entwined with foliage on either side of second-floor windows – A
Listed status: category A (6 July 1966)
Owner: Portfolio Holdings plc

Description: The main part of the sculpture programme on this narrow, five-storey building is concentrated in the upper part of the left-hand division of the façade, and consists of a pair of *Muses* seated on octagonal turrets rising from the sides of a central oriel window, a keystone in the arch between them carved with a winged female figure rising from the prow of a ship and a colossal standing figure of *Pallas Athena*, shown here without a spear but identified by her helmet, in the aedicule inserted into the gable. Though physically distinct, the figures are related as part of a single iconographic programme: the *Muses* – one of whom (on the left) reads (or sings) from an open manuscript while the other strums a lyre – epitomising the cultural activities which flourish under the dispensation of Athena, and the winged figure almost certainly representing her daughter Nike.[1]

On the right-hand bay, which contains the staircase and elevator, there is a pair of naked putti leaning on a blind cartouche in the pediment above the entrance, and a domed

octagonal turret in the attic with *Wind Gods* in beaten lead panels encasing the top stage of the drum. Minor decorative details include a substantial blind cartouche in the broken pediment of the central aedicule window, with cherub masks in the capitals and brackets of the adjacent columns; several other smaller blind cartouches on the first-floor balcony and on either side of the blank tablet over the entrance; ornamental ironwork, containing acanthus scrolls, shields and arabesques on the third-floor and basement windows.

Discussion: The building was commissioned by the Glasgow Athenæum Company Ltd as an extension to their existing premises at 8 Nelson Mandela Place (q.v.), and was designed to accommodate a school of music, a theatre, a restaurant, a billiard room and a gymnasium. At the time it was erected, the Buchanan Street façade was one of the tallest in Glasgow.[2] It was also one of the first to exploit the aesthetic potentials of combining a narrow site with the increased height made possible by the introduction of mechanical elevators. Burnet was something of a pioneer in this regard, and the design of the right-hand bay as a series of soaring parallel mullions, with an aedicule window suspended mid-way between the fourth and fifth floors, is possibly intended to suggest the vertical movement of the elevator within. By comparison, the treatment of the sculpture is somewhat conservative, with the exception, perhaps, of the Mannerist elongation of the putti.

The building was occupied by the Royal College of Music and Drama until 1988, when it was taken over by Scottish Youth Theatre. In 1998 it was bought by Portfolio Holdings, and currently awaits refurbishment as a retail development.

Condition: Good, apart from some general weathering and some minor damage to the putti.

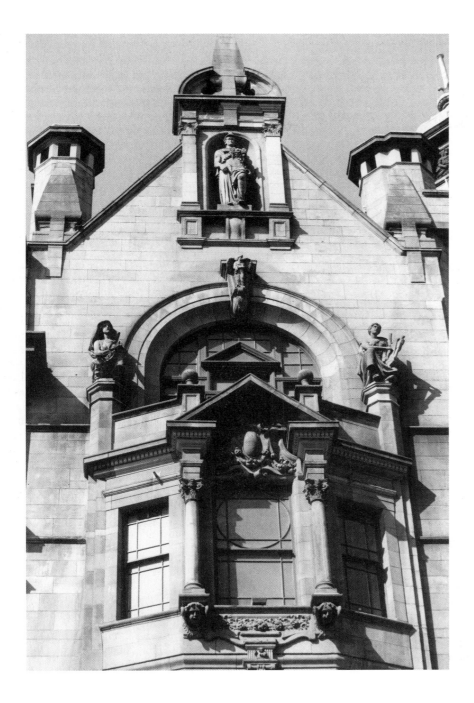

Notes
[1] According to a fifteenth-century guidebook,
Nike's temple on the Acropolis in Athens was also a
'school of musicians, founded by Pythagoras'. See
Warrington, p.364. [2] A, 31 July 1891, p.16.

Other sources: GCA, B4/12/1/1799, B4/12/1/1072;
BI, 15 August 1891, p.77, 15 September 1891, p.92; B,
1 April 1893, p.256, 21 October 1893, p.302; AA,
1893, p.11 (ill.); Teggin *et al.*, p.29 (ill.); McKean *et al.*,
p.98; Stewart McIntosh, 'The street of dreams', H, 22
January 1998, p.16; Phil Miller, 'Last act for city
theatre', *Glaswegian*, 19 March 1998; McKenzie,
pp.56 (ill.), 57; LBI, Ward 18, pp.47–8.

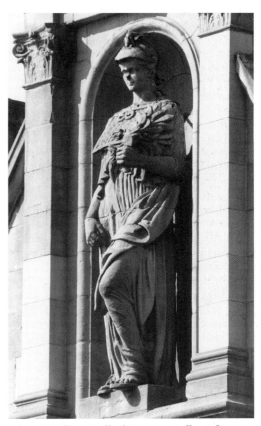

(above) **William Kellock Brown**, *Pallas Athena*

William Kellock Brown, *Figurative Programme*

Former Cleland Testimonial, 249 Buchanan Street

Coat of Arms
Sculptor: William Mossman Senior

Architects: David and James Hamilton
Date: 1835–6
Material: yellow sandstone
Dimensions: arms approx 1.8m high
Inscriptions: see below
Listed status: category B (15 December 1970)
Owner: Hermes Property Management Ltd

Description: Located on the attic storey, and marking the transition of the building from Buchanan Street to Sauchiehall Street, the sculpture group consists of an escutcheon bearing a leaping hare crossed with a hunting horn, a helmet and falcon perched on a gauntlet. The escutcheon is supported by a pair of scrolls, and an escrol runs across the bottom of the group carrying a Latin inscription of which only the last three words are legible: ' … QUI PENSE DEUS'. Below this, on a convex frieze, the inscription 'THE CLELAND TESTIMONIAL' appears in raised letters.

Discussion: The building was erected as a memorial to Dr James Cleland (1770–1840), a key figure in the development of Glasgow in the early nineteenth century. The son of a packing case manufacturer, he became Superintendent of Public Works in 1814, overseeing many important civic projects, such as the draining and levelling of Glasgow Green. In addition to publishing *Annals of Glasgow* (1817) and *The Rise and Progress of the City of Glasgow* (1820) he was also responsible for compiling the first systematic census of the city in 1821. To mark his retirement in 1834, a group of merchants donated £2,000 to a memorial fund, which was later increased to £4,600 by public subscription. As a recent commentator has noted, however, this sum was not spent in commissioning

William Mossman Senior, *Coat of Arms* [RM]

… a statue, a bust or a stained glass window for the Cathedral. Instead – and we wonder where the suggestion came from – it was agreed 'to erect a productive building in a suitable part of town to be designated *The Cleland Testimonial*, which the distinguished statist should hand down as an honoured heirloom in the family'.[1]

Cleland himself occupied the completed building until his death. The building was later amalgamated with the adjacent tenement to become part of the George Hotel, and in 1999 the entire block was sold and refurbished as part of the Glasgow Development Agency's development of the north end of Buchanan Street.

The imagery on the coat of arms closely matches the entry listed under '*Cleland* (that Ilk, co. Lanark)' in Burke's *General Armory*, although the accompanying mottoes are recorded here as 'Non sibi' (trans.: 'not for himself') and 'for sport'.[2] The attribution of the work to William Mossman is based on entries in his job book, which provide a detailed account of his financial dealings with his client. On 17 October 1835, for example, he records a payment of £10 for 'working at the Arms', followed by an entry on 10 November

confirming that the work had been completed.[3] Four days later he noted that he had

> Settled with Dr. Cleland about carving his arms &c. for Testimonial and found him not fully as [illegible] as I could have supposed, he having kept one pound from my account and gave it to my son John by way of encouraging him for his diligence and Cleland and [illegible] having kept off a Ballance which I was due then of £1–17–6, when in fact if I had kept as regular an Account against Alex.ʳ Cleland it would at least have amounted to three or four times that sum, however thank God they cannot now say I owe them one farthing. – W.M.[4]

The reference here to the eighteen-year-old John Mossman may well be the earliest documentary evidence of his activity as a sculptor. The elder artist's troubled dealings with Cleland were not over yet, however, and in January of the following year he had carved four lion heads for the same building, for which he 'hope[d] to be paid the sum of – £2–.2–', but for which he in fact received only £1 10s.[5] A final entry, dated 24 March, records a payment of 4 shillings for carving four letters.[6]

Related work: Portrait bust of Cleland by William Mossman, date and whereabouts not known.[7]

Condition: The building was cleaned in 1999, but the sculpture is very badly weathered.

Notes
[1] Anon., 'James Cleland, LL.D. (1770–1840)', GCCJ, July 1971, p.289. [2] Sir Bernard Burke, *The General Armory*, London, 1884. [3] GCA, TD 110, 'Jot Book of William Mossman, 1835–9', n.p. [4] *Ibid.*, 14 November 1835. [5] *Ibid.*, 14 and 23 January 1836. [6] *Ibid.*, 24 March 1836. [7] Johnstone.

Other sources
Daniel Frazer, *The Making of Buchanan Street*, Glasgow, 1885, p.76; Charles Menmuir, 'A Forgotten Glasgow Landmark: "The Cleland Testimonial": City Honours a Great Public Servant', EC, 18 July 1931; McKean *et al.*, pp.71, 99; Williamson *et al.*, p.223; McKenzie, p.57.

Burgh Hall Street PARTICK

Partick Burgh Hall, 3–9a Burgh Hall Street

Allegorical Roundels

Sculptor: William Mossman Junior

Architect: William Leiper
Date: *c.*1872
Material: yellow sandstone
Dimensions: internal diameters 1.07m (lower roundels); approx. 75cm (upper roundel)
Inscriptions: incised in the lower roundels, from east to west – MISERI / CORDIA; JUSTITIA; VERITAS
Listed status: category B (15 December 1970)
Owner: Glasgow City Council

Description: Located above the ground-floor windows, the three main roundels depict classically draped, seated female figures representing, from east to west: *Misericordia* (Mercy, shown in profile proffering a bowl which has been filled from a jug); *Justitia* (Justice, seated frontally, holding a sword and a set of scales); *Veritas* (Truth, with naked breasts and her feet placed on the neck of a writhing serpent). The slightly smaller fourth roundel is in the attic pediment and contains an unidentified female head. Additional decorative carving includes branches of olive and oak in the spandrels above the arched east entrance.

Discussion: Leiper's design for the building was the winner in a competition in 1865, and was one of several works chosen to show the 'Progress of British Architecture' in the Paris Exhibition in 1867. The foundation stone was laid on 12 March 1871.

Condition: Good overall, though the nose of *Misericordia* is slightly chipped.

William Mossman Junior, *Misericordia*

Sources
B, 12 October 1872, p.812; BA, 11 April 1884, p.179; Gildard (1892), p.6; Thomas Grieg and Alastair Clarkson, *William Leiper*, unpublished thesis, GSA, 1979, p.20; Williamson *et al.*, p.371.

Byres Road HILLHEAD

On gable of tenement building at junction of Byres Road and University Avenue

Illuminated Wall Sculpture

Sculptors: Michelle de Bruin and Callum Sinclair

Architects: Fraser Harle (of Simister Monaghan Architects)
Date: 1993
Materials: slate, black granite, onyx, glass and halogen bulbs
Dimensions: approx. 1.2m × 2.4m
Listed status: not listed
Owner: Glasgow West Housing Association

Description: Abstract sculpture mounted high on the south-east gable of a modern tenement building. The work comprises a central disc of black granite with arms radiating at irregular intervals suggesting a solar eclipse, and with the phases of the moon and a variety of Celtic knot designs inlaid in slate in the background masonry. The radiating arms are designed to be illuminated from internal halogen bulbs wired to a light sensor.

Discussion: The piece was commissioned by Hillhead (now Glasgow West) Housing

Michelle de Bruin and Callum Sinclair, *Illuminated Wall Sculpture* [CS]

Association with funding from Scottish Homes, GDA and Glasgow West Conservation Trust, as part of a tenement development replacing a block demolished in the 1970s.

Condition: Good, but the internal illumination has been inoperative since *c.*1998.

Sources
Information provided by Callum Sinclair; McKenzie, pp.96, 97 (ill.).

James Young (attrib.), *Portrait of James Thomson*

Cambridge Street CITY CENTRE

Cambridge Buildings, 8–12 Cambridge Street / 202–12 Sauchiehall Street

Seven High relief Heads and Associated Decorative Sculpture

Sculptor: James Young (attrib.)

Architects: John Baird & James Thomson
Date: 1897–1902
Material: red sandstone
Dimensions: heads approx. life-size
Listed status: category B (22 March 1977)
Owner: Teesland Investment Co. Ltd and others

Description: The eclectic classicism of this five-storey commercial building is almost baffling in its complexity; no two bays are quite the same and the increasingly dramatic concentration of structural elements in the upper storeys as they approach the corner defies conventional architectural logic. The treatment is in fact highly sculptural, particularly in the liberal use of attached, free-standing, plain and barley-sugar colonettes and the extraordinary clustering of pilasters in the attic storey.

The relief heads are located in narrow ornamental panels above various second- and third-storey windows, four on Cambridge

Street and three on Sauchiehall Street, with little discernable pattern in their distribution. All but one are idealised representations of allegorical types, including a cherub, a monarch and a female deity with a floral crown. The exception is the male mask above the second-floor window, two bays from the corner on Cambridge Street, which is a portrait of the architect, James Thomson. Other carved details include: a square panel containing a Latin cross and enclosed by a label in the form of a knotted rope, two floors above the portrait; a small triangular panel in the attic above this containing the monogram 'IO' (?) in entwined letters; a large panel with an armorial crosslet held by a gauntlet with a large cherub mask below the Sauchiehall Street attic; a miscellany of cherub and lion masks, thistles, shamrocks and crosses above the attic windows on both frontages. The meaning of the imagery has not been deciphered.

Discussion: The attribution of the work to James Young is based on the inclusion of the portrait of James Thomson, a device used by Young on Connal's Building, 34–8 West George Street (q.v.) and several other buildings of approximately the same date (see related work, below). Confirmation of the subject's identity is provided by a contemporary sketch

of the architect reproduced in the popular Glasgow periodical the *Bailie*.[1] As is often the case in collaborations between Young and Thomson, the finished work differs considerably from the carvings indicated on the architects' plans. In this case drawings submitted by Baird & Thomson to the Dean of Guild Court in April 1902,[2] only the strapwork on the window labels and decorative panels are shown, and many of these are in locations different from those executed.

Related work: Other carved portraits of Thomson are to be found on Pearl Assurance Building, 133–7 West George Street (1896–9) and Liverpool London & Globe Insurance Building, 116 Hope Street (1899–1901), both by or attributed to James Young.

Condition: Generally very good, though the upper arm of the Latin cross is broken off.

Notes
[1] *Bailie*, vol.5 (no.1266), 20 January 1897, opp. p.1. I am grateful to my colleague Gary Nisbet for drawing my attention to this source. [2] GCA, B4/12/1/8965.

Other sources
BI, 15 February 1897, p.173; Nisbet, 'City of Sculpture'; Williamson *et al.*, p. 240.

Carlton Place GORBALS

The Sheriff Court of Glasgow and Strathkelvin, 1 Carlton Place

Symbolic Relief
Sculptor: Jake Kempsell

Architects: Keppie, Henderson & Partners
Date: 1985–6
Material: Hopton Wood limestone
Dimensions: approx. 1.5m high × 3m wide (carved surface)
Listed status: not listed
Owner: The Sheriff Court of Glasgow and Strathkelvin

Description: Located on the canopy above the reception desk in the entrance lobby, the relief is based on the legend of St Kentigern, the patron saint of Glasgow, and combines scenes from his life with more general references to Scottish culture and history. The composition is divided into three principal areas. On the left is a free interpretation of the arms of Glasgow, including a tree with a flaming limb, a robin, a bell and a fish. (For an analysis of the symbols, see Appendix C, Coats of Arms.) On the right, St Kentigern preaches from a mound which has miraculously risen from the ground to enable him to address the multitude, with a crown being placed on his head as described in the vision of St Columba. He is flanked by a pair of angels and the undulating lines running below the hill are symbolic of the River Clyde. In the centre is a set of scales decorated with symbols from the Pictish Dinnichen Stone, with a wolf and a deer yoked to a ploughshare below.

Discussion: Kempsell was one of two winners of a limited competition organised in December 1984, by the Property Services Agency (PSA), who were seeking wall sculptures for two major public buildings then under construction. (For an account of the competition and selection process, see Kentigern House, Brown Street.) His intention was to emphasise the antiquity of Scots law by relating the traditional symbols of Justice (scales) to Scotland's Pictish and Celtic heritage, but also to suggest, through the scene of St Kentigern preaching from the hill, that the secular law of the Sheriff Court is subject to the higher authority of the Church. In his published statement, Kempsell explained that most of the images in the relief 'contain more than one meaning', expressing the hope that this would 'encourage imaginative interpretation by those who spend time looking' at it. He goes on to say, however, that the panel 'also has a decorative purpose and is intended to enhance the space in which it is placed and please the eye of the most casual observer'.[1]

Above the exterior entrance there is roundel (approx. 1.5m diameter) incised with the royal arms of Scotland.

Condition: Good.

Note
[1] Commemorative book, published by PSA, *Sheriff Court Glasgow and Strathkelvin*, Glasgow, 1986, p.76.

Other sources
Williamson *et al.*, p.510; information provided by the artist.

Jake Kempsell, *Symbolic Relief* [RM]

Carmunnock Road CASTLEMILK

On north side of roundabout at junction of Carmunnock Road and Ardencraig Road

Southern Arch
Sculptor: Rick Kirby

Founder (figures): M.S. Meridian
Blacksmith (poles): A.L. Sillars
Date: 1999–2000
Materials: bronze figures on mild steel poles; cast stone wall at base
Dimensions: figures 1.6m high; poles 3.2m high
Listed status: not listed
Owner: Glasgow City Council

Description: The sculpture is in the form of a pair of female figures 'balanced precariously on large poles, their hands joined to form an archway over their heads as they look down upon the people passing below'. At the base of the poles is a curved stone seating area inset with casts of children's hands and feet.

Discussion: Southern Arch is one of five major public sculptures commissioned by the Castlemilk Environment Trust in 1999 as part of its 'Gateways and Landmarks' project, the first phase of an ambitious long-term public art initiative. The Trust was formed in 1996 under the aegis of the Castlemilk Partnership, which was itself established in 1988 after Castlemilk had been designated by the Scottish Office as an area requiring major improvements in its social provision and urban infrastructure. As part of its Environmental Action Plan, the Trust implemented a strategy designed to enhance both the physical fabric and the external perception of Castlemilk by the placement of high-quality artworks in twenty key locations. After consultation with the SAC, an open competition was announced in April 1999, inviting artists to submit proposals for sculptures to be placed in one or more of five

sites identified as entrance points, or 'gateways', to the Castlemilk Estate. From the 110 submissions received, ten were selected for exhibition at the Fringe Gallery, Castlemilk Arcade, with the nomination of the five winning designs following on 21 June.

The total budget for the project was £117,500, with £50,000 contributed by the SAC

Rick Kirby, *Southern Arch* [RM]

and the Trust providing matched funding from its own resources. An allocation of £23,500 was made for each work, including a standard fee of £4,000 for the participating artists. Included in the contract was a requirement that each artist would act as a workshop leader with a community group, and that where appropriate the outcome of the workshops would be incorporated into the finished sculpture. In Rick Kirby's case, the workshops were held with members of Castle Kids Out of School Care, who made plaster casts of each other's hands and feet in 'gestures of non-verbal communication'. These were later rendered in stone by Kirby and inserted into the wall in the seating area, thus extending the theme of 'unspoken mutual support' evoked by the main figures. The sculpture was installed in February 2000, but was not formally unveiled until the autumn. It is Kirby's first work in bronze.

Related work: Other works in the 'Gateways and Landmarks' programme include *On the Up and Up*, by Doug Cocker (also on Carmunnock Road), *Gateways* by Paul Grime (Castlemilk Drive), *Gateway*, by Michael Dan Archer and *King of the Castle*, by Kenny Hunter (both Fernhill Road) (qq.v.).

Condition: Good.

Sources
Unpublished design brief and various related documents provided by Matthew J. Finkle, Project Officer, Castlemilk Environment Trust; 'Environment Trust Major Landmarks', *The 'Milk Round*, May 2000, p.6.

On the east side of Carmunnock Road, opposite Castlemilk West Parish Church

On the Up and Up
Sculptor: Doug Cocker

Steel fabricators: ADAC Engineering Services
Date: 1999–2000
Materials: granite blocks and slabs on steel armatures

of two parallel planes, creating a more serpentine outline through the slight mis-alignment of the curves on its two sides. There are eight units in each column.

Discussion: One of five sculptures commissioned by the Castlemilk Environment Trust as part of the 'Gateways and Landmarks' initiative, *On the Up and Up* is designed to reflect, through both its form and title, the mood of optimism with which the recent environmental problems of Castlemilk are being addressed. The columns were erected by the Bon Accord Granite Company Ltd, using granite blocks imported from China. As part of the commission, the artist conducted workshops with disabled children from COJAC (Caring Operations Joint Action Council), using their drawings and collages as the basis for the design of four banners which were later flown from the flagpoles erected by an adjacent housing development.

Related work: For a full discussion of the background to the 'Gateways and Landmarks' programme, see *Southern Arch*, Carmunnock Road, above. Other works in the programme include *Gateways* by Paul Grime (Castlemilk Drive), *Gateway*, by Michael Dan Archer and *King of the Castle*, by Kenny Hunter (both Fernhill Road) (qq.v.). A maquette for *On the Up and Up* is in the collection of the artist.

Condition: Good, though with some surface graffiti.

Sources
Unpublished design brief and various related documents provided by Matthew J. Finkle, Project Officer, Castlemilk Environment Trust; 'Environment Trust Major Landmarks', *The 'Milk Round*, May 2000, p.6.

Doug Cocker, *On the Up and Up* [RM]

Dimensions: 6.4m high
Listed status: not listed
Owner: Glasgow City Council

Description: The work consists of two sets of repeated barrel-like shapes arranged vertically to form a pair of tall, contiguous columns. Though apparently similar in both structure and outline, the columns are subtly different in their exploration of the effect of rhythmic continuity created by the repetition of identical forms. The components of the column nearest the road are fully three-dimensional, and are 'threaded' together on an internal steel rod. By contrast, the neighbouring column is composed

Castlemilk Drive CASTLEMILK

At the junction of Castlemilk Drive and Croftfoot Road

Gateways
Sculptor: Paul Grime

Mason and builder: McFarlane Masonry Ltd, Glasgow
Date: 1999–2000
Material: granite
Dimensions: gates 2.4m high × 1.9m wide; supporting pillars 40cm square at base
Listed status: not listed
Owner: Glasgow City Council

Description: The work consists of two identical trabeated structures reminiscent of Egyptian or early Greek pylons, placed on the grass verges on either side of north entrance to Castlemilk Drive. Stylized images of various natural and everyday objects – a tree, a bus, a football pitch and many others – are sharply incised on the surfaces of both gates.

Discussion: One of five sculptures commissioned in 1999 by the Castlemilk Environment Trust through of its 'Gateways and Landmarks' initiative, this work explores the powerful connotations associated with the notion of the formal entrance. Though strictly non-utilitarian, except as an incentive for pedestrians to take 'short-cuts' between the pavements of the two adjoining roads, the work metaphorically conflates the function of both entrance and exit, while simultaneously evoking a 'rite of passage' from one part of the estate to another. In carrying out the commission, the

Castle Street TOWNHEAD

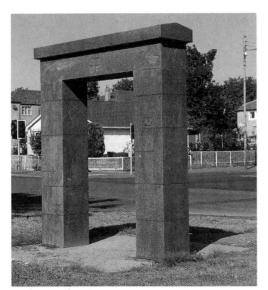

Paul Grime, *Gateways* [RM]

artist collaborated with children from St Bartholomew's School and members of the Castlemilk Youth Complex in a series of workshops, using their designs of objects associated by them with Castlemilk as a basis for the images decorating the gates.

Related work: For a discussion of the 'Gateways and Landmarks' programme, see *Southern Arch*, Carmunnock Road. Other works in the programme include *On the Up and Up*, by Doug Cocker (Carmunnock Road), *Gateway*, by Michael Dan Archer and *King of the Castle*, by Kenny Hunter (both Fernhill Road) (qq.v.).

Condition: Good, though with some light surface graffiti.

Sources
Unpublished design brief and various related documents provided by Matthew J. Finkle, Project Officer, Castlemilk Environment Trust; 'Environment Trust Major Landmarks', *The 'Milk Round*, May 2000, p.6.

St Nicholas Garden, behind Provand's Lordship, at the junction of Castle Street and Macleod Street.

The garden was designed by Gary Johnson for the architects James Cunning Young & Partners, winners of a limited competition organised in 1993 by the Glasgow Development Agency. Situated at the rear of Provand's Lordship, it consists of an L-shaped cloister for the display of historic sculptural artefacts, a set of steel railings and a herbaceous central area. The intention of the commission was to create a contemporary re-interpretation of the historical environment associated with Provand's Lordship, which was built in 1471 as a manse for the nearby Chapel and Hospital of St Nicholas, and is the oldest surviving residential building in Glasgow. Recognising that the house was created at a 'time of cultural shift from the Medieval to the Renaissance period',[1] the aim of the designer was to combine the medicinal and culinary functions of the physic garden that originally served the hospital with the more decorative concerns that came into fashion in Scottish garden practice in the sixteenth century. Thus the garden falls into two distinct parts: on the outer edge are plants in common use for medicinal purposes in the Middle Ages; in the centre is a knot garden, where the layout of the paths and borders is based on a Celtic pattern. There is also a camomile lawn planted between the setts in the main paved area, its fragrance designed to be released by the footfall of garden users.

In addition to the four main works catalogued below, the garden also contains three coats of arms of unknown origin belonging to the People's Palace Museum, and a modern copy of a broken datestone discovered during excavation of the site.

The scheme, completed in 1995 with additional funding from the European Regional Development Fund, Glasgow City Council and Strathclyde Regional Council, was the winner of a Scottish Natural Heritage Environmental Regeneration Award ('Supreme Award'), and joint winner of a Hilight/Emap Construct Award for exterior lighting.

Note
[1] Marcus Field, 'Medieval and Renaissance form reinvented in a garden', AJ, 2 November 1995, pp.26–7 (incl. ills).

Other sources
National Landscape Awards 1995, British Association of Landscape Industries, Keighly, n.d. (1995), pp.1–3 (ills); GH, 24 June 1995, p.12 (incl. ills).

In the L-shaped cloister

Thirteen Keystone Masks, including nine 'Tontine Faces'

Sculptors: David Cation, Mungo Naismith, and Archibald Macfarlane Shannan (all attrib.)

Dates: 1737–42, 1758–9, c.1872 and c.1873
Material: yellow sandstone
Dimensions: height 58.5 cm and 44 cm (nos 5 and 6)
Listed status: building listed category A (6 July 1966)
Owner: Glasgow City Council

Description: The collection is a miscellany of salvaged architectural carvings, including a number that belonged to the eighteenth-century Tontine Hotel (originally the Town Hall). Visually, they may be divided into four distinct groups, with variations in style and size strongly suggesting they are the work of at least two – though possibly as many as four –

different artists (see Discussion below). For the purposes of this study, they will be identified numerically from one to thirteen, beginning at the south (left) end of the west wall, though it should be noted that this sequence does not correspond to their original arrangement (see note 3 below). The groups are as follows:

1. Numbers 1–4 are in a grotesquely distorted style and have the appearance of theatrical masks. Despite some deep cutting in the face muscles, the overall treatment is very flat, and unlike the masks in groups 3 and 4, they are shorn of decorative details at the sides of the face and under the chin.

2. Numbers 5 and 6 are much smaller than those in the other three groups, and more naturalistically carved. Though somewhat crudely executed, stylistically they conform to the mainstream tradition of the classical male keystone head.

3. Numbers 7 and 8 are nineteenth-century imitations of the style of the masks in group 4.

4. Numbers 9–13 are traditionally thought to be portraits of specific individuals whose identities are not recorded. There is much comic exaggeration in the carving of the features, and the treatment of incidental details, such as hair, moustaches, collars, wigs and other headgear is extremely stylised.

The heads are mounted individually in open-fronted stainless steel boxes inserted into the re-inforced concrete beam of the stone-clad rear walls of the cloister. Each head is laid on a bed of inert pigmented resin, and is secured from the sides by stainless steel clamps fitted with padded plates. This device allows the heads, each of which weighs approximately a third of a tonne, to be easily removed at any time.[1]

Discussion: A full account of the history of the masks would require consideration of a large, complex and frequently inconsistent body of evidence, together with the numerous speculations it has given rise to in the past. This is beyond the scope of the present study, which presents a summary of the current consensus regarding their origins and vicissitudes, together with a brief outline of the process through which they came to be incorporated in the garden.

The most detailed account of the masks is to be found in the writings of the journalist James Cowan (pseudonym 'Peter Prowler'), whose researches were presented in a series of articles published intermittently in the 1930s and 1940s, and eventually gathered together in his 1951 anthology *From Glasgow's Treasure Chest.*[2] The main focus of his investigation is the core group of ten masks known collectively as the 'Tontine Faces', nine of which are included in the present collection – namely nos 1–4 and nos 9–13. Their name derives from the fact that they were originally located on the keystones of the rusticated basement arcade of the Tontine Hotel, which stood at the eastern end of the Trongate until its demolition in 1911. The building, however, was originally erected as the Town Hall, and only taken over by the Tontine Society in 1781, who added an extension (designed by William Hamilton) to the rear and opened up the basement arcade as a loggia. It was, moreover, built in two stages, and this has an important bearing on the history of the masks. The five easternmost bays were erected between 1737 and 1742, and included masks 1, 2, 3 and 4 from the present collection (the fifth mask from this series has almost certainly been destroyed); the remaining five bays were completed in 1758–9, and included masks 9, 10, 11, 12 and 13.[3] (The status of nos 5, 6, 7 and 8 is explained below.)

The authorship of the ten masks has traditionally been ascribed to Mungo Naismith, a distinguished eighteenth-century Glasgow mason and carver, who is known to have worked closely with Deacon James Cross (often spelt Corse), the foreman mason responsible for the construction of both halves of the building.[4] The surviving documentation relating to this matter, however, is both fragmentary and ambiguous, and on the evidence assembled by Cowan, it seems more likely that Naismith was responsible only for the five later masks, and that the three payments of £5 each recorded in the Council minutes as having been paid to him between 7 October 1758 and 13 January 1759 were in fact for this work.[5] By contrast, there is no mention of Naismith's name in any of the minutes relating to the erection of the first half, whereas his colleague David Cation (pronounced *caution*) is recorded as having spent 59 weeks producing decorations 'in the towns [*sic*] new hall'.[6] It is on this basis, as well as the pronounced differences in style and quality, that Cowan attributes the early group to Cation and the later to Naismith.

The subsequent history of the masks is closely bound up with the fate of the building, which was acquired by the Tontine Society in 1781 and re-opened as a hotel and coffee room two years later.[7] It was at this point that the masks acquired their sobriquet. Although the building itself survived until 1911, it had by that time changed hands once again, and in 1869 was converted to retail premises for the drapers Moore Taggart & Co.[8] This apparently necessitated the removal of the lower arcade, and with it the keystone masks. Perhaps the most significant aspect of this episode in their history is not the fact that they were removed from public view, but that their disappearance should have become a matter of such intense local concern. In his 1872 guide to Glasgow, John Tweed, for example, lamented how the Tontine building had been:

> … alas! transformed into a drapery warehouse… [T]he beauty of the Tontine has disappeared; even the sculptured masks which stretched along the whole front have vanished, and nobody seems to know what has become of them. We owe this to the City 'Improvement' Trust.[9]

The claim here that the whereabouts of the

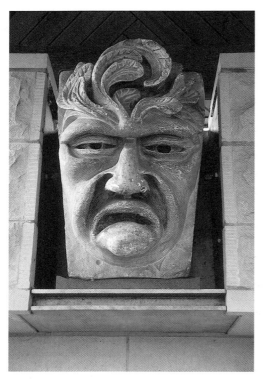

David Cation(?), *Tontine Face* **(no.1)** [RM]

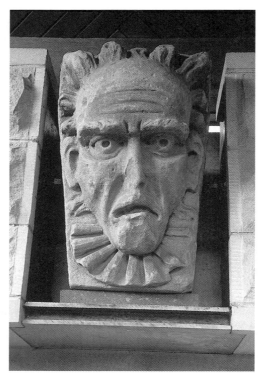

Archibald Macfarlane Shannan(?), *Keystone Mask* **(no.7)** [RM]

masks was unknown was not strictly true, as the matter had by this time been taken up in the correspondence columns of the press, and it was through these that they were traced, with some assistance from the Glasgow Police Board, to the yard of the prominent Glasgow builder Peter Shannan. Writing under the pseudonym 'Cornelius Nepos', a correspondent in the *Glasgow Herald* of 22 January 1870 gave a detailed account of his enquiries into the matter, in the process raising important issues regarding the propriety of the masks being allowed to pass into private hands. His letter is worth quoting at length:

I came to Glasgow from a considerable

distance yesterday morning, and went to the Address you kindly gave me of Mr. Peter Shannon [*sic*], at Somerville Place. He was not there, but I traced him to another part of the City where he was employed, and soon found the decent and respectable Tradesman, as I know and take him to be. I began civilly to question him about these ancient interesting Relics. He said he had them in one of his Workshops in the Gallowgate; but he at once astounded me by saying that they were now his absolute Property; that he got them from Mr. Carrick, the Master of Works of the City, in lieu of some work he had done for the City Improvement Company, or Civic Incorporation; that some

considerable Balance of Money was still due to him from that source; and he re-asserted that he claimed these Relics now as his own absolute property, and would not part with them for a large price! ... I felt, as I have already remarked, very much astounded by this statement – very much astounded indeed that, if it were true, Mr. Carrick, the Master of Works of this great City, should have taken it upon him privately to dispose of those Relics in such a manner, seeing that they had stood more than a Century at the Tontine near *the Cross* of Glasgow, and were relished and justly regarded as the ostensible public property of the Citizens.

I have to thank Mr. Moir for what he has done in this matter at the Police Board, and also Bailie Osborne for the natural and significant remark he made, 'Is that the proper place for them?' No, indeed, it is not. But the matter, I should think, cannot rest where it is. I therefore most earnestly and respectfully call upon the Lord Provost, Magistrates and Council of Glasgow to require some explanation or other from their responsible Servant, *the Master of Works*; and ask him distinctly to state upon what authority, or assumed authority, did he take it upon him to dispose of these ancient and renowned Relics, which had given delight to thousands and tens of thousands of Glasgow people, young and old. And assuming the statement of Mr. Peter Shannon (as above given) to be true, has our Master of Works, I ask, taken any guarantee whatever for their safety and preservation? If not, he might as well have taken down the *Statue of King William* [q.v., Cathedral Square], at *the Cross* of Glasgow, and disposed of it privately to any of his friends. [...] But surely I have stated enough and more than enough to attract and arouse the attention of our present Civic Rulers, and to induce them to order some *Memoranda* or other to be placed on the Municipal Records about these

ancient Relics, for the information and satisfaction of future generations, who may be eager to trace them out, and to learn from them lessons of wisdom and delight which animated their Forefathers.[10]

No such memoranda, nor any guarantee of their future safety appear to have been produced. With regard to Peter Shannan, his determination not to part with the masks, even for 'a large price', was somewhat short-lived, and in 1872, when he was awarded the contract to erect a new warehouse for Messrs Fraser, Sons & Co. at the foot of Buchanan Street, he incorporated the masks into the arches of the building's exterior court.[11] According to a later commentator, the masks had been 'purchased at considerable cost … by the late Mr Hugh Fraser, who wished to preserve as well as adorn the warehouse … with those grotesque images'.[12]

At this point the first of several new complications enters the narrative. To begin with, the courtyard of Fraser's building had a total of thirteen bays – nine on the south frontage, and four on the west – each of which was fitted with a keystone mask in the arches of the upper windows.[13] The ten 'Tontine' masks were therefore augmented by a further three which were almost certainly, to judge by contemporary photographs, newly-commissioned imitations (though not copies) of the group attributed to Naismith. Cowan speculates that these may have been made by Shannan's son, the then 22-year-old sculptor Archibald Macfarlane Shannan.[14] No documentary evidence is produced to support this supposition, but given the younger Shannan's known interest in architecture, and the fact that his early inclinations as a sculptor were 'towards the imaginative side of the Art',[15] the attribution is not wholly implausible.

By far the most serious cause of confusion in the subsequent history of the masks, however, is the fire which broke out in the Buchanan Street warehouse on 14 October 1888.[16] This destroyed most of the building, though miraculously part of one wall appears to have survived intact. The four masks on this wall – nos 9, 10, 12 and 13 from the present sequence – remained in situ until the building was altered in the mid-1930s, at which time they were brought inside and displayed as 'Original Masks from the Old Tontine' in a special gallery.[17] Of the nine that came down in the fire, only eight were recovered, among which were the three modern pieces attributed to Shannan, and five of the original 'Tontine' works.

Using Cowan's detailed investigations as a guide, the route the masks followed from the time of the fire until their installation in St Nicholas Garden may be described as follows. Of the eight masks salvaged from the fire, two were acquired by the lawyer William Hill, who installed them as ornaments in the garden of his country house at Barlanark.[18] These were inspected by Cowan as recently as 1946, and from the photographs he made of them they are clearly identifiable as nos 1 and 8 in the present sequence – that is to say, one from the original group attributed to David Cation (no. 1), and one from the group of three made in 1872. The other six were taken by the builder Thomas Mason – partner in the firm of Morrison & Mason who rebuilt Fraser's warehouse after the fire – and placed in the garden of his mansion at Craigiehall. Of these, only four were seen and photographed by Cowan (nos 11, 2, 3 and 4 in the present sequence),[19] although it is possible that the other two were also there but remained unnoticed by him. This already immensely confusing state of affairs is exacerbated by the further complication that Mason is known to have exhibited a group of *seven* masks at the RGIFA exhibition of 1894,[20] though precisely which ones they were is a matter requiring further research.

In his investigations, Cowan was assisted by the then Curator of the People's Palace Museum, James Davidson Boyd, whose 'active co-operation … contributed so helpfully to unfold the mystery of the Tontine Faces'.[21] Not surprisingly, there was a desire to have the masks brought into public custody, and Cowan concludes his study with the prediction that 'all these interesting antiquities will soon be suitably arranged in the People's Palace, with the main points of their history clearly stated'.[22] In the event it was not until much later, probably the mid-1970s, that the masks were finally gathered together and deposited in the Museum's collection, with six placed in the Museum's store at the Templeton Business Centre and the remainder in the Winter Garden at the rear of the Museum. No records appear to have been made as to precisely how and when they were acquired from Barlanark, Craigiehall and the interior of Fraser's on Buchanan Street.

The remaining masks in the series, nos 5 and 6, are of much less historical importance than the works discussed above, and only tangentially connected with them. They are similar in size and style to the set of eight keystone masks currently extant on the second-floor windows of 116–20 Argyle Street (q.v.), and were almost certainly made as part of the same scheme. The building itself was erected in 1873 as an extension to the main Fraser's premises on Buchanan Street. Some alterations were made in 1933,[23] and it is likely that the two masks were removed at this time. The carver is anonymous.

Of the 'Tontine Faces' themselves, it is important to recognise the uniqueness of their place in the history of Glasgow, and the rich vein of folklore associated with them, including the well-established custom among Glasgow parents to enjoin sulking children not to 'make a Tontine Face'.[24] The assertion by 'Cornelius Nepos' that they have 'given delight to … tens of thousands of Glasgow people' is corroborated by John Strang's description of them as 'caricature countenances which so long excited wonder and laughter among crowds of gaping gossipers'.[25] There is also a popular

tradition, dating back at least as far as the late eighteenth century, of ridiculing public figures by pointing out a physical resemblance to one or other of the masks. This practice continues today, and as recently as 1996 the *Herald* started a series of such visual comparisons, demonstrating a particularly striking similarity between mask no. 7 and the politician Michael Heseltine.[26] The masks may even be said to have generated their own apocrypha, with decorative heads on buildings in various parts of Glasgow frequently provoking the erroneous claim that yet another 'Tontine Face' has been discovered.[27]

Related work: In the People's Palace is a collection of seven plaster masks closely resembling and identical in scale to the 'Tontine Faces'. These were discovered in the early 1920s by Henry Cornish, Master of Works at Glasgow Art Gallery and Museum, and are believed to be copies or casts of the models from which the ten original faces were carved.[28]

Condition: Numbers 5 and 6 are very worn, but the others are all in reasonably good condition. When the remaining eleven were inspected by Gary Johnson in the Winter Gardens of the People's Palace in 1994 as part of his research for the design of the St Nicholas Garden, they were found to have been badly affected by the dampness of the environment. On the advice of the conservation staff of the Burrell Collection, they were de-humidified before their installation in the cloister.[29]

Notes
[1] Field, *op. cit.*, p.27. [2] James Cowan, *From Glasgow's Treasure Chest*, Glasgow, 1951, pp.387–435. [3] *Ibid.*, pp.406–7. All ten masks can be seen *in situ* in the photographs of the building made by Thomas Annan in the late 1860s. These are reproduced in Anita Ventura Mozley (ed.), *Thomas Annan: Photographs of the Old Closes and Streets of Glasgow 1868/1877*, New York, 1977, plates 20, 41. The relative positions of the masks as presently arranged in the cloister and the original sequence may be expressed as follows, the numbers in brackets corresponding to the bays on the Tontine Hotel and reading from the left: 1(6), 2(8), 3(9), 4(10), 9(1), 10(2), 11(3), 12(4), 13(5). [4] See, for example, John Strang, *Glasgow and its Clubs*, Glasgow, 1864, p.8. [5] Cowan, *op. cit.*, p.433–4. [6] Robert Renwick (ed.), *Records and Charters of the Burgh of Glasgow*, vol.6, Glasgow, 1911, p.97. [7] Cowan, *op. cit.*, p.392. [8] *Ibid.* [9] Tweed (*Guide*), p.31. [10] 'Cornelius Nepos', quoted in Tweed (*Glasgow Ancient and Modern*), vol.2, pp.421–2. [11] Cowan, *op. cit.*, p.394. [12] EC, 29 June 1935. [13] GH, 2 January 1880, quoted in Cowan, *op. cit.*, pp.394–5. [14] Cowan, *op. cit.*, p.421–3. [15] Obituary, *Journal of the Royal Scottish Academy*, quoted in Cowan, *op. cit.*, p.424. [16] GH, 16 October 1888, quoted in Cowan, *op. cit.*, p.402. [17] ET, 7 June 1935. [18] Cowan, *op. cit.*, p.404. [19] *Ibid.*, p. 417. [20] *Ibid.*, p.416. [21] *Ibid.*, p.401. [22] *Ibid.*, p.419. [23] GCA, B2/12/1933/59. [24] Cowan, *op. cit.*, p.405. [25] Strang, *op. cit.*, p.8. [26] GH, 9, 16 January 1996. [27] 'Peter Prowler' (James Cowan), 'Glasgow's Sculptured Faces', EC, 18 August 1934; Cowan, *op. cit.*, pp.395–7. [28] Cowan, *op. cit.*, pp.408–12. [29] Sam Clarke, 'Headhunter's Shock Find', *Saturday Times*, 3 December 1994, p23; also information provided by Gary Johnson.

Other sources
NBDM, 19 November 1888; H. M'A. T., 'Curios at Barlanark: an Interesting "Tontine Faces" Discovery', EC, 1 June 1935; Ormonde, 'The Tontine Faces', ET, 7 June 1935; H. M'A. T., 'The Tontine Faces', EC, 29 June 1935; Gomme and Walker, pp.52–3 (incl. ills.); McKean *et al.*, pp.57–8 (incl. ills); McKenzie, pp.4–7 (incl. ill.).

In the centre of the garden

Font

Sculptor: Tim Pomeroy

Date: 1994–5
Materials: grey granite with fibre-optic cables
Dimensions: 74cm high × 1.09m diameter
Listed status: building listed category A (6 July 1966)
Owner: Glasgow City Council

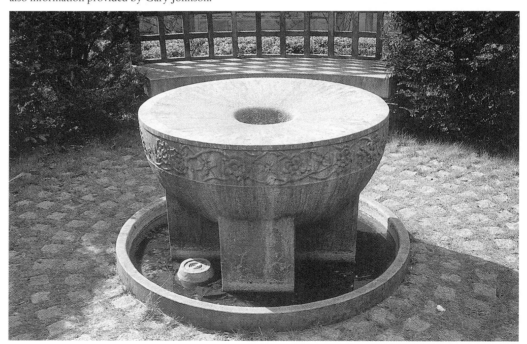

Tim Pomeroy, *Font* [RM]

Description: The font is in the form of a perfect hemisphere supported by cruciate legs, and is placed within a basin designed to collect water overflowing from the upper rim. The water thus collected is recirculated through the core of the font, and can be seen bubbling in the centre. At night the bubbling is illuminated by fibre-optic cables. Immediately below the rim of the font is a decorative band carved in low relief with entwined oak branches and wild roses. The work weighs 2.5 tonnes.

Discussion: The initial idea for the work was inspired by a proposal from the architects to incorporate modern re-interpretations of the famous painted bosses in the vault of the Blacader Aisle of Glasgow Cathedral into the roof trusses of the garden's cloister. The idea proved impractical, but Pomeroy developed the concept by taking the convex form of the bosses as the basis for the design of the font, though in this case the support comes from below rather than above. The oak branches on the font refer to the emblem of Bishop Muirhead, the builder of Provand's Lordship, and the roses are related to the so-called Apothecary's Rose (*Rosa Gallica Officinalis*), a plant frequently used by medieval physicians.

Because of the size and weight of the granite block, *Font* was carved in a stonemason's workshop near St Andrews, an arrangement which necessitated the artist living in a caravan from December 1994 until the completion of the work in March the following year. The 700-kg granite seat a few metres from *Font* was made at the same workshop.

Condition: Good.

Sources
Unpublished statement by artist, 1995; *National Landscape Awards 1995*, British Association of Landscape Industries, Keighly, n.d. (1995), pp.1–3 (ills); Field, *op. cit.*; McKenzie, pp.6 (ill.), 7.

In the camomile lawn

Carved Pavement Plaques
Sculptor: Tim Pomeroy

Date: 1995
Material: granite
Dimensions: 25cm × 25cm
Listed status: building listed category A (6 July 1966)
Owner: Glasgow City Council

Description: The work consists of ten square paving setts carved with images of human internal organs – including a brain, a pair of lungs and an intestine – referring specifically to the parts of the body that the herbs in the original physic garden were thought to have been able to restore to health. Here they are placed at intervals among the plain setts of the main walkway, which has living examples of the herbs themselves growing in the spaces between the paving blocks. They thus provide an 'imaginative extension to the [conventional] plant label', and a reminder to visitors of the 'continued practical uses of herbs in medicine and health care'.

Condition: Good.

Source
Unpublished statement by artist, 1995.

In the south and west boundary walls

Decorative Gates and Railings with Eight Semi-abstract Figures
Sculptor: Jack Sloan
Fabricators: Hector McGarva and Archie Sinclair (figures)

Date: 1995
Material: mild steel
Dimensions: 2.51m × 2m (fixed railings); 2.52m × 1.25m (gates); component bars 6cm and 2cm wide

Inscriptions: cut from steel panels at the foot of each figure – ST. NICHOLAS; MUIRHEAD; MARY; BRYSON; MARSHALL; WHITELAW; FOULIS; EARDLEY
Listed status: building listed category A (6 July 1966)
Owner: Glasgow City Council

Description: The work consists of eight rectangular steel units mounted on ashlar pillars, which together form the southern boundary to the garden. Five of the units are hinged gates; the remainder are fixed. Each is composed of a series of slender vertical bars, variously decorated with imagery derived from the Glasgow arms (birds, fish, bells, leaves) and open-work reliefs depicting historical figures associated either with Provand's Lordship or the surrounding area. Though heavily stylised in their treatment, each of the figures may be recognised by the small inscription panel at its feet, as well as a central disc displaying a symbolic attribute. Beginning at the south-east entrance, the figures are as follows:

St Nicholas (fl. 4th century). Namesake of the hospital founded in 1471 on what is now Macleod Street; also the patron saint of sailors and money-lenders. Attributes: sailing ship and three coins.

Bishop Andrew Muirhead (1455–73). Builder of St Nicholas Hospital, St Nicholas Chapel (which stood on this site until 1820) and of Provand's Lordship (originally a manse for his chaplain). Attributes: St Nicholas Chapel; acorns on his vestments (a reference to his coat of arms).

Mary Queen of Scots (1542–87). Stayed at Provand's Lordship in 1567 while her sick husband, Lord Darnley, resided at the Bishop's Palace. Here she is reputed to have written two of the 'Casket Letters' to her lover, the Earl of Bothwell, which were used as incriminating evidence at her trial in England. Attributes: open casket and sheet of paper.

William Bryson (fl. 1642–70). A fashionable

Jack Sloan, *Decorative Gate (Joan Eardley)*

and wealthy tailor, responsible for adding the extension containing the stone staircase to Provand's Lordship in 1670. Attribute: Provand's Lordship.

John Marshall (fl. 1704). Appointed by the University of Glasgow as the first overseer of the Physic Garden, then located off the High Street, south of Provand's Lordship. Attributes: mortar and pestle.

Mathew Whitelaw (fl. 1753). Maltman and owner of Provand's Lordship in the 1750s. He probably converted it to a brewery and public

house, which it remained until well into the nineteenth century. Attribute: a tankard.

Robert Foulis (1707–76) Publisher and founder of the Foulis Academy in Glasgow University in 1854, more than a decade before the Royal Academy of Art in London. Though short-lived, it trained many of Scotland's leading eighteenth-century artists. With his brother Andrew, produced some of the finest folio editions of books such as the *Iliad* and the *Odyssey*, now critically recognised for their elegant typefaces and bindings. Attributes: book and quill pen.

Joan Eardley (1921–63) Painter. Trained at Glasgow School of Art, she achieved international recognition for her powerfully gestural landscapes, but is best remembered locally for her images of tenement life drawn from the neighbourhood of her studio a few hundred yards from Provand's Lordship. Attributes: palette and brushes.

Discussion: In his account of the design, Sloan points out that the dominant verticality of the railings was intended to echo the Gothic style of the nearby Barony Church, and that the elongated forms of the figures themselves, conceived as 'spiritual guardians', were inspired by the portal figures of Chartres Cathedral and the decorative work of Charles Rennie Mackintosh. As a further enhancement of the 'uplifting qualities' of the decoration, the images derived from the Glasgow arms are mostly placed in the upper parts of the design, the only exception being the fish, which doubles as a gate-latch. Sloan describes the arrangement as follows:

> The bird perches on top, wings lifted. Two of the slender verticals sprout leaves from the tree. Square Celtic bells hang from the top of the frame. While in the Glasgow rhyme the tree never grew, bird never flew or bell rang, here the fish, though forever trapped within its box, can swim to become the bolt and take the ring from the miracle,

in the form of a padlock, in its mouth.

The sequence of the figures is also significant. Religious personalities are grouped at the eastern end, nearest the Cathedral, while the figures associated with the 'mercantile and cultural aspirations' of Glasgow are found further west, thus echoing an important aspect of the city's historic development.

Condition: Painted black and in good condition.

Sources
Unpublished proposal by Jack Sloan, 6 July 1995; McKenzie, pp.6 (ill.), 7.

On the south façade of the Royal Infirmary, overlooking Cathedral Square

Monument to Queen Victoria
Sculptor: Albert Hemstock Hodge

Architect: James Miller
Date: 1914
Material: bronze
Dimensions: colossal
Signed: on the right side of the base of the throne – ALBERT HODGE SCULPTOR 1914
Inscriptions: on the rear of the throne – V (enclosed in a wreath); on a plaque below the statue – THIS BUILDING WAS ERECTED TO COMMEMORATE / THE 63 YEARS ILLUSTRIOUS REIGN OF / QUEEN VICTORIA / THE WORK WAS COMMENCED IN THE / YEAR 1905 AND COMPLETED IN 1915
Listed status: category B (15 January 1997)
Owner: North Glasgow University Hospitals NHS Trust

Description: Located on the roof of the porch projecting over the (now disused) south entrance to the hospital's Jubilee Block, the Queen is shown seated on a throne, holding an orb in her left hand and a sceptre in her right. Her crown is placed on an elaborately pleated head-dress, and she wears a cameo portrait

medallion of Prince Albert on a chain round her neck. Her facial expression is one of stern authority. Incidental details on the building include groups of wreaths, lion masks and torches on the stonework supporting the throne, and a series of projecting crowns, margents and capital masks on the façade to the rear, all carved from Giffnock sandstone and possibly modelled by Hodge.

Discussion: The statue was commissioned as part of the rebuilding of the Royal Infirmary, which consists of three connected blocks, including a Jubilee Block built specifically to commemorate the Queen's Diamond Jubilee of 1897.[1] The Jubilee Block stands on the site of Robert and James Adam's Royal Infirmary of 1792, and was built last in order to allow the hospital to continue operating during the construction of the Administration and Surgical Blocks. Miller's design was criticised for the extravagance of its detailing and the immensity of its scale, which was thought to have an 'injurious effect' on the adjacent cathedral.[2] The management of the competition also came under fire, and the choice of Miller's proposal was enforced by the committee after their consultant R. Rowand Anderson had selected a less grandiose design by H.E. Clifford.[3] The foundation stone was laid by the Prince of Wales on 23 April 1907,[4] and the building was formally opened on 7 July 1914 by King George V.[5]

Research on the background to and progress of Hodge's commission has proved disappointing. The statue is shown on Miller's elevation drawing of August 1909,[6] and a contemporary commentator described the statue as 'beautifully modeled'.[7] Otherwise, however, there appears to have been very little press coverage of the commission, and because it was not erected until after the grand opening of the hospital, it did not form part of the ceremony.

A number of other minor sculptural works are to be found elsewhere on and in the hospital

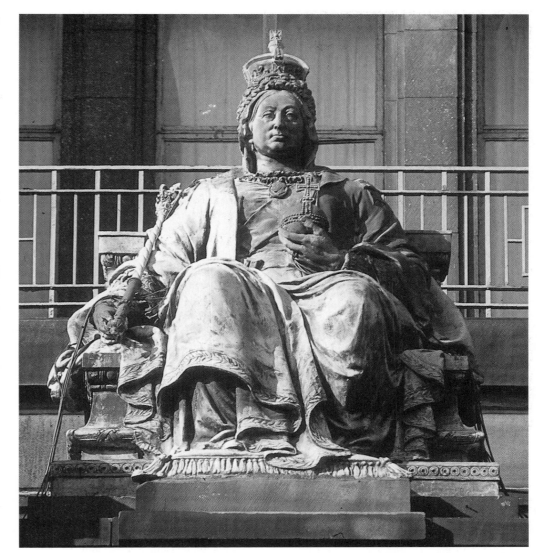

Albert Hemstock Hodge, *Queen Victoria* [RM]

buildings, including four portrait medallions:

1. *Joseph Lister*, on the rear (east) façade of the Accident and Emergency block, north end. Bronze, unsigned, undated and inscribed 'LISTER / 1827–1912 / OPIFER PER ORBEM'

(trans.: 'bringing aid to the world'). Portrait enclosed in a wreath.

In the foyer of the north entrance to the Templeton (Surgical) Block:

2. *Sir William Macewen*, 1934, by Alexander Proudfoot.
3. *Joseph Lister*, 1908, by Johan Keller.
4. *Sir David Cuthbertson*, 1986, by Gerald Laing.

Also in the foyer is a marble statuette of *Florence Nightingale* (1820–1910), unsigned, undated, approx. 92cm high. This was donated by Rebecca Strong, a Matron of the Infirmary and former 'Nightingale Nurse'.

Related work: The pediment on the City Chambers (q.v.) was also commissioned to mark the Queen's Diamond Jubilee.

Condition: The surface of *Queen Victoria* has a heavy green patination overall and the there is some rusting on the pillars of the throne. The statue is draped with numerous electric wires.

Notes
[1] Anon., 'Reconstruction of Royal Infirmary', BN, 11 January 1901, p.57. [2] Anon., 'Proposed new Infirmary', B, 24 June 1905, pp.670–1. [3] BN, 11 January 1901, p.57; Anon., 'Glasgow Royal Infirmary', B, 6 June 1903, pp.588–9. [4] 'Glasgow New Royal Infirmary', *Ibid.*, 18 May 1907, p.604. [5] GH, 7, 8 July 1914; ET, 7 July 1914. [6] GCA, TD 972/6. [7] GH, 23 June 1914, p.10.

Other sources
B, 12 January 1901, p.42, 2 February 1901, pp.112, 114, 15 June 1901, p.585, 6 July 1901, p.11, 19 January 1907, p.72; GCA, M.P. 34/128; GH, 4 January 1918, p.3 (obit.); Williamson *et al.*, pp.146–7; Nisbet, p.523; McKenzie, pp.vii, 2, 3 (incl. ill.).

On the former Royal Asylum for the Blind, 92 Castle Street

Christ Healing a Blind Boy
Sculptor: Charles Grassby

Architect: William Landless
Date: 1881
Material: yellow sandstone
Dimensions: figures slightly larger than life-size
Inscriptions: on the front of the plinth – 1881 / PRESENTED BY SIR CHARLES TENNANT BART.
Listed status: category B (15 January 1997)
Owner: North Glasgow University Hospitals NHS Trust

Description: The following account of the installation of the sculpture is provided by the *Building News*:

A niche in the hexagonal tower of the new Asylum for the Blind, Glasgow, was last week enriched with a group of statuary representing our Saviour restoring sight to the blind. The figure of the Saviour, which is of heroic size, is seated, with the right hand raised in the act of benediction, while the left is placed on the head of a kneeling youth with upturned face, in the act of prayer. The treatment of the drapery and accessories is Mediaeval, in keeping with the architecture of the building ...[1]

Minor decorative details include some richly carved floral capitals beside the entrance at the north end.

Discussion: The Asylum was founded in 1804, and the first building on Castle Street was erected in 1827–8 by public subscription. In 1878, after the building had fallen into disrepair, a competition was announced for a design for a replacement. William Landless' Franco-Flemish proposal was accepted, and the building was

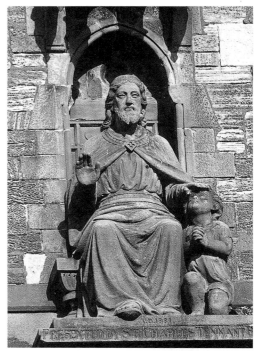

Charles Grassby, *Christ Healing a Blind Boy*

erected in 1879–81 at a cost of £21,000.[2]

Condition: Acquired by the managers of the Royal Infirmary as an extension in 1935, the building has been empty since 1989 and is very dilapidated. The statue is very grimy but otherwise in reasonably good condition.

Notes
[1] BN, 25 March 1881, p.346. [2] B, 9 August 1879, p.886; Groome, vol.3, p.141, states that the new building was erected 1882–3.

Other sources
GCA, AGN 1194 (Grassby obits); LBI, Ward 25, p.34; Williamson *et al.*, p.147; Nisbet, p.522 (incl. ill.); McKenzie, pp.6 (ill.), 7.

Cathedral Square TOWNHEAD

On the north-east corner

Monument to James Lumsden
Sculptor: John Mossman

Date: *c*.1859–62
Inaugurated: 17 December 1862
Materials: bronze statue on a pink granite pedestal
Dimensions: statue 2.14m high; pedestal 3.05m high
Inscription: on the front of the dado – JAMES LUMSDEN / LORD PROVOST OF GLASGOW / FROM 1843 TO 1846 / DURING WHICH PERIOD / THE MUNICIPALITY WAS GREATLY EXTENDED: / FOR NINETEEN YEARS / HONORARY TREASURER OF / THE ROYAL INFIRMARY / TO WHICH INSTITUTION HE RENDERED / MOST VALUABLE SERVICES: / THROUGHOUT LIFE / AN ENERGETIC AND SUCCESSFUL PROMOTER OF / THE PUBLIC INTERESTS / AND BENEVOLENT ENTERPRISES / OF THIS HIS NATIVE CITY / BORN 1778 / DIED 1856
Listed status: category B (22 December 1992)
Owner: Glasgow City Council

James Lumsden (1778–1856), Lord Provost of Glasgow 1843–6. Born in Argyle Street, Glasgow, he was the head of the wholesale stationery firm James Lumsden & Son, founded by his father. He was three times president of the Incorporated Company of Stationers, and briefly, towards the end of his life, the chairman of the Clydesdale Bank. He entered the Town Council in 1822, after spending some years as a Commissioner of Police. As Lord Provost he received the Prince and Princess of Wales on their visit to Glasgow to lay the foundation stone of the new Glasgow University building on Gilmorehill, for which service he was

granted a knighthood. As well as devoting his energies to raising money for the Royal Infirmary during his nineteen years as honorary treasurer, he also promoted the building of model lodging houses, founded the Glasgow Native Benevolent Society and, in 1850, established a bursary for theology students at Glasgow University.[1]

Description: Mossman's portrait corresponds closely to a contemporary description of Lumsden as being 'about the ordinary height, straight, broad shouldered and of rather portly form'.[2] Despite a lifetime of public service he was not, apparently, a very skilful public speaker, his style being characterised as 'homely to a degree that did not suggest superior scholastic training', and prone on occasion to being 'mirth-provoking from mere verbal mishap'.[3] Mossman accordingly presents him as a man of practical business rather than an orator, holding a roll of papers in his left hand, a pince-nez in his right and with the medallion on his Lord Provost's chain of office partially concealed between the top two buttons of his frock coat. His pose is informal, with his left hand placed casually on his hip and his overcoat unbuttoned. The architect Thomas Gildard noted that the use of modern costume was still regarded as problematic at this time, but that Mossman had treated the overcoat in such a way as to 'give picturesqueness to the figure without impairing the dignity of the statuesque repose'.[4] The statue stands on a granite plinth, and the pedestal has no ornamentation except a band of key pattern in the upper dado.

Discussion: Commissioned by private subscription, this was the first public monument to be erected in the vicinity of the Cathedral. It is not known precisely when work on the statue was begun, but by July 1860, the correspondent of the *Glasgow Gazette* was able

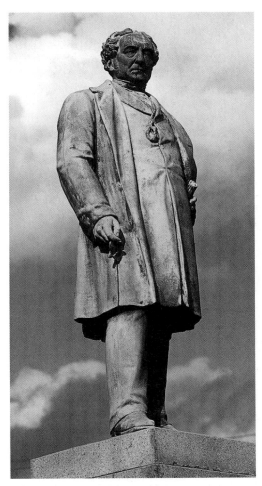

John Mossman, *James Lumsden*

to report that he had viewed the nearly-completed clay model in Mossman's studio, and that it was due to be 'despatched [*sic*] to London during the month of August, there to be executed in bronze'.[5] As the first public statue to be completed by Mossman since the erection of his *Monument to Sir Robert Peel* (q.v., George Square), the statue was inevitably

compared with the earlier work, and although Lumsden was described as a 'less favourable subject', the *Gazette* writer judged the result to be 'equally effective with his statue of Peel'. In particular it had 'the same distinctness of outline, and *sense* of perspective' as the Peel statue, while also 'contriv[ing] to combine the idea of the nervous restlessness of the late worthy magistrate with that of the repose which befits a permanent memorial'.[6]

In recognition of Lumsden's 'unflagging zeal in [sic] behalf of the Royal Infirmary' the subscribers applied to the directors of the hospital to allow the statue to be 'erected in front of that noble institution'. The request was 'cheerfully acceded to', and the monument was placed behind the iron perimeter railing in front of the south façade of Robert and James Adam's Royal Infirmary building.[7] It remained in that position after the replacement of the Adams' building by the present structure by James Miller, but was moved to its present site a few yards to the north-east in the 1990s when the Cathedral Precinct was redesigned.

In his inauguration speech, Sheriff Bell described the statue as an 'acceptable and well merited memorial of a worthy and conspicuous fellow townsman. There is', he went on,

> ... surely no more fitting ornament for the public places of our city than the representations, in marble or in bronze, of those who made their lives remarkable by energetic exertions on behalf of the best interests of all classes of the inhabitants of such a city.

He concluded by commending the statue as an 'excellent likeness' of Lumsden 'as he lived', and a credit to the 'talents and genius of the Scottish sculptor by whom it has been executed'.[8] Gildard was present at the unveiling, and claims to have been

> ... near enough to the late George Ewing to hear what he was saying to a little group of

eager listeners. He said that he had looked at the statue from all available points – one, unfortunately, he could not command – and that, what few statues did, it looked well from all.[9]

Condition: Good.

Notes
[1] Anon., *Biographical Sketches of the Hon. the Lord Provosts of Glasgow*, Glasgow, 1883, pp.86–90. [2] *Ibid.*, p.90. [3] *Ibid.* [4] Gildard (1892), p.9. [5] GG, 28 July 1860, p.3. [6] *Ibid.* [7] Anon., *op. cit.*, p.90. [8] Anon., 'Inauguration of the Statue of the late James Lumsden Esq.', GH, 18 December 1862, p.3. [9] Gildard (1892), p.9.

Other sources
GG, 20 December 1862, p.5; BN, 26 December 1862, p.500; B, 3 January 1863, p.16; Tweed (*Guide*), p.19; Anon., 'Men You Know – No.59', *Bailie*, 3 December. 1873, pp.1–2; Anon., 'Men You Know – No.105', *Bailie*, 21 October 1874, p.2; Gildard (1892), p.2; Worsdall (1981), pp.42–3 (incl. ill.); Read, p.365; Williamson *et al.*, p.153; Lyall, p.4 (ills); McKenzie, pp.2 (ill.), 3; LBI, Ward 25, p.64.

In the centre of the west side of the square, facing Castle Street

Monument to David Livingstone

Sculptor: John Mossman, assisted by Francis Leslie and James Pittendrigh Macgillivray

Founder: Cox & Sons
Designers (pedestal): Campbell Douglas & Sellars
Date: 1875–9
Erected: 19 March 1879 (George Square); re-erected 1960 and 1990
Materials: bronze statue and reliefs on a granite pedestal
Dimensions: statue approx. 2.4m high; reliefs 61cm × 46cm (side panels), and 61cm × 76cm (front and rear panels).
Inscriptions: on the statue – J MOSSMAN Sᶜ· 1877 / COX & SONS. FOUNDERS. (left side of plinth); on the pedestal – J. MOSSMAN H.R.S.A. Sᶜ·

(lower left side of dado); DAVID LIVINGSTONE / BORN. AT. BLANTYRE / MARCH. 9. 1813 / DIED. AT. ILALA / LAKE. BANGWEOLO. AFRICA / MAY. 1. 1873. (relief, rear of dado)
Listed status: Category B (15 December 1970)
Owner: Glasgow City Council

David Livingstone (1813–73), missionary and explorer, born in Blantyre, Lanarkshire. From the age of ten he worked in a cotton mill, thereafter studying science at the Andersonian (now Strathclyde) University under Thomas Graham. Among his fellow students was James Young, who went on to make a fortune from the industrial manufacture of paraffin, and who contributed generously to Livingstone's African expeditions. Livingstone received a degree from the Faculty of Physicians and Surgeons in 1840 and in the same year he was sent by the London Missionary Society to southern Africa. Deciding that the opening up of new territory was more important for the Mission than conversion, he spent twelve years pioneering, during which time he crossed the Kalahari Desert and became the first European to reach Lake Ngami. Setting out from Cape Town again in 1852 on an expedition of pure exploration he charted much hitherto unexplored territory, and in 1855 discovered the Victoria Falls on the Zambezi River. On his return to England in 1857 he relinquished his ties with the Missionary Society and was invited to head a British expedition to central Africa. During the expedition, 1858–64, he discovered Lake Nyasa but was appalled by the extent of the slave trade in the area. His last expedition, the aims of which were to suppress the slave trade and to discover the watershed between Nyasa and Tanganyika, left England in 1865. Though hampered by dysentery and Arab slave traders, he broke much new ground, partly in conjunction with Sir Henry Morton Stanley. He died at Ilala, and his body was taken to England, where it was placed in Westminster Abbey on 18 April 1874.[1]

Description: Mossman presents the celebrated explorer in a relaxed yet authoritative pose, leaning with his right elbow on a draped tree stump and with the strap of his binoculars case thrown over his shoulder. The fingers of his left hand are inserted in the pages of a bible, while his right hand holds his familiar peaked cap. At his feet there is a still life group consisting of a sextant, an astrolabe

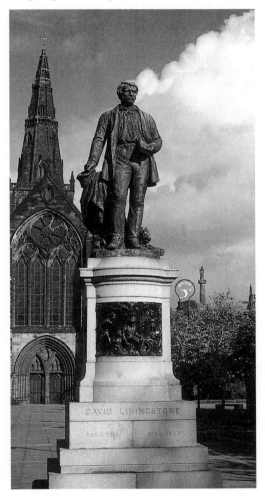

John Mossman, *David Livingstone*

and a length of chain attached to an ankle clasp. There are four relief panels in the pedestal: Livingstone comforting an African family with readings from the Bible (front); the scourging of a native woman (right); Livingstone taking a sextant reading, with a native cutting down a palm tree in the background (left); an inscription (see above) enclosed by palm leaves and other African flora (rear).

Discussion: Mossman was awarded the commission to make this work after being invited to compete with William Brodie and the London sculptor William Calder Marshall in April 1875, all of whom submitted models anonymously.[2] Fund-raising had begun in October of the previous year, when a £500 surplus from the fund gathered by the London Geographical Society to send an expedition to Africa to search for Livingstone was set aside as the 'nucleus of a sum of 1,500*l.* to be raised for procuring a statue'.[3] By April 1875, the fund had climbed to £2,000, of which £350 had been raised by £5 subscriptions, with the remainder almost certainly donated by Livingstone's personal friend, the industrialist James Young of Kelly (who also paid for the erection of the *Monument to Thomas Graham* in George Square, q.v.).[4] Work proceeded quickly. By December of the following year the clay model was ready for casting, and almost exactly a year later the finished bronze was on display, along with another work by Mossman, the *Monument to Thomas Campbell* (q.v., George Square), in the foundry of Cox & Sons in Thames Ditton, Surrey.[5]

The monument was erected in the centre of the west side of George Square and inaugurated in March 1879. Among those attending were Mossman himself, as well as Livingstone's daughter and sister. The unveiling was performed by James White of Overtoun, the chairman of the subscribers. In a lengthy address, Sheriff Clark emphasised the important role played by statues of national heroes in providing inspiration to the younger

generation, and praised Mossman's skill in revealing the subject 'almost as he was in life'. 'Is there among this vast crowd', he asked,

> … any young man, any boy who feels the difficulties of struggling forward in life … let him look to this statue. […] I hope that you will not be satisfied with the mere cursory glance you may get of this statue to-day, but that days and months – ay, years and generations after this – the people of Scotland will come and contemplate this statue, and give thanks that they were privileged to have such a countryman as Dr. Livingstone, and I hope they will not forget the sculptor by whose aid his likeness had been placed before them.

Mossman is reported to have 'bowed his acknowledgements for the compliment'.[6]

In March 1959, the *Glasgow Herald* reported that a plan to remove the statue and replace it with an information bureau had been approved by the Parks Committee.[7] This was opposed by Dr Hubert F. Wilson, Livingstone's grandson and the chairman of the Scottish National Memorial Trust to David Livingstone, who complained that the 'present day civic fathers' did not 'maintain the same interest in Livingstone as their predecessors did'. If the statue were moved, he claimed, 'many visitors would be denied an opportunity of seeing it, and the annual commemorative service, which was usually attended by more than 1,000 young people, may be affected'.[8] The convenor of the Parks Committee, Joseph Flanagan, took the opportunity to re-activate the long-standing hostility to the statuary of George Square (see George Square, Introduction), claiming that 'if he had his way every statue would be removed to Bellahouston Park'.[9] He made it clear, however, that no decision had been made, and that one possibility under consideration was the relocation of the monument to another part of the Square 'in place of one of the less important

statues'.[10] The final decision to move the work to Cathedral Square appears to have met with the approval of the Livingstone Trust, who 'offered no objection to the transfer'.[11] On 27 January 1960, the statue was wrapped in sackcloth and hoisted from its pedestal, and after spending a short time in 'a sculptor's yard for cleaning',[12] was re-erected on an island site opposite Provand's Lordship, a few yards west of the statue of James White of Overtoun (q.v.), who had performed the original unveiling in George Square.[13] It was moved to its present position in 1990 as part of the comprehensive redesign of Cathedral Square.

Condition: Good.

Notes
[1] Somerville, pp.273–5; EB, vol.11, pp.1–3. [2] Anon., 'Statues, Memorials &c.', BN, 9 April 1875, p.417. [3] Anon., 'Proposed statue in Glasgow to Dr Livingstone', B, 3 October 1874, pp.826–7. [4] *Ibid.*; Somerville, p.275, states that it is to Kelly that 'we owe [the] statue of the African explorer in George Square'. [5] A, 1 December 1877, p.304. [6] Anon., 'Unveiling of the Livingstone Memorial Statue', GH, 20 March 1879, p.3. [7] *Ibid.*, 24 March 1959, p.5. [8] Anon., 'Opposition to moving of Livingstone statue', *Ibid.*, 2 April 1959, p.8. [9] *Ibid.*, 24 March 1959, p.5. [10] *Ibid.*, 2 April 1959, p.8. [11] *Ibid.*, 28 October 1959, p.5. [12] *Ibid.*, 27 January 1960, p.9. [13] Bett, pp.27, 44.

Other sources
Tweed (*Guide*), p.19; BN, 16 July 1875, p.75, 11 August 1875, p.142; BA, 19 October 1877, p.199, 21 March 1879, p.131; GCA, C1/3/7, p.311, C1/3/ 9, p.2169; Gildard (1892), pp.2, 10; BI, 16 May 1900, p.17; McFarlane, pp.33–36; GH, 28 October 1959, p.5; Woodward, pp.118–19; Read, p.364, (incl. ill.); Melville, p.8; Williamson *et al.*, p.153; McKenzie, pp.2 (ill.), 3; LBI, Ward 25, p.61.

On the east side of the Square, beside the entrance to the Necropolis

Monument to James White of Overtoun

Sculptor: Francis Leslie

Date: 1890
Inaugurated: 21 August 1891

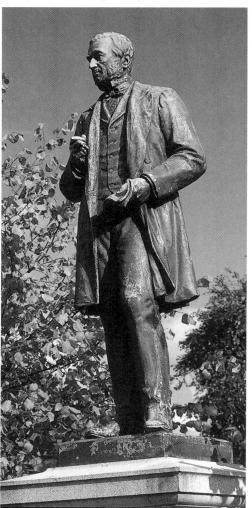

Francis Leslie, *James White*

Materials: bronze statue on an axed grey granite pedestal
Dimensions: statue approx. 2.4m high; pedestal 2.4m high
Inscriptions: on the statue – FRANK. LESLIE. Sc 1890 (left side of plinth); on the pedestal – JAMES WHITE / OF OVERTOUN / 1812–1884 / ERECTED BY HIS FELLOW CITIZENS (lower pedestal, front)
Listed status: category B (22 December 1992)
Owner: Glasgow City Council

James White of Overtoun (1812–84), solicitor and manufacturer. Born on the outskirts of Glasgow, he was educated at the city's Grammar School and Glasgow University, where he studied law. He practised as a solicitor, and was a partner for seventeen years in the firm of Couper & White. At the age of 40 he left to become a partner in the family firm of J. & J. White (Manufacturing Chemists). During this time he was president of the Chamber of Commerce, director and then deputy chairman of the Glasgow and South-Western Railway Company and a member of the committee appointed in 1866 to investigate and rearrange the affairs of the North British Railway. His many other public roles included chairmanships of the National Bible Society, the Glasgow Deaf and Dumb Institution and the committees appointed to distribute relief funds to the victims of various disasters, including the sinking of the *Daphne* (q.v., Elder Park).[1]

Description: The subject is shown standing in an informal pose, with the left leg slightly advanced. He is wearing an unbuttoned frock coat, a waistcoat and a bow tie, and holds a sheaf of papers in his left hand and an eyeglass in his right.

Discussion: The original intention of the memorial committee, chaired by the Dean of Guild William McEwan, was to erect a 'handsome monument or tablet' inside the Cathedral. The Cathedral did in fact grant

permission for this, but as no suitable space was available the committee had to 'look out for some other way of executing the commission'.[2] By chance, the Old Barony Church was being demolished at this time, to provide easier access to the Necropolis, and part of the space created by its removal was acquired by the directors of the Merchants' House from the Corporation with the intention of reserving it '… as a place on which memorials or statues may be erected commemorative of gentlemen who had done good work in the city, and who had not been interred in the Necropolis'.[3] White satisfied both of these conditions and a site was granted just to the left of the new entrance to the Necropolis.

The statue was unveiled by Sir James King at a ceremony attended by 'a large gathering of friends of the late gentleman as well as the general public'. In accepting the monument on behalf of the City, the Lord Dean of Guild John Ure noted that 'the only other statue which he had the privilege of receiving for the citizens was that noble work of art representing Dr. Norman MacLeod [q.v., Castle Street], which was in full view of the place where they stood'.[4] He went on to express the hope that it would 'soon be followed by others'. In his own speech, Sir James King credited John Mossman with the work, with no acknowledgement of Leslie's contribution, despite the fact that it is his name which appears on the plinth. This prompted a correspondent of the *Building News* to point out that Leslie, whom he describes as having been Mossman's 'right hand man' for 35 years, had been responsible for the entire work.[5] His claim that Leslie had been anxiously requested by the statue committee to finish the monument after Mossman's death, and that Mossman's trustees had granted him permission to do so, suggests that the commission had been awarded to the Mossman firm, with the work itself carried out by Leslie as an employee.

A small adjustment was made to the position of the statue in 1990 as part of the redesign of the Cathedral Precinct, but its orientation remains the same.

Related work: A model for the statue was exhibited at the RGIFA in 1892 (no.769) under Leslie's name.[6]

Condition: Good.

Notes
[1] Anon., 'The late James White of Overtoun, unveiling of the statue in Glasgow', GH, 22 August 1891, p.9. [2] *Ibid.* [3] *Ibid.* [4] *Ibid.* [5] A. Stewart Picken, 'James White of Overtoun Statue', BN, 11 September 1891, p.381. [6] Billcliffe, vol.3, p.38.

Other sources
Anon., 'Men You Know – No.221', *Bailie*, no.221, 10 January 1877, pp.1–2; Read, p.365; Williamson, *et al.*, p.153; McKenzie, pp.4, 5 (ill.); LBI, Ward 25, p.63.

At the south entrance, facing John Knox Street

Monument to James Arthur
Sculptor: George Anderson Lawson

Date: 1893
Inaugurated: 26 July 1893
Materials: bronze statue on a Creetown granite pedestal
Dimensions: statue approx. 2.2m high; pedestal 3.5m high
Inscriptions: on the statue – GEO. A. LAWSON Sᶜ. 1893. (left side of plinth); on the pedestal – JAMES ARTHUR / 1819–1855 (front of dado); A MEMORIAL OF RESPECT / AND ESTEEM FROM THOSE / WHO WERE IN HIS EMPLOYMENT (lower pedestal, front)
Listed status: category B (22 December 1992)
Owner: Glasgow City Council

James Arthur (1819–85) home and overseas wholesale distributor. Born in Arthurlie near Paisley, he spent much of his childhood at Neilston before serving his apprenticeship as a draper with a Mr Henderson at Hamilton. At the age of 18 he opened his own draper's shop in High Street, Paisley, and in 1849 set up a retail business in Buchanan Street, Glasgow, in partnership with Hugh Fraser. The partnership soon expanded into wholesaling, opening a warehouse in Miller Street which was later extended to Queen Street. In 1856, Arthur and Fraser separated, Arthur taking the wholesale side of the business and building it up over 30 years into the best known Scots soft goods company in the world, with warehouses in

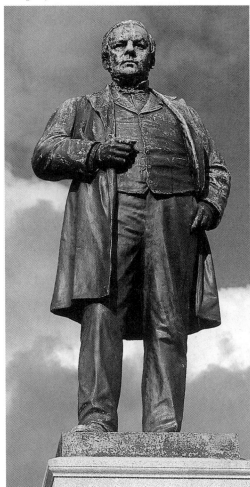

George Anderson Lawson, *James Arthur*

London, Newcastle and Edinburgh, and business interests in Canada, South Africa, Australia, New Zealand, India, China, Malaysia, Dutch East Indies and the Argentine. The company was particularly successful in Scandinavia and also ran a shirt factory in Glasgow, a garment factory in Leeds and a linen factory in Londonderry. The business prospered after James Arthur's death, reaching its peak volume of trade in 1920, but declining in the 1930s. The Queen Street warehouse was destroyed by German bombing and the company was finally taken over in the early 1960s.[1]

Description: The subject is shown standing in a relaxed posture, with the thumb of his left hand tucked into his trouser pocket and his right hand raised to his waist. He is wearing an unbuttoned frock coat, a waistcoat and a bow tie. Lawson modelled the face on photographs of Arthur supplied after his death.

Discussion: Originally located to the right of the entrance to the Necropolis, on a site gifted by the Merchants' House of Glasgow, this work formed a pendant to Francis Leslie's stylistically similar statue of James White of Overtoun (q.v.), erected three years earlier on the opposite side. As with the White monument, the committee of subscribers was chaired by William McEwan, the Dean of Guild, though in this case the subscriptions came entirely from the employees of Arthur's drapery firm, Arthur & Co. Ltd. The unveiling ceremony was also performed by Sir James King, with Lord Provost Bell, as well as Arthur's widow and son among the large gathering. In his address, McEwan described the statue as being 'the work of an artist of high fame'.[2] The pedestal was designed by the architects Morris & Hunter, from Ayr, and made and erected by J. & G. Mossman for £220.[3]

The monument was moved a few yards south-west to its present site in 1990.

Condition: Good.

Notes
[1] John F. Barclay, *Arthur & Company Limited: one hundred years of textile distribution*, Glasgow, 1953, pp.64–6; Anon., 'Men You Know – No.124', *Bailie*, no.124, 3 March 1875, pp.1–2. [2] Anon., 'James Arthur Memorial', GH, 27 July 1893. [3] GCA, TD 1309 (uncatalogued) Mossman ledger (October, 1890–July 1898), 11 February 1893, p.144.

Other sources
Read, p.365; Williamson *et al.*, p.153; McKenzie, pp.3–5 (incl. ill); LBI, Ward 25, p.62.

In the centre of the Square

Bishop's Palace Memorial Pillar
Sculptor: Robert Gray

Designer: James Miller
Date: 1912–15
Unveiled: 11 July 1915
Materials: silver-grey granite with bronze plaque
Dimensions: pillar 1.93m high; plaque 32cm × 30cm
Inscription: in relief letters on the bronze plaque – PRESENTED TO THE / CORPORATION OF GLASGOW / BY FRANCIS HENDERSON ESQ. / LORD DEAN OF GUILD OF THE CITY / IN THE YEARS 1910–12 / TO MARK THE SITE OF THE BISHOP'S PALACE / WHICH WAS BUILT IN THE THIRTEENTH CENTURY / AND WAS FINALLY REMOVED IN 1792.
Listed status: category C(s) (22 December 1992)
Owner: Glasgow City Council

Description: A tapered stone pedestal on a stepped base and capped by a cavetto cornice. The four sides of the main shaft are decorated with relief panels of flowers woven into traditional Scottish interlace patterns and (on the south face) a Glasgow coat of arms. There are thistles in the cornice. On the north face is a bronze panel combining an inscription (see above) and an engraved image of the fifteenth-century Episcopal Palace. Begun in the thirteenth century, the Palace achieved its most

Robert Gray, *Bishop's Palace Memorial Pillar*
[RM]

developed form under Bishop John Cameron (1426–66), occupying the walled precinct in front of the west end of the Cathedral. It had become a ruin by the seventeenth century, and in 1792 was demolished to make way for the Royal Infirmary. The relief shows the building restored and in its proper relationship with the Cathedral.

Discussion: The pillar was commissioned by Francis Henderson, Lord Dean of Guild 1910–12, who desired to 'leave some visible token behind him of the pleasure he had experienced in being associated with the public work of the city'. His particular interest was the Cathedral 'and everything connected with it

and the older life of Glasgow', and in October 1911, he applied to the Statute Labour Committee for permission to erect a 'plain Scottish granite obelisk about four feet in height with a flat top and inscription thereon' to mark the site of the original Palace.[1] The committee unanimously accepted his proposal. At the unveiling, which despite the 'inclement weather' was well attended, Bailie Ure commended the memorial not only as a 'link with the historic past' but also as a 'proof that the spirit of commercialism had not altogether enslaved the merchant princes'.[2]

When first erected it was placed within the grounds of the Royal Infirmary, a few yards in

front of the main entrance. It was moved slightly to the south during the remodelling of the Square in 1990, though it is still well within the archaeological area of the Bishop's Palace.

Condition: Good.

Notes
[1] Anon., 'Gift from Dean of Guild', GH, 27 October 1911, p.12. [2] Anon., 'Glasgow Bishop's Palace Memorial Obelisk Unveiled', unknown newspaper cutting, 12 July 1915, MLG, 'Glasgow Scrapbook No.10', p.87.

Other sources
GCA, C1/3/45, p.2532; Gomme and Walker, p.17; Williamson *et al.*, pp.141–3; McKenzie, pp.1–3 (incl. ill.); LBI, Ward 25, p.65.

Cathedral Square Gardens TOWNHEAD

In the centre of the Gardens

Equestrian Monument to King William III

Sculptor: not known

Founders: Cant & Lindsay
Date: 1734
Erected: 1735 (re-erected 1894 and 1926)
Materials: lead statue on a Callalo stone pedestal
Dimensions: larger than life-size
Inscriptions: on the pedestal: (south side) –
OPTIMO PRINCIPI, / WILLIELMO III. BRITANNARUM REGI, PIO, FORTI, / INVICTO, CUJUS VIRTUTE, CONSILIO, ET FELICITATE, / IN SUMMO SÆPE DISCRIMINE SPECTATIS, / FÆDERATI BELGIIJ CIVITATIBUS TANTUM NON DELETIS, / INSPERATA PARTA EST SALUS; / BRITANNIÆ ET HIBERNIÆ / RELIGIO PURIOR, JURA, LIBERTASQUE, / RESTITUTA, CONSERVATA, ET POSTERIS, / SUB LEGITIMO PIORUM PRINCIPIUM BRUNSVICENSIUM /

IMPERIO, SUNT TRANSMISSA; / INTENTATUM DENIQUE, A GALLO TOTI EUROPÆ / SERVITUTIS JUGUM EST DEPULSUM: / HOC IMMORTALIUM MERITORUM MONUMENTUM, / LABENTE SEPTIMO POST OBITUM LUSTRO, / SUMMO SENATUS, PROPULIQUE, GLASGUENSIS PLAUSU / ACCEPTUM, POSUIT, CIVIS STRENUUS ET FIDUS, / JACOBUS MACRAE, / COLLONIÆ MADARASSIANÆ EXPRÆFECTUS. / MDCCXXXV.; (north side, added 1897) – IN HONOUR OF / THE MOST EXCELLENT PRINCE, / WILLIAM III. SOVEREIGN OF GREAT BRITAIN, / PIOUS, VALIANT, INVINCIBLE, / BY WHOSE COURAGE, COUNSEL, AND ADDRESS, / OFTEN DISPLAYED IN THE GREATEST DANGER, / TO THE UNITED PROVINCES, WELL NIGH OVERPOWERED, / UNEXPECTED SAFETY WAS OBTAINED; / TO BRITAIN AND IRELAND / PURER RELIGION, LAW, AND LIBERTY, / WERE RESTORED, MAINTAINED, AND TRANSMITTED / TO POSTERITY, / UNDER THE JUST GOVERNMENT OF PATRIOTIC PRINCES / OF THE BRUNSWICK

LINE; / AND THE YOKE OF SLAVERY, / INTENDED BY THE FRENCH FOR THE WHOLE OF EUROPE, / WAS AVERTED: / THIS MONUMENT OF HIS IMMORTAL DESERTS, / IN THE XXXIII YEAR AFTER HIS DECEASE, / BEING ACCEPTED, WITH THE HIGHEST APPROBATION, / BY THE MAGISTRATES AND PEOPLE OF GLASGOW, / WAS ERECTED BY HER ACTIVE AND FAITHFUL CITIZEN, / JAMES MACRAE, / LATE GOVERNOR OF THE PRESIDENCY OF MADRAS. / MDCCXXXV. A bronze plaque on the grass immediately in front of the statue contains a medallion with portraits of William III and Queen Mary II, and the inscription: IN COMMEMORATION OF / THE TERCENTENARY OF / THE GLORIOUS REVOLUTION / OF 1688–89 / WHICH SECURED OUR LIBERTIES / BOTH CIVIL AND RELIGIOUS / ERECTED BY / THE PROVINCIAL GRAND BLACK CHAPTER OF SCOTLAND / IN MAY 1989.
Listed status: category A (6 July 1966)
Owner: Glasgow City Council

William III, Prince of Orange and King of Britain (1650–1702). Born at The Hague, the only son of William II, Prince of Orange, and Mary, daughter of Charles I of Britain, he was declared Stadtholder of the Netherlands in 1672 after the invasion by Louis XIV of France. After marrying Mary, eldest daughter of the future James II of Britain, he concluded a truce with France in 1678 (though aggression continued). Realising that James II would not unite with him against France, he stirred up the English opposition against him and successfully ousted him, being declared joint sovereign of Britain, along with Mary, in 1689. He overcame the Irish resistance to him at the famous Battle of the Boyne in 1690 and continued to rule Britain until his death, which was the result of a fall from his horse.[1]

Description: The design of the monument is based on the second-century AD statue of the emperor Marcus Aurelius on the Capitoline Hill in Rome, and presents the King as a Roman general wearing a knee-length skirt overlaid with tasses, a decorated cuirass, a cloak and a laurel crown. He holds a baton in his outstretched right hand, and the horse is shown cantering with its right foreleg raised.

Discussion: This is the city's oldest sculptural landmark, and the only example of a free-standing public statue in Glasgow dating from before the nineteenth century. Surviving records give no indication of the identity of the sculptor, and the fact that there was no established sculptural tradition in Glasgow at this time makes it unlikely that it was produced by a local artist. It is believed to have been cast by Cant & Lindsay[2] and an attribution to the Belgian artist Peter Scheemakers has been proposed, on the grounds of its similarity to his statue of the same subject in the Market Place in Hull, dating from 1735.[3] In her discussion of the Hull work, Margaret Whinney notes the stiffness of the figure, as well as the relatively static treatment of the cloak compared to Rysbrack's more dynamic conception in his

monument to William III in Queen Square, Bristol, which also dates from 1735.[4] The Glasgow statue corresponds very closely to her description of the Hull version. The attribution has been disputed by Ingrid Roscoe, however, who contends that the work is 'not stylistically related to Scheemakers's output'.[5] An alternative suggestion has been tentatively proposed by Catharine Gibson, who has described the horse in the Glasgow monument as 'almost an exact replica of Le Seur's equestrian statue of Charles I' in Trafalgar Square, London, going on to suggest that it may have been cast from Le Seur's original moulds, or copies made from them.[6] In the absence of any firm documentary evidence, however, all such attributions must remain speculative. Early sources are also unclear on the question of the material, with some commentators describing the work as being made of bronze, and others of 'some baser metal'.[7] The modern consensus is that it is made of lead.

The statue was commissioned in 1734 by James Macrae, the son of an impoverished washerwoman from Ayr, who rose, after a colourful career as a seaman, to become the Governor of the Presidency of Madras. On his retirement he returned to Scotland with an immense personal fortune and became a burgess of Glasgow and an Ayrshire landowner. His commitment to the Protestant cause is indicated by his choice of the name 'Orangefield' for his estate near Prestwick.[8] Robert Reid records a traditional belief that Macrae's original wish was to erect the statue in the Cartsdyke estate near Greenock, and that it was only when this proposal was rejected by the local laird that it was offered to Glasgow.[9] This seems unlikely. Quite apart from the incongruity of relegating such a major monument to a remote country location, the description of it as having been 'given in compliment to the City' in the lengthy panegyrical poem composed, probably by John McUre, to mark its inauguration, suggests it was intended for the city from the start.[10] This

supposition is supported by the earliest references to the statue in the council minutes. On 2 January 1733, for example, the Lord Provost tabled a letter from a friend in London who reported that Macrae had 'signified his inclination to make a present to the town of an equestrian statue of the late King William, to be set up in this city, if it were acceptable to the town'.[11] The minute goes on to say that the offer had been accepted, and that Macrae had written to the council on 6 December 1732, indicating his

> … pleasure to find the general reception his designed present met with and that he has long been acquainted with the firm attachment of the city of Glasgow to the Revolution principles, and therefore thought an equestrian statue of our glorious hero and deliverer (under God) from popery and slavery might be an agreeable present to perpetuate as much as possible the memory of that great and good Prince.[12]

Macrae concludes by stating that he will 'endeavour to get the statue finished and sent down next summer and take the best advice about the posture'. The fact that his letter was sent from Blackheath, suggests that the statue was made in London.

In any event it was on the Trongate, immediately in front of, and parallel to, the façade of the Tontine Hotel, that the statue was erected, and where it was to remain for 163 years. It was surrounded by a 'curious Iron Rail of excellent workmanship',[13] with a group of four cannon reputed to have been used at the Battle of the Boyne (1690) set vertically into the pavement at each corner 'to protect the pedestal from street traffic'.[14] These were provided by the merchant Thomas Clark, who demanded 'payment of 8s sterling for each hundered [sic] weight of twenty eight hundred and three quarters and fourteen pound as the weight of the toun cannons'.[15] This was regarded by the council as excessive, and he was asked to settle

for six shillings per hundredweight or 'remove and take away the said four cannons and dispose of them as he pleases'.[16] He appears to have accepted the lower offer.[17]

Neither the fence nor the cannon appear to have been very effective in their role of protecting the monument, and in 1781 the *Glasgow Mercury* reported that:

Yesterday se'ennight, a young man, disordered in his mind by intemperence, got upon the Pedestal on which the Equestrian Statue of King William stands, and mounted the Horse, when his phrenzy led him to cut off the Laurel with which the Statue was crowned, and otherwise maltrait it. What is surprising he got up and down without receiving any hurt. He is since confined in the Cells.[18]

Notwithstanding such acts of vandalism, the statue was a uniquely important urban landmark during the century and a half in which it stood in the Trongate, which by the mid-eighteenth century had decisively taken over from the Cathedral precinct as the city's true civic focus. With the familiar pilasters and rusticated arcade of the Tontine Hotel serving as a backdrop, it became almost a symbol of Glasgow itself. It features prominently in numerous representations of the Trongate, ranging from the famous painted view by John Knox (which tellingly exaggerates its scale),[19] to the mid-Victorian photographs of Thomas Annan, where it rises as a truly monumental presence among the ephemeral swirl of citizens at its base.[20]

The powerful sense of historical continuity it embodied during its sojourn in the Trongate is vividly expressed by a correspondent of the *Glasgow Herald*:

If it were miraculously endowed with the gift of speech, what tales could it tell of stirring events and strange vicissitudes! It had already been fully ten years in existence when 'Bonnie Prince Charlie' and his army arrived in Glasgow in such a bedraggled condition after the futile expedition to Derby. It witnessed almost the earliest signs of our coming phenomenal greatness as an industrial and trading community. Hard by its shadow in days of yore was the city's mercantile and social centre ...[21]

With the further growth of Glasgow, however, and the consequent westward migration of the city's social and administrative heart, the Cross was to lose much of its importance, and as the nineteenth century progressed the statue was gradually abandoned, in the *Glasgow Herald* writer's words, to 'the society of the vulgar', with little to look down upon except 'scenes of poverty – honest, and, alas, too often the reverse'.[22] This was to become a matter of increasing public concern. 'We confess', wrote the correspondent of the *Builder* in 1867,

... that we were not so well pleased with the condition in which we found the statue of King William, its pedestal being at this moment converted into a post for a pair of cast iron urinals! These are certainly excellent improvements in their place; but they are rather destructive of the amenities as well as the artistic effect of an equestrian statue. If the necessity of the thing must overpower all other considerations, why should poor King William not be shifted to the Valhalla at George-square? ... Let us, then, put in our humble plea for the removal of the statue of 'Protestant Willie' – a king whose memory ought to be dear to the hearts of all good Scotsmen – to a nobler site and more congenial company.[23]

Interestingly, the journal's editor found it necessary to intervene in this article with a footnote on the statue's qualities as a work of art, providing a concise summary of the somewhat mixed feelings the work provoked at the time:

It is the fashion among guide-book writers, who follow each other, of course, like sheep, to disparage this fine old statue, and to repeat that it is 'of no great merit as a work of art' – (*Vide* 'Black's Guide to Glasgow', p.23; Miller's 'Illustrated Guide', p. 27.) We

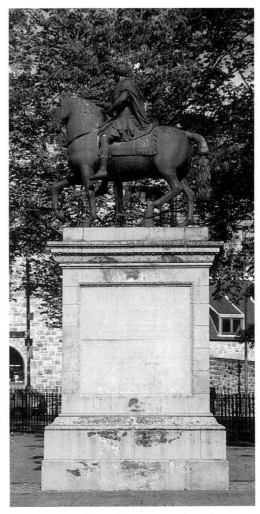

Anon., *King William III* [RM]

Cathedral Square Gardens 69

can only say that, in our opinion, with the exception of Marochetti's Duke of Wellington in front of the Exchange, it is the best equestrian statue we have seen in Glasgow. The horse is not much worth, and the pedestal, we admit, is abominable; but the historical portrait of the man is invaluable.[24]

Aesthetic judgements aside, by far the most pressing concern in this part of the city as the end of the century approached was traffic congestion, and when the City Architect John Carrick drew up his plan to widen the Trongate as part of a wholesale redevelopment of the Cross, the consensus was that the statue of King William was, quite literally, standing in the way of progress, and that the time had come for it to find a new home.[25] Though there was a general agreement that it should be removed, the question of where it should be removed to was less clear, and the Special Committee appointed in 1893 to look into the matter deliberated for over three years before a decision was made.[26] Glasgow Green and Cathedral Square were among the options considered, but these were objected to by the Glasgow Archaeological Society, on the grounds that the statue would make no historical sense if it were removed from the vicinity of the Cross.[27] After entering into consultations with the Caledonian Railway Company, whose new station was to be built at the east end of the newly widened Trongate, the decision was made to place King William behind this building, at the western apex of the triangular island created by the new street line. The change of location enabled the Council to replace the 'abominable' pedestal and to add an English translation of the original Latin inscription, with both sets of texts ornamented with gold leaf. The whole operation was carried out for £195, and was completed in October 1897, with a light iron rail added a few weeks later.[28] Scenically, this was a very satisfactory solution, though its proximity to the rear of a railway station, at a time when horse-drawn transport was becoming a rarity, can have done little to mitigate the growing perception of the monument as an anachronistic remnant from a forgotten era.

Barely twenty years had passed, however, before its location had become problematic once more, and with the second wave of redevelopment at Glasgow Cross in the 1920s (see London Road, below) the council found it necessary to remove the monument from the area altogether. Once again, the debate was characterised by the now familiar lack of decisiveness over where it should be resited, and although there was some support for the view that it should be placed at the junction of London Road and the Gallowgate (more or less where the Mercat Cross is today) the preferred solution was to remove it first and decide what to do with it later.[29] In April 1923 it was put in storage, probably Mossman's yard, where minor repairs were carried out, including the introduction of a ball and socket joint in the tail which allows the lower half to swing in the wind.[30] A little over three years later, in August 1926, the council finally decided to re-erect the statue 'in the grass plot in Cathedral Square',[31] reverting, as it happens, to a proposal made as early as December 1893. The cost of the removal was £414.[32]

Throughout the debate the Grand Orange Lodge of Scotland had lobbied for the retention of the statue in the vicinity of the Cross, and even after its erection made an unsuccessful demand that the council provide 'a pathway … either around or leading up to the statue'.[33] Nor were they alone in their dissatisfaction with the council's treatment of the statue, for in 1954 Douglas Percy Bliss, the Director of Glasgow School of Art, protested angrily at what he regarded as the incongruity of its location. 'Surely', he asked,

… Glasgow is not ashamed of the Protestant King or of his statue? Dutch William, arrived as a Caesar in a tight-fitting cuirass with a skirt and a victor's wreath on his head, is riding cock-horse to parade among the trees near the gas works.[34]

The gas works are gone, and the trees are more mature than they were in Bliss's day, but even so the site can scarcely be judged a success, at least from an aesthetic point of view. Perhaps there was an element of political prudence on the council's part in consigning a work of such undoubted sectarian associations to a relative urban backwater, though even today it still provides a regular rallying point for the annual Orange Order parade on 12 July. Yet it is arguable that a monument of such antiquity, with a history so bound up with the changing fortunes of the city, deserves a situation more suited to its importance. It is also ironic, given the form of transport it celebrates, that its closest neighbour, and the site which provides the best view of it today, is a transparent perspex bus shelter. The decision to exclude the monument from the recent redesign of Cathedral Precinct was widely perceived as a lost opportunity to restore the monument to a more suitable position.

Condition: Maintenance problems have been a feature of the statue since the early nineteenth century. In October 1823, for example, James Cleland reported to the council that

… the statue of King William at the Cross has lately been observed to incline considerably forward on the horse. On inspection I found that part of the back drapery which fixed the statue to the horse had given way.[35]

It is not known if his recommendation that the statue should be 'set erect on the horse and re-soldered' was carried out, though his proposal that the iron rail and associated masonry enclosing the pedestal should be renewed was accepted, and executed in June 1824, at a cost of £62 10s. 1d.[36] The statue has

been painted on many occasions, the earliest recorded example of which was 4 October 1736, when John Duff, a wright and painter, was commissioned to coat the statue and the pedestal 'three times in oyl', and the 'iron ravil near the statue two times'.[37] The most recent recoating (brown paint on the statue, white on the pedestal) occurred in October 1999. At present the monument is tilting badly to the left and is likely to require remedial treatment in the near future.

Notes

[1] DNB, vol.LXI, pp.305–25. [2] Malcolm Baker, 'Proper Ornaments for a Library Grotto: London Sculptors and their Scottish Patrons in the Eighteenth Century', in Pearson, p.48. [3] LBI, Ward 25, p.66. See also Gomme and Walker, p.287, and McKean et al., p.19. [4] Whinney, p.178, and plates 122, 123. [5] Letter from Ingrid Roscoe to Edward Morris, 25 October 1999. [6] Letter from Catharine Gibson to Edward Morris, 28 October 1999. [7] Anon., 'Statues, Memorials &c.', BN, 9 April 1875, p.417. [8] Senex, vol.1, pp.363–7. See also Charles Tennant, 'Macrae of Orangefield', Scots Magazine, February 1982, p.536. [9] GH, 26 February 1894. [10] Tweed (Glasgow Ancient and Modern), vol.2, p.429. [11] Robert Renwick (ed.), Extracts from the records of the burgh of Glasgow, Glasgow, 1909, vol.5 (1718–38), p.389. [12] Ibid., pp.389–90. [13] Tweed, op. cit., vol.2, p.429. [14] Eyre-Todd (1934), p.163. [15] Renwick, op. cit., vol.6 (1739–59), p.77. [16] Ibid., p.78. [17] Two of the cannon were sold to a scrap iron dealer in the mid-nineteenth century, but the remaining two are clearly visible in period photographs (see, for example, Stewart, p.13). These were finally removed in 1926 and presented by the Council to George Eyre-Todd in 1932; see Eyre-Todd (1934), p.163. [18] Glasgow Mercury, 2 February 1781, quoted in Tweed, op. cit., vol.2, p.432. [19] John Knox, Old Glasgow Cross, oil on canvas, 1826, GAGM, pl.20. [20] Mozley, pl.20. [21] Anon., 'King William's Statue, the life-story of its donor', GH, 17 February 1894. [22] Ibid. [23] 'A run through Glasgow', B, 11 May 1867, p.325. [24] Ibid. [25] In fact calls for the statue's removal had been made as early as 1838. In his guide to Glasgow, T.F. Dibdin, for example, complained that the statue 'seemed to have been left in the centre of the street on purpose to ride over you. It has no business here as it is incessantly in the way.' Dibdin, p.665. [26] Minutes of the meetings of the committee set up to 'consider the propriety of removing the Statue of King William'

appear regularly in the Council records during this period. The earliest is 9 June 1893 (GCA, C1/3/20, p.288), and the decision was finally made on 20 November 1896 (C1/3/24, p.43). [27] Ibid., C1/3/22, 1 March 1894, p.159. [28] Ibid., C1/3/24, pp.825, 828. [29] Ibid., C1/3/69, 13 April 1923, p.2122. [30] Keelie, p.39. [31] GCA, C1/3/75, 27 August 1926, p.228.] [32] Ibid., C1/3/76, 12 November 1926, p.137. [33] Ibid., C1/3/80, 21 December 1928, p.424. [34] Bliss, p.3. [35] Renwick, op. cit., vol.11 (1823–33), p.58. [36] Ibid., pp.63–4, 107–8. [37] Ibid., vol.5 (1718–38), p.467.

Other sources

Tweed (Guide), p.31; B, 9 July 1898, p.29; EC, 10 July 1937, p.6; ET, 14, 21 September 1977, 29 January 1983, 7, 21 March 1987, 10 September 1999, p.10; Teggin et al., p.18 (ills); Williamson et al., p.153; McKenzie, pp. 4, 5 (ill.).

At the north-west corner of the Gardens

Monument to the Reverend Dr Norman Macleod

Sculptor: John Mossman, assisted by Daniel MacGregor Fergusson

Founder: James Moore of Thames Ditton
Date: 1881
Unveiled: 26 October 1881
Materials: bronze statue on a granite pedestal
Dimensions: statue approx 2.4m high; pedestal 2.67m high
Inscriptions: on the statue – J. MOSSMAN. Sᶜ. 1881. (left side of plinth); on the pedestal – NORMAN MACLEOD / 1812–1872 (front of dado)
Listed status: category B (15 December 1970)
Owner: Glasgow City Council

Reverend Dr Norman Macleod (1812–72), Minister of the Barony Church and influential liberal Presbyterian. Born in Campbeltown, the son of a minister, he was ordained in 1838 and took charge of the parishes of Loudoun, Ayrshire and Dalkeith (1843) before moving to Glasgow. He was a founder of the Evangelical Alliance (1847), and as a moderate helped

resolve the conflict engendered by the great Disruption of 1843, in which a third of the Church of Scotland clergy seceded to form the Free Church of Scotland in an attempt to force church reforms. He became editor of the *Christian Instructor* in 1849 and of *Good Words* in 1860. He was appointed chaplain to the Queen in 1857, Convener of the India Mission of the Church of Scotland in 1864, and finally Moderator of the Church of Scotland in 1869. His Barony Parish was a very large one, comprising 87,000 souls, many of them Highlanders, among whom he established his reputation for ministering to the needs of the poor. The Highlands also provided Macleod with material for numerous publications, including *Wee Davie*, *The Starling* and *Reminiscences of a Highland Parish*, while his extensive travels provided inspiration for books such as *Eastward 1866*, which recalled his visit to Egypt and Palestine, and *Peeps at the Far East* which stemmed from his tour of India in 1867 where he gained wide acclaim for his preaching. He never fully recovered, however, from the physical strains of this tour. He died in Glasgow and was buried at Campsie (now Lennoxtown) graveyard.[1]

Description: One of the most brilliant public speakers of his day, Macleod is represented in the act of preaching, with his left hand slightly raised and his fingers inserted in the pages of a bible. There is a pile of books at his feet. Under the flowing Geneva gown of a Presbyterian minister he wears the court dress of the Moderator of the General Assembly of the Church of Scotland, with the hood of a Doctor of Divinity on his shoulders. The pendant on his breast, a Latin Cross combined with a Saltire, is the badge of the Dean of the Order of the Thistle. Mossman, who was a personal acquaintance of Macleod, was praised for the accuracy of the likeness and the vividness of his portrayal of the subject's personality.[2] Thomas Gildard noted in particular that the treatment of the draperies was 'singularly in keeping with

John Mossman, *Norman Macleod* [GN]

the grand, manly figure of the minister of the Barony'.[3] The statue stands a little to the west of the site of James Adam's demolished Old Barony Church, where Macleod was Minister for 21 years. This was superseded in 1890 by Burnet & Campbell's larger Gothic structure on Castle Street, which the statue now faces. The pedestal was designed by D.P. Low, of Haig & Low.[4]

Discussion: This was the first statue to be erected in Cathedral Square after the comprehensive redesign of the area by the City Improvement Trust in the 1870s. Following Macleod's death in 1872, his Barony Church congregation decided to commission a modest monument with 'more or less of the character of a private memorial'. Gildard describes how Mossman was asked to make a model of a seated figure to be carved in marble and placed in the Cathedral.[5] Such was Macleod's popularity, however, that the subscription had to be widened to include 'contributions from men of all ranks and classes – from nobles of the land to humble artizans – and also from men of different religious communions', with the result that a more public commemoration was felt to be appropriate. For Dr J.A. Campbell MP, who gained the permission of the City Improvement Trust to erect the monument in Cathedral Square, the 'unavoidable' delay which this entailed was an advantage, as it allowed 'the claim of Dr. Macleod's memory to such public distinction as it receives today to be tested by the lapse of several years – a test which it has well stood'.[6] Mossman himself was also 'better pleased with the idea of a standing attitude, more favourable to the representation of the subject and to the opportunity for the artist'.[7] The sculptor was present at the unveiling ceremony, which was performed by the Very Reverend Principal Caird.[8]

Related work: Mossman exhibited a portrait of Macleod at the RA in 1868 (no.1126).[9] A bust of Macleod by Patric Park was exhibited at the RA in 1842 (no.1381),[10] and an oil portrait by Taverner Knott, dated 1848, is in the SNPG (PG 633).

Condition: Good.

Notes
[1] EB, vol.VI, p.458. [2] Anon., *Unveiling of the statue of Dr. Macleod 1881*, Glasgow, 1881, pp.17, 21. [3] Gildard (1892), p.9. [4] *Ibid*, p.10. [5] *Ibid*., p.9. [6] Anon., *op. cit.*, p.13. [7] Gildard (1892), p.9. [8] GH, 27 October 1881, p.3. [9] Graves, vol.5, p.313. [10] *Ibid*., vol.6, p.53.

Other sources
Anon., 'Men You Know – No.105', *Bailie*, no.105, 21 October 1874, p.2; Anon., 'Men You Know – No.1060', *Bailie*, no.1060, 8 February 1893, pp.1–3 (incl. ill.); GCA, C1/3/11, p.2769, 3 February, 1881; Gildard (1892), p.2; Read, p.365; Williamson *et al.*, p.153; McKenzie, pp.4, 5 (ill.); LBI, Ward 25, p.67.

Centre Street KINGSTON

Hamish Allan Centre, 180 Centre Street / Wallace Street

Pediment Reliefs

Sculptor: not known

Architect: Alexander Beith McDonald
Date: 1914–16
Material: red Locharbriggs sandstone
Dimensions: figures approx. life-size
Inscription: on the Glasgow arms – LET
 GLASGOW FLOURISH
Listed status: not listed
Owner: Glasgow City Council

Description: Two red brick and sandstone terrace blocks joined by an archway, with channelled ashlar basement storeys, canted oriel windows on the upper floors and various Baroque details. Each of the main façades has a broken segmental pediment in the centre, with two smaller curvilinear pediments at either end. On Wallace Street these contain: a globe under a cloud and sunburst, with palm leaves below

and flaming torches on either side; a firefighter's helmet superimposed on an axe crossed with a hose and a hydrant key; a phoenix rising from a pair of crossed torches. The corresponding pediments on Centre Street contain: a half-length female figure, partially clothed and holding a bird in each hand; a shield with the Glasgow arms flanked by Ionic columns with lion masks in the capitals; a bearded male figure, possibly Neptune, enclosed by flames and holding a dragon or sea monster. The cornice on both façades has corbels carved variously with a bishop's mitre and symbols from the city arms: a bell, a bird, a pair of salmon and a tree.

Discussion: The building was erected for the Glasgow Corporation Fire Department as the South Side Fire Station, incorporating an engine room and accommodation for firefighters. The imagery used in the carvings is unusual in its combination of the conventional emblems of the firefighting profession with mythological references. It is also extremely thorough in its

Anon., *Pediment Relief* [RM]

exploration of the symbolic meaning of water, and its power to subdue fire. The Wallace Street building was recently used as a police station, but the two blocks are now occupied by the Hamish Allan Centre, a refuge for homeless people.

Condition: Good.

Sources
GCA, B4/12/1914/418, 484; Williamson *et al.*, p.510.

Church Street PARTICK

Tennent Memorial Building, 38 Church Street

Allegorical Figures of Night and Day and Associated Decorative Carving

Sculptor: Archibald Dawson

Architect: Norman A. Dick

Date: 1933–5
Material: yellow sandstone
Dimensions: figures approx. life-size
Inscription: in cartouche above entrance – THE /
 TENNENT MEMORIAL / 1935
Listed status: category B (15 December 1970)
Owner: North Glasgow University Hospital NHS Trust

Description: The two figures are seated at

either end of a length of raised cornice above the inscription panel over the main entrance, and act as terminals to the semicircular relieving arch enclosing the central window. On the left a blind female figure symbolising *Night* is shown in a posture suggesting repose, with her cheek resting on her back-turned wrist, and her elbow supported by her raised left knee. A bunch of flowers hangs limply from her right hand, and

Archibald Dawson, *Night*

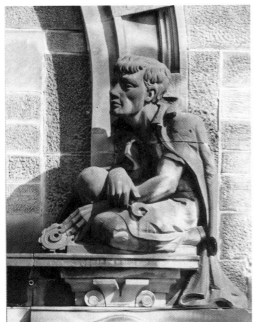

Archibald Dawson, *Day*

her eyes are closed. The male figure on the right has a similar pose, but is more alert, holding a spanner in one hand and a cog wheel in the other. His eyes are wide open. Both figures wear capes, which hang from their shoulders and fall beyond the level of the cornice to touch the string course below. The twin themes of Night and Day are extended to the decorative details on the Solomonic columns flanking the entrance. On the left the capital is in the form of

an owl with a pair of mice (possibly its nocturnal prey) tucked in the corners, and there is a series of pateræ in the surrounding moulding decorated with crescent moons and stars. The cartouche in the panel between the column and *Night* is carved with a sprig of nightshade. The flowers on the corresponding cartouche under the figure of *Day* are daisies, while the column below has a crowing cock in the capital and sunflowers in the pateræ.

Additional details elsewhere on the building include a pair of rectangular panels carved with griffins and thistles at either end of the building and a staff of Asclepius in the keystone over the central window.

Discussion: Originally an eye infirmary, the building was erected by the trustees of Dr Gavin Paterson Tennent in commemoration of his 39 years' service to the Western Infirmary (1874–1913). A bronze memorial plaque incorporating a portrait of Paterson was recently removed from the foyer and placed in Gartnavel Hospital, where the Eye Infirmary is now located. The carvings are typical of Dawson's tendency to develop a complex programme of abstract symbolism on the basis of a relatively simple thematic idea, in this case the function of the building as a preserver of the ability to see providing the pretext for his exploration of imagery related to the presence or absence of light. They also demonstrate his extraordinary inventiveness in the treatment of incidental details, as well as his abiding interest in the affectionate portrayal of animals. Dawson used himself and his wife as the models for the two figures.[1]

Condition: Good, though the figures are blackened.

Note
[1] Hamish Dawson, 'The Man Behind the Chapel Carvings', *Avenue*, no.19, January 1996, p.9; conversation with Hamish Dawson, 7 December 2000.

Other sources
B, 7 June 1935, p.1087; Teggin *et. al.*, p.66 (ills); McKean *et al.*, p.176; Williamson *et al.*, p.347; McKenzie, pp.96, 97 (ill.).

The Briggait, 64–76 Clyde Street and 127–55 Bridgegate

Sea Horses and Portraits of Queen Victoria

Sculptor: not known

Architects: Clarke & Bell
Date: 1873
Material: sandstone
Dimensions: all representational features larger than life-size
Inscriptions: on the coats of arms – LET GLASGOW FLOURISH
Listed status: category A (15 October 1970)
Owner: Glasgow City Council

Description: The Clyde Street frontage is in the form of a double triumphal arch, with pairs of attached Tuscan columns flanking two arched entrances, a line of oculus windows on the first storey and an attic balustrade. There are two pairs of winged sea horses facing each other at attic level, with medallions containing frontal portraits of Queen Victoria inserted between them. The entrance arches have male bearded masks in keystones. The entire façade is painted white, with a number of details picked out with other colours, including Victoria's hair and crown (yellow), the leaf fronds in the adjacent panels (blue) and the swags draped over the oculi (blue and yellow).

The rear of the building, facing Bridgegate, is in a more Mannerist style, with a wide gable dominating the design. Sculpted features include a pair of roundels in the bottom corners of the gable containing colossal male bearded heads, possibly representing Neptune; two reliefs of the arms of Glasgow immediately below them; an acroterion on the gable consisting of an urn flanked by grotesque inverted fish. This frontage is also painted white, with the details of the Glasgow arms highlighted in blue, green, pink and yellow.

Discussion: Designed originally as a fish market, the building was refurbished in the early 1980s and converted to the Briggait shopping centre. This was not a success, and the building is now empty and awaiting a new use.

Condition: Good.

Sources
Worsdall (1982) p.144 (incl. ill.); Denny Macgee, 'Glasgow's fishmarket gets £1.5m face lift', *Scotsman*, 13 January 1983; Williamson *et al.*, pp.194–5.

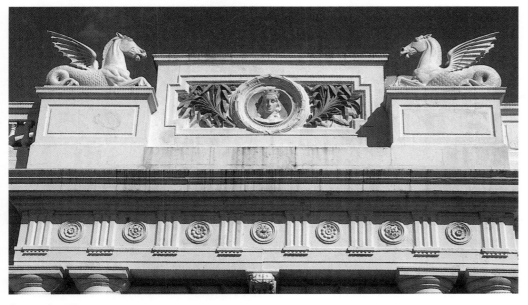

Anon., *Sea Horses* [RM]

On Custom House Quay, a few yards east of Glasgow Bridge

La Pasionaria (Monument to Dolores Ibarruri)

Sculptor: Arthur Dooley

Date: 1974–9
Erected: 5 December 1979
Material: fibreglass on a steel pedestal
Dimensions: statue approx. 3m high
Inscriptions: on the plinth – BETTER TO DIE ON YOUR FEET THAN / LIVE FOR EVER ON YOUR KNEES; Dolores Ibarruri / (La Pasionaria); on plaque on the pedestal, THE CITY OF GLASGOW / AND THE BRITISH / LABOUR MOVEMENT / pay tribute to the / courage of those / men and women / who went to Spain / to fight Fascism / 1936–1939 / 2,100 VOLUNTEERS / WENT FROM BRITAIN; 534 WERE KILLED, / 65 OF WHOM CAME / FROM GLASGOW

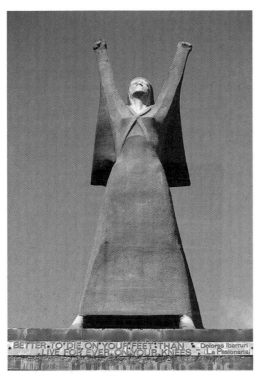

Arthur Dooley, *La Pasionaria*

Listed status: not listed
Owner: Glasgow City Council

Dolores Ibarruri (1895–1989), known as 'La Pasionaria' (The Passion Flower), Communist heroine of the Spanish Civil War (1936–9) and the most famous Spanish woman of her generation. Sentenced to fifteen years' imprisonment for her part in the October Revolution of 1934, she was elected as a Communist member of the Popular Front government two years later. In her energetic opposition to Fascism she came to be regarded as a symbol of Republicanism, appealing particularly to the women of Spain. A dedicatee of work by Picasso, she is widely believed to

have inspired the character Pilar in Ernest Hemingway's *For Whom the Bell Tolls* (played by Ingrid Bergman in the film version). After the death of General Franco in 1975 she ended a long period of exile in the Soviet Union and returned to Spain to become a Member of Parliament. She died in November 1989, survived by only one of her five children.[1]

Description: Raised on a tall steel girder, the figure is shown with feet set widely apart and clenched fists raised in a gesture of aggressive defiance. The treatment of the dress and cape is extremely simplified, producing a distinctive abstract X-shaped configuration. The statue faces the River Clyde.

Discussion: The memorial was commissioned in 1974 by the International Brigade Association in Scotland (IBAS), who raised the sculptor's £3,000 fee through an appeal to Trade Unionists and supporters of the Labour movement in Scotland.[2] Dooley visited Glasgow in June to examine possible sites, eventually choosing a location on Custom House Quay, perhaps unaware of the controversy this would later cause.[3] The artist estimated that the statue would be completed by March of the following year. In the event, it took two and a half years to produce, the artist making more than six attempts before he was happy with the 'gaunt, outstretched figure'.[4] His original plan to cast the statue in bronze also had to be abandoned, due to its prohibitive cost. The Association acknowledged that the project was underfunded, and that Dooley's fee had 'in no way compensated him for all his work'.[5]

From the outset the monument was fraught with controversy, with opinions of its desirability divided clearly down party lines. Despite the enthusiastic endorsement of the project by the ruling Labour group, which contributed £400 to the preparation of the site,[6] many Tory members of the Council were fiercely opposed to its erection. Their objections were both aesthetic and political. Councillor J. Young described the statue as 'an

artistic lump of graffiti', and warned that if the Tory party were returned to power in the 1982 local government elections it would be demolished.[7] For Councillor Ross Mackay, the statue was 'a poisonous old brute', and he argued that the site should have been used for a statue to 'Scotland's own fighting men'.[8] The site itself appears to have been a particularly contentious issue. A motion to ban the statue from Clyde Street was initially carried, but overturned in September 1979, when Councillor Mike Kelly announced that he would 'press for it to be given a place in George Square', should Clyde Street be refused.[9] After the ballot, which approved of the site by 34 votes to 29, the *Glasgow Herald* reported the off-the-record opinion of a councillor that the statue 'would not last ten minutes before being pushed into the Clyde'.[10] Further difficulties arose when it was discovered that the completed statue was heavier than had been anticipated. Under the headline 'Red Lady hits weight problem', the *Evening Times* reported that 'the Blacksmith who helped the sculptor is having to take off some metal as the weight of the monument is too much for both transportation and site'.[11] The report does not specify how much material had to be removed, or from which part of the monument, but it is likely that the steel girder which forms the pedestal was shortened.

The climate of hostility generated by Conservative members forced the council to postpone plans for an official unveiling, to which Dolores Ibarruri herself, then aged 84, was to be invited.[12] Because the Labour group did not have an overall majority, a vote in favour of a public ceremony was viewed as unlikely to be successful, and moreover, there were fears that the 'extremists on the council who were passionately opposed to *La Pasionaria*' would create an embarrassing disturbance. Bailie Jean McFadden, leader of the Labour group, predicted that the ceremony would go ahead after the party gained full

control of the council. In fact it never took place, and on 5 December 1979, the Secretary of the IBAS remarked that he had been 'really surprised to see the statue actually in place this morning when I passed on my way to the trade union centre'.[13]

Throughout the development of the monument Dooley, described by the *Glasgow Herald* as 'one of Britain's most controversial sculptors',[14] had been living frugally in a working men's hostel on Anderston Quay at a cost of about £2 10s. per week. He returned to Liverpool before the statue was painted and erected. Two years later, the former shipyard welder, Irish Guards piper and brewery worker, who was also incidentally a member of the Communist Party, was reported as being 'virtually penniless, working and sometimes sleeping in an unheated, semi-derelict factory, now his studio'. He was unable to afford the fare to Glasgow to see the finished work on site.[15]

Condition: Good, but with some corrosion on the plinth.

Notes
[1] Hugh Massingbred, *Daily Telegraph Fourth Book*

of Obituaries: Rogues, London, 1999, pp.62–6. [2] Gordon Perrie, 'Sculptor with something to say is suffering in silence', GH, 22 February 1982, p.7. [3] GH, 26 June 1974, p.14. [4] Perrie, *op. cit.* [5] *Ibid.* [6] 'Quay site goes to La Pasionaria', GH, 28 September 1979, p.5. [7] 'Move to reject La Pasionaria', *ibid.*, 13 October 1981. [8] Tom Shields, 'La Pasionaria takes up her post on Custom House Quay', *ibid.*, 6 December 1979. [9] *Ibid.*, 28 September 1979, p.5. [10] *Ibid.*, 28 September 1979, p.5. [11] 'Red Lady hits weight problem', ET, 1 September 1977, p.3. [12] GH, 26 June 1974, p.14. [13] Tom Shields, *op. cit.* [14] GH, 26 June 1974, p.14. [15] Perrie, *op. cit.*

Additional source
McKenzie, pp.65–7 (incl. ill.).

Cobden Road SIGHTHILL

Beside the roundabout at the junction of Cobden Road and Turner Road

St Rollox Monument
Sculptor: Jack Sloan

Fabricator: Hector McGarva
Date of unveiling: 26 June 1995
Materials: corten steel (main structure); stainless steel (railway track)
Dimensions: approx. 12m high × 2.6m × 1.6m at base (main structure); 1.52m × 61cm × 61cm (rail)
Inscription: on a plaque beside the monument –
THE ST. ROLLOX MONUMENT / JACK SLOAN 1995 / TO COMMEMORATE THE BUILDERS OF / THE STEAM AND DIESEL LOCOMOTIVES / WHICH WERE EXPORTED FROM / GLASGOW TO THE WORLD / FUNDED BY THE MILLER GROUP AND THE GLASGOW DEVELOPMENT AGENCY
Listed status: not listed
Owner: Glasgow City Council

Description: A modernist interpretation of a medieval shrine, with three square-section piers supporting a spire and enclosing an enlarged representation of a section of railway track. The soaring verticality of the structure, together with the spiky angularity of its details, are intended to recall the traditional form of the Eleanor Cross, though the excessive height and slenderness of the spire is equally reminiscent of George Kemp's *Monument to Sir Walter Scott* in Edinburgh.

Discussion: The monument was designed to commemorate two aspects of the area's history: the chapel of St Roche, built nearby in 1508 by Thomas Muirhead (the name 'St Rollox' is a corruption of 'St Roche'); the demise of the St Rollox railway and locomotive works which formerly occupied the site. Sloan himself describes the rail as being 'enshrined at the centre of the monument as though it were a precious casket'.

Condition: Good.

Source
Unpublished artist's statement by Jack Sloan.

Jack Sloan, *St Rollox Monument* [RM]

Concert Square COWCADDENS

North-east corner of Concert Square, at the junction with West Nile Street

Clyde Clock
Sculptor: George Wyllie

Clockmakers: William Potts & Sons
Date: 1999–2000
Material: stainless steel
Dimensions: approx. 6m high
Inscription: on copper plate inserted in
 pavement – The Clyde Clock / George
 Wyllie 2000 / Gifted to the City of Glasgow
 / By Radio Clyde / Generously supported
 by Glasgow City Council Scottish
 Enterprise Glasgow and Lang's Hotel
 [remainder illegible]
Owner: Glasgow City Council

Description: The clock mechanism is contained in a stainless steel cube mounted on a pair of simplified running legs in the manner of a cartoon image of a human figure from which the body has been omitted. There are clock dials on all four vertical faces.

Discussion: The work was commissioned by Radio Clyde to celebrate its 25th year as an independent local broadcaster, and as a gesture of gratitude to the city of Glasgow. Supported by the GDA, through its 'Artworks for Glasgow' scheme, the clock is designed to provide a 'focal landmark' in an area that has recently been developed in the style of a European 'piazza', as well as a rendezvous point for users of adjacent facilities such as Buchanan Bus Station and the Glasgow Royal Concert Hall. It was also, in the view of the sponsors, intended to 'stand as a permanent testimony to the talent of one of the city's favourite artists, George Wyllie', who, despite his international reputation, has in fact produced very few permanent public works in Glasgow.

Wyllie's design was the winning submission in a limited competition which also included entries by Ian McColl, Andy Scott, Lorraine Aaron and Michael Marriot. In addition to its humorous pun on the proverb *tempus fugit*, the work also embodies the notion of hurried movement in the numerals on the clock faces, which are in italicised Gill Sans presented in reverse. However, its primary role as a rendezvous point is emphasised by its chime, which occurs only once a day, at the 'ideal meeting time' of 8pm. Ironically, the sponsors' original intention that the work should be installed in December 1999, on the eve of the Millennium, was frustrated by construction work on an adjacent hotel, and it was not until

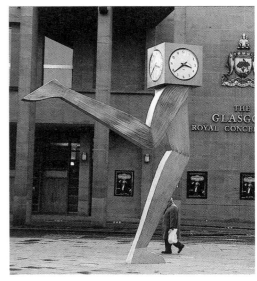

George Wyllie, *Clyde Clock* [RM]

December 2000 that it was finally unveiled.

Related work: A model of the sculpture was displayed on 29 December 1999, in the Holiday Inn Garden Hotel, Concert Square.

Condition: Good.

Sources
Information pack provided by GDA Press Office; 'Glaswegians make a date with artist's new timepiece', ET, 31 December 1999, p.15; H, 8 December 2000, p.9.

Cowglen Road POLLOK

Adjacent to north entrance Cowglen Shopping Centre, 45 Cowglen Road

Reconciliation

Sculptor: Stephen Broadbent

Founders: Varleys of St Helens
Unveiled: 19 September 1990
Material: cast iron
Dimensions: 4.06m high
Inscriptions: on north side of base –
RECONCILIATION; in the outer circle of the
paving – N / S / E / W
Listed status: not listed
Owner: Glasgow City Council

Description: The sculpture is in the form of a full-length term composed of two embracing figures whose bodies have become joined in such a way that the front of one reads as the back of the other and vice versa. There is no plinth, but the figure rises from a shallow pyramidal base set within a circular brick surround. The points of the compass are indicated in polychrome mosaic around the border.

Discussion: Broadbent produced three identical casts of the sculpture, which were unveiled simultaneously in Glasgow, Belfast and Liverpool; the unveilings, like the sculpture itself, were intended to symbolise the historical and cultural unity of the three cities. Writing in a brochure produced for the unveiling, the sculptor described his aim as being to 'unite three cities and various communities – each with historical links and stark problems'. He went on to describe the sculpture as

> … a very simple statement of basic desire. Through their embrace, two figures become one. This unity is emphasised by the root solidarity of the form. The individuals have

become grounded in each other, potentially to become one in 'body and spirit'. The figures are universal. Within their features can be identified any one of us, any group of us, transcending the boundaries of gender, colour or creed.

The location of the Belfast edition at Carlisle Memorial Gardens was felt to be particularly apt as it stands at an intersection of the Catholic and Protestant communities.

The model for the statue was produced in one week in the Carlisle Memorial Centre, a converted Methodist church. Assisted by his colleague Paul Greggs and the photographer Dave Williams, Broadbent gathered a team of young helpers from schools in each of the three cities, ensuring that those from Belfast were drawn from both the Protestant and Catholic communities. One helper from each city was assigned to a programme of library research to determine a style of lettering appropriate to the inscription for the different sites: the Art Nouveau letterforms of Charles Rennie Mackintosh were chosen for Glasgow, Gaelic for Belfast and Gothic for Liverpool. (In the event plain sans serif capitals were used.)

As part of the working process, Broadbent pinned drawings of actual-size profiles on the four faces of a polyurethane block, which three of his assistants carved into shape over a period of three days. Strengthened with fibreglass, the rough model was then delivered to Belfast docks for shipment to Liverpool. Work on the model continued for two months at Bridewell Studios, Liverpool, and after being displayed to the public, was delivered to Varleys Iron Foundry on 9 October for casting. The casting of the second copy took place in the following month, and was attended by the team of young assistants, who were invited to spend a week in

Liverpool for the event. Each cast weighs 4½ tons.

The project was supported by the local authorities of the respective cities, with funding raised by a variety of voluntary groups, including the Glasgow Council for Voluntary Services. The total cost, including casting and erection of the statues and the preparation of the sites, was £50,000.

Condition: Good, but with some surface biological growth and much light graffiti.

Related work: The two other versions of the

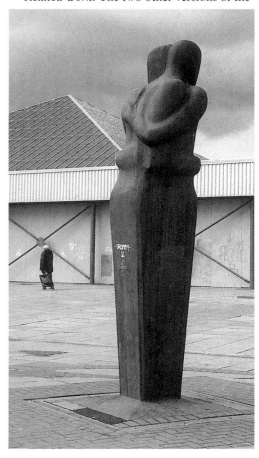

Stephen Broadbent, *Reconciliation* [RM]

statue are at Carlisle Memorial Gardens, Carlisle Circus, North Belfast and at the junction of Concert Street and Bold Street, Liverpool.

Source
The above text is based on the entry on the Liverpool copy in Terry Cavanagh, *Public Sculpture of Liverpool*, Liverpool, 1997, pp.29–30 (incl. ill.).

Craigpark DENNISTOUN

Dennistoun Public Library, 2a Craigpark

Figurative Programme

Sculptor: William Kellock Brown (attrib.)

Architect: James R. Rhind
Builder: John Porter & Sons
Building opened: 29 December 1905
Materials: bronze (dome figure); yellow sandstone (all else)
Dimensions: figures life-size
Listed status: category B (17 June 1992)
Owner: Glasgow City Council

Description: A two-storey classical structure with boldly projecting entablatures on the first floor and attic, a row of arched windows in the *piano nobile* and a dome supported by an octagonal drum on the south-west corner. A finial on the dome supports a winged female figure in bronze, with an open book resting on her extended forearms. She wears a classical tunic, the folds of which are arranged to suggest they are being blown by the wind. On attic pedestals adjacent to the main outward-facing corners of the drum are three stone female figures in various seated and crouching postures. The figure on the left is draped and has her left hand placed on a globe; in her right hand she holds an object worn beyond recognition. The middle figure is naked and holds a laurel wreath, while the right-hand

figure, tucked somewhat obscurely down a side lane, is draped and holds a painter's palette and a sculpted bust.

In the spandrels of the central Serlian window are pairs of adult figures seated back to back, each accompanied by a child. On the left, a naked male sits in a pensive posture, with his chin resting on his hand and an open book placed on the floor at his side, while the child beside him holds a miniature winged figure. The adult figure on the right is female, and is seated facing a large globe. It is likely that the groups are intended to symbolise Literature/Art and Geography respectively. Additional carver work includes a panel with the arms of Glasgow in the pediment over the north door and a pair of winged lions flanking the window above it.

Discussion: The library was created as part of a comprehensive wave of district library building initiated by Glasgow Corporation in the early years of the twentieth century, the purpose of which was to augment the existing centralised services provided by the Mitchell and Stirling's Libraries. The proposal was first mooted in June 1898, when the Council passed a resolution to insert a clause in a forthcoming parliamentary bill, granting itself the 'power to establish and maintain public Libraries for the advantage and enjoyment of all the people of the city'.[1] The bill was passed unopposed in the following year.

Initially, the intention was to build eight

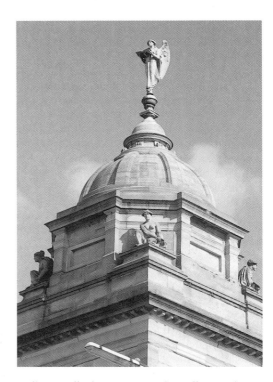

William Kellock Brown (attrib.), *Allegorical Figures* [RM]

libraries 'at points carefully selected to serve the convenience of the inhabitants', supplemented by a modest programme of 'subsidiary reading rooms for outlying districts'.² No more than the preliminary stages of the scheme had been put into effect when an unexpected offer of financial assistance from the expatriate Scots millionaire and philanthropist Andrew Carnegie, at that time staying in Knockderry Castle in Dunbartonshire, led the Council radically to revise its ambitions. In his letter to the Lord Provost, Sir Samuel Chisolm, Carnegie explained the motive behind his intervention:

It will give me pleasure to provide … one hundred thousand pounds for Branch Libraries, which are sure to prove of great advantage to the masses of the people. It is just fifty-two years since my parents, with their two little boys, sailed from the Broomielaw for New York in the barque *Wiscassett*, 800 tons, and it is delightful to be permitted to commemorate the event upon my visit to you.

Glasgow has done so much in municipal affairs to educate other cities and to help herself that it is a privilege to help her.

Let Glasgow flourish, so say we all of us Scotsmen throughout the world.³

In addition to this main grant of £100,000, Carnegie contributed £5,000 towards the construction of the library in Kinning Park (q.v., 330–46 Paisley Road), which was still an independent burgh when the library was opened in 1904, and provided a further top-up of £15,000 towards the main project in 1907.⁴ In all he donated £120,000. Sixteen libraries were eventually built (including the conversion of one existing building), with three small reading rooms erected in more remote areas of the city. The total cost of the scheme was £337,480, including capital expenditure on the sites, the construction of the buildings themselves and the purchase of books and periodicals.⁵ Carnegie thus contributed more than a third of the entire cost of the scheme.

As an attempt to create institutions of a primarily 'educational or instructive character', but which also recognised the importance of 'recreative reading',⁶ the district libraries scheme was a product of the city's celebrated policy of 'municipal socialism'. The libraries themselves were divided into three classes, or 'grades', according to the size of the population they served, with their contents reflecting the history, industry and 'local character' of the surrounding area. This was referred to as the 'principle of differentiation', and its aim was to ensure a minimum of duplication of material from one library to the next. Differentiation of a more social kind was also involved, with most libraries reserving a separate section for 'boys and girls' and another for 'ladies'. (The ladies' sections were not a great success and were abandoned in the later stages of the scheme.⁷) As a whole, however, the scheme was driven by a genuinely egalitarian desire to maximise opportunities for access. Indeed one of the most remarkable features of the scheme was the networking of all the branches through a complex and sophisticated inter-library loan system. In the words of a contemporary commentator, the libraries were not 'so many independent and isolated institutions, but rather constituent members of one large establishment'. Published statistics suggest that the scheme was a massive social and educational success.⁸

Of the fifteen libraries that were built *de novo*, nine had significant sculpture programmes, and with the exception of Langside Library, which disappeared many years ago, and Townhead Library, which was demolished as recently as 1998,⁹ these are all recorded in the present volume. A detailed comparison of the various individual sculpture schemes is beyond the scope of this entry. There are, however, a number of common factors which are worth noting at this stage, and which are pertinent to several later entries.

The task of designing the libraries was shared among eight different architectural practices, selected in a competition adjudicated by Horatio Kelson Bromhead in 1902,¹⁰ but the bulk of the work went to the Inverness architect James R. Rhind, who was responsible for no less than seven of the buildings. His style

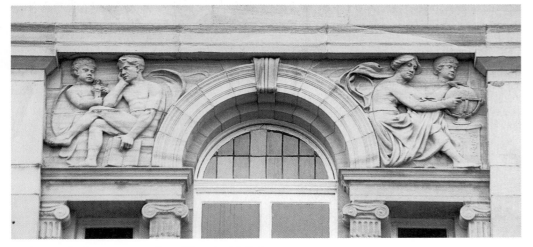

William Kellock Brown (attrib.), *Allegorical Reliefs* [RM]

tended towards a restrained Baroque classicism, often with considerable refinement in the treatment of detail, and with figurative sculpture forming an integral part of the design in each case. What is particularly interesting about his contribution, however, is the fact that he appears to have employed the same sculptor, William Kellock Brown, on six of them. While it is not unusual in Glasgow at this time for architects to give work to a favourite artist on more than one occasion, the collaboration in this case was especially productive, enabling Brown to experiment with a variety of different solutions, and develop his ideas over a period of time. Here it should be noted that Brown's authorship of the work is supported by documentary evidence only in the case of Parkhead Library (q.v., 64–80 Tollcross Road), and that the ascription of the remaining library sculptures to him is based on their similarity to this scheme. While normally such an approach to attribution should be used only with extreme caution, the correspondences in this case are so striking that there can be little doubt of his responsibility for the five undocumented schemes. There is, to begin with, an immediately recognisable pattern in his repeated use of a limited number of stock components, including bronze dome figures (three of which – Parkhead, Dennistoun and Hutchesontown – are cast from the same mould), seated corner figures, free-standing attic groups consisting of a standing female with children crouching at her feet and various pairs of reclining figures in relief. (It may well be that the recurrence of images of children throughout the scheme is an acknowledgement of Carnegie's reference to the 'two little boys' in the letter quoted above.) The systematic recycling of these components in different permutations from one library to the next forms an especially interesting aspect of the project. Indeed one might say that the consistency of artistic concern evident in the six schemes is such that they must be seen as components of a single evolving scheme, in much the same way that the libraries themselves were thought to be 'one large establishment'. The supposition of Brown's authorship is given additional force by a number of stylistic mannerisms that occur repeatedly from one scheme to the next, a good example of which is his treatment of the female face. This tends to have a square-jawed, somewhat expressionless character, with the hair parted in the middle and swept round at the sides. In many cases – including the bronze figures on the Parkhead, Dennistoun and Hutchesontown domes – there is also a tiny lock of stray hair in the centre of the forehead that is so distinctive it might almost be said to constitute Brown's personal 'signature'.

Viewed as a whole, Brown's achievement in this group of commissions is a notable one, not least in terms of the quantity of work he produced in such a short period. The libraries he worked on were opened between March 1905 and November 1906, during which time he completed four bronze dome figures, five triple attic groups, eight seated corner figures, two crouching infants, six griffins and more than thirty full-size figures in relief. This is an impressive output by any standards. It has to be said, however, that the speed of the production may have affected the standard of the carving, which is not always especially high. With some exceptions (such as the lunette reliefs on Hutchesontown) the figures tend to be realised with a crudity of technique that borders in places on the perfunctory. The figures perform their role as decorative adjuncts to the main structure effectively enough, but generally lack the finesse and sophistication of their counterparts on either the Kingston Halls or the demolished Townhead Library.

Related work: The other libraries decorated by Kellock Brown are as follows: Bridgeton (23 Landressy Street); Woodside (343–7 St George's Road); Maryhill (1508 Maryhill Road); Govanhill (170 Langside Road); Hutchesontown (192 McNeil Street).

Condition: Generally good, though there is some weathering in the reliefs and on the face of the right-hand attic figure. The panel in the raised attic section of this bay was originally carved with a festooned escutcheon.

Notes
[1] *Descriptive Hand-Book of the Glasgow Corporation Public Libraries* (hereafter *Hand-Book*), Glasgow, 1907, p.19. [2] *Ibid.* [3] Stevenson (1914), p.90. [4] *Ibid.*, p.92. [5] *Ibid.*, p.93. [6] *Hand-Book*, p.21. [7] Stevenson (1914), p.93. [8] *Hand-Book*, p.21. [9] Lorna MacLaren, 'Row as city statues set sail for the US', H, 15 June 1999, p.15; see 188–92 Castle Street, Appendix A, Lost Works. [10] BN, 13 February 1903, p.277.

Additional source
Williamson *et al.*, p.446.

Cromwell Court WOODSIDE

In paved area to the rear of tenements on Cromwell Court

Milestone

Sculptors: Callum Sinclair and Michelle de Bruin

Date: 1994
Materials: Caithness slate, granite and sandstone
Dimensions: monoliths 1.46m × 13cm × 39cm
Listed status: not listed
Owner: not known

Description: Sculpture and landscape architecture are brought together here in a work intended to 'transform the environment' by providing an 'informal gathering place for residents'.[1] The centrepiece is a pair of roughly hewn vertical monoliths of Caithness slate placed side by side in an arrangement reminiscent of prehistoric standing stones, and with the narrow space between them designed to function as a primitive sundial. The reference to Druidical practices is further elaborated in the diagrammatic representation of the solar disc at the apex of the two monoliths, and the pair of rune-like circles on their inside faces. The slabs themselves stand in a circle of granite setts located asymmetrically within a paved area bordered by low stone walls with inbuilt seating.

Discussion: Commissioned by the residents of Cromwell Court, the work was one of seven 'Glasgow Milestones' created in response to Glasgow's year as European City of Culture in 1990. For a discussion of the 'Milestones' programme, see entry for *Calvay Milestone*, Barlanark Road.

Condition: Good.

Related work: Other works in the 'Glasgow Milestones' project are *Milestone* (Duke Street), *Rosebud* (East Garscadden Road), *Govan Milestone* (Govan Road), *The Works* (Springburn Way), *As the Crow Flies* (West Princes Street).

Note
[1] Rae and Woolaston, p.30.

Other sources
Location map, *Milestones*, Glasgow Milestones, n.d. (1994); McKenzie, pp.98 (ill.), 99.

Callum Sinclair and Michelle de Bruin, *Milestone* [RM]

Crown Street GORBALS

On the north wall of Kwik Save supermarket

Shopping Baskets

Sculptor: Jack Sloan

(See illustration overleaf)
Date: 1998
Material: galvanised steel
Dimensions: approx. 90cm × 76cm
Inscription: on right hand basket – NO / FRILLS
Listed status: not listed
Owner: Kwik Save

Six stylized variations of the theme of the modern supermarket basket, each overflowing with consumer produce, including fruit, fish, cheese and soap powder. As contemporary interpretations of the traditional cornucopia, with references also to the historic genre of the still life, they are a witty comment on the culture of consumerism, as well as a reminder of the activities that go on inside the building they were commissioned to decorate.

Condition: Good.

Source
Information provided by the sculptor.

Dalintober Street KINGSTON

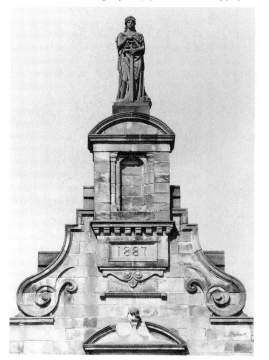

Jack Sloan, *Shopping Baskets*

Former Scottish Co-operative Wholesale Society warehouse, 44 Dalintober Street

Allegorical Figure of Justice and Associated Decorative Carving
Sculptor: James A. Ewing (attrib.)

Architects: Bruce & Hay
Date: 1886–8
Material: yellow sandstone
Dimensions: figure approx. 3.3m high
Inscriptions: in the spandrel over the main door – SCOTTISH SOCIETY / LIMITED / CO-OPERATIVE WHOLESALE; on datestone in gable – 1887; in separate panels on fourth floor – S. C. and W. S.
Listed status: category B (15 December 1970)

James A. Ewing (attrib.), *Justice*

Owner: Persimmon Developments Ltd(?)

Description: The statue is on a segmental gable on the top storey and is the crowning feature of the whole building. A large sword extends downwards from her breast to her feet, and in her left hand she holds a small set of scales, parts of which are made of copper or bronze. The figure is carved from four separate blocks in a crude but monumental style.

Distributed over the façade below there is an exceptionally rich programme of subsidiary carved decoration, among which are the following: in the ground-floor arches, three large keystone masks with elaborate headgear (cornucopias, boats, a harvest scene); also on the ground floor, four roundels containing two unidentified armorial devices, the Glasgow arms and a boat with twin masts and a mother and child beneath a Gothic canopy; a pair of disembodied arms embracing the mouth of a cornucopia at the base of the right hand turret. The adjoining building to the north (date not known, but probably also by Bruce & Hay) has two pairs of clasped hands on the first floor and a lion sejant on the gable.

Discussion: As with all the major Co-op buildings in Glasgow, the company records are incomplete and no primary documentation relating to the sculpture has been found (see also 71 Morrison Street). The treatment of the figure, however, with its heavy features, thick neck and rope-like drapery folds, is sufficiently similar to James A. Ewing's later work on the neighbouring block at 95 Morrison Street (q.v.) to suggest that this work is also by him.

Condition: Fair. The building is currently being refurbished.

Sources
LBI, Ward 51, p.20; Williamson *et al.*, p.516; McKenzie, p.31.

McCormick House, 46 Darnley Street

Allegorical Female Figure and Associated Decorative Sculpture

Sculptor: not known (possibly William Shirreffs)

Architect: D. Bennet Dobson
Date: 1901–2
Material: red Locharbriggs sandstone
Dimensions: figure life-size
Inscription: on datestone – 1902
Listed status: category A (22 March 1977)
Owner: John McCormick & Co. Ltd

Description: A three-storey commercial building in the Glasgow Style, with shallow oriel windows and a castellated roof. On the stepped parapet above the main oriel is a standing female figure of undetermined symbolism. Naked, apart from a loose drape held to her midriff, she shields her eyes with her raised right hand, which also holds a flower. The datestone is in a tablet decorated with holly branches between the first- and second-floor windows, and the base of the oriel is carved with a large cherub mask enclosed by two pairs of wings. The smaller oriel at the south end of the building has a large cartouche featuring a mermaid with bifurcated fish tails and outstretched arms. Further grotesque details appear in the drain pipe at the opposite end of the building, which has a cast-iron dragon inserted at the join between two sections of pipe, its open jaws acting as a gully and its tail entwined around the pipe below. Interior work includes brass finger plates decorated with plant forms, a marble dragon above a door and bronze or brass panels featuring Neptune and a sailing ship.

Discussion: The building was designed for the publishers Miller & Lang, who specialised in art books and greetings cards. In addition to the exterior and interior sculpture work, the building also has an extensive programme of stained glass designed by W.G. Morton, with subjects ranging from *The Birth of Venus* to *The Four Seasons*. The attribution of the sculpture to William Shirreffs is based on the close similarity of the cherub mask at the base of the oriel to those on the pillars flanking the staircase in the north porch of Kelvingrove Art Gallery and Museum (q.v., Kelvingrove Park).

Condition: The stone sculpture is sound but grimy, and the cast-iron dragon is painted light brown.

Sources
BI, 16 April 1901, p.12, 14 February 1903, p.173; Teggin *et al.*, pp.62–3 (ills); Williamson *et al.*, p. 574.

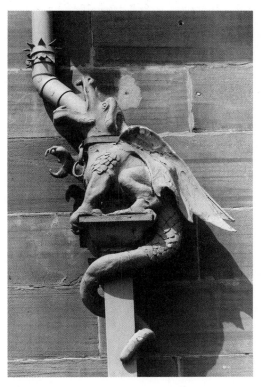

(above) Anon., *Decorative Ironwork*

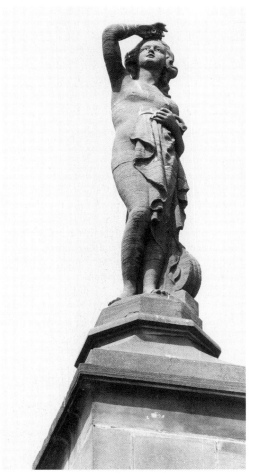

Anon., *Allegorical Female Figure*

Douglas Street CITY CENTRE

On the RGI Kelly Gallery, 118 Douglas Street

Roof Sculpture and Entrance Gate
Sculptor: John Creed

Architects: Armitage Associates
Date: 1996–7
Materials: mild steel and stainless steel
Dimensions: 2.5m × 50cm × 40cm (roof sculpture); 2.4m × 1.2m (gate)
Listed status: not listed
Owner: RGIFA

John Creed, *Roof Sculpture* [AL]

Description: A two-part work consisting of an abstract sculpture attached to the roof of the building and a matching security gate on the entrance below. The roof sculpture is composed of a series of vertical, blade-like forms in forged mild steel, linked horizontally by stainless steel bars and arranged in a step-wise formation linking the upper fascia with the short section of hipped roof rising steeply behind it. Similar forms are used in the gate, though these are organised in parallel sequences with a central hinge which allows the gate to fold round the entrance walls when opened. All the forged steel components have a charcoal grey finish.

Discussion: Creed was invited by the architects to make the work as part of a refurbishment of the single-storey gallery, formerly the Blythswood Gallery, which had been gifted to the RGIFA by the art collector John D. Kelly in 1965. It is not known who designed the original building or precisely when it was erected. The design of the iron features, which the client selected from four alternative proposals submitted by the artist, is intended to suggest a series of stylised 'brush-strokes'. The vertical accent created by their grouping provides a foil to the low horizontality of the building, while at the same time integrating architectural form with the 'sculptural and tactile qualities' of hot forging. The cost of the work, including design and manufacture, was £5,250.

Condition: Good.

Source
Unpublished statement by John Creed, 7 April 2001.

On the former City of Glasgow Friendly Society Building, 121 Douglas Street / Sauchiehall Lane

Monument to John Stewart
Sculptor: William Kellock Brown

Architects: John Keppie & Henderson
Founder: not known
Date: 1920–1
Material: bronze
Dimensions: figures life-size
Inscription: on a plaque below the statue – CITY OF GLASGOW / FRIENDLY SOCIETY / FOUNDED BY / JOHN STEWART / 1862

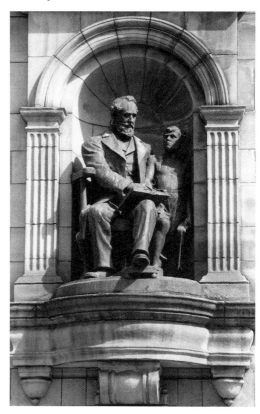

William Kellock Brown, *John Stewart*

Listed status: category B (15 December 1970)
Owner: Gandon Pender

Description: The statue is in a pilastered niche on the first floor of the Douglas Street façade of a large commercial building, the main frontage of which is at 182–200 Bath Street. John Stewart, the founder of the City of Glasgow Friendly Society, is shown seated with his left arm extended round the waist of a young boy standing by his side. While Stewart is fully dressed in a frock-coat, waistcoat and watch-chain, the boy is barefoot and naked to the waist; this, together with the strap-like object in his left hand, suggests that he is a child labourer. Resting on Stewart's knee is an open book, to which he points with his right hand, as if in the act of teaching the boy to read. Several other large, leather-bound tomes are piled under the seat of his chair.

Discussion: The establishment of the City of Glasgow Friendly Society in 1862 was symptomatic of the rapid growth of provident organisations in the middle of the nineteenth century, and which enabled 'members of the industrial classes [to] arrange with one another for mutual aid during sickness or on the arrival of old age'.[1] It appears, however, that Stewart was unhappy with the financial arrangements prevailing among the societies at that time, and was prompted to form his own company 'through the refusal of another society … to grant certain reforms that Mr. Stewart, … along with several others, deemed necessary for the safety of the concern'.[2] In 1892 the firm's funds stood at £111,623, enabling it to provide a 'sick fund', an endowment scheme for both children and adults, as well as 'life insurance, pure and simple'.[3] By this time, however, Stewart's own health was failing, and the management of the business was increasingly taken over by his son, James Stewart.[4]

The domed corner tower on which the statue is located was built by Keppie & Henderson as an extension to an existing building by John Baird I, and was designed to accommodate the Society's board room and manager's office.[5] In his obituary, Kellock Brown is praised for his work in 'beautifying large public buildings in Glasgow', the Stewart portrait being described as 'one of his best works of this kind'.[6] The treatment of the face closely resembles the lithographic portrait of Stewart published in the *Bailie* in January 1894.[7]

Condition: Good.

Notes
[1] Anon., 'Men you know – no.1110', *Bailie*, 24 January 1894, p.1. [2] *Ibid.* [3] *Ibid.* [4] *Ibid.* [5] Williamson *et al.*, p.213. [6] GH, 21 February 1934, p.15. [7] Anon., *op. cit.*

Other sources
GCA, B4/12/1920/336 (Keppie & Henderson plan); Gomme and Walker, pp.78, 284; LBI, Ward 18, pp.18–19; McKenzie, pp.76, 77 (ill.).

Drumoyne Drive GOVAN

Former Elder Cottage Hospital, 1a Drumoyne Drive

Relief of Mother and Child
Sculptor: not known

Architect: John James Burnet
Date: 1902–3
Material: yellow sandstone
Dimensions: approx. 1m × 76cm
Listed status: category A (15 December 1970)
Owner: Linthouse Housing Association

Description: The relief is in a framed rectangular panel above the main entrance and depicts a woman suckling a baby with a sunburst in the background. There is a cartouche, some fruit swags and a pair of decorative consoles in the doorhead, and a pair of datestones inscribed 'AD' and '1902' (entwined) at either end of the main facade.

Discussion: The hospital was commissioned by Isabella Elder and opened in 1903 to provide free medical treatment to the people of Govan, with a surgical ward designed to cater particularly for injured shipyard workers who would otherwise have to travel a distance of some ten miles to the Western Infirmary. The image of the mother and child reflects her original intention that it should be a maternity hospital, and it was not until the building was

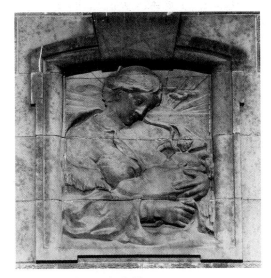

Anon., *Mother and Child*

completed that she decided a general hospital would be of more benefit to the community. The building was in use as a hospital until its closure in 1987.

The work may be tentatively ascribed to James Pittendrigh Macgillivray on the basis of the resemblance of the sunburst motif to several other of his works in Glasgow (see, for example, Anderson College of Medicine, 56 Dumbarton Road).

Condition: Good.

Sources
Williamson *et al.*, pp.593–4; Smart (1996), p.88; C. Joan McAlpine, *The Lady of Claremont House: Isabella Elder, Pioneer and Philanthropist*, Argyll, 1997, pp.170–3 (incl. ill.).

Duke Street CALTON

Former Ladywell School, 94 Duke Street

Six Portrait Roundels
Sculptor: John Crawford

Architect: John Burnet
Date: *c.*1858
Material: yellow sandstone
Dimensions: portraits slightly larger than life-size
Inscriptions: painted on the gable walls of the two end pavilions – GLASGOW SCHOOL BOARD / ALEXANDER'S PUBLIC SCHOOL
Listed status: category A (15 December 1970)
Owner: Glasgow City Council

Description: The building is in the early Italian Renaissance style, with an arcaded

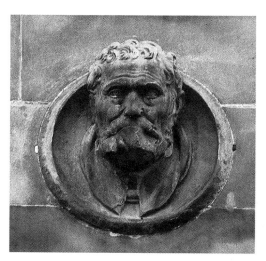

John Crawford, *Michelangelo* [RM]

central block flanked by pedimented pavilions and a domed tower at the east end. The portraits, which project from the roundels as fully three-dimensional heads, are located above the arcade on the north wall, and may be identified, from the left, as follows: Homer, Aristotle, Shakespeare, an unknown man, Michelangelo and Milton.

Discussion: Built at a cost of £6,000, the school was funded by James Alexander, of R.F. & J. Alexander, cotton spinners and manufacturers, whose original cotton mill building (now a working men's hostel) stands a short distance to the east. It seems likely that the unidentified portrait is Alexander himself. After falling into a dilapidated condition, the building was refurbished and converted to office premises in the summer of 2000, and is now administered by East End Partnership.

Related work: To celebrate the re-opening of the building in 2001, East End Partnership commissioned an oil painting by Lynn Morrison, which now hangs in the entrance foyer. The painting shows the main façade of the building, with the portrait roundels appearing as faces in the clouds. Other educational buildings in Glasgow which are decorated with portrait roundels of historical figures include the former Albany Academy (q.v., 44 Ashley Street) and Abbotsford School (q.v., 129–31 Abbotsford Place, Appendix B, Minor Works).

Condition: All six portraits have suffered some damage and erosion; in the case of the fourth this is particularly severe.

Sources
Anon., 'The Late John Crawford' (obit.), GH, 13 February 1861, p.4; Jack House, 'Ask Jack', ET, 4 December 1982, p.2; Worsdall (1982), p.39; information provided by East End Partnership.

Duke Street DENNISTOUN

*On wall beside pavement opposite junction
with Annebank Street*

Dennistoun Milestone
Sculptor: Jim Buckley

Founder: Archibald Young (Brassfounders)
 Ltd, Kirkintilloch
Installed: 26 September 1991
Materials: patinated bronze and glass; sandstone
 (pedestal)
Dimensions: 1.03m × 58cm × 70cm (main
 sculpture); 70cm × 92cm × 92cm (pedestal)
Inscription: on a bronze plate on the wall in
 front – THE DENNISTOUN MILESTONE /
 COMMISSIONED BY DENNISTOUN COMMUNITY
 COUNCIL / FOR GLASGOW'S YEAR OF CULTURE
 1990 / SPONSORED BY W.D. AND H.O. WILLS /
 ARTIST JIM BUCKLEY – GLASGOW SCULPTURE
 STUDIOS / UNVEILED BY THE RT HON THE
 LORD PROVOST OF GLASGOW / MRS SUSAN
 BAIRD CBE OSTJ JP D UNIV 26. 9. 91
Owner: Dennistoun Community Council(?)

Description: Inserted into a gap in the iron
railings on the coping of a low stone wall, this
modest essay in geometric abstraction is replete
with references to architecture. The main
central mass consists of a cubic base capped by
a spire-like superstructure which together recall
the upper stages of a modernist skyscraper,
while the narrow vertical projections which
bisect the front and rear planes are equally
reminiscent of the canted oriels and exterior
stair turrets of the traditional Glasgow
tenement. Fenestration is also subtly evoked in
the small groups of glazed apertures in the
centre of the front projection and on the upper
surface, and in the rows of small square
indentations decorating the sides of the main
mass.

Discussion: The work was commissioned by
Dennistoun Community Council with support
from Dennistoun Conservation Association
and funding from the tobacco manufacturers
W.D. & H.O. Wills, whose large factory on
Alexandra Parade had recently closed down. It
was one of seven 'Glasgow Milestones'
produced in response to the city's designation
as European City of Culture in 1990. (For a full
discussion of this scheme, see *Calvay Milestone,*
Barlanark Road.) Although the components of
the piece were cast by Archibald Young in
Kirkintilloch, their assembly was carried out by
Buckley in Glasgow Sculpture Studios, enabling
him to insert into the interior space a clear
acrylic block containing local memorabilia.
These included a clay pipe found at Whitehall
School, a tobacco knife from the Wills factory,
a bottle of water from the River Molendinar
and a text by a local writer on life in a tenement.
Described by Buckley as both 'a shrine or time
capsule of the past and a monument to the
future',[1] the work is consistent with his interest
in exploring the relationship between the
exterior form of a sculpture and the interior
space it encloses.

Condition: Good, but with some light
graffiti.

Related work: The other 'Glasgow
Milestones' are *Milestone* (Cromwell Court),
Rosebud (East Garscadden Road), *Govan
Milestone* (Govan Road), *The Works*
(Springburn Way), *As the Crow Flies* (West
Princes Street).

Note
[1] Buckley *et al., Glasgow Milestones,* Glasgow, n.d.
(1991), n.p.

Other sources
Location map, *Milestones,* Glasgow Milestones, n.d.
(1994); Rae and Woolaston, p.28.

Jim Buckley, *Dennistoun Milestone* [RM]

Dumbarton Road PARTICK

Anderson College of Medicine, 56
Dumbarton Road

Narrative Tympanum Relief and Two Winged Figures

Sculptor: James Pittendrigh Macgillivray

Architects: James Sellars, completed by John
 Keppie
Date: 1888–9
Material: yellow freestone
Dimensions: 1.9m high × 3.8m wide
 (tympanum); 2.1m high (winged figures)
Listed status: category B (15 December 1970)
Owner: University of Glasgow

Description: The tympanum is on the first
floor of the south wall, facing Dumbarton
Road, and shows a bearded male figure in
period costume demonstrating a medical
examination to a class of eight students ranged
in standing and seated postures on either side.
The subject of the examination kneels in the
foreground with his sleeve rolled. On the first
floor of the adjacent east wall, a little beyond
the entrance to the college grounds, is an oval
window flanked by winged female figures,
possibly symbolising *Day* and *Night*. The
figure on the left is shown against a background
filled with clouds and has bats' wings; in her
right hand she holds a sword and her right is
foot placed on a globe. The remaining figure is
reminiscent of a Christian angel, with
conventional wings and a halo enclosed by an
aureole; in her hands she carries a book and a
corn stalk. A pair of serpents, carved as mirror
images of each other, writhe at their feet.

Discussion: It seems likely that the doctor in
the tympanum is a portrait not of John
Anderson, the benefactor after whom the
college is named, but Peter Lowe, the sixteenth-
century physician who founded the Faculty
(now Royal College) of Physicians and
Surgeons of Glasgow. This supposition is based
on the resemblance of his features and dress to a
portrait of Peter Lowe.[1] It is also relevant that

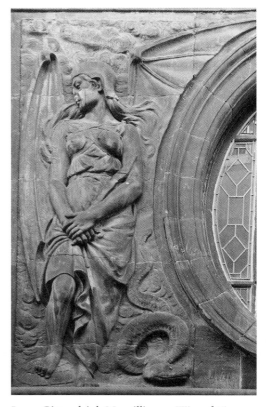

James Pittendrigh Macgillivray, *Winged Figure
(Night)*

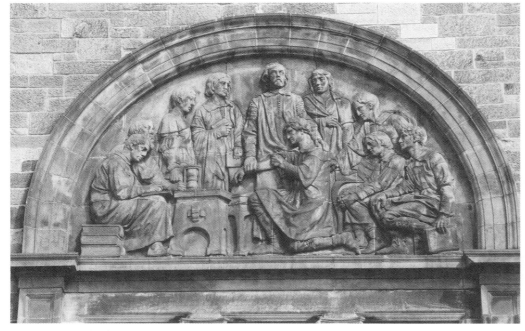

James Pittendrigh Macgillivray, *Narrative Tympanum*

the treatment of the snakes in the angel panels is identical to the one found on the *Monument to Peter Lowe* in Glasgow Cathedral, modelled by Macgillivray four years later.

Macgillivray submitted a tender of £120 for the execution of this work, and won the commission against a rival estimate of £145 from the firm of McGilvray & Ferris. In the event, the remaining decorations on the building – including ten square panels filled with arabesques on the attic of the main east wall – were carved by McGilvray & Ferris for a fee of £72 2s. 11d.[2]

Condition: The tympanum is sound, though much blackened. The nose on the left angel has broken off, and the face of the right angel has also suffered some damage.

Notes
[1] Reproduced in Alexander Duncan, *Memorials of the Faculty of Physicians and Surgeons in Glasgow*, Glasgow, 1896, n.p. [2] HAG, Honeyman & Keppie Job Books (1881–94), 29 March 1889, p.93.

Other sources
Read & Ward-Jackson, 4/11/149–50; Williamson *et al.*, p.342; McKenzie, pp.96, 97 (ill.).

Dundas Lane CITY CENTRE

On the rear elevation of the Carlton George Hotel, 44 West George Street

Carter's Hitch

Designer: Robert Hutchison

Fabricator: Hector McGarva
Date: 1998
Material: stainless steel tubing
Dimensions: 14m high
Listed status: not listed
Owner: Wordie Property Company

Description: An elongated abstract sculpture in which a continuous length of 100mm steel tubing is twisted and looped into a simulation of a rope tied with a 'carter's hitch'. The sculpture is attached to the building eight metres above street level on brackets projecting approximately 100mm from the wall plane.

Discussion: The form of the sculpture was largely dictated by its context. According to Robert Hutchison, the height of the building and the excessive narrowness of the lane called for 'a vertical structure with an uncomplicated form'. After abandoning his initial plan to use the theme of the 'tree of life', the artist chose to base the design on a traditional knot, using an illustration from a book on the early history of the Wordie family's carting business as a guide. The 'carter's hitch' was used as a method of securing ropes from the earliest days of carting, and is still in use today. As a result of a disagreement with the architect over the quality of the fabrication, Hutchison withdrew from the commission and has now dissociated himself from the finished work. The total cost was £18,000, a proportion of which was contributed by the Glasgow Development Agency under its 'Artworks for Glasgow' scheme.

Condition: Good.

Sources
Unpublished artist's statement; conversation with Robert Hutchison.

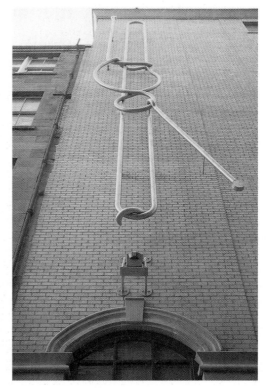

Robert Hutchison, *Carter's Hitch* [RM]

East Garscadden Road DRUMCHAPEL

In front of the entrance to the Mercat Business Centre

Rosebud
Sculptor: Doug Cocker

Installed: February 1992
Materials: stainless steel (sculpture); brick (pedestal)
Dimensions: approx. 1.5m high × 60cm diameter at base; 1.97m × 90cm × 90cm (pedestal)
Listed status: not listed
Owner: See below

Description: The sculpture consists of a central conical mass which rises from a three-stage circular plinth and is capped by a complex arrangement of curvaceous forms obliquely suggestive of a flower coming into bloom. It has very roughly milled surfaces, which create fragmented patterns of reflected light, and is secured to a concrete slab with bolts.

Discussion: Commissioned by the Public Arts Team of the Drumchapel Community Organisations Council, it was intended as a metaphor of organic growth, embodying the process of redevelopment taking place in the surrounding area at the time it was erected. *Rosebud* was one of seven 'Glasgow Milestones' produced in Glasgow in response to the city's designation as European City of Culture in 1990. (For a full discussion of this programme, see entry for *Calvay Milestone*, Barlanark Road.) Drumchapel Community Organisations Council ceased to exist in the mid-1990s and the ownership of the sculpture, and therefore the responsibility for its care, are now unclear.

Condition: Good, but with much surface grime.

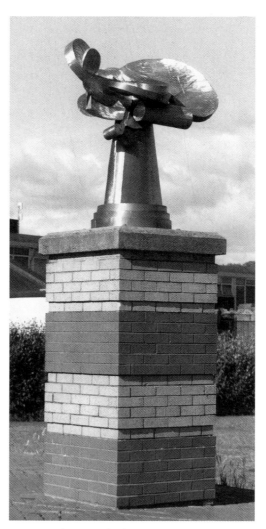

Doug Cocker, *Rosebud*

Related work: The other works in the 'Milestone' series are *Milestone* (Cromwell Court), *Dennistoun Milestone* (Duke Street), *Govan Milestone* (Govan Road), *The Works* (Springburn Way), *As the Crow Flies* (West Princes Street).

Sources
Rae and Woolaston, p.27; Location map, *Milestones*, Glasgow Milestones, n.d. (1994).

Edmiston Drive IBROX

At the junction of Edmiston Drive, Hinshelwood Drive and Copland Road

James Wilson Memorial Fountain
Sculptor: John P. Main

Date: 1907
Materials: bronze bust on polished pink granite pedestal
Dimensions: 3.15m high overall; bust 82cm high
Signed: on rear of bust, near base – J P MAIN / SCULPTOR
Inscriptions: incised on pedestal – JAMES WILSON MA BSC MBCM / A DISTINGUISHED SCHOLAR / OF GLASGOW UNIVERSITY / AND FOR 21 YEARS / AN EMINENT MEDICAL PRACTITIONER / IN GOVAN (east face); BORN 1852 DIED 1906 / HONOURED AND ESTEEMED / FOR HIS DEVOTION TO DUTY / ZEAL FOR THE PUBLIC GOOD AND / HIS GENEROUS SYMPATHY AND HELP / TO THE SUFFERING AND DISTRESSED (south face); ERECTED 1907 / BY PUBLIC SUBSCRIPTION / AS A TRIBUTE TO HIS WORTH / AND IN APPRECIATION OF HIS / LIFE AND WORK (north face)
Listed status: not listed
Owner: Glasgow City Council

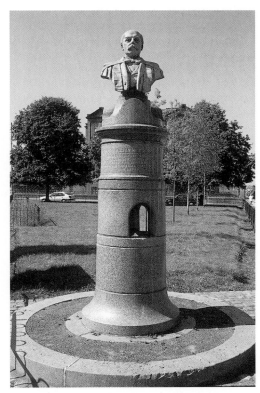

John P. Main, *James Wilson Memorial Fountain*
[RM]

James Wilson (1852–1906), medical practitioner. Born in Glasgow, he studied at the University of Glasgow, where he won the Blackstone Medal in Latin. He later switched to medicine, graduating MBCM in 1884. He then started medical practice in Govan, where he spent the rest of his active life. He served for some time on the Govan Town Council and on the County Council, and was also president of the Govan Conservative Association. In 1902 he organised a petition to erect a monument to Mrs Elder (q.v., Elder Park). He died suddenly of an apoplectic seizure at his home in Ibrox, leaving a widow.[1]

Description: The monument is in the form of a portrait bust mounted on a cylindrical pedestal, with access to the drinking fountain provided by three arched openings, the shape of which form a visual echo of the scalloped treatment of the shoulders. The subject wears the academic robes of Glasgow University.

Discussion: Erected a year after Wilson's death, the monument no longer functions as a fountain, although the remains of the disconnected pipe work are visible in the interior chamber.

Related work: A copy of the bust was exhibited at the RGIFA in 1909 (no.774).[2]

Condition: Good.

Notes
[1] 'Obituary: a Govan Doctor', GH, 31 March 1906, p.3. [2] Billcliffe, vol.3, p.176.

Additional source
McEwan, p.388.

At the east end of the Edmiston Drive frontage of Ibrox Football Stadium

Ibrox Disaster Memorial

Sculptors: Andy Scott, assisted by Alison Bell

Founders: Beltane Studios
Date: 2000–01
Date of unveiling: 2 January 2001
Materials: bronze statue on a red brick base; aluminium (plaques)
Dimensions: statue approx. 2.4m high; base 2.28m × 1.79m × 97cm; centre plaque 55cm × 70cm
Inscriptions: on lower central aluminium plaque – Team Captain, John Greig / Erected on 2nd January 2001 to commemorate those who lost their lives in / tragic events at Ibrox Stadium / by / Andy Scott / with Alison Bell / Scott Associates Sculpture and Design / Glasgow, January 2001.; the left and right plaques list the names of the victims of disasters at the stadium
Listed status: not listed
Owner: Glasgow Rangers Football Club Plc

Description: The monument consists of a larger than life-size portrait of John Greig, the former captain of the Glasgow Rangers football team, raised on a rectangular base attached to the wall of the stadium. Greig, who has been nominated by Rangers supporters as the greatest player in the history of the club, is shown standing 'in a dignified pose' with a football held between his left hand and his hip, and with his head turned in the direction of the entrance where the disaster took place. He wears an armband. On the front of the base are

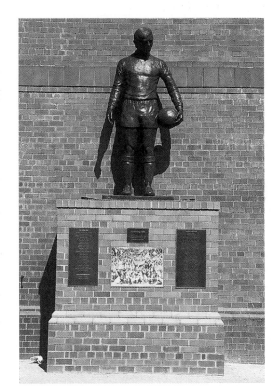

Andy Scott, *Ibrox Disaster Memorial* [RM]

three inscription plaques (see above), together with an image of a crowd of spectators from a Rangers football match. This was transferred from a press photograph to the aluminium plate by Photocast of Liverpool, using a unique photo-etching process.

Discussion: Although the primary purpose of the monument is to mark the 30th anniversary of the death of 66 Ibrox spectators in 1971, two earlier disasters involving fatalities are also acknowledged by the work. The first was on 2 April 1902, when a portion of the stadium's terrace collapsed during a Scotland versus England match, killing 25 people. (As a result of this tragedy, the fund-raising campaign for the commemorative statue to Isabella Elder was temporarily suspended; see *Monument to Isabella Ure*, Elder Park). In 1961, a similar disaster left two people dead. By far the most serious accident in the grounds of the club, however, was that which occurred in the closing minutes of an 'old firm' (Rangers versus Celtic) match on 2 January 1971, in which 66 people lost their lives and 145 were seriously injured. The cause of the tragedy has never been satisfactorily explained. In the immediate aftermath of the event it was believed that a crowd of fans departing from Stair 13 were suddenly attracted back onto the terraces by a dramatic equaliser, and that the collective force of their movement caused the protective rails to buckle and collapse. This explanation has since been discredited, and it now believed that the disaster was triggered by a single fan stumbling on the steep incline of the stairs, immediately causing others to lose their balance and thus precipitate a downward surge from which fans on the lower steps were powerless to escape. The accident was made all the more poignant by the fact that the players remained unaware of the event until after the conclusion of the match, and indeed it was not until the playing field had been turned into a 'temporary morgue' that the full extent of the disaster became clear. The incident had important consequences for the sport nationally, and in 1975 the government introduced the Safety of Sports Grounds Act, which imposed stringent regulations on the management of football stadiums. The Ibrox stadium was itself rebuilt to a new design soon afterwards.

The commission to produce the monument was awarded to Scott Associates in October 2000, in the expectation that it would be completed in time for the 30th anniversary of the disaster on 2 January 2001. In the event it was impossible to complete the work to the specifications set out in Scott's proposal, and a number of temporary measures were introduced to enable the sculptor to meet the deadline. For example, the schedule specified that the base should be constructed with imperial-sized facing bricks in order to match the existing masonry on the stadium walls. As it was not possible to have these manufactured in the time available, metric-sized bricks were used instead, resulting in an unsatisfactory mis-alignment of the new brickwork with the old. The fact that the base was built in December also caused problems, and the leaching of salts which often occurs when bricks are laid in extreme cold has produced an unsightly surface staining. Accordingly, the base was enclosed in a layer of new bricks in April 2001.

The unveiling took place as planned on 2 January 2001, and began with a service by the Rev. Stuart MacQuarrie, followed by the unveiling of the statue by the chairman of Rangers Football Club, David Murray. Among those present were the Minister for Sport, Sam Galbraith, the Lord Provost, Alex Mosson and the Rangers' manager, Dick Advocaat, together with 470 survivors of the disaster and relatives of those who perished. A further 5,000 fans witnessed the ceremony on giant video screens inside the stadium itself. Acknowledged by both the local and the national press as a memorable and dignified event, the ceremony transcended the sectarian hostilities which have often marred Glasgow football culture in the past, particularly the deep-rooted antagonism between the Rangers and Celtic clubs. Large numbers of Celtic supporters attended the unveiling, linking their scarves with those of the Rangers fans, while a minute's silence was observed at Celtic Park, the home of the Celtic team, at the outset of their match on the same day.

Related work: A fibreglass replica of the statue of John Greig will be included in the Rangers' training facility currently under construction in Milngavie.

Condition: See above.

Sources
Unpublished proposals by Scott Associates, 10, 27 October 2000; miscellaneous press cuttings provided by Scott Associates; letter from Andy Scott to the author, 23 March 2001.

On three residential blocks, 10–32 Edzell Street

Four Relief Panels: The Modern Myth

Sculptor: Brian Kelly

Architects: Simister Monaghan, Architects
Cast by: Plean Pre-cast
Date: 1987–8
Material: stone aggregate reinforced with resin
Dimensions: each panel 90cm square
Signed: in lower right corner of first panel and
 lower left of other three – © B R K '87
Listed status: not listed
Owner: Whiteinch & Scotstoun Housing
 Association

Description: The panels are inserted in raised sections of unfenestrated yellow brick wall above the entrances of numbers 10–12, 18–20, 22–4 and 30–2 Edzell Street, with the two middle panels appearing on the same block. Reading from left to right, the subjects of the individual panels are as follows:

1. The Sea – a harbour scene, including a submarine, a ship, a buoy, a ladder, a girder and a length of chain.

2. The Land – a landscape with architectural and industrial ruins and a sycamore (?) tree shedding seeds.

3. Air – an aerial view of an agricultural/industrial landscape, including the wing of an aeroplane, a bird, the branch of a tree and the upper section of an electricity pylon.

4. Space – an astronomical scene, including a globe, a telescope on the roof of an observatory, a space shuttle and the planets of the Solar System.

Discussion: Kelly was invited by the architects to make the work on the strength of a mural commission he had completed for them in Govan in 1986. The initial suggestion was to produce a series of panels on the subject of the Four Seasons, but this was rejected by the artist as something of a cliché, and after consultation with the management group of Whiteinch & Scotstoun Housing Association a more complex iconography integrating aspects of history, technology and the natural world was decided upon. The theme of industry, with specific

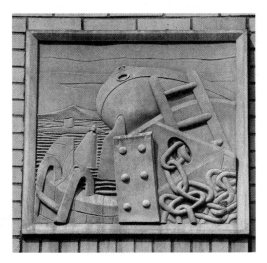

Brian Kelly, *The Modern Myth (The Sea)*

reference to the impact on Whiteinch of the decline of shipbuilding on the Clyde, runs through all four panels, with the secondary themes of the sea, the land, air and space providing an opportunity to vary the emphasis in the imagery from one panel to the next. Partly an elegiac meditation on the passing of former prosperity, partly an optimistic prediction of future regeneration, the treatment of the subject matter reflects the sculptor's concern with postmodern eclecticism, and the inherent ambiguity of historical representation.

The panels were cast in Stirling using reinforced rubber moulds taken from clay models produced in the artist's studio. A combination of coarse and fine aggregate was used in the finished works, with a colour pigmentation added to match the stone detailing used elsewhere on the buildings. They are secured by steel bolts and cement. The raised fillet surrounding the panels, which create the impression that the panels are framed, was not part of the sculptor's intention, but was introduced by the architects to prevent erosion by rain water. The total cost of the panels, including design and production was approximately £4,000.

Condition: Good, though the third panel has some surface grime.

Sources
Unpublished GCC information sheet 'Percentage for art in Glasgow: Summary of Developments to Incorporate Artwork'; 'Four Low Relief Panels: Edzell Street Housing', information booklet provided by Simister Monaghan, Architects, 1989; conversation with Brian Kelly, October 2000.

Elder Park GOVAN

The Park is situated in the north-west corner of the burgh of Govan, opposite the Fairfield (lately Kvaerner-Govan) Shipping Yard offices, and covers an area of about 37 acres. The land was purchased in 1883 by Mrs Isabella Elder for £37,500, and converted to a park as a memorial to her late husband, the shipbuilder and proprietor of the Fairfield Yard, John Elder and his father David Elder. Designed by the architect John Honeyman,[1] it was formally opened by the Earl of Rosebery on 27 June 1885, with trade processions and a banquet in the Burgh Hall.[2] It was Mrs Elder's intention that the park should provide the inhabitants of Govan with 'healthful recreation by music and amusement',[3] and there were regular concerts performed by local brass bands in the octagonal cast-iron band-stand (removed during the Second World War), as well as fireworks displays which Mrs Elder mounted annually for many years.

Of all Mrs Elder's numerous gifts to the Burgh of Govan, the park was regarded as the one which brought the most long-term benefits to the community. In her speech at the inauguration of the *Monument to Isabella Ure* (see below) in 1906, the Duchess of Montrose expressed the view that:

> … the gift that will make her memory linger longer in the hearts of the toiling masses in Govan is the gift of this beautiful Elder Park. (Applause.) Here, in the summer evenings, within sight of flowers and green trees, and with the rest afforded by comfortable seats, weary workers can forget for a while their daily toil, whilst the children have a happy playground here, far removed from the crowded streets. (Applause.) We recognise in this gift Mrs Elder's wise philanthropy, as she recognised the vast importance of

providing this breathing space in a crowded industrial district, which, had it not been for her generosity, would have become a mass of dwellings, and before many years have passed, would have been lost forever for purposes to which it is now devoted – that is for the healthy recreation and enjoyment of thousands of the working classes, both young and old.[4]

By the time this speech was made, the two principal sculptural monuments that are to be found in the park today had already been erected. It would seem, however, that Mrs Elder intended from the beginning that sculpture should play a role in defining the character of the park. In November 1890, under the title 'A suggestion for Elder Park', the *Govan Press* reported that Mrs Elder had from time to time 'engaged the attention of the people of Govan' with the suggestion that 'minor pieces of statuary or sculpture, if obtainable on reasonable terms, might be introduced with advantage, so as to add to the attractions of the Park'.[5] Describing the statue of John Elder (see below) as the 'first fruit' of this thinking, the article goes on to remark that

> In this regard a beautiful piece, emblematic of Scotch story, has been frequently mentioned as peculiarly suited for the adornment of a Scottish park … This piece is a group, extremely well chiselled, of an elderly man in the lowland garb, engaged in extracting a thistle spine from the bare foot of a youthful Scot, who had unwittingly trod upon it, accompanying his action the caution 'Ye maunna' tramp on the Scotch thistle' or, in other words 'Nemo me impune lacessit'. This handsome group, which was much admired while on show in the Glasgow [International] Exhibition [of 1888], is now on sale at the yard of sculptors Messrs J. Gibson & Co.

There is no evidence that the work was ever

purchased, but the fact that the matter was discussed demonstrates the seriousness with which sculpture was regarded as a component in the design of the park. In addition to the works listed in chronological order below, the extensive decorative carving, including a large Govan coat of arms, by Holmes & Jackson on the Elder Library (also commissioned by Mrs Elder) should be noted. An £80,000 renovation programme in 1995 included cleaning of the carved sandstone gate pillars by James Young and the installation of floodlights on the two principal monuments.[6]

Notes
[1] *Bailie*, no.662, 24 June 1885, p.1. [2] GH, 29 June 1885. [3] Smart (1996), p.88. [4] GP, 19 October 1906. [5] *Ibid.*, 29 November 1890, p.2. [6] *Bulletin*, July 1995, p.5.

Other sources
GCA, 'Deed of Gift of Elder Park, Burgh of Govan', Elder Park Papers, vol.iv, H-GOV 27(2); *Glasgow News*, 29 June 1885; NBDM, 29 June 1885; Rob and Linda Gault, *The Govan Heritage Trail*, Glasgow, 1994.

On the main drive, midway between the Govan Road entrance and the Elder Library

Monument to John Elder
Sculptor: Joseph Edgar Boehm

Founder: James Moore of Thames Ditton
Pedestal made and erected by Alexander Macdonald & Co., Aberdeen
Foundation stone laid: 21 April 1888
Unveiled: 28 July 1888
Materials: bronze statue; pedestal in polished red Peterhead granite on axed grey Aberdeen granite steps
Dimensions: statue 3.05m high; pedestal 3.66m high × 2.74m square at base
Signature: on the left side of the plinth – J. E. BOEHM. FECIT
Inscriptions: in bronze panels recessed into the

dado of the pedestal –

on the front (west) face: JOHN ELDER / ENGINEER AND SHIPBUILDER / BORN AT GLASGOW 8 MARCH 1824 / DIED 17 SEPTEMBER 1869; on the left face: TO COMMEMORATE / THE ACHIEVEMENTS OF HIS GENIUS, / AND / IN GRATEFUL ACKNOWLEDGEMENT OF HIS SERVICES / TO THE COMMUNITY AMONG WHOM HE LIVED / THIS STATUE / WAS ERECTED BY PUBLIC SUBSCRIPTION / MAY 1888; on the rear face: BY HIS MANY INVENTIONS, PARTICULARLY / IN CONNECTION WITH THE COMPOUND / ENGINE, HE EFFECTED A REVOLUTION / IN ENGINEERING SECOND ONLY TO THAT / ACCOMPLISHED BY JAMES WATT, AND / IN GREAT MEASURE ORIGINATED THE / DEVELOPMENTS IN STEAM PROPULSION / WHICH HAVE CREATED MODERN COMMERCE; on the right face: HIS UNWEARIED EFFORTS TO PROMOTE / THE WELFARE OF THE WORKING CLASSES, / HIS INTEGRITY OF CHARACTER, FIRMNESS / OF PURPOSE, AND KINDNESS OF HEART, / CLAIM, / EQUALLY WITH HIS GENIUS, / ENDURING REMEMBRANCE.

Listed status: category B (15 December 1979)
Owner: Glasgow City Council

John Elder (1824–69), marine engineer. Born in Glasgow, the son of David Elder, 'the father of marine engineering on the Clyde',[1] he was educated at Glasgow High School and served his apprenticeship under his father in the works of Robert Napier, where he later managed the drawing office. In 1852 he became a partner in the firm of millwrights, Randolph, Elliot & Co., re-named Randolph, Elder & Co., shifting the focus of the firm first to marine engineering and then (1860) to shipbuilding, eventually creating the Fairfield shipyard. His principal achievement was the perfection of the compound (high and low pressure) engine, which led to large savings on coal and thus enabled steamships to make long voyages on

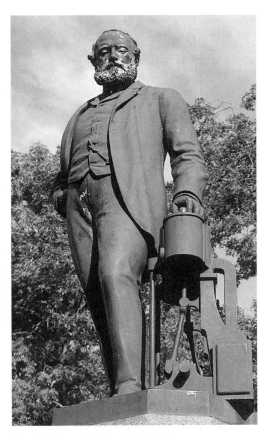

Joseph Edgar Boehm, *John Elder*

which refuelling was impossible. He also invented the surface condenser, which eliminated the use of damaging sea water. In 1868 Randolph left the firm, leaving Elder as sole proprietor of what had become the largest shipbuilding and engineering complex in the world. He was elected president of the Institute of Engineers and Shipbuilders of Glasgow in the following year. He was an enlightened employer, with a far-sighted attitude towards the management of his workforce of over 4,000 men. In providing schools for the children of

his employees, and generally making 'great efforts to secure their welfare and comfort',[2] he initiated a pattern of philanthropic works that was to be continued on a larger scale by his widow, Isabella Elder, who briefly took over the management of his business concerns after his death in 1869, at the age of 45.[3]

Description: The statue represents John Elder standing upright beside a model of a compound engine, his open jacket tucked behind his right arm to reveal a waistcoat and watch-chain. The posture is described by Archibald Craig as

… easy, graceful and, at the same time, familiar. The right foot is placed forward, the right hand rests on the side, while the left touches, one might almost say affectionately, the top of one of the cylinders of the engine. The head inclines a little forward, the eyes resting on the engine. The countenance reflects thought and that contentment which is born of success.[4]

He goes on to comment that in 'producing the likeness, Mr. Boehm was assisted by a bust of Mr. Elder by Mr. [Hiram] Power [*sic*], of Florence, and by photographs'. (See Related work, below.) The pedestal, which weighs six tons, is composed of three blocks supported by two steps, and has bronze acanthus ornaments on the ogee mouldings of both the base and the entablature. Hermetically sealed inside the pedestal is a glass jar containing enamel and lithographic portraits of John Elder, a photograph of Mrs Elder, an engraved portrait of David Elder, a Jubilee medal, a printed list of office bearers of the Memorial Committee and a manuscript account of its proceedings, patent specifications of John Elder's improvements in engines and boilers (patent no.1214), a memoir of John Elder by Professor Macquorn Rankine, a plan of Elder Park, printed programmes of the first public performances of the Govan Police Band in Elder Park, a list of Managers of the Poor for the parish of Govan, several copies of the *Govan Press* and many other 'documents

relative to the Elder Park and the burgh of Govan'.[5] The statue is encircled by twelve granite pillars linked by wrought iron chains, with a modern iron rail enclosing the whole monument.

Discussion: The earliest recorded indication of a desire to raise a public monument to John Elder is a letter published in the *North British Daily Mail* on 1 December 1883, in which W.B. Walker, a Fairfield employee, stated that 'the workmen engaged in Messrs John Elder & Co.'s engineering establishment were … busily engaged in considering how best to proceed in the instituting of a fund for the erection of a memorial to [the] late lamented and highly esteemed' John Elder.[6] Informal discussions had, in fact, been going on 'for some time', but with the announcement of Mrs Elder's plan to create Elder Park as a joint memorial to her husband and his father, the workers were prompted to 'put the matter into practical shape'.[7] Two days later a 'largely attended meeting of Fairfield workmen was held in the engineering department … during the dinner hour', at which delegates were nominated from the 'fitters', finishers', boiler shed, turning, pattern-making, and smiths' department of the yard' to begin making arrangements for the creation of a full executive committee.[8] The meeting was reported in the *Evening Citizen*, which took the opportunity to comment on the aptness of project:

> Although of slight build compared with the grand old man his father, MR. JOHN ELDER was personally handsome. His curling hair and fine features were such as an intelligent sculptor may well delight to model; and the statue, if entrusted to worthy hands, cannot fail to form a fitting addition to the Park which MRS. ELDER has presented to the town.[9]

Interest in the project quickly extended to the wider Govan community, and on 21 February 1884, a public meeting – 'called by placard'[10] – was chaired by Lord Provost Alexander Campbell and a General Committee appointed.

The main concern of the committee over the next three years was fund-raising, with the task of making the final decision as to what form the memorial should take deliberately postponed until such time 'when sufficient funds were in hand'; an unsolicited proposal received from George Smith, of the Sun Foundry, Glasgow, was accordingly rejected, with the explanation that 'the matter of "designs" being as yet quite premature, the Committee were not in a position to consider it'.[11] Subscriptions flowed in briskly at the start, with £50 being returned from the engineering firm J. & W. Beardmore in May, followed two months later by a personal donation of £100 (with a promise of a 'further subscription if required') from Elder's own successor at the Fairfield Yard, William Pearce. This level of income proved difficult to sustain, however, largely as a result of the recession through which Govan was struggling in the 1880s; the mere £29 0s. 6d. contributed by the work-force of the iron department in the Fairfield Yard perhaps gives a truer indication of the generally sluggish economic condition of the Burgh than the generous one-off donations of wealthy individuals like Pearce.[12] More than two years later, the subscriptions were still less than £800, 'with no immediate prospect', according to the Provost, 'of an improvement in the trade of the district'.[13] Nevertheless, the committee refused to be downcast, and with renewed vigour set itself the task of trying to complete the monument in time for the first anniversary of the opening of the Park the following summer. The committee proved to be adept at devising new strategies for soliciting money from the people of Govan, including advertisements in the local press, house to house canvassing, a 'snowball' scheme and a benefit football match by Glasgow Rangers Football Club.[14] One committee member proposed selling tickets costing between 6d. and 5s. for seats at the inauguration of the monument, calculating with impressive precision that such a scheme would realise a total of £562 12s.;[15] another unspecified scheme 'for the collecting of small sums' was discussed, but rejected on the grounds of the 'committee being somewhat adverse to it'.[16] The benefit football match did not take place, and it is unclear how many of the other suggestions were acted upon, but those that were appear to have been reasonably successful. On 10 May 1887, the chairman was able to report to the committee that 'their prospects were now brightening', and by July the funds had climbed to £1,600, bringing the committee within striking distance of its target figure of £2,400.

By this time, the committee had a clearer idea of the sort of memorial it wanted. A proposal to erect an 'educational institute rather than a statue' was discussed in October 1886, but the consensus all along seems to have been firmly in favour of the latter.[17] Nor does there appear to have been much debate about who should be invited to make it, and in April of the following year the chairman was requested to 'communicate with Mr. Boehm of London and ascertain the probable cost of a statue such as would meet the requirements of the Committee'.[18] There is little doubt that the choice of Boehm was determined largely by the personal preference of Mrs Elder, for whom he had 'already executed several commissions in sculpture … to her utmost satisfaction', and with whom she seems to have been on good personal terms.[19] The use of a London-based sculptor did, however, create certain practical difficulties, which in turn led to a delay in the completion of the work. The fact that Boehm was very busy in 1887 with work for the imminent Queen's Jubilee meant that the committee's frequent requests for him to 'hurry on the work' went largely unheeded.[20] Mostly, however, the problems were in communication. A sketch model prepared by Boehm in the early stages of the commission, and sent to Glasgow

'for the inspection of the committee', simply failed to arrive in time for the meeting;[21] even the completed plaster cast could not be sent to Glasgow for fear of delaying the work still further, and had to be judged on the basis of photographs rather than first hand experience of the work itself.[22] As it happens, Mrs Elder was a frequent visitor to London, and on at least two occasions took the opportunity to call on Boehm in his studio to relay the wishes of the committee to him in person.[23] A studio visit was also undertaken by the chairman in September, who insisted on paying his own expenses; he was accompanied by E.E. Walker, the vice-chairman, who happened to be in London visiting friends at the time.

None of these difficulties prevented the committee making their own, often very positive interventions in the development of the work, and they were to offer several suggestions that turned out to be crucial to its final appearance. They had, for example, strong views on the question of scale, and insisted that the finished work be increased from five to seven times the height of the 1' 6" plaster model. More crucially, it was also at the committee's suggestion that Boehm introduced the image of the compound engine, perhaps the monument's most distinctive feature. Boehm's initial intention was to place the subject's left hand on a square pillar, but this, as the committee pointed out, 'represented nothing in the history or life of John Elder'; the engine, on the other hand, was itself a 'memorial of the genius' of the subject.[24] A proposal that the pedestal should carry a view of the house in which he was born was discussed but not implemented, but the committee's desire that the number of granite pillars surrounding the statue should be increased from six to twelve was accepted by Boehm. On the whole, Boehm seems to have been willing to comply with the committee's wishes throughout, the only exception being his insistence on retaining chains to link the pillars, arguing that the

substitution of rails, as suggested by the committee, would not 'improve the general effect'.[25]

The full-size plaster model of the statue was ready for delivery to the foundry by the beginning of 1888, and, in accordance with the terms of the deed of agreement, £1,000 was paid to Boehm as the first instalment of his fee.[26] It is not clear precisely how much money had been raised by this time, though the committee appears to have been sufficiently confident of achieving its target to be able to fix a date in April for laying the foundation stone. The final tally at the completion of the commission was £2,017 11s. 1d., which with bank interest brought the grand total up to just over £2,067.[27] In the end Boehm was paid £2,000 – not £2,000 guineas as originally intended – with an additional £10 19s. 4d. for the small models. The surplus of just over £56 was used for various incidental expenses, such as a medallion combining the Govan arms with a miniature facsimile of the Elder memorial itself, commissioned from the Glasgow goldsmiths George Edward & Sons to present to Lord Lothian at the unveiling, and a set of photographs by T. & R. Annan & Sons of the committee assembled in front of the completed monument.[28]

The inauguration on 28 July 1888, was a major public event in Govan, and, despite a torrential downpour, which created 'no small amount of personal discomfort' to those attending, attracted huge crowds. The atmosphere was a curious mixture of celebration and mourning, with the flags on Clyde shipping flown at half-mast and an official reception for visiting dignitaries in the Burgh Chambers. Overwhelmingly, however, the day belonged to the working people of Govan. In its report of the event, the *Glasgow Herald* noted that the 'people of Govan [had], as was to be expected, arranged a great trades' demonstration and *fete* to do honour to the great engineer', going on to provide a detailed list of the many local companies who were represented by contingents of workers in the

main parade. The parade itself, headed by the Memorial Committee, covered a distance of about a mile from the Burgh Chambers on Summertown Road to the Park and took almost two hours to complete. Under the supervision of the local police force and members of the Royal Naval Artillery Volunteers, the route was lined with so many people that Lord Lothian, who performed the unveiling ceremony, confessed to being 'perfectly astounded coming through the streets of Govan to see such an enormous turnout'. Those who assembled in the Park for the ceremony listened in the rain to speeches from a covered platform as a prelude to the veil being lifted from the statue by a pulley designed by Boehm himself, and the presentation of the medallion to Lord Lothian. The platform party, which included Boehm, later repaired to the Burgh Hall for 'cake and wine' and more speeches.[29]

As the first monument of its kind to be erected in the Burgh, it is perhaps not surprising that its inauguration proved such a popular attraction with the local residents. Yet there is reason to believe the success of the event reflected the genuine esteem with which Elder had been regarded by the Govan community. In its report on the event, the *Glasgow Herald* quotes extensively from the address of Principal Caird, who tellingly remarked that

Mrs Elder bade him express to the gathering her deep sense of the spontaneous and unprompted kindness which had led to the creation of that memorial of her revered husband by a famous artist's hand. She knew that its value as a work of art was great, and she bade him say that what enhanced it in her eyes and made it more precious than the material beauty was the fact that the idea of such a memorial originated and had been carried into execution mainly by the efforts of the working men of Govan. (Cheers).[30]

It is appropriate that the statue to John Elder, one of the most distinguished figures in

the history of Govan, should be sited a short distance from the Fairfield Yard, the fruit of his own success as an engineer, and the source of much of the Burgh's commercial prosperity.

Related work: The bust by Hiram Powers on which Boehm based his likeness of Elder was executed in Florence in 1872, after Mrs Elder had seen and approved the plaster model on a trip to Italy in May of the same year. Elder had never actually sat for Powers, who used photographs and a small plaster cast of the subject supplied by Mrs Elder as a guide.[31] The marble is now in GAGM (S.91), and the plaster model is in the Smithsonian Institute, Washington.[32] There is also a marble bust of John Elder by Archibald Macfarlane Shannan, 1906, in the foyer of Elder Library, commissioned as a pendant to an existing bust of Mrs Elder.

Condition: Good, though with much light graffiti on the pedestal and some white paint on the face and legs.

Notes
[1] Craig, p.103. [2] GH, 30 July 1888, p.9. [3] Stevenson (n.d.), n.p. [4] Craig, p.115. [5] GH, 26 July 1888. [6] NBDM, 1 December 1883, p.5. [7] GH, 30 July 1888, p.9. [8] Craig, p.101. [9] EC, 6 December 1883. [10] Craig, p.102. [11] GCA, H-GOV 27 (1), *Minute Book of the John Elder Statue Committee 1884–1888*, 24 April 1884. [12] *Op. cit.*, 10 July 1884. [13] *Op. cit.*, 7 September 1886. [14] *Op. cit.*, 10 May 1887. [15] *Op. cit.*, 14 September 1887. [16] *Op. cit.*, 4 July 1887. [17] *Op. cit.*, 5 October 1887. [18] *Op. cit.*, 26 April 1887. [19] *Op. cit.*, 10 May 1887. [20] *Op. cit.*, 4 July 1887. [21] *Op. cit.*, 10 May 1887. [22] *Op. cit.*, 14 September 1887. [23] *Op. cit.*, 12 July 1888. [24] *Op. cit.*, 14 September 1887. [25] *Op. cit.*, 25 June 1888. [26] *Op. cit.*, 13 January 1888. [27] *Op. cit.*, 14 August 1887. [28] *Op. cit.*, 5 December 1887. [29] GH, 30 July 1888, p.9. [30] *Ibid.* [31] Richard P. Wunder, *Hiram Powers: Vermont Sculptor, 1805–1873*, vol.2, *Catalogue of Works*, Newark, London and Toronto, 1991, p.38. [32] Information provided by Hugh Stevenson.

Other sources
GP, 7 January, 11, 25 February, 21, 28 April, 28 July, 4 August 1888; Smart, (1996), pp.85–7; McKenzie, pp.38, 39 (ill.).

In a circular enclosure in the southern part of the park, beside the Langlands Road entrance

Monument to Isabella Ure (Mrs John Elder)

Sculptor: Archibald Macfarlane Shannan

Founder: J.W. Singer & Sons
Date of unveiling: 13 October 1906
Materials: bronze statue on an Aberdeen granite pedestal
Dimensions: statue 1.98m high × 1.83m × 1.09m at plinth; pedestal 1.68m high × 3.81m × 2.82m at base
Signed: on the rear of the plinth – A MCF SHANNAN ARSA / SCULPTOR 1905; on the left side of the plinth – SINGER FOUNDER
Inscriptions: on front of the pedestal – MRS JOHN ELDER LL.D.; on the rear of the pedestal – ERECTED BY / PUBLIC SUBSCRIPTION 1905
Listed status: category A (15 December 1970)
Owner: Glasgow City Council

Isabella Elder, née Ure (1828–1905), the daughter of a solicitor, she was a noted benefactress and champion of women's rights. In 1857 she married the shipbuilder John Elder, becoming the 'sole proprietrix' of the Fairfield Shipbuilding and Engineering Company for nine months on his death 12 years later. Thereafter she devoted herself 'mainly to the task of administering her large fortune so that it shall be productive of the greatest amount of happiness to the greatest possible number'.[1] Her many gifts to the city included: North Park House, in the west end, which became the premises of Queen Margaret College, the first college for women in Scotland (1884); Elder Park (1885); Elder Library (1903) and Elder Cottage Hospital (1903). In addition she contributed generously to the fund for a Training Home for Cottage Nurses, 'an institution which enables the poorest women

here to have the blessing of careful nursing in their own homes when they are ill'.[2] She also donated £12,500 to Glasgow University to establish the John Elder Chair in Naval Architecture and Marine Engineering, and contributed to the endowment of the Regius Chair of Civil Engineering and Mechanics. In 1901 she received an Honorary Degree in Law from Glasgow University.[3]

Description: In its report of the unveiling, the *Govan Press* described the statue as follows:

The sculptor … has succeeded in evolving a capital likeness of the late Mrs. Elder. The pose is natural, and the statue depicts Mrs. Elder's eager earnestness of countenance and pleasant benign smile. She is shown dressed in her academic robes and is seated in an architectural chair.[4]

The robes are those of Glasgow University, and the costume includes a mortar board which she holds in her lap. The pyramidal structure of the figure is continued in the pedestal, which has flared sides, their curvature increasing sharply as they approach the lower plinth. The front and rear faces also have convex projections, and the inscription at the foot of the front face is carved on a rococo shield enclosed by scrollwork and laurel branches. Ex-Bailie Williamson explained in his speech at the inauguration ceremony that the committee 'had not exposed the many virtues of Mrs Elder upon the pedestal of the statue, but Mr Shannan by the kindness on the benign lady's face and outstretched hand showed how very generous Mrs Elder was'.[5]

Discussion: The circumstances surrounding the origination of the monument were described by ex-Provost John Marr[6] in his speech at the inauguration. 'It was felt', he explained,

… by every class in the community that we owed it to ourselves that we should, by erecting a permanent memorial to Mrs Elder,

give tangible expression to our high appreciation, our admiration, and our love and regard for the beneficent lady who showered such splendid gifts upon us.[7]

There was, however, a complication which suggested the need for caution in undertaking such an enterprise. 'It was well known', Marr went on,

… that, for several years, Mrs Elder had been in very feeble health and if this movement of erecting this statue were started and by any chance should be delayed in its execution there was some anxiety as to how it might affect her. In 1902, however, the matter was brought to an issue by a requisition, numerously signed, placed in my hands by the late Dr. Wilson,[8] requesting me, as the then Provost of the Burgh, to call a public meeting of the inhabitants to take into consideration the propriety of erecting a public memorial to Mrs Elder.[9]

The meeting duly took place in Govan Town Hall on 29 January 1902, the outcome of which was the establishment of a General Committee for the collection of subscriptions and an Executive Committee chaired by Marr himself.[10] The initial proposal was to commission an 'Artist of eminence' to paint a full-length portrait, to be placed in the Elder Library, which she herself had gifted to the Burgh, and which was then in the course of construction. This was immediately objected to on the grounds that relatively few people would see such a work, and that to do '… justice to that noble lady and to the Burgh of Govan … they ought to have a statue of Mrs Elder executed and placed where all might see her as they could see that of her husband in the Elder Park'.

Mrs Elder herself apparently had no preference either way, but the unanimous decision of the joint committees was for a bronze statue, at an estimated cost of £2,000, to

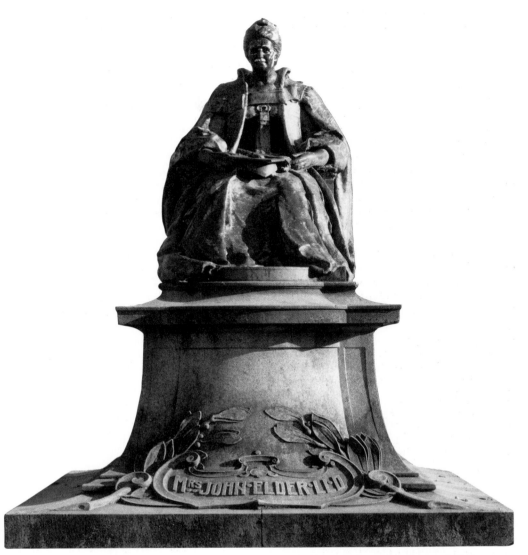

Archibald Macfarlane Shannan, *Isabella Ure*

be placed in front of the Library.[11]

Despite the enthusiastic support for the project, there was a major setback in the early stages of the fund-raising. On 2 April 1902, a portion of the terracing at Ibrox football stadium collapsed during a Scotland versus

Elder Park 101

England match, killing 25 spectators,[12] and as a mark of respect the collection of donations was suspended (see *Ibrox Disaster Memorial*, Edmiston Drive). By the autumn of the same year, however, it was felt to be 'opportune' for canvassing to be resumed and 'vigorously carried out'.[13] According to Marr the response was 'almost phenomenal', and that 'within little more than two months after the commencement of the canvass the success of the movement was assured'.[14] Throughout the development of the project the committee regularly sought the advice of Mrs Elder's nephew, John Francis Ure, a barrister in London. On 3 December 1903, Marr was able to report to him that the committee was 'making very good progress', and that with subscriptions amounting to £1,523 15s. they were now able to 'safely entrust the execution of the work to a fully competent artist'.

By this time it had already been decided that the commission should go to a local sculptor, who would have the advantage of being able to see the subject as often as required, and consult with her and her friends on a regular basis. It is clear that the main consideration here was Mrs Elder's failing health, though the emphasis on this practical aspect of the commission may also have been partly coloured by her own earlier experience of dealing with Joseph Edgar Boehm in the production of the *Monument to John Elder* in the 1880s, which had often been impeded by the difficulties of communicating with a London studio (see above). Among Glasgow sculptors, two in particular were identified as likely candidates for the commission – Archibald Macfarlane Shannan and William Kellock Brown – both of whom had received studio visits by Marr and other members of the committee the previous November.[15] Shannan was by far the better known of the two, not least in Govan, where he had recently completed the main part of his work on the Town Hall (q.v.); he also had the advantage of being at work on two important

portrait commissions – *Lord Kelvin* (q.v., Kelvingrove Park) and *Harry Alfred Long*, described by Marr as 'parties personally known to us' – at the time of the studio visit.[16] Brown on the other hand was not only a much younger and less experienced artist, but also, to the committee, something of an unknown quantity. 'In Mr Brown's studio,' Marr noted, 'we did not see the statue of any person known to us and the figures which we saw appeared, for the most part, to be ideal representations.' He did concede, however, that these were 'evidently well and skilfully done'. The extent of their lack of familiarity with his work is revealed in their letter requesting information about his background and achievements, which included such questions as 'Where did you receive your Art training, for what period, and give particulars?', and 'How long have you practised your profession?'.[17] In the end, however, it was Mrs Elder's wishes that proved decisive. After discussing the matter with her on his visit to Glasgow for Christmas 1902, Ure recommended to the committee that Shannan should be given the commission, and on 22 January 1903, a motion to accept this recommendation was carried by a majority vote.[18] Shannan was informed of the decision on the following day in a telegram that captures the sense of urgency in the committee's desire to get the commission under way without any further loss of time: 'Pleased to inform you that you have been selected to execute statue. Would like to see you today before one o'clock.'[19]

Work began almost immediately, with photographs of Mrs Elder being supplied to Shannan and sittings arranged early in February. By the end of the month a formal agreement had been drawn up, using Glasgow Council's contract with Thornycroft for the *Monument to William Ewart Gladstone* (q.v., George Square) as a model.[20] In the meantime subscriptions had climbed to £1,923 14s., with the prospect of more money still to be donated, enabling the committee to offer a fee of £1,800,

to be paid in instalments as various stages of the commission were completed. In addition to an over life-size figure 'cast in the finest bronze of suitable thickness' and a pedestal of '"fine-axed" Scotch granite or other granite approved by the Committee', Shannan was also required to produce a portrait bust of Mrs Elder to be placed in the Library.[21] A time limit of 24 months was imposed on the contract, with the curious qualification that Shannan should

… endeavour to have it completed at such a favourable period of the year as might probably enable Mrs Elder if in health to be present at the unveiling or at all events at the inauguration of the statue. By this I mean it would be desirable that these events should take place in the summer.[22]

The subsequent execution of the statue went more or less as planned, although the sculptor had to be written to on several occasions when he appeared to be falling behind schedule.[23] On 30 December, Shannan presented several alternative sketch models of the figure to the committee, one of which was approved for further development. He also showed a model for the bust, which was accepted, subject to some minor modifications; photographs of both were to be made for submission to Mrs Elder and other members of the committee.[24] The process was not without its moments of comic misunderstanding, however, and on one occasion Mrs Elder became alarmed by a photograph of what she mistakenly thought to be a plaster cast of the sculptor's wife. This turned out to be a 'rough and hurried sketch intended merely to show a female figure in a sitting posture wanted by the King of Siam'.[25] Final approval of the design for the bust was given on 13 April 1904, allowing the committee to release the first payment of £300, and by 13 June of the following year a full-size clay model of the main figure was ready for inspection.[26] This was also approved – subject to 'some slight alteration in the pose of the hands' – enabling

Shannan to press on with the completion of the plaster cast over the following month.[27]

Shannan was also instructed at this time to meet Mr Holmes, the Burgh Surveyor, to discuss the arrangements for constructing a 'concrete basement' in the Park, suggesting that the question of the statue's site had finally been settled by this time. From the beginning the assumption had been that it would be erected in front of the Library, and that it should '… correspond in size and style with the building as much as possible, so as to give a sense of homogenousness [sic] and harmony to the whole and to directly connect the building with the donor'.[28]

J.J. Burnet, the architect of the Library, and a man of 'great judgement and taste', was to act as a close collaborator with Shannan 'with reference to the proper position, height etc. of the statue'.[29] There was also a proposal that the existing statue of John Elder should be moved and placed beside the new work in front of the Library. It appears, however, that Mrs Elder wished it to be otherwise, and her preference for the statue to be placed 'in some other part of the Park' was the deciding factor. It is interesting to note that the committee were aware that if the statue were 'disconnected' from the building in this way, it would require an entirely different treatment.[30] It must be assumed that the choice of a seated pose, in contrast to the standing posture of Boehm's earlier work, was a consequence of this decision.

By November 1905, the statue appears to have been approaching completion, and the committee was able to begin making preparations for the unveiling, which was provisionally scheduled for the following spring. On 21 November, however, the chairman reported that Mrs Elder had died, and that the unveiling would have to be postponed until 'some time after May 1906'.[31] A payment to Shannan of £400, the final instalment of his fee, on 27 March 1906, confirms that the statue

had been cast by this time, and the completed work was in position in the Park, surrounded by a protective barricade, shortly after its arrival from the foundry on 19 May.[32] It was at this time that the committee took the opportunity to commission a further work from Shannan, a bust of John Elder costing £150 to accompany the marble portrait of Mrs Elder in the Library.

Invitations to perform the unveiling were sent to Lord Rosebery (who had inaugurated the Park in June 1885) and Sir Henry Campbell Bannerman, both of whom declined. In the event, the ceremony was performed by the Duchess of Montrose, a personal friend of Mrs Elder, and herself a noted benefactress. The weather on the mid-October Saturday chosen for the inauguration turned out to be far from ideal, and although the audience was spared the torrential downpours that accompanied the unveiling of her husband's statue in 1888, the 'snell wind' that blew across the park created much discomfort and very nearly persuaded the organisers to cut the proceedings short. The statue itself was covered by a rough canvas, held together by 'a bright purple satin riband' which apparently matched the colour of the costume in which the Duchess was 'becomingly attired'. The drama of the moment of the unveiling is well captured by the reporter from the *Govan Press*: 'Amid an impressive silence, Her Grace slowly drew back the covering of the statue, and the silence gave way to loud and prolonged cheering as the splendid memorial came into view.'[33]

After a number of speeches, the platform party made their way to the Town Hall for a 'cake and wine banquet', with Shannan himself among the 400 guests. In his toast to 'The Sculptor', ex-Bailie Williamson, former Convenor of the Parks Committee, told the audience how Shannan had 'from the very beginning … made it his pride to make by the statue of Mrs Elder the work of his life, and he was sure that they would agree with him that

Mr Shannan had succeeded admirably in doing so'. In his reply, Shannan

… confessed that he had made a great effort to do the statue … well. (Applause.) He assured them that had it not been for the very many friends of Mrs Elder and for the aid and assistance of the kind lady herself he would not have succeeded nearly so well … Kindness and love were at the root of it all. (Applause.)[34]

The sentiment echoes the frequent claims made during the course of the afternoon's speeches that the work of the committee had been a 'labour of love', and in particular the curious observation by the Duchess that although the statue

… might not have a monetary value of an extreme figure, still it was an evidence that the whole community of Govan had contributed their pennies, their three-penny pieces and their sixpences to show their high appreciation of one whom they all sincerely missed.[35]

By the time the monument was completed, the donations had totalled slightly over £2,000; Shannan had received £1,750 of his fee leaving a balance of £50, from which £22 13s. was deducted to cover the cost of the concrete foundation. A sum of £71 6s. 11d. remained in the fund after the expenses of the inauguration were paid. This was finally disposed of in 1912, with £50 donated towards the printing of a memorial publication by Archibald Craig,[36] and the balance used to reimburse the committee's clerk for postage expenses and to pay a small honorarium for the treasurer, John Rankine.[37]

Related works: Marble busts of Mrs Elder and John Elder by Shannan in the foyer of Elder Library, made in 1906 as supplements to this commission. The bust of Mrs Elder was exhibited at the RGIFA in 1906 (no.874) and the RSA in 1910 (no.194).[38]

Condition: sound, but with some graffiti on

the pedestal, and the face has been disfigured by thick paint marks. The area between the subject's forearms has accumulated a quantity of soil from which weeds have begun to grow.

Notes

[1] *Bailie*, no.662, 24 June 1885, pp.1–2 (incl. ill.).
[2] GP, 'The Mrs John Elder Memorial. Unveiling of Statue in Elder Park', 19 October 1906, p.2. [3] GH, 16 September 1997, p.3. [4] GP, *op. cit.* [5] *Ibid.*
[6] See Govan Town Hall, 401 Govan Road, for Shannan's portrait of Marr. [7] GP, *op. cit.* [8] See *James Wilson Memorial Fountain*, Edmiston Drive.
[9] GP, *op. cit.* [10] GCA, H-GOV 28(1), *Mrs Elder Memorial Minute Book* (hereafter, *Minute Book*), 29 January 1902. [11] *Ibid.* [12] Smart, (1996), p.95.
[13] GP, *op. cit.* [14] *Ibid.* [15] *Minute Book*, 22 January 1903. [16] GCA, H-GOV 28(2), *Letter Book and Testimonial to Mrs John Elder L.L.D.* (hereafter, *Letter Book*), Marr to John Ure, 3 December 1902.
[17] *Ibid.*, A. MacDonald to Kellock Brown, 18 December 1902. [18] *Minute Book*, 22 January 1903.
[19] *Letter Book*, p.128. [20] *Ibid.*, A. Macdonald to Shannan, 6 February 1903. [21] *Minute Book*, 5 February 1903. [22] *Letter Book*, A. Macdonald to Shannan, 21 February 1903. [23] C. Joan McAlpin, *The Lady of Claremont House: Isabella Elder, Pioneer and Philanthropist*, Argyll, 1997, p.176.
[24] *Minute Book*, 30 December 1903. [25] McAlpin, *op. cit.*, p.176. [26] *Minute Book*, 13 April 1904.
[27] *Ibid.*, 13 June 1905. [28] *Letter Book*, A. Macdonald to Archibald Craig, 24 January 1903.
[29] *Ibid.*, John Marr to John Ure, 3 December 1902.
[30] *Ibid.*, A. Macdonald to Archibald Craig, 24 January 1903. [31] *Minute Book*, 23 November 1905.
[32] *Ibid.*, 22 May 1906. [33] GP, *op. cit.* [34] *Ibid.*
[35] *Ibid.* [36] Archibald Craig, *The Statue of Mrs John Elder, Govan*, Govan, 1912. [37] *Minute Book*, 14 October 1912. [38] Billcliffe, vol.4, p.106; Laperriere, vol.4, p.147.

Other sources
Bailie, no.582, 12 December 1883, pp.1–3 (incl. ill.), no.1049, 23 November 1892, pp.1–5 (incl. ill.); McKenzie, pp.38–41 (incl. ill.).

John McArthur, *SS Daphne Memorial* [RM]

A few yards east of the Monument to Isabella Ure

SS Daphne Memorial
Sculptor: John McArthur

Founder: Archibald Young (Brassfounders) Ltd, Kirkintilloch
Date: 1997
Materials: bronze relief on a granite base
Dimensions: relief 52cm × 52cm; base 86cm × 71cm × 74cm
Signed: SCULPTED BY; JOHN MCARTHUR
Inscription: on the bronze relief, in two parts –

(1) S.S. DAPHNE / DISASTER ON THE CLYDE / A VESSEL OF 500 TONS BUILT BY ALEXANDER STEPHEN & SONS FOR THE LAIRD LINE'S / IRISH TRADE, DAPHNE CAPSIZED AT HER LAUNCH ON THE 3RD OF JULY, 1883. SHE / HEELED OVER AND SANK AS SHE ENTERED THE WATER AND 124 WORKERS OF VARIOUS /

PROFESSIONS PERISHED. INCLUDED WERE A NUMBER OF APPRENTICES AGES RANGING / FROM 14 TO 20 YEARS. MOST WORKERS WERE TRAPPED BELOW DECKS IN HOLDS / ENGINE-ROOM AND CABINS IN WHICH THEY WERE WORKING; (2) COMMISSIONED BY; GLASGOW DISTRICT COUNCIL / DESIGN BY; GOVAN PRACTICAL AND / HISTORICAL ART GROUP
Listed status: not listed
Owner: Glasgow City Council

Description: The bronze relief is placed on the slightly inclined upper surface of the granite base, and depicts the partially submerged hull of the cargo vessel SS *Daphne* in the River Clyde. In the background can be seen the various dockland buildings of the north bank of the river, opposite the Govan shipyards.

Discussion: The *Daphne* capsized as a result of design faults and the inadequate securing of her ballast. The tragedy was known as the 'Linthouse Disaster', after the area in Govan where Stephen's yard was located. An Appeal Fund was launched on 25 July 1883, in an attempt to raise £40,000 for the 60 widows and 150 dependent children, and included a benefit football match between the Rangers and Dumbarton Football Clubs at Kinning Park. In the event, £30,000 was raised. Walter Wilson, the proprietor of the Colosseum warehouse on Jamaica Street, gave a 'widow's bonnet', free of charge, to 'each of the widows of the unfortunate workmen who lost their lives in this accident'.[1]

The capsize was one of the most tragic events in the history of Clyde shipping, and yet curiously it remained uncommemorated until the erection of this monument. Designed by members of the Govan Practical and Historical Art Group, the main image was derived from a contemporary photograph published in the *Govan Press*.[2] The two editions of the bronze relief were cast from an aluminium positive taken from a plaster model, which was in turn taken from a clay original. It was made at a cost

of £3,000, with funding from Glasgow District (now City) Council, and with the granite donated by the Co-operative Funeral Service.

Condition: Good.

Related work: An identical copy of the monument is in Victoria Park.

Notes

[1] Mamie Magnasson, *A Length of Days: the Scottish Mutual Assurance Society 1883/1983*, London, 1983, pp.45–7 (incl. ill.). [2] GP, 7 July 1883.

Other sources

Information provided by Govan Reminiscence Group and Govan Practical and Historical Art Group; McKenzie, pp.40 (ill.), 41.

In the centre of the pond in the north-east corner of the park

The Launch

Sculptor: George Wyllie

Date: 1998–2000
Material: stainless steel
Dimensions: 5.5m high
Inscriptions: on the label – PIPEWORK VILLAGE and CM (abbr.: 'Champagne Magnum')
Listed status: not listed
Owner: Govan Fair Committee

Description: A slender V-shaped steel column representing the most frontal section of a ship's prow, with a larger-than-life champagne magnum placed beside it.

Discussion: The work was commissioned by the Govan Fair Committee as part of the Burgh's annual summer festival. Wyllie was given access to the Kvaerner-Govan engineering workshop and Pipework Department to produce the work, which was made in two days with the assistance of a welder (John Brown) and a fabricator. The signatures of two other assistants – 'Wilf' and 'Simmy' – are concealed on the under side of the bottle.[1] The completed sculpture, which weighs half a ton, was carried on a float as part of the procession through the streets of Govan on Friday, 5 June 1998. It was due to be erected in the park immediately afterwards, but due to installation problems, this did not take place until nearly two years later.

A former mariner, Wyllie noted in a typically provocative remark that

The Kvaerner workshops are staffed entirely by sculptors, and they make massive objects which, when welded together, become the ultimate sculpture – a ship. Anthony Caro, conceptualists and paint-a-brick merchants, eat your heart out.[2]

Despite its apparent playfulness, however, the work is motivated by a serious desire to draw attention to the decline of the traditional heavy industries of Glasgow, and the social and economic costs this has entailed. *The Launch* is thus a continuation of the concerns embodied in such major earlier works as *The Straw Locomotive*, a temporary sculpture manufactured in the Hyde Park locomotive workshops in Springburn, and carried through the streets of Glasgow as part of the 1987 Mayfest.[3]

Condition: Good.

Notes

[1] GH, 4 June 1998, p.19. [2] *Ibid.* [3] Lyall, p.93 (incl. ills); Patrizio, pp.138–9. See also Introduction.

Additional source

McKenzie, p.104.

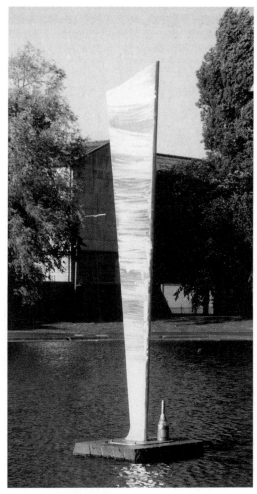

George Wyllie, *The Launch*

Elie Street PARTICK

Above the entrances to 1 and 3 Elie Street

Topographical Scenes at Partick Cross

Sculptor: Lynn Clark

Cast by: Plean Pre-cast
Date: 1990
Material: stone aggregate reinforced with resin
Dimensions: 90cm × 1.07m
Listed status: not listed
Owner: Partick Housing Association

Description: Placed directly above the entrances to the two closes, the work consists of a pair of relief panels depicting Partick Cross as it exists today and as it was earlier in the twentieth century. Both scenes are framed by comically distorted Ionic columns which support an arch with reclining figures in the spandrels, not unlike a proscenium arch. The use of exaggerated perspective in the depiction of the converging streets is also reminiscent of a theatre set design. In the contemporary view (left) the scene includes a modern double-decker bus, a set of traffic lights, a sailing boat on the River Clyde and the buildings of the Western Infirmary as they exist today. The spandrel figures are female and are shown reading books. By contrast, the companion scene has a tram running on a cobbled street, a gas lamp attached to a tenement wall, a ship on the river and the old Western Infirmary. The spandrel figures are male in this case, and are shown face down holding corn stooks. Common to both scenes is a clock in the foreground with its hands reading ten past one, and the University tower in the distance. Many of the spaces between the buildings in both panels are also filled with decorative forms reminiscent of leaves.

Discussion: The treatment of the subject was prompted in part by Brian Kelly's slightly earlier work, *The Modern Myth*, on Edzell Street (q.v.). Kelly also provided technical advice on the use of cast stone aggregate. The

Lynn Clark, *Partick Cross* [GN]

panels were commissioned by Partick Housing Association.

Condition: Good.

Sources
Partick Housing Association; information provided by the artist.

Elmbank Lane CHARING CROSS

At the rear of the King's Theatre

Abstract Wall Relief

Sculptor: Keith McCarter

Architects: Richard Seifert Co-Partnership
Date: c.1972
Material: pink shot-blast concrete
Dimensions: 2.6m high × 23.4m long
Listed status: not listed
Owner: Lodge Inns(?)

Commissioned as part of Seifert's incomplete development centred on a multi-storey office block (now the Lodge Inn Hotel) in pre-cast concrete, the mural forms part of the walkway connecting Charing Cross railway station with Bath and Elmbank Streets. The structure is composed of 19 discrete units, each approximately 1.3m wide, juxtaposed into a unified arrangement of advancing and receding planes, and incorporating a wide variety of textural effects. It is the only large-scale example in Glasgow of the fashion formalist abstract art in public spaces that flourished elsewhere in Britain during the late 1960s and early 1970s. With the closure of the Seifert office in Glasgow almost immediately after the termination of the project, much of the relevant documentation appears to have been lost or destroyed, and it has not been possible to reconstruct the history of the commission.

Related work: McCarter made an almost identical work the following year at the Headquarters of the Department of the Environment, London.[1] A smaller, and very

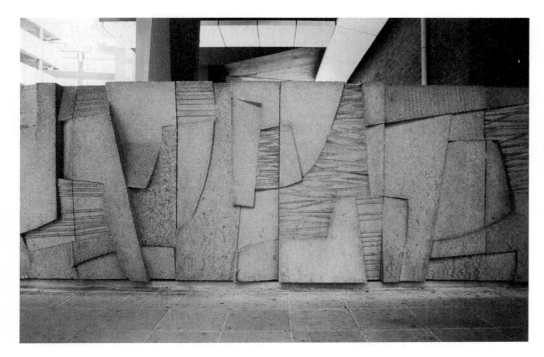

inferior example of the same approach to abstract urban decoration by an unknown sculptor can be found on the perpendicular arm of the Lane, opposite the entrance to Charing Cross Station.

Condition: Good.

Note
[1] Redstone, p.140 (incl. ill.).

Other sources
Rosenberg, p.162; Williamson *et al.*, p.214; McKenzie, pp.79, 80 (ill.).

Keith McCarter, *Abstract Wall Relief* [RM]

Elmbank Street BLYTHSWOOD

On the former Strathclyde House, 94 Elmbank Street / Holland Street

Statues of Cicero, Galileo, James Watt and Homer

Sculptor: John Mossman

Architect: Charles Wilson
Date: 1878
Material: yellow sandstone
Dimensions: figures larger than life-size
Inscriptions: on a panel on the north wing: 1887 / THE JUBILEE / OF THE REIGN OF QUEEN / VICTORIA; on the north triumphal arch: THE HIGH SCHOOL; on a panel on the south wing: 1897 / THE SIXTIETH YEAR / OF THE REIGN OF / QUEEN / VICTORIA; on the south triumphal arch: THE HIGH SCHOOL.
Listed status: category A (15 December 1970)
Owner: Glasgow City Council

Description: The four statues are raised on rusticated piers projecting from the centre of the west frontage, occupying the spaces between the first-floor windows. From the left they are:

Cicero (Marcus Tullius), first century AD Roman orator, shown wearing a toga, with scroll in left hand and right arm extended as if addressing an audience.

Galileo (Galileo Galilei, 1564–1642), Italian astronomer and physicist, shown wearing Renaissance tunic and heavy robe, holding a telescope and a globe.

James Watt (for biographical details, see *Monument to James Watt*, George Square), shown in contemporary dress holding a governor mechanism and a pair of dividers.

Homer, ancient Greek bard and presumed author of the *Odyssey* and the *Iliad*, shown

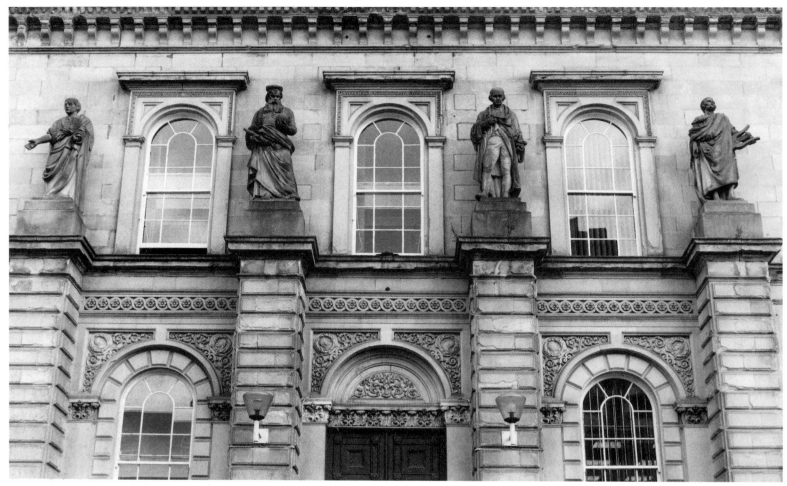

John Mossman, *Cicero, Galileo, Watt and Homer*

with face upturned and holding a lyre. As a
blind poet, Homer is the only one of the
group whose eyes are carved without pupils.
(But see Related Work, below.)

All are carved from two blocks, with the
exception of *Cicero*, which is assembled from
three. The carving of this statue is also much

cruder than the others (see below).

In the spandrels above the entrance and
ground-floor windows of the central bay there
are six profile heads in relief. The subjects have
not been identified, but are all in the classical
style and almost certainly predate the figures.
Additional minor work includes a keystone
mask in the southern triumphal arch, four
pineapple vases at the entrance gate on Holland
Street and three decorative keystones at the
entrance to the eastern side of the main

building. These are carved, from the left, with a
bell, a Glasgow coat of arms inscribed 'SURSUM
SEMPER' (trans.: 'ever upwards') but with the
bell omitted, and an open book. The separation
of the bell from the central image may be an
acknowledgement of the belfry in the roof
directly above.

Discussion: The main building was designed
by Charles Wilson in 1846 as the Glasgow
Academy, a 'private school for young
gentlemen',[1] with some alterations made by

John Burnet in 1867. In 1878, the building was sold by the directors to the Glasgow School Board, who converted it to Glasgow High School. Side wings, designed by J.L. Cowan, were added to the north end in 1886 and the south in 1897, both with triumphal arch screens connecting them to the main block. William McCaig and Watson, Salmond & Gray were responsible for designing the buildings erected on Holland Street when the school's eastern side was reconstructed between 1938 and 1957.[2] The entire complex was taken over by Strathclyde Regional Council (now defunct) in the late 1970s.

The statues date from the transition of the building from the Academy to the High School. A drawing of the west elevation by Wilson in the RCAHMS[3] shows that he intended to include four full-size, standing allegorical figures, but these were not executed, presumably for financial reasons. In May 1878, the school's Board of Directors met to discuss the omission, subsequently inviting Mossman to produce the four statues in time for the opening of the school in September.[4] The provision of the sculpture programme appears to have been paid for by members of the Board, with 'no part of the cost of the statues or their erection [falling] on the ratepayers'.[5] Wilson had been dead for fifteen years by the time they were made, and as the figures on his drawing do not indicate specific subjects, it is reasonable to assume that the choice of historical figures was determined by Mossman himself, probably in consultation with the school's directors. As Stoddart has pointed out, the quartet is a well balanced mixture of 'Ancients and Moderns – a Roman, an Italian, a Scot and a Greek'.[6] It may be relevant to note that they are not placed in chronological order, but with the two classical figures on the outside and the more modern figures immediately flanking the entrance bay. Stoddart also notes that the work is stylistically consistent with the general pattern of Mossman's development as an artist in the

1870s, which is characterised by a loss of the 'quality of formal chastity'[7] that typified such earlier architectural work as his statues for David Hamilton's Union Bank on Ingram Street (see Corinthian, 191 Ingram Street). His contemporaries appear to have been impressed by the work, however. Speaking of the statuary group in his address to the Glasgow Philosophical Society, David Thomson expressed the opinion that '… this added grace lightens up the whole elevation, which previously was wanting somewhat in expression'.[8]

In 1956, *Cicero* had become dangerous, and was replaced at a cost of £1,200. The name of the sculptor, and the reason for making the replacement smaller than the remaining three are not recorded.[9]

Related work: Mossman's slightly earlier work on the St Andrew's Halls also includes a representation of Homer (see Mitchell Theatre, Granville Street). Interestingly, where the Elmbank Street *Homer* is the only one in its group with no pupils carved in the eyes, the Granville Street version is the only one *with* pupils. The portrait medallions in the entrance spandrels are stylistically very similar to those in the upper frieze of the Wilson Street façade of the former County Buildings (q.v., Wilson Street) by Walter Buchan, and may therefore be by him.

Condition: Fair.

Notes
[1] McKean *et al.*, p.152. [2] Williamson *et al.*, p.207. [3] Reproduced in McKean *et al.*, p. 152. [4] Harry A. Ashmall, *The High School of Glasgow*, Edinburgh, 1976, p.31. [5] GWH, 21 December 1878, p.6. [6] Stoddart (1995), p.14. [7] *Ibid.* [8] Quoted *ibid.* [9] GCA, C1/3/133, 10 August 1956, p.704.

Other sources
Groome, vol.3, p.151; B, 9 July 1898, p.25; Gomme and Walker, p.288; Young and Doak, no.53 (incl. ill.); Stoddart (1980), pp.45 (ill.), 46; Jack House, 'Ask Jack', ET, 15 January 1983; Nisbet, 'City of Sculpture'; Teggin *et al.*, p.55 (ills); McKenzie, pp.78 (ill.), 79.

Errol Gardens GORBALS

20–50 Errol Gardens / 201–29 Cumberland Street / 38–40 Pine Place

Bird and Fish Panels

Sculptor: Jules Gosse, assisted by Alison Doyle

Architects: Hypostyle Architects
Date: 1997
Material: beaten copper
Dimensions: bird panels approx. 2.1m × 1.05m; fish panels 63.5cm × 63.5cm
Listed status: not listed
Owner: New Gorbals Housing Association

Description: The bird panels are in the form of triptychs placed at regular intervals under the eaves of the building's two main frontages, and depict swallows in flight against a background of leafless trees. There are eight triptychs altogether, with the same design repeated

Jules Gosse, *Fish Panel* [RM]

throughout. The fish panels are inserted in the steel railings at street level, with the species of fish alternating between pike, stickleback, smelt and grayling, and on Pine Place there is a small single panel of a leafless branch in the first-floor balcony.

Discussion: The sculptor's original intention was to place the bird panels on the back of the building, with the series continuing round the inside faces of the entire U-shaped block, thus suggesting the direction a real flock of swallows might follow in negotiating a path around a building of this kind. However, this was changed in accordance with the policy of the Crown Street Regeneration Project to site commissioned artworks only on the public frontages of their buildings. The fact that birds, trees and fish are incorporated in the Glasgow arms is relevant to the meaning of the work, though this was less important to the artist than the poetic attraction of releasing wildlife symbolically into an urban environment.

Condition: Good.

Source
Information provided by the sculptor.

Fernhill Road CASTLEMILK

At the junction of Fernhill Road and Croftfoot Road

Gateway

Sculptor: Michael Dan Archer

Date: 1999–2000
Material: Dolomitic limestone
Dimensions: 2m high
Listed status: not listed
Owner: Glasgow City Council

Description: The work consists of two D-shaped blocks with integral rectangular bases located on either side of the entrance to the east drive of the former Castlemilk House estate. The main curved surfaces are tooled to a stippled finish, while the vertical faces are more cleanly cut, suggesting that the two parts are the separated fragments of a larger object such as a millstone or a gigantic fossil. On examination, however, it is clear that the relationship is metaphorical rather than literal, as the two internal faces are clearly not designed to dovetail with each other. The two stones are mounted on concrete platforms, with the bases concealed by mounds of soil.

Discussion: Gateway is one of five sculptures commissioned by Castlemilk Environment Trust through its 'Gateways and Landmarks' initiative of 1999. As part of his commission Archer ran workshops in stone carving with Castlemilk Women's Group, whose members

Michael Dan Archer, *Gateway* (detail) [RM]

ranged in age from 60 to 75 years. A selection of their carvings was displayed in the exhibition *Gateways and Landmarks*, held in the Fringe Gallery, Castlemilk Arcade, in May 2000, and a bronze cast of a hand holding a bowling ball, modelled by Archer from the hand of one of the workshop participants, is due to be inserted in a small niche in the rear of the stone on the right at a later date.

Related work: For a full discussion of the background to the 'Gateways and Landmarks' programme, see *Southern Arch*, Carmunnock Road, above. Other works in the programme include *On the Up and Up* by Doug Cocker (Carmunnock Road), *Gateways* by Paul Grime (Castlemilk Drive) and *King of the Castle*, by Kenny Hunter (Fernhill Road).

Condition: Good, though with some surface graffiti.

Sources
Unpublished design brief and various related documents provided by Matthew J. Finkle, Project Officer, Castlemilk Environment Trust; 'Environment Trust Major Landmarks', *The 'Milk Round*, May 2000, p.6.

At the junction of Fernhill Road and Bowhouse Way

King of the Castle
Sculptor: Kenny Hunter

Date: 1999–2000
Material: Jesmonite
Dimensions: figure 1.65m high; base 3.3m diameter
Inscription: in incised letters at the base of the dome – somewhere in the distance is my future
Listed status: not listed
Owner: Glasgow City Council

Kenny Hunter, *King of the Castle* [RM]

Description: A young boy wearing modern casual clothes and a short cape is shown standing on a hemispherical base with a pair of binoculars raised to his eyes. The elevation of the site, together with the orientation of the figure, suggest that the boy is studying events in the east end of Glasgow.

Discussion: King of the Castle is one of five public artworks commissioned by Castlemilk Environment Trust as part of the first phase of its 'Gateways and Landmarks' programme, initiated in 1999. As a figurative image, the sculpture is intended to 'subvert our notions about [Castlemilk]', while at the same time questioning the tradition of the civic monument through the informality of the boy's pose and dress. It is also part of the sculptor's intention to suggest the more fantastic aspect of children's play, with the addition of a small cape to the boy's shoulders evoking the adventures he experiences imaginatively through the use of binoculars. In producing the work Hunter collaborated with members of the Castlemilk Writers' Group, who joined him on a visit to Ian Hamilton Finlay's garden, Little Sparta, in Lanarkshire to study examples of artworks that combine sculpture with literary texts. The inscription on the base, which uses letterforms cast from a fridge magnet alphabet, was composed by one of the workshop participants.

Related work: For a discussion of the 'Gateways and Landmarks' programme, see *Southern Arch*, Carmunnock Road, above. Other works in the programme include *On the Up and Up* by Doug Cocker (Carmunnock Road), *Gateways* by Paul Grime (Castlemilk Drive) and *Gateway* by Michael Dan Archer (also Fernhill Road).

Condition: Painted white, with some surface graffiti. There has also been some minor damage to the structure.

Sources
Unpublished design brief and various related documents provided by Matthew J. Finkle, Project Officer, Castlemilk Environment Trust; conversation with Kenny Hunter; 'Environment Trust Major Landmarks', *The 'Milk Round*, May 2000, p.6.

Flemington Street SPRINGBURN

North Glasgow College (formerly North British Locomotive Company building), 110–36 Flemington Street

Allegorical Female Figures of Speed and Science, with Associated Decorative Carving
Sculptor: Albert Hemstock Hodge (attrib.)

Architect: James Miller
Builders: P. & W. Anderson Ltd
Date: 1909

Materials: red Locharbriggs sandstone; bronze (arrow and dividers)
Dimensions: figures approx. 2m high (seated)
Inscriptions: in tablets below each figure – SPEED and SCIENCE; in pediment above entrance – N. B. L. CO.
Listed status: category A (29 January 1990)
Owner: North Glasgow College

Description: The figures are seated on projecting sections of entablature above the pilasters flanking the main central doorcase. *Speed*, on the left, is shown riding on a winged chariot, most of which is concealed by her

voluminous draperies. The impression of velocity is powerfully conveyed by her twisting posture and by the dynamic opposition between the forward thrust of her bronze arrow and the billowing mass of her cape. Her companion, *Science*, has a more frontal pose, and is shown seated on a terrestrial globe encircled by a collar inscribed with the signs of the Zodiac. With her right hand she applies a pair of dividers to the surface of the globe, and in her left hand holds a lighted torch. The broken pediment above the door contains an image of the front of a locomotive, which is carved in realistic detail, including lengths of railway track shown in cross-section under the wheels. Draped on either side is a block and tackle, with their heavy iron chains entwining themselves below with a more conventionally naturalistic swag. The references to engineering, science and travel are further elaborated in a series of eight vertical panels inserted in the divisions between the bays of the central section and end pavilions. From the left, these contain the following: a pair of dividers and a ball pein hammer; a screw-jack; a pump(?); a crank/transmission mechanism; a winged wheel; a ratchet; a governor mechanism; a caduceus. It is interesting to note that the second and eighth panels differ from the other six in that they are encircled with chains rather than floral swags.

Discussion: The building was designed as the head offices of the North British Locomotive Company, which was formed in 1903 from the amalgamation of Sharp, Stewart & Co., Neilson Reid & Co. and Dübs & Co., the three largest locomotive works in Glasgow.[1] It was formally opened by the Earl of Rosebery in 1909, and remained the company's headquarters until its closure in 1961. In the following year it was taken over as an annexe of Stow College, and in 1991 became North Glasgow College.[2]

The attribution of the sculptures to Albert Hodge is based on their close similarity to his work on the slightly earlier Clydeport Building (q.v., 16 Robertson Street), particularly the treatment of the faces and draperies. It is also relevant to note that Hodge and Miller collaborated on several major works, including Caledonia Chambers (q.v., 75–95 Union Street) and the Industrial Hall for the International Exhibition in Kelvingrove Park in 1901.[3] The treatment of the locomotive as emerging from the wall plane has been compared, somewhat fancifully, to the Belgian Surrealist René Magritte's painting *Time Transfixed* (1939).[4]

Condition: Generally good, though there is much green surface algae on the figures, with a particularly heavy growth of moss on the knees of *Science*.

Notes
[1] Oakley (1946), p.82. [2] Leaflet, *North Glasgow College: Historic Interest Trail*, Glasgow, n.d. (1991). [3] Kinchin (1988), pp.62–3. [4] Frank Arneil Walker, *Glasgow*, London, 1992, p.116.

Other sources
Williamson *et al.*, p.428; Sloan and Murray, pp.3 (ill.), 32; Mark O'Neill, *Springburn Heritage Trail*, Glasgow, n.d., p.8.

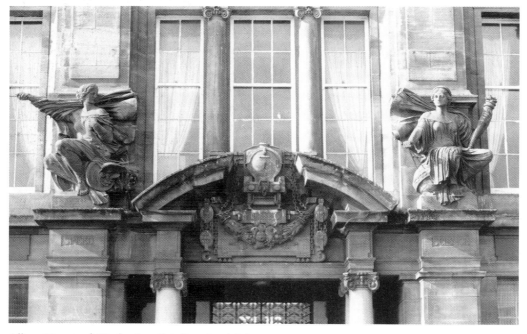

Albert Hemstock Hodge (attrib.), *Speed* and *Science*

Gallowgate PARKHEAD

*On the former Parkhead Savings Bank,
1448–56 Gallowgate / Burgher Street*

Prudence Strangling Want and Associated Decorative Carving

Sculptors: Archibald Macfarlane Shannan (allegorical group); Holmes & Jackson (decorative carving)

Architects: Honeyman, Keppie & Mackintosh
Builders: Shaw & Campbell
Date: 1908–9
Material: grey Giffnock sandstone
Dimensions: main figure approx. 2.2m high
Inscriptions: below the city arms on both
 façades – GLASGOW / SAVINGS / BANK
 (repeated on separate panels above the
 banking hall windows on Burgher Street); on
 the royal arms – IN DEFENCE / NEMO ME
 IMPUNE LACESSIT (trans.: 'no one provokes
 me with impunity'); on the Glasgow arms –
 LET GLASGOW FLOURISH
Listed status: category B (15 December 1970)
Owner: Trustee Savings Bank Scotland plc

Description: The main figure group is located
in a niche below the dome on the north-east
corner tower, and depicts Prudence as a semi-
draped male figure and Want as a snarling wolf.
There are also three pairs of standing putti in
the spandrels of the arched windows of the
Burgher Street banking hall and a fourth pair
crouching in a panel above the first-floor
window on the Burgher Street façade of the
main building. Additional decorative carving
includes a panel with the royal arms of Scotland
over the main corner entrance and two shields
with the arms of Glasgow on the second storey
of each façade.

Discussion: The building was designed as a
combined bank and tenement for the Glasgow
Savings Bank, and is in a Baroque style of a
kind used frequently on large public buildings
in Glasgow at this time. In particular, the
dramatic treatment of the corner, with its
dome-capped projecting turret and major
sculpture group, is very typical of its period.
No details of the architects' transactions with
Shannan have been found, but the relevant
Honeyman & Keppie job book records the
following estimates received for the carver
work: H. & H. Martyn & Co., £736 14s. 6d.;
Holmes & Jackson, £246 13s.; McGilvray &
Ferris, £313; James C. Young, £261; William
Kellock Brown, £339 11s.; William Oceais
(handwriting illegible), £315 13s. By a small
margin, the Holmes & Jackson tender was the
lowest. In the event they were paid £261 19s. on
16 June 1908, followed by an additional
payment of £6 on 28 October, though this
appears to have included interior work referred
to as 'caps in corridor' and 'carving at chimney
pieces'. Payment was made through the
building firm, Shaw & Campbell.[1]

Related work: The model of the main group
was exhibited at the RSA in 1909 (no.510)
under the title *Prudence strangling poverty*[2] and
is illustrated as *Thrift strangling poverty* in J.D.
Campbell's *The Savings Bank of Glasgow*,
Edinburgh, 1986, p.83.

Condition: The main figure group is very
worn, with numerous small cracks, holes and
broken details. The carver work is generally
sound.

Notes
[1] HAG, Honeyman & Keppie Job Books (1902–8),
21 September p.140. [2] Laperriere, vol.4, p.147.

Other sources
AA, 1907, p.51 (ill.), 1909, p.92 (ill.); B, 31 October
1908, p.457; Williamson *et al.*, p. 471.

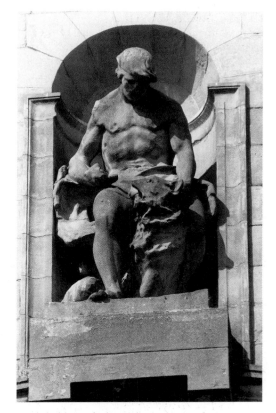

Archibald Macfarlane Shannan, *Prudence
Strangling Want*

George Square CITY CENTRE

INTRODUCTION

George Square is Glasgow's principal urban space, and the acknowledged centre of the city's public life. Dominated on its eastern side by the City Chambers, it provides an appropriately grand setting for outdoor civic ceremony, as well as a traditional mustering point for a range of other less official, and often spontaneous, demonstrations of popular concern, such as political rallies, protest marches and the collective celebration of Hogmanay.

To the modern visitor George Square presents a conventionally Victorian appearance, indistinguishable in its formality from municipal plazas found in major towns all over Britain. Its design is characterised by a geometric arrangement of manicured parterres, punctuated by bronze memorials to various historic dignitaries. With the exception of the *Monument to Sir Walter Scott*, these are all placed on or near the perimeter, facing outwards from the main compass points, and with the corner statues turned to an angle of 45°. Although the disposition of the monuments is not strictly symmetrical on either of its axes, their placement is clearly governed by considerations of order and the desire to create an impression of overall visual harmony.

Despite its apparent rationality, the layout of George Square was in fact determined less by deliberate strategic planning than by a series of *ad hoc* decisions made over a number of years, and it was not until comparatively recently that it was given the form it has today. Its origins can be traced back to the time of the Jacobite Rebellion, when it existed as a 'marsh surrounded by meadow-lands and kitchen gardens'.[1] With the prosperity that followed the end of the American War of Independence, and the accompanying westward expansion of the city, the decision was made to have the area 'ruled off as a west-end square'.[2] Initially, however, it was a square in name only, and for many years it remained a 'hollow filled with green-water, and a favourite resort for drowning puppies'.[3] It did not begin to be colonised by public statuary until the appearance of Flaxman's *Monument to Sir John Moore* in 1819, and even this was to stand alone on the southern edge for thirteen years before being joined by the *Monument to James Watt* on the south-west corner. Solitude, however, was not the only problem this statue had to contend with, and on the whole the arrival of Moore's monument marked an inauspicious start to the protracted process which was eventually to turn George Square into the outdoor sculpture gallery it is today. To begin with many of the householders on the Square objected to the use of the space for a public monument, and tried, albeit unsuccessfully, to prevent it being erected. The reasons for their objections are not entirely clear (see below), but we do know that it remained a target of local hostility for some years after it was installed. A contemporary satirical cartoon shows it under attack by mud-throwing vandals, some of whom in fact appear to be trying to pull it down with ropes.[4] The activities of the washerfolk in the background provide evidence of the practical use the Square was still being

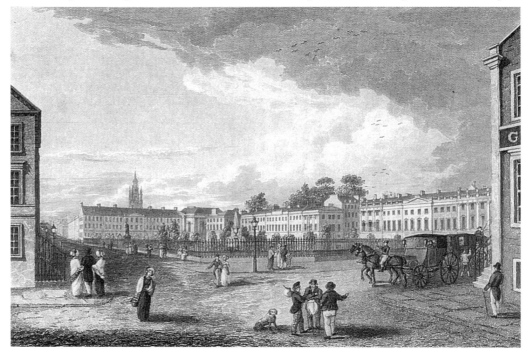

Joseph Swan, *George Square*, from Leighton, *Select Views of Glasgow*, 1828. [GSA]

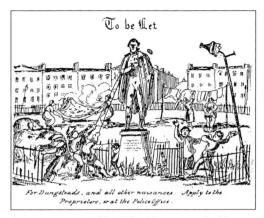

Anon., cartoon of *Sir John Moore* attacked by vandals. From the *Northern Looking Glass*, March 1825 [MLG]

put to at this time, and may help to explain why the statue was seen as an infringement of residents' rights.

Matters soon began to improve, however, and in a slightly later cartoon the vandals and launderers have been replaced by rather more well-to-do citizens promenading among beds of neatly laid out shrubs and trees. Even Moore himself is made to raise his arms and exclaim: 'My stars what a change!!!'.[5] Joseph Swan's view of the Square from the south-east in 1828 gives a broader impression of its appearance at this time, with the perimeter fence clearly visible, and with Flaxman's statue just rising above the tops of the trees.[6] Like the earlier cartoon it also shows a handsome fountain in the centre, even though the text accompanying Swan's engraving refers to the '*jet d'eau* or cascade of water' as something the owners of

the Square were at that time only intending to erect.[7] As historical evidence Swan's engravings are, of course, highly ambiguous, and this is nowhere better demonstrated than in his use of a modified version of the same image to show how the Square looked almost exactly a decade later.[8] The trees are visibly more mature, Chantrey's statue of James Watt has arrived on the far corner and, most dramatically, the fountain has been replaced by the towering form of the *Monument to Sir Walter Scott*. Curiously, the figures on the street remain exactly as they were in 1825, no less petrified in their poses, it would seem, than the bronze and sandstone effigies of the dead that were now beginning to populate the Square in increasing numbers.

Although the erection of the Scott monument in 1838 produced a radical change in the appearance of the Square, it did not disturb its character as an essentially private space, accessible only to those in possession of a key.[9] It was not until well after the middle of the century that it began to assume the more genuinely public status it has today. The event that triggered this development was the Corporation's decision in 1866 to site Marochetti's newly commissioned *Equestrian Monument to Prince Albert* in the middle of the Square, and to import the same sculptor's earlier statue of Queen Victoria from St Vincent Place to provide it with a companion. This was an ambitious undertaking, which required such major alterations to the existing layout that they could not be done without the consent of the owners of the adjacent buildings. As with the statue of Moore, some objected, and this prompted the City Architect John Carrick to investigate the question of ownership more closely. It transpired that the ground in fact belonged to the Corporation, which found itself 'unexpectedly in possession of what had been for generations regarded as belonging to the co-terminous proprietors'.[10] With a free hand to place the monuments precisely where they

Joseph Swan, *George Square*, from Leighton, *Strath-Clutha*, c.1839 [MLG]

George Square 115

wanted them, the Corporation seized the opportunity to redesign the Square as a whole. All the existing fixtures – railings, shrubs and trees (some of which were, as it happens, beginning to decay) – were torn up, and a 'broad paved place, 80 feet in width' was driven through the centre of the Square.[11] On either side were two large rectangular lawns, which were in turn divided by spacious cross-walks designed to converge on the circular paved areas surrounding monuments of the Queen and Prince Albert, now successfully installed on either side of the Scott monument under the superintendence of John Mossman.[12] Although the lawns have undergone various modifications since then – today they are much smaller, leaving the corner statues isolated in their own circular beds – the transformation of George Square was essentially complete. What had begun as a utilitarian green, accessible to a select few, had evolved into Glasgow's 'great centre for the display of public objects of art'.[13]

Public monuments, by their nature, tend to create an impression of permanence, and never more compellingly than when we encounter them in what appear to be carefully planned groups. But this can be misleading. The distribution of the statues in George Square has changed many times during the course of its history, sometimes in response to new arrivals, sometimes as part of a more general reconsideration of the pattern of relationships between them. That there is something mildly ironic about a monument that moves from one location to another was pointed out by the correspondent of the *Building News* as early as 1868:

Although such mere materialism as a slated and fenestrated big box of stone, timber, and cast iron might occasionally be removed, one's idea of the peculiar status of a statue is the *statu quo*. In Glasgow we exercise an extraordinary amount of deliberation in choosing sites for our statues; but, after all, we surely either choose not well, or else are

foolish enough not to let well enough alone. The Queen's statue, erected only a few years ago in St. Vincent-place, has been lately erected over again in George-square, and the other day the Town Council resolved that the statue of Sir John Moore be removed to make way for that of Lord Clyde.[14]

To say that the statues in George Square have been treated like chess pieces on a board is not as fanciful as it may sound; it is, after all, with the Queen (who has occupied three positions) and one of her Knights (Moore) that many of the more strategic moves have been made. Other protagonists have been plucked from the field altogether, such as Mossman's *Monument to David Livingstone* (q.v.), which was removed to Cathedral Square in 1959 to make way for an information bureau, which has itself long since vanished. The last truly significant reshuffle occurred in 1924 with the construction of Burnet's *Cenotaph*. Gladstone was relocated from his place opposite the entrance to the City Chambers to a position close to the centre of the northern side, while the Queen and her Consort made the short journey westwards to the positions they occupy today. It was also at about this time that the Council took the opportunity to add the names of the sculptors to the pedestals, at a cost of about £15, and to repair the damage to the existing inscriptions.[15]

Whether or not George Square can be regarded as a successful piece of urban design has been a matter of dispute more or less since its inception. As early as 1825 John Leighton condemned the lack of a 'uniform plan' in the styles of the surrounding buildings.[16] Since then the critical attacks have tended to concentrate more specifically on the statues: for some commentators they are too numerous; for others the choice of subjects is ill conceived. Writing in the 1890s under the pen-name of Max O'Rell, Paul Blouët complained that the space was

... literally crowded with statues, a regular carnival. It looks as if the Glasgow folk had said: 'We must have some statues, but do not, for all that, let us encumber the streets with them; let us keep them out of the way in a place to themselves...' At a certain distance the effect is that of a cemetery, or picture to yourself Madame Tussaud's exhibition à la belle étoile.[17]

He was not the only writer to find the spectacle funereal. Not long after the turn of the century the *Glasgow Herald* carried a leader which asserted that: 'It is scarcely an open question whether the open space of George Square is put to the best aesthetic use in being clothed with images of the dead.'[18]

Even the novelist Neil Munro found he could exploit the situation for its comic potential by putting the fictitious question: 'Whit'na graveyaird's this?' into the mouth of Edward VII on his arrival in Glasgow on the train from Edinburgh.[19] For James McFarlane, assessing the situation in the 1920s, the time had come when

... no further statues should be erected, and that those now in place, save the dominant monument of Scott and the equestrian figures of Victoria and Albert, should be removed elsewhere. The more famous men should be sent to keep the high company of Carlyle, Kelvin and Roberts in Kelvingrove.[20]

This was not the first time the wholesale decanting of the statues from George Square to another part of the city had been contemplated, nor would it be the last. In 1891, for example, the satirical magazine *Quiz* suggested that they would be seen to better advantage in Cathedral Square,[21] and in 1957 the council actively considered a plan to move them to Bellahouston Park.[22]

Thankfully, none of these recommendations was acted upon, but the criticisms have

continued more or less unabated down to the present day. As recently as 1973 the *Glasgow Chamber of Commerce Journal* described the Square as a 'melange' consisting of little more than a 'dozen isolated statues standing erect in an expanse of asphalt', the whole spectacle 'reminiscent of a salesman's display in a monumental mason's yard'.[23] The same article goes on to complain that there is 'no obvious sense in the selection' other than the fact that 'the date when each statue was commissioned discloses why the authorities of the day thought the statue needed'. This criticism has some validity, of course, and there is undoubtedly an element of arbitrariness in the choice of the writers, scientists and political figures brought together for commemoration in this way. Realistically, however, it would be difficult to imagine how it ever could have been otherwise, given the slowly evolving circumstances under which they were each commissioned, and it is to the credit of those who have been responsible for each successive redesign that some measure of balance and visual coherence among the statues has been maintained. The debate, however, remains far from settled, and even today rumours continue to emanate at intervals from the City Chambers that a major reconsideration is imminent.[24] In the mid-1990s, the architects Page & Park submitted a suggestion for radically altering the design of the Square as an adjunct of its proposal for converting the former Post Office building into a Museum of Scottish Art. Part of their intention was to remove the two equestrian monuments and to commission two new works by the contemporary sculptor Alexander Stoddart. The museum proposal came to nothing, and the £200,000 package of improvements which was eventually carried out in the Square in 1998 did not involve any interference with the statues.

In addition to these proposals to remove or rearrange the statues, another aspect of the recent history of the Square deserves to be

Grinneal, International Festival of Sand Sculpture, George Square, July 2000 [RM]

mentioned here: its popularity as a location for temporary sculpture. In recent years George Square has provided an ideal context for the work of performance artists and other contemporary practitioners committed to the idea of re-examining the values and conventions of traditional public art. A particularly spectacular example was the International Festival of Sand Sculpture, which was staged in George Square in July 2000, at the invitation of the local artists' collective Grinneal.[25] A massive popular success, the festival involved the production of six colossal figure groups in an enclosure on the north side of the Square, with the entire process of making the sculptures presented as a public performance. The inclusion of a standing figure of *Minerva*, which rose to a height of some four metres in a

pose not so very different from William Kellock Brown's interpretation of the same subject on the old Athenæum Theatre (q.v., 179 Buchanan Street), suggests that the project was not in any way intended as a critique of the grand historic tradition of monumentalism. Rather it was an attempt to bring such work to a wider audience: to bring it, quite literally, down to the level of the pedestrian. The sculpture itself may have been swept away after only a few short weeks, but the tradition it celebrated will not be so easily disposed of.

Very different in approach, and more in keeping with the subversive motivations of much recent performance art, was a piece entitled *Working Class Hero* by Ross Birrell, in which the artist mounted a plywood plinth for two hours on 17 October, to offer himself as a

Ross Birrell, *Working Class Hero* [RJ]

flesh and blood riposte to the bronze heroes distributed over the rest of the Square.[26] Vastly smaller in scale, and even more ephemeral than the Grinneal's *Minerva*, this cunning parody of the tradition of the grand urban monument raised important questions not only about the aesthetic value of such work, but more relevantly about the historical and political power structures that are perpetuated through them.

What emerges clearly from the study of George Square is that there is scarcely a moment in its history when it was not at the centre of vigorous public contestation. Nor should we underestimate the strength of feeling it has often aroused. Writing under the pseudonyms such as 'A Peninsular Veteran' and 'A Citizen Seer', a number nineteenth-century correspondents to the *Glasgow Herald* appear to have been outraged by the proposal to shift the John Moore monument even by a few yards.[27] For the reviewer of the *Building News* the statue of Lord Clyde – the primary cause of that particular disturbance – was a much more straightforwardly aesthetic disaster, redeemed only by the fact that, as the work of Foley, it was 'a vast relief from the many Marochettis to which Glasgow has so long been almost invariably doomed'.[28] More positively, the MP Walter Buchanan seems to have been motivated by genuine pride when he commended John Mossman's statue of Robert Peel as the first work of public sculpture by a native of the city, and was clearly reflecting the sentiment of many Glaswegians when he expressed the hope that this: '... first great attempt should lead hereafter to further eminence in the high department of art of which he has now given such an admirable specimen. [Hear, hear.]'[29]

It is Glasgow's good fortune that this hope was more than amply fulfilled, and that Mossman and many of his younger contemporaries went on to produce a stream of distinguished works, many of them in George Square itself. Though he was writing in the 1870s, when many major changes were still to come, John Tweed probably came closest to capturing the true significance of the Square when he described it as: '... an open breathing space in the heart of the city, which, whether in point of beauty, usefulness, or interest, will compare favourably with any public square either in or out of London'.[30]

Despite its critics, and its own occasional identity crises, George Square remains, in the resonant phrase of Gomme and Walker, Glasgow's *Grand' Place.*

Notes
[1] Somerville, p.10. [2] Anon., 'Glasgow's "Grand" Place': A Chapter on Statuary', BI, 16 May 1900, p.17. [3] Somerville, p.12. [4] NLG, 25 June 1825, reproduced, Somerville, p.21. [5] Reproduced in Lindsay, p.116. [6] Leighton (1828), between pp.86 and 87. [7] *Ibid.*, p.87. [8] Leighton (c.1839), ill. opp. p.105. [9] Somerville, p.20. [10] Anon., 'The improvements on George Square', *Glasgow Daily Herald*, 18 October 1866, p.2. [11] *Ibid.* [12] *Ibid.* See also contemporary photographs reproduced in Lyall, pp.30–4 and in Gibb, p.96. [13] *Glasgow Daily Herald., op. cit.*, 18 October 1866, p.2. [14] Anon., 'Gossip from Glasgow', BN, 6 March 1868, p.160. [15] GCA,C1/3/68, p.733. [16] Leighton (1825), p.87. [17] 'L'ami MacDonald', quoted in 'Casual Column', GH, 30 December 1920, p.6. [18] Quoted in McFarlane, p.38. [19] House, p.149. [20] McFarlane, p.38. [21] GCCJ, October 1962, p.415. [22] Anon., 'Site suggested for Glasgow statues from George Square to Ballahouston Park', GH, 9 August 1957, p.3; 'Letters to the Editor', GH, 9 September 1957, p.6, 21 September 1957, p.4. [23] Anon, 'The Streets of Glasgow (No. 5): Elegance East of Renfield Street', GCCJ, November 1973. p.390. [24] The most recent was in July 2000. See Josie Saunders, 'Leave our statues alone', ET, 26 July 2000, pp.8–9. [25] Andrew Eaton, 'Bring your bucket and spade', *Big Issue in Scotland*, 6–12 July 2000, pp.34–5 (incl. ills). [26] Guest and McKenzie, pp.8–10. See also www.sstq.demon.co.uk/dang_ground/index.htm. [27] For a fuller discussion, see *Monument to Field*

Marshal Lord Clyde, below. [28] Anon., 'Gossip from Glasgow', BN, 11 September 1868, p.614. [29] Anon., 'Inauguration of the Peel Statue', GDH, 29 June 1859, p.3. [30] Tweed (*Guide*), p.4.

Other sources
Anon., 'A Run through Glasgow', B, 11 May 1867, p.326; Anon., 'Statues, Memorials &c.', BN, 9 April 1875, p.417; Anon., 'Some notes about George Square, Glasgow', BI, 15 May 1897, p.21; GH, 15 May 1924, p.8; Gomme and Walker, p.57 (incl. ill.); Lindsay, pp.61–2; *George Square Glasgow: 'The City's most picturesque breathing space'*, leaflet, Glasgow, n.d.; Teggin *et al.*, pp.26–7 (ills), p.84; McKean *et al.*, p.79; Williamson *et al.*, p.177.

On the south side of George Square, a few yards west of the centre

Monument to Sir John Moore
Sculptor: John Flaxman

Date: 1810–19
Unveiled: 18 August 1819
Materials: bronze on a polished Aberdeen granite pedestal
Dimensions: statue 2.6m high; pedestal 3m high
Inscriptions: on the pedestal – TO COMMEMORATE / THE MILITARY SERVICES OF / LIEUTENANT-GENERAL SIR JOHN MOORE K.B. / NATIVE OF GLASGOW / HIS FELLOW CITIZENS / HAVE E[R]ECTED THIS MONUMENT. / 1819. (front of dado); JOHN FLAXMAN R.A. (lower right side of dado, added 1923)
Listed status: category A (6 July 1966)
Owner: Glasgow City Council

Lieutenant-General Sir John Moore (1761–1809), British army officer. Born in 'Donald's Land', in the Trongate, Glasgow, he began his military life in 1776 when, under the guidance of the Duke of Hamilton, he entered the 51st Foot as an ensign. He then served as captain-lieutenant in the Duke of Hamilton's regiment in America (1778–83) followed by a short period as MP for the united burghs of Lanark, Selkirk, Peebles and Linlithgow. His military career was resumed in 1787, and he rose through the ranks, seeing service in the Mediterranean, Corsica, the West Indies, Ireland, Holland and Egypt. In 1803 he took charge of the training of forces at Shorncliffe Camp in Kent, and by his flexible tactics and efficient, humane discipline, earned a reputation as one of the greatest trainers of infantrymen in military history. The effectiveness of his method was shown in the Peninsular War, where he was sent in 1808 to combat Napoleon. During the retreat of his army to Corunna in 1809, Moore was mortally wounded in the hour of victory. His heroic death is commemorated in Rev. Charles Wolfe's poem 'The Burial of Sir John Moore', and a monument was erected over his grave in the field of battle by his chief French adversary, Marshal Soult.[1]

Description: The subject is shown standing with his right leg slightly advanced, a sword (now missing) in his left hand, and the right 'placed in an easy position across the breast'.[2] He is in military dress, but with much of his uniform 'finely concealed by the drapery of a military cloak thrown gracefully around the person, and falling easily and naturally down'.[3] The pedestal consists of a tapered cylindrical dado with a plain cornice and base, and is supported by a square plinth.

Discussion: On 8 February 1809, the Lord Provost, James Black, chaired a meeting of 'merchants, manufacturers and other inhabitants of the City of Glasgow' in the Town Hall to discuss the possibility of commissioning a monument to Sir John Moore, the news of whose death had reached the city a few days earlier.[4] The monument was to be paid for privately, and the process of raising funds involved the distribution of subscription papers in shops and banks, in order 'that all citizens may have an opportunity of subscribing',[5] as well as the placement of advertisements in Glasgow and London newspapers. Personal approaches were also made to generals and other officers who had served under Moore's command.[6] The initial results were not only

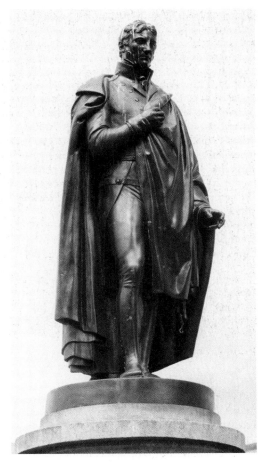

John Flaxman, *Sir John Moore*

disappointing, but the method of raising the contributions was also criticised. Mr Campbell, of Blythswood, for example, who had been asked to 'take charge of the Subscriptions at the West End of the Town',[7] responded by stating that 'the measure of collecting subscriptions from persons unconnected with Glasgow is not at all approved of by Sir John Moore's personal friends'.[8] Another subscriber, William Furlong,

announced that his subscription would not be released until the monument was completed, and that he would 'withhold it altogether if the monument did not please his own tastes'.[9]

By June, however, a total of £3,589 19s. had been donated or pledged,[10] and as this was regarded as sufficient for the project to proceed a committee was appointed to discuss the 'nature and situation of the monument'.[11] Initially, the main focus of the committee's concern was the question of 'whether the monument should be erected in the choir of the High Church or externally in some other part of the city',[12] but the debate quickly broadened into a more comprehensive review of the various possible forms it could take. The task of summarising the available options fell to John Craig, who presented his findings in a lengthy letter to his colleagues on 7 July 1809, qualifying his account with the view that the final decision should not be made until guidance had been sought from the 'sculptor whom we may employ'.[13] Among the various types of monument he identified were: an obelisk, a column, a mausoleum, a colossal statue, an equestrian statue and a pedestal carrying a sarcophagus. An obelisk was immediately discounted on the grounds that one already existed in Glasgow, while a mausoleum was thought to run the risk of looking 'merely like a garden temple' unless it were very large.[14] An equestrian statue would have been too costly, and was regarded, moreover, as unsuitable for a subject other than a king or an emperor.

Craig's analysis of the merits and demerits of a column highlights a number of more general concerns relating to the monument, and offers a valuable insight into attitudes towards public sculpture at a time when there were very few historical precedents in Glasgow to provide a model:

> By itself I consider the column a very incomplete and ungraceful form... On the column, however, there may be placed a pedestal carrying a statue. With regard to this several difficulties occur. First, with respect to the materials. The column and pedestal may be of freestone; but the statue can scarcely be of the same material. Marble … will not be sufficiently durable in the climate; of artificial stone [i.e., Coadstone] there has not yet been sufficient experience. Bronze, no doubt, will do if it is not too expensive.[15]

His remarks on the appropriate way of depicting Moore are equally illuminating:

> A naked statue, though in every respect preferable to one that is clothed, is too oposite [sic] to all modern ideas: an antique dress would want character, and appear affected: the dress of a modern General Officer is scanty, formal, minute, and mean.[16]

There were also problems of scale:

> The expense I fear would be so great that your funds would admit of a Column and Statue of only very small dimensions; and as it would most probably be placed in the Green it would be subjected to the disadvantages of comparison with an Obelisk which, including its Pedestal, is about 140ft. high.[17]

The obelisk referred to is the *Monument to Lord Nelson*, in Glasgow Green (q.v., Appendix B, Minor Works).

Craig's enquiry into the question of whether a colossal statue would be suitable for 'being erected in a street or a very small square' prompted a wide-ranging review of the question of location: 'In Glasgow there is no proper square. – St. Enoch's, if it were to be paved all over might do in point of size, though it would be rather too large; but the Buildings are far too mean for such a decoration.'[18]

Curiously, there is no mention of George Square in his report, although the problems associated with siting the statue there were considered in detail at a later meeting:

> The South side of George's Square … would be decidedly objected to by some of the Proprietors. The Southwest corner of the same Square, immediately within the Railing, might probably be agreed to; and, if there were any prospect of Statues being erected at the other angles, or even at the Southeast angle alone, this would be a most unexceptionable situation; but, it is feared that a single statue so situate, would give the Square an awkward and unfinished appearance.[19]

Alternative sites considered were the Trongate, at the point where Argyle Street, Stockwell Street and Glassford Street converge, and the junction of Wilson and Hutcheson Streets. A statue sited in one of these locations, Craig argued, would require a massive and richly ornamented pedestal if it were not to look 'meagre and mean', and it should be in bronze for durability, with a pedestal of either freestone or marble. There must, however, be 'no bas-reliefs or carvings, as neither would probably be durable'. The decoration of the pedestal would therefore have to depend 'chiefly on its form and mouldings'.[20]

The committee's lack of experience in commissioning works of public sculpture is highlighted by the events that followed their examination of Craig's proposals. Far from providing a clear way forward, his report merely generated an even more protracted consultation process, in which the views of a number of 'persons capable of giving … accurate information on the points mentioned in Mr. Craig's letter' were sought.[21] In particular they hoped an independent advisor would provide guidance in selecting a suitable sculptor. Among those whom they approached were the Professor of Painting at the Royal Academy, Henry Fuseli, and the inventor James

Watt, who was himself destined to be the next historical figure commemorated in the Square (see below), and whose design of a machine for copying sculpture presumably qualified him as an authority on matters relating to public monuments. By far the most crucial figure in this process, however, was James Moore, the subject's brother, and it is in their letter to him that the committee first raised the possibility of Flaxman's involvement, albeit only in an advisory role:

> Probably an artist should be consulted, and if you think so, without meaning at all to confine your choice, we would just hint that Mr. Flaxman's opinion, in consequence of his eminence, and of his having been employed to make a statue for Glasgow of Mr. Pitt, would be satisfactory to some of the subscribers.[22]

The hint went unheeded, and Moore's advice to the committee was not to contact Flaxman at this stage, on the grounds that by doing so they might unintentionally place themselves under an obligation to offer him the commission, or 'hurt him by rejecting his plan and employing others'.[23]

By the spring of 1810, after the subscribers had voted decisively in favour of a 'pedestrian statue',[24] a consensus within the committee had begun to form in favour of Flaxman as the artist 'most likely to execute the statue in a superior stile [sic]'.[25] Nevertheless, they were still reluctant to make a firm decision without the approval of Moore, who they also hoped would know of the whereabouts of a portrait bust which could be used as a model for his brother's likeness. This time Moore was a little more forthright in stating his reasons for not wanting Flaxman to be involved in the scheme:

> The reputation of Mr. Flaxman is great, but perhaps you are not quite aware for what species of excellence he is chiefly distinguished. I understand his reputation is

for compositions of a different kind from that which you have decided upon.[26]

While admitting that Flaxman would have been a good choice had the commission been for a 'species of historical composition', he goes on to say that his own preference was for Joseph Nollekens (1737–1823), who had a reputation for 'taking the best likenesses, and carving the best busts'. With remarkable deference, the committee accepted this recommendation and immediately offered the commission to Nollekens, who was sent, via Moore himself, a long and detailed schedule of conditions the statue would be required to satisfy. Though very much flattered by the offer, Nollekens reluctantly declined the commission on the grounds that at the age of 73 he was 'no longer capable of undertaking so great a work'.[27] Clearly disappointed by the fact that his suggestion had come to nothing, Moore moved swiftly to find an alternative candidate. By now his opposition to Flaxman had hardened into overt hostility, and in a letter of 30 April he delivered an extraordinary tirade on the defects of the sculptor's work, describing his figures as 'lamentable' and 'so ill executed as to be ludicrous'. He confessed to being unable to decide whether such shortcomings stemmed from 'carelessness or a defect of talent', but was adamant that Flaxman was the wrong man for the job. Among the alternatives, Richard Westmacott (1775–1856) was a strong contender, except that his works were not 'well considered by men of taste'. This left the rising star of English sculpture John Charles Rossi (1762–1859) as the only artist who, in his opinion, was 'likely to make a good statue'.[28]

Understandably, the committee were now more confused than ever, and rather than act on Moore's recommendation a second time they decided to extend the circle of their advisers even further. The architect William Stark was consulted, who in turn discussed the matter with the antiquarian Thomas Hope, the

Marquess of Douglas and Clydesdale and an amateur sculptor named Swinburn. He also spoke to Lord Elgin, 'whose researches in Athens have led him to an intimate acquaintance with sculpture'.[29] Nollekens, Westmacott and Rossi all emerge from these deliberations as plausible candidates, as does John Bacon the Younger (1777–1859), but the consensus was overwhelmingly in favour of Flaxman: of all the sculptors then at work in Britain, he was the one 'best qualified to treat in a proper manner a heroic subject in sculpture, and to combine with portraiture that degree of action, dignity and character which we ought to look for in such a statue'.[30] On 21 June 1810, the committee voted unanimously for Flaxman, who formally accepted the commission four days later.[31]

A number of conditions were laid down as to how the representation of Moore should be approached. The statue was to be as 'colossal as the funds will permit', with the face based on the oil portrait by Sir Thomas Lawrence belonging to Moore's family (now in the National Portrait Gallery, London). Flaxman was to avoid using 'trophies and other ornaments', and ensure that the pose was free of 'exaggeration'. Of particular importance was the treatment of his dress, and the fact that Flaxman had been described by Stark as an 'advocate for dressing his figures in the costume of the day',[32] was probably a major factor in securing his appointment. From the beginning the committee had regarded the use of modern military dress as desirable but problematic,[33] and Flaxman's task was to find a way to suppress 'the minuteness, the points, bandages and constraint of modern military dress, without leaving it doubtful to what profession the person belonged'. In short, he was to produce 'such a statue as the ancients would have erected to a warrior'.[34]

On accepting the commission, Flaxman agreed to prepare 'one or two small models of the statue on its pedestal',[35] one of which may

have been the work exhibited at the Royal Academy in 1813 (no.911).[36] By August 1818, Flaxman was able to inform the committee that the

> … statue of Sir John Moore with the pedestal and basement having been finished some time, I shall be happy to prepare immediately for the conveyance and erecting of them as soon as I shall be favoured with the committee's orders for that purpose, and as the season is far advanced much delay will prevent this part of the work being performed during the fine weather …[37]

Even at this late stage, however, the project had not entirely freed itself from difficulties. It is not known when the committee finally settled on George Square as the site of the monument, but it appears that a number of residents in the neighbouring terraces did indeed object to the decision, as predicted by the committee in February 1810 (see above), and attempted to use what they mistakenly believed to be their right of servitude over the central space to prevent its erection.[38] Ultimately, the sub-committee's pessimistic assessment that the residents' resistance would be 'too great to overcome'[39] turned out to be unfounded, and in August of the following year the statue was finally erected and unveiled.[40] The statue was cast from three tons of bronze salvaged, according to a recent source, from cannon 'captured (or surplus) at the end of the Napoleonic Wars'.[41] The same source also records that the pedestal weighs ten tons. Of the £3,600 in the subscription fund, £400 was set aside for the inscription and the construction of a circular iron railing round the monument, with part of the 'considerable surplus' used to repair the damage caused by lightning to the Lord Nelson Monument in Glasgow Green (q.v.).[42]

In the years following its erection the statue was to become the focus of diverse popular and critical opinions. It is known to have been vandalised by hooligans, and a contemporary satirical cartoon shows a group of children throwing rocks at it and swinging from it on ropes, possibly in an attempt to pull it down (see illustration, p.115).[43] Among the *cognoscenti*, however, it soon came to be regarded as a masterpiece. Sir David Wilkie, for example, described it as 'the finest modern statue in Europe'.[44] Indeed, when the Council decided to move the monument several yards to the west of its original location in order to create a symmetrical relationship with the planned statue of Lord Clyde, there were renewed protests, with many objections appearing in the correspondence columns of the press under pseudonyms such as 'A Constant Reader' and 'A Peninsular Veteran'. (For a fuller discussion, see *Monument to Lord Clyde* below.)

Related work: There is a monument to Sir John Moore by John Bacon the Younger in St Paul's Cathedral, London, dated 1809. Robert Forrest also made a statue of Moore in 1823 for Douglas Park, near Hamilton, and exhibited a piece entitled *Death of Sir John Moore* at the RSA in 1841 (no.566).[45]

Condition: Good, but the sword is missing.

Notes
[1] *Chambers Encyclopædia*, vol.VII, p.300; DNB, vol.38, pp.366–72; EB, vol.VII, p.7. [2] GH, 20 August 1819, p.4. [3] Leighton (1828), p.87. [4] NLS, MS 2732, *Sederunt Book of the Committee of Subscribers, Glasgow, to Sir John Moore's Monument* (hereafter *Sederunt Book*), minute of meeting, 8 February 1809, p.1. [5] *Ibid.*, 23 February 1809, p.14. [6] *Ibid.*, 18 February 1809, p.9. [7] *Ibid.*, 9 March 1809, p.16. [8] *Ibid.*, 29 March 1809, p.20. [9] *Ibid.*, 13 June 1809, pp.26–7. [10] *Ibid.*, 13 June 1809, p.29. [11] *Ibid.*, 28 June 1809, p.35. [12] *Ibid.*, 7 July 1809, p.37. [13] *Ibid.*, 7 July 1809, p.37. [14] *Ibid.*, 13 February 1810, p.94. [15] *Ibid.*, 7 July 1809, p.38. [16] *Ibid.*, 9 November 1809, p.80. [17] *Ibid.*, 7 July 1809, p.39. [18] *Ibid.* [19] *Ibid.*, 13 February 1810, p.111. [20] *Ibid.*, 7 July 1809, p.40. [21] *Ibid.*, 7 July 1809, pp.45–6. [22] *Ibid.*, 29 August 1809, p.48. The statue of Pitt was first exhibited in the Town Hall on the Trongate and is now in GAGM (S.30). See Kelvingrove Museum, Kelvingrove Park. [23]

Sederunt Book, 29 August 1809, p.63. [24] *Ibid.*, 28 March 1810, p.118. The vote was carried by a majority of 77, with only three votes for a column and two for an obelisk. [25] *Ibid.*, 3 April 1810, p.121. [26] *Ibid.*, 20 April 1810, p.125. [27] *Ibid.*, 8 May 1810, pp.147–8. [28] *Ibid.*, 8 May 1810, pp.149–50. [29] *Ibid.*, 21 June 1810, p.155. [30] *Ibid.*, 21 June 1810, pp.155–6. [31] *Ibid.*, 25 June 1810, pp.165–6. [32] *Ibid.*, 21 June 1810, p.156. [33] *Ibid.*, 9 November 1809, p.38. [34] *Ibid.*, copy of letter from C.D. Macdonald to John Flaxman, 21 June 1810, pp.158–64. [35] *Ibid.*, copy of letter from John Flaxman to C.D. Macdonald, 14 July 1810, p.166. [36] Graves, vol.3, p.124. [37] NLS, MS 9819 f.104, MS letter from John Flaxman to Colin Donald, 4 August 1818. [38] Anon., 'Glasgow's "Grand" Place': A Chapter on Statuary', BI, 16 May 1900, p.18. See also Introduction, above, and *Monument to Prince Albert*, below. [39] Anon., *op. cit.* [40] GH, 20 August 1819, p.4. [41] Anon., 'The Streets of Glasgow (No. 5): Elegance East of Renfield Street', GCCJ, November 1973, p.390; see also GH, 20 August 1819, p.4. [42] NLS, MS 2735, MS *Sederunt Book of the Committee of Subscribers to Lord Nelson's Monument, 1805–1820*, 20 July 1819, p.107. [43] NLG, vol.1, no.1, 1825, reproduced in Lindsay, p.116 and Barr, p.6. [44] GH, 29 June 1859, p.3. [45] Laperierre, vol.2, p.75.

Other sources
James Cleland, *The former and present state of Glasgow*, Glasgow, 1840 (2nd edition), p.115; Pagan, p.173; Somerville, pp.88 (incl. ill.), 97; BI, 15 May 1897, p.21; McFarlane, pp.28–9; House, p.150; David Irwin, *John Flaxman 1755–1826: Sculptor, Illustrator, Designer*, London, 1979, pp.182 (ill.), 183; Lindsay, p.61; Read, p.117; Williamson *et al.*, p.177; Pearson, p.91; McKenzie, p.49.

On the south-west corner of George Square

Monument to James Watt
Sculptor and founder: Francis Leggatt Chantrey

Date: 1830
Erected: 16 June 1832
Materials: bronze on a Devonshire granite pedestal
Dimensions: statue approx. 2.1m high; pedestal approx. 3.66m high

Inscriptions: on the statue – F CHANTREY / SCULPTOR FOUNDER / 1830 (left side, under chair seat); JAMES WATT / BORN / 19 JANUARY 1736 / DIED / 25 AUGUST 1819 (rear, under chair seat); on the pedestal – JAMES WATT / BORN 1736. DIED 1819. (front); SIR FRANCIS CHANTREY R.A. (lower left side of dado, added 1923)
Listed status: category A (6 July 1966)
Owner: Glasgow City Council

James Watt (1736–1819), pioneer inventor and engineer. Born in Greenock, the son of a shipwright, he began his professional career at the age of seventeen by opening a business in Glasgow as a maker of mathematical instruments. In 1764 he became interested in steam engines, and in 1769 patented his own improved version, which reduced the consumption of fuel and steam by the use of a separate condenser. In 1774 he went into partnership with Mathew Boulton at Soho, Birmingham, and marketed the first practical cylindrical steam engines, which revolutionised industry, replacing horse and water power. In Scotland he surveyed the Forth and Clyde, Caledonian and other canals, made improvements to Clyde estuary ports and designed the heating system for the first Hunterian Museum. Amongst his other inventions were a letter-copying press and a machine for copying sculpture.[1]

Description: In this larger than life-size portrait 'the great benefactor of mankind' is shown seated in a sabre leg chair 'in a contemplative mood, with compasses in the right hand, and a scroll lying on the knee, on which is described the model of a steam engine'; the face was said by a contemporary to be a 'striking likeness'.[2] The pedestal has half cylinder projections from the front and the rear, and is raised on a square plinth.

Discussion: The decision to erect a monument to 'the late Mr. Watt' was made at a public meeting in Glasgow on 24 November 1824, with the then Lord Provost Mungo Nutter Campbell in the chair. By January of the following year £2,079 9s. 7d. had been raised, including 100 guineas subscribed by the City Council and £30 from the Glasgow Mechanics' Institute and Technical College of Science. The Glasgow Water Company, under the chairmanship of Kirkman Finlay (see 7 West George Street, below), was also to donate 100 guineas, although this apparently caused 'some disquiet amongst some local people who objected to the use of a public company's funds being used in this way'.[3] By April 1825, the fund had risen to £3,062 4s. 7d., and it is likely that the decision to offer the commission to Chantrey was made at this time. The Chantrey ledger book in the RA records an order for statue on 16 March 1826, with the fee set at £3,000.[4] Chantrey was to visit Glasgow in November 1831, to select a site, and his choice of the south-west corner of George Square may have been determined, among other things, by the fact that this part of the Square had been deemed for some years as 'in need of "improvement" in the form of shrubbery'.[5] A payment of £1,500 on 11 November 1827,[6] suggests that the statue was substantially completed by this time, though it was not until Monday, 11 June 1832, that the *Glasgow Herald* was able to report that the statue had arrived at Port Dundas, 'where it [lay] preparatory to being removed to George Square'.[7] The figure, which weighs two tons, was installed 'under the skilful direction of Mr. Broom, the builder, and Mr Swedenbank from the establishment of the sculptor in London',[8] and the inauguration took place on the following Saturday. The final cost of the monument was £3,454.[9]

Apart from its immense relevance to the history of Glasgow, the statue is of interest in part because of the unusually close relationship between the artist and the sitter, and the fact that they maintained contacts with each other that 'went well beyond those normally existing between patron and portraitist'. Chantrey, who is described by his biographer, George Jones, as inclining 'rather to practical science than to literature and hypothesis', was a great admirer of Watt's achievements, and his numerous portrait busts of him were regarded at the time as the epitome of the sculptor's renowned ability to suggest the inner workings of a powerful mind. They are known to have exchanged letters, with Watt on one occasion

… telling Chantrey about his new machine for reproducing sculpture, and Chantrey 'threatening' Watt 'with a visit' so as to be able to inspect it. Chantrey also discussed with Watt his own efforts to modify the standard sculptor's pointing machine used to rough out works in marble.[10]

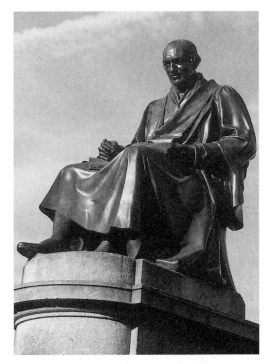

Francis Leggatt Chantrey, *James Watt*

In another letter to Watt, Chantrey described how he had 'very much improved upon the bungling instrument which we [sculptors] have been in the habit of using'.[11]

Related work: The statue is one of numerous representations of Watt in Glasgow, most of which are either attached to buildings or designed as part of an architectural scheme. These are by John Greenshields (1824, designed for the Glasgow Mechanics' Institution, now in Queen's College, George Street; see University of Strathclyde, below); Charles Grassby (1864, designed for St Martin's Leather Works, now in the McPhun Park, q.v.); John Mossman (1878, Strathclyde House, Elmbank Street; 1886, Athenæum, 8 Nelson Mandela Place, qq.v.); James Young (1899, Connal's Building, 34–8 West George Street, q.v.); Albert Hodge (1906, Clydeport Building, 16 Robertson Street, q.v.). Chantrey himself made four other variations of the design in marble, including those in St Mary's Church, Handsworth (1825); the Hunterian Museum (1830, see University of Glasgow, below); SNPG (1832, formerly in Westminster Abbey); Watt Institution, Greenock (1838?). GAGM also has a marble bust by Chantrey dated 1816 (S.286), which was made for Watt's son, and served as the prototype for all later representations.[12]

Condition: Good.

Notes
[1] EB, vol.19, pp.662–65. [2] GH, 18 June 1832, p.2. [3] Alison Yarrington, Ilene D. Lieberman, Alex Potts and Malcolm Baker, 'An Edition of the Ledger of Sir Francis Chantrey, R.A., at the Royal Academy, 1809–1841', *The Walpole Society 1991/1992*, vol.56, 1994, p.216. [4] *Ibid.* [5] *Ibid.* [6] *Ibid.*, p.215. [7] GH, 11 June 1832, p.2. [8] *Ibid.*, 18 June 1832, p.2. [9] Yarrington *et al.*, *op.cit.*, p.215. [10] Clyde Binfield (ed.), *Sir Francis Chantrey, Sculptor to an Age, 1781–1841*, Sheffield, 1981, p.74. [11] Quoted by Alex Potts in *Sir Francis Chantrey 1781–1841, Sculptor of the Great*, London, 1980 (ex. cat.), p.9. [12] Stevenson (n.d.), n.p.

Other sources
James Cleland, *The former and present state of Glasgow*, Glasgow, 1840 (2nd edition), p.115; Somerville, p.98; A. Humboldt Sexton, *'The First Technical College' A Sketch of 'The Andersonian' and the Institution Descended from it: 1796–1894*, London, 1894, pp.73–5; BI, 16 May 1900, p.17; McFarlane, pp.21–2; Read, p.117; Williamson *et al.*, p.177; Pearson, p.91; Noszlopy, p.68; McKenzie, pp.50, 51 (ill.).

In the centre of George Square

Monument to Sir Walter Scott

Sculptors: John Greenshields (modeller); John Ritchie (carver); William Mossman (inscription)

Architect: David Rhind (column and pedestal)
Mason: James Govan
Date: 1834–8
Erected: 2 June 1838
Material: yellow freestone
Dimensions: statue 3.2m high; column 24.4m high
Inscription: on the south face of the pedestal –
 WALTER SCOTT
Listed status: category A (6 July 1966)
Owner: Glasgow City Council

Sir Walter Scott (1771–1832), poet and novelist. Born in Edinburgh, the son of a Writer to the Signet, he was educated at the Royal High School and Edinburgh University. His early career was in Law, and he became Sheriff Depute of Selkirkshire in 1799. He made his name first as a poet and later as a novelist, and his familiarity with the legends, history and countryside of Scotland, particularly of the Borders, combined with his gift of story-telling, were to make him one of the most widely read authors of all time. He is best known for his series of 'Waverley' novels. Also a leader in the field of taste, he played a central part in the promotion of early tourism in Scotland, and the home he built for himself at Abbotsford, on the River Tweed near Melrose, was one of the first buildings in a truly romantic Gothic style. Although highly successful as a writer he was

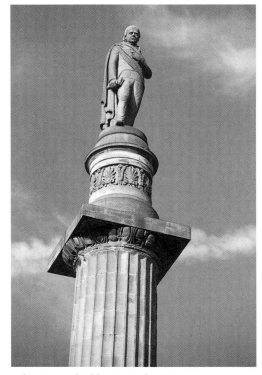

John Greenshields, *Sir Walter Scott*

unfortunate in business, and his debts were still unpaid when he died at Abbotsford. He was buried with great ceremony in Dryburgh Abbey.[1]

Description: Scott is shown standing in a relaxed posture with his right foot slightly advanced and his left hand raised to his chest; he holds a pen in his left hand and a book in his right. Dressed in a cutaway coat, he also wears a shepherd's plaid, which passes diagonally across his chest and falls to the ground from his right shoulder. The statue is composed of four blocks, with the joins occurring at the hips, shoulders and thighs, and stands on a decorated cylindrical pedestal supported by a Doric column. The column itself is raised on a

rectangular pedestal with sarcophagi inserted into each of the four sides and pairs of lion masks on the corner piers.

Discussion: Prompted by the belief that a monument to Scott would be a 'means of inspiring others to emulate that great and glorious man who had shed such a lustre on the annals of his country',[2] a monument committee was formed on 18 October 1832, less than a month after the author's death. The inaugural meeting took place in the Town Hall, attracting nearly 200 delegates, who between them donated £1026 14s. towards the cost.[3] It is interesting to note that the list of subscribers includes Thomas Campbell and James Oswald, who were themselves to have monuments erected to them in George Square shortly afterwards, as well as James Lumsden, whose bronze memorial is in Cathedral Square (qq.v.). Greenshields, a sculptor much admired by Scott, appears to have been the committee's preferred candidate for the commission, probably on the basis of an earlier *sic sedebat* portrait he had made of the author for Robert Cadell, the owner of a large collection of Scott's original manuscripts.[4] At the time of the George Square commission, however, Greenshields was extremely busy producing a series of 'huge and elaborately carved vases' for another patron, and it was only after being 'urgently and repeatedly solicited' by the committee that he reluctantly agreed to submit a design.[5] His biographer Daniel Reid Rankin records that he produced his model 'rather hurriedly', and that during

… the few days he was engaged on the design he often declared that it must be a failure, for he had little heart in the work, – and it could never come half up to the sitting statue. The head and features of this figure were repeated from the 'sic sedebat' statue … Although correct in proportions and details, this model was the least effective of the artist's designs.[6]

The same author notes that when Greenshields was told on his deathbed that his work had been selected in preference to designs by Robert Forrest and John Ritchie, he received the news 'without emotion or remark'.[7]

In the event the statue was carved by John Ritchie in his studio in Musselburgh, and arrived in Glasgow in sections on Wednesday, 30 May 1838.[8] By coincidence, Scott's son, Major Sir Walter Scott, was stationed in Glasgow with the 15th Hussars at this time.[9] Preparations in George Square had been under way since July the previous year,[10] and after being coated with oil the statue was placed in position on the top of the column on 2 June 1838.[11] In its coverage of the event the *Glasgow Herald* reported that

The likeness, we are glad to say, is exceedingly good and the drapery well executed. It is scarcely fair to say anything about the monument until the scaffolding be taken down and the business finished, but at present the column is commented on as being too long for its girth, and more like a good walking stick than anything else.[12]

The final cost of the monument was £1,710 13s., which the chairman of the subscription committee, Robert Ferrie, considered excellent value, particularly in view of the fact that it could 'in no respect be surpassed for beauty and chasteness of design by the Column erected in Edinburgh to the memory of Lord Melville, and which cost nearly £4000'.[13] The published expenditure sheet of 16 January 1839, records that David Rhind was paid £31 10s. for his design of the column, while John Ritchie received £84 for carving the statue.[14] No reference is made to Greenshields' fee, or to the 4 shillings known to have been paid to William Mossman on 2 October 1838, for cutting the 'eleven letters' of Scott's name on the pedestal.[15]

On completion, the statue was the first public monument to Sir Walter Scott anywhere in the world, pre-dating the larger and more celebrated memorial on Princes Street, Edinburgh, by almost a decade. In a sly reference to the traditional antagonism between Glasgow and Edinburgh, the antiquarian traveller T.F. Dibdin, who was in Glasgow when the foundation stone was laid in October 1837, suggested that the '*Spartans* have here shot a-head of the *Athenians*'.[16] It was also regarded locally as an important cultural landmark at a time when 'the glories of Florence, in the time of the Medicis, have dawned on the commerce now irradiating the spires of Glasgow'.[17] Subsequent critical opinion, however, has not always been so favourable. In 1922 James McFarlane wrote that 'as a work of art the figure is indifferent, being the work not of a sculptor, but a mason. The plaid is over the wrong shoulder, as has often been remarked.'[18] There is also a popular legend that Greenshields committed suicide by flinging himself from the top of the column after his blunder had been pointed out to him. In fact neither story is true. Not only had the sculptor died 'in his bed' more than two years before the column was erected, but the placement of the plaid on the right shoulder obeys a convention which correctly identifies Scott as a native of the Borders rather than a Highlander.[19] More seriously, the view has often been expressed that the monument is too large for its context, and that it places an undue importance on Scott's achievement at the expense of the more modest effigy of Burns (q.v.) a few yards away. It was even suggested at the time the Square was remodelled in 1924 that it should be removed altogether to make way for the Cenotaph (q.v.).

Condition: Good.

Notes
[1] EB, vol.16, pp.411–2. [2] GH, 19 October 1832, p.2. [3] *Ibid.*, 2 November 1832, p.3. [4] This marble portrait is now in Parliament House, Edinburgh. See Pearson (ed.), p.156. [5] Anon. (Daniel Reid Rankin), *Notices Historical, Statistical, & Biographical, relating to the Parish of Carluke from 1288 till 1874*, Glasgow, 1874, p.321. [6] *Ibid.*, p.322. [7] *Ibid.* [8] GH, 1 June 1838, p.2. [9] *Ibid.*, 4 June 1838, p.2. [10] *Ibid.*, 21

July 1837, p.4. [11] *Ibid.*, 4 June 1838, p.2. [12] *Ibid.*
[13] GCA, TD 200/34, 'Statement of subscriptions
and expenditure for Sir Walter Scott's Monument in
George Square, Glasgow', p.2. The statue referred to
is Chantrey's monument of Melville in St Andrew
Square, carved by Robert Forrest. [14] *Ibid.*
[15] *Ibid.*, TD 110. 'Jot Book of William Mossman,
1835–9', 2 October 1838. [16] Dibdin, p.667. [17]
GH, 19 October 1832, p.2. [18] McFarlane, p.16.
[19] House, p.149.

Other sources
James Cleland, *The former and present state of
Glasgow*, Glasgow, 1840 (2nd edition), p.115; BN, 9
April 1875, p.417; B, 9 July 1898, p.22; BI, 16 May
1900, p.17; W. Sinclair, 'A Clydesdale Sculptor', GH,
20 April 1935, p.11; ABJ, 18 November 1914, p.309;
Gomme and Walker, p.235; Woodward, pp.87–90;
Jack House, 'Ask Jack', ET, 27 August 1980, p.30;
Read, pp.116–17 (incl. ills); Teggin *et al.*, p.27 (ills);
Williamson *et al.*, p.177; Lindsay, p.61; McKenzie,
pp.46–9 (incl. ill.).

*On the west side of George Square, a few
yards north of the centre*

Equestrian Monument to Queen Victoria

Sculptor and founder: Baron Carlo Marochetti

Date: 1850–4
Inaugurated: 6 September 1854 (St Vincent
 Place); re-erected 18 December 1866
Materials: bronze statue and reliefs on a red and
 grey granite pedestal
Dimensions: statue 2.44m high on a 2.74m ×
 1.22m plinth; reliefs 61cm × 2.13m and 61cm
 × 61cm
Inscriptions: in bronze relief on the dado – VR
 (enclosed in a wreath with a crown above);
 IN / COMMEMORATION / OF / HER MAJESTY'S
 / VISIT TO GLASGOW / 14TH AUGUST / 1849
 (rear, enclosed in a wreath); on the plinth –
 BARON CARLO MAROCHETTI. R.A[.] (lower
 right side of dado, added 1923)
Listed status: category A (15 December 1970)
Owner: Glasgow City Council

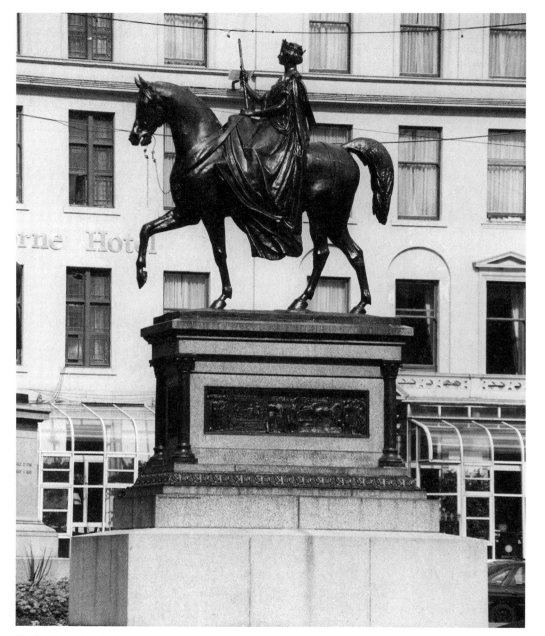

Carlo Marochetti, *Queen Victoria* [RM]

Queen Victoria (christened Alexandrina Victoria, 1819–1901), British monarch. Born the only child of Edward, Duke of Kent, fourth son of George III, she succeeded to the throne in 1837 on the death of her uncle, George IV. Her long reign restored dignity and popularity to the British crown and may have saved the monarchy from abolition. She was devoted to her husband, Prince Albert of Saxe-Coburg-Gotha, whose advice she relied on and whose premature death she mourned for the remaining 40 years of her reign. Her most notable qualities were her devotion to duty, her strong Christian faith and her belief in family values. Her great love of Scotland prompted the acquisition of Balmoral Castle as a royal residence, which she had rebuilt in 1856 and visited almost every year until her death.[1]

Description: Seated side-saddle, with the her cloak and dress draped on either side of the horse's back, the Queen is shown with an imperial sceptre raised in her right hand and her left hand gripping the horse's reins: her crowned head is turned a little to the right. The horse is depicted as if in slow forward motion, with its left hind leg slightly advanced and the right foreleg raised. The pedestal, which is decorated with bronze Corinthian colonettes on the corners and a bronze acanthus frieze in the base moulding, has four relief panels inserted into the dado. Those at the front and rear carry inscriptions (see above), while the sides depict narratives from the Queen's visit to Glasgow in 1849. On the left (north) panel the Queen is shown being conducted into the crypt of Glasgow Cathedral by Rev. Duncan Macfarlan, the Principal of Glasgow College (now Glasgow University). The memorial to John Knox in the Necropolis (near which Macfarlan himself was later to be buried) is visible in the background. On the right panel, the Queen is shown conferring a knighthood on Provost James Anderson, using Colonel Gordon's sword in a ceremony on board the ship *Fairy*, which had brought the royal party to Glasgow from Roseneath.[2] Hermetically sealed within a cavity in the pedestal is a bottle containing a number of historical documents, including papers relating to the Queen's visit to Glasgow, Dr Strang's 'Mortality Bills for 1853' and his pamphlet *Progress of Glasgow*, a list of members of the Town Council and committees 'of the various corporate and charitable institutions of the city' and copies of the *Glasgow Courier*, the *Scottish Guardian*, the *Daily Mail* and the *Edinburgh Almamack*.[3]

Discussion: Queen Victoria's first visit to Glasgow on 14 August 1849, was considered an event of such importance that proposals for erecting a commemorative monument were being discussed within little more than a fortnight of her departure. Among the initial suggestions was the reconstruction 'in a more permanent material' of the temporary triumphal arch placed at the north end of Glasgow Bridge and its removal to a more convenient site, possibly in front of the cathedral.[4] By the end of October, however, this, along with the various other arches erected for the visit, was ordered to be taken down and the proposal was abandoned. A series of public meetings followed, during which it was decided that an equestrian monument was 'the most appropriate memorial that could be erected', and on 29 August 1850 almost exactly a year after the Queen's visit, a 'numerous committee was appointed to carry the resolution into effect'.[5] Presiding over the meeting, the historian Archibald Alison 'eloquently descanted on the personal graces of her Majesty's mind and form', and observed that by

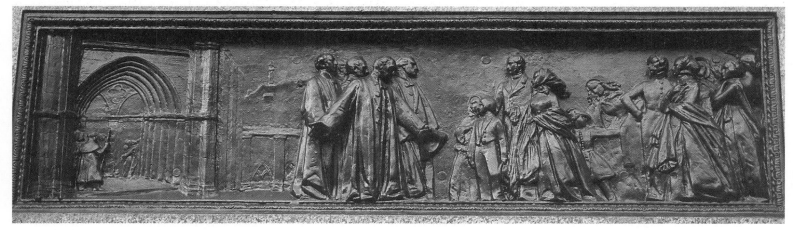

Carlo Marochetti, *Queen Victoria Conducted into the Crypt of Glasgow Cathedral* [RM]

erecting such a work Glasgow 'would have the singular felicity of possessing the first equestrian statue of a woman in Great Britain'. Twenty subscriptions of £100 and one of £200 were collected at the meeting, followed within a week by 'succesful endeavours ... to obtain smaller sums, several of 50L and under'.[6] A sub-committee was appointed under the chairmanship of the Lord Provost Sir James Anderson, who was granted an interview with Prince Albert at Buckingham Palace to discuss the proposal. It was unanimously agreed that Marochetti, whose work was admired by the Queen, should be given the commission. The contract stated that the sculptor would be bound to 'design, execute and erect the statue ... for the net proceeds of the subscriptions', and that

> ... the equestrian group and the bas reliefs [were] to be of the finest monumental bronze, the pedestal to be entirely of the best granite, of the Baron's selection; and the interior to be of good substantial mason work, or of granite as he might prefer.[7]

It was also stipulated that before being cast a full-size clay model should be presented to the committee. The model was duly inspected at Marochetti's studio by Anderson, the former Lord Provost Alexander Hastie MP, Earl Granville and Viscount Canning, who all gave it a glowing recommendation.[8]

The statue was originally erected in the centre of St Vincent Place at the junction with Buchanan Street. Marochetti himself selected the site, which required the approval of the Town Council, the police and the Statute Labour Committee.[9] The completed bronze arrived by direct steamer from London on 30 August 1854, by which time the pedestal was already in the process of being erected. The Glasgow engineer Robert Napier took charge of transporting the statue from the Broomielaw to St Vincent Place, as well as erecting it on the pedestal in preparation for its inauguration a week later.[10]

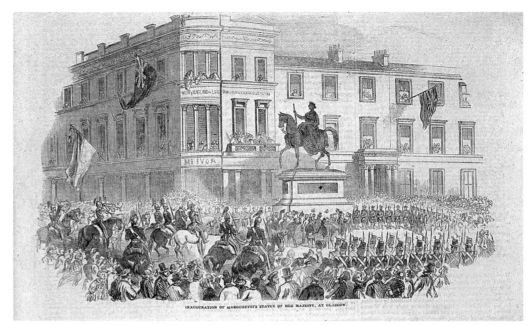

Inauguration of the *Monument to Queen Victoria*, from the *Illustrated London News*, 16 September, 1854 [MLG]

The inauguration ceremony was one of the most lavish of its kind ever staged in Glasgow and included a procession which set out from the Council Halls on Wilson Street at about midday, and made its way to St Vincent Place by a circuitous route through Queen Street, George Square, West George Street and Buchanan Street. In St Vincent Place itself, the neighbouring streets were barricaded in anticipation of the large numbers of onlookers, who began assembling as early as 10am. By the time the procession reached the site, 'every spot from which a glimpse of the statue could be obtained was densely thronged', with 'every one seemingly appearing more anxious than another to testify their loyalty to their Queen'. The populist basis of the event was underlined by several of the speakers, including James Anderson, who described the Queen's visit in 1849 as 'one of the most interesting and important events in the history of our city'. He also reminded his listeners that despite the fact that the statue had been funded by private subscription, 'it was from the first intended that this memorial should be the property of the public'. At the conclusion of the speeches, the 'covering was removed, and the statue of her Majesty presented to the thousands assembled, who testified their admiration of the noble work of art by loud and reiterated cheers'. The National Anthem was then performed 'amidst the waving of hats and handkerchiefs', followed by three cheers for Marochetti, who 'bowed his acknowledgements'. Marochetti was guest of honour at the banquet later in the day, and spoke of the warmth with which he had been treated by the people of Glasgow. 'I am proud', he concluded, 'to own my obligations to this good city, and, in returning thanks for the honour you have done me, let me give back

collectively your greetings in the motto of your city arms – "Let Glasgow Flourish".[11]

The unveiling was reported extensively in the local and the national press, with a wide range of opinions expressed regarding the statue's qualities both as a monument and as a work of art. The *Glasgow Courier* was unstinting in its praise of Marochetti's achievement, drawing attention to the special problems posed by the subject:

The first difficulty which the gifted sculptor had to contend with was the position of a female on horseback. It was essential to the composition of this group that it should possess that first quality, balance, and all who have seen the statue will unite with us in bearing testimony to the admirable manner in which the difficulty … has been overcome. The result is a well-balanced, harmonious group, admirable from every point of view … The likeness is admirable, and will convey to posterity the true features of our beloved Sovereign … The horse is admirable, capitally drawn, full of true expression, motion, and fine blood, and so arranged that with its royal burden, a compact, well-arranged composition (to speak artistically) is the result, leaving nothing to be desired… The Queen sits [on] her horse with a consciousness of her high position, with the dignity of a great sovereign, yet with the gentleness of her sex. Her steed seems proud of his royal burden; he is instinct with life and motion; and, as a work of sculpture, reminds us in one respect of the steed of the Marcus Aurelius of the Capitol, in the onward motion by which he is animated.[12]

A slightly more sober assessment was offered by the correspondent of the *Building Chronicle*, who seemed slightly bemused by the hysteria provoked by the 'great event in Glasgow':

The local papers have been in ecstasies about the superlative excellence of the composition in the management of every, even the minutest, detail; and the Lord Provost confidently pronounces it to be the greatest triumph of Baron Marochetti's genius. These laudations, we believe, are the outgoings of a pardonable feeling of patriotic pride, and indulged in because the artist's well-earned fame is deemed powerful enough to silence criticism. But the fact is, that, although the public generally are beginning to appreciate the many merits of our new statue, the first emotion on the withdrawal of the curtain on Wednesday was one of disappointment.[13]

Among the statue's many weaknesses, by far the most serious stemmed from the intractable difficulties associated with 'the placing of a *female figure* on horseback', and the unsatisfactory relationship between the horse and the rider which this entailed:

To be true to nature it was necessary that the figure of Her Majesty should be smaller in proportion to the size of the horse than is usually the case with equestrian statues. This detracts so much from the desired effect of queenly majesty and dignity that we almost wish that the sculptor had taken the liberty of idealising, and had magnified the human figure to more heroic bulk. Instead of that, the development of the bust and arms is within the truth. Any approach to grossness would, of course, be very objectionable; but, in the delicate effort to hit the happy mean, it had been better in this case that the figure had been full and round rather than that there should be any exaggeration of the prominence which, in all equestrian statues, the horse gains at the expense of the rider.[14]

Though the writer here discreetly omits to mention it in his analysis, it is worth noting that the problem was exacerbated by the fact that the Queen was physically very small – only about five feet tall.

Predictably, the Edinburgh papers were even more pointed in their criticisms, although the chauvinistic bias of the *Edinburgh Evening Post* appears to have extended beyond the traditional local rivalry between the two Scottish cities:

We must confess … that we are no admirers of the work of the Baron Marochetti: they are somewhat clipped and affected in their style and expression – more like toys on a large scale than genuine productions of masculine talent. His notions of equine points and proportions have been derived from another soil than ours – elegant in the *salon* perhaps, but far too pinched and meagre for the road, the turf, or the field. A true horseman takes no interest in such feckless-looking creatures.[15]

A recurring concern in the press coverage was the fact that Glasgow already possessed an equestrian statue by Marochetti – his *Monument to the Duke of Wellington* of 1844 in Royal Exchange Square (q.v.) – and many commentators took the opportunity to draw critical parallels between the two works. Indeed, given the fact that the route of the procession included Queen Street, and that the marchers therefore filed directly in front of the Wellington monument, it was perhaps inevitable that 'the preconceived ideas of the multitude' would be 'formed on the model' of the earlier work.[16] On this matter too, opinions were sharply divided. For the *Glasgow Courier* the two works were perfectly complementary, the effect of 'life and motion' in Queen Victoria's horse providing an ideal foil for the 'calm dignity of [Wellington's] pose and steed'.[17] By contrast, the *Building Chronicle* took a much more negative view, somewhat implausibly attributing what it regarded as the less ample treatment of Queen Victoria to the fact that Marochetti had less funds at his disposal, and was therefore forced to economise on bronze. Compared to Wellington, it argued,

'the entire erection has a pinched, contracted, and *contracted-for* appearance'. By far its most damning criticism, however, was reserved for Marochetti's decision to represent the horse with two of its legs 'elevated in a walking posture', which it regarded as no more than a display of technical virtuosity with no aesthetic or symbolic justification. Why, it asked,

… should any one go out of his way to meet difficulties, when there is no end to be gained by it unless that of confirming his fame for a gift which every one admitted him to possess. If the Baron had succeeded, in despite of a self-interposed obstacle, in producing a work of art as free from blemish as the Wellington Monument, it would be the extravagance of criticism to find fault with him because he chose to give a specimen of his ability to represent a horse in motion, having already shown how he could model a horse at rest.[18]

And this leads the writer to what he regards as the nub of the issue: the fact that Marochetti had to revert to the clumsy device of supporting

… the elevated hind leg by one of those tricks of art which cannot be used too sparingly. Glasgow prejudice cannot offend Edinburgh vanity by ridiculing the horse which sits upon its tail before the Register Office without being exposed to the retort that the steed which bears her Majesty's statue in Glasgow looks as if it had a spike in its foot. To support the left hind leg, as a prop for the group, the hoof rests upon a plant, which a jealous member of the Scottish Rights Association may discover to have a suspicious resemblance to a thistle.[19]

The detailed attention paid by the *Building Chronicle* to the raised hind leg is of interest in the present context because it is clearly at variance with the statue that exists today, which has both its hind legs placed squarely on the

plinth. That the writer was not *imagining* the raised leg and the thistle is confirmed by the woodcut of the inauguration reproduced in the *Illustrated London News* which shows the rear of the horse very much as described.[20] It should also be noted that the design of the existing pedestal differs in a number of details from the one indicated in the woodcut, which has convex rather than flat faces on the front and rear, and no bronze colonettes on the corners. These discrepencies have led one contemporary scholar to deduce that the present statue is in fact 'not the real thing, or not the thing which was put up in 1854', arguing further that Marochetti 'could not have done anything so limp as the portrait of Anna Neagle at present in the Square'.[21] If the statue is indeed a different work from the one Marochetti erected in St Vincent Place, the assumption must be that when it was moved to George Square in 1866 in order to form a pendant with the *Monument to Prince Albert* (q.v.), the council took the opportunity to replace it with an entirely new work by another sculptor. This is a fascinating theory, but one which must be discounted on several grounds. As a well-known representation of a reigning monarch by one of her own favourite sculptors the monument was a work of immense national importance – of such importance in fact that it was necessary for the council to obtain permission from the Queen herself merely to change its location.[22] It seems highly unlikely, under these circumstances, that the Council could have taken such a radical step as substituting a new work without the matter being reported in the press. It also raises the question of what became of the original statue. A simpler and much more plausible explanation is that Marochetti himself made alterations to the horse's legs to bring it into conformity with those on the Albert monument, the design of which had probably been finalised long before the decision to place the two statues side by side in George Square had been made. An entry in the council minutes

of 10 July 1868, recording a payment of £230 4s. 6d. to Marochetti as the balance of the 'expense of removing and altering the Statue of Her Majesty', seems to confirm this view.[23] Given the ferocity of the criticisms provoked by his use of the thistle and the raised leg, one suspects that Marochetti welcomed the opportunity to remove the offending detail, and thereby reaffirm his mastery of the more conservative idiom of 'a horse at rest'.

Whether or not the monument was replaced at a much later date remains a possibility, albeit an unlikely one. What should be noted, however, is that the present position of the statue does not correspond to its original location in George Square. When the Victoria and Albert monuments were first erected in the Square, they were placed in the centre, on either side of the *Monument to Sir Walter Scott*, facing south, as can be seen from numerous historic photographs of the Square.[24] They were moved to the west side of the Square in May 1924, after the construction of the Cenotaph (q.v.), and have remained there ever since.

Related work: Numerous small replicas of the statue by Marochetti exist in private and public collections, including the NGS.[25]

Condition: Good, apart from some minor damage to the bridle.

Notes
[1] EB, vol.X, p.421. [2] Duff, pp.107–8. [3] GH, 1 September 1854, p.4. [4] *Ibid.*, 3 September 1849, p.4. [5] Anon., 'The Equestrian Statue in Honour of Her Majesty's Visit to Glasgow', *ibid.*, 8 September 1854, p.6. [6] Anon., 'Notes from the Provinces', B, 7 September 1850, p.425. [7] It is not known exactly what the 'net proceeds' were, but the *Building Chronicle* states that the sum raised was 'not a third of what was obtained for that of Wellington' (16 September 1854, p.77). As the Wellington Monument cost about £10,000, it can be calculated that the funds available to Marochetti were approximately £3,000. [8] Anon., 'The Equestrian Statue of her Majesty', GH, 1 September 1854, p.7. [9] *Ibid.*, 7 August 1954, p.5. [10] *Ibid.*, 8 September 1854, p.7. [11] *Ibid.*, pp.6–7. [12] Quoted, *ibid.*, 8 September 1854, p.7. [13] 'The equestrian statue in commemoration of Her

Majesty's visit to Glasgow', BC, 16 September 1854, p.77. [14] *Ibid.*, p.78. [15] *Edinburgh Evening Post*, quoted in Anon., 'Marochetti's statue of the Queen', ILN, 16 September 1854, p.50. [16] BC, 16 September 1854, p.77. [17] Quoted, GH, 8 September 1854, p.7. [18] BC, 16 September 1854, p.78. [19] *Ibid.* The 'horse which sits upon its tail' is a reference to John Steell's equestrian monument to the Duke of Wellington, 1852, in front of Register House, Princes Street, Edinburgh. [20] Anon., 'Marochetti's statue of the Queen', ILN, 16 September 1854, pp.249–50. [21] Letter from Philip Ward-Jackson to the author, 9 March 1999. [22] GCA, C1/1/69, 2 March 1865, p.36. [23] *Ibid.*, C1/3/1, p.183. [24] See, for example, Lyall, pp.30–3. [25] Pearson, p.92 (ill.). I am grateful to Philip Ward-Jackson for drawing my attention to this work.

Other sources
B, 14 April 1855, p.173; GH, 14 August 1854, p.6, 4 September 1854, p.6; Somerville, p.62; BI, 16 May 1900, p.7; McFarlane, pp.23–4; House, p.150; Read, pp.117, 369; Teggin *et al.*, p.26 (ill.); Williamson *et al.*, pp.177–8; Pearson (ed.), p.91; McKenzie, pp.50, 51 (ill.).

On the north-east corner of George Square

Monument to James Oswald

Sculptor and founder: Baron Carlo Marochetti

Date: 1856
Re-erected: 26 September 1875
Material: bronze on a granite pedestal
Dimensions: statue approx. 2.6m high; pedestal
 approx. 3.6m high
Inscriptions: on the pedestal – ERECTED / BY / A
 FEW FRIENDS / TO / JAMES OSWALD / M.P. /
 1855 (front of dado); BARON MAROCHETTI SC
 (top left of plinth, added 1923)
Listed status: category B (4 September 1989)
Owner: Glasgow City Council

James Oswald of Auchincruive (1779–1853), Liberal politician. The son of a wealthy landowner and merchant, Oswald was a leading supporter of the movement that led to the Reform Act of 1832, and became one of the first Members of Parliament for Glasgow to be elected by manhood suffrage. A powerful orator, he represented the city in the years 1832–7 and 1839–47. In 1841 he succeeded to the family estate at Auchincruive, to which he retired after completing his second term in parliament.[1]

Description: The subject wears a frock coat and is shown striking an informal pose, with his left leg slightly advanced. His right hand is placed casually on his chest, and in his left hand he holds a walking cane and top hat.

Discussion: The monument was financed by private subscription, with contributions from Oswald's 'many personal friends and admirers', and was originally erected in Sandyford Place, off Sauchiehall Street, in 1856.[2] The reasons for its relocation are connected with the long-standing dissatisfaction among his family and supporters that the monument to his political opponent Robert Peel (q.v.) had been erected in George Square, a much more prestigious and central site, less than three years after Oswald's statue had been unveiled. In July 1875, his great nephew R.A. Oswald successfully petitioned the Council to have the monument moved to the north-east corner of the Square, in order that it should 'accord with that of Sir Robert Peel (of like character) in the north west corner'.[3] The removal work was carried out by J. & G. Mossman at a cost of £83 10s.[4]

The representation of a public figure in contemporary dress was unusual at this time, and provoked some hostile criticism. Shortly before it was moved to George Square, the *Builder* noted that there was

> … an effigy in Glasgow, representing a worthy of that city clad in frock coat with hat in hand (one of Christie's best), which is very provocative of laughter when on a wintry day he offers the spectator a hatful of snow. Far better make the monument an architectural one, and if a likeness is wanted be content with a medallion in bronze or marble, than produce such scarecrows.[5]

Carlo Marochetti, *James Oswald* [RM]

In time the monument came to be known simply as 'the Man with the Hat', and it is recorded that young boys 'in a less vicious age than at present, delighted in tossing small stones into the hat, so obligingly tilted to serve as a receptacle. From time to time workmen had to mount ladders and clear out the contents.'[6] It

has also been claimed that Joseph Conrad was invited by Neil Munro to throw a stone into the hat while they were dining in the nearby North British Hotel, in order to become an 'honorary Glaswegian'. After several attempts he succeeded, and the party returned to their dinner.[7]

Related work: Marochetti made a plaster medallion of Oswald, *c.*1847/8 (private collection, London)[8] and a portrait bust which was exhibited at the Scottish Exhibition of Arts and Manufactures Connected with Architecture in January 1856.[9] A bust of Oswald by James Fillans, and belonging to John Tennant, of St Rollox was exhibited at the Portrait Exhibition in the Corporation (now McLellan) Galleries in 1868.[10]

Condition: Good.

Notes
[1] Anon., 'Profiles of Former Directors: James Oswald (1779–1853)', GCCJ, July 1969, pp.394–5. [2] McFarlane, p.26; BI, 15 May 1900, p.18. [3] GCA, T-MJ/599, letter from Jas Bain to R.A. Oswald, 27 July 1875. [4] *Ibid.*, invoice from J. & G. Mossman, September 1875. [5] 'Public monuments and their position', B, 8 August 1874, p. 671. [6] Anon., *op. cit.*, p.394. [7] House, p.152. [8] Information from Philip Ward-Jackson. [9] GH, 2 January 1856, p.7. [10] Annan, cat. no.456.

Other sources
Somerville, p.199; BI 16 May 1900, p.17; Read, p.117; Williamson *et al.*, p. 178; McKenzie, pp.50–3 (incl. ill.).

On the north-west corner of George Square

Monument to Sir Robert Peel

Sculptor: John Mossman

Founders: Robinson & Cottam
Erected: 28 June 1859
Materials: bronze on a granite pedestal
Dimensions: statue 2.7m high; pedestal 3.66m high
Inscriptions: on the statue – J MOSSMAN. SCULP

1859 (left side of plinth); ROBINSON & COTTAM / STATUE FOUNDRY / PIMLICO (rear of plinth); on the pedestal – ROBERT PEEL (front of dado); BORN JULY 2 1788 / DIED JULY 5 1850 (rear of dado); J.MOSSMAN H.R.S.A. SC (lower right side of dado, added 1923)
Listed status: category B (15 December 1970)
Owner: Glasgow City Council

Sir Robert Peel (1788–1850), English statesman. Born near Bury, Lancs. and educated at Harrow, he studied classics and mathematics at Oxford and law at Lincoln's Inn. He entered Parliament as a Tory in 1809 and was Secretary for Ireland 1812–18, during which time he opposed Catholic emancipation and instituted the Irish constabulary. As Home Secretary from 1822, he was instrumental in the reform of the criminal law and in 1829 he introduced into London the improved Police which he had established in Ireland. Not always having the support of his own party, he proposed Catholic emancipation in 1829, and in 1832, after the passing of the Reform Act (which he had opposed), he became the leader of the Conservative Party. As Prime Minister 1834–5 and 1841–6 he introduced financial measures which brought the country out of debt, and the last act of his government was the repeal of the Corn Laws. He died after being thrown from his horse while riding on Constitution Hill.[1]

Description: Peel is shown 'in a standing attitude, with a parliamentary paper in his hand, as if in the act of commencing to speak' to the House of Commons, and with an expression of 'high intellectual activity, and indomitable strength of will under an aspect of majestic repose'.[2] Mossman's representation of the subject wearing contemporary dress was regarded as a particularly innovative aspect of the work, and his success in adapting 'modern habiliments to the requirements of sculpture'[3] was widely admired. 'We have never seen', the *Glasgow Herald* noted

... in any work of sculpture, the disadvantages of modern costume more sucessfully overcome. [The subject] is attired in a plain frock coat but the folds are so carefully arranged as to exhibit an outline of truly classic grace. From the fine pose of the head, the absence of whiskers, and the simple

John Mossman, *Robert Peel* [RM]

cravat round the neck without shirt collar, there is nothing of the merely conventional or vulgar.[4]

Discussion: The decision to erect a monument to Sir Robert Peel in Glasgow was made at a public meeting in the Trades Hall, attended by 'men differing very much in their political views', but 'unanimous in acknowledging that he had conferred great benefit on his country'. The date of the meeting is not known – the *Glasgow Herald* merely notes that it was 'shortly after' Peel's death – but the award of the commission to Mossman was not made until the committee had taken the opportunity to examine a number of monuments to Peel already erected other parts of the country,[5] and which may have included the marble statue by Alexander Handyside Ritchie in Montrose, erected in 1852.

This was to be Mossman's first statue in bronze – in fact the first major public commission in Glasgow awarded to any sculptor from the west of Scotland – and the committee appears to have been conscious of the element of risk involved in entrusting the work to a local artist. For Mossman, too, it was a crucial moment in his career:

Mr Mossman, although he had not executed any great monument, had a very considerable reputation as a sculptor; and he entered upon the execution of the Peel statue knowing that it would make or mar his reputation. He has devoted all his energy to the execution of the work.[6]

By April 1855 the architect James Wylson was able to report in the *Builder* that the head, which 'presents an excellent, characteristic likeness', as well as a small model of the figure, had been completed in plaster.[7] In December of the same year the committee held two meetings in Mossman's studio at 83 North Frederick Street, and suggested a number of alterations.[8] When these were carried out the committee

… expressed their entire satisfaction with the model, which they accordingly adopted, and gave instructions to the sculptor to proceed with the stucco cast, with the view to having the statue finished without delay. This will occupy him between four and five months.[9]

Subscribers were given an opportunity to inspect the model in Mossman's studio during the two days following the visit.

The committee's hope that the statue would be 'finished without delay' proved to be over-optimistic, and the casting was not begun until January 1859.[10] It was at this time that the decision was made to site the monument at the north-west corner of George Square, 'corresponding with the statue of James Watt' (q.v.) on the opposite corner.[11] There was to be a further delay before the statue was finally erected, which the *Builder* attributed, somewhat skeptically, to a 'want of marble for the pedestal'.[12] On 25 June 1859, however, the same journal reported that workmen were 'busy in the erection of the pedestal', and three days later the monument was ready for inauguration. In his speech at the ceremony, the MP Walter Buchanan said that 'it was a matter of congratulation to the committee of subscribers that they could select a Glasgow artist' and that 'it would be most gratifying … if [Mossman's] first great attempt should lead hereafter to further eminence'.[13] At a banquet on the same evening, Mossman is reported as stating that

… from the commencement of the undertaking he had felt very deeply the responsibility to produce a work worthy of the subject, and he felt all the deeper obligation laid upon him from the fact that the employment of sculptors might be encouraged or discouraged in proportion to the success of the statue.[14]

The pedestal was designed by Mossman's close associate, the architect Alexander 'Greek' Thomson. According to Thomas Gildard both Thomson and Mossman wanted to omit the

'cope and cornice', but were overruled by the committee who 'knew better than the sculptor and the architect'.[15]

Despite the general approval of the statue as a work of art, the monument was for many years the focus of anti-Tory sentiment in Glasgow, and when Professor John Nichol referred to it in his speech at the inauguration of the *Monument to Thomas Campbell* (q.v.) as an earlier work by Mossman, his remarks were greeted by hisses from the crowd.[16] The erection of the monument in such a prestigious location was also a source of discontent among the descendants of the radical MP James Oswald, whose monument was moved from Sandyford Place to the north-east corner of George Square as a result of their lobbying (see *Monument to James Oswald*, above).

Related work: A bust of Peel by Mossman, 'taken from the Peel Statue constructed by the talented sculptor', was exhibited in 1855 at the Scottish Exhibition of Arts and Manufactures Connected with Architecture, organised by the Glasgow Institute of Architecture, in Bath Street, Glasgow.[17] Mossman also included a medallion portrait of Peel as a symbol of Politics on the façade of the former Queen's Rooms, 1 La Belle Place (q.v.).

Condition: Good.

Notes
[1] EB, vol.13, pp.1106–8. [2] GH, 4 June 1855, p.7; B, 25 June 1859, p.429. [3] GH, 29 June 1859, p.3. [4] *Ibid.*, 4 June 1855, p.7. [5] *Ibid.*, 29 June 1859, p.3. [6] *Ibid.* [7] B, 14 April 1855, p.173. [8] GH, 14 December 1855, p.4. [9] *Ibid.*, 28 December 1855, p.4. [10] B, 29 January 1859, p.82. [11] *Ibid.* [12] *Ibid.*, 25 June 1859, p.429. [13] GH, 29 June 1859, p.3. [14] *Ibid.* [15] Gildard (1892), p.10. [16] GH, 29 December 1877, p.5. [17] *Ibid.*, 2 January 1856, p.7.

Other sources
BN, 10 June 1859, p.546; Anon., 'Men you know – No. 105', *Bailie*, no.105, 21 October 1874, pp.1–2; Somerville, p.156; Gildard (1892), pp.2, 9; BI, 16 May 1900, p.17; McFarlane, p.25; Read, p.117, (incl. ill.); Williamson *et al.*, p.178; Pearson, pp.91, 93 (incl. ill); McKenzie, p.50.

Equestrian Monument to Prince Albert

Sculptor and founder: Baron Carlo Marochetti

Date: 1863–6
Inaugurated: 18 October 1866
Materials: bronze statue and reliefs on a granite pedestal
Dimensions: statue 2.44m high on a 2.74m × 1.22m plinth; reliefs 61cm × 2.14m and 61cm × 61cm
Inscriptions: in bronze relief on the dado – ALBERT / PRINCE / CONSORT (front, enclosed in a wreath); A (rear, enclosed in a wreath and surmounted by a crown); on the plinth – BARON CARLO MAROCHETTI. R.A. (lower left side of dado, added 1923)
Listed status: category A (15 December 1970)
Owner: Glasgow City Council

Albert of Saxe-Coburg-Gotha (born Francis Charles Augustus Albert Emmanuel, 1819–61), prince consort of Queen Victoria and father of King Edward VII. Born at Rosenau near Coburg, second son of the Duke of Saxe-Coberg-Gotha and a direct cousin of Queen Victoria, he was educated at Coburg and at Bonn University. He first met Victoria in 1836 and was married to her on 10 February 1840. He did not take an active part in British politics, but was a great influence on the Queen, being devoted to the patronage of the arts, science, architecture and social reform. Two projects carried out at his suggestion were the Great Exhibition of 1851 and the establishment of the South Kensington Museum in 1857. He died of typhoid fever.[1]

Description: In its report on the inauguration, the *Glasgow Herald* describes the statue as follows:

With regard to this work of art it seems to be generally admitted that an excellent likeness has been secured. His Royal Highness is represented in a military uniform, bestriding a charger, which he reins with his left hand, while his right, holding a plumed hat, falls in easy posture by his side. The figure of the horse is designed similarly to that on which the Queen's statue is mounted; the chief difference being that in the new work the animal is thrown into a curveting attitude, with ears turned backwards and neck finely arched.[2]

The report omits to mention that the legs of the Queen's horse were modified in order to match those of the new work (see *Equestrian Monument to Queen Victoria*, above). The pedestal is also identical to that of the Queen Victoria monument, with grey granite in the plinth, red granite in the dado, bronze corinthian colonettes at the corners and a bronze acanthus frieze in the base moulding. There are four bronze reliefs on the pedestal. The front and rear panels carry inscriptions (see above). The right (south) panel depicts figures 'illustrative of the industrial arts': the two central figures represent *Education* and *Industry* and are shown reclining on a locomotive; the outer figures are personifications of *Agriculture* and *Commerce*. The left (north) panel has a composition of figures emblematic of the fine arts: *Music*, *Painting*, *Sculpture* and *Architecture*. Inside the pedestal is a bottle containing 'copies of the local newspapers, minutes of the Memorial Committee, and other documents'.[3]

Discussion: The first meeting concerned with the possibility of erecting a monument to Prince Albert was called by the Lord Provost Peter Clouston in February 1862, 'in compliance with the wishes of many influential citizens'. At the time, the death of the prince was 'fresh in the public mind', and it was felt that a great industrial community like Glasgow

was under an obligation to 'commemorate a Prince who had lent his influence in many ways towards the advancement of the national prosperity'. Donations amounting to £2,700 were received, and a sub-committee was appointed to discuss the procurement of plans and a suitable site.[4] The debate concerning the form the monument should take was wide-ranging. Among the possibilities considered were an ornamental building in the centre of George Square (proposed by former Lord Provost Sir James Anderson); a 'useful public institution' such as a 'school of Arts, as it was to do in London'; and a building similar to the Temple of Theseus in Athens, containing a statue of Albert. The latter proposal was submitted by the architect Alexander 'Greek' Thomson, who intended that it should be erected in the West End (now Kelvingrove) Park.[5] A further meeting was held in February of the following year, by which time the subscriptions had increased to £6,000, and it was at this point that the idea of an equestrian statue was was first proposed.[6] There were some objections to this, on the grounds that a horse and rider group had militaristic overtones that were out of keeping with Albert's commitment to the arts of peace, and the *Glasgow Citizen* concluded that as an embodiment of his 'character and life' such a monument 'must be altogether a failure'.[7] The decisive factor, however, was the opinion of the Queen, who expressed a strong preference for the depiction of Albert on horseback. It was also at her suggestion that Marochetti, whose earlier works in Glasgow included her own equestrian monument (see above) as well as that of the Duke of Wellington (q.v., Royal Exchange Square), was awarded the commission.[8]

The question of where the statue was to be erected was not settled until Marochetti's work on the design was well under way. Serious consideration was given to the possibility of creating an entirely new site for it in St George's (now Nelson Mandela) Place by

demolishing St George's Tron Church, with Provost Clouston proposing that the £13,000 required for this be raised by levying rates on the 'various properties between Hope Street and George Square, according to a graduated scale'.[9] There were, however, too many objections to this, and the proposal was abandoned. Turning their attention next to George Square, the sub-committee once again encountered resistance from neighbouring property owners, but an enquiry in the Burgh records confirmed that the ground belonged entirely to the council, and that they were within their rights to make whatever alterations they pleased. The result was an extensive remodelling of the Square (see Introduction, above). The Albert monument was placed in the centre of the eastern half of the Square, facing south, with Marochetti's earlier *Equestrian Monument to Queen Victoria* relocated from St Vincent Place to form a pendant on the opposite side of the Scott monument.[10] The removal of the statue of Queen Victoria required the approval of the Queen herself, and its new status as part of a symmetrical pair necessitated alterations to the pedestal and the horse's legs (see fuller discussion above).

The inauguration took place on Thursday, 18 October 1866, with the unveiling performed by the Queen's second son Alfred, the Duke of Edinburgh, who was granted the freedom of the city. The committee had hoped that the Queen herself would be able to attend the ceremony, but when this proved to be 'out of the question', the 'substitution of a Prince of the blood was joyfully welcomed'. For the occasion George Square was decorated by Wylie & Lochhead with festoons of evergreens forming 'a sort of sylvan colonnade', and despite the appalling weather, the Square and neighbouring streets were thronged with many thousands of

Carlo Marochetti, *Prince Albert* **and** *Queen Victoria*

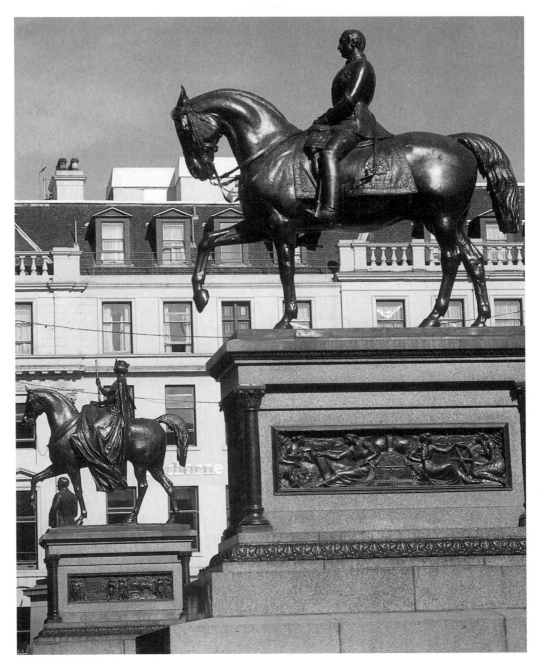

spectators.[11] Despite earlier reservations about the appropriateness of the equestrian form, the finished statue was recognised as a good likeness and a successful embodiment of the 'calm, simple, and at the same time dignified nature of the subject'.[12]

Related work: During the period in which the monument was being executed Marochetti was also engaged on the commission to produce a seated statue of Prince Albert for the Albert Memorial in London. When this was rejected he apparently tried to persuade the architect Gilbert Scott to accept in its place 'the cast of an equestrian Albert that he just happened to have in his studio – probably the Glasgow one'.[13] Scott rejected the proposal on the grounds that 'an equestrian figure was inconsistent with the general design and object of the Memorial'. In 1888, however, the Queen ordered a replica of the statue to be erected in Windsor Great Park, London, as an expression of 'her great pleasure in the Women's Jubilee Offering'.[14] A miniature copy of the statue also exists in the collection of the Duke of Argyle, Inveraray Castle. The statue was moved to its present location in May 1924, as part of the major alterations made to the Square during the construction of the Cenotaph.[15] There appears, however, to have been some doubt as to whether it would be retained. In its report on the alterations, the *Glasgow Herald* described the statue as 'being stored meantime until it is decided if it is to be re-erected', noting ironically that 'the Glaswegian of the future may have to travel to Windsor and content himself with the replica'.[16]

Condition: Good.

Notes
[1] EB, vol.I, p.200. [2] Anon., 'Inauguration of the Prince Consort memorial', GH, 19 October 1866, p.4. [3] *Ibid.* [4] *Ibid.* [5] *Ibid.*; 'Albert Memorials', B, 6 December 1862, p.870; 'The Glasgow Memorial to the Prince Consort', BN, 12 December 1862, p.460. [6] GH, 19 October 1866, p.4. [7] *Glasgow Citizen*, 1 March 1862, p.3, quoted in Darby and Smith, p.74. [8] GH, 19 October 1866, p.4. [9] Anon., 'The improvements on George Square', *Ibid.*, 18 October

1866, p.2. [10] This arrangement is clearly visible in many nineteenth-century photographs. See, for example, Lyall, pp.30–3. [11] Anon., 'Inauguration of the Prince Consort memorial', GH, 19 October 1866, p.4. [12] *Morning Journal*, 19 October 1866, p.2, quoted in Darby and Smith, p.76. [13] Ben Read, in Chris Brooks (ed.), *The Albert Memorial*, New Haven and London, 2000, p.187. [14] GH, 15 May 1924, p.8. [15] A contemporary photograph of the statue being hoisted from its pedestal is reproduced in ET, 'Millennium Memories' supplement, 30 June 1999, p.5. [16] GH, 15 May 1924, p.8.

Other sources
GH, 9 October 1866, p.2; GCA, C1/3/1, p.54; Somerville, p.62; BI, 16 May 1900, p.17; McFarlane, pp.23–4; Read, p.117; Williamson *et al.*, p.177–8; McKenzie, pp.50, 51 (ill.).

On the south side of George Square, a few yards east of the centre

Monument to Field Marshal Lord Clyde

Sculptor: John Henry Foley

Founder: Elkington & Co.
Date: 1867
Inaugurated: 5 August 1868
Materials: bronze on a granite pedestal
Dimensions: statue approx. 2.5m high; pedestal approx. 3m high
Inscriptions: on the statue – J. H. FOLEY RA Sculpr / LONDON 1867 (right side of plinth); ELKINGTON & CO / FOUNDERS (rear of plinth); on the pedestal – FIELD MARSHALL LORD CLYDE / G.C.B.: K.S.I. BORN IN GLASGOW 20. OCTOBER 1792 / THIS MEMORIAL / OF HIS DISTINGUISHED MILITARY SE[R]VICES / IS ERECTED BY / HIS FELLOW CITIZENS 186[7] (front of dado); J. H. FOLEY R.A. SC (lower left side of dado, added 1923)
Listed status: category B (15 December 1970)
Owner: Glasgow City Council

Colin Campbell, Lord Clyde (1792–1863), military leader. Born (as Colin McLiver) in Glasgow, son of a joiner, and educated at the

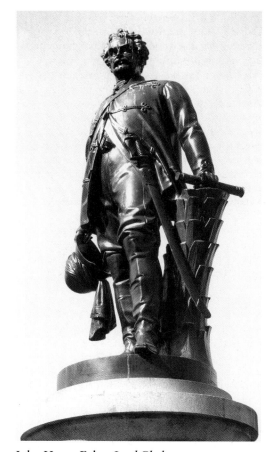

John Henry Foley, *Lord Clyde*

Grammar School, he entered the 9th Regiment of Foot as an ensign at the age of fifteen. He fought in the Peninsular War under Sir John Moore, being severely wounded at San Sebastian. During a long period of garrison duty in America, Gibraltar, Barbados and Demerara he reached the rank of Major. After campaigns in China (1832) and India (1848), he took part in the Crimean War as Field Marshall, his most famous exploit being his command of the 'Thin Red Line' of the 42nd Black Watch,

which repulsed the Russians at the Battle of Balaclava in September 1854. In 1857 he was Commander-in-Chief of the Indian Army during the Mutiny and during a series of brilliant operations he took part in the relief of Lucknow. Nicknamed 'Old Careful' because of his concern for the well-being of the men under his command, he was raised to the peerage in 1858, with a pension of £200 a year. Much liked by Queen Victoria, he died at Chatham, and was buried in Westminster Abbey.[1]

Description: In its report on the inauguration, the *Glasgow Herald* describes Lord Clyde as being represented

> … in a standing posture, with his left foot thrown forward. He is attired in a short, loose tunic, apparently a sort of military undress, the legs being encased in heavy riding boots rising above the knee, and into which the trousers are tucked. The left hand, grasping a telescope, rests on the stump of a palm tree, designed, no doubt, to suggest the scene of the hero's crowning triumph; while the right hand hangs by the side, holding a sort of helmet cap, encircled with the veil so necessary in Indian campaigning. A belt, which seems intended for slinging the telescope, crosses the left shoulder, and from the left side depends a sword, the baldric which supports it being concealed under the tunic.[2]

A separate article in the same edition of the newspaper provides the following additional details:

> The hero of Lucknow is represented … with the chest expanded and the head thrown slightly backwards. The manliness, vigour and elasticity of the frame are more those of Sir Colin Campbell of twenty years ago, than Lord Clyde, the conquerer of the Indian Mutiny. Altogether it is one of the finest bronze figures in Glasgow, and in every way worthy of Mr. Foley the sculptor,

and of the city for which it is executed. The likeness is wonderfully accurate, as shown in the striking character of the features – from that mixture of grimness and care and eminent intelligence which mark the face of the statue, and which, it is easy seeing, are reproductions from the living visage of the hero.[3]

The pedestal consists of a tapered cylindrical dado on a square plinth, and is identical to that used by Flaxman on the neighbouring *Monument to Sir John Moore* (q.v.)

Discussion: Plans to erect a monument to Lord Clyde were initiated at a public meeting in the Merchants' Hall soon after his death, and the commission was offered to 'Mr. J.H. Foley, of London' without a competition. Various suggestions were put forward regarding both the form the monument should take and its location. Equestrian and non-figurative monuments were considered, and the proposed sites ranged from the west door of Glasgow Cathedral to the West End (now Kelvingrove) Park beside the guns captured from the Russians in the Crimean War. The most radical proposal was that a statue of Clyde should be erected beside Marochetti's *Monument to the Duke of Wellington* in Exchange Square (q.v.), with Flaxman's *Monument to Sir John Moore* (q.v.) moved from George Square to form a trio of Britain's greatest military leaders.[4] In the event, a more modest arrangement was settled upon, with a standing figure conceived as a 'suitable companion' to Flaxman's statue in George Square. It was, however, necessary to move the Moore monument 'a little to the westward, in order to admit of a symmetrical arrangement',[5] a matter which was to cause some public disquiet (see below). In February 1868, the council authorised work to begin on the preparation of the site, after receiving word from Foley that the statue would be 'out of the moulder's hands in two months … and would probably be in Glasgow a fortnight

afterwards'.[6] The unveiling ceremony in the following August was performed by Sir James Campbell.

Once erected, the statue prompted mixed reactions. The correspondent of the *Building News*, for example, was scathing:

> After a tedious delay the statue of Lord Clyde has been placed upon its pedestal. From not only the reputation of its sculptor, Foley of London, but from evidence of his genius, as seen in a model of Burke, lately shown in our Fine Art Exhibition, something great was expected. It is a statue that may 'please the million', but I am not sure that it will altogether satisfy the fit few who are versed in not only the canons but the associations of art. The treatment is eminently realistic, and there is a melodramatic, not to say 'bumptious', air about it, which is as alien to the highest class of art as it was to the character of the modest-minded soldier whose services it seeks to commemorate. This may perhaps arise in some degree from a slight anachronism. The accessories all indicate the brief but brilliant career in India, while the face and the whole bearing of the statue point to a period fully twenty years earlier. In especially artistic repose Foley's Lord Clyde cannot for a moment be compared with the statue it has displaced, the Sir John Moore of Flaxman.[7]

A slightly more conciliatory line was taken by the *Builder*, although the somewhat grudging observation that the statue was, if nothing else, at least good value for money, suggests that it was written by the same correspondent:

> Whatever the value of the Lord Clyde statue as an expression of British art, the results otherwise cannot fail to be satisfactory to the subscribers. The amount contributed was, with its interest, £2,350 0s. 3d.; and after

£1,200 was paid for the figure, £398 7s. 2d. for the foundation and pedestal, and some indefinite sum for petty expenses, there was left a balance of £656 16s. 10d. Of this £94 10s. was presented to the secretaries, city architect, and treasurer's clerk; 5s. per pound returned to the subscribers, and the remainder was given to the Royal Infirmary.[8]

By far the most topical issue in relation to the monument, however, was the choice of site, and the resulting need to relocate the existing statue of Sir John Moore. In its report on the Council meeting in which the proposal was approved, the *Glasgow Herald* inaccurately stated that the magistrates had authorised 'the removal of the statue of Sir John Moore to *another side* of George Square'.[9] This provoked an immediate protest from a number of elderly residents who saw it as a slur on the memory of Sir John Moore and those who had served under him. Writing under the pen-name of 'an Indignant Citizen', one reader of the *Glasgow Herald* described how he was

... surprised, in fact I should say shocked, at the cool effrontery of some parties who, without the slightest discussion, propose to remove the statue of the hero of Corunna to the other side of George Square to make room for the forthcoming memorial to Lord Clyde. The statue to the memory of Sir John Moore was placed in its present site by the citizens in 1817 [*sic*], in the faith that it would be allowed to stand there in all time coming; few of the then subscribers are now among us and likely enough these few have little influence with the Town Councillors. Shame upon the subscribers to the Clyde Memorial to take so mean an advantage. The statue to Moore was the first in George Square, as a work of art it has few rivals. Of the character of the statue of Clyde we know nothing. These points are worthy of consideration. John Moore was 'slain in battle'; Colin Campbell, Lord Clyde, died in

his bed. Sir John was buried with his 'martial cloak around him'

'Slowly and sadly we laid him down, From the field of his fame fresh and gory'.

Sir Colin's obsequies were attended by his newly formed aristocratic friends, among whom his vast wealth was divided. Altogether, the incidents in the career of Sir John Moore are greatly more touching than those regarding Lord Clyde; and most assuredly the citizens of Glasgow have as much cause to be as proud of the soldier who defeated [Marshal] Soult, and who brought his army triumphantly through great difficulties and in the face of the great Napoleon, as of him who defeated a few Indian chiefs. I trust the proposed piece of vandalism will never be carried out.[10]

No less forthright were the views of 'A Citizen Seer', who wrote to the editor a few days later:

It is just to-day that I have observed the intention of altering the position of the statue of Sir John Moore, to make way for that of Lord Clyde. Many strange things happen now-a-days ... Are we to ignore the taste of the last generation? I hope not; chivalry forbids it. Lord Clyde, was he living, would himself, notwithstanding his connections with Glasgow, have protested against a move so Vandal-like. The code of honour forbids it. In no history will you see one hero supplanting the position of another, or if so, it is that of a conqueror over a fallen adversary. This is not the case in this matter. Both in their day did well – this one not being beyond the other in merit – the proportions of which we will not attempt to discriminate upon. The most beautiful piece of statuary ever presented is that of Sir John Moore, and it is not well kept, considering that it is public property. As a native of Glasgow, I protest against

such barbaric taste, and hope, if you have any feeling of veneration – the object in view – you will council another arrangement.[11]

In fact no such 'council' was necessary, as it was never the intention of the subscribers to 'supplant' the Moore statue in the way described here. Nevertheless, the subscription committee appears to have been stung by the ferocity of these criticisms, and in a letter of their own to the *Glasgow Herald*, the joint secretaries of the subscription committee, William Watson and Andrew Bannatyne, attempted to set the record straight:

Sir, – There have been some letters in the newspapers lately as to the removal of Sir John Moore's statue, written under entire misapprehension of what is proposed to be done. The first we shall notice is the belief that Sir John Moore's statue is to be removed to 'the other side' of George Square. Such an idea was never thought of. The second error is committed by your correspondent of this morning, who seems to think that Lord Clyde is to usurp the place of Sir John Moore. There is no such intention. What is proposed is to remove the statue a few yards to the west, so as to enable the statues, representing two of the most distinguished warriors of this century, both natives of Glasgow, to stand facing the south, the proper exposure for a statue. [...] We write only to obviate any misapprehension that may result from the imperfect information of your correspondents.[12]

Imperfect as their information may have been, the views of these independent commentators are worth quoting at length because they provide an unusually detailed insight into Victorian perceptions of the meaning of public monuments, in particular the very special considerations that accompany the representation of military figures. The apparent seriousness of the debate surrounding the

precise location of the Moore statue also provides an ironic sequel to the difficulties experienced by the subscribers in having the monument erected in the first place (see above). It seems reasonable to assume that the 'Indignant Citizen' and the 'Citizen Seer' were sufficiently molified by Watson and Bannatyne's explanation to allow the matter to rest. By 1891, John Somerville was was able to note the 'fitting appropriateness' of the statue of the younger soldier being placed near that of 'his first great chief'.[13]

Related work: Foley exhibited a 'model of the head of the statue of Lord Clyde, to be erected in George Square' at a portrait exhibition held in the then recently opened Corporation (now McLellan) Galleries on Sauchiehall Street in 1868.[14] 'It is,' commented the correspondent of the *Building News*, '(in an art sense) broad, simple, and heroic, and wholly dwarfs the rival busts by [George Gamon?] Adams and [George Edwin] Ewing'.[15] A painting of Lord Clyde by Henry W. Phillips was included in the same exhibition (cat. no.328). There were, however, no other sculptural portraits in the exhibition, and the work by Ewing referred to here may have been the bust shown at the RSA in 1863 (no.810).[16]

Notes
[1] EB, vol.II, p.1014. [2] GH, 6 August 1868, p.6. [3] *Ibid.*, p.4. [4] GG, 22 August 1863, p.4. [5] *Ibid.*, p.6. [6] 'Town Council Proceedings', GH, 7 February 1868, p.6. [7] BN, 11 September, p.614. [8] B, 23 October 1868, p.716. [9] 'Town Council Proceedings', GH, 7 February 1868, p.6, italics added. [10] *Ibid.*, 8 February 1868, p.8. [11] *Ibid.*, 10 February 1868, p.6. *Building News*, 6 March 1868, p.160, also notes that 'letters to the editor' were received on the subject by writers describing themselves as 'A Constant Reader' and 'A Peninsular Veteran'. These have not been traced. [12] GH, 11 February 1868, p.2. [13] Somerville, p.187. [14] *Illustrated Catalogue of the Exhibition of Portraits on loan in the New Galleries of Art, Corporation Buildings, Sauchiehall Street*, Glasgow, 1868, cat. no.439a. [15] 'Gossip from Glasgow', BN, 11 September 1868, p.614. [16] Laperriere, vol.2, p.20.

Other sources
GCA, C1/3/1, p.36; BN, 23 October 1868, p.716; B, 9 July 1898, p.220; McFarlane, pp.31–3; Read, p.117; Teggin *et al.*, p.27 (ill.); Williamson *et al.*, p.177; McKenzie, pp.48 (ill.), 49.

In a flower bed on the south-east corner of George Square

Monument to Thomas Graham
Sculptor: William Brodie

Founder: R. Masefield & Co., Chelsea
Date: 1871
Unveiled: 6 June 1872
Materials: bronze on a grey granite pedestal
Dimensions: statue approx. 2.1m high; pedestal approx. 3.66m high
Inscriptions: on the statue – Wᵐ BRODIE R.S.A. / SC. / 1871 / R MASEFIELD & CO / FOUNDERS (right, under chair seat); on the pedestal – THOMAS GRAHAM. / 1805 1869 (front of dado), Wᵐ BRODIE R.S.A. Sc (lower right side of dado, added 1923)
Listed status: category B (4 September 1989)
Owner: Glasgow City Council

Thomas Graham, (1805–69), chemist. Born in Glasgow, the son of a merchant, he entered the University with the intention of becoming a minister. After graduating in 1826, he went on to study chemistry at Edinburgh University under Professor Hope. After two years spent in Hope's laboratory he worked successively as a lecturer at the Mechanics' Institute in Glasgow, as Professor of Chemistry at the Andersonian Institution (where he taught David Livingstone) and in the Chair of Chemistry at University College, London (1837–55). He then became Master of the Mint, a post which he held until his death. Throughout his life he continued his researches, his best known work being in the field of diffusion of gases, and to which he contributed 'Graham's Law'. Often referred to as 'the father of colloid chemistry', his publications included *Elements of Chemistry*

(1837) and *Chemical and Physical Researches* (published posthumously in 1876). He also made important discoveries about the composition of meteorites.[1]

Description: The subject is seated in a sabre leg chair, similar in style to that of the earlier *Monument to James Watt* (q.v.) on the opposite corner of the Square, wearing the robes of a Doctor of Civil Law of the University of Oxford. His right hand supports his chin and his arm rests on a book, the cover of which shows a glass retort and other experimental equipment. Brodie achieved what a contemporary described as an 'admirable' likeness of Graham by studying photographs as well as a painted portait by George Frederick Watts. The pedestal, which is made of granite

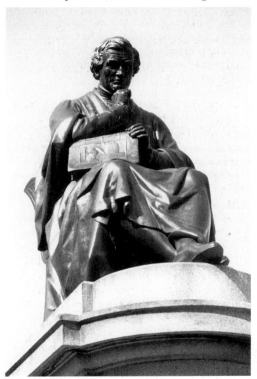

William Brodie, *Thomas Graham*

from the quarries of Shearer, Smith & Co., Dalbeattie, has half-cylinder projections on the front and rear of the dado and a square plinth.[2]

Discussion: As with the monument to David Livingstone in Cathedral Square (q.v.), the statue was erected at the expense of the industrialist James Young, of Kelly, 'in token of long personal friendship',[3] and donated to the Council 'on behalf of the City as the property of the public in all time coming'. A former student of Graham's, Young had achieved wealth and fame through the commercial production of paraffin. In accordance with his wishes the unveiling was conducted without public ceremony.

Related work: A commemorative medal with a portrait of Graham by J.W. Minton was struck by the Philosophical Society of Glasgow, in tribute to his services as Vice-President. A specimen, believed to be the only surviving example, is in the collection of the University of Strathclyde.[4] There is also a plaster bust of him in HAG (GLAHA 44215).

Condition: Good.

Notes
[1] R. Angus Smith, *Life and Works of Graham*, Glasgow, 1884; Edith Frame, 'Thomas Graham: a Centenary Account', *Philosophical Journal*, vol.7 no.2, 1970, pp.116–27; Somerville, p.188. [2] GH, 7 June 1872, p.4. [3] McFarlane, p.23. [4] Frame, *op. cit.*, p.126.

Other sources
BI, 16 May 1900, p.17; McFarlane, p.22; Teggin *et al.*, p.27 (ill.); Read, p.117; Williamson *et al.*, p.177; McKenzie, p.49.

On the south side of George Square, a few yards south-west of the Monument to Sir Walter Scott

Monument to Robert Burns

Sculptors: George Edwin Ewing, assisted by Francis Leslie (statue); James Alexander Ewing (reliefs)

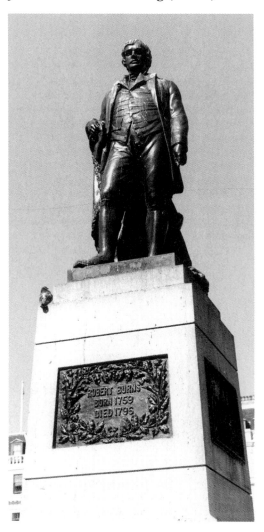

George Edwin Ewing, *Robert Burns*

Founders: Cox & Sons (statue); J.C. Wilson & Co. (reliefs)
Pedestal by Meldrum Brothers, Dumfries
Date: 1876–7 (statue); 1885–7 (reliefs)
Unveiled: 25 January 1877
Materials: bronze on a granite pedestal
Dimensions: statue 2.74m high; pedestal 3.66m high; reliefs approx. 66cm × 97cm
Inscriptions: on the statue – EWING FECIT. 1876 (left side of plinth); COX & SONS ART FOUNDERS LONDON (right side of plinth); on the pedestal – ROBERT BURNS / BORN 1759 / DIED 1796 (front relief panel, ornamented with thistles and holly); G. E. EWING (lower right side of dado, added 1923); on the right narrative panel – J A EWING
Listed status: category B (15 December 1970)
Owner: Glasgow City Council

Robert Burns (1759–96), Scotland's national poet. The son of an impoverished Ayrshire farmer, he rebelled as a youth against the conservative social order of his day, and later made social inequality and the abuse of power a major concern in his writing. He began composing poetry in 1783, publishing *Poems, Chiefly in the Scottish Dialect* in 1786. He became an excise officer in 1789 and moved to Dumfries two years later. In addition to his love poetry and his narrative poems on political themes he also wrote numerous folk songs. Many of these were based on his research into traditional Scottish folk music, and published in James Johnson's *Scots Musical Museum* (1787–1803). His unique standing as a poet is reflected in the celebratory 'Burns Suppers', which still take place annually in many parts of the world on the anniversary of his birth.[1]

Description: Burns is represented as a 'superior Scottish peasant', with his '... broad Kilmarnock bonnet half crushed in the hollow of his right elbow, and holding the "wee crimson-tipped flower" in his hand, in an easy and graceful attitude of poetic contemplation.'[2] Dressed in a frock-coat, waistcoat and knee-

breeches, the figure is supported from behind by a pillar concealed by a folded plaid, with thistles growing from the rear. The founders, Cox & Sons, described the cast of the statue as 'one of the most perfect they had ever produced'.[3] On the pedestal there are three panels depicting scenes from his best-known poems: a cottage interior from 'The Cottar's Saturday Night' (left); the poet being crowned, from 'The Vision' (rear); revelries at Alloway Kirk, from 'Tam O'Shanter' (right). A planned panel of 'The Twa Dogs' was not carried out.[4]

Discussion: In its report on the inauguration of this statue, the *Glasgow Herald* noted that the monument

> … had its origins in a suggestion contained in the *Glasgow Evening Citizen*, that a statue of Burns should be erected in Glasgow. Practical form was given to the suggestion by a gentleman who proposed [that] a subscription by the people should be limited to one shilling per subscriber.[5]

The gentleman in question was probably William Wilson, a merchant and magistrate in Glasgow, and his idea seems to have been highly successful, attracting around 40,000 contributors, and eventually realising a fund of approximately £2,000.[6] Subscribers were mostly from Glasgow but also included residents of other towns in the west of Scotland as well as 'Scotsmen in distant parts of the world'.[7] The fund was administered by a committee chaired by Wilson, and included the architect James Salmon, the City Architect John Carrick and Dr James Hedderwicke, the 'esteemed editor of the *Citizen*'[8], who 'advertised [the subscription] daily without charge'.[9]

Burns' unique popularity, together with the unusual nature of the subscription scheme, ensured that the development of the project was closely monitored by the national as well as the local press, and there were few important aspects of it that were not the subject of ongoing public scrutiny and debate. For the correspondent of the *Building News* the first question to be asked was whether such a monument either desirable or appropriate in Glasgow:

> What form the monument may take has not yet been discussed by those chiefly interested, but a writer in the *Newcastle Chronicle* has kindly obliged us with a few hints. He says:- 'I was glad to learn that Glasgow is about to put Edinburgh to shame in one particular at least. Every one who has visited Edinburgh knows what a miserable monument to the national poet of Scotland, Robert Burns, is allowed to disfigure Calton-hill. It is indeed the opprobium of Scotland that the metropolis of the kingdom should be so disgraced. The Glasgow folk are raising a fund by shilling subscription wherewith to erect a worthy monument to Burns in S. George's-square [*sic*].' The only monument now possible in George-square, supposing a site in George-square is to be sought, and the authorities to grant it, is a statue. Now, the 'miserable monument that is allowed to disfigure Calton-hill', 'the opprobium of Scotland', 'the disgrace of the metropolis', is a statue, and something more, a statue by Flaxman, and a Greek temple.[10] The Greek temples of 'the Modern Athens' are among its proudest ornaments, and it will be something new to most people to hear of a statue by Flaxman as either a 'miserable monument' or as a 'disgrace to the metropolis'. I know not why Burns should have a monument in Glasgow. He was in nowise associated with the city; he was the national poet, and his genius has been nationally commemorated – in the mausoleum over his grave at Dumfries, and in the cenotaphs at his birthplace, and in the capital of his country.[11]

The writer's concluding observation that the city 'ought to be just before it is generous' and erect a monument to the Glasgow poet Thomas Campbell (q.v., below) instead did nothing to impede the progress of the Burns project, but was in fact instrumental in initiating the scheme to commemorate Campbell, whose statue now stands a few yards from the Burns monument.[12] The same correspondent returned to the subject of the Burns statue a few months later, this time speculating on the method the committee proposed to adopt for selecting a sculptor:

> Nearly £1,500 having been collected in shillings for a statue of Burns in Glasgow, the committee is now all sixes and sevens as to who is to be the sculptor. Some say give the commission to a man enjoying the highest position in the profession, such as Foley; others, give it to Mr. Ewing, a local artist. 'Glasgow has two able sculptors, Mr. Mossman, and Mr. Ewing, and Mr. Mossman having done two excellent statues, Mr. Ewing's turn has now come'; and others are for a competition, but limited to Scottish sculptors. Because that an artist [*sic*] has done excellent work he is to be withheld from an opportunity of doing more is an argument that I do not understand, and so will not consider; but I am surprised that it has been said that Glasgow has two able sculptors when it has three. The Atlantes or Caryatides at the Bank of Scotland [2 St Vincent Place, (q.v.)], by William Mossman (a younger brother), have been pronounced … to be works of the highest excellence. To me it seems there is no reason why the Burns statue should not be competed for, and there are several why it should. The fact that it has been contributed to by nearly thirty thousand persons has made it a public matter – not a matter for one artist or another unless he be in a position whose supremacy is undisputed.[13]

Undaunted, the committee decided in the end to dispense with a competition and award the commission directly to Ewing, who was 'accordingly requested … to prepare and

submit a model' for their approval. However, this merely prompted further criticism, and in a satirical profile in the *Bailie*, Ewing is characterised as a dilatory Bohemian who 'muddles instead of models', as well as an opportunist whose appointment was based more on the influence of his 'kyind friends' on the committee than his reliability as a producer of public sculptures. 'The work may be in progress', it wryly commented several months after the commission was awarded,

> ... or it may not. In point of fact it may be postponed until the arrival of the classical and rather uncertain period of time known as the Greek Kalends, though little delay took place in the absorption of the first instalment of cash. Under the circumstances, the BAILIE, with the generosity for which he is renowned, gives GEORGE a precedence to which he is scarcely entitled, and cries, 'Walk up, ladies and gentlemen, and admire the special waxwork.' Wax, probably, is the medium in which GEORGE could most fittingly be presented to the public. It certainly is the material with which he ought to be most familiar. He was brought up to 'figgers', and in due time, no doubt, he will produce an entirely satisfactory figger of Burns.[14]

It has been claimed that the public wrangling over the commission precipitated Ewing's decision to leave Glasgow for America,[15] though there is some confusion over the date when this occurred (see biographical entry, below). Not all the press was quite so hostile, however. In its announcement that Ewing had 'at length completed the model for the Burns statue' in September 1875, the *Builder*, struck a much more conciliatory note, reminding its readers of the special problems associated with producing an image of a historical figure such as Burns, who by the late nineteenth century had achieved almost mythical status:

It is somewhat difficult to form an adequate notion of the difficulties with which the artist has had to contend in producing a work which shall be regarded on all hands as a fitting memorial to the great national bard. The few available portraits of Burns vary considerably, and each has its distinct class of admirers according as it coincides with the idea they have formed of the man.[16]

In the event, Ewing based his depiction of Burns' face on the famous oil portrait by Alexander Nasmyth (1787, SNPG, PG 1063), with reference also to the more finely detailed drawing in red chalk by the poet's friend Archibald Skirving (1796/8, SNPG, PG 745),[17] but there was also the problem of the pose. 'Again', the *Builder* went on,

> ... supposing the sculptor to have overcome all difficulties relating to facial expression, a matter which must have cost him considerable anxiety was the posing of the figure. While seeking to embody a striking and popular idea of the poet in the circumstances of his daily life, it was essential to avoid too lofty a conception on the one hand, and that which is meretricious or commonplace on the other, and when one considers how much serious labour and thought is involved in these points, the delay which has taken place in the completion of the model is easily accounted for.[18]

For his part, Ewing appears to have been aware of the huge burden of responsibility that came with the commission, and went so far as to demand that 'the statue should not leave his studio until he had been able to fully realise and embody his own ideal of Burns'.[19] It must be said, however, that this did not prevent him from exploiting the opportunities for self-publicity which the commission brought with it, and in March 1876, he invited a 'large company of ladies and gentlemen' to his studio at 287 Bath Street to inspect the clay model and

witness the production of the plaster cast. As was customary on such occasions, sociability was aided by the provision of 'cake and wine'.[20] Nevertheless, his anxiety that the finished statue should be 'the most complete of Burns in existence'[21] continued to act as a restraining force, and even after the bronze casting had been completed he was reluctant to release it for public view, asking for more time in order that he 'might give to it some improving touches'.[22] The committee appears to have been surprisingly tolerant of these demands and later expressed the view that 'the additional time bestowed on it [had] contributed to the perfecting of the work'.[23]

The decision to include reliefs on the pedestal was not made until work on the main statue was in progress, and the funding for these was raised from the neighbouring towns of Ayr, Paisley, Cumnock, Kilmarnock and Irvine, once again by shilling subscription. The *Glasgow Herald* noted that 'the people in all these places ... gladly availed themselves of the opportunity afforded to them' to be involved in the commemoration of Scotland's national poet.[24]

The reliefs were not completed until 1887, and when the statue was inaugurated by Lord Houghton, the poet and biographer of Keats, on 25 January 1877, the spaces on the pedestal were still blank. Nevertheless, the unveiling, which coincided with the anniversary of Burns' birth, was a major civic event. The day was declared a public holiday, and there were trade processions from Glasgow Green which joined a crowd of over 30,000 in George Square, the largest crowd recorded for a public unveiling in Glasgow before the Cenotaph. The occasion was also commemorated by a special performance at the Theatre Royal on the preceding evening.[25]

On completion of its business, the committee transferred the custody of the statue, together with its pedestal and foundations, to the 'Lord Provost, Magistrates and Council of

the City of Glasgow for behoof of the whole body and community thereof', stipulating that it should be maintained 'in the said Square or in some other public place to which the inhabitants of the said Burgh have free access'.[26]

Related work: There are copies of the relief panels in Burns' Cottage, Alloway.

Condition: Structurally sound, but with some biological growth on the statue and copious quantities of birdlime on the pedestal.

Notes
[1] EB, vol.3, pp.516–8. [2] B, 25 September 1875, p.860. [3] *Ibid.*, 16 December 1876, p.1229. [4] *Ibid.* [5] GH, 25 January 1877, p.4. [6] Somerville, p.245. Somerville claims the suggestion for the subscription scheme came from a Mr John Browne, but there is no other record of his involvement in the project. [7] GH, 25 January 1877, p.4. [8] Pagan, vol.i, p.lxii. [9] Somerville, op. cit. [10] The monuments referred to here are John Flaxman's marble portrait of Burns in the SNPG (1824–32, PGL 139), which was removed from the Burns Monument in Regent Road, Edinburgh, after the building had become damp, and the Burns Monument on Calton Hill, Edinburgh, 1830, by Thomas Hamilton. [11] 'Gossip from Glasgow', BN, 27 December 1872, p.496. [12] 'Gossip from Glasgow', *ibid.*, 16 May 1873, p.572. [13] *Ibid.* [14] Anon., 'Men You Know – no.76', *Bailie*, no.67, 1 April 1874, p.1. [15] Woodward, p.60; Pearson, p.93. [16] B, 25 September 1875, p.860. [17] Somerville, p.245. [18] B, 25 September 1875, p.860. [19] GH, 25 January 1877, p.4. [20] 'Burns Statue', GWH, 4 March, p.6. [21] *Ibid.* [22] Somerville, p.245. [23] GH, 25 January 1877, p.4. [24] *Ibid.* [25] *Ibid.* [26] GCA, M.P. 20/91–5, MS 'Assignation by Burns Monument Committee in favour of The Glasgow Corporation', 25 January 1877.

Other sources
Bailie, no.224, 31 January 1877, pp.2–3 (incl. ill.); Somerville, p.213; B, 9 July 1898, p.25; McFarlane, pp.17–19; House, p.154; ET, 10 April 1982, 7 January 1984; Woodward, p.118; Read, p.117; Nisbet, 'City of Sculpture'; Teggin *et al.*, p.27 (ill.); Williamson *et al.*, p.177; McKenzie, pp.49–50, 51 (ill.).

On the south side of George Square, a few yards south-east of the Monument to Sir Walter Scott

Monument to Thomas Campbell

Sculptor: John Mossman, assisted by James Pittendrigh Macgillivray

Founders: Cox & Sons
Date: 1875–7
Erected: 29 December 1877
Materials: bronze on a polished granite pedestal
Dimensions: statue 2.6m high; pedestal 3.66m high
Inscriptions: on the statue – J MOSSMAN SC / 1877 (left side of plinth); COX & SON FOUNDERS (right side of plinth); on the pedestal – THOMAS CAMPBELL / POET / BORN 1777, DIED 1844. (front of dado); J MOSSMAN H.R.S.A. SC (rear lower left of dado, added 1923)
Listed status: category B (15 December 1979)
Owner: Glasgow City Council

Thomas Campbell (1777–1844), poet, historian and political commentator. Born in Glasgow and educated at the Grammar School, he entered the University at the age of twelve and there distinguished himself during seven years of study. He later moved to Edinburgh to study law and began his successful literary career with *The Pleasures of Hope*, published in 1799. Visiting Germany in 1800 he witnessed the battle of Hohenlinden, which inspired his most famous poem 'Ye Mariners of England' and several other patriotic war songs. In 1803 he settled in London and received a pension of £200 per annum from George III in recognition of his literary achievements. In 1854, a posthumous edition of his poems was published with illustrations by J.M.W. Turner.[1] As well as writing poetry he also contributed historical articles to encyclopaedias, edited the *New Monthly Magazine* and the *Metropolitan Magazine*, was vociferous in defence of the

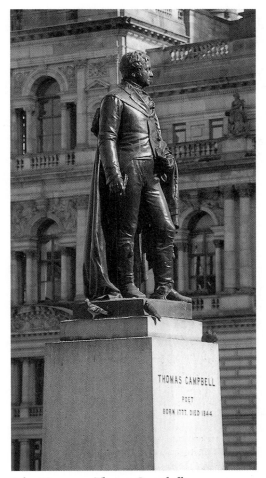

John Mossman, *Thomas Campbell*

causes of Greece and Poland and helped launch the movement which led to the foundation of London University. He was Rector of Glasgow University in 1826. In declining health he retired to Boulogne in 1843, dying there in the following year. He was buried in Westminster Abbey.[2]

Description: The poet is shown standing with

his left foot advanced, holding a quill pen in his right hand and a sheaf of manuscripts in his left. He is dressed 'in the costume of the latter part of the reign of George IV',[3] with cutaway coat, knee-length boots and a cloak, part of which is draped over his left forearm.

Discussion: The idea that Glasgow should honour its most popular poet with a statue was first proposed in May 1868, when the *Building News* made the following observation as part of its reporting on the imminent arrival of Foley's statue to Lord Clyde (q.v.):

'Peace hath its victories no less renowned than war', and now that Glasgow has discharged a debt to the memory of its two greatest soldiers, it may, perhaps, at least think of the claims of Thomas Campbell the poet, and Archibald Alison the historian. There is still a vacant corner or two in George-square.[4]

The same periodical repeated the suggestion in 1872, this time pointing out that the only public memorial to Campbell in his native city was a portrait in the Corporation (now McLellan) Galleries, and that if the city were to be 'just before it is generous, an early, if not a first debt, is due to Thomas Campbell'.[5] The first practical steps towards the realisation of the scheme were taken in the following year, when a committee, led by Sheriff Glassford Bell and the architect Bailie James Salmon, was formed with the intention of raising the necessary funds.[6] Subscriptions of £500 were received immediately,[7] rising to £900 by the end of the year. As a target of £2,000 had been set, no attempt was made at this time to commission designs or identify a suitable site.[8] By April 1875, however, the funds had increased to £1,124 18s., and although it was still felt that about £300 were still required,[9] the project went ahead. A little over a year later, the *Building News* was able to report that 'on Thursday week competitive designs by Mr. Brodie (Edinburgh), Mr. Mossman and Mr.

Ewing (both Glasgow) were exhibited, when Mr Mossman's was unanimously selected'.[10]

At this time the intention was to have the statue ready for inauguration on 27 July 1877, the anniversary of Campbell's birth. However, the finished bronze was still apparently with Cox & Son at their foundry in Thames Ditton in early December, together with Mossman's statue of David Livinstone (q.v., Cathedral Square),[11] and it was not until 29 December 1877, almost the end of Campbell's centenary year, that the monument was finally unveiled. The event was intended to be a simple one, with no 'great public demonstration', though the 'season of the year and other circumstances' did not deter several thousand members of the public from attending.[12] Mossman himself was present, and thanked the committee for the support he had received during the execution of the commission. John Nichol, Professor of English Literature at Glasgow University, referred in his speech to Mossman's contribution to Glasgow's public sculpture, indicating his monument to Sir Robert Peel on the north-west corner, and reminding the audience that his statue of David Livingstone was also underway. The unveiling was performed by Dr James A. Campbell MP, who was born in George Square in 1825.

In his obituary, James Pittendrigh Macgillivray is recorded as having acted as Mossman's assistant in the production of the statue, but the extent and nature of his contribution has not been determined.[13]

Related work: Marble busts of Campbell by Edward Hodges Baily are in GAGM (S.26, dated 1826) and HAG (1828, GLAHA 44183). There is also a bronze plaque commemorating the poet's birthplace on the former British Linen Company Bank at 215 High Street (q.v.).

Condition: Good.

Notes
[1] *The poetical works of Thomas Campbell. With notes, by the Rev. W.A. Hill, M.A. illustrated by twenty vignettes from designs by Turner*, London,

1854. [2] Somerville, pp.247–68; EB, vol.II, pp.490–1. [3] BN, 11 August 1876, p.142. [4] *Ibid.*, 1 May 1868, p.289. [5] *Ibid.*, 27 December 1872, p.496. The portrait referred to is probably the bust by Edward Hodges Baily; see 'Related work'. [6] Somerville, p.265. [7] BN, 16 May 1873, p.572. [8] *Ibid.*, 19 September 1873, p.324. [9] *Ibid.*, 9 April 1875, p.417; B, 27 March 1875, p.290. [10] BN, 11 August 1876, p.142. [11] A, 1 December 1877, p.304. [12] GH, 29 December 1877, p.5. [13] *Scotsman*, 30 April 1938, p.17.

Other sources
BI, 16 May 1900, p.17; McFarlane, pp.19–21; Read, p.117; Melville, p.8; Williamson *et al.*, p.177; Pearson, p.99; McKenzie, pp.48 (ill.), 49.

In the centre of the north side of George Square

Monument to William Ewart Gladstone

Sculptor and founder: William Hamo Thornycroft

Date: 1899–1902
Unveiled: 11 October 1902
Materials: bronze statue and reliefs on a Kemnay granite pedestal
Dimensions: statue 2.6m high; pedestal 3.96m high; reliefs 1.11m × 78cm
Inscriptions: on the statue – GLADSTONE; on the pedestal – WILLIAM EWART GLADSTONE / BORN 29 DEC 1808 / DIED 19 MAY 1898 (front of dado); HAMO THORNYCROFT RA SC / 1902 (lower left of dado, added 1923); on the right relief – HAMO THORNYCROFT; HAWARDEN
Listed status: category B (15 December 1970)
Owner: Glasgow City Council

William Ewart Gladstone (1809–98), English statesman and four times Prime Minister. Born in Liverpool, he began his parliamentary career in 1832. In 1843 he became President of the Board of Trade under Robert Peel and subsequently held a series of cabinet posts, as a Conservative until 1859 and thereafter as a

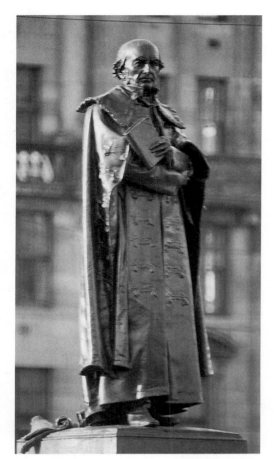

William Hamo Thornycroft, *William Ewart Gladstone* [RM]

Liberal. Succeeding Lord John Russell as Liberal Party leader in 1867, he formed his first government in the following year and remained a dominant figure in British politics for the next quarter century. Though he began his career as a Tory and strict Anglican he became a passionate advocate of social reform. The most persistent political issue during his time in office was that of Ireland, for which he tried unsuccessfully to secure Home Rule. He

received the freedom of the City of Glasgow in 1865, and became Lord Rector of Glasgow University in 1879.[1]

Description: The subject stands erect in the robes of the Rector of Glasgow University with his arms folded across his chest, and with a book in his left hand. There are several other books and a sheaf of manuscripts at his feet. The treatment of the left hand creates the impression that the index finger is tucked between the leaves of the book, though in fact this is a tactful device to conceal the disfigured remains of the finger, which had been amputated after a shooting accident in 1845. On the pedestal there are two narrative reliefs showing: on the left (east) face, Gladstone as Prime Minister addressing the House of Commons; on the right, Gladstone 'engaged in his favourite recreation of tree-felling' in the grounds of Hawarden Castle. In the latter panel he is shown 'with his sleeves rolled up, [leaning] on his axe, while seated on a log beside him are his wife, his daughter (Mrs. Drew) and his favourite grandchild, Dorothy Drew'.[2] The panels are modelled in very low relief and are very slightly concave, following the curvature of the dado. A bronze coat of Glasgow arms draped with a swag is attached to the front of the pedestal.

Discussion: Glasgow was one of several British cities that responded swiftly to the news of Gladstone's death in May 1898 by forming a memorial committee. It appears, however, to have been reluctant to put forward a definite proposal until the plans of the Gladstone National Memorial Fund were settled,[3] and it was not until February of the following year, 'at the request of a number of gentlemen of all political opinions', that the Lord Provost David Richmond called a public meeting in the Council Hall of the City Chambers 'to consider the propriety of organising a subscription'.[4] The meeting took place on 15 February, and was so well attended that it had to be reconvened in the Banqueting Hall. A management sub-

committee was appointed, chaired by Richmond and with the City Chamberlain James Nicol acting as secretary and treasurer. A total of £600 was donated by 78 subscribers, among whom were the editors of the Glasgow *Daily Mail* and *Weekly Mail*. It was estimated that between £4,000 and £5,000 would be required.[5] On 3 March the *Glasgow Herald* announced that £2,500 had been raised and that further donations were requested 'from all classes'.[6] By June it was felt that the fund, now standing at £3,754 18s. 9d., was sufficient to place the commission in 'the hands of a sculptor of eminence'.[7] It was also at this time that the sub-committee determined that the monument should be sited on the eastern side of George Square, immediately facing the entrance to the City Chambers.[8]

Four London sculptors – Thornycroft, Alfred Gilbert, Edward Onslow Ford and George Frampton – were invited to submit models, three feet in height, by October, with a premium of 50 guineas to be paid to the three unsuccessful candidates.[9] When all four sculptors declined the invitation to compete, the committee adjourned 'for a few days' to deliberate.[10] Their decision was to offer the commission directly to Thornycroft,[11] who agreed to make a work consisting of 'a statue 8ft 6" in height and cast in the finest bronze'. Given Thornycroft's admiration for 'The Grand Old Man' of English politics, and the 'eager pleasure' with which he accepted the commission to commemorate Gladstone in the Strand, London (1905),[12] it is safe to assume that the Glasgow statue was one in which he took a strong personal as well as a professional interest. It was to be mounted on a 'pedestal of fine axed Scotch granite, 13 feet in height and enriched with two bronze reliefs the subjects and models of which be submitted by me to the committee for approval'. The work was to be completed within 18 months and the fee of £3,500 was to be paid in four stages: £500 on signing the agreement; £500 on completion of

the full-size model in clay; £1,000 when the statue was cast in bronze and £1,500 when the monument was erected.[13] Thornycroft's life was insured for £500 for the duration of the commission.[14]

After a visit to Thornycroft's London studio to inspect his model in November 1900,[15] work proceeded and by February 1902 the artist was able to predict that the statue would be ready to unveil 'soon after the Coronation' of Edward VII, then scheduled for June. He also requested guidance on the choice of subjects for the relief panels. Without limiting him to any particular subject, the sub-committee offered the following suggestions: 1. 'Mr. Gladstone felling a tree'; 2. 'Mr. Gladstone seated in his study'; 3. 'Mr. Gladstone receiving the freedom of the City of Glasgow in the City Hall'; 4. 'Mr. Gladstone as a graduate at Oxford'; 5. 'Mr. Gladstone reading the lesson in church'.[16] Although Thornycroft did not pursue the idea of showing Gladstone receiving the freedom of the city in a relief panel, his portrayal of the main figure wearing the robes of the Rector of Glasgow University may be seen as a comparable concession to local interest. This distinguishes the monument from other major contemporary representations of Gladstone, such as in London and Edinburgh, in which he is dressed as the Chancellor of the Exchequer (see Related work, below).

During the execution Thornycroft sent photographs of the two reliefs to the sub-committee for their inspection as well as a sample of the granite he intended to use for the pedestal. The advice of the builder, Thomas Mason, was sought on the quality of the granite, and there was some discussion as to whether the stone should be polished or axed, and what difference this would make to the cost. In March the sub-committee also received a letter from James Fleming, the Chairman of Glasgow School of Art, stating that he had 'seen the full length model of the statue in Thornycroft's studio and expressed a very favourable opinion of its merits'.[17]

At a meeting of the sub-committee on 7 July 1902, it was reported that Thornycroft would be unable to finish the work until September. The unveiling, originally scheduled for the first fortnight of August, finally took place on Saturday, 11 October 1902, the ceremony being performed by the Earl of Rosebery.[18]

Before the commission was completed the sub-committee made enquiries as to the ownership of the clay model of the main figure, and the likely cost of making replicas of it 'should such be wanted by any members of the committee'.[19] Thornycroft stated that he would need to 'touch it up' and that bronze casts could be made for £50 each.[20] In addition the artist's advice was sought on the disposal of the surplus from the subscription fund which, after deducting the sculptor's fee (£3,500), the cost of the unveiling ceremony (£165 18s. 10d.) and the production of the memorial publication *Gladstone in Glasgow* (£107), stood at £400. Writing to Thornycroft the committee stated: '… we have a beautiful sculpture hall in our art galleries… Can you do anything for this hall – à la Gladstone – for the money in hand?'[21] Thornycroft suggested '… a marble bust of the great man. This with pedestal would cost £300 about. A carefully enriched marble copy of the famous bust of Homer in the British Museum would cost say £100 and would be a not inappropriate way of disposing of the balance.'[22] Both suggestions were approved and the two works are in Kelvingrove Museum today – nos. S.96 B (Gladstone) and S.101 (Homer).

Originally sited opposite the main entrance to the City Chambers, the monument was moved to its present location during the construction of the Cenotaph (q.v.). Permission from the Parks Department was required for its removal, which was carried out by the firm of J. & G. Mossman on 14 and 15 March 1923.[23] A photograph of the statue being hoisted onto the pedestal in its new location was published by the *Glasgow Herald*, which noted that its removal was 'a source of great interest to the moving crowds about the centre of the city'.[24]

Related work: Thornycroft was also commissioned to make a bronze Gladstone monument for London (Strand, 1905), with support from the Gladstone National Memorial Fund. The Fund also contributed to the commissioning of a memorial in Edinburgh by James Pittendrigh Macgillivray (Coates Crescent, 1917). Other comparable monuments to Gladstone are in Westminster Abbey, London (1903) and Liverpool (1904, St John's Gardens), both by Thomas Brock.

Condition: Good.

Notes
[1] EB, vol.IV, p.564; House, p.151. [2] 'Statues, Memorials, &c.', BN, 17 October 1902, p.540. [3] GCA, M.P. 30/663 (book of cuttings from GH), 16 February 1899. [4] *Ibid.*, 9 February 1899. [5] *Ibid.*, 16 February 1899. [6] *Ibid.*, 3 March 1899. [7] GCA, G4/1, 6, *Lord Provost's Office Minutes of the Gladstone Memorial Statue Committee* (hereafter *Minutes*), 6 June 1899. [8] *Ibid.*, 23 June 1899. [9] *Ibid.* [10] *Ibid.*, 4 August 1899. [11] *Ibid.*, 17 August 1899. [12] Manning, p.137. [13] *Minutes*, 17 November 1899. [14] *Ibid.*, 29 January 1900. [15] *Ibid.*, 17 November 1899. [16] *Ibid.*, 14 February 1902. [17] *Ibid.*, 24 March 1902. [18] *Ibid.*, 19 September 1902. [19] *Ibid.*, 9 April 1902. [20] *Ibid.*, 7 July 1902. [21] *Ibid.*, 19 August 1908. [22] *Ibid.* [23] GH, 15 March 1923. [24] GH, 24 March 1923.

Other sources
BA, 16 June 1899, p.416, 30 June 1899, p.452; BN, 30 June 1899, p.875; Cowan, p.95; McFarlane, pp.26–8; Borenius, pp.134, 135 (ill.); Read, pp.379–85 (incl. ills); Manning, pp.137–40 (incl. ill.); Williamson *et al.*, p.178; Cavanagh, pp.173–5 (incl. ill.); Louise Boreham, 'The Gladstone Memorial, Edinburgh', in Guest and McKenzie, pp.27–32 (incl. ill.); McKenzie, pp.50, 52 (ill.).

In the centre of the east side of George Square

The Cenotaph
Sculptor: Ernest Gillick
Architect: John James Burnet

Mason: John Emery & Sons
Date: 1921–4
Inauguration: 31 May 1924
Materials: polished granite and bronze
Dimensions: cenotaph 9.76m high; lions
 approx. 1.85m high × 2.55m long; palm leaf
 approx. 6.1m long ; St Mungo approx. 1.22m
 high
Inscriptions: on the cenotaph – PRO PATRIA
 1914 1919 / 1939 1945 / TO THE IMMORTAL
HONOUR OF THE / OFFICERS, NON-
COMMISSIONED OFFICERS / AND MEN OF
GLASGOW WHO FELL IN THE GREAT WAR /
THIS MEMORIAL IS DEDICATED / IN PROUD
AND GRATEFUL RECOGNITION BY / THE CITY
OF GLASGOW (front); PRO PATRIA 1914–19 /
TOTAL / OF / HIS MAJESTY'S FORCES /
ENGAGED / AT HOME AND ABROAD /
8,654,465 / OF THIS NUMBER / THE CITY OF
GLASGOW/RAISED OVER 200,000; UNVEILED /
ON / SATURDAY 31ST MAY 1924 / BY / FIELD
MARSHAL EARL HAIG OF BEMERSIDE / O.M.
K.T. C.C.B. / COMMANDER IN CHIEF OF THE
EXPEDITIONARY / FORCES IN FRANCE AND
FLANDERS / 1915–1919 (rear); THESE DIED IN
WAR / THAT WE AT PEACE MIGHT LIVE / THESE
GAVE THEIR BEST / SO WE OUR BEST SHOULD
GIVE (north side); GREATER LOVE HATH NO
MAN / THAN THIS, / THAT A MAN LAY DOWN
HIS LIFE / FOR HIS FRIENDS (south side); on
the 'war' stone – THEIR NAME LIVETH FOR
EVERMORE; on the central slab – PAX
Listed status: category B (15 December 1970)
Owner: Glasgow City Council

Description: Glasgow's monument to the
First World War is designed on a rectangular
U-plan, and consists of a central stepped area
flanked by a pair of low walls terminating in
giant couchant lions. A truncated obelisk
(strictly, the cenotaph itself) rises from the
eastern side, the upper part of which takes the

John James Burnet, *The Cenotaph* [SS]

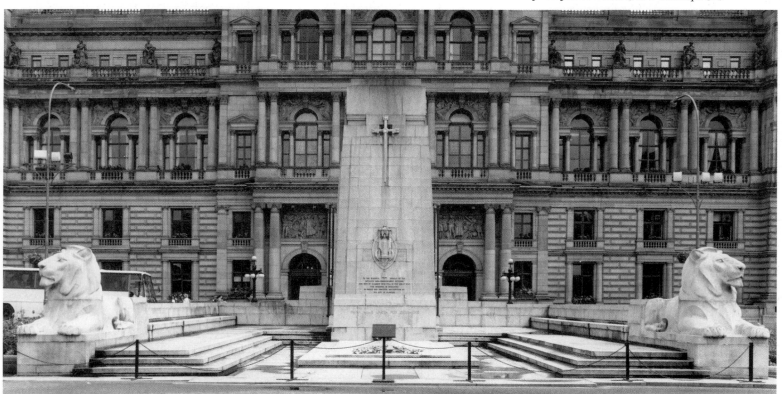

form of a sarcophagus decorated with four carved wreaths. The central area contains a horizontal slab bearing a relief carving of a large palm leaf and a wreath.[1] Between this and the cenotaph is a simple altar-like block known as the 'war' stone or 'great' stone.[2] On the front of the cenotaph is a figure of St Mungo in a *baldacchino*, which is itself embedded in a Glasgow coat of arms. Attached to the wall above this is a gilded metal cross sculpted into the form of a sword. The rear wall of the cenotaph has an Imperial coat of arms carved in relief and a set of six bronze wreaths attached to flagpoles.

Discussion: Plans to erect the monument were first proposed on 9 February 1920, by Sir James Watson Stewart, who called a public meeting

> ... for the purpose of marking in a fitting and permanent form the heroism and self-sacrifice of the officers, non-commissioned officers and the rest of the Navy, Army, Air Force and Auxiliary Forces belonging to Glasgow who fell in the Great War.[3]

With a response described by the *Glasgow Herald* as 'gratifying in the extreme', it was decided

> ... after careful consideration that the most appropriate memorial would be a cenotaph, and the most suitable place for its erection would be in the very heart of the city, in that square which had already been hallowed by memories of war.[4]

In April 1921, Sir George Frampton, Sir Edwyn Lutyens, Sir John James Burnet and Sir Robert Lorimer were invited to submit designs,[5] but the unanimous preference of the committee was for 'the well known Glasgow architect', and in June the commission was offered to Burnet.[6] Preliminary drawings were submitted and approved in September, and in November the architect was instructed to prepare a full set of working drawings and models.[7]

Burnet's initial proposal, which was presented to the committee on 20 April 1922, consisted of

> ... an open vault of 50 ft by 27 ft, stretching west into the Square. From the east end of the vault rises the Cenotaph to a height of about 30 ft above the level of the Square, the front of the Cenotaph showing to the Square. The vault, the floor of which is about 7 ft below the level of the Square, is entered by steps on each side of the Cenotaph.[8]

The walls of the vault were to be 'surmounted by a frieze of bay leaves interrupted by panels bearing the names of the various countries in which the war was carried on'. Though the committee appears to have approved of the design in general, there were misgivings about the inclusion of the vault, and after 'an exchange of views' Burnet was asked to 'submit a proposal for the erection of a bronze railing round the vault to prevent accidents'. A much more ominous development occurred, however, when the Provost Thomas Paxton moved an amendment 'that the whole matter be remitted back to Sir John Burnet in order that he might prepare a design for a Cenotaph without a vault'.[9] Although the amendment was defeated in a vote, the design was in fact rejected by the Corporation, and Burnet was required to resubmit his proposal.[10] The result was the design that exists today.

In addition to the concern about the appropriateness of the vault, the question of the location of the monument also prompted much debate. The principal objections to Burnet's design had in fact come from the members of the Parks Committee, who were unanimous in their disapproval of the plan to locate the memorial on the eastern side, on the grounds that this required the removal of the statues of Gladstone, Queen Victoria and Prince Albert.[11] A more radical objection was made by Rosslyn Mitchell, who argued at a committee meeting in

July 1922, for the outright rejection of the scheme. The memorial was wrong for the site, he claimed, because

> ... a great mass of masonry 25 feet high placed on one side of the Square was a most inappropriate form of memorial. It would reach right over the doorway of the City Chambers and up to the first storey of the building. Therefore, coming from the Square, the whole architectural features of the City Chambers would be obscured. Going out from the building from the main hall into the open air they would be walking up to a mass of granite, just as if they were walking into a prison wall.[12]

Although he conceded that Burnet's design was 'a beautiful piece of work, and a credit to the architect and to those whom it commemorates', the fact that it would allow nothing to be seen from the door of the City Chambers other than the top of the Scott Monument was a major design fault. Among the suggestions for alternative sites were the north side of the Square, on the axis of North Hanover Street,[13] and the centre of the Square itself, with the consequent removal of the Scott monument.[14] Insisting that he was concerned only with the 'aesthetic side of the question', Mitchell suggested that the Master of Works should 'get a wooden structure erected to show the size of the monument and what it would look like. If it looked alright he would withdraw his objection'.[15]

Whether such a structure was made is not known, but the objection does appear to have been withdrawn, and the original decision – made as far back as March 1921 – to erect the cenotaph in the 'position occupied by the Gladstone statue',[16] was eventually confirmed. The statues of Gladstone, Queen Victoria and Prince Albert were relocated, creating in the process the single most radical change in the appearance of George Square since it was comprehensively redesigned in 1866 (see

Introduction, above). Burnet himself argued that the site on which the monument was built was the one it had been designed for,[17] and this was supported by the *Glasgow Herald*, which noted that the whole conception of the scheme arose from

> … the conditions imposed by the site, which made it imperative that the main or ceremonial entrance to the Municipal Buildings should not be unduly screened from public view by a monument of any great breadth or height of base.[18]

By far the most powerful argument, however, arose from the historical and sentimental associations bound up with that particular part of George Square. It was here that '… the Glasgow soldiers were recruited by successive Lords-Lieutenant, and whence they matched to war. It was here also that those who returned took the salute. The place was, in a measure, hallowed ground.'[19]

With the question of the design and the site settled, the only outstanding matter to consider was whether the structure should be built of Blaxter freestone, Revelstone freestone or granite. The committee were unanimous in their choice of polished grey granite from Kemnay, near Aberdeen, and in April 1922, tenders were accepted from John Emery & Sons for the construction, and J. & G. Mossman for the removal and re-erection of the Gladstone statue.[20] A series of delays in the final stages of the construction, caused by 'difficulties and accidents at the quarries'[21] led to the postponement of the inauguration from 15 September to Armistice Day (11 November) 1923. Still not complete by this time, the monument was finally unveiled by Earl Haig on Saturday, 31 May 1924, in a ceremony attended by many thousands of spectators. Among the guests were Burnet himself and Lord Blythswood, the chairman of the committee supervising the construction, who formally asked the Lord Provost to 'accept the custody of the memorial on behalf of the Corporation and the general body of the citizens'.[22]

The inscriptions relating to the Second World War were added in 1945.[23]

Related work: A similar design, but on a smaller scale, was used by Burnet on his Hunter memorial (1925) in Glasgow University.

Condition: Good.

Notes

[1] According to Williamson *et al.* (p.177) and Lyall (p.37) this area was originally intended to be filled with a reflecting pool. No confirmation of this has been found in the primary documentation. [2] GH, 21 April 1922, p.10. [3] *Ibid.*, 2 June 1924, p.11. [4] *Ibid.* [5] *Ibid.*, 26 April 1921, p.6. [6] *Ibid.*, 7 June 1921, p.6. [7] *Ibid.*, 20 September 1921, p.6, 23 November 1921, p.7. [8] *Ibid.*, 21 April 1922, p.10. [9] *Ibid.* [10] *Ibid.*, 12 May 1922, p.6. [11] *Ibid.* [12] *Ibid.*, 7 July 1922, p.5. [13] *Ibid.*, 23 December 1920, p.9. [14] *Ibid.*, 7 July p.5. [15] *Ibid.* [16] *Ibid.*, 3 March 1921, p.4. [17] *Ibid.*, 7 July 1922, p.5. [18] *Ibid.*, 21 April 1922, p.10. [19] *Ibid.*, 3 March 1921, p.4. [20] *Ibid.*, 12 August 1922, p.6. [21] *Ibid.*, 28 July 1923, p.6. [22] *Ibid.*, 2 June 1924, p.12. [23] *Ibid.*, 22 January 1947, p.6.

Other sources

GH, 30 December 1920, p.6, 13 April 1921, p.7, 20 September 1921, p.6, 22 April 1922, p.9 (ill.), 13 May 1922, p.6, 17 May 1922, p.10, 30 June 1922, p.6, 30 June 1922, p.6 (ill.), 1 July 1922, p.8, 15 March 1923, p.7, 28 May 1923, p.6, 15 May 1924, p 8; McFarlane, pp.6, 36–7; GCA, PA3/94, *City of Glasgow War Memorial Unveiling … Order of Proceedings*, Glasgow, 1924; Teggin *et al.*, p.27 (ill.); Lyall, p.36 (ill.); McKenzie, pp.48 (ill.), 49.

The City Chambers, 80 *George Square / George Street / John Street / Cochrane Street*

Allegorical and Decorative Sculpture Programme

Sculptors: James Alexander Ewing, Farmer & Brindley, Edward Good, Charles Grassby, George Anderson Lawson, Francis Leslie, James Pittendrigh Macgillivray, James Harrison Mackinnon, John Mossman, John Rhind and John Tweed

Architect: William Young
Builders: Morrison & Mason
Wrights: George Adam & Son, Glasgow; Starkie, Gardner & Co., London
Date: 1883–8
Inaugurated: 22 August 1888
Opened: September 1889
Materials: Binnie sandstone (statues); Polmaise and Dunmore sandstone (reliefs)
Listed status: category A (15 December 1970)
Owner: Glasgow City Council

INTRODUCTION

The City Chambers is the seat of local government in Glasgow, and consists of three connected buildings occupying the site bounded by George Square, George Street, Montrose Street and Cochrane Street. Its completion in 1888 marked the end of a succession of moves by Glasgow Town Council, which began nearly eighty years earlier when the cramped premises of the old Tolbooth on the Trongate, its home since the early eighteenth century, were vacated for a new building at the foot of the Saltmarket (by William Stark, now the Justiciary Court). Subsequent moves to Wilson Street (1844) and Ingram Street (1874) (both part of City and County Buildings, q.v., by Clarke & Bell) proved inadequate to the council's increasingly

extensive 'civic, legal and penal' responsibilities, which had expanded in tandem with the city's burgeoning population and industrial power. Despite the collapse of the City of Glasgow Bank in 1878, a Municipal Buildings Act was passed in the same year, enabling the council to extend its borrowing powers and acquire, by compulsory purchase, a large new site on the eastern side of George Square.[1] Built in direct rivalry to the recently erected Town Hall in Manchester[2] the City Chambers was a gesture of renewed urban self-confidence as much as a functional solution to the council's accommodation problems. In its opulence and scale it is the single most grandiose building of Victorian Glasgow. It also has the single most extensive programme of architectural sculpture in the city.

The commission to design the building was awarded to Young after a complex and not always well-managed selection process, beginning with an open competition announced in March 1880.[3] Charles Barry (son of Sir Charles Barry, designer of the Houses of Parliament) was appointed joint Assessor with the City Architect John Carrick, who determined the basic layout of the plan and set a maximum cost of £150,000. A total of 96 designs were received, many from local architects such as Campbell Douglas & Sellars, John Burnet and James Salmon.[4] The winner was George Corson, of Leeds, but his design was ruled out on the grounds that it could not have been built within the allocated budget. (Barry's misgivings were partly based on the architect's failure to make allowances for the 'expensive sculpture' that such a building would require.)[5] A new competition was announced in May 1881,[6] extending the scope of the project and raising the construction allowance to £250,000. The building was now to include a central quadrangle, as well as accommodation for the Gas, Water, Land Valuation, Sanitary and Police Departments in addition to the Municipal Chambers themselves. 125 sets of

designs were entered by 110 architects, and after the competition had passed into a third stage, the commission was finally given to Young, a Paisley-born architect working in London, whose entry had been submitted under the pseudonym 'Viola'.[7]

Building work began on 6 October 1883, with the laying of the foundation stone by the Lord Provost John Ure. The event was marked by a public holiday, allowing an estimated 600,000 people to attend, the largest recorded gathering in Glasgow, and with a number of Masonic and trade processions terminating in George Square. The Square itself was decorated with temporary triumphal arches and there were fireworks in all the major Glasgow parks in the evening.[8]

The contractor for the masonry was the firm of Morrison & Mason, who employed 230 stonecutters at their Polmadie yard under the supervision of Brisbane Muir.[9] The yard was the first in Glasgow to introduce machine technology for working stone,[10] which allowed the main structure of the building to be assembled largely from pre-hewn blocks, with only the 'finer work, such as the carving of the capitals' and the relief sculptures executed *in situ*.[11] Young himself remarked on how

> … every stone was brought to the site fully worked and ready for its place in the building, so that on the site scarcely the sound of a hammer was heard, and the great fabrick rose so quietly that it seemed to many enquiring onlookers as if the work was suspended.[12]

The progress of the work was in fact interrupted several times through strikes[13] and extended periods of heavy frost, but by December 1886 the *Glasgow Herald* was able to report that

> … the whole of the heavy masonry of the four façades has been completed, and what remains to be done further is to place in

position the balustrades … and afterward to erect the stone figures with which several of them will be surmounted.[14]

Morrison & Mason provided the lifting tackle for hoisting the statues into position, as well as a shed with skylights and '100 feet of shelving' for the use of carvers and sculptors.[15]

The completion of the exterior masonry was marked by the placement of the topmost stone on the main tower on 6 October 1887, exactly four years after building work had been begun.[16] Although the interior was still unfinished at this time, the council took advantage of the visit by Queen Victoria to the International Exhibition at Kelvingrove Park (q.v.), and invited her to inaugurate the building officially on 22 August 1888.[17] In September of the following year the City Chambers were finally thrown open to the public, attracting 400,000 visitors in ten days; the first meeting in the new Council Chamber was held on 10 October.[18] The scale of the entire project may be judged from the quantities of materials it consumed: 19,000 cubic feet of granite, 350,000 cubic feet of stone and 10 million bricks. It was estimated at the time that if the exterior and interior walls were 'stretched in a straight line they would reach a distance of half a mile'.[19] The eventual cost was £529,909 7s. 8d., of which £8,000 was allocated to sculpture.[20]

Stylistically the City Chambers are a free interpretation of Renaissance classicism, with a two-storey rusticated plinth supporting a complex arrangement of coupled Corinthian columns, balustrades, pilasters and arched windows. It is a notable feature of the building that the four main façades are designed very differently, though a measure of visual uniformity is provided by the identical treatment of the four corner towers. From the beginning it was intended that the building should be 'of a broad and dignified rather than of a florid character',[21] with sculpture introduced 'to a large extent in the place of

ornamental carving'.[22] In fact a substantial amount of ornamental work is incorporated into the design, and between January 1886 and October 1887 there were nearly 80 carvers employed on 'the capitals of columns and such work'.[23] On the whole, however, the sculpture on the City Chambers is both restrained and coherently conceived. Free-standing statues and panels in bas-relief provide a pattern of visual accents at various key points in the structure, as well as a narrative expression of the building's cultural and historical purpose.

The progress of the sculpture programme was a matter of considerable public interest. In 1886, for example, the *Glasgow Herald* reported that

… the sculptural subjects which are to be placed about the buildings will have such an effect in adding to their appearance that the utmost care is being taken to ensure that they shall be placed so that they will be seen to the best advantage. The method followed is to model them in clay, and then to take plaster casts, which, before they are cut in stone, are suitably coloured and raised to the positions they will ultimately occupy in order that the effect may be judged of.[24]

This appears to have been a genuinely experimental process, and not all the plaster models viewed in this way went on to be executed in stone. In the same report the *Herald* noted that

… yesterday [Thursday, 2 December] a stone-tinted plaster cast of one of the sitting figures that will grace the central portion of the Cochrane Street front was hoisted to its seat, and was viewed from the street by the architect, Mr. Young.[25]

In the event no such figure was used on the Cochrane Street façade. Whether or not Young decided against it on purely aesthetic grounds is difficult to say, but it is worth noting that this was not the only modification he made to the

sculptural scheme during the construction of the building. The series of 'about 18' groups that were originally planned for Cochrane Street[26] was reduced to nothing more than a pair of relief figures over the door (see below), while on the George Square frontage eight full-length statues, six large attic groups and two pairs of reclining figures in relief – all of which are clearly indicated on Young's published drawings – were eventually dispensed with.[27] No doubt economic considerations played a large part in these changes, and it may well be that the additional expense incurred by Young's last-minute redesign of the Jubilee Pediment (see below) – for which he requested 'a special grant'[28] – forced him to make savings elsewhere. It is an interesting reflection on the changing perception of architectural sculpture at this time, however, that even in the reduced form it eventually took, the scheme still managed to impress the commentator of the progressive *Scottish Art Review* as 'over lavish'.[29]

The stone used on the main exterior facing of the City Chambers came from a variety of sources, including quarries at Polmaise (George Square and George Street elevations), Dunmore, near Bannockburn (John Street and Cochrane Street elevations), with polished pink granite from Corelly, near Aberdeen used on the first six feet on the ground storey. For the sculptures a more specialised stone was brought from Binnie, near Broxburn, which was chosen for its fine texture and imperviousness. These qualities would, according to the *North British Daily Mail*,

… give permanence to the fine and sharp lines of the sculptor's work. This arises from the fact of its being to some extent impregnated with the oil from the well-known oil-producing shales which are found so plentifully in the district from which the stone is got.[30]

All the stone was required to be seasoned for three months before being used.[31]

THE SCULPTORS

A decorative programme as complex and extensive as this could not have been undertaken without the participation of many different sculptors, all of whom naturally brought their own personalities, as well as their private concerns as artists, to the specific tasks they were given. Fortunately, the surviving documentation relating to the City Chambers provides us with a reasonably detailed record of the different contributions made by the various sculptors involved, and how their individual inputs were managed in relation to the project as a whole. It would appear that Young himself was personally responsible for the choice of carvers and sculptors, and that their wages were paid by the main contractors, Morrison & Mason, in 'such sums, and in such instalments, as the Architect shall direct'.[32] Among the sculptors themselves, some of them, like John Mossman, were native Glaswegians; others, like George Lawson, were brought in from further afield, presumably on the strength of their reputations as national figures. In most cases it is possible to identify which sculptor was responsible for which part of the scheme, and the records also occasionally reveal how much they were paid (see below). There remain, however, one or two frustrating gaps in our knowledge. We cannot be sure, for example, who modelled and carved the four standing figures on the central tower. It is also difficult to know precisely what contributions were made by Charles Grassby, Edward Good, James Harrison Mackinnon and the English firm of Farmer & Brindley, who are merely recorded as having been responsible for general decorative work more or less over the entire building.[33] At the same time it is important to remember that work of this kind is by its nature collaborative, and that the process of carrying a sculptural idea through from conception to the finished statue is often a complex one, involving a creative input from more than one artist. There can be no more vivid illustration of this

than the Jubilee Pediment. Conceived by Young, designed and modelled by Lawson and finally chiselled by Ewing and his assistants into the physical object we see today, it would be wholly out of keeping with the spirit in which it was made to ascribe its creation to any one of these men at the expense of the others. So it is with much else on this structure, which Young described as having been 'erected by the citizens of Glasgow'.[34] What cannot be denied is the crucial role that Young himself played in steering the sculpture programme through as a unified aesthetic statement. From the beginning it was his intention that 'all the carving and sculpture should have a meaning'.[35] The pains he was prepared to take over the impression the statues made on the viewer is eloquent testimony of the importance he attached to sculptural meaning as a logical extension of the meaning of the building as a whole.

Condition: Despite the care taken in the selection of the stone, the exterior masonry began to deteriorate very soon after the building was completed. In April 1901, the builder Alexander Muir submitted a detailed report on the matter to the City Engineer, A.B. McDonald, stating that the decay was 'of such a serious nature' that arresting it 'should become a question of serious and immediate consideration'.[36] A number of statues and reliefs were identified as in need of urgent remedial treatment, including the allegorical groups on George Street, the spandrel figures on George Square and the Jubilee Pediment, which he recommended should be 'cleaned and rehewn where required'. The decay in the figurative reliefs above the entrance appears to have been particularly severe, and large sections of it may even have been replaced in 1905 (see below). The true scale of the task did not begin to become clear until after the repair work was under way, and in July 1902, after £2,400 had already been spent, McDonald reported to the Council that 'it [did] not appear probable that what has been already done represents more

than one-fourth of the entire work'.[37] The precise cause of the problem proved difficult to determine. The council had been warned against the use of sandstone even before the building had been begun, and the astonishing speed with which its earlier premises on Ingram Street (1874, now demolished) had decayed was cited as a spectacular example of how sandstone reacted to the 'smoke-laden atmosphere' of Victorian Glasgow.[38] On examination, the 'aggravated dilapidation' proved to be 'assignable to organic rather than atmospheric causes',[39] a fact which was later confirmed by the Corporation Bacteriologist, Dr Buchanan, who described the building as the victim of an 'infective disease'.[40] The treatment recommended by Muir was an application of three liberal coats of 'Szerelmey stone liquid', which not only arrested the decay but also had the advantage of being 'practically colourless', and therefore could be used on any part of the building 'without making that part stand out in strong contrast to the remainder'.[41] The method seems to have been effective, although the *Builder* reported in 1906 that some parts that had been treated had already begun to deteriorate again.[42]

The building has been cleaned twice in recent times: in 1979, Frank Lafferty & Co. used a much-criticised chemical process which left the surface of the stone vulnerable to biological growth; in the mid-1980s, hot water was used. At a conference of conservation scientists, held in Glasgow in 1995, it was confirmed that the infestation of green algae which has coated almost every statue on the building was caused by the chemicals used in the earlier cleaning.[43] Details of the condition of individual components of the scheme are given, where relevant, in the entries below.

Notes
[1] Bell and Paton, p.84; GCA, D-TC 6/31, Box I. [2] B, 21 July 1877, p.741; BN, 12 October 1877, p.355. [3] GCA, M.P. 7 (179), 'New Municipal Buildings for the city of Glasgow: instructions to

competing architects'. [4] Anon., 'Glasgow Municipal Buildings Competition', BA, 10 September 1880, p.118. [5] Charles Barry, 'Glasgow Municipal Buildings. Report by Charles Barry, F.S.A.', BA, 10 September 1880, pp.121–2. [6] BA, 3 June 1881, p.279. [7] BN, 13 January 1882, p.43; B, 12 August 1882, p.224. [8] Young, p.11; Cowan, pp.115–17; GH, 8 October 1883, pp.9–11; Glendinning *et al.*, p.314. [9] NBDM, 20 October 1887, p.2. [10] Young, p.12. [11] BA, 12 June 1885, p.287. [12] Young, p.12. [13] BA, 12 June 1885, p.287. [14] 'Glasgow Municipal Buildings: proposed Queen's Jubilee Memorial', GH, 3 December 1886, p.4. [15] GCA, D-TC 6/31, 'Glasgow Municipal Buildings 1883. Contracts Nos 1, 2 & 3', pp. 15, 17. [16] NBDM, 20 October 1887, p.2. [17] BN, 24 August 1888, p.257. [18] *Ibid.*, 6 September 1889, p.336; Young, p.12; Cowan, p.117. [19] NBDM, 20 October 1887, p.2. [20] GCA, D-TC 6/31, 'Papers relating to the Glasgow New Municipal Buildings 1884–5' vol.2, p.209; 'Glasgow Municipal Buildings 1883. Contracts Nos 1,2 & 3', p.22. [21] GCA, M.P. 7 (179), 'New Municipal Buildings for the city of Glasgow: instructions to competing architects'. [22] Young, p.13. [23] *Glasgow News*, 5 January 1886 (n.p., cutting in D-TC 6/21, vol.2); 'The new Municipal Buildings', NBDM, 20 October 1887, p.2. [24] 'Glasgow Municipal Buildings: proposed Queen's Jubilee Memorial', GH, 3 December 1886, p.4. [25] *Ibid.* [26] A, 8 July 1882, p.24; B, 12 August 1882, p.224. [27] B, 11 November 1882, p.620. See also Young's plans, GCA D-AP 4/1, which differ from the published drawings, especially in the even more lavish use of figurative sculpture. [28] 'Glasgow Municipal Buildings: proposed Queen's Jubilee Memorial', GH, 3 December 1886, p.4. [29] Anon., 'The new Glasgow Municipal Buildings', SAR, vol.1, no.4, September 1888, p.93. [30] 'The new Municipal Buildings', NBDM, 23 July 1889, p.2. [31] GCA, D-TC 6/31, 'Contracts', p.22. [32] GCA, D-TC 6/31, 'Contracts', pp.22, 319. [33] NBDM, 20 October 1887, p.2. [34] Young, p.9. [35] GH, 3 December 1886, p.4. [36] GCA, D-TC 6/31, Box 2, Alexander Muir, 'Report on Municipal Buildings, George Square'. [37] GCA, D-TC 6/31 (vol.3), 'Committee on Municipal Buildings', 7 July 1902, p.66. [38] G. Linwood, 'The New Municipal Buildings for Glasgow', B, 26 August 1882, p.289. [39] GCA, D-TC 6/3 (Box 1), A.B. McDonald, 'Memorandum by the City Engineer', 7 October 1902. [40] GCA, D-TC 6/31 (vol.3), 'Committee on Municipal Buildings', 15 November 1904, p.88. [41] Muir, *op. cit.*, p.1. [42] Anon., 'The decay of Glasgow Municipal Buildings', B, 16 June 1906, p.682. [43] J. Northcroft, '"Dear green place" starts to worry scientists', H, 20 September 1995.

Other sources
BA, 2 April 1880, p.159; BN, 26 August 1882, p.289,
15 September 1882, p.322 (incl. ills), 9 October 1885,
p.589, 11 December 1885, p.958, 20 April 1888, p.562
(incl. ill.), 9 May 1890, p.672, 12 July 1912, p.62, 30
August 1912, p.307, 8 November 1912, p.646, 27
December 1912, p.902, 9 May, pp.631–7; NBDM, 6
October 1883; *Description of the ceremonial on the
occasion of Laying the Foundation Stone of the
Municipal Buildings, in George Square, Glasgow, on
6th October, 1883*, Glasgow, 1885; BN, 1 May 1885,
p.686 and accompanying ill.; *Glasgow News*, 26
November 1886, B, 22 September 1888, p.209, 12
October 1889, p.260, 9 July 1898, p.21; *The City
Chambers, Glasgow*, photographs by Bedford
Lemere & Co., n.d.; BJ, 5 February 1902, p.433;
Stevenson (1914), pp.26–33 (incl. ills); BN, 2 May.
1913, pp.608, 622–3 (ills) *Let Glasgow Flourish For
Ever: A Guide to the City Chambers*, Glasgow, 1953;
'Architectural Sculptor', (obit. of J.H. Mackinnon),
GH, 8 November 1954, p.9; Gomme and Walker,
pp.192–4 (incl. ills); Colin Cunningham, *Victorian
and Edwardian Town Halls*, London, 1981,
pp.138–40; Alison Claire Gibb, 'Glasgow City
Chambers: a Study', unpublished dissertation, GSA,
1987; Johnstone; Teggin *et al.*, pp.24–6 (incl. ills);
Williamson *et al.*, pp.159–63; Pearson, p.94 (ill.); *The
City Chambers, Glasgow*, Glasgow, 1992; McKenzie,
pp.52 (ill.), 53.

West Elevation – George Square

First storey, above entrance

Allegorical Frieze

Sculptor: George Anderson Lawson

Dimensions: figures larger than life-size
Inscription: on the coat of arms above the
central keystone – LET GLASGOW FLOURISH

Description: The treatment of the main
entrance is based on the Arch of Constantine in
Rome, which Young had visited 'a short time
before preparing the designs for these
buildings'.[1] Following classical precedent, the
area between the arches and the entablature is
devoted to narrative relief carving, though in
this case celebrating not militarism but 'the
peaceful victories of art, science, and
commerce'.[2] The frieze is divided by coupled

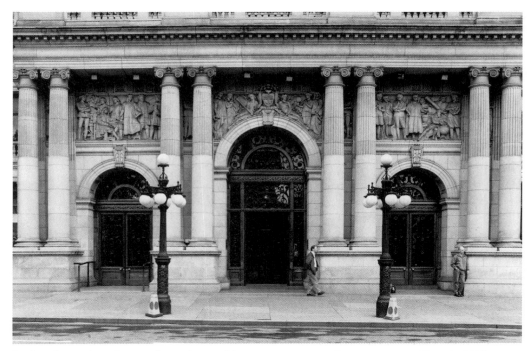

George Anderson Lawson, *Allegorical Frieze* [SS]

Ionic columns into three main sections, with
rectangular panels above the side arches and a
pair of spandrels flanking the taller central arch.
The spaces between the columns are occupied
by single figures, which allow the frieze to be
read as a continuous horizontal band. In the
central section a Glasgow coat of arms is
flanked by reclining female figures, both
winged, symbolising religious concepts: *Glory*
(with a trumpet) and *Victory* (a palm branch).
These are in turn flanked by standing female
figures symbolising the virtues: *Hope* (an
anchor), *Faith* (a palm branch), *Truth* (a mirror)
and *Charity* (a bowl?). The figures in the side
panels are emblematic of the various branches
of knowledge. On the left the figures include:
'Astronomy, knowledge of the heavens;
Geology, knowledge of the earth; Chemistry,
knowledge of the compounds or matter;
Engineering, knowledge of forces; Medicine,
knowledge of the body, and so on, representing

scientific knowledges'. On the right side, 'the
art knowledges are represented by Architecture
and Sculpture, knowledge of forms and designs;
Painting, knowledge of colour; Music,
knowledge of sound, and so on'.[3] Young
described the figures as 'all bringing their
respective knowledge to support the central
motto, "Let Glasgow flourish." This – Religion,
Virtue, and Knowledge – may be taken to
embody the missing half of the motto, "by the
preaching of the Word"'.[4]

Condition: By the beginning of the twentieth
century the frieze, along with much of the
exterior stonework elsewhere on the building,
had become severely decayed (see above). In
1905, the council received tenders from three
leading Glasgow sculptors to carry out repair
work, including the replacement of the entire

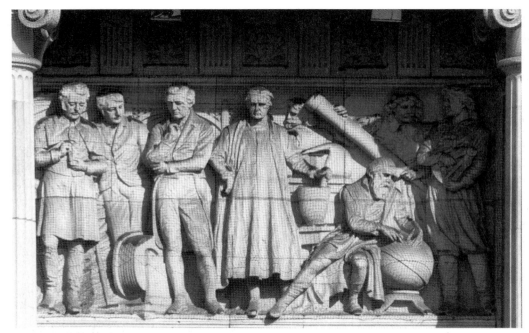

George Anderson Lawson, *Allegorical Frieze* **(detail)**

The Trades and Industries of Glasgow

Sculptor: John Mossman

Dimensions: figures approx. life-size

Description: The second storey of the west façade is a true *piano nobile*, and is dominated by a series of Venetian windows which run the entire length of the building. There are twenty-two spandrels in all, the majority of which contain single figures presented as either reclining or stooping to perform various tasks; the exceptions are the outermost bays, where they are grouped in pairs. In most cases the female figures are classically draped and recumbent, while their semi-naked male counterparts tend to be more heroically active. The figures are complemented by a rich vocabulary of industrial objects, such as hand-tools, machine components and other emblems of commercial activity, which enable the subjects to be identified as follows: stonemasonry and carpentry; tailoring and weaving; tanning and spinning(?); farming and coopering; chemistry and navigation; municipal government (in the centre); commerce and communication; slaughtering and baking; hairdressing and cobbling; gardening and printing; engineering and shipbuilding. It is interesting to note that the subject of the first spandrel is a stonemason, and that the background includes a section of the Parthenon frieze. Contemporary photographs of the engineering and shipbuilding spandrels show clearly the relationship between the design of the reliefs and the structure of the surrounding masonry.[1] This, together with the stipulation in Morrison & Mason's contract that blocks of stone were to be 'left rough on face for the sculpture in the spandrils', appears to confirm the fact that this part of the scheme was carved *in situ*.[2]

Condition: Good.

central panel with a bronze copy and the selective restoration of details in the side panels and the figures between the columns. There is no record that these repairs were authorised, and no evidence of bronze-work in the central panel. The likely explanation was that the council was deterred by the estimates, which ranged from £1,125 (McGilvray & Ferris) to £1,385 (Archibald Macfarlane Shannan), with William Kellock Brown offering to carry out the work for £1,300. It is worth noting, however, that Shannan also submitted a tender of £125 for the repair of the reliefs using a material patented by the Dreyfus Stone Co.,[5] and it is likely it is this method that was used. At present the physical fabric of the reliefs is in a fair condition, with the upper surfaces of the figures treated with a bituminous anti-pigeon coating.

The wrought iron gates in the entrance arches are by George Adam & Son, who were paid £150 for carrying out the work.[6] The cast iron lamp standards are by Walter Macfarlane & Co.[7]

Notes
[1] Young, text to plate 2. [2] *Ibid*. [3] GH, 3 December 1886, p.4. [4] Young, text to plate 2. [5] GCA, D-TC 6/31 (Box 1). [6] GCA, M.P. 20, 'New Municipal Buildings: statement of cost', pp.622–3. [7] Anon., 'The Glasgow new Municipal Buildings', BA, 6 September 1889, p.174.

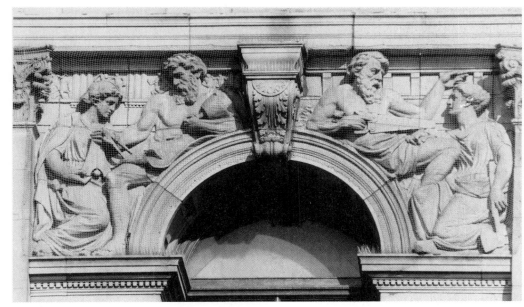

John Mossman, *Stonemasonry and Carpentry*

Notes
[1] BN, 16 September 1887, p.453 (incl. ills). [2] GCA, D-TC 6/31, 'Contracts', p.27.

Other sources
NBDM, 20 October 1887, p.2; GH, 3 December 1886, p.4.

On the third-storey balustrade
Eight Allegorical Female Figures
Sculptor: John Rhind

Dimensions: statues 2.28m high

Description: The figures are all draped and seated on pedestals aligned vertically with the coupled Corinthian columns in the *piano nobile*. In October 1886, the *North British Daily Mail* reported on the progress of this part of the scheme:

Above the panels, standing on pedestals over the columns, will be eight figures, four of which are already placed, representing the graces or goddesses presiding over the trades. The four already fixed represent Hygiene, Wisdom, Peace and Plenty.[1]

It also noted that the section of blank wall behind the figures was to be 'carved into a rich frieze, as has been done on the façade towards George Street'. This is indicated on Young's drawing, but was not actually carried out. The figures referred to in the report are on the left of the central bay; those on the right include *Harmony*, *Piety*, *History* and *Prosperity*.[2] The Corporation's financial report on the construction records a payment of £960 to Morrison & Mason for 'Figures for Second Floor Balustrade', which suggests that Rhind may have been responsible only for modelling the statues.[3] The contractors were also paid £6 16s. for preparing the eight pedestals, and £1 per statue for raising them into position.[4]

Condition: Good.

Notes
[1] NBDM, 20 October 1887, p.2. [2] These are the subjects listed in GH, 3 December 1886, p.4 and Young, text accompanying plate 1. The attributes on the statues are not clearly visible, and it is not possible to specify the order in which they have been placed. [3] GCA, M.P. 20, 'Statement of cost', pp.622–3. [4] GCA, D-TC 6/31, 'Contracts', p.299.

John Rhind, *Allegorical Female Figure*

In the centre of the George Square façade
Jubilee Pediment

Sculptors: George Anderson Lawson (modeller); James Alexander Ewing (carver) assisted by John Tweed and others

Dimensions: figures approx. 2.44m high; pediment 15.2m long × 3.36m high at apex

Description: The Jubilee Pediment takes its name from the fact that its completion coincided with the fiftieth anniversary of Queen Victoria's accession to the throne in 1837. In the introduction to his commemorative book on the building, William Young provides the following account of the symbolic programme of the pediment:

The sculpture subject … represents Queen Victoria seated on her throne and her subjects from all parts of the world coming to her with their homage and congratulations. The centre figure is that of the Queen, with a lion at her feet, supported on each side by figures emblematic of England, Scotland, Ireland, and Wales. The spaces at each side of the centre group are filled with figures illustrating the various British possessions. On one side Canada is represented, accompanied by an American Indian; Australia is shown by a gold digger; the other figures represent New Zealand and the other colonies of the empire which lie to the west of Great Britain. On the other side of the pediment are sculptures representing India, a native chief being one of the subjects, with the head and front of an elephant shown behind. After India comes Africa, symbolised by a white man having his hand round a negro. Farther on, and extending out to the end of the pediment, figures representing other dependencies which lie to the east of Europe are indicated.[1]

He concludes his description by noting that

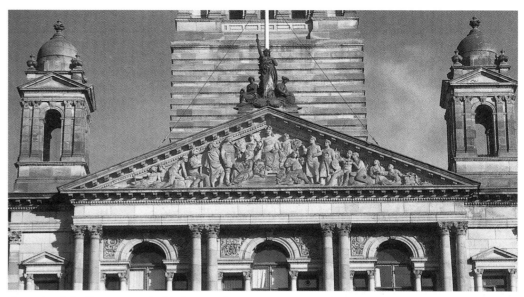

George Anderson Lawson, *Jubilee Pediment*

the scale of the figures was decided upon after he and Lawson had spent time in the British Museum 'measuring and studying' the Elgin Marbles, and that the Glasgow figures are 'rather larger than those which adorned the famous Greek temple'.[2]

Discussion: As executed, the design differs radically from Young's original intention, which was to show a symbolic figure of Glasgow, with 'the Clyde at her feet sending her manufactures and her arts to all the world'. In November 1886, however, he wrote to the convener of the building committee, outlining an entirely new scheme, and stressing the degree of significance he attached to the pediment in relation to the sculpture programme as a whole. 'I have', he explained,

… been for some time thinking over a matter in connection with the new Municipal Buildings, which seems to me one of considerable importance, and I first communicate my ideas to you, as convener of the committee, in the hope that you will bring it before the Lord Provost and others

if you think fit, so that the matter may be taken up at a meeting of the committee. The time has now arrived when the model for the sculpture in the pediment of the George Square front should be put in hand, and it seems to me that a most important and imperial memorial may be made of this. I may remind you that I have carried out my original idea that all the carving and sculpture should have a meaning, and so far everything is illustrative or symbolic of something in connection with Glasgow. [...] But it has occurred to me that as next year will be the Queen's jubilee, and as a great many towns (I suppose all important towns and cities) will be putting up memorials in honour of the occasion, we might take the opportunity of making the pediment a memorial of the Queen's jubilee. I would suggest that the subject might be 'The Jubilee of Queen Victoria, 1887' [...] As a

memorial it would be a long way ahead of the usual statue or drinking fountain, which is generally adopted, and will largely be adopted again. The subject is a truly imperial one, and will have an interest for all, now and hereafter. It is following on the lines of the grand sculptures on ancient buildings, to record in stone the greatest event of the day, and, in my opinion, it is equal as a subject to anything ancient or modern. Consider! this is the only building in the country (perhaps in the world) where such a grand memorial is possible as an actual record executed, as it will be, in the jubilee year.[3]

Young concludes his letter by offering to have a model of the pediment 'put in hand at once' and, if required, send a sketch or a photograph of it to the Queen for her approval. After consideration of his letter, and after allowing Young to state his case in person at a subsequent meeting, the committee authorised the production of a clay model by Lawson, which was examined in January of the following year.[4] It appears that the committee was not overwhelmingly impressed, and the motion to allow him to proceed was challenged by one councillor, who forced a division on the issue. The vote went narrowly in Young's favour, with the former Lord Provost, Andrew Ure, among the thirteen members who opposed the motion.[5] Financial considerations were almost certainly uppermost in the committee members' minds. Young himself had acknowledged that additional funds would be needed, but that the extra expenditure would not exceed £1,500 and that 'probably £1,000 might do it'.[6] The final cost was in fact £1,500.[7]

Condition: Good, but with some surface biological growth.

Notes
[1] Young, p.18. [2] *Ibid.* [3] Letter from William Young to convener of building committee, quoted in GH, 3 December 1886, p.4. [4] GCA, M.P. 16, pp. 433–4. [5] *Ibid.*, p.434. [6] *Ibid.*, p.433. [7] GCA, D-TC 6/31, vol.2, p.209.

On the apex of the Jubilee Pediment
Acroterion Group of Liberty, Riches and Honour

Sculptors: George Anderson Lawson (modeller); James Alexander Ewing (carver)

Dimensions: central figure approx. 3m high

Description: The *North British Daily Mail* describes the group as representing 'Liberty, with Trade and Commerce at her feet, and bringing Prosperity in her train'.[1] This is slightly at variance with Young's own account: 'The central figure is emblematic of Truth, holding up the light of liberty over the city, and in her train are two supporting figures of Riches and Honour.'[2] At any rate, the striking similarity of the central figure to Bartholdi's *Statue of Liberty* in New York (1886) has often been remarked upon.

Discussion: The records are unclear as to the authorship of this group, but the fact that most contemporary descriptions treat it as an integral part of the design of the Jubilee Pediment suggests that it was modelled by Lawson; the treatment of the surface is also very much in the style of Ewing. The cost of erecting the statue on its pedestal was £1 10s.[3]

Condition: Structurally good, but with a heavy biological growth on the surface.

Notes
[1] NBDM, 20 October 1887, p.2. [2] Young, p.18; see also GH, 3 December 1886, p.4. [3] GCA, D-TC 6/31 'Contracts', p.302.

On the upper stage of the central tower
The Four Seasons

Sculptor: not known

Dimensions: figures colossal

The four statues are free-standing and face outwards from the peristyle supporting the

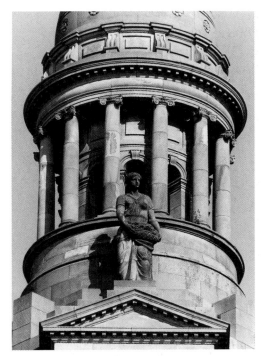

Anon., *Autumn*

cupola. They are orientated to the four cardinal points of the compass, with *Spring* facing to 'the opening east', *Summer* to 'the sunny south', *Autumn* to 'the declining west' and *Winter* to 'the bleak north'.[1]

Condition: Fair.

Note
[1] 'The new Municipal Buildings', NBDM, 23 July 1889, p.2.

On the cupola of the main tower
Finial

Designer and fabricator: not known

Material: gilded copper
Dimensions: 5.48m high

George Square, City Chambers 157

Surmounting the cupola is a large gilded copper finial composed of an orb, a cross and a weather vane. The *Scottish Art Review* was highly critical of the design of the tower, and accused the architect of attempting to compensate for its deficiencies with a

> … metal vane of such massive design that it might have been carved in stone, and of such huge proportions as to constitute a fitting termination to the great pyramid of Gizeh. To the daily paper this eighteen feet or so of untarnished copper has been a source of unlimited satisfaction, but the judicious in art grieve, and turn their eyes from looking upward.[1]

The tower itself is 70 metres high.
Condition: Good.

Note
[1] Anon., 'The new Glasgow Municipal Buildings', SAR, vol.1, no.4, September 1888, p.94.

On the corner towers
Cherub and Lion Groups and related decorative carving
Sculptor: not known

Dimensions: cherubs larger than life-size

Description: At either end of the George Square elevation are substantial corner towers decorated with a variety of sculptural features. In addition to the Mossman spandrels already discussed, these include: floral schemes in the segmental pediments above the first-floor windows; rectangular relief panels containing various devices associated with trade between the pilasters on the second and third floors; groups of naked cherubs supporting urns on each corner of the towers at attic level. These features are repeated on each of the other three elevations, though with minor variations such as the substitution of winged lions for cherubs on the north-east and south-east towers.

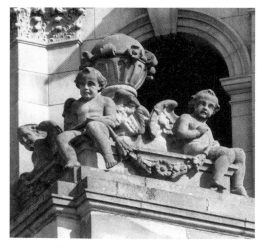

Anon., *Cherubs*

Discussion: Published versions of Young's design show a number of differences to the scheme as executed, including larger and more complex figure groups in place of the cherub and lion groups, standing figures in the pairs of arched niches on each of the middle storeys, and reclining figures in the segmental pediments on the ground floor entablatures.[1]
Condition: Fair.

Note
[1] BN, 1 May 1885, p.686 and accompanying ill.

In the George Square entrance loggia
Two Pairs of Symbolic Caryatids
Sculptor: John Mossman

Dimensions: figures 2.13m high

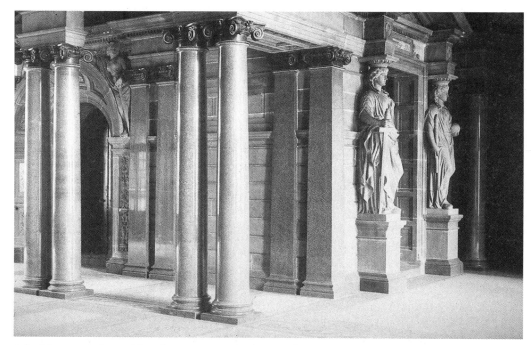

John Mossman, *Caryatids* **and James Pittendrigh Macgillivray,** *Spandrel Figures.* **Photograph from William Young,** *The Municipal Buildings of Glasgow,* **1890. [GSA]**

The statues are designed as classical Greek caryatids, and provide support for the entablatures projecting over the entrances to the stairs leading to the Banqueting Hall and the Council Chamber. Their subjects may be identified from their attributes as, from the left: *Honour* (holding a wreath) and *Virtue* (a lily) at the entrance to the north staircase; *Power* (a sword) and *Knowledge* (an orb and a torch) at the entrance to the south.[1] The choice of subjects was intended to represent an 'old traditional saying, quoted in Lord provost Ure's speech when laying the foundation' (see above), in which he referred to the 'pillar of wisdom, the pillar of strength, the pillar of purity or uprightness, and the pillar of honour'.[2]

There are two small bronze figure sculptures on display in this part of the loggia: a male classical nude by an unknown sculptor, and a female nude holding a bunch of grapes by J. Angel, 1915. Both are approximately 60cm high.

Condition: Good.

Notes
[1] GN, 5 January 1886 (n.p., cutting in D-TC 6/31, vol.2). [2] GH, 3 December 1886, p.4.

Above side doors in inner loggia
Female Spandrel Figures
Sculptor: James Pittendrigh Macgillivray

Dimensions: figures life-size
Inscriptions: in the north spandrel – VICE IS ABHORED; PEACE IS BELOVED; in the south spandrel – VIRTUE IS REWARDED; EVIL DOERS ARE PUNISHED; in the arabesque panels below – GMB ('Glasgow Municipal Buildings')

The figures' attributes are almost identical to those of the caryatids, and include (clockwise from the north pair): a lily, a wreath, a sword and a key. Similarly, the inscriptions are a variation on the 'motto which was cut in letters over the door of the Old Tolbooth': 'To this house vice is hateful; by this house peace is beloved; by this house upright men are honoured; and evil doers punished'.[1] Each of the vertical arabesque panels below the figures contains a small trophy representing an aspect of art or industry, including an Ionic capital, an artist's palette and brushes, a set of engineering tools and a group of musical instruments.

Condition: Good.

Note
[1] GH, 3 December 1886, p.4.

North Elevation – George Street
Allegorical Figure Groups, Putti and Associated Decorative Carving
Sculptor: John Mossman

Dimensions: figures approx. 3m high; putti approx. 1.8m high

Description: Composed of a series of banded Ionic columns on the ground floor and pairs of giant Corinthian columns spanning the floors above, the George Street façade is more boldly designed than the George Square elevation. However, the sculpture programme is both simpler and less extensive. On the first floor is a low-relief frieze consisting of foliated scrolls punctuated by a series large naked putti involved in activities such as playing musical instruments, fishing, farming and carrying bowls of produce. These appear in the spandrels of the triplet windows and in panels inserted between the columns and pilasters. On the attic are two groups of draped monumental female figures, the pedestals of which are on sections of projecting entablature supported by pairs of Corinthian columns. In each group the central figure is standing, with her two companions seated at her feet. The group on the left symbolises the *Arts of Peace*, with the figures shown weaving (left), writing (right) and holding a corn stalk (centre, possibly *Ceres*). The group also includes a plough and a wheatsheaf. On the right the figures represent the concerns of *Justice*, with an armoured figure holding an axe on the left, a classically draped figure holding a pitcher on the right and the central figure holding a sword. There is a lion mask and a swag on the front face of each pedestal. The spandrels of the second-storey Venetian windows in the outer bays are, unlike those on George Square, purely ornamental.

Discussion: The George Street façade was regarded by many commentators as the most successful part of the building's exterior. The *Scottish Art Review*, for example, noted that

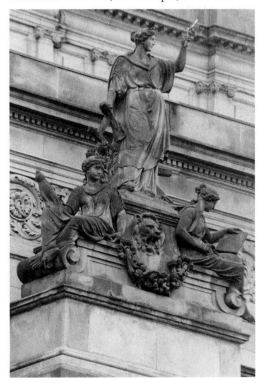

John Mossman, *The Arts of Peace*

... the importance of the banqueting-hall is well marked by the rich band of sculpture in the form of a boldly-cut acanthus scroll carried through the entire length of the surmounting attic, as also by the groups of children amid foliated scrolls in high relief upon the spandrels of the windows.[1]

It was less complimentary about the banded Ionic columns on the ground floor, however, which it referred to as being of the 'cheese and tea-box' order.

The wrought iron gates were installed by the London firm of Starkie, Gardner & Co. for £75.[2]

Condition: Good, but with a heavy coating of green algae on the main figures and much grime on the putti.

Notes
[1] Anon., 'The new Glasgow Municipal Buildings', SAR, vol.1, no.4, September 1888, p.94. See also Gourlay, p.472. [2] GCA, M.P. 20, 'New Municipal Buildings: statement of cost', pp.622–3.

East Elevation – John Street
Glasgow Arms, Datestone and Decorative Carving
Sculptor: not known

Inscription: on the datestone below the central pediment – AD 1887

This is the plainest of the four external elevations, using a restrained vocabulary of pilasters and colonettes reminiscent of the early Italian Renaissance. There are no figure sculptures on this façade, which, according the *Builder*, 'being mainly occupied with business offices, receives a simple treatment which does not require their aid'.[1] There is, however, a small amount of decorative carving, including a Glasgow coat of arms in the central pediment and some floral decoration in the spandrels of the windows below.

Condition: Fair.

Note
[1] B, 12 August 1882, p.224.

South Elevation – Cochrane Street
Above arched entrance to the quadrangle
Spandrel Figures
Sculptor: not known

Dimensions: a little larger than life-size

The south façade is a variation on the George Square frontage, though with a slightly less grand central bay, and with the Venetian windows on the second floor replaced by plainer aedicules. It is also the elevation that suffered most from the changes to Young's original design. Initially, sculptures were intended to be 'freely introduced', and at one point a stone-tinted plaster model of a seated figure was placed on the third-floor balustrade to enable Young to judge its effect from the ground (see Intoduction, above). The pedestals on which the figures were intended to sit remain, but in the event the only sculpture that was executed is a pair of reclining female

Anon., *Spandrel Figures*

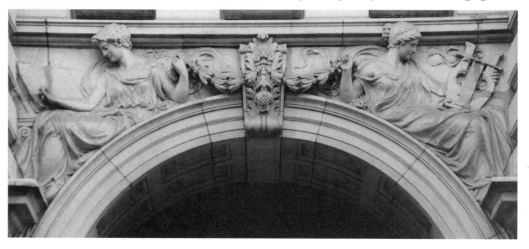

spandrel figures over the central archway. The figure on the left reads a book, her companion on the right holds a lyre, and with their free hands they hold the ends of a garland which spans the space between them, partly concealing the keystone. The reduction of the sculpture programme may have been a consequence of the more ambitious treatment of the Jubilee Pediment.

The wrought iron gates were installed by the London firm of Starkie, Gardner & Co. for £75.[1]

Condition: Good.

Note
[1] GCA, M.P. 20, 'New Municipal Buildings: statement of cost', pp.622–3.

Other sources
A, 8 July 1882, p.24; B, 12 August 1882, p.224; BN, 15 September 1882, n.p. (ill.)

Quadrangle
Armorial Panels and Putti
Sculptors: not known

Dimensions: panels approx. 90cm × 1.2m; putti approx. 1.2m high

The quadrangle may be entered through gates

Anon., *Armorial Panel* [RM]

in the centre of the George Street and Cochrane Street façades. There is a small amount of relief carving, including a series of thirteen square panels above the ground-floor windows on the east wall containing images associated with the Glasgow coat of arms (a bell, a fish, a bird in a tree) repeated symmetrically around a central image of St Mungo. In the north-west corner there is a group of naked putti entwined with acanthus scrolls between a pair of oculi on the first floor. There are keystone masks on these windows, and on the arch in the adjacent wall.

Condition: Fair.

John Street

On triumphal arches connecting the main building to eastern extension

Trophies and Coats of Arms

Sculptor: not known

Architects: John Watson & David Salmond
Date: 1913–23
Dimensions: 1.5m × 4.3m

Within a quarter of a century of the opening of the City Chambers in 1889, accommodation problems had arisen again, and in 1913 plans were drawn up for an additional building on the site opposite the John Street elevation. Watson & Salmond's original design, though more austerely Roman than Young's earlier building, made provision for four colossal attic figures on the end bays of the Cochrane Street frontage, but these were not executed.[1] The austerity is relieved, however, by the series of large, deeply carved escutcheons on the triumphal arches connecting the two buildings across John Street. Apart from minor variations in detail, the treatment of the two arches is identical. On the southern face of each arch is a Glasgow coat of arms, set within an arrangement of intricately draped flags; on the north there is a complex tableau of maritime and industrial imagery, including the prow of a ship projecting by several feet.

Condition: Good but blackened.

Note
[1] Anon., 'Glasgow Municipal Buildings extension: the selected design', BN, 2 May 1913, p. 608 incl. ill. (n.p.).

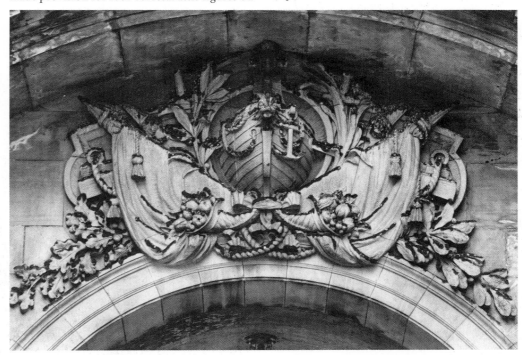

Anon., *Trophy*

George Street CITY CENTRE

Alexander Turnbull Building, 151–9 George Street

Pediment Figures
Sculptor: not known

Architects: Frank Burnet & Boston
Date: 1897
Material: red Locharbriggs sandstone
Dimensions: figures life-size
Listed status: category C(S) (4 September 1989)
Owner: University of Strathclyde

Description: Two youths, naked apart from lengths of cloth draped over their hips, are seated on either side of a large blind cartouche in the pediment above the entrance of this six-storey commercial building. Each figure clutches his shin with one hand and has the other looped inside a volute of the cartouche. There is a mass of heavily carved foliage in the background, while the outer corners of the pediment are filled with references to maritime trade: on the left a cable drum; on the right the prow of an antique ship cleaving stylised waves.

Discussion: Designed originally as a warehouse, the building is now occupied by the Media Services and Psychology Departments of the University of Strathclyde. The unidealised treatment of the anatomy of the figures, together with their expressive poses, suggests the work of one of the exponents of the New Sculpture, possibly Francis Derwent Wood. (See, for example, *Mercury*, Mercantile Chambers, 35–69 Bothwell Street.)

Condition: Overall sound, though the building and sculptures are blackened with pollution.

Source
Williamson *et al.*, p.178.

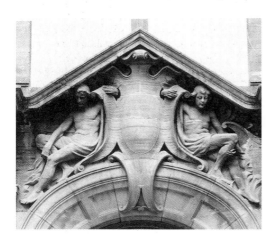

Anon., *Pediment Figures*

Glasgow Parish Council Chambers, 266 George Street

Spandrel Figures
Sculptor: James Charles Young (attrib.)

Architects: Thomson & Sandilands
Mason: William Shaw & Son
Date: 1900–02
Material: red sandstone
Dimensions: figures approx. life-size
Inscriptions: above coat of arms – PARISH
 COUNCIL GLASGOW; below coat of arms –
 PROTEGERE ET SUSTINERE (trans.: 'protect
 and sustain')
Listed status: category A (9 March 1989)
Owner: Glasgow City Council

Description: A tall public building designed in 'a confused mixture of styles',[1] including giant coupled Ionic columns with a Doric entablature, canted oriel windows and a central

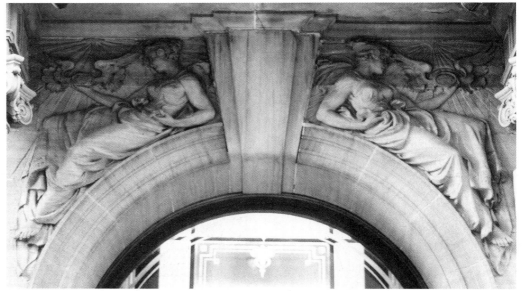

James Charles Young (attrib.), *Spandrel Figures*

dome flanked by pavilions. Reclining in the spandrel over the doorway are two female figures, both draped, with sunbursts above their heads. Almost identical in both pose and dress, they are shown gathering the folds of their robes into their waist with one hand, and holding a small winged medallion with the other. These are inscribed with an anchor (left) and a sword. In the entablature above them is a Glasgow coat of arms surmounted by a crown. Minor carved decorations include floral capitals in the ground-floor windows, wreaths on either side of the coat of arms and on the second-floor balconies, and blind cartouches below the columns.

Discussion: The building was erected as premises for the Glasgow Parish Council shortly after the amalgamation of the two councils which had formerly taken responsibility for the city's schools, poorhouses, hospitals and asylums. Noting its proximity to the City Chambers (q.v., George Square), one contemporary commentator claimed that although it was smaller, the building was 'no discredit to that world-renowned structure'.[2] The anchor (symbol of Hope) and the sword (Justice) on the winged shields may have been used in deliberate emulation of the imagery on some parts of the earlier building. The attribution of the carving to James Young is based on the resemblance in the pose and treatment to the same sculptor's allegorical spandrel figures on Govan Town Hall of c.1898 (q.v., 401 Govan Road), also by Thomson & Sandilands.

Condition: Fair, but with some discoloration.

Notes
[1] Williamson *et al.*, p.178. [2] *Glasgow and Lanarkshire Illustrated*, Hamilton, n.d. (1904?), p.43.

Other sources
BI, 16 May 1900, p.45, 14 July 1900, p.61, 16 January 1902, pp.148, 152 (incl. ill.); GH, 22 April 1901; BJ, 28 November 1906, pp. 264, 271 (incl. ill.); Gomme and Walker (1987), p.263; McKean *et al.*, p.78.

Glasgow Green CALTON

INTRODUCTION

Glasgow Green occupies an area of 136 acres, and stretches for approximately 1½ miles along the north bank of the River Clyde east of the Saltmarket. Its origin can be traced back to 1450, when James II of Scotland granted a tract of land to Bishop William Turnbull, who in turn gifted the land to the community.[1] Until the opening of Kelvingrove Park (q.v.) four centuries later it was the only public park in Glasgow, and was often referred to simply as 'the Public Green'. A detailed account of the Green would encompass much that is central to the development of Glasgow, and the role the city has played in the wider pattern of Scottish history. It was, for example, on the part of the Green known as Fleshers' Haugh that Bonnie Prince Charlie reviewed his troops during an ill-fated attempt to rally the Jacobite cause in 1746.[2] Less than twenty years later, 'on a fine Sabbath afternoon, in 1765', James Watt was to change the course of industrial history by conceiving his idea of the separate condenser for the steam engine. 'I had not walked further than the golf-house' he wrote in a letter to a friend, 'when the whole thing was arranged in my mind.'[3] More important than any individual event, however, is the symbolic role the Green has played in the life of the city, and its potency as a focus of popular sentiment. A vital public resource in the heart of the densely populated industrial east end, it has from time immemorial been 'esteemed as peculiarly the birthright and property of the people, and the east-ender watches over it with a jealous care which is almost savage in its manifestations'.[4] As recently as 1981 the City Council was forced to abandon its plan to bisect the Green with a motorway link from Townhead to Gorbals by sheer force of popular opposition, not least by a pressure group known by the acronym GRIM

(Glasgow Resistance to Incoming Motorways).[5]

The physical appearance of Glasgow Green as it exists today derives from a series of improvements carried out by the Superintendent of Public Works James Cleland (see 249 Buchanan Street) between 1815 and 1826, including some much-needed draining and levelling, the creation of a network of carriage drives and walkways and an extensive programme of tree planting. This was to usher in the heyday of the Green as the setting for many manifestations of public culture, such as sporting and leisure pursuits, popular entertainment and so on, but also, more crucially, for a variety of forms of political activism. Described by one writer as the 'Areopagus of the east-end',[6] and by another as the 'university of the people',[7] it was the natural mustering place for political rallies dating from the period of the Reform Acts of the 1830s to the great workers' demonstration of 1884. The western entrance, opposite the courthouse was for many years the Glaswegian equivalent of Speakers' Corner in London, providing soap-box orators of every social, political and religious persuasion with a platform from which to denounce their opponents to an attentive but usually sceptical audience.

Less conspicuous, but no less vital, has been the role of the Green in promoting the safety of those taking advantage of the commercial and recreational benefits of the river, and in 1790 the Glasgow Humane Society was founded 'for the purposes of … rescuing persons from drowning in the Clyde',[8] establishing a small dwelling house for a full-time warden close to the point where the river takes a sharp westward turn. The house is occupied today by George Parsonage (b.1944), who combines his life-saving duties with a thriving practice as a sculptor, specialising in fantastic, Wyllie-esque

structures made from metal debris salvaged from the river banks. The many hundreds of discarded supermarket trolleys which find their way into the Clyde have proved to be a particularly rich source of inspiration, and which Parsonage's fertile imagination has transformed variously into sailing ships, wading birds and other riparian subjects. An entirely independent artist, he refuses to sell his work,

George Parsonage, *Junk Sculpture*

or to exhibit it in mainstream galleries, preferring instead to display it on a temporary basis in his riverside garden until it is donated to the annual Macmillan charity auction.[9]

In recent years Glasgow Green has suffered badly from neglect, and many of the sculptures and monuments located in it are in a poor state of repair. A particular cause for concern is the condition of the Doulton Fountain (see below), which may be taken as symptomatic of the general process of deterioration that has been allowed to occur since the Second World War. In 1997, however, the city council made a successful application to the Heritage Lottery Fund, and was awarded £6.65 million to initiate a massive redevelopment programme. This will include the restoration and rebuilding of the Doulton Fountain on a new site in front of the People's Palace Museum, an extensive scheme of landscape improvements and the creation of a supervised children's 'playing village'. Work is scheduled for completion towards the end of 2001.[10]

Notes
[1] 'Noremac', pp.19, 27. [2] Macdonald, p.12. [3] King, pp.19–20. [4] *Ibid.*, p.27. [5] *Ibid.*, p.32. [6] James Paton, quoted *ibid.*, p 27. [7] 'Noremac', p.15. [8] King, *op. cit.*, p.26. [9] Ann Donald, 'Living Treasures', GH, 14 October 1995, pp.24–5 (incl. ills). [10] Anon, 'It's green for go', *Glaswegian*, February 1998, pp.16–17.

Other sources
Tweed (*Guide*), pp.25–8; Cowan, pp.306–11; Vic Rodrick, 'Green for go', ET, 2 December 1997, p.3; Elizabeth Buie, '£6.65m Green light for park', GH, 3 December 1997, p.5 (incl. ill.); McKenzie, pp.19–20.

McLennan Arch, Saltmarket entrance opposite Justiciary Court

Classical Relief Panels
Sculptor: not known

Architects: Robert and James Adam; John Carrick

Date: *c.*1796
Material: yellow sandstone
Dimensions: panels approx 1.2m × 90cm
Inscription: in the entablature – THIS ARCH WAS PRESENTED TO HIS FELLOW CITIZENS / BY BAILLIE JAMES MCLENNAN. J.P. / SENIOR MAGISTRATE OF THE CITY OF GLASGOW, DEACON CONVENOR OF THE TRADES' HOUSE / AND SINCE 1884 ONE OF THE REPRESENTATIVES OF THIS WARD IN THE TOWN COUNCIL / MDCCCXCIII
Listed status: category B (15 December 1970)
Owner: Glasgow City Council

Description: Modelled loosely on the triumphal arches of Imperial Rome, the building has a central arched carriageway flanked by lower, square-headed pedestrian openings, with the bays divided by detached giant Ionic columns on the front (west) elevation, and pilasters on the rear. The relief panels are located between the columns, just below the entablature. On the left a male figure, probably Orpheus, is shown seated on a rock in front of an oak tree playing a lyre, with a sunburst radiating from behind his head. At his feet is a still life group consisting of a horn, a pair of woodwind instruments and an open music score, while in the background a horse prances on a bluff of rock. The panel on the right has the three dancing Graces, one of whom plays a tambourine.

Discussion: The arch is composed of architectural fragments salvaged from Robert and James Adam's Assembly Rooms, which were built on Ingram Street in 1796[1] and demolished almost a century later in 1890. The removal of the columns and entablature from the centre of the main façade of the Adams' building, and their adaptation as a free-standing structure, is said to have been carried out 'under direction' of the City Architect John Carrick,[2] although he in fact died in 1890, at least two years before the arch was erected at the junction of Greendyke Street and Monteith Row, on the

Anon., *Orpheus* [RM]

Anon., *The Three Graces* [RM]

north side of Glasgow Green.[3] A much-travelled building, it was moved a short distance west to provide a termination to Charlotte Street in 1922, much to the approval of the members of the Glasgow Institute of Architects (who suggested that the front should face south, 'so that it might be seen to the best advantage'),[4] then dismantled once again and re-erected in its present location in 1991–2, after it had begun to tilt.[5]

Related work: A design for the Assembly Rooms published posthumously in the *New Vitruvius Britannicus* (1802)[6] shows an unexecuted coat of arms flanked by seated figures on the attic, similar to the attic group on Robert and James Adams' Trades House (85–91 Glassford Street, q.v.). (Ironically, Adam's original design for the Trades House had no such attic figures.[7]) A carved medallion salvaged from the Assembly Rooms was discovered by James Cowan in 1934 built into a folly in a private garden in Easterhouse.[8] It is not known if it still exists.

Condition: Generally good, but with considerable wear on the faces of the three Graces.

Notes
[1] Worsdall (1981), p.44. [2] LBI, Ward 26, p.33. [3] *Ibid.*, has 1894 as the date of its erection; Williamson *et al.*, p.457, have 1892. [4] GCA, C1/3/70, p.473; Young and Doak, no.13. [5] LBI, Ward 26, p.33. [6] Reproduced in King, pl.67. [7] McKean *et al.*, p.63. [8] Cowan, p.179.

Other sources
'Noremac', p.15 (ill.); Gomme and Walker, p.61; McKean *et al.*, pp.32–3 (incl. ill.); Eunson (1997), pp.10–11 (incl. ills); McKenzie, pp.20, 21 (ill.).

Immediately east of McLennan Arch

Sir William Collins Memorial Fountain

Sculptor: John Mossman

Date: 1881–2
Materials: bronze (statue and portrait medallion); pink and grey granite (fountain)
Dimensions: overall height approx. 4m; statue approx. 1.5m high; portrait panel 54cm × 48cm
Signatures: on the plinth of the statue, left side – J MOSSMAN SC / 1882; on the shoulder of the portrait – J MOSSMAN SC 1881
Inscriptions: on a bronze plaque fixed to the east side – ERECTED / BY TEMPERANCE REFORMERS / IN RECOGNITION OF / VALUABLE SERVICES / RENDERED TO / THE TEMPERANCE CAUSE / BY / SIR WILLIAM COLLINS / LORD PROVOST / OF THE CITY OF GLASGOW 1877–80 / 29TH OCTOBER 1881
Listed status: category B (16 March 1993)
Owner: Glasgow City Council

William Collins (1817–95), born in Glasgow, the son of a publisher and temperance reformer, was educated in Glasgow and entered his father's business as an apprentice at an early age. In 1848 he became a partner, and when his father died in 1853 he continued the business on his own, manufacturing stationery as well as publishing. The firm expanded greatly and he took on several partners, including his two elder sons, in 1859. In 1868 he joined the City Council, was elected a magistrate in 1873 and was Lord Provost 1877–80, the first total abstainer to be elected to that office. He was knighted in 1880, and later (1888–94) served on the Glasgow School Board. He died in Edinburgh and is buried in Glasgow Necropolis.[1]

Description: The fountain consists of a rectangular pedestal in grey granite with drinking bowls (no longer functional) in pink granite projecting from the sides. Above the bowls, the water outlets are in the form of bronze lion masks (right side missing). A draped female figure representing *Temperance* stands on a squat Doric column, contemplating a flower and with an inverted jug in her right hand. The portrait medallion is a rectangular panel on the west side of the pedestal, facing the Courthouse.

Discussion: The fountain was originally located further to the west, at the Saltmarket entrance to the Green,[2] and was moved to its present position in 1991–2 when the McLennan Arch was erected there. In August 1994, the statue was badly damaged when vandals pulled it from its pedestal, using a hay bale in an unsuccessful attempt to cushion its fall.[3] The repair work, including the re-attachment of its head, was carried out by EK Metal Fabricators, East Kilbride.

Condition: Generally good, but a quantity of paint has been thrown on the cornice and there is some light graffiti on the portrait.

Notes
[1] Anon., *Biographical Sketches of the Hon. the Lord Provosts of Glasgow*, Glasgow, 1883, pp.340–4. [2] See, for example, Lyall, pp.76–7. [3] 'Yobs wreck Green statue', ET, 10 August 1994.

Other sources
Groome, vol.3, p.128; Read and Ward-Jackson, 4/11/76–8 (ills); Williamson *et al.*, p.457; McKenzie, pp.20, 21 (ill.).

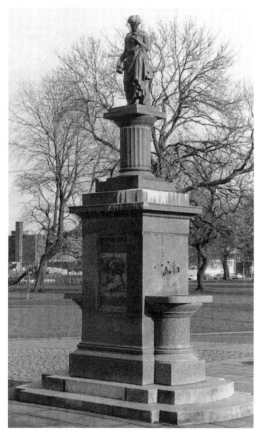

John Mossman, *Sir William Collins Memorial Fountain* [RM]

On the main carriageway, east of the Saltmarket entrance

Doulton Fountain

Designer: Arthur Edward Pearce
Modellers: John Broad, Herbert Ellis, Arthur Edward Pearce, Frederick Pomeroy, and possibly other students and graduates of the City and Guilds of London Institute Technical Art School, Kensington, and Lambeth School of Art[1]
Modelling supervisor: William Silver Frith

Manufacturer: Doulton & Co.
Date: 1888
Materials: terracotta on an iron frame
Dimensions: overall height 13m; outer basin 21m diameter; figures approx. life-size
Signatures: see below
Inscriptions: below the four reliefs of the Glasgow arms on the ground basin – LET GLASGOW FLOURISH; see also below
Listed status: category A (15 December 1970)
Owner: Glasgow City Council

Description: The fountain is a three-storey structure designed in a florid style derived from French Renaissance architecture. Broadly conical in its overall shape, it has a standing portrait of Queen Victoria at the apex and a complex figurative programme celebrating the

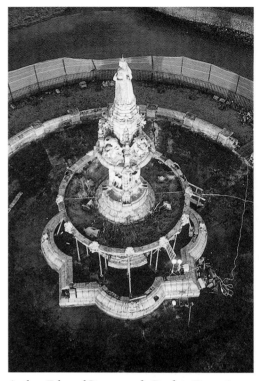

Arthur Edward Pearce *et al.*, *Doulton Fountain* [BB]

British Empire below. An internal hydraulic system, now defunct, originally pumped water through the central column to a group of four kneeling maidens holding inverted pitchers on the upper level. From here the water flowed into a cantilevered circular basin on the first storey, subsequently spouting through the mouths of lion heads and grotesque masks into the larger ground basin on which the main structure is raised. Designed on a quatrefoil plan, the ground basin has reliefs of the Glasgow arms, including miniature half-length images of St Mungo (mostly very damaged), in the centre of the four convex sections. Surrounding the main structure is a large

circular pool enclosed by an outer retaining wall divided by 24 pedestals which were originally capped with urns.

At the time of writing, the fountain is in an advanced state of dilapidation, and for safety reasons has been cordoned off with a tall wire fence. Many parts, including the entire upper sections of some figures, are missing or have been temporarily placed in storage by Glasgow Museums Service awaiting a proposed restoration programme (see Condition, below). For simplicity, the details of its main components will be described in their complete form, with notes on their present physical condition appended as required.

a) *Four Allegorical Groups Representing the Colonies in the Eastern and Western Hemispheres*

Inscriptions: in raised letters on cartouches below relevant groups – CANADA; STH AFRICA; AUSTRALIA; INDIA; incised on left or right side of the plinth of each group – DOULTON & CO. / LAMBETH

The groups are located on plinths projecting from arched openings in the vaulted lower structure. Each is composed of a male and a female figure in national costume, and is accompanied by the 'various emblems of the history of the industrial occupations of the peoples, together with some of the leading mineral, vegetable and animal products of those countries'.[2] In most cases the male figure is standing, while the female is seated, though in *Australia* this arrangement is reversed. Working clockwise from the north-west face, the groups are as follows:

Canada
Modeller: William Silver Frith

This group is

> … represented by a figure of a trapper, habited in leather costume, and bearing in his hand the head of a moose-ox and over his arm skins and furs. At his feet is a beaver. At the side is a female figure warmly clothed in blanket costume and seated on the stump of a felled tree. She bears a shaft of wheat and one hand rests on a felling-axe. At her feet are blocks of coal and a miner's pick, and in the background the rock of sugar-maple is growing.[3]

The heads and upper torsos of both figures are missing, as are a number of key details such as the beaver, the axe (with the female figure's right hand), the pick, the leafy growth behind the head of the female and the horns of the moose. The moose head, together with the male figure's midriff, is in store.[4]

William Silver Frith, *Canada* [RM]

South Africa
Modeller: Herbert Ellis
Signed: bottom left – H. ELLIS

> To represent the South African Colonies, there are figures of a farmer of European race, standing armed over his crops, and a seated figure of a native woman, surrounded by the various products of her country; the spade on which one hand rests referring to the mineral resources, the vine and maize to the agriculture, and the heap of wool and the ostrich in the background to the animal produce.[5]

The losses here include the left arm and rifle of the farmer and the ostrich. The woman's left arm, the handle of the spade and the head and torso of the farmer are in store.[6]

Australia
Modeller: Frederick Pomeroy

This group is

> … typified by the figure of a gold-digger resting on his spade and a female bearing a sheaf of wheat; her hand rests on a sheep, and a vine grows beside her, these referring to the wool and wine industries, as the fan-palm in the background does to the climate.[7]

Only the sheep and the lower half of each figure remain *in situ*. The fragmentary remains of the heads and torsos are mostly in store, though some details, including the collar and right shoulder of the male figure, have been lost.[8]

India
Modeller: John Broad
Signed: on the plinth – J. BROAD SC

> The Indian Empire is portrayed by a male figure, armed, representative of the military history of the vast country, and at his side is a trophy of native arms of various periods.

The female figure has reference to the arts and industries, typical examples of the manufactures being grouped around her; in her hand is a scroll of manuscript, to suggest the wonderful literature of India's many-centuried past; the other hand rests on a piece of pottery and a silken shawl, as specimens of the manual industries. In the background is some growing rice … a column surmounted by a group of figures calls to mind [India's] picturesque architecture.[9]

Very little of this group has survived. Only the legs of the two figures and part of the trophy are *in situ*, and a small number of isolated fragments are preserved in store.[10]

b) *Four Servicemen*
Modeller: not known

These are presented as sentries facing outwards from apsidal niches sunk into the central column supporting the superstructure. Working clockwise from the north, the figures represent the 'typical regiments of the three kingdoms',[11] as follows: *Black Watch Highlander* (intact); *Grenadier Guardsman* (legs and rifle butt *in situ*, torso in store, head and rifle lost); *Sailor in Royal Navy* (legs *in situ*, head and torso in store); *Royal Irish Fusilier* (intact apart from lower part of rifle).[12]

c) *Four Female Water Carriers*
Modeller: not known

Grouped round a central octagonal shaft, and divided from each other by ornate buttresses, these figures are located directly above the servicemen. Though all four are in similar kneeling postures, with an inverted vase resting on the raised right knee, there are minor variations in the positions of the hands and the treatment of their hair and draperies. The heads of all four figures have been damaged.[13]

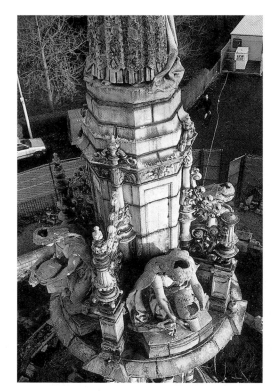

Anon., *Water Carriers* [BB]

d) *Queen Victoria*
Modeller: John Broad
Signed: on south face of plinth – J. BROAD. SC

Raised on a three-stage octagonal base, and dominating the entire design, 'Her Majesty is represented as bearing the orb and sceptre, and wearing the imperial crown'.[14] A distinctive feature of the statue is the treatment of the lace-work on her dress, which is decorated with floral designs of great delicacy. The sculpture was made in five sections, with the hands and the rod of the sceptre modelled separately, and the body divided at the waist. A contemporary commentator, who presumably had access to

the work before it was installed on the fountain, expressed the hope that the 'join round the middle of the skirt' would be 'obliterated when in situ'.[15] The join is not easily visible today.

Discussion: The fountain was manufactured originally as Doulton & Co.'s principal display at the 1888 International Exhibition in Kelvingrove Park (q.v.), where it was situated to the north of the Indian section of the main building.[16] It was intended as a personal gift to

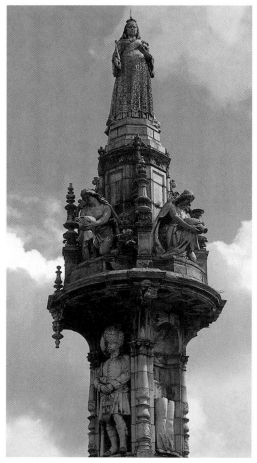

John Broad, *Queen Victoria*; anon., *Water Carriers* and *Servicemen* [RM]

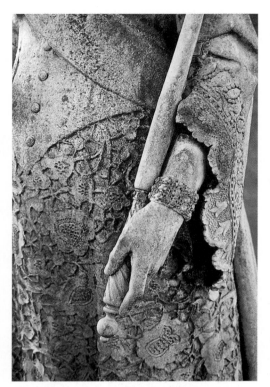

John Broad, *Queen Victoria* (detail) [BB]

the city of Glasgow by Sir Henry Doulton, not as a part of the company's commercial display, which included a number of interior stands of structural stoneware, decorative 'Art Pottery' and sanitary appliances, as well as a second fountain, designed by George Tinworth, under the dome of the main exhibition hall (see Related Work, below).[17] The firm also provided sanitary ware for WCs and Retiring Rooms, and much of the decorative tile-work throughout the exhibition buildings.[18]

One of the principal attractions of the exhibition, the fountain was an enormous popular success. Queen Victoria 'expressed interest' in it on her visit to the exhibition on 24

August, when Doulton himself was on hand to 'explain its concept'.[19] A writer describing himself as a 'foreign visitor' was almost ecstatic with admiration:

> From Lipton's I went and had a look at the Doulton fountain. O, what a lovely piece of work! How Grand! I hear it is entirely constructed of terra cotta, and the largest thing of its kind ever executed.[20]

The same writer records that he had also heard that 'Messrs Doulton & Co. have presented this beautiful fountain to the city of Glasgow', and goes on to speculate: 'How well it would look in one of the city's public parks or squares. I wonder where the corporation intend putting it.'[21]

In fact the question of where the fountain should be relocated was a matter of prolonged debate. In a plan published in January 1889, John Carrick, the City Engineer, proposed that it should be left *in situ* in Kelvingrove Park as part of a major development featuring a new civic art gallery. This was rejected, however, and after a local ratepayers' plebiscite organised by the Glasgow *Evening News* in November, the entire site was cleared. Among the alternative sites considered by the Council were Queen's Park, Cathedral Square and Glasgow Green itself. Even here it should be noted that there was some disagreement as to which *part* of the Green would be the most suitable, and the original intention was to site it a little north of the *Hugh Macdonald Memorial Fountain* (q.v., Minor Works), roughly where the People's Palace (q.v.) is today. Eventually a site closer to the west entrance was settled on, with Queen Victoria facing the High Court of the Justiciary on the Saltmarket.[22] The dismantling and reconstruction of the fountain, which was paid for by Doulton himself, involved a number of minor modifications in the design, including the re-arrangement of the positions of two of the Water Bearers.[23] It is not clear why these changes were made.

The inauguration took place on 27 August 1890, which was designated as a special 'fountain day' in Glasgow.[24] In his address Doulton gave a brief outline of the symbolic meaning of the fountain, in the process emphasising the essentially didactic purpose of such large-scale public works. 'It is to me a great honour', he began,

> … to be associated with a work which I venture to think is beautiful as well as useful. I think we have a combination here of science and art… I think I may say that here the artist has combined with the engineer in giving you a very beautiful work, and in a few words I would like to tell you what it means. It symbolises the Empire. I don't think Englishmen, at least most Englishmen, rightly appreciate – I hope you do in Glasgow – the greatness and glory of our empire. The Queen rules over something like one-fifth of the inhabitants of the globe, and our commercial supremacy and our material supremacy will stand or fall together… May I dare to hope of the people of Glasgow that, inasmuch as this fountain has some lessons to teach, they will draw some of these lessons; that they will see how our empire was won by the enterprise of our discoverers and by the self-abnegation of our missionaries, and how it has been maintained by the valour of our soldiers.[25]

The sentiment was echoed by the Lord Provost in his speech at the luncheon following the inauguration. 'There was', he said,

> … in that fountain an alliance of the useful and the beautiful, and that was an alliance which in this country they should strive to make closer… There was a struggle – almost even a warfare – going on for commercial supremacy in the world, and if the colonies which could give them the raw materials were not united to them by closer ties than at present, this country might ultimately suffer.[26]

He also took the opportunity to paraphrase an informal conversation with Doulton in which the manufacturer had expressed his views on recent developments in British art education. He claimed that the fountain

... could never have been produced except for the recent interest taken in art schools in England, which to a certain extent had the approval and support of the Government, and for which a great deal had been done in connection with municipalities. That fountain was the outcome of an effort made by the City and Guilds Institute. The City companies in London gave a considerable amount of money, and formed a City Guilds Institute, which had one home for science and art in Kensington, and had a branch for the teaching of art in South London. They were called an inartistic people. He repudiated that altogether. They did not need to go to France for patterns for works of art... But of all the arts that which was at a low ebb was sculpture. They had had great sculptors, and one of the great masters was Flaxman. But the teaching of modern sculpture was a very costly business. To help this the City Guilds Institute founded a modelling school on South London. The fountain was designed first of all by a young man [Arthur Pearce] in the firm's employment, who was an ordinary clerk in the office. He went to the Lambeth Art School, and there displayed such a talent as induced Mr. Firth [sic] to ask the speaker [Doulton] to take him out of the office and make him a designer, as he had shown all the instincts of an artist. That young man, who was now between twenty-seven and twenty-eight years of age, had designed that fountain. In this case the making of such a large piece of art work involved very considerable difficulty. All the groups ... were designed by the master of the modelling school. The modelling was all

done by young men who were trained in the modelling school in South London, and but for the training they had received at that school it would have been impossible that such a work could have been turned out.[27]

Throughout the debate generated by the fountain, a recurring theme was the suitability of terracotta for large-scale public works of this kind. One particular advantage was that it could be worked very quickly, and the Provost himself noted that 'from the time it was decided to produce the fountain till it was erected only eight months elapsed, whereas in the case of monuments it was not a case of months but years'.[28] It was also ideal for work requiring both delicacy of treatment and durability. According to the British Architect:

... the work finely illustrates the freedom afforded by the material to a capable modeller, and it is also well to bear in mind that when burnt the substance is considered practically imperishable and impervious to atmospheric influences.[29]

Unfortunately, however, it proved less resistant to other forms of attack, and during a thunderstorm in the summer of 1894 the statue of Queen Victoria was struck by lightning and 'totally destroyed'. A photograph by T. & R. Annan & Sons taken shortly afterwards shows the fountain with the top statue missing.[30] Because the fountain was produced 'direct from the artist's hands without moulds' the figure could not be replaced with a new cast from the original model, and since a replacement would cost as much as creating an entirely new work, the City Engineer suggested that the fountain 'be completed by adding some less important feature'. Doulton was against this on the grounds that it would 'greatly mar the harmony' of the fountain, and offered to 'reinstate the figure and provide a lightning conductor for the sum of £500'.[31] A comparison between the present statue and photographs of

the original shows a number of minor modifications to the design, including a slight lengthening of the sceptre. Changes in the design of the scroll-work in the buttresses separating the Water Carriers also suggest that the damage from the lightning extended to the stage below.[32]

Related work: In addition to the work described here, Doulton & Co. also erected a second terracotta fountain at the 1888 exhibition under the dome of the main exhibition hall as an adjunct to their commercial stand. Designed by George Tinworth, it was composed of a 'pyramidal column' decorated with reliefs of biblical subjects with references to water 'either in its natural aspects or artificial uses', and with a scene from the Deluge (Gen. 7. 1) at the apex.[33] Another work by Tinworth, a relief of The Release of Barabbas, was also loaned by Doulton to the exhibition in the sculpture gallery.[34] Rival fountains in the Exhibition grounds included the illuminated 'Fairy Fountain', by W. & J. Galloway of Manchester, a little to the north of the Tobacco and Flower Kiosks,[35] and a cast iron fountain beside Kelvingrove House by McDowall, Steven & Co., who also supplied the exhibition with drinking fountains and garden seats.[36]

Condition: Like all fountains in Glasgow, the Doulton has suffered from the combined effects of vandalism, weather erosion and municipal neglect. Maintenance difficulties began as early as June 1896, when it became necessary not only to repair a leak which had appeared in one of the basins, but also to erect a higher railing around it 'to prevent children getting access to the structure'.[37] A few months later the City Engineer reported that the fountain had already sustained 'a good deal of malicious damage'.[38] In 1953, the Glasgow Herald pointed out that the fountain was 'in need of a good scrub', that the 'South African lady wants a hand' and that one of the half-length statues of St Mungo on the ground basin had 'four times lost his head'.[39] The

disconnection of the water system at about this time provided further encouragement for vandals, and by 1990 the fountain had become so unsafe that it was necessary to shore up the central structure with scaffolding. As part of its development plan for Glasgow Green (see Introduction, above), the City Council commissioned a detailed report on the fountain by Glasgow University Archaeological Research Division (GUARD) in the summer of 1999,[40] with the intention of using their recommendations in the implementation of a proposal to dismantle, renovate and re-erect the fountain on a new site in front of the People's Palace Museum (q.v.).[41] It should be noted, however, that the restoration plan has not been without its critics. The distinguished sculptor George Wyllie, for example, has claimed that: 'Even if repaired it would still be an obsolete symbol of Empire', recommending that it should be preserved 'as a glorious ruin like the Parthenon in Athens'.[42]

Notes

[1] BA, 16 March 1888, p.199. [2] *International Exhibition Glasgow 1888, Official Guide*, p.68. [3] BA, 16 March 1888, p.199. [4] Beverley Ballin Smith, *The Doulton Fountain, Glasgow*, Glasgow, 1999, pp.18, 20–1, 28. [5] BA, 16 March 1888, p.199. [6] Smith, *op. cit.*, pp.19, 26–7, 31. [7] BA, 16 March 1888, p.199. [8] Smith, *op. cit.*, pp.18, 24–5, 30. [9] BA, 16 March 1888, p.199. [10] Smith, *op. cit.*, pp.18, 22–3, 29. [11] *Official Guide*, p.68. [12] Smith, *op. cit.*, pp.10–15. [13] *Ibid.*, pp.8–9. [14] *International Exhibition Glasgow 1888, Official Guide*, p.101. [15] BA, 16 March 1888, p.199. [16] Kinchin (1988), pp.16 (plan), 34; for Doulton's Indian Pavillion, see Atterbury and Irvine, p.11 (incl. ill.). [17] *International Exhibition Glasgow 1888: The Official Catalogue*, 1888, pp.58, 84, 200, 231. [18] *Ibid.*, p.57. [19] Stanley K. Hunter, *Kelvingrove and the 1888 Exhibition*, Glasgow, 1990, p.88. [20] Harold Hickman, *A Foreigner's Visit to the Glasgow International Exhibition*, Glasgow and Edinburgh, 1888, p.51. [21] *Ibid.* [22] Hunter, *op. cit.*, pp.107–8. [23] Smith, *op. cit.*, p.8. [24] Hunter, *op. cit.*, p.107. [25] A, 5 September 1890, p.9. [26] *Ibid.*, p.10. [27] *Ibid.* [28] *Ibid.* [29] BA, 16 March 1888, p.199. [30] Lyall, p.138. [31] GCA, C1/3/22, p.117. [32] Smith, *op. cit.*, pp.6–9. [33] *Official Catalogue*, pp.58, 200; see also Atterbury and Irvine, p.28 (incl. ill.).

[34] Hunter, *op. cit.* p.70. [35] *Ibid.*, p.109. [36] *Ibid.*, p.108. [37] GCA, C1/3/23, 23 June 1896, p.523. [38] *Ibid.*, C1/3/24, 24 November 1896, p.62. [39] GH, 23 March 1953, p.9. [40] Smith, *op. cit.*; Caitlin Evans, with John Arthur, Beverley Ballin Smith, Keith Speller and Gary Tompsett, *The Doulton Fountain*, Glasgow, 1999. [41] ET, 2 December 1997. [42] GH, 1 March 1997, p.7.

Other sources
T. Raffles Davison, *Pen-and-Ink Notes at the Glasgow Exhibition*, London, 1888, pp.15–17 (incl. ill.); *Maclaren's Guide to the Exhibition*, Glasgow, 1888, p.10; *Elliot's Popular Guide to Glasgow and the Exhibition*, 1888, p.77; BA, 28 December 1888, p.456, 12 September 1890, p.199; B, 9 July 1898, p.29; 'Noremac', p.23; Young and Doak, no.119 (incl. ill.); Atterbury and Irvine, pp.89–90 (incl. ill.); Worsdall (1982), p.105 (incl. ill.); Hume and Jackson, p.39 (incl. ill.); Read and Ward-Jackson, 4/11/56–75 (ills); McKean *et al.*, p.33 (incl. ill.); Williamson *et al.*, p.457; Eunson (1997), pp.4–5 (incl. ills); GH, 3 December 1997, p.5, 4 December 1998, p.10; ET, 28 December 1998; McKenzie, pp.20, 21 (ill.).

The People's Palace Museum, a short distance from the east end of Monteith Row

Nine Allegorical Figures
Sculptors: William Kellock Brown (figures); James Harrison Mackinnon (decorative work)

Architect: Alexander Beith McDonald
Masons: Morrison & Muir
Date: 1894–8
Material: red Locharbriggs sandstone
Dimensions: *Progress* approx. 2.4m high, other figures approx. 2.1m high
Inscription: in the Glasgow arms – LET GLASGOW FLOURISH
Listed status: category A (15 December 1970)
Owner: Glasgow City Council

Description: The city's museum of popular history is a three-storey, domed structure with an iron and glass Winter Garden to the rear. The main frontage is in a style which 'partakes of Vignola's manner … and might be called an adaptation of the later French Renaissance', with figurative sculpture used 'externally to emphasise the principal features'.[1] On the attic balustrade, and aligned with the columns and pilasters of the second floor, are six free-standing female figures identified by their attributes as allegories of: *Shipbuilding* (model boat); *Mathematical Science* (dividers and open book); *Sculpture* (figurine); *Painting* (palette and brush); *Engineering* (crown wheel and pulley) and *Textile Industry* (distaff). On the attic are three further female figures: *Science* (globe and compass) and *The Arts* (books) seated left and right of the centre bay and, standing at the apex of the entire scheme, *Progress*, shown with a bronze torch in her right hand, a laurel branch in the left and a cornucopia at her feet.[2] Above the arch of the main entrance there is a pair of winged youths holding torches, seated on a decorative cartouche bearing the arms of Glasgow.

Discussion: The idea of erecting a museum specifically for the residents of the east end of Glasgow can be traced back to 1866, when the Council raised £2,500 for the purpose by selling a bleaching green in Bridgeton.[3] The project does not appear to have been regarded as a major priority, however, and it was not until the late 1880s that any practical steps were taken to bring the scheme to fruition. By this time the plans for Kelvingrove Museum (q.v., Kelvingrove Park) in the west end were under way, and the Council was aware of the increasing disparity of provision between the two halves of the city. The success of the Kibble Palace in the Botanic Gardens had also confirmed the desirability of Winter Gardens as a recreational resource.[4] For some time previously the Council had seen it as its 'duty to cultivate the taste of the inhabitants for art by the establishment of district exhibitions',[5] but after discovering that there was no suitable accommodation in the east end for such events, 'the committee in charge of the matter were

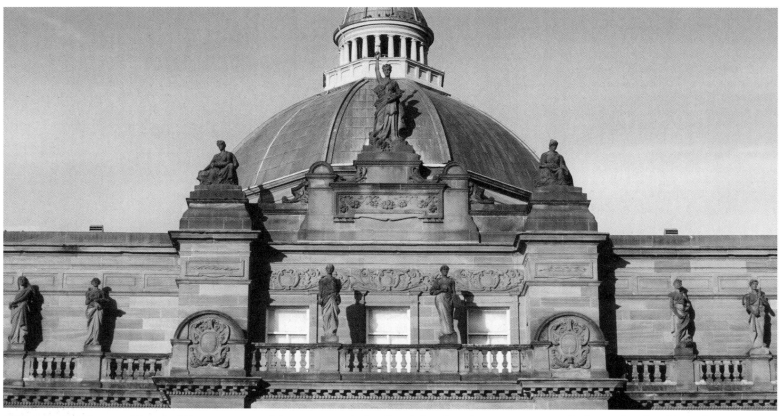

William Kellock Brown, *Allegorical Figures* [RM]

forced to report that unless permanent buildings were erected the project would require to be abandoned'.[6] Discussion began in earnest in December 1889, but once again there were delays, with disagreements over the site and the details of the construction dragging on for several years. There was also a significant minority who questioned the desirability of such a project at a time of economic depression.[7] By April 1894, however, the dimensions, style and position of the building were finally determined and the cost capped at £20,000.[8] As one commentator pointed out, the delays were not in fact 'hurtful to the scheme, but proved rather advantageous, for with every delay the ideas of the committee entrusted with the work expanded, and the extent of the proposed institute grew with almost every new proposal'.[9] One important change was the substitution of a dome for the pediment shown on plans submitted by McDonald to the Dean of Guild Court in January 1895,[10] but there was also a reduction in the number of second-floor standing figures from ten to six. The building was opened on 22 January 1898 by the Earl of Rosebery at a ceremony attended by an estimated 3,500 ticket holders.[11]

The attribution of the figures to Kellock Brown is based on a typed document of uncertain date and authorship in the City Archive.[12] A number of later hand-written amendments cast doubt on the reliability of some of its contents, including a deleted sentence describing the two seated figures as being 'from the studio of Messrs. McGillivray [*sic*] & Ferris'.

Related work: In the building's grounds are several examples of salvaged architectural sculpture, including an Adamesque sphinx from the demolished St Mungo's Halls, Bridgeton and a painted wheatsheaf from the United Co-operative Bakery on McNeil Street. Among the sculptures preserved inside the building are two gasoliers, rescued from a set of fourteen made by John Mossman for the Unitarian Church on

St Vincent Street (demolished 1983) and, in the Winter Garden, Thomas Clapperton's bronze *Springtime*, recently removed from its pedestal in the McPhun Park (q.v.).

Condition: The building was cleaned in 1983. There is some damage, however, including a broken right forearm on the winged youth on the left. There is also a considerable growth of moss on the surface of the cartouche.

Notes
[1] GCA, M.P. 29/218. [2] GCA, M.P. 29/219. [3] Bob Morrow, 'The Palace on the Green', *Scots Magazine*, March 1986, p.603. [4] GH, 24 January 1898, p.11. [5] *Ibid.* [6] *Ibid.* [7] BI, 15 December 1892, p.141. [8] GCA, M.P. 30/1023. [9] GH, 24 January 1898, p.11. [10] GCA, B4/12/1/3618. [11] GH, 24 January 1898, p.11. [12] GCA, M.P. 29/218–9.

Other sources
BA, 4 May 1894, p.305, 21 December 1894, p.484; B, 5 May 1894, p.355, 9 June 1894, p.449, 15 December 1894, p.440, 29 January 1898, p.114, 9 July 1898, p. 29; BI, 16 May 1894, p. 29, 15 December 1894, p. 141; GH, 20 January 1898, p.4; 'Noremac', pp.21–3 (incl. ills); Stevenson (1914), p.165; 'Architectural Sculptor', (obit. of Mackinnon), GH, 8 November 1954, p.9; Teggin *et al.*, p.22 (incl. ills); Williamson *et al.*, p.454; McKenzie, pp.20–3 (incl. ill.).

Glassford Street MERCHANT CITY

Trades House, 85–91 Glassford Street

Armorial Group and Griffin Panels
Sculptor: not known

Architects: Robert and James Adam
Date: 1791–4
Material: yellow sandstone
Dimensions: armorial group 1.53m × 3.36m; griffin panels 76cm × 2.3m
Inscription: on a shield at second-storey level on the Virginia Place extension – JAMES GILLIS / DEACON CONVENOR / ERECTED 1888 / THOMAS MASON / COLLECTOR
Listed status: category A (6 July 1976)
Owner: The Trades Hall of Glasgow Charitable Trust

Description: The armorial group is on the attic of the centre bay of the building's three-storey Palladian east façade, and consists of a shield bearing the arms of Glasgow, with a pair of allegorical female figures as supporters. Slightly larger than life-size, the figures are seated with their heads and torsos facing forward, and their legs turned to the side. With attributes including a trident (left) and a lyre, they may be assumed to represent *Maritime Trade* and *The Arts* respectively. The griffin panels are above the pedimented first-floor windows on either side of the coupled Ionic columns of the central aedicule, and show pairs of griffins passant on either side of a central urn.

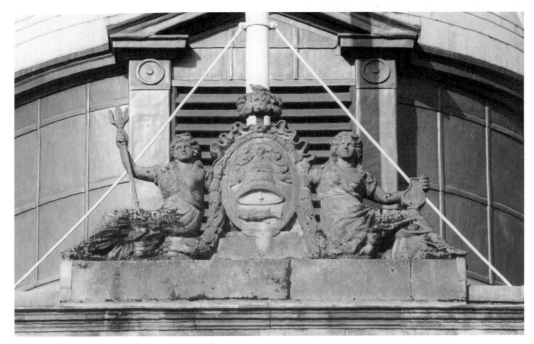

Anon., *Armorial Group* [RM]

Discussion: One of four major buildings designed by the Adam brothers for Glasgow in the 1790s, the Trades House is the only one to have survived intact (but see McLennan Arch, Glasgow Green). The sculpted components are variations on decorative devices used repeatedly by the Adams, both as internal as well as external features. The griffins, for example, are almost identical to those on the entrance pediment of Osterley Park, Middlesex, and the plaster ceiling of Syon House, Middlesex, both dating from the early 1760s, while the treatment of the attic figures is reminiscent of the lion and unicorn group above the clock on the balustrade of their demolished Royal Infirmary, Cathedral Square (1792).[1] It is interesting to note, however, that both features differ from the details indicated on the drawing of the façade published posthumously in *New Vitruvius Britannicus*.[2] Here the relief panels are shown as figurative friezes, probably based on the 'Hercules' panel discovered by Robert Adam during his excavation of the Palace of Diocletian in Split,[3] and are clearly intended to match the capitals of the central aedicule, which in this version of the design has a more ornate Corinthian order. On the attic, the armorial group has been replaced by a clock, though the loss of a central sculpted feature is compensated by a pair of trophies on the outer bays. Curiously, the executed group is almost identical to the two armorial devices planned for the Assembly Rooms, but not carried out.[4] In both cases the design of the Glasgow arms is typical of the Adam brothers in the use of the bell to fill nearly the entire surface of the shield, and the placement of the tree above as a free-standing acroterion. A further variation on this arrangement is to be found on James Adam's unexecuted design for a Corn Market on High Street, where the allegorical figures are separated from the escutcheon and placed on a slightly lower level.[5]

The building has been extended and modified several times, and in 1888 James Sellars added the north bay with a rear extension to Virginia Place. This included an inscribed shield and a carved relief of a Roman imperial *fasces* rising vertically from the centre of a broken pediment on the top storey.

Condition: Extensive repair work was carried out on the façade in 1927, including the replacement of many mouldings and decorative details. The relief panels and attic group appear to have remained intact, though they were sprayed with 'Cephasite' stone preservative, re-sized and covered with English gold leaf.[6] The legs of the attic figures are badly affected by surface biological growth.

Notes
[1] See Yarwood, pl.25, King, pl.1, and Gomme and Walker, ill.31. [2] George Richardson, *New Vitruvius Britannicus*, 1802, reproduced in King, ill.69. [3] See King, p.24. [4] For a discussion of this, see McLennan Arch, Glasgow Green. [5] See King, ill.132. [6] GCA, T-TH1/34/9.

Other sources
Young and Doak, no.14 (ill.); Gomme and Walker, p.64; McKean *et al.*, p.63 (incl. ills); Walter L. Spiers, *Catalogue of the Drawings and Designs of Robert and James Adam in Sir John Soane's Museum*, Cambridge, 1979, p.14; Williamson *et al.*, pp.43, 167–8, 180, pl.18; Glendinning *et al.*, p.180.

Gorbals Street GORBALS

Citizens' Theatre, 119 Gorbals Street

Statues of Shakespeare, Burns and Four Muses

Sculptor: John Mossman

Architects: Campbell Douglas (original building); Building Design Partnership (modern frontage)
Date: *c.*1878
Material: yellow freestone
Dimensions: figures approx. 2.14m high
Listed status: original theatre category B (15 December 1970)
Owner: Glasgow City Council

Description: The six statues are in the theatre foyer, with the four Muses placed against the west wall flanking the entrance, and the portraits of Shakespeare and Burns facing towards them on the small flight of steps leading to the auditorium. *Shakespeare* and *Burns* are in period costume overlaid with heavy cloaks, and hold a scroll and a pair of pipes respectively. The Muses may be identified by their attributes as follows: *Tragedy*, holding a dagger (now missing, together with the hand); *Comedy*, holding a mask (missing); *Dance*, raising her tunic to expose her left leg; *Music*, strumming a lyre. It should be noted that some early commentators identified the first two as *Literature* and *Drama* respectively.[1] The ornate plasterwork in the interior includes replicas of the muses in the proscenium arch and masks of *Ceres* and *Bacchus* over the boxes executed to a 'fairground quality' by Joseph Sharp during architectural alterations by Alexander Skirving in 1887.[2] At the rear of the foyer there are also two pairs of colossal elephant heads on drum

pillars (total height approx. 2.4m) attached to the walls flanking the doors to the auditorium, as well as bronze portrait medallions, as follows: on the left, *Richard Walden* (the owner of the theatre 1886–1922), unsigned, 30cm diameter, mounted on a wooden board; *James Bridie* (1888–1951, playwright and founder of the Citizens' Theatre), life-size portrait mounted on a bronze plaque, signed on the

right by Benno Schotz.

Discussion: Designed by Campbell Douglas (of Campbell Douglas & Sellars), the building was opened in 1878 as Her Majesty's Theatre, soon afterwards changing its name to the Royal Princess's. The façade incorporated six Roman Doric columns salvaged from the portico of the Union Bank in Ingram Street (now Corinthian, q.v., 191 Ingram Street) after John Burnet made

extensive alterations to David Hamilton's original design. For many years it was believed that the six attic statues by John Mossman originally surmounting the columns on the Bank were also relocated on the theatre. However, in 1937 the journalist James Cowan traced the source of this misapprehension to an error in the work of the bank's historian Sir Robert Rait, demonstrating in the process that the statues on the parapet of the theatre were an entirely new set, made specifically for the building.[3] It is these figures that are now in the foyer. The theatre became the Citizens' Theatre in 1945, at which time it shared its façade with the Palace Theatre of Varieties (later the Palace Bingo Hall). In 1977 the building was damaged by fire, leaving the façade in such a dangerous condition that it had to be demolished.[4] As with Mossman's work on the Union Bank, there was some confusion over the fate of the parapet statues. A council report of October 1991, states that fibreglass replicas of the statues were to be made and placed in the landscaped area to the north of the theatre, while the current LBI describes the figures in the foyer as copies of Mossman's originals.[5] This seems highly unlikely, as the condition of the statues is very poor, and there is no record of what became of the prototypes. It would appear that the four Muses were placed in a council store in Finnieston and returned to the theatre *c.*1988. The statues of Burns and Shakespeare had meanwhile been taken for safe-keeping to the restaurant area of the Tron Theatre at Glasgow Cross, rejoining their companions a little later.[6]

Related work: See discussion of earlier statue of Shakespeare in Appendix A, Lost Works, Theatre Royal, Dunlop Street.

Condition: Very distressed. All six statues are weather-worn, and *Shakespeare* and *Burns* have been coated with white paint which has badly flaked. Several important details are missing, including most of the right foot of *Burns* and the dagger and left hand of *Tragedy*. According to theatre legend, the dagger is still

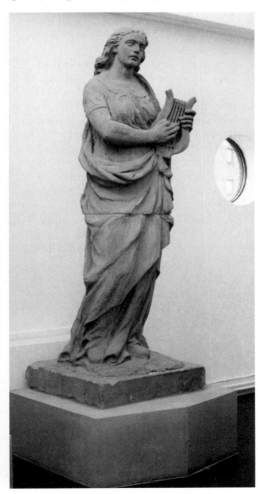

John Mossman, *Shakespeare* [GN]

John Mossman, *Music* [GN]

on the premises, but it is not known where.

Notes
[1] See, for example, Cowan, 'The Mystery of the Twelve Statues', *From Glasgow's Treasure Chest*, Glasgow, 1951, p.242. [2] Williamson *et al.*, p.511; LBI, Ward 51, p.27. [3] Cowan, *op. cit.*, pp.329–42. [4] See Harris, ill.185. Harris states here that the fire occurred in May 1973. [5] 'Gorbals Local Plan, Listed Buildings Survey Report', J.H. Rae, October 1991, p.83; LBI, Ward 51, p.27. [6] Jack Scrimgeour, 'A Tale of Two Statues', *Scots Magazine*, July 1988, p.376.

Other sources
GH, 12 July 1977, pp.6, 8, 15 July 1977, p.15; William I. Taylor, 'Scotland's theatrical treasures', GH, 14 September 1979, p.6; Marianne H. Hay, *Glasgow's Theatres and Music Halls – a Guide*, Glasgow, 1980, p.25; Worsdall (1982), p.146 (incl. ill.); McKenzie, pp.28–31 (incl. ill.).

On pavement opposite Citizens' Theatre

Fountain with Relief Panels
Sculptor: Jim Harvey (panels)

Date: 1990
Material: red sandstone
Dimensions: panels 46cm × 33cm; overall height of fountain 3m
Inscriptions: on the apex of the fountain – 1889 / 1990
Listed status: not listed
Owner: Glasgow City Council

Description: Inserted in rectangular compartments on the exterior faces of a disused hexagonal drinking fountain, the panels occupy niches which previously provided access to the water spouts. The imagery of the reliefs is a free interpretation of aspects of local history and topography, incorporating: a miner's lamp (surveillance camera?) with tower blocks behind and a leaf/bud-like object in the foreground (east face); a crane hook with buildings (north-west); a beehive on an Ionic capital, the right volute of which takes the form of a nautilus shell (south-west).

Discussion: The main structure of the fountain dates from 1889 and was first erected at the junction of Cathcart Road and Crown Street. Scheduled for demolition during a major road-widening scheme in 1989, it was rescued by Jim Harvey, who persuaded Glasgow City Council to relocate it to its present site and sponsor the carving of the reliefs. At the time, Harvey was a third year student in the Department of Environmental Art at Glasgow School of Art.

Condition: The stonework on the original structure has been cleaned but is in a generally distressed condition, and the modern reliefs have become chipped in places.

Sources
Information provided by Glasgow City Council Conservation Department; Eunson (1996), p.68 (ill.); McKenzie, pp.30 (ill.), 31.

Jim Harvey, *Fountain Relief* [RM]

Commercial building, 4–16 Gordon Street

Narrative and Allegorical Reliefs of Children and Associated Decorative Carving

Sculptors: John Thomas (modeller); Alexander Handyside Ritchie (carver)

Architect: David Rhind
Builder: David Rae
Date: 1853–7
Material: yellow sandstone
Dimensions: figures in pediments approx. 90cm high; panels 1.12m square; keystone masks colossal; interior panels approx. 90cm diameter and 90cm × 1.8m
Inscriptions: on lintels over central and left hand entrances – CBS (entwined)
Listed status: listed category A (6 July 1966)
Owner: Royal Bank of Scotland

Description: This three-storey block was built as the head office of the Commercial Bank of Scotland[1] to a design loosely based on the Farnese Palace in Rome, incorporating rusticated arched windows in the ground floor, a series of low segmental pediments over the three principal first-floor windows and a raised central attic. The sculpture programme is concentrated in the pediments, supplemented by a pair of square panels inserted into the vermiculated pillars on the ground floor, and consists of an extended celebration of banking and commerce. Unlike conventional interpretations of such a theme, however, the scenes in this case are acted out entirely by infants, who are shown in a variety of narrative and allegorical situations. The central pediment, which is the largest of the three, represents *Commerce*, and has six naked and semi-naked

children offering tributes in the form of fruit, machine parts and packaged goods to a central figure holding an anchor and an inverted cornucopia. The pediment to the left shows *Glasgow flanked by Trade and Manufacture*, while that on the right symbolises *Edinburgh flanked by Art, Science and Industry*. The square reliefs below contain groups of children, three in each case, involved in the process of making coins and bank notes, and are shown working the arm of a die-stamp and a printing press respectively. According to a contemporary commentator, the combination

of activities associated with the manufacture of both metal and paper currencies was 'peculiar to the banking system of Scotland'.[2] Supplementary decorative carving includes a series of bearded male masks in the keystones of the eleven ground-floor arches, a pair of large lion masks above the narrative panels and a number of smaller lion masks in the cornice.

The interior of the central part of the building, which is currently the Glasgow City Branch of the Royal Bank of Scotland, has a set of six circular and three rectangular plaster relief panels by James H. Clark, dating from 1941, displayed below the ceiling in the main banking hall. These depict scenes of modern labour, including groups of miners, dock workers and aviators.

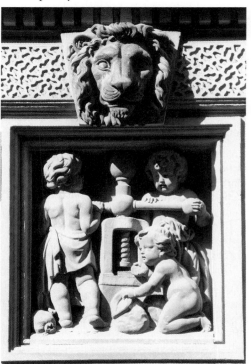

John Thomas and Alexander Handyside Ritchie, *Cherubs Working Die-stamp*

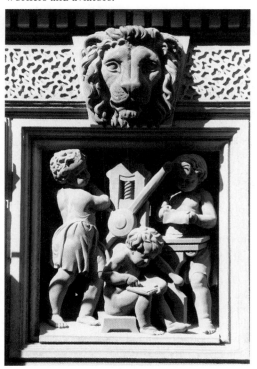

John Thomas and Alexander Handyside Ritchie, *Cherubs Working Printing Press*

Discussion: Contemporary sources are inconsistent in their attribution of the authorship of the work. Tweed describes the reliefs as being '… from the designs of the late Mr Handyside Ritchie',[3] while Gildard asserts that the '… sculptures (by Handyside Ritchie, I think) of the small pediments in the Commercial Bank are worthy of that noble building'.[4] By contrast, the *Civil Engineer and Architect's Journal* stated in 1856 that the '… figurative embodiment of [the] idea of the architect's was entrusted in the modelling to Mr. Thomas, of London, who also furnished the models for the heads in the keystones'.[5] It seems reasonable to assume that the earlier source is the more reliable, and indeed the attribution to Thomas is supported by the close similarity of the banking reliefs to his work on the West of England & South Wales District Bank, Bristol, carved in 1857.[6] At the same time it is equally likely that local commentators such as Gildard and Tweed would be reliably informed on matters concerning the involvement of a Scottish sculptor. On balance, and bearing in mind the fact that Ritchie had earlier worked under Thomas on the sculpture scheme for the Houses of Parliament,[7] the evidence suggests that the reliefs were designed by Rhind himself, modelled by Thomas and carved by Handyside Ritchie. The Minutes Books of the Royal Bank of Scotland unfortunately throw no further light on the question of authorship, recording only an agreement to '… expend £200 in addition to the contract price in the sculptural decoration of the premises'.[8]

Related work: The sculpture programme on this building is one of a number in Glasgow in which adult commercial activities are allegorised through the depiction of children. Other significant examples include: the former banking hall on Virginia Place (see 191 Ingram Street), 31–9 St Vincent Place and 81–91 St Vincent Street (qq.v.). In 1886 the building was extended onto Buchanan Street with a new

building in an entirely different style, the purpose of which was to give the bank a more imposing entrance.[9] (See 113 Buchanan Street.)

Condition: Good.

Notes
[1] BN, 3 June 1887, p.832. [2] *Civil Engineer and Architect's Journal*, January 1856, p.1. [3] Tweed (*Guide*), p.34. [4] Gildard (1892), p.10. Gunnis also attributes the work to Ritchie, but he may be confusing this with Ritchie's work in the Commercial Bank in Edinburgh. [5] *Civil Engineer and Architect's Journal*, January 1856, p.1. [6] Illustrated in John Booker, *Temples of Mammon: the Architecture of Banking*, Edinburgh, 1990, pp.87–8. [7] Read, p.120. [8] Royal Bank of Scotland *Minute Books*, 8 February 1855. [9] BN, 3 June 1887, p.832.

Other sources
Groome, vol.3, p.138; BC, December 1855; B, 11 May 1867, p.327, 9 July 1898, p. 23; Hitchcock, vol.1, p.366; Young and Doak, no.78 (incl ill.); Read, p.366; Worsdall (1988), p.39 (incl. ill.); Williamson *et al.*, p.225; McKean *et al.*, pp.112–13; McKenzie, pp.62–3 (incl. ill.).

Commercial building, 42–50 Gordon Street

Athena

Sculptor: not known

Architect: George Bell II, of Clarke & Bell
Date: 1886
Material: yellow sandstone
Dimensions: figure approx 1.7m high
Inscription: in incised numerals above the first floor – 1886
Listed status: category B (21 July 1988)
Owner: Liverpool Victoria Friendly Society Ltd

Carved in high relief, *Athena* is shown seated frontally in an elliptical medallion above the building's 'boldly consoled and pedimented entrance'.[1] She wears a helmet, an armoured breastplate and a classical tunic, holds a spear and a miniature fortress and is accompanied by a number of the symbolic attributes traditionally associated with Pallas Athena,

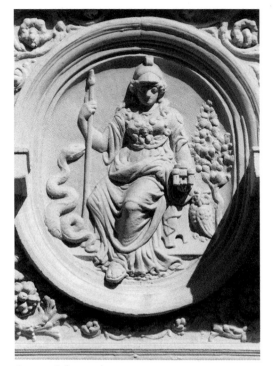

Anon., *Athena*

including a snake, an owl and a tree. The fortress and the owl are particularly relevant to the original purpose of the building, which was erected for the Royal Exchange Assurance Company. Minor decorative details include a dense mass of acanthus scrollwork in the area surrounding the medallion, and a winged cherub supporting the datestone. The quality of the carving throughout is crude but vigorous.

Condition: The relief was cleaned and recoated with white paint in 1999.

Note
[1] McKean *et al.*, p.114.

Other sources
LBI, Ward 18, p.70; Williamson *et al.*, p.226; McKenzie, p.62.

Standard Buildings, 82–92 Gordon Street / 94–104 Hope Street

Atlas, Allegorical Pediment Relief and Associated Decorative Carving

Sculptor: James Young (attrib.)

Architect: James Thomson
Date: 1890
Material: red sandstone
Dimensions: Atlas and pediment figures colossal
Inscriptions: below the corner attics on both frontages – STANDARD BUILDINGS; on the fourth floor, Hope Street – SL (entwined); on the first floor, Gordon Street – JT and 1890 (both entwined)
Listed status: category B (21 July 1988)
Owner: Central Standard Buildings Ltd

Description: The main part of this building consists of a six-storey Italianate block with projecting end bays, a complex arrangement of French pavilion roofs and a five-storey extension on Hope Street. A varied architectural vocabulary of detached colonettes, balustrades and cornices is complemented by an extensive, if erratic, use of lavishly carved ornamental rinceau friezes, some of which incorporate rams' heads. These appear chiefly above the second-storey windows on both the Gordon Street and Hope Street frontages, and over the two entrances on Hope Street.

Carved in the round, the figure of *Atlas* is in the centre of the Hope Street attic, and is shown in a crouching position, supporting a large globe on his shoulders. The attic pediment on the corner at Gordon Street contains a relief carving of *The Parable of the Wise and Foolish Virgins*. The five standing figures are presumably the wise virgins on their way to the house of the groom, while the foolish virgins are shown reclining or kneeling in the corners.

The composition is identical to Sir John Steell's treatment of the subject on the Standard Buildings on George Street, Edinburgh (1839). (See also Related work, below.)[1]

Discussion: The building was commissioned by the Standard Life insurance company, whose commitment to the virtues of foresight and careful investment is clearly reflected in the choice of subject matter in the pediment. The relevance of Atlas to life insurance is less clear, and it is interesting to note that this part of the scheme was singled out for particular criticism, albeit on aesthetic rather than thematic grounds. After complimenting the style of the building as a whole, the correspondent of *Building Industries* commented acidly that

> … if any fault must be found, it is with the figure of Atlas surmounting the western elevation, and pretending to stagger under the weight of the globe he carries on the back of his neck, the planet being so manifestly a hollow sham of something quite other than stone as to more than rub shoulders with the ridiculous. Atlas and his globe might be removed to the cellars with advantage perhaps.[2]

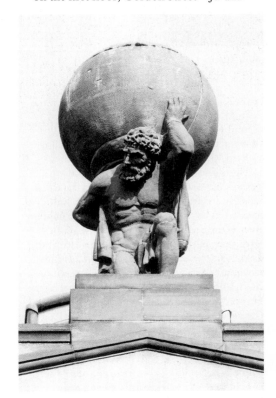

James Young (attrib.), *Atlas*

James Young (attrib.), *Parable of the Wise and Foolish Virgins* [GN]

The attribution of the sculpture to James Young is based on the close professional association that existed between the families of the sculptor and the architect.

Related work: In 1979 the Standard Life Association commissioned Gerald Laing to produce a 21m-long bronze frieze on their head offices on George Street, Edinburgh, with a modern re-interpretation of the theme of the Wise and Foolish Virgins.

Condition: Good.

Notes
[1] Pearson, p.75 (incl. ill.). [2] BI, 16 June 1890, p.58.

Other sources
Strachan, p.227 (incl. ills); Nisbet, 'City of Sculpture'; McKean *et al.*, p.115; Williamson *et al.*, p.227; Pearson, p.112; McKenzie, pp.72–3 (incl. ill.).

Archibald Macfarlane Shannan, *James Kirkwood* and *John Marr*

Govan Road GOVAN

Former Govan Town Hall, 401 Govan Road, between Summertown Road and Merryland Street

(1) *Portrait Roundels, Portrait Keystone and Procession of Putti*
Sculptor: Archibald Macfarlane Shannan

(2) *Allegorical Spandrel Figures and Related Decorative Carving*
Sculptor: James Charles Young

Architects: Thomson & Sandilands
Date: 1897–1904
Unveiling of portrait of Councillor Russell: 16 May 1904
Material: red Locharbriggs sandstone
Dimensions: roundels 61cm diameter; keystone portrait 46cm high; frieze 1.52m × 5.95m; spandrel figures slightly larger than life-size
Inscriptions: on the coats of arms over the entrance gate and in the putti frieze – NIHIL SINE LABORE (trans.: 'nothing without labour'); in the spandrels on the south façade – MUSIC; DRAMA
Listed status: category B (15 December 1970)
Owner: Glasgow City Council

Description: Thomson & Sandilands were the winners of a competition organised by the Govan Police Commissioners and the Town Council in 1897 to rebuild the original Govan Burgh Buildings of 1868, producing a design that has been described as having 'French Second Empire and Neo-classical elements of disparate and uncertain scale … combined in an elaborate Beaux Arts composition'.[1] The two portrait roundels are on either side of the entrance arch on the east façade, and represent the incumbent Provosts of Govan during the period the building was erected: on the left,

James Kirkwood, (Provost 1892–1901); on the right, John Marr (1901–4).[2] The keystone portrait is over the smaller entrance on Merryland Street, and represents Councillor Richard Russell.[3]

The spandrel figures are in the window recesses of the terminal pavilions on the three main frontages, and are depicted in reclining poses carrying various attributes, including: on the north façade, *Textile Industry* (hank of yarn, spinning wheel); east façade (north end), *Science*(?) (chemical retorts, dividers, writing instrument); east façade (south end), *Commerce* (model ship and a ship's prow(?)); south façade, *Architecture* (models of a Gothic cathedral and a classical temple). Minor decorative carving by Young on the south façade includes lion masks, festoons and urns.

In addition to the Town Hall and Burgh Offices, the building also incorporates a theatre and concert hall in the southern wing, the function of which is identified by cartouches

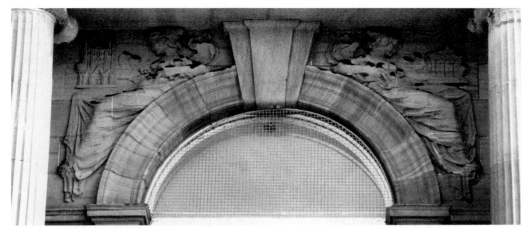

emblematic of music and drama in the spandrels flanking the Diocletian window above the entrance. Below them is a bas-relief frieze of putti, among whom are

> ... pipers leading a group who, with garlands, draw a decorated boat, around which are others bearing shipbuilding tools and the Govan coat of arms. 'Applause' striking cymbals and 'Fame' carrying laurels follow and complete the panel.[4]

A wrought iron version of the Govan arms, by an unknown metal worker, fills the arch above the gate in the main entrance on Govan Road.

Discussion: Despite its isolated position on Merryland Street, the portrait of Councillor Russell is in fact a key image, and provides a number of important insights into the history of the building as a whole. As Convenor of the Council's Repairs and Building Committee since 1895, Russell had managed a budget of

some £150,000, with responsibility for developing several major building projects in Govan, including the Town Hall itself. The building, however, appears to have quickly become inadequate for the council's needs, and at some point before completion it was decided that the 'ante-room accommodation' should be extended by erecting an additional wing on Merryland Street. It was at this point that the council found it 'opportune to honour their colleague' by allocating a portion of the new wing's £6,000 budget to commissioning a commemorative portrait. The unveiling of the portrait on Monday, 16 May 1904, marked the 'total completion of the magnificent suite of halls, the Govan Town Halls and Burgh Buildings'.[5]

In his reply to the toast proposed to him by ex-Bailie Harley at the reception following the unveiling, Shannan is reported to have commented on

> ... the kindness he had received at the hands of the Govan Town Council while working

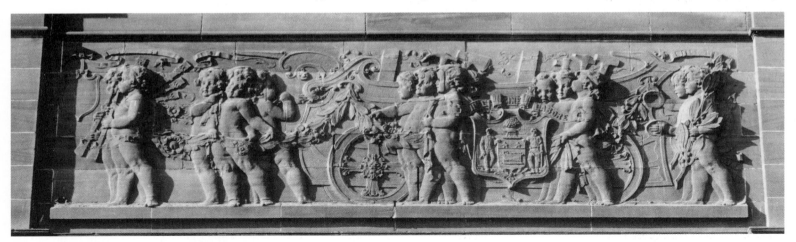

Archibald Macfarlane Shannan, *Procession of Putti*

for them. He felt especially indebted to the people of Govan because it was largely to them that he owed his introduction to anything he had done in a public way. (Hear hear.) His other works had all been of the glory type and had brought him lots of fame without giving him funds to wear it becomingly. (Laughter.) He might say that when he was engaged upon the bust of Councillor Russell, he had heard passing, people several times remark [sic] how pleased they were that that gentleman was to be so honoured – (applause)…[6]

Shannan was paid £40 for the Russell portrait.[7] Precisely which of his sculptures Shannan had in mind in his reference to works 'of the glory type' is unclear. It is worth noting, however, that his most important commission in Govan, the *Memorial to Mrs John Elder* (q.v., Elder Park), was begun in January 1903, and completed in October 1906; at the time the Russell portrait was unveiled, he would have received only a small part of his fee for this major work.

The cost of the Town Hall was originally estimated at £25,000, but rose to £34,000 by the time of completion.[8] It is not known what proportion of this was devoted to the sculpture programme as a whole.

Condition: The building was cleaned recently and the general condition of the sculptures is good. Minor damage includes splits in the stone of the putti frieze and a broken nose on the portrait of Bailie Marr. The spandrel figures are heavily encrusted with bird lime and have a coating of black, bituminous pigeon repellent. The interior of the main hall originally included a figurative frieze in plaster above the proscenium arch.[9]

Related work: A plaster model of the putti frieze was exhibited at the RGIFA in 1902 (cat. no. 627).[10] The spandrel figures are similar to those on the exterior of the Parish Halls, George Street (q.v.), by the same architects.

Notes
[1] Williamson *et al.*, p.591. [2] Brotchie, p.198. [3] GP, 20 May 1904, p.5. [4] GAPC, 16 April 1901, n.p. [5] GP, 20 May 1904, p.5. [6] *Ibid.* [7] *Ibid.* [8] *Ibid.* [9] AA, 1899[1], p.107 (ill.). [10] Billcliffe, vol.4, p.106.

Other sources
GCA – GDC4/2/166 (plans), AGN 273; BA, 25 February 1898, p.140; GP, 27 April 1889, p.3, 13 January 1905, p.6; BI, 15 August 1896, p.77, 15 May 1897, p.27, 15 February 1898, p.173; BN, 21 May 1897, p.739 (incl. ill.), 21 June 1898 (incl. ill.); GAPC, 21 June 1898, n.p.; AA, 1902, p.113 (ill.); Brotchie, pp.184, 192–3 (incl. ill.), 196–8; BA, 19 July 1908, p.36; Gomme and Walker (1987), pp.263–4; Worsdall (1988) p.72 (incl. ill.); Nisbet, 'City of Sculpture'; McKenzie, pp.40 (ill.), 41.

Former Govan Press Building, 577–81 Govan Road

Six Portrait Roundels
Sculptor: not known

Date: 1889–90
Material: red sandstone
Dimensions: approx. 61cm diameter
Inscriptions: below each of the roundels:
GUTTENBERG (*sic*); SCOTT; JC (entwined) 1890 JWB (entwined); BURNS; CAXTON.
Listed status: category B (15 May 1987)
Owner: Glasgow City Council

Anon., *John Cossar* and *Jane White Brown* [RM]

Description: The medallions are inserted into rectangular panels between the first- and second-storey windows, forming a long horizontal frieze threaded behind the line of giant pilasters which divide the building's five bays. The four outer medallions are presented separately, while the two in the centre, representing John Cossar and his wife Jane White Cossar (née Brown), are joined. The characterisation of the faces is crude but vigorous.

Discussion: The three-storey building was erected by the publisher John Cossar (1841–90) as a combined tenement and office block adjoining his printing works on Burndyke Street. Remembered chiefly for his local newspapers, Cossar launched the *Govan Chronicle*, the Burgh's first weekly paper in May 1875, followed in 1878 by the *Govan Press*, which the firm produced for more than a century.[1] A Centenary Supplement to the paper, published in October 1978, explains the choice of imagery on the façade in the following way:

[Cossar] decorated the frontage of [his] building with sculptures of two men who could write, Robert Burns and Sir Walter Scott; of two men who gave the written word tremendous power by inventing printing – Gutenberg, the German inventor of movable types, and Caxton, who introduced printing to England; and of two very important people on the local scene – himself and his wife.[2]

The construction of the building coincided with a peak in the company's early prosperity, though Cossar himself died within a year of its completion. The business was managed for a further 36 years by his widow (known locally as 'Granny Cossar'), who expanded the list of titles to include the *Clydebank Press* and the *Renfrew Press*. A vivid, if rather oblique, insight into John Cossar's declining health in the last years of his life is provided by the records of his involvement with the commissions for two of

Govan's most important sculptural monuments. At a meeting of the John Elder Memorial Committee in September 1887, the chairman, ex-Provost Campbell, announced that the committee

> … deeply regretted the absence of Mr Cossar, the secretary, through ill health, but it was pleasant for them to know that though he was absent from them in the body, he was with them in spirit, and that he was in a fair way of recovery. He had gone to the country to recruit his health, and it was hoped that by next meeting he would be with them again.[3]

The minutes of the following meeting do not record the names of those attending. He was also a member of the William Pearce Memorial Committee, but was reported by ex-Bailie Carmichael in his speech at the unveiling ceremony in 1894 as one of four of the 'eighteen gentlemen associated with [the] undertaking at the outset' who were 'not now with them to celebrate the culmination of their duties'.[4]

Condition: The reliefs are in good condition, but the building has begun to suffer from a lack of maintenance since the closure of the offices in the mid-1970s. There are fears that the building may one day be demolished.

Notes
[1] Patrick Donnelly, *Govan on the Clyde*, Glasgow, 1994, p.36 (incl. ill.). [2] GP, 27 October 1978 ('Cossar Centenary Supplement'). [3] GCA, H-GOV 27 (1), *Minute Book of the John Elder Statue Committee 1884–1888*, 14 September 1887. [4] GP, 13 October 1894 ('Sir William Pearce Memorial Supplement').

Other sources
Anon., 'The Cossar Story', *Printing World, Incorporating Newspaper World*, vol.193, no.14, 4 October 1973, pp.264, 270–1 (incl ill.); GP, 29 October 1976, p.6; MLG, MS 'Index of Wills' (1927); McKenzie, pp.40 (ill.), 41.

Bank of Scotland (former British Linen Company Bank), 816–18 Govan Road / 1 Water Row

Zephyrs, Figurative Capitals and Associated Decorative Carving

Sculptors: Francis Derwent Wood and Johan Keller (modellers); Richard Ferris (carver)

Architect: James Salmon & Son
Date: 1897–1900
Material: red sandstone
Dimensions: main figures life-size; capital figures approx. 46cm high
Inscription: on the sail of the ship above the door: B L Co.
Listed status: category A (15 December 1970)
Owner: Bank of Scotland

Description: Designed to combine bank premises, shops and dwellings, the building has been described by David Walker as 'pure late Victorian Glasgow with two bold chimneys framing a corner bay, but in the crown of thorns at its truncated roof and in the non-period sculpted details … at the ground floor, *Art Nouveau* is clearly evident'.[1] The sculpture programme is concentrated above the entrance, and consists of a ship's prow emerging in full sail from beneath an oriel window, its stem carved with a miniature female nude. Seated on the capitals of the columns flanking the entrance are winged *Zephyrs* blowing through

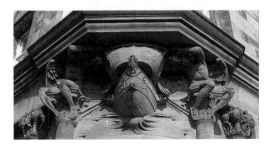

Francis Derwent Wood, *Zephyrs*

conches into the billowing sails of the ship. On the Govan Road and Water Row façades there is a series of seven ground-floor capitals in a Byzantine idiom, each carrying a tiny figure emblematic of different forms of labour, including a beekeeper, a navigator and a fisherman.

Discussion: The building has the most ambitious carvings of the three branches built by the British Linen Company around the end of the nineteenth century in Glasgow (see, for example, 215 High Street), and the figures are noted for the expressive power of their postures. The fluid treatment of the stonework in the waves below the ship is also very distinctive. Walker notes that there is some debate as to whether the design was by James Salmon or his partner John Gaff Gillespie, both of whom treated sculpture as an integral part of their designs.[2] Contemporary sources are less ambiguous, however, in their attribution of the sculpture work: the ship and Zephyrs were modelled by Wood, and the capitals by Keller; the carving is all by Ferris.[3]

Related work: Salmon & Son's drawing of the doorway was exhibited at the RGIFA in 1901 (no.760).[4]

Condition: Good.

Notes
[1] David Walker, 'The Partnership of James Salmon and John Gaff Gillespie', in Alastair Service (ed.), *Edwardian Architecture and its Origins*, London, 1975, pp.239–40. [2] Walker, *op. cit.* [3] BI, 15 September 1897, p.93. [4] Billcliffe, vol.4.

Other sources
GAPC, 22 August 1899, n.p.; Read, pp.366–8 (incl. ills); Teggin *et al.*, pp.34, 62 (incl. ills); Bowes, p.12 (incl. ill.); Williamson *et al.*, pp.595–6 (incl. ill.); McKenzie, pp.36 (ill.), 37.

Govan Cross, at the junction with Burleigh Street

Monument to Sir William Pearce

Sculptor: Edward Onslow Ford

Designer and builder of pedestal: Robert
 Lawson, Aberdeen
Founders: Broad & Sons
Unveiled: 6 October 1894
Materials: bronze statue on a Peterhead granite
 pedestal
Dimensions: statue 2.97m high; pedestal 3.73m
 high × 2.44m × 2.44m at base
Signature: on the right side of the plinth –
 BROAD & SONS FOUNDERS LONDON
Inscriptions: on the pedestal – front (east) face –
 SIR WILLIAM PEARCE / BART. MP, / DIED 18TH
 DECEMBER 1888 / AGED 55 YEARS; right face –
 AS A SHIPBUILDER AND ENGINEER / HIS
 ORIGINALITY OF THOUGHT AND /
 MARVELLOUS SKILL IN EXECUTION /
 CONTRIBUTED LARGELY TO THE /
 DEVELOPMENT OF THE NAVY / AND
 MERCANTILE MARINE. / IN TOKEN OF HIS
 EMINENCE / IN HIS PROFESSION HE WAS /
 CREATED A BARONET IN 1887 / HIS EXTENSIVE
 AND / ACCURATE KNOWLEDGE LED TO / HIS
 APPOINTMENT TO SERVE ON / THE ROYAL
 COMMISSION ON / TONNAGE, / LOSS OF LIFE
 AT SEA / AND DEPRESSION OF TRADE. / HIS
 CAREER FURNISHED A / STRIKING EXAMPLE OF
 WHAT / GENIUS COMBINED WITH ENERGY, /
 INDUSTRY AND INDOMITABLE / COURAGE MAY
 ACCOMPLISH, / EVEN IN A SHORT BUSINESS
 LIFETIME; rear face – ERECTED / BY / PUBLIC
 SUBSCRIPTION / IN GRATEFUL RECOGNITION /
 OF HIS NUMEROUS NOBLE / QUALITIES, AS A
 MAN AND / EMPLOYER OF LABOUR / 1894; left
 face – FOR A TIME HE SERVED AS / A
 COMMISIONER OF POLICE / OF THE BURGH OF
 GOVAN. / HE WAS ALSO HONORARY /
 COLONEL OF THE SECOND / VOLUNTEER
 BATTALION / HIGHLAND LIGHT INFANTRY;

PROVINCIAL GRAND MASTER / OF GLASGOW; /
A COMMISIONER OF SUPPLY, / JUSTICE OF THE
PEACE, / AND DEPUTY LIEUTENANT / OF THE
COUNTY OF LANARK. / WHEN GOVAN WAS
MADE / A PARLIAMENTARY DIVISION / IN 1885
HE WAS RETURNED AS / ITS FIRST
REPRESENTATIVE, / AND WAS RE-ELECTED IN
1886.
Listed status: category B (15 December 1970)
Owner: Glasgow City Council

Sir William Pearce (1833–88), shipbuilder. Born
in Kent, he served his apprenticeship in
Chatham Naval Dockyard, where he was put in
charge of building *Achilles*, the first iron
warship constructed in any HM dockyard. In
1863 he joined Lloyd's Register and was
appointed surveyor for the Clyde district. The
following year he became Robert Napier's
shipyard manager, a position he held until 1870,
when Mrs John Elder (q.v., Elder Park)
persuaded him to become one of three men to
take over the running of the Fairfield yard at
Govan. Under his dynamic management this
yard became the biggest in the world, with a
labour force of 5,000 building ships for the
Admiralty and Atlantic liners for all the major
international shipping lines. Much of the
commercial success of his vessels was based on
their superior speed, and this was further
exploited by his creation of the Blue Riband
challenge for the fastest transatlantic crossing,
which was won by Fairfield ships throughout
the 1880s. In 1880 he stood unsuccessfully as a
Conservative candidate for Glasgow, but was
returned as the first MP for Govan five years
later. Politically he remains an ambiguous
figure. Though presenting himself as a
champion of the working classes, his voting
record reveals a consistent anti-labour position,
fiercely opposing such measures as the
introduction of property rights for crofters and
the granting of funds for the alleviation of
agricultural distress. He campaigned against the
Liberal government's Employers' Liability Bill

and established a committee to review
Clydeside ironworkers' wages 'with a view to
the reduction thereof'. Undoubtedly his
numerous charitable works, for which he was
regularly and fulsomely praised in the local
press, played a part in securing his political
credibility in the eyes of his employees. His
sponsorship of the construction of Glasgow
University's Pearce Lodge (q.v., University
Avenue) from architectural fragments salvaged
from the Glasgow Old College on the High
Street was also an important public gesture.
Such activities have to be seen, however, in the
context of his actual financial means. In 1884,
when the average wage of his workers was £1
per week, his own weekly income was £3,700.
Noted for his flamboyant lifestyle – he owned a
steam pleasure launch which he frequently used
to entertain his parliamentary colleagues – his
career was not without scandal, and in 1885 he
was assaulted by the father of a young girl
whom he was reported to have seduced. Pearce
died in Glasgow after a brief cardiac illness,
almost certainly brought on by overwork, and
is buried in Kent. The Fairfield yard was passed
on to his son, Sir William George Pearce.[1]

Description: The subject is shown wearing a
tightly buttoned frock coat, stepping forward
with a plan inscribed with a drawing of a ship
(identified by local maritime historians as one
of Pearce's famous 'Ocean Greyhounds')
unfurled in his hands. The statue was described
in the *Govan Press* as a 'magnificent counterfeit
of the deceased baronet'.[2] The pedestal weighs
25 tons and is in five stages, with an anthemion
moulding on the cornice, corner volutes on the
base and a plain limestone plinth. The plinth is
sunk slightly below pavement level, and is
surrounded by a hexagonal kerb.

Discussion: The statue was erected by public
subscription, but unlike the two comparable
monuments in Govan, *John Elder* and *Isabella
Ure* (qq.v., Elder Park), the relevant Memorial
Committee minute books have not survived. A
two-page supplement devoted to the

inauguration was published by the *Govan Press*, however, and this enables us to reconstruct a rudimentary outline of its origination and the progress of the commission.[3] The response of the people of Govan to the news of Pearce's death appears to have been very swift, with the 'desire to immortalise his personality in bronze and his genius in granite … warmly taken up by the community'. 'Scarcely had the grave closed', the article goes on,

> … over the body of the esteemed Baronet, when the working-men of Govan and their more opulent brethren, as well, thought that something should be done to keep green the memory of one so dear to all of them, and Provost Fergusson was at once asked to convene a public meeting to consider the matter.

The meeting was 'very largely attended', and after a unanimous resolution that a 'monument or something of the kind should be erected', a General Committee was appointed, which in turn 'devolved the labour of love' on an eighteen-member executive. Fundraising began immediately, and with a number of 'noblemen and gentlemen' expressing a willingness to become patrons, it was not long before a 'substantial sum' had been raised. After consultation with Lady Pearce, it was decided that 'a statue would be the most suitable form' for the monument, and that the 'services of Mr Onslow Ford, of London, the renowned sculptor' should be sought.

Public monuments as ambitious as this are rarely completed without setbacks, and in this case a particular cause of delay was the difficulty the committee encountered in finding an appropriate site. Lady Pearce herself had undertaken to provide a site, but was at first unable to find one 'free from adverse criticism'. In the end her purchase of the triangular plot of land at the junction of Govan Road and Burleigh Street turned out to be a 'triple boon' to the people of Govan, as it involved the

demolotion of 'a lot of old and unsightly houses' and thus the creation of a 'beautiful breathing space for the public which would remain in all time coming a sort of lung for the overcrowded district'.

Not surprisingly, most of the *Govan Press* supplement is devoted to the celebrations accompanying the inauguration of the monument, which finally took place nearly six years after Pearce's death. It was a lavish affair, comparable, in the view of the *Press* reporter, to the

> … day upon which a similar tribute was paid to the memory of the late Mr John Elder, and since that day there has certainly not been in Govan a demonstration of such gigantic dimensions and exuberant display, nor one in which the interest of the citizens was so manifestly popular.

The proceedings began with the arrival of the various invited guests – including Lady Pearce and other relatives, Lord and Lady Kelvin, members of the Council and so on – at the Burgh Halls at 2.30pm, who then headed a procession which made its way via Plantation Road and Paisley Road West to Govan Cross. The procession, made up of various 'contingents' of workers as well as lorries carrying tableaux associated with local commercial and voluntary organisations, was estimated to be roughly a mile long, and 'the time it occupied in passing a given point, half an hour'. In addition to the 'perfect sea of faces' that filled the streets, the buildings on the route were decorated with displays of flowers and bunting, which increased in density to become, at the Cross itself, 'one solid mass of luxuriant and abundant decoration'. A number of private households displayed banners carrying mottos such as 'Oh Willie we have missed you', and the owner of the then incomplete building immediately behind the statue (now Brechin's Bar) took advatage of the scaffolding to view the ceremony. It appears that the organisers

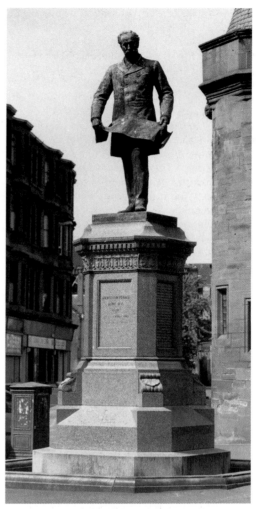

Edward Onslow Ford, *Sir William Pearce*

underestimated the size of the platform, and many of the invited guests 'had to be content with standing room'. However, this merely added to the sense of occasion, and when Lord Kelvin finally 'pulled the lacing from the covering of the statue', the 'assembled multitude' responded with 'loud and prolonged cheers'. Ford himself was present at the ceremony, and was able to witness what one speaker described as the crowd's 'hearty appreciation of his genius and art'. A tribute was also paid to Lord Kelvin, who was presented with a 'handsome and massive gold medallion with the inscription on one side, "Unveiling of Sir William Pearce Statue"'. The Supplement concludes with its final verdict: 'A great day it surely was, with great honour paid to a great man – and yet no greater than he deserved.'

A notable feature of the coverage of the *Govan Press* is the stress it places on Pearce's standing in the community, and the general importance attached to the symbolic function of public memorials of this kind. On several occasions it draws attention to the apparent unanimity of support for the statue across the whole spectrum of social classes in Govan, with the 'horny handed sons of toil' as eager to contribute what they could from their slender means as the most affluent of middle class residents. It is clear also that the scale of the attendance was partly a reflection of the energetic way in which Pearce had involved himself in local affairs. He was not only the Grand Master of the Provincial Grand Lodge of the Glasgow Freemasons, which marched near the head of the procession from the Burgh Hall, but also an 'honorary member' of nearly every one of the friendly societies that made up the bulk of the rest of the parade. Above all, the importance of the statue was its longevity as a public statement, and the fact that it embodied certain desirable values in a permanent form. Not only would it be seen by 'generation after generation to remind them of what Sir Wiliam

had done for Govan, for the Clyde, for Scotland, and for the whole world', it would also provide the community with a touchstone for their own social aspirations. In his speech at the unveiling, ex-Provost Fergusson declared that:

> This statue, where so many people passed daily was not only a beautiful thing but it was an incentive and an encouragement to every passing apprentice to do what he could to emulate the professional career of the great founder of the Fairfield Yard. (Loud applause.)

As a celebration of the positive aspects of Pearce's life, with no reference to the ruthlessness with which he pursued his goals, or the harsh economic and political facts that lay behind his achievement (see above), the monument may be considered a paradigm of the late-Victorian approach to the commemoration of 'great' individuals.

Related work: A *Monument to Sir William Pearce* by Albert Toft, was formerly in Craigton Cemetery, 1578 Paisley Road West, but was removed by the City Council in 1970 after being vandalised. It included a bronze portrait bust, a series of four allegorical figures and narrative reliefs depicting shipbuilding scenes.

Condition: Good, but with some minor graffiti on the pedestal. The statue is known locally as 'the Black Man', due to the discoloration of the bronze, though in fact the heavy surface oxidisation has produced a vivid green patina.

Notes
[1] Anon., 'Profiles of the Clyde Shipbuilders: Sir William Pearce (1835 [sic] – 1888)', GCCJ, February 1971, pp.127–9; Slaven and Checkland, vol.1, pp.229–30; John O. Foster, 'William Pearce 1833–1888, Copper Trousered Philanthropist', *Society of Friends of Govan Old, Seventh Annual Report*, December 1997, pp.18–31. [2] GP, 22 September 1894, p.5 (Obituary). [3] GP, 13 October 1894 ('Sir William Pearce Memorial Supplement').

Other sources
Bailie, 'Men You Know', no.350, 2 July 1879, no.388, 24 March 1880; GH, 18 December 1888, p.5; BA, 8 May 1891, p.352, 12 October 1894, p.251; BI, 15 October 1892, p.109; GP, 6 October 1894, p.4; Brotchie, pp.190–1, 196 (incl. ill.); Read, p.365 (incl. ill.); Williamson *et al.*, p.592; Rob and Linda Gault, *Govan Heritage Trail*, Glasgow, 1995; McKenzie, pp.35 (ill.), 36.

On the corner of Govan Road and Elder Street, beside the entrance to the Kvaerner-Govan Shipyard

Govan Milestone
Sculptor: Helen Denerley

Installed: 29 June 1994
Materials: welded copper and mild steel, with scrap metal
Dimensions: 4.58m high × 4.22m wide
Inscription: on plaque on wall behind sculpture
– GOVAN MILESTONE / BY / HELEN DENERLEY / JUNE 1994
Listed status: not listed
Owner: Govan Housing Association

Description: The work consists of a pair of copper arcs arranged vertically in an 'hour-glass' formation and aligned on a cruciform plan. In the centre are four cormorants, constructed from chain links, lengths of steel cable, nuts and bolts and other scrap metal products gathered from the Kvaerner Yard. These are placed symmetrically around the junction of the two arches, with their necks and beaks extended to form a pair of smaller, secondary arches.

Discussion: Denerley was one of three artists invited to submit a design for the project by Govan Housing Association in February 1993, as part of a £440,000 environmental improvement scheme, with funding from Scottish Homes and Glasgow Development Agency. During the execution of the work, a series of children's workshops, funded by

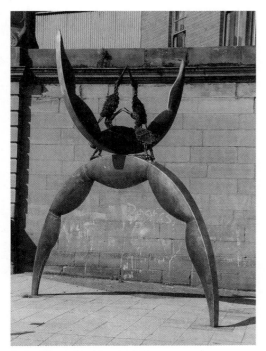

Helen Denerley, *Govan Milestone* [RM]

Strathclyde Regional Council, enabled pupils from local schools to make birds and masks, which were exhibited at the time of the unveiling.[1] This form of related activity was very much in line with the Housing Association's desire that the Milestone should 'reflect the hopes and aspirations of Govan's community, the lives and concerns and above all the sense of humour of the people who live in the area'.[2]

The sculpture was also part of the 'Glasgow Milestones' scheme, initiated in response to Glasgow's 1990 celebrations as European City of Culture by the Glasgow Sculpture Studios, who provided advice and support for the Housing Association in their development of the commission. For a full discussion of this scheme, see *Calvay Milestone*, Barlanark Street.

Of the *Govan Milestone*, Helen Denerley writes:

The two curved arches are the balance in our lives. The claw like shapes are reminiscent of ships, waves or crabs – the rivets are the engineering. The birds are the community – courting, mating, building nests, but they also look up – our hopes.[3]

The critic Clare Henry reported that the work met with the general approval of the local residents, 'even if the shipyard workers may criticise the welding'. Despite assistance from a local blacksmith in Strathdon, Aberdeenshire, where the work was manufactured, Denerley herself conceded that: 'It's true. They won't be very impressed. Welding mild steel to copper is not easy, and it's not spot on.'[4]

Related work: The other works in the 'Milestones' series are *Milestone* (Cromwell Court), *Dennistoun Milestone* (Duke Street), *Rosebud* (East Garscadden Road), *The Works* (Springburn Way), *As the Crow Flies* (West Princes Street).

Condition: Good.

Notes
[1] Leaflet, *The Govan Milestone, 29 June 1994*, Govan Housing Association, 1994. [2] Rae and Woolaston, p.25. [3] *Ibid.* [4] Clare Henry, 'So you can see the join', GH, 16 July 1994, p.6.

Other sources
Location map, *Milestones*, Glasgow Milestones, n.d. (1994); Rae and Woolaston, pp.1, 4, 10, 28 (incl. ills); McKenzie, pp.38, 39 (ill.).

Kvaerner-Govan (former Fairfield) Yard Offices, 1030–48 Govan Road

Engineer, Shipwright and Associated Decorative Carving

Sculptors: James Pittendrigh Macgillivray (figures) and McGilvray & Ferris (reliefs)

Architect: John Keppie
Date: 1890
Material: red sandstone
Dimensions: figures life-size
Listed Status: category A (15 December 1970)
Owner: Kvaerner-Govan Ltd

Description: The two figures are attached to the channelled ashlar wall on either side of the arched entrance to the reception room of the Yard offices. The *Engineer* is on the left, and is shown with a plan in his right hand and the helm of a ship placed against the wall behind him; behind the *Shipwright* is an anvil and a large cog. Each figure stands on the prow of a ship decorated with dolphins and stylised waves and supported by a half-cylindrical pedestal projecting from the dado. The figures, both of whom are bearded, are informally dressed in working aprons and cloth caps. There are, however, minor differences in their dress which may suggest a difference of status. The *Engineer*, for example, wears a collar and tie and a waistcoat, and has his sleeves rolled only as far as the forearm; the sleeves of the *Shipwright* are rolled above the elbow and his shirt is open at the collar. The latter also wears a full-length apron, more suggestive of manual labour than the shorter garment tucked into the waist of the *Engineer*.

In the lunette above the entrance is a pair of *Mermaids* reclining on stylized waves, with a blind shield between them, writhing salmon filling the remaining spaces and the mask of a helmeted *Viking Sea God* in the keystone above. There is a mask of *Neptune* in the frieze over

the top-storey windows.

Discussion: The building was commissioned by Sir William George Pearce, the son of Sir William Pearce, from whom he inherited the Fairfield shipyard on the latter's death in 1888.[1] The arrangement of the figures is strongly reminiscent of the traditional design of the Govan coat of arms, which has a draughtsman and a ship's carpenter on either side of a shield displaying a ship on the stocks. The fish in the lunette may also refer to salmon incorporated in the arms in acknowledgement of the Burgh's dependence on fishing before the growth of the shipbuilding industry. Although the figures are clearly not intended as portraits of specific individuals, it is worth noting that William Pearce and Charles Randolph, the business partners under whom the Fairield Yard achieved its world pre-eminence, trained as a shipwright and an engineer respectively. The use of Viking imagery in the keystone has now acquired a peculiar aptness in the light of the recent take-over of the company by the Norwegian firm Kvaerner.

The attribution of the work is based on entries in the MS copies of the Honeyman and Keppie job book, which records a payment of £251 31s. 1d. to Macgillivray on 9 April 1890, and £90 15s. 1d. to McGilvray & Ferris on 12 May 1890. A separate bid of £20 was made by McGilvray & Ferris for carving the pair of Corinthian capitals in the central colonnade, undercutting a rival estimate by James Young by £8; their bid was accepted on 4 February 1890.[2]

Related work: A fibreglass relief, measuring approximately 66cm × 60cm featuring the statuary on the entrance, made by John McArthur *c.*1993, is in St Gerard's Secondary School, Vicarfield Street, Govan.

Condition: Good.

James Pittendrigh Macgillivray, *Engineer* and *Shipwright* [RM]

Notes
[1] Anon., 'Profiles of the Clyde Shipbuilders: Sir William Pearce (1835 [*sic*] – 1888)', GCCJ, February 1971, p.129. [2] HAG, Honeyman and Keppie Job Books (1881–94), 4 February, 9 April 1890, p.108.

Other sources
BI, 15 May 1891, p.25; B, 9 July 1898, pp.29–30; Hume, pp.261, pl.55; Worsdall (1988), p.106 (incl. ill.); Williamson *et al.*, p.596; McKenzie, pp.38, 39 (ill.).

At the north end of the square, adjacent to the entrance to the former Meat Market

Calf

Sculptor: Kenny Hunter

Carver (inscription): Jonathan Kemp
Date: 1998–2000
Installed: May 2000
Materials: patinated bronze statue on a
 Kilkenny limestone base
Dimensions: calf 1.13m high; base 47cm × 70cm
 × 1.2m
Inscription: running in a single line round the
 base (line breaks at corners) – ANIMALS CAME
 FROM OVER THE HORIZON. THEY BE /
 LONGED *there* & *here*. LIKEWISE /
 THEY WERE IMMORTAL. EACH LION WAS /
 LION AND EACH OX WAS OX
Listed status: not listed
Owner: Molendiner Park Housing Association

Description: A yearling calf with a garland placed round its neck. Larger than life-size, the animal stands in a stationary pose on a rectangular stone base.

Discussion: The monument was commissioned by the Molendiner Park Housing Association as part of a comprehensive redevelopment of the historic area surrounding the city's former cattle and meat markets. Several major architectural practices were involved in the scheme, including Page & Park Architects and Richard Murphy Architects, with Glasgow Building Preservation Trust taking responsibility for the restoration of the Tuscan Doric entrance gate to the disused meat market which forms the immediate backdrop to the statue. Under the management of Visual Art Projects, the commission was incorporated into the programme of the Glasgow 1999, UK City of Design and Architecture Festival, which designated Graham Square as one of five 'Millennium Spaces' targeted for imaginative urban development.[1]

Hunter's initial intention was to place a gilded calf on a tall column at the southern entrance to the square (which is in fact a short cul-de-sac), thus creating a distinct landmark on the model of the columns in St Mark's Square, Venice.[2] At this early stage in the creative process the artist's thinking inclined towards the treatment of the calf as a 'symbol of society living with doubt',[3] its principal iconographic reference deriving from the legend of the golden calf in the Old Testament.[4] At the same time, this was integrated with a wider pattern of contemporary cultural concerns, including the problematic status of the notion of permanence in public art. In his account of an exhibited version of the statue, Andrew Patrizio offers the following commentary:

> *Golden Calf* is a kind of response to this problem by Hunter, who has selected a biblical moment in which a society demonstrated its lack of spiritual faith. The calf denotes misguided idolatry from a Judeo-Christian perspective but Hunter focuses on it because the animal has many other meanings ascribed to it by different cultures. It is an ambiguous icon in a multi-cultural and multi-referencing society.[5]

Equally relevant in this 'multi-referencing' process are the connotations of sacrifice and the social dependence on animals bound up with the site of the finished work; Graham Square formed part of a drove road leading to a meat market, which was itself later to become an abattoir.

Although the proposal was enthusiastically endorsed by Glasgow 1999, the ambivalence of the work's religious associations proved problematic for some members of the Housing Association's committee, and after some discussion Hunter agreed to modify the iconography by introducing a number of changes in the statue's form. The connection with the legend of the golden calf, and thus with the notion of idolatry, was suppressed by bringing the statue down from its column and placing it on a simple cubic base much closer to the ground, and by replacing the gold surface with a light green bismuth patination. A garland was also placed round its neck as a tribute to its unique beauty as a living creature, and a quotation from John Berger's essay 'Why Look at Animals'[6] was inscribed on the base as a reminder of the complicated mixture of guilt

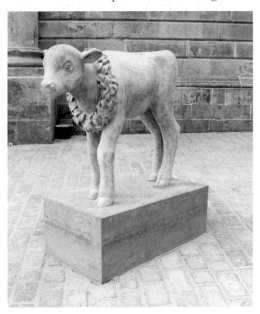

Kenny Hunter, *Calf* [RM]

and wonder which characterises the relationship between man and the animal kingdom in a post-industrial age. Overall, although none of the work's original meanings were entirely lost through this change of emphasis, the final work represents a transition, in the artist's words, 'from the iconic to the ironic'.

Related work: The gateways and other architectural fragments of John Carrick's original cattle and meat market buildings incorporated in the new development have several keystones carved with human and animal masks, including a bull, a cow and a ram. Versions of *Golden Calf* were included in the travelling exhibition *ark* in Edinburgh and in *Kenny Hunter: Work 1995–1998* at the Arnolfini Gallery, Bristol, both in 1998. Small editions of *Calf* are also in private collections.

Condition: Good.

Notes

[1] Unpublished document, 'Project Profile: Graham Square urban space', Molendiner Park Housing Association Ltd, Glasgow, 1996, *passim*. [2] *Ibid*., n.p. [3] Artist's statement, *ark: a Travelling Gallery exhibition touring schools and community venues around Edinburgh*, Edinburgh, 1998. [4] *Holy Bible*, Exodus 32; 1 Kings 12. [5] Andrew Patrizio, 'Imagology', in Kenny Hunter, *Work 1995–1998*, ex. cat., Arnolfini, Bristol, 1998, p.8. [6] John Berger, 'Why Look at Animals?', *About Looking*, London, 1980, pp.4–5.

Other sources

Williamson *et al.*, p.456; Sam Clarke, 'Glasgow in search of the golden cow', ET (undated cutting in Kenny Hunter archive); Simon Grant and Irene Maver, *Five Spaces: new urban landscapes for Glasgow*, Glasgow, 1999, pp.40–5 (incl. ills); Andrew Guest, 'Art and Architecture in Scotland: questioning the players', *Sculpture Matters*, no.8, June 2000, p.13 (incl. ill.); Riches *et. al.*, pp.40–2 (incl. ill.); conversation with Kenny Hunter.

Granville Street ANDERSTON

On the west façade of the Mitchell Theatre, Granville Street / Berkeley Street / Kent Road

Figurative Programme

Sculptors: John and William Mossman Junior, assisted by Daniel MacGregor Fergusson

Architect: James Sellars
Mason: James Watson
Date: 1875–7
Building inaugurated: 13 November 1877
Material: yellow freestone
Dimensions: all figures colossal
Inscriptions: on panels between the caryatids on the attic storey – RAPHAEL; WATT; M.ANGELO; NEWTON; FLAXMAN (north section); PURCELL; BACH; HANDEL; MOZART; BEETHOVEN (south section)
Listed status: category A (6 July 1976)
Owner: Glasgow City Council

Description: The west façade is the only surviving part of the building originally erected as the St Andrew's Halls, the bulk of which was destroyed by fire in 1962 (see below). It has three storeys, including a giant Ionic colonnade *in antis* on the first floor, a basement of banded ashlar and an attic comprising a pair of end pavilions connected by a recessed entablature. An exclusively trabeated structure, its design is characterised by the familiar Greek Revival device of 'threading' vertical and horizontal components into a unified geometric whole. However, despite the dominant horizontal emphasis created by the colonnade, the architect clearly intended the end pavilions to be seen as discrete units, and has used the sculpture programme to underscore their relative visual autonomy. Thus the main figure

groups are placed on pillars projecting from the basement at the ends of each pavilion, providing accents at the points of transition from the central section to the wings. The confinement of the caryatids to the attics of the end pavilions also encourages the viewer to read these as vertical units rather than as lateral extensions of the centre bays. By contrast, the pair of atlantes which frame the main door are enclosed by an Egyptian pylon, a uniquely dramatic feature which has no counterpart in the outer bays. Far from being a mere embellishment, figurative sculpture is used to articulate the underlying logic of the structure, each component of the programme performing a subtly different role.

Thematically, the four allegorical groups are a visual counterpart to the catalogue of artists' and musicians' names inscribed on the attic (see above), combining references to history and mythology in a wide-ranging, if somewhat erratic, celebration of the entire tradition of western culture. Each group consists of a principal standing figure, with subsidiary figures in seated or crouching postures on either side. From the left, these are as follows:

(1) *Literature.* The central figure is Homer, who stands in an ample toga with his right arm raised, his face turned to the sky and a small six-stringed lyre in his left hand. The treatment, which shows the poet gripped by inspiration, is more rhetorical than Mossman's slightly earlier interpretation of the same subject on Elmbank Street (q.v.). It is also worth noting that Homer, despite his blindness, is the only figure in the entire scheme whose eyes are cut with pupils. The seated figures are Shakespeare (on the left), shown with a quill pen and a large folio open on his knees, and Dante, who holds a book. Stoddart observes that where Shakespeare is

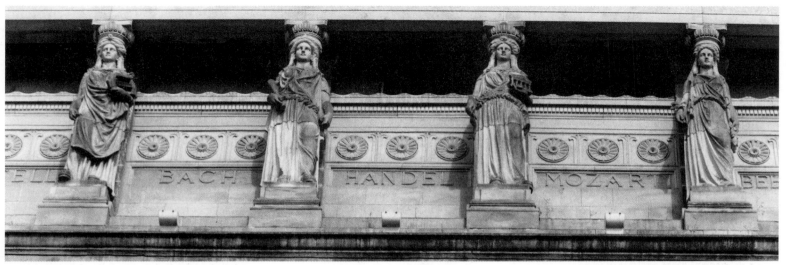

William Mossman Junior (attrib.), *Caryatids*

'intensely alert', Dante has a more 'brooding pose'.[1] In fact the interpretation of Dante is consistent with the Romantic representations of one of his most famous characters, the melancholy Count Ugolino.[2] Stoddart also notes the similarity between the awkward 'doubled-back hand' on which his cheek rests and Rodin's treatment of the same detail in *The Thinker* (1880).[3]

(2) *The Visual Arts*. Michelangelo stands in the centre, flanked by seated figures of Leonardo da Vinci (left) and Raphael. Michelangelo has a miniature copy of the Belvedere Torso cradled in his right arm, a confirmation, perhaps, of Mossman's own commitment to the sculpture of classical antiquity; the book in his left hand acknowledges his achievement as a poet. Leonardo is also shown with a book, in this case propped on his knee, while Raphael holds a partially unfurled scroll, possibly a drawing.

(3) *Ancient Arts*. Pallas Athena rises between two male figures emblematic of Sculpture (left, semi-naked with mallet and chisel) and Architecture (more contemplative, with a scroll). It is possible that these figures are intended as portraits of Praxiteles and Ictinus. Athena herself is dressed in a toga, decorated cuirass and heavily plumed helmet, and holds a sword and a miniature winged Nike.

(4) *Music*. Apollo wears a short tunic and cape and holds a six-stringed lyre and a plectrum; the instrument is slightly larger than Homer's, and has incised decoration on the soundbox and may therefore be a Kithara rather than a lyre.[4] The treatment of the torso, with its delicate draperies, emphasises the youthful beauty of the subject. At his feet are two female Muses, identified tentatively by Stoddart as Erato (left) and Polyhymnia.[5] As with all the pairs of subsidiary figures, these are presented in contrasting poses, one (Erato) glancing downwards as she plays a tambourine, the other twisting upwards in a more dynamically spiralling pose to play a long-necked stringed instrument.

All the groups are carved from two main blocks, with the exception of *The Visual Arts*, which is made from three.

The atlantes are enclosed by the pylon which forms the main entrance to the theatre. Although they perform identical structural roles, the figures are subtly contrasted in their treatment, with the older of the two (on the left) shown with a beard and a tunic made of conventional cloth, while his younger companion is clean-shaven and wears an animal pelt. The caryatids are grouped in two sets of four in the attic storeys of the end pavilions, and carry a variety of attributes, mostly emblematic of the arts. From the left these are: a wreath and a laurel branch; a palette and brushes (broken); a tubular object, possibly a telescope; a four-stringed lyre; a lyre; a telescope(?); a temple and a pair of dividers; a wreath and a laurel branch. Each figure is composed of four separate blocks.

In addition to the sculpted decorations described above, the building also has a series of ornamental cast-iron lamp standards, twelve in

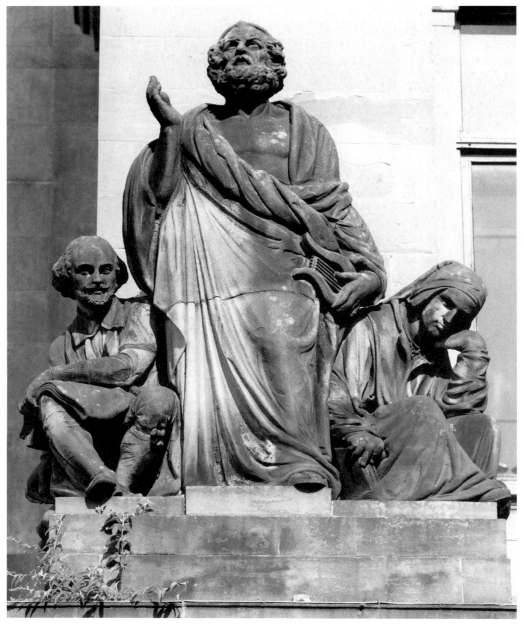

John Mossman, *Homer, Dante* **and** *Shakespeare*

all, on the dado projecting from the basement. These were manufactured by Walter Macfarlane & Co., at the Saracen Foundry.

Discussion: Before the erection of the St Andrew's Halls, the two principal concert venues in Glasgow were the City Hall in Candleriggs and the Queen's Rooms in La Belle Place (now Hindu Temple, q.v.). By the early 1870s, these were perceived as inadequate to the city's expanding cultural needs, both in terms of their relatively small size and, in the case of the City Hall, its 'inconvenient position' in the centre of town.[6] The situation prompted a 'syndicate of Glasgow gentlemen' to form the Glasgow Public Halls Company in 1871, with the object of 'building public halls, which, whilst they meet a long-felt want, should be an ornament and credit to the city'.[7] The projected cost was £80,000, which was to be raised by the sale of shares valued at £10 each. By May 1875, £73,000 had been raised in this way.[8] The initial design for the building was drawn up by John Cunningham, whose Philharmonic Hall in Liverpool was identified as a suitable precedent. On Cunningham's death in 1872, the commission passed to the Glasgow architect Campbell Douglas, who had acted as his 'associate' in drawing up the early sketches,[9] though the final design is generally regarded today as the work of his partner, the thirty-year-old James Sellars.[10]

Although an eclectic who worked in many styles, Sellars was a profound admirer of Alexander 'Greek' Thomson (1817–75), and this building, with its Grecian detailing and 'Shinkelesque' colonnade, carries the disciplined classicism associated with Thomson into the last quarter of the nineteenth century, long after the Greek Revival had ceased to be fashionable elsewhere in Britain. Perhaps the clearest evidence of his debt to Thomson, however, is in his treatment of the atlantes flanking the entrance. These are identical in almost every detail to figures sketched by Thomson on his unexecuted competition design for the South

Kensington Museum (1864),[11] and might almost be described as a deliberate *homage* by the younger architect to his recently deceased mentor.[12] The presence of such an overt borrowing is immensely interesting in the context of the study of Victorian architecture in Glasgow, and is particularly relevant to our appreciation of the full extent of Thomson's influence. In terms of sculptural history, it is a matter of regret that the city's greatest nineteenth-century architect was never given an opportunity to erect a building incorporating a significant sculpture programme. His two most ambitious designs in this regard – the South Kensington Museum and the Albert Memorial (1862, also unexecuted)[13] – reveal a profound understanding of the role of sculpture in architecture and a very evident willingness to use it when he felt its presence would enhance his design. Indeed, in the third of his Haldane Lectures he wrote approvingly of the colossal figures on the temple at Agrigentum, Sicily, describing them as

> … figures of very good design, which stand in front of the piers forming what may be termed the clerestory. Their arms are raised so as to bring their elbows level with the top of the head – which is thrown forward, and the hands are clasped at the back of the neck.[14]

Sellars' incorporation of this idea in his own building may thus be seen as a belated realisation of a crucial aspect of Thomson's thinking. It is, so to speak, architectural sculpture in the conditional mood: how Thomson *would* have used it, had he been given the opportunity.

The foundation stone for the building was laid, with 'Masonic honours', on 22 May 1875,[15] and the completed building was inaugurated on 13 November 1877, with a performance of Handel's *Messiah*.[16] The interior included an organ, described as a 'magnificent instrument of ornamental appearance', built by T.C. Lewis &

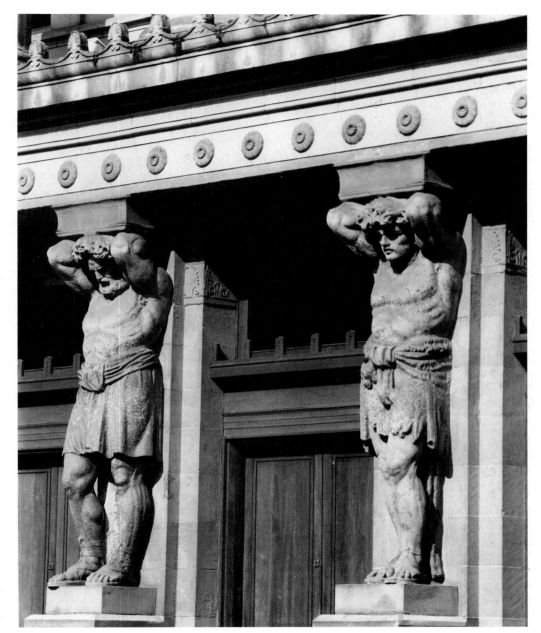

William Mossman Junior, *Atlantes*

Co. from a design by Sir Henry Smart and W.T. Best, of St George's Hall, Liverpool.[17] As a commercial venture the scheme was not a success, and although the motives of the shareholders were described as 'semi-philanthropic' rather than purely profit-oriented, by June 1889 they had become 'tired of their annually recurring deficit of £500' and decided to 'throw the building on the property market'.[18] A private buyer proved difficult to find, and after some prevarication the building was acquired by the Corporation as a 'permanent public institution'. The agreed price was 'something under £40,000', less than half the £107,000 'expended on the erection and maintenance' of the building by the shareholders.[19]

On the morning of 2 November 1962, the building was gutted by a fire which left only the west façade intact.[20] Within a matter of weeks it was decided that the site should be acquired by the Libraries Department for a much-needed extension to the Mitchell Library (q.v., North Street),[21] and in 1965 Sir Frank Mears & Partners were appointed to develop a plan to connect the surviving façade with the existing library.[22] The extension, which contains the Mitchell Theatre, was completed in 1980.[23]

The figurative carvings on the west façade are arguably the finest achievement of the Mossman firm, and the scheme as a whole is one of the most successful examples in Glasgow of the synthesis of architecture and sculpture. Primary source material relating to the scheme is, however, frustratingly scarce, and there are many questions raised by it that cannot be properly answered at present. We do no know, for example, what proportion of the cost of the building was allocated to the sculpture, or if the plan to include an extensive figurative relief depicting the *Arts and Industry* on the attic entablature was abandoned for economic reasons.[24] Nor can we be sure how the designing, modelling, carving and supervision of the various parts of the scheme were divided between the partners in the Mossman firm. A photograph of the studio dating from the time of the commission shows the main allegorical groups rising above a workforce of at least two dozen artisans, with several other unfinished commissions and a number of uncarved blocks distributed randomly over the floor.[25] Fascinating as this image is, it unfortunately throws almost no light on how the production of the work was organised, or who was in charge of the individual parts of the scheme. It is clear from independent sources that William Mossman Junior was responsible for the atlantes, the treatment of which is consistent with his work on the Bank of Scotland at 2 St Vincent Place (q.v.).[26] Thomas Gildard's assertion that William was the sculptor of the 'caryatides' suggests that he may also have carved the female figures in the attic, though it should be borne in mind that he mistakenly describes the entrance figures as 'caryatides', and it is probably these works that he was referring to. Broadly, the current consensus is John Mossman was responsible for the design and conception of the scheme as a whole and the modelling of the allegorical groups, while his younger brother William designed and probably carved the caryatids and atlantes.[27]

Contemporary critical responses to the building and its sculptures were mixed. In 1888, for example, the *Builder* described the façade as 'dignified and refined, but very cold',[28] going on to complain a decade later that the figures were not only squat, out of proportion and badly posed, but altogether 'the building's weakest features'.[29] Charles Gourlay, in his survey of Glasgow buildings in 1919, offered a more sympathetic appraisal, describing the placement of the caryatids in the attic as 'a better use of this feature than … in the Erechtheion itself'.[30]

Condition: In May 1901, the City Curator reported to the council that the stonework of the Halls was being 'maliciously destroyed by being chipped, and also that the building [was] being disfigured with chalk', going on to recommend that 'a board be put up on each side of the building, intimating that persons damaging or disfiguring the building will be prosecuted'.[31] The same report recommended that the 'sculpture underneath the verandah … be cleaned, and that it be remitted to the City Engineer to get this done'.[32] Further restoration work was carried out on the sculptures at the time of the construction of the extension. The present condition of the sculptures is very good overall, though the atlantes have a pock-marked appearance due to the incomplete removal of an earlier coat of paint, and the main allegorical groups have accumulated a large amount of surface moss. The arm on Athena's Nike is also missing.

Notes

[1] Stoddart (1980), p.37. [2] *Inferno*, 32:24–33. [3] Stoddart, *op. cit.*, p. 37. [4] *Ibid.*, p.38. [5] *Ibid.* [6] B, 1 December 1877, p.1196. [7] *Ibid.*, 22 May 1875, p.471. [8] *Ibid.* [9]*Ibid.*, 1 December 1877, p.1196; BA, 9 January 1880, pp.20–1. [10] Most contemporary sources cite Campbell Douglas as the architect, though this is probably a shorthand reference to the practice. B, 26 October 1889, p.291 attributes the design unequivocally to Sellars. [11] See Stamp (1999), pp.154–5. [12] I am grateful to my colleague Gary Nisbet for drawing my attention to this important detail. See also Stoddart (1994), p.90. [13] Reproduced, *ibid.*, p.89. [14] Alexander Thomson, 'Greek Architecture', in Gavin Stamp (ed.), *The Light of Truth and Beauty: the Lectures of Alexander 'Greek' Thomson Architect 1817–1875*, Glasgow, 1999, pp.152–3. [15] B, 22 May 1875, p.471. [16]*Ibid.*, 1 December 1877, p.1196. [17]*Ibid.*, 22 May 1875, p.471, 1 December 1877, p.1196. [18] *Ibid.*, 15 June 1889, p.452, 1 February 1890, p.87. [19]*Ibid.*, 26 October 1889, p.291 & 1 February 1890, p.87. [20] GCA, C1/3/145, p.1290. [21] *Ibid*, p.1832. [22] Anon., *The Mitchell Library Glasgow: 1877–1977*, Glasgow District Libraries, 1977, p.13. [23] Williamson *et al.*, p.279. [24] BN, 8 December 1876, p.586; BA, 2 January 1880, p.8 (ill.). [25] Lyall, p.84. [26] Gildard (1892), p.5. [27] Stoddart (1980), p.39. [28] B, 26 May 1888, p.369. [29] 'The Architecture of our large provincial towns', B, 9 July 1898, p.25. [30] Gourlay, p.477. [31] GCA, C1/3/28, p.604. [32] *Ibid*. The reference here is to the atlantes.

Other sources
BN, 16 May 1873, p.572, 5 June 1874, p.611; B, 20 June 1874, p.523; ILN, 29 June 1878, pp.605–6 (incl. ill.); BI, 15 July 1901, p.61; Cowan, p.167; Gomme and Walker, pp.153–4, 156 (incl. ill.); Young and Doak, no.89 (incl. ill.); Woodward, pp.164, 167; Jack House, 'Ask Jack', ET, 5 June 1982; Read, p.366; Teggin et al., pp.67–9 (incl. ills); McKean et al., pp.157, 170 (incl ills); McKenzie, pp.84 (ill.), 95.

Greenhead Street BRIDGETON

On Greenview School, 47 Greenhead Street

The Mathematician and Associated Reliefs

Sculptor: William Brodie

Architect: not known
Date: 1873–4
Material: Redhall freestone
Dimensions: figure approx. twice life-size
Listed status: category B (15 December 1970)
Owner: Glasgow City Council

Description: Placed on a pedestal above the broken segmental pediment of the building's west wing, the figure is of a boy of about ten years old sitting on a rock with his chin resting on his wrist and his elbow supported by his raised right knee. He is dressed in knee-breeches and a loose-fitting shirt, and holds a slate and a piece of chalk, as if about to begin writing. At his feet there is a group of carpenter's tools, and the pediment below is filled with an open book superimposed on a *fasces* flanked by oak branches.

Discussion: The main (southern) part of the building was designed by Charles Wilson as Greenhead House for Dugald McPhail in 1846, and converted by the Trustees of James Buchanan into the Buchanan Institution for Destitute Children shortly after his death in 1857.[1] A dining hall was added by an unknown architect to the north end in 1873 at a cost of £1,200. This was originally a single-storey block, with the statue exposed against the sky, and it was not until some time after 1913 that the attic storey behind the pediment was added.[2] The statue was described as representing '... a boy, whose garments bespeak

William Brodie, *The Mathematician*

him as one of the humble class which the foundation is intended to benefit'.[3] It is interesting to note, therefore, that later photographs of the interior of the schoolrooms show pupils wearing shirts with broad collars identical to that worn by the boy in the statue.[4] The building later became St Aidan's Roman Catholic School.

Related work: A small marble version of the statue (approx 60cm high) is in the City Art Gallery, Dundee. The pose of the figure is very similar to Brodie's slightly earlier *Monument to Thomas Graham* in George Square (q.v.). A marble bust of James Buchanan by Brodie is in the Director's Office of the Merchants' House (q.v., West George Street), and Brodie was also responsible for Buchanan's monument in the Dean Cemetery, Edinburgh. Buchanan was Brodie's benefactor, and financed his study trip to Rome in 1853.

Condition: Generally good, but coated with cream paint.

Notes
[1] Anon., *Historical Sketch of the Buchanan Institution*, Glasgow, 1913, p.14. [2] *Ibid.*, frontispiece, p.16. [3] BN, 4 September 1874, p.300. [4] Anon., *op. cit.*, pp.28–9.

Other sources
LBI, Ward 26, p.18; Williamson et al., p.465; Teggin et al., p.22 (incl. ill.); McKenzie, pp.22 (ill.), 23.

215 High Street / 7–9 Nicholas Street

Allegorical Female Figure, Commemorative Plaque and Decorative Carving

Sculptor (plaque): William Forrest Salmon

Sculptor (statue): not known

Architects: Salmon, Son & Gillespie
Date: 1895
Materials: red sandstone (figure and carvings); bronze (plaque)
Dimensions: figure over life-size; plaque 61cm × 61cm

Signature: in cursive script on the plaque – W. Forrest Salmon
Inscription: on the plaque – ON / THIS SITE / STOOD THE HOUSE / IN WHICH THE / POET CAMPBELL / LIVED / BORN 1777 / DIED 1844
Listed status: category B (20 March 1977)
Owner: Robert Bell

Description: The allegorical figure is at the apex of the crow-stepped gable and stands on a two-stage pedestal buttressed by a pair of detached volutes. The pose is one of supplication, with hands clasped and face upturned, but there are no attributes to suggest a specific allegorical meaning. She is dressed in an elaborate robe reminiscent of a classical chiton, which is fastened at the shoulder and falls in deep folds to her feet. Directly above the entrance is an oculus decorated with fruit garlands, a pair of foliated roundels, a small blind cartouche and a naked amorino crawling out from beneath the keystone. A small amount of floral relief work appears on the underside of the oriel window above. Six further naked amorini are carved in a variety of poses on the voussoirs of the large arched window on the ground storey, and on the extreme left, above a fluted pilaster, there is a square escutcheon. The bronze plaque is located on the side wall on Nicholas Street, and shows a street scene with figures, including the building which previously occupied the site. This was the residence of the poet Thomas Campbell, and is depicted as a two-storey end terrace house with crow-stepped gables, typical of early nineteenth-century buildings on the High Street.

Discussion: The building was designed as a bank for the British Linen Company, and is one of several elegant *fin de siècle* premises

Anon., *Allegorical Female Figure* [RM]

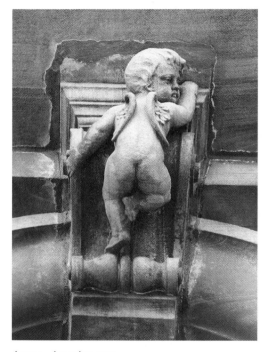

Anon., *Amorino* [RM]

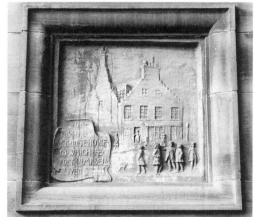

William Forrest Salmon, *Commemorative Plaque*

commissioned by them in Glasgow. McKean *et al.* attribute the design to William Forrest Salmon, but according to Glendinning *et al.* he ceased designing *c.*1892.[1] Williamson *et. al.* give the date of the building as 1905.[2]

 Related work: Monument to Thomas

Campbell, George Square.
 Condition: Good.

Notes
[1] McKean *et al.*, p.27; Glendinning *et al.*, p.593.
[2] Williamson *et al.*, p.181.

Other sources
GCA, TD 1309 A:51; B, 9 July 1898, p.28; ET, 6 October 1984, 19 July 1986; Teggin *et al.*, pp.20–1 (ills); McKenzie, pp.18 (ill.) 19.

Hillhead Street GILMOREHILL

At the entrance to the Hunterian Art Gallery

Diagram of an Object
Sculptor: Dhruva Mistry

Founder: Arch Bronze Foundry
Date of unveiling: 23 April 1990
Materials: bronze on a concrete base
Dimensions: 2.4m × 1.2m × 1.2m
Inscription: on a plaque on the upper surface of the base – DHRUVA MISTRY / Indian: born 1957 / DIAGRAM OF AN OBJECT / 1990 / Bronze / A Glasgow 1990 Commission / by the Hunterian Art Gallery, University of Glasgow, / with support from Glasgow District Council's Festival Budget. / Unveiled by the Lord Provost, Mrs Susan Baird, 23 April 1990
Listed status: not listed
Owner: University of Glasgow

Description: The sculpture is a semi-abstract representation of a seated mother and child, whose tube-like limbs form a structural arrangement reminiscent of a chair. Conceived as a permanent 'landmark' to draw attention to the entrance to the Hunterian Art Gallery, the work sits directly on a triangular concrete base at the top of a short flight of steps leading to the gallery door. There is no plinth.

Discussion: The work was commissioned by the Hunterian Art Gallery as a contribution to the 1990 celebration of Glasgow as European City of Culture. Within the Festivals Office itself, there was a strong belief that a number of visual arts projects for the year might be conceived as commissions, and as the Hunterian had made several unsuccesful attempts to acquire a piece by Mistry in the past, the Festival provided an opportunity for this ambition to be realised. The resulting sculpture was intended to fulfil the

 … threefold purposes of (a) being a major work by an artist desirable to include in the University's collection (b) contribute to the amenity of a public space in the University's precincts where it could be available to all and (c) serve to 'landmark' the building in a way which signalled the home of the University's art collections.[1]

 In its initial discussions with the artist, the Gallery considered siting the sculpture on the roof 'to provide a clearly visible symbol for the building on the skyline'.[2] However, the sculptor's interests at this time 'did not lend themselves to such a location, and a ground-level site was chosen' instead.[3] The preparation of the site required the removal of a small tree and an area of planting.

 The contract with the artist was approved in

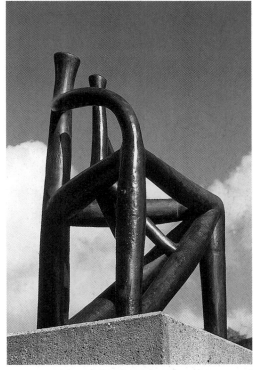

Dhruva Mistry, *Diagram of an Object*

October 1989, and work on the full-size plaster model, made *in situ* at the foundry in Putney, was begun in November. The component parts were cast, assembled welded, chased and patinated in the remarkably short period of five months.[4] The total cost of the commission was

£17,255, with the main items of expenditure allocated as follows: artist's fee, £7,000; cost of casting, £7,000; commissioning fee (Nigel Greenwood), £700; preparation of base, £500.[5] The Glasgow District Council's Festivals Budget contributed 43 per cent of the costs.

Stylistically, the work was something of a departure for Mistry, who derived his inspiration from the mainstream modernist form of the Mother and Child associated with

Henry Moore, combined with a reference to the important collection of chair designs by Charles Rennie Mackintosh in the Gallery. The first piece by Mistry to be acquired by a public or private collection in Scotland, it was unveiled by the Lord Provost of Glasgow, Susan Baird.

Condition: Good. On the artist's advice the artificial patination of the surface was fixed by waxing in 1995.

Notes
[1] Undated letter from C.J. Allan to the Lord Provost. All documents cited here are from Hunterian Art Gallery files. [2] Unpublished attachment to letter from Andrew Guest to Chris Allan, 5 February 1991. [3] *Ibid.* [4] Allan, *op. cit.* [5] Letter from Chris Allan to Dhruva Mistry, 30 August 1989.

Additional source
McKenzie, pp.94 (ill.), 95.

Hope Street CITY CENTRE

Atlantic Chambers, 43–7 Hope Street

Columbia, Britannia and Associated Decorative Carving
Sculptors: McGilvray & Ferris

Architect: John James Burnet
Builder: Alexander Muir & Sons
Date: 1899–1900
Material: red sandstone
Dimensions: figures life-size
Inscription: on tablet above enrance – ATLANTIC
 CHAMBERS
Listed status: category A (15 December 1970)
Owner: Dan-Tan Investments Ltd

Description: Five bays wide and seven storeys high, this steel-frame structure reflects the architect's interest in the vertical elevator buildings of contemporary Chicago, and was noted by the *Building News* as being 'fitted up with all the latest improvements, electric lighting throughout, and an electric passenger elevator from street-floor to top'.[1] The sculpture is similarly transatlantic in its references, with allegorical figures of *Columbia* (carrying a shield decorated with stars and

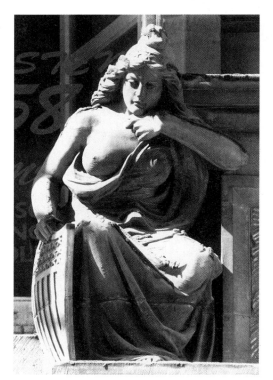

McGilvray & Ferris, *Columbia*

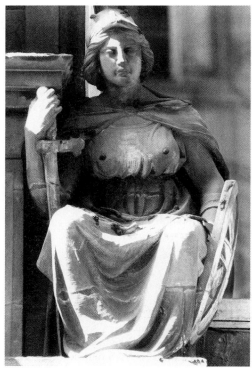

McGilvray & Ferris, *Britannia*

stripes) and *Britannia* seated on the cornice in front of the first-floor windows flanking the central bay. The aedicule above them has a relief panel showing a ship in full sail, above which a smaller winged female figure, armoured with a shield and winged helmet, is shown rising through a segmental pediment. The lettering on the inscription panel above the entrance (see above) is carved in relief against a pattern of stylised waves.

Discussion: A published perspective drawing of the building shows a number differences from the sculpture programme as carried out, including a third allegorical figure in the decorated niche in the centre of the top storey.[2]

Condition: Only partly occupied, the building is poorly maintained, but the sculpture and carver work is in fair condition.

Notes
[1] BN, 2 February 1900, p.159. [2] AA, 1899¹, p.114.

Other sources
GAPC, 11 July 1899, n.p.; AA, 1899¹, p.104; Gomme and Walker, pp.199 (ill.), 203–4; Young and Doak, no.125 (incl. ills); McKean *et al.*, p.108 (incl. ills); Williamson *et al.*, p.227; McKenzie, pp.70 (ill.), 71.

Former Glasgow Evening News Building, 67 Hope Street

Two Seated Female Figures and Associated Decorative Carving
Sculptor: not known

Architect: Robert Thomson
Date: 1899–1900
Material: red Locharbriggs (or possibly Corncockle) sandstone
Dimensions: female figures slightly larger than life-size; amorini approx. 1.2m
Listed status: category B (22 March 1977)
Owner: Dan-Tan Investments Ltd

Description: The central storeys of this tall, narrow façade are articulated by two slender sets of canted oriel windows enclosed within

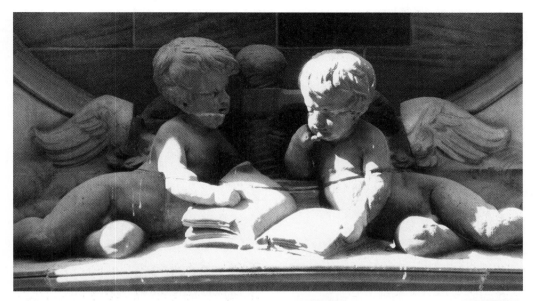

(above) Anon., *Amorini*

(right) Anon., *Seated Female Figure*

arched recesses. In the attic storey, however, the vertical rhythm gives way to a more spacious triplet arrangement, culminating in a corbie-stepped gable framed by slender octagonal turrets. The change of accent is underlined by the placement of a pair of seated female figures with blind shields on projecting platforms at the base of the turrets. Their excessive height makes it difficult to read their details from ground level, but their poses appear to be exact mirror images of each other. They have no allegorical attributes. Closer to the pavement, in the arched recess above the right hand entrance, a pair of amorini leaf through a large tome, with a printing press behind them and a pair of owls on either side. (The corresponding arch over the left hand entrance also contains a carved feature, but this is concealed by a temporary screen.) Minor carved details include a number of vividly snarling lion masks in the consoles

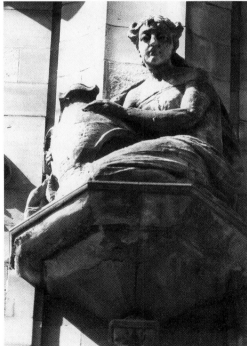

supporting the second and fifth floors, in the keystones of the adjacent arches and in the keystone of the arched window in the top storey.

Discussion: A photograph published not long after the building was completed shows that the gable and the side turrets were originally capped by winged griffins.[1] The highly conventional style of these features, and of the sculpture which has survived, seems curiously at odds with a contemporary observation that the building was not an 'exposition of any particular style' of architecture, but an 'attempt to apply the principles ruling them all to the new conditions of this class of building'.[2]

Condition: The building is largely unoccupied, and is in a very grimy state. There is some wear on the putti, particularly at the joins in the stone, and the seated figures have suffered general surface erosion.

Notes
[1] BJ, 28 November 1906, p.272. [2] GAPC, 7 November 1899, n.p.

Other sources
McKean *et al.*, p.109, (incl. ill.); Williamson *et al.*, p.227; McKenzie, pp.70 (ill.), 71.

Former Scottish Temperance League Building, 106–8 Hope Street

Statues of Faith, Fortitude and Temperance, Relief Medallions, Putti and Masks

Sculptor: Richard Ferris

Architects: Salmon, Son & Gillespie
Builders: Thaw & Campbell
Date: 1893–4
Material: red Dumfriesshire sandstone
Dimensions: figures approx. 2m high; medallions 1.42m high
Inscriptions: see below
Listed status: category A (15 December 1970)
Owner: Scottish Mutual Assurance plc

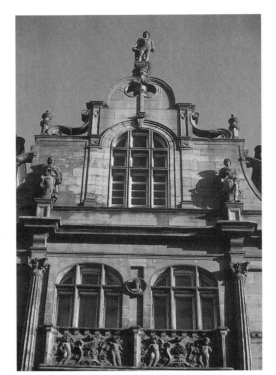

Richard Ferris, *Figures* and *Reliefs*

Description: Despite its overall appearance of verticality, this five-storey building in the Flemish Renaissance style is in fact divided into three distinct horizontal compartments, each of which creates subtly different opportunities for sculptural embellishment. Flanking the central oriel window at first-floor level is a pair of large oval medallions filled with crouching female figures. These are shown holding discs inscribed with dates ('1844' (left) and '1894') marking the first fifty years of the Scottish Temperence League's campaign against alcohol abuse.[1] There are cherub masks in the keystones of the arches of the coupled ground-floor windows, and a male mask in the first bay on Renfield Lane.

The middle section is separated from the lower storeys by a balustrade which runs across the entire width of the building, its horizontal accent balanced by the pairs of slender, baluster-like Corinthian pilasters which rise from it to span the two central storeys. Between them, in the absolute centre of the façade, is a pair of rectangular relief panels with shields bearing a lion rampant (left) and a Glasgow coat of arms, each flanked by winged putti holding swags. In the space between the central windows on the fourth storey is a roundel with a protruding female head and the inscription 'PRUD / ENTIA'. There are further cherub masks in the decorative bands in the pilasters and between the third-floor windows.

The upper part of the building takes the form of a two-stage Flemish gable, elegantly framed by pairs of curvaceous flying buttresses, delicate finials and open scrolls. Positioned in front of the gable wall are two full-length allegorical statues holding large shields decorated with emblems appropriate to their symbolic roles: on the left, a male figure of *Fortitude* (vase); on the opposite side, a female *Faith* (torch).[2] At the pinnacle of the entire building is *Temperance*, a free-standing male figure holding an open book, and with a bronze fitment in the left hand which suggests it originally held an object which has since been lost. All three figures have substantial masses of drapery falling in elaborate folds from their shoulders.

Discussion: It has been argued that in carving the figures Ferris was following models designed by one of the professional sculptors known to have been associated with the Salmon practice, such as Johan Keller or Francis Derwent Wood.[3] A photograph of the model for one of the central panels, reproduced in the *British Architect* is, however, credited to Ferris alone, and it seems safe to assume that the programme as a whole is entirely his own work.[4] If so, it is a relatively early commission for Ferris, and despite the view of one critic that

the 'sculptured work is … very good and effective'[5] the standard of the carving is not especially high.

Condition: Good.

Notes

[1] A particular target of the League's campaign in the 1840s was the leader of the Church of Scotland, Norman Macleod (q.v., Cathedral Square Gardens), who described alcoholic drinks as 'one of the mercies of the Creator'. See Smout, p.141. [2] GAPC, 15 August 1899, n.p. [3] Christopher Bowes, 'John Gaff Gillespie and the Lion Chambers', G.S.A. dissertation, 1989, p.8. [4] BA, 4 December 1896, p.397. [5] *Ibid.*, p.399.

Other sources

B, 17 June 1893, p.475, 9 July 1898, p.24; BN, 21 September 1894, p.391 (incl. ill.); AA, 1894, p.100 (ill.); Young and Doak, no.120 (incl. ill.); Williamson *et al.*, p.227; McKean *et al.*, p.109; Glendinning *et al.*, p.593; McKenzie, pp.72, 73 (ill.).

Former Liverpool, London and Globe Insurance Building, 112–18 Hope Street / 121–3 St Vincent Street

Allegorical Statue, Figurative Reliefs and Associated Decorative Carving

Sculptor: James Young (attrib.)

Architect: James Thomson
Builders: B. & W. Anderson
Date: 1899–1901
Material: red Locharbriggs freestone
Dimensions: figures larger than life-size
Inscriptions: in gilded relief letters above the entrances on both façades – LIVERPOOL & LONDON & GLOBE INSURANCE BUILDINGS (see also below)
Listed status: category B (21 July 1988)
Owner: not known

James Young (attrib.), *Allegorical Figures and Decorative Carving*

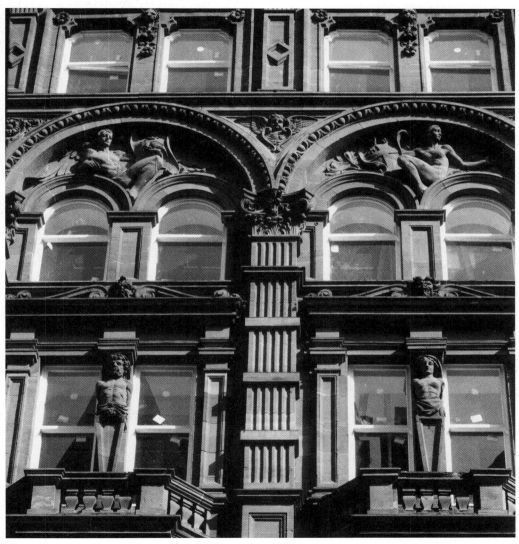

Description: The scale and grandeur of this seven-storey extravaganza in the Franco-Flemish style typifies the approach of the many financial institutions competing for dominance in *fin de siècle* Glasgow, and like many of James Thomson's buildings, provides a rich variety of opportunities for sculptural embellishment. At the apex of the central gable is an aedicule occupied by a full-length female figure, the only free-standing statue on the entire building. This differs from most of the carver work elsewhere on the façade in its tendency towards idealisation, with the demure grace of the posture – one hand on her breast, the other

extending a long tress of hair – possibly intended as an evocation of Prudence, or some other generalised virtue associated with the insurance industry. The figure is flanked on either side by male terms, while beyond them, acting as finials to the stage below, are a lion and a unicorn, both carved in the round. A more precisely focused symbolic programme is developed in the series of full-size reclining figures which fill the lunettes of the fourth-storey arches, and which function as a rebus based on the company's name. These are, from the left: a winged male holding a shield decorated with a liver bird (signifying Liverpool); a female blowing a trumpet and holding a shield inscribed with a St George's cross and a small unsheathed sword (London); a male figure holding a globe; a naked woman holding a ribbon inscribed 'INSURANCE'.

Other significant carver work on this frontage includes: a series of male and female terms in the divisions between the third-floor windows in the outer bays, with grotesque masks framed by flattened volutes on the cornices above; various miniature decorative features such as a liver bird, a winged globe and a sequence of human masks in the sill panels of the second-floor windows; grotesque masks with margents suspended from their mouths between the fifth-floor windows in the outer bays; a pair of corbel griffins on the small arched windows at first-floor level adjacent to the north-west corner; a number of small masks, animal and human, distributed variously on the corbels, lintels and keystones of the windows on the two corner turrets. One of these – located on the fourth floor of the north-west corner – is a portrait of the architect.[1]

The St Vincent Street frontage is shorter than Hope Street, and has only one large lunette relief, in this case filled with a pair of naked putti holding a ribbon inscribed 'L & L & G'. The remainder of the decorative work is on the same pattern as Hope Street, with the exception of the main entrance, which is slightly more

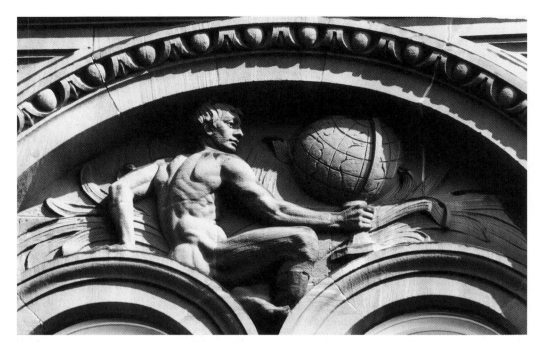

James Young (attrib.), *Allegorical Figure*

monumental. This has a pair of small curvilinear pediments above the door, each filled with heraldic devices relevant to the company's name. On the left there are two shields decorated with a liver bird and a St George's cross, again with a tiny sword in the top left division. On the right, a pair of liver birds frame a winged globe, with a small '+' inscribed on the wing. The capitals of the columns framing the entrance have small but vividly carved lion and griffin heads protruding from the foliage.

Discussion: The attribution of the sculpture to James Young is based on its stylistic resemblance to his contemporary work on Connal's Building (q.v., 334–8 West George Street), particularly the inclusion of a miniature portrait of James Thomson.

Related work: The Pearl Assurance Building, 133–7 West George Street, also has a portrait of Thomson.

Condition: In 1999 the building underwent a comprehensive redevelopment which included

the demolition and rebuilding of the interior structure and the restoration of the exterior stonework. Apart from some minor wear and damage the condition of the sculpture is good.

Note
[1] For a discussion of this detail, and confirmation of Thomson's likeness, see Cambridge Buildings, 8–12 Cambridge Street.

Other sources
GAPC, 17 January, 30 May 1899, n.p.; BI, 15 June 1899, p.45, 16 May 1901, p.29; Nisbet, 'City of Sculpture'; McKean *et al.*, p.131 (ill.); Williamson *et al.*, p.235; Teggin *et al.*, p.48 (ills); McKenzie, pp.72, 73 (ill.).

Lion Chambers, 170–2 Hope Street

Busts of Judges, Armorial Shield and Associated Ornaments
Sculptor: not known

Architects: Salmon, Son & Gillespie
Builders: Yorkshire Hennebique Constructing
 Co., Ltd
Date: 1905–7
Material: concrete
Listed status: category A (6 July 1966)
Owner: Rabvend Ltd and other commercial
 organisations

Description: The building occupies a narrow site on the corner of Hope Street and Bath Lane, and rises through eight storeys to a height of 34m. The design is characterised by the relative plainness of its rendered surfaces, the elegant abstract simplicity of its main forms and the use of cantilevered projections at first-, fourth- and fifth-storey levels to increase the interior floorspace as the building ascends. Sculpture is kept to a minimum, but plays an important role in articulating several key points of the design. The decorative programme consists of the following: a large heraldic shield in low relief on the recessed wall, midway between the first and second floors; a pair of busts of judges projecting from the squinches marking the transition from the right hand block of oriel windows to the plainer wall above; a medallion in the centre of the string course stretching between them.
Discussion: Commissioned by William G. Black, a solicitor and lay member of the Glasgow Art Club, the building was designed to incorporate a firm of stationers and printers in the ground floor and basement, a suite of law chambers in the middle storeys and a group of studios for 'artist painters' in the attic.[1] The busts of judges are portraits of Lord Provost Sir John Ure Primrose, Bart., and Sheriff Guthrie.[2]

The construction of Lion Chambers was a landmark in the history of Glasgow architecture, as it was the first block in the city to be built using the Hennebique system of 'ferro-concrete', in which iron columns and beams are dispensed with in favour of a skeletal concrete frame reinforced with steel rods. The use of this process caused considerable excitement in Glasgow, and the during the months it was being erected it was

> … one of the sights of Glasgow; for wet or dry, gloom or shine, it always had at least three or four arrested spectators, staring up at it from over the way, these spectators largely made up of members of the building industries.[3]

The use of this process was also relevant to the treatment of sculpture, as is clear from a description by W.N. Twelvetrees:

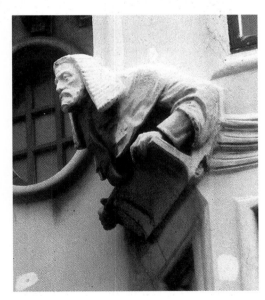

Anon., *Portrait of a Judge* [GN]

Ornamental cornices and mouldings were formed *in situ*, and finished by the plasterer to the exact architectural lines required. Other enrichments, such as medallions, keystones and figures were cast in advance in strong plaster moulds. When casting these the necessary reinforcement was incorporated with the concrete to enable the details to be effectively secured and tied to the same structure.[4]

It is assumed that the 'plasterers' referred to here were craftsmen employed by the Hennebique company, working from designs prepared by the architect. Whether the main creative personality behind the design was James Salmon Junior or James Gaff Gillespie is a matter of speculation. The architect Jack Coia claimed that the building was undoubtedly designed by Gillespie, with whom he studied from 1916. Others have argued that Salmon's well-documented interest in architectural sculpture suggests that the work is his.[5]
Condition: In March 1995 the building was declared dangerous after a number of pieces of the concrete rendering came loose and fell onto Hope Street. A report was prepared by the Glasgow Buildings Preservation Trust, and the building is currently awaiting restoration.

Notes
[1] BJ, 28 November 1906, p.272. [2] Anon., 'Buildings Having Sculptured Representations of Glasgow Men at the Time of Building', GH, 18 July 1923, p.8. [3] BI, 16 April 1906, p.2. See also pp.1, 9 (ill.). [4] W.N. Twelvetrees, '"Lion Chambers," Hope Street, Glasgow. Some Interesting Constructive Details', BI, 15 July 1907, p.53. [5] Bowes, pp.25–36 (incl. ills).

Other sources
BI, 16 August 1907, pp.72–3 (incl. ill.); BJ, 28 November 1906, p.272; AA, 1907, p.55 (incl. ill.); GH, 28 April 1924; Gomme and Walker, p.224 (incl. ill.); Young and Doak, no.160 (incl. ill.); McKean *et al.*, p.110 (incl. ill.); Williamson *et al.*, p.228; GH, 22 May 1995; McKenzie, pp.76, 77 (ill.).

Hospital Street GORBALS

On the railway viaduct, between Cleland Street and Cumberland Gardens

History of Scottish Theatre
Sculptor: Jack Sloan

Fabricator: Hector McGarva
Date: 1995–8
Material: galvanised steel
Dimensions: approx. 2.6m × 3.6m (average size)
Inscriptions: on plaques below each relief –
HISTORY / OF / SCOTTISH / THEATRE,
 followed by names of plays and their authors
 as detailed below
Listed status: not listed
Owner: Crown Street Regeneration Project

Description: The work consists of nine abstract/figurative reliefs mounted on the brick in-fill walls of the nineteenth-century viaduct's stone arches. The series plots the development of Scottish theatre by illustrating scenes from a series of plays regarded as landmarks in the history of Scottish drama. The relevant *dramatis personae* are glimpsed in each case though a grille-like structure embedded in a rythmic pattern of abstract curlicues reminiscent of the opulence of Rococo theatre

Jack Sloan, *History of Scottish Theatre* (detail)

interiors, and with the brick arches suggesting prosceniums. From the left the plays are as follows, with notes provided by the sculptor:

1. *Ane Satyre of the Thrie Estaitis*, by David Lindsay (1490–1555). A political morality play which combines elements of medieval Mystery plays with Renaissance drama, and concerns the tensions within the individual and the state. First performed in Linlithgow in 1540, it was revived several times during the twentieth century.

2. *The Gentle Shepherd*, by Allan Ramsay (1684–1758). A pastoral drama concerned with the lives and loves of shepherds and shepherdesses. The shepherd of the title turns out to be of 'gentle' birth, i.e., a gentleman living the life of a lowly shepherd. First staged in the 1720s it was a key document of the Scottish Enlightenment, and was perfomed more than 160 times between 1780 and 1820.

3. *The Douglas*, by John Home (1722–1808). A sentimental drama of a Highlander who, brought up as a shepherd, saves by chance his unknown step-father's life. As a result he is reunited with his mother and regains his true social position. Machinations of a villain bring about the death of the hero and the suicide of his mother. Caused a sensation when first performed in Edinburgh in 1756 and went on to be translated into French and Italian.

4. *De Montford*, by Joanna Baillie (1762–1851). One of her 'Plays of the Passions', this Gothic melodrama explored the passion of hatred. It was the most successful of her works for stage, providing roles for some of the most famous actors of her time.

5. *Peter Pan*, by J.M. Barrie (1860–1951). Although a play essentially for children, it shows a concern for the deeper aspects of dreams and fantasy that characterise Barrie's

later work. First presented in 1904, it is still being successfully produced today.

6. *Tobias and the Angel*, by James Bridie (1888–1951). Based on material from the Apocrypha, this play demonstrates Bridie's insistence on the dangers of illusion and pretension.

7. *In Time of Strife*, by Joe Corrie (1894–1968). This play explores the terrible hardships which striking imposed on mining families.

8. *The Carlin Moth*, by Robert McLennan (1907–84). Written in Scots, the play is concerned with the love of a young man for a carlin (witch) who tries to lure him to his death.

9. *The Cheviot, the Stag and the Black, Black Oil*, by John McGrath (b.1939). This explored the analogies between the rise of the oil industry and the Highland Clearances and the historic tradition of absentee landlordism in Scotland. First performed by the 7:84 Company, it went on to tour successfully and was later filmed for television.

Discussion: This is the most ambitious work to have been produced so far under the aegis of the Crown Street Regeneration Project, and was commissioned as part of a long-term refurbishment of the viaduct by the Glasgow Development Agency, who plan eventually to build an upper level railway station to serve the Citizens' Theatre (q.v., Gorbals Street). (It was, in fact, the proximity of the Theatre that provided the theme.) Work on the commission was begun in 1995, but the financial problems and eventual bankruptcy of the original fabricators led to a delay in its completion.
Condition: Good.

Sources
Unpublished artist's notes provided by Turner & Townsend, Project Management; McKenzie, pp.28, 29 (ill.).

Hunter Street CALTON

Tenement building, 202–4 Hunter Street

Trophy of Agricultural Implements and Produce

Sculptor: not known

Architect: John Gordon
Date: *c*.1902
Material: red Locharbriggs sandstone
Dimensions: approx. 7m × 1.8m
Inscriptions: above first-floor bay windows –
 1902 ; JAM (both entwined)
Listed status: category B (19 November 1992)
Owner: Bass Leisure Retail(?)

Description: Perhaps the largest, and certainly the most unusual relief of its kind in Glasgow, the trophy occupies the entire area between the windows on the first and second floors of the building, which was erected by the seed merchants J. & A. McArthur as a tenement adjoining their store. Its contents include an escutcheon bearing a wheatsheaf, a rake, a scythe, a bulging sack, a sickle, a malting shovel, a pitchfork(?) and a sieve, all garlanded together, suspended from a lion's mouth by a ribbon and adorned with thistles, oak leaves and potatoes. Additional decorative details include keystones above the two entrances carved with a caduceus (left) and a trident entwined with a dolphin.
 Condition: The building was recently cleaned and the relief is in good condition.

Sources
GCA, B/12/1/8247; Nisbet, 'City of Sculpture'; Williamson *et al.*, p.461.

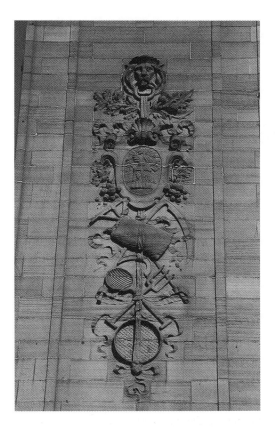

Anon., *Agricultural Trophy* [RM]

Ingram Street MERCHANT CITY

Hutchesons' Hall (Glasgow and West of Scotland Headquarters of the National Trust for Scotland), 158 Ingram Street / 2–4 John Street

Statues of George and Thomas Hutcheson

Sculptor: James Colquhoun

Architect: David Hamilton
Builder: Kenneth Mathieson
Dates: *c*.1649 (statues); 1802–5 (building)
Material: yellow freestone
Dimensions: approx. 1.68m high (statues);
 approx. 90cm high (pedestals)
Inscriptions: on the pedestals – GEORGE HUTCHESON / DIED 1693. [*sic*]; THOMAS HUTCHESON / DIED 1641.; on the frieze – FOUNDED BY GEORGE HUTCHESON & THOMAS HUTCHESON OF LAMBHILL, 1639 & 1641. – REBUILT, 1805; in a panel in the centre of the attic – HOSPITAL. All inscriptions in raised, gilded letters
Listed status: category A (6 November 1966)
Owner: National Trust for Scotland

Description: The style of the building has been described as an 'idiosyncratic … mixture of French Neo-classicism and the English Baroque of Wren and Gibbs',[1] and comprises a channelled ashlar basement, a *piano nobile* recessed behind a giant Corinthian order and central clock-tower terminated by a fluted conical spire. The statues are in plain apsidal niches sunk into the walls between the pilasters at either end of the Ingram Street frontage. Depicted in contemporary dress, and 'to their full bigness',[2] the subjects are posed in the manner reminiscent of classical *contrapposto*, with the weight of the body borne by one leg only, and the head and torso turned in the direction of the outstretched free leg. This arrangement, together with their symmetrical placement, allows both statues to face marginally towards the centre of the building.
 On the left is *George Hutcheson*

(c.1555–1639), eldest son on Thomas Huchesone (died c.1595) and Helen Herbertsone. He was a landowner, notary and money-lender, and one of 'Glasgow's greatest benefactors'.[3] The founder of Hutchesons' Hospital, a charitable institution for the relief of up to twelve 'poor, aiget, decreppit men',[4] he died two years before the construction of the building was begun, leaving his brother Thomas to implement the terms of his bequest. He is shown here dressed in a doublet, knee-breeches, shoes and stockings, a falling ruff, an indoor cap trimmed with lace and long gown of the type worn at this time by professionals and officials. He holds a money-bag in his right hand, and an engraving published in 1838 suggests that he originally held a scroll in his left hand.[5]

Thomas Hutcheson (c.1590–1641), youngest brother of George, and also a notary, he studied at the University of Glasgow, graduating in 1610. He laid the foundation stone of the new hospital on 19 March 1641, extending the scope of the establishment to include a 'publick School, where the twelve boys that are on the foundation are taught gratis'.[6] He died before the completion of the building in 1650 (see below). In this statue he is shown wearing a doublet, pantaloons trimmed with ribbons, boots, a cap and a demi-gown. He holds a book in his left hand.

It should be noted that the date of George Hutcheson's death is given incorrectly on the pedestal as 1693. The misalignment of the last two digits suggests that they may have been replaced after becoming detached at some point, the restorer inadvertently reversing the numbers. (For a discussion of the reliability of the inscriptions in more general terms, see below).

Minor carved details elsewhere on the building include swags on the 'hatbox' motifs in the attic and on the globe supporting the weathervane on the spire (gilded), and a sculpted shield supported by acanthus volutes in the centre of the attic.

Discussion: The statues pre-date the present building by over 150 years, and were made originally for the garden front of Hutchesons' Hospital, which stood on the Trongate, at the south end of what is now Hutcheson Street. The building was a long two-storey structure in the Scots Renaissance style, with dormer windows and an elaborate rusticated entrance arch connecting the street frontage to a five-stage square tower attached to the rear. McUre describes the statues as being 'in two different Niches, on each side of the Steeple',[7] and this is confirmed by early engravings which show two round-headed recesses above the arched opening in the tower.[8] The north face of the tower also carried a stone tablet inscribed with a Latin eulogy, translated by a prize-winning Humanities student at Glasgow University in 1850 as:

> Behold the Brothers Hutcheson! Who came / Heaven-sent, the Wretched and Poor to Bless. / This Home they Built – Memorial of their Name – / A Resting-Place of Sorrow and Distress. / For when no Offspring blest their lot below, / And boundless Store of golden Wealth was theirs, / Nobly they chose the Sons of Want and Woe – / Old Men and helpless Orphans – for their Heirs.[9]

Hill describes the tablet somewhat ambiguously as being located 'below and apparently between the statues',[10] but it is difficult to reconcile this with the evidence of the engravings, which show two small rectangular panels below the niches. The tablet itself has been lost.

The statues were commissioned shortly after the death of the two brothers, but the precise details of when they were made and installed remain unclear. Contemporary Hospital documents record the purchase of two blocks of stone from 'Londoune' in November 1643, at a cost of £99, Scots money. On 14 April 1649, there is also a record of a fee of £66 13s. 4d. being paid to James Colquhoun 'in part

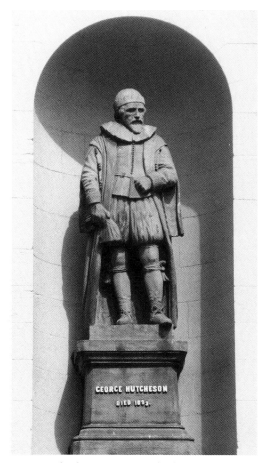

James Colquhoun, *George Hutcheson* [RM]

payment of cutting umq[l] George and Mr. Thomas Hutcheson's yair portraitors'.[11] The situation is complicated, however, by evidence of further payments made in November 1655 and August 1656, for the 'hewing, forming, and putting up of Mr. *Thomas* Hutcheson's portraiture in the hospital', and another in September 1659, for 'for perfyting and upsetting of umq[ll] Mr. *Thomas* Hutcheson his picture'.[12] Whether this extended time-scale

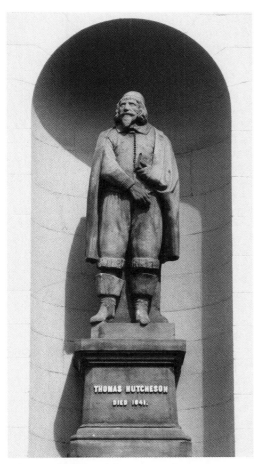

James Colquhoun, *Thomas Hutcheson* [RM]

reflects a delay in the making of the work, or in the settlement of the sculptor's fee cannot be determined on the evidence currently available.

Almost immediately after the death of the brothers, the Hospital patrons began acquiring land to the north of the garden, eventually extending their property as far as Ingram Street. With the gradual expansion westwards of the town itself, and the consequent increase in the value of property adjacent to Glasgow Cross, it

became more profitable to rent the Trongate premises to shopkeepers and warehousemen, and by the late eighteenth century the building had all but ceased to perform its original function as a hospital and school. In 1795, the building was demolished and the land to the north feud for development. A plot of ground on Ingram Street was bought for £1,450, and in 1802 David Hamilton was commissioned to design a new Hospital, incorporating a meeting hall for the patrons and other charitable organisations. This was completed in 1805, at a cost of £5,201 5s. 1d.,[13] and stands at the head of the street named after the Hospital's original benefactors. Meanwhile, their statues had been removed from the Trongate building at a cost of £2 3s. 6d. and placed in store in the Merchants' House on the Bridgegate. In the Hospital accounts there are records of payments to W. Reid, an architect and marble worker from King Street, Tradeston, for 'work about the old Statues', the first in 1805 for £14 11s., the second in March of the following year for an unspecified sum.[14] The nature of Reid's work is not stated, but he may have been commissioned to make the pedestals in preparation for their installation on the new building.[15] It appears, however, that the statues remained in the Merchants' House until 1817, when that building was sold, and were not placed in their niches until 1824. The cost of the installation was £26, which may have included the construction of the niches themselves.[16] The reasons for the delay are a matter of speculation. It is clear from Hamilton's design that he intended to incorporate statues on the main façade,[17] though it should be noted that the figures he indicates are very different in their posture, dress and scale from the portraits of the Hutcheson brothers.

Three further issues remain to be discussed. Firstly, the statues were for many years believed to have been made from marble. The confusion can be traced back to the Hospital's acquisition of the stone, as explained by Hill:

In the Accounts of 13th November 1643, there is entered for 'two marble stones qt was brot from Londonne £99' Scots money, the letter underscored being written more like an 'n' than a 'u'. The material, however, of the statues has been ascertained to be fine freestone, of a description, irrespective of the price, which leads strongly to the inference that the place whence the blocks came was Loudon [or Loudoun], in Ayrshire, and not the English metropolis, where sculptural marble would probably, at that time, have required to be purchased.[18]

It has also been pointed out that the mistake may have arisen from the fact that the word 'marmor', the Latin for marble, was also used in Scotland for a form of hard native sandstone, and that when the statues were 'scraped' in the early twentieth century, this was confirmed as the material from which they are made.[19] Secondly, there is evidence to suggest that the statues were originally painted. Among the transactions noted by Hill in his examination of the Hospital Minutes is a payment in April 1673, of £7 6s. 8d. made to 'twa pynters for grinding and laying on ye cullor on ye portrates'.[20] It seems plausible to suggest that the 'work about the old Statues' carried out by Reid in 1805 included the removal of the paint in anticipation of their being placed on Hamilton's new façade, where polychrome statues would have appeared both stylistically incongruous and, in a post-Winckelmann era, anachronistic.

Thirdly, and most importantly, there is reason to believe that the inscriptions on the pedestals are incorrect. The fact that the figures were carved posthumously, and that the subjects are represented in a way that does not reflect the disparity in their ages, strongly suggests that Colquhoun worked from existing portraits in creating their likenesses. No painted images of them have survived, but engraved copies of a portrait of Thomas attributed to Van

Dyck, and of his brother by George Scougall provide a reliable basis for comparison.[21] While an examination of their facial features provides almost no relevant information, the treatment of their hair and beards reveals an interesting pattern of similarities. In the engraving after Van Dyck, Thomas is shown with a bald cranium, a full but neatly trimmed beard and a moustache brushed down over his mouth. This description closely matches the head of *George* in the statue. By contrast, in the engraved version George has a full head of hair, a long goatee beard without side whiskers and a flamboyantly upturned moustache, all of which, with only minor differences, correspond to the treatment of the head on the statue of Thomas. Given that the statues were in store for nearly thirty years, and that the pedestals with their inscriptions were probably made during this interim period, the supposition that the brothers have been wrongly identified seems reasonable. On balance, and bearing in mind also the fact that the inscription on the pedestal nominally assigned to George already contains an error in the date (see above), the conclusion must be drawn that the identities of the two brothers have been accidentally reversed in the inscriptions.

Related work: Interior work includes a pair of bronze portrait busts of the brothers, dated 1912 by Archibald Macfarlane Shannan, flanking the entrance to the Great Hall. These were acquired from Hutchesons' Grammar School, and are probably the works exhibited by Shannan at the RGIFA in the following year (nos 1 and 7).[22] Unlike the exterior statues, these portraits are correctly identified by their inscriptions. Further portraits of the brothers appear in the plaster cornice of the Great Hall. There is also a relief panel of three elderly men, 'clothed in their grey cloaks, in which they had to attend divine worship twice a day in the Tron Kirk',[23] in the Merchants' House, West George Street (q.v.). These are traditionally thought to represent Hospital residents, but are more likely to be merchants.

Condition: The statues are in good condition, but the imagery on the carved shield in the attic is weathered beyond identification.

Notes
[1] Williamson *et al.*, p.168. [2] John McUre, *History of Glasgow*, Glasgow, 1736 and 1830, p.68, quoted in William H. Hill, *History of the Hospital and School in Glasgow Founded by George and Thomas Hutcheson of Lambhill, A. D. 1639–41*, Glasgow, 1881, p.76. [3] James McFarlane, 'Hutchesons' Hospital' (1916), *Old Glasgow Club Transactions*, vol.3, 1913–18, p.200. [4] McUre, quoted in Hill, *op. cit.*, p.40. [5] Dibdin, ill. opp. p.750. [6] McUre, quoted *ibid.*, p.75. [7] Quoted in Tweed (*Glasgow Ancient & Modern*), p.906. [8] *Ibid.*, p.905; Hill, *op. cit.*, p.84. [9] Quoted Tweed, *op. cit.*, p.907. [10] Hill, *op. cit.* p.76. [11] *Ibid.*, p.41. [12] *Ibid.*, p.77. [13] *Ibid.*, p.137. [14] *Ibid.*, p.138. [15] The engravings referred to above (note 8) are not sufficiently detailed for it to be possible say whether or not the statues had pedestals. However, the scale of the niches relative to the adjacent windows suggests they did not. [16] Williamson *et al.*, for example, claim that the niches were made at this time. See p.168. [17] See, for example, drawing in HAG, reproduced in McKean *et al.*, p.73. [18] Hill, p.77. [19] McFarlane, *op. cit.*, p.201. [20] Hill, *op. cit.*, p.77, n.3. [21] *Ibid.*, facing pp.18, 42. [22] Billcliffe, vol.4, p.106. [23] Graham, p.112 (incl. ill.); see also Cowan, p.100 (incl. ill.).

Other sources
Dibdin, pp.749–51; Gomme and Walker, p.81 (incl. ill.); Young and Doak, no.19 (incl. ill.); Jack House, 'Ask Jack', ET, 28 September 1977; Worsdall (1981), p.100; Nisbet, p.521; McKenzie, pp.44 (ill.), 45.

Trustee Savings Bank, 177 Ingram Street / 99 Glassford Street / Virginia Place

St Mungo, Atlantes, Allegorical Figures and Related Decorative Carving

Sculptors: George Frampton (modeller); William Shirreffs (carver)

Architects: Burnet, Son & Campbell
Ironwork manufacturers: Longden & Co.;
 George Adam & Son
Date: 1894–9

Materials: yellow sandstone; bronze (crozier)
Dimensions: *St Mungo* 1.83m high
Inscriptions: see below
Listed status: category A (15 December 1970)
Owner: Trustee Savings Bank Scotland PLC

Description: A Beaux Arts interpretation of the Roman Baroque style, this single-storey, domed banking hall exploits the plasticity of its main structural features to great visual effect, treating sculpture as a genuinely organic extension of the architecture rather than as applied decoration. The chief feature on Ingram Street is the central doorcase, which is composed of a recessed aedicule with Doric and Corinthian columns *in antis*, broken pediments of various sizes and a range of figurative motifs. On the lintel is a small segmental pediment containing a gilded Glasgow coat of arms, which includes an escrol inscribed with the motto 'LET GLASGOW FLOURISH' in raised letters. A tablet below this carries the inscription 'SAVINGS BANK' (also gilded). The coat of arms breaks the upper edge of the pediment to form a smaller triangular pediment, which is in turn broken by a miniature half-length image of *St Mungo*. Above this a larger, full-length statue of *St Mungo*, carved by Frampton himself,[1] rises within an aedicule flanked by twisted columns. The design of *St Mungo*'s crozier is of particular interest, as it combines a bell and a fish from the Glasgow arms, with clusters of leaves in place of conventional crockets.[2] The crozier and the undergarment of *St Mungo*'s cope are both gilded. In the spaces between the aedicule and the scrolls of the main pediment are female figures in low relief engaged in activities associated with industry and agriculture: on the left, spinning with bales of cloth at her feet; on the right, picking fruit from a tree, with sheaves of corn at her feet. The entire upper section of the doorcase is supported by naked atlantes, which crouch in postures powerfully expressive of their weight-bearing role. These are among

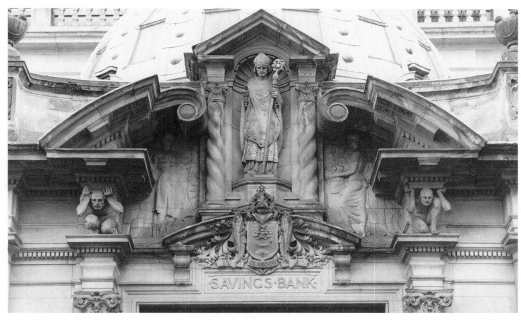

George Frampton, *St Mungo*

George Frampton, *Atlas*

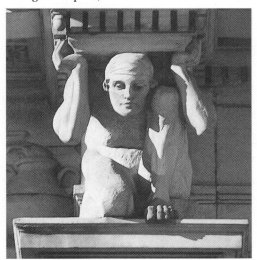

(right hand holding a ship, left resting on a globe, capstan at her feet) and *Industry* (holding a hammer and a governor mechanism, anvil at her feet). They thus relate to the inscription 'Industry' on the cartouche at the east end of the Ingram Street façade. The window on Glassford Street is identical, except for the female figures, which in this case relate to the inscription 'Frugality': one holds a bunch of keys and has a chest at her feet; the other holds a goblet and a vase and has a pitcher at her feet.

At attic level on both corners of the Ingram Street elevation there is a curved relief panel depicting pairs of naked putti. Those at the Glassford Street end are shown with cogs and other machine parts at their feet, and with a Viking ship, its prow carved into the form of a

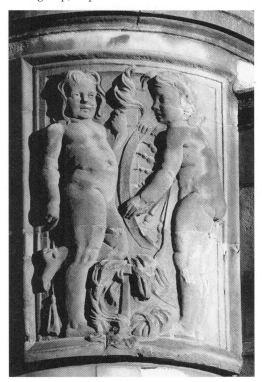

George Frampton, *Putti*

the most distinctive details of the scheme (but see Discussion, below). There are small blind cartouches and urns on the attic flanking the entrance.

The motif of the broken pediment is repeated on the two windows of the Ingram Street façade, each of which contains a cartouche bearing the gilded monogram 'GSB' (entwined), as well as the inscriptions 'INDUSTRY' (east window) and 'FRUGALITY' (west) in gilded relief letters. Other details on this façade include a pair of small blind cartouches and urns on the attic storey adjacent to the central pediment, and two modern TSB logos of painted metal attached to the ashlar wall between the entrance and the windows.

On the Virginia Street façade the window surround repeats the design of the Ingram Street entrance in a simplified form, with crouching atlantes supporting a broken pediment filled with a pair of seated cherubs (in the round) and female figures (in relief). The female figures are emblematic of *Commerce*

Ingram Street 209

griffin, stretching between two smaller panels at either side. Their counterparts on the Virginia Place corner are shown spinning yarn, with a sheet of cloth unfurled in a single side panel on the left.

Extensive use is made of decorative wrought iron, described in 1899 as being 'in harmony with the scheme'.[3] The basement grilles and main gate, which incorporates the gilded monogram 'GSB' in entwined letters and a lock formed into a pair of miniature arched niches, are by Longden & Co. of London, while the stanchions, lamp standards and railings are by the Glasgow firm George Adam & Son.[4] There is also a bronze letterbox, elaborately decorated with oak leaves, and a bell push entwined with mistletoe at the main entrance. The interior plaster work is by Robert McGilvray, and includes several pairs of putti in the broken pediments below the dome.[5]

Discussion: The building was designed by John James Burnet as an extension to the National Savings Bank of Glasgow on Glassford Street, built by his father John Burnet in 1865–6. Financial difficulties struck early in the development of the project, and in June 1895, the *Builders' Journal* reported that there had been

> … a little trouble over the adoption of the plans. Government sanction to expend £18,000 of the surplus funds was obtained, but in going more closely into the plans, the Architects found that a further sum of £8,000 would be required to complete them. The Trustees intend going on with the increased estimate notwithstanding adverse criticisms in certain quarters, and to this end application has again been made to the Government Department to draw upon the surplus funds up to £26,000.[6]

The final cost was about £25,000, with the design confined to a single storey 'in deference to the desire of the National Debt Commissioners'.[7]

There also appears to have been some

Longden & Co., *Letterbox* [RM]

confusion over the identity of the designer. In August 1898, the editor of the *Builder* printed a correction to an article which had appeared in the previous month[8] attributing the design to 'Mr Burnet' alone:

> In reference to our recent article on Glasgow architecture, Mr Burnet [i.e., the younger] asks us to state that the work imputed to him was done by the late firm of Messrs John Burnet, Son & Campbell. The mistake was due to the title on the drawings sent in by Mr Burnet.[9]

It is generally accepted today, however, that the design is exclusively the work of J.J. Burnet, the son of John Burnet, who, as it happens, died in the year in which this erratum appeared. In this connection it is worth noting that a biographical sketch of the younger Burnet published in the *Builders' Journal* in 1901 refers specifically to a number of buildings for which he had been 'solely responsible', even though they were 'nominally associated with his father'.[10] The author then goes on to cite the Savings Bank as an illustration of the fact that his work 'suffers by the artists working under him upon the details of his buildings'.[11] In particular he singled out

> … the crouching figures supporting the pediments and very low bas-relief on the

wall under them … The designs were modelled by Mr. George Frampton A.R.A., but they are weak and out of scale, this doubtless arising from the work not having been modelled and carved on the spot by the designer.[12]

The correspondent of the *Builder* found the atlantes equally unsatisfactory, describing them as 'the only things that do not seem quite happy … they are almost too much doubled up, and yet too small in scale for the work they appear to be doing'.[13] It should be noted, however, that these figures are shown in some detail in Burnet's drawings and must, therefore, correspond very closely to his intentions.[14]

Related work: A drawing of the building by Alexander McGibbon was exhibited at the RA in 1895.[15]

Condition: On Virginia Place the relief figures *Industry* and *Commerce* are badly weathered, and the head of one of the putti is missing. Many other sculpted details are badly affected by moss and surface algae.

Notes
[1] Williamson *et al.*, p.183. [2] For Frampton's comments on this design, see *St Mungo as the Patron of Art and Music*, Kelvingrove Museum, Kelvingrove Park. [3] GAPC, 16 May 1899, n.p. [4] *Ibid.* [5] Anon., 'Savings Bank, Glasgow', BN, 31 January 1896, p.167. [6] Anon., 'North of the Tweed. Notes from Glasgow', BJ, 18 June 1895, p.301. [7] BN, 31 January 1896, p.167. [8] Anon., 'The Architecture of Our Large Provincial Towns. XVI. – Glasgow', B, 9 July 1898, p.24. [9] Anon., 'Glasgow Architecture', B, 13 August 1898, p.153. [10] Anon., 'Men who build. No. 65 – John James Burnet, A.R.S.A.', BJ, 9 October 1901, p.139. [11] *Ibid.* [12] *Ibid.*, pp.138–40. [13] B, 9 July 1898, p.24. [14] GCA, B4/12/1/3388. [15] BJ, 18 June 1895, p.301.

Other sources
GH, 31 May 1957, pp.6–7; Gomme and Walker, pp.202–3 (ills.), 209–10; Read, p. 366; Worsdall (1982), p.51 (ill.), (1988), p.67; Read and Ward-Jackson, 4/11/141–6; Teggin *et al.*, p.23 (ills); McKean *et al.*, pp.74–5 (incl. ill.); Glendinning *et al.*, pp.321–2 (incl. ill.); McKenzie, pp.44–6 (incl. ill.); Jezzard, vol.I, pp.59–60.

178–80 Ingram Street

Sculpture Scheme

Sculptors: Alexander Stoddart and Jack Sloan

Architects: Page & Park
Builder: Henry Boot Ltd
Date: 1994
Material: bronze
Dimensions: capitals and inscription plates
 21cm × 61cm; shutter panels approx. 2.15m ×
 61cm
Inscriptions: see below
Listed status: not listed
Owner: The Bernard Reinhold Trust

Alexander Stoddart and Jack Sloan, *Sculpture Scheme*

Description: The work consists of three elements, each running the length of one of the building's three storeys. On the ground-floor pillars are four bronze 'pilotis' or 'capital-types' by Alexander Stoddart. These contain portrait masks of historical figures associated with architecture in eighteenth-century Glasgow, in particular the 'Merchant City' district in which the building is located. A bronze plate is inserted in the base of each pillar with gilded relief inscriptions identifying the subjects of the portraits, together with their dates and professions. These are, from the left: MUNGO NAISMYTH / 1730 MASON 1770; DAVID HAMILTON / 1768 ARCHITECT 1843; THOMAS CLAYTON / 1710 PLASTERER 1760; ALLAN DREGHORN / 1706 MERCHANT 1764. In their design the capitals make references to the four orders of classical architecture: Doric (Naismyth); Ionic (Hamilton); Corinthian (Clayton); Composite (Dreghorn).

On the first floor is a series of six bronze window surrounds, again by Stoddart, incorporating images in relief of Roman imperial *fasces*, or bundles of rods bound with tape. Those on the sills of the windows are tightly bound, while those on the lintels are in the process of unravelling. The scheme is completed by *Grasp the Thistle*, by Jack Sloan. This consists of six pairs of sliding bronze shutter panels on the upper windows decorated with stylized thistles and large protruding spikes. Mounted on rails, the shutters are designed to close automatically at night.

Discussion: The sculpture programme was conceived as an integral part of the commercial building commissioned by the Reinhold Trust after a fire in 1992 had destroyed the building previously occupying the site. It embodies a complex programme of architectural and historical references, part of the purpose of which is to suggest a dialogue between classical restraint, signified by eighteenth-century architectural practices, and the less disciplined eclecticism that typifies much modern design.

Alexander Stoddart, *Portrait Capital (David Hamilton)* [RM]

The images of bound and unbound rods on the central windows thus serve to 'mediate' between the historicism of the ground-floor portraits and the uninhibited modernity of the thistles above. The image of David Hamilton also involves a conscious acknowledgement of an earlier portrait of the architect elsewhere in Glasgow. Stoddart notes that

> … the representation of Hamilton on this façade shows him as a young man. This balances the already extant representation of the architect on Charles Wilson's Queen's Halls building at La Belle Place [now the Hindu Temple, q.v.], where he is depicted as an old and venerable veteran, signifying, for the purposes of that decorative scheme, the entirety of Glaswegian architecture.

In addition to its nationalistic overtones, the use of the thistle also echoes a decorative device found frequently on buildings in the Merchant City (for example, 102–4 Brunswick Street, *c*.1860, by Robert Billings), while the image of the *fasces* provides a link with the rear elevation of the Trades Hall on Glassford Street (q.v.). Generally, the sculptural elements of the façade may be said to constitute a narrative in the literal sense that they attempt to 'present a story of the City' in the form of a unified visual conceit.

Condition: Good.

Sources
Unpublished documents provided by Page & Park,

Architects, including: Jack Sloan, 'Frieze of Shutters for 178–180 Ingram Street', 24 August 1993, Alexander Stoddart, 'Bernard Reinhold Trust, 178–180 Ingram Street, Glasgow', 1 September 1993; Rodger, pp.41–2 (incl. ill.); McKenzie, pp. 44 (ill.), 45.

Corinthian, 191 Ingram Street / Virginia Place

Allegorical Statues, Narrative Tympana and Associated Decorative Carving

Sculptor: John Mossman

Architects: James Salmon Senior and John Burnet
Dates: 1841–3, 1853–4 and 1876–9
Material: yellow sandstone
Dimensions: second-storey statues 2.29m high; Virginia Place tympana 62cm radius
Inscriptions: in voussoirs of tympanum over entrance – PAISLEY / 1788; AYR / 1773; GLASGOW / 1809; SHIP / 1760; THISTLE / 1761; SIR W FORBS / 1773; ABERDEEN; PERTH; below the coats of arms of the second-floor windows – DUNDEE; KILMARNOCK; GREENOCK; PERTH; AYR; PAISLEY; ABERDEEN (Ingram Street); EDINBURGH (Virginia Place, west); GLASGOW (Virginia Place, east)
Listed status: category A (15 December 1970)
Owner: King City Leisure Ltd

Description: An imposing three-storey *palazzo* in the north-Italian Mannerist style, with a single-storey extension at the rear, erected originally as the Union Bank of Scotland (but see Discussion, below). On the Ingram Street elevation there are eight standing allegorical statues placed between pairs of granite columns on the second floor, including six single figures in the middle bays, and two groups of two at either end. All the figures are female, and may be identified by their attributes as follows: *Navigation and Commerce* (globe and sexton); *Britannia* (trident); *Wealth* (cornucopia); *Justice* (sword and scales); *Peace* (olive branch); *Industry* (bobbin); *Glasgow* (key and coat of arms); *Mechanics and Agriculture* (sheaf of corn, sickle, wheel). Further figurative work appears at the main entrance, which includes a broken segmental pediment containing an escutcheon bearing the arms of Glasgow and Edinburgh, with a corn stook and sickle in the crest, and with seated female supporters holding a caduceus and a scroll (left), and a sword and a purse(?). The tympanum over the door is in the form of a shell niche with a coat of arms enclosed by an arc of small shields inscribed with the names and foundation dates of the six banks which merged to form the Union Bank of Scotland in 1843 (see Inscriptions, above).[1] Minor details at the entrance include a pair of additional shields on the brackets supporting the pediment. These are carved with Roman horsemen, one of which (left) appears to be a miniature copy of the equestrian statue of Marcus Aurelius on the Capitoline Hill, Rome, but may in fact refer to the monument to William III in Glasgow (q.v., Cathedral Square Gardens). Returning to the second floor, the lunettes above the windows in the bays between the statues contain the coats of arms of the Scottish towns in which the Union Bank was represented by a branch, with the name of each town inscribed in the lintel (see Inscriptions, above).

On the rear elevation, facing the south arm

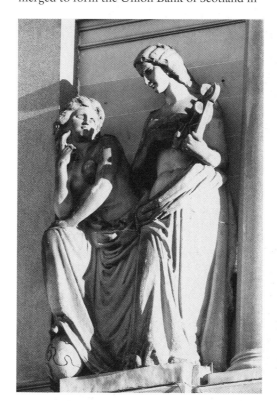

John Mossman, *Navigation and Commerce*

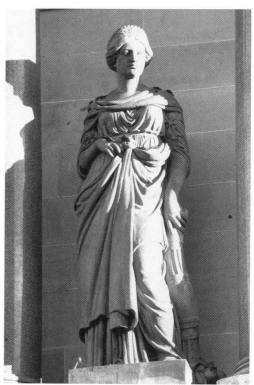

John Mossman, *Wealth*

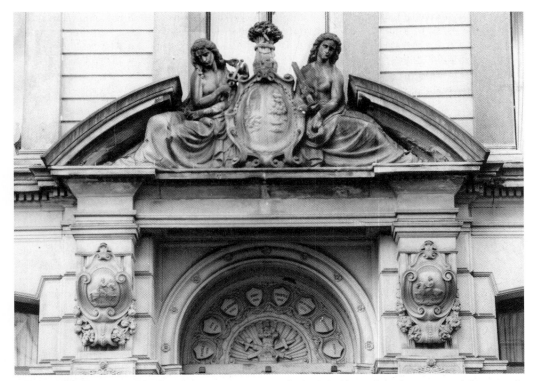

John Mossman, *Armorial Group*

John Mossman, *Narrative Tympana*

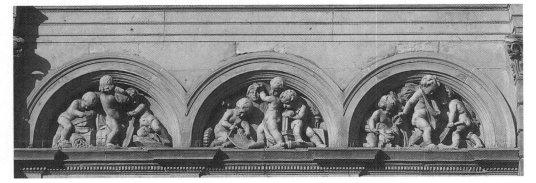

reaping corn (right). These are located above the central triplet window. At attic level there is an elaborate blind cartouche with a bearded mask enclosed in copious quantities of fruit and foliage. The pediments above the windows in the outer bays are also filled with acanthus scrolls, blind cartouches and swags.

Discussion: The building and its sculptures have a complicated history which is very much bound up with the development of the Merchant City during the later phase of its expansion.[2] The site was originally occupied by the Virginia Mansion, reputed in its day to have been 'one of the finest specimens of the town residences of the "Tobacco Lords", so famous in old Glasgow story'. This faced Virginia Street, as Ingram Street at that time was an unsurfaced drove road known as 'Back Cow-Lane'.[3] The building was purchased in 1828 by the Glasgow Bank Company, which merged with the Ship Bank in 1836 and later with the Glasgow Union Banking Company to become the Union Bank of Scotland.[4] In 1841 the Mansion was demolished to make way for a new building designed by David Hamilton, possibly with the assistance of his son James. This extended the northern frontage to the line of Ingram Street itself, and featured a hextastyle Roman Doric portico with six full-length figures by John Mossman on the attic. In December 1842, the *Glasgow Herald* described the portico as 'very chaste', and predicted that 'when the statues by Mossman, the younger [i.e., John], are set up, the building will be a great ornament to the street'.[5] The same newspaper reported eleven months later that the statues were in the process of being installed on their pedestals, commenting that 'sculpture of this distinction is exceedingly rare' in Glasgow, and predicting that Mossman would 'rise to eminence in his profession'.[6]

Hamilton's design included a smaller portico, also with Roman Doric columns, on the Virginia Street elevation, but this was removed in 1854–5 by James Salmon Junior,

of Virginia Place, there is a group of three semi-circular tympana filled with naked children engaged in various activities related to banking and economic production: carrying sacks of coins and writing in a ledger (left); measuring and hammering (centre); ploughing, sowing and

who replaced it with a single-storey banking hall. The interior plaster decoration in this part of the building includes work by John Thomas, whose full-size female personifications *Europe*, *Asia*, *Africa*, and *America*, each flanked by emblematic animals, are in the corners of the coved ceiling, as well as four roundels of the arms of Glasgow and other Scottish cities on the north wall. There are also numerous cherubs entwined in garlands in the cornice. In addition to the lunettes and decorative carving that exist today, the exterior elevation included a dwarf arcade in the side sections of the attic, apparently intended for statues that were never made.[7] This part of the attic has since been removed.

Further, and even more radical changes were made in 1876 when the building was remodelled by John Burnet. Salmon's banking hall at the rear was retained, but the Ingram Street façade was widened and entirely redesigned. This involved the demolition of Hamilton's portico, the columns from which were removed and later incorporated into the façade of the Royal Princess's Theatre in the Gorbals (later to become the Citizens' Theatre, destroyed by fire in 1973).[8] For many years it was believed that the attic statues were also removed to the theatre, but they were in fact stored in J. & G. Mossman's freestone yard until 1879, when they were reinstated on the new building in their present positions. To the original series of six individual figures John Mossman added a new pair of figure groups at either end, which were carved between May 1877 and November 1879. Unlike the six original statues, which are fully draped, the newer figures are all naked to the waist. James Cowan records that Mossman was paid £1,058 17s. 4d. for these two statues 'along with the other carvings on the building', which presumably included the pediment group and the various armorial devices.[9]

In December 1927 the Union Bank transferred its business to a new head office at 110 St Vincent Street, and the building was subsequently converted by Lanarkshire County Council for use as the High Court. Much of the interior plaster work was concealed by false ceilings as a result. However, with the acquisition of the property in 1999 by King City Leisure, and its refurbishment as Corinthian, a leisure, hospitality and conference centre, this important interior work has been restored and exposed once again to view.

Condition: Good.

Notes
[1] There are some curious anomalies in this scheme: the name of the private banker Sir William Forbes is mis-spelt; the Ship Bank was founded in 1749, not 1760; the inscriptions for Aberdeen and Perth are undated, possibly because they did not join the Union until later. [2] For a full account of the vicissitudes of the building see George Fairfull Smith, 'Lanarkshire House, Glasgow, the Evolution and Regeneration of a "Merchant City" Landmark', *Architectural History*, vol.42, 1999, pp.293–306. [3] Tweed (*Guide*), p.11. [4] Smith, *op. cit.*, pp.294, 297. [5] GH, 9 December 1842, p.4, quoted in Smith, *op. cit.*, p.296. [6] GH, 27 November 1843, p.4. [7] Tweed, *op. cit.*, p.11. See also vintage photograph reproduced in Smith, *op. cit.*, p.300. [8] See Harris, ill.185. [9] Cowan, 'The Mystery of the Twelve Statues', *From Glasgow's Treasure Chest*, Glasgow, 1951, pp.239–42. Cowan's essay was written in May 1937, and was based on his study of Mossman's job books, which have now been lost.

Other sources
B, 8 March 1879, p.267; Groome, vol.3, p.137; Gomme and Walker, pp.158f. (incl. ill.), 314; Charles W. Munn, *Clydesdale Bank: the First One Hundred and Fifty Years*, London and Glasgow, 1988, pp.16, 21; Teggin *et al.*, p.23 (ill.); McKean *et al.*, p.74; Williamson *et al.*, p.183; McKenzie, pp.46–7 (incl. ill.), back cover.

Ingram Hotel, 197–201 Ingram Street

Abstract Sculpture
Sculptor: Richard Coley

Architect: T.M. Miller & Partners (now The Miller Partnership)
Date: 1971–3

Materials: fibreglass, anodised aluminium and polished steel balls
Dimensions: approx. 1.85m diameter
Listed status: not listed
Owner: Stakis Hotels

Description: The sculpture consists of a brooch-like dish of glass fibre and steel, and is mounted on a series of vertical anodised aluminium fins on the north façade of the hotel.

Discussion: In 1971 the Reo Stakis Organisation were granted permission to demolish the building which stood at 201 Ingram Street, and replace it with a new structure incorporating a hotel and restaurant. A drawing of the proposed elevation by David Meek (of T.M. Miller & Partners) included a 'mural by artist', and although no details were given, the Planning Department insisted that a decorative work be included in the final construction. Richard Coley was invited to

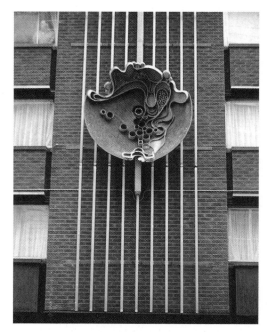

Richard Coley, *Abstract Sculpture* [RM]

work the sketch up into a finished design stylistically consistent with the many restaurants and hotels being developed by the Stakis Organisation at this time.

Condition: Good.

Sources
Information provided by the sculptor; GCA, B4/12/1971/135; McKenzie, pp.46, 47 (ill.).

John Street MERCHANT CITY

Italian Centre, 7 John Street / Ingram Street

Sculpture Programme

Sculptors: Alexander Stoddart, Jack Sloan and Shona Kinloch

Architects: Page & Park
Date: 1988–90
Listed status: not listed
Owner: Classical House Ltd

Bounded by Ingram Street, John Street and Cochrane Street, the Italian Centre was developed by Classical House Ltd from a block of early nineteenth-century warehouses which by the mid-1980s had become semi-derelict. The design was inspired partly by the Swiss Centre in London, and adopts the historic form of an Italian *palazzo*, with commercial and domestic units grouped around a central courtyard, and with the pedestrianised area on John Street treated as an integral part of the scheme. The overall cost of the development was £4.2 million, which was raised with the support of Glasgow City Council (the owners of most of the property) and the Glasgow Development Agency. From its inception the development was intended not only to act as a catalyst in the economic regeneration of the Merchant City but also to contribute to the cultural life of the area. This commitment is reflected in the unusually high proportion of

the budget allocated to sculpture and fine craft work. In all, the cost of the artworks was £320,000, representing approximately 8 per cent of the total funds. A widely admired development, the project won the 1995 Best Practice Award of the British Urban Regeneration Association, the judging panel of which were particularly impressed by the 'role played by public art in the project'.[1]

The works of the three artists involved in the sculpture programme are intended to be read as components of a single scheme. However, because of their divergent approaches to style, and the differences of medium and scale in the work, they are listed here as separate pieces.

Italia

Sculptor: Alexander Stoddart

Material: glass-reinforced polymer
Dimensions: 2.6m high
Inscription: on the plinth – ITALIA

Located on the attic of the Ingram Street façade, this colossal statue is designed to acknowledge the large proportion of Italian retailers within the building, while simultaneously paying tribute to the historic contribution of Italian artisans to the Merchant City. It thus embodies the primary purpose of the development as a whole. Rigorously neo-Classical in style, the figure incorporates a number of symbolic attributes associated with the culture of classical

Alexander Stoddart, *Italia*

Italy, including a palm branch in her raised right hand and an inverted conucopia in her left. Her garment is a classical chiton with a shawl draped over the left shoulder. The alignment of the statue with the axis of Glassford Street places the Italian Centre in a direct relationship with one of the city's principal retail areas immediately to the south. This figure, like the following two, was cast by Stoddart in his studio in Paisley.

Condition: Good.

Mercury and Mercurius
Sculptor: Alexander Stoddart

Material: glass-reinforced polymer
Dimensions: each figure twice life-size
Inscription: on the plinth below each figure –
MERCVRY; MECVRIVS

A pair of matching figures seated on small

Alexander Stoddart, *Mercury*

mounds of rock on plinths at either end of the attic of the John Street elevation. The use of English and Roman variants of the same name as titles signifies the two alternative 'manifestations' in which the Roman deity is encountered in classical mythology, thus proposing an 'interesting dialogue' in the relationship between ancient lore and modern Merchant City life. On the left, *Mercury* holds a caduceus, and therefore 'represents the God in his high artistic role'; protruding over the edge of the plinth is a tortoise, possibly referring to the emblem of Cosimo de Medici and its motto: FESTINA LENTE (trans.: 'make haste slowly'). On the right, *Mercurius* holds a money-bag signifying his 'lower commercial function'.

Condition: Good.

Mercurial
Sculptor: Alexander Stoddart

Founder: Morris Singer
Materials: bronze on a grey granite pedestal
Dimensions: statue 2.05m high; pedestal 54cm × 84cm × 84cm
Inscriptions: on left (north) face of plinth –
STODDART fecit / BACK adj. / Paisley 1989 / MORRIS / SINGER / FOUNDERS / LONDON

The placement of this work on the pavement facing the John Street façade is intended to establish a triangular relationship with the attic figures. This, together with the use of the adjectival form of the name, indicates a fusion of the dual aspects of *Mercury* and *Mercurius* into a unified mythological concept.

Condition: Good.

Guardians and Associated Mythological Figures
Sculptor: Jack Sloan

Fabricators: Archie Sinclair and others
Material: galvanised steel

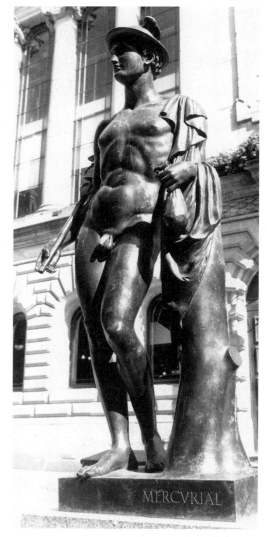

Alexander Stoddart, *Mercurial*

Dimensions: main figures approx. 2.4m high

This part of the scheme is located in the internal courtyard, on the south elevation of the Cochrane Street block, and is devoted to 'the

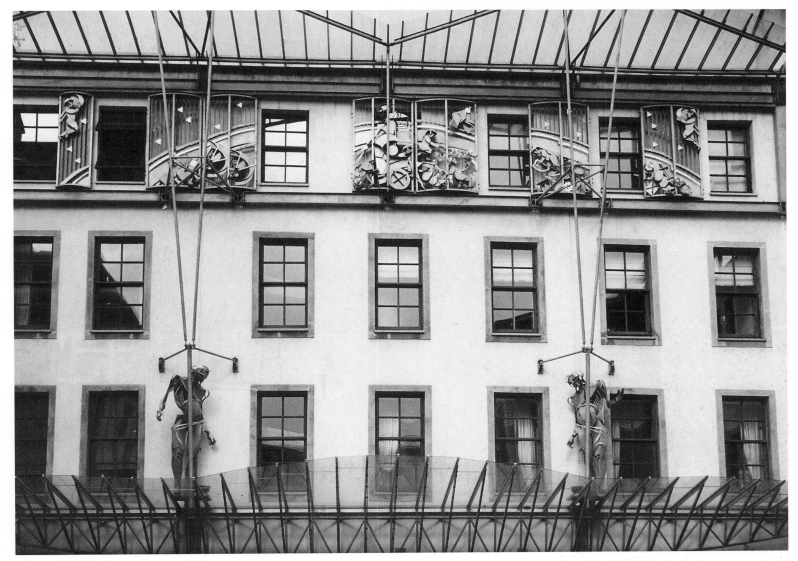

Jack Sloan, *Guardians* and *Mythological Panels*

elemental theme of "sky"'. It consists of a pair of schematic figures, partially gilded, supporting an upper canopy on long steel poles. On the third floor is a series of sliding steel window shutters incorporating images of Apollo 'pulling the sky across the elevation from the setting of the sun to the rising of the moon'. An alternative statement issued by the architects describes the scheme as representing 'the chariot ride of Phaeton across the skies'. The shutters were fabricated at Glasgow Sculpture Studio.

Condition: Good.

Thinking of Bella
Sculptor: Shona Kinloch

Founder: Powderhall Bronze
Material: bronze
Dimensions: man and dog life-size

The group consists of 'a fat man and a dog', and is placed at ground level beside the pool in the courtyard. The playfully irrational ellision of the name of the Glasgow suburb 'Bellahouston' in the title complements the subtly caricatured treatment of the two figures and the unexplained intensity of the relationship between them. Both figures have their faces raised to the sky, thus echoing the theme of the frieze, while the three-cornered granite plinth on which they are placed refers to the 'concept of triangulation' in the arrangement of the exterior sculptures.

Condition: Good.

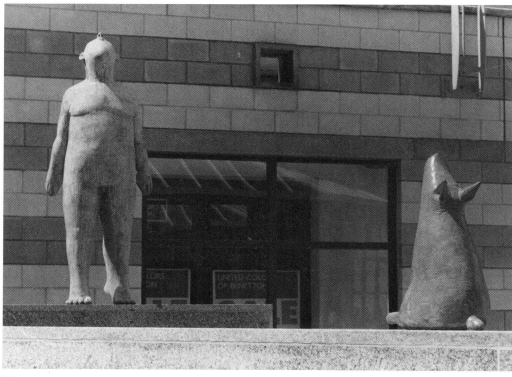

Shona Kinloch, *Thinking of Bella*

Note
[1] Anon., 'Italian Centre wins national award', *The Bulletin*, June 1995.

Other sources
All quotations from unpublished information sheets issued by Page & Park, Architects, n.d. (*c.*1990); Dan Cruickshank, 'Glasgow renaissance', AJ, 27 November 1991, pp. 27–30; Williamson *et al.*, p.184; Rodger, pp.40–1; McKenzie, pp.44 (ill.), 45.

Kelvingrove Park WEST END

INTRODUCTION

Kelvingrove Park (originally known as West End Park) was created in response to the increasingly pressing need for civic amenities generated by the mid-nineteenth-century expansion of the city, a process in which many of the open spaces formerly occupied by private estates were being systematically swallowed up by more densely populated tenemented and terraced developments. Glasgow was not alone in making provisions of this kind, and the council's bold decision to preserve an extensive area of open landscape in the heart of what might otherwise have been profitable building land was symptomatic of a general trend among nineteenth-century British cities. The need for such spaces – often referred to at the time as the 'lungs' of a city – was in fact so acute that it became a matter of government intervention, with a Parliamentary Select Committee set up as early as 1833 to 'consider the best means of securing Open Spaces in the Vicinity of populous Towns'. By the time the Recreational Grounds Act was passed in 1859, the first phase of Kelvingrove Park was already complete.[1] Even so, it was recognised that Glasgow had undergone a 'somewhat late awakening' to the desirability of preserving areas of natural beauty within its boundaries.[2]

The opportunity to develop the park did not in fact arise until 1852, when the contiguous properties of Kelvingrove and Woodlands, together with parts of the Claremont and Blythswood estates, were put up for sale by their trustees.[3] Between them they covered an area of about 66 acres, and had a market value of £100,000. In the event, the council paid only £77,000, with the neighbouring landlords being asked to defray the remainder of the cost through an increase of two pence in the pound on the local domestic rates, on the grounds that

the value of their property would be enhanced by the removal of such a substantial area of potential building land.[4] The later acquisition of the Kelvinbank and Clayslaps estates extended the boundary of the park to the south, and in the late 1860s, after some difficult negotiations with the University, an area of about twenty acres was annexed from the lands of Gilmorehill on the west side of the River Kelvin.[5] The eventual cost, including the design and construction work, was £270,000.[6]

The overall shape of the Park was determined by a scheme for the development of the entire Woodlands area devised by the architect Charles Wilson, whose handsome convex terraces still dominate the eastern side of the park from on high. Internally, however, the details of the layout were the creation of Joseph Paxton,[7] designer of the Crystal Palace, and former chief gardener on the Duke of Devonshire's estate at Chatsworth. Despite its public status, the style of Kelvingrove is in fact very much in the tradition of the aristocratic *jardin anglais*, with its various combinations of 'carriage drives, walks, shrubbery and sward', as well as its extensive tree planting, all designed to respond to the undulations of the terrain with an informality reminiscent of the 'picturesque' aesthetic perfected in the eighteenth century by designers such as Capability Brown. The inclusion of a short stretch of the River Kelvin – its banks largely colonised today by giant hogweed and many other equally undomesticated flora – only adds to the illusion of the Park as a fragment of 'natural' landscape miraculously flourishing in the centre of a dense metropolis.

The early history of the Park is very much bound up with the great series of international exhibitions staged within it between 1888 and 1911. These were truly extraordinary affairs,

transforming the Park on each occasion into a temporary architectural wonderland, complete with entire 'ethnic villages', and providing architects such as James Miller with an opportunity to turn their wildest and most grandiose fantasies into reality, if only for a few months.[8] From the abundance of contemporary visual documentation – including postcards, photographs and paintings – it is clear that sculpture played a central part in creating the desired atmosphere of festive excess. Miller's Industrial Hall of 1901, for example, was encrusted with ornamental and figurative sculpture by Albert Hodge as extravagent as anything in the tradition of 'Spanish Renaissance, with a Moorish tendency' from which it was allegedly derived.[9] Much of it, not least the fantastic wand-waving angels terminating its entrance porch and central dome, was also on an appropriately colossal scale. None of these figures was meant to last, of course, and their disappearance need not be a cause of any great regret. A very different matter is the loss of the full-size figure of *Britannia* which once presided over the entrance to the Jeffrey Reference Library, built as an extension to the original Kelvingrove Mansion in 1876, after it had been converted to a public museum.[10] Old photographs suggest this was a fine piece of text-book classicism, although the addition of a 'large black sun' on her head when the building was used as a Japanese pavilion in the 1901 Exhibtion cannot have done much to enhance its dignity.[11] It was destroyed shortly afterwards.[12]

If the exhibitions themselves came and went, however, their legacy was far from ephemeral. Kelvingrove Art Gallery and Museum, with all its associated statuary, was built – or at least begun – with profits from the 1888 event, and the *Doulton Fountain*, originally constructed on

the site now occupied by the Museum, still exists, albeit removed to Glasgow Green (q.v.) and in a sorry state of disrepair. More importantly, throughout this whole period the park itself had been acquiring works of sculpture quite independently of the exhibitions movement. Indeed, since the installation of Auguste Cain's *Bengal Tigress* in 1866 the history of the Park has been marked by a steady accumulation of sculptural monuments as a permanent enhancement of its appeal as a public space, and it is the dozen or so works that have their home there today which give it its relevance to the present study.

For the most part the distribution of sculptures in Kelvingrove is in keeping with the informality that characterises the appearance of the Park as a whole. This is not to deny that a great deal of careful consideration has been given to the way many individual monuments have been positioned in relation to their surroundings. Using the *Monument to Thomas Carlyle* and the *Highland Light Infantry Memorial* as terminals for the Prince of Wales Bridge makes good visual sense, even if they bear no relation to each other thematically. The *Monument to Earl Roberts*, high up on the eastern entrance from Park Circus, is a piece of pure urban theatre, a *coup d'oeil* as spectacular as anything to be found anywhere in the British Isles. But these are the exceptions. More typical is Paulin's *Monument to Lord Lister*, tucked away in the shady grotto just to the west of Kelvin Way. Powerful as it is as an aesthetic statement, its presence is curiously unassertive; it neither beckons from afar, nor clamours for the attention of those who happen to find themselves strolling, or sitting, close by. It is as much a part of the place as the trees and rocks that surround it, one of a multitude of surprises lying in wait for any visitor prepared to follow the Park's twisting walkways wherever they happen to lead.

The deliberate casualness that governs the placement of monuments in Kelvingrove Park provides an interesting contrast to the only other public space in Glasgow with a comparable body of sculptural work, George Square. Here everything is laid out according to a strict formula, the position of each work carefully calculated to balance with its immediate neighbours, the whole ensemble a strictly stage-managed affair. Opinions have varied as to which is the more satisfactory approach to the display of public monuments. The group of city worthies who commissioned the *Monument to Lord Kelvin* saw George Square as a natural first choice, and it was only after they discovered that it was already 'full' that they switched the location to Kelvingrove Park. As it happens it was at about this time – early in the twentieth century – that commentators were beginning to complain that George Square was already overcrowded, and there was at least one proposal that it should be cleared and its entire collection of statuary deported to Kelvingrove. (See George Square, Introduction.)

How much credibility should be attached to such notions is difficult to say, but there is no question that if the scheme had ever gone ahead, the addition of a further dozen works to those already *in situ* would have changed the character of Kelvingrove Park beyond recognition, transforming it from what it is today – a typical Victorian recreational area that happens to contain some statuary – into something much closer to the 'sculpture parks' of more recent times. Such speculation is not entirely idle. The belief that George Square should be emptied of its historic bronze inhabitants is one that surfaces regularly in the city council's deliberations,[13] and there is no guarantee that it will not one day be put into action. Should this ever happen, one important consideration must be borne in mind. There is no question that a park is a wonderful context for viewing statues. When it is properly managed, the placement of an object produced by human artifice within the spectacle of natural forms undergoing their own cycles of growth and change is almost always a winning formula. Bronze is enhanced by foliage not only because their juxtaposition reminds us that 'nature' and 'culture' depend on each other in a vital symbiosis, but also, rather more straightforwardly, because they look so good together. But there can be drawbacks in this arrangement. Under normal circumstances statues require very little maintenance; vandalism and graffiti are much greater threats to their survival than anything time and the elements on their own can inflict on them. By contrast, it is in the nature of trees and other flora that they grow, relentlessly spreading themselves upwards and outwards, and in the process appropriating their surroundings with often quite alarming rapidity. Even the most apparently 'natural' parks have to be kept under control. In Kelvingrove Park there are several major works which have suffered from the unchecked growth of the surrounding foliage, as was noted as long ago as 1937, when J. Buyers Black, one of the commissioners of the *Monument to Thomas Carlyle*, complained that the trees and shrubs, which were 'comparatively small' at the unveiling 21 years earlier, had 'grown to such dimensions as quite to envelop and dwarf the memorial' – hardly an appropriate fate for a statue commemorating a 'literary giant'.[14] Some of the most telling details on Paul Montford's figure groups on the Kelvin Way Bridge are on the sides facing out towards the river, and during the summer months they are completely concealed by the dense foliage burgeoning from the banks below. The same is true of the magnificent panels of ornamental scrollwork on the Prince of Wales Bridge; they are literally invisible to all except those prepared physically to lean over the parapet – not a solution to be recommended – or study them with binoculars from a viewing position much further down the river.

Its tendency to camouflage objects with foliage is not the only way in which the River

Kelvin has been implicated in the history of the Park's sculpture. If the story of the two figure groups on the Kelvin Way Bridge being pitched from their pedestals into the water during an air raid is remarkable enough in itself, the sequel is surely more extraordinary still. The very notion that a bronze arm from each should have snapped off, only to remain on the river bed like so much maritime booty until a drought in 1995 brought them to light – one would be inclined to dismiss such a claim as mere Glasgow folklore were the incident not so well documented (see below). Doubtless they would have been recovered sooner if the Park authorities had heeded the warnings of those concerned about the quantities of rubbish and polution that had been accumulating in the river since before the Second World War. When Tom Honeyman took up his post as Director of the Art Gallery and Museum in 1939, one of the first events he organised was an exhibition of works from the gallery's sculpture collection, which he displayed on the bank of the river not far from the north entrance. Entitled 'Scum and see the Sculpture', it was an imaginative use of the gallery's resources to draw attention to the shocking condition into which the river had been allowed to fall.[15] The sculptures were later returned to the Gallery; the pollution, alas, remains.

Whether or not the resources for dealing with such problems will become available in the future is difficult to predict. The fact that the park's two fountains, one of which is a work of immense historical importance, are not only dysfunctional but rapidly deteriorating is a very public sign of the low priority at present given to the maintenance of this aspect of our sculptural heritage. No less worrying is the regular incidence of petty vandalism which has begun to mar the appearance of several key works, including the loss of the tail of the *Bengal Tigress*, and the theft of the St George figurine from the *Monument to Earl Roberts*, to name only the most obvious examples. But

these issues must be kept in perspective. There is no major park in Glasgow that does not find itself on the same cleft stick of having to choose between minimal routine maintenance and ploughing more serious resources into the upkeep of monuments created in times of infinitely greater material prosperity. If the problems at Kelvingrove seem more conspicuous, it is because the park and its contents were more splendid to begin with. For all its imperfections, the sculpture collection remains a resounding tribute to the imagination and foresight of those who created the park in the 1850s, and a source of endless pleasure to those who still use it today.

Notes
[1] Fisher, p. 252. [2] 'Noremac', p.11. [3] *Ibid.*, p.29; McLellan, p.41; *Glasgow Courier*, 'The West-End Park', 6 May 1852, n.p. (p.2). [4] John Gair, 'Kelvingrove Park: its history and contribution to the people and city of Glasgow', unpublished thesis, GSA, 1976, p.7; McLellan, p.42. [5] McLellan, p.42. [6] 'Noremac', p.29. [7] *Ibid.*; B, 23 August 1872, p.141. [8] For a full account of these exhibitions see Kinchin and Kinchin, pp.17–125. [9] 'The Buildings of the Glasgow International Exhibition', RIBAJ, 28 September 1901, pp.480–2. [10] 'Noremac', p.35. [11] Kinchin and Kinchin, p.83. [12] Stevenson (1914), p.44. See also Kelvingrove Park, Appendix A, Lost Works, below. [13] Most recently in July 2000. See Josie Saunders, 'Leave our statues alone', ET, 26 July 2000, pp.8–9. [14] GH, 2 July 1937, p.9. [15] Honeyman, p.36.

Other sources
MLG, *Miscellaneous Cuttings Books*, 'Kelvingrove'; Douglas Percy Bliss, 'Sculpture in Glasgow', GH, 20 February 1954, p.3.

At the junction of three walkways north-west of the Stewart Memorial Fountain

Bengal Tigress
Sculptor: Auguste-Nicolas Cain

Founder: F. Barbedienne, Paris
Date: 1866–7
Unveiled: 27 September 1867

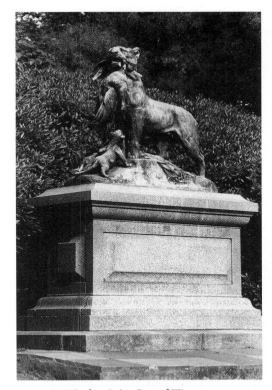

Auguste-Nicolas Cain, *Bengal Tigress*

Materials: bronze on a pink granite pedestal
Dimensions: life-size
Signed: on upper surface of plinth, front – A CAIN 1866; on upper surface of plinth, rear – F BARBEDIENNE FONDEUR PARIS
Inscriptions: on front of pedestal – PRESENTED / TO HIS NATIVE CITY BY / JOHN S KENNEDY / NEW YORK; on step below pedestal – 1867
Listed status: category B (6 July 1966)
Owner: Glasgow City Council

Description: The statue, the first sculptural monument to be installed in Kelvingrove Park, is of a tigress returning from the hunt with a dead peacock to feed her two new-born cubs. Early photographs show that it was originally

placed in a triangular flower bed at the confluence of several main walkways on the upper slopes of the park, slightly to the south of the *Monument to Field Marshal Earl Roberts*; the area was separated from the walkways by a low iron fence.[1] In the early part of the twentieth century the monument was moved a few yards to its present site,[2] where it now sits on a flight of paved steps. This allows the monument to be approached and examined more closely, although the dense mass of rhododendrons to the rear makes it difficult to study it in the round. A notable feature is the treatment of the bird's plumage, which sweeps through the space between the tigress's legs and dissolves with great subtlety into the plinth, itself modelled naturalistically as a small knoll.

Discussion: On 14 July 1866, John Stewart Kennedy, expatriate son of a prosperous Glasgow merchant, wrote to the Glasgow City Council from his home on Broadway, New York, outlining an exceptionally generous offer. 'During a late sojourn in Europe', he explained,

> ... I visited the Studio of M. Auguste Cain, Artist in Paris, and found him engaged in the execution of a Work for the Paris Exhibition of 1867, the subject being 'A Royal Bengal Tigress bringing the first food to its Young'. It is to be cast in Coin Bronze by M. Barbidienne [*sic*] of Paris. I was much struck with the beauty of the work and believing it to be possessed of great artistic merit and calculated to ornament any City in which it may be placed, I ordered a copy to be prepared and have now much pleasure in tendering it through you to my native City Glasgow. I expect it will be completed in the course of the present Autumn and on being notified of your acceptance of the same I will give directions for the preparation of a suitable pedestal for its reception at such place in the West End [i.e., Kelvingrove] Park or that vicinity as you may be pleased to designate.[3]

The council unanimously accepted the gift, with 'their best thanks'.[4] A little more than a year later, the sculpture was ready for installation, and after some discussion in the Parks Committee as to an appropriate site, was assigned a location 'in the triangular piece of ground to the North East of the Flower Plots'.[5] The statue was formally presented to the City by the donor's brother, the Rev. Thomas Kennedy, at the unveiling ceremony, after which the party 'adjourned to Kelvingrove House, where wine and cake were served, and various toasts were given appropriate to the occasion'.[6]

Though he was an accomplished sculptor of animals in his own right,[7] it is believed that Cain based his design in this case partly on the work of the distinguished painter Rosa Bonheur,[8] who made sketches of animals in the Jardin des Plantes in Paris.[9] The work is thought to have cost £1,000.[10]

Related work: Another cast, identical to the Glasgow work, was placed on Cherry Hill, in New York's Central Park in 1867, and later moved to Central Park Zoo.[11] A small version of the statue (32.5cm × 47.5cm) was auctioned at Sotheby's in 1995.[12]

Condition: In July 1886, the statue was rebronzed,[13] and apart from some graffiti and red paint sprayed on the tigress's mouth the surface condition of the statue remains good. It has, however, suffered some structural damage. The tail was cast in two parts, and in recent years the lower section has been broken off on at least two occasions. On the first, the missing piece was found in the neighbouring bushes and replaced; it has now disappeared, leaving the rivet holes of the remaining section clearly visible. The force required to remove the lower section has clearly weakened the junction of the tail with the animal's lower spine, and what is left of the tail is very insecurely attached.

Notes
[1] Michael Moss and John Hume, *Glasgow As It* Was, vol.II 'Sports and Pastimes', Nelson, 1975, pl.31. [2] See illustration in 'Noremac', p.39. [3] GCA, C1/1/69, 20 September 1866, pp.174–5. [4] *Ibid.* [5] GCA, C1/3/1, 2 September 1867, p.84. [6] *Ibid.*, 27 September 1867, p.99; B, 5 October 1867, p.738. [7] P.G. Hamerton describes him as the 'greatest of all living sculptors of animals'. See P.G. Hamerton, 'The Present State of the Arts in France', *The Portfolio* (1891), p.204. [8] B, 5 October 1867, p.738; probably *Famille de tigres*, exhibited in plaster at the 1867 Paris Exposition Universelle (Group 1, class 3, no.16). See S. Lani, *Dictionnaire des Sculpteurs de l'Ecole française*, 1914, vol.1, p.236. [9] Stevenson (n.d.), n.p. [10] EC, n.d. (c.1935), cutting in MLG, *Glasgow Scrapbook* No.17, p.82. This source states erroneously that the statue was designed by Rosa Bonheur. [11] Stevenson (n.d.), n.p. [12] Sotheby's sale catalogue, *Animalier Bronzes, Sporting and Scottish Paintings, Drawings and Watercolours*, Gleneagles Hotel, 29 August 1995, lot 556, p.33 (incl. ill.). [13] GCA, D-TC 14/1/17, 27 July 1886, p.1086.

Other sources
McLennan, p. 50; Read and Ward-Jackson, 4/11/16–17; Williamson *et al.*, p. 282; McKenzie, pp.86, 87 (ill.).

In the centre of the south-east area of the park

Stewart Memorial Fountain

Sculptors: John Mossman and James Young

Architect: James Sellars
Founder: H. Pringle & Co.
Builder: James Robertson
Date: 1872
Materials: bronze (upper figure and reliefs); red and grey sandstone, granite, marble, majolica
Dimensions: 12.2m high; 19.8m diameter (outer basin)
Signed: on the plinth of upper statue, left side – J MOSSMAN SC 1872; on the plinth of upper statue, right side – H. PRINGLE & Co. FOUNDERS
Inscription: on the north relief panel – TO COMMEMORATE / THE PUBLIC SERVICES OF / ROBERT STEWART / OF MURDOSTOUN / LORD

PROVOST OF THE CITY OF GLASGOW / FROM
NOVEMBER 1851 TO NOVEMBER 1854 / TO
WHOSE UNWEARIED EXERTIONS / THE
CITIZENS ARE MAINLY INDEBTED FOR THE
ABUNDANT / WATER-SUPPLY FROM LOCH
KATRINE / THIS FOUNTAIN WAS ERECTED
1872. For additional minor inscriptions see
'Description', below. (Note: A group of four
grey marble plaques set into the ground at
the four cardinal points outside the lower
basin provide a detailed account of the
Bridgegate restoration scheme. See
'Condition', below.)
Listed status: category A (15 December 1970)
Owner: Glasgow City Council

Description: The design is an elaborate
Gothic confection, often described as French in
style, but incorporating a reference to Scottish
architecture in the use of a modified version of a
'crown cupola' as its central motif. Structurally,
the fountain consists of four stepped buttresses
grouped in radial formation around a massive
central pier, its three principal levels divided by
water basins of various shapes and sizes. In all
its aspects the design gains in lightness and
delicacy as it ascends. The buttresses, pierced by
lancet openings at the lower level, spring into
crocketed ogee ribs which in turn sweep
upwards to support the decoratively carved
quatrefoil of the topmost basin. In the middle
storey, the central pier telescopes suddenly into
the more slender form of a clustered column,
narrowing even further in its upper stage to
provide support for the work's crowning
feature, a draped female figure in bronze by
Mossman. The entire structure is placed within
a circular granite basin of plain design.

If the structure of the fountain is complex,
its symbolism is equally so, combining elements
of portraiture and heraldry with numerous
references to literature, all interspersed with a
richly imaginative array of neo-medieval
grotesques. Though nominally a tribute to
Robert Stewart and his role in the conversion of

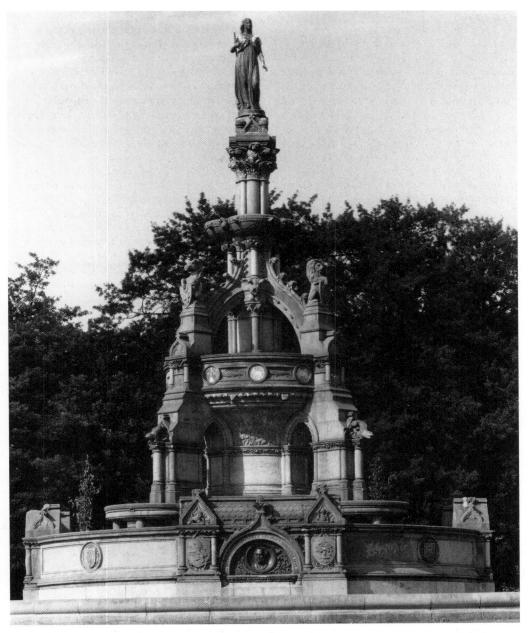

John Mossman and James Young, *Stewart Memorial Fountain*

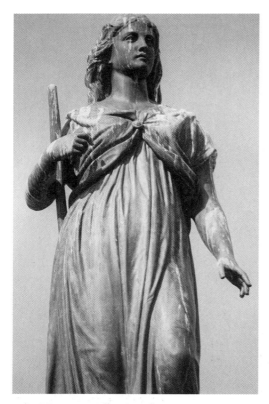

John Mossman, *Ellen Douglas* [RM]

Loch Katrine (see 'Discussion', below), the real focus of its imagery is the Romantic folklore associated with the Trossachs, the geographical area in which the Loch is located, and in particular the image of the region disseminated through the writings of Sir Walter Scott. Originally gilded, Mossman's figure is identified by the oar tucked under her right arm as Ellen Douglas, the heroine of Scott's narrative poem, *The Lady of the Lake*[1] with the reference reinforced by the legend that Mossman has attempted to depict her in the act of straining to hear the hunting call of her lover, James Fitz-James.[2] First published in 1810,

Scott's poem has been credited not only with drawing the attention of the world to the scenic beauty of the Trossachs, but with the creation, virtually overnight, of the entire Scottish tourist industry.[3] Certainly by the time the fountain was designed, Scott's name was so closely bound up with this part of the Perthshire Highlands that even the official documentation of the waterworks project is replete with acknowledgements of the 'Great Wizard', and the degree to which his poetic vision had shaped public perception of it.[4] Standing within its own expanse of water – often referred to in contemporary accounts as its 'pond' – the fountain can plausibly be regarded as a symbolic representation of the small island in the middle of the Loch itself, known to this day as 'Ellen's Isle'.

Examples of all aspects of the fountain's overall symbolic programme are to be found in

the decoration of the main central basin on the lower tier. Here each of the four cardinal compass points is marked by a semi-circular bronze panel set into an architectural frame consisting of a pair of squat, pedimented piers linked by a 'fish-scale' ogival canopy, the design as a whole strongly reminiscent of a medieval reliquary. The subjects of the panels are as follows:

South – a portrait in high relief of Robert Stewart, enclosed in thistles and with the inscription 'BORN 1811 – ROBERT STEWART – DIED 1866' in the border;

East – allegorical female figures representing *Loch Katrine* (reclining, pouring water from an urn, bullrushes behind) and *Glasgow* (crowned and seated with Glasgow arms and a bale of goods); Glasgow Cathedral is in the background, and the border is inscribed

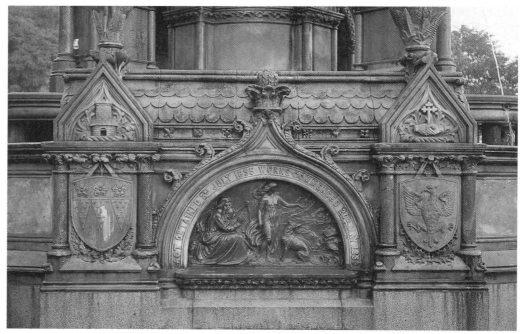

John Mossman and/or James Young, *The Lady of the Lake* [RM]

North – a text panel (see 'Inscriptions', above);

West – an illustration of Canto II, vv.4–5 of *The Lady of the Lake*, with Ellen, her spaniel and the minstrel Allan-Bane; Ellen's Isle is in the background and the border is inscribed 'ACT OBTAINED 2ND JULY 1855 WORKS COMMENCED 20TH MAY 1856'.

The pillars framing the bronze panels are in each case decorated with various armorial shields and their associated monograms and crests, in commemoration of the Provosts and Bailies who played a part in the waterworks project. Beginning on the left side of the portrait of Stewart, and running anti-clockwise, the shields relate to the following: Robert Stewart and Glasgow; Provost Andrew Galbraith and Bailie James Hannan; Robert Stewart and Glasgow (repeated); Provost Andrew Orr and Bailie James Gourlay. Further armorial devices appear in the roundels inserted in the panels between the 'reliquaries', each containing a lion rampant on a shield.

Ascending to the next tier, the principal buttresses stand within circular basins supported by groups of plain red sandstone colonettes. Extending outwards from the main central platform, these were designed to be filled from above by gargoyles carved into the form of mythical beasts shown crawling, head downwards, through ferns and other flora onto the capitals of colonettes attached to the outer faces of the buttresses. The large curved expanses of masonry between the buttresses are filled with a continuous frieze of stylized bull-rushes, symbolic of the shores of Loch Katrine, and into which various gaming scenes have been inserted. Among the animals depicted here are a heron, a moorhen, a frog and a dog chasing a duck, the latter almost certainly an illustration of the question posed in Scott's poem:

James Young, *Water Carrier* [RM]

Smiled she to see the stately drake
Lead forth his fleet upon the lake,
While her vexed spaniel, from the beach
Bay'd at the prize beyond his reach?

(Canto II, v.5)

Aquatic references are continued on the middle water bowl, with its outer surface decorated with various species of freshwater fish (pike, carp, eel and many others), alternating with faience roundels of the signs of the Zodiac, while the designer's preoccupation with blazonry achieves its most complete realisation in the alternating heraldic lions and unicorns which terminate the buttresses. Decorative carving on the upper part of the structure is for the most part devoted to the enrichment of its various water outlets, including groups of dragons with outstretched wings clinging to the inner angles of the cupola and female half-figures holding inverted urns in the topmost capital. Perhaps the most distinctive feature of the work, however, is the sheer abundance and range of its references to the natural history of the Trossachs: the lizards, frogs and other tiny amphibians found crawling over the bases of the lower colonettes; the birds of prey, including an owl, that divide the four

sections of the upper water bowl; above all the brilliantly carved masses of flora – ferns, foxgloves, the ubiquitous bullrush – that burgeon from the topmost capital. A final acknowledgement of the geography of the Trossachs appears in the pedestal of the terminal statue, with the names of the four principal lochs carved in a series of small triangular panels: Katrine (facing south), Venachar (east), Drunkie (north) and Achray (west).

Discussion: The fountain is named after Robert Stewart, Lord Provost from 1851 to 1854, and a key figure in the conversion of Loch Katrine into a source of drinking water, the single most decisive measure in the promotion of public health in Victorian Glasgow. It was also during his term of office, and with his enthusiastic support, that Kelvingrove Park itself was created.

About a year after Stewart's death in September 1866, the council began to consider proposals for a memorial, and in its initial discussions was torn between the desire to acknowledge Stewart's personal contribution to the improvement of the City and the more general need to celebrate the successful completion of the waterworks project as a whole; for some members of the council an ornamental fountain was simply not an appropriate way to commemorate 'the services of individual Lord Provosts'.[5] There was also some disagreement over the question of where the fountain should be sited, and in the early stages the preference of the Water Commissioners was for St Enoch's Square,[6] doubtless on the grounds that it would be accessible to more people there than in the comparative obscurity of a park in a residential area. In the end, the argument for Kelvingrove prevailed, and the dilemma of the fountain's theme was resolved by defining it as a remembrance of Stewart specifically in relation to his role in 'securing the introduction of Loch Katrine Water into the City'.[7]

A competition, held in the summer of 1870, attracted over 75 submissions from architects and sculptors resident not only in all parts of Britain but also, in a handful of cases, France and Belgium.[8] The response was in fact so good that the submissions, which included models as well as drawings, had to be transferred from the Water Commissioners' Hall to the more spacious venue of the Corporation (now MacLellan) Galleries on Sauchiehall Street 'in order that the Committee might have a better opportunity of inspecting them'.[9] A shortlist of ten was drawn up, and in the final selection the design by James Sellars, entered under the code name 'Undine', was chosen.[10] In the meantime, however, there had been some grumbling that the projected cost of the memorial, up to £4,000, was excessive, and although Sellars' proposal was estimated at a relatively modest £2,780, he was awarded a premium of £50 and asked, along with four other shortlisted competitors, to submit a modified version of his proposal in line with a new upper limit of £2,000.[11] His proposal was selected once again, and this time the commission went ahead.

Work on the fountain was completed in August 1872, and the inauguration took place in the same month, 'in the presence of several thousand of the worthy citizens'. It was an immediate popular success. The *Building News* reported that as '… an architectural work, this fountain is the subject of universal admiration, the profession, the press, and the public uniting … in giving it almost unqualified praise'.[12]

For the *Glasgow Citizen*, Mossman's contribution was worthy of particular commendation:

The crowning ornament is the figure of the 'Lady of the Lake', by our distinguished local artist, Mr. Mossman. The sculptor has been happy in his realisation of the poet's beautiful ideal –

And ne'er did Grecian chisel trace
A Nymph, a Naiad, or a grace

Of finer form or lovelier face.
[*The Lady of the Lake*, Canto I, v.18]

From all points the *pose* of the 'Lady' is graceful and dignified.[13]

James Young's work on the carved sections of the fountain were also described as 'alike spiritedly modelled, and excellently executed'.

There were, however, dissenting voices. The author of the 'Gossip from Glasgow' column in the *Building News*, for example, was much less enthusiastic about Mossman's statue:

It would perhaps be too much to say that the gilding of the statue … is as the gilding of refined gold, a 'wasteful and ridiculous excess'; it may, however, be safely said that the result attained is far from satisfactory … There is certainly not the calm beauty in the statue in situ that there is in the plaster cast in Mossman's studio.[14]

He went on to make the curious prediction that

Time (although not generally an improver of ladies) may, with an atmosphere impregnated with the various products of Glasgow factory chimneys, perhaps yet restore the Lady of the Lake to what I have no doubt was at once the sculptor's and the architect's desire.[15]

This writer's criticism was not confined only to the sculpture; its problems were more fundamental:

But while … admirable architecturally, I fear that the fountain as a fountain is not altogether a success. If, as the great dramatist says,

Men's evil manners live in brass, their virtues
We write in water,

it can scarcely be complimentary to the memory of Lord-Provost Stewart, the water being so scant and the brass so plenteous; if,

however, the chief idea sought to be impressed is that the water from Loch Ketturin [*sic*] is a most valuable boon to the community, then this could have been better illustrated than by showing that it is much too valuable to be wasted upon 'inexplicable dumb show'. The water is not only petty in quantity, but the playing of it is commonplace to a degree, and this poverty of play is felt the more when we look at the eminently suggestive outlines of the building. Besides, more water and a different treatment were required by a very important consideration. The statue on the summit is wholly gilt … and so much brilliance requires some support, which it would have received from glassy domes, cascades and curtains. Instead, the water trickles in tiny rills from beneath the statue's feet, as if the thought intended to be conveyed was that the Lady of the Lake was the discoverer of the source of the Lake, not that Loch Ketturin was bounteously bestowing its water upon Glasgow.[16]

Because the fountain's hydraulic system has been out of operation for a number of years, it is impossible to gauge today how fair this criticism is. Contemporary photographs do indeed suggest that the play of water erred a little on the side of restraint, and consisted only of a series of isolated jets, some propelled upwards from within the outer basin, but mostly falling in a multitude of slender over-flows from gargoyle spouts. At the same time, this appears to have been precisely what Sellars wanted. As the *Glasgow Herald* noted: 'In his design Mr. Sellars has judiciously kept in view that the structure should not be a mere garden fountain, depending on water jets for its outlines, but a monument architecturally grand in itself.'[17]

Even so, despite its undoubted grandeur, one suspects that the impression the fountain made on Sellars' contemporaries was not so much a structure designed to marshall a joyous

abundance of aquatic movement and sound as a building that merely happens to be full of leaks. A recent description of it as being like a 'vast Victorian cruet-stand', seems a little harsh, however.[18]

Condition: As with most public fountains conceived in periods of municipal prosperity, the *Stewart Memorial Fountain* has suffered from more recent fluctuations in the city's fortunes. Maintenance problems began to occur within little more than a decade of its completion, and although at first these were merely matters of recoating the bronze statue and reliefs,[19] by the mid-1890s the granite rim of the outer basin was in need of repair, and the pipework required some attention to restore it to good working order.[20] In 1937, one of the cast iron cherubs that stood leaning on a paddle above the four drinking fountains on the outer rim (see 'Related work', below) was damaged and had to be restored.[21] When it was reinstated two years later, it was found that another one had been broken in the meantime, and the council decided to remove all four permanently.[22] At some point the eight stone birds of prey perched on the side pillars of the 'reliquaries' were also removed, possibly in 1951, when the Mossman firm was commissioned to make a number of repairs to the fabric.[23]

In 1988 a complete restoration programme was initiated by the Bridgegate Trust, at a cost of £158,000, enabling 'the water to flow once more, for the pleasure of all who see it'. Sadly, the pleasure turned out to be short-lived, and by the middle of the 1990s a combination of persistent vandalism and recurring difficulties with the pipework forced the council to disconnect the water supply and suspend all further maintenance activity. Deterioration of the masonry continues, and at the time of writing both unicorns are without horns and the head of one of the first-storey dragons is in the process of detaching itself from its body. With its smaller basins filled with stagnant puddles, its extensive surface graffiti and general air of dilapidation, the architectural wreck that exists today is not much more than a melancholy reminder of the splendid object inaugurated in August 1872. In September 2000, however, the city council announced its intentions to refurbish the fountain for a second time.[24]

Related work: The cherubs which originally stood on the four pedestals on the outer basin appear from old photographs to have been identical to those on the drinking fountain at the gates of Alexandra Park (q.v., Alexandra Parade) and the *John Aitken Memorial Fountain* on Govan Road (q.v., Appendix B, 'Minor Works', cherub also lost). These were probably acquired as a standard mass-produced item from the catalogue of the founders Cruickshank & Company of Denny.

Notes
[1] Sir Walter Scott, *Poetical Works*, Edinburgh, 1871, pp.243–344. [2] Thomas Annan and James M'Gale, *Photographic Views of Loch Katrine etc.*, Glasgow, 1877, p.28. [3] See J.H Paterson, 'The Novelist and his Region', *Scottish Geographical Magazine*, vol.81, no.2 (1965), pp.146–52. [4] Ibid., p.7. [5] GCA, D-TC 14/1/17, 12 December 1867, p.1056. [6] *Ibid.* [7] *Ibid.*, p.1066. [8] BN, 23 August 1872, p.141. [9] GCA, D-TC 14/1/17, 9 November 1870, pp.1066–7. [10] *Ibid.*, p.1068. [11] *Ibid.*, 9 December 1870, pp. 1068–9; BN, 23 August 1872, p.141. [12] BN, 23 August 1872, p.141. [13] Quoted, *ibid.* [14] BN, 27 September 1872, p.240. [15] *Ibid.* [16] BN, 23 August 1872, p.141. [17] Quoted, *ibid.* [18] GH, 23 March 1953. [19] GCA, D-TC 14/1/17, 13 April 1888, p.1083. [20] *Ibid*, 28 May 1895, p.1086. [21] GCA, C1/3/96, 21 April 1937, p.1561. [22] GCA, C1/3/100, 6 September 1939, pp.2797–8. [23] GCA, C1/3/121, 28 February 1951, p.1789. [24] 'Why the water ran dry …', *Glaswegian*, 23 September 1999, p.11.

Other sources
BN, 7 February 1868, p.91, 13 October 1871, p.276, 23 February 1872, p.150; GCA, D-TC 13/661 (plans for site, 1871); GH, 15 August 1872, p.3; 'Men you know – No.105', *Bailie*, no.105, 21 October 1874, pp.1–2; Sir Bernard Burke, *The General Armory of England, Scotland, Ireland and Wales*, London, 1884; Gildard (1892), p.3; McLellan, pp.49–50; 'Noremac', p.39; Read, p.365; Read and Ward-Jackson,

4/11/1–15; Williamson *et al.*, pp.281–2; McKenzie, pp.86, 97 (ill.).

At the eastern end of Prince of Wales Bridge

Highland Light Infantry Memorial
Sculptor: William Birnie Rhind

Unveiled: 28 September 1906
Material: grey sandstone
Dimensions: figure colossal; figure and base 4.28m high
Inscription: in bronze letters attached to the front of the base – TO THE MEMORY / OF / THE OFFICERS / NON-[C]OMMISSIONED OFFICERS [AND M]EN / OF THE / HIGHLAND LIGHT INFANTRY / WHO FELL / IN THE SOUTH AFRICAN WAR / [1]899 1900–01–02 / ERECTED BY COMRADES AND FRIENDS. A bronze plate on the rear of the base lists the soldiers of the 1st, 3rd and 4th Battalions, Mounted Infantry Companies and Volunteer Service Companies who died in action
Listed status: category A (20 May 1986)
Owner: Glasgow City Council

Description: The monument takes the form of a 'vigorous representation of a soldier engaged in scouting duty' and is designed to convey 'a vivid impression of the strenuousness of active military service'.[1] Wearing a sola topi and puttees, and equipped with a rifle, amunition belt, water canister, bed-roll and satchel, the soldier is shown clambering over a naturalistically carved rock as if responding to an unexpected event. His eyes are fixed on the near distance, and his posture is expressive of the urgency of the situation in which he finds himself.

Discussion: The council's original intention was to erect the monument in Glasgow Green, at the junction of the main carriageways opposite the Courthouse,[2] but in response to the 'strongly-expressed desire' of the

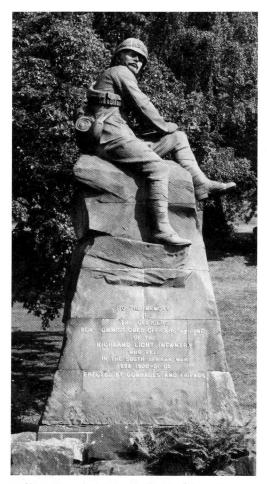

William Birnie Rhind, *Highland Light Infantry Memorial*

subscribers, the Kelvingrove Park site was allocated instead.[3] It was the first war memorial to be erected in the Park. A contemporary commentator observed that it was 'fitting that the memorial of the officers and men of the Glasgow Regiment who sleep their last sleep in the sun-scorched plains of Africa should occupy a commanding position in one of the most popular resorts in the city'.[4] It should be noted also that the directional axis of the bridge focuses the implicit drama of the soldier's gaze, while the small rock garden in the centre of the triangular plot provides an effective complement to the rusticated base on which he sits.

The unveiling ceremony was performed by Field Marshal the Duke of Connaught, Inspector-General of the Forces and Colonel-in-Chief of 'the Regiment whose bravery the monument is designed to perpetuate'. Dressed in the uniform of the Highland Light Infantry, he was received at the City Chambers by Lord Provost Bilsland and escorted by a troop of Scots Greys through the streets of Glasgow, which were lined by 'crowds of spectators, whose hearty cheers were freely acknowledged by His Royal Highness'. In the immediate vicinity of the Park, many householders displayed flags from their windows. The Park itself 'looked radiant in the bright sunshine', and it was noted that 'long before the time fixed for the formal ceremony the air was filled with the martial strains of a band of pipers'. A guard of honour was provided by the 2nd Battalion of the HLI, accompanied by about 'eighty bemedalled veterans'.[5] In a spectacle 'calculated to stir the most languid pulse', the programme included a performance by the pipers of the 'pathetic strains of the "Flowers of the Forest"', followed by the 'Last Post' from the buglers.[6] The Duke's address to the gathering, which began after the 'final melancholy note had died away', was followed by an acceptance speech by Councillor Mitchell, who stated that:

> To possess such a work of art was something to be proud of; but to know that it spoke of the bravery of the officers and men of a Regiment which had been so long and so closely associated with Glasgow must fill the heart of every citizen with deep gratitude.[7]

The event concluded with the Duke's departure by carriage to Buchanan Street Station, where he 'joined the 5 p.m. Grampian Express for Aberdeen en route to Balmoral'.[8]

Condition: Despite Councillor Mitchell's description of the monument as a 'treasure' which the 'Corporation would cherish ... as something to be jealously cared for',[9] it was necessary within a year to erect an iron railing around the site, 'for the protection of the H.L.I. Memorial'.[10] This work was carried out by A. & J. Main & Co. Ltd, for £33.[11] In 1933, in response to a letter from the Secretary of the Highland Light Infantry Regimental Association drawing attention to the condition of the stonework, the council carried out a programme of restoration work on the statue. The council minutes record that a 'special process for cleaning and preservation' was used, but do not specify what this was.[12] More recently, some damage has occurred to the rifle in the soldier's left hand, which lacks its barrel and butt. In all other respects, the condition of the monument is very good.

Related work: Stylistically similar war memorials by Rhind include the two-figure monument in Tilligarth Park, Alloa, and the more complex battle narrative of the *Royal Scots Guards Memorial* in St Giles Cathedral, Edinburgh. Models for both works were exhibited at the Royal Scottish Academy exhibition, 1904 (nos 407 and 344 respectively).[13]

Notes
[1] Anon., 'Unveiling of the H.L.I. Memorial'. *Highland Light Infantry Chronicle*, December 1906, pp.129–34. [2] GCA, C1/3/33, 2 August 1905, p.2267. [3] *Ibid.*, C1/3/34, 7 March 1906, p.1024. [4] Anon., *op. cit.*, p.129. [5] *Ibid.* [6] *Ibid.*, p.132. [7] *Ibid.*, p.133. [8] *Ibid.* [9] *Ibid.* [10] GCA, C1/3/36, 19 November 1906, p.264. [11] *Ibid.*, C1/3/37, 19 April 1907, p.1508. [12] *Ibid.*, C1/3/89, 21 June 1933, p.2021. [13] *Academy Architecture*, 1904[II], p.88.

Other sources
GH, 29 September 1906; 'Noremac', pp.39–41; Bliss, p.3; private correspondence from Major W. Shaw to Gary Nisbet, 29 January 1988; Williamson *et al.*, p.282; McKenzie, pp.90, 91 (ill.).

West of mid-point of Kelvin Way, beside the putting green

Monument to Lord Kelvin

Sculptor: Archibald Macfarlane Shannan

Founder: J.W. Singer & Sons
Date: 1908–13
Unveiled: 8 October 1913
Materials: bronze statue on a Creetown granite pedestal
Dimensions: figure approx. 2m high; pedestal 1.48m × 2.98m × 2.3m
Signed: on the rear of the plinth, right side – A. MCF. SHANNAN ARSA / SCULPTOR GLASGOW; on the front of the plinth, right side – SINGERS FOUNDERS / FROME
Inscription: on the cartouche at base of pedestal, front – KELVIN
Listed status: category B (15 December 1970)
Owner: Glasgow City Council

William Thomson, Lord Kelvin (1824–1907) scientist. Born in Belfast, son of James Thomson, Professor of Mathematics at Glasgow University, he entered Glasgow University at the age of ten; he later studied in Cambridge, winning numerous prizes, and in Paris. At the age of 22 he was made Professor of Natural Philosophy at Glasgow University, where he remained a dominating figure for 53 years. His specialist fields were thermo-electricity and the design of marine instruments, and his discoveries were a source of inspiration to scientists for over half a century. It was as a result of his researches into submarine telegraphy that the first trans-Atlantic cable was laid. He was also the first to determine mathematically the Absolute Zero of Temperature, and the Kelvin temperature scale is named after him. His papers and lecture tours led to numerous honours, and he was knighted (1866), raised to the peerage with the title Baron Kelvin of Largs (1892), and became President of

the Royal Society (1890). He died at Netherhall, his home near Largs, and was buried in Westminster Abbey.[1]

Description: The subject is depicted seated, wearing the academic gown of his *Alma Mater*, Cambridge University, notebook in hand and pencil poised as if he is about to write. To the rear of his chair is a group of scientific instruments 'symbolical of the departments of science in which [he] achieved fame',[2] including a mariner's compass and a navigation sounding machine. The back of the seat itself reproduces in relief the insignia of the University of Glasgow – a standing Bishop framed by the motto 'VIA VERITAS VITA' (trans.: 'the way, the truth and the light') – under a projecting Gothic canopy. The rear of the pedestal also has a cartouche identical in design to the inscription tablet at the front, but without a text.

Discussion: On 5 May 1908, five months after Lord Kelvin's death, the Lord Provost William Bilsland convened a meeting in the City Chambers in response to the 'widely expressed opinion … in the City and the West of Scotland that a Memorial should be erected in Glasgow to signalise the exalted genius and profound scientific achievements of the late Lord Kelvin'. The meeting resolved to 'establish a worthy Memorial of [Lord Kelvin] in the City where he lived and laboured', and to 'inaugurate a Subscription Memorial Fund for the purpose of carrying out the foregoing Resolution'.[3] Those attending the meeting responded generously, donating more than £1,400,[4] and with further subscriptions pouring in over the following months, the fund had reached £2,750 by October. This, however, was still short of the estimated £3,000 required for the monument, and it was necessary for the Provost to make a discrete appeal to those members of the committee who had not so far subscribed.[5] On 11 December, the chairman of the committee was able to report that the funds stood at £3,027 8s., and that the project could therefore proceed.[6]

On the question of who should be invited to make the work, the committee's deliberations were pre-empted by the arrival in October of a letter from Archibald Macfarlane Shannan, who asked to be considered for the commission on the grounds that he had made a portrait bust of Kelvin while he was alive. His plea was supported by a letter from the distinguished painter Sir James Guthrie, President of the RSA, recommending Shannan as a 'competent sculptor for such work'.[7] The committee appear to have felt this to be sufficiently reliable testimonial and awarded the commission to Shannan, but only 'on the distinct condition that [he] submits a model that shall meet with the Committee's approval and acceptance'.[8] Discussions with Shannan began immediately, and it was agreed ('on Mr Shannan's own

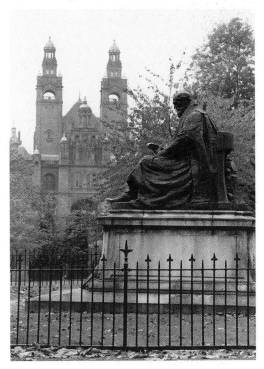

Archibald Macfarlane Shannan, *Lord Kelvin* [RM]

suggestion') that he should produce a pair of clay models, three feet high, one showing the subject seated and the other standing.[9] In the event he produced three such models – two standing and one seated – which were inspected in his studio at 36 Buccleuch Street by a sub-committee.[10] The sub-committee included the distinguished architect J.J. Burnet, with whom Shannan had earlier collaborated in executing his *Monument to Mrs John Elder* (Elder Park, q.v.). In February 1910, plaster casts of all three were presented to a 'sub-executive committee', which, after deciding to adopt the seated version, instructed Shannan to proceed with the production of the full-size model in clay.[11] This was inspected in Shannan's studio and approved for casting in October of the following year.[12]

During all this time, and indeed almost up to the final completion of the statue itself in the autumn of 1912, the matter of where it should be located had remained unresolved. In the early stages of the planning the consensus was that 'an appropriate situation would be George Square, preferably the south east corner facing the General Post Office, if available'.[13] Of course, it was not available: the *Monument to Thomas Graham* had occupied that particular corner since 1871, as the members of the committee will have discovered on the evening of 16 December 1908, when they concluded their meeting by walking to George Square to inspect the site for themselves.[14] In fact George Square was already being heavily criticised for what some commentators regarded as its overcrowding with memorials (see George Square, Introduction). No such problem existed in Kelvingrove Park, and it was here, on the site of the bandstand originally constructed for the 1888 International Exhibition, that Shannan's finished bronze finally found a home.[15]

A recurring theme in the documentation of this monument is the element of doubt regarding the adequecy of a statue as a memorial to a figure of Kelvin's historical stature. For example, in his letter of apology for his absence at the inaugural meeting of 1908, Lord Inverclyde wrote that he would 'almost be inclined to have said that no greater memorial could exist than his compass and his sounding machine'. The sentiment was echoed by Principal MacAlister, who asserted that: 'Lord Kelvin needed no memorial to keep his name upon the lips and in the minds of men', and that it was only because 'Glasgow owed it to herself to establish in some permanent form a signal embodiment of her gratitude for his life-long service' that the memorial was justified.[16] A similar ambiguity is evident in the speeches at the unveiling ceremony. In its report on the event, the *Glasgow Weekly Herald* paraphrased the address of A.J. Balfour MP, who observed that

> Lord Kelvin's fame did not rest upon statues, but upon a surer foundation – upon the gratitude with which posterity would look back upon achievements which had never been surpassed in the whole annals of physical science. (Cheers.)[17]

His fellow MP, Augustine Birrell, the Lord Rector of Glasgow University, went further, describing statues as 'often doubtful joys', and speculating that

> … some day orators might be employed to go about the country, not unveiling but veiling old statues, and delivering speeches not in appreciation but in depreciation [*sic*] of their subjects, and showing cause why their effigies should no longer be allowed to thrust themselves upon public attention.[18]

No doubt recalling the purpose of the event at which he was speaking, he immediately qualified his remarks with the prediction that: '… no such unkind fate would ever befall the statue which it is now his honour to unveil. (Laughter and cheers.)' The report goes on to note that the '… right hon. gentleman then withdrew the covering, and asked the Lord Provost to take care of a beautiful memorial to a truly memorable man'.[19]

Shannan received a total of £3,000 for the work, 'inclusive of pedestal and other accessories'. Payment was in regular instalments of £500, the last of which was made on the day of the unveiling.[20]

Related work: The bank interest on the capital from subscription left a surplus £266, of which £250 was used by the committee to purchase a bronze statuette of Kelvin, the sketch for the Kelvingrove Park monument, from Shannan's widow.[21] This is now in Kelvingrove Art Gallery (S.146), which also owns a statuette of Kelvin in a standing pose (S.147), purchased in 1920. A marble bust of Kelvin by Shannan, gifted to the Royal Society of Edinburgh by Professor Crum Brown in the name of Lady Kelvin, was exhibited at the RSA in 1916 (no.53). Other busts by Shannan were exhibited at the RGIFA in 1897 (no.908, lent by the Glasgow Philosophical Society) and 1908 (no.706); and at the RSA in 1897 (no.100, lent by the Glasgow University Students' Union) and 1907 (no.201). The RGIFA also exhibited a work entitled 'Lord Kelvin' in 1913 (no.25), though whether this was a bust or a full figure is not known.[22]

Condition: The statue has been coated with brown paint, which is flaking to reveal some surface corrosion and patches of oxidisation; there is also some green algae. Structurally the monument is in excellent condition.

Notes

[1] EB, vol.10, pp. 414–15. [2] GH, 9 October 1913. [3] GCA, TD 1073/13/15. [4] *Ibid.* [5] GCA, *Minute Book of Lord Kelvin Memorial Fund*, G4/1, p.61. [6] *Ibid.*, p.66. [7] *Ibid.*, p.62. [8] *Ibid.* [9] *Ibid.*, p.67. [10] *Ibid.*, p.69. [11] *Ibid.*, p.70. [12] *Ibid.*, p.73. [13] *Ibid.*, p.62. [14] *Ibid.*, p.67. [15] *Ibid.*, p.74. [16] GH, 6 May 1908, p.12. [17] *Glasgow Weekly Herald*, 11 October 1913, p.9. [18] *Ibid.* [19] *Ibid.* [20] *Minute Book*, pp.73, 79, 80–1, 94. [21] *Ibid.*, p.95. [22] Laperriere, vol.4, pp.146–7; Billcliffe, vol.4, p.106.

Other sources
BI, 16 May 1908, p.29; B, 4 July 1908, p.12; GCA,

C1/3/46, pp.276, 1734; Williamson *et al.*, p.282; Read, p.365; Read and Ward-Jackson, 4/11/34–37; McKenzie, pp.90, 91 (ill.).

On the eastern side, overlooking the Park from Park Circus

Monument to Field Marshal Earl Roberts

Sculptors: Harry Bates (modeller); prepared for casting by E.A. Rickards assisted by Henry Poole

Founder: J.W. Singer & Sons
Date: 1915–16
Unveiled: 21 August 1916
Dimensions: 3.5m high (statue); 5.64m high (pedestal)
Materials: bronze statue, subsidiary figures and narrative reliefs on a granite pedestal
Signed: on the plinth of allegorical figure of *War* – SINGERS / FOUNDERS (left side, front)
Inscriptions: on the north face of the pedestal – FIELD MARSHAL EARL ROBERTS / OF KANDAHAR PRETORIA AND / WATERFORD V.C. K.G. K.P. / G.C.B. O.M. G.C.S.I. G.C.I.E. / BORN IN I[N]DIA / 30TH, SEPTEMBER 1832 / DIED IN FRANCE WHILE O[N] A VISIT TO THE / TROOPS ENGAGED IN THE GREAT WAR / 14TH, NOVEMBER 1914; on the south face of the pedestal – INDIAN MUTINY · UMBEYLA · ABYSSINIA · LUSHAI · AF[G]HANISTAN / BURMAH · SOUTH AFRICA / 'I SEEM TO SEE THE GLEAM IN THE NEAR DISTANCE / OF THE WEAPONS AND ACCOUTREMENTS OF THIS ARMY / OF THE FUTURE, THIS CITIZEN ARMY, THE WARDER OF / THESE ISLANDS, AND THE PLEDGE OF THE PEACE AND / OF THE CONTINUED GREATNESS OF THIS EMPIRE' / EXTRACT FROM LORD ROBERTS' SPEECH IN GLASGOW ON 6TH, MAY 1913. Note: On the north face the groups of letters indicating Roberts' various awards are separated by bronze facsimiles of the medals associated with them (e.g., 'O.M.' is followed by a cross-shaped medal inscribed 'For Merit'). Further medals appear on the south face, though these hang from ribbons in a line separating the two sections of text. For additional minor inscriptions, see below.
Listed status: category A (15 December 1970)
Owner: Glasgow City Council

Frederick Sleigh (1st Earl) Roberts (1832–1914), British soldier. Born at Cawnpore, India, second son of General Sir Abraham Roberts, and educated at Eton, Sandhurst and Addiscombe. Received a commission in the Bengal Artillery in 1851 and acted as *aide-de-camp* to his father at Peshawar in 1852. In 1856 he was appointed to the quarter-master general's department of the staff where he remained for 22 years. During this time he distinguished himself on several occasions, notably at the engagement of Khudaganj in 1858, where he won the VC for gallantry, and at the capture of Lucknow in the same year. He was also involved in the campaigns in Abyssinia (1868) and Lushai (1871), and in 1878 he commanded the field forces on the frontier with Afghanistan, where after a series of brilliant manoeuvres he quelled the insurgent Afghans and captured Kabul. The following year he relieved the British forces besieged at Kandahar in a famous battle which was fought after a 300–mile march. In 1881 Roberts was sent to Natal as commander-in-chief of the forces, but by the time he arrived peace had been made with the Boers. He returned to India and in 1885 succeeded Sir Donald Stewart as commander-in-chief in India, a position he held until 1892. During the Boer War, 1900, he commanded the British troops in South Africa until the relief of Mafeking and the capture of Pretoria, when he returned to England to succeed Lord Wolsely as commander-in-chief of the army. From 1905 onwards he devoted his time to advocating compulsory military service in Britain. After the outbreak of war, 1914, he

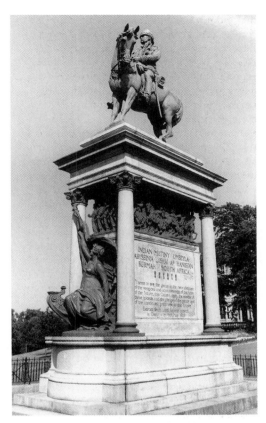

Harry Bates, *Monument to Earl Roberts*

was a frequent visitor at the War Office. He died at St Omer after an attack of pneumonia while on a visit to the troops in the trenches. He was buried in St Paul's Cathedral.[1]

Description: Roberts is depicted wearing a pith helmet and military tunic and is mounted on his Arab charger 'Volonel'. A distinctive feature of the work is the effect of disciplined rapport suggested in the relationship between horse and rider; the soldier is confident and alert, the animal dynamic and tense, as if awaiting the signal to spring forward. From the beginning, however, it was the artist's intention

that the work should read as more than a mere portrait elevated on a granite slab. In Susan Beattie's words, the equestrian group was conceived as 'the culmination of an aesthetic experience which begins … at the base of the pedestal'.[2] With its four corners defined by bronze-capped Ionic columns, the pedestal is in fact a powerful visual conception in its own right, amplifying the theme of military conquest through an elaborate programme of narrative and symbolic imagery. On the front face sits a bronze figure of *Victory*, colossal in scale and modelled fully in the round. In a gesture of triumph, her right hand thrusts a lance into the air, unfurling a standard which billows back to enclose her semi-naked torso, while below her the prow of a ship projects forward several feet from the base of her throne, its sides decorated with reliefs of a victory parade, a pair of naked male and female figures and the motto 'VIRTUTE ET VALORE' (trans.: 'by virtue and courage'). The ebullience of *Victory* is balanced at the rear by an armoured figure representing *War*. Seated on a pair of crossed mortars, and naked apart from a helmet and chain mail tunic over his knees, the figure is conceived as the epitome of masculine sternness and restrained physical power, his destructive potentials acted out metaphorically by the miniature relief of a lion attacking a horse on the outer face of his shield.

The entire upper section of the pedestal is devoted to a narrative frieze depicting scenes from Roberts' march from Kabul to Kandahar, leading the infantry and cavalry divisions of the Sikh, Highlander and Gurkha regiments. The treatment of the figure groups here reveals the full range of Bates' skill in the manipulation of illusionistic spaces, and his management of the transition between the front, side and rear planes is both witty and visually convincing. Equally well observed is the group of mounted soldiers on the right side. Modelled almost in the round, and handled with great expressive force, they bear an uncanny resemblance to Roberts himself, as if Bates intended them to be

read as miniature variations on the main statue.

As with many great public monuments of this kind, the artist's interpretation of the theme is embodied as much in the decorative details as in the principal symbols. A close examination of the bronze capitals of the corner columns, for example, reveals an inventive elaboration of the conventional Ionic form, with the volutes entwined with grotesque sea monsters and hung with tiny copies of the helmets worn by Roberts and the figure of *War*. Woven into the design is a series of wreaths containing the letter 'R', which alternate with diminutive reprises of the motto 'Virtute et Valore', already familiar from the inscription on the prow of the ship below.

Discussion: Glasgow responded swiftly to the news of the death of Earl Roberts in November 1914, and before the month was over an executive committee had been formed to discuss the possibility of erecting a memorial.[3] The proposal met with widespread popular support. As much as £1,000 was pledged at the inaugural meeting,[4] and by the middle of the following January the total contributions had risen to just over £6,000.[5] A distinctive aspect of the approach to fund-raising was the designation of an official Lord Roberts 'Flag Day' as a way of enabling 'all classes of the community' to make a contribution.[6] This took place on 26 December, with over 4,000 volunteers, mostly women but assisted by members of the Glasgow Boys' Brigade, distributing 250,000 souvenirs of Roberts in exchange for small donations. Promoted under the slogan 'a bob for Bob's Day',[7] it was not, as the *Glasgow Herald* pointed out

> … a 'flag day' strictly speaking. In place of miniature standards a button bearing a [photographic] likeness of Lord Roberts will be offered… In addition, there are 12,000 postcards, the gift of Mr Thomas E. Baird, stationer.[8]

Collectors were on the streets from 8am to 7.30pm, concentrating particularly on 'public works, railway stations, the tramway cars, and football matches', and with the coverage extended until 9.30pm for 'places of amusement'.[9] At the end of the day the collection boxes were delivered to the Queen Street branch of the British Linen Bank (q.v., Appendix A, Lost Works), the staff of which 'patriotically sacrificed a portion of their Christmas holidays' to count the takings.[10] A total of £1977 15s. 2d. was collected.[11]

If the fund-raising was a remarkable success, the question of the form the memorial should take was no less speedily resolved, largely as a result of an intervention by the Earl's widow, the Dowager Countess Roberts, who suggested that the memorial should be a duplicate of Harry Bates' much admired equestrian portrait of her husband, erected in Calcutta in 1898. In a letter to the council, she drew attention to the fact that the plaster model for the statue – a 'beautiful work of art and a perfect likeness' of her husband – was still in the possession of Bates' widow. 'I fancy', she went on, 'it would cost a great deal less to have it reproduced than to get another designed and cast and I don't think there is any one now living who could produce so excellent a statue.'[12] The committee immediately made contact with Mrs Bates, who offered to organise the production of a copy for £5,000, inclusive of all foundry work and granite carving.[13] After studying photographs of the Calcutta original and the plaster cast then on display at the Crystal Palace, the committee unanimously agreed to accept the offer, albeit on a reduced estimate of £4,500.[14]

The prospect of producing a second cast from Bates' original masterpiece proved highly attractive, and several sculptors contacted the council 'offering their services'.[15] These included Sir George Frampton, who asked Sir Nathaniel Dunlop to

> … tell the Lord Provost that it will give me

real pleasure to place my services at his disposal in connection with seeing the monument through to its final completion. I have always considered Bates' monument to be one of the finest works of art of our time.[16]

It is not clear if Frampton was proposing himself for the commission to supervise the work; if so, his appeal was disregarded, and the committee acceded to Mrs Bates' recommendation that the work should be given to E.A. Rickards, of the firm Lanchester, Stewart & Rickards, assisted by Henry Poole, who had worked with her husband on the Calcutta statue. The casting was to be done by J.W. Singer & Sons, of Frome, Somerset.

From the committee's point of view the simplicity of this arrangement had a number of practical advantages, and unlike so many major public commissions in Glasgow, the Roberts memorial was brought to completion within the time stipulated in the contract, in this case one year, and almost entirely without a hitch. In October, only eight months after the agreement was signed, Henry Poole was able to report that 'considerable progress had been made with the bronze founders and the granite firm',[17] and by the following month the statue was ready for inspection at the foundry by a council sub-committee. Mrs Bates herself seems to have played an active part in the development of the project, and contributed a suggestion that the centre of the pedestal should incorporate drainage channels to reduce the effects of erosion and discoloration from rainwater.[18]

Towards the end of 1915 the committee began to give serious thought to the two outstanding issues that required a decision: the question of a site for the statue and the date of the unveiling. Arrangements were made for a sub-committee to visit Kelvingrove Park on 1 December, in order to inspect 'the site desired at the Flag Staff … in front of Park Terrace and also the site in front of the Art Galleries'. The minutes record that the Superintendant of Parks, 'in anticipation of the visit caused to be erected a skeleton frame work showing the height of the statue and its dimensions so as to enable the committee to appreciate the effect on both positions'.[19] Of the two options, the 'commanding site' beside the flagstaff was the preferred choice.

On the matter of the unveiling, there was some discussion as to whether the ceremony should take place immediately after the statue was completed or delayed until the end of the War. It was unanimously decided that it should proceed 'as soon as possible',[20] though last-minute delays at Singer's, due to the pressure of war work, meant that the installation of the monument did not take place until 5 July 1916,[21] with the consequent postponement of the planned unveiling from spring to August.

The unveiling itself was a massive popular success. The programme began with a parade of veterans and active servicemen in George Square, who later marched to St Andrew's Halls for a lunch accompanied by a concert of popular vocal and instrumental music, and later proceeded to Kelvingrove Park to join the main celebrations. Here the proceedings, which 'started with military promptitude sharp on three o'clock', were both brief and 'unaccompanied by oratory'. The committee's original intention was that the unveiling should be performed by the Dowager Lady Roberts in the company of Lord Rosebery. Neither was able to attend, Lady Roberts because of ill-health, and Lord Rosebery because he had 'retired from the unveiling business'. Their places were taken by the Dowager's daughter, Lady Roberts, and the Earl of Derby. The formalities began with an inspection of the lines of veterans, 'who made a brave display with their gleaming medals and faded ribbons', followed by an invitation by the Lord Provost to Lady Roberts to

… unveil the memorial to her illustrious father, and, the cord being pulled, the Union Jack which enwrapped the statue dropped, revealing the martial figure of the great soldier on his famous charger. Loud cheers were raised and were taken up by the crowds in the distance.

The invited guests then repaired to Kelvingrove Museum for a reception in the Sculpture Hall where toasts were offered to, among others, Mrs Bates and Henry Poole, both of whom were present.[22]

In March 1917, the council began the process of winding up the affairs of the memorial, which included disposing of the surplus funds. The total sum raised from the subscription, including bank interest, had been £6,699. 8s. 1d. After paying £4,500 to Mrs Bates, who dealt directly with the founders and other tradesmen, the remainder was distributed variously between the Glasgow Branch of the Soldiers' and Sailors' Help Society (£1,000); the Glasgow Soldiers' Home (£200) and J.W. Singer, for additional lettering on the inscription (£63 11s.). Small honoraria were also paid to the committee's secretary and treasurer, Mr Samuel and his assistant Mr Scringeour.[23] This was not quite the end of their dealings with the monument, however. In December 1921, it became necessary to protect the statue from vandals, and the Parks Sub-Committee arranged for it to be enclosed by a railing.[24]

The Kelvingrove monument was not the only replica to be made from Bates' Calcutta original, and in 1924 Henry Poole produced another version for Horse Guards' Parade in London. This, however, consists only of the horse and rider group, mounted on a plain pedestal, and thus disregards a central aspect of Bates' sculptural intentions. Indeed, the strength of his desire to ensure that the base was worthy of the dynamic vitality of the portrait it supports can be judged by the fact that the 'embellishments' of the pedestal, which were not part of the original contract for the Calcutta

monument, were produced not only on his own artistic initiative but also at his own personal expense. It very nearly ruined him.[25] In Glasgow, the dramatic impact of his solution is underlined by the sheer magnificence of its location. Seen from below, it provides a visual climax to the picturesque sweep of the Park's eastern slopes; approached from Park Circus it 'commands' (the word is surely appropriate in this case) practically the entire spectacle of the West End, including the University on Gilmorehill and, when the trees are not in leaf, Kelvingrove Museum. As an essay in urban monumentalism, Bates' design is by consent one of the most successful works of its kind, perhaps anywhere in the world, and was admired not only by fellow sculptors such as Frampton, but also the wider artistic community; the painter G.F. Watts, for example, described the Calcutta prototype as 'without exception the finest equestrian statue of modern times'.[26] Local commentators, however, have often criticised the treatment of the horse's head, pointing out that when viewed from the south west, 'the animal seems headless – a serious disadvantage to the spectator'.[27]

Condition: The bronze portions of the monument have been coated with brown paint, and the pedestal is disfigured by a small amount of surface graffiti. Damage to the fabric of the statue includes the loss of the miniature image of *St George and the Dragon* which terminated the prow of the ship of the allegorical figure of *Victory*.[28] Described by Susan Beattie as 'a little *tour de force* of expressive modelling', the theft of this detail is one of the most serious acts of criminal damage to be suffered by a public monument in Glasgow in recent times. One of the small tube-like projections on the helmet of *War* has also been broken off.

Related work: In her letter apologising for not being able to attend the unveiling, the Dowager Lady Roberts referred to a model of the monument, 'about six feet high (pedestal and all) on the staircase' in her home at Ascot,

and which she described as 'a constant joy' to her.[29] A statuette of Roberts belonging to Bates' widow was also exhibited at the 1901 International Exhibition in Kelvingrove Museum (no.202).[30]

Notes
[1] Stevenson (n.d.), n.p. [2] Beattie, p.220. [3] GCA, *Minute Book of Lord Roberts Memorial Fund*, G4/1, 26 November 1914, p.100. [4] *Ibid.*, 30 November 1914, p.104. [5] *Ibid.*, 13 January 1915, p.117. [6] GH, 23 December 1914, p.6. [7] ET, 24 December 1914, p.5. [8] GH, 26 December 1914, p.4. [9] *Ibid.* [10] ET, 24 December 1914, p.5. [11] *Minute Book*, 13 January 1915, p.117. [12] *Ibid.*, 13 January 1915, pp.118–19. [13] *Ibid.*, 13 January 1915, pp.120–1. [14] *Ibid.*, 22 January 1915, p.125. [15] *Ibid.*, 13 January 1915, p.122. [16] Ibid., 22 January 1915, p.125. [17] *Ibid.*, 22 October 1915, pp.132–3. [18] *Ibid.*, 13 January 1915, pp.137–8. [19] *Ibid.*, 13 January 1915, p.136. [20] *Ibid.*, 13 January 1915, p.136. [21] *Ibid.*, 5 July 1916, pp.141–3. [22] 'Lord Roberts: Statue Unveiled at Glasgow', GH, 22 August 1916, p.5. [23] *Minute Book*, 28 March 1917, pp.154–6. [24] GCA, C1/3/66, p.528. [25] Beattie, p.220. [26] *Ibid.*, p.229. [27] Bliss, p.3. [28] See Read and Ward-Jackson, 4/11/45–6. [29] GH, 22 August 1916, p.6. [30] *International Exhibition Glasgow 1901: official catalogue of the fine art section*, Glasgow, n.d. (1901), p.116.

Other sources
BN, 19 February 1915, p.230; BI, 16 December 1915, p.139; Read, pp.365–6 (inc. ill.); Read and Ward-Jackson, 4/11/38–47; Williamson *et al.*, pp.55, 281, pls 92, 95; Teggin *et al.*, pp.77–8 (incl. ill.); McKenzie, pp.84 (ill.), 85–6.

At the western end of Prince of Wales Bridge

Monument to Thomas Carlyle
Sculptor: William Kellock Brown

Unveiled: 4 November 1916
Material: grey granite
Dimensions: whole monument 3.7m high
Inscription: raised letters at the foot of the base – CARLYLE / 1789 1881
Listed status: not listed

Owner: Glasgow City Council

Thomas Carlyle (1795–1881), essayist and historian. Born in Ecclefechan, Dumfriesshire, Carlyle was educated locally and at Edinburgh University, where he studied Divinity and Law. He worked as a teacher for several years, but abandoned this in 1819 to become a full-time writer, producing essays and works of historical scholarship. He was a great admirer of Goethe and his German contemporaries, whose writings he translated. In the late 1820s he published *Sartor Resartus*, a mixture of autobiography and German philosophy. In 1834 he moved to Chelsea, where he produced *The French Revolution*, widely regarded as his greatest work. This was followed by *Chartism* (1840), in which he opposed conventional economic theory, and works on his two great historical heroes, Oliver Cromwell (1845) and Frederick the Great (1858–65). The beauty and grandeur of his prose style gained him a reputation as one of the distinctive voices of Victorian literature, on a par with John Ruskin. He became rector of Edinburgh University in 1865, but after his wife's death in the following year, became a virtual recluse.[1]

Description: In its report on the unveiling, the *Glasgow Herald* provides the following description of the monument:

The sculptor, Mr A. Kellock Brown [*sic*], has chiselled this impressive effigy out of grey granite, a singularly appropriate medium for such a subject, and he has chiselled it unconventionally. The vivid head seems to emerge out of the granite block; there is no modelling of the limbs, merely an arm sketchily treated, the rest a rough-hewn mass. The sculptor has concentrated on the head and features, which are after all vital things in effigies of the intellectually great...[2]

The aptness of the treatment was confirmed by Lord Guthrie, who quoted a description of Carlyle by the Glasgow poet Alexander Smith

in his speech at the unveiling ceremony:

> In Carlyle's aspect there is something aboriginal, as of a piece of unhewn granite which had never been polished to any approved pattern, whose natural and original vitality had never been interfered with.[3]

In art historical terms, Brown's representation of the body as a crudely formed, but powerfully abstract mass recalls Rodin's *Monument to Balzac* (1898), in which the moral

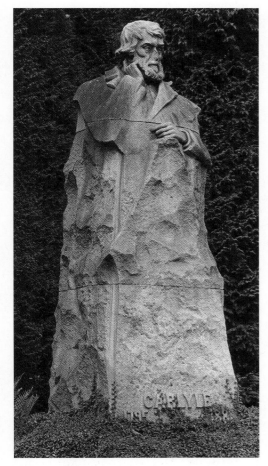

William Kellock Brown, *Thomas Carlyle*

and literary stature of the subject is conveyed by a radical simplification of form. Equally, the presentation of Carlyle's head emerging from a block of natural rock could be said to anticipate, albeit on a smaller scale, Gutzon Borglum's monumental portraits of American presidents on Mount Rushmore.

Discussion: It was not until 1911, thirty years after Carlyle's death, and twenty years after the Corporation had acquired Whistler's celebrated portrait of him, *Arrangement in Grey and Black No. 2* (1873), that a group of the great Victorian writer's admirers formed a working party to investigate the possibility of erecting a public memorial to him in Glasgow.[4] The main driving force behind the project was Dr J. Buyers Black, who later explained that:

> The idea of the statue came into my mind because Scott and Burns [were] adequately represented in Glasgow, and because on the invitation of Provost Swan I had the privilege as a boy of ... actual conversation with the sage of Chelsea.[5]

Although the proposal attracted the 'adhesion of 400 influential citizens in every walk of life', it was decided that the project should be suspended until after the Scottish Exhibition of National History, Art and Industry, held in Kelvingrove Park in 1911, was over. By May 1913, it was felt that the 'time was ripe' to re-activate the proposal, and an executive committee was appointed to take the matter in hand. Opinion was divided as to what form the memorial should take, and for some the establishment of a travelling scholarship at Glasgow University was preferable to a conventional monument that would 'merely ... add one to the many statues in the city'. The consensus, however, was for a statue, and after rejecting a proposal to acquire a reproduction of an existing statue by Joseph Edgar Boehm in London (1882), the executive committee decided to commission a new work by open competition.[6] Twelve artists submitted a total of

fifteen designs, which were exhibited in Kelvingrove Art Gallery in October 1914, and from which Kellock Brown's watercolour design, entered under the code letter 'J', was unanimously selected.[7] The estimated cost was £2,000,[8] which was eventually raised through a grant from the surplus of the 1911 exhibition, matched by funds raised by private subscription.[9]

In the following month, Buyers Black applied to the council for permission to erect the monument in Kelvingrove Park.[10] The council responded in March 1915, offering a site in the 'field near the central plot, in the east division' of the Park,[11] but this does not appear to have been regarded as satisfactory and in the early part of 1916 Buyers Black asked the council to consider allocating the space in front of Kelvingrove Art Gallery.[12] This was rejected by the Parks Committee on the grounds that the 'layout of the front of the Art Gallery had not been decided on',[13] and the plot beside the Prince of Wales Bridge was offered instead.[14] As it happens, the council did in fact relent, and eventually granted the site in front of the Art Gallery, but only after the arrangements with the Prince of Wales Bridge site were too far advanced to be changed.[15] It was here, on an axis with the Highland Light Infantry Memorial, that the monument was unveiled by Carlyle's niece, Margaret Carlyle Aitken, on 4 November 1916.[16]

For Buyers Black, however, this was not the end of the matter. In 1937 he wrote to the *Glasgow Herald* complaining that the neighbouring trees and bushes had 'grown to such dimensions as quite to envelop and dwarf the memorial'. Arguing that the tree-lovers of Glasgow 'would be sorry to see the trees and foliage at Kelvingrove drastically dealt with', he concluded that 'the removal of the statue would be a worthy solution of the problem', and that it was now more obvious than ever that 'the correct position for the statue of a great Scottish literary giant [was] in front of the Galleries'.[17]

It is worth remembering that the idea of erecting a memorial to Carlyle in the period immediately before the First World War was very controversial, and for many it seemed a highly inappropriate time to be celebrating a writer whose achievement was associated with a life-long devotion to German culture, and who was well known for his passionately anti-French stance in the Franco-Prussian War of 1870–1. As one reviewer put it: 'It takes a spice of courage for some of us even to open our Carlyles just now'.[18] For his supporters, however, it was part of his essential 'greatness' as a writer that he transcended the contingencies of history. He was 'emphatically a man of heroic mould, of whose character and work a large view must be taken'[19] and it was on this basis that the executive committee felt confident that the monument would 'meet with the approval not only of lovers of literature and students of history, but also the thinking members of all classes'.[20] It is significant, nevertheless, that the unveiling ceremony 'was not largely attended by the public',[21] and that since then the statue has been the target of regular criticism. In 1954, Douglas Percy Bliss described the carving as being 'far from … powerful and direct', and the treatment of the hands 'pathetically puny',[22] while for the journalist Jack House it was frankly the worst monument in Glasgow.[23]

Condition: The monument was treated with a 'special process for cleaning and preservation' in the early 1930s.[24] The nose has been broken off and replaced several times in the past, but now appears to be lost for good. Otherwise the condition of the monument is very good.

Related work: A plaster sketch model by Brown is in GAGM (S.194), which also has a plaster sketch of Boehm's seated portrait of Carlyle (1874, S.161).

Notes
[1] EB, vol.3, pp.923–4. [2] GH, 6 November 1916, p.9. [3] *Ibid.* [4] *Ibid.*, 14 May 1913, p.8. [5] *Ibid.*, 2 July 1937, p.9. [6] *Ibid.*, 20 May 1913, p.7. [7] BN, 27 November 1914, p.678. [8] GH, 20 May 1913, p.7. [9] *Ibid.*, 6 November 1916, p.9. [10] GCA, C1/3/52, p.315. [11] *Ibid.*, p.979. [12] GH, 2 July 1937, p.9. [13] *Ibid.* [14] GCA, C1/3/55, p.1680. [15] GH, 2 July 1937, p.9. [16] *Ibid.*, 6 November 1916, p.9. [17] *Ibid.*, 2 July 1937, p.9. [18] *Ibid.*, 4 November 1916, p.7. [19] *Ibid.* [20] *Ibid.*, 14 May 1913, p.8. [21] *Ibid.*, 4 November 1916, p.7. [22] Bliss, p.2. [23] House, p.150. [24] GCA, C1/3/89, 21 June 1933, p.2021.

Other sources
BN, 30 October 1914, p.553; BI, 16 August 1916, p.75; Williamson *et al.*, p.282; McKenzie, pp.90, 91 (ill.).

Kelvin Way Bridge, adjacent to the north-east entrance to the grounds of Glasgow Art Gallery and Museum

Allegorical Figure Groups
Sculptor: Paul Raphael Montford

Founder: A.B. Burton
Architect: A.B. McDonald
Builder: John Emery & Sons
Date: 1914–24
Material: bronze
Dimensions: figures larger than life-size
Signed: on the front of each plinth, left – PAUL R MONTFORD Sc; on the front of each plinth, right; A. B. BURTON / FOUNDER / THAMES DITTON
Inscriptions: on small bronze panels attached to the plinths of the north-east and north-west groups – THIS GROUP WAS BADLY DAMAGED BY ENEMY ACTION DURING THE NIGHT OF 13–14 MARCH 1941. RESTORED UNDER THE SUPERVISION OF BENNO SCHOTZ RSA BY THE MORRIS-SINGER CO LTD 1951. (But see Condition, below.)
Listed status: category B (15 December 1970)
Owner: Glasgow City Council

Description: The groups are located on the corner abutments of the bridge and are the only examples of major figurative sculptures of this kind in Glasgow. Each group consists of a pair of seated figures facing outwards from a tapered central pillar, the exposed sides of which are decorated with scrolls and strapwork in low relief. At the apex of the pillars are groups of entwined dolphins, their tails supporting ornate, open-works lamps. The figures are grouped in symbolic pairs signifying, at various levels of abstraction, the concerns of civil society, with particular reference to Glasgow's pre-eminence in the fields of industry and commerce. The subjects and their locations are as follows:

North-east: *Peace* (female figure with sleeping child and spinning wheel) and *War* (shouting male figure with spear).

North-west: *Philosophy* (elderly bearded male figure holding a skull) and *Inspiration* (female figure with arms outstretched, holding a lute).

South-east: *Navigation* (female figure with hand on tiller) and *Shipbuilding* (female figure holding model ship).

South-west: *Commerce* (female figure holding a purse, with feet resting on ledgers) and *Industry* (male figure with hammer and anvil).

Discussion: A bridge was first constructed over this sharp westward turn in the River Kelvin in 1880 to facilitate access to the Park from its south gate. A smaller footbridge was built beside it for the 1888 International Exhibition, but both were later replaced when a broader structure was required to accommodate the traffic moving between the Industrial Hall and the Saracen Fountain in the follow-up Exhibition of 1901.[1] This remained in use until just after the third and final Exhibition of 1911, but with the creation of the Kelvin Way – a broad, straight thoroughfare stretching from Radnor Street to University Avenue – in 1912 it was replaced with a new structure designed by the city engineer, A.B. McDonald.[2]

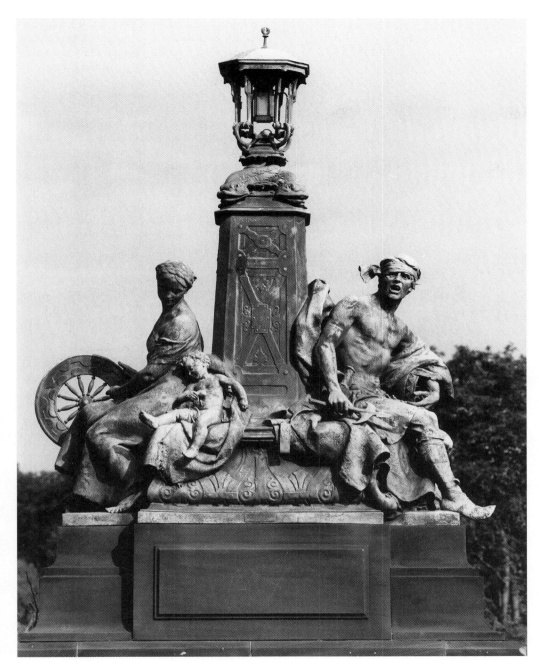

Montford won the commission in an open competition organised by the Corporation in 1914, with Sir George Frampton acting as the adjudicator.[3] Twenty-eight entries were received, and of the 94 models on display at the McLellan Galleries in May, Montford's was described by Frampton as '... the work of one of the few competitors who has taken the architecture of the bridge and its surroundings into consideration'. 'I have no doubt', he went on, '... that when the figures have been worked out full size they will make a noble and dignified addition to the decoration of the bridge.'[4] Among the runners-up were the local artist Alexander Proudfoot, who was awarded a premium of £50, and Richard Garbe from London.[5]

Although the statues are among the finest of their kind in Glasgow, the history of their creation was by no means trouble-free; indeed from the beginning the Corporation appears to have had mixed feelings about the desirability of adorning the bridge with such a grandiose decorative scheme. A reference to 'certain allegorical statuary proposed to be placed at the north and south ends' of the bridge appears in the minutes of the sub-committee on parks as early as 2 February 1912,[6] only to be followed a week later by an instruction to McDonald to prepare a series of alternative designs, one with 'less floral scrollwork thereon' and another 'without any ornate decoration' at all.[7] It was not until October of the following year, when the construction of the bridge was nearing completion, that the council finally addressed itself to the subject of statuary, and began considering such matters as the form it should take and how much it was likely to cost.[8]

In the four years during which Montford worked on the commission his relationship with the council was characterised by a succession of wrangles over money. From the

Paul Raphael Montford, *Peace* and *War*

Kelvingrove Park 237

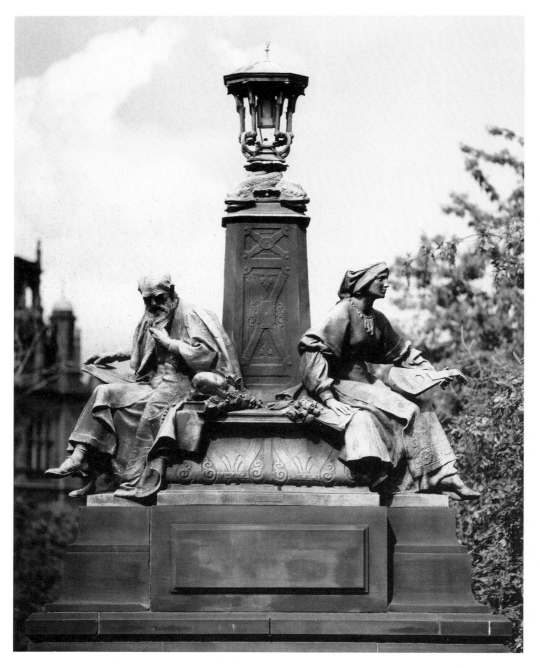

sculptor's point of view, the main problem was that the outbreak of war had driven all the costs associated with production spiralling upwards, not least the price of bronze, and in January 1916, he made an unsuccessful request that the agreed price of £850 per group should be increased to £1,050.[9] For their part, the council's expenses were no less affected by the war, and in February of the same year took the precaution of insuring the models of *Navigation* (in plaster) and *Shipbuilding* (clay) – the only full-size pieces completed by that time – for £1,100 against the risk of damage by enemy aircraft.[10] Montford's own life was also insured, with premiums that had to be increased periodically to match the payment of successive instalments of his fee.[11]

Towards the end of the year a sub-committee, set up exclusively to deal with the negotiations over his fee, agreed to pay the balance of his contract on the basis of a regular salary of £60 per month, but not without imposing some stiff conditions of their own. In particular they were anxious about the time the work was taking, and insisted that the four plaster models should be ready to hand over to the founder in fifteen months at the latest. They also took the opportunity to insert a clause enabling the council to terminate the contract at any time if the arrangement proved unsatisfactory.[12]

In a series of letters to the committee in July 1917, Montford outlined the difficulties he was having in bringing the third group, *Industry* and *Commerce*, to completion, with a note of the special outlay required for the fourth.[13] The plea appears to have met with some success, and after a personal interview with Councillor Barrie in September his monthly allowance was increased to £70.[14] But this was not the last of his appeals for more money. When the fourth

Paul Raphael Montford, *Philosophy* **and** *Inspiration*

group was finally completed in May 1918 – only three months late – he not only demanded an additional payment of £70 for the extra time he had spent on the commission, but also a 'bonus' to reflect the increased cost of living caused by the war.[15] By this time a total of £2,575 had been paid to Montford alone,[16] more than three quarters of the £3,400 budgeted for the entire process of modelling and casting. The council's response was, to say the least, generous, and in the 'Minute of Renunciation' drawn up to bring Montford's involvement to a conclusion, it was agreed that he should receive 100 guineas as an *ex gratia* payment, with an additional 25 guineas for his assistant.[17]

Throughout the time of his participation in the project, Montford regularly exhibited work in progress: the models for *Philosophy* and *Inspiration*, for example, were shown at the Royal Academy in 1917, while *War*, *Industry* and *Shipbuilding* appeared there in the following year.[19] On both occasions, however, the council insisted that it was his responsibility to insure them against the risk of damage in transit. Curiously, the council itself was faced with a similar situation in August 1918, when it enquired into the possibility of exhibiting the completed plaster models in the Glasgow Art Gallery before casting.[20] A.B. Burton, the bronze-founder to whom they had awarded the commission to cast the work, strongly advised against this, presumably because of their fragility, suggesting instead that they be stored for the duration in his own premises in London at a rental of £36 8s. per annum.[21] This was the beginning of a process of delay and postponement even more protracted than the earlier dealings with Montford. Using the high cost of bronze as a pretext, Burton managed to extend the rental arrangement for nearly four years, and it was not until March 1922 that a

Paul Raphael Montford,
Navigation **and** *Shipbuilding*

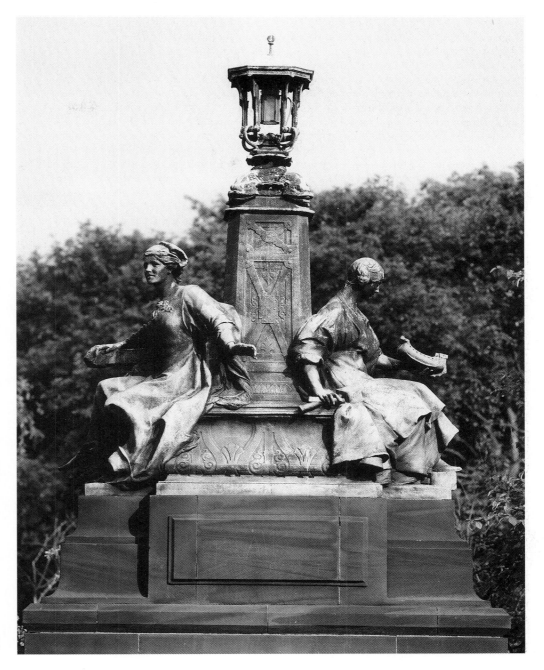

formal estimate was received, amounting to £950 per group, exclusive of the scaffolding and lifting tackle required to place them in position. The council accepted this estimate, but only after persuading the Art and Museum Fund, which had pledged £1,000 to the cost of the work, to double of its contribution.[22] In August 1924, Burton received an instalment of £1,000 towards his fee for bringing two thirds of the casting work to completion,[23] but it was not until June 1926 that the finished statues were ready to be forwarded to Glasgow.[24] Two months later, more than twelve years after Montford had been given the original commission, the City Engineer was able to report to the council that the work of erecting the groups had been completed.[25]

Despite the difficulties and frustrations Montford experienced in making the work, the result is an outstanding artistic achievement by any standards, and Frampton was clearly right in his prediction that it would make a 'dignified addition to the decoration of the bridge'. It is, however, more than just ornamental appendage to the pre-existing structure designed by McDonald, and its interest lies as much in the complexity of its intellectual content as its impact as a visual statement. The basic symbolic programme is relatively straightforward, with the principal figures readily identified by their costumes and gestures. Interpretation is aided by the artist's use of the simple device of setting clearly contrasting figurative types against each other, which in all cases but one involves an opposition between a male and a female. The intelligence with which the symbolism is extended into and elaborated through an array of incidental details constitutes the work's unique strength. It abounds with telling metaphors. Without interrupting her work at a spinning wheel, the young mother embodying the concept of *Peace* glances over her shoulder to see that her baby has quite literally 'fallen' asleep in the act of playing. In one hand he still clutches a rag doll,

its limbs even more thoroughly relaxed than his own, but the harder form of the wooden horse emerging from under his left arm hints at a more combative form of play, and thus provides a subtle link with the aggressive instincts associated with the neighbouring figure of *War*. This too is replete with ambiguity. The last word in bellicose self-assertion, the shouting warrior is as much a victim as a conqueror, his head wrapped in a makeshift bandage, the futility of his aspirations indicated by the broken point of his spear. In many cases the details are memorable as much for their technical virtuosity as their symbolic meaning – for example the very painterly evocation of the effect of woodgrain on the carpenter's tools at the feet of *Shipbuilding*. Elsewhere, natural objects, such as the horned cattle skull lying at the feet of *War*, and the rich array of ropes, chains, anvils, machine components and other emblems of the industrial revolution are all presented with a directness that celebrates their inherent visual interest as ready-made sculptural forms.

Condition: A major public monument conceived and produced during the First World War, the Kelvin Way Bridge sculptures were seriously affected by the events of the Second. On the night of 13–14 March 1941, the bridge was seriously damaged by a German landmine, with two of the statue groups precipitated into the River Kelvin (see Inscriptions, above). They were to remain there until January 1949, when the council arranged for them to be retrieved. The process was described in detail by the *Glasgow Herald*:

A start was made yesterday by employees of the Parks Department of Glasgow Corporation to raise from the north bank of the river Kelvin a statue representing 'Peace and War' which was displaced from the north west corner of the Prince of Wales Bridge in Kelvingrove Park during the air raids in March 1941.

The workmen decided that the use of a crane might damage the statue and they relied on a block and tackle suspended to a tree nearby. As the statue weighs between three and four tons, progress was slow, and when the men finished work last night the statue had been moved only a few feet.

Another statue representing 'Shipbuilding and Industry' which stood on the north east end of the bridge also fell into the river during the raids. An attempt to recover it will be made after the first statue has been lifted.

When the statues have been raised they will be cleaned and renovated before being replaced on the bridge. It is believed that neither has been seriously damaged.[26]

In addition to the mistaken reference to the bridge as the Prince of Wales Bridge, the discussion of the statues includes several confusions which should be noted here. For example, the *Peace* and *War* group is described as being on the north-west corner, when in fact it is on the north-east. More seriously, the second group is identified as having fallen from the north-east abutment, but the title 'Shipbuilding and Industry' is a conflation of the two groups at the south end. Moreover, the statement that the groups were not seriously damaged was later contradicted by a report that they had been 'so seriously damaged … that the committee have recommended that Mr Benno Schotz, the sculptor, be asked to report on their condition'.[27] The repair work was carried out by the Morris Singer Company of Walthamstow, under Schotz's supervision, and included the replacement of an arm from one of the figures in each group, with part of the £1,200 cost met by the War Damage Commission.[28] The original arms themselves were to remain in the Kelvin until August 1995, when a particularly dry summer, and a consequent drop in the level of the river, enabled them to be sighted and retrieved.[29] A

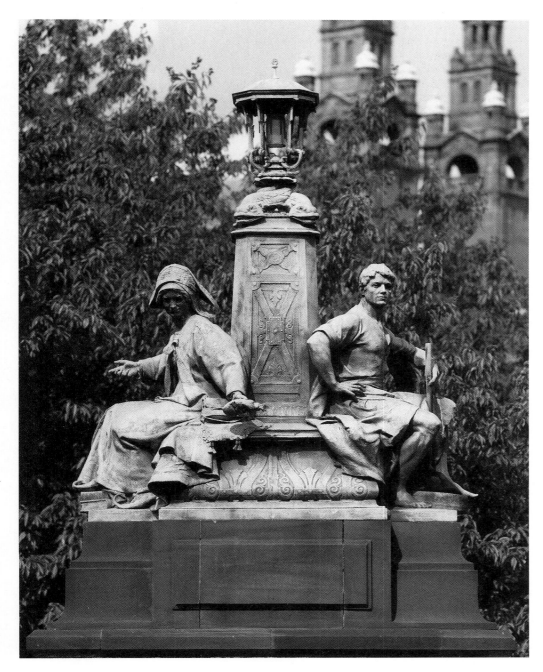

proposal by their discoverers – Mr D. Currie and Mrs Isobel Scobie – that they should be re-attached to the statues was rejected by GAGM, on the grounds that the 'replicas had now toned in with the originals'.[30] Here it should be noted that only one of the recovered arms appears to have belonged to any of the figures from either of the groups cited in the report quoted above, or to which explanatory labels have been attached (see Inscriptions, above): the arm holding a spear, from *War* on the north-east abutment. The other arm, which is naked, bears no resemblance to the arms on either of the figures in the *Philosophy* and *Inspiration* group on the north-west corner, to which a label is attached. The lack of correspondence between the physical evidence of the recovered objects and the information offered on the plaques has still to be explained (but see also *La Innocenza*, Kelvingrove Park, in Appendix A, Lost Works). In the meantime, a dispute over the legal ownership of the detached arms also remains unresolved.[31]

The statues have been coated with brown paint, but this has failed to prevent the appearance of extensive areas of bright green patina.

Notes
[1] David Boyce, *Bridges of the Kelvin*, Glasgow, 1996, p.22. [2] GCA, C1/3/46, p.745. [3] B, 6 March 1914, p.291. [4] GCA, C1/3/51, pp.1636–7. [5] *Ibid.* [6] *Ibid.*, C1/3/46, p.739. [7] *Ibid.*, p.749. [8] *Ibid.*, C1/3/49, p.2630. [9] *Ibid.*, C1/3/51, p.2007; C1/3/54, p.793. [10] *Ibid.*, C1/3/54, p.985. [11] *Ibid.*, C1/3/55, p.1680. [12] *Ibid.*, C1/3/55, p.2143. [13] *Ibid.*, C1/3/57, p.1629. [14] *Ibid.*, pp.1951–2. [15] *Ibid.*, C1/3/59, p.1273. [16] *Ibid.*, p.1601. [17] *Ibid.* [18] *Ibid.*, C1/3/56, p.575. [19] *Ibid.*, C1/3/58, p.582. [20] *Ibid.*, C1/3/59, p.1601. [21] *Ibid.*, p.1737. [22] *Ibid.*, C1/3/66, p.1024. [23] *Ibid.*, C1/3/71, p.2053. [24] *Ibid.*, C1/3/75, p.1909. [25] *Ibid.*, p.2280. [26] 'Statues To Be Taken From River', GH, 25 January 1949, p.3. [27] 'Future of Park Statues', GH, 10 May 1950, p.3. [28] GCA, C1/3/122, p.692. [29] 'Statue find after farewell to arm', GH, 9 May

Paul Raphael Montford, *Commerce* and *Industry*

1995, p.6; 'Arm a bit puzzled', *Daily Record*, 25 August 1995, p.15. [30] GAGM, unpublished correspondence, 25 August 1995. [31] Jim McLean, 'Legal wrangle over statue's arm: bronze warrior in new battle', ET, 19 November 1996, p.19.

Other sources
BN, 22 May 1914, p.706; Beattie, pp.191, 233 (incl. ill.); Read, p.365; Read and Ward-Jackson, p.iv, 4/11/18–33; Teggin *et al.*, pp.78–9 (incl. ills); Williamson *et al.*, p. 629; McKenzie, pp.82, 88–9 (incl. ills).

West of mid-point of Kelvin Way, beside putting green

Monument to Lord Lister

Sculptor: George Henry Paulin

Founders: McDonald & Cresswick
Date: 1923–4
Unveiled: 17 September 1924
Materials: bronze statue on a grey granite pedestal
Dimensions: figure 1.95m high; pedestal 1.34m × 2.7m × 1.75m
Signed: in cursive script on the right side of the plinth, front – G H Paulin 1923
Inscription on the front of the pedestal: LISTER
Listed status: not listed
Owner: Glasgow City Council

Joseph Lister, 1st Baron Lister, of Lyme Regis (1827–1912), surgeon and pioneer of antiseptics. The second son of Joseph Jackson Lister, microscopist of Upton, Essex, he graduated in Arts at London University in 1847 and in Medicine in 1852. He was appointed surgeon at the Edinburgh Royal Infirmary in 1856 and subsequently Lecturer in Surgery at Glasgow University. He became Professor of Clinical Surgery at Edinburgh University in 1869 and at King's College Hospital, London in 1877. His introduction of the antiseptic system in 1860 was of immense importance, revolutionising modern surgery and allowing the performance of operations which had

previously been impossible because of the risk of infection. He also made significant observations on inflammation and coagulation of the blood. He was President of the Royal Society, 1895–1900.[1]

Description: In designing the monument, Paulin was undoubtedly conscious of Macfarlane Shannan's neighbouring statue of Lord Kelvin (q.v.), and his decision to show his subject seated in academic robes, with one foot in advance of the other, may have been prompted by a desire for his statue to be seen as a complement to the earlier work. Stylistically, however, the two figures are very different. Where Kelvin is presented in a rather static, foursquare pose, Paulin has given his subject a much more dynamic posture, with the asymmetrical arrangement of the feet echoed in the tilt of the shoulders and the expressive turn of the head. The treatment of the draperies is also much more powerfully sculptural, creating a variety of surface and outline very different to the somewhat shapeless overall impression made by Kelvin. Equally intense is the treatment of the hands, one of which grips the arm of the chair, while the other clutches the robes over his abdomen in a gesture which borders of the melodramatic. There is a staff of Asclepius in relief above the inscription on the pedestal and a horizontal wreath carved in the stone step immediately below it.

Discussion: A meeting was called by the Lord Provost at the 'request of several prominent gentlemen' a few weeks after Lister's death in February 1912, to consider whether there ought to be a memorial to Lister in Glasgow. Those present quickly arrived at the unanimous resolution that Glasgow should indeed commemorate the achievement of the great pioneer of modern medicine, whose discoveries had done 'so much for the alleviation of human suffering'.[2] What was less clear was the form the memorial should take. Given his connections with the Royal Infirmary, it seemed natural that the monument

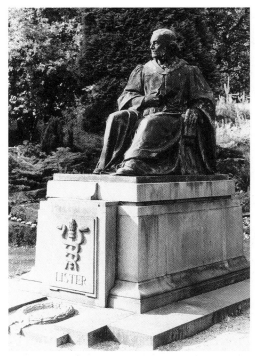

George Henry Paulin, *Lord Lister*

should be located there, and among the initial proposals was 'a monument, of artistic design, in the neighbourhood' of the hospital.[3] Parallel to this, consideration was also given to a number of rather more ambitious proposals with an 'international character', including the establishment of a Lister Award for contributions to surgery 'in any part of the world', a Lister Research Fund for promoting fellowships and studentships, and the conversion of the Lister Ward in the Royal Infirmary into a museum.[4] Before any decision was made, however, it became known to the committee appointed to manage the project that the Royal Society and the Royal College of Surgeons in London had also initiated a memorial scheme, and were anxious to co-

operate with the Glasgow project. As it happens, the London scheme was remarkably similar, and included a Lister Research Fund, the erection of a memorial tablet in Westminster Abbey and a 'monument in a public place in London'.[5] After several months of discussion, and the regular exchange of minutes between the two committees, the preferred option was the establishment of the Lister Museum as the local component of the scheme, with a portion of whatever subscriptions were raised allocated to London for the International Memorial Fund. Subscribers would be requested to 'intimate what proportions of their contributions [were] to be assigned to the Local and the International Funds respectively'.[6]

Because no firm course of action had been decided upon by the time of the outbreak of the First World War, discussion was suspended and not resumed until November 1920.[7] By June of the following year the fund had accumulated just over £2,600, which was felt to be sufficient only for the retention of Lister's relics in the infirmary, and an 'architectural monument with a bust', to be erected 'on a space facing Castle Street and adjacent or attached to the Lister Ward'.[8] After failing to persuade the managers of the Royal Infirmary to support the plan for the museum, the committee were forced to reconsider their entire approach, and on 17 January 1922, 'unanimously resolved that a seated statue of Lord Lister should be erected in the Kelvingrove Park adjacent to the statue of Lord Kelvin'.[9]

Three sculptors were invited to submit designs – William Kellock Brown, George Henry Paulin and Alexander Proudfoot. Proudfoot declined to participate, and after studying the models submitted by the other two, the committee decided to offer Paulin 2,000 guineas for the creation of a 'seated statue with pedestal and other accessories complete'. Kellock Brown was paid a premium of 200 guineas.[10] Paulin's contract was signed on 2

February 1923, and by early in July of the following year the completed work, cast by the Edinburgh firm of McDonald & Cresswick, was placed in position in Kelvingrove Park. Sir Hector Cameron, one of Lister's last surviving house surgeons, performed the unveiling.[11]

A plaque at 17 Woodside Place, a stone's throw from Kelvingrove Park, commemorates Lister's residence there, 1860–9. The Park was in fact one of Lister's favourite haunts, and he regularly spent an hour or so there before breakfast pondering medical problems and composing papers.

Related work: There are two portrait medallions of Lister in the Royal Infirmary (q.v., Castle Street).

Condition: The statue has been coated with brown paint, which is very weathered, and there is some surface birdlime. Otherwise the condition of the statue and pedestal is good.

Notes
[1] EB, vol.10, pp.1033–4. [2] GCA, G4/2/1, *Minute Book, Lister Memorial Fund*, 27 February 1912. [3] *Ibid.*, 11 March 1912. [4] *Ibid.* [5] *Ibid.*, 13 November 1912. [6] *Ibid.* [7] *Ibid.*, 2 November 1920. [8] *Ibid.*, 14 June 1921. [9] *Ibid.*, 17 January 1922. [10] *Ibid.*, 20 December 1922. [11] GH, 18 September 1924, p.3.

Other sources
GH, 6 May 1924, p.5 (ill.), 5 July 1924, p.8, 2 September 1924, p.6 (notice of unveiling), 18 September 1924, pp.3 (ill.), 7–8 (report of unveiling); *Scotsman*, 18 September 1924; *Lancet*, 20 September 1924, pp.625–6; Williamson *et al.*, p.496; McKenzie, pp.90, 91 (ill.).

A few yards west of Glasgow Art Gallery and Museum

Cameronians (Scottish Rifles) War Memorial

Sculptor: Philip Lindsey Clark

Founder: M. Manenti

Date of unveiling: 9 August 1924
Materials: bronze on a grey granite base
Signed on the statue: P LINDSEY CLARK Sc. 1924 / M. MANENTI. FOUNDRY
Dimensions: figures life-size
Inscriptions: on the front of the base – TO THE GLORIOUS MEMORY OF ALL RANKS / THE CAMERONIANS (SCOTTISH RIFLES), WHO, / TO UPHOLD LIBERTY AND JUSTICE IN THE WORLD, / LAID DOWN THEIR LIVES IN THE TWO WORLD WARS / 1914–1918 AND 1939–1945 [Note: the original of this inscription ran: 'TO THE GLORIOUS MEMORY OF 7074 OFFICERS, WARRANT OFFICERS, NON-COMMISSIONED OFFICERS AND MEN OF ALL BATTALIONS OF THE CAMERONIANS (SCOTTISH RIFLES), WHO, / TO UPHOLD LIBERTY AND JUSTICE IN THE WORLD, / LAID DOWN THEIR LIVES IN THE GREAT WAR, 1914–18']; THE 6/7th BATTALION, CAMERONIANS (SCOTTISH RIFLES) / WAS DISBANDED ON THE 31st MARCH 1967 / AND THE 1st REGULAR BATTALION ON THE 14th MAY 1968 / THUS ENDING THE REGIMENT'S LONG MILITARY ASSOCIATION / WITH THE CITY OF GLASGOW; THIS PLAQUE WAS UNVEILED BY / THE LORD PROVOST OF GLASGOW / THE RT. HON. JOHN JOHNSTON; on the left side of the base – BE THOU FAITHFUL UNTO DEATH / AND I WILL GIVE THEE A CROWN OF LIFE [Revelation 2.10]; on the right side of the base – O VALIANT HEARTS, WHO TO YOUR GLORY CAME / THROUGH DUST OF CONFLICT AND THROUGH BATTLE FLAME; / TRANQUIL YOU LIE, YOUR KNIGHTLY VIRTUE PROVED: / YOUR MEMORY HALLOWED IN THE LAND YOU LOVED. A tablet on the rear of the base gives a list of relevant battles and their dates
Listed status: not listed
Owner: Glasgow City Council

Description: The last and most dramatic of the three major war monuments erected in the Park is presented as a scene of combat at the

front line, with the physical and emotional urgency of the moment accentuated by the expressive treatment of form. It is, however, more than just a 'snapshot' of soldiers in action. A pamphlet published to accompany the unveiling explains the symbolic programme underpinning its conception:

The central figure is that of a Sergeant in the act of 'advancing over the top' symbolising Victory. On his right lies the dead body of a young Officer of the Regiment whose span of life has been ruthlessly cut short, visualising Sacrifice; and on the left is a Lewis Gunner covering with his fire the advancing troops, typifying that dogged determination to succeed and of 'sticking it' for which our men were so remarkable.[1]

The sculpture stands on a simple rectangular base raised on a flight of steps, with a band of floral decoration running between the inscription tablets.

Discussion: The monument was commissioned as the second part of a three-stage scheme to commemorate the Regiment's 'close association with the city'. The first stage was the placement of a Memorial Tablet in 'The Cameronians' Corner' of Glasgow Cathedral; the third was to be the establishment of a Regimental Memorial Club in Glasgow,[2] though at the time of the unveiling of the memorial, only £3,500 of the projected cost of £7,000 had been raised.[3]

Lindsey Clark enlisted in the First World War as a private, rose to the rank of captain and was awarded the DSO for valour by King George V,[4] so it is appropriate that his tribute to the men he fought with should take the form of a realistic scene of combat. The memorial was unveiled by Field Marshal the Rt. Hon. the Earl Haig of Bemersyde, in the presence of 'many thousands and in delightful weather'.[5] It is recorded, however, that

Several women and girls in the crowd around the Memorial, owing to the strain of the ordeal and the somewhat oppressive atmosphere, fainted, but were promptly attended to by the ambulence corps on duty. A soldier was also overcome.[6]

In November 1947, Colonel W.K. Rodger, Secretary of the Cameronians 1939–45 War Memorial Fund, applied to the council for permission to alter the original inscription tablet in recognition of the members of the battalion who had lost their lives in the Second World War (see above), and to carry out cleaning and restoration work. Permission was granted, and the council contributed £30 towards the cost.[7] Further cleaning and restoration was carried out in 1958, and ten years later an additional inscription tablet was inserted on the front face of the pedestal (see above) to mark the disbanding of the regiment.[8]

Condition: The sculpture has been painted brown, but generally is in good condition. The marble facing on the front of the pedestal has begun to come loose, with some deterioration in the pointing.

Notes
[1] Anon., *The Cameronians (Scottish Rifles). Regimental War Memorial Unveiling*, Hamilton, 1924, p.2 (GCA, Misc. Pamphlets vol.II, PA11/2/5). [2] *Ibid.*, p.3. [3] *Ibid.*, p.8. [4] *Ibid.*, p.2. [5] *Ibid.*, p.4. [6] *Ibid.*, p.7. [7] GCA, C1/3/117, p.256. [8] *Ibid.*, C1/3/137, p.687.

Other sources
GCA, C1/3/63, pp.1917, 2057, C1/3/64, pp.534, 807, 1036, 1277, 1309–10, C1/3/65, p.1503; GH, 11 August 1924; Derek Boorman, *At the Going Down of the Sun: British First World War Memorials*, York, 1988, pp.47–8 (incl. ill.); Williamson *et al.*, p.283; McKenzie, pp.88 (ill.), 89. A short black and white film of the unveiling ceremony is preserved in the Scottish Film Archive.

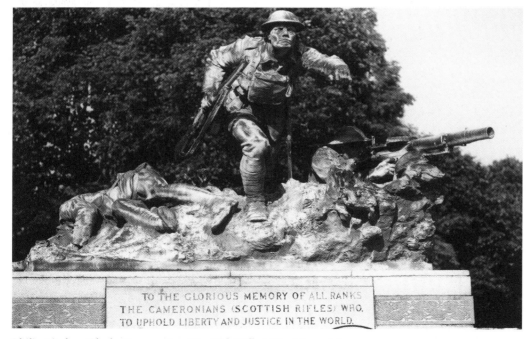

Philip Lindsey Clark, *Cameronians (Scottish Rifles) War Memorial*

In the Tom Honeyman Memorial Garden, between the north bank of the River Kelvin and the putting green

The Psalmist
Sculptor: Benno Schotz

Unveiled: 24 June 1973
Material: *ciment fondu*
Dimensions: statue 2.44m high
Signed: in cursive script on the upper surface of the plinth – Benno Schotz
Inscriptions: on the upper surface of the plinth – THE PSALMIST; on the plaque beside the right-hand bench – TO THE MEMORY OF / TOM JOHN HONEYMAN J. P., LL.D / 1891–1971 / MEDICAL PRACTITIONER, ART DEALER, DIRECTOR GLASGOW ART GALLERIES / AND MUSEUMS 1939–54 LORD RECTOR OF GLASGOW UNIVERSITY 1953–56 / SON AND CITIZEN OF GLASGOW / THIS GARDEN HAS BEEN CREATED BY THE GOODWILL AND GENEROSITY / OF HIS MANY FRIENDS AND ADMIRERS / LED BY THE GLASGOW TREE LOVERS / SOCIETY AND THE GLASGOW ART GALLERY AND MUSEUMS ASSOCIATION
Listed status: not listed
Owner: Glasgow City Council

Description: The sculpture forms part of the memorial garden created in Kelvingrove Park as a tribute to Tom Honeyman, the former Director of Glasgow Art Gallery and Museum and close personal friend of Benno Schotz.[1] Set in a small triangular shrubbery, *The Psalmist* is presented as a stylized figure with arms outstretched, as if addressing the two benches set into the wall opposite.

Discussion: The decision to include a sculpture by Schotz in the garden was made in September 1972,[2] some four months after the council had gifted the site to the Society.[3] For its part, the Society was required to submit a 'draft of the sculpture' to the council, and to 'confer with the Director of Parks to ensure

correct "balance" in the plans thus co-ordinating the work of the sculptor and the Director of Parks'.[4]

Stylistically, the work is not unlike the early modernist semi-abstract sculptures of Picasso and Lipchitz, with perhaps a reminiscence of Giacommeti in the roughness of its surface. At the same time, the tubular treatment in its outstretched arms gives the figure a distinctively tree-like appearance appropriate to its surroundings. Though he does not mention this work specifically in his autobiography, Schotz devotes a lengthy passage to the importance of trees as a source of inspiration in his figurative work. 'It was on a winter's day about 1950,' he begins,

… when walking beside the River Kelvin, in the Botanic Gardens that I noticed the exposed roots of a tree high on the inclined bank. The roots suggested themselves to me as reclining and intertwining figures. I rushed home for my sketchbook to draw them. This was my first revelation that one can see more in a tree than just the bark and wood it contains. Thus my search for figures in trees began.

I looked at every tree in Kelvingrove Park, and in the Botanic Gardens. A new world opened up for me. I found subject matter for my sculpture, of which I knew nothing before. The best time for drawing them was naturally in the winter, when the branches were bare. […]

My whole sculptural development took on a new slant. It always had a human angle, but now it clarified itself for me. Just as some people see figures, or faces, in the fire, so I began to see figures in the tree trunks and their branches. When I began to analyse the reason for this development, as an artist seldom does anything without a reason, my only deduction was that I was merely projecting on to the trees my latent, perhaps even subconscious emotions. I began to see

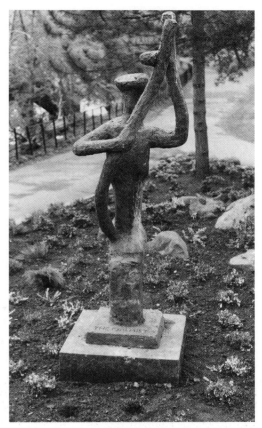

Benno Schotz, *The Psalmist* [RM]

in them my yearnings, frustrations, sorrows, and joys.[5]

A commission from the Glasgow Tree Lovers' Society seems an appropriate resolution to this long-standing sculptural concern.

Related work: A bronze maquette of *The Psalmist* (38.8cm high) was sold at auction by Christie's in 1997. Another full-size version of the figure forms part of a group entitled *Saraband*, in the Vale of Leven School, Alexandria (West Dunbartonshire).[6]

Condition: A small part of the surface of the main trunk of the figure has chipped off, and the figure as a whole has a generally distressed appearance. There is some light graffiti.

Notes
[1] Honeyman, p.56. [2] GCA, *Minutes and agendas of the ... [Glasgow Tree Lovers'] Society*, TD 454/1/27, 19 September 1972. [3] GCA, *Minutes of ... Annual General Meetings of the [Glasgow Tree Lovers'] Society*, TD 454/4/5, 25 May 1972. [4] GCA, *Minutes and agendas*, TD 454/1/28, 16 January 1973. [5] Schotz, p.198. [6] Christie's Scotland, *The Studio Sale of Benno Schotz, R.S.A.*, Glasgow, 1997, Lot 132.

Other sources
MLG, *Glasgow Scrapbook* no. 27, p. 15 (invitation card); McKenzie, pp.89–90.

In front of the north entrance to Glasgow Art Gallery and Museum

Children of Glasgow Fountain
Sculptor: Michael Snowden

Founder: not known
Date: 1988
Material: bronze
Dimensions: column approx. 6.7m high
Inscription: on a metal plaque beside the
 fountain – CHILDREN OF GLASGOW FOUNTAIN
 / SCULPTOR, MICHAEL SNOWDEN, RSA. /
 PRESENTED BY SIR MICHAEL HERRIES
 CHAIRMAN / THE ROYAL BANK OF SCOTLAND
 / TO COUNCILLOR PAT LALLY, LEADER OF
 THE COUNCIL / ON 7 JANUARY 1991 / THE
 CHILDREN OF GLASGOW FOUNTAIN WAS
 CONCEIVED BY THE ROYAL BANK OF
 SCOTLAND / AS PART OF ITS CONTRIBUTION
 TO GLASGOW GARDEN FESTIVAL 1988 AND
 THEN ACCEPTED / BY THE LORD PROVOST OF
 GLASGOW TO COMMEMORATE GLASGOW 1990,
 CULTURAL CAPITAL OF EUROPE
Listed status: not listed
Owner: Glasgow City Council

Description: The central feature is a bulbous bronze column, designed to be enclosed by a cylindrical curtain of water cascading from its upper rim. The curvature of the shaft and the dramatically spreading form of the bell capital are strongly reminiscent of Egyptian architecture, and thus form an interesting complement to the historic artefacts on display in the Museum's Egyptology Department. The surface of the column is decorated with images of children in very shallow relief playing games, accompanied by a cat, a dog and a bird, with several squirrels climbing over the trunks of trees. The trees themselves rise the full length of the column, their branches extending into the under-side of the upper bowl. A line of Royal Bank of Scotland logos is included at the base. The column stands in a stone basin, which is enclosed in a larger circle of rusticated stone.

Discussion: Michael Snowden was awarded the commission on the basis of a personal recommendation to the Chairman of the Royal Bank of Scotland, Sir Michael Herries. The work cost £150,000 to make.

Condition: The fountain has taken on a neglected appearance since the water was switched off in the early 1990s, with regular quantities of rubbish accumulating in the empty basin. There is some light graffiti on the column and the floodlights in the basin have been vandalised.

Sources
Murray, pp.102–3 (ills); unpublished letter from the Royal Bank of Scotland, 6 April 1998; McKenzie, pp.88 (ill.), 89.

In landscaped area in front of the south façade of Kelvingrove Museum, west side

Relief Map of the West End of Glasgow
Sculptor: Kathleen Chambers

Founders: Powderhall Bronze
Base designed by: Page & Park Architects
Date: 1996
Material: bronze
Dimensions: relief 14cm high × 1m × 92cm;
 pedestal 90cm high
Listed status: not listed
Owner: Glasgow City Council

Description: Larger and more ambitious than the relief map on Buchanan Street by the same artist, this later work offers a bird's-eye view of the entire west end of Glasgow, from Maryhill to Govan, and from Charing Cross to Anniesland. The work clearly reveals the pattern of linked 'drumlins' that form the city's underlying geological structure, while at the same time providing a vivid demonstration of the inventiveness with which Glasgow architects and planners have taken advantage of

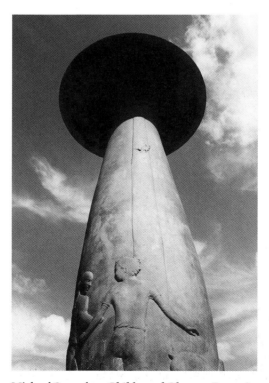

Michael Snowden, *Children of Glasgow Fountain*
[RM]

the natural undulations of its topography. The elegant symmetry of Charles Wilson's Park Circus is revealed here as a true masterpiece of urban design, its western façades dominating the escarpment of Kelvingrove Park in a gesture of architectural brinkmanship that has few equals in the history of terrace building.

Discussion: Though the construction of the work required a painstaking study of many different maps and aerial photographs, the result does not attempt to imitate the realistic models favoured by planning departments; on the contrary, it is very much a sculptor's response to the task of representing a city. Familiar structures such as Glasgow University and the towers of Trinity College are represented in a simplified form in order to clarify their role as urban landmarks, while the use of broken patterns of wavy lines and other tactile graphic devices to represent open spaces enables the strictly topographical information it contains to be accessed with ease by the visually impaired. At a time when new forms of 'site specific' and environmental art are being explored in Glasgow, and when many artists are beginning to treat the city itself as the raw material of their work, Chambers' relief maps provide an interesting link between these emerging 'interventionist' practices and the traditional idea of a sculpture as a discrete object made from materials that will last.

The work was commissioned jointly by Glasgow West Preservation Society, Glasgow District (now City) Council, Strathclyde Regional Council and Glasgow Development Agency. The total cost, including casting, intallation, the manufacture of the base and the artist's fee, was approximately £20,000.

Condition: Small rust spots have appeared on one or two parts of the surface due to the presence of iron filings in the patination.

Source
Information provided by Kathleen Chambers.

Glasgow Art Gallery and Museum

Sculpture Programme

Sculptors: Edward George Bramwell, Aristide Fabbrucci, George Frampton, Johan Keller, William Birnie Rhind, Archibald Macfarlane Shannan and Francis Derwent Wood
Carvers: William Reid Dick, McGilvray & Ferris, James Harrison Mackinnon, James M. Sherriff, William Shirreffs, William Vickers and James Charles Young

Architects: J.W. Simpson and E.J. Milner Allen
Masons: Morrison & Mason (basement); Peter McKissock & Son (superstructure)
Date: 1892–1902
Materials: bronze (north porch group); red Locharbriggs freestone (pavilion figures and exterior carving); grey Giffnock sandstone (interior carving)
Dimensions: see below
Inscriptions: see below
Listed status: category A (15 December 1970)
Owner: Glasgow City Council

PART I – INTRODUCTION

a) Origins
Throughout the second half of the nineteenth century, Glasgow's municipal collections had been divided between the McLellan Galleries on Sauchiehall Street and Kelvingrove Mansion in the West End (now Kelvingrove) Park. Neither venue was wholly satisfactory, and as the city's collections grew in scope and importance, the inadequacy of this arrangement

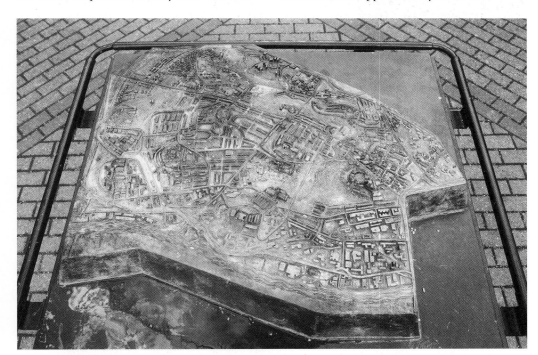

Kathleen Chambers, *Relief Map* [RM]

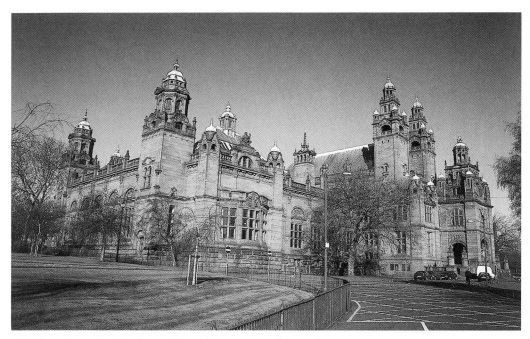

J.W. Simpson and E.J. Milner Allen, *Glasgow Art Gallery and Museum* [RM]

became apparent.[1] Moves to improve the situation began when Glasgow hosted the first of what was to become a series of major cultural celebrations, the Glasgow International Exhibition of 1888. Though the primary aim of the event was to consolidate the city's growing reputation as a centre of art, design and industry, part of its purpose was also to generate funds to finance the construction of a magnificent new building incorporating a School of Art, a Concert Hall and a permanent home for its collection of art treasures.[2]

The exhibition was a cultural and commercial success. With a surplus of £46,000 (eventually rising to £49,000 through bank interest) the organisers formed the Association for the Promotion of Art and Music in the City of Glasgow, and in March 1891, approached the Corporation to discuss a location. Exactly a

year later the Corporation agreed to grant a site in Kelvingrove Park (adjacent to the site of the Main Hall of the Exhibition), provided that the Association doubled its existing funds through private subscriptions. This appears to have presented no great difficulty, and within a few months an appeal to 'a limited number of citizens' had attracted a further £60,000.[3] The Association continued to supervise the progress of the building for several years, with the council acting as guarantor, though by December 1895, the council found it necessary to 'relieve the Association of their existing obligations, take over their funds, and complete the building themselves'.[4]

Ironically, the transition from private to municipal control did little to curtail the steady escalation in the cost of the venture – a factor which was to prove crucial to the programme of

sculptural embellishment eventually incorporated into the design. The initial estimate of £120,000, set at the time the design competition was announced, quickly rose to £155,000 after the winning plans had been studied by a firm of independent quantity surveyors. This necessitated a further appeal to the 'educated intelligence and generosity of the citizens to provide the balance'.[5] By the time the architects had completed their working drawings in March 1893, that figure had been revised upwards to £170,710.[6] The eventual cost was £257,000 – more than double the sum budgeted at the start of the project.[7] As part of its strategy to keep the overspend under control the Corporation abandoned the original intention to include a School of Art, which many had regarded as problematic to begin with. This eventually found its home in Charles Rennie Mackintosh's revolutionary new structure at 167 Renfrew Street (q.v.), built for a mere £14,000.[8]

The commission to design the new Museum went to the London architects J.W. Simpson and E.J. Milner Allen, whose proposal was the winning entry in a two-stage competition assessed by fellow London architect, Alfred Waterhouse. The competition was not without its critics, and the overall quality of the submissions, which seemed to reflect the worst excesses of late-Victorian free-style eclecticism, was widely derided. According to the *Builder*, the bulk of the 62 entries were 'frankly bad', with styles ranging from 'tawdry "Classic"' and 'unspeakable "Baronial"' to 'the atrocity of a Leicester Square "Alhambra"'.[9] There were also criticisms of the selection process, particularly the appointment of a single architect to act as adjudicator, as well as a degree of disquiet that local architects such as Honeyman & Keppie and J.J. Burnet (whose 'able and well studied' proposal was not even shortlisted) should have been overlooked in favour of a London firm. 'As a matter of fact', the *Builder* concludes,

… the award has been given to a design that embodies, skilfully enough, the latest 'London fashion'. The commercial capital of the North, grey, grimey, and damp, yet palatial Glasgow, has an architectural character of its own that is well worth studying. It is a pity that the new Art Galleries will hardly be in keeping with this character.[10]

Though it is nowhere stated explicitly, there was clearly a suspicion of metropolitan bias in the management of the competition in a way that threatened to re-activate the bitter hostilities that surrounded the appointment of George Gilbert Scott to design Glasgow University a quarter of a century earlier.

As for the winning design itself, this was described as 'an astylar composition on severely classical lines, but with free Renaissance treatment in detail'.[11] In lay terms, this means that it has no columns, a regular geometric ground plan and an abundance of bizarre historicist ornamentation. Structurally, the building is dominated by its spacious central hall, a magnificent barrel-vaulted conception with a clerestorey rising above the gallery ranges which flank it on either side. Projecting from the main façade is a large entrance porch, complete with Palladian staircases and capped by a pyramidal tower in three stages, each of which subdivides into an increasingly complex arrangement of aedicules, pedimented windows and finials, the whole ensemble finished with a domed hectastyle tempietto. Behind this a pair of towers rise to a height of 150 feet to form the strongest vertical accents of the entire building, and which can be seen, and recognised with ease, from many vantage points in the surrounding city. Their architectonic power is reinforced by a pair of two-storey pavilions framing the porch, variations of which appear on the extremities of the north and south façades. These corners are also marked by two-storey towers with turrets echoing the main

north towers in a slightly simplified form.

More than anything, however, the appearance of the building is characterised by the extravagance of its detailing. Described by recent commentators variously as 'Hispanic Baroque' and 'Jacobean-cum-Spanish Renaissance'[12] in style, its peculiar eclecticism frankly defies classification. A contemporary verdict on it as being 'far too much like a casino' and 'wanting in sobriety, and restfulness, and dignity'[13] is probably as close as any words will come to evoking the peculiarly mongrel-like coarseness of its treatment. But it is important to remember the circumstances in which it was built. Compared to the monstrous Byzantine confection designed by James Sellars for the 1888 Exhibition,[14] or James Miller's equally outlandish medley of Hispanic motifs that rose beside it in the follow-up event of 1901,[15] Glasgow Art Gallery and Museum is a model of stylistic restraint. The fact that it was conceived in the context of a larger cultural festival in Kelvingrove Park should also be borne in mind when considering the question of its orientation, and the mistaken popular notion that it was inadvertently built back to front. Though for all practical purposes the south front, facing the busy Argyle Street, is nowadays generally perceived as the main entrance, the principal frontage in fact faces north, towards the River Kelvin and Gilbert Scott's University on Gilmorehill, a building it was almost certainly intended to rival.

Given the exuberance of its conception, and the purpose for which it was erected, it is not surprising that the architects intended from the outset that sculptural ornamentation should feature prominently in the design. Most of the major decisions about the form the programme should take, including the number and disposition of the figures, were made by Simpson and Allen themselves, and the details indicated in their published plans of 1892 are remarkably close to the scheme as it was finally produced.[16] What they were less clear about

J.W. Simpson and E.J. Milner Allen, *Glasgow Art Gallery and Museum* (detail of north porch), from *Selected Design*, 1892. [GCA]

was the actual design of the figures, or who should execute them, and these were matters they appear to have been reluctant to address until the building was at a surprisingly advanced stage. Though the construction work had been proceeding steadily since the foundation stone was laid in September 1894, by the summer of 1898 not so much as a capital appears to have been carved. Indeed by this time the absence of sculpture was so conspicuous that a somewhat puzzled reporter from the *Builder* noted that the amount of *uncarved* stone on the building made it impossible to guess what its final appearance would be like.[17]

Despite the lack of tangible evidence on the

building itself, however, Simpson and Allen had in fact already begun to turn their attention to the question of sculpture, and in July 1897, they presented the council with an outline of their strategy for realising this aspect of the commission. 'The time has now arrived', they announced in their quarterly report,

… when the sculpture and carving forming part of our design should be put in hand, in order to allow proper attention and care being devoted to these important matters. It is our hope and desire that this portion of our work shall rank with the best continental monuments, and be such as the citizens can regard with pride and satisfaction.[18]

At this stage their main concern was to persuade the council to allow them to appoint a single master sculptor whose task it would be to 'model the designs of the various portions, and be responsible for their proper execution', in addition to executing a number of key parts of the scheme himself. They had very clear ideas as to what sort of sculptor was required for such a job:

It is necessary that he should be a man of strong decorative feeling in his work, and in sympathy with our design – a man sufficiently eminent to command the respect of those working under him, yet not too old to fear working on a scaffold, or too busy to give close personal attention, and undertake to maintain a reasonable punctuality in producing his models. Further, we do not apprehend that the committee would consent to pay what may be called the 'fancy prices' obtained by some of the leading men.[19]

In retrospect it is very evident that the job description was framed to suit the sculptor they had in mind, rather than the other way round, and after ruling out the possibility of employing a sculptor from France, on the grounds that bringing an artist from abroad would be both costly and difficult to administer, they went on to propose George Frampton as the man best suited to the task. Mindful, perhaps, of the possibility of causing further bad feeling by the appointment of yet another English artist to a key position, they conclude their report by adding the further stipulation regarding the team of sculptors he would be expected to gather round him:

In his choice of subordinates he must, of course, be primarily guided by the question of ability, but we desire that a large proportion of the work as they may be competent to undertake shall be allotted to Glasgow craftsmen.[20]

The council appears to have had no quarrel with this or any of their suggestions, and Frampton was accordingly invited to begin preparing sketches and estimates. It should be noted, though, that not everybody was happy with this arrangement. For example, Thomas McEwan, the Secretary of the Scottish Stone-Carvers Society, wrote to the council to complain about Frampton's appointment, and demanded to know why Glasgow sculptors had not been given a chance to compete for the post[21] – not an unreasonable request, given the committee's apparently patriotic desire that the work should be executed by local men. One such local artist, William Shirreffs,[22] was even more forthright in his condemnation of the decision, pointing out that the architects had clearly

… not made a very careful examination of the Architectural Sculpture of the public buildings of Glasgow, or they would have seen they could compair [sic] favourably with any similar work in the United Kingdom and all of the best of that work was done by native or resident Artists.

In his view, the failure to consider Glasgow sculptors was a snub not only to the artists themselves but also to the art education system. 'Art Schools', he observed,

… may not make Artists – only they are not made without them, and they will be of very little purpose if we are to be shut out from having any opportunity practising what we have learnt on the best of our buildings.[23]

Both his and McEwan's arguments appear to have been ignored.

As part of the quarterly report already referred to, Simpson and Allen also included a detailed technical schedule of the proposed sculpture and ornamental work, specifying the location, material and dimensions of every part of the building that involved carving or modelling.[24] It is a strictly factual list, making no distinctions in status between such major items as the bronze figures on the towers and much more subsidiary features of the kind that are quantified, in some cases, in their hundreds – keystones, consoles, capitals and so on. It is an interesting document, all the same – certainly an exhaustive one – and proved to be useful as a point of reference in the later stages of the scheme's development.

For a more discursive account of their intentions, however, we must turn to a second report, in this case composed jointly with Frampton, which was submitted to the council three months later.[25] It is clear from this that the grand unifying concept of the programme was to be the celebration of the historical traditions of art and music, but viewed from a specifically Scottish perspective. Thus the first work they describe in detail is the free-standing group 'St Mungo as Patron of Art and Music', which was to be located under the arch of the main entrance, and was clearly intended to establish from the outset a focus for the scheme's overall symbolic purpose. The theme of Glasgow's historic role as a mediator of the arts was to be elaborated in the reliefs in the surrounding spandrels. Individual figures representing the particular arts of painting, architecture, sculpture and so on (but also including religion

and commerce) were to be used as terminals for the various corner pavilions, with more generalised allegorical concepts of 'Fame' and 'Immortality' embodied in bronze figures surmounting the three main towers.[26]

As a supplement to the figurative work there was to be an extensive programme of decorative carving through which the cultural achievements of the world from all periods of history were to be, quite literally, spelt out. This is divided into three principal groups:

1. The tympana over the thirty ground-floor windows with cartouches bearing the names of 'the great artists of the Renaissance period, surmounted by the arms of their native city or country'.

2. The thirty-six piers dividing the main exterior bays terminating in cartouches bearing the names of Scottish clans, 'the north, south-east and west fronts being apportioned according to the relative geographical position of the clan counties'.

3. The capitals and spandrels in the three interior spaces bearing the emblems of the trades and crafts of Glasgow, the names of great musicians and key figures from Scottish history.

With some modifications (especially to the second group, see below) these proposals were carried out as described.

In their explanation of the rationale of the programme the authors place a great deal of emphasis on the 'essentially *structural* nature' of their conception of sculpture and carved work. 'It is', they claimed,

… no mere filling of panels with ornaments which may be left blank or unfinished without interfering with [the building's] form or design, but is in every case an integral part of the design, marking points deliberately selected as necessary for enrichment, in order to complete an outline

or enforce the simplicity and mass of an adjoining part.[27]

They also went to some lengths to stress the relevance of the project to the cultural life of Scotland, claiming that the 'thread of national feeling' that had been woven into the design would ensure that the building would be perceived 'distinctly as a *Scottish* monument'.[28] Conscious, perhaps, of the awkwardness of their position as English artists creating a work of such overtly patriotic intent they do, in fact, come close to overplaying their hand in this matter. After recording that Frampton had made it his task to visit the studios of all the 'principal carvers of the Glasgow and Edinburgh districts', they go on to express their

… gratification at the alacrity with which the principal firms have come forward to work under your Master Sculptor without jealousy or difficulty. Their desire is evidently not so much to profit pecuniarily as to have some share in the completion of a great municipal undertaking. With such a spirit manifested, the Corporation may be confident that their efforts will result in really fine work.[29]

By chance, the carvers nominated to produce this fine work were all from Glasgow, though the document gives an assurance that they had been selected by Frampton 'solely on their merits'.

Their emphasis on these two aspects of the scheme – its patriotic nature and its integral relation to the architectural conception – was clearly a tactic on the part of Frampton and his colleagues to prepare the council for the real bombshell their Report contained: their estimate of what it was all going to cost. In the original budget £5,000 had been allocated to sculpture; they were now asking for £15,644 6s. Frampton's fee alone, for the figurative work and 'Superintendence' of the contract, was

£9,000. This was evidently a matter on which they anticipated some resistance from the sub-committee, and the Report is as much a manifesto for the art of public sculpture – a plea to be allowed to carry out the scheme – as a working document. The tactic resorted to in its closing paragraphs is little short of moral blackmail:

It should be borne in mind in considering these estimates, that cost is entirely a matter of *quality* in such work. It can undoubtedly be done far more cheaply, and, if the committee does not see fit to sanction the proposed expenditure, there are two courses open:- 1st, to have the work executed by inferior craftsmen; 2nd, to carry out a portion only, and leave the building unfinished.

The first alternative will not, we believe, recommend itself to the committee. The building will be visited and criticised by the artists and *cognoscenti* of all nations, and the work must be such as we can show them without fearing its comparison with their own productions.

The second raises a purely financial question, which we are not competent to discuss. We can, however, affirm that full value will be obtained for the money spent, and that the work proposed is required for the completion of the building.[30]

The Report concludes by stressing the urgency of the situation, and the need for the work to begin 'without delay' if the building is to be completed on time.

In its insistence on the desire to produce work that will not expose the city to ridicule, and the somewhat arch claim that its authors were unable to comment on matters of finance, the document embodies a familiar antagonism between the artist and the philistine; it illustrates the long-standing myth, legitimated by the Romantic Movement, that creative imagination is forever being forced to trim its

aspirations to suit the demands of a pragmatic bureaucracy, whose only concern is to save money. In this case, the council's behaviour was very much in accordance with the stereotype, and its response to the Report was, to say the least, cautious. 'After considerable discussion', the Town Clerk was instructed to

… request the Architects to furnish the sub-committee with charcoal drawings of the sculptor and carving work referred to in their and Mr. Frampton's report, which is estimated to cost about £15,000. He was instructed to state that, as the sub-committee have some misgivings regarding the money which that work involves, they are desirous that the Architects should likewise supply charcoal drawings showing the sculptor and carving work which could be executed at an expenditure of about £10,000. Further that they be requested to supply charcoal drawings showing sculptor and carving work which they contemplated when the original sum of £5,000 was included in the estimates.[31]

The three alternative versions of the scheme, complete with drawings and photographs, were duly produced, prompting further deliberations by the council, which in turn demanded yet more precise details and yet more accurate costings. This continued for a full six months. Indeed the story of the scheme's progress from this point until its eventual acceptance by the council in May 1898, is one of almost chronic procrastination. Apparently paralysed by the prospect of the cost of the scheme spiralling out of control, the council resorted to an almost Kafkaesque proliferation of working groups and sub-committees, each generating its own volume of reports and memoranda to be remitted back and forth between the Parks Department, the Town Clerk and the City Engineer, none of whom seemed able to summon the will to approve the necessary expenditure. For Frampton and the architects

the experience was immensely frustrating, as is evident from their assertion that they

… would willingly do anything practicable, but, short of having the work modelled by men of different abilities and submitted to the committee, we fail to see how they can judge of the different work by contrast.[32]

It is not difficult to imagine the exasperation they felt in having to explain to their paymasters that 'the difference between the best work and inferior work, though great in effect, yet lies in very manifold and subtle points of detail'.[33]

The negotiations continued through the early months of 1898, coming to a head on 14 April when the architects produced a revised estimate of £13,043. Taking the opportunity to summarise – one suspects with a growing weariness – the main events up to that point they once again stressed that 'Glasgow would never regret having taken advantage of the opportunity', should the scheme go ahead.[34] Once again they were asked to reconsider it. A week later came their response:

With reference to the meeting of the Sub-Committee on Sculpture on 14th instant, and our report to you of the same date, we beg to say that we have reconsidered it, as directed, but we find ourselves unable to withdraw it.[35]

More extraordinary still, this adamant assertion of the integrity of the scheme was accompanied by two new alternative estimates – £19,450 and £14,243 – both of which were *higher* than the one they had been asked to revise.[36] The disparity in this case arose from the choice of companies to undertake the carver work, their own preference being for the London studio of William Aumonier rather than the assortment of less expensive Scottish firms. It is unlikely that they ever expected the higher estimate to be taken seriously, and even the second had to be justified on the somewhat

disingenuous ground that although it represented an increase on the price quoted earlier in the month, it still produced a net saving of £1,401 on the *original* estimate of October the year before.[37]

At this point the committee's opposition to the scheme suddenly and unexpectedly collapsed. Whether they had genuinely come round to believing the architects' arguments, or were simply exasperated with the whole business, is not recorded, but it appears that after 'a full interchange of views', the committee unanimously conceded that the sculpture was after all 'an essential feature of the building', and voted to accept the lower of the two estimates.[38] There were, however, strings attached. For some reason the council appears to have been unhappy about the £2,800 earmarked by the architects for George Lawson to execute the eight allegorical figures on the corner pavilions, and insisted that this work should be shared among 'three or four eminent sculptors', selected by open competition.[39] Precisely why they made this intervention is difficult to say. It is unlikely that the council had any personal objection to Lawson, who, having just completed the great Jubilee Pediment on the City Chambers, George Square (q.v.), was as reputable a sculptor as any working in Scotland at that time. Nor were there any financial advantages in this arrangement, apart from a paltry saving of £120, and even this was swallowed up by the award of 10-guinea honoraria to the unsuccessful competitors.[40]

All the same, the competition was itself an event of some note, and did much to stimulate public interest in the progress of the scheme. Advertisements were placed in the local press and the architectural journals inviting sculptors to

… submit sketch models to one-inch scale for eight seated stone figures (each about seven foot six inches high over all) forming a

portion of the external decoration of the galleries. The cost of the executed work is not to exceed £350 per figure or composition.[41]

Competitors were allowed to submit designs for any one or all of the subjects, but it was stipulated that no more than four commissions would be given to any one artist. This was an aspect of the competition that the *British Architect* thought misguided, pointing out that '... were it possible to find one man capable of producing the best artistic results in each case, he should most certainly be entrusted with the whole lot'. 'No doubt', it went on to speculate, '... it is pure benevolence on the part of the corporation which gives rise to this curious condition; but artistically considered, such a condition is radically wrong.'[42]

The deadline for entries was 1 December, and the successful applicants were expected to deliver the finished piece by 1 January 1900.[43] With 150 models received from 47 sculptors the response was, to say the least, enthusiastic, and on Friday, 2 December Frampton and Simpson made their recommendations to the council.[44] Their deliberations were meant to remain confidential until all the details had been fully ratified, but the news apparently 'oozed out' on the day of the meeting, enabling the *British Architect* to report the results in broad outline. The council, it announced,

> ... were to be recommended to bestow the execution of four of the figures upon Mr. Derwent Wood ... Another figure is (if the Council agree) to go to John S. Rhind, of Edinburgh, and another to Johan Keller, of Glasgow School of Art. Two other figures will probably be executed by London sculptors.[45]

The London artists turned out to be Edward George Bramwell and Aristide Fabbrucci (not A. Falkner, as reported by the *British Architect*),[46] who were entrusted with the

 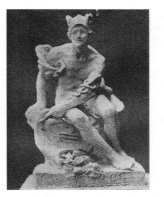
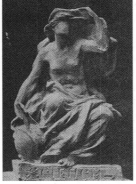

figures representing 'Literature' and 'Commerce' respectively. Derwent Wood was given 'Music', 'Architecture', 'Painting' and 'Sculpture'; 'Science' went not to John Rhind but his son William Birnie Rhind, and the remaining subject, 'Religion', went to Keller. Predictably, it was the English sculptors who got the lion's share of the work; even Keller only managed to win his commission because none of the original submissions for 'Religion' were thought to be satisfactory.[47] This minor hitch apart, Frampton and Simpson pronounced themselves well satisfied with the 'considerable excellence' of the submitted work,[48] and in the fortnight straddling the new year, all the models were put on public display in the Corporation (now McLellan) Galleries.

Competition maquettes: Bramwell, *Religion*; Keller, *Commerce*; Bramwell, *Literature*; Keller, *Science*; Keller, *Literature*; Keller, *Religion*. *The British Architect*, 26 May, 1899 [GSA]

Meanwhile, the actual work on the building was progressing, and was to continue throughout 1899 without any serious setbacks. By the summer of the following year, the group of wooden sheds that the sculptors had been using as workshops were ready for removal from the site, and their sale in July – for the princely sum of £33 4s. 6d.[49] – suggests that the bulk of the work had been completed by this time. Macfarlane Shannan's bronze tower figures were the only major pieces that were not completed by September, when the builders,

McKissock & Son, began clearing the site,[50] but these were certainly in place by the time the 1901 Exhibition was officially opened on 2 May, as can be seen from photographs showing the newly completed building beside James Miller's temporary Industrial Hall.[51] Sculpture was to feature prominently in both buildings, with a loan exhibition of bronze and marble works in the central hall of the Museum, many of which were later purchased for the permanent collection,[52] while in the Industrial Hall the chief attraction was a colossal portrait by Albert Hodge of King Edward VII, the first statue to be raised in his honour.[53]

Despite the fact that it had been used in the 1901 Exhibition, the building was still in fact incomplete, and various forms of fitting out and finishing work – including the design, carving and installation of an elaborate stone memorial panel – continued until well into 1902. By August, however, the council began making arrangements for a loan collection to be brought from London,[54] and at 2.15pm on Saturday, 25 October, accompanied by an organ concert, the building was officially opened by the Lord Provost. The general public, however, had to wait until 6pm to be admitted.[55] The event was advertised by the *Glasgow Herald*, which reminded its readers that 'the galleries formed a great attraction during the International Exhibition held at Kelvingrove last year'.[56] It might well be added that the idea for the building had been germinated in 1888, as part of the planning of an earlier event of the same kind. Two International Exhibitions, fourteen years and over a quarter of a million pounds later, Glasgow at last had its own permanent Art Gallery and Museum.

b) The Sculpture Debate

Given the time it took for the council to come to a decision, and the sheer complexity of the negotiations involved, it seems ironic that the scheme as finally executed is almost identical to the proposal outlined by Frampton and the architects in their Report of October 1897. Not one of their main objectives had to be modified in any significant way, and even their estimate of the cost turned out to be correct to within little more than £1,000. The only real concessions they had to make were in the artists assigned to carry out some parts of the work, but the loss of Aumonier for the decorative carving and Lawson for the pavilion figures could hardly be perceived as a climb-down on their part. Nevertheless, the mere fact that it was necessary to undergo such an extended discussion process at all before the scheme could be approved is itself significant, and provides an insight into the cultural climate in which public sculptors had to work at this time. In particular it highlights the special difficulties encountered by artists working for municipal authorities. The issue was taken up by Waterhouse in a letter he wrote to the council on 29 October 1897, responding to their request for his opinion on the architects' Report. Though conceding that the increase from the original budget of £5,000 to £15,000 was indeed a 'very material addition to the cost of the building', his main concern was to stress the uniqueness of the project, and to encourage the council to raise their own expectations of what Glasgow could and ought to be contributing to this aspect of national culture:

In the highest periods of Art the best sculpture was, undoubtedly, associated with the best architecture. Sculpture never has justice done it unless it remain in the place, the light, and the distance from the eye for which the artist designed it. Though in France this association of the two arts, and the prominent place given to sculpture are still the fashion, unhappily in this country it is very unusual to employ sculptors of the first class on architectural work, and our buildings suffer lamentably from this cause. Glasgow has now an opportunity of reviving the practice, and, I believe, if she does so she will never repent it.

The sculpture programme could not be omitted, he went on to argue, 'without seriously detracting from the beauty of the building', and it was important that the building had an external appearance worthy of the role for which it was designed. As an international showpiece for the visual arts it was vital that it was perceived as 'a monument of first-class sculpture as well as architecture, and a fitting palace of the arts'. Normal considerations of cost were to be tempered by the knowledge that it would not be judged in terms of 'the way such work is ordinarily executed on buildings in this country'.[57]

The *British Architect* agreed with Waterhouse, and joined the debate with an even more forthright criticism of British practice:

In this country, to the architect of any structure of magnitude there is no period of greater anxiety than when the time comes for him to present to the authorities under whom he works his scheme and estimate for the sculpture and decorative carving best fitted to give the crowning touch to his conception. He generally finds his committee embued with the cast-iron notion that this matter is an artizan's affair, to be priced per labour-time at trade-union rates. And he begins to regret he is an Englishman, and turns with envy to France, where the public are so well educated … that any fiasco through misplaced economy, or misjudgement in the selection of sculpture for any great erection, scarcely ever occurs.[58]

Like Waterhouse, it also urged the council to transcend its habitual penny-pinching concerns and seize this unique opportunity to cover itself in glory:

It, no doubt, seems to the Glasgow Corporation a big undertaking to spend from £15,000 to £20,000 on sculpture alone,

an expenditure for which they must inevitably be held responsible by the ratepayers, out of whose pockets the money must come. They may well hesitate, therefore, before finally committing themselves to it. On the other hand, the fact that these buildings are to be the embodiment of the art of the city, and that such union of good sculpture with good architecture is in itself a fine object lesson, all too rare in this country, of the union of the arts, will, we sincerely trust, have full weight in the decision. It may seem a bold thing for a municipality in this money-worshipping matter-of-fact Britain to undertake, but it is a thing, which, if done, shall rebound to the credit of Glasgow and its corporation in generations to come. Let Glasgow flourish! – not merely in Commerce, but in art.[59]

It is interesting that both the *British Architect* and Waterhouse contrast British practices with the much more healthy situation for sculptors in France, and the fact that Simpson and Allen included photographs of the Hôtel de Ville in Paris as part of their submission suggests that the French approach was widely regarded as a model worth emulating. To its credit, the council does seem to have appreciated the force of this argument, and in July 1898, the *Builders' Journal* was able to report that

… not only the sculptors, but the carvers who are to carry out the carved ornament, have been sent to Paris at the expense of the Corporation to examine all the old and modern work there. They were met there by the architect, Mr. Simpson, and Mr. Frampton, the sculptor appointed by the city, and spent some days visiting the most notable buildings.[60]

But was this enough? In retrospect the energy expended on securing the programme seems a little out of proportion to the value of the end product, and Waterhouse's prediction that it would be seen as a 'monument to sculpture' was surely more wishful thinking than a realistic evaluation of its merits. There are many fine individual pieces, certainly, but as a unified conception, integrating architecture and sculpture, it is scarcely a work of outstanding importance. Judged in relation to the scale of the building as a whole, the quantity of figurative work is actually quite modest, and with the exception of the truly commanding presence of Frampton's *St Mungo* in the north porch, most of the other figures appear isolated and remote – a series of discrete statements rather than components in an organically coherent scheme. The presence of empty niches on many of the corners merely adds to the impression of a programme that remains, despite the time and the effort required to bring it into existence, both incomplete and curiously unresolved.

It must be said also that the idealism, so confidently expressed in the first Report, was never translated very successfully into practice. As already noted above, when the architects claimed that local sculptors had come forward to work under Frampton 'without jealousy or difficulty', they overlooked the perfectly legitimate complaints from at least two sculptors that Frampton had been appointed without a competition. Their claim that local sculptors were motivated by a desire 'not so much to profit pecuniarily as to have some share in the completion of a great municipal undertaking' is also difficult to square with their often far from altruistic behaviour in actually carrying out the work. Rhind, for example, was deeply critical of the selection procedure for the pavilion figures and made 'certain complaints' to that effect.[61] Shannan protested about 'the loss sustained by him through his workshop, adjoining the New Art Galleries, having been removed several times … during the time he was engaged in executing his contract', and successfully sued the Corporation for compensation of £25.[62] William Shirreffs also had reasons of his own to be unhappy with the way he was treated, and although we do not know the cause of his grievance, his refusal to allow his models to be viewed on the site may have led to the termination of a part of his contract.[63]

At the same time, it is important that we do not lose sight of the larger context in which these difficulties occurred, and for a work of this scale and complexity to have been completed without some minor disputes with the workforce would have required a miracle indeed. In retrospect, the decision by Simpson and Allen to hold their ground in defence of the integrity of the sculpture scheme seems eminently well judged; without their determination, Kelvingrove Museum may well have joined the list of 'numerous failures' they claimed to be 'in evidence all through the country' at that time.[64] If nothing else, the history of their struggle with the Council provides us with a salutary reminder of the obstacle course of hoops and hurdles that often have to be negotiated in the realisation of a substantial, publicly funded sculptural programme, with lessons that are as relevant in the early years of the twenty-first century as they were at the dawn of the twentieth.

Notes
[1] Stevenson (1914), pp.35–7. [2] Association for the Promotion of Art and Music in the City of Glasgow, *Kelvingrove Art Gallery and Museum: Selected Design*, Glasgow, 1892, p.1 (hereafter *Selected Design*), GCA, F12/2 (Box 2). [3] *Ibid.*, p.1; GCA, C1/3/23, pp.122–3. [4] GCA, C1/3/23, p.125. [5] *Selected Design*, p.1. [6] GCA, C1/3/23, p.124. [7] Kinchin and Kinchin, p.56. [8] Buchanan, p.17. [9] B, 30 April 1892, p.335. [10] *Ibid.*, p.336. [11] *Selected Design*, p.2. [12] Kinchin and Kinchin, p.58. [13] B, 23 April 1892, p.318. [14] Kinchin and Kinchin, pp.22, 50–1. [15] *Ibid.*, pp.58–9. [16] See *Selected Design*, illustrations (n.p.). [17] B, July 9, 1898, pp. 25–6. [18] GCA, C1/3/24, p.643. [19] *Ibid.* [20] *Ibid.* [21] GCA, F12/2 (Box 2), Letter from Thomas McEwan to J. Shearer, 29 July 1897. [22] Misspelt as 'Shireffs' throughout the Kelvingrove

Museum documentation. [23] GCA, F12/2 (Box 2), Letter from William Shirreffs to J. Shearer, 28 July 1897. [24] *Ibid., Glasgow New Fine Art Galleries: Reports, Minutes, Correspondence &c.* (hereafter *Reports*), pp. 9–11. [25] *Ibid.*, pp.1–3. [26] *Ibid.*, p.1. [27] *Ibid.*, p.2. [28] *Ibid.* [29] *Ibid.* [30] *Ibid.*, p.3. [31] *Ibid.*, p.5. [32] *Ibid.*, p.8. [33] *Ibid.* [34] *Ibid.*, pp.17–18. [35] *Ibid.*, p.19. [36] *Ibid.*, p. 20. [37] *Ibid.* [38] GCA, C1/3/25, p.480. [39] *Ibid.* [40] *Ibid.*, C1/3/26, p.89. The estimates for the eight figures appear to have changed several times during the development of the commission, and the exact costs are difficult to disentangle from the surviving documentation. The report in the *Builders' Journal* of 18 May 1898 (p.270), that Shannan and Young were to receive £1,600 for eight figures, and that Lawson was to receive £2,800 for a further eight is clearly a misreading of the *alternative* estimates submitted by Simpson and Allen the previous month (*Reports*, pp.18, 20). It seems safe to assume that the intention in putting the work out to competition was to bring the allocation down to £200 per statue, and that this eventually rose to £350, bringing the total expenditure up to £2,800, precisely the sum the architects had provisionally assigned to Lawson. See BA, 8 July 1898, p.19, but also BJ, 20 July 1898, p.418. [41] BA, 10 June 1898, p. 396. [42] BA, 8 July 1898, p.19. [43] *Ibid.* [44] GCA, C1/3/26, p.89. [45] BJ, 9 December 1898, p.413. [46] BA, 16 December 1898, p.435. [47] GCA, C1/3/26, p.170. [48] GCA, C1/3/26, p.89. [49] *Ibid.*, C1/3/27, p.819. [50] *Ibid.*, C1/3/28, p.912; C1/3/27, p.260. [51] Kinchin and Kinchin, pp.58–9. [52] GCA, C1/3/29, p.109. These included Rodin's *John the Baptist* and *Burghers of Calais*, both in plaster, William Goscombe John's *The Elf* and Edwin Roscoe Mullins' *My punishment is greater than I can bear* (both marble, now in the Kibble Palace, see Botanic Gardens, above). [53] Kinchin and Kinchin, p.63. See also Kelvingrove Park, Appendix A, Lost Works. [54] GCA, C1/3/29, p.864. [55] *Ibid.*, p.1054. [56] GH, 25 October 1902, p.9. [57] *Reports*, pp.4–5. [58] BA, 24 December 1897, p.471. [59] BA, 6 May 1898, p.306. [60] BJ, 20 July 1898, p.418. See also BA, 8 July 1898, p.19. [61] GCA, C1/3/26, p.475. [62] *Ibid.*, C1/3/28, p.976. [63] *Ibid.*, C1/3/26, p.253. [64] *Ibid.*, C1/3/24, 1897, p.643.

Other sources
International Exhibition Glasgow 1901: official catalogue of the fine art section, Glasgow, n.d. (1901), pp.108–17; Williamson *et al.*, pp.277–8; Teggin *et al.*, pp.80–1; McKean *et al.*, pp.163, 177–8 (incl. ills); Johnstone; McKenzie, pp.86–9 (incl. ills); Jezzard, vol.I, pp.60–2.

PART II – FIGURATIVE WORK
North Elevation – Central Porch

St Mungo as the Patron of Art and Music
Sculptor: George Frampton

Material: bronze
Dimensions: figures colossal
Signed: on rear of plinth, right side – GEO FRAMPTON 1900

Description: In the architects' original design the main arch is occupied by a conventional allegory of the arts, with a standing male figure in the centre holding a palette, and a pair of seated figures at his feet. Below this is a door with a lintel inscribed 'SCHOOL OF ART'.[1] The abandonment of the plan to include accommodation for an art school enabled Frampton to reinterpret the theme, in the process underlining the element of civic patriotism which pervades the building as a whole. St Mungo is seated in the centre holding a crozier in his left hand, and with his right hand outstretched in benediction. His vestments are decorated with various motifs in relief, including angels on the sash falling from his shoulders and variations on the tree, bell and fish motif of the Glasgow coat of arms woven into the lace tunic over his knees.[2] Seated at the saint's feet are female figures holding attributes associated with the Liberal Arts: an open book (left) and a portable organ (right). These face in strictly opposite directions, like monumental book-ends, and with their heads lowered in concentration they provide a graceful counter-point to the rigid frontality of St Mungo.

Discussion: Writing in the *Studio*, Walter Shaw Sparrow drew a profound, if slightly obscure philosophical lesson from Frampton's treatment of the group:

It is conceived and modelled in a gallant and gracious spirit, the most welcome attribute of its style being a manliness that is not at all obtrusive, not at all ostentatious. To put the truth plainly, Mr Frampton has here achieved that fine harmony of masculine and feminine qualities which ought always to be present in the work done by an artist of genius, for the reason that genius itself is neither masculine nor feminine, but each and both – is, indeed, a single creative act with a double sex.[3]

Whether or not Frampton recognised his own creative intentions in Sparrow's gloss is difficult to say. In an earlier article of his own in the *Studio*, however, he does record an interesting anecdote which throws light on a slightly different aspect of the work:

Hanging up in my studio is a model of the head of a pastoral staff which I placed in the hand of a statue of St Mungo I was commissioned to execute for a building in the City of Glasgow. Not long ago a distinguished antiquary happened to visit me and this object caught his eye. Now in place of the conventional crocket I had broken the curves of the head of the staff by some little clusters of conventionally treated leaves which it seemed might be supposed to have sprung from the simple sapling from which the earliest shepherd's crook was most probably fashioned. 'But where are the crockets?' said he, to which I had to reply that there were none, but that I thought my little clusters of leaves fulfilled the artistic purpose of the crocket, and yet added a touch of originality and individuality to my work. 'Dear! dear! dear!' was the only comment, 'I never saw a pastoral staff without crockets, and I cannot think how you can have let yourself design one without any'. I found it a hopeless task to persuade my distinguished friend that a nineteenth century designer might be allowed to think for himself as well as the craftsmen of the thirteenth century, and we parted in mutual esteem.[4]

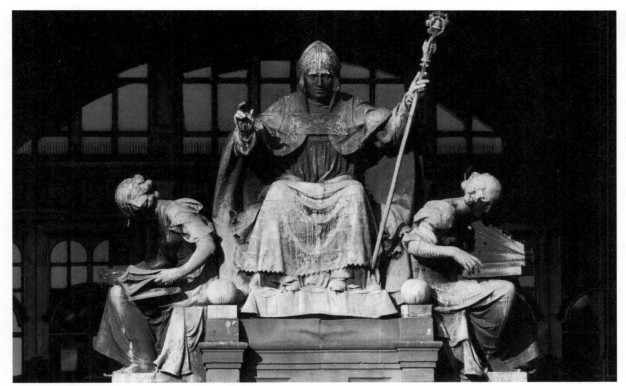

George Frampton, *St Mungo as the Patron of Art and Music*

The crozier referred to here belongs to Frampton's earlier statue of St Mungo on the Trustee Savings Bank (q.v., 177 Ingram Street), but the crozier at Kelvingrove is identical. In addition to the crockets, both croziers also incorporate a fish and a bell from the arms of St Mungo.

Frampton was paid £2,000 for the group.[5]

Related work: The plaster model of the group was exhibited in the Winter Garden of the People's Palace Museum for several years after the completion of the bronze.[6] This was later destroyed, but the heads of the three figures have survived and are now stored in the Museum.[7] A series of photographs of the St Mungo group is in the archive of the Henry Moore Institute, Leeds.[8] These are listed incorrectly as dating from 1897.

Condition: Good, though there is some minor surface graffiti.

Notes
[1] *Selected Design*, illustrations. (n.p.). [2] The motif of an avenue of linked trees with other emblems inserted between them seems to have been a favourite of Frampton's, and is used in two plaster models for memorial tablets and in the background of his 1902 marble portrait of Sir James Fleming in Glasgow School of Art; see *Studio*, vol.XVIII, no.79, October 1899, pp.50, 52, and vol.LIV, no.223, October 1911, p.39. It was also used on his *Memorial to Charles Mitchell*, Newcastle; see Spielmann, pp.92–3. [3] W.S.S. [Walter Shaw Sparrow], 'Mr. George Frampton, A.R.A., and his work for Glasgow Art Gallery', *Studio*, vol.XXII, no.95, February 1901, p.14. [4] George Frampton, 'The Art of Wood-Carving: Part I', *Studio*, vol.XII, no.55, October 1897, p.46. [5] *Reports*, pp.2, 14, 18, 20. [6] Eunson (1997), p.6 (ill.). [7] GAGM, no.S.81. [8] Henry Moore Institute, Leeds, P/A5/a–k.

Other sources
A.L. Baldry, 'The Art of 1900', *Studio*, vol.XX, no.87, June 1900, pp.3–20 (incl. ills); Beattie, pp. 94–7; Teggin *et al.*, pp.38, 80–1 (incl. ills); Jezzard, vol.I, pp.60–3, 257, vol.II, 3/10 (ill.); Ray McKenzie, 'The Sculpture Programme of Kelvingrove Art Gallery', *Journal of the Scottish Society for Art History*, vol.5, 2000, pp.15–20.

In the spandrels of the north, east and west arches of the entrance porch

Reliefs Representing Music, Literature and Manufacturing Arts

Sculptors: George Frampton (modeller); William Shirreffs (carver)

Material: red Locharbriggs freestone
Dimensions: 2.6m high (full-length figures)

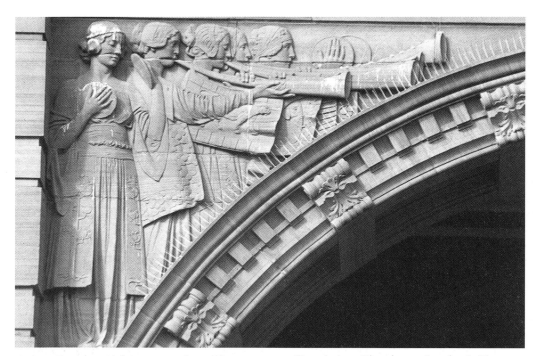

**George Frampton, *The Empire Salutes Glasgow*
(detail)** [RM]

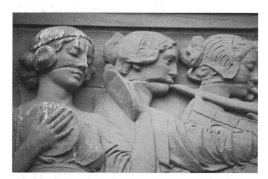

**George Frampton, *The Empire Salutes Glasgow*
(detail)** [RM]

Description: Complementing the *St Mungo* group are three pairs of spandrels in the arches of the north porch, extending the celebration of Glasgow culture with figures emblematic of art, music and commerce. *The Empire Salutes Glasgow*, in the centre arch, is composed of groups of female musicians in medieval dress with cymbals and long, curved horns. The outer figure on each side is shown full length, facing outwards and with the head in very high relief. Because of the narrowing of the compartment towards the centre, the other figures are visible only as torsos or heads in profile, with their relative positions in space expressed through variations in the depth of the carving. Stylistically, the horn-players are very similar to the figures on a silver cabinet door panel, made by Frampton some years earlier,[1] though here the curvature of the horns is used to brilliant effect as a device for filling the awkward corners of the spandrels. They are also draped with

banners showing various exotic animals associated with the colonies, including a lion, an elephant and a kangaroo. Carved acanthus leaves are inserted at intervals in the voussoirs of the arches and the keystone has a Glasgow coat of arms surmounted by a miniature St Mungo holding a bronze crozier (complete, in this instance, with crockets).

The arches in the east and west returns of the porch are narrower and lower than the north, with more space between the keystone and the cornice, allowing Frampton to treat each spandrel as a uniform frieze rather than as a pair of separate panels. *The Industries of Glasgow at the Court of Mercury* (east) shows a naked youth with a caduceus seated in the centre, framed in a shell-like enclosure created by his own outspread wings. He is flanked by lines of female figures, identical in treatment to those on the north face, bearing models emblematic of Glasgow's main industries: a ship, a bridge, a loom, and so on. In *Love Teaching Harmony to the Arts* (west) the central figure reads from a book spread open on his lap with his right hand raised, while the female figures, some of whom are singing, carry the familiar attributes of music and the visual arts: a portable organ, a set of pan pipes, a palette and a statuette. In both cases the extrados of the arch is draped with decorative forms such as swags and cornucopias which flow outwards from the central motif. These do not appear in the photographs of Frampton's clay models which were published in the *Studio*, and may not have been designed by Frampton himself.[2] As on the north face there are floral voussoirs inserted into the arches, and coats of arms in the keystones. Here, however, the emblems of St Mungo are divided between the two shields – a bird below 'Mercury' and a ring below 'Love' – and the shields are also enclosed in foliage.

Discussion: Walter Shaw Sparrow described the figures in the spandrels as being 'happily characteristic of the sculptor's manner', noting

that the lines were 'everywhere composed so as to contrast effectively with those of the surrounding architecture'.[3] The attribution of the carving to Shirreffs is based on Sparrow's description of the reliefs as having been carved 'from the models prepared by Mr Frampton'.[4] It should also be noted that Shirreffs was paid £1,808 for his work on the north façade, whereas Young received only £980 for the south.[5] Frampton's fee for modelling the three spandrels was £1,800.[6]

Condition: The faces of many figures have suffered badly from the masonry joints which run through their chins, and a combination of weathering and repointing has destroyed much of the detail. Some of the more protruding parts of the west spandrel, such as the palette and manuscripts held by the female figures, appear to have broken off.

Notes
[1] See E.B.S., 'Afternoons in studios: a chat with Mr. George Frampton, A.R.A.', *The Studio*, vol.VI, no.34, January 1896, p.211. [2] Sparrow, *op. cit.*, pp.14–18. [3] Sparrow, *op. cit.*, p.18. [4] *Ibid.* [5] *Reports*, p.2. [6] *Ibid.*, p.20.

Other sources
Beattie, pp.97–9; Teggin *et al.*, pp.80–1 (incl. ill.).

Above attic windows on the entrance porch

Masks of 'The Great Trio of Greek Art'

Sculptors: George Frampton (modeller); William Shirreffs (carver)

Material: red Locharbriggs freestone
Dimensions: masks larger than life-size
Inscriptions: on shields below masks –
 PHEIDIAS; ICTINUS; APELLES

Description: On the attic storey of the porch, the transition from the main structure to the tower is articulated by a series of dormer windows topped by broken pediments. Rising from the centre of these are portrait heads 'in full relief' of the three key great artists of classical Greece, identified by the names inscribed in relief on the shields below them: *Pheidias*, the sculptor, facing east; *Ictinus*, the architect, facing north; and *Apelles*, the painter, facing west. The shields are flanked by *amorini*, each of which also holds a tool or an attribute appropriate to its art: a mallet and a torso (*Pheidias*); a pair of dividers and an Ionic column (*Ictinus*); a drawing tablet(?) (*Apelles*).

Condition: the face of *Ictinus* is very worn.

Source
Reports, pp.1–2.

On attic of central pavilions, north elevation

Four Seated Female Figures Symbolising the Arts

Sculptor: Francis Derwent Wood

Material: red Locharbriggs freestone
Dimensions: figures 2.29m high
Inscriptions: on shields in pediments below
 each figure – MUSIC; ARCHITECTURE;
 SCULPTURE; PAINTING

Description: The pavilions are located in the re-entrant angles between the north porch and the main structure, and form an integral part of the architectonic massing at the base of the central towers. In addition to their inscriptions, the identities of the figures are indicated by their attributes. They are, from east to west: *Music*, playing a violin and with mouth open in song; *Architecture*, holding a miniature Ionic column; *Sculpture*, holding a mallet and a miniature carved angel, and with the right arm resting on a female torso; *Painting*, holding a palette and brushes and a drawing board(?). All the figures except *Architecture*, wear laurel crowns, and the shields bearing their names are enclosed with branches of oak (*Music* and *Sculpture*) and mistletoe (*Architecture* and *Painting*).

Discussion: In their report on the 1898 competition (see above), Frampton and Simpson commented that

For 'Music', 'Architecture', 'Painting', and 'Sculpture', we had no difficulty in selecting the models. Those submitted by the author marked A are characterised by great beauty of line and knowledge of form, and are thoroughly suitable, in their decorative treatment, to the architecture of the buildings. A few points will require consideration in working the designs out to larger scale, notably the projections, in special reference to points of view.[1]

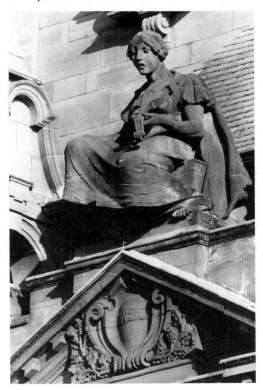

Francis Derwent Wood, *Music*

Derwent Wood was the only competitor to be awarded more than one commission. Photographs of his 'preliminary studies' were reproduced in the *Studio*,[2] and were later described by Walter Shaw Sparrow as being 'so easy and so free in style, so robust in monumental character'. He went on to suggest that 'Mr. Wood has every reason to be satisfied, for the completed statues take rank among the best examples of modern British work in architectural sculpture'.[3] M.H. Spielmann was no less impressed, describing the group as having a '… richness of style and a good arrangement of lines in keeping with the building. There is a breadth and an appreciation of simplicity of detail which is so valuable in decorative sculpture.'[4] Of the four statues he singled out *Architecture* as the 'most sculpturesque and quiet, if not the most pleasing of all'.[5]

Related work: Small sketches for all four figures were exhibited by Wood in the 1901 exhibition in the Museum itself (nos 157 and 163).[6]

Condition: The bronze violin bow of *Music* is missing, and the little finger of the right hand is broken off.

Notes
[1] GCA, C1/3/26, p.89. [2] *Studio* (18) December 1899, n.p. [3] Sparrow, *op. cit.*, p.14. [4] Spielmann, p.155. [5] *Ibid.* [6] *International Exhibition Glasgow 1901: official catalogue of the fine art section*, Glasgow, n.d. (1901), p.114.

Other sources
BA, 16 December 1898, p.435; West, p.300; Beattie, p.73 (ill.).

On attic of north-east pavilion

Seated Female Figure Symbolising Religion
Sculptor: Johan Keller

Material: red Locharbriggs freestone
Dimensions: 2.29m high

Description: The figure is shown with her right hand placed on a model ship, and with her left hand pointing skywards.

Discussion: Keller was the only local sculptor to win a commission in the 1898 competition (see above). In addition to his plaster model for *Religion*, he also submitted designs for *Literature*, *Science* and *Commerce*, none of which were accepted, though the latter two were awarded commendations.[1] All four designs were illustrated in the *British Architect*.[2] However, the adjudicators were unimpressed by the entries for *Religion*, and allocated Keller this subject on the strength of the 'boldness of treatment and originality' of his *Science*.[3] The confused origin of the figure is reflected in the use of a model ship as an attribute. Though presumably intended to symbolise the nave of a

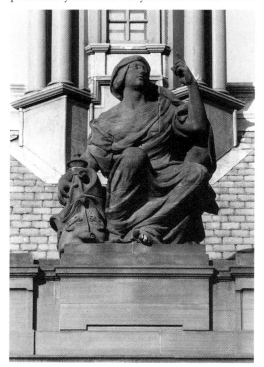

Johan Keller, *Religion*

church, in Glasgow the motif is more commonly interpreted as an emblem of naval architecture (see next entry). The figure is neither signed nor inscribed.

Condition: Good.

Notes
[1] GCA, C1/3/26, p.170. [2] BA, 26 May 1899, p.366. [3] GCA, C1/3/26, p.89.

On attic of north-west pavilion

Seated Female Figure Symbolising Commerce
Sculptor: Aristide Fabbrucci

Material: red Locharbriggs freestone
Dimensions: 2.29m high
Signed: FABBRUCCI / LONDON 1898

The figure is helmeted and holds a model of a ship's hull and a caduceus. Although his original submission for the 1898 competition was for *Painting*, the adjudicators awarded this commission to Fabbrucci because they found the 'general effect' of his work to be 'very pleasing and characterised by refined taste'.[1]

Condition: Good.

Note
[1] GCA, C1/3/26, p.89.

On attic of south-east pavilion

Seated Female Figure Symbolising Literature
Sculptor: Edward George Bramwell

Material: red Locharbriggs freestone
Dimensions: 2.29m high
Signed: E G BRAMWELL Sc.

Bramwell shows the figure wearing a wreath and holding a quill pen and an open book. He was awarded the commission for this figure on the strength of his entry for *Painting* in the

1898 competition. In their assessment of his submission, the judges noted that the

> ... general lines of the composition are exceedingly good, and accord well with the architectural surroundings. The treatment would be suitable for the subject proposed with but slight modification, but the curved top of the chair should be removed to allow the head to tell against the sky.[1]

The offending chair is clearly visible in the photograph of Bramwell's model for *Painting*, reproduced in the *British Architect*.[2] The criticism seems curious, however, given that the sky behind the finished figure is blocked by the turret which rises from the pavilion roof behind it.

Condition: Good.

Notes
[1] GCA, C1/3/26, p.89. [2] BA, 26 May 1899, p.366.

Additional source
Nisbet, p.521 (ill.).

On attic of west pavilion, south elevation

Seated Male Figure Symbolising Science

Sculptor: William Birnie Rhind

Material: red Locharbriggs freestone
Dimensions: 2.29m high

Discussion: Rhind's interpretation of the subject was selected 'on account of its dignity of composition, and the manner in which it supports and emphasises the lines of the architecture'. The assessors go on to suggest, however, that the treatment could be 'improved by the omission of the boy figure and the substitution of symbolic accessories to the design'.[1] As executed the figure, the only male among the pavilion statues, is shown resting his elbows on the arms of a chair, with a pile of books, a dinosaur skull and a globe at the base,

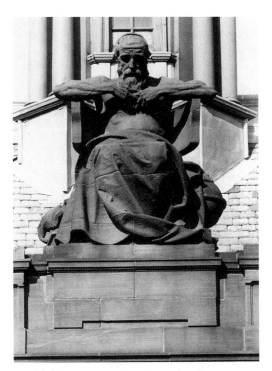

William Birnie Rhind, *Science*

an arrangement possibly based on a painting of *Archimedes* by Niccolo Barabino (1831–91).[2]

Related work: A signed bronze maquette of this work was sold at Christie's, London, in March 1988.[3] Similar figures by Rhind include his *Personification of Science* on the Armstrong Building, Victoria Road, Newcastle (1906), and *Allegory of Learning* on Shipley Art Gallery, Gateshead (1917).[4] The latter includes a small child.

Notes
[1] GCA, C1/3/26, p.89. A photograph of the original model with a naked boy standing beside the main figure is reproduced in BA, 26 May 1899, p.361, while Spielmann, p.127, reproduces a photograph of the amended model. [2] Illustrated, *Magazine of Art*, 1892, opp. p.366. [3] Stevenson (n.d.), n.p. [4] Usherwood *et al.*, pp.63, 143 (incl. ills).

PART III – DECORATIVE CARVING

a) Exterior
Scottish Counties and Artists' Names

Carvers: William Reid Dick, James Harrison Mackinnon, William Shirreffs (north façade); James Charles Young (south façade); William Vickers (east and west façades)

The programme of decorative relief carving forms a continuous and integrated scheme running round the entire exterior of the building, and although different parts were executed by different artists,[1] the architects' intention was that it should be seen as a single, evolving statement. It is divided into two parts:

i) Above the main windows is a series of thirty tympana containing the names and coats of arms of the Scottish counties. These are in alphabetical order, running anti-clockwise from the bay immediately to the right of the south-west pavilion.

ii) The thirty-six pilasters dividing the window bays are terminated with festooned cartouches bearing the names of 'the great artists of the Renaissance period, surmounted by the arms of their native city or country'.

As it stands the programme differs in two important respects from the scheme outlined by Frampton and the architects in their original proposal of October 1897. Firstly, the Scottish counties are given in their document as 'clan' names, and the intention was that they should be disposed according to their relative geographical positions in Scotland: 'e.g., Campbell to the west front, Sutherland to the north, &c.'. Secondly, the positions of the two divisions of the scheme are reversed, with the

artists' names appearing on the pilasters not, as initially proposed, in the tympana.[2] In all other respects, the scheme is identical to the architects' original conception.

The counties referred to in the tympana are presented alphabetically, as follows:

ABERDEEN; ARGYLL; AYR; BANFF; BERWICK (south façade, west section); BUTE; CAITHNESS; DUMBARTON; DUMFRIES; EDINBURGH (south façade, east section); ELGIN AND NAIRN; FIFE; FORFAR; HADDINGTON; INVERNESS (east façade); KINCARDINE; KINROSS AND CLACKMANNAN; KIRKCUDBRIGHT; LANARK; LINLITHGOW (north façade, east section); ORKNEY AND SHETLAND; PEEBLES; PERTH; RENFREW; ROSS (north façade, west section); ROXBURGH; SELKIRK; STIRLING; SUTHERLAND; WIGTON (west façade).

The artists' names in the pilaster cartouches are not in alphabetical order, nor do they appear to follow any strict chronological of geographical pattern:

GIOTTO; BRUNELLESCHI; VAN EYCK; DONATELLO; DELLA ROBBIA; BRAMANTE (south façade, west section); BOTTICELLI; LEONARDO DA VINCI; SANSOVINO; ALBRECHT DÜRER; MICHELANGELO; GIORGIONE (south façade, east section); TITIAN; RAPHAEL; CORREGGIO; HOLBEIN; BENVENUTO CELLINI; VIGNOLA (east façade); PALLADIO; TINTORETTO; PAOLO VERONESE; JEAN GOUJON; RUBENS; VELASQUEZ (north façade, east section); VAN DYCK; CLAUDE LORRAINE; REMBRANDT; TENIERS; MURILLO; WREN (north façade, west section); JAMES GIBBS; WATTEAU; HOGARTH; REYNOLDS; GAINSBOROUGH; CHAMBERS (west façade).

Minor Exterior Relief Decorations

North Elevation
Numerous decorative motifs, consisting of conventional swags, volutes, cherub and lion masks in various combinations, appear in many other parts of the north façade. These include:

i) the subsidiary pediments and spandrels on the porch and main towers;

ii) the pediments of the 'Great Trio';

iii) the colonettes in the peristyle above the north porch;

iv) the four cylindrical piers flanking the central staircases;

v) the spandrels above the bow windows on the outer pavilions.

East and west elevations
There are reliefs above the four tower entrances at each end of the east and west elevations. These are described in the 1897 Report as being: 'emblematical of "Naval and Mercantile Shipping", the centre pieces being formed by the prows of ships and galleons'.[3]

Notes
[1] The allocation of the work to different carvers is given in the 'Report by the Architects and Master Sculptor on the Sculpture and Carving' of October 1897. See *Reports*, p.2. See also 'Architectural Sculptor', GH, 8 November 1954, p.9, for the contribution to the north façade by Mackinnon and his apprentice, William Reid Dick. [2] *Reports*, p.1. [3] *Reports*, p.1.

b) Interior

Names and Crests of Glasgow Trades; World Composers; Figures from Scottish History

Sculptors: McGilvray & Ferris (Central Hall); James Sherriff (East and West Courts)

Central Hall

The upper part of all the main supporting pillars are carved with the crests of the Trades and Guilds of Glasgow. Their names are given in raised, gilded letters and each is surmounted by a castle. Reading anti-clockwise from the west end of the south wall they are: BARBERS; CORDINERS; WEAVERS; MASONS; HAMMERMEN; BONNET-MAKERS; BAKERS; COOPERS; MALTMEN; WRIGHTS; SKINNERS; TAILORS; GARDENERS AND FLESHERS.

The spandrels between the arches on the first-floor gallery are filled with elaborate scrollwork and festoons surrounding

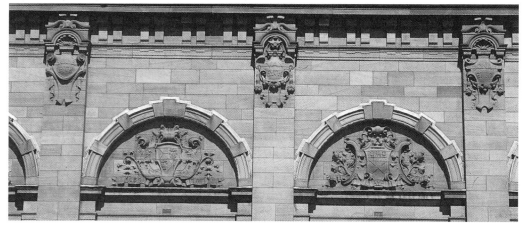

James Charles Young, *Scottish Counties and Artists' Names* [RM]

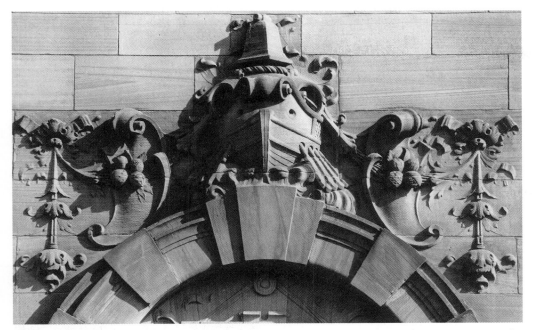

William Vickers, *Decorative Carving*

cartouches bearing the names of famous composers. Reading anti-clockwise from the west end of the south wall they are: D'AREZZO; MOZART; WAGNER; HANDEL; PURCELL; WALLACE; GLUCK; MENDELSSOHN; MEHUL; TALLIS; SCARLETTI [*sic*]; BALEE; LULLY; PALESTRINO [*sic*]; AUBER; ARNE; BEETHOVEN; LISZT; BENNET; CHERUBIN [*sic*]; BACH; WEBER; DI LASSO; BELLINI; DIBDIN; SCHUMANN; HAYDN; GOUNOD; ROSSINI; BRAHMS; CHOPIN; SCHUBERT; SPOHR; BISHOP; DONIZETTI; VERDI.

Coats of Arms

On the columns flanking the door to the north porch are the coats of arms of the two principal commercial organisations of Glasgow: the Trades House and the Merchants' House. The former incorporates a *fasces*, a cherub mask, a festoon and the motto 'UNION IS STRENGTH'; the latter consists of a conventional version of the arms of Glasgow, augmented by a ship and a ribbon bearing the motto 'TOTIES REDEUNTES EODEM' (trans.: 'always returning to the same place').

On the south wall the entire central section of the second storey is devoted to a large and elaborate architectural structure framing the combined arms of Glasgow and the British Empire. The central motif is a shield bearing a lion rampant and the legend 'LET GLASGOW FLOURISH' in raised, gilded letters, with much use made of swags and scrollwork in the interstices. Above it is a broken segmental pediment, which supports a pair of seated lions bearing a gilded sword and cross, while the flanking sections show blind cartouches supported by pairs of banded columns.

East and West Courts

The cartouches in the spandrels of the arches at first-floor level bear the names and dates of famous figures from Scottish history. Reading clockwise from the north end of the east wall of the East Court they are: ST. COLUMBA 521–597; MALCOLM CANMORE 1024–1093; DAVID I 1084–1153; BISHOP WISHART – 1316; SIR WILLIAM WALLACE 1270–1305; ROBERT THE BRUCE 1274–1329; JOHN BARBOUR 1316–1395; JAMES I 1394–1437; BISHOP TURNBULL 1400–1454; HENRY THE MINSTREL; SIR DAVID LINDSAY 1490–1555; JOHN KNOX 1505–1572; MARY STUART 1542–1587; GEORGE BUCHANAN 1506–1582; ALEX HENDERSON 1583–1646; ALLAN RAMSAY 1686–1758; DAVID HUME 1711–1776; SIR JOHN MOORE 1761–1809; ADAM SMITH 1723–1790; DUGALD STEWART 1753–1828; ROBERT BURNS 1759–1796; SIR WALTER SCOTT 1771–1832; FRANCIS JEFFREY 1773–1850; THOMAS CAMPBELL 1777–1844; LORD CLYDE 1792–1863; THOMAS CARLYLE 1795–1881.

Reading clockwise from the south end of the west wall of the West Court the names continue as follows: JOHN NAPIER 1550–1610; GEORGE HUTCHESON 1580–1639; COLIN MACLAURIN 1698–1746; COLIN DUNLOP 1706–1777; ROBERT FOULIS 1707–1776; JAMES HUTTON 1726–1797; JOHN HUNTER 1728–1793; JOSEPH BLACK 1728–1799; WILLIAM MURDOCH 1754–1839; JOHN RENNIE 1761–1821; JAMES WATT 1736–1819; DAVID DALE 1739–1806; ALEXANDER WILSON 1766–1813; CHARLES MCINTOSH 1766–1843; HENRY BELL 1767–1836; ROBERT BROWN 1773–1858; CHARLES TENNANT 1768–1838; DAVID NAPIER 1790–1869; J. B. NEILSON 1792–1865; ARCHD. MCLELLAN 1797–1854; THOMAS GRAHAM 1805–1869; SIR J.Y. SIMPSON 1811–1870; JAMES NASMYTH 1808–1890; JOHN ELDER 1824–1869; DAVID LIVINGSTONE 1813–1873; J. CLERK MAXWELL 1831–1879.

North entrance hall

Foundation Stone

On the south wall at the foot of stairs to East Hall

Carver: James Harrison Mackinnon

Designer: J.W. Simpson or E.J. Milner Allen
Materials: sandstone (main panel); marble (inscription tablet)
Dimensions: approx. 3m × 1.83m

Though it was designed in 1901, the decorative panel visible in the wall today commemorates the official laying of the Foundation Stone by the Duke and Duchess of York on 10 September 1897. The ceremony was a grand occasion, in which the Duke used a gold trowel, made by the goldsmiths William Alexander & Son at a cost of £52 10s., as well as a plummet (£17 10s.) and mallet (£5) to assist the Master Mason, Mr. McKissock, in ensuring the stone was 'well and truly laid'. For her part the Duchess placed the lid on a casket containing 'contemporary local literature and other articles' which McKissock had inserted into the wall cavity.[1]

The stone itself is carved as an arched panel with the arms of the House of York embedded in a complex design of medieval heraldic devices, festoons and decorative scrollwork. Additional ornaments include emblematic roses, dolphins and the prow of a ship. Below the main arms a ribbon is inscribed 'ICH DIEN' ('I serve'). The rectangular memorial slab is inscribed: THIS STONE WAS LAID ON / THE TENTH SEPTEMBER 1897 / BY HIS ROYAL HIGHNESS THE DUKE OF YORK K.G. / THE HON DAVID RICHMOND LORD PROVOST / JOHN W. SIMPSON / E.J. MILNER ALLEN / JOINT ARCHITECTS.

Note
[1] GCA, F12/2 (Box 2).

Other source
Anon., 'Architectural Sculptor', (obit. of Mackinnon), GH, 8 November 1954, p.9.

PART IV – INTERIOR SCULPTURES INDEPENDENT OF THE BUILDING

The Art Gallery contains a significant collection of historic and contemporary sculptures, some of which were purchased from the temporary display organised for the International Exhibition of 1901 (see Introduction, above, n.52). Of particular historic interest, however, is Flaxman's portrait of William Pitt the Younger, which was commissioned independently and which precedes the establishment of the city's museum services by almost half a century.

In the corridor to the right of the north entrance

Statue of William Pitt the Younger

Sculptor: John Flaxman

Date: 1812
Material: marble
Dimensions: statue 1.86m high; pedestal 97cm high
Signature: at the base of the pillar – JOHN FLAXMAN R.A. / SCULPTOR
Inscription: on the front of the pedestal – GULIELMO PITT / CIVES GLASGUENSES / POSUERUNT / A.D. 1812. (Trans.: 'Glasgow citizens set this up for William Pitt'.)
Listed status: category A (15 December 1970)
Owner: Glasgow City Council

William Pitt the Younger (1759–1806), British Tory politician. The son of William Pitt, first earl of Chatham, he received his early education at home and later at Pembroke Hall, Cambridge, where his exceptional brilliance led to his being called to the bar in 1780. His real interest was in politics, however, and in 1782, after being elected as a Member of Parliament for a 'pocket borough' in Westmoreland, he was appointed Chancellor of the Exchequer; he became Prime Minister two years later, at the age of twenty-four. The main achievement of the early part of his first ministry was the

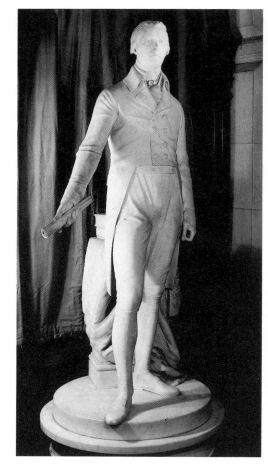

John Flaxman, *William Pitt the Younger* [GAGM]

introduction of economic reforms to combat the massive debt incurred during the American War of Independence, devising a 'sinking fund' based on the fiscal theories of Adam Smith (q.v., Hunterian Museum, University of Glasgow). He also tried to introduce constitutional reforms, but with the outbreak of war with France in 1793 his repressive treatment of the radicals, and his later

suspension of the Habeus Corpus Act, contributed to his reputation as an essentially reactionary politician. In 1801, he resigned over opposition to his proposals for Catholic emancipation in Ireland, an event which is believed to have precipitated the madness of King George III. The outbreak of the second war with France in 1803 led to his return as Prime Minister in the following year, and although his skilful international diplomacy was probably a less decisive factor in the defeat of Napoleon than Nelson's victory at Trafalgar (1805), he came to be regarded at the conclusion of the war as the 'saviour of Europe'. Though he was one of the greatest debaters of all time, and dominated parliament during a period renowned for its outstanding orators, he was a shy and socially ineffectual man, with almost no experience of the world beyond his parliamentary activities. He travelled little, never once visiting Scotland, and took no interest in the arts or literature. He died in January 1806 and was buried in Westminster Abbey.[1]

Description: Dressed in a Georgian swallowtail coat, a cravat, knee-breeches and buckle shoes, the subject stands with his right leg placed slightly in advance of the left and with a roll of paper in his extended right hand 'as if making a speech in the House of Commons'.[2] Behind the figure is a draped pillar supporting a pair of books.

Discussion: The decision to erect a commemorative statue to Pitt was prompted not, as has been suggested, by the statesman's death in 1806,[3] but by the news of his successful negotiation of peace with Napoleon in Amiens in March 1802. The proposal was initiated privately by a group of 'Merchants and other respectable Inhabitants of the city',[4] but was immediately endorsed by the city council, which stated at a meeting in June 1802, that it

… highly approved of the design [i.e., proposal] and would most chearfully [*sic*] allot a proper place in the city for erecting

the said Statue as a token to the present and as a monument to succeeding generations of the eminent worth and transcendant [*sic*] abilities of the great Statesman who has been a principal means under providence of preserving entire and unimpaired our most excellent Constitution amidst the Revolutions and convulsions which have been the unhappy fate of the surrounding nations…[5]

As a demonstration of its commitment to 'a purpose so truly patriotic and praiseworthy' the council unanimously appointed three of its members – Laurence Craigie, James Black and Kirkman Finlay (see Merchants' House, 7 West George Street) – to join the subscription committee, adding a further three councillors in February of the following year.[6]

Not everybody in Glasgow was quite so enthusiastic about the proposal, and a satirical handbill entitled 'The "Heaven-born Minister!"', which circulated in Glasgow in 1806, provides a rather different perspective on how Pitt's political achievement was viewed at that time by the common man. The main part of the handbill is a draft of a verse inscription, 'respectfully Dedicated to the Subscribers to his Statue', in which the subject is lampooned as an ineffectual and dangerously conceited bungler… 'He was', it points out, the

Advocate for Reform, which did not succeed;
The Opposer of the Slave-trade,
which increased:
The Patron of Irish Catholics,
who were not emancipated;

It was also during his administration that

The bulwarks of British Freedom were subverted;
The ancient Nobility degraded;
The Poor additionally depressed,
And
The middling classes of society annihilated;
And the

Sources of corruption deepened and enlarged:

The peroration takes the form of a catalogue of all those who, like Napoleon together with sundry 'Collectors of Taxes' and 'Contractors for the Army', were

Enriched, ennobled, protected, and aggrandized,
By this Friend of the People!
The Saviour of Britain!!
The Protector of Europe!!!
This 'Heaven-born Minister'!!!!
This Pilot that weathered the storm!!!!
Erect this Memorial,
Indicative of his unequalled merit,
And of their eternal gratitude and inconsolable regret.

The text for the inscription is accompanied by a series of footnotes in which other aspects of the received view of his stature as a politician are called into question, not least his reputation as a speaker. 'His eloquence', it contends

… was frothy; it was always unsubstantial; it very rarely produced conviction; but its object was answered by the plausibility of it, which furnished the means of a justification, or rather, which protected against an unbearable sense of shame, those who, from motives of self-interest, gave him their support. In all matters of state, rightly so denominated, he was conspicuous for nothing but the imbecility of his plans, and the fondness of his expectations, arising from that arrogance which had been born with him, and which had been nursed up by the flattery of the supple slaves, with whom he was, and loved to be, continually surrounded.

In conclusion, the writer declares that the erection of the monument

… will only serve to perpetuate his disgrace, and to make the contrast more striking between the father and the son… The father

carried the glory of the nation, at a small expence [sic], to the greatest height; the son, at most enormous expence, depressed it to such a state, that nothing but the most vigorous exertions can save us from falling a prey to the French. Yet a public monument is to be raised to the memory of the son, of whom the chief exploits to be recorded are, that he talked more, and to worse purpose, than any man in Europe, and added more to the burdens, and took more from the liberties of his country, than any of his predecessors. The system of this man, it is hoped, will be buried with him.

The handbill is signed by D. M'Kenzie, of no.151 Trongate, and dated 18 March 1806.

According to Irwin it was not until two years later that the commission was awarded to Flaxman, who used his rejected design of 1807 for a monument to Pitt in Westminster Abbey as the basis for the Glasgow statue.[7] The sum available for the commission was £1,300. By June 1812, the subscribers were able to report that the statue was 'completely finished', and that it was expected to arrive from Flaxman's studio in London in the middle of July. Their request for permission to erect the statue in the Town Hall, at that time located on the Trongate, was approved by the council, which unanimously agreed that 'the statue of Mr Pitt shall be placed at the east end of the Town Hall, during pleasure'.[8] In 1816 the council vacated the Trongate premises in the first of a series of moves before finally settling in the City Chambers (q.v., George Square). Whether the statue was relocated with each successive move is not known, and according to GAGM records it did not become part of the Glasgow Museums' collection until 1877. However, a watercolour by Mark B.A. Dessurne dating from 1859 shows the statue clearly on display in the Corporation Galleries on Sauchiehall Street, suggesting that it was transferred to the Museum's collection at the time the Council

took over the McLellan Galleries in 1856.[9]

Critical evaluations of the merit of the statue as a work of art have varied. For George Eyre-Todd, writing in the 1930s, it was 'esteemed as the finest achievement of the sculptor's art in possession of Glasgow'. More recently, Irwin has described the statue as lacking 'any sense of vitality', and that consequently 'it must unfortunately rank among Flaxman's weaker pieces'.[10]

Condition: Good.

Notes
[1] EB, vol.14, pp.477–80. [2] Irwin, pp.181–3. [3] *Ibid.*, p.181. [4] GCA, C1/1/45, p.261. [5] *Ibid.*, p.262. [6] Ibid., pp. 263, 526. [7] Irwin, p.181. The model is now in the Soane Museum, London. [8] GCA, C1/1/49, p.623. [9] See McLellan Galleries, 254–90 Sauchiehall Street. Dessurne's watercolour is illustrated in George Fairfull Smith, 'The Fine Arts in Glasgow', in George Rawson (ed.), *Missionary of Art: Charles Heath Wilson 1809–1882*, Glasgow, 2000, p.34. [10] Irwin, p.183.

Additional source
James Cleland, *The former and present state of Glasgow*, Glasgow, 1840 (2nd edition), p.115.

PART V APPENDIX – LOST SCULPTURES

The domes on the two main towers and the north porch were originally finished with bronze female figures emblematic of 'Victory'[1] by Archibald Macfarlane Shannan. In Simpson and Allen's original conception these were to be designed with outspread wings, but their profiles were simplified on the advice of Alfred Waterhouse, who found them 'antagonistic to the tapering lines of the towers'.[2] This was the only part of the entire sculptural scheme that Waterhouse regarded as unsatisfactory. As executed they were: *Success*, 2.13m in height, on the north porch, the model of which was exhibited at the RGIFA in 1900 (832);[3] *Immortality* (also known as *Glory*) and *Fame* on the main towers, both 2.3m high.

Shannan's sculptures, though beautifully designed, do not appear to have been very

Archibald Macfarlane Shannan, *Success*. Photograph from *Academy Architecture*, 1900[1]
[GSA]

soundly made. In 1923 the figure on the eastern tower was beginning to deteriorate, and was repaired, along with some of the associated masonry, by John Emery & Sons, at a cost of a little less than £708.[4] In November 1940 the then Director of the Museum, Tom Honeyman, ordered all three figures to be removed for the duration of the war 'in the interests of public safety'.[5] Once again Emery was commissioned to carry out the task of removing them and placing them in storage in the roof of the Museum.[6] It proved, however, to be an impossible task, as Honeyman was to recollect in his Rectorial address to Glasgow University in 1954:

> I have to take you back – but only a little bit – some 15 years. Once upon a time there were two angels. They were made of bronze. They were perched on the two high towers on the roof of the Art Gallery. They looked directly across the … River Kelvin.
>
> To get them down we had to saw them in half. They were hollow. They had not been well cast. Of course, they were weather-beaten and it was not difficult to see how they had been patched up to look their part from a distance. They went the way of all metal at that time, and I do not know what happened to them. Maybe they became part of a weapon of war.[7]

Only a bronze wreath on the base of *Success* remains. The extensive refurbishment of the building, begun in 1999, prompted calls for the replacement of the three statues with modern replicas,[8] but it appears unlikely that these will be acted upon.

Notes
[1] *Reports*, p.4. [2] *Ibid.* [3] Billcliffe, vol.4, p.106; illustrated in *Academy Architecture*, 1900[1], vol.17, p.135. [4] GCA, C1/3/68, p.1164. [5] *Ibid.*, C1/3/103, p.341. [6] *Ibid.*, p.412. [7] T.J. Honeyman, *The Clear Horizon*, Glasgow University Rectorial Address, 1954, pp.4–5. [8] Gary Nisbet, 'The Art of Success', *Saturday Times*, 10 April 1999.

Kelvin Walkway KELVINBRIDGE

Outside the Big Blue diner, below Kelvin Bridge

Big Bluey
Sculptor: Philip Benson

Date: 1995
Material: poplar
Dimensions: 4.57m high
Inscription: on metal plaque – BIG BLUEY / CREATED BY / PHILIP BENSON 1995
Listed status: not listed
Owner: Sandro Giovanazzi

Carved directly from the stump of a poplar tree, and stained blue, the sculpture is in the form of a giant dolphin leaping from the river embankment. Benson conceived the idea of creating the work in April 1995 after a 25 metre poplar tree, its roots weakened by winter flooding, had toppled into the River Kelvin. As a precaution, Council workers planned to fell three neighbouring trees that were listing badly, but on Benson's request, agreed to leave a five metre stump of one of them for him to carve. At the time, Benson was without carving tools of any kind, as these had been stolen when thieves raided his basement flat in January. In June, however, he approached Sandro Giovanazzi, the owner of the nearby Big Blue diner, and offered to carve an eye-catching feature on the terrace in exchange for a new set of tools, including a power saw. According to Giovanazzi:

> He just came in off the street, pointed to the tree outside and said 'buy me the tools and I'll carve you a dolphin'. He handed over a beautiful carving as collateral and we agreed to put up the money and contact the council for permission.[1]

Philip Benson, *Big Bluey* [RM]

The carving took a month to complete.
Condition: Poor. The left fin has been broken off, and the stain has faded.

Note
[1] ET, 5 June 1995, p.3.

Additional source
West End Free Press, June 1995, p. 3.

Killermont Street COWCADDENS

In the main concourse of Buchanan Bus Station

Wincher's Stance

Sculptor: John Clinch

Date: 1994
Unveiled: 23 February 1995
Material: bronze
Dimensions: figures life-size
Inscription: in raised letters on bronze plaque
 set into pavement – WINCHER'S STANCE / BY /
 John Clinch / NAMED BY / Susan Ritchie /
 COMMISSIONED BY / Strathclyde Passenger /
 Transport Executive
Listed status: not listed
Owner: Strathclyde Passenger Transport
 Executive

Description: A pair of lovers embracing in reunion, with a weekend case at the feet of the man. The man wears dungarees and the woman a tam-o'-shanter, a short dress and high-heeled shoes. A copy of the *Evening Times* protrudes from a pocket on the side of the case. The sculpture is placed directly on the pavement without a plinth.

Discussion: In August 1994 Strathclyde Passenger Transport Executive (SPTE) appointed Robert Breen, of Art in Partnership Scotland, to act as their agent in the organisation of the commission. From an initial list three artists – John Clinch, David Annan and Ivan Polley – were invited to submit proposals based on a prepared brief. The proposals were judged by a panel consisting of: Councillor Gordon, Chair of Roads and Transportation Committee, Strathclyde Regional Council; Mike Hayes, Director of Planning, Glasgow District Council; Professor Dugald Cameron, Director, Glasgow School of Art; Robert Breen, Art in Partnership, Scotland; R.S. Lockley, Director General, SPTE; J. McNamee and H.M. Taylor, Directors SPTE.

The cost of the project was £39,507, of which £12,000 was contributed by the Glasgow Development Agency. The three invited artists were offered design fees of £800, plus £200 expenses, and the successful artist was awarded an all-inclusive commission budget of £27,000. The title 'Wincher's Stance' – derived from the Glasgow verb 'to winch' (trans.: 'to kiss and cuddle')[1] – was selected from 600 entries submitted in an open competition organised by the *Evening Times*. The winning suggestion was from Miss Susan Ritchie of Penilee, who was awarded a return trip to Paris for two with three nights' accommodation. The sculpture was unveiled by John Clinch and Susan Ritchie at the official opening of the refurbished Bus Station in February 1995.

Note
[1] Michael Munro, *The Patter: a guide to current Glasgow usage*, Glasgow, 1985, p.77.

Other sources
Unpublished documents provided by SPTE; McKenzie, pp.56 (ill.), 57.

John Clinch, *Wincher's Stance*

Clydebuilt, Scottish Maritime Museum, Braehead Shopping Centre

The Shipbuilders

Sculptors: Andy Scott and Kenny Mackay, of Scott Associates Sculpture and Design Limited

Date: 2000
Unveiled: 17 May 2000
Materials: fibreglass and steel
Dimensions: figures approx. 2.4m high
Listed status: not listed
Owner: Capital Shopping Centres

Description: The sculpture depicts two shipyard workers hauling a ship by chains towards the River Clyde. The ship is represented only by its prow, which is attached to the north wall of the museum, creating the illusion that the main part of the hull is about to emerge from the building. Dressed in the working outfits of shipyard artisans from the past (flat cap, scarf and jerkin) and the present (overalls and welding cap), the two larger than life-size figures are placed on the far side of the railing adjacent to the walkway at the rear of the museum, leaning over the space below in a manner suggestive of the physical effort required to move the ship.

Discussion: Scott Associates were approached by Capital Shopping Centres, the developers of the Braehead shopping complex, to undertake the commission on the strength of their earlier *Heavy Horse* (1997, Glasgow Business Park, Easterhouse), which is also a commemoration of traditional working practices in Scotland. With an almost entirely open brief, the sculptors approached the commission as an opportunity to celebrate 'the great skill and engineering that the Clyde has to offer' in a way that would be relevant to 'the past, present and future' of the yards.[1] A number of structural considerations were addressed in the fabrication and installation of the sculpture in order to ensure its stability. The figures are mounted on steel frames welded to L-shaped fixing plates, which are in turn fastened to the concrete coping of the walkway with resin anchors. To provide additional security against wind vibration, the bottom halves of the figures are filled with expanded foam. The links of the chains are welded together to form rigid connections with the internal steel frame of the ship, which is attached to the wall with concealed metal flanges. For safety reasons the chains are raised to a height sufficient to prevent children attempting to climb on them. The work cost £35,000, took approximately six months to make, and was unveiled by Manchester United Football Club manager Sir Alex Ferguson, a native of Govan.

Condition: Good.

Note
[1] 'Fergie ships in', *Gazette Group (R&E)*, 25 May 2000, p.8.

Other sources
Alan Davidson, 'Sir Alex comes home', ET, 18 May 2000, p.15; 'Back to his roots', *Paisley Daily Express*, 18 May 2000, p.1; 'Companies line up to go for awards', ET, 29 May 2000, pp.24–5; information provided by Andy Scott.

Andy Scott and Kenny Mackay, *The Shipbuilders* [RM]

La Belle Place KELVINGROVE

Hindu Temple , 1 La Belle Place / 7–11 Clifton Street

Narrative Friezes, Portraits, Trophies and Associated Decorative Carving

Sculptors: John Mossman assisted by Walter Buchan

Architect: Charles Wilson
Date: 1857–8
Material: freestone
Dimensions: side relief 1.8m × 30.6m; front relief 1.8m × 16.8m
Inscriptions: on south gable – ERECTED BY DAVID BELL OF BLACKHALL / MERCHANT IN GLASGOW / MDCCCLVII / CHARLES WILSON M.Q.R. ARCHITECT / MOSSMAN SCULPTOR / W T EDMISTON WRIGHT / WILLIAM YORK BUILDER
Listed status: category A (6 July 1966)
Owner: The Trustees of Hindu Mandir

Description: Formerly the Queen's Rooms, the building was designed as a concert hall by Charles Wilson, the architect of numerous West End residential blocks, including the adjoining tenement at 2–5 La Belle Place (see 'Related work', below), completed in the previous year. Wilson appears to have been concerned that the concert hall, despite its larger dimensions and more grandiose status, should harmonise visually with its neighbour, and accordingly repeated a number of features of the earlier building, including the cornice line and the motif of the decorated semi-circular lunette. At the same time, the new building has a distinctive identity of its own, largely as a result of its erudite references to the architecture of the Early Italian Renaissance. The box-like simplicity of its structure, with its walls articulated by rhythmically spaced arches, owes a clear debt to Leon Battista Alberti's quattrocento masterpiece, the church of St Andrea in Mantua, albeit without the central tower and with the tomb recesses on the side wall replaced by windows.[1]

The narrative frieze runs in a continuous band immediately below the attic on the two main frontages, and is conceived as a celebration of the blessings of civil society. On Clifton Street, the story unfolds as a mythical history of civilisation, its eight distinct figure groups providing allegorical representations of the key stages in the progress of humanity from barbarism to enlightenment. A contemporary reviewer provides the following detailed description:

> [A]t the south end, we have man in a barbarous or savage state, clothed with the skins of beasts, and bearing the rudest implements of the chase … Next we have man obtaining mastery over the horse, and subduing it to his service. Then we have the plough and the sower – representative of the rise of agriculture – with a group of reapers gathering in the harvest. In the centre is an angel-like form, presiding, as it were, over the destinies of the race, and smiling over their peaceful energies… To the right of the central figure are groups representative of science, navigation and commerce, with one fell group embodying the spirit of war. In the commercial group there are three figures, designed as portraits – and they are well rendered – of three of our most eminent Glasgow citizens, namely Mr Bell, the projector and proprietor of the edifice; Mr Robert Hutchison, and Mr Robert Baird.[2]

This section of the frieze terminates with a seated bard, possibly Homer, strumming a lyre.

On the La Belle Place frontage the treatment is symbolic rather than narrative, with Minerva enthroned between a pair of seated female Victories in the centre, and figure groups representing the various branches of science and art on either side, including Music on the left, and Painting, Sculpture and Architecture on the right. As on the east façade, the figure groups here are replete with both portraiture and topical references, including the use of Mrs Bell, the proprietor's wife, as a model for Minerva,[3] and the building's designer Charles Wilson to symbolise Architecture. Wilson is shown

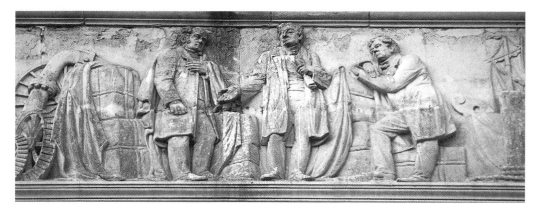

John Mossman, *Progress of Humanity* (detail) [GN]

offering Minerva the plans of the Queen's Rooms themselves, while his assistant follows with a model of his earlier building, the Neilston Institution, Paisley.[4]

Further portraits appear in the group of seven small roundels on Clifton Street, each of which represents a major branch of human achievement, with relevant imagery displayed in the lunettes below them. The identities of the portraits, and the contents of the lunettes are, from the left, as follows: James Watt (Science: Grecian bust, books, dividers, chemical retorts, telescope); Robert Burns (Poetry: open eye enclosed in scrollwork); Sir Joshua Reynolds (Painting: mother suckling a baby, palette and brushes, half-rolled drawing); David Hamilton (Architecture: owl perched on a Corinthian capital, Masonic emblems); John Flaxman (Sculpture: winged figure holding a statuette); George Friderick Handel (Music: lyre, pipes and other instruments); Sir Robert Peel (Politics: bust of Mercury).

The outer lunettes on Clifton Street are filled with the arms of the United Kingdom (left) and Glasgow, and are surmounted by lyres, as are the three lunettes on La Belle Place.

Discussion: The rapid expansion of the West End as a fashionable residential district in the 1850s brought with it a corresponding demand for places of entertainment that were more accessible than the City Hall and the theatres in the centre of town. The merchant David Bell seized the opportunity in 1857 by building the Queen's Rooms on the southern edge of the newly opened Kelvingrove Park. With its flexible interior spaces, and seating arrangements in which 'the most fastidious might enjoy themselves in comfort', it quickly became 'a favourite resort of West-End people for assemblies, concerts and miscellaneous entertainments'.[5]

It was also much admired as a work of architecture, and the sculpture in particular was singled out for high praise. Among the numerous contemporary reviews of the

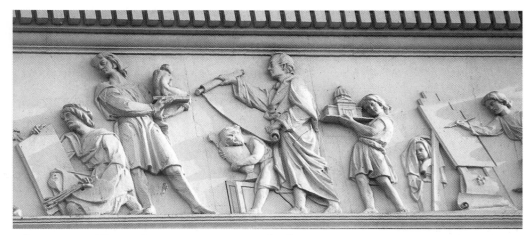

John Mossman, *The Arts Pay Homage to Minerva* (detail) [GN]

building, however, few can quite match the enthusiasm expressed by the correspondent of the *Glasgow Gazette*, who delivered the following encomium shortly before the building was completed:

> Mr David Bell, of Blackhall, deserves very great credit indeed for the erection, at his own expense, of these magnificent rooms ... We may remark that the stone chiselling on them is not surpassed by any work of the same kind in the city. The figures are exquisite. We may be pardoned for the observation, because it has struck us particularly, whether it is meant to be so on the original plan we cannot tell, that one group of these figures, viz., the one on the eastern side of the building bears a striking resemblance to Mr Bell himself. He seems as if he were in the act of holding out his right hand to an eminent citizen, viz., Mr Robert Hutchison, who has one of the finest collections of paintings in Glasgow, while another eminent citizen, viz., Mr Stevenson Dalglish,[6] who materially aided to found the school of design in Glasgow, is looking on

smilingly, apparently, at the whole scene. We hope we give no offence, we are sure we mean none, when we say, that whether meant for them or not, we never saw such striking likenesses of any three gentlemen as those we have above named chiselled out upon solid stone. Let their fellow citizens who know them well just go, see, and admire, and we leave this short criticism to be treated by them accordingly.[7]

By the end of the century, however, the critical climate had cooled slightly, and the *Builder* found little to say about it except that 'the detail is refined and the general effect good, though the sculpture is but moderate'.[8]

In 1912 the building ceased to function as a concert hall, and the interior was later destroyed by fire. For many years it was used as a Christian Science church and reading room, before becoming a Hindu temple.

Related work: David Bell was also the developer of the neighbouring tenements at 2–5 La Belle Place, which, like the former Queen's Rooms, incorporates numerous references to him in the decorative carving (probably also by

Mossman and/or Buchan). These are mostly to be found in the tympana over the ground- and first-floor windows and include his monogram 'DB' (entwined) and a winged bell, as well as a variety of symbols such as flowers, stars, crosses and masks which are likely to have Masonic significance. Bell's name is also enshrined in 'La Belle Place', the street on which the buildings stand.

Condition: Generally sound, though the building has been painted and the portrait heads are very worn. Some minor alterations to the sculpture programme have occurred in the past,

including the removal of an acroterion from the apex of the pediment.[9] It has also been claimed that the portrait medallions were originally inscribed with names, and that these were removed when the building was converted for religious use.[10]

Notes

[1] It may be relevant to note that Alberti's personal emblem was a winged eye, not unlike the eye used to symbolise poetry here in the lunette above the portrait of Robert Burns (see below). See EB, vol.1, p.427. [2] Unidentified source, quoted in Teggin *et al.*, pp.64–5. [3] Tweed (*Guide*), p.41. [4] Worsdall (1982), p.80. [5] Tweed (*Guide*), p.41. [6] Identified as Robert

Baird in the review quoted above. [7] GG, 23 January 1858, p.4. [8] 'The Architecture of Our Large Provincial Towns', B, 9 July 1898, p.25. [9] Stoddart (1995), p.17, claims that this was a statue of Queen Victoria. Early photographs suggest that this was in fact an armorial group with a central obelisk. See, for example, Gomme and Walker, p.98. [10] Teggin *et al.*, p.66.

Other sources

Anon., 'Men You Know – No.105', *Bailie*, no.105, 21 October 1874, p.2; Gildard (1892), pp.3, 8; Young and Doak, no.79 (ill.); Stoddart(1980), pp.19–21 (incl. ills); Worsdall (1982), p.104 (incl. ill.), (1988), pp.62–3 (incl. ills); McKean *et al.*, p.166; Williamson *et al.*, pp.279–80; McKenzie, pp.86, 87 (ill.).

Landressy Street BRIDGETON

Bridgeton District Library, 23 Landressy Street

Figurative Programme

Sculptor: William Kellock Brown (attrib.)

Architect: James R. Rhind
Builder: John Porter & Sons
Building opened: 17 May 1906
Material: yellow sandstone
Dimensions: figures approx. life-size
Inscriptions: in the main entablature –
 BRIDGETON PUBLIC LIBRARY; over the south
 entrance – BOYS / AND GIRLS
Listed status: category B (16 March 1993)
Owner: Glasgow City Council

Description: The building is in two sections, the main part consisting of a two-storey block in the Renaissance style, with a series of round-headed windows divided by Ionic columns on the first floor, and a pair of three-bay pedimented pavilions at either end. There is a

gentle concave curvature in the façade. Adjoining it at the north end is a single-storey reading room lit by three tall round-headed windows, and with an elaborate decorated panel in the attic.

The pediments in the main block are filled with pairs of reclining allegorical figures flanking blind cartouches. The figures on the left are draped females holding unfurled scrolls and books; those on the right are semi-naked males, one of whom uses a pile of books as a headrest. The lunettes between the window-heads of the reading room are filled with figurative reliefs representing the following allegories: *Learning* (seated male figure, naked except for a billowing cape, presenting a book to a group of three naked youths); *Industry* (draped female figure, frontally posed, holding a palm branch and a hammer, and with a cog-wheel at her feet); *Art* (draped female figure, frontally posed, with outstretched hands holding a palette and brush and an armless classical figurine); *Commerce* (naked male figure, seated in profile on a bale, with harbour

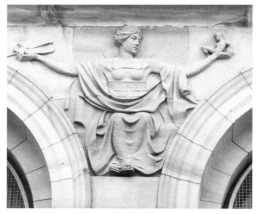

William Kellock Brown (attrib.), *Art* [RM]

scene in very low relief in the background). An oculus in the attic panel is flanked by a pair of naked winged youths with inverted cornucopias.

Discussion: As executed, the programme corresponds very closely to a drawing submitted by Rhind to the Dean of Guild Court in 1903.[1] The only significant departure is the expansion of the lunette on the extreme left from a single figure to a narrative group in

order to fill a larger space than that indicated on the plan. The attribution to Kellock Brown is based on the similarity of the programme to that on Parkhead Library (q.v., 64–80 Tollcross Road), and the presence of many stylistic features, such as the treatment of the hair on the figure of *Art*, which are distinctively associated with Brown. For a full discussion of this, and the origination of the library scheme, see the entry for Dennistoun District Library, 2a Craigpark.

Related work: The other libraries designed by Rhind and decorated by Kellock Brown are as follows: Govanhill (170 Langside Road); Maryhill (1508 Maryhill Road); Hutchesontown (192 McNeil Street); Woodside (343–7 St George's Road).

Condition: The overall condition is very poor, with many of the finer details lost through weathering. The erosion is particularly serious in the most northerly relief on the reading room. Here the two youths on the left have lost all their facial features, and the third has almost completely disappeared.

Interestingly, in its present condition this figure has the deceptive appearance of having been carved in extreme *basso-relievo*. A comparison with contemporary photographs, however, shows that it was originally cut as deeply as the adjacent figures.

Note
[1] GCA, B4/12/1/9923.

Other sources
Descriptive Hand-Book of the Glasgow Corporation Public Libraries, Glasgow, 1907; Stevenson (1914), pp.89–94; Williamson *et al.*, p. 465.

Langside Avenue SHAWLANDS

Langside Public Halls, 1 Langside Avenue

Allegorical Figures of Commerce and Plenty and Related Decorative Carving

Sculptor: John Thomas

Architects: John Gibson; rebuilt by Alexander Beith McDonald
Date: 1847; rebuilt 1902–3
Materials: Portland stone (figures and royal arms); Binnie sandstone (main building and all other details)
Dimensions: figures colossal
Inscriptions: in Glasgow arms – LET GLASGOW FLOURISH; in royal arms – IN DEFENCE
Listed status: category A (15 December 1970)
Owner: Glasgow City Council

Description: The building is in an opulent Venetian *palazzo* style, with pilasters and coupled half-columns on both storeys and a richly ornamented attic entablature. Rusticated masonry is used throughout, and the centre bay on the main north-west frontage is slightly in

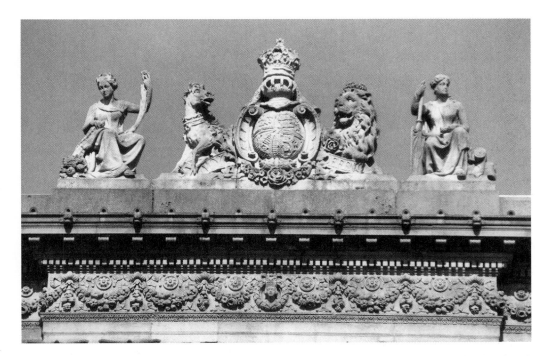

John Thomas, *Coat of Arms* flanked by *Peace* and *Plenty*

advance of the side bays. The principal sculptural feature is a free-standing royal arms of Britain on the attic above the central bay. This is supported by a lion and a unicorn, which are in turn flanked by seated female figures representing *Peace* and *Plenty*. The Glasgow arms are carved in the lunette above the main entrance, and there are five keystone heads in the round-headed windows on the ground floor representing the Rivers Clyde, Thames, Severn, Tweed and Humber.[1] There is also a small bust of Queen Victoria in the centre of the attic frieze, and a lion mask in a scallop shell pediment over the north-west entrance. Additional carver work includes a line of swags in the attic frieze and a series of urn finials on the roof.

Discussion: Described variously as 'meagre and ineffective'[2] and as an 'architectural gem',[3] the building was erected originally as the National Bank of Scotland at 57 Queen Street.

In 1901 it was replaced by a warehouse, but instead of being demolished it was merely 'evicted'[4] from Queen Street, and reassembled stone by stone on its present site on the north-west corner of Queen's Park, its interior being converted by the City Engineer for use as a public hall.[5] It was reopened on 24 December 1903.[6] Thomas's drawings for the two main figures are in the collection of the RIBA (II, f.20),[7] but it is unclear whether he was also responsible for carving the work, or if he simply produced models to be executed by others. It is stated in the *Builder*, for example, that the 'ornamental portions of the work are by Mr Thomas, the *modeller* employed at the new Houses of Parliament'.[8] The *Illustrated London News*, on the other hand, describes the work as being 'in the best style of Mr John Thomas', going on to observe that 'the decorative parts of the Architecture, generally, were executed from his models'. It is also interesting to note that the

author of this article appears to have felt it necessary to defend the quality of Thomas's work, describing him as a sculptor 'whose talents, so often called into question, have been so often eulogised in these pages'.[9]

Condition: The coat of arms and figures are badly weatherworn.

Notes
[1] Williamson *et al.*, p.549; Worsdall (1982), p.136, identifies the rivers as the Clyde, Thames, Shannon, Tweed and Wye. [2] B, 28 October 1848, p.517. [3] BI, 16 January 1904, p.148. [4] *Ibid.* [5] Williamson *et al.*, pp.548–9. [6] BI 16 Jan 1904, p.148. [7] Jill Lever (ed.), *Catalogue of the Drawings Collection of the Royal Institute of British Architects*, vol.T–Z, Amersham, 1984, p.36. [8] B, 14 November 1846, p.549, italics added. [9] ILN, 7 July 1849, p.12.

Other sources
GG, 15 January 1848, p.2; Groome, vol.3, p.138; BI, 15 June 1901, p.45; Gomme and Walker, pp.121 (ill.), 122n.; Young and Doak, no.34; Read, p.365; Read and Ward-Jackson, 4/11/147–8 (ills).

Langside Road GOVANHILL

Govanhill and Crosshill Public Library, 170 Langside Road and Calder Street

Figurative Programme

Sculptor: William Kellock Brown (attrib.)

Architect: James R. Rhind
Builder: John Emery & Sons
Building opened: 16 March 1906
Materials: bronze (dome figure); yellow sandstone (all other work)
Dimensions: dome figure 1.2m high; other figures roughly life-size
Listed status: category B (23 March 1992)
Owner: Glasgow City Council

Description: The building is a single-storey structure, with three tall, round-headed windows divided by coupled Ionic columns on its two main façades. The end bays on the south (Calder Street) frontage are decorated with segmental pediments surmounted by attic figure groups, while the east (Langside Road) façade extends to an additional entrance bay surmounted by a dome on a hexagonal drum. The attic figure groups consist of a central, heavily draped female figure with crouching children at her feet. The children in the left group hold a laurel branch and a book; those on the right are more in the form of large babies, and hold only books. The dome on the Langside Road frontage is surmounted by a

bronze angel posed with her weight on one leg, as if in flight; her right arm is raised and her left hand is placed on her breast. At the base of the dome are two seated female figures, both of which wear short-sleeved dresses. The figure on the left reads from a book and probably symbolises *Learning*, while her companion applies a pair of dividers to a globe, and is therefore an emblem of *Geography*. Below the dome, in a panel above the main entrance, are two putti entwined in lengths of strapwork and seated back to back on either side of a blind cartouche.

Discussion: In June 1995, the bronze angel was stolen by four men, apparently posing as workers removing it for refurbishment.[1] After a

short police investigation, assisted by publicity from the *Daily Record*, the figure was discovered with 'its right arm hanging off'. The city council arranged for the arm to be restored[2] and the figure, referred to locally as *Minerva*, was replaced on the dome. At the time of the incident, the *Daily Record* estimated that the statue weighed approximately one ton, and that it had a market value of £250,000. Both assertions seem rather exaggerated. The outstretched arm of the figure originally held a ribbon, which flew out in an arc behind its wings.[3] This had already been removed before the theft, though precisely when is not known.

The attribution to Kellock Brown is based on the similarity of the programme to that on Parkhead Library (q.v., 64–80 Tollcross Road), and the presence of many stylistic features, such as the treatment of the hair on the central figure in the right-hand attic group on Calder Street, which are distictively associated with Brown. The relative crudity of the treatment of the carved figures, particularly noticeable in the columnar structure of the female figure in the left attic group, is also consistent with the attribution to Brown. For a full discussion of this, and the origination of the library scheme, see Dennistoun District Library, 2a Craigpark.

In his autobiography, the Glasgow psychologist R.D. Laing wrote of his memory of the figure on the dome as a symbol of hope beyond the grimness of his childhood in Govanhill in the 1930s. 'My life saving consolations', he recollected, 'were moonlight and gaslight, the angel on the dome of the library ...'[4] He returned to the subject in a later passage in which he describes himself as having been 'very imbued with books. Right outside my bedroom window', he goes on, 'was the dome of a public library on top of which was an angel, poised on one foot, as though to take off

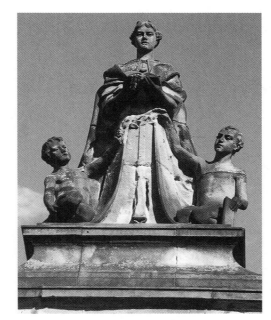

to the moon and the stars'.[5]

Related work: The other libraries designed by Rhind and decorated by Kellock Brown are as follows: Bridgeton (23 Landressy Street); Maryhill (1508 Maryhill Road); Hutchesontown (192 McNeil Street); Woodside (343–7 St George's Road).

Condition: Generally good, though the face on the female attic figure is very worn.

Notes
[1] *Daily Record*, 22 June 1995, p.13. [2] *Daily Record*, 3 July 1995. [3] *Descriptive Hand-Book of the Glasgow Corporation Public Libraries*, Glasgow, 1907, p.87. [4] R.D. Laing, *Wisdom, Madness and Folly*, London, 1985, p.48. I am grateful to Johnny Rodger for drawing my attention to this passage. [5] *Ibid.*, p.66.

Additional source
Williamson *et al.*, p.525.

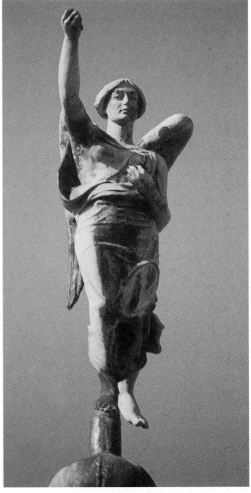

(above left) William Kellock Brown (attrib.), *Figure Group* [RM]

(above right) William Kellock Brown (attrib.), *Winged Figure* [RM]

Langside Road QUEEN'S PARK

Victoria Infirmary, 517 Langside Road

a) Main administration block
Puma and Coats of Arms
Carver: James Harrison Mackinnon

Architect: James Sellars
Date: 1889–90
Material: Giffnock sandstone
Dimensions: puma larger than life-size
Inscriptions: on the entablature – THE VICTORIA INFIRMARY; on the royal arms – DIEU ET MON DROIT (trans.: 'God and my right')
Listed status: category B (5 December 1989)
Owner: Victoria NHS Trust

Description: The puma is in the segmental pediment on the attic of the hospital's administration block, and is depicted in profile, striding forward with its teeth and claws exposed and its tail trailing on the ground. It is carved directly onto the masonry of the tympanum, with mortar joins in both vertical and horizontal directions clearly visible. There are three escutcheons on the same façade: the royal arms in the compartment below the puma; the arms of Glasgow and Renfrewshire (main image a single-masted galley, or lymphad) above the first-floor windows in the flanking towers.

Discussion: The building was erected after Dr Ebenezer Duncan had begun a campaign in 1878 for a hospital on the south side of Glasgow. Financial difficulties led to a delay of ten years before the building was begun, and it was not until August 1888, that the foundation stone was laid, in a ceremony attended by Queen Victoria. The hospital was formally opened by the Duke of Argyll in February 1890.[1] The reasons for incorporating an image of a puma (or cougar) on an otherwise relatively unadorned building are not entirely clear, but may be connected to a local legend that the cat is able to heal other animals by licking their wounds.[2] The fact that the puma is known to be harmless to man, despite being carnivorous, may also be relevant. In any event, the animal has been adopted by the hospital as its own symbol of medical care, and appears as part of the badge of the Infirmary's nurses. It also gives its name to the hospital's theatre group, the Puma Players.

Related work: A similar cat, which may also have originated as part of a hospital, appears on the rear of a tenement in Ruthven Street (see Ruthven Lane).

Condition: Good.

Notes
[1] S.D. Slater and D.A. Dow (eds), *The Victoria Infirmary of Glasgow, 1890–1990*, Glasgow, 1990, pp.237–9. [2] Michael Smith (1999), pp.620–1.

Other sources
BA, 27 July 1888, p.69 (incl. ill.); B, 9 July 1904, p.48; Anon., 'Architectural Sculptor' (obit. of Mackinnon), GH, 8 November 1954, p.9; Gomme and Walker, p.300; Worsdall (1982), p.87, (1988), p.70 (incl. ills); S.D. Slater, 'It's a panther', *Scots Magazine*, September 1990, pp.648–50; Williamson *et al.*, pp.550–1; Johnstone.

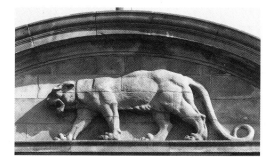

James Harrison Mackinnon, *Puma*

b) Pathology Department
The Reaper
Sculptor: Douglas Bisset

Architect: not known
Date: 1965
Material: yellow sandstone
Dimensions: 1.03m × 3.05m
Listed status: not listed
Owner: Victoria NHS Trust

Description: A bas relief panel in three blocks above the western entrance to the mortuary, the work depicts a male harvester stooping to mow corn with a sickle, accompanied by a pair of running dogs at one end of the field and a fleeing hare at the other. The mower wears a hat and carries a wheatsheaf under his arm.

Discussion: This is a rare example of a public sculpture by Bisset, and was probably commissioned as a result of his personal acquaintance with the designer of the building. It is described by Williamson *et al.* as being in the style of Eric Gill, but the treatment of the corn and the animals owes more to the sculptor's early contact with Archibald Dawson at GSA, while the subtly stylised design of the figure is reminiscent of early twentieth-century Danish sculpture. Unlike the traditional conception of the 'Grim Reaper', the harvester here is neither menacing nor melancholy. Rather the scene is presented as a joyful affirmation of the energy of life, the reaper going about his work amid the regenerative fecundity of the natural world.

Condition: Sound, but with some surface staining.

Sources
Williamson *et al.*, p.551; information provided by Ian Harrison.

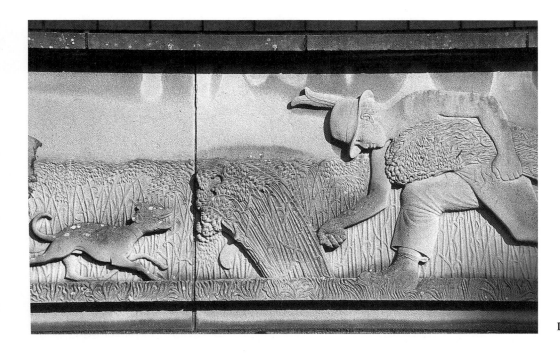

Douglas Bisset, *The Reaper* (detail) [RM]

London Road GLASGOW CROSS

*Mercat Building, 15–23 London Road / 26
Gallowgate*

Six Allegorical Figures and
Associated Decorative Carving

**Sculptors: Benno Schotz, Archibald
Dawson and Alexander Proudfoot
Carvers: Holmes & Jackson**

Architect: A. Graham Henderson (for
 Honeyman & Keppie)
Date: *c.*1925–8
Material: yellow sandstone

Dimensions: figures approx. 2m high
Inscriptions: on first-floor entablatures on west
 elevation: MERCAT BUILDING
Listed status: category A (15 December 1970)
Owner: Glasgow City Council

Description: The building is designed on a
trapezoid plan and forms a wedge-like
termination to the flared east end of the
Trongate. Each of the three main façades has a
pair of figures sitting or crouching at either end
of the first-floor entablatures. The three pairs
are by different sculptors, and their subjects are
as follows:

North (Gallowgate) elevation, semi-naked
female figures of *Industry* (holding a
hammer and a cog wheel) and *Shipbuilding*
(holding a model ship), by Archibald
Dawson.

West (Glasgow Cross) elevation, naked
female figure of *Painting* (holding palette
and brushes) and naked male figure of
Sculpture (holding mallet and chisel,
embedded in roughly hewn block of stone)
by Benno Schotz.

South (London Road) elevation, naked
female figures of *Literature* (holding a book)

London Road 277

and *Science* (?) (holding an unidentified cylindrical object) by Alexander Proudfoot.

Below each figure is a trophy, carved by Holmes & Jackson, incorporating a blind cartouche surrounded by floral swags and a miscellany of objects associated with the arts and crafts: those on the left of each façade include a saw, an anvil and a cog-wheel; those on the right combine an Ionic capital with musical instruments. Additional minor carving includes a series of blind cartouches decorated with acanthus leaves in the keystones of the first-floor windows on all three frontages, and the prow of a ship decorated with chainwork and surmounted by a winged mask in the keystone over the apsidal recess on the west façade.

Discussion: The building was erected as part of a plan to impose a much-needed uniformity on the architectural incoherence of Glasgow Cross. Prompted by the destruction by fire of the Tontine Hotel in 1911, the City Engineer, A.B. McDonald, submitted a proposal to the City Improvement Committee of Glasgow Corporation for the redevelopment of the north-east corner of the Trongate. This was approved in February 1912, and a competition inviting plans was announced in July 1914.[1] At this stage the scheme was confined to a replacement of the old Tolbooth with a new commercial block, the retention of the Tolbooth Steeple and provision for a new Mercat Cross. Honeyman & Keppie's winning design was published in the *Builder* the following year[2] and shows the Mercat Cross joined to the south-west corner of the Tolbooth Steeple, and the Steeple itself connected to the commercial block by a heavily sculpted arch. By this time, however, the council had decided that 'the advantages, from a traffic point of view, of transferring the Steeple to another site' had become obvious, and asked the architects to prepare a second plan with the Steeple relocated at the confluence of London Road and

Gallowgate, more or less where the Mercat Cross is today (q.v., 1 Saltmarket).[3] It is in this plan that the Mercat Building, referred to at this stage as 'Building B', makes its first appearance. The outbreak of the First World War prevented the implementation of the plan, and when the scheme was revived in the late 1920s, the council had decided against moving the Steeple,

(above) Alexander Proudfoot, *Science*(?)

(left) Benno Schotz, *Sculpture*

and the commission for the design of the Mercat Cross had passed to Edith Burnet Hughes. The design of 'Building B' itself also underwent a number of modifications before reaching its final form, and at one point included a dome at the west end with a pair of seated figures in front of it, in addition to the six figures that were carried out.[4]

Though all six figures were clearly designed to be read as part of a unified programme, the treatment is by no means identical throughout, and a comparison between the three pairs reveals interesting differences in the three artists' styles. Where Dawson adheres to a slightly old-fashioned New Sculpture idiom – the women are rather sweet-faced, their closely cropped hair mostly concealed under tight headscarves – Proudfoot's figures have a more brashly Art Deco modernity, with stylized breasts and masses of decoratively flowing hair. Schotz's figures are probably the most distinctive, with far greater dynamism and complexity in their poses. The sculptors were paid £300 for each pair of figures, and the cost of the decorative carving was £318 10s.[5]

In his autobiography Schotz recounts an episode from the commission which throws an interesting light on the treatment of architectural sculptors in Glasgow at this time.

Shortly before beginning work on carving his figures, he took the precaution of measuring the blocks the builders had installed on the façade, and discovered that they did not project as far as the architect had specified, and were therefore unsuited to the figures he had modelled. The distinguished London sculptor William Reid Dick advised John Keppie, the senior partner in the architect's firm, to insist that the builder replace the blocks. 'Oh no', he is said to have replied, 'Benno will slightly redesign the figures to suit the stones.' This he accordingly did, as did Dawson, a fact which may account for the noticeably cramped appearance of their figures' legs. Proudfoot, on the other hand, was unaware of the changes required. When his full-scale models arrived on site, it was found that the legs of both figures projected beyond the surface of the block, so that extra pieces of stone had to be added to accommodate the knees.[6] The joins are clearly visible.

At the time of writing the Mercat Building is being considered by Glasgow City Council for conversion to an overhead station as part of a CrossRail route linking the High Street to Pollokshields. Part of the proposal is that the rear of the building, which already has an overhead freight line, should be excavated

further to provide a passenger station. The estimated cost of the development is £5m.[7] An even more radical solution to the problem of Glasgow Cross has been proposed by the sculptor Alexander Stoddart. This involves the completion of the north-east quadrant, the realignment of the Mercat Cross and the erection of a pair of colossal bronze figures commemorating the architect Robert Adam and his Italian contemporary Gianbattista Piranesi in the triangular site at the east end of the Trongate. The proposal was recently under consideration by the Glasgow Development Agency.

Condition: Sound, though with much green biological growth on the surface, especially of the two west-facing statues.

Notes
[1] B, 23 February 1912, p.216, 10 August 1914, p.43. [2] *Ibid.*, 9 April 1915, p.336. [3] John Lindsay (Town Clerk), *Minutes and Reports re Glasgow Tolbooth Steeple*, Glasgow, May 1915, p.5. [4] GCA, B4/12/1928/114. [5] HAG, Honeyman & Keppie Job Book, (1926–37), 8 June 1928, p.54, 3 July 1928, p.55. [6] Benno Schotz, *Bronze in My Blood*, Edinburgh, 1981, p.78. [7] GH, 23 May 1995.

Other sources
HAG, Honeyman & Keppie Job Book (1926–37), pp.48–58; Teggin *et al.*, p.19; McKean *et al.*, p.56; Williamson *et al.*, p.179; McKenzie, pp.18–19.

Maryhill Public Library, 1508 Maryhill Road

Figurative Programme
Sculptor: William Kellock Brown (attrib.)

Architect: James R. Rhind
Builder: W. & J. Taylor
Building opened: 4 September 1905
Materials: yellow sandstone
Dimensions: figures life-size
Inscriptions: on the attic entablature –
 MARYHILL PUBLIC LIBRARY; on the lintel over
 the south entrance – BOYS AND GIRLS
Listed status: category B (10 July 1989)
Owner: Glasgow City Council

William Kellock Brown (attrib.), *Figure Group*
[RM]

Description: The main, west-facing frontage of this building has two storeys and a basement, with coupled Ionic columns dividing a group of three arched windows on the first floor, and projecting entrance bays framing the central section. The principal entrance is at the north end, and is decorated with a broken pediment containing a pair of reclining putti flanking a blind cartouche. Above this, at attic level, is a segmental pediment surmounted by a free-standing sculpture group consisting of a draped female figure flanked by seated youths. An additional pair of standing putti frame an oculus above the south entrance.

Discussion: This was one of seven district libraries designed by James Rhind for Glasgow Corporation. William Kellock Brown is credited with the execution of the sculpture on the basis of its resemblance, particularly the main group, to his work on Parkhead Library (q.v., 64–80 Tollcross Road). For a full discussion of this, and the background to the library scheme, see entry for Dennistoun Library, 2a Craigpark.

The putti above the entrance to the 'Boys and Girls' reading room do not appear in a photograph of the building taken at the time it was opened, and must therefore have been added later.[1]

Condition: The main group is badly weatherworn.

Related work: The other libraries decorated by Kellock Brown are as follows: Bridgeton (23 Landressy Street); Govanhill (170 Langside Road); Hutchesontown (192 McNeil Street); Woodside (343–7 St George's Road).

Note
[1] *Descriptive Hand-Book of the Glasgow Corporation Public Libraries*, Glasgow, 1907, p.65.

Other sources
GCA, B4/12/1/9526; Williamson *et al.*, p.407.

Gorbals Economic and Training Centre (former Hutchesontown District Library), 192 McNeil Street

a) Figurative Programme
Sculptor: William Kellock Brown (attrib.)

Architect: James R. Rhind
Date: 1904–6
Building opened: 17 November 1906
Materials: bronze (dome figure); red sandstone
 (all else)

William Kellock Brown (attrib.), *Winged Figure* **and** *Griffins*

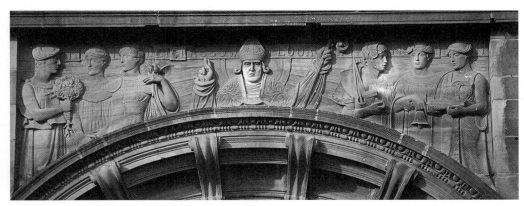

William Kellock Brown (attrib.), *St Mungo with Female Figures*

Dimensions: dome figure life-size; lunette
approx. 1.2m × 2.4m
Inscriptions: on a ribbon in the lunette – LET
GLASGOW FLOURISH; above the entrances –
BOYS AND GIRLS
Listed status: category B (23 March 1992)
Owner: Glasgow City Council

Description: This two-storey building is
designed in a hybrid Elizabethan style, with
three small turrets and a central tower, all of
which are capped with domes. The dome on the
tower supports a winged female figure in
bronze, with an open book resting on her
extended forearms. She wears a classical tunic,
the folds of which are arranged to suggest they
are being blown by the wind. In a deeply
recessed spandrel over the main entrance arch
on McNeil Street there is a low-relief frieze
showing a group of six female figures flanking a
half-length St Mungo, who offers benediction.
The emblems of the Glasgow arms – a tree, a
bird, a bell and a fish – are distributed among
the female figures, with one holding a ship and
another empty-handed. Secondary decorative
carving includes a series of four free-standing
griffins seated on pierced buttresses at the base
of the dome; a swag in the lunette under the

entrance arch; a number of further bells and
fishes in the scroll pediment on the tower below
them and in square panels on the three turrets.
Discussion: The building was one of seven
district libraries designed by James Rhind for
Glasgow Corporation, and for which Kellock
Brown appears to have executed all the
sculpture. For a full discussion of this, and the
background to the library scheme, see entry for
Dennistoun Library, 2a Craigpark. Here it is
necessary to note only that the dome figure is
identical to those on the libraries at Dennistoun
and Parkhead (q.v., 64–80 Tollcross Road), and
was almost certainly cast from the same mould.
The attribution of the spandrel reliefs to
Brown is slightly more problematic. The
carving is not only much more delicate than the
work on the other libraries, but their quasi-
medieval style is also at odds with the generally
classical treatment of the figures usually
adopted by Brown in this series of
commissions. At the same time, it should also
be borne in mind that the style of building itself
is very different from the text-book classicism
of the other six libraries designed by Rhind, and
it may well be that Brown has simply adapted
his style in response to the character of the
building.
Related work: In addition to those noted
above, the other libraries designed by Rhind
and decorated by Kellock Brown are as follows:

Bridgeton (23 Landressy Street); Govanhill (170
Langside Road); Maryhill (1508 Maryhill
Road); Woodside (343–7 St George's Road).
Condition: Generally good, with some
minor damage on the lunette figures.

b) *Three Dancing Muses*
Sculptors: Members of Gorbals Arts Project

Material: patinated bronze
Date: 1997

The figures are in the form of two-dimensional
metal cut-outs and are mounted on a steel frame

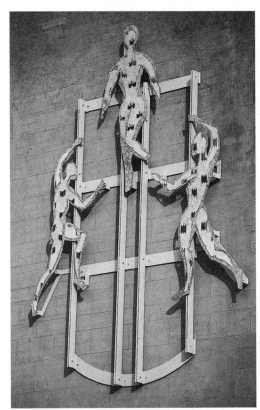

Gorbals Art Project, *Three Dancing Muses*

attached to the north wall. The intention of the project was to symbolise the three related cultural forms of Technology, History and Architecture, which are evoked by the images of computer chips, books and the library building itself cut from the surfaces of the figures. The project was co-ordinated by the artists Sam McVeigh and Cath Keay and executed in conjunction with Bellarmine Arts Association and pupils of St Francis's Primary School.

Sources
Descriptive Hand-Book of the Glasgow Corporation Public Libraries, Glasgow, 1907; Williamson *et al.*, p.510; Gorbals Officer Working Group, *Gorbals Annual Report*, Glasgow, 1997, p.39 (incl. ill.); McKenzie, pp.26 (ill.), 27; conversation with Cath Keay.

McPhun Park BRIDGETON

The McPhun Park is an enclosed area of recreational ground between King's Drive, Newhall Street and the River Clyde. Formerly known as the 'Dassy Green', it is named after John Pollock McPhun, a City Magistrate from 1893 to 1897, whose memorial fountain (now destroyed, see Appendix A, Lost Works) was erected after his death. The land was gifted to the City by his family, and became a division of Glasgow Green in 1900.[1]

Among the trees beside Newhall Street

James Watt
Sculptor: Charles Benham Grassby

Date: *c.*1864
Material: yellow sandstone
Signed: on the right face of the plinth –
GRASSBY. SCULPTOR
Inscription: on the front face of the plinth –
JAMES WATT / 1736–1819
Dimensions: 1.82m high
Listed status: not listed
Owner: Glasgow City Council

James Watt (1736–1819), inventor. For further biographical information, see *Monument to James Watt*, George Square.
 Description: The subject, now headless, is shown leaning casually on a large cylindrical steam condenser, dressed in a cutaway jacket, waistcoat and knee-breeches, and with a pair of dividers in his hand. The condenser is realistically depicted, with bolts securing the end plates and a manifold projecting from one side. A group of rusty metal pins on the upper surface suggests it may once have had another mechanical component attached to it.
 Discussion: The statue was commissioned by W. & J. Martin in 1864, and stood in a niche over the gateway to their Atlantic Mills leather works at 8 Baltic Street, Bridgeton.[2] In September 1936, the company presented it to Glasgow Corporation, before the demolition and rebuilding of the works.[3] Its arrival in the McPhun Park caused some disquiet among local residents, and one correspondent to the *Evening Citizen*, writing under the nom de plume 'South-East', objected to it in the fiercest of terms:

> As a frequenter of the little park at the foot of Tullis Street, Bridgeton, I protest against the condition of the statue that was installed there about a year ago. It is in a filthy condition and sadly in need of repair. Apart from that there is nothing to indicate who it is in memory of. It might be Napoleon or Wellington for anything the public knows. If it was placed there to beautify the park those responsible have a sad lack of taste. I hope

Charles Benham Grassby, *James Watt*

that the powers that be will get a move on and either put it in order or remove it, as it is a blot in what I consider one of the best parks in Glasgow, a park that is appreciated by all the old folks who go there for peace and quiet.[4]

A note appended to this letter by the editor confirmed the subject of the statue was indeed James Watt. A less hostile view of the work was expressed in a letter to the same paper published two days later, which pointed out the aptness of the location, due to its proximity to the part of Glasgow Green known as Flesher's Haugh, where Watt frequently walked, and where, according to legend, he conceived the idea of the separate condenser. Even this writer, however, found the condition of the statue unsatisfactory, drawing attention to the 'large white splatches [*sic*]… on the pants of the "clothes"', and describing Watt as suffering from 'a serious skin disease of the face. Perhaps', he concluded, 'the Corporation will give him a coat of paint and put up a plate so that people may know who he is.'[5] It is presumed that the inscription on the plinth was added after this, and that the subsequent loss of the head was caused by vandals.

Related work: The pose of the figure is closely modelled on the statue of Watt by John Greenshields which stood on the roof of the (demolished) Glasgow Technical College on Bath Street, and is now in the Royal College of the University of Strathclyde (q.v.).

Condition: Very poor. As well as being headless, the statue has a badly damaged right knee, and the entire surface is chipped and covered in graffiti. A major renovation scheme for Glasgow Green drawn up in 2000 includes a plan to clean the statue and replace the head with a fibreglass copy.

Notes
[1] Eunson (1997), p.25. Note: this source states that the park was gifted to the city by Robert McPhun, a local wood turner. [2] Williamson *et al.*, p.457;

Eunson (1997), p.25. [3] GCA, C1/3/95, p.2515. [4] EC, 13 July 1937, p.6. [5] EC, 15 July 1937, p.6.

Other sources
Nisbet, 'City of Sculpture'; McKenzie, pp.22 (ill.), 23.

A little to the east of the southern entrance from Newhall Street

'Springtime' Pedestal
Sculptor, Thomas John Clapperton

Date: *c.* 1949
Material: sandstone
Dimensions: whole pedestal 2.14m high; reliefs 33cm × 85cm and 33cm × 61cm
Listed status: not listed
Owner: Glasgow City Council

Description: The pedestal consists of two lower stages of cyclopean masonry supporting a band of ashlar carved with four figurative

friezes in low relief. These show groups of naked children involved in various games, including playing on a see-saw, in the company of a goose, a goat, a dog, a bird and some sheep. It was designed to support a life-size bronze figure of a naked boy seated on a rock, with a pipe in his left hand and a pair of squirrels at his feet. Known locally as 'Peter Pan', the figure was removed for safe keeping in 1975, and is now in the Winter Garden at the rear of the People's Palace (q.v., Glasgow Green). The complete work was included in the exhibition *Sculpture in the Open Air*, in Kelvingrove Park in 1949, and was later presented to the city by ex-Lord Provost Dr James Welsh.

Condition: Good, but with some minor graffiti.

Sources
T.J.H. (T.J. Honeyman), *Sculpture in the Open Air*, ex. cat., illustrated supplement, Glasgow, 1949, p.7; McKenzie, pp.22 (ill.), 23.

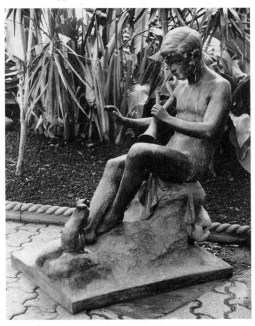

Thomas John Clapperton, *Springtime* (pedestal) [RM] **Thomas John Clapperton**, *Springtime* [RM]

Merkland Street PARTICK

Partick Underground Station

Some of the People
Sculptor: David Mach

Date of installation: December 1996
Materials: steel, glass, photographs
Dimensions: 2.5m high
Listed status: not listed
Owner: Strathclyde Passenger Transport
 Executive

Description: The work consists of a steel-framed rectangular box with glass panels reminiscent of illuminated display units used by advertising companies; the structure is free-standing and rises from floor to ceiling. On the panels are larger than life-size representations of typical Underground users, each image consisting of a vertically sliced photograph overlaid on a background of repeated postcards (3,000 in all). Glimpsed in fragments through the interstices of the photographs, the postcards show a range of images relevant to Glasgow and its surroundings, including Loch Lomond and the Strathclyde Pipe Band. The people depicted in the main images are: an angler with rod and stool on his way to visit a 'favourite fishing haunt'; a young mother with her two daughters who regard using the Underground as 'the most exciting way to travel'; an elderly woman on a shopping expedition; a student on her way to college. The placement of the structure in the middle of the passageway, together with the fragmented treatment of the images, is intended to enable the box to 'appear to connect with the flow of energy of the station concourse'.

Discussion: The piece was commissioned by Strathclyde Passenger Transport Executive to

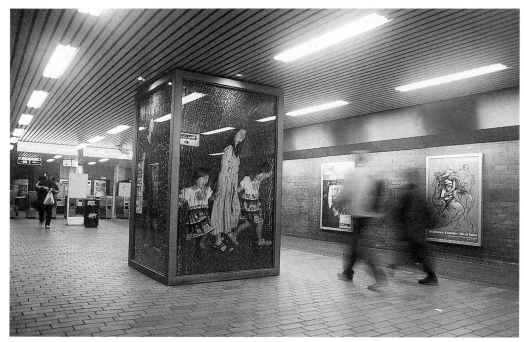

David Mach, *Some of the People* [RM]

commemorate the centenary of the opening of the Glasgow Underground in 1896, the third in the world after those in London and Budapest. Funding was provided by SPTE and Artworks for Glasgow, with the commission managed by Art in Partnership. Though much used by the public, Partick Underground Station was felt to lack a visual focus. The work was designed to provide the station with a more distinct 'sense of place', in the process creating a point of interest that will 'lift the individual out of the mundane rush to work'.

Related work: Mark Firth's *Chthonic Columns* in St Enoch Underground Station

(q.v., St Enoch Square) was commissioned simultaneously with *Some of the People*. Jointly, the two works were designed to celebrate 'the two central characteristics of the Underground: the technical achievement of building it, and the people of the City of Glasgow who use it'.

Condition: Good.

Source
All information and quotations from Project Information Sheet provided by Art in Partnership.

On the former Springburn Public Halls, 11 Millarbank Street

Two Allegorical Figures and Related Decorative Carving

Sculptor: James Milne Sherriff

Architect: William B. Whitie
Building opened: 10 May 1902
Materials: red Locharbriggs sandstone; bronze (St Mungo's crozier)
Dimensions: figures approximately 1.8m high
Inscriptions: on tablets in the upper pediment – SONG MUSIC STORY; in the coat of arms above the entrance – LET GLASGOW FLOURISH
Listed status: catgeory B (4 August 1988)
Owner: Glasgow City Council

Description: The figures are in framed niches on either side of the central window on the main (east) façade on Millarbank Street. Both figures are female, classically draped and have emblems associated with engineering. The figure on the left stands beside a full-size locomotive wheel and holds a model train engine; the figure on the right stands beside an anvil with a hammer leaning against it and holds a large machine component. A broken segmental pediment in the attic has two large putti standing back to back and holding ribbons, a shield decorated with a tree and a pair of inscription tablets (see Inscriptions, above). There is also a Glagow coat of arms over the main entrance. Additional carver work includes numerous swags, wreaths, shields, blind cartouches and decorative keystones, as well as a series of four square panels on the south (Keppochhill Road) façade carved with the emblems of the Glasgow arms: a bird, a bell, a salmon and a tree.

Discussion: The construction of the building was financed by the Reid family, proprietors of the engineering firm Neilson Reid & Co., and formed part of an agreement with Glasgow Corporation which committed both parties to the funding of a Winter Garden in Springburn Park.[1] For many years the focus of public life in Springburn, the building was in regular use as a venue for meetings and concerts until the 1950s, and later for sports events. The inclusion of sculpted 'Greek goddesses' on the façade is described in a local guidebook as a 'magnificent Victorian fancy' and an embodiment of the Springburn community's 'pride in [its] engineering achievement, by implication the product of a civilisation the equal of the ancient Greeks'.[2] Unfortunately, the parallel remains equally relevant today, and the recent decline of the engineering industries in Springburn is all-too-graphically mirrored in the dilapidated condition of the building as it exists at present. Vacant for many years, it has suffered from a combination of neglect and vandalism, and has now reached the point at which it may be beyond repair. This is a matter of local concern, and attempts have been made by the Springburn Museum Trust to secure funds for its restoration, so far without success. The threat to the statues in particular has recently been highlighted by the Glasgow press.[3]

Related work: In the summer of 1999 the collaborative arts group Heisenberg staged a nocturnal illumination of the east façade as part of the 1999 Festival of Architecture and Design, with 2,000 candles placed on the building's cornices, capitals and entablatures, as well as on the two main figures. Entitled *Memorial for Springburn Public Hall*, the work was intended both as a tribute to the building's historical significance, and a lament for its present condition.[4] The event successfully drew attention to the seriousness of the problem and as a result the City Council have begun talks with private developers to explore the possibility of finding a new use for the building.[5]

Condition: The statues are badly affected by damp staining, surface spalling, growths of moss and heavy deposits of bird lime. The locomotive wheel is also cracked.

Notes
[1] Mark O'Neill, *Springburn Heritage Trail*, Glasgow, n.d., p.14. [2] *Ibid.* [3] See, for example,

James Milne Sherriff, *Allegorical Figure*

James Milne Sherriff, *Decorative Carving* [RM]

Lorna MacLaren, 'Fears for city's sculptural heritage as statues are lost to an American's garden', H, 17 June 1999, p.10. [4] Ruth Wishart *et al., In Partnership: Working with Glasgow for 1999,* Glasgow, 1999, pp.20–3 (incl. ills). [5] 'Bizarre art show saves derelict hall', ET, 1 February 2001.

Other sources
BA, 16 June 1899, p.415; GAPC, 20 May 1902, n.p.

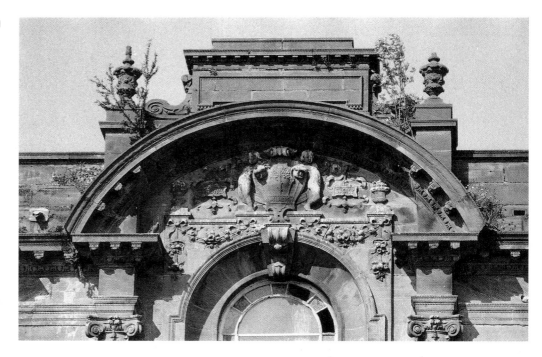

Montrose Street MERCHANT CITY

On the Department of Environmental Health, 23–5 Montrose Street

Hygieia

Sculptor: William Kellock Brown (attrib.)

Architect: Alexander Beith McDonald
Builder: Alexander Thomson & Son
Date: *c.*1894–7
Material: Overwood sandstone
Listed status: category B (4 September 1989)
Owner: Glasgow City Council

Description: The figure is located on the attic of the east frontage of the building, directly above the main entrance, and is depicted in a classical tunic with one breast exposed. A large snake with V-shaped incisions on its back clings to her tunic and drinks from a bowl in her hand. There is a lighted lamp in a small tripod at her feet. Apart from a Glasgow coat of arms over the entrance and a number of garlands and cartouches, it is the only sculptural decoration on an otherwise extremely ornate building in the Mannerist style.

Discussion: Currently occupied by the City Council's Department of Environmental Health, the building was originally known as the Sanitary Chambers and was designed by the City Engineer, A.B. McDonald, for the Council's Office of Public Works. It was built for approximately £19,000. The attribution of *Hygieia* to William Kellock Brown is based on its similarity to works known to have been executed by Brown for buildings designed at the same date by McDonald, including, most notably, the People's Palace (q.v., Glasgow Green). Here the distinctive treatment of the heads of the standing figures, with their excessively elongated necks, is very reminiscent of *Hygieia*. The very crude treatment of the

draperies and hands, however, is equally reminiscent of the work of James Alexander Ewing, especially his pediment figures on the former Co-operative House (q.v., 95 Morrison Street).

Condition: Extremely poor. The face of the figure has been badly eroded, there is a deep notch in the back of the right forearm and the snake has lost its nose. A Glasgow coat of arms has also been removed from the attic of the south façade.[1]

Note
[1] See Stevenson (1914), ill. opp. p.202.

Other sources
GAPC, 17 January 1893, n.p.; BN, 28 June 1895, p.933, 21 May 1897, p.758; BJ, 2 July 1895, p.327; Nisbet, 'City of Sculpture'; Williamson *et al.*, p.185; McKean *et al.*, p.78.

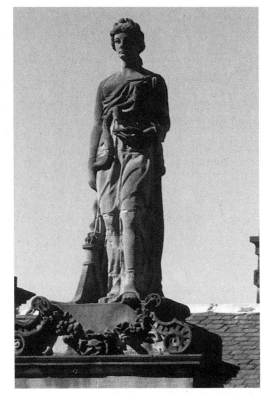

William Kellock Brown (attrib.), *Hygieia* [RM]

Morrison Street KINGSTON

Former Co-operative House, 95 Morrison Street

Pediment Group with Acroterion Figure

Sculptor: James Alexander Ewing

Architects: Bruce & Hay
Date: 1895–7
Material; grey sandstone
Dimensions: pediment approx. 2.44m high × 7.3m wide; figure approx. 3.3m high
Inscription: in the attic entablatures of the end pavilions and below the central pediment – THE SCOTTISH / CO-OPERATIVE WHOLESALE / SOCIETY LIMITED
Listed status: category B (15 December 1970)

Owner: Persimmon Developments Ltd

Description: In his letter accepting the contract to model and carve the scheme, Ewing outlined his intention to fill the pediment with nine figures 'representing Justice and brotherhood as having brought Commerce from the four quarters of the Globe'.[1] *Justice* is seated on a raised pedestal in the centre and holds a set of scales and a palm branch (?). She is flanked by two standing female figures, one holding a spade and the other with a cornucopia at her feet, who reach across her knees to greet each other with a gesture reminiscent of the Co-operative Wholesale Society's trademark emblem of a pair of clasped hands. The remaining six figures, mostly seated, combine references to industry (a cog-wheel and a mallet on the right) and the empire (a palm tree and an elephant) on the left, with the image of linked hands repeated several times. Above the pediment, the acroterion figure represents *Cybele*, the 'Goddess of all the things the Earth sustains and is attended by two lions as showing nothing is so ungovernable but she will master it'.[2] Carved from six blocks of stone, she is shown wearing a simplified crown, with a key in her right hand and an inverted cornucopia in her left. The lions are couchant, facing outwards from the sides of the pediment. Additional minor carving includes a female keystone mask over the main door, with a brooch decorated with a pair of clasped hands; a series of panels on the dado beside the entrance

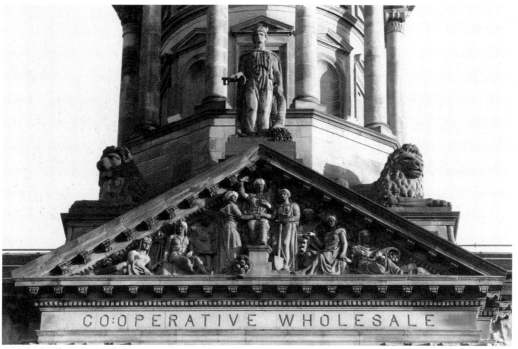

James Alexander Ewing, *Pediment Group*

filled with acanthus scrolls entwined variously with putti shaking hands, swags inscribed 'UNITY', lion masks and birds eating berries.

Discussion: The building was the third, and most splendid of the four linked warehouses and offices erected by the Scottish Co-operative Wholesale Society on the site bounded by Morrison, Carnoustie, Wallace and Dalintober (q.v.) Streets. The style is French Second Empire, and the design is generally thought to have been adapted by the architects from their submission for the City Chambers (q.v., George Square) competition of 1880.[3] Much of the documentation relating the Co-op's building activities appears to have been lost, and there is very little in the surviving records relating to the sculpture contract. However, the minutes of the Building Committee do provide some interesting details in connection with the construction process. There is, for example, a recurring complaint about the 'scarcity of stonemasons' in Glasgow in the 1890s[4] which did much to impede the progress of the construction. The reference in an early minute to the presence of '65 hewers 5 builders 2 carvers & 2 labourers' engaged on the site at one time[5] also provides an interesting insight into how the labour force was composed on a building project of this kind. More relevantly, the minutes reveal a clear desire on the part of the committee to keep the expenditure under control, and this was more often than not achieved by the systematic elimination of carver work. In July 1894, for example the committee recommended a number of alterations to the design, the 'whole of the suggestions being reductions of what seems to be unnecessary ornamentation'.[6] It is presumed that the decision not to execute the pair of reclining figures on the pediment over the main door indicated in a drawing by the architects[7] was made for the same reason. It is also clear from the minutes that the inclusion of empty niches on many parts of the façade – a widespread practice in Glasgow architecture – was for the practical purpose of reducing the weight of the structure, and not for reasons of symbolism.[8]

The scheme was originally crowned by a colossal female figure representing *Light and Life* on the central dome. However, when this was examined by steeplejacks engaged in routine maintenance in 1994, it was found to be 'in such a poor condition' that it had to be removed for safety reasons.[9] Scottish Co-op immediately announced its intention to commission a fibreglass replacement, in the meantime placing the 'rubble and cement' remnants of the original in store. The decision to use fibreglass rather than stone for the new work prompted one newspaper to complain that a historic Glasgow landmark was to be replaced 'on the cheap',[10] but by March 1998, when the premises were sold to a private developer, no replacement of any kind had been made. Locally, the statue was often referred to inaccurately as 'Life and Liberty', and there is also an apocryphal legend that it was 'gifted [to Glasgow] by the USA in 1897'.[11] This is clearly contradicted by Ewing's letter of acceptance, in which he states his intention of making a 'figure in Concrete about 10 feet high', and that this was 'to be Light and Life with [a] torch made of copper'.[12]

The same source also reveals that he was paid £317 for the entire sculpture scheme, a surprisingly modest fee for the most comprehensive statement on any building in Glasgow of the Co-op's early commitment to the ideals of equity, social justice and international trade.

Condition: Generally very good, with some bird lime and light green surface staining in places.

Notes
[1] GCA, AGN 1899, Letter from James A. Ewing to
the Directors of the Scottish Co-operative Wholesale
Society, 23 September 1895. [2] *Ibid.* [3] Williamson
et al., p.516. [4] GCA, (S)CWS 1/1/116, *Minutes of
Building Committee*, 6 August, 17 September, 3
October 1894. See also 20, 27 August 1894. [5] *Ibid.*,
23 July 1894. [6] *Ibid.*, 9 July 1894. [7]*Ibid.*,
B4/12/1/2587. [8] *Minutes*, 24 October 1894.
[9] Letter from H. Smith, Premises Controller,
Scottish Co-op, 24 March 1995. [10] 'A Flamin'
Liberty', *Glaswegian*, 6 March 1997, p.9. [11] *Ibid.*
[12] Ewing, *op. cit.*

Other sources
G. Barclay Robertson, 'The Dividend days', *Scots
Magazine*, July 1998, pp.69–72 (incl. ill.); McKenzie,
pp.31–3 (incl. ill.).

*Former Scottish Co-operative Wholesale
Society warehouse, 71 Morrison Street*

Allegorical Figure of Plenty

Sculptor: not known

Architect: James Ferrigan
Date: 1915–20
Material; grey sandstone
Dimensions: larger than life-size
Inscriptions: on corbels below columns in
 central bay and on attic tablet – SCWS
Listed status: category B (15 December 1970)
Owner: Miller Developments

Description: The figure is in a scroll
pediment incorporated in the central granite-
columned Doric doorpiece. She is shown seated
with her hand on a plough, and with the
products of agriculture – wheatsheaves, a
cornucopia and a basket of vegetables – ranged
on either side. It is likely that the sculptor
intended her as a representation of Demeter, the
Greek goddess of the harvest, though it is

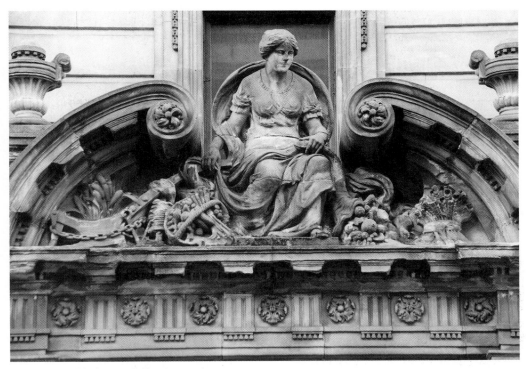

Anon., *Plenty* [RM]

equally possible he was following Ewing's
earlier lead (see above) and conceived her as
Cybele, the Great Mother Goddess. The
cartouche on the keystone below is also
decorated with ears of wheat, and there are
winged cherub masks in the capitals of the
columns.

Discussion: The building is in the French
Renaissance style, and with some minor
differences of emphasis that betray its later date
(such as the use of flattened arches and a more
abstract treatment of window surrounds) was
designed to match the appearance of the earlier
block immediately to the west (see above). The
north-east corner was completed in 1933. As

with all the major Co-op buildings in Glasgow,
the company records are incomplete and no
primary documentation relating to the
sculpture has been found. This is regrettable,
given the comparatively conservative treatment
for a work of this date.

Condition: The fabric is sound, but there is
much heavy green algae on the surface.

Sources
LBI, Ward 51, p.20; Williamson *et al.*, p.516;
McKenzie, pp.32, 33 (ill.).

Naburn Gate GORBALS

Domestic terrace, 1–16 Naburn Gate / 5–7 Camden Terrace / 170–88 Cumberland Street

Relief Panels of the History of Architecture

Sculptors: Andy Scott and staff of Scott Associates Sculpture and Design

Cast by: Allscot Plastics Ltd
Architect: Tom Walker (of Coupar Cromar)
Builders: Miller Homes
Date: 1998–9
Material: fibreglass treated with aluminium powder
Dimensions: various – largest approx. 1.4m × 2.1m; smallest approx. 1.4m × 1.1m
Listed status: not listed
Owner: privately owned

Description: Located under the eaves of the building, the work consists of thirteen square and rectangular panels, some grouped in pairs, running the length of Naburn Gate from the corner tower at Alexander Crescent to the first two bays of Camden Terrace and continuing along Cumberland Street. The history of twentieth-century architecture is illustrated in a

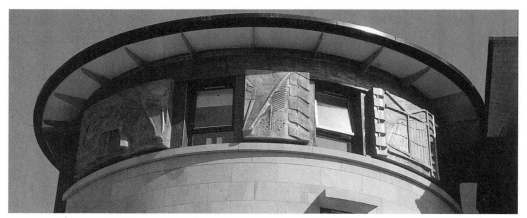

Andy Scott, *History of Architecture* (detail) [RM]

chronological progression, with each panel incorporating stylized representations of a small number of buildings selected as paradigms of the decade in which they were built. Among the architects represented are Charles Rennie Mackintosh, Frank Lloyd Wright and Jorn Utzen, with a master plan of the new Gorbals development included in the last panel.

Discussion: Scott was invited to make the work on the strength of his earlier achievements in Gorbals and elsewhere in Glasgow, and produced the designs in consultation with the architect Tom Walker. The clay models were made in groups of two, and the finished panels installed between August 1998 and July 1999, as the scaffold was moved from one part of the building to the next. The total cost of the commission was £50,000, including a small amount of decorative iron and ceramic tile work in the closes.

Condition: Good.

Source
Information provided by Andy Scott.

The Necropolis TOWNHEAD

INTRODUCTION

Under the terms of reference agreed with the Public Monuments and Sculpture Association, sculptures located in churchyards and cemeteries are excluded from consideration in the series of volumes to which this book belongs. This in no way implies a value judgement concerning the quality of such work. Rather it is an acknowledgement that funerary sculptures tend to be very different in kind from those produced for purely secular purposes, and that they have a very specialised role to play within the often enclosed contexts in which they are found. It is almost literally true to say that they exist in another world. For this, and a number of related practical reasons, it is felt that the study of monuments belonging to the numerous graveyards of Glasgow would be better served if they were treated as a separate subject of study rather than as an adjunct to mainstream urban work.

Terms of reference are not rules, however, and it was never envisaged that they should be rigidly enforced under all circumstances, or without recognising that occasional exceptions would have to be made. In the case of the Glasgow Necropolis there are several compelling reasons why this should be so. To begin with, at least one of its major monuments – the statue of John Knox – was erected several years before the ground on which it stands was designated as a cemetery. It was thus a work of secular sculpture in the fullest sense, as much a part of the public culture of Glasgow as any of the statues then beginning to be erected in George Square. Indeed, the presence of several couples strolling casually among the trees in Joseph Swan's engraving *Glasgow from Knox's Monument* of 1828,[1] suggests that climbing the hill to enjoy the panoramic view from the base of the column was a popular leisure pursuit at this time. Historical events may have overtaken it a little later, but at the time it was erected, the *Monument to John Knox* was an integral part of mainstream urban life in Glasgow – a cultural reference point as well as a physical landmark from which the rest of the city could be regarded.

This leads to the second major reason for the inclusion of the Necropolis in this study. The view of the city from the summit of the hill may be splendid, but the Necropolis itself provides an equally breathtaking spectacle when contemplated from below. It is, in short, one of the most conspicuous sights in the whole of Glasgow, clearly recognisable from miles around in all directions, and with its numerous sculptural monuments forming an integral part of the characteristically craggy and romantic outline it presents to the sky.[2] The omission of such work in a study committed to the understanding of historic sculpture in the public domain would be an anomaly indeed.

Against this, however, we must set the equally pressing consideration of scale, and the need to impose a sensible limit on the number of works that can be accommodated within these pages. On a rough estimate there are probably in the region of 100 gravestones, tombs and monuments in the Necropolis which incorporate sculptural work of interest,

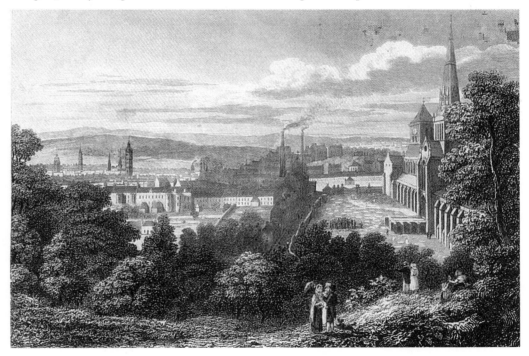

Joseph Swan, *Glasgow from Knox's Monument*, from Leighton, *Select Views of Glasgow*, 1828. [MLG]

including an impressive array of portrait busts and medallions, narrative friezes, symbolic figures and elaborate decorative programmes, as well as a group of four major portrait statues of colossal dimensions. To give every one of these the attention it properly deserves is simply beyond the scope of this study. The compromise solution adopted here is to concentrate on a selection of seven key monuments as a token representation of the much more extensive body of work of which they form a part. These include all four free-standing portrait figures, along with a small number of other works which have been chosen not only because of their exceptional historic interest, but also because they were made by important sculptors whose achievements are not otherwise well represented in Glasgow. An annotated list of a further 22 monuments is provided in Apendix B. It should be stressed, however, that this is no more than a sample, and that a full study of the Necropolis remains to be undertaken.

HISTORY OF THE NECROPOLIS

The Necropolis is located on a prominent geological outcrop immediately to the east of Glasgow Cathedral and occupies an area of some 37 acres. Although the Necropolis itself was not created until the 1830s, the area on which it is formed has had a distinct topographical identity since the middle of the seventeenth century, and can be recognised in many early works of visual documentation, such as the sweeping view of Glasgow published by Captain Slezer in 1693, which, like Swan's image of over a century later, shows the city from the summit of the hill.[3] By this time the land had been acquired by the Merchants' House of Glasgow (q.v., 7 West George Street), which appears to have been content to allow it to languish for many decades as a 'mere wilderness, or little better, known by the name of the Fir Park, or the Merchants' Park', with no attempt to exploit it as either a

natural or a commercial resource.[4] Towards the end of the eighteenth century the fir trees began to decay, and in 1804 the trustees of the Merchants' House ushered in a 'new era in the natural history of that beautiful cliff' by appointing a keeper and replanting the entire area with a wider range of deciduous trees.[5] A more radical change came about in the mid-1820s, however, when the trustees, always anxious to combine public service with financial gain, began to realise that an elevated tract of ground hard by the Cathedral might be used for another, much more profitable purpose. At a time when frequent killer epidemics, coupled with a major population explosion, had brought the problem of disposing of the dead to a crisis, the commercial potential of creating a 'hygienic' burial ground proved irresistible, and in September 1832, the trustees began using the land adjacent to the eastern bank of the Molendiner Burn for interments. In March of the following year they were granted formal permission to sell burial plots on the rest of the hill.[6] A competition to design the layout was held in 1831, with 'economy, security and picturesque effect' as the main requirements.[7] In the event none of the submitted designs was used, and the task of devising a plan for the plots, together with the intricate pattern of paths and carriageways twisting between them, fell to the garden designer George Mylne, who became the Necropolis' first Superintendent.[8] It is largely to his skill, aided by the natural advantages of the site, that we owe what has been justly described as 'the most Sublime of all British cemeteries'.[9]

Though it began as a commercial venture, the Necropolis soon came to embody an important dimension of nineteenth-century aesthetic culture. With their often morbid preoccupation with death, and their compulsion to memorialise great individuals, the Victorians brought a new depth of poetic meaning to the funerary arts, exploring a vein of creative expression that is at once melancholy and

celebratory. A little known poem published by Mary MacArthur in 1842, captures with some poignancy the ambiguous mixture of sentiments engendered by the spectacle of so many memorials crowded together within a confined area, at the same time acknowledging the part played by sculptors in the evocation of such feelings:

With faltering step I trace my devious way,
Awed by the touching grandeur of the scene,
And, pausing oft, a passing tribute pay
To worth departed, and to wo serene.

While all around with varied aspect stand,
The lettered tomb-stone, obelisk and shrine;
Some richly garnished by the sculptor's hand,
Some marked alone by chasteness of design

Meet emblems here attest the artists' powers, –
The torch reversed, that shall for ever burn;
The votive wreath of chiselled fruit and
 flowers;
The drapery graceful and the classic urn;

The fluted pillar, with its garlands twined;
The simple tablet and the mystic shield;
The broken column, with its cause assignes,
And all that fancy can to sorrow yield.[10]

The architects too had a part to play in this, and opportunity to work on a tiny scale, unimpeded by the normal constraints of function and utility, proved liberating for many designers, who rose to the occasion by producing miniature architectural gems in almost every documented national and period style, as if bringing the illustrations in Sir Banister Fletcher's *History of Architecture on the Comparative Method* magically to life. With its impressive mausoleums, its spacious family tombs and the endless variety of even the more modest lairs that line its carriageways, the Necropolis is a 'city' of the dead in the truest sense of the word.

The Necropolis has long been recognised as a uniquely rich embodiment of Glasgow's

historic culture, and as such it constitutes an important resource in any attempt to understand how the city has evolved over the past century and a half. This was well expressed by William Reid, who wrote in 1884 that the 'Necropolis is to Glasgow what Westminster Abbey is to the nation'. He went on to suggest that nobody could

> ... survey the scene from the summit of this romantic burial-ground... and fail to feel that this is a fit resting-place for those who have presided over the commercial, philanthropic, literary, and religious interests of the great city which stretches away on both sides down to the banks of the Clyde and far beyond.[11]

It is one of the great paradoxes of Victorian Glasgow that its phenomenal vitality is nowhere more eloquently demonstrated than in its obsession with memorialising the dead.

The catalogue entries are arranged in chronological order, with the Greek letters noted at the head of each article referring to the alphabetical system used to identify the various compartments into which the cemetery is divided.[12]

Notes
[1] Leighton (1828), plate opp. p.55 (reproduced in Gomme and Walker, p.48). [2] See, for example, 'The Necropolis or Fir Park Cemetery of Glasgow – 1866', in Anon. [John Buchanan, Andrew Scott and William Henry Hill, *The Merchants' House of Glasgow*, Glasgow, 1866, ill. between pp. 388, 399. See also the frontispiece to George Blair, *Biographical and Descriptive Sketches of the Glasgow Necropolis*, Glasgow, 1857, which includes three of the works listed below among the monuments identified on the skyline with numerals. [3] John Slezer, *Theatrum Scotiae*, London, 1693, plate 17, (reproduced in Gomme and Walker, p.49). [4] Blair, *op. cit.* p.21. [5] *Ibid.*, p.23. [6] Anon. [Laurence Hill?], *A Companion Guide to the Necropolis: or, Notices of the History, Buildings, Inscriptions, Plants &c. of the Fir Park Cemetery of the Merchants' House of Glasgow*, Glasgow, 1836, pp.10–21. [7] *Ibid.*, p10; Blair, p.26. [8] Berry, n.p. [9] James Stevens Curl, *The Art and Architecture of Freemasonry*, London, 1991, p.207.

[10] Mary MacArthur, *The Necropolis: an Elegy, and other poems*, Glasgow, 1842, p.5. [11] William Reid, *The Merchant Evangelist*, Edinburgh, 1884, pp.210–11. [12] A plan of the Necropolis, with a key to the system, can be found in Jimmy Black, *The Glasgow Graveyard*, Edinburgh, 1992, p.36.

Other sources
John Strang, *Necropolis Glasguensis, with Osbervations [sic] on Ancient and Modern Tombs and Sepulture*, Glasgow, 1831; Dibdin, pp.696–701; James Cleland, *The former and present state of Glasgow*, Glasgow, 1840 (2nd edition), p.115; James Pagan, *Historical and descriptive account of the Cathedral Church, Necropolis, &c...*, Glasgow, 1866; James Stevens Curl, *A Celebration of Death*, London, 1980, pp.209–11; McKenzie, p.9.

In the centre of Kappa

Monument to John Knox
Sculptors: William Warren (designer); Robert Forrest (carver)

Architect: Thomas Hamilton
Date: 1825
Material: yellow sandstone
Dimensions: 3.6m high (statue); 17m high (statue and column)
Inscriptions: on the pedestal – To testify Gratitude for inestimable Services / in the Cause of Religion, Education, and Civil Liberty; / To awaken Admiration / Of that Integrity, Disinterestedness, and Courage, / Which stood unshaken in the midst of Trials, / And in the Maintenance of the highest Objects; Finally, / To Cherish unceasing Reverence for the Principles and / Blessings of that Great Reformation, / By the influence of which our Country, through the / Midst of Difficulties, / Has arisen to Honour, Prosperity, and Happiness. / This monument is Erected by Voluntary Contribution / To the Memory of / John Knox; / The Chief Instrument under God, of the Reformation in Scotland, on the 22nd Day of September 1825. / He died – rejoicing in the faith of the Gospel – at Edinburgh, / On the 24th November A.D. 1572, in the 67th year / Of his

Age. (west side); "The Reformation produced a revolution in the sentiments of mankind / the greatest as well as the most beneficial that has happened since the / publication of Christianity." / In 1547 and in the city where his Friend George Wishart had suffered, / John Knox, surrounded with dangers, first preached the doctrines of the / Reformation. In 1557 on the 24th of August, the Parliament of Scotland / adopted the Confession of Faith presented by the Reformed / Ministers, and declared popery to be no longer the religion / of this kingdom. / John Knox became then a Minister of Edinburgh, where he continued to / his death, the incorruptible guardian of our best interests. / "I can take God to witness, he declared, that I never preached in con- / tempt of any man – and Wise men will consider, that a true friend cannot / flatter; especially in a case that involves the salvation of the bodies and / souls, not of a few persons, but of a whole realm." When laid in the / grave, the Regent said, "there lieth He who never feared the face of man; / who was often threatened with dag and dagger, yet hath ended his days / in peace and honour." (south side); Among the early and distinguished friends of the Reformation / should be especially remembered, Sir James Sandilands / of Calder, Alexander Earl of Glencairn, Archibald Earl of Argyll, and Lord James Stewart, afterward known by the name / of "the Good Regent" – / John Erskine of Dun, and John Row, who were distinguished among / the Reformed Ministers for their cultivation of ancient and modern / literature – / Christopher Goodman and John Willock, who came from England / to preach the gospel in Scotland – / And John Winram[,] John Spottiswood, and John Douglas, who with / John Row, and John Knox, compiled the first Confession of Faith, / which was presented to the Parliament of Scotland: And also the / first Book of Discipline. (east side); Patrick Hamilton, a youth of high rank and distinguished attainments was the first Martyr in Scotland for the cause of the Reformation / He was condemned to the flames at St. Andrews in 1528, and the twenty-fourth year of his age. / From 1530 to

1540, persecution raged in every quarter; many suffered / the most cruel deaths, and many fled to England and the continent. / Among these early Martyrs, were Jerome Russell and Alexander Kennedy, / two young men of great piety and talents, who suffered at Glasgow / in 1538. / In 1544 George Wishart returned to Scotland from which he had / been banished, and preached the gospel in various quarters. In 1546, / this heavenly-minded man, the friend and instructor of Knox, was also / committed to the flames at St. Andrews. (north side)

Listed status: category A (15 December 1970)
Owner: Glasgow City Council

John Knox (1514–72), Scottish preacher and church reformer. After studying for the

William Warren and Robert Forrest, *John Knox*
[RM]

priesthood in St Andrews, he came under the anti-Catholic teaching of George Wishart, who was burned for heresy in 1546. Knox himself suffered persecution, and, after taking refuge in St Andrews Castle in 1547, was captured and forced to serve on a French galley for nineteen months. After being liberated he served as Chaplain in Ordinary to Edward VI, but when Mary Queen of Scots acceded to the throne he was forced to flee again, this time to Geneva, where he became minister of a congregation of English exiles. In 1555, having adopted the doctrines of Calvin, he returned to Scotland, where the success of his preaching caused such alarm among the Catholic clergy that he was summoned to appear before the Church authorities at Blackfriars, Edinburgh. By this time the Reformation movement had gained such popular support that the Church was reluctant to prosecute him, and in August 1560, largely as a result of his efforts, Presbyterianism was sanctioned by Parliament as the official religion of Scotland. He died in Edinburgh in 1572, and is buried in St Giles' Kirkyard (now Parliament Square).[1]

Description: The statue is composed of seven blocks, and is raised on a primitive Doric column, the superstructure of which consists of a cylindrical pedestal supported by a wide pedimented abacus with dog-ear acroteria. Knox is shown dressed in a Geneva cap and gown, with a bible extended in his right hand and his left hand placed across his chest. The monument is not only the tallest structure in the Necropolis, but also stands at its highest point, rising to an elevation of approximately 87 metres above the level of the River Clyde and overlooking what the nineteenth-century art collector Archibald McLellan described as 'one of the finest panoramic views in the kingdom'.[2] It also provides one of the defining landmarks of the Necropolis when viewed from below, as can be seen from numerous popular prints and topographical representations of the Townhead area. (See, for example, north relief panel on

Marochetti's *Equestrian Monument to Queen Victoria,* George Square.)

Discussion: This was the first monument to be erected in the area known at the time as the Fir Park, and which did not become the Necropolis until 1833 (see above). A subscription, organised by James Carmichael, attracted donations from several public bodies, including the Merchants' House (the owners of the land), as well as some 350 private citizens, mostly tradesmen, manufacturers and ministers.[3] Both Robert Forrest and Thomas Hamilton were among the subscribers, the latter providing his design 'gratuitously'; he is also recorded as having made a special journey from Edinburgh to advise the committee on the choice of site.[4] The production of the statue was closely supervised by a management committee, which was chaired by Henry Monteith MP, of Carstairs, and included many prominent Glasgow figures, such as James Cleland (see 249 Buchanan Street). The treasurer was the lay preacher William McGavin, who would himself later be the subject of a commemorative monument (also carved by Forrest) in an adjacent division of the Necropolis (see below).

The foundation stone was laid on 22 September 1825, by Rev. Stevenson MacGill, Professor of Theology at Glasgow University, who is credited with first proposing the project, and through whose efforts permission was granted by the Merchants' House in 1824 for the erection of the monument on their property.[5] The ceremony was preceded by a meeting in the Trades House, followed by an extended programme of prayers and speeches in St George's Church, in which Knox's achievements were celebrated and the progress of the commission reviewed. The committee appears to have been very satisfied with what had been achieved, and in his address MacGill spoke approvingly of the work of the two sculptors responsible for making the statue:

And I am sure all this company will join

with me in thinking, that Mr. Warren, some of whose works are now before you[6] has done himself much honour in the manner in which he has copied the face, and conceived and executed the figure and expression of the great Reformer. Indeed it is but justice to him, to mention, that on every occasion he has displayed not only great talents as an Artist, but the ardour and the earnestness of a friend deeply interested in the object, and zealous to promote its success. I have the pleasure to add, that Mr. Forrest has, on every occasion, displayed the same excellent feeling. He is already well known to the public, as a statuary in works of great merit, and we have the fullest confidence, that the work which he has now undertaken, and to which he has liberally subscribed, will add to his growing reputation.[7]

Other speakers included William McGavin, whose address was greeted with loud and prolonged cheering,[8] and the Rev. Patrick McFarlane, who took the opportunity to rebuke a group of unnamed citizens who had refused to contribute to the subscription fund on the grounds that 'they saw no necessity for erecting a monument' to somebody who had 'already a sufficient memorial in the state of the country, and in the gratitude and affection of the people of Scotland'. On the contrary, McFarlane argued,

… the feeling which led to the erection of such a monument as that which has been this day so auspiciously commenced, is the same in kind, with that which has led to the erection of statues, obelisks, or other memorials to Pitt, and Moore, and Nelson and James Watt. It is BECAUSE Knox has a monument in the condition of the country, and in the gratitude and veneration of his countrymen, that we begun [sic] this day to rear this stately column, which is to lend its aid in perpetuating his memory – the wish to make it visible to the world, that he yet lives in the hearts of this people, and to express towards him when dead, that respect and affection which he so justly received when alive.[9]

At the conclusion of the speeches the party proceeded to the Fir Park for the formal ceremony, part of which involved placing a number of hermetically sealed glass bottles containing contemporary memorabilia in a cavity in the pedestal. Among their contents were 'specimens of the gold, silver, and copper coins of the present reign', copies of six Glasgow newspapers, a Scottish almanac, a Glasgow Directory, a number of statistical documents and excerpts from McCrie's *Life of Knox*.[10] The final event on the programme was a supper at the Black Bull inn.[11]

Despite the committee's satisfaction with the finished monument, the statue soon began to attract criticism, particularly with regard to the interpretation of Knox's appearance. Though the face was modelled on a 'carefully preserved likeness' in Glasgow University, the treatment of the main part of the figure was thought to be both awkward and lacking in authenticity. 'The attitude', wrote George Blair,

… is not greatly admired, particularly the position of the left arm, which has the appearance of stiffness. Perhaps it is well that the considerable height of the column removes the defects as well as the merits of the statue from a too near inspection. Even at the distance to which it is thus elevated above the spectator, the colossal size of the statue produces an appearance of robust physical power which did not belong to the Reformer.[12]

By presenting Knox as a figure of imposing physical stature, the amplitude of his cap and gown merely accentuating his monumentality, Warren, it appears, was perpetuating a popular myth about his appearance. Blair confirms this by quoting from another contemporary writer, Dr M'Crie, who observed:

There are, perhaps, few who have attended to the active and laborious exertions of Knox who have not been led insensibly to form the opinion that he was of a robust constitution. This is, however, a mistake. He was of small stature, and of a weakly habit of body – a circumstance which serves to give a higher idea of the vigor of his mind… Nor can we overlook his beard, which, according to the custom of the time, he wore long, and reaching to his middle – a circumstance which I mention rather because some writers have assured us that it was the chief thing which procured him reverence among his countrymen.[13]

Curiously, the statue was also criticised for precisely the opposite reason. Writing much later, in 1874, Daniel Reid Rankin complained that the figure

… conveys an idea of feebleness, – not sanctioned by the rules of art, unless specially to express age or frailty. The feet are sprawlingly placed; the right arm projects from the drapery of the gown with no ease or elegance – the hand grasping a small book, with the wrist drooping as if semi-paralyzed; the left arm, from near the elbow, being laid across the breast in the act – judging from the drapery – of holding up the front of the gown. Energy is entirely wanting, either in feature or action, whereas one acquainted with the history of John Knox, setting aside art, would assuredly look for this characteristic of the man.[14]

A much more sweeping condemnation, however, came from the pen of the English antiquarian traveller, the Rev. T.F. Dibdin, who felt that the monument had 'the air of a triumphant pillar to the memory of a warrior or statesman' which was inappropriate to a 'place consecrated to the ashes of the dead'.[15] Though he was evidently unaware of the fact that the ground was still secular at the time the

monument was erected, the extraordinary diatribe he appends in a footnote to this remark is worth quoting in full, as evidence of the strength of feeling the monument was able to provoke:

I here solemnly and sincerely 'enter my protest' against the taste manifested in the statue of John Knox, and I do so under the three following heads:- 1. The size of the monument is obtrusively large. It is not 'part and parcel' of a burial ground. It is an erection for a square, or public highway. 2. The statue itself wants simplicity and grandeur. Because Knox might or might not have worn a bonnet, therefore there is placed upon his head a most ponderous and inelegant coverture – in the shape of leaves and flowers sprouting out of a large clod of earth. 3. The inscription strikes me as being altogether a mistake. Instead of the elaborate inscription which we now see – occasionally fraught with what Dr. Parr calls 'the gorgeous declamation of Bolingbroke' – I would have only the two words

JOHN KNOX

Therefore it is, that I should have desiderated the aforementioned 'thirteen minutes private conference' with good Dr. M'Gill. Is all reform hopeless here?[16]

The somewhat obscure assertion in the penultimate sentence is a reference to the footnote in Dibdin's text which *precedes* the one quoted here, and in which he describes how his conversation with the Rev. Stevenson MacGill was cut short by an interruption by Principal Macfarlan. 'Had I', he explains, 'but enjoyed thirteen minutes private conference with him before the whole of the KNOXIANA were resolved, – then! – What then? Read the following note.'[17]

Dibdin was not alone in having reservations about the monument's site, and this was an issue that was later taken up by George Blair.

The focus of his concern, however, was the debate that apparently took place concerning the aptness of its proximity to the cathedral, the symbol of all that the Reformation set out to destroy. 'We cannot say', he wrote,

… that we agree with those who think that the statue of the Reformer ought to have looked away from the Cathedral, instead of looking at it. Even if that magnificent edifice were still identified with Roman Catholic worship, it would ill comport with the intrepid spirit of Knox to turn his back to the foe. He, who in life, 'never feared the face of man', may surely be permitted, in the grim security of monumental stone, to confront, with unabashed visage, one of the few existing remnants of that stupendous system which the thunders of his terrible eloquence overturned.[18]

As part of its mission to overturn the symbols of Catholicism – which involved 'dingin' doun' anything that was *externally* beautiful or ornamental' – the Reformation also took a hard line on decorated tombstones, and the irony that the Knox monument was soon to be surrounded by such 'Romish mummery' was not lost on Blair:

It was not a little remarkable… that a monument to John Knox was destined to be the first ornament of the first garden-cemetery in Scotland. The stern Reformer now stands surrounded with much that would have seemed to him an idle mockery of death. From his lofty pedestal, grimly he looks down upon a once Romish cathedral, which is now preserved with watchful solicitude; and beautiful sepulchral monuments are rising all around him, as if to demonstrate that the Presbyterian worship is not incompatible, in its simplicity, either with the graces of architectural art, or with the exuberant manifestations of the most endearing affections. There is something of

retributive justice in the apparent coincidence.[19]

George Eyre-Todd records the additional irony that the monument is raised on the spot where the 'rites of sun-worshippers of pre-Christian times were performed'.[20] Notwithstanding such incongruities, Warren and Forrest's statue of Knox has come to be regarded as a potent embodiment of Calvinist self-righteousness, and a symbol of one of the great mould-breaking moments of Scottish history.

Condition: On completion of its business in 1827, the subscription committee offered Glasgow Corporation the surplus of £71 to retain as a trust fund for the future upkeep of the monument. A minute of 16 October 1827, records that this was accepted, but only 'under this express declaration, that the Corporation shall not, by doing so, be held to have become, in any shape, responsible for the expense of repairing and maintaining the said Monument, or beyond the sum so deposited, with the ordinary interest due thereon'.[21] By 1869, when the accumulated interest had increased the fund to £295, the monument was 'in need of considerable repair', and J. & G. Mossman were invited to submit an estimate of the costs required for a 'complete renovation'.[22] The Trustees provisionally agreed to accept their estimate of £165, but only after seeking tenders from a number of other sculptors in order to 'judge of the reasonableness of the amount charged by Messrs Mossman'. Despite the fact that most of these were lower, with only James Grant Junior submitting a higher estimate of £171, the Mossmans were awarded the commission.[23] In their letter of acceptance, the Mossmans outlined the precise details of the work required to 'put the Monument of John Knox into a proper state of repair':

… viz. – by re-chisseling [*sic*] and polishing all the wasted surfaces on figure and column – repairing basement entirely – and

removing all the defective stones and substituting new ones. Recutting the Inscriptions and carefully examining and repointing the joints all.[24]

A report by John Whyte, of the Office of Public Works, also specified that they were to reduce the size of the pedestal, but in such a way that it would not 'interfere with the proportions of the monument'.[25] A comparison between the inscriptions on the monument with the text published by George Blair in 1857[26] suggests that a number of minor errors were introduced during the recutting process, particularly in the eccentric use of capital letters (see Inscriptions, above). It is also interesting to note that in several places the Mossmans have not entirely erased the original inscription. In the sixth line of the east face, for example, the phrase 'the Good Regent' is closed with two slightly misaligned sets of inverted commas. In July 1890, repairs were necessary again, and after many years' delay, the trustees authorised a payment of £42 from the fund for these to be carried out, once again by J. & G. Mossman.[27]

The current condition of the monument is sound, though with some general wear on the pedestal. The patchy discoloration on the constituent stones of the statue may indicate the extent of the repair work carried out by Mossman in 1870, and the presence of small fragments of green metal in parts of the inscription (see especially lower part of west face) suggests that the letters may have originally been inset with bronze.

Notes

[1] Blair, pp.174–5. [2] Quoted in Blair, p.180. [3] Blair, pp.83–4. [4] *Account of the Laying of the Foundation Stone of Knox's Monument*, Glasgow, 1825 (hereafter '*Account*'), p.22. [5] *Ibid.*, pp.7, 8. [6] A footnote at this point records that a 'Portrait of Knox and a design of the Monument were hung up in the Hall'. [7] *Account*, p.23. [8] *Ibid.*, pp.46–7. [9] *Ibid.*, pp.28–9. The monuments referred to are Flaxman's marble statue of William Pitt, 1812, commissioned for the Town Hall, and now in GAGM (see Kelvingrove Museum, Kelvingrove

Park); Flaxman's bronze *Monument to Sir John Moore*, 1819, in George Square (q.v.); David Hamilton's *Lord Nelson Obelisk*, 1804, in Glasgow Green (q.v., Appendix B, Minor Works); and Greenshields' sandstone statue of James Watt, 1824, then on the attic of the Mechanics' Institute on Bath Street, and now in the University of Strathclyde (q.v.). [10] *Ibid.*, pp.10–11. [11] Blair, p.171. [12] *Ibid.*, p.175. [13] *Ibid.*, pp.175–6. [14] Anon. [Daniel Reid Rankin], *Notices Historical, Statistical, & Biographical, Relating to the Parish of Carluke from 1288 till 1874*, Glasgow, 1874, p.297. [15] Dibdin, p.699. [16] *Ibid.*, pp.699–700. [17] *Ibid.*, p.699. [18] Blair, p.176. [19] *Ibid.*, pp.177–8. [20] Eyre-Todd (1934), p.470. [21] GCA, C1/1/56, p.466. [22] *Ibid.*, T-MH 52/8/9, 10 November 1869, 12 May 1870. [23] The alternative estimates were as follows: Robert McCord, £150; William Taylor, £149 16s.; Alex Clubb, £125; Thomas Watson, £45. GCA, *ibid.*, 12 May 1870. [24] *Ibid.*, 3 May 1870. [25] *Ibid.*, 12 May 1870. [26] Blair, pp.172–2. [27] GCA, C1/3/17, p.227; C1/3/24, pp.329, 826; C1/3/31, pp.895, 897–8.

Other sources

Mary MacArthur, *The Necropolis: an Elegy, and other poems*, Glasgow, 1842, pp.9–10; Pagan, pp.180, 165; Berry, n.p., no.25 (incl. ill.); McKenzie, pp.11–13 (incl. ill.).

In the centre of Sigma

Monument to William McGavin
Sculptor: Robert Forrest

Architect: David Bryce
Date: 1834
Material: yellow freestone
Dimensions: statue 2.44m high; whole monument 10.6m high
Signature: on the west side of the base – JOHN BRYCE, ARCHITECT
Inscriptions: on the front (west) face of the pedestal – To / the Memory / of / WILLIAM M'GAVIN, / Merchant, Glasgow; / Author of the / "Protestant," &c. &c. / who died on the XXIII, of August, MDCCCXXXII. aged Fifty-nine years. / THIS / Monument has been Erected / by his fellow Citizens. / MDCCCXXXIV (Note: the words 'to', 'the

Memory', 'Author' and 'Protestant' are engraved in copperplate script.)
Listed status: category A (15 December 1970)
Owner: Glasgow City Council

William McGavin (1773–1832), philanthropist, lay preacher and 'controversialist', known in his time as 'The Protestant'. Born at Darnlaw, near Auchinleck in Ayrshire, on the estate of James Boswell, he received only a few weeks' formal education at the local village school, and was otherwise entirely self-taught. He worked in succession as a weaver, a teacher, a cotton-merchant and a banker with the British Linen

Robert Forrest, *William McGavin* [RM]

Company. In 1800 he joined the congregation of the Rev. James Ramsay, for whom he occasionally preached as a co-pastor and with whom he established an independent 'congregational' church. He later withdrew from the pastorate and became an itinerant preacher, working with a number of benevolent and religious societies in Glasgow. Between 1818 and 1822 he contributed a series of letters to the *Glasgow Chronicle*, dealing with points of controversy between the Catholic and the reformed churches; these were later published in four 8vo volumes as *The Protestant*, and eventually ran into six editions. Some statements in the letters prompted the Catholic church to sue McGavin for libel in 1821, winning damages of £100. Such was the extent of his popular support, however, that a public subscription in his favour raised £800. Among his other publications were essays refuting the socialist principles of Robert Owen of Lanark, and William Cobbett's account of the Protestant Reformation, as well as an edition of Knox's *The History of the Reformation in Scotland* (1826). He died suddenly from apoplexy while dining,[1] and was buried in the Wellington Street Chapel (now demolished), with a 'plain, but elegant, marble monument… erected over his grave by his widow'.[2] An ornamental pillar was also erected to his memory in Auchinleck churchyard.[3]

Description: McGavin is dressed in a frock coat and knee-breeches, with a heavy cloak draped across his left shoulder, and is shown striding forward with the palm of his right hand placed on the cover of a bible, as if in the act of discoursing on its contents. The statue is raised on a two-stage cylindrical pedestal in a florid Baroque style.

Discussion: On 17 January 1833, five months after McGavin's death, a group of 'respectable Gentlemen' met at the Exchange Sales Rooms in Glasgow in response to a newspaper advertisement calling for proposals to raise a monument to their 'much respected townsman'.[4] By this time £230 had been raised 'by the exertion of friends'. However, as many other citizens had 'expressed a wish to add still to these subscriptions, in order that something of a more public nature might be erected', a committee was formed to 'carry any further measures into effect'. The committee was chaired by John Alston, with Alexander Allan (possibly the shipmaster, see *Tomb of Alexander Allan and Family* below) acting as secretary; among the ordinary members were James Cleland (see 249 Buchanan Street, above) and Archibald McLellan (see 254–90 Sauchiehall Street, below). In an anonymous memoir appended to the posthumous works of McGavin, the editor notes that by 1834 the

> … plan of the monument and statue [had been] agreed upon, and contracted for. It is at present in progress, and in a few weeks expected to be raised in the Merchant's [sic] Park of Glasgow, a few paces below that of the illustrious Knox.[5]

No further details of the commission are given, but the engraving reproduced as a frontispiece to the book shows the figure in a slightly less dramatic pose than the statue as executed, and with two sets of decorated urns on the corners of the pedestal which have since been removed. George Blair recorded that the portrait was 'an excellent likeness of the deceased'.[6] He also noted the aptness of the monument's location in relation to Forrest's slightly earlier *Monument to John Knox* (q.v., above). 'Indeed', he wrote,

> … there is something peculiarly appropriate in the proximity of these two monuments. The principles of Knox found an interpreter in McGavin; and that indomitable spirit of independence which characterised 'The Reformer,' was not wanting in 'The Protestant'.[7]

T.F. Dibdin took a slightly more critical view, and after noting that the statue was analogous to the Knox monument in point of 'size, form, and obtrusiveness', went on to ruminate on the incongruity of erecting such an imposing monument to 'the late editor of a periodical journal entitled *The Protestant*':

> How limited is fame! I had never heard of this journal. Mr. Strang was astonished, but not so much as I was, when I was led to contemplate the figure of its editor. What limbs! What stockings! What small clothes! What a head and physiognomy! It was soothing, in opposition to this colossal vulgarity, to see little plats of earth, encircled by delicate iron railing, teeming with flowers – with a cineray vase or two, and sculptured emblems of mortality.[8]

On the question of the statue's relation to the Knox monument, it should be added that McGavin played a central part in initiating the plan to erect the earlier statue, and that, as a professional banker at the time, he acted as treasurer to the subscription committee.[9]

In his brief discussion of the monument, McGavin's biographer William Reid describes the Necropolis as 'the last resting-place of the remains of William M'Gavin'. He also refers to his remains as lying beside the monument, suggesting that they were transferred there from his grave in Wellington Street Church (see above) when the building was demolished.[10]

Condition: In 1870 a subscription was opened to raise £30 to carry out some repair work on the statue. Subscribers included the ironmaster William Connal (see 34–8 West George Street), who contributed £5 towards the £56 11s. that was eventually collected. The precise nature of the repairs is not known, but in a letter dated 25 May 1870, Alex Clubb offered to repoint the masonry joints, chisel and polish the decayed parts of the statue and to 'work two new vases for the two that is broke' for £30.[11] The present condition of the monument is good, though it is very blackened, and there is much green biological growth on

the surface. There are also some weeds growing in the masonry joints.

Notes
[1] Blair, p.258. [2] Anon. (ed.), *The Posthumous Works of the Late William McGavin, Author of The Protestant, etc.*, 2 vols, Glasgow, Edinburgh and London, 1832, vol.1, p.ccccxlii. [3] DNB, vol.35, pp.84–5; William Reid, *The Merchant Evangelist*, Edinburgh, 1884, p.212. [4] Anon., *op. cit.*, p.ccccxliii. [5] *Ibid.*, p.ccclxiv. [6] Blair, p.251. [7] *Ibid.*, pp.251–2. [8] Dibdin, p.700. [9] Anon., *op. cit.*, p.ccclxxvi. [10] Reid, *op. cit.*, pp.211–12. [11] GCA, T-MH 52/8/9, 25 May 1870.

Other sources
Mary MacArthur, *The Necropolis: an Elegy, and other poems*, Glasgow, 1842, pp.10–11; Anderson; Woodward, pp.71–4; Berry, n.p., no.16; Johnstone; McKenzie, pp.12, 14 (ill.).

At the south end of Beta

Monument to Lieutenant-Colonel Alexander Hope Pattison
Sculptor: John Ritchie

Date: 1838
Material: yellow sandstone
Dimensions: figure approx. 2.1m high; pedestal approx 6.1m high
Signature: on the plinth, left side – JOHN RITCHIE
Inscriptions: on the pedestal – SALAMANCA. / MADRID. / RETREAT OF ARANJUEZ. / PYRENEES. (north side); MASSENA'S RETREAT. / CAMPO MAYOR. / FUENTES D'ONORO. / BADAJOZ. (east side); BUSACO. / REDINHA. / CASAL NOVA. / FOZ D'ARONCE (south side); on the base – LIEUTENANT COLONEL ALEXANDER HOPE PATTISON, K.H., / COMMANDER OF THE TROOPS IN THE BAHAMAS, &c., &c., / AFTER SERVING HIS COUNTRY TWENTY-EIGHT YEARS / WITH HONOUR & FIDELITY / DIED AT NASSAU NEW PROVIDENCE, ON THE 11TH JANY., 1835, / AGED 48 / THIS MONUMENT TO HIS WORTH AND SERVICES IS ERECTED / BY HIS FRIENDS &

FELLOW-CITIZENS. / 1838 (west side); A.D. MDCCCXXXVIII / BY A GRANT FROM / THE MERCHANTS' HOUSE OF GLASGOW / OF THE REQUISITE GROUND / THE CONTRIBUTORS / WERE ENABLED TO PLACE COL. PATTISON'S MONUMENT / NEAR HIS FATHER'S TOMB. (north side)
Listed status: category A (15 December 1970)
Owner: Glasgow City Council

Alexander Hope Pattison (1787–1835), Scottish soldier, who entered active service in the army during the Peninsular War. He rose to become Commander-in-Chief of the 2nd West India Regiment and later Commander of the British forces in the Bahamas, where he died. A veteran of 28 campaigns, he was wounded twice and made a Knight of Hanover for his military services.[1] His principal military achievements are indicated in the lists of battles ('each word a chapter'[2]) inscribed on the pedestal (see above). He was the son of John H. Pattison (died 1807), a wealthy Glasgow merchant, who planted six Canadian poplars on his estate at Kelvingrove to commemorate the birthdays of his children. Known as 'The Pattisons', these grew to a height of ninety feet, and remained standing in Kelvingrove Park (q.v.) until the late 1860s, when they were removed after a storm had made them unsafe.[3]

Description: The subject is shown standing with his left leg slightly advanced, his right hand placed on his waist and the right resting on the pommel of his sword; he wears a knee-length military tunic, belted at the waist and with a stiff, upright collar. George Blair describes the figure as follows:

> The lineaments are those of a fine, manly figure, standing with head uncovered, and 'his martial cloak around him', in an easy and unconstrained attitude. As a work of art it is almost faultless.[4]

In fact his cloak is draped over his left forearm. The front (west) face of the pedestal is

John Ritchie, *Alexander Hope Pattison* [RM]

carved with the armoreal bearings of the Pattison family: a shield with three shells in the chief and a lion rampant below, the crest consisting of a knight's helmet flanked by a boar's head and a castle, with three mottoes in escrols above and below the shield: 'HOSTIS HONORIS INVIDIA' (trans.: 'Envy is an enemy to honour'); 'NEC ASPERA TERRENT' (trans.: 'Difficulties do not daunt'); 'TACHE SANS TACHE' [tâche] (trans.: 'Strive (to be) without reproach'). Further martial references appear in the series of carved trophies (a plumed Greek helmet crossed by a sword) on the corner pillars.
Discussion: The site for the monument was provided by the Merchants' House, at that time

the owners of the Necropolis, to enable it to be erected near the grave of his father, whose ashes were removed from St David's churchyard in 1833 and reinterred in the Necropolis with those of his wife, Hope Margaret Moncrieff.[5] Many other family members, including Pattison's nephew and secretary (also Alexander Hope Pattison) are buried nearby to form a distinct enclave, raised from the main carriageway by a double flight of steep steps.

A vivid description of the statue is provided by Mary MacArthur in her verse elegy on the Necropolis of 1842:

Beneath, the martial cenotaph appears,
That bears a soldier's statue and his name,
Erected by his townsmen and compeers,
To prove their friendship, and record his fame.

He sleeps far off among the Indian isles;
His battle fought, his final victory won…[6]

This would appear to confirm that Pattison is buried not in the Necropolis, but in the Bahamas, where he died.

Condition: Good, but with much green biological growth on the surface of the statue.

Notes
[1] Irving, p.405. [2] Blair, p.325. [3] Cowan, p.142. [4] Blair, p.325. [5] Blair, p.324. [6] Mary MacArthur, *The Necropolis: an Elegy, and other poems*, Glasgow, 1842, p.12.

Other sources
Black, p.46; McKenzie, pp.10 (ill.), 11.

At the north end of Omega

Charles Tennant Memorial
Sculptor: Patric Park

Date: 1841
Materials: Carrara marble (statue); grey granite (pedestal)
Dimensions: figure approx. 2m high; pedestal 2m high
Inscription: on a tablet on the front of the pedestal – CHARLES TENNANT / of St ROLLOX, / Died 1st October 1838 / Aged 71. / Erected by a few of his friends / as a tribute of respect.
Listed status: category A (15 December 1970)
Owner: Glasgow City Council

Charles Tennant (1768–1838), chemical manufacturer. After beginning his career as a weaver in the village of Ochiltree, in Ayrshire, Tennant made his fortune by developing a chemical method of bleaching textiles, which until then was a time-consuming process, requiring large tracts of land to expose cloth to the wind and sun. Though not trained as a chemist, he discovered that a mixture of chlorine and lime produced an effective bleaching agent. His chemical works at St Rollox, a notorious pollutant slightly to the north of the Necropolis, was set up in 1799, and

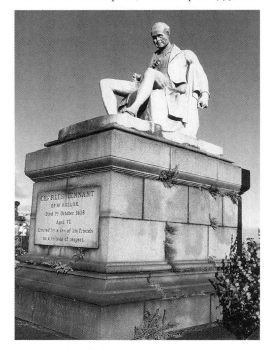

Patric Park, *Charles Tennant* [RM]

grew to be the largest of its kind in Europe, with a 436-foot chimney, known locally as 'Tennant's Stalk' (demolished *c.*1940). Tennant himself was nicknamed 'Wabster Charlie' by Robert Burns.[1]

Description: The figure is seated on a sabre-leg chair wearing an open tailcoat, waistcoat and cravat, with his left arm hanging loosely over the chair back and his right hand resting on his thigh; the chair is entirely concealed by a mass of folded draperies. His head is bowed forward in what was described as 'an attitude expressive of meditation' by George Blair, who goes on to state that 'the vigorous conception and exquisite modelling of the work, stamp it as one of the finest productions of Mr. Park, the late eminent sculptor'. The pedestal is raised on a two-stage base.

Discussion: Park exhibited the finished marble at the RA in 1841 (no.1247), where it was noted in the catalogue that it was 'to be erected in the City of Glasgow'.[2] One of the few full-size statues in the Necropolis made from white marble, it has been somewhat uncharitably described as looking 'like a casualty of the product that made his family fortune'.[3] The pose is thought to be derived from Chantrey's *Monument to James Watt* (q.v., George Square).

Condition: Badly eroded by the atmosphere, with several of its extremities (nose, fingers, toes) broken off.

Related work: A plaster bust of Charles Tennant (n.d.) by Park is in GAGM (S.113).

Notes
[1] Oakley (1946), p.44. [2] Graves, vol.6, p.53. [3] Berry, n.p., no.26.

Other sources
Worsdall (1988), p.96 (ill.); Black, p.54; Johnstone; McKenzie, pp.11, 13 (ill.).

William Motherwell Memorial
Sculptor and designer: James Fillans

Mason: Councillor McLaughlin of Irvine
Date: 1851
Inaugurated: 21 June 1851
Material: yellow sandstone
Dimensions: approx. 4m high
Inscriptons: see below
Listed status: category A (15 December 1970)
Owner: Glasgow City Council

William Motherwell (1797–1835), journalist, politician and minor poet. He was born at 177 High Street, in a tenement block designed by James Adam,[1] and at the age of fifteen entered the Sherrif-Clerk's Office in Paisley, achieving the position of Sherrif-Clerk Depute six years later. He became the editor of the *Paisley Advertiser* in 1828 and the *Glasgow Courier* in 1830. In addition to his own poetry, he also published a biography of Robert Burns (see George Square), whose work he co-edited with James Hogg. An outspoken Tory, his views often made him unpopular, but he also had a wide circle of admirers, who were attracted to the 'wild and weird fancy' of his verse, much of which was concerned with Viking legend and the splendours of Valhalla. Dubbed 'our modern Ossian' by George Blair, he died unexpectedly from a fit of apoplexy.[2]

Description: The monument is in the form of a miniature temple, with a canopy in a hybrid Tudor style raised on a stepped pedestal, the upper stage of which is incised with bas-relief panels illustrating episodes from Motherwell's life and poetry. On the side facing the carriageway is a medieval jousting scene, which shows one knight being unhorsed by another, while a third carries off a young woman who tries to discover his identity by lifting his visor. On the left side is a scene showing the poet with his childhood sweetheart Jeannie

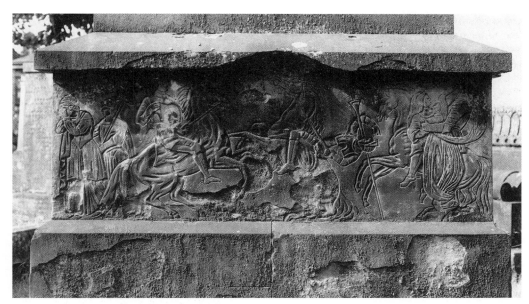

James Fillans, *William Motherwell Memorial* (detail) [RM]

Morrison, while the right side illustrates lines from his poem 'Halbert the Grim':

> Now redder and redder flares far its bright
> eye,
> And harsher these dark hounds of hell yell
> out their fierce cry,
> Sheer downward! right downward! then
> dashed life and limb,
> As careering to hell sank Halbert the Grim.[3]

The front panel was inscribed with lines from a verse eulogy by William Kennedy, but this is now illegible.[4] A portrait bust of Motherwell in Parian marble was originally placed in the canopy, and the central cavity contains a hermetically sealed bottle preserving Motherwell's collected poems, some in manuscript, a selection of contemporary newspapers and statistical publications and a list of the members of the subscription committees.[5]

Discussion: Blair records that 'considerable funds' had been donated towards the commissioning of a monument to Motherwell shortly after his death, but that no action was taken until 16 years later. He offers no explanation of this 'memorable instance of procrastination'.[6] In the meantime, Motherwell's grave in the Necropolis had been regularly visited by his friend James McNab, who occasionally marked the spot with a card printed with a fragment from the poet's verse:

> When I beneath the cold red earth am sleeping
> Life's fever o'er
> Will there for me be any bright eye weeping
> That I'm no more?
> Will there be any heart still memory keeping
> Of heretofore?[7]

This served to draw attention to the lack of a suitable monument, and in 1851 a memorial committee was established in Glasgow, with sub-committees in Edinburgh and Paisley, to raise the necessary funds. This was apparently accomplished 'without much difficulty'.[8] The

construction of the monument was unusual in that all the masonry was precut before it was brought to the Necropolis, allowing it to be erected entirely within a few hours before its inauguration on 25 June 1851. 'This operation', wrote Fillans' biographer, James Paterson: '… was consequently performed without the clink of a hammer, so that the edifice, like the temple of Solomon – to compare small things with great – was elevated in solemn silence'.[9]

The inauguration was attended by about twenty friends and admirers, including Fillans himself and the members of the subscription committee. Blair noted that a 'few ladies also graced the ceremony with their presence'.[10]

Fillans had a high personal regard for Motherwell, who was in fact his first patron,[11] and evidently took the commission very seriously, making a special visit to Eglinton Castle to study suits of armour for the joust scene.[12] He also worked on the reliefs in what Blair described as an 'effective, though somewhat novel manner'.[13] Fillans himself throws some light on this in a letter he wrote in early February 1851:

> Yesterday I commenced my second baso-relievo for Motherwell's monument. I expect, now that I have got a fair starting, to have the whole finished by the latter end of this week. I sketch them on the stone, and cut without models; saving a great deal of time.[14]

This unusual method of working perhaps explains the surprising coarseness of the finished reliefs, which lack the Flaxmanesque elegance and purity of line evident in the engraved versions of his designs published in Paterson's biography.[15]

Condition: The main structure is sound, but the relief and inscription panels are in a very poor condition, with only the joust scene reasonably intact. Deterioration appears to have set in early, and by the time George Blair wrote his guide in 1856 the panels were already 'sadly

effaced'. The portrait bust is now missing, but was still *in situ* in April 1939, when it was photographed by James Cowan.[16] It was described by Blair as an 'admirable likeness' and 'altogether worthy of the genius' of its creator.[17]

Related work: There are two plaster busts of Motherwell by Fillans in Paisley Art Gallery and Museum.

Notes
[1] Cowan, p.293. [2] Blair, pp.62–6. [3] *Ibid.*, p.70. [4] The full inscription originally ran: Erected / by admirers of the poetic genius of / William Motherwell, / Who died 1st November 1835, aged 38 years. / "Not as a record he lacketh a stone! / 'Tis a fond debt to the singer we've known – / Proof that our love for his name hath not flown, / With the frame perishing – / That we are cherishing / Feelings akin to the lost poet's own." (Blair, p.62). [5] James Paterson, *Memoir of the Late James Fillans, Sculptor*, Paisley, 1854, p.95. [6] Blair, p.70. [7] Blair, pp.61, 71. [8] Paterson, *op. cit.*, p.94. [9] *Ibid.*, p.95. [10] Blair, p.70. [11] *Ibid.*, p.372. [12] Paterson, *op. cit.*, p.93. [13] *Ibid.*, p.94. [14] *Ibid.*, p.93. [15] *Ibid.*, plates XXV, XXVI, XXVII. [16] Cowan, p.293. [17] Blair, p.62.

Other sources
Berry, n.p., no.11; Black, p.61; McKenzie, pp.14 (ill.), 15.

On the south corner of Alpha

Houldsworth Family Mausoleum
Sculptor and architect: John Thomas

Date: 1854
Materials: marble (figures); yellow sandstone (building)
Dimensions: figures 2m high
Inscription: on the left panel inside the mausoleum – IN / AFFECTIONATE MEMORY OF / WILLIAM HOULDSWORTH / DIED 15 DEC. 1853, AGED 55 YEARS, / THOMAS HOULDSWORTH / DIED 1 APRIL 1866, AGED 26 YEARS. / HELEN HOULDSWORTH, / DIED 19 AUG. 1867, AGED 26 YEARS. The remainder of the inscription on this panel is illegible; right panel – mostly illegible, but includes JOHN HOULDSWORTH / DIED 1859, AGED 53 YEARS.

Listed status: category A (15 December 1970)
Owner: Glasgow City Council

Henry Houldsworth & Sons, of Cranstonhill, family firm of ironmasters, described as 'princes among Glasgow merchants'.[1] The company was founded by Henry Houldsworth (?1775–1852), who came to Glasgow from Manchester in 1799 to take charge of a cotton mill on the River Kelvin. With the decline of cotton as a staple industry in Glasgow, the family business turned to iron manufacture, opening ironworks on their estate at Coltness and later at Dalmellington in Ayrshire. The discovery of blackband ironstone on their land enabled them the take the lead in the manufacture of iron using James Beaumont Neilson's revolutionary hot blast process (see Connal's Building, 34–8 West George Street). All three of Houldsworth's sons – Henry (1797–1867), William (1798–1853) and John (1807–59) – participated in the family business. However, John Houldsworth was also well known as a yachtsman and a major patron of the arts, amassing a fine collection of paintings by contemporary British artists such as David Roberts, Clarkson Stanfield, Thomas Faed and Edwin Landseer, many of whom were his personal friends.[2]

Description: The building is an open-type mausoleum in a Graeco-Egyptian style, with a pair of allegorical female figures raised on rectangular bases projecting from the corners on either side of the entrance. On the right *Charity* carries a child, while *Hope*, on the left, leans on an anchor ('Hope we have as an anchor of the soul', Hebrews 6.19). Inside, a third figure, representing *Faith*, stands with eyes raised, a bible clasped to her breast and a pair of suppliant angels kneeling at her feet.

Discussion: Commissioned by John Houldsworth in 1854, possibly in response to the death of his brother William the year before, the mausoleum is significant as an example of the support offered to the London

sculptor John Thomas by a major Glasgow art patron. The relationship appears to have been an especially fruitful one, and in 1858, when Houldsworth acquired the end pavilion of Charles Wilson's newly erected Park Terrace, he invited Thomas to design the interior fitments and furnishings 'in the most artistic way known at the time'.[3] This included carved chimneypieces, gasoliers and much 'Valuable Statuary', as well as plaster decorations incorporating portrait medallions and naturalistic

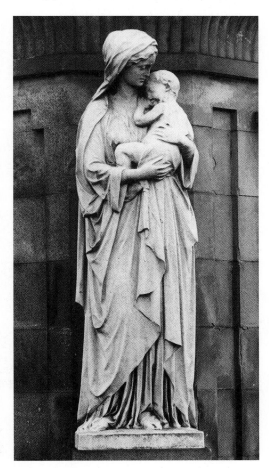

John Thomas, *Charity* [RM]

panels.[4] According to a later commentator:

> The magnificence of the furniture, &c., was so much talked about that the Queen and Prince Albert paid Mr Thomas' studio a visit to see them. On leaving Her Majesty said, 'You say the gentleman's name is Houldsworth. It ought to be Goldsworth.'[5]

The writer goes on to add that the work was not carried out, but this has recently been shown to be incorrect, and the scheme was all but complete when Houldsworth died in 1859, after which the contents of the house were sold by auction.[6] It seems appropriate, therefore, that Houldsworth should be interred in a structure designed and decorated by the sculptor who masterminded the lavish domestic scheme he was unable to enjoy except, perhaps, for a few months.

Condition: The elevated position of the monument, together with its relative proximity to the former St Rollox chemical works (see *Charles Tennant Memorial*, above) has adversely affected the exterior marble figures, with many details, such as the facial features of *Hope* and the baby, eroded almost beyond recognition. The interior group is better preserved, though this has been disfigured by patchy discoloration caused by rain penetration from the oculus in the roof.

Notes
[1] Anon. [J.O. Mitchell, J. Guthrie Smith and others], *Memoirs and Portraits of One Hundred Glasgow Men*, 2 vols, Glasgow, 1866, vol.1, p.165. [2] Anon., *op.cit.*, p.166; Slaven and Checkland, vol.1, pp.45–6. [3] Anon., p.166. [4] George Fairfull Smith, 'Furniture and Plenishings for 1 Park Terrace, Glasgow: a little known commission designed by John Thomas (1813–1862)', *Furniture History*, vol.XXXIV (1998), pp.268–9. [5] Anon., *op. cit.*, p.166. The reliability of the Queen Victoria anecdote has recently been questioned. See Smith, *op. cit.*, p.268. [6] Smith, *op. cit.*, pp.268–74.

Other sources
Read, pp.188–9 (incl ills); McKenzie, pp.11, 13 (ill.).

In the centre of Alpha

Tomb of Alexander Allan and Family

Sculptor and designer: James Pittendrigh Macgillivray

Masons: A. MacDonald & Co. Ltd
Date: *c*.1894–9
Materials: bronze (figures); pink Aberdeen granite (main structure)
Dimensions: 1.77m high (figures); 4.3m high (main structure)
Signature: on the right panel – Macgillivray's palmette motif
Inscription: on a panel in the dado below the left angel – IN LOVING MEMORY OF / ALEXANDER ALLAN / SHIPOWNER GLASGOW / BORN 29th MAY 1825, DIED 2nd APRIL 1892 / AND HIS WIFE / JANE SMITH / BORN 27th OCTOBER 1830, DIED 18th FEBRUARY 1892 / AND THEIR CHILDREN / ALEXANDER ALLAN / BORN 7th DECEMBER 1855, DIED 10th DECEMBER 1855. / GEORGE WILLIAM ALLAN / BORN 4th OCTOBER 1860, DIED 19th SEPTEMBER 1861. (There are further inscriptions on the centre and right panels, but these post-date the monument by many years.)
Listed status: category A (15 December 1970)
Owner: Glasgow City Council

Alexander Allan (1825–92), shipping line owner and temperance campaigner. He was the youngest of five brothers, who, together with their father, Alexander Allan Senior, formed the Allan Line, one of the most powerful shipping dynasties of the nineteenth century. The family business was founded in 1819 as a modest trading company plying cargoes of coal, iron, herring and sugar from Greenock to Quebec, and returning with wheat, flour, potash and timber. Alexander Junior joined the family business in 1846, shortly after the improvements on the River Clyde allowed the

company to transfer its base from Greenock to Glasgow. The success of the company was based on close family ties, with each of the five brothers taking responsibility for a different aspect of the business, or running one or other of its numerous regional offices, which by the 1850s extended from Glasgow to Montreal and Buenos Aires. From 1861, the company played a leading role in the emigration movement from Scotland to Canada. In 1854, Alexander Allan married Jane Smith, the daughter of Robert Smith, the proprietor of the City Line, and a staunch supporter of the Scottish Temperance League. Allan became a member of the League in the year of his marriage, and later served as its vice-president for 25 years. It was through

his influence that Allan Line vessels were not only staffed mostly by abstainers, but carried Temperance League tracts as reading matter for their passengers. He was also a leading supporter of the Glasgow United Evangelical Association, and was heavily involved with his wife in charitable work in Glasgow. In 1890 he undertook a world cruise to improve his health, but became seriously ill in Ceylon and was forced to return home after six months. He never fully recovered, but strangely it was his wife who died first after catching a chill in February 1892; Allan survived her by six months. Their combined estate at this time was valued at over £1 million. The Allan Line was purchased by the Canadian Pacific Railway

Company in 1909 and was finally dissolved in 1931.[1]

Description: Loosely based on the Erectheum in Athens, the monument consists of a pedimented tabernacle with pilasters and acroteria, flanked by a pair of lower side screens. The central compartment is occupied by a pair of male angels, each of which has an arm and a wing extended over a smaller central aedicule. This originally contained a bronze double portrait of Alexander and Jane Allan, but this has now been removed.

Discussion: Macgillivray began work on the monument some time before his departure from Glasgow in 1894, and completed the bronze figures in his studio in Edinburgh.[2] In January 1899, the *Builder* noted that the main structure had 'just been completed at the Aberdeen Granite Works',[3] and by the following April the *Studio* was able to report that the 'colossal memorial of impressive design' was 'being reared' in the Necropolis.[4]

Condition: Apart from the loss of the central portrait panel, which has exposed an unsightly area of rough stonework in the central aedicule, the general condition of the monument is fair. The figures are badly stained, however, and there is some minor structural damage, including a crack in the tip of the lower wing of the right angel, which has left the terminal feather very loose. The base of the right hand section of the relief has also been slightly dislodged from the main structure and the coping stone is missing from the end pier on the right.

Notes
[1] Slaven and Checkland, vol.2, pp.262–4. [2] SAR, 1 February 1906, pp.119–22. [3] B, 28 January 1899, p.99. [4] *Studio*, vol.XVI, no.73, April 1899, p.205.

Other sources
Spielmann, p.151; McKenzie (1999), pp.10 (ill.), 11.

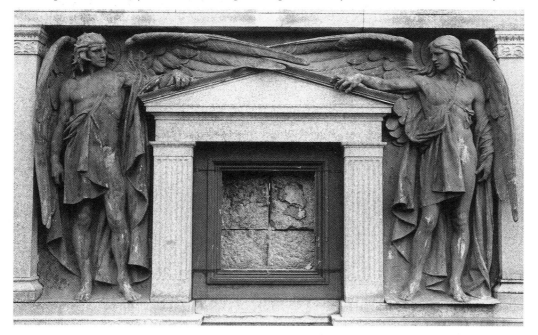

James Pittendrigh Macgillivray, *Angels* [RM]

Nelson Mandela Place CITY CENTRE

Former Athenæum, 8 Nelson Mandela Place (60 West George Street)

Portrait Statues and Allegorical Figure Groups

Sculptor: John Mossman
Carver: James Harrison Mackinnon

Architect: John James Burnet
Date: 1886–8
Building opened: 30 January 1888
Material: yellow sandstone
Dimensions: figures larger than life-size
Inscriptions: on tablet above west entrance –
 THE ATHENÆUM; in cast iron entrance gates –
 THE GLASGOW ATHENÆUM LTD; in raised
 numerals on cast iron gullies on rone pipes –
 1888 (left), 1992 (right)
Listed status: category A (6 July 1966)
Owner: Grosvener Buchanan PLC

Description: The design of the façade
incorporates a simplified version of a Roman
triumphal arch, with three Diocletian windows
divided by Ionic columns on the first floor, a
channelled ashlar basement and a plain attic.
The allegorical groups are at the extreme ends
of the first floor, on pedestals beside the
windows above the entrances. On the left is
Scientific Education, which consists of a portrait
of James Watt seated beside a steam condenser
and with a governor mechanism in his hand.
(For biography, see *Monument to James Watt,
George Square.*) He is shown with his hand on
the shoulder of a standing youth, who holds a
pair of dividers and a scroll. Above the right
entrance is *Literary Education*, an unidentified
male figure with three books piled under his
chair and another resting on his knee. He is also
accompanied by a youth. In both groups, the
adults are dressed in eighteenth-century

costume, with lengths of cloth draped over their
knees, while the youths are in classical tunics.
 The portraits are at attic level, and are shown
standing on the entablature above the Ionic
columns. From the left these are:

John Flaxman (1755–1826), English sculptor,
depicted holding a miniature copy of the
Belvedere Torso and a modelling knife, with
a pile of books at his feet. (For biography,
see Biographies.)

Sir Christopher Wren (1632–1723), English
astronomer and geometrician, founder of the
Royal Society and the greatest architect of
his day. In addition to designing St Paul's
Cathedral, he also built 53 of London's 'city
churches' as part of the reconstruction of the
capital after the Great Fire of 1666.[1] He is
shown here holding a model of the dome of
St Paul's.

Henry Purcell (1659–95), the most important
English musician of the Baroque period, was
court composer to Charles II and organist of
Westminster Abbey. Many of his works,
including the opera *Dido and Aeneas* and his
incidental music to Shakespeare's *A
Midsummer Night's Dream*, are still
regularly performed today.[2] In this portrait
he holds a rolled manuscript.

Sir Joshua Reynolds (1723–92), English
portrait painter and art theorist who, as the
first President of the Royal Academy of
Arts, London (founded 1768), dominated
British painting in the second half of the
eighteenth century. An advocate of the
Grand Manner, he tried, with only limited
success, to establish a British School of
history painting comparable to the masters
of the Italian Renaissance. His influential
Discourses on Art (1769–91) remains the

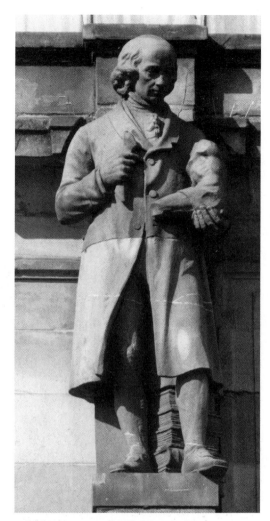

John Mossman, *John Flaxman*

most succinct and eloquent statement of the
academic doctrine of art.[3] He is shown here
with a palette and brushes.

 All four figures are dressed in period
costume, and each statue is composed of two

blocks of stone.

Discussion: The building was erected by the Glasgow Athenæum Ltd, with profits from the sale of its earlier premises on Ingram Street (Assembly Rooms, demolished).[4] Inaugurated by Charles Dickens in 1847, the organisation aimed to 'fill the great educational vacuum between the Mechanics' Institute and the University',[5] an aspiration which is clearly reflected in the subject matter of the sculptures on the façade. The decision to include the sculptures did, however, meet some opposition. According to James Lauder, in his 1897 account of the history of the Athenæum, the directors:

> … did not at first feel justified in incurring the expense in the execution of these figures, but they were afterwards fortunate in having them presented – the first three respectively by the Marquess of Bute, Mr. John Burnet, F.R.I.B.A., and Messrs. Burnet, Son & Campbell, the architects, whilst the fourth was given jointly by Messrs J.A. Campbell and J.G.A. Baird. The façade was thus completed shortly [i.e., approximately two years] after the opening of the building.[6]

The building was later joined with the adjacent former Liberal Club and the former Athenæum Theatre (q.v., 179 Buchanan Street) to become the premises of the Royal Scottish Academy of Music and Drama. It was converted to flats shortly after the latter's move to Renfrew Street in 1988.

Condition: The building was cleaned in 1992, though the sculptures appear to have been omitted from this process. The oculi at either end of the first floor were originally decorated with cherub masks and palm fronds, which were removed some time after 1913.[7]

Notes
[1] EB, vol.X, p.760. [2] *Ibid.*, vol.VIII, p.306. [3] *Ibid.*, vol.VIII, p.543. [4] Fisher, pp.13–14. [5] Oakley (1946), p.52. [6] James Lauder, *The Glasgow Athenæum: a Sketch of 50 Years' Work, 1847–1897*, Glasgow, 1897, p.120. [7] B, 9 July 1898, n.p. (ill.); Oakley (1980), pp.69, 109.

Other sources
BN, 2 April 1886, p.561; Gildard (1892), p.2; B, 9 July 1898, pp.22–3; Groome, vol.3, p.136; Cowan, p.165; 'Architectural Sculptor', (obit. of Mackinnon), GH, 8 November 1954, p.9; Read and Ward-Jackson, 4/11/90–6 (ills); Nisbet, 'City of Sculpture'; Teggin *et al.*, p.29 (ills); McKean *et al.*, pp.97, 98 (ill.); Williamson *et al.*, p.249; McKenzie, pp.57–9 (incl. ill.); LBI, Ward 18, p.218.

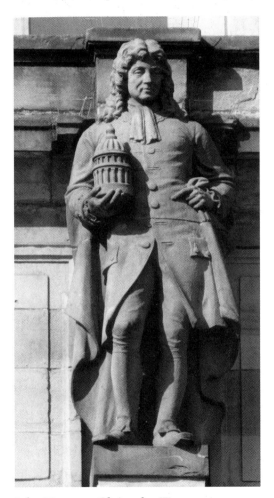

John Mossman, *Christopher Wren*

Royal Faculty of Procurators, 12 Nelson Mandela Place (62–8 West George Street)

Keystone Portraits and Associated Decorative Carving

Modellers: Alexander Handyside Ritchie (portraits); James Steel (decorative work)
Carver: James Shanks

Architect: Charles Wilson
Date: 1854
Materials: yellow freestone; bronze (St Mungo's crozier)
Dimensions: masks slightly larger than life-size
Inscriptions: Latin mottoes on coats of arms illegible
Listed status: category A (6 July 1966)
Owner: Royal Faculty of Procurators in Glasgow

Description: Designed in the style of a Venetian Renaissance *palazzo*, with echoes of Sansovino's Library in St Mark's Square, this two-storey building was commissioned by the Faculty (later Royal Faculty) of Procurators as a demonstration of their 'fine taste and princely magnificence'.[1] Its three main façades are on West Nile Street, West George Street and the north-west corner of Nelson Mandela Place, with a further single bay adjoining the Athenæum. The two round-arched entrances and twelve windows on the ground storey have portrait heads in the keystones representing 'the most distinguished Scottish law lords and lawyers'.[2] Beginning with the single face on the wall beside the Athenæum these are:

1. Andrew, Lord Rutherford (1781–1854), judge;
2. Henry Thomas, Lord Cockburn (1779–1854), judge and author of *Circuit Journeys* (Edinburgh, 1888);
3. Francis, Lord Jeffrey (1773–1850), judge and critic;

4. Sir James Wellwood, Lord Moncrieff (1776–1851), judge;
5. John Miller (1735–1801), Professor of Law, Glasgow University;
6. James Reddie (1773–1852), Town Clerk of Glasgow;
7. Duncan Forbes of Culloden (1685–1747), Lord Advocate;
8. Henry Home, Lord Kames (1696–1782), judge and author;
9. James Dalrymple, 1st Viscount Stair (1619–95);
10. John Erskine of Carnock (1758–92), advocate and antiquary;
11. Robert, Lord Blair of Avontoun (1741–1811), Lord President of the College of Justice;

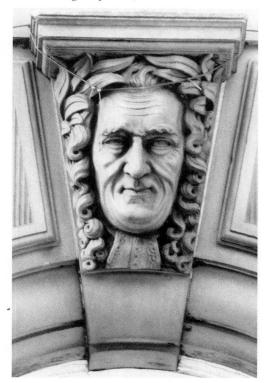

Alexander Handyside Ritchie, *Lord Kames*

12. Henry Peter, 1st Baron Lord Brougham and Vaux (1778–1868), Whig reformer, Lord Chancellor of England and inventor of brougham carriage;
13. William Murray, 1st Earl of Mansfield (1705–93), Lord Chief Justice;
14. Henry, Lord Erskine (1746–1817), Lord Advocate.[3]

The placement of Lords Jeffrey and Stair over the entrances to the building was intended to 'remind entrants of the penetration and sagacity, the acumen and erudition, as well as the probity necessary successfully to master and practise the difficult science of jurisprudence'.[4] For likenesses Ritchie used sources ranging from existing oil portraits, engravings, busts, photographs and death masks, as well as a sitting from Lord Brougham, the only subject living at the time.[5]

James Steel is documented as having produced models for the extensive programme of ornamentation elsewhere on the building, which, like the masks, was carved by Shanks.[6] On the first floor of the east and west frontages, at either end of the library, there are Serlian windows with shields on the keystones displaying a variation of the arms of the city of Glasgow (a standing bishop with a salmon on the dexter side and a bird and a bell on the sinister), as well as various naturalistic forms such as thistles. These windows are in turn flanked by shell-niched recesses, four in all, with socles that may have been intended to carry standing figures.[7] Rosettes appear at intervals on the first-floor balconies. The cornice is heavily decorated with ribbons, stars, lion masks, grotesques and branches, while further naturalistic forms appear in the spandrels of the south and west entrances and the keystones and reveals of the first-floor windows. The keystones on the eight first-floor windows have horned satyr heads enclosed in foliage.

Related work: Distributed through the

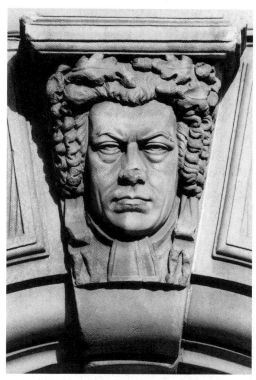

Alexander Handyside Ritchie, *Lord Brougham and Vaux*

interior of the Hall are plaster copies of the keystone masks, as well as marble portrait busts of James Reddie, 1847 by Patric Park, and Francis Jeffrey, 1853 by Peter Slater. Among the Faculty's collection are also busts by George Edwin Ewing (*Andrew Bannatyne*, 1865), James Pittendrigh Macgillivray (*Sir James Robertson*, 1891), Carlo Marochetti (*Robert Lamond*, 1849) and John Mossman (*William Towers-Clark*, 1875).

Condition: The noses of nos. 1, 4, 5 and 12 are chipped.

Notes
[1] BN, 31 August 1860, p.683. [2] *Ibid.*
[3] Biographical information from EB and Smailes

(1990). [4] BN, 31 August 1860, p.683. [5] Stoddart (1995), p.15. [6] BN, 31 August 1860, p.683. [7] Stoddart, op. cit., pp.14–15.

Other sources
BN, 31 August 1860, p.679 (ill.); Tweed (Guide), pp.36–7; Gomme and Walker, pp.120–2; Young and Doak, no.80 (incl. ill.); Jack House, 'Ask Jack', ET, 16 May 1979; J. Aitchison, 'The Royal Faculty of Procurators in Glasgow: the architecture and keystones', n.d. (1979?), unpublished typescript, MLG; Read and Ward-Jackson, 4/11/97–111 (ills); Teggin et al., pp.37, 42 (ills); McKean et al., pp.124 (ill.), 125: Williamson et al., p.249; McKenzie, pp.58, 59 (ill.); Michael Smith (1999), p.618; LBI, Ward 18, p.219; information provided by Royal Faculty of Procurators in Glasgow.

New City Road COWCADDENS

Chinatown

Dragon Gate and Lions

Sculptors: see below

Architects: The Yunnan Corporation, Yunnan, China
Date: 1990
Materials: glazed ceramic (dragons); green and black granite (lions)
Dimensions: dragons approx. 1.2m long; Chinese lions 76cm high on pedestals 61cm × 38cm × 51cm; African lions 61cm high on pedestals 61cm × 46cm × 1.02m
Inscriptions: Chinese characters on plinths of west lions (trans.: 'Glasgow China Town')
Listed status: not listed
Owner: China Town Investments Ltd

Description: The Dragon Gate is at the west entrance to Chinatown, a specialised retail and cultural centre occupying a site of several acres bounded by New City Road, Garscube Road and the access road to the M8 motorway. The gate has two stages, with pagoda-style roofs decorated with brown glazed ceramic ridges and finials, including a pair of recumbent dragons facing each other across a spiked sphere symbolising a pearl. Flanking the central arch is a pair of small brick pedestals supporting decorative lions in green granite, which may be identified by their design, and the ferocity of their expressions, as Chinese. The female lion (left) has a doll in the form of a miniature lion in her paws, signifying both play and motherhood, while the decorative ball held by the male lion symbolises his mastery of the world. In the mouth of each lion is a loose granite sphere, which appears to have been carved *in situ*. A second pair of lions is located at the entrance to the Chinatown Restaurant, which occupies much of the ground floor on the south side of the main building. Carved from black granite, these are African rather than Chinese, and are in more relaxed couchant postures.

Discussion: The complex was developed by Mr Maurice Lim as a social and commercial focus for the large Chinese community in the Garnethill area. After an unsuccessful attempt to identify local craftworkers to produce the decorative components of the scheme, the commission for the entire complex was awarded to the Yunnan Corporation, which manufactured the lions and ceramic details in their workshops in China. The lions were produced by teams of young women carvers who worked by rotation in groups of five, each taking responsibility for a particular detail. A total of 95 carvers worked on each lion. The design and iconography of the scheme were determined by many aspects of traditional Chinese practice, such as the demand that no two pairs of lions are repeated in any one scheme, and that a pearl is placed between the dragons on the gate to prevent discord between them.

Condition: Generally good, though the ball

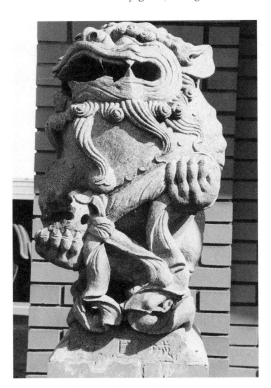

Various sculptors, *Chinese Lion* [RM]

in the paws of the male Chinese lion is
damaged. In August 2000, its lower jaw was
also smashed and the internal sphere stolen.

Source
Information provided by Mr Maurice Lim,
Chinatown Groceries Limited.

101–3 New City Road / Shamrock Street

Allegorical Figures, Putti and Associated Decorative Carving

Sculptor: not known

Architect: Neil C. Duff
Date: *c.*1910
Material: red Locharbriggs sandstone
Dimensions: figures and putti slightly larger
 than life-size
Inscriptions: on royal arms – DIEU ET MON
 DROIT (trans.: 'God and my right') / NEMO
 ME IMPUNE LACESSIT (trans.: 'no-one
 provokes me with impunity'); on cartouche
 over ground-floor window, Shamrock Street
 – GSB (entwined); above entrance and
 second-floor window on Shamrock Street –
 1910 (entwined)
Listed status: category B (10 June 1987)
Owner: Regent Quay Development Company
 Ltd

Description: Combined commercial and
tenement building in an Edwardian Baroque
style occupying the triangular site at the
confluence of New City Road and Shamrock
street, the convex eastern corner capped with a
dome. The most substantial component of the
sculpture scheme is the attic group in the centre
of the Shamrock Street elevation, which consists
of a large blind cartouche supported by putti
standing on a pedestal, with allegorical female
figures seated on either side. The figure on the
left holds a model ship and represents
Shipbuilding; that on the right holds a money-

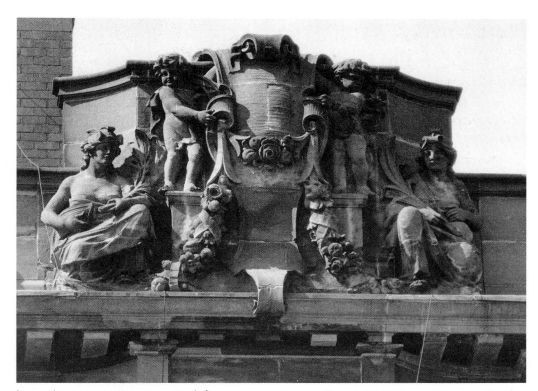

Anon., *Allegorical Figures* [RM]

bag and represents *Commerce*. Both figures
hold palm fronds and are fully draped apart
from their exposed shoulders. In the tympanum
above the main entrance in the eastern corner
there is a large royal coat of arms of Britain,
flanked by pairs of seated putti holding garlands
on the adjacent cornice. Two further pairs of
putti are seated in the attic tympana on the
north-west corner. Among the numerous minor
details distributed irregularly over all four
façades are window keystones carved with
crossed keys, a cornucopia spilling coins, a
caduceus, lion and cherub masks and a variety
of garlands, festoons and blind cartouches.
There is also some decorative wrought
ironwork, including a series of balconies on the
north elevation and a gilded weather-vane on
the dome.

Discussion: The building was erected for the
Glasgow Savings Bank, and was later taken over
as a branch of the Trustee Savings Bank. The
bank premises are currently occupied by a
children's nursery.

Condition: Generally good, though many
details are weather-worn and the main figure
group is heavily coated with a green biological
growth. The building has been cleaned.

Sources
GCA, B4/12/2/2540; McKean *et al.*, p.151 (incl. ill.);
Williamson *et al.*, p.271.

North Street ANDERSTON

Mitchell Library, 201 North Street

a) Exterior work
Allegorical Figures of Wisdom and Literature

Sculptors: Johan Keller and Thomas John Clapperton

Architect: William B. Whitie
Masons: P. & W. Anderson
Date of sculptures: *c*.1909
Building opened: 16 October 1911
Materials: Blackpasture stone (*Wisdom*); bronze (*Literature*)
Dimensions: both statues colossal
Inscription: on bronze plaque above entrance –
THE / MITCHELL / LIBRARY / OPENED BY / THE RIGHT HON. THE / EARL OF ROSEBERY / AND MIDLOTHIAN / K.G. K.T. LL.D. ETC. / 16TH OCTOBER 1911
Listed status: category B (15 December 1970)
Owner: Glasgow City Council

Description: The female figure of *Wisdom* is seated on a throne above the entrance porch projecting from a central rotunda on the North Street frontage. Heavily robed and hooded, she wears a laurel crown and is shown holding an unfurled scroll in her lap. Her tunic is secured with a decorated clasp. Above the rotunda is a copper-clad dome[1] finished with a lantern supporting a female personification of *Literature* in bronze. Dressed in a more lightweight tunic reminiscent of a Hellenistic *peplos*, this figure is shown striding forward, the agitated folds of her robes creating patterns expressive of her windswept location. With her raised left hand she secures the hood on the back of her head, while her right arm is extended to proffer a partially unfurled scroll. The use of a scroll as an attribute suggests that

she might be intended to represent the classical muse Clio.[2] Additional carving includes a male keystone mask enclosed by foliage in the lintel of the main doorcase and a pair of seated putti flanking the inscription plaque.

Discussion: The Mitchell Library was founded in 1877 with a bequest from the tobacco merchant Stephen Mitchell (see below) and, with the exception of the National Library of Scotland in Edinburgh, remains the most important public reference library in Scotland. Originally housed in a warehouse at 60 Ingram Street, it quickly outgrew its accommodation and 1891 was moved to Miller Street, where it occupied the premises left vacant after the Water Commissioners Department had been transferred to the newly completed City Chambers (q.v., George Square). Problems of

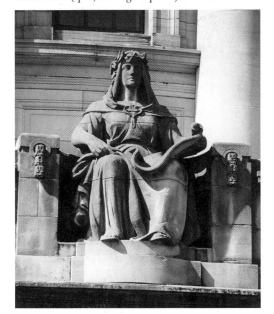

Johan Keller, *Wisdom* [RM]

space arose once again, and by the turn of the century it had become clear to the council that its long-term needs could only be met by the 'erection of an entirely new building'.[3] A site between North Street and St Andrew's Halls was allocated, and in 1905 an architectural competition, adjudicated by the architect John Keppie, at that time President of the Glasgow Institute of Architects, and the City Engineer A.B. McDonald, was announced.[4] A total of 76 designs was received, 'the general merit of which was very great'.[5] There were some 'anxious deliberations' and much indecision before the final selection of the winner was made, largely due, it would appear, to a clash of opinion between the assessors and a small group of councillors. In the end the council turned out to be 'modest enough in this matter to accept the teaching of those better qualified than themselves', and the result was perceived as a victory in the attempt to 'resuscitate the somewhat affronted system of skilled assessorship in matters of architectural selection for municipal and other public bodies'.[6]

Even so, suspicions lingered, and the announcement that the winner of the competition was the Glasgow architect William B. Whitie prompted one correspondent of the *Building News* to raise questions about the integrity of the selection process. Signing himself 'Reorganiser', he pointed out that not only was Whitie a 'late assistant of our city engineer', but that a surprising number of the winners of the district library competitions also happened to be former or present employees of the engineer's office.[7] The insinuation here that Whitie's success was the product of favouritism is curious, given the fact that the *Building News* itself had followed the progress of the competition in some detail, even to the point of describing the exact moment when the Lord Provost publicly 'unsealed the envelope containing the name of the architect who drafted the plan'.[8] One can only conclude that the 'system of skilled assessorship' referred to

above was regarded with such scepticism at this time, that the apparent propriety of the process was perceived as little more than a smokescreen concealing the nepotistic practices that determined the way such appointments were really made.

Whitie's design is Renaissance in style, based specifically on 'English examples of the XVIIIth century'.[9] Channelled ashlar is used extensively throughout, and the main North Street frontage is dominated by a central domed rotunda and end pavilions articulated by giant Ionic columns. From the sculptural point of view, the most significant aspect of the commission is the extensive modifications made to the design during the process of execution, most notably in the treatment of the central bays. In the original winning scheme this is very understated, and is distinguished from the flanking bays only by the height of its arched window and the inclusion of a raised attic. The relative lack of importance attached to this part of the design is confirmed by the placement of the main entrance in the bay adjacent to the north pavilion, rather than in the centre. No sculpture of any kind is indicated on Whitie's drawings, and indeed it appears to have been the general restraint of the design that was regarded as its primary virtue. According to the reporter in *Building Industries*, carved ornaments were to be 'introduced where desirable, but the elevation is not of an ornate character'.[10]

Although this version of the design was still being published in the architectural press as late as September 1907 when the construction work was already well under way,[11] Whitie had in fact by this time radically reconsidered his approach to the centre of the north façade. An unpublished drawing of 1906 shows it as it would eventually be built, with the middle bays dominated by its massive domed rotunda, and the main entrance reconfigured as a projecting central porch.[12] More relevantly, the two principal figure sculptures – on the dome and

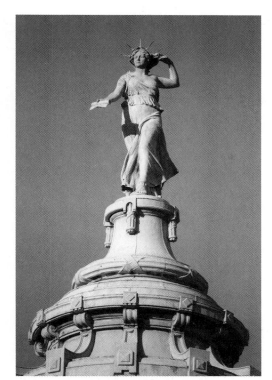

Thomas John Clappeton, *Literature* [RM]

above the porch – have also now appeared. The decision to include a dome is therefore crucial to the sculpture programme, as without it the figures would not have been required. It also presents a puzzle. In its coverage of the competition, the *Builder* specifically refers to 'designs with domes', one of which it regarded as 'the most grandiose' of all the submissions, going on to note, however, that it was 'quite beyond the expenditure proposed'.[13] Given the fact that Whitie's original design exceeded the £40,000 budget by £4,479,[14] one can only suppose that the aesthetic gains achieved by the new scheme justified whatever additional outlay was required by the introduction of this major new feature.

The figures indicated on Whitie's drawing show the position and scale of the two sculptures as executed, but there are interesting differences in their design. The dome figure, for example, is represented as *Athena*, and is posed rather statically with a spear in her raised right hand and a shield in her left. Clapperton's much more lively treatment of the figure can be seen clearly in the album of documentary photographs made by Andrew Brown, the Clerk of Works, and which is now preserved in the Library.[15] In addition to a series of views of the plaster model, the album also includes an interesting pair of the completed bronze itself taken in the spring of May 1909. From these we can see that the finished work had been delivered to the site by 5 May, and that six days later a rope truss had been attached to the neck and waist before it was hoisted into position.

The seated figure above the door also underwent some major modifications during its execution. In Whitie's drawing it is shown in a dynamically twisting posture derived from the Delphic Sibyl on Michelangelo's Sistine Ceiling, an art historical reference that recalls McGilvray & Ferris's adaptation of the same precedent some two years earlier on the façade of the Annan Gallery on nearby Sauchiehall Street (q.v., Royal Highland Fusiliers Museum). This is very different from the static monumentality of the work Keller finally produced. Here it is also worth noting that until recently the statue was attributed to a fictitious sculptor named John Miller.[16] This was in fact based on a misreading of Keller's surname, and the subsequent transcription of 'Johan' to the anglicised 'John'. The entry in the RGIFA catalogue for 1910 clearly confirms Keller's authorship of a half-size model 'representing Wisdom; external decoration of Mitchell Library in North Street'.[17]

The memorial stone of the Library was laid on 17 September 1907,[18] by Andrew Carnegie, who was in Glasgow as a guest of the Library Association Conference,[19] and whose

contribution to library provision in Glasgow is described elsewhere (see Dennistoun Library, 2a Craigpark). The building was completed four years later, with the Earl of Rosebery performing the opening ceremony on 11 October 1911. This event does not seem to have gone entirely to plan, and as late as 1937 the *Evening Citizen* reminded its readers that the 'furious controversy aroused by the noble visitor's jocular allusion to "this cemetery of books" is still remembered throughout Scotland'.[20] As a reference library, the Mitchell was intended to augment the network of district lending libraries already established, its central status reflected in popular local references to it as 'the British Museum of the West of Scotland'.[21] An important part of its policy was a commitment to the preservation of the 'more ephemeral publications of the day, which, unless so kept by a public library, go out of existence, and become lost to the future student of history'. Its creators also took particular pride in its 'extensive collection of periodical publications, which, by their mere bulk, are impossible to private persons, but which, nevertheless, will be of the utmost value as works of reference'.[22] The immense quantities of historical data that have been gathered from such publications in the preparation of the present volume confirm the wisdom of this policy.

On 26 October 1962, the building immediately to the west of the library, the St Andrew's Halls, was destroyed by fire.[23] The site was later transferred to the Libraries Department and rebuilt as an extension to the Mitchell Library, incorporating the City Archive and the Mitchell Theatre (q.v., Granville Street).

b) Interior works
Inside main entrance, at foot of stairs

Portrait Bust of Stephen Mitchell
Sculptor: John Mossman

Date: 1881
Material: marble
Dimensions: slightly larger than life-size
Inscription: painted on pedestal – STEPHEN MITCHELL / BORN 19TH SEPT. 1789 DIED 21ST APRIL 1874

Stephen Mitchell (1789–1874), born in Linlithgow, where his family had been established as tobacco manufacturers since 1723. He joined the firm in 1809, became its director in 1820 and transferred the business to Glasgow in 1825. On his retirement in 1859 he moved to Moffat, where he became 'keenly interested in the Subscription Library, which had been founded at the instigation of Robert Burns'.[24] He died on 21 April 1874 as a result of a fall. By the terms of an earlier bequest, his trustees deposited £66,998 10s. 6d. with the city council, which was to remain invested until the accumulated interest had brought it to £70,000. This was then to be used to establish a library in which 'books on all subjects not immoral should be freely admitted',[25] and which was to be 'freely open to the public under suitable regulations'.[26] In 1932, the *Evening Citizen* humorously pointed out the dependence of the library on the success of the Mitchell tobacco business: 'Smokers may feel entitled to take pride in the fact that but for their devotion to tobacco the "Mitchell" might never have existed'.[27]

Discussion: A display panel prepared by Library staff states that Mitchell was a 'quiet, reserved man' and that when, after his death, the council

> … resolved to have a bust of him placed in the Library, only a silhouette could be found to provide the sculptor, James [*sic*]

Mossman, with a portrait from which to work. The result was said by those who had known Mitchell to be a good likeness, but his best memorial is the Library which bears his name.

Another probable source for the likeness is a photograph of Mitchell commissioned by the Imperial Tobacco Company,[28] though it should be noted that Mossman has substituted a classical toga for the wing collar and bow tie worn by the subject in the live sitting.

On right hand (north) wall in the entrance lobby

Memorial Tablet to Francis Thornton Barrett
Sculptor: George Henry Paulin

Date: 1922
Year of unveiling: 1923
Material: bronze
Dimensions: 91.5cm high × 58cm wide (whole tablet); 39cm high (portrait)
Signature: in cursive script beside the portrait – G H Paulin / 1922
Inscription: in raised letters below portrait – FRANCIS THORNTON BARRETT, LL.D / FIRST LIBRARIAN OF THE MITCHELL LIBRARY / FROM 1877 / AND CITY LIBRARIAN FROM 1901 TO 1915. / ERECTED BY THE CORPORATION OF GLASGOW / IN APPRECIATION OF HIS DISTINGUISHED / SERVICES IN INITIATING AND DEVELOPING / PUBLIC LIBRARIES / THROUGHOUT THE CITY

Dr Francis (Franklin) Thornton Barrett (d.1919), a native of Birmingham, was City Librarian in Glasgow for 38 years, and the first Librarian of the Mitchell. He was a leading figure in the demand for improved public library facilities in Glasgow in the 1890s, and also played a central role in organising the competition for the new building.

Description: A rectangular tablet, with

semicircular upper edge incorporating a three-quarter profile of the subject in low relief. The treatment of the features, and the position of the head, suggest that Paulin based the likeness on a photograph of Barrett published some years earlier in a survey of distinguished members of Glasgow Corporation by David Willox.[29]

Discussion: The proposal to erect a tablet 'commemorative of the services of the late F.T. Barrett' was first presented to the council in August 1919, and remitted to a special sub-committee for discussion. The sub-committee does not appear to have met until January 1922, but its recommendation that Paulin should be invited to submit a design was accepted by the council the following February. His design was approved in July, and by January of the following year the work was ready for installation. The council minutes do not record the date of the unveiling.[30]

Notes
[1] Cowan, p.26. [2] Cowan, (*ibid.*) describes the statue as the 'Lady of Light and Learning'. [3] Stevenson (1914), p.85. [4] BN, 6 January 1905, p.10. [5] *Ibid.*, 7 July 1905, p.13. [6] BI, 15 July 1905, p.50. [7] BN, 22 September 1905, p.416. See also discussion of district libraries, Dennistoun Library, 2a Craigpark. [8] *Ibid.*, 14 July 1905, p.44. [9] B, 15 July 1905, p.69. [10] BI, 15 July 1905, p.50. [11] *Ibid.*, September 1907, p.83. [12] GCA, B4/12/2/632. [13] B, 23 September 1905, p.321. [14] BN, 6 January 1905, p.10. [15] MLG, G644466, *Photographs of The Mitchell Library in progress, 1907–1911*, by A. Brown. [16] See information display, south corridor, Mitchell Library. [17] Tracy Smith, 'Elusive Sculptors: sources for identifying and accrediting architectural sculpture'. *Scottish Archives: Journal of the Scottish Records Association*, vol.5, 1999, pp.107–14. [18] BI, 16 September 1907, p.84. [19] EC, 30 October 1937, p.4. [20] *Ibid.* [21] *Ibid.* [22] Stevenson (1914), pp.86–7. [23] GCA, C1/3/145, p.1271. [24] EC, 30 October 1937, p.4. [25] *Ibid.* [26] Stevenson (1914), p.83. [27] EC, 2 July 1932, p.4. [28] MLG, Photographic Collection (Illustrations), vol.14, p.49. [29] David Willox, *Members of the Glasgow Corporation 1907–1910: a Poetical Sketch*, Glasgow, n.d., p.111. [30] GCA, C1/3/61, p.1931, C1/3/66, p.800, C1/3/67, p.2000 and C1/3/68, p.511.

Other sources
Woodward, p.163; Parker, n.p. (p.2); McKean *et al.*, p.170; Williamson *et al.*, p.279; McKenzie, pp.84 (ill.), 85.

Observatory Road DOWANHILL

Notre Dame High School, 160 Observatory Road

Relief Panels, Statues and Associated Symbolic Carving

Sculptor: not known

Architect: Thomas S. Cordiner
Dates: 1937–41 and 1949–53
Material: yellow sandstone (unless indicated otherwise)
Dimensions: see below
Inscriptions: on the foundation stone – 13TH JUNE 1939; see also below
Listed status: category A (28 July 1987)
Owner: The Order of Notre Dame

Description: An extensive programme of narrative sculpture is incorporated into the structure of this distinguished brick and ashlar building, much of it in the form of related sequences of relief panels on liturgical and educational themes.

On piers flanking the main (south-east) entrance

Eight Devotional Panels

Dimensions: each panel 35cm × 35cm

The panels are arranged vertically in two groups of four. From the top, the subjects on the left are: (1) *The Victorious (or Paschal) Lamb of God* – a lamb holding a banner emblazoned with the monogram 'IHS' (Greek, trans.: 'Jesus'), signifying the Resurrection; (2) *The Grapes and the Wheat* – symbols of the Eucharist, signifying the Last Supper; (3) *The Pelican* – emblem of self-sacrifice (the pelican saves its young by piercing its own breast), signifying Christ's death on the cross; (4) *The Rose* – the Mystic Rose, symbol of Our Lady (also found on the school badge). On the right: (1) *The Pentecostal Dove* – symbol of the Holy Spirit; (2) *The Pomegranate* – the inner unity of countless seeds in one fruit, alluding to the Church; (3) *Fish with the Chi-rho monogram* – Chi-rho monogram formed by entwined Greek letters X and P, the first two letters in Christ's name. The fish is an ancient symbol of Christ, based on the Greek word *ichthus*, which was seen as an acrostic on 'IHS'. Here there are three fishes above a triangle representing the Holy Trinity; (4) *Lilies* – symbol of the Virgin Mary, also found on the school badge.

Above the first-floor windows of the south-east entrance block

Five Panels of the Academic Disciplines

Dimensions: each panel approx. 90cm × 60cm

From the left: (1) *History & Geography* – a girl holding a globe and a lion; (2) *Literature* – a girl holding a quill pen, ink pot and scroll of paper; (3) *Religious & Moral Education* – a nun holding a cross over a praying girl's head; (4) *The Arts* – a girl holding a violin and painter's palette; (5) *Maths & Science* – a girl holding a compass, with scientific apparatus in background.

On piers flanking side (south-west) entrance

Nine Panels with Inscriptions from the Litany of Loretto

Dimensions: each panel 38cm × 38cm

The panels are arranged vertically in two groups of four, with the ninth panel in the centre, above the door. From the top, the subjects on the left are: (1) SEDES SAPIENTIÆ (trans.: 'seat of wisdom'); (2) VAS SPIRITUALE (trans.: 'spiritual vessel'); (3) VAS HONORABILE (trans.: 'vessel of honour'); (4) FOEDERIS ARCA (trans.: 'Arc of the Covenant). On the right, from the top: (1) ROSA MYSTICA (trans.: 'mystical rose'); (2) VAS INSIGNE DEVOTIONIS (trans.: 'singular vessel of devotion'); (3) IANUA CALI (trans.: 'gate of heaven'); (4) TURRIS DAVIDICA (trans.: 'Tower of David'). Over the door is *The Virgin Mary*, who is shown reading from an open book inscribed 'MATER BONI CONSILI' (trans.: 'mother of good counsel'), and high above this is a panel carved with the school's badge (cross, three six-point stars, lily, rose and entwined monogram 'ND').

In a niche on the rear wall of the north-east block

Statue of St Cecilia

Dimensions: figure approx. 2.1m high

The patron saint of music is shown holding a harp, with two half-length angels flanking a portable organ in a panel under her feet.

Above the side entrance of the north-east block

Relief Panel

Dimensions: approx. 1.2m × 90cm

The panel is inscribed 'LAUS DEO' (trans.: 'praise the Lord') and shows two girls, one with head bowed, the other with face raised and holding a prayer book.

Beside the north-west boundary wall

Statue of the Virgin and Child

Material: marble(?)
Dimensions: approx. 2.1m high

The statue is enclosed in a large, free-standing brick tabernacle, with its open side facing the rear of the school building. The Virgin Mary stands upright with the infant Jesus seated in the crook of her left arm; Jesus holds an orb and raises his right hand in a gesture of benediction.

On the rear wall of the south-west block

Relief Panel of Mary, Martha and Jesus

Dimensions: 1.12m × 2.98m

In this panel Martha, the patroness of housekeeping, is shown kneeling beside a low table supporting a jug and some plates, her left hand outstretched towards Mary, her right hand holding a plate. Mary sits on the table with her back to Martha and facing Jesus, who sits in a chair and touches her elbow. An accompanying panel is inscribed 'MARY YOU HAVE CHOSEN THE BETTER PATH'.

Discussion: The relevant minutes of the Education Department appear to have been lost, and very little is known of the genesis and history of the sculptures on this building. In particular, it is difficult to know whether or not some parts of the scheme were executed during the second phase of building, which was resumed in 1949 after being suspended during the Second World War. It is believed by some local scholars that the carvings may have been produced in Italy by Italian sculptors and

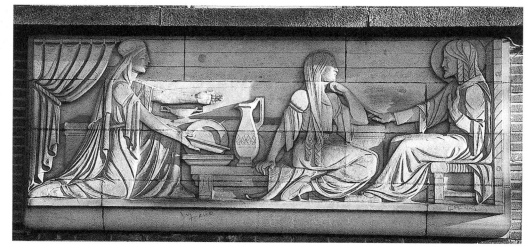

Anon., *Mary, Martha and Jesus* [RM]

brought to the school ready-made, but this has not been confirmed by any documentary evidence. It may be relevant to note, however, that the scheme as executed does not correspond very exactly with the elevation drawings submitted by Cordiner to the Dean of Guild Court in 1938. These show the five education panels above the windows in the entrance pavilion, but omit the vertical set, while the statue of *St Cecilia* is indicated as an empty niche. The standard of the workmanship is extremely high throughout.

Condition: All reliefs and statues are in good condition.

Sources
GCA, B4/12/1938/278; GH, 9 October 1953, p.5; Williamson *et al.*, p.358, pl.109; 'Notre Dame High School', information leaflet produced by the school for 'Doors Open Day', 1996; Dick Louden, 'There is nothing like Notre Dame', H, 4 February 1997, p.18.

Old Rutherglen Road GORBALS

110–50 Old Rutherglen Road / 7–49 Errol Gardens

Topographical Relief Panels
Sculptor: Jules Gosse

Architects: Tom Walker (of Cooper Cromar)
Date: 1996
Material: glass-reinforced plastic
Dimensions: approx. 1m × 2.5m
Listed status: not listed
Owner: New Gorbals Housing Association

Description: Four relief panels depicting two views of the River Clyde and its environs in compartments between the second- and third-floor windows. The panels are designed as triptychs with slightly canted sides. In the first view, the vantage point is Glasgow Green looking west towards the McLennan Arch (q.v.) and the Albert Bridge (q.v., Saltmarket), and with the Finnieston crane visible in the distance. The second is located further up river, with rowing boats and anglers shown against a background including the familiar landmark of Templeton's Business Centre (q.v., Templeton Street). Each view appears twice, and the entire

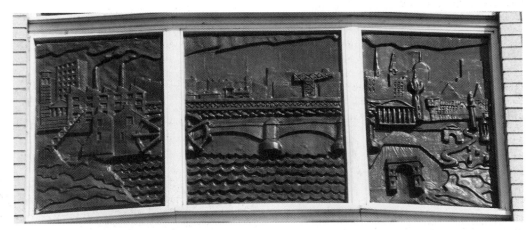

Jules Gosse, *Topographical Panels* [RM]

sequence is repeated on the contiguous block on Errol Gardens.

Discussion: Designed by Tom Walker and modelled by Gosse at the Glasgow Sculpture Studios, Maryhill, the panels were commissioned as part of the Crown Street Regeneration Project.

Condition: Good.

Source
Information provided by the sculptor.

Talbot Centre (Former Kingston Halls, Public Library and Police Office), 330-46 Paisley Road

Allegorical Figure of Learning and Three Portrait Medallions

Sculptor: Richard Ferris

Architect: R.W. Horn
Builders: Morrisson & Muir
Dates: 1904 (*Learning*); 1907 (medallions)
Building opened: 8 September 1904
Materials: red Locharbriggs sandstone (*Learning*); bronze (medallions)
Dimensions: statue approx. 2.1m high; portraits approx. life-size
Signatures: in cursive script below the shoulder of each portrait – R. Ferris. 1907
Inscriptions: below Diocletian window – KINGSTON HALLS; above door – KINGSTON / PUBLIC LIBRARY; on datestone on east elevation – 1903 (entwined)
Listed status: category B (17 June 1986)
Owner: Glasgow City Council

Description: The building is in a restrained Italian Baroque style, with a scroll pediment over the main entrance and a blank rectangular pediment in the centre of the attic. The figure of *Learning* is in an aedicule on the first floor above the library entrance on the right, and is shown wearing a dress which combines nineteenth-century buttoned cuffs with puffed shoulders of the kind associated with the aesthetic movement, but possibly derived from the work of early Italian Renaissance painters such as Carpaccio. She also wears a laurel crown. In the crook of her left arm she holds a large, limp volume, which appears to have been picked up from a small pile of books at her feet. The portrait medallions are in the form of

cartouches attached to rectangular panels distributed around the main central doorframe, with two on the flanking buttresses and the third in the centre of the entablature above. The design of the middle cartouche differs slightly from the other two. Additional carver work includes a Glasgow coat of arms, a pair of winged cherub masks, a pair of terms and a number of blind escutcheons.

Discussion: The architect was working for the City Engineer's Department when he was awarded the commission to design this building, which was erected as part of the wave of district library construction undertaken by

the Corporation in the early years of the twentieth century with financial support from the expatriate Scots philanthropist Andrew Carnegie. The medieval appearance of the main figure seems curiously at odds with the style of the façade, and also provides an interesting variation on the more generally classical approach to library symbolism on the majority of the other district libraries, particularly the work of William Kellock Brown. (For a full discussion of this, see Dennistoun Public Library, 2a Craigpark.) There is no documentary evidence of the authorship of the figure, but it is ascribed here to Ferris on the

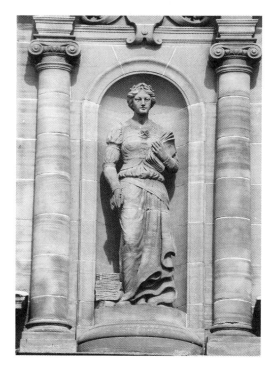

Richard Ferris (attrib.), *Learning* [RM]

Richard Ferris, *Portrait Medallion* [GN]

basis of his signature on the medallions. It should be noted, however, that these were added about four years after the building was opened.[1] The subjects of the portraits have not been identified.

Condition: Good.

Note
[1] See photograph reproduced in *Descriptive Hand-Book of the Glasgow Corporation Public Libraries*, Glasgow, 1907, p.39, which shows the building without the medallions.

Other sources
Nisbet, 'City of Sculpture'; Williamson *et al.*, p.591; McKenzie, pp.32, 33 (ill.); information provided by Liz Arthur.

Paisley Road West KINGSTON

Angel Building, 2–20 Paisley Road West / Govan Road

Angel

Sculptor: not known

Architects: Bruce & Hay
Date: *c*.1885
Material: cement
Dimensions: colossal
Listed status: category B (17 June 1986)
Owner: La Fiorentina(?)

Description: Winged female figure on the summit of a three-stage pavilion roof on the south-east tower of the tenement building at the junction of Paisley Road West and Govan Road. Entirely gilded, the figure wears a tightly fitting robe and has a five-pointed star on the crown of her head. Her left hand hangs by her side, while her right is raised to her breast.

Discussion: Almost nothing is known about the origination of this statue, which has for many years been regarded as one of the great enigmas of nineteenth-century Glasgow. Not the least of its oddities is its asymmetrical placement on the south tower. This immediately prompts speculation as to whether or not the architects had planned a corresponding figure for the truncated roof of the adjacent north tower, not unlike the matching angels Archibald Macfarlane Shannan

was to place on the towers of Kelvingrove Museum (q.v., Kelvingrove Park) some fifteen years later. Equally puzzling is the star prominently displayed on the figure's head, the symbolism of which has never been adequately explained. The argument that this refers to the stars, or 'mullets', which appear on the coat of arms of the neighbouring district of Govan is difficult to sustain in view of the fact that the angel is neither in Govan nor facing towards it. On the question of authorship, James Alexander Ewing may be tentatively proposed on the grounds of its stylistic similarity to several of his works elsewhere in Glasgow. The treatment of the draperies, for example, is reminiscent of his figures on the former Co-operative House (q.v., 95 Morrison Street), while the design of the wings closely resembles those on the attic figure of *Harmony* on the former Velvet Rooms (q.v., 520 Sauchiehall Street). Both buildings are by Bruce & Hay.

Despite this lack of reliable historical information – or perhaps because of it – the Kingston *Angel* has generated its own rich vein of folklore, including a belief that Lord Haw Haw identified the statue as a landmark which would guide German bombers to the Clyde in the Second World War.[1] There is also a local legend that part of the building was at one time occupied by the Seamen's Mission, and that Lord Denholm unsuccessfully applied for

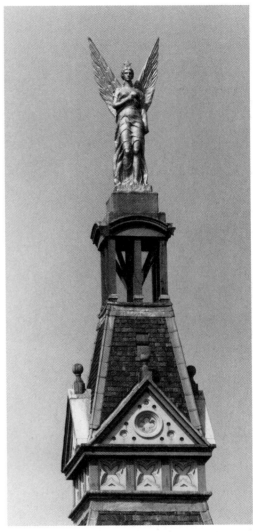

Anon., *Angel*

permission to move the statue to their new premises at 9 Brown Street (q.v.) in the 1920s. In February 2000, the proprietors of the neighbouring Angel public house offered a miniature copy of the statue, together with a bottle of malt whisky, as a prize for the most plausible explanation of the statue's origin.[2] The results have yet to be announced.

Condition: In 1992 the statue was examined during maintenance work on the roof and was found to be so deteriorated that it was necessary for it to be taken down and repaired. Extensive areas, including the face and wings, were remodelled by Robert Pollock, of Magnum Signs, using a polyurethane compound. The entire statue was subsequently coated by Allscot Plastics Ltd with a 5cm layer of laminated fibreglass mixed with gold pigment, followed by a final 'flow coat' of gold. The statue is now secured with steel rods extending approximately 1.8m into the tower.

Notes
[1] John McCann, 'Guessing game over pub guardian angel', ET, 16 February, p.15. [2] *Ibid.*

Other sources
LBI, Ward 51, p.28; Williamson *et al.*, p.600; McKenzie, pp.32, 33 (ill.); *Local News for southsiders*, February 2000, p.2, March 2000, p.4, May 2000, p.2, June 2000, p.3, July 2000, p.3.

Port Dundas Road COWCADDENS

In front of Buchanan House, 58 Port Dundas Road

Locomotion
Sculptor: Frank Cossell

Architects: Ian Burke, Martin & Partners
Date: 1966–7
Unveiled: December 1967
Materials: bronze statue on a pebbledash concrete base
Dimensions: statue 2.44m high; base 3m high
Listed status: not listed
Owner: Railtrack PLC

Description: A naked male athlete sprinting between two metal hoops, one slightly larger than the other. The statue is mounted on a base designed as an inverted V, echoing the concrete supports on the ground floor of Buchanan House.

Discussion: Cossell was working for the Architectural Department of the London Midland Region of British Rail at Euston when he was commissioned to make the statue as part of their £1.8 million development of the company's new headquarters in Glasgow. The intention was to symbolise the 'power and virility' of railway travel, with the parallel hoops suggesting the almost endless extension of the track. All documentation relating to the commission appears to have been mislaid or destroyed, apart from a small number of press reports on the unveiling. These reveal a recurring preoccupation among journalists with the omission of the figure's genitals, which was regarded as ironic on a statue ostensibly designed to embody the notion of 'virility'. When questioned on the matter, Cossell replied that he had given it

> ... a great deal of thought. And in the end I decided it would be better if I didn't have it completely true to life. This way no one could be offended. It is a pity in a way, for the whole theme of the statue is power and virility.[1]

The statue took eight months to complete, and was unveiled by the retiring Chairman of the British Rail Board, Sir Stanley Raymond, who discreetly made no reference to the 'anatomical omission' in his speech.[2]

Related work: A more recent example of the adaptation of the male anatomy to conform to conventional notions of public propriety is

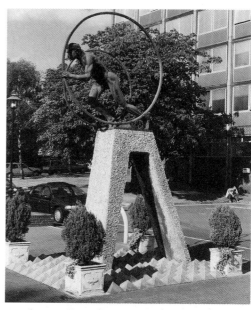

Frank Cossell, *Locomotion* [RM]

Andy Scott's *The Bringer* (1991) (q.v., Springburn Way).

Condition: Good.

Notes
[1] Graham MacLean, 'A man's a man for a' that', *News of the World*, 17 December 1967. [2] *Ibid.*

Other sources
James Cox, 'Frankly speaking', *Daily Record*, 20 December 1967; Williamson *et al.*, p.263.

Queen's Drive CROSSHILL

On the façade and attic of Balmoral Crescent, 78–118 Queen's Drive

Liberty and Corbel Figures
Sculptor: not known

Architect: William M. Whyte
Builder: Hugh Wilson
Date: *c*.1886
Material: yellow sandstone

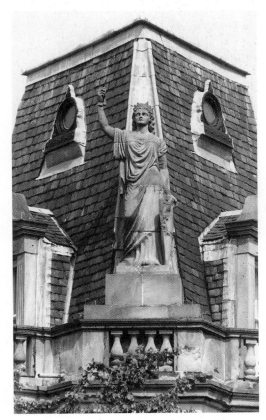

Anon., *Liberty*

Dimensions: *Liberty* approx. 2.2m high; corbel figures approx. 60cm high
Inscription: on datestone on south façade – 1886
Listed status: category B (22 March 1977)
Owner: privately owned

Description: The sculpture scheme forms part of a block of nine tenement buildings in an elaborate French Renaissance style, and is a fine example of the use of carved ornamentation to express the private, and in this case somewhat eccentric interests of the developer. The colossal figure of *Liberty* stands on the attic at the south-east corner and holds a blind shield and the remains of what may have been a torch, a sword or a set of scales. On her head she wears a stylized crown reminiscent of Bartholdi's *Statue of Liberty* in New York (1886). At ground-floor level there are twenty four half-length corbel figures, arranged in various groupings above the entrance bays and oriel

windows of the middle and end tenements. Those above the entrances are in sets of four and have attributes relating to several generic themes which may be provisionally identified as follows: nos.78–82, the crafts (attributes include rolled plans, a hammer and chisel, a pair of dividers and a distaff); nos.96–100, the seasons (sickle and wheatsheaf, flowers); nos.114–8, the arts (a harp, a palette and brushes, a book). All but one of these figures is female. The remaining twelve are presented in pairs under the balustraded sills above the oriel windows and are in the form of miniature terms with no attributes. The two most westerly figures were identified in an article in the *Glasgow Herald* in 1923 as portraits of the architect William Whyte and the builder Hugh Wilson. According to this source, 'Old Hugh Wilson was well known in the streets of Glasgow by his square hat, butterfly tie and his Dundreary whiskers'. Of the architect, the author writes that he 'also had Dundreary whiskers, but latterly shaved them off'.[1]

Discussion: Local lore has it that the development was originally opposed by a

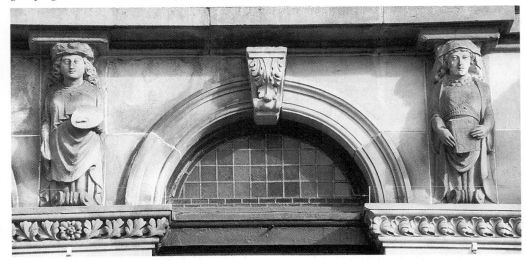

Anon., *Figurines* [SS]

number of local Bailies, whose caricatured portraits Whyte ordered to be carved on the façade after finally obtaining permission to build. Many of the figures in the oriel windows do indeed look 'distinctly ridiculous among the caryatids'.[2] It is also believed that Whyte was an enthusiastic supporter of all things American, and that the similarity of the attic figure to the *Statue of Liberty* in New York was intended to 'ensure that passers-by would be reminded of his favourite country'.[3]

Condition: Fair, apart from the loss of the attribute in the raised right hand of *Liberty*, and some erosion on the faces of the corbel figures.

Notes
[1] Anon., 'Buildings Having Sculptured Representations of Glasgow Men at the Time of the Building', GH, 18 July 1923, p.8. [2] Worsdall (1979), p.102. See also pl.38. [3] Jack House, 'Ask Jack', ET, 6 February 1980.

Other sources
Worsdall (1982), p.108; Williamson *et al.*, pp.554–5.

Queen Street CITY CENTRE

At the junction of 69 Queen Street and Springfield Court

Caged Peacock

Sculptor: George Wyllie

Glass manufacturers: Glasworks
Date: 1996–7
Materials: stainless steel with glass inlay
Dimensions: cage 90cm diameter; bird's tail approx. 2.1m wide
Listed status: building listed category B (4 September 1989)
Owner: Princes Square Consortium

Description: The sculpture takes the form of a humorously alarmed peacock with its body trapped in a spherical cage, and its head and tail protruding through the bars. Attached to the wall above the ground-floor shop fascia of 69 Queen Street, it is suspended over the centre of the entrance to Springfield Court, but with the supporting bracket cranked towards Queen Street in order to 'improve the sight lines from that direction'. The body of the peacock is composed of a multitude of small 'open "feather" shapes', which have been welded together and into which small pieces of coloured glass have been inserted.

Discussion: Wyllie's design was selected by Guardian Royal Exchange, the owners of the building at the time of the commission, in a competition which included entries by Jules Gosse, Joe Ingleby, Calum Sinclair and Alan Cairns. The main purpose of the commission was to 'highlight the approach to the rear entrance to Princes Square', which was also owned by Guardian Royal Exchange. The choice of a peacock was thus a direct response to Alan Dawson's earlier version of the bird on the attic of 34–56 Buchanan Street (q.v.). In his written proposal Wyllie included a rhyming couplet paraphrased from William Blake: 'A peacock high up in the Air / Suggests the way to Princes Square'. He also stated that stainless steel was to be used because 'it is strong, remains bright, requires minimal maintenance and is particularly vandal resistant'. It may be relevant, therefore, to note that the building to which it is attached, George S. Kenneth's red sandstone commercial structure dating from 1899–1907, has coats of arms inscribed with the Latin mottoes: 'AUDACES JUVO' (trans.: 'I assist the bold') and 'CLARIOR HINC HONOS' (trans.: 'hence the brighter honour'). (See also 69–71 Queen Street, Appendix C, Coats of Arms.) The total cost of the work was £10,000.

Condition: Good.

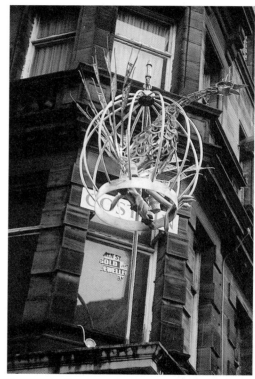

George Wyllie, *Caged Peacock* [RM]

Sources
Unpublished artist's statement and competition brief; Elvin; Williamson *et al.*, p.186.

Royal Exchange House, 100 Queen Street

Transition
Sculptor: John Creed

Date: 1989–90
Material: mild steel
Dimensions: screens 2.3m high × 2m wide ×
 60cm deep; gates 3.2m high × 1.12m wide ×
 1.35m deep
Inscriptions: on plates attached to each section
 – 'TRANSITION' / Designed / and Made by /
 JOHN CREED / Glasgow / 1990
Listed status: not listed
Owner: The Scottish Metropolitan PLC

Description: The work consists of a pair of
decorative screens and gates in the stepped
entrance to the 1954–7 building by Frank
Burnet & Boston. The main elements are
forged, with the joints variously welded,
riveted, pinned and bolted, and the finish is
created by a process of hot-dip galvanisation
with modified alkyd-based paint of black
micaceous iron oxide. The gates are hinged with
decorative washers of machined brass.

Discussion: Creed's intention in the design
was to explore the dualism of free movement
and organic growth within the constraints of a
formal geometric structure. The notion of
freedom relates to the potted plants used in the
foyer, while the surrounding architecture
provides the theme of stability. Part of his aim
also was to acknowledge the relationship
between the interior and the exterior of the
building, to allow the entrance area to be
'implanted "naturally" with a sympathy to
human access and movement around the object'
and to 'utilize the depth of the existing coping
to create a three-dimensional form which helps
draw the eye inward and, at the same time,
discourage abuse of the coping'.[1]

Commissioned by Scottish Metropolitan
Properties Ltd, the screens and gates were
designed in autumn 1989 and installed in
August 1990, at a total cost of £11,500. In July
1996, the entire work was removed for
regalvanisation, and the sandstone copings were
replaced with marble.

Condition: Good.

Note
[1] Unpublished notes provided by the sculptor.

Other sources
'Art in Public Places – Examples of Good Practice',
SAC handlist; Williamson *et al.*, p.187; Helen
Bennett, 'Forging Ahead', *Crafts*, no.119,
November/December 1992, pp.36–8 (incl. ill.);
Chatwin, p.66; McKenzie, pp.46, 47 (ill.).

John Creed, *Transition*

Renfield Street CITY CENTRE

1–11 Renfield Street / 60–70 Gordon Street

Allegorical Female Figures, Quadriga, Putti and Related Decorative Carving
Sculptor: William Birnie Rhind (attrib.)

Architect: John James Burnet
Date: 1896–9
Material: yellow sandstone
Dimensions: main figures approx. 2.3m high;
 putti approx. 1.2m high
Inscriptions: on the attic shields – AFRICA;
 INDIA; CANADA; AUSTRALIA
Listed status: category B (15 December 1970)

Owner: Greenfield Farms Ltd

Description: A five-storey retail block in a
mixed Venetian Renaissance and Baroque style,
with figure sculpture concentrated below the
octagonal corner dome. In the pediment above
the central window on the first floor is a
partially gilded quadriga, depicted frontally and

driven by a semi-naked female figure. Above this, on the drum of the dome, are two female figures symbolising *Summer* (left, naked to the waist, wearing a laurel crown and holding fruit and flowers) and *Winter* (hooded, with hands clutching her shawl as if hunched against the cold). The pillars flanking the drum are terminated with pairs of naked putti supporting shields decorated with animals signifying the British colonies: *Africa* (left, a lion) and *India* (an elephant). Two further colonial groups are placed on either side of the mansard roof on the pavilion at the north end of the Renfield Street façade: *Canada* (a bear) and *Australia* (a kangaroo). Minor decorative carving includes grotesque keystone masks above the first-floor windows, and lion masks on consoles on the second floor.

Discussion: The building was originally designed by Boucher & Cousland in 1858 as a four-storey warehouse for John Black & Son.[1] In 1896, J.J. Burnet was commissioned by R.W. Forsyth to make substantial alterations, including the addition of an attic storey and the reconstruction of the corner as a domed tower with a Corinthian order.[2] All the sculpture dates from this period.

Related work: The attribution to Birnie Rhind is based on the similarity of the work, both in style and imagery, to his schemes on Charing Cross Mansions (q.v., 540–6 Sauchiehall Street) and the former Sun Life Building (q.v., 38–42 Renfield Street).

Condition: The building is painted cream. Overall the sculptures are weather-worn, with some damage to the face of *Winter*.

Notes
[1] 'New Warehouses in Renfield Street, Glasgow', BN, 10 December 1858, pp.1224–5. [2] GCA, B4/12/1/5076.

Other sources
Young and Doak (1971), no.65; McKean *et al.*, p.115; Williamson, *et al.*, p.226; GCA, TD 1309/A/38; McKenzie, pp.62, 63 (ill.); LBI, Ward 18, pp.121–2.

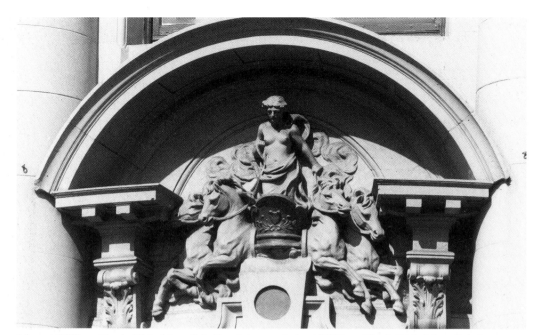

(above) William Birnie Rhind (attrib.), *Quadriga* [RM]

(below) William Birnie Rhind (attrib.), *Summer and Winter* [RM]

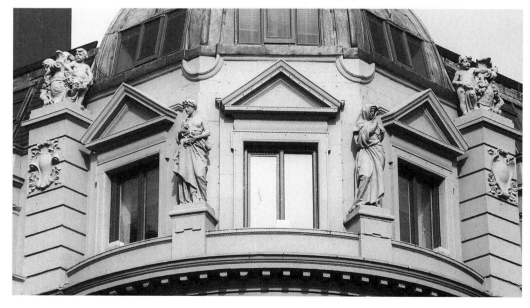

*Commercial block, 38–42 Renfield Street /
117–21 West George Street*

Aurora, Apollo, Allegorical Figures of Night and Morning and Related Decorative Carving

Sculptor: William Birnie Rhind

Architect: William Leiper
Date: 1892–4
Material: red freestone
Dimensions: main figures colossal
Inscriptions: above ground-floor roundel on
 West George Street – MITHRAS; in second-
 storey roundels on corner tower – JUPITER;
 URANUS; MARS; VENUS; MERCURY; SATURN
Listed status: category A (15 December 1970)
Owner: Abbey National PLC

Description: A four-storey commercial
building in the French Renaissance style, with
two additional attic storeys featuring dormer
windows, gables of various designs and a dome-
capped octagonal corner tower. *Aurora* is
shown standing in a biriga enclosed in the
volutes of a scroll pediment on the north-west
corner, immediately in front of the dome. The
horses are wildly animated, with their hooves
thrust over the cornice. *Apollo* stands on a socle
in the centre of a segmental pediment above the
third-floor windows on the Renfield Street
frontage, and is shown naked, holding a lyre in
his left arm and a torch in his right. On the
adjacent volutes are reclining figures
representing *Night* (male, naked apart from a
cape which he pulls over his head) and *Morning*
(female, semi-naked, drawing a hood from her
face).[1] Between the first- and second-storey
windows on the three exposed faces of the
corner tower are relief panels containing pairs
of winged female figures supporting the
armorial shields of the kingdoms of Scotland
(lion rampant), England (three lions passant)
and Ireland (harp). Additional carving includes:
a roundel containing a bust of the Persian god

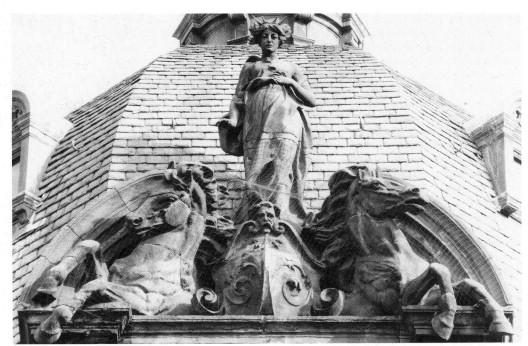

(above) William Birnie Rhind, *Aurora*

(right) William Birnie Rhind, *Apollo*, *Night* and
Morning

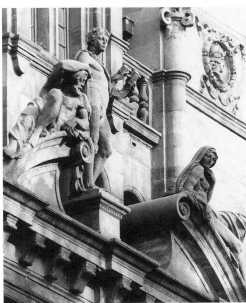

Mithras flanked by putti with upright and
inverted torches (above ground-floor window,
west end of West George Street); six roundels
of the deities of the Solar System (second floor,
corner tower); three roundels containing the
sun and other planets (fourth floor, corner
tower); one frontal and two profile heads
enclosed in wreaths (attic gable, south end of
Renfield Street); animals and signs of the Zodiac
(capitals, ground floor).

There is a marble relief similar in design to
the armorial panels above the interior fireplace.

Discussion: Designed by William Leiper as
the Glasgow headquarters of the Sun, Fire &
Life Insurance Company, the building was one
of the first in Glasgow to exploit the dramatic

Renfield Street 323

effect of a domed corner tower. Leiper was awarded a silver medal for the design at the Paris International Exhibition of 1900.[2]

The sculpture programme is one of the most varied on any commercial block in Glasgow, demonstrating a consistency and inventiveness in its exploration of the symbolism of the sun that reflects Birnie Rhind's view of architectural sculpture as a rigorously intellectual, rather than a merely ornamental, discipline.[3] In addition to its numerous cosmological references, and its allusions to Greek and Persian mythology, the scheme also incorporates citations from the history of European sculpture. The reclining figures on the Apollo pediment are clearly derived from Michelangelo's Medici Chapel in Florence (1520–34), with the female figure sufficiently close in her pose to *Aurora* on the tomb of Lorenzo de' Medici to be regarded as a deliberate – and quite undisguised – 'quotation' from the earlier work.[4] Given the fact that Rhind had made a similar borrowing from Michelangelo on J.J. Burnet's Charing Cross Mansions (q.v., 540–6 Sauchiehall Street) a few years earlier, it seems safe to assume that the sculptor himself was responsible for the choice of imagery. This supposition is supported by the drawing submitted by Leiper to the Dean of Guild Court in May 1892, which shows the Apollo group superimposed on other architectural details in a way that suggests it has been added as an afterthought, possibly by a different hand.[5] The fact that the drawing also shows the corner pediment without Aurora is further evidence that the final form of the scheme was not decided upon until after Rhind had become involved in the commission.

Critical reactions to the programme were mixed. M.H. Spielmann, for example, remarked that:

Taken in parts, the broken pediment is very pleasing, but the two halves of it appear too far apart, and the figures upon them –

happily conceived and boldly modelled – are too closely based on Michael Angelo's 'Day' and 'Night' on the Medici tomb, while the figure between is in a more classic taste.[6]

He went to concede, however, that there was no doubt about the 'general grace and beauty' of the work, and that the 'freely armorial' panels over the entrance were 'not open to objection'.[7]

Related work: A 'half-size model' of one of the armorial panels was exhibited at the RGIFA (no.700) in 1895.[8]

Condition: Good.

Notes
[1] BN, 25 August 1893, p.237 (plus ills). [2] BN, 4 November 1904, p.649. [3] 'Sculpture in Scotland', A, 16 January 1891, p.46. [4] Goldscheider, pl.180. [5] GCA, B4/12/1/1980. [6] Spielmann, p.128. [7] *Ibid.* [8] Billcliffe, vol.4, p.33.

Other sources
BI, 16 May 1892, supplement, p.iv; AA, 1894, p.68 (ill.), 1904[1], p.69, (ill.); B, 5 January 1895, p.15, 9 July 1898, p.22; GAPC, 3 January 1899, n.p., (incl. ill.); Young and Doak (1971), no.121 (incl. ill.); Thomas Greig and Alastair G. Clarkson, 'William Leiper', unpublished dissertation, GSA, 1979, pp.50–1; Worsdall (1982) p.63, (1988), p.48 (incl. ills); Gomme and Walker (1987), pp.226, 258–9 (incl. ill.); Teggin *et al.*, pp.43–5 (incl. ill.); Williamson *et al.*, p.250; Nisbet, p.524 (incl. ill.); McKenzie, pp.58, 59 (ill.); LBI, Ward 18, p.210–11.

Castle Chambers, 59–69 Renfield Street / 51–7 West Regent Street

Four Allegorical Female Figures, Athena and Related Decorative Carving

Sculptor: William Kellock Brown (attrib.)

Architects: Frank Burnet & Boston
Date: 1898–1902
Builders: Morrison & Mason Ltd
Material: red Locharbriggs sandstone

Dimensions: figures larger than life-size
Inscriptions: see below
Listed status: category B (21 July 1988)
Owner: Tominey Estates Ltd and others

Description: Extensive, seven-storey commercial block in a flamboyant Baronial-Baroque style, with a domed corner tower. The four allegorical female figures are on the ground floor, in rectangular compartments deeply recessed between the corbels supporting the tower. Dressed as Pre-Raphaelite maidens, and with matching postures in each pair, they are shown holding objects loosely emblematic of agriculture or the natural world: a wheatsheaf, a bundle of twigs, a bird and a nosegay. A fifth

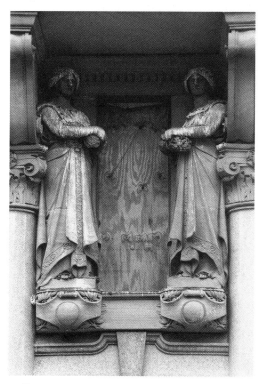

William Kellock Brown (attrib.), *Allegorical Female Figures* [RM]

William Kellock Brown (attrib.), *Athena* **(detail)**
[RM]

female figure, identified by her helmet and spear as *Athena*, appears at the top of the tower, just below the dome. The mythological theme is continued on the Renfield Street frontage, with a head of *Mercury* in a roundel on the most northerly of the third-floor balconies. Two further roundels appear on the floor below, in this case with female heads decorated with various symbolic devices, including an oak-leaf crown and a star superimposed on a crescent moon. In the scroll pediment above the entrance (no.65) is a pair of putti flanking a

cartouche inscribed 'CASTLE CHAMBERS', and at attic level, beside the southern gable, is a horse sejant with shield. The motif of a shield carved with a castle and inscribed 'FORTIS ET FIDUS' (trans.: 'strong and true') is used repeatedly on various parts of the façade. The most prominent example is in the panel between the second- and third-floor windows on the corner tower, where it is framed by pairs of playful amorini, one of which is shown skipping with a swag.

With minor variations in their distribution, the same decorative elements appear on the West Regent Street frontage. The mythological heads, all female in this case, have now been increased to four and are arranged in a line on the third-floor oriel windows. The putti in the pediment over the entrance (no.55) are larger, more muscular and more cramped in their postures than those on Renfield Street, while the horse sejant, now in the centre of the attic, is accompanied by a heraldic lion.

Discussion: The building was designed by James Carruthers[1] for the wine and spirit merchants G. & J. MacLachlan, whose Castle Brewery dominated the brewing and public house industry in Glasgow during the 'golden age of... pub design'.[2] Castle Chambers itself was built for £28,000, and originally combined the Palace Restaurant on the ground storey with the firm's headquarters and rented office accommodation on the floors above.[3]

The sculpture programme as executed differs in several ways from the scheme indicated on the architect's original drawings. Plans submitted to the Dean of Guild in June 1898, omit the ground-floor maidens and show two free-standing female figures on the attic balustrade beside the dome on Renfield Street. There are also cartouches inscribed 'REGENT CHAMBER' and 'RENFIELD CHAMBER' above the

main entrances.[4] In a perspective view exhibited at the RGIFA in 1900, however, the maidens are clearly indicated, although *Athena* is shown as an unidentified semi-naked female figure.[5]

The attribution of the sculpture to Kellock Brown is not secure, and a number of contemporary secondary sources ascribe the work to Ernest Gillick.[6] However, a stylistic comparison between the maidens and Kellock Brown's slightly later work on several district libraries, particularly the treatment of the hair on the female figures, strongly suggests the hand of the Glasgow sculptor.[7]

Related work: Several free-standing figure groups by an unknown sculptor were included on another block built by Burnet, Boston & Carruthers for the Castle Brewery at 39 Renfield Street (c.1903, now demolished).[8]

Condition: The exterior of the building was cleaned and restored in 1999. This involved the removal of trees growing from the joins in the masonry of *Athena* and a thick encrustation of bird lime on the heads and shoulders of the maidens. The bird lime has now returned.

Notes
[1] McKean *et al.*, p.122. Other sources attribute the design to Frank Burnet: see, for example, Rudolf Kenna and Anthony Mooney, *People's Palaces: Victorian and Edwardian Pubs of Scotland*, Edinburgh, 1983, p.106. [2] Kenna and Mooney, *op. cit.*, p. 88. [3] *Ibid.*, pp.89, 106. [4] GCA, B4/12/1/6592. [5] 'New Premises, Glasgow', BN, 21 September 1900, p.395. [6] Gomme and Walker (1987), p.261; LBI, Ward 18, p.233. [7] See, for example, Dennistoun District Library, 2a Craigpark. [8] 'New Premises, Nile Street, Glasgow', BN, 19 September 1902, p.397 (plus ill.); Kenna and Mooney, *op. cit.*, p.88.

Other sources
B, 9 July 1898, p.27 (ill.); BI, 16 August 1898, p.77; Woodward, p.32; Kenna and Mooney, *op. cit.*, pp. 30–1; Williamson *et al.*, p.231; McKenzie, pp.74 (ill.), 75.

Glasgow School of Art, 167 Renfrew Street / 15 Dalhousie Street / Scott Street

Keystone Relief and Decorative Ironwork

Architect/Designer: Charles Rennie Mackintosh
Carvers: Holmes & Jackson
Ironwork Fabricators: George Adam & Son

Dates: 1898–9; 1907–9
Opening dates: 20 December 1899; 15 December 1909
Materials: yellow sandstone; wrought iron
Dimensions: see below
Listed status: category A (6 July 1966)
Owner: The Governors of Glasgow School of Art

Widely regarded as Charles Rennie Mackintosh's finest architectural achievement, and one of the most beautiful buildings in the world, the School of Art was for many years revered as a pioneering contribution to the emergence of the Modern Movement. Nowadays it is more realistically appreciated as a masterpiece of 'freestyle' eclecticism, combining aspects of traditional Scottish building styles with Arts and Crafts, Art Nouveau and Secessionist elements in an outstandingly imaginative, if sometimes eccentric synthesis. The site on Renfrew Street was secured after the proposal to incorporate accommodation for art students in Kelvingrove Art Gallery and Museum (q.v., Kelvingrove Park) was abandoned; working studios, it was argued, were incompatible with galleries requiring 'unembarrassed circulation for easy-going sightseers'.[1] A competition, announced in February 1896, was won by the firm of

Honeyman & Keppie, who were officially credited as the architects, though it was an open secret that Mackintosh, their junior partner, was wholly responsible for the design. With a building fund of only £14,000 (the equivalent of roughly £588,000 today) at their disposal, the School Governors insisted that the structure should be one of 'great simplicity and plainness'.[2] In the event, the funding still proved to be inadequate, and only the eastern half of the building – from Scott Street up to and including the asymmetrical entrance bay – was erected according to Mackintosh's original plans. The much modified west wing was built a decade later, following a second wave of fundraising.

Despite the Governors' demand for plainness, Mackintosh succeeded in incorporating a range of brilliant decorative features into the design, many of which blur the distinction between traditional architectural ornamentation and contemporary notions of sculpture as an expressive form. Described by one recent commentator as a 'paradox of reduction and enrichment',[3] the building is in fact a perfect embodiment of Mackintosh's philosophy of architecture as a creative unity in which every aspect of art and design practice plays a part.

a) *Keystone Relief*

Modeller: Charles Rennie Mackintosh
Carvers: Holmes & Jackson

Date: 1899
Material: Giffnock or Whitespot sandstone
Dimensions: 1m high

Description: The relief is above the main entrance on the north façade, and consists of a

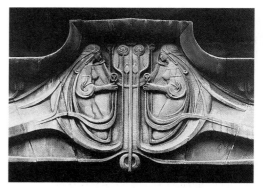

Charles Rennie Mackintosh, *Keystone Relief*
[GSA]

central rose tree flanked by a pair of identical kneeling maidens proffering flowers. The treatment is very stylized, with naturalistic forms such as the faces and hands of the figures embedded in a complex pattern of curvaceous abstract shapes which lend the motif as a whole the appearance of large flower. In keeping with Mackintosh's belief in the unity of architecture and the handicrafts, the relief is designed as an integral part of the structure. It is carved directly onto the lintel and adjacent voussoirs, and incorporates a series of serpentine lines which flow outwards from the maidens' headgear and the stems of their flowers to merge with the mouldings in the architrave. The illusion of organic growth is further enhanced by the sharply projecting cornice above the lintel, which curves upwards in the centre, as if under pressure from the relief below.

Discussion: As the only example of figurative sculpture on the entire building, the relief is a uniquely interesting work, and its prominent position immediately above the entrance suggests that Mackintosh attached great importance to it. Stylistically, the design is in a fully-fledged Art Nouveau idiom, with inflections characteristic of the work of the group of Glasgow artists known as 'The Four', of which Mackintosh was a leading member.

The imagery is also consistent with the iconographic interests of The Four, who tended to overlay naturalistic forms with a veneer of mysticism typical of the *fin de siècle*, and which is thought by some to have its roots in the work of such occult sects as the Rosicricians. Mackintosh's own belief in the symbolic importance of natural forms was stated clearly in a lecture he gave in 1902, shortly after designing the relief: 'Art is the flower. Life is the green leaf. Let every artist strive to make his flower a beautiful living thing.'[4] In the case of this work, however, it seems likely that Mackintosh has adapted the symbolism specifically to suit its position above the main door, with the fact that the relief is the first work of art a student will encounter on entering the building uppermost in his mind. Indeed, the ritualistic formality of the maidens' postures suggests that they were conceived as a fulfillment of W.R. Lethaby's demand that 'Portals must have Guardians'.[5] The general arrangement of the figures in relation to the rose tree is also reminiscent of a design Mackintosh produced for a diploma certificate for the School's Arts Club in 1893, while he was himself still a student. In this case the rose tree is probably intended to symbolise Fine Art (beauty), while the accompanying apple tree signifies Design (usefulness). The maidens in the relief are thus acolytes, who by pledging their own unopened flowers to the larger tree of art are intended to instill in the students the need for sacrifice and discipline in the attainment of artistic maturity. It is, quite literally, something they must 'look up to'.[6]

Mackintosh's plaster model of the left half of the relief, signed and dated 1899, has been lost. It was, however, illustrated in the German magazine *Dekorative Kunst* in 1902.[7] Holmes and Jackson were paid £10 18s. for carrying out the carving.[8]

Condition: Good.

b) *Stanchions and Entrance Lamp*
Designer: Charles Rennie Mackintosh
Fabricators: George Adam & Son

Dates: 1899 and 1909
Material: wrought iron
Dimensions: 5.18m high; discs approx. 40cm diameter

Description: Mackintosh's decision to set the building back from the line of the pavement in order to allow for a basement created the need for a protective screen along the length of the north façade. The main structure is of stone, and consists of a sequence of inverted arches divided by irregularly but symmetrically spaced pillars. Between the pillars there is an iron railing composed of tubular rods linked at the top by a continuous iron capping, with eight tall stanchions introduced at the ends of each of the four wide bays.

The stanchions themselves are composed of several elements. The lower section is made up of triple groups of closely spaced iron strips, each approximately 13cm wide, which give way above the capping to a dense cluster of vertical tendrils finished with spoon-like tips. Rising from the centre is a tall vertical rod, with a decorative plate attached to it a short distance from the top. A further strip of flat iron forms a wide open arch connecting the lower part of the central rod with the capping on the railings. The structure of the stanchions is the same throughout, but variations are introduced in the design of the decorative motifs on the upper discs, each of which takes the form of a stylized representation of an animal or other natural form. Curiously, there are a number of repetitions here, with five different designs distributed among the eight units. Identified numerically from the east (left) end, the sequence is as follows: 1, 2, 3, 1, 4, 5, 5, 4.

The arch motif which connects the stanchions to the main railing is repeated on a larger scale in a wide metal strip connecting the two pillars flanking the central stairway. In the centre of this is a lamp-holder in the form of an iron box with square apertures of blue glass. The top is also decorated with a pair of small, propellor-like projections fitted with plates cut in the form of Mackintosh's characteristic divided square motif.

Discussion: The question of whether or not Mackintosh intended the stanchions to have symbolic meaning – and if so, how that meaning should be interpreted – has given rise to much speculation. Most commentators are agreed that the totem-like appearance of the stanchions as a whole, and the striking resemblance of the discs to hieroglyphs,

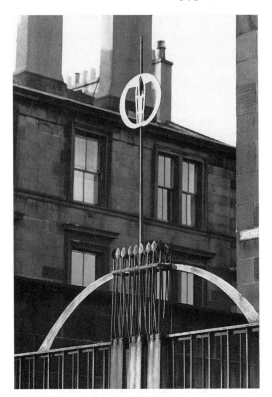

Charles Rennie Mackintosh, *Stanchion* [GSA]

strongly suggests that their function cannot be merely decorative. According to William Buchanan, the discs were inspired by Japanese heraldic emblems, or 'mons', and are intended as representations of animals associated with productive labour, identifying them from the left as: a ladybird; an ant; a scarab beetle; a ladybird; a bee; a bird; a bird; a bee.[9]

A more arcane line of interpretation has been proposed by Timothy Neat, who has suggested that the discs combine animal and plant imagery with more profound cosmological references. Thus the first image, Buchanan's ladybird, is simultaneously a 'flower in bloom', a bird's skull flanked by 'conventionalised wings', 'the Egyptian falcon-god Horus, who brings the sun back from the darkness every morning', a 'dove as an emblem of the Holy spirit that moves through all living things' and a chalice. In more abstract terms it represents 'death as a new beginning – it is the link between Alpha and Omega – the necessary low point from which any spiritual journey must begin'.[10] On the matter of the design of the stanchions as a whole, Neat has also advanced the theory that as well as being 'totems', they may also be read as stylized flowers, but once again with a cosmological dimension:

A plant grows, leaves cluster around its base, a long stem shoots vertically up, and a flower blooms at the top. Each flower is then seen silhouetted against the circular disc of the sun which has given it light and life. Above the vertical railings at the bottom of each totem is an iron hemisphere representing the earth out of which the flower has grown (and over which the sun rises).[11]

In the light of Mackintosh's stated view of the role of art ('Art is the flower. Life is the green leaf.') such a reading is perhaps not as far-fetched as it may seem. If nothing else, Mackintosh's treatment of the stanchions demonstrates his unique genius for reconciling traditional Ruskinian notions of naturalistic enrichment in architecture with the more abstract geometrical idiom associated with the continental Secessionist movement.

Although the stanchions were designed and made in two phases, there appear to be no significant differences in the treatment of the two sets of four. Both were fabricated by George Adam & Son, who were paid £83 15s. and £87 2s. in December 1899 and April 1909 respectively.[12]

Condition: The insertion of the stanchions and the vertical rods of the main screen directly into the coping poses a serious maintenance difficulty, as the rusting and subsequent expansion of the iron, has frequently caused the stone to split. Accordingly, when the number of rods was doubled in 1950 to deter children climbing through them, they were attached to a narrow fillet raised some inches above the wall. A horizontal band was added to the clusters of tendrils at the same time, in order to prevent vandals from bending them down.[13] The screen is painted black, the most recent coat having been applied in February 2000.

c) *Window Brackets*
Designer: Charles Rennie Mackintosh
Fabricators: George Adam & Son

Dates: 1899 and 1909
Material: wrought iron
Dimensions: overall height 2.35m; knot motifs, 31.75cm × 31.75cm × 31.75cm average

Description: The main first-floor studio windows on the north façade are fitted with a series of twenty-six iron brackets. These are distributed along the length of the building in groups varying slightly in number according to the size of the windows they are attached to. Thus, there are sets of four brackets on all the five full-size windows, while the two slightly narrower windows at the west end have only three. The main stem of each bracket springs from a T-section support projecting horizontally from the masonry below the sill, rises in a gentle curve for the main part of its length and finally makes a sharp turn inwards to join the astragal of the window above. The head of each stem is decorated with a large knotted form, while the ends of the lower supports are finished with small horizontal plates of a more regular geometric design. Typically, Mackintosh has varied the form of both the knots and the geometric plates from one window to the next.

Discussion: As with much of Mackintosh's ironwork, the brackets have a practical as well as an ornamental function, providing a much-needed bracing for the window frames and a support for the planks on which window cleaners have traditionally rested their ladders. It is, however, the decorative quality of the knotted forms that has been the main concern of Mackintosh commentators. H. Jefferson Barnes has described them as 'fantastic cage-like structure[s] rather reminiscent of the basket hilt of a great sword'. He goes on to claim that in the brilliance of their design they 'anticipate much of modern sculpture'.[14] More recently they have been interpreted as representing the various phases in the development of a flower:

The three sets of brackets to the east record the growth of a seed. Starting from the centre, the first set of brackets has stamen-like forms in the centres of their heads. The next set has a small seed in each head. In the final set each head contains a full, round seed. The brackets on the windows to the west have flower-like heads, though they do not seem to express a similar idea of growth.[15]

Though largely speculative, such a reading is clearly consistent with the interpretation of the stanchions below them as symbolic flowers.

In addition to the question of the programmatic development of the designs of the individual groups, it is important to note

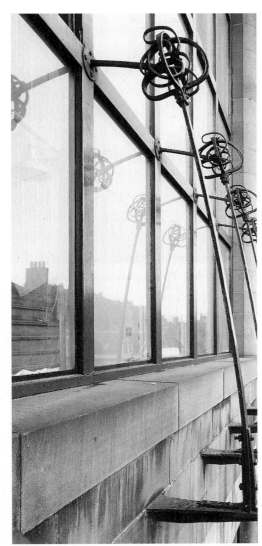

Charles Rennie Mackintosh, *Window Bracket*
[GSA]

that there are subtle but significant differences between the way the knots on the two halves of the building are attached to their stems. On the eastern section, dating from 1899, the stems pass directly through one of the main members of the knot; those on the 1909 phase are much less securely attached, and the knots themselves tend to be less robust in their construction. This raises interesting questions about the nature of Mackintosh's working relationship with the craftsmen he entrusted with the execution of the work, and the degree of freedom or otherwise he allowed them in the interpretation of his designs. Jefferson Barnes' observation that the earlier brackets may have been 'the work of a better blacksmith' may be discounted, however, as the School records show that both sets of brackets were fabricated by George Adam, who was paid £25 4s. for the early set and £21 for the later.[16]

Condition: Generally good, though the rusting of the lower brackets, caused by the attachment of a wide upper plate on to the T-section irons, has made their preservation 'a costly headache'.[17]

d) *Pair of Finials*

Designer: Charles Rennie Mackintosh
Fabricators: George Adam & Son (attrib.)

Date: *c.*1898
Material: wrought iron
Dimensions: each 2.24m overall height; trees 48.4cm (north) and 76cm (east) wide

Description: Located on the two octagonal stair turrets which break the roofline of the north and east façades, the finials are among the School's most distinctive features, and a particularly memorable contribution to the Garnethill panorama. The basic design in both cases is loosely derived from the Glasgow coat of arms, and consists of a stylized bird hovering over a cage-like representation of a tree. The version on the north façade has a simpler structure, the tree consisting of four roughly rectangular ribs with a large leaf-like disc attached to each. At the base are four crossbars carrying coloured glass balls. In the east version the number of rectangular ribs has been doubled, and an additional series of semi-circular ribs has been introduced, giving the structure as a whole a more spherical form. There are no crossbars, but the centre is occupied by a large metal ball.

Discussion: Early drawings by Mackintosh show that his original intention was to refer more directly to the Glasgow arms, with the bird sitting directly on the tree, and a large salmon placed beneath it.[18] It is also believed that he intended them to act as weather-vanes.[19]

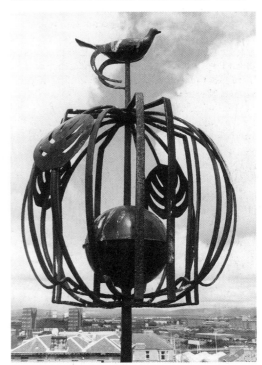

Charles Rennie Mackintosh, *Finial* (east) [RM]

Barnes regards the development of the design as evidence of the uniqueness of Mackintosh's powers of invention, and his predisposition to treat functional objects as 'pure sculpture'. He also judges the north finial to be the less successful of the two, and assumes on this basis that it was designed earlier.[20] The fact that the east version is more 'developed', may, however, have a symbolic explanation. For Buchanan *et al.*, the ball in the centre of the east finial represents a seed, and it is through this that 'the idea of growth and the fullness of nature is expressed'.[21] This notion is further elaborated by Timothy Neat, who interprets the relative openness of the north finial as emblematic of the '"innocent" state in which the students enter the School of Art', thus providing a link with the symbolic keystone carving on the entrance directly below (see above). By contrast, the more elaborate east finial 'gives symbolic expression to the "fullness of experience and vision" with which young artists should leave the School'.[22] Together, they thus form 'poetic symbols which honour "the green leaf" of life and "the flower of art" – as all good Art Schools should'.[23]

The School records indicate a number of payments to George Adam & Son for ironwork, but none have been identified which refer unambiguously to the finials; an 1898 estimate of £83 15s. for 'Balcony and finials' may be for this work, though it should be remembered that the iron rail on the Director's balcony has small finials of its own.[24] It is possible that the payment of £15 made on 28 November, ostensibly for 'iron brackets', was in fact for the roof finials.[25] In any event, it seems likely that the work was carried out by Adam. Three other iron fabrication companies were employed by the School – Walter Macfarlane & Co., Bryden & Middleton and R. Smith & Son – but their work was confined to the plain balconies, railings and spiral stairs inside the building. The more artistically ambitious commissions were invariably given to George Adam, who was also entrusted with the production of the key used in the ceremonial opening of the first half of the building in 1899. He was paid £2 10s for this work.[26]

Condition: Early photographs show that the east finial was originally fitted with crossbars similar to those on the north. When and why these were removed is not known. The same photographs also show that the coloured balls on the crossbars of the north finial are modern replacements of four small 'box-like shapes'. According to Barnes these may have been bells,[27] and thus a further reference to the Glasgow arms. Both finials are painted black and are in sound condition.

e) *Iron Screen and Gate*

Designer: Charles Rennie Mackintosh
Fabricators: George Adam & Son (attrib.)

Date: *c.*1909
Material: wrought iron
Dimensions: length 7.81m; height at north end 2.58m; height at gate end 4.24m

Description: The south-west corner of the building is enclosed by a cage-like screen, with a gate leading to the access area in front of the entrance to the sub-basement. The main structure consists of a series of vertical rods with a wire mesh in-fill. At intervals the rods are gathered into clusters augmented by flat, tapered bands to form skeletal columns. These are decorated with a variety of motifs, including small basket-like forms composed of horizontal rings and pierced oval plates which recall the bird skulls on the first and fourth stanchions on the north frontage (see above). The baskets are also reminiscent of the dense patterns of squares used by Mackintosh in much of the interior woodwork. The entire design, including the gate, is asymmetrical.

Discussion: There are no references to the

Charles Rennie Mackintosh, *Iron Screen* [GSA]

screen among the recorded payments to George Adam & Son, but an unspecified payment of £24 19s. on 6 February 1909, may have been for this.[28]

Condition: Painted black, though the inner parts of the cages have proved difficult to recoat, and are thus vulnerable to corrosion.

f) *Interior Work*

A third wrought iron variation on the Glasgow arms, 1.27m in length, projects over the main stair-well from the balustrade of the Museum on the first floor. In this case the tree is represented by an irregular series of concentric circles with spiralling arrow-headed attachments, and the bird and fish (both replacements of Mackintosh's originals, which were damaged in the 1960s) are reduced to simple abstract forms. The gilded cast-iron bell hanging below the fish was acquired independently by the School's Director Francis H. Newbery, and can be seen on his desk in an early photograph of his office.[29] It has been

claimed that Mackintosh designed the coat of arms as a support for the bell.[30]

Among the School's collection, there are many fine sculptures on public display, including portrait busts by Benno Schotz, Alexander Proudfoot and George Frampton. The School also has an extensive collection of plaster casts.

g) *Unexecuted Work*

The tall stone cylinders set within niches on either side of the oriel windows of the Library on the west front were intended by Mackintosh to be carved with full-length portraits of historical figures such as Benvenuto Cellini, Andrea Palladio and St Francis of Assisi and other symbolic representations of the arts. In their drive to reduce costs, however, the Building Committee blocked the £1,000 Mackintosh had set aside for this work.[31] It should be remembered that the design of the west elevation was altered at a late stage, and that the original proposal of 1897 does not include any provision for figurative carving.[32] It is possible, therefore, that the attenuated form

of the figures, as indicated on Mackintosh's 1907 drawing,[33] was inspired by the plaster casts of the column figures from the west portal of Chartres Cathedral, which were purchased by the School in 1905, after the completion of the first phase of the building.[34]

Other sculptures indicated on drawings by Mackintosh but not carried out include a coat of arms on the east gable[35] and a figurative plaster frieze on the north wall of the Museum on the first floor.[36]

Notes

[1] B, 23 April 1892, p.317. [2] Buchanan, p.17. [3] *Ibid.*, p.51. [4] *Ibid.*, p.32. [5] *Ibid.*, p.30. [6] For a more detailed discussion of this, see Timothy Neat, *Part Seen, Part Imagined: Meaning and Symbolism in the Work of Charles Rennie Mackintosh and Margaret Macdonald*, Edinburgh, 1994, pp.30–4. [7] *Dekorative Kunst*, 19 March 1902, p.216. Reproduced in Buchanan, p.21. [8] GSA Archive, 'Abstract of Income and Expenditure', 31 December 1901, 3/5/2/8a. [9] Buchanan, p.27. [10] Neat, *op. cit.*, p.162. [11] *Ibid.*, pp.161–2. [12] GSA Archive, *Building Fund Cash Book*, 3/5/2/1, p.14 (2 December 1899); *Building Fund Contracts Ledger*, 3/5/2/5, p.25 (27 April 1909). [13] H. Jefferson Barnes, *Charles Rennie Mackintosh: Ironwork and Metalwork at Glasgow School of Art*, Glasgow, 1968, n.p.

('Introduction'). [14] *Ibid.* [15] Andrew MacMillan, James Macaulay and William Buchanan, 'A Tour of the School', in Buchanan, p.79. [16] GSA Archive, 3/5/2/1, p.13 (7 June 1899); *Building Fund Contracts Ledger*, 3/5/2/5, Item 1 (22 June 1908). [17] Barnes, *op. cit.*, 'Introduction'. [18] See drawing of east elevation dated March 1897, reproduced in Buchanan, p.84. [19] Barnes, *op. cit.*, 'Introduction'. [20] *Ibid.*, text accompanying plate 12. [21] Buchanan, p.82. [22] Neat, *op. cit*, p.32. [23] *Ibid.*, p.34. [24] GSA Archive, 3/2/5/18. [25] *Ibid.*, *Building Fund Cash Book*, 3/5/2/1, p.11 (28 November 1898). [26] *Ibid.*, 3/2/5/18. [27] Barnes, *op. cit.*, text accompanying plates 11, 12. [28] GSA Archive, *Building Fund Cash Book*, 3/5/2/1, p.7. [29] Buchanan, pp.102–3. [30] Barnes, *op. cit.*, text accompanying plate 18a. [31] Buchanan, p.40; see also GSA Archive, *Building Fund Contracts Ledger*, 1907, item 1. [32] See drawing of west elevation, 1897, reproduced in Buchanan, p.92. [33] *Ibid.* [34] GSA Archive, 'List of items for entry in Inventory Stock Book. From 1st February 1901', p.9 (June 1904). [35] Reproduced in Buchanan, *op. cit.*, p.84. [36] GCA, TD 1309–A:123/4.

Other sources
Howarth, pp.81–3; McKean *et al.*, pp.148–9 (incl. ills); Williamson *et al.*, pp.265–8; McKenzie, pp.76–9 (incl. ills).

Robertson Street CITY CENTRE

On the Clydeport Building, 16 Robertson Street, Broomielaw

Mythological and Historical Figure Programme

Sculptors: John Mossman (first phase); Albert Hemstock Hodge (extension)

Architect: John James Burnet
Builders: Morrison & Mason (first phase);

Alexander Muir & Sons (extension)
Dates: 1882–6 and 1906–8
Material: yellow sandstone
Dimensions: see below
Listed status: category A (6 July 1966)
Owner: Clydeport PLC

Description: The building is in a grandiose Baroque style, with giant Composite columns supporting a pediment on the main Robertson Street frontage, and a domed corner tower at

the junction with Broomielaw. Two distinct bodies of work may be identified in the sculpture programme, the first executed by John Mossman when the five most northerly bays were built in the 1880s, and the second by Albert Hemstock Hodge, forming part of the extension added twenty years later. These will be described separately to begin with, after which the relationship between them will be briefly discussed.

First phase – 1884–6

Sculptor: John Mossman

Allegorical Pediment Relief

Dimensions: figures colossal

A personification of *Father Clyde* holding a decorative paddle is seated on a throne in the centre of the pediment, flanked by figures symbolising the 'Eastern and Western hemispheres bringing their merchandise'.[1] Among the subsidiary figures are: a reclining, semi-naked man with a governor mechanism in his hand and a cog-wheel at his feet; a kneeling male figure wearing a cloak and offering textiles; an oriental figure offering a casket; a reclining male nude tying a ship to a capstan. Trees and other plant forms can be glimpsed between the figures and the back of Father Clyde's throne is in the form of a shell niche.
Condition: Very worn.

Poseidon and Triton

Dimensions: figures colossal

An acroterion on the apex of the pediment depicts Poseidon standing in the prow of a small boat pulled by two rearing sea horses; a half-length Triton is shown rising from the sea beneath the keel of the boat.
Condition: Very worn.

Putti and Apprentices

Dimensions: figures approx. 1.8m high

The roofline of the original five-bay Robertson Street façade was terminated with decorative attic pedestals flanked by standing male infants and youths whose clothing and attributes suggest they are intended to symbolise various agricultural and industrial occupations. Those at the north end are fully dressed and hold a paddle and a cog-wheel. The second pair are semi-naked, and are shown carrying an

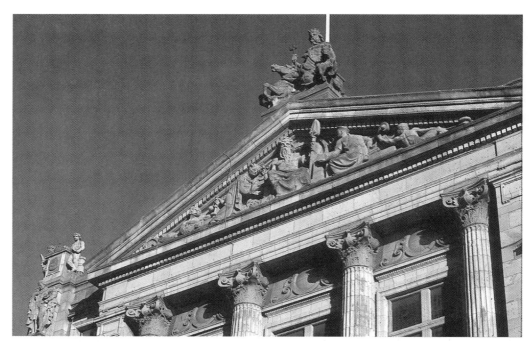

John Mossman, *Poseidon* and *Allegorical Pediment*

agricultural tool (left) and an unidentified container (right). In both cases the front faces of the pedestals are decorated with the Glasgow arms (on the right superimposed on a globe), and surmounted by acroteria in the form of a three-masted sailing ship (left) and a wheatsheaf. The full-length portraits of Thomas Telford and James Watt, which stand on the socles below, were added during the construction of the extension (see below).
Condition: Good.

Ship Prows

Dimensions: approx. 2m high

A pair of sculpted ships' prows protrude from the basement wall a little below the level of the first-floor window sills on either side of the

entrance arcade. Decorated with chains, anchors and ropes, these are the largest and most elaborate of their kind on any building in Glasgow, and are distinguished by their adaptation of the head of Poseidon's trident as a bowsprit. Miniature versions of the ship's prow motif are incorporated into the capitals of the Composite columns in the portico above.
Condition: Good.

Second phase – 1906–8

Sculptor: Albert Hemstock Hodge

Mythological Groups

Dimensions: figures approx. 2.2m high

On attic pedestals at either end of the entablature below the corner dome are free-

standing statuary groups featuring female mythological figures accompanied by colossal representations of animals. On the left is *Demeter Leading a Bull*, the female figure striding forward with a corn-stalk in her extended left hand, and her right hand gripping an iron chain attached to the bull's bridle. The interpretation of this group has caused some difficulty among earlier commentators. James Cowan, for example, confessed that 'in spite of considerable research' he was unable to determine its meaning, drawing the somewhat fanciful conclusion that it was intended as a 'reference to Glasgow's trade in cattle from overseas'.[2] More recently, the authors of *Glasgow Revealed* have suggested it might be a depiction of *Europa and the Bull*[3] on the grounds that the bull, as an incarnation of the god Zeus, relates iconographically to both Poseidon on the pediment and Amphitrite on the opposite side of the dome (see below). It may be relevant to note here that Hodge is known to have sculpted a similar group entitled *Europa Leading the Bull* on the Legislative Building in Manitoba, Canada.[4] The situation is complicated by the fact that a photograph of Hodge's model for this figure reproduced in *Academy Architecture* was given the more general caption of 'Prosperity'.[5] The use of a corn-stalk as an emblem, however, as well as the meadow-grass shown in the space below the bull's belly, confirm the identity of the figure as Demeter, the goddess of the harvest.

At the opposite end of the entablature is *Amphitrite with a Pair of Seahorses*. This group is equally dynamic in conception, with the horses prancing wildly on surging waves, their forelegs entwined and their tails emerging from behind Amphitrite. The bronze trident Amphitrite holds in her right hand is a reminder that she was the wife of Poseidon and the mother of Triton, thus connecting her with Mossman's acroterion group, and the somewhat incongruous cog-wheel in her left hand is perhaps intended to link her with the imagery in the Robertson Street pediment. In this case Cowan's suggestion that it may have some 'reference to the world-wide distribution of Glasgow's products in engineering', which he supports by pointing out the globe under her right foot, seems more plausible.[6]

Condition: Good.

Albert Hemstock Hodge, *Demeter* [RM]

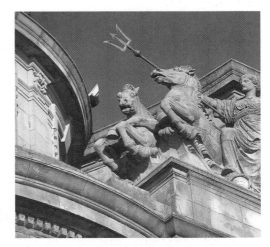

Albert Hemstock Hodge, *Amphitrite* [RM]

Historical Portraits

Dimensions: figures colossal

Three full-length standing portraits are placed on attic pedestals on either side of the Robertson Street pediment and immediately to the left of the corner dome; there is also a single putto immediately to the right of the *Amphitrite* group. All three figures are depicted in a mixture of contemporary dress overlaid with florid masses of classical drapery. From the left these are:

Thomas Telford (1757–1843), civil engineer. Born near Westerkirk, Dumfriesshire, he began his career as a mason, later becoming a self-taught architect. In 1786 he was appointed surveyor of Shropshire, a post which entailed building several bridges over the River Severn, including the cast-iron span at Bewdley. He also designed and built aqueducts, harbour works, roads and canals, including the Caledonian Canal in the Scottish Highlands. His crowning achievement was the Menai Straits Bridge in North Wales, which made masterly use of wrought iron links to suspend the deck. He was the first president of the Institute of Civil Engineers (ICE, founded in 1828).[7] Telford is shown here with a roll of engineering plans in his hand, as if in the process of conducting a site survey. He is also wearing the presidential chain of the ICE.

Condition: Good.

James Watt (1736–1819). For biographical details, see *Monument to James Watt*, George Square. Watt is shown with his left hand placed on a separate condenser, his most important contribution to steam technology, and his right

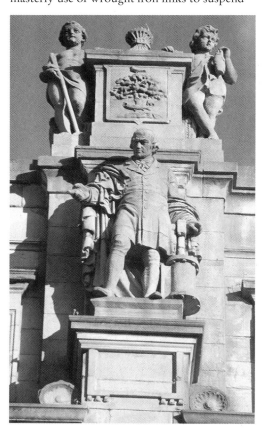

Albert Hemstock Hodge, *James Watt*; **John Mossman**, *Apprentices* [RM]

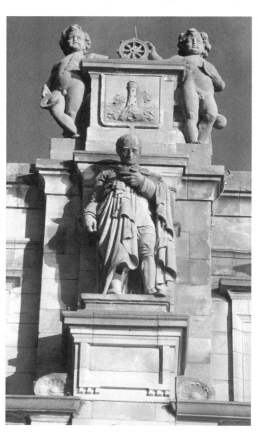

Albert Hemstock Hodge, *Henry Bell* and *Apprentices* [RM]

hand extended as if explaining its function.

Condition: Good.

Henry Bell (1767–1830), engineer, born in Torphichen, near Linlithgow, whose contribution to steam propulsion heralded the era of mechanised navigation. After studying with the Scottish engineer John Rennie in London, he returned to Scotland in 1790, settling in Glasgow as a carpenter. In 1812 he launched his 28–ton 'Comet', the first commercially successful steamship in Europe.[8] Late in his life he was awarded an annual grant of £100 by the Clyde Navigation Trust in recognition of his services to the improvement of the Clyde.[9] The figure has been mistakenly identified elsewhere as William Murdock[10] and Robert Stevenson.[11] However, the inclusion of a model boat as an attribute makes it likely that it is a portrait of the creator of the 'Comet'.[12] On the pedestal above are two naked putti flanking a pedestal decorated with a shield showing a lighthouse on the front face and a miniature helm above. The putto on the left holds a sickle, while his companion has his right hand placed on the helm.

Condition: The face is very worn.

Interior work

The interior includes extensive plaster work by Robert McGilvray (first phase) and George Rome & Co. (second phase), stained glass by Stephen Adam, a wood carving of a sailing ship by an anonymous carver in the Reception Room and a War Memorial by Benno Schotz in the entrance hall. There is also a copy of James Tannock's portrait of Henry Bell (SNPG, PG911) in the Board Room.

Discussion: The building was commissioned by the Clyde Navigation Trust, which during its heyday in the nineteenth century was second only to Glasgow Corporation as 'the most important business governing body in the city'.[13] By 1881 its premises on St Vincent Street had become inadequate, and the Trustees felt the time was right to demolish the property it owned on Robertson Street, which at the time was occupied by the Marine Division of the Police.[14] Burnet's proposal was submitted in March of the following year and accepted in September.[15] There is no record of a competition. From the beginning, keeping the cost of the scheme under control appears to have been an important consideration, and in June 1883, Burnet was instructed to effect a saving of £7,242 by 'making the frontage to the building on Robertson Street less ornate and expensive'.[16] Whether or not this led to the omission of the attic pedestal figures is not known (see below). In view of the fact that the final cost of the exterior carver work was a mere £600, this seems unlikely.[17]

Within months of the completion of the building in April 1886, the Trust began making plans to extend their accommodation into the adjoining property on the corner of Broomielaw, which it also owned. Burnet was commissioned to make a detailed survey of its condition, and to report on the possibility of converting it for office use. Concluding that it was far too dilapidated to be worth renovating, Burnet submitted a proposal for an entirely new design 'in order to show the capabilities of the site', and which he claimed would 'internally as well as externally be an extension of the present building'. This included a massive clock tower, which he intended to be a dominant feature of the harbour, in the process 'supplying a want which in Liverpool and other seaports is so admirably supplied'.[18] A drawing published in the *Architect* shows the tower rising to over twice the height of the main building, with seated female figures on the top stage and a colossal seated male figure, possibly Poseidon, at ground-floor level. The design also shows a line of four attic figures, including the two flanking the pediment, which were omitted from the first stage.[19]

No action was taken on this design, and it was not until July 1905, that discussions were resumed concerning the extension. By December, when the decision to proceed was made, the Trustees had firmly decided against the clock tower, stating in the Minutes that the 'chief feature will be a dome at the Broomielaw corner'.[20] They also rejected Burnet's plan for a new entrance on the Broomielaw frontage. A sketch of the new design published in the *Glasgow Herald* in December shows the dome as an octagonal structure, with a curved parapet terminated by small domed tempietti, each of which is decorated with a pair of seated figures.[21] At what point Hodge was drafted into the scheme, and the mythological groups decided upon, is not known. It is significant also that the *Glasgow Herald* illustration, like Burnet's own plan preserved in the City Archive, does not include the attic portraits, but shows the pedestals on both sections as empty.[22] This raises the possibility that Hodge himself may have played a role in the discussion that led to their inclusion.

Summary: The attribution of the two different phases of the sculpture programme is a source of confusion among some modern commentators. In *Glasgow Revealed*, for example, the entire scheme is credited to Hodge, while an entry in the *Dictionary of Scottish Sculptors* lists all the work in the north section, including the portraits of Bell (identified wrongly as Murdoch [sic]) and Watt, as by Mossman. Hodge can be discounted as the sculptor of the first phase, as he was only eleven years old when it was completed; a photograph of the north section published in 1896, six years after Mossman's death shows that the attic pedestals were still empty at this time.[23] It should be noted that the attribution to Mossman of the first phase of the scheme – the pediment, acroterion, ships' prows and the two northernmost pairs of putti – is supported only by secondary documentation and cannot therefore be taken as secure. On the basis of the stylistic evidence, however, the supposition seems credible.

Hodge's authorship of the mythological groups is confirmed by the publication of photographs of his model for *Demeter Leading a Bull* in *Academy Architecture* in 1901.[24] It is assumed here that Hodge also produced the three portraits, including Telford and Watt on the north section.

One final issue remains to be resolved: whether Burnet intended to include attic portraits as part of the 1882–6 scheme. There are two relevant facts here. Firstly, on the 1896 photograph referred to above, the pedestals flanking the pediment are not only empty, but the walls above them are also decorated with triglyphs. It seems unlikely that they would have been ornamented in this way if Burnet had planned to add free-standing statues at a later date. Secondly, the pedestals are extremely narrow, and in the case of the portrait of Watt, scarcely deep enough to accommodate both the figure and the condenser. On balance it seems likely that Burnet's intention to include the figures did not emerge until the design of the extension in 1888,[25] and that the final decision to add them to the original scheme was arrived at in consultation with Hodge.

Notes
[1] Cowan, p.233. [2] *Ibid.*, p.233. [3] Teggin *et al.*, p.31. [4] Baker, p.84 (incl. ill.). [5] AA, 1909[1], p.85. [6] Cowan, p.233. [7] EB, vol.IX, p.871. [8] EB, vol.I, p.949. [9] Brian Osborne, *The Ingenious Mr. Bell*, Argyle, 1995, p.111. [10] McKenzie, p.66. [11] Unpublished information pack, Clydeport plc, p.1. [12] Teggin *et al.*, pp.31–2. [13] Cowan, p.231. [14] GCA, *Clyde Navigation Trust Minutes*, T-CN/1/13, 10 February 1881. [15] *Ibid.*, T-CN12/817, 12 March 1882, p.788; BA, 6 October 1882, p.474. [16] GCA, T-CN/1/13, 12 June 1883, p.924. 17] *Ibid.*, T-CN3/331, 1 June 1883. [18] *Ibid.*, T-CN/1/4 *Report on the Condition...*, 11 January 1887, p.313. [19] A, 20 January 1888, pl.138. [20] GCA, T-CN/1/20, 4 December 1905, p.20. [21] GH, 1882, p.474. [16] GCA, T-CN/1/13, 12 June 1883, p.924. 17] Ibid., T-CN3/331, 1 June 1883. [18] Ibid., T-CN/1/4 Report on The Condition..., 11 January 1887, p.313. [19] A, 20 January 1888, pl.138. [20] GCA, T-CN/1/20, 4 December 1905, p.20. [21] GH,', B, 9 July 1898, p.29; Gomme and Walker, pp.193 (ill.), 220–1; McKean *et al.*, pp.44–5, 49 (incl. ills); Williamson *et al.*, pp.259–60; McKenzie, pp.66, 67 (ill.).

Royal Exchange Square CITY CENTRE

On the east side of the Square, opposite Ingram Street

Equestrian Monument to the Duke of Wellington

Sculptor: Baron Carlo Marochetti

Founders: Soyer (statue); de Braux (reliefs)
Architect: James Smith (pedestal)
Date: 1840–4
Inauguration: 8 October 1844
Materials: bronze statue on Peterhead granite pedestal
Dimensions: statue approx. 3.6m high; pedestal 2.6m high; end panels 61cm × 1.16m; side panels 61cm × 2.7m
Inscriptions: on the front of the pedestal – WELLINGTON; on south relief panel (bottom edge, towards right end) – DE BRAUX FONDEUR

Listed status: category A (15 December 1970)
Owner: Glasgow City Council

Arthur Wellesley, Duke of Wellington (1769–1852), English soldier and politician. Born in Dublin, he studied at Chelsea, Eton and the French Military School at Angers. From 1787 he rose steadily through various regiments and was sent to India in 1797, where he distinguished himself as a military leader, taking a major part in the defeat of Tipu, the Sultan of Mysore, and the capture of Seringapatem. For his outstanding generalship in expelling the French troops from Spain he received the title of Duke of Wellington in 1814. His greatest victory was against Napoleon at Waterloo on 18 June 1815, which effectively brought the Napoleonic Wars to a close, and won him the reputation as the 'conqueror of the world's conqueror'. From 1818 he played a leading role in British political life, becoming Prime

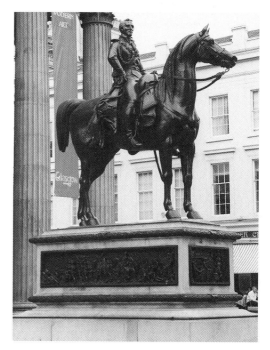

Carlo Marochetti, *Duke of Wellington*

Minister in 1827. Already unpopular for his advocacy of Catholic emancipation, his government fell in 1830 for its opposition to parliamentary reform. Known in old age as the Great Duke, he was venerated by many as an incomparable public servant; his house in Piccadilly was known simply as No.1 London. He died at Walmer and was buried with great pomp in St Paul's Cathedral.[1]

Description: Located in front of the portico of the Glasgow Gallery of Modern Art (formerly the Royal Exchange), the statue faces east across Queen Street towards Ingram Street, with which it is axially aligned. The subject is seated on his charger 'Copenhagen', dressed in the full uniform of a field-marshal, with his right hand on his hip, his chest expanded and his head turned slightly to the right. His posture is intended to suggest that of 'a general reviewing his troops'. The horse has the 'broad forehead and wide nostrils' of an Arab, and is shown 'standing with fore-feet a little in advance, in an easy posture, the reins lying slack'.[2]

The pedestal is decorated with bronze pulvinated friezes on the cornice and base, and has four narrative relief panels on the dado illustrating events in the Duke's life and career. Working clock-wise from the right (north) panel, their subjects are as follows:

The Battle of Assaye. A scene of turbulent combat representing Wellington's decisive victory over the Marathas in 1803, his first military success, which enabled him to negotiate a lasting peace in India. A party of Indians is shown on the left, including an elephant and the conquered chief kneeling in obeisance. Wellington is on horseback in the centre, and there is a group of officers struggling to rescue a gun carriage on the right. There are many Scots soldiers among the troops, and the background is 'entirely Asiatic, with mosques, minarets &c.'[3]

The Soldier's Return. The interior of a soldier's

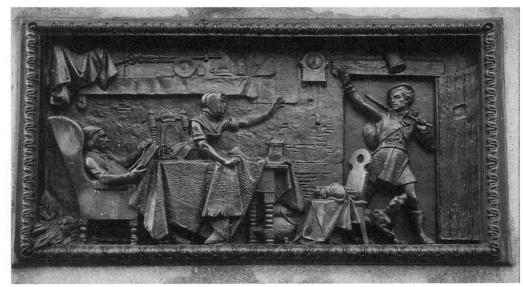

Carlo Marochetti, *The Soldier's Return* [RM]

family cottage, with his father in an armchair beside the fire reading the Bible and his wife 'flying to meet her husband with uplifted hands, in token of joyful surprise, as the "poor but honest soldier" opens the door'.[4]

The Battle of Waterloo. This was the last victory of Wellington's military career. On the left are the church of Waterloo and the village of Hougoumont in flames, with broken guns and carriages and a party of Guards in the foreground. Wellington is in the centre, advancing on horseback at the moment he is thought to have ordered the final charge with the exclamation 'Up, Guards, and at 'em'. Behind him are more infantrymen and mounted officers, with a wounded soldier at the far right being treated by a surgeon.

The Blessings of Peace. Having 'saved his country from the inroads of the foe', the soldier is depicted ploughing a field as a demonstration that agriculture, and the cultivation of peaceful

occupations, are the 'final and best conclusion of war's alarms'.[5]

Discussion: The decision to erect a monument to Wellington in Glasgow was made at a public meeting on 18 February 1840, with the Duke of Hamilton proposing and the historian Archibald Alison seconding the motion.[6] A number of donations ranging between £100 and £300 were received from business firms and private individuals in Glasgow and the west of Scotland, and within a few months a fund of nearly £10,000 had been raised.[7] This was by far the largest, as well as the most speedily gathered, private subscription for any monument in Glasgow in the nineteenth century. The process of selecting a sculptor began with the appointment of a sub-committee, which by the end of April had compiled a list of sixteen candidates for consideration. In addition to such leading British artists as John Steell (1804–91), John Gibson (1790–1866), Francis Chantrey (1781–1841) and Richard Westmacott (1775–1846), the list also included the

distinguished Danish sculptor Bertel Thorwaldsen (1768?-1844) as well as Marochetti himself.[8]

Differences of opinion were evident in the sub-committee from the outset, with much of the debate focused on the desirability or otherwise of awarding the commission to Marochetti. Alison quickly emerged as the leader of the pro-Marochetti faction, while Archibald McLellan, supported by the *Art Union*, spearheaded the campaign to block his appointment. A full account of the extraordinary controversy which resulted from this clash of opinions is given elsewhere,[9] and can only be recounted in outline here. Conducted largely in the pages of newspapers such as the *Glasgow Constitutional*, the affair dragged on throughout 1841. Accusations of corruption and political intrigue characterised many of the exchanges, and the episode was not without its more picaresque moments.[10] Much of the hostility directed at Marochetti stemmed from his involvement in the design of the mausoleum of Napoleon at the Invalides in Paris, which no doubt rendered him a somewhat eccentric choice in the eyes of many. There was also a strong undertone of chauvinistic suspicion of an artist who appeared to many to represent a challenge to the British tradition of conservative idealism embodied in the work of Chantrey. Described variously as 'the veriest trash' and 'like nothing in the heavens above or the earth below', the 'theatrical extravagance and meretricious absurdity'[11] of his work may have suited the 'impassioned ideas of the Italian people', but had no place among the sober citizens of Glasgow. Compared to Flaxman's *Monument to Sir John Moore* in George Square (q.v.), a statue by Marochetti would be 'like putting Jim Crow beside Taglioni'.[12]

One by one, however, the alternative candidates were eliminated from the contest, and with the death in November 1841, of Chantrey, the Italian sculptor's only serious

rival, the commission fell, more or less by default, into Marochetti's lap. Nationalistic sentiments were still in evidence in the terms of the contract, which specified that not only should the Duke be represented 'in the Prime of Life', but that he should also be mounted on a 'high bred English horse'.[13] Work on the commission proceeded with astonishing speed, and by August 1842, a mere eight months after the contract had been issued, Marochetti was ready to invite the committee to Paris to inspect the clay model before it was cast in plaster. In September 1844, after a delay probably caused by a dispute with his founder Soyer, the finished bronze was dispatched from Paris via Le Havre and Liverpool, arriving in Glasgow a few days after Marochetti himself.[14] The inauguration took place on Tuesday 8 October, with Alison delivering a brief address. The climax of the event was the removal of the covering from the statue with a block and tackle suspended from the portico of the Royal Exchange, accompanied by 'the booming of the guns of the artillery, which had been placed in Bell's Park, and which signalised the moment of the inauguration to every part of the city'.[15] Crowd control appears to have been a problem, though there were no serious disturbances apart from one minor incident in which a group of revellers made off to the Trongate with a rope to lasso the statue of King William III.[16]

Not surprisingly, critical responses to the monument were mixed. Despite the fact that Marochetti had confounded all expectations of theatrical excess by producing a work of great dignity and restraint, the *Art Union*, which had been hostile towards him from the start, still found reason to complain, grimly predicting that it 'may be long before experience will remove so grievous a blot upon the character of the country'. It would, however, be difficult to imagine a more tautological objection to an equestrian monument than their assertion that it looked 'too much like a real man on horseback'.[17] On the whole, however, the work

was favourably received. The reliefs in particular were much admired, inviting comparisons with painters such as Sir David Wilkie and allegedly moving a number of bystanders at the inauguration almost to tears with their pathos.[18] Queen Victoria made a detour to see it on her visit to Glasgow in 1849, pronouncing it to be 'very like and beautifully executed'.[19]

For Marochetti it was a personal triumph, as well as the beginning of a long and productive relationship with the people of Glasgow, from whom he was to receive three more public commissions over the next twenty years. The most famous of these, as it happens, was his equestrian monument to Queen Victoria herself, originally sited in St Vincent Place and now in George Square (q.v.). Once again one of the prime movers behind this project was Archibald Alison, who used his speech at the inauguration dinner to settle a few old scores and vindicate the decision to introduce Marochetti's work to the streets of Glasgow:

> Fifteen years have now elapsed since a question arose in this city as to the artist to whom was to be entrusted the formation of the Duke of Wellington statue. There was a great keenness, and a very laudable and proper anxiety evinced on the part of many most meritorious men in this country that it should be given to a British artist – that the hero of Great Britain should be commemorated by the genius of Great Britain. But there were others who thought that the fine arts constituted a republic, where there is no distinction of nation and country – that wherever genius exists, there a countryman is to be found. (Immense applause.) Baron Marochetti was then wholly unknown to every member of the Wellington Committee. His reputation, indeed, had been wafted across the Alps, but none had seen his works, and the only specimen we had was in the small model he

had sent of the statue of Emmanuel Fillibert, which now graces the city of Turin. The moment that statue was beheld it was seen he was a man among a million, and that to that man Glasgow should entrust its great work. I need not say how that work has been accomplished. (Hear, hear.)[20]

By this time the Wellington monument had come to be regarded as a touchstone of excellence for equestrian statues, and the fact that the procession which preceded the inauguration of the Queen Victoria statue had to file past it *en route* to St Vincent Place was seized upon by several commentators as an opportunity to make a direct comparison between the two works. On the whole, the later statue was judged to be inferior.[21]

Today the *Monument to the Duke of Wellington* is one of the most fondly regarded works of public art in Glasgow, as is clearly testified by the traffic cones which regularly appear on the head of either the rider or the horse (and sometimes both) after the revelries of the weekend. Indeed, a recent proposal by Julian Spalding, the former Director of the Gallery of Modern Art, to remove the statue provoked a storm of protest. His argument that it was no longer 'relevant' to the function of the building behind it was greeted with almost universal derision. This is almost certainly the incident which lies behind the recent advertising campaign by the *Evening Times* newspaper, which features the statue, complete with cone, accompanied by the slogan 'Some things never change'.

Related work: A set of small bronzes (42.5cm high) of the model was issued in the nineteenth century, inscribed CM / FONDU PAR MOREL ET Cie LONDRES', one of which was in a Christie's sale in London on 13 April 1983. It is believed that a full-size copy of the statue is at Stratfield Saye, Hampshire.[22] Equestrian monuments to the Duke of Wellington by sculptors on the sub-committee's original list include those on Princes Street, Edinburgh, 1852, by Steell and in Trafalgar Square, London, 1829, by Chantrey.[23] A marble bust by Chantrey, dated 1836, is also in the collection of GAGMA (S.3).

Condition: Within a year of the statue's erection the *Builder* reported that it had been 'wantonly defaced. The reins of the horse attached to the peaceful figure of the plough… were knocked off and carried away.'[24] In the early 1920s the right stirrup was broken off and later replaced by McLean & Co., Metal Window and Door Makers. More recently the spurs were removed and are still missing.

Notes
[1] EB, vol.19, pp.755–7. [2] *Glasgow Constitutional*, quoted in B, 19 October 1844, p.527. [3] *Ibid.* [4] *Ibid.* [5] *Ibid.* [6] Philip Ward-Jackson, 'Carlo Marochetti and the Glasgow Wellington memorial', *Burlington Magazine*, vol.132, no.1053, December 1990, p.852. [7] 'Inauguration of the Wellington statue, Glasgow', ILN, 26 October 1844, p.269; see also James Cleland, *The former and present state of Glasgow*, Glasgow, 1840 (2nd edition), p.115. [8] Ward-Jackson, *op. cit.*, p.852. [9] *Ibid.*, pp.851–61. [10] W.J. Bankes, an intermediary between Marochetti and the sub-committee, was forced to flee the country after being arrested while 'enjoying himself with a guardsman in Green Park', *ibid.*, p.858. [11] *Ibid.*, p.855. [12] *Ibid.*, p.856. [13] *Ibid.*, p.859. [14] *Ibid.* [15] ILN, 26 October 1844, p.269. [16] Ward-Jackson, *op. cit.*, p.860. [17] *Ibid.*, p.861. [18] B, 19 October 1844, p.527; Ward-Jackson, *op. cit.*, p.860. [19] Duff, p.109. [20] 'The equestrian statue in honour of Her Majesty's visit to Glasgow', GH, 8 September 1854, p.6. [21] See, for example, 'The equestrian statue in commemoration of Her Majesty's visit to Glasgow', BC, 16 September 1854, p.77. [22] Information provided by Hugh Stevenson. [23] Read, pp.7, 8 (incl. ills). [24] B, 25 October 1845, Supplement, p.11.

Other sources
Tweed (*Guide*), p.8; B, 9 July 1898, p.23; McFarlane, pp.30–1; Worsdall (1982), p.115 (ill.), (1988), p.92 (incl. ill.); Read, pp.7 (ill.), 8, 167; Teggin *et al.*, pp.28, 96 (ills); Williamson *et al.*, p.167; McKenzie, pp.46, 47 (ill.).

Ruthven Lane HILLHEAD

On the rear elevation of 13 Ruthven Street, facing Ruthven Lane

Puma

Sculptor: not known

Architect: George Bell II (of Clarke & Bell)

Date of installation: 1902–3
Material: yellow sandstone
Dimensions: approx. life-size
Listed status: not listed
Owner: privately owned

Description: Heavily concealed by trees, the relief panel is inserted between a pair of windows on the second storey of the otherwise undecorated rear wall of a tenement building. The animal is vividly characterised, and is shown with a snarling expression, as if stalking its prey.

Discussion: Despite engaging the attention of numerous local researchers over the years, the

Anon., *Puma*

presence of the carving on this building has never been satisfactorily explained. The fact that it does not appear on George Bell's plans for the rear elevation[1] suggests that it was inserted by the builder on his own initiative, possibly using a stone salvaged from a demolished building elsewhere. This view is further supported by the fact that the animal is carved from a single block, and that its insertion in the wall disturbs the regular pattern of the surrounding masonry. An alternative theory is that it is a portrait of a pet belonging to George Barlas, who commissioned the tenement as an addition to his existing property to the west. Though consistent with other examples of sculpted tributes to beloved cats on Glasgow buildings (see, for example, Burleigh Street, Appendix B, Minor Works), this seems unlikely, as the sheer eccentricity of keeping a dangerous animal in a residential suburb in Edwardian Glasgow would almost certainly have been recorded in local anecdotal lore. There is also some uncertainty as to the species of cat it represents, with some commentators referring to it as a leopard, others merely as a 'big cat'. The consensus of opinion, however, is that it is a puma, and as such relates to other known examples incorporated in Glasgow buildings, such as the Victoria Infirmary (q.v., Langside Road) and the Western Infirmary (demolished, puma now in storage). In these two examples, however, the cats were included specifically as symbols of 'healing', and therefore do not fully explain the recurrence of the image on a domestic block. The work remains an enigma.

Condition: The animal's face is weather-worn.

Note
[1] GCA, B4/12/1/9145–7.

Other sources
Anon., 'Leopard Mystery', *West End News and Partick Advertiser*, 23 November 1973, p. 8; Jack House, 'The black panther of Hillhead', ET, 30 April 1980, p.17; Gary Nisbet, letter to the editor, *Scots Magazine*, September 1990, p.648; Michael Smith (1999), p.618.

Saltmarket GLASGOW CROSS

Mercat Cross, 1 Saltmarket

Unicorn and Associated Decorative Carving

Sculptors: Margaret Cross Primrose Findlay (modeller); Dawson & Young (carvers)

Architect: Edith Burnet Hughes
Builders: Thaw & Campbell
Date: 1929–30
Building inaugurated: 24 April 1930
Material: yellow sandstone
Dimensions: unicorn approx. 2m high
Inscriptions: see below
Listed status: category B (16 March 1993)

Owner: Glasgow City Council

Description: The building is in the form of a traditional Scots market cross, and consists of a single-storey, octagonal chamber with vaulted interior, a balustraded proclamation platform and a slender column supporting a unicorn sejant.[1] The unicorn faces due west, and holds an armorial shield decorated with thistles. On the west façade is a bronze tablet engraved in elaborate copperplate script: 'The / Mercat Cross / of / Glasgow / Built / in / The Year of Grace / 1929'. This is contained within a pilastered aedicule, which has a Glasgow coat of arms in the lintel and capitals incorporating miniature St Andrew's crosses overlaid with thistles. On the east side there is a lintel inscribed with the motto of the Order of the Thistle (and of the Kings of Scotland): 'NEMO ME IMPUNE LACESSIT' (trans.: 'No one provokes me with impunity'). Above this is a decorative panel containing thistles and a St Andrew's cross. Higher still, in the balcony, is an armorial device, including a shield with St Andrew's cross, a lion rampant, a helmet and the inscription: 'NON CRUX SED LUX' (trans: 'Not the cross, but the light'). The interior contains extensive wood carvings by Dawson & Young from models by Margaret Findlay.

Discussion: The Mercat Cross was commissioned by the Glasgow antiquarian Dr William George Black, and gifted to the City as

a replacement of the much older structure which was thought to have existed in the vicinity. The exact location of the original, however, as well as the details of its history and appearance, had been matters of speculation for some time, both among serious historians and

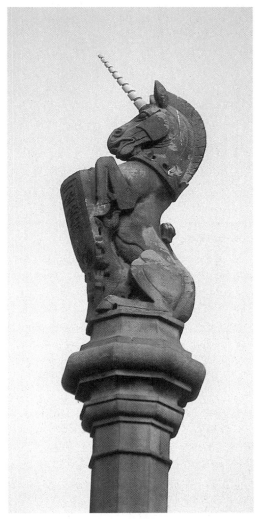

Margaret Cross Primrose Findlay, *Mercat Cross* **(detail)** [RM]

more popular commentators. In 1872, for example, John Tweed observed that the intersection of the Saltmarket and Trongate was a Cross only in name, 'for there is no cross to be seen. No doubt', he went on, '… a cross stood somewhere about the centre of the junction of the great streets that terminate here, but several generations have elapsed since it was seen, and all trace of it has long been lost.'[2]

Black himself conducted extensive research into the history of the Cross, presenting his findings in a lecture during the 1911–12 session at Glasgow School of Art (of which he was a benefactor), and in a substantial pamphlet published in 1913.[3] He was unable to draw any firm conclusions as to the design or location of the original, however, deducing from the 'singularly conflicting' nature of the evidence that there may in fact have been two crosses in Glasgow.[4] A crude illustration of the High Street in *Glasghu Facies* shows a columnar structure, about a five metres high, on a stepped base and with some carver work at the top, though this was probably located at the north end of the High Street and is unlikely to have been the City's official Market Cross.[5] The Council minutes of 1659 record an instruction, probably from General George Monk, Cromwell's Commander-in-Chief in Scotland, to demolish a guardhouse 'builded about and upon the croce'.[6] It appears that in the process the Market Cross, described elsewhere as an 'octagon figure … finely spangled with thistles',[7] was 'altogither defaced', so that it became necessary to 'remove the samyne mercat croce with all convenient diligence and make it equall with the grund'.[8] The repair of the pavement at the site was completed 'by the sight and aduijce [advice]' of Bailie James Colquhoun, sculptor of the Hutcheson Brothers on the former Hutchesons' Hall (now at 158 Ingram Street, q.v.).[9]

By the middle of the nineteenth century, the absence of the Cross had become a matter of concern, provoking extensive correspondence

in the local press, and prompting the City Architect John Carrick to authorise a series of excavations in the vicinity of the nearby St Andrew's Church, where the shaft of the Cross was thought to have been buried. The search proved fruitless. It was this situation which Black set out to rectify in November 1911, when he approached the council with a proposal to build a modern replica. It was not possible to carry the project out right away, but with the partial implementation of Honeyman & Keppie's grandiose redesign of the area in the 1920s (see Mercat Building, 15–23 London Road) the opportunity arose to put the proposal into effect. Work was completed on 13 March 1930, and the building was formally presented to the City a little over a month later in a ceremony in which the

> … streets converging on the Cross were crowded by many thousands of citizens who behaved with extraordinary good order, and who took the temporary interruption of traffic with good humour.[10]

In his address from the proclamation platform, the Lord Provost stressed the historic importance of the Mercat Cross as a 'symbol, the significance of which went to the very heart of the being and existence of Glasgow'.[11] As a replacement for an older monument which had been 'torn down by rude hands', the new Cross had a double function:

> It proved that we had realised the meaning and value of that ancient centre of our civic life. It proved also that there was an earlier generation which attached to the ancient Cross no such value.[12]

The reconstruction of the Cross was thus an act of 'atonement', which he hoped would signal a 'change of heart in the citizens of Glasgow towards their past'.[13] In an unofficial ceremony on 17 March 1930, Black placed a lead casket containing a vellum booklet into a cavity in the wall. The booklet, 'engrossed with

great beauty by Miss Helen A. Lamb', recorded the names of all the 'men and women of skill associated in carrying out the actual building', the text of his 1911 offer and the Town Clerk's letter of acceptance.[14]

Condition: Good.

Notes

[1] For historic examples see Helmut Petzsch, *Architecture in Scotland*, London, 1971, p.88. [2] Tweed (*Guide*), p.30. [3] GSA Archive, *Annual Report*, 1911–12, p.27; William George Black, LL.D., *Glasgow Cross: With a Suggestion as to the Origin of Scottish Market Crosses*, Glasgow and Edinburgh, 1913. [4] Wm. George Black, C.B.E., LL.D., 'Mercat Cross Ceremonial', *Old Glasgow Club Transactions*, vol.6, 1928–33, p.8. [5] John M'Ure *alias* Campbell, *Glasghu Facies: a view of the City of Glasgow; etc.*, Glasgow, 1736, incorporated in Tweed (*Glasgow Ancient and Modern*), vol.1, p.260. [6] Black, 'Mercat Cross Ceremonial', p.13. [7] Black, *Glasgow Cross*, p.9. [8] Black, 'Mercat Cross Ceremonial', p.13. [9] Black, *Glasgow Cross*, p.8. [10] Black, 'Mercat Cross Ceremonial', p.11. [11] *Ibid.*, p.12. [12] *Ibid.* [13] *Ibid.*, p.16. [14] *Ibid.*, p.8.

Other sources

Nisbet, 'City of Sculpture'; Teggin *et al.*, p.20 (ills); McKean *et al.*, p.56; Williamson *et al.*, p.179; McKenzie, p.19.

Saltmarket / Laurieston Road GLASGOW GREEN / GORBALS

On outward faces of abutments terminating Albert Bridge

Medallion Portraits of Queen Victoria and Prince Albert
Sculptor: George Edwin Ewing

Engineers: Bell & Miller
Builders: Hanna, Donald & Wilson
Date: 1871
Materials: bronze medallions set in Peterhead granite roundels
Dimensions: medallions approx. 90cm diameter
Signature: on medallions of Victoria – EWING FECIT (unclear); no signature visible on Albert medallions
Inscriptions: on the foundation stone, in the centre of the north-west abutment – FROM THE CONTINUED INCREASE OF THE POPULATION OF GLASGOW / AND THE SURROUNDING DISTRICTS, AND IN ORDER / TO PROVIDE MORE AMPLE MEANS OF COMMUNICATION BETWEEN / THE NORTH AND SOUTH BANKS OF THE CLYDE, / HUTCHESONTOWN BRIDGE, / ERECTED ANNO DOMINI 1830, HAS BEEN TAKEN DOWN, / AND / BY THE FAVOUR OF ALMIGHTY GOD, IN THE PRESENCE OF THE / HON. WILLIAM RAE ARTHUR, LORD PROVOST OF THE CITY, / AND THE PUBLIC BODIES OF THE CITY, / THE RIGHT HON. THE EARL OF DALHOUSIE, G.M.M., / ASSISTED BY / THE GRAND MASONIC LODGE OF SCOTLAND, AND NUMEROUS OTHER LODGES, / LAID THE FOUNDATION-STONE OF THE BRIDGE, / TO BE CALLED / THE ALBERT BRIDGE OF GLASGOW, / ON FRIDAY THE THIRD DAY OF JUNE, MDCCCLXX., / ERA OF MASONRY, 5870, / IN THE THIRTY-THIRD YEAR OF THE REIGN OF OUR MOST GRACIOUS SOVEREIGN, QUEEN VICTORIA. The plate also features the names of the members of the Bridge Trustees, followed by the prayer: WHICH UNDERTAKING MAY / THE SUPREME ARCHITECT OF THE UNIVERSE / BLESS AND PROSPER. On polished slabs of Peterhead granite at the south end of the parapet, east side – ERECTED BY THE TRUSTEES / OF THE / GLASGOW BRIDGES ACT OF PARLIAMENT, / PASSED A.D. 1866: / THE HON. JOHN BLACKIE, JUN., LORD PROVOST. / ALBERT BRIDGE, / COMMENCED A.D. 1868: / THE HON. JAMES LUMSDEN, LORD PROVOST.; west side – ALBERT BRIDGE, / OPENED A.D. 1871: / THE HON. WILLIAM RAE ARTHUR, LORD PROVOST. / ARCHITECTS, R. B. BELL AND D. MILLER, C.E; / CONTRACTORS, HANNA, DONALD, AND WILSON. / ALBERT BRIDGE, / FOUNDATION-STONE LAID A.D. 1870, / BY THE / EARL OF DALHOUSIE, / GRAND MASTER OF SCOTLAND: / THE HON. WILLIAM RAE ARTHUR, LORD PROVOST
Listed status: category B (22 March 1977)
Owner: Glasgow City Council

Description: Two pairs of identical bas-relief profiles of Queen Victoria and Prince Albert

George Edwin Ewing, *Queen Victoria* [GN]

George Edwin Ewing, *Prince Albert* [GN]

are inserted in roundels on the outside faces of the pillars at either end of the bridge, with Victoria on the north-west and south-east corners, and Albert on the remaining two. The direction of their profiles allows the two subjects to face each other across the Clyde. The crowns on the portraits of Victoria are gilded and their tips extend beyond the edge of the medallion into the surrounding stonework. Other decorative features on the bridge include pairs of painted, double-sided cast iron panels showing the arms of Glasgow in the centre of the parapets and spandrels in the arches filled with scroll work and the arms of the counties of Lanark, Renfrew, Ayr 'and other city incorporations' as well as those of Prince Albert.[1]

Discussion: Modelled on Blackfriars' Bridge in London,[2] and described as 'the most handsome' of all the bridges over the Clyde,[3] the present structure was designed as a replacement for Robert Stevenson's five-arch Hutcheson Bridge of *c.*1830, which by the middle of the century was no longer wide enough to cope with the increasing volume of traffic.[4] In its report on the plan for the bridge, the *Builder* noted that circular recesses were to be left 'in the outside elevations of the towers for the reception of large medallion busts in marble or bronze as shall afterwards be decided'.[5] It also reported that the armorial shields were intended to be 'bronzed and relieved with gilding', rather than painted.

The foundation stone was laid on 3 June 1870, by the Earl of Dalhousie, Grand Master Mason, in a ceremony that proved a disappointment to many. 'The Procession', commented one observer,

… cannot be described as a very Imposing one. The Weather destroyed its Appearance. The Flags, thoroughly Saturated, drooped unattractively, and hid their Mottoes; while the various Pennons and numerous Insignia were almost entirely Concealed by Umbrellas. The Absence of Cavalry was felt to be a great loss.[6]

The opening of the bridge a year later was equally low-key. According to the same writer it was 'opened for traffic on the 21st day of June, 1871, at 6 o'Clock a.m. with no more ceremonial than if it had been a common gateway'.[7]

Condition: Physically sound, though the surfaces of the medallions are marred by a mixture of flaking paint, oxidisation and dirt and there is much rust on the iron work. In September 1999 the entire bridge was re-surfaced but the ironwork was not restored or repainted.

Notes
[1] B, 15 April 1871, p.284; Williamson *et al.*, p.625. [2] Tweed (*Guide*), p.29. [3] Oakley (1946), p.118. [4] McKean *et al.*, p.39. [5] B, 14 September, 1867, p.685. [6] Tweed (*Glasgow Ancient and Modern*), pp.1219–20. [7] *Ibid.*, p.1221.

Other sources
B, 14 September 1867, p.685, 18 June 1870, p.493; GCA, F6/2 (1) ('Minutes of Parliamentary Trustees on the Bridges over the River Clyde', issued 10 July 1868); ILN, 18 June 1870, pp.624 (ill.), 638, 1 July 1871, pp.645–6 (incl. ill.); Groome, vol.3, p.127; Jack House, 'Victoria and Albert', ET, 23 April 1980, p.16; Nisbet, p.525 (incl. ill.); McKenzie, p.20.

On the façade of the Savoy Centre, 128–52 Sauchiehall Street

Ten Allegorical Figures and Associated Carvings

Sculptor: William Birnie Rhind (attrib.)

Architects: David & Hugh Barclay
Date: 1892–4
Material: red freestone
Dimensions: approx. 2.2m high (figures)
Listed status: category B (15 December 1970)
Owner: Burford Midland Group PLC and
others

Description: This five-storey block was built as a warehouse for the cabinet-makers Cumming & Smith at a cost of £35,000. The three middle storeys are linked by giant pilasters, which impose a symmetrical ABABBBABA horizontal pattern, where A is a single and B a triple bay. The figures are carved in relief in the spandrels between the arches enclosing the fourth-storey windows, and are divided into three groups: two pairs of females, naked to the waist, reclining on the arch mouldings in each set of outer bays; two erect figures flanking the central bay. Each female figure holds an object associated (in some cases very loosely) with commerce, trade or husbandry. In the left-hand group these include a flail; a palm branch; a dove (perched on outstretched wrist, with airborne dove nearby); a flail (extended towards a leaping chicken). In the right-hand group the figures hold, from the left: a model galleon; a torch and a book (with smiling sun emerging from behind adjacent arch); a trumpet; a mirror and a pair of dividers. Of the two upright figures in the centre the male (left) is a warrior with arms outstretched, holding a sword and a shield; the female, identically posed, holds a scroll and a dough paddle. The style of the carving is rough but expressive, with bold undercutting in the drapery folds and deeply drilled eyes, enabling the details to be read easily from ground level.

Additional carver work includes: decorative panels inserted in the broken pediments above first-floor windows, with floral work including a rose, a thistle, a shamrock and a fleur-de-lis, plus the monogram 'C & S' in the centre; high-relief masks of *Athena* and *Mercury* in the attic pediments.

Discussion: Worsdall attributes the work to William Birnie Rhind,[1] but does not cite his source.

Condition: A cleaning and restoration programme carried out in 1998 led to the replacement of the four ground-floor consoles with plain blocks, and the consequent loss of four winged cherub masks. There is much general erosion in the figures, and a number of details are missing, including the hilt of the sword carried by the central warrior. The torso of this figure has also been badly damaged, possibly by the addition of a lamp or some other fixture that has since been removed. The upper surfaces of many of the figures have been coated with a bituminous material designed to protect them from birds.

Note
[1] Worsdall (1988), p.50.

Other sources
GCA, B4/12/1/1916; BI, 16 December 1891, p.140, 16 May 1892, p.29; Worsdall (1982), p.66; Williamson *et al.*, pp. 239–40; McKean *et al.*, p. 142; McKenzie, pp.76, 77 (ill.).

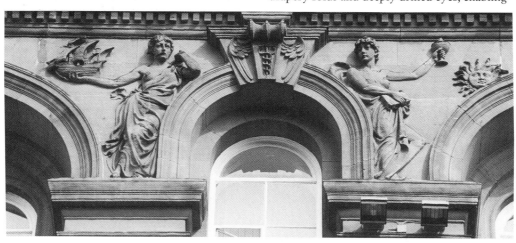

William Birnie Rhind (attrib.), *Allegorical Figures* [RM]

Bank of Scotland, 235 Sauchiehall Street and 147 Blythswood Street

Two Allegorical Figures, Armorial Shield and Associated Decorative Reliefs

Sculptor: Benno Schotz

Architect: A. Graham Henderson (of Keppie Henderson & Partners)
Date: 1929–31

Materials: yellow sandstone (figures and reliefs); bronze (shield)

Dimensions: main figures approx. 2.3m high

Inscriptions: in gilded letters engraved directly in the masonry of both frontages – BANK OF SCOTLAND; at the base of the shield – TANTO UBERIOR (trans.: 'sustained growth')

Listed status: category B (22 March 1977)

Owner: Bank of Scotland

Description: The statues are in niches above the main Sauchiehall Street entrance of this austere example of inter-war Classicism. On the left, a female figure carries an empty cornucopia; the male, on the right, stands with his arms folded. Both are supported by projecting brackets decorated with armorial devices (lion rampant left, saltire right) and with stylized horses lying belly up on the undersides. The bronze shield is in the arch over the main entrance and consists of a Bank of Scotland crest supported by two semi-naked female figures, each of which holds an inverted cornucopia spilling coins. Above the crest are a medieval helmet and a further cornucopia. Over the windows in the outer bays of the ground floor, and rising organically from their keystones, are blind cartouches enclosed by a rich vocabulary of patriotic emblems and devices associated with trade – crowns, agricultural tools, bulls' and rams' heads, pulley wheels and cornucopias. These are repeated on the outer windows on the Blythswood Street façade with further variations in the imagery (e.g., the prows of ships). Under the upper cornice on both frontages there are pairs of lion masks superimposed on horizontal *fasces* and framed by stylized Ionic volutes.

Discussion: In his autobiography Schotz refers briefly to his experience working with the Keppie Henderson architectural partnership:

I carried out several architectural commissions for John Keppie, but they had to be as Keppie wanted them. He was a classical architect, and his figures had to be

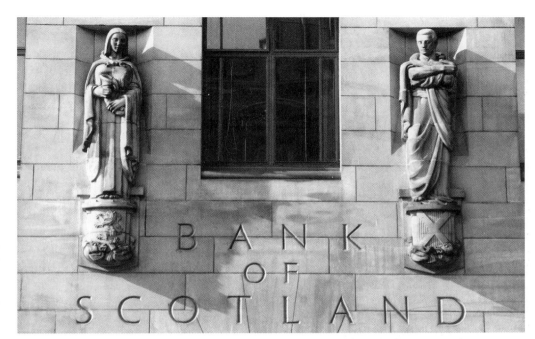

Benno Schotz, *Allegorical Figures*

pseudo-Greek. I was surprised that even in those days architects had to hide the cost of sculpture in the brick or woodwork, otherwise the clients would have cut them out, and this was a time when there was no scarcity of money. They simply had no time for the ornamentation of their buildings. Yet, once they saw it, they asked no questions. They were pleased to have it, and took pride in it.[1]

The Dean of Guild plans show that significant changes were made in the completed scheme, with a pair of standing figures removed from the Blythswood Street elevation, and those executed on Sauchiehall Street moved closer to the centre.[2] In any event, the simple, box-like character of the structure provides an ideal context for the disciplined simplicity of

Schotz's Art Deco style.

Related work: Other branches of the Bank of Scotland with full sculpted crests are at 1–3 Bridge Street (*c*.1857), 2 St Vincent Place (1867–70) and 93 St Vincent Street (1924–6) (qq.v.).

Condition: Good.

Notes

[1] Benno Schotz, *Bronze in My Blood*, Edinburgh, 1991, p.78. [2] GCA, B4/12/1929/658.

Other sources

B, 29 November 1929, p. 940, 14 June 1935 (incl. ill.); Gomme and Walker (1987), p.270; Williamson *et al.*, p.242; McKean *et al.*, p.143; McKenzie, pp.76, 78 (ill.).

McLellan Galleries, 254–90 Sauchiehall Street

Bust of Queen Victoria
Sculptor: John Mossman

Architect: James Smith
Date: 1854
Material: yellow freestone
Dimensions: bust larger than life-size, bust and pedestal approx. 1.8m high
Listed status: category B (15 December 1970)
Owner: Glasgow City Council

Description: The portrait consists of a head and upper torso supported by a cylindrical pedestal, with the junction between them concealed by a mass of folded draperies. It is

John Mossman, *Queen Victoria*

located in a niche over the main entrance, with a small pediment above containing an armorial shield, and a larger pediment below filled with the arms of Glasgow. The bust itself marks the exact centre of the building.

Discussion: The block is in the style of a Renaissance *palazzo* and was built by Cruikshank & Co. for the wealthy art collector and Glasgow councillor Archibald McLellan as his commercial premises and gallery. A deed of bequest, drawn up in 1853 made provisions for his collection to be passed to the city, but on his 'premature death' in the following year it was found that 'the state of his affairs would not permit of the carrying out of his patriotic purpose'.[1] In what seemed a controversial move at the time,[2] the council decided in 1856 to purchase the building for £44,500 and the collection for the 'nominal sum' of £15,000[3] and reopen the building as the Corporation Galleries. This was to form the nucleus of the city's municipal art collection. In 1903, after the collection had been transferred to Kelvingrove Art Gallery and Museum, Burnet, Boston & Carruthers added the dome to the south-east corner and converted the frontage into Tréron's *Magasin des Tuileries*. Further changes were made in 1912–13 by A.B. McDonald, the City Engineer, including a red sandstone extension at the rear to Renfrew Street. This otherwise plain structure has various minor decorative features among which are a pair of carved wreaths enclosing a Glasgow coat of arms and a half-length St Mungo; a rectangular panel inscribed 'MCLELLAN / GALLERIES', its border decorated with a bell and a fish; a pair of smaller panels decorated with crowns and *fasces*.

Condition: Good.

Notes
[1] Stevenson (1914), p.35. [2] Oakley (1946), p.192. [3] Stevenson (1914), pp.34, 35.

Other sources
GCA, B4/12/1/9658, 1903; GH, 20 February 1854;
BI, 16 March 1910, p.189, 15 February 1911, p.173, 16 September 1911, p.93, 16 March 1912, pp.179, 190 (incl. ill.); BN, 20 February 1914, p.261; Jack House, 'Ask Jack', ET, 18 July 1979; Williamson *et al.*, p.242; McKenzie, pp.76, 78 (ill.); George Fairfull Smith, 'The Fine Arts in Glasgow', in George Rawson (ed.), *Missionary of Art: Charles Heath Wislon 1809–1882*, Glasgow, 2000, p.38.

Royal Highland Fusiliers Museum, 518 Sauchiehall Street

Two Seated Michelangelesque Figures
Sculptors: McGilvray & Ferris

Architects: Honeyman, Keppie & Mackintosh
Date: 1903–4
Material: red Dumfries sandstone
Dimensions: figures larger than life-size
Inscriptions: in square panels on the third storey, one letter per bay – R H F
Listed status: category B (15 December 1970)
Owner: Royal Highland Fusiliers

Description: The figures are seated on projecting semi-circular platforms supported by large consoles on either side of the central bay of the third storey. Their poses are derived from the *Delphic Sybil* (left) and the *Prophet Isaiah* (right) on Michelangelo's Sistine Ceiling, the latter being slightly more freely interpreted.[1]

Discussion: The building was designed as premises for T. & R. Annan & Sons, photographers and fine art dealers. From its modest beginning in Woodlands Road, the photographic studio established by Thomas Annan in 1855 was to change its address six times in the following half century, each move marking a growth in its prosperity. On Sauchiehall Street alone the firm occupied no less than four premises, of which no.518, built largely from the profits the company made from its work as official photographers to the Glasgow International Exhibition of 1901, was the most prestigious.[2] The inclusion of a

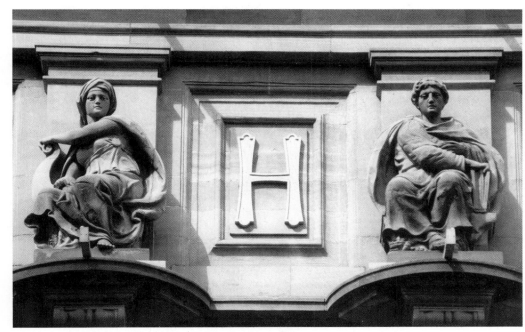

McGilvray & Ferris, *Seated Figures*

sculpture programme was a clear advertisement of the firm's success, the impeccable art historical pedigree of the figures serving to remind their clients that photography, as an independent visual medium, had at last achieved cultural respectability.

One of the sons referred to in the company name was James Craig Annan, known today, among other things for his portraits of the leading artists of the Glasgow Style movement. Chief among them was Charles Rennie Mackintosh, who produced the working drawings of the building and who may also have been responsible for the design of the façade. Annan was a man of wide-ranging cultural interests, with a life-long commitment to the visual arts, and it seems likely that the historic references in the sculpture programme were as much a reflection of his own personal tastes as a product of the architect's creative thinking. At the same time, Mackintosh's admiration for the Sistine Ceiling was profound. Describing it as a 'most marvelous decoration',[3] he made use of modified versions of the Sistine sybils in several other works, including a Glasgow School of Art Club invitation card of 1892.[4] Indeed, in an early version of the design of the façade Mackintosh included three figures, which are drawn as if he intended them to be carved in relief and inserted into panels in each of the three bays on the third storey. These can be identified, from the left, as the *Delphic Sybil*, the *Libyan Sybil* and the *Prophet Isaiah*. The middle figure was eventually omitted and the remaining two were carved in the round and placed on projecting pedestals between the bays. Curiously, McGilvray & Ferris reversed the positions indicated in Mackintosh's drawing when they came to execute the work, with the gestures of the figures directed outwards, rather than towards the centre of the building.

The reduction of the figures from three to two may have been for reasons of cost. The relevant Honeyman & Keppie job books reveal a remarkable range of quotations for the carver work, and the presumption must be that McGilvray & Ferris's estimate of £100 was accepted because it was the lowest. Among the other bidders were Holmes & Jackson (£104), William Kellock Brown (£140), James C. Young (£150), Archibald Macfarlane Shannan (£350) and Johan Keller (£400). In the event, McGilvray & Ferris were paid an additional £10 for the inscription panel and £3 for corbels.[5]

Since 1959 the building has been occupied by the Royal Highland Fusiliers Museum, who replaced the Annan monograms which appeared in the middle bays of the third storey and upper gable with the middle letter of their own monogram and a trophy with crossed flags. A small display, with vintage photographs of the building at the time it was erected, is included in the Museum.

Condition: Good.

Notes
[1] Goldscheider, pls 128, 143. [2] William Buchanan, *The Art of the Photographer: J. Craig Annan,* Edinburgh, 1992, p.26. [3] Pamela Robertson, *Charles Rennie Mackintosh: the Architectural Papers,* Oxon, 1990, p.84. [4] William Buchanan (ed.), *Mackintosh's Masterwork: Glasgow School of Art,* Glasgow, 1989, p.24. [5] HAG, Honeyman & Keppie Job Books (1902–8), 20 August 1903, p.21, 18 March 1904, p.22.

Other sources
GCA, TD 1309 A: 525; AA, 1904[1], p.90 (ill.); BJ, 28 November 1906, p.263 (incl. ill.); Teggin *et al.,* p.56 (ill.); Williamson *et al.,* p.243; McKean *et al.,* p.145 (incl. ill.); D.W.L. Jameson, *John Honeyman and his Practice,* unpublished thesis, GSA, 1993; McKenzie, pp.79, 81 (ill.).

520 Sauchiehall Street

Two Caryatids, Allegorical Figure of Harmony and Colossal Bust of Beethoven

Sculptor: James Alexander Ewing

Architects: Bruce & Hay
Date: 1897–8
Material: red sandstone
Dimensions: all figures larger than life-size
Listed status: category B (15 December 1979)
Owner: Romano Wines Ltd

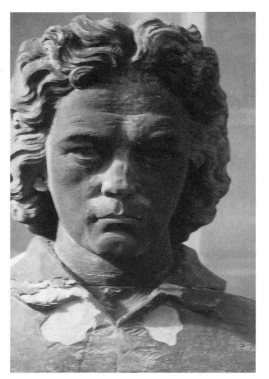

James A. Ewing, *Beethoven* [RM]

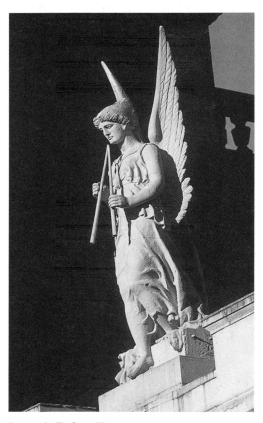

James A. Ewing, *Harmony*

Description: The caryatids are at either end of the first floor and are shown holding torches; the figure on the right also holds a lyre. *Harmony* is in the centre of the attic storey, and is presented as a free-standing, winged female striding forward with a pair of slender pipes held to her lips. The bust of *Beethoven* is above the entrance to the rear of the premises, at 341 Renfrew Street.

Discussion: The building was designed as a warehouse for the piano and organ dealer T.A. Ewing, and was originally called The Velvet Rooms; it was also popularly referred to as The Ewing Galleries, possibly in acknowledgement of its immediate neighbour, T. & R. Annan & Sons (see above). The architects' plans show the words 'PIANOS' and 'ORGANS' inscribed on the parapet on either side of *Harmony*, with 'T.A. EWING' above the first floor; whether these appeared on the building is not known. According to legend, the bust of Beethoven was placed at the rear of the building so that all the instruments entering or leaving the warehouse had to pass beneath it.

In 1913 the building was taken over by the Vitagraph Electric Theatre Ltd, who commissioned James Fairweather to convert it to the King's Cinema Theatre; it was later renamed the Curzon Classic.

Condition: The much-butchered façade is a sad remnant of the original design, which had a row of richly ornamented Ionic columns *in antis* between the caryatids. Fortunately the figures themselves have survived the successive alterations to the building, though they are all badly worn, particularly the left hand caryatid, which originally held a pipe organ. All three have been insensitively painted, and the torches of the caryatids are now fitted with electric lamps. The bust of Beethoven is in good condition, apart from some minor spalling.

Sources
GCA, TD 1309 A:137, TD 1320; Stewart (1997), p.82 (incl. ill.); McKenzie, pp.79, 81 (ill.).

Albany Chambers, 528–34 Sauchiehall Street

Statue of Britannia and Associated Armorial Reliefs
Sculptor: not known

Architects: Burnet Son & Campbell
Date: 1896–9
Material: red sandstone
Dimensions: figure larger than life-size
Inscriptions: on a shield between the third and fourth floors – ERECTED / 1897 / THE 60TH YEAR OF / QUEEN VICTORIA'S / REIGN; on the pediment over the central doorway – ALBANY CHAMBERS
Listed status: category A (15 December 1970)
Owner: Stakis PLC

Description: Britannia is placed in a shell niche at the apex of the main gable, and carries a

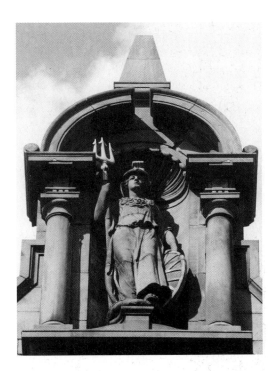

trident with bronze prongs. The patriotic theme is continued in a pair of shields bearing lions rampant in the space below the niche, and in the armorial shields decorating the subsidiary gables.

Discussion: The building, a five-storey commercial and domestic block, was designed as an extension to Charing Cross Mansions (see next entry). The architects' plans, dated 1896, show a number of sculptural details that were not carried out, including a pair of cherubs flanking a cartouche on the second floor and seated figures on either side of a broken segmental pediment over the entrance.

Condition: Good.

Sources
GCA, B4/12/1/5344; Williamson *et al.*, p.244; McKean *et al.*, p.145; McKenzie, p.80.

Sauchiehall Street CHARING CROSS

Charing Cross Mansions, 540–6 Sauchiehall Street / 2–30 St George's Road / 357–9 Renfrew Street

Figurative Programme
Sculptor: William Birnie Rhind

Architect: John James Burnet
Date: 1889–91
Material: red sandstone
Dimensions: figures colossal
Inscriptions: see below
Listed status: category A (15 December 1970)

Owner: not known

Description: The sculpture programme is concentrated on the centre bays of the building's convex façade and consists of five pairs of figures distributed in a symmetrical formation around a large clock face. At the base is a broken segmental pediment (which originally formed part of the central door frame) enclosing a Glasgow coat of arms. The arms are placed on an elaborate cartouche incorporating a circular band inscribed 'LET GLASGOW FLOURISH', and surmounted by a

half-length *St Mungo* rising from the battlements of a miniature castle. Richly detailed garlands flow down from the sides of the cartouche and extend horizontally in a sinuous band along the lower cornice of the entire central section. The upper part of the cartouche rises between a pair of reclining putti, which reach down to support the exposed corners of a tasselled drape passing behind the cartouche. Immediately above the putti are full-length standing female figures with attributes suggestive of *Spring* (a garland of flowers, left) and *Autumn* (a sheaf of corn and a sickle, right).

Sauchiehall Street 349

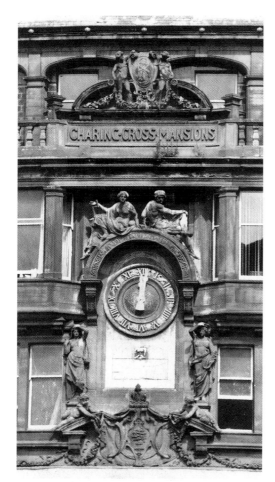

William Birnie Rhind, *Figurative Programme*
[RM]

Each is naked to the waist and raises an arm to remove her head covering, which in the right hand figure is a distinctive wide-brimmed hat. In their postures and their proximity to the oriel windows above them they resemble caryatids, though they are not in fact load-bearing. At a slight remove from the main scheme, but still at first-floor level, is a further

pair of female figures. These are represented in crouching poses and are supported by slender colonettes rising from the ground floor. The figure on the right is hooded and has her eyes cast down; her counterpart on the left looks up and holds an inverted pitcher on her shoulder.

On the second storey an arched canopy supported by corbels and framed by a pair of canted oriel windows dominates the centre bay. A bronze clock fills the central space, the Roman numerals of its outer disc alternating with the signs of the Zodiac. In the centre of the plain expanse of marble below the clock is a small bearded male mask, possibly Father Time. Above the clock, the space between the canopy and the attic entablature contains a pair of recumbent male and female figures emblematic of *Industry* (right, with hammer and cog-wheels) and *Commerce* (left, with dough paddle).

The upper stage of the scheme begins with a large inscription 'CHARING CROSS MANSIONS' on a panel inserted into the attic balustrade, above which is a second broken pediment, festooned with garlands and containing a pair of standing youths supporting a cartouche. This bears the monogram 'RS&S' in entwined letters raised against a gilded background. A lion sejant holding a monogrammed shield on a two-stage pedestal rising from the roof caps the scheme.

Other minor details include a pair of monogrammed shields (identical in design to those already described, but with more complex floral surrounds) on either side of the central canted windows on the second floor; shields with alternating datestones ('1888' and '1890', entwined) on all dormer windows; gilded lion masks in the upper cornices (curved sections only); shields with the single letter 'S' in the iron parapets on all pavilion roofs; an inscription 'CHARING + MANSIONS' on the attic of the corner turret on Renfrew Street.

Discussion: The building was erected as a combined commercial and domestic development for the merchant Robert Simpson,

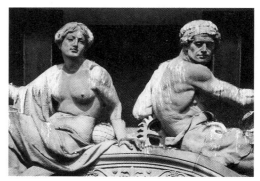

William Birnie Rhind, *Figurative Programme*
(detail) [RM]

who, despite the ubiquity of his company monogram ('RS&S'), does not appear to have occupied any part of the building himself.[1] In its design it is a direct outcome of J.J. Burnet's training at the École des Beaux Arts in Paris, with many of its key features – including the end pavilions, the audacious three-stage tower and the extensive use of decorative ironwork on the roof – inspired by the Hôtel de Ville in Paris. It was also one of the first buildings in Glasgow to take advantage of the improved transport that allowed red sandstone to be imported in quantity from southern Scotland, exploiting the richness of the new material in the undulating balustrades, ornate dormer windows and other details which animate its spectacular convex frontage.

The choice of 'Charing Cross Mansions' as the name of the building was fiercely criticised at the time of its erection. The correspondent of *Building Industries*, for example, observed condescendingly that to

… thus lug into Glasgow domestic nomenclature the name of a London centre (reasonably enough so called after the village of Charing which stood there before London had stretched so far west) is not at all in good taste…

The same writer was equally critical of the sculpture programme:

Some may be of the opinion that there has been rather an overloading of ornament at the Sauchiehall Street rounding, and most will condemn outright the fantastic something which at this point, and in much insane wriggling and convolution, struggles aloft into the smoke.

Conceding, however, that 'tastes may differ on these points', he goes on to pronounce the building as a whole to be 'a credit to the designers'.[2]

While it is safe to assume that the principal lines of the 'insane wriggling' were determined by Burnet, it seems equally likely that Rhind himself was allowed a degree of freedom in his treatment of the figures in detail, particularly in their poses. Of special interest are the reclining figures on the arch above the clock, which, like the pediment figures he carved for William Leiper's contemporary Sun Life Building (q.v., 117–21 Renfrew Street), are strongly reminiscent of the celebrated nudes symbolising *Night* and *Day* on Michelangelo's Medici Tomb in Florence (1520–34).[3] References to the work of Michelangelo are, of course, commonplace in architectural sculpture at this time; the same arrangement is used several times on the Hôtel de Ville itself, and Mackintosh was to make a similar borrowing on his design for the nearby Annan studio a few years later (see above, 518 Sauchiehall Street). In this case, however, the pose of the male figure, with its distinctively entwined limbs and the dynamic opposition of the head and the upper torso, seems particularly indebted to the great High Renaissance prototype.

While it is true that these and many of the other figures on the façade are individually very fine, the real strength of the scheme lies in its coherence as an ensemble. In the arrangement of their limbs and draperies, the six central figures are linked in a pattern of eloquent formal connections, creating a rhythmic continuity that not only surrounds the clock but also subtly imitates the circular motion of its hands. It seems likely, moreover, that the clock provides a key to the more thematic concerns that underpin the design. The resemblance of the upper figures to Michelangelo's *Night* and *Day* has been noted, and although in this case the imagery is very different, the theme of contrasting times of day is clearly evoked in the crouching female figures in the outer bays, one of which raises her face to the sky, while the other withdraws under a deeply shaded hood. Significantly, these figures face east and west respectively. The notion of the cyclic passage of time is repeated in the reference to spring and autumn already noted in the standing female figures, where once again the stress is on the beginning and the end of a temporal process. In the absence of any documentary evidence such an interpretation must remain conjectural, but it is at least plausible to assume that a reflection on the meaning of time played a part of the architect's thinking when he designed the figurative scheme encircling a clock face inscribed with the signs of the Zodiac.

Condition: The principal figures are liberally coated with birdlime and the fingers of St Mungo have broken off. The most serious damage has occurred on the lower putti, where the weather has created patterns of deep erosion along the grain of the sandstone.

Notes
[1] Alison White, 'Charing Cross Mansions', unpublished dissertation, GSA, 1992, p.5. [2] Tubal-Cain, 'Notable New Buildings in Glasgow', BI, 16 June 1890, p.58. [3] See Goldscheider, pl.180.

Other sources
BI, 16 April 1890, p.22; AA, 1891, p.74 (ill.); B, 9 July 1898, p.25; Young and Doak, no.107 (incl. ill.); Gomme and Walker, pp.95, 196 (ill.), 202, 204–5; McKean *et al.*, p.144 (incl. ill.); Williamson *et al.*, p.244; Nisbet, p.521; McKenzie, pp.80–1 (incl. ill.).

Cameron Memorial Fountain and Clock Tower, at the junction of Sauchiehall Street and Woodside Crescent

Portrait Medallions of Charles Cameron and Associated Decorative Work

Sculptor: George Tinworth

Architect: Robert Bryden (of Clark & Bell)
Date: 1895–6
Inaugurated: 24 October 1896
Materials: bronze (portrait medallions); Doulton terracotta and Peterhead granite (main structure)
Dimensions: fountain 8.2m high; portraits life-size
Inscriptions: on panels below the drum – IN HONOUR OF / SIR CHARLES CAMERON. BART. D.L.LL.D. / IN RECOGNITION OF / HIS MANY SERVICES TO THIS CITY / AND TO SCOTLAND / DURING 21 YEARS IN PARLIAMENT / 1874 1895 (north and south sides); ERECTED BY / PUBLIC SUBSCRIPTION / 1896 (east and west sides)
Listed status: category B (20 May 1986)
Owner: Glasgow City Council

Sir Charles Cameron (1841–1925), newspaper editor and politician. Born in Dublin, son of the newspaper proprietor John Cameron, he was educated at Madras College, St Andrews and Trinity College, Dublin, where he graduated in medicine in 1862. He went on to study medicine in Paris, Berlin and Vienna. He was editor of the *North British Daily Mail* in Glasgow, 1864–74, and was also managing director of the *Weekly Mail*. A radical Liberal, he was MP for Glasgow, 1874–85, the College Division, 1885–95 and, after losing his seat to Sir John Stirling-Maxwell, returned as a member for Bridgeton, 1897–1900. He was one of the leaders of the Temperance Movement, and brought in acts for abolishing imprisonment for debt in Scotland, municipal

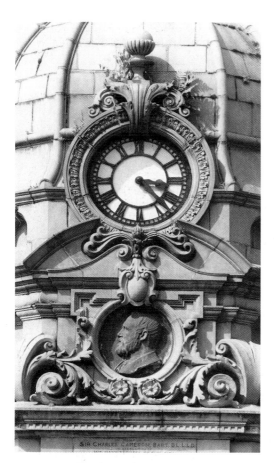

franchise for women and reforms of the Scottish Liquor Laws. Created a Baronet in 1893, he retired from politics in 1900 and spent his later years in Surrey.[1]

Description: A two-stage structure in an exuberant Baroque style, with large volutes projecting from the subsidiary faces, bulbous attached colonettes, vaulted interior and ogee dome. The profile portrait medallions, which are identical, are on the north and south sides of the drum beneath the dome.

Discussion: The fountain was erected as the concluding part of a two-stage tribute to Cameron, following the presentation of a full-length portrait by Joseph Henderson in the Corporation (now McLellan) Galleries on 26 November 1895.[2] An immensely popular and successful politician, Cameron was present at the inauguration with his wife Lady Cameron, who turned the water supply on with a gilt and silver key decorated with the Cameron arms. The key was designed and made by the silversmiths R. & W. Sorley, of Buchanan Street. The fountain itself was designed jointly by Robert Alexander Bryden, working for Clarke & Bell, and a Mr Lightbody, of Doulton & Co.[3]

George Tinworth, *Portrait of Charles Cameron*

Condition: The medallions are in good condition, as is the fabric of the tower, apart from some minor damage to the surface. However, the structure as a whole is tilting badly. A report by the City Council's Director of Architecture in 1995 determined that the top of the monument had moved from 8.72 inches to 10.5 inches 'off plumb' between 1926 and 1985, with no further movement since that date. The monument was therefore judged to be stable.[4] A proposal to restore it to an upright position at a cost of £15,000 is currently being assessed. The clock was replaced in June 1908 by James Ritchie & Co., Edinburgh,[5] and the water has since been disconnected.

Notes
[1] GCA, M.P. 27, pp.193–200 (cuttings from NBDM); GCCJ, August 1982, p.254, September 1982, pp.294–5. [2] NBDM, 27 November 1895, p.2. [3] NBDM, 26 October 1896, p.4. [4] Unpublished reports and correspondence, GCA, Department of Architecture and Related Services, 20 February, 11 April 1995. [5] BI, 15 June 1908, p. 45.

Other sources
AA, 1896[1], p. 90 (ill.); BA, 20 March 1896, p.201 (plus ill.); B, 9 July 1898, p.25; Eyre-Todd (1909), p.32; *West End News*, 15 February 1974, p.1, 22 March 1974, p.7; Atterbury and Irvine, p.89; Williamson *et al.*, pp.283–4; *Glaswegian*, 2 February 1995, p.9; *Bulletin*, May 1995, p.5; Hunter, p.70; Gilbert T. Bell, 'Springburn's ornamental column: a monument that moved', *Springburn News*, April 1998, p.7; McKenzie, pp.84 (ill.), 85.

Scott Street GARNETHILL

On Garnethill Convent Nursery, 45 Scott Street

Charity

Sculptor: not known

Architect: James Sellars (of Campbell Douglas & Sellars)
Building opened: 20 December 1882
Material: yellow sandstone
Dimensions: whole panel 1.3m × 3.04m; central roundel 1.05m diameter
Listed status: category B (21 July 1988)
Owner: St Aloysius College

Description: Located above the entrance on the building's east façade, the work consists of a rectangular relief panel incorporating a medallion of a half-length mother and child, with pairs of gambolling amorini in adjacent panels.

Discussion: The main part of the building was originally a private villa belonging to the merchant David Anderson. In 1880, in fulfilment, apparently, of a proposal, made in 1861 to 'put an end to a sort of disgrace which has been attached to the city of Glasgow in not housing a childrens' hospital amidst this vast population', the house was purchased for £2,000 and converted to the Sick Children's Hospital.[1] There was some opposition, not only from local residents, but also from some parts of the medical profession, on the grounds that a hospital devoted to children would involve the 'necessity to admit mothers along with their children'.[2] After much fund-raising and campaigning, however, the project eventually went ahead. The stated purpose of the hospital was to

... provide treatment for children of the poor suffering from non-infectious diseases or

accidents and to set up a dispensary for advice and medicine; to 'promote the advancement of medical science with reference to the diseases of children' and provide instruction for students and, finally, 'to diffuse among all classes of the community, and chiefly among the poor, a better acquaintance with the management of children during illness, to educate and train

women in the special duties of children's nurses, and to instruct lady pupils in the care of sick children'.[3]

The cost of converting the villa, which included the addition of the section with the relief, was £12,510.[4]

Related work: An identical relief of a mother and child, though without the amorini, is on the former Sick Children's Dispensary, now part of

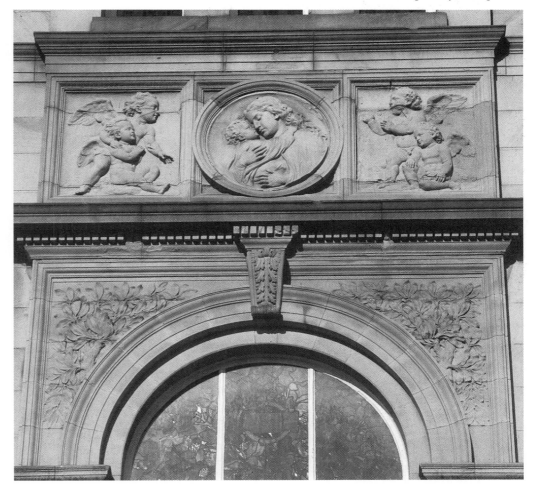

Anon., *Charity* [RM]

the Barnes Building of Glasgow School of Art, 9–13 West Graham Street (q.v.).

Condition: Generally fair, though there is some erosion, and a coat of white paint was recently removed.

Notes
[1] Edna Robertson, *The Yorkhill Story: the History of the Royal Hospital for Sick Children, Glasgow*, Glasgow, 1972, pp.9, 21. [2] *Ibid.*, p.17. [3] *Ibid.*, p.26. [4] *Ibid.*

Other sources
BN, 29 December 1882, p.830; BA, 8 August 1888, p.96; B, 9 July 1898, p.27; Williamson *et al.*, p.269.

Springburn Park SPRINGBURN (BALGRAYHILL)

The park was formed in 1892 from 52 acres of land acquired by Glasgow Corporation. A further 15 acres were added in 1904, when Mr (later Sir) Hugh Reid purchased the lands of Cockmuir and presented them to the city. Reid and his three brothers, all partners in the locomotive firm Neilson, Reid & Co., contributed £10,000 towards the erection of, amongst other buildings, the park's (now derelict) Winter Garden in 1900. Their father, James Reid, had earlier gifted an ornate cast-iron bandstand, which stood on the site now occupied by the *Ornamental Column* (q.v.). Manufactured by Macfarlane's Saracen Foundry, it was removed *c.*1970.[1]

At the east end of the main cross-walk

Monument to James Reid of Auchterarder

Sculptor: William Goscombe John

Date of unveiling: 3 October 1903
Materials: bronze figure and reliefs on a grey granite pedestal
Dimensions: statue approx. 2.3m high; pedestal 2.94m high × 2.15m × 2.15m at base; side panels 82cm × 56cm; main tablet and rear panel 33cm × 67cm
Signatures: on left edge of plinth – W. GOSCOMBE JOHN A. R. A. / 1903; on lower right fillet of each of the side panels – W.

GOSCOMBE JOHN
Inscriptions: on the front (west) face of the pedestal – JAMES REID / OF / AUCHTERARDER / AND THE / HYDE PARK / LOCOMOTIVE WORKS / BORN -1823 / DIED – 1894 / ERECTED BY PUBLIC SUBSCRIPTION / 3RD OCTOBER 1903; on the rear (east) panel – LET / GLASGOW / FLOURISH / DEAN OF / GUILD / GLASGOW / 1893–1894 / DUCE DEO / MERCE / BEATI (trans.: 'With God as leader, business will be blessed'); on the right (south) panel – PRESIDENT / ROYAL GLASGOW / INSTITUTE OF FINE / ARTS 1891–1894; on the left (north) panel – PRESIDENT / INSTITUTION OF / ENGINEERS AND / SHIPBUILDERS IN / SCOTLAND 1882–84
Listed status: category B (12 November 1989)
Owner: Glasgow City Council

James Reid (1823–94), proprietor of the Hyde Park Locomotive Works, Springburn. Born at Kilmaurs, Ayrshire, he was a blacksmith's assistant before moving to Greenock, where he worked first as an engineer with Scott, Sinclair & Co., and later with Caird & Co., with whom he became chief draughtsman in 1850. In the following year he became manager of the Hyde Park Locomotive Works, then at Anderston in Glasgow, later buying the company from Walter M. Neilson after it had moved to Springburn. Under his energetic leadership the company was vastly expanded, employing 2,500

workers and producing around 200 locomotives per year in the 1890s. A local benefactor, he donated funds for the erection of the bandstand in Springburn Park, and served on the committees of several institutions, including Springburn School Board. He was elected Lord Dean of Guild in 1893, President of the Institute of Engineers and Shipbuilders in Scotland in 1882, and served as a JP for the counties of Lanark and Perth. An enthusiastic patron of the arts, he was President of the RGIFA 1891–4, and amassed a fine collection of paintings, many of which were later presented to the city. He died while playing golf at St Andrews.[2]

Description: The subject is shown in a relaxed pose, with his advanced right foot placed on a slightly raised corner of the plinth and a partially unrolled sheaf of plans in his left hand. He wears a knee-length frock-coat, which is unbuttoned and tucked behind his right arm to reveal his waistcoat. The relief panels on the pedestal are decorated as follows: on the right (south) face, a draped female figure with a laurel crown seated in front of an Ionic colonnade and holding an inscription tablet (see above); on the left (north) face, a hooded female figure seated in front of a railway bridge and holding an inscription tablet; on the rear (east) face, a rectangular panel in three compartments superimposed on a wreath and featuring the symbols of the Glasgow coat of arms, a sailing

ship and an inscription (see above). The pedestal stands on a square paved area within a flower bed surrounded by a low iron rail.

Discussion: The campaign to raise funds for the monument to James Reid, widely regarded

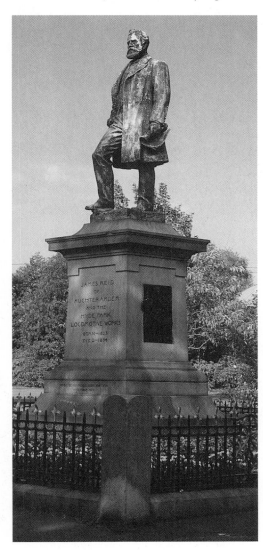

William Goscombe John, *James Reid* [RM]

as Springburn's greatest industrialist, was launched in October 1900, by the *St Rollox and Springburn Express*, and the unveiling ceremony was performed by ex-Lord Provost of Glasgow Sir James Bell.[3] A photograph taken at the time of the unveiling shows the statue without the flower bed or railing, both of which must have been added at a later date.[4]

Related work: Bronze maquette, *c*.1903, signed by John and inscribed 'sketch model for Reid statue', in GAGM (S.289).

Condition: Structurally sound, but the surface is irregularly patinated and mottled.

Notes
[1] Mark O'Neill, *Springburn Heritage Trail*, Glasgow, n.d., p.24; Gilbert T. Bell, *Springburn News*, April 1998, pp.7–8. [2] Stevenson (1914), p.46; Oakley (1946), p.82; Stevenson (n.d.), n.p. [3] Dr Gilbert T. Bell, *A Monumental Walk: the Sculpture and Monuments of the Springburn Area*, Glasgow, 2000, n.p. [4] Walter Gilmour, *Keep off the Grass!*, Glasgow, 1996, p.87.

Other sources
Fiona Pearson, *Goscombe John at the National Museum of Wales*, (ex. cat.), Cardiff, 1979, p.87; Read, p.364; Read and Ward-Jackson, 4/11/48–52 (ills); Andrew Stuart, *More Old Springburn*, Ochiltree, 1994, p.32; O'Neill, *op. cit.*, p.24.

In the centre of the park, at the intersection of the two main cross-walks

Ornamental column

Sculptor/designer: not known
Manufacturer: Doulton & Co.

Date: 1912
Materials: white Doulton terracotta; bronze (unicorn's horn)
Dimensions: approx. 9m high
Inscriptions: see below
Listed status: category B (12 November 1989)
Owner: Glasgow City Council

Description: The column is raised on a group of four volutes set at right angles to each other,

and has an elaborate Ionic capital decorated with female masks. Above the capital is a cubic block with chamfered edges supporting a unicorn sejant with its forelegs resting on a shield inscribed with a St Andrew's cross. On the lower part of the shaft of the column is a series of four ornamental shields bearing the names and emblems of the home nations – IRELAND (harp), SCOTLAND (thistle) and ENGLAND (rose) – and the arms of Glasgow.

Discussion: The monument as it exists today

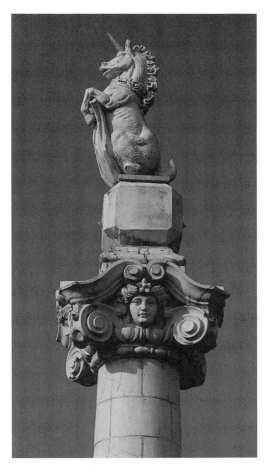

Doulton & Co., *Ornamental Column* (detail) [RM]

is only the upper part of a much larger structure, which was designed as a fountain and originally stood in Balgray Pleasure Park; both the park and the fountain were the gift of Sir Hugh Reid. The lower stage of the fountain consisted of a circular outer basin, above which was a series of smaller basins divided by buttresses decorated with large, water-spouting sea monsters. On the central drum supporting the column were four roundels containing portraits of Sir William Wallace, Robert the Bruce, Sir Walter Scott and Robert Burns, with a number of the classics of Scots engineering, such as the *Comet* and the steamship the *Clyde* depicted in small rectangular panels below them. The block supporting the unicorn also incorporated a weather vane. The fountain was dismantled *c.*1970, shortly before the Pleasure Park was built over, but what became of the bottom stage when it was re-erected in Springburn Park is not known.[1] It now stands on the site originally occupied by the cast-iron bandstand donated to the community by Sir Hugh Reid's father, James Reid (q.v., above).

Condition: Fair, but one of the capital masks is badly eroded and the tail of the unicorn is broken.

Note
[1] For a discussion of this, and speculation regarding the designer of the column, see Dr Gilbert T. Bell, *The Monument That Moved*, Springburn Museum Trust Information Sheet, no.3, Glasgow, 1999.

Other sources
O'Neill, *op. cit.*, p.24; Stuart (1998), p.109 (incl. ill.); Walter Gilmour, *Keep off the Grass!*, Glasgow, 1996, p.89 (incl. ill.).

In the Robert Innes Memorial Garden, at the north end of the park, near Belmont Road

Monument to Robert Innes
Sculptor/designer: not known

Date of inauguration: 10 July 1997
Material: steel
Dimensions: components actual sizes; backing plate 1.25m square
Inscriptions: on a plaque attached to the top left hand corner of the backing plate – THIS GARDEN IS / DEDICATED / TO THE MEMORY OF / LORD PROVOST BOB INNES / LORD PROVOST OF GLASGOW 1992–94 / OPENED BY MRS INNES ON 10TH JULY 1997 / GLASGOW CITY COUNCIL; on the locomotive wheel axle – 175023
Listed status: not listed
Owner: Glasgow City Council

A modest but highly unusual memorial, the sculpture is an assemblage of real locomotive components, including a bogey wheel with brake-block linkage and suspension spring, a section of railway track and a train buffer, all attached to a slightly tilted backing plate supported by two steel struts. Robert Innes was a respected City councillor whose 'brief tenure as Lord Provost was tragically cut short'.[1]

Description: The locomotive parts are painted black, the backing plate white.
Condition: Good.

Note
[1] Gilbert T. Bell, *A Monumental Walk: the Sculpture and Monuments of the Springburn Area*, Glasgow, 2000, n.p.

Anon., *Monument to Robert Innes* [RM]

Springburn Way SPRINGBURN

At the junction of Springburn Way and Kay Street

The Bringer
Sculptor: Andy Scott

Cast by: Allscot Plastics Ltd
Date: 1991
Materials: fibreglass figure on a brick pedestal
Dimensions: statue 2.15m high (to top of head); plinth 1.6m × 1.23m; pedestal 50cm × 1.88m × 1.51m
Inscription: on plaque on east face of the pedestal – THE BRINGER / BY / ANDREW SCOTT / CHANGE IN SPRINGBURN / 1991
Listed status: not listed
Owner: not known

Description: The recent recovery of Springburn from the post-war collapse of its main industries is symbolised here by a larger than life-size male figure sounding a trumpet raised high above his head. The figure is very squat in its proportions, with a pronounced muscularity in the treatment of the limbs.

Discussion: Scott's design was selected from six proposals submitted by members of Glasgow Sculpture Studios (then located at Hanson Street, in the City's east end) and was produced in the Studio for a total cost of £10,000. During the process of working up the design from the maquette the artist was asked to simplify the treatment of the genitals in order not to cause offence to passers-by. (See also *Locomotion*, 1967, by Frank Cossell, Port Dundas Street, for a similar adaptation of the male anatomy to conform to modern perceptions of public propriety.)

Condition: The fibreglass is treated with a chemical retardant which allows the sculpture to be easily cleaned when defaced or sprayed with graffiti. It was in fact necessary to remove a quantity of white paint, which had been poured over it within a month of its installation. There is some flaking of the surface, leaving a number of small patches of exposed fibres.

Sources
Information provided by Andy Scott; Dr Gilbert T. Bell, *A Monumental Walk: the Sculpture and Monuments of the Springburn Area*, Glasgow, 2000, n.p.

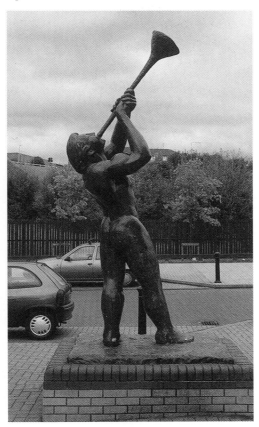

Andy Scott, *The Bringer* [RM]

In a paved seating area at the junction of Springburn Way and Cowlairs Road

Springburn Milestone: 'The Works'
Sculptor: Sibylle von Halem

Date of inauguration: 14 May 1993
Materials: red sandstone, brick and bronze
Dimensions: 44cm high × 21 cm × 1.68m (main section)
Inscriptions: on several of the bronze inlays – WORKS
Listed status: not listed
Owner: Glasgow City Council

Description: Constructed from architectural fragments salvaged from the demolished School Annexe at Morrin Street, the sculpture consists of a curvaceous main central section (mounted on bricks) surrounded by four isolated blocks (placed directly on the pavement). In the upper surface of the main section the artist has taken six moulded voussoirs which originally formed part of an arch, and reassembled them to create a serpentine line with subsidiary branches at either end. An examination of the sides of the components shows that this has been achieved by the simple device of laterally reversing the direction of alternate voussoirs. The resulting alignment of the moulded channels was intended to represent the 'sinuous curves of the railway line' indicated on maps of the Springburn Cross area. A certain amount of recarving was necessary to achieve this, and the stones have been partially sandblasted to produce a variety of surface textures. For the most part, however, the 'old, weathered surface' of the original stones has been preserved. In the outlying blocks the mouldings run vertically, and have their tops cut at an angle suggestive not only of randomness in the distribution of architectural fragments, but also 'the type of angle that a lectern might have'. The upper surfaces of the blocks are inlaid with bronze plates representing the area's major industrial

Sibylle von Halem, *The Works* [RM]

sites, principally the former railway works. The plates were cast from patterns made in plaster, using a sand-mould process, and the varied angles of the surfaces allow them to reflect the light in different ways throughout the day. The five elements of the sculpture are unified visually by a border of shaped paving blocks which follow the contours of the central section and link it with the outlying blocks in the manner of railway branch lines.

Discussion: The work was commissioned by Springburn & Possilpark Housing Association

Ltd, in conjunction with the Springburn Museum Trust and Elmvale and Balornock Primary Schools, with funding provided by the Foundation for Sports and the Arts, Glasgow District (now City) Council, the Scottish Arts Council and Strathclyde Regional Council. The sculpture was part of the 'Glasgow Milestones' project, initiated by Glasgow Sculpture Studios in 1990, which aimed to encourage collaborations between practising artists and local communities in the expression of their historical identity. In this case the stress is on the social and urban restructuring of the area brought about by the collapse of its railway and engineering works. In her published statement, the artist observed that

> Some of these works have of course disappeared altogether and the sites have been rebuilt to provide much needed housing; others still exist as buildings awaiting a change of function… The repetition of the word Works, so striking on some of the maps which were used in the formation of the final design, has been retained by inscribing it in the bronze inlays

– this is to identify the shapes, but also to draw attention to the phenomenal amount of work done there by the people of Springburn, past and present.

She also noted that before the development of the railway and other metalworking industries in the Industrial Revolution, many local residents worked as quarrymen and stonemasons, and that 'this layering of history is echoed in the way the bronze forms of the Works are superimposed on the much older stones'.

Condition: There is some surface algae and a little light graffiti.

Related work: For a full discussion of the 'Glasgow Milestones' scheme, and references to other works generated by it, see *Calvay Milestone,* Barlanark Road.

Sources
All quotations from *The Springburn Milestone,* booklet published to accompany the inauguration; Rae and Woolaston, figs 21, 32; Location map, *Milestones,* Glasgow Milestones, n.d. (1994); Dr Gilbert T. Bell, *A Monumental Walk: the Sculpture and Monuments of the Springburn Area,* Glasgow, 2000, n.p.

Springfield Court MERCHANT CITY

Adjacent to east entrance of the Glasshouse extension to Princes Square

As Proud As…

Sculptor: Shona Kinloch

Founders: Powderhall Bronze
Architects: Hugh Martin Partnership
Date: 1998–2000
Date of unveiling: 18 February 2000
Material: patinated bronze
Dimensions: figure 1.82m high; pedestal 91cm high
Listed status: not listed
Owner: Princes Square Consortium

Description: A naked man, standing on a cylindrical pedestal with his hands lightly clasped across his chest ('as if keeping a secret'), his head turned a little to the left. The subtle exaggeration in the anatomical proportions of the body, together with the unnaturally small facial features, lends the figure a gently caricatured quality. Behind him, and facing in the opposite direction, is a life-size peacock, its outspread tail merging with the upper part of the pedestal to form an elaborately incised surface pattern.

Discussion: The work was commissioned by the Princes Square Consortium as a 'percentage for art' component in their eastern extension of Princes Square shopping mall (q.v., 34–56 Buchanan Street). After studying Kinloch's earlier piece *Thinking of Bella* in the Italian Centre (q.v., 7 John Street), the clients felt that the 'scale, design and character' of her work was suitable for the new development and invited her to submit a proposal. A major requirement of the commission was that it should extend the 'Tree of Life' and 'Peacock' motifs used throughout the decorative work in and on Princes Square. The artist accordingly produced a number of designs exploring the combination of a figure with a tree and a peacock, including several with the tree or the bird balanced on the man's head. Her eventual choice was 'a heroic or proud-looking figure (as proud as a peacock?) standing 6' high with a peacock tucked under his arm', the peacock's feathers 'twisting around the man's middle' and merging into his legs. Further consultation with the clients led to some minor modifications to the design, as well as a decision to alter the location of the work from the north-west corner of the Glasshouse to a more prominent site at the east entrance, where it would be visible from Queen Street. Invoking the popular association of the peacock with ostentatious display, the sculptor explained that she 'thought it would be fun to play this against a male nude who certainly looks pretty chuffed with himself'.[1]

The total cost of the sculpture was £22,700, including a fee of £9,000 for the artist and foundry costs of £12,500. It was unveiled on 18 February 2000 by George Wyllie, whose *Caged Peacock* at 69 Queen Street (q.v.) was commissioned as part of the same scheme.

Condition: Good.

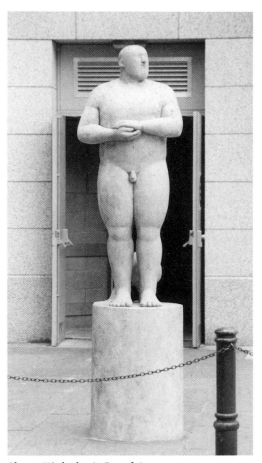

Shona Kinloch, *As Proud As …* [RM]

Note
[1] *ET*, 18 February 2000, p.15.

Additional source
All other quotes from the artist and details of the commission are from 'Glasgow: Springfield Court. The Glasshouse, Princes Square', unpublished report provided by Hugh Martin Partnership, 26 June 2000.

Royal (formerly National) Bank of Scotland, 22–4 St Enoch Square

Symbolic Figures and Associated Decorative Carving

Sculptors: Phyllis Archibald and Richard Ferris

Architect: Alexander Nisbet Paterson
Builder: Alexander Muir & Sons
Bronze-founders: J.W. Singer & Sons
Date: 1906–7
Materials: yellow sandstone; bronze
Dimensions: figures approx. 2.15m high
Inscriptions: below figures – EXCHANGE; SECURITY; PRUDENCE; ADVENTURE; on tablet in doorcase – IN PATRIAM FIDELIS (trans.: 'be faithful to your country')
Listed status: category B (15 December 1970)
Owner: Royal Bank of Scotland

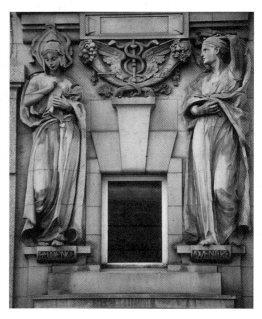

Phyllis Archibald, *Prudence* and *Adventure* [RM]

Description: Two pairs of full-length standing figures are placed in compartments above the side entrance and ground-floor window of the outer bays, and represent the four principal emblems of banking. From the left, these are: *Exchange* (holding a model ship); *Security* (a casket, with keys and chains above); *Prudence* (a scroll); and *Adventure* (attribute unclear). The space between each pair of figures is occupied by an identical decorative scheme comprising pairs of outstretched wings, crossed cornucopias and entwined snakes. Boldly designed swags in a similar style appear on the outer windows of the third and fourth storeys, and in the broken pediment above the central attic window. The bronze central doorcase also has some significant ornamentation, including an inscription tablet (see above), a set of armorial bearings and a series of square pateræ with repeated images of a sailing ship, St Andrew and a stook of corn.

Discussion: The four exterior figures have been described as the building's 'only concession to Glasgow tradition' in bank architecture.[1] Structurally they function as caryatids, and their placement on either side of the pink granite facing on the ground floor was intended to 'emphasise the Bank's portion of the premises',[2] the upper storeys of which were devoted to warehouses and offices. Their relatively low position was also noted at the time as having the 'additional advantage that they are seen from the street in much closer proximity than is usual'.[3]

The design and execution of the sculptural details were closely supervised by the architect, but contemporary sources are ambiguous on the question of how the modelling and carving tasks were divided between Phyllis Archibald and Richard Ferris. According to the *Building News*, 'Miss Archibald modelled the fine figures on the principal façade, while Mr. Ferris was responsible for the other ornamental sculpture'.[4] However, the caption accompanying an illustration of the building in *Academy Architecture* identifies the 'Ornamental Sculpture' as the work of Ferris.[5] On balance it seems likely that the six figures were modelled by Archibald and carved by Ferris, and that Ferris carved the ornamental reliefs from his own designs.

Related work: The interior of the main banking hall originally contained a pair of amorini by Archibald symbolising *Cash* and *Credit* reclining on the pediment above the fireplace.[6] The Royal Bank of Scotland has no record of when they were removed, but a coat of arms of the National Bank remains *in situ*.

Condition: The figures have suffered some minor physical damage, such as the loss of the left big toe on *Adventure*.

Notes
[1] John Booker, *Temples of Mammon, The Architecture of Banking*, Edinburgh, 1990, p.217. [2] BN, 26 August 1910, p.295. [3] *Ibid*. [4] *Ibid*. [5] AA, 1909[I], p.78. [6] ABJ, 28 November 1906, pp.254–5, 24 August 1910, pp. 185–6 (ills), 190; BN, 26 August 1910, n.p. (ill. to p.295).

Other sources
GCA, B4/12/2/1409; BJAE, 28 November 1906, pp.254–5 (incl. ill.); AA, 1907[II], p.89 (ill.), 1909[I], pp.78, 79 (ills); McKean *et al.*, p.52; Williamson *et al.*, p.200; McKenzie, p.65.

In St Enoch Underground Station

Chthonic Columns
Sculptor: Mark Firth

Date of installation: December 1996
Material: aluminium
Dimensions: 2.5m high × 84cm diameter at base

Signed: on exposed surface of base plate – MARK
FIRTH 96
Inscriptions: see below
Listed status: not listed
Owner: Strathclyde Passenger Transport
Executive

Description: Located in the station's main
concourse, between the entrance and the ticket
office, the work consists of a pair of 'classically
styled' columns set sharply off-plumb between
the floor and the ceiling. In overall appearance
the columns are reminiscent of giant barbells,
though the telescopic form of the bases and
capitals evokes associations with hydraulic
rams, and their isolated position in the low,
tunnel-like space of the concourse suggests a
role analogous to that of pit props. At any rate,
the skewed angle of their placement is intended
to recall the 'essential function of *support* in a
complex underground system, suggesting the
weight of earth above the traveller's head and
the responsibility that such underworld
columns carry'. In the column nearest the
entrance the main shaft has been replaced by a
beam of light shining from the underside of the
capital onto a polished plate on the upper
surface of the base. This is inscribed with an
encoded pictogram incorporating
diagrammatic, numerical and discursive
information relating to, among other things, the
engineering specifications used in the
construction of the underground railway
system. The reference to such tolerances as
'38/64ths of an inch' in the cross-section of the
railway track is intended to remind the viewer
of the precision required in engineering projects
of this kind.

Discussion: The piece was commissioned by
Strathclyde Passenger Transport Executive
(SPTE) to commemorate the centenary of the
opening of the Glasgow Underground system
in 1896, the third in the world after those in
London and Budapest. Funding was provided
by SPTE and Artworks for Glasgow, with the
commission managed by Art in Partnership.
Since its opening in the 1979, St Enoch
Underground Station, though much used by
the public, was felt to lack a visual focus. The
work was designed to provide the station with a
more distinct identity and a 'sense of place', in
the process creating a point of interest that will
'lift the individual out of the mundane rush to
work'. The title *Chthonic Columns* refers to the
'chthonic deities', inhabitants of the
underworld in Greek mythology.

Related work: David Mach's *Some of the
People* in Partick Underground Station (q.v.,
Merkland Street) was commissioned
simultaneously with *Chthonic Columns*.
Jointly, the two works were designed to
celebrate 'the two central characteristics of the
Underground: the technical achievement of
building it, and the people of the City of
Glasgow who use it'.

Condition: Good, but the light beam is no
longer functioning.

Sources
All quotations from Project Information Sheet
provided by Art in Partnership; McKenzie, p.65.

Mark Firth, *Chthonic Columns* [AP]

At the junction of St George's Road and Maryhill Road

St George and the Dragon
Sculptors: J. & G. Mossman

Date: 1897
Material: yellow sandstone
Dimensions: statue approx. 2m high; pedestal
 2.06m high
Inscription: on a red granite plaque on the base
 – ST. GEORGE AND THE DRAGON / PRESENTED
 TO THE PEOPLE OF GLASGOW / BY THE CO-
 OPERATIVE WHOLESALE SOCIETY LTD
Listed status: category C(S) (6 April 1992)
Owner: Glasgow City Council

Description: St George is shown in full armour thrusting a lance into the mouth of a dragon which writhes under the belly of the prancing horse, gripping the plinth with massive talons.

Discussion: The statue was commissioned from the Mossman firm by the Co-operative Wholesale Society in 1897 as the attic feature of their building at the junction of St George's Road and Gladstone Road. The building was demolished in the comprehensive redevelopment of St George's Cross in 1985, but the statue was salvaged from the wall head, carefully dismantled into twelve pieces and placed in storage on the Clydeside Quay.[1] In 1988, after a £250,000 restoration of the Cross by the Scottish Development Agency and Glasgow District (now City) Council, the statue was reinstated as a free-standing monument in the centre of a small landscaped area, surrounded by white-painted railings, and formally gifted to the people of Glasgow by the Co-operative Wholesale Society.[2] The original Co-operative Wholesale Society building was erected at a cost of £25,000, of which £100 was paid to the Mossmans for the statue.[3] Johnstone states that the statue was carved by Charles Grassby, working under contract for the Mossman firm, which by 1897 had been acquired by Peter Smith.

Condition: The lower part of St George's lance is missing and the nearside rein has become detached from the horse's mouth. There is also some spalling on the horse and the dragon has lost part of a claw.

Notes
[1] Moira Allison, 'When will St George go dragon-slaying again?', GH, 29 March 1986, p.9. [2] *Glasgow Guardian*, 29 April 1988, p.2, 15 November 1988, p.21. [3] Allison, *op. cit.*

Other sources
'Woodside Local Plan', unpublished consultative statement by J.H. Rae, Director of Planning, Glasgow, April 1986; Williamson *et al.*, p.306; Johnstone; Fisher, p.226; Stuart (1998), pp.10–12 (incl. ills); McKenzie, pp.99, 101 (ill.).

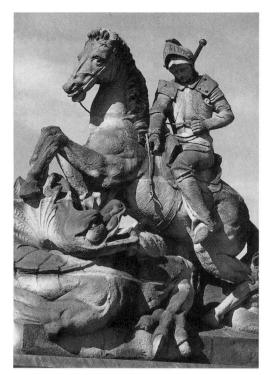

J. & G. Mossman, *St George and the Dragon*

Woodside Public Library, 343–7 St George's Road

Figurative Programme

Sculptor: William Kellock Brown (attrib.)

Architect: James R. Rhind
Builder: John Porter & Sons
Building opened: 10 March 1905
Material: yellow sandstone
Dimensions: main figure approx. 2.1m high; putti 1.22m high
Inscriptions: on the entablature – WOODSIDE PUBLIC LIBRARY; above the north door – BOYS AND GIRLS
Listed status: category B (15 December 1970)
Owner: Glasgow City Council

Description: This is the simplest and most refined of the seven district libraries designed by James Rhind for Glasgow Corporation. It is a single-storey structure in the High Renaissance style, with tall round-headed windows, coupled Ionic columns with stopped fluting and an attic balustrade. The main sculpture group consists of a free-standing female figure holding a book, with a youth and an infant crouching at her feet. She is dressed in a high-waisted garment of no specific period style, worn under a long gown of a type that has been associated with the learned professions since *c.*1600. In the segmental pediment below this there are three naked female figures, two reclining with their elbows resting on piles of books, the third rising from the centre with her hands on her head. The reclining figures have infants at their feet, one of which (left) reads from an open book. There are also two tall naked putti standing on either side of the oculus above the north entrance.

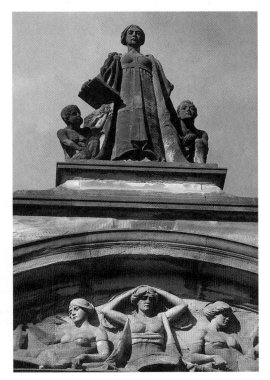

William Kellock Brown (attrib.), *Figure Group*

Discussion: The attribution to Kellock Brown is based on the similarity of the main figure group to that on Parkhead Public Library (q.v., 64–80 Tollcross Road). For a full discussion of this, together with information on the origination of the library scheme as a whole, see Dennistoun Public Library, 2a Craigpark.

Related work: The other libraries designed by Rhind and decorated by Kellock Brown are as follows: Bridgeton (23 Landressy Street); Govanhill (170 Langside Road); Maryhill (1508 Maryhill Road); Hutchesontown (192 McNeil Street).

Condition: There is extensive weathering in the pediment figures and the left arm of the infant in the main attic group is badly worn. A decorative panel flanked by crouching figures has been removed from above the main entrance.

Sources
BN, 13 February 1903, p.227; *Descriptive Hand-Book of the Glasgow Corporation Public Libraries,* Glasgow, 1907, p.55 (ill.); Williamson *et al.,* p.298; Stuart (1998), p.15 (incl. ill.); McKenzie, pp.99, 101 (ill.); information provided by Liz Arthur.

Former Church of St George's in the Fields, 485 St George's Road

Christ Feeding the Multitude

Sculptor: William Birnie Rhind

Architects: Hugh & David Barclay
Date: 1885–6
Material: yellow freestone
Dimensions: tympanum approx. 2.2m high × 9.2m wide
Inscription: on the frieze – SAINT GEORGE'S IN THE FIELDS
Listed status: category A (6 July 1966)
Owner: privately owned

Description: The relief is in the pediment above the hextastyle Ionic portico of the building's main frontage, and occupies the entire area of the tympanum. There are twelve figures, arranged in two groups flanking the central figure of Christ, who raises his right hand in benediction. Among the other figures are a number of elderly men, one of whom is seated with a walking staff, two mothers with young children and a semi-naked female figure reclining in the lower left corner. The group also includes a boy carrying what appears to be a basket, and a young man placing a loaf of bread in a satchel. More loaves appear on a small bluff of rock in the centre of the foreground, and there are two palm trees in the

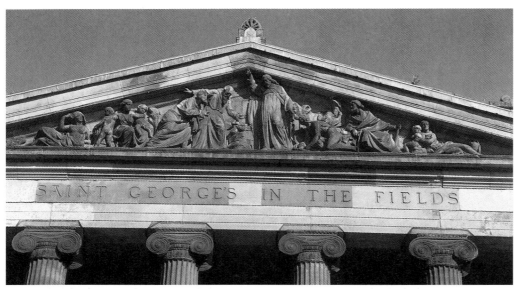

William Birnie Rhind, *Christ Feeding the Multitude* [RM]

Discussion: The miracle of the five loaves and two fishes is narrated in all four of the Gospels, but the most detailed is by Matthew.[1] Here the event is described as taking place in 'a desert place', but one which is sufficiently fertile to grow grass for the crowds to sit upon. On his arrival Christ performs the miracle of healing the sick before commanding his disciples to distribute the loaves and fishes among the crowd of some 5,000 souls. Rhind's

middle distance.

interpretation of the event is emblematic rather than literal, but there are many aspects of his composition that closely match the biblical source. The two cloaked figures to the left of Christ are clearly disciples, their gesticulating hands expressing both piety and amazement at the event they are witnessing. The bearded man seated on the right carrying a staff may well be a cripple restored to health, and the inclusion of two mothers with young offspring seems to be Rhind's response to the explicit mention by

Matthew of 'women and children' among the multitude.[2] Additionally, it is plausible to suggest that the boy carrying the basket refers to Matthew's statement that members of the crowd 'took up of the fragments that remained twelve baskets full'.[3] The scene is not without its irregularities, however. Though the loaves are prominently displayed there are no fish, and the presence of a sensually reclining classical female figure with naked breasts in the left hand corner is difficult to account for in theological terms. The building was converted to housing in 1989.

Condition: The relief has suffered extensive damage and is in a generally distressed condition. Many key details have been lost, including the whole of Christ's right hand, the face of the young man crouching on his right and the nose on the face of the stooping disciple. The masonry has also weathered very unevenly, and there is a thick layer of bird lime on several of the figures' heads.

Notes
[1] *Holy Bible*, Matthew, 14.13–21. [2] *Ibid.*, 14.21. [3] *Ibid.*, 14.20.

Other sources
'Modern architecture in Scotland, V – St. George's-in-the-Fields Church, Glasgow', BA, 25 January 1889, pp.78–9 (plus ill.); AA, 1894, p.78 (ill.); Young and Doak, no.109 (incl. ill.); Gomme and Walker (1968), pp.163, 165 (ill.); Worsdall (1982), pp.30–1 (incl. ills); Teggin *et al.*, p.70 (ill.); Williamson *et al.*, pp.60, 71–2, 298; McKenzie, pp.99–101 (incl. ill.).

Former Bank of Scotland Building, 2 St Vincent Place / 24 George Square / 2 Anchor Lane

Atlantes, Arms of the Bank of Scotland and Associated Decorative Carving

Sculptor: William Mossman Junior

Architect: J.T. Rochead
Date: 1867–70
Material: yellow sandstone
Dimensions: atlantes and female figures approx. 1.8m high
Inscriptions: on the shield – TANTO UBERIOR (trans.: 'sustained growth')
Listed status: category A (6 July 1966)
Owner: Portfolio Holdings Ltd

Description: This three-storey Italianate *palazzo* is the earliest of the group of three connected commercial buildings which now occupy the entire west side of George Square, and which were built to replace the plainer terraced hotels that previously stood on the site. The principal sculptural work is concentrated on the doorcase, and was described by John Tweed in 1872 in the following vivid terms:

> The boldest and most striking object in the building is the massive entablature over the St Vincent Place entrance. The ponderous masonry is supported by a pair of herculean Atlantes, which, with bowed heads, strained trunks, and wearied faces bent hopelessly to earth, testify to the success of the artist in his attempt to harmonise the attitude and expression of the figures to the vastness of the task imposed upon them. The figures comprise only the head, arms, and trunk; the arms are crossed over the bent head as if to give additional support, and the whole pose

of the group is exceedingly striking. These sculptures are from the studio of our townsman, Mr. William Mossman.[1]

Above the entablature is a Bank of Scotland shield enclosed in oak branches and capped by a cornucopia cascading coins. Seated on either side are two draped allegorical female figures, one of which (*Abundance*, left) holds a larger version of the cornucopia, the other, symbolising *Justice*, raises a set of scales (missing). This is the standard arrangement for a figurative group used by the Bank of Scotland on its more prestigious branches (see Related works, below). There are keystone masks in the lunettes of all 18 ground-floor windows, some

of which have mythological references, such as the helmeted figure on George Square inscribed 'TELEG'. Other decorative work includes: a shell lunette incorporating a keystone mask above the door; shell pediments on the ground- and first-floor windows; lion masks on brackets and panels containing floral swags, ribbons and blind inscription tablets under the upper cornice. The attic balustrade originally carried a series of festooned urns which have since been removed.[2]

The interior contains a series of twelve approximately life-size plaster caryatids attached to Corinthian pilasters below the ceiling of the former banking hall, with attributes including a cornucopia, a set of scales, a hank of yarn and a caduceus. There are also twelve male and female keystone masks in the intervening lunettes. William Mossman may

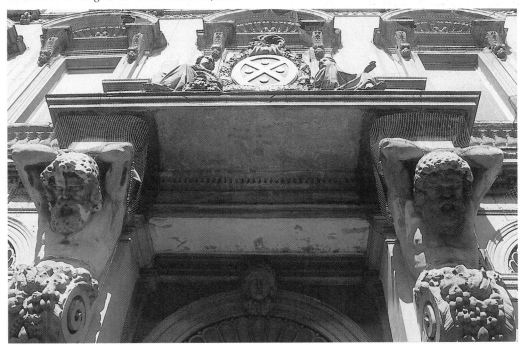

William Mossman Junior, *Atlantes* **and** *Armorial Group* [RM]

have executed this work.

Discussion: The atlantes were among the most admired pieces of architectural sculpture of their day. The correspondent of the *Building News*, for example, praised the 'rare excellence' of Mossman's work, describing the atlantes as 'remarkable for their expression of greatness and power'.[3] Thomas Gildard also spoke of how the 'grand massive treatment, the gigantic power, in the Atlantes of the doorway to the Bank of Scotland surprised us; we were proud that we had such a Glasgow artist'.[4]

Related works: Other Bank of Scotland buildings with fully sculpted crests are at 1–3 Bridge Street (*c.*1857), 235 Sauchiehall Street (1929–31) and 93 St Vincent Street (1924–6).

Condition: The atlantes and many of the keystone masks are very weathered. The building closed as a bank in October 1995, and is now in use as a bar and restaurant.

Notes

[1] Tweed (*Guide*), p.6. [2] See Lyall, p.34. [3] 'Gossip from Glasgow', BN, 5 June 1874, p.611. [4] Gildard (1892), p.5.

Other sources

Groome, vol.3, p.138; BN, 4 September 1874, p.298; B, 3 October 1874, p.826, 9 July 1898, p.22; *Bailie*, 21 October 1874, pp.1–2; BA, 11 April 1884, p.179; Gomme and Walker, p.157f. (incl. ill.); Hitchcock, *Early Victorian Architecture*, vol.1, pp.366–7; Read, p.366; Read and Ward-Jackson, 4/11/119–20 (ills); Williamson *et al.*, p.176; Woodward, pp.116–17; McKean *et al.*, pp.85, 89, 90 (incl. ills); LBI, Ward 25, p.141; McKenzie, pp.46, 47 (ill.).

Anchor Line Building, 12–16 St Vincent Place

Decorative Masks and Associated Carving

Sculptors: H.H. Martyn & Co. (modellers)

Manufacturers: Doulton & Co.
Architect: James Miller

Builders: Thaw & Campbell
Date: 1905–7
Material: Doulton Carrara ware terracotta
Dimensions: main masks larger than life-size; putti approx. 1.5m
Inscription: on a plaque on the Anchor Lane façade – CLYDESDALE / BANK PLC RESTORED 1994 / MACPHERSON AND BELL ARCHITECT / BINGDON BUILDERS LTD CONTRACTORS / IBSTOCK HATHERNWARE LTD SUPPLIER
Listed status: category A (15 December 1970)
Owner: Clydesdale Bank PLC

Description: A five-storey commercial building in an Edwardian Classical style, replete with maritime references. On the ground floor there is a large *Neptune* mask framed by seaweed, conches and a pair of naked putti riding sea monsters in the pediment over the main entrance and a pair of masks of *Mercury* above the windows on either side. The latter have tiny sphinxes on the crown of their helmets. The side entrances have blind cartouches on the entablatures and floral work on the lintels and architraves. A balcony running the full width of the façade on the second storey is decorated with a series of gilded square and octagonal relief panels containing anchors entwined with rope, the symbol of the Anchor Line Company, and the monograms 'AL', 'AD' and 'LD', as well as a number of small gilded pateræ. The central section of the balcony is supported by brackets carved with blind shields and small masks. On the under-side of the upper entablature are three roundels filled with floral work, and the attic is finished with four urns. On the fifth floor of the Anchor Lane frontage there is a single window decorated with a pair of cherub masks, a blind shield and a number of swags.

Further allusions to the sea are incorporated in the decorative wrought ironwork, including wreaths enclosing anchors crossed with tridents and oars, and crested with sailing ships in the street-level railings, and anchors and harpoons

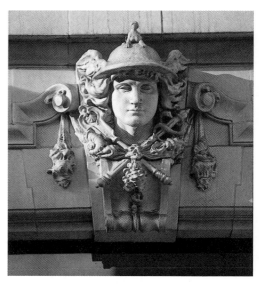

H.H. Martyn & Co., *Mercury*

in the entrance gates.

Discussion: The building was erected for Messrs Henderson Brothers Ltd of the Anchor Line Steamship Company. The finished structure differs in a number of details from Miller's plan, which shows a pair of colossal female figures reclining on the entrance pediment and ships' prows flanked by cherubs above the side doors.[1]

Condition: Very good. The building was restored in 1994 (see Inscription, above).

Note

[1] GCA, B4/12/2/1193.

Other sources

GCA, T-BK 136 (contract), AGN 637; BI, 16 May 1906, p.29, 16 March 1907, pp.178–9 (incl. ill.); BJ, 28 November 1906, p.274; B, 29 June 1907, p.787, 19 July 1935, p.131; AA[11], 1908, p.58 (ill.); Anon., 'The History of the Anchor Line', *The Syren and Shipping*, 28 June 1911, p.317; Frew, ch.2; Williamson *et al.*, p.232; McKean *et al*, p.91 (incl. ill.); Sloan and Murray, p.29; McKenzie, pp.60 (ill.), 61; LBI, Ward 25, p.142.

Allegorical Figures, Coats of Arms and Associated Decorative Carving

Sculptors: John Mossman, William Mossman Junior and Charles Grassby

Architect: John James Burnet
Date: 1871–4
Material: yellow freestone
Dimensions: main figures approx. 2.4m high
Inscriptions: on the Glasgow arms – LET
 GLASGOW FLOURISH; in the entrance lunette
 and burgh roundels (see below)
Listed status: category A (15 December 1970)
Owner: Clydesdale Bank PLC

Description: A three-storey commercial
building in the style of a Venetian *palazzo*, with
a rusticated basement, and clusters of pilasters
and columns in pairs and triplets in the two
storeys above. The sculpture is concentrated
chiefly in the asymmetrically placed entrance
bays. On the ground floor is a series of
roundels carved with the arms of the various
Scottish towns 'in which the chief offices of the
Banking Company are situate',[1] each enclosed
in naturalistic foliage. These are inscribed, from
the left: DUMFRIES (winged shepherd); AYR
(triple-towered castle); GREENOCK (three-
masted ship); DUNDEE (vase of lilies).[2] A pair of
similar roundels appears in the entrance bays, in
this case filled with busts surrounded by
thistles. The lunette above the main entrance
contains a sphere enclosed in a pair of wings
and decorated with foliage, a ribbon inscribed
'LITORE AD LITUS' (trans.: 'from shore to
shore'); a large mask of *Father Clyde* (by
Grassby[3]) in the keystone. In the narrow bays
flanking the window above the entrance are
relief panels containing full-length female
figures by William Mossman Junior.[4] These
represent, on the left, *Sowing* (with a lamb at
her feet) and *Reaping* (standing on a stook of

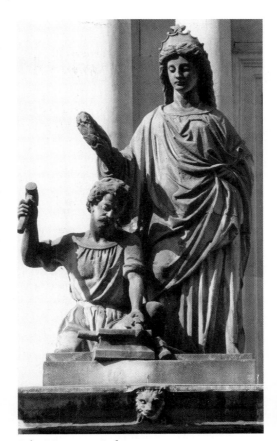

John Mossman, *Industry*

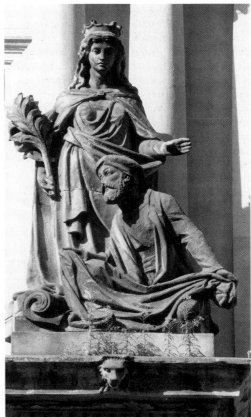

John Mossman, *Trade*

corn). Above these figures are smaller panels
filled with a bird (left) and a sailing ship (right),
both of which are enriched with foliage. On the
second floor are two free-standing figure
groups by John Mossman[5] denoting *Industry*
(left) and *Commerce* (right). Each consists of a
classically draped female muse overlooking a
seated male figure performing an activity
relevant to their symbolic meaning: the muse of
Industry holds a laurel wreath over the head of
a blacksmith; *Commerce*, holding an olive
branch, stands behind an oriental cloth vendor.

Between them is a broken segmental pediment
containing a Glasgow coat of arms. Above this,
on the attic storey, is a shell niche, a scrolled
pediment containing thistles, a blind cartouche
and a variety of ornamental swags and drapes.
Other decorative details include lion masks
inserted at intervals on the cornices of all three
floors and a series of urns on the attic
balustrade, variously capped with miniature
elongated domes and cone-shaped finials.

Discussion: Burnet was awarded the
commission to design the building as the head

offices of the Clydesdale Bank after being invited to compete with three other architects.[6] Described in the *Building News* in 1871 as 'the principal "event" of the season',[7] the building was erected at a total cost of £100,000.[8] Not all of Burnet's design was built, however, and the omission of the three easternmost bays accounts for the asymmetry of the façade.

Gomme and Walker describe the façade as 'Glasgow's most lavish display of ornamental Baroque stonework', but are not uncritical of Burnet's treatment of ornament:

> The energetic accumulation of detail lacks something of the sense of logic and purpose evident in the best work of the true Baroque period;… At any rate it is difficult not to feel that the choice and placing of the

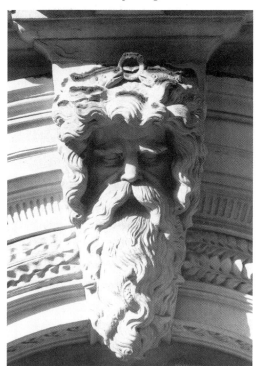

Charles Grassby, *Father Clyde*

ornament… is somewhat arbitrary: the decision to use this rather than that does not always seem to spring from a coherent principle: the building is perhaps better described as theatrical than dramatic.[9]

The tendency towards an over-use of ornament in Burnet's work of this period was also noted by contemporary commentators. The *Bailie*, for example, described him as 'more of a decorator than an architect' in this building, eschewing 'the large lines of the magnificent entablature of the Madeira Court warehouse [demolished] for petty prettiness of broken pediments [and] three-quarter columns'.[10]

Thomas Gildard's attribution of a series of 'bas-relief medallions on the offices of the Scottish Amicable Assurance Company' building opposite (q.v., 31–9 St Vincent Place) to William Mossman[11] may actually be a mistaken reference to the roundels on this building.

Condition: The building has been restored, but the thistles in the upper pediment are very weathered and the Glasgow motto is almost illegible.

Notes
[1] 'The new Clydesdale Bank in Glasgow', B, 13 June 1874, p.499. [2] With the exception of Dumfries, the symbols correspond closely to the descriptions provided in Urquhart. [3] Williamson *et al.*, p.232. [4] 'Men You Know – No.105', *Bailie*, no.105, 21 October 1874, p.1. [5] Gildard (1892), pp.2–3. [6] 'Gossip from Glasgow', BN, 3 February 1871, p.85. [7] *Ibid.*, 19 May 1871, p.393. [8] J.M. Reid, *The History of the Clydesdale Bank: 1838–1938*, Glasgow, 1938, p.163. [9] Gomme and Walker, pp.159–60. [10] Quoted, *ibid.*, p.159, n.9. [11] Gildard, pp.5–6.

Other sources
BN, 28 July 1871, p.76, 27 September 1872, p.240, 19 September 1873, p.325, 26 June 1874, p.711; B, 9 July 1898, p.22, 16 July 1898, p.65; Groome, vol.3, p.137; Read, p.366; Worsdall (1982), p.60, (1988), p.45 (incl. ills); Read and Ward-Jackson, 4/11/121–7 (ills); Charles W. Munn, *Clydesdale Bank: the first one hundred and fifty years*, London and Glasgow, 1988, pp.78–9; Teggin *et al.*, p.28 (ill.); McKean *et al.* pp. 89–91 (incl. ill.); McKenzie, p.61; Michael Smith (1999), p.618; LBI, Ward 25, p.144.

Commercial building, 31–9 St Vincent Place

Allegorical Female Figures, Putti and Associated Decorative Carving
Sculptor: William Mossman Junior

Architects: Campbell Douglas & Stevenson (original building); Frank Burnet & Boston (later additions)
Builders: Robert McCord & Son
Date: 1870–3; 1903–6
Material: yellow freestone
Dimensions: spandrel figures approx. 1.5m; first-floor putti approx. 90cm; upper-floor putti approx. 1.25m
Listed status: category B (15 December 1970)
Owner: The Clydesdale Bank Pension Fund

Description: A five-storey commercial building in the style of a Renaissance *palazzo*, with rusticated basement, Serlian windows on the three principal floors and corbelled oriels capped by segmental pediments in the floors above. The female figures are carved in relief in the spandrels flanking the arch of the central doorway and are both shown holding flowers and leaning on the voussoirs of the arch below. The pediment on the aedicule window on the floor above has a group of putti hauling fish on board a miniature Viking longboat. Further putti appear in the five pediments of the attic windows. These are seated in pairs on either side of blind cartouches, in some cases using the cornices of the broken pediments for what appear to be reading and writing activities. There is some repetition in their design. Other decorative work includes: the branches of various species of tree in the ground-floor spandrels (including, oak, palm, and mistletoe), some of which also have putti climbing through them, as well as masks and grotesques inserted into the scrollwork; floral carvings in roundels on the first and second floors and in the tympanum over the central window; leaf work

on the keystone over the main door.

Discussion: Campbell Douglas & Stevenson designed the building for the Scottish Amicable Assurance Company following their victory in a limited competition. The two upper storeys, which are in a slightly heavier Baroque style, were added by Frank Burnet & Boston in 1903–6. The scheme originally included three full-size statues representing *Truth* and *Justice* in niches flanking the central window on the second storey, and *Amity*(?) in an aedicule in the centre of the attic balustrade.[1] These were disposed of when the upper storeys were added, though it is not clear why the new work necessitated the removal of the statues in the second-storey niches. In his memoir of John Mossman, Thomas Gildard refers to William's 'bas-relief medallions on the offices of the Scottish Amicable Assurance Company', which he then goes on to discuss in the following terms:

> At his death a brief obituary notice was sent to a Glasgow newspaper, in which it was mentioned that the extreme delicacy of the medallions had the praise of no less able and severe a critic than [Alexander] 'Greek' Thomson; but the editorial judgement deemed that this was better – 'they were very generally admired'. Hamlet says something about the censure of one o'erweighing a whole theatre of others; and the press expects us to weigh being 'very generally admired' with the opinion of one no less able as an art critic than as an architect. There can scarcely be any greater 'damning with faint praise' of a work of sculpture than saying it has general admiration – the admiration of the ignorant and the vulgar.[2]

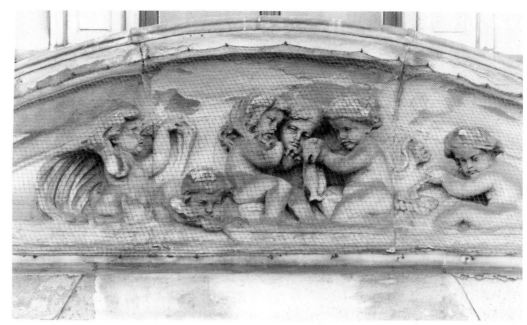

William Mossman Junior, *Putti*

There are, however, no medallions on the façade of the building, and it may be that Gildard has inadvertently confused this scheme with William Mossman's work on the Clydesdale Bank opposite (q.v., 30–40 St Vincent Place).

Condition: Overall very poor. The putti in the first floor and attic pediments are particularly worn and damaged. The building was restored in the early 1980s after a proposal to demolish it was abandoned due to a public outcry.

Notes
[1] Tweed (*Guide*), p.34, text and illustration. A late nineteenth-century photograph reproduced in Lyall, p.28, also shows the *Truth* and *Amity* in their niches. It has been suggested, however, that another vintage photograph in the collection of the Mitchell Library (VM: C8589) shows that the statues were in fact located on the attic (Nisbet, 'City of Sculpture'). Unfortunately the details are not sufficiently clear to confirm this beyond doubt, and on balance the evidence of Tweed and Lyall seems more reliable. [2] Gildard, pp.5–6.

Other sources
BN, 28 July 1871, p.76, 23 February 1872, p.150, 27 September 1872, p.240, 19 September 1873, p.325; BA, 11 April 1884, p.179; B, 9 July 1898, p.22; Read, p.366; Read and Ward-Jackson, 4/11/128–31 (ills); Teggin *et al.*, p.41 (ill.); McKean *et al.*, p.91; Williamson *et al.*, p.233; McKenzie, pp.58, 59 (ill.); LBI, Ward 25, p.140.

St Vincent Street CITY CENTRE

Commercial building, 78 St Vincent Street / West Nile Street

Phoenix Trophies

Sculptors and founders: Bromsgrove Guild of Applied Arts

Architects: John A. Campbell & Alexander D. Hislop
Builders: Thaw & Campbell
Date: 1912–13
Materials: Blackpasture stone and bronze
Dimensions: trophies approx. 2m × 2m
Inscriptions: in upper roundels of main doors – EST^D 1721; in lower roundels – PA C° (entwined)
Listed status: category B (15 December 1970)
Owner: Rosa Associates (Delaware) LP

Description: A tall, seven-storey commercial block in a severe neo-Classical style, with giant Doric columns on the basement and a heavily projecting cornice below the attic. There are three carved trophies, each consisting of a large phoenix rising with outspread wings from a still-life group of helmets, swords and other military objects. The largest of the three is attached to the corner above the ground-floor entablature, while the two smaller versions are at the ends of the two façades. Variations on the phoenix design appear in roundels on the bronze doors at the main entrance on St Vincent Street.

Discussion: The building was erected for the Phoenix Assurance Company, whose premises were on the ground and first floors. It was noted in the *Architects' and Builders' Journal* that 'the lower portion of the building [was] designed to emphasise the position occupied by the insurance offices'.[1] As executed, the reliefs differ from the sculpture programme indicated on Campbell & Hislop's drawings, which show only a rough sketch of a bird marked 'Phoenix Arms' in a panel above the entrance.[2] It seems safe to assume that the decision to include the trophies was made in collaboration with the Bromsgrove Guild itself.

Condition: Good.

Notes
[1] 'Phoenix Assurance Building, Glasgow', ABJ, 28 October 1914, p.273. [2] GCA, B4/12/1912/240.

Other sources
Young and Doak, no.170 (incl. ill.); Gomme and Walker (1987), p.295; Williamson *et al.*, p.233; McKenzie, pp.60 (ill.), 61.

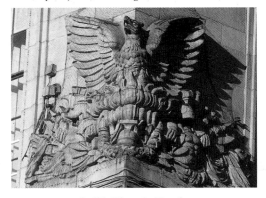

Bromsgrove Guild, *Phoenix Trophy*

Commercial building 81–91 St Vincent Street

Pediment Relief

Sculptor: not known

Architect: David Rhind (attrib.)
Date: *c*.1860
Material: yellow sandstone
Dimensions: putti approx. 90cm; masks approx. 25cm high
Listed status: category B (15 December 1970)
Owner: PAT (Pensions) Ltd/BBA Group Pensions Trustees Ltd/Cheltenham & Gloucester PLC

Description: A three-story *palazzo* derived from Michelangelo's Farnese Palace in Rome. The sculpture is confined chiefly to a single segmental pediment in the centre of the building, and shows a group of putti engaged in various maritime activities such as hauling bails of goods onto a boat and taking readings from a sextant. There is a line of seven male and female masks on the attic windows.

Discussion: The building has been attributed to David Rhind on the basis of its similarity to his Commercial Bank at 2–15 Gordon Street (1853–7, q.v.),[1] which also feature reliefs of children engaged in a witty parody of adult commercial activities. Stylistically, however, the figures are unlike those of John Thomas, who tends to depict children as miniature adults. The

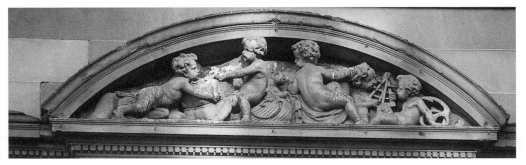

Anon., *Putti*

more infant-like treatment of the figures on this building is reminiscent of the work of John Mossman on Virginia Place (1855, q.v.) and his brother William at 31–9 St Vincent Place (1870–3, q.v.).

Condition: Good, though much begrimed with bird droppings.

Note
[1] Gomme and Walker, p.118.

Other sources
Teggin *et al.*, p.47 (ill.); McKean *et al.*, p.129 (incl. ill.); Williamson *et al.*, p.234; McKenzie, pp.60 (ill.), 61; LBI, Ward 18, p.148.

Former Bank of Scotland Chambers, 93 St Vincent Street / 20 Renfield Street

Arms of the Bank of Scotland and Associated Decorative Carving

Sculptor: not known

Architects: Balfour & Stewart
Date: 1924–6
Material: yellow sandstone
Dimensions: figures approx. 2m high
Inscriptions: below the shield – TANTO UBERIOR (trans.: 'sustained growth'); on the lintel above the Renfield Street entrance – RENFIELD HOUSE
Listed status: category B (22 March 1977)
Owner: Bass Leisure Retail

Description: A tall, six-storey commercial building, designed as the main Glasgow office of the Bank of Scotland. The armorial group is located in the broken segmental pediment over the main door, with *Abundance* (holding an inverted cornucopia cascading coins) on the left and *Justice* (bronze scales) on the right of a Bank of Scotland crest. A smaller version of the cornucopia is repeated above the crest. As part of the Bank of Scotland's corporate logo, the image of the coin (or 'bezant') appears in the interstices of the St Andrew's cross in the crest

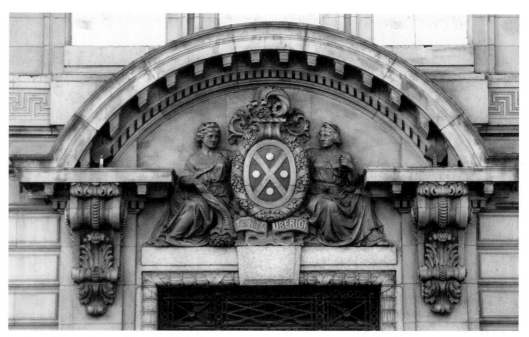

and as a decorative enrichment of the large brackets supporting the pediment. A number of shields with the St Andrew's cross appear in the pilaster capitals in the attic storey, and there are lion masks at either end of the richly carved garland on the cornice. All the minor decorative features are repeated on the Renfield Street frontage, which also has a lion mask with a wreath in its mouth in the keystone over the door.

Discussion: The main sculpture group on the doorcase follows the established formula used by the Bank of Scotland on its more prestigious branches, the earliest example of which in Glasgow is John Crawford's attic group at 1 Bridge Street (q.v.), dating from 1857. The present example is historically interesting because of its very late date, and the conservatism of its design in relation to the style of the building, which has been described as 'somewhat uncertain American classic'.[1] The treatment is in fact very closely modelled on

Anon., *Arms of the Bank of Scotland*

John Mossman's group at 2 St Vincent Place (q.v.), carved more than half a century earlier, with only minor modifications introduced in the posing of the figures to accommodate the slightly more constricted space of the pediment.

Related work: An example of the Bank of Scotland shield from the same period is by Benno Schotz at 235 Sauchiehall Street.

Condition: Good.

Note
[1] McKean *et al.*, p.139.

Other sources
Williamson *et al.*, p.234; McKenzie, pp.30–1, 46, 60–1 (incl. ills).

Commercial building, 105–13 St Vincent Street

Four Allegorical Female Figures and Associated Decorative Carving

Sculptor: not known

Architect: Frank Southorn
Date: 1911–12
Material: yellow sandstone
Dimensions: figures approx. 2.8m high
Inscriptions: see below
Listed status: category B (21 July 1988)
Owner: Scottish Mutual Assurance PLC

Description: The façade of this eight-storey block is articulated by a series of advancing and receding planes, punctuated by giant pilasters and short balconies. The figures are seated at the ends of the balconies and may be provisionally identified by their attributes as follows (from the left): *Security* (beehive at her feet, unidentified object in her hand); *Victory* (wreath); *Wisdom* (open book); *Abundance* (cornucopia). Minor decorative details include cherub masks in keystones over the entrance arches and the capitals of the giant pilasters; lion masks with wreaths in their jaws in the attic cornice. The inscription tablets above the three entrances are decorated with swags.

Discussion: The block was built as the head office of the Scottish Temperance Life Assurance Co. Ltd, which later changed its name to the Scottish Mutual Assurance Society. It was erected using 'the new Cage system, with a complete steel framework to support every part of the building', which allowed the architect to design it to 'the maximum height permitted under the Glasgow Building Act'.[1] Research has so far failed to reveal the identity of the sculptor, but the monumental treatment of the figures allows a tentative attribution to Albert Hodge.

Condition: Following a number of years of neglect, an extensive refurbishment programme was begun in 1999, involving the cleaning of the exterior stonework and the construction of an entirely new building behind the original façade. A number of bronze escutcheons and panels inscribed 'SCOTTISH MUTUAL ASSURANCE SOCIETY' were also removed at this time.

Note
[1] Mamie Magnusson, *A Length of Days: The Scottish Mutual Assurance Society 1883/1983*, London, 1983, p.97.

Other sources
BI, 16 January 1911, p.157; Magnusson, *op. cit.*, p.90 (ill.); Williamson *et al.*, pp.234–5; McKenzie, p.72.

131 St Vincent Street

Tree of Life

Sculptor: Alan Dawson

Date: 1997
Material: forged steel
Dimensions: 3.5m high
Owner: Hill Samuel Life Assurance Ltd

Description: A stylized representation of a tree on a plain stone pedestal located in the basement forecourt of the offices of Aon Risk Services. The trunk of the tree is a rigidly vertical column composed of alternating round and square-sectioned bars, slightly splayed at the base and opening above into a knotted arrangement of spiralling tendrils enclosing a core of angular blade-like forms. At the top of

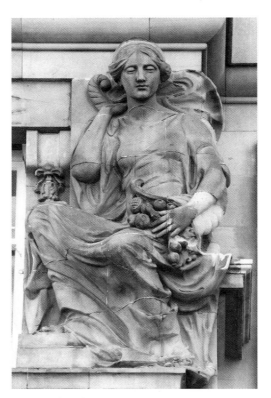

Anon., *Security*

Anon., *Abundance*

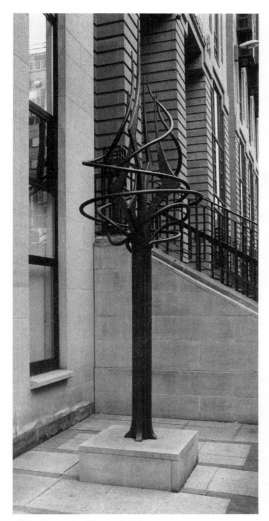

Alan Dawson, *Tree of Life* [RM]

the tree, the component bars are gathered into a cluster of sharply extruded points.

Discussion: The sculpture was commissioned by Keppie Design as part of the refurbishment of 131 St Vincent Street, implementing Glasgow City Council's 'percent for art' policy. The imagery reflects the artist's awareness of the importance of the tree in the Glasgow coat of arms, as well as his belief in the affinity between heated metal and the organic forms of nature. Stylistically reminiscent of Art Nouveau, the fluid linearity of the components of the tree embodies the contemporary approach to blacksmithing as a process of 'drawing in three dimensions'.[1] After being forged by hand, the sculpture was galvanised and coated with black paint.

Related work: Alan Dawson has produced variations of the 'Tree of Life' theme for several clients, including the Pasta House Restaurant in Whitehaven, Cumbria.[2] See also Princes Square, 34–56 Buchanan Street.

Condition: Good.

Notes
[1] John Creed, quoted in Chatwin, p.66. [2] *Ibid.*, pp.93–5.

Other sources
Information provided by the sculptor; Rodger, pp.71–2; McKenzie, pp.72–5 (incl. ill.).

Commercial building, 188–92 St Vincent Street

Allegorical Figure of Justice
Sculptor: not known

Architects: Frank Burnet & Boston
Date: 1897
Material: red Locharbriggs sandstone
Dimensions: figure colossal
Inscription: on the datestone – '1897' (entwined)
Listed status: category C(S) (21 July 1988)
Owner: City Site Investments Ltd

Description: The façade of this three-storey building is divided into two bays, one with an oriel window and attic gable, the other with a strongly accented doorcase framed by detached columns and topped by a broken scroll pediment. *Justice* is represented as a classically

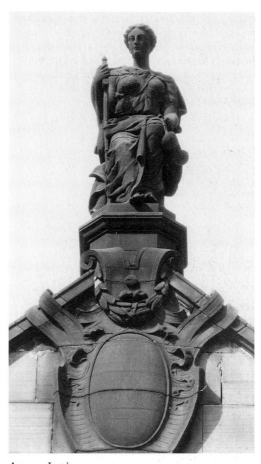

Anon., *Justice*

draped female figure seated at the apex of the gable and holds a sword in her right hand and a set of scales in her left. Minor decorative details include blank cartouches above all three windows in the oriel and the first-floor window in the adjacent bay.

Discussion: The use of a figure symbolising justice on a building erected as 'business premises'[1] is difficult to account for, and research has so far failed to reveal the identity

of the sculptor. The treatment of the right hand and sword is very similar to the figure of *Justice* attributed to Richard Ferris at 54 Turnbull Street (q.v.), though the style is more generally reminiscent of the work of William Kellock Brown (see, for example, People's Palace, Glasgow Green).

Condition: Sound but very grimy.

Note
[1] AA, 1899[1], p.105.

Other sources
GAPC, 16 May 1898, n.p.; Williamson *et al.*, p.236; McKenzie, pp.74 (ill.), 75.

Commercial Union Building, 200 St Vincent Street / West Campbell Street

St Andrew, Allegorical Figures and Associated Decorative Carving

Sculptors: Archibald Dawson (first phase); Mortimer, Willison & Graham (second phase)

Architect: John James Burnet
Dates: 1926–9; 1953
Material: yellow sandstone
Dimensions: St Andrew approx. 2.4m high; seated figures approx. 2.15m high
Inscriptions: on the corbel below *St Andrew* – 1927 (entwined); on the cartouche below the cornice on the south-west corner – N B & B (entwined); on the capital to the right of the entrance – IOU (entwined). See also below.
Listed status: category A (6 July 1966)
Owner: Glasgow City Council

Description: The building is designed as an austerely cubic block, five bays wide on both frontages, with five tiers of unadorned windows above a ground-floor arcade. The figure of *St Andrew* is located above the St Vincent Street

Archibald Dawson, *St Andrew***; Mortimer, Willison & Graham,** *Seafarer and Seafarer's Wife*

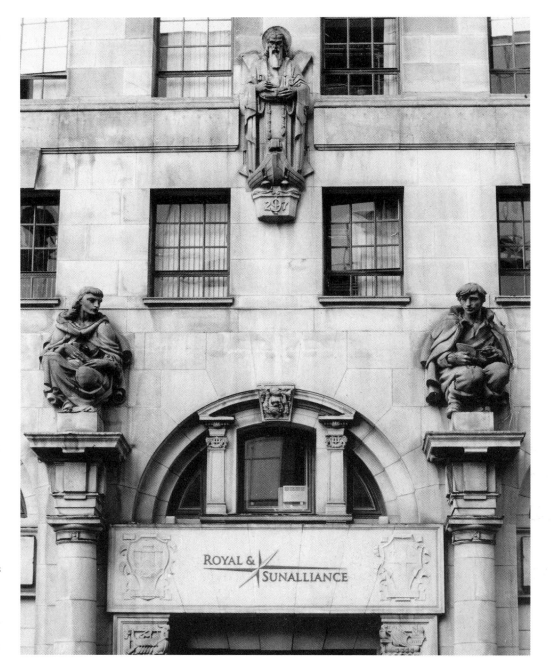

entrance, interrupting a shallow string course running between the first and second floors. He is a shown standing in the prow of a ship, with a model ship in his hand and a saltire at his back. Above the columns flanking the entrance are crouching figures representing a *Seafarer* (right) and a *Seafarer's Wife*. The male figure is dressed in a heavy cape with an upturned collar and holds a model ship; the female wears a shawl and holds what appears to be a pouch or money-bag. Minor decorative work includes a pair of heraldic shields in low relief on the lintel of the main door, one carved with a castle and inscribed 'EDINBURGH', the other with a cross of St George and inscribed 'LONDON'. The

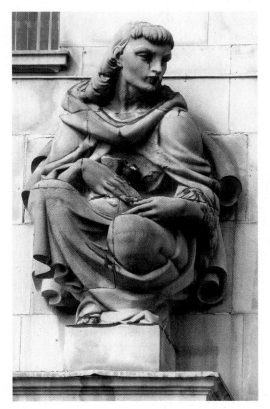

Mortimer, Willison & Graham, *Seafarer's Wife*

keystone in the arch above has a tiny triton riding on a seahorse and blowing a conch, while the capitals of the flanking columns are fashioned in the shape of ships (Viking longboat, left, galleon, right). Further maritime imagery appears in the capitals of the ground-floor pilasters, which are in the form of crossed seahorses accompanied by stylized tridents.

Discussion: J.J. Burnet returned from London in 1925 to design this building, his last major commission, for the Glasgow branch of the North British & Mercantile Insurance Company. Though less radically modernist than his Kodak House, in Kingsway, London (1911), its geometric simplicity is in stark contrast with the Baroque exuberance which typified much his earlier work. For Gomme and Walker it is

> … a design at the farthest remove from Waterloo Chambers [q.v., 15–23 Waterloo Street], making its effect by complete simplicity and straightforwardness. (For this reason the sculpture, added to the façade some time after the building was finished, seems to [us] unfortunate.)[1]

In fact the sculpture has a very complex relationship with the history of the building, and only some of it was added after the building was opened (and after Burnet's death). A photograph of the building from *c.*1930 shows *St Andrew* clearly *in situ*, but with the socles above the entrance columns vacant.[2] As it happens, Burnet himself appears to have wanted more rather than less sculpture. It is clear from the drawing he submitted to the Dean of Guild Court that he originally intended to include a colossal female figure seated on a pedestal projecting from the basement at the west end of St Vincent Street.[3] Moreover, the blocks of dressed stone protruding from the transoms in the ground-floor Diocletian windows suggest that further relief work may have been intended for these spaces. It is also worth noting that on Burnet's drawing the entrance figures, both of

Jack Mortimer with clay model of sculpture programme, 200 St Vincent Street. The *Bulletin*, 12 March 1953. [GSA]

which are seated females, are very much larger than the statues executed.

The reason for the delay in carrying out the entrance figures is unclear. It is known that Dawson instructed one of his carvers, probably Willison, to add the monogram 'IOU' to the right hand capital beside the entrance, cleverly disguising the 'I' as the mast of a ship, as a reminder to the architect that he had not been paid. It is possible, therefore, that the programme was left incomplete because of funding difficulties. Dawson's own financial problems were to continue into the next decade, and in 1936 his business was taken over by Jack Mortimer in lieu of debts (though apparently they were to remain on good terms). The statues themselves were produced in 1953 by Mortimer's own company of Mortimer, Willison & Graham, and are executed in a style closely modelled on the robust naturalism of Dawson, with the same expressive treatment of the hands and powerfully volumetric draperies. The description by Teggin *et al.* of the female

figure as having a 'hair style anticipating the film era of the '30s' is thus partially explained by her origin at a later date.[4] Hamish Dawson, the son of the sculptor, records that Jack Mortimer, who served an 'almost medieval apprenticeship' with Dawson, paid tribute to his teacher by modelling the two crouching figures on Dawson and his wife.[5]

Condition: Generally fair, but the faces of the entrance figures are badly chipped, and there is some green biological growth on the surface.

Notes
[1] Gomme and Walker, p.209. [2] *Ibid.*, p.201. [3] GCA, B4/12/1926/177. [4] Teggin *et al.*, p.49. [5] Hamish Dawson, 'The Man Behind the Chapel Carvings', *Avenue*, no.19, January 1996, p.10.

Other sources
Anon., 'Final sculpture is carved on a Glasgow building', *Bulletin*, 12 March 1953; Young and Doak, no.172 (incl. ill.); McKean *et al.*, p.132 (incl. ill.); Williamson *et al.*, p.236; McKenzie, pp.74 (ill.), 75; information provided by Edward Graham.

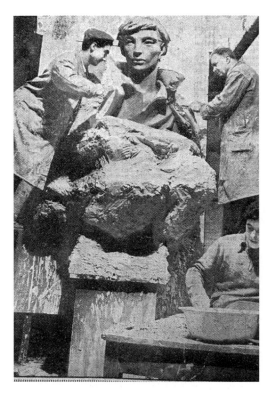

Assistants at work on plaster model of *Seafarer*. The *Bulletin*, 12 March 1953. [GSA]

Stepford Road EASTERHOUSE

Stepford Road Sports Pavilion

Untitled

Sculptors: Staff and Students of Glasgow School of Art Department of Sculpture and Environmental Art

Fabricators: Stockweld Ltd
Lighting: Northern Lights
Date: 1998–9
Installed: July 1999
Material: milled and welded stainless steel
Dimensions: 4.88m high × approx. 3m diameter
Owner: Stepford Road Sports Trust

Description: Semi-abstract sculpture reminiscent of the FIFA World Cup trophy, with a football supported by rods in the centre of an enclosure of four curved forms opening from a square platform, the whole supported by a column divided vertically into four sections. The upper part of the work is illuminated by an electric lamp concealed in the central platform. In appearance the curved forms resemble the segments of orange traditionally used by footballers for half-time refreshment, while also suggesting a group of players competing to take possession of the ball. However, in its overall configuration, the sculpture is also intended to suggest a more organic structure, such as a tree or plant, with petals opening to reveal a central bud.

Discussion: Commissioned as a 'design feature' to accompany the newly built Stepford Road sports facility, the sculpture is intended primarily to provide a landmark by which the building may be identified from Edinburgh Road, the neighbouring trunk road linking Easterhouse with the centre of Glasgow. The sports facility, which comprises the pavilion and adjacent playing fields, was developed as part of a £1.4 million improvement scheme designed to help establish the 'social infrastructure required to successfully sustain communities which have previously lived with low or no amenities as the norm'. Funding was provided by Greater Easterhouse Partnership Management Board, Glasgow City Council, Scottish Homes, the Lottery Sports Fund, Glasgow Development Agency and local sponsorship. In September 1988, the Sports Trust approached the Department of Sculpture and Environmental Art of Glasgow School of Art for general advice on the management of a

public art commission, and after considering several alternative strategies, invited the Head of the Sculpture section Paul Cosgrove to develop the project as a student competition. The brief for the commission stipulated that the selected work should 'reflect the mood of vitality, health and a celebration of life in keeping with the philosophy of the centre', that it should be 'symbolic of inclusion, not parochialism, and that it should reflect a positive expression of hope and confidence'. It was also required to be 'sturdy, durable [and] resistant to vandalism', as well as scaled to 'the individual and the existing building'. The budget was £10,000, exclusive of the installation cost, which was financed through the building fund. From the range of proposals submitted, the Trust selected a design by Emily Fields, a second year sculpture student, whose maquette was constructed from card, plasticene and tailors' pins. Fabricated off-site, the finished piece was bolted onto a concrete base in July 1999, and inaugurated shortly afterwards. It weighs approximately two tons.

Condition: Good.

Sources
Information sheet provided by Stepford Road Sports Trust; conversation with Paul Cosgrove.

Emily Fields and others, *Untitled* [RM]

Templeton Street CALTON

Templeton Business Centre, 62 Templeton Street

Allegorical Female Figure and Associated Decorative Carving

Sculptor: not known

Architect: William Leiper
Date: 1888–92
Material: red Ayrshire sandstone

Dimensions: figure colossal
Inscription: in the Glasgow arms – LET GLASGOW FLOURISH; on datestone – 1890
Listed status: category A (6 July 1966)
Owner: Scottish Enterprise Glasgow

Description: Based loosely on the Doge's Palace in Venice, the building is an inventive variation on the fortified Gothic style, combining 'Guelphic' machicolations with a rich vocabulary of ornamental fenestration. The main figure stands on the apex of a decorative gable in the centre of the west façade; crowned, and holding a distaff, she symbolises the *Textile Industry*. The gable itself is lavishly ornamented with large, flame-like crockets. A pair of male figurines, one holding a book and the other a painter's palette, protrude from the capitals of the columns dividing the central windows, while in the adjacent capitals these have been replaced by rams' heads. Subsidiary decorative carving includes four large and eight small rosettes, a line of five armorial shields above the central windows and a Glasgow coat of arms in the upper gable.

Discussion: The building was designed as a

Anon., *Allegorical Female Figure* [GN]

factory for the carpet manufacturer John Stewart Templeton, whose product is reflected in the striking abstract polychrome terracotta and 'Ruabon' brick decoration that distinguishes the façade. The general extravagance of the design is explained by the firm's desire to be recognised as 'patrons of the arts', and to erect 'instead of the ordinary and common factory something of permanent architectural interest and beauty'.[1] It also provides a dramatic illustration of the problems associated with the High Victorian ideal of architectural design as the surface beautification of a utilitarian structure. Apparently the façade was insufficiently tied to the internal iron frame, causing part of the building to collapse during construction in 1889. Leiper disclaimed responsibility for the disaster on the grounds that his role in the commission was to 'design elevations and outside ornamentation, the engineers undertaking the design of the

structural portions and all iron work, floors etc.'[2]

Related work: The figure may be compared to Kellock Brown's version of the same subject made by a few years later for the People's Palace (q.v., Glasgow Green), though there the quality of the design and carving is much coarser.

Condition: Good, though with extensive green biological growth on the surface of the main figure.

Notes
[1] BJ, 12 January 1898, p.488. [2] GCA, M.P. 21/305.

Other sources
GCA, M.P. 21/295–313, B4/12/1/1169; B, 9 July 1898, p.29; Gomme and Walker, p.226 (incl. ill.); Thomas Greig and Alastair G. Clarkson, 'William Leiper', unpublished dissertation, GSA, 1979, pp.41–9; Worsdall (1982), pp.148–50 (incl. ills); McKean *et al.*, p.32 (incl. ill.); Williamson *et al.*, p.459; McKenzie, pp.22 (ill.), 23.

Tollcross Road TOLLCROSS

Parkhead Public Library, 64–80 Tollcross Road / Helenvale Street

Figurative Programme
Sculptor: William Kellock Brown

Architect: James R. Rhind
Building opened: 6 August 1906
Materials: bronze (dome figure); red
 Locharbriggs sandstone (all else)
Dimensions: figures approx. life-size
Inscriptions: on the entablatures of both façades
 – PARKHEAD PUBLIC LIBRARY; on the lintel
 over the Helenvale Street entrance – BOYS
 AND GIRLS
Listed status: category B (23 March 1992)

Owner: Glasgow City Council

Description: Of the seven libraries designed by Rhind for Glasgow Corporation at the beginning of the twentieth century, this is the most complex, with its two equally impressive façades exploiting the corner site to maximum effect. The principal library block is of two storeys, with channelled ashlar on the ground floor and a line of arched windows divided by Ionic pilasters above. On Tollcross Road this arrangement runs to three bays, with the adjacent reading room block linked to it by a pedimented entrance bay. The Helenvale Street frontage has five window bays framed by slightly projecting end pavilions capped by

segmental pediments. Dominating the corner, and articulating the transition between the two frontages, is a corner tower capped by a dome on an octagonal drum.

A ball finial on the dome supports a winged female figure in bronze, with an open book resting on her extended forearms. She wears a classical tunic, the folds of which are arranged to suggest they are being blown by the wind. Seated on attic pedestals adjacent to the drum are three female figures with various attributes. From the left, they may be described as follows: semi-naked with the straps of a heavy cape across her breast, her left hand placed on a globe and an unidentified object in her right hand; draped, holding a palette and a sculpted

bust; naked in a crouching posture and holding a tilted pitcher. Directly above the entrance pediment is a free-standing sculpture group consisting of a heavily draped female figure wearing a laurel crown and with a small book open in her hands. Kneeling at her feet is a pair of naked male youths holding a laurel branch and a book. Two more children appear on attic pedestals projecting from the sides of the broken pediment over the reading room, though these are in the form of over-sized putti in contorted postures; one (on the left) holds a shield, while the other displays an open book. Minor decorative carving includes an escutcheon embedded in strapwork and foliage in the entrance pediment.

Discussion: The sculpture programme on this building occupies an important place in the study of the seven district libraries designed by James Rhind, as it is the only one which can be ascribed to William Kellock Brown on the basis of secure documentary evidence.[1] For an analysis of its relationship with the other library sculptures attributed to Brown, and a full discussion of the historical background to the district library scheme as a whole, see Dennistoun Public Library, 2a Craigpark.

A comparison between the design of the sculptures indicated on the architect's plans and the work as executed reveals a number of interesting changes. For example, the attic putti above the reading room are shown on a drawing dating from 1903[2] as seated female adults; there is also a pair of reclining figures in the entrance pediment, and the dome figure has vertically extended wings. In a further set of drawings published in the *Architect* in 1906 (after the completion of the building)[3] the attic figures have been replaced by a pair of lions, the pediment over the entrance is blank and the dome figure has been given a running posture. Perhaps the most significant change, however, is that the sculptures in this drawing are generally much more animated than the works actually executed. This is particularly noticeable in the triple group above the main entrance, which is represented in the drawing as a family group at play rather than the more soberly 'statuesque' conception that appears on the building. The only exceptions to this rule are the attic putti, and these, as it happens, are among the most contorted of any of the figures produced by Brown in his work on the libraries.

Related work: The other libraries decorated by Kellock Brown are as follows: Bridgeton (23 Landressy Street); Govanhill (170 Langside Road); Maryhill (1508 Maryhill Road); Hutchesontown (192 McNeil Street); Woodside (343–7 St George's Road).

Condition: Good.

Notes
[1] Anon., 'Parkhead Library', A, 14 September 1906, p.180 (incl. ill.). [2] GCA, B4/12/2/220. [3] Anon., *op. cit.*

Other sources
Descriptive Hand-Book of the Glasgow Corporation Public Libraries, Glasgow, 1907; Nisbet, 'City of Sculpture'; Williamson *et al.*, p.470.

William Kellock Brown, *Allegorical Figures*

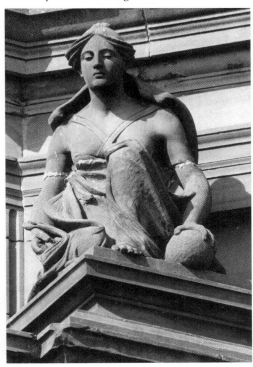

William Kellock Brown, *Allegorical Figure*

Tron Theatre, 71 Trongate and Parnie Street

Cherub / Skull

Sculptor: Kenny Hunter

Founder: Powderhall Bronze
Architects: John James Burnet (screen wall); RMJM Associates (1997 modifications)
Date: 1899 (building); 1997–9 (sculpture)
Material: bronze, powder coated with metallic gold

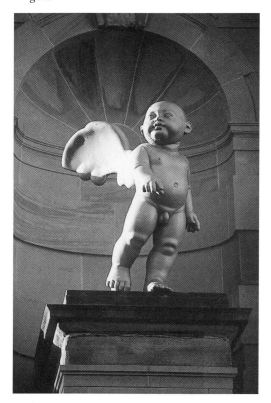

Kenny Hunter, *Cherub*

Dimensions: cherub 1.39m high; skull 60cm × 71cm × 52cm
Listed status: building listed category A (15 December 1970)
Owner: Glasgow City Council

Description: Though conceived as a unified sculptural statement, the work is in two physically distinct parts. On the north-east corner of the screen wall fronting Trongate, a winged cherub strides forward from an elevated apsidal niche. Balancing this, on the diagonally opposite corner on Parnie Street, a square, box-like recess sunk into the exterior wall above the stage door is filled with a colossal human skull.

Discussion: The work was commissioned by Visual Art Projects, Glasgow, as part of a £5 million collaborative refurbishment programme masterminded by architects Paul Stallan and Alan Dickson and incorporating interior work by artists such as Tracy MacKenna, Daphne Wright, Richard Wright and Andy Miller. The cherub was completed first, and installed in November 1997, with the skull following in the winter of 1998. Both pieces were modelled in Glasgow Sculpture Studios, Maryhill, and cast in Edinburgh.

In their approach to the design, the architects were guided by a desire to combine modern technological solutions to questions of function with an acknowledgement of the unique historical interest of the existing structure. Described by a recent commentator as a 'guddle of buildings of various ages and styles', and by the architects themselves as a 'city in miniature',[1] this includes the remnants of the Tron Steeple (q.v.), built in the 1590s and altered in the mid-nineteenth century, James Adam's Tron Kirk of 1793 and the flamboyant neo-Baroque screen wall built by J.J. Burnet in 1899 to disguise a railway tunnel air-shaft.

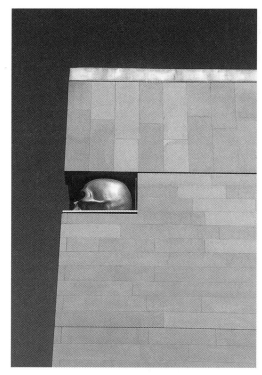

Kenny Hunter, *Skull* [RM]

As a contributing artist, Hunter was faced with a similar dilemma, particularly with regard to the treatment of the niche. Because we do not know whether or not Burnet had intended to fill this with a free-standing statue, the challenge faced by Hunter was to produce a work which reflected the playfulness and visual exuberance of the screen but without attempting to imitate the kind of image Burnet himself might have used had he decided to complete the scheme in this way. The resulting piece disposes of the dilemma with a characteristically post-modern mixture of irony, serio-comic irreverence and traditional craft skill. Ambiguity is evident on almost every level, evoking the ubiquity of winged cherubs

in traditional ecclesiastical art while simultaneously recalling their more extrovert descendants that have cavorted across the insides (and outsides) of theatres since at least the middle of the eighteenth century. The fact that the cherub – in both its sacred and secular incarnations – has become irredeemably associated with *kitsch* is also relevant to the tawdry commercialism that dominates this part of the city centre, leaving the viewer unable to judge whether it is about to take flight or fall to the pavement below. It is worth remembering, however, that such low-brow associations were no deterrent to the great exponents of architectural sculpture in the nineteenth century, including Burnet himself, who used gambolling infants to adorn such major buildings as Charing Cross Mansions (q.v., 540–6 Sauchiehall Street). It is from this tradition – robust, invigorating, shameless – that Hunter's cherub is ultimately descended.[2]

The same provocative ambivalence characterises the skull component of the work. With references ranging from Hamlet's 'Alas, poor Yorick' soliloquy to the nihilistic imagery of the Hell's Angels, it succeeds in being 'theatrical' in both the literal and the figurative sense.

Related work: A painted, glass-reinforced plastic edition of *Cherub / Skull* was exhibited at Arnolfini, Bristol in 1998,[3] and is now in a private collection in Germany.

Notes
[1] Rodger, p.38. [2] For a fuller analysis of this work see John Calcutt, 'Seriously Kitsch: Kenny Hunter's *Cherub*, in Guest and McKenzie, pp.60–5; see also Andrew Patrizio, 'Imagology', in Kenny Hunter, *Work 1995–1998*, ex. cat., Arnolfini, Bristol, 1998, pp.7–9. [3] Hunter, op. cit., p.2.

Other sources
McKean *et al.*, p.59; Williamson *et al.*, p.158, ill.13; Fisher, p.40; McKenzie, pp.18 (ill.), 19; Riches *et al.*, p.40; private conversations with Kenny Hunter.

Tron Steeple, at the entrance to the Tron Theatre, 71 Trongate

Carved Corbels and Boss
Sculptor: not known

Architect: John Carrick (pedestrian arches)
Date: 1855
Material: sandstone
Listed status: category A (6 July 1966)
Owner: Glasgow City Council

Description: The vaulted interior of the ground floor of the steeple has a series of four carved capitals at the springing of the main cross-ribs, four floral corbels terminating the transverse ribs and a large floral boss at the intersection. The capitals show a Glasgow coat of arms and a bearded bishop with a St Andrew's cross on his tunic, each design appearing twice. In all four capitals the central image is framed by a pair of large salmon emerging from a floral design.

Discussion: The building is a late Gothic survivor from the original Tron Kirk (or Laigh Kirk) of *c.*1593, which was rebuilt by James Adam in 1793 after a fire destroyed the main building. At one point it housed the town's public weighing beam, or 'tron'. The Tudor-style arches which pierce the lower storey, and through which the pavement now passes, were

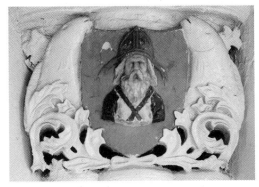

Anon., *Decorative Corbel*

created by John Carrick as part of his road-widening scheme in the mid-nineteenth century, and it is assumed that the carvings were added at this time.

Condition: Very worn and thickly coated with paint.

Sources
Pagan, p.174; Gomme and Walker, p.296; McKean *et al.*, p.59 (incl. ill.); Williamson *et al.*, p.158, ill.13; Lyall, pp.12, 13 (incl. ills).

173–87 Trongate / 17–43 Stockwell Street / 118–22 Osborne Street

Neptune and Ceres
Sculptor: not known

Architect: Frank Burnet & Boston
Date: 1925
Material: red sandstone
Dimensions: figures approx. life-size
Listed status: category B (22 March 1977)
Owner: Five Oaks Projects Ltd

Description: This six-storey retail and warehouse block in the Edwardian Classical style has a substantial figurative group symbolic of trade and commerce concentrated on the main entrance at no.177. Seated on the left is *Neptune*, shown with a trident in his right hand and the left placed on the muzzle of a horse emerging from the sea; on the opposite side, *Ceres* holds a corn-stalk and is accompanied by a miniature figure of *Mercury* standing on a pedestal decorated with a caduceus. A series of smaller figures appears at the foot of the festooned oculus below the main group, including a seated male holding a ship (left) and a seated female holding an object which is difficult to recognise but may be either a furled standard or an inverted cornucopia. In the centre, above a datestone inscribed '1925', is a tiny figure, possibly St Mungo, standing in a miniature forest.

Discussion: The building was erected by the

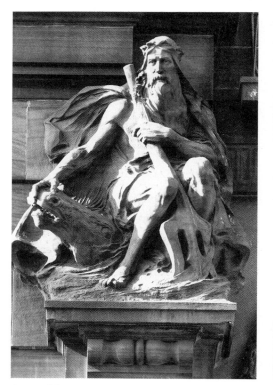

Anon., *Neptune*

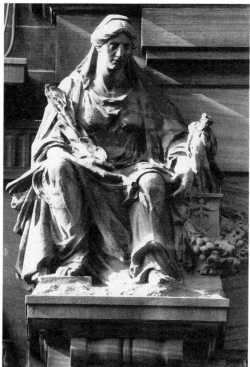

Anon., *Ceres*

*Commercial building, 190 Trongate / 2–4
Glassford Street*

Seated Male and Female Attic Figures and Associated Decorative Carving

Sculptor: William Birnie Rhind

Architect: Thomas P. Marwick
Masons: Alexander Muir & Sons
Date: 1901–3
Material: yellow Plean sandstone
Dimensions: figures colossal
Inscriptions: in Glassford Street coat of arms –
IN DEFENS / NEMO ME IMPUNE LACESSIT
(trans.: 'no one provokes me with
impunity'); on attic panels on both frontages
– NBS (entwined). See also below
Listed status: category A (15 December 1970)
Owner: Royal Bank of Scotland PLC

Description: The figures are seated in pairs,
back to back on either side of the gable
windows on both the Trongate and Glassford
Street frontages. The two pairs appear to be
identical to each other, with a draped female
figure on the left and a male, naked apart from a
headband, on the right. There are no attributes
or any other indication of symbolic meaning,
though the angle of their heads suggest that
they are observing the events in the street
below; this is particularly noticeable in the male
figures. Each of the figures is carved from four
separate blocks. Additional carving includes a
relief of the royal arms of Scotland in the
lunette over the Glassford Street entrance and a
pair of decorative panels below the gable
windows.

Discussion: The building was designed for
the National Bank of Scotland in a mixture of
Scottish Baronial and Italian Baroque styles
reminiscent of the same architect's building for
the *Scotsman* in Edinburgh, which also has a
sculpture programme by William Birnie Rhind.
As executed, the scheme differs significantly

City Improvement Department as part of a
scheme to widen Stockwell Street.[1] The
inclusion of a sculpture of such florid intensity
on a structure otherwise devoid of carved
ornament is something of a puzzle, and the
closer one examines it the more incongruous it
appears in relation to the disciplined austerity
of the building as a whole. It may not be quite
as 'atrocious' as it has been described by recent
commentators,[2] but it is not without its
contradictions, displaying a crudity of
technique that seems at odds with the artist's
ambitious attempts to create an effect of fluid
movement (see especially *Neptune's* beard). It
appears, however, to have been part of the

architects' intentions from the beginning,
though the executed work differs slightly from
their original drawing of the façade, which
shows both main figures as female.[3]

Condition: Overall very worn. The small
figure in the centre is also obscured by a pole
supporting a modern clock.

Notes
[1] Williamson *et al.*, p.188. [2] *Ibid.* [3] GCA,
B4/12/1923/534.

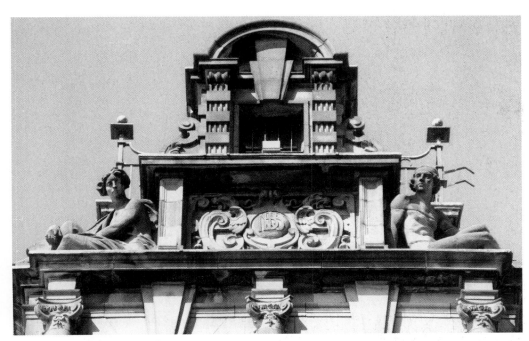

William Birnie Rhind, *Seated Figures*

from Marwick's original drawings, which show groups of three standing youths in place of the seated figures.[1] A model of the bank was exhibited at the RSA in 1902.

On the Trongate frontage, at ground-floor level, there is also a bronze plaque decorated with holly and acorns and inscribed: 'ON THIS SITE / STOOD THE SHAWFIELD MANSION / WHERE / PRINCE CHARLES EDWARD STUART / RESIDED IN 1745. / ERECTED BY THE / PEN AND PENCIL CLUB, 1910'. Designed by Colen Campbell, and illustrated in his *Vitruvius Britannicus*,[2] Shawfield Mansion was one of the most splendid private residences of the early eighteenth-century Merchant City and the home of the Glassford family, from which the street takes its name. It was demolished in the 1790s, and, not, as the plaque might suggest, at the time the present building was erected.

Notes
[1] GCA, B4/12/1/8501. [2] See Gomme and Walker, p.50.

Other sources
BI, 16 September 1901, p.93; B, 20 June 1903, p.638; BJ, 28 November 1906, p.256; McKean *et al.*, p.62; Williamson *et al.*, p.188.

Glasgow District Court, 54 Turnbull Street / St Andrew's Street

Allegorical Figures of Law and Justice and Associated Decorative Carving

Sculptor: Richard Ferris (attrib.)

Architect, A.B. McDonald
Masons: William Steven & Son
Date: 1903–6
Building opened: 23 March 1906
Materials: red Dumfriesshire sandstone; bronze chain on scales of *Justice*
Dimensions: figures a little over life-size
Inscriptions: on datestone above north entrance – 1904; in coat of arms in main gable – LET GLASGOW FLOURISH
Listed status: category B (4 September 1989)
Owner: Glasgow City Council

Description: The figures are seated on attic pedestals on either side of the central gable of the east frontage. On the left is *Law*, a bearded male figure in a sabre leg chair holding a scroll; *Justice*, a female figure in a billowing cape holding a sword and a set of scales, is on the right. The gable between them is filled with a large Glasgow coat of arms. Additional ornamental carving includes wreaths, thistles, garlands and blind cartouches at the arched entrance to the courtyard on Turnbull Street and on various parts of the St Andrew's Street elevation.

Discussion: The building was designed by the City Engineer, A.B. McDonald, in a hybrid Renaissance style, and was erected at a cost of £36,000. It was built as the Central Police Office, which it remained for 26 years, later becoming the headquarters of the Central Division of the Criminal Investigation Department. It is now a District Court. The attribution to Richard Ferris is based on the identical treatment of the face and draperies of the female figure to other works thought to be by him, such as *Learning*, on the former Kingston Public Halls (q.v., 330–46 Paisley Road) and *Ellen Douglas*, on the United Distillers Building (q.v., 64 Waterloo Street). The repetition in all three figures of the sleeves, with their distinctive arm band and three-buttoned cuff, is particularly striking.

Condition: Generally good, though the face of *Justice* is badly worn, with the pattern of the erosion following the grain of the stone.

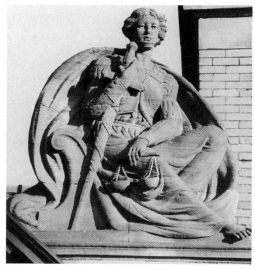

Richard Ferris (attrib.), *Justice* [RM]

Sources
Stevenson (1914), ill. opp. p.284; Douglas Grant, *The Thin Blue Line: the Story of the City of Glasgow Police*, London, 1973, p.51; McKenzie, pp.20, 21 (ill.).

Caledonian Chambers, 75–95 Union Street

Caryatids, Atlantes and Associated Decorative Carving
Sculptor: Albert Hemstock Hodge

Architect: James Miller
Builder: P. & W. Anderson Ltd
Date: 1901–3
Material: white freestone
Dimensions: figures colossal
Inscription: above the main door – CALEDONIAN / CHAMBERS
Listed status: category B (15 December 1970)
Owner: Railtrack Property

Description: Grouped in pairs, the figures are located beneath the projecting first-floor balconies in the side towers of this large seven-storey commercial building. All four figures are naked, and are presented in crouching postures expressive of their role as load-bearing members. Each figure is composed of three separate blocks. There are, however, a number of significant differences in the treatment of the two pairs. The caryatids, at the south end, have both arms raised, with their hands tucked behind their necks, and are placed against backgrounds incorporating ships' prows emerging from masses of draperies. The ships' prows are carved with winged figurines. The atlantes at the opposite end have more expressively twisted poses, with protruding shoulders and only one raised elbow. There are no ships' prows in the background and their draperies are treated as wind-blown cloaks. Characteristic of all four figures, however, is the fanciful headgear they wear, which ranges in style from a decorated band pulled tightly round the brow (right atlas) to an elaborate amalgam of a mob cap with puffed caul and a mask reminiscent of an ancient military helmet (left caryatid). Additional carver work includes three large reliefs of the royal arms of Scotland in the end and central bays, with numerous elaborate blind cartouches distributed over the rest of the façade.

Discussion: The building was designed as offices for the Caledonian Railway Company, incorporating shops on the ground floor and station accommodation above. Miller's plan, submitted to the Dean of Guild in May 1901, omits the caryatid and atlantes, but shows pairs of smaller seated figures flanking cartouches in the ground-floor pillars of the towers and beside escutcheons on the fourth floor.[1] The executed work is ascribed here to Albert Hodge on the basis of secondary sources only.[2] However, in view of its stylistic similarity between the figures and other documented work by Hodge, particularly the

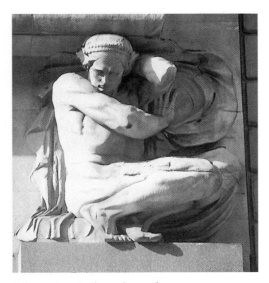

Albert Hemstock Hodge, *Atlas* [GN]

Michelangelesque male figures in his relief panels for the interior of the Grosvenor Restaurant (destroyed; see Appendix A 'Lost Work') the attribution seems secure.[3]

Related work: Miller's work for the company included the design of the railway viaduct across Argyle Street, popularly known as the 'Hielanman's Umbrella' (1901–6),[4] incorporating cast-iron pilasters decorated with delicate Renaissance arabesques. In 1999 Railtrack won the Ian Allan National Railway Heritage Award for its restoration of this and the station building.

Condition: Fair, but with many minor surface chips and some erosion at the mortar joins. The figures have also been damaged by the attachment of eyelets for anti-pigeon wires, and the insertion of a scaffold pole in the right atlas during repair work in spring 2000.

Notes
[1] GCA, B4/12/1/8334. [2] Sloan and Murray, p.22 and Nisbet, p.523; McKean *et al.*, p.106; Williamson *et al.*, p.246. Read and Ward-Jackson, 4/11/132–5, attribute the work to Francis Derwent Wood, as do Teggin *et al.*, p.47. [3] See, for example, *Mining*, reproduced B, 21 October 1905, p.420. See also *Science and Art*, p.437, below. [4] McKean *et al.*, p.69.

Other sources
BJ, 28 November 1906, p.273; Leslie D. Howson, 'Central Station, Glasgow, an architectural and historical study', unpublished dissertation, GSA, 1977; Brian J. Frew, 'The Commercial Architecture of James Miller', unpublished dissertation, GSA, 1988; Nisbet, 'City of Sculpture'; McKenzie, pp.62–3 (incl. ill.); information provided by Liz Arthur.

Former National Bank of Scotland, 78–82 Union Street

Relief Medallions of British Monarchs

Sculptor: not known

Architects: Balfour & Stewart
Date: 1925
Material: granite
Dimensions: each medallion approx. 18cm diameter
Inscriptions: round the circumference of the four portrait medallions – GULIELMUS IIII D: C: BRITANNIA REX F: D:; VICTORIA. DEI. GRA. BRITT. REGINA. FID. DEF. IND. IMP.; EDWARDUS VII D: C: BRITT: OMN: REX F: D: IND: IMP; GEORGIUS V D: C: BRITT: OMN: REX: F: D: IND: IMP; in the exergues below St George – 1925
Listed status: category B (21 July 1988)
Owner: Bristol & West PLC

Description: The medallions are in square panels in the metopes above the building's two entrances and are in the form of enlarged gold sovereigns from the reigns of William IV, Victoria, Edward VII and George V, the four most recent British monarchs at the time the building was designed. They are divided into two groups of three, each group consisting of a pair of heads facing each other, with the verso image of St George and the Dragon in the centre. The inscriptions are identical to those found on the relevant coins, including the

Anon., *British Monarchs* (detail)

archaic Roman numeral 'IIII' for William IV. The reference to coinage is emphasised by the fact that their edges are milled.

Discussion: The Greek Doric design of the ground floor was the result of Balfour & Stewart's conversion of an existing building for the National Bank of Scotland in 1924. A reference to 'raised carved paterae filling metopes and frieze' on their plan suggests that

the medallions are made of granite rather than bronze.[1]

Condition: The medallions are painted gold on a blue ground.

Note
[1] GCA, B4/12/1924/452.

Additional source
Williamson *et al.*, p.245.

University Avenue GILMOREHILL

*University of Glasgow Students' Union,
42 University Avenue*

St Kentigern and Symbols of the
Four Nations

Sculptor: not known

Architects: Arthur & McNaughtan
Date: *c.*1930
Material: yellow sandstone
Dimensions: St Kentigern approx. 1.5m high;
 panels 40cm × 40cm
Inscriptions: in Gothic lettering on border of
 centre panel – UNIVERSITATIS GLASGUENSIS
 SIGILLUM COMMUNE (trans.: 'common seal of
 the University of Glasgow'); in Gothic
 lettering on heraldic panels, from the left –
GLOTTIANA; ROTHSEIANA; TRANSFORTHANA;
LOUDONIANA; in arms of the University
above central window – VIA VERITAS VITA
(trans.: 'the way, the truth and the life')
Listed status: category B (20 May 1986)
Owner: University of Glasgow

Description: The symbols of the 'four
nations' are carved in low relief in adjacent
panels above the main entrance and feature the
following devices (from the left): a double-
headed eagle superimposed on a hammer
crossed with a paddle (Glottiana); a ship
superimposed on a pick-axe crossed with a
distaff (Rothseiana); a cornucopia superimposed
on a sword crossed with an axe and a crook
(Transforthana); an anchor entwined with rope
and superimposed on a gaff crossed with a
spade (Loudoniana). St Kentigern is shown in a
slightly larger relief panel inserted in the centre
of the other four. There is also some strapwork
incorporating thistles and a fleur-de-lis on the
window heads of the turrets flanking the
entrance.

Discussion: The 'four nations' panels refer to
the geographical regions from which the
University's students are traditionally drawn:
Clydesdale, Rothesay, Albany and Teviotdale.

Related work: Identical panels of the 'four
nations' are found on several other buildings in
the University campus, most notably on the
John McIntyre Building (q.v., University of
Glasgow).

Condition: Fair.

Sources
'University Union', GH, 4 December 1930, pp.3, 7
(incl. ills); Williamson *et al.*, p.345; Fisher, p.388.

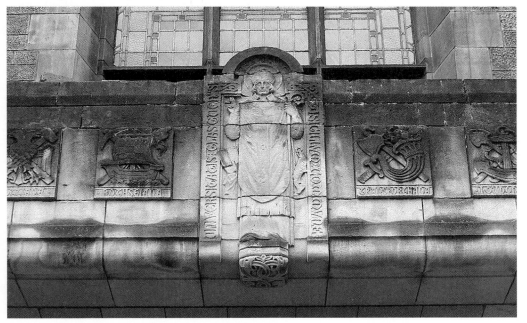

Anon., *St Kentigern* and *Symbols of the Four Nations* [RM]

*Pearce Lodge, at junction of University
Avenue and Kelvin Way*

Decorative Carving and
Inscriptions

Carver: not known

Architect: Alexander George Thomson
Dates: 1632–58 (original carving); 1884–8
 (erection of building)
Material: sandstone, with gilded details
Inscriptions: on tablet in north gable – HIS
 AEDIBUS / AB ANTIQUA UNIVERSITATIS SEDE /
 TRANSLATIS AS NOVUM / PRAESENTIA
 PRAETERITIS / CONIUNXIT / GULIELMUS
 PEARCE / AD MDCCCLXXXVII (trans.: 'By
 moving these buildings from the ancient seat
 of the university, William Pearce again
 united the present with the past, AD 1887');
 on tablet above keystone of north arch – HAE
 AE DES EXTRUCTAE / SUNT ANNO DOM /
 CIC[reversed]IC[reversed]CLVI (trans.: 'These
 buildings were erected in 1656'); on tablet on

south façade – ACADEMIA GLASGUANA, CUM BIUVILEGIIS / BONONIENSIS; ANNO AERAE VULG CIC[reversed]CDL CURA ET IMPENSIS GULIELMI TURNBULLI / EPISC. GLAS. FUNDATA FUIT AUCTOIRATE / VERO JACOBI SECUNDI REGIS SCOTORUM (trans.: 'The Glasgow Academy, with prerogative from Bologna, was founded in the year of bronze [?] commonly 1450, at the trouble and expense of William Turnbull, Bishop of Glasgow, by the authority of James II King of the Scots'); on tablet on west façade – ANN. DOM. / 1658
Listed status: category A (15 December 1970)
Owner: University of Glasgow

Description: In its report on the opening of the building the *Builder* provides the following description:

The masonry, which is of a very vigorous character, dates back to A.D. 1632–58. The entrance for pedestrians is through the original archway, conspicuous by its massive rusticated quoins and voussoirs, which opens into a handsome arcaded piazza. The ancient sculpted escutcheon bearing the Royal Scottish Arms and the monogram 'C. R. 2', a fine old carved shield with the arms of the University, and a tablet relating to the foundation by Bishop Turnbull, A.D. 1451, and the curiously carved window-head and dormers, on which may be recognised the arms of England, Scotland, Ireland and France, are embodied in the structure. These several features have been grouped with the new work, which is designed in harmony with the mixed Jacobean and French style of the old College.[1]

Other notable decorative features include the pair of high-relief urns on 'fishscale' pedestals flanking the Scottish arms, and the numerous grotesque masks included in many of the strapwork window heads, which appear on the front, rear and sides of the building.
Discussion: The building is constructed from

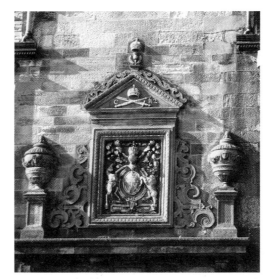

Anon., *Decorative Carving*

stone salvaged from the original seventeenth-century premises on the High Street (the monogram 'CR2' refers to the reign of Charles II), which the University vacated in the 1860s after the completion of Gilbert Scott's Gothic Revival building on Gilmorehill. The decision to recycle parts of the old structure in this way was prompted by a suggestion in November 1883, by the architect Alexander George Thomson that 'steps be taken for the conservation of the picturesque façade of the old University in the High Street'. Referring to the recent re-erection of the Lion and Unicorn Staircase (q.v., University of Glasgow) on the west façade as a successful precedent, he recommended that 'the chief decorative members of the ancient stonework should be embodied in the construction of a principal gatehouse or lodge at one of the entrances to the grounds of the new University'.[2] The scheme 'advanced with unexpected rapidity', and in the following month the *Builder* reported that the University Senate, 'having had

before them Mr Thomson's letter and design, resolved to remove the ancient gateway, under which so many generations of students have passed, to University Avenue'. It also announced that the shipbuilder William Pearce (q.v., Govan Road) had offered 'in the handsomest manner… to contribute the whole expense' of the rebuilding, estimated at about £2,500.[3] It is likely that this gesture of munificence played a part in securing Pearce's knighthood in 1887, the year the building was completed.

Related work: Because of the relatively small scale of the lodge only a proportion of the decorative stonework from the original building could be conserved, and many other window heads and decorative panels visible in photographs of the Old College before it was demolished have been lost.[4] Included in the High Street building was also a stone bust of an early rector and benefactor of the college, Zachary Boyd (c.1585–1653) by Robert Erskin, c.1657, which stood in a niche over the entrance to the library tower in the inner court.[5] This is now in the Hunterian Museum (GLAHA 44157).

Condition: There is much general weathering, and the head of the unicorn in the royal arms is missing.

Notes
[1] B, 10 December 1887, p.798. [2] *Ibid.*, 1 December 1883, p.742. [3] *Ibid*, 8 December 1883, p.775. [4] See Thomas Annan, *Memorials of the Old College of Glasgow*, Glasgow, 1871. [5] See Dibdin, pp.702 (ill.), 703; Pearson, p.130 (ill.).

Other sources
Gomme and Walker, p.46 (incl. ill.); Worsdall (1981), p.98 (incl. ill.); McKean *et al.*, pp.26–7 (incl. ills); Lyall, p.6 (incl. ill.); McKenzie, p.93.

*Rankine Building, on the east corner of
University Avenue and Oakfield Avenue*

Untitled

Sculptor: Lucy Baird

Architects: Keppie Henderson & Partners
Fabricators: Leeway Forbes, Edinburgh
Date of inauguration: 3 October 1990
Material: stainless steel
Dimensions: 11m high × 3m wide
Inscription: on plaque below sculpture –
 1840–1990 / This sculpture, by LUCY BAIRD,
 commemorates the / 150th anniversary of
 the establishment of the Regius / Chair of
 Civil Engineering and Mechanics at the /
 University of Glasgow. It was made possible
 through / the generosity principally of
 Norwest Holst; also British Steel Stainless,
 graduates of the Department / of Civil
 Engineering, local civil engineering /
 companies, the Scottish Arts Council, and
 the City of / Glasgow District Council
Listed status: not listed
Owner: University of Glasgow

Description: Located on the south-east wall
of the building's unused lift shaft, the work is a
semi-abstract relief in 2mm Hyclad 316 folded
steel, with a 2B finish, attached to the wall with
12mm decorative bolts. The three sections, each
of which weighs approximately 200 kilos, are
welded and riveted together to form a unified
design, and the surface of the steel has been heat
treated and rubbed with abrasive cloth. The
imagery is drawn from the history of civil
engineering, incorporating references to the
major structural forms associated with the
discipline, though these are suggested obliquely,
rather than literally described. In her
competition submission the artist explained that
she had not referred

 … too specifically to definite forms of civil
 engineering, but rather tried to amalgamate
 them into something more general and

symbolic, i.e. bridge/tunnel as supports,
boat/submarine as movement,
lighthouse/pylon as a source/power supply.

 In the early stages of the design she
considered making the work from copper, but
settled for stainless steel because of the

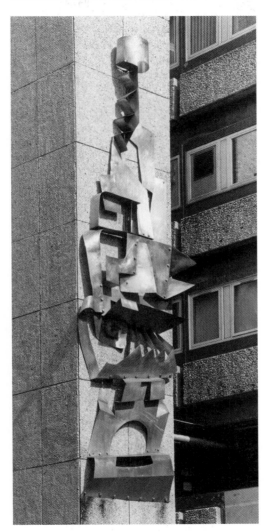

Lucy Baird, *Untitled* [RM]

'lightness of feeling' that could be achieved with
it.

 Discussion: The work was commissioned by
the Department of Civil Engineering to
commemorate the 150th anniversary of the
founding of the Regius Chair in Civil
Engineering in 1840, the event which
established the legitimacy of engineering as an
academic discipline. With a grant of £1,000
from the SAC, the Department organised a
competition, open to all artists born or resident
in Scotland, from which a shortlist of four was
selected. The runners-up were Nigel Mullan,
Michael Henderson and George Wyllie, each of
whom received £250 for producing a maquette.
In its schedule for the commission, the
department allowed considerable latitude in the
treatment of the subject:

 There is no 'theme' prescribed for the work
 of art but it should incorporate a reference to
 the Department's association with or
 contribution to civil engineering. This
 reference may be conveyed either in abstract
 or representational terms.

 It is interesting, however, that the structural
requirements are specified in some detail:

 The maximum possible weight for the
 sculpture depends upon its geometry, its
 projection from the wall, its position on the
 wall and the number of fixing points. As a
 guide, and assuming that the work projects
 on average 0.5m from the wall, a single fixing
 could carry a weight of 250 kg at the centre
 of either wall; two fixings could carry 500 kg
 and,… in broad terms, the loading could
 increase in this way dependent upon the
 number of fixings needed. Greater load
 could be carried near the junction of the two
 walls.

 A further stipulation was that the sculpture,
because of its inaccessible position, should be
'maintenance-free as far as possible'. The
tendency on the part of the commissioners to

concentrate on technical rather than aesthetic considerations was clearly registered by the artist, who 'rather astutely' asked the general manager of Leeway Forbes to accompany her at a meeting called by the committee to 'seek assurances that Lucy could in fact complete the sculpture'. In the process of fabrication, the sculptor 'encountered difficulties in getting the steel the colour she wanted', and although the 'finish was not what she envisaged', both she and the commissioning body were 'very pleased with the result'. Work on erecting the piece began on 17 September 1990 and was completed two days later, a week before the department's anniversary celebrations. Because of the size and position of the sculpture, there was no unveiling ceremony.

In addition to the subvention from the SAC, support was also received from British Steel Stainless, who donated the materials (valued at approx. £3,000), Norwest Holst (£5,000), the Glasgow City of Culture Festival Office (£500) and private donations (£3,000). The artist received a fee of £4,000 and the cost of fabrication was £4,510.

Related work: Copper maquette, 92cm high, in the collection of the artist.

Condition: Good, but with some surface staining.

Sources
All information and quotations from correspondence and related documents kindly provided by Department of Civil Engineering; McKenzie, pp.93–5 (incl. ill.).

John McIntyre Building, adjacent to main University gate

St Kentigern and Symbols of the Four Nations

Sculptor: not known

Architect: John James Burnet, of Burnet, Son & Campbell

Date: 1886–8
Material: yellow sandstone
Dimensions: St Kentigern approx. 1.8m high; inscription panel 1.5m × 80cm; heraldic panels 40cm × 40cm
Inscriptions: in Gothic lettering in vesica surrounding St Kentigern – UNIVERSITY OF GLASGOW; on base of statue – ST. KENTIGERNUS; in Gothic lettering on heraldic panels above the entrance, from the left – GLOTTIANA; ROTHSEIANA; TRANSFORTHANA; LOUDONIANA; in Gothic lettering in panel above the heraldic panels – UNIVERSITAS GLASGUENSIS; in Roman lettering on panel between second-storey windows – THIS BUILDING / ERECTED FOR THE USE / AND BENEFIT OF THE / STUDENTS OF GLASGOW / BY JOHN MCINTRYE M.D. O.D. / I HAM. HAMPSHIRE. A FORMER / STUDENT OF THE UNIVERSITY. / IS DEDICATED TO THE MEMORY / OF HIS BELOVED WIFE ANNE DAU / GHTER OF THE LATE FRANCIS / TWEDDELL ESQUIRE OF THREEP / WOOD. NORTHUMBERLAND / 1887; in Roman lettering on crest above inscription panel – PER ARDUA; below shield – 1887; in entwined Roman letters on escutcheons above second-storey windows – AM; JM
Listed status: category B (15 December 1970)
Owner: University of Glasgow

Description: The statue of St Kentigern is in a niche framed by an inscribed vesica at the east end of the north façade. In the recess behind the statue are a bird and a salmon with a ring in its mouth, from the Glasgow coat of arms. A Gothic canopy supported by slender columns surmounts the niche, and the base of the statue is carved with thistles. Above the main entrance is a series of four low-relief panels carved with the following devices (from the left): a double-headed eagle superimposed on a hammer crossed with a paddle (Glottiana); a ship superimposed on a pick-axe crossed with a distaff (Rothseiana); a cornucopia superimposed

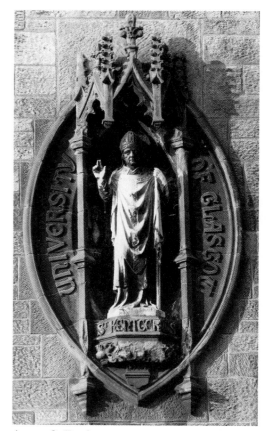

Anon., *St Kentigern*

on a sword crossed with an axe and a crook (Transforthana); an anchor entwined with rope and superimposed on a gaff crossed with a spade (Loudoniana). These refer to the 'four nations… from which the students are drawn': Clydesdale, Rothesay, Albany and Teviotdale.[1] Above the main inscription tablet is a crest showing a hand holding an upright sword, and the monograms above are the initials of the donor John McIntyre and his wife Anne.

Discussion: Erected initially as a Students' Union, the building is now a branch of John

Smith & Son Ltd, booksellers.

Related work: Identical panels of the 'four nations' are found on several other buildings in the University campus, most notably on the present Students' Union, 32 University Avenue (q.v.).

Condition: The statue of St Kentigern is in a poor condition, with a broken crozier, much surface deterioration and a bird nesting in the niche behind. The thistles on the under-side of the base have crumbled almost beyond recognition.

Note
[1] 'University Union', GH, 4 December 1930, p.7; Fisher, p.388.

Other sources
GCA, B4/12/184; BA, 13 May 1888, p.24; LBI, Ward 17, pp.50–1.

University Gardens GILMOREHILL

On the south façade of the Modern Languages Building, 16 University Gardens

Knowledge and Inspiration
Sculptor: Walter Pritchard

Architect: W.N.W. Ramsay
Date: 1957–60
Date of inauguration: 11 February 1960
Materials: copper and bronze
Dimensions: approx. 2.3m high × 1.2m wide
Listed status: not listed
Owner: University of Glasgow

Description: Mounted high on a plain ashlar wall, the sculpture consists of an elderly male figure seated in a shell-like enclosure, with an androgynous youth, standing on his left hand and right shoulder. The old man is bearded and reads from an unfurled scroll; the youth stands in a balletic posture, releasing a dove from its outstretched hands.

Discussion: Ramsay's design was the successful entry in a limited competition for a new University Arts Building in 1952, but funding difficulties delayed the start of the project until 1957. From the beginning his intention was to include a wall-mounted sculpture, though the subject, and the precise form it would take, were left undecided until the appointment of the sculptor at a later date. Published drawings show an abstract figure in a style vaguely reminiscent of the work of Henry Moore and Barbara Hepworth, but sufficiently modernist in style to prompt the following slightly bemused observation from a contemporary commentator: 'As will be seen from the piece of modern sculpture (a Papal Bull?) above the door… all the plans are in the modern conception'.[1]

An undated 'Schedule of Quantities' among the project documents refers to an allowance: '… meantime [of] the Provisional Sum of £1,000 for supply and erection of wrot [sic] iron sculpture on front Elevation, this work to be executed by a specialist nominated by the Architect'.[2] As with many sculptural projects commissioned by the University (see especially James Watt Engineering Building of the same year), the staff were very vocal in their opinions of the work. For example, at some point after the choice of sculptor, medium and subject had been settled, Professor Alan M. Boase made the following detailed criticism of the design:

> In my judgement the lower figure is entirely successful. The forms involved seem to be a most happy use of the medium. I consider, however, that the Committee would be well

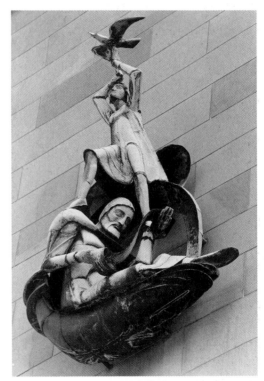

Walter Pritchard, *Knowledge and Inspiration*

advised to ask the artist to submit an amended version of his conception of the upper figure. It is to be supposed that this is Inspiration (or Invention?) springing from the Meditations of Accumulated Learning symbolised by the old gentleman below. Yet it is a deformed creature which does not look like a child because its head is too small. Its limbs are awkward and grotesque, lacking the happy use of the medium mentioned above. It should moreover be borne in mind that the whole feature will be usually seen from a steep angle or from below and to the right (onlooker's right). This will further foreshorten the figure. (The rather too heavy curled lower edge of its garment is the only indication that this fact has been taken into consideration.[3]

While acknowledging that it would be an impertinence on his part to 'suggest how the artist should improve his work', the insistence of his demand that the perceived faults in the design should be corrected throws an interesting light on the general mood of nervousness that prevailed in the University in supporting what was still undoubtedly regarded as risky 'modern' work. 'It would', he claimed,

> … be disastrous to pass for approval… a sketch which if carried out as it is at present will, despite its merits, undoubtedly provoke some not wholly unjustified merriment. At a time when we are threatened by an immense wave of philistinism this would be more than a pity. It would be an act of irresponsibility on our part.[4]

Pritchard's sketches have not been located, so it is difficult to know how radically his design was altered. By 10 April, however, the 'overall shape [had] been agreed with the sculptor' and a timber armature had been formed 'to the rough shape of the two figures'. The production of the final metal piece began shortly after.[5]

Condition: Good.

Notes
[1] *Glasgow University Magazine*, February 1953, pp.218–19. [2] GUABRC, BE 56/1, item no.64. [3] *Ibid.*, BE 61/2, 'Metal Sculpture Feature for new Art Building', undated transcript of letter by Alan M. Boase. [4] *Ibid.* [5] *Ibid.*, BE 56/1, 'Progress Report No. 25'.

Additional source
McKenzie, pp.94 (ill.), 95.

University of Glasgow GILMOREHILL

Main Building

Architect: George Gilbert Scott

Builder: John Thompson (of Peterborough)
Date: 1866–86
Material: Kenmure freestone (dressings)
Listed status: category A (15 December 1970)

The present University building was commissioned as a replacement of the Old College on the High Street, which was sold to the North British Railway Company in 1863. The award of the commission to the London architect George Gilbert Scott caused some consternation among local architects, particularly the leading Greek Revivalist Alexander Thomson, who argued that Scott's neo-medieval design was alien to the dominant Classicism of the Glasgow townscape. Scott

himself described his building as being in a

> … style which I may call my own invention, having already introduced it at the Albert Institute in Dundee. It is simply a 13th- or 14th-century secular style with the addition of certain Scottish features peculiar to that country in the 16th century.[1]

Despite his commitment to historicism Scott made almost no use of sculpture in the design. The building is devoid of figurative work and the use of carved detailing is minimal. Minor exceptions include a small number of stiff leaf capitals and corbel heads, a group of seated eagles on the viewing platform of the spire (completed 1887–91 by J. Oldrid Scott) and a relief of an owl and a monkey among scrollwork in the tympanum above the exterior entrance to the Bute Hall.[2] Some of this work

was carried out by James Harrison Mackinnon, though it has not been possible to determine precisely the extent of his contribution.[3] It should also be noted that the south façade incorporates a number of empty tabernacles on the buttresses between the first-floor windows, which may have been intended to be filled with standing figures, and that there are numerous corbels and bosses, both on the exterior and interior of the building, which have been left as roughly cut cubes.

The sculptures recorded in this part of the catalogue are either works which were added at a later date or which belong to subsidiary buildings on the University campus, with those on departments outwith the main precinct listed under their own street names. There are, however, several interior pieces which are of some historic interest, including two important

figure sculptures in the collection of the Hunterian Museum, and a group of portraits in various other publicly accessible parts of the building.

Notes
[1] McKean *et al.*, p.179. [2] See also Appendix B, Minor Works, and Appendix C, Coats of Arms. [3] 'Architectural Sculptor', (obit. of Mackinnon), GH, 8 November 1954, p.9.

Other sources
Gomme and Walker, pp.168–71 (incl. ills); Williamson *et al.*, pp.335–8; Glendinning *et al.*, pp.302–3 (incl. ill.).

Above the entrance to the Hunterian Museum

Portrait of William Hunter
Sculptor: not known

Dimensions: approx. 90cm

Roundel with a colossal profile portrait of William Hunter of an unknown date in the tympanum above the door to the Museum; sandstone or plaster, painted gold on a blue ground.

In the Hunterian Museum

Statue of James Watt
Sculptor: Sir Francis Leggatt Chantrey

Date: 1830
Material: marble
Dimensions: statue 1.4m high; pedestal 90cm high × 80cm × 1.3m
Signatures: on the left side of the statue, beside the bottom of the rear leg of the chair – CHANTREY SC. / 1830; on the front of the pedestal – CHANTREY SC. 1826 [*sic*]
Inscriptions: on the front of the pedestal – THIS STATUE OF / JAMES WATT / FELLOW OF THE ROYAL SOCIETIES / OF LONDON AND EDINBURGH / AND MEMBER OF THE INSTITUTE OF FRANCE / IS PRESENTED BY HIS SON / TO THE UNIVERSITY OF GLASGOW / IN GRATITUDE FOR THE ENCOURAGEMENT / AFFORDED BY ITS PROFESSORS / TO THE SCIENTIFIC PURSUITS / OF HIS FATHERS [*sic*] EARLY LIFE.; on the back of the chair – JAMES WATT / LL.D. FRS. L & E / AND ONE OF THE FOREIGN MEMBERS OF THE NATIONAL / INSTITUTE OF FRANCE / _____ / PRESENTED BY HIS SURVIVING SON / TO THE UNIVERSITY / OF GLASGOW / IN GRATEFUL TESTIMONY / OF EARLY ENCOURAGEMENT / GIVEN TO HIS FATHER'S / PURSUITS BY THE / PROFESSORS OF THE COLLEGE
Listed status: category A (15 December 1970)
Owner: University of Glasgow

James Watt (1736–1819), pioneer inventor and engineer. (For full biography, see *Monument to James Watt*, George Square, above.)
Description: The subject is seated in a sabre leg chair, and is shown applying a pair of dividers to the outline of a steam engine inscribed on a large sheet of paper spread across his lap. His pose is one of relaxed contemplation, with his head lowered, his knees splayed outwards and his forelegs casually crossed. A partially unrolled sheaf of papers is tucked behind his left foot. The informality of the pose is accentuated by the use of contemporary dress, particularly the open, buttonless gown which falls in heavy folds to the floor, largely concealing the front of the chair and overlapping the edge of the plinth. The statue is mounted on a plain rectangular pedestal with cylindrical projections front and rear.
Discussion: Commissioned by James Watt, the son of the inventor, the statue was presented to the University in acknowledgement of his father's connections with the institution, which had awarded the inventor an honorary LL.D in

Francis Leggatt Chantrey, *James Watt* [HAG]

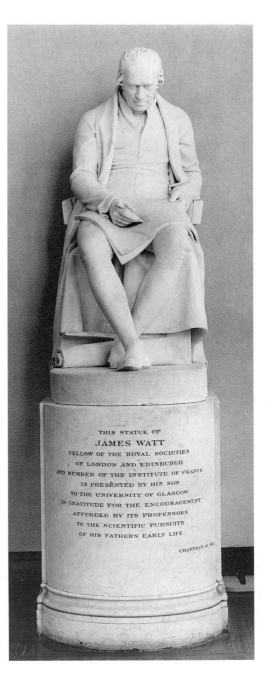

1806.[1] At the time the statue was commissioned, the University occupied premises on the High Street, and the monument was placed in the Hunterian Museum, for which Watt had designed the heating system. The statue was moved to its present location in the current Hunterian Museum during the transfer of the University to Gilmorehill in the 1870s. According to a hand-written memorandum found on the pedestal at a later date, it was re-erected there on 1 September 1871.[2]

No primary documentation relating to the commission has survived within the University, and the principal source of information on its genesis is an entry under 'James Watt's Second Statue' in the Chantrey ledger book in the RA, which records that the order for the commission was received from the younger Watt in January 1830, and that a payment of £1,000 was made on 14 May 1833.[3] The presence of conflicting dates on the statue and pedestal has led to some speculation that the statue was in fact originally commissioned for St Mary's Parish Church, Handsworth, but this seems highly unlikely.[4] It is possible, however, that the pedestal was originally designed for the earlier monument, but discarded in favour of a neo-Gothic design more in keeping with the style of the chapel in which it is located.[5]

Although the Handsworth monument is widely regarded as Chantrey's masterpiece, and appears to have been his own favourite work,[6] the Hunterian statue has not lacked admirers of its own. In his account of his visit to Glasgow in 1838, for example, the travel writer T.F. Dibdin described it in the following ecstatic terms:

> I never passed this matchless production, of the chisel of Chantrey, without almost instinctively taking off my hat, and making obeisance to it. The figure is all life; the countenance is all soul. In the latter, you discern the gentle workings of deep thought; some truth discovered; some mighty result

anticipated. Inspiration sits upon the brow. The lips breathe and speak as you hold silent discourse with the figure. And what benignity of expression lights upon the whole countenance! Where was ever seen the representation of a human being who seemed to live so entirely for the benefit of the human race? I cannot tell what I may feel if ever I should be planted before the *Apollo Belvedere* – but I do know what I *have* felt before the James Watt of Sir Francis Chantrey. If the first be a divinity in *form*, the latter is a divinity in *mind*. It, alone, seemed to compensate the toil and expense of the whole journey.[7]

In the collection of the Hunterian Museum there is also a mid-nineteenth-century painting by William Stewart entitled *Interior of the first Hunterian Museum*, which shows the statue being admired by an artisan, whose companion examines a glass case containing a model of Watt's Newcomen engine.[8]

Related work: See *Monument to James Watt*, George Square, above.

Condition: Good.

Notes

[1] Alison Yarrington, Ilene D. Lieberman, Alex Potts and Malcolm Baker, 'An Edition of the Ledger of Sir Francis Chantrey, R.A., at the Royal Academy, 1809–1841', *Walpole Society 1991/1992*, vol.56, 1994, p.213. [2] HAG, GLAHA 44337, photocopy of memorandum signed by the Keeper of the Hunterian Museum (signature illegible), 1871(?).[3] Yarrington *et al.*, p.213. [4] HAG, GLAHA 44337, miscellaneous correspondence. See especially letter from Nicholas Penny to Martin Hopkinson, 9 February 1981. [5] Noszlopy, p.69. [6] *Ibid.* [7] Dibdin, pp.719–20. [8] C.J. Allan, *A Guidebook to the Hunterian Art Gallery of the University of Glasgow*, Glasgow, 1991, p.5 (ill.).

Other sources

Whinney, pp.404–8; Alex Potts, 'Chantrey as the National Sculptor of Early Nineteenth-Century England', *Oxford Art Journal*, November 1981, pp.17–27.

Statue of Adam Smith
Sculptor: Hans Gasser

Date: *c*.1867
Materials: marble (statue); painted oak (pedestal)
Dimensions: 2.02m high (statue and plinth); 70cm high × 60cm × 60cm (pedestal)
Listed status: category A (15 December 1970)
Owner: University of Glasgow

Adam Smith (1723–90) social philosopher and political economist. Born in Kirkaldy, where he also received his elementary education, he was sent at the age of fourteen to the University of Glasgow to study moral philosophy, and later spent six years at Balliol College, Oxford. In 1751 he became professor of logic at Glasgow, transferring to moral philosophy in the following year. In 1759 he published his first work, *The Theory of Moral Sentiments*, but it is his later book, *An Inquiry into the nature and causes of the Wealth of Nations* (1776) by which he is best remembered. In this he propounded his influential theory that social evolution was guided by the 'invisible hand' of competition. A lifelong friend of David Hume and other leading Scottish thinkers of his day, he was a key figure in the Scottish Enlightenment. He became Rector of Glasgow University in the last years of his life and died in Edinburgh.[1]

Description: The subject is depicted wearing eighteenth-century costume, including a wig, a long jacket secured only by the top button, a waistcoat, a pair of knee-breeches, stockings and buckled shoes; a lace collar protrudes from the top of the waistcoat, which has one of its middle buttons unfastened. The right hand is extended in a pointing gesture, and the left hand rests on top of a draped tree stump with the fingers inserted in the pages of a book. Two more volumes appear on the ground in front of the tree stump, which has a sprig of oak leaves and acorns at its base.

Discussion: There is some uncertainty as to

when and how the statue came into the possession of the University. According to some notes in the relevant HAG object file[2] it may have been presented to the University in 1867 by the Adam Smith Club of Glasgow, which appears to have been a diners' club; other documents in the same file suggest that it was purchased by the University ten years later.

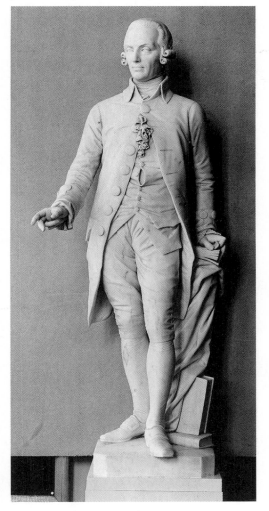

Hans Gasser, *Adam Smith* [HAG]

Despite an extensive search undertaken in the 1980s by the then curator, Martin Hopkinson, no records of the statue's acquisition were found in either the University Archive or the Library's Special Collection. There is even some doubt that such an organisation as the Adam Smith Club of Glasgow existed. The presence of a statue by Gasser in Glasgow is both interesting and puzzling, as the German master appears to have had no other connections with Scotland, and very few with Great Britain generally. One of a small handful of *Kostümfiguren* by Gasser, it is also untypical of his work, which tended towards dramatic subjects in a Romantic idiom. The confused history of the statue is further compounded by mistaken references in the early literature to a statue of Smith by Gasser belonging to Oxford University.[3] No such statue exists in the University's collection.

Related work: The plaster model for the statue is in the Landermuseum für Kärnten, in Klagenfurt, Germany. This is signed on the rear of the plinth with Gasser's monogram 'HG' (entwined) and inscribed 'ADAM SMITH' on the front. The drapery on the tree stump is less elaborate, however, and the oak sprig is omitted. Other representations of Adam Smith include medallions by James Tassie in the SNPG (PG 157) and the Ashmolean Museum, Oxford (probably Gasser's source for the likeness), and a portrait bust by Marochetti (1852), also in the Ashmolean. A statue of Smith of 1862 by Josef Cesar is in the Handelsakademie, Vienna.

Condition: Generally good. However, the two protruding fingers of the right hand have been damaged and repaired twice: in October 1978, and in May 1995 during repair work on the museum's roof and ceiling.[4] The wooden pedestal was made in 1881.

Notes
[1] EB, vol.16, pp.904–7. [2] HAG, GLAHA 44315. [3] See, for example, R. Eitelberger v. Edelberg, *Kunst und Künstler Wiens der neueren Zeit*, Vienna, 1879, p.172; the error is repeated by Thieme and Becker. [4] HAG, GLAHA 44315.

Additional source
The HAG file includes relevant extracts from Martina Hinteregger, 'Das Denkmal und das Grabmal bei Hans Gasser', unpublished thesis, University of Vienna, 1993.

Beside the first floor entrance to the Bute Hall

Sir William Ramsay Memorial Plaque
Sculptor: George Henry Paulin

Date: 1919
Material: bronze
Dimensions: 34cm diameter (portrait roundel); 43cm × 97cm (plaque)
Signature: in cursive script beside neck – G. H. Paulin / 1919
Inscriptions: on the plaque beside the portrait – SIR WILLIAM RAMSAY K.C.B.: / OFFICER OF THE LEGION OF HONOUR: / COMMANDER OF THE CROWN OF ITALY: / ORDRE POUR LE MÉRITE: F.R.S.: LL.D. / (GLASGOW, JOHNS HOPKINS BALTIMORE) PH.D. / (TÜBINGEN, CRACOW, CHRISTIANA): / D.SC. (DUBLIN, / LIVERPOOL, BIRMINGHAM, SHEFFIELD, BRISTOL, DURHAM): / SC.D. (CAMBRIDGE, COLUMBIA, NEW YORK, OXFORD): / M.D. (HEIDELBERG, JENA): PROFESSOR OF / CHEMISTRY UNIVERSITY COLLEGE LONDON / 1887 TO 1913 / *born at glasgow 2nd october 1852: / died at hazelmere bucks 23rd july 1916*; on the marble tablet: ERECTED IN AFFECTIONATE REMEMBRANCE / BY HIS FELLOW STUDENTS AND OTHER FRIENDS

Description: A profile portrait recessed in a roundel on the left side of the plaque. The plaque is mounted on a marble tablet, which is in turn located in a blind Gothic arch.

Source
HAG, GLAHA 44297.

At the foot of the staircase leading to the Randolph Hall

John Veitch Memorial Tablet
Designer: John Oldrid Scott
Sculptor: not known

Builder: R. Bridgeman
Date: 1896
Unveiled: 1 December 1896
Materials: marble, porphyry(?) and gold mosaic
Dimensions: portrait larger than life-size; whole tablet approx. 2.5m × 1.1m
Inscription: on panel in base – TO THE MEMORY OF / JOHN VEITCH M.A. LL.D. / PROFESSOR OF LOGIC RHETORIC AND METAPHYSICS / IN THE UNIVERSITY OF ST ANDREWS 1860–1864 / PROFESSOR OF LOGIC AND RHETORIC / IN THE UNIVERSITY OF GLASGOW 1864–1894 / BORN AT PEEBLES OCT. 24 1829. DIED THERE SEP. 3 1894 / THROUGH MYSTERY TO MYSTERY, FROM GOD AND TO GOD

Description: A head and shoulders portrait in three-quarter profile, in an oval recess decorated with gold mosaic. The surrounding tablet is in the Early Renaissance style.

Sources
Glasgow University Magazine, 25 November 1896, pp.43–4; HAG, John Veitch object file; Williamson *et al.*, p.339.

At the head of the staircase leading to the Randolph Hall

Francis Sandford Memorial Tablet
Designer: John Oldrid Scott
Sculptor: not known

Builder: R. Bridgeman
Date: 1896
Unveiled: 1 December 1896
Materials: marble, porphyry(?) and mosaic
Dimensions: portrait roundel approx. 60cm diameter; whole tablet approx. 2.5m × 1.1m
Inscription: on the base panel – IN MEMORY OF / THE RIGHT HON FRANCIS RICHARD SANDFORD KCB PC LLD / SON OF SIR DANIEL K SANDFORD D CL PROFESSOR OF GREEK 1821–1838 / SNELL EXHIBITIONER 1842 / SEC TO THE EDUCATION DEP[t] 1870–84 UNDER SEC FOR SCOTLAND 1885–88 / CREATED BARON SANDFORD OF SANDFORD 1891 / BORN IN THE OLD COLLEGE MAY 14th 1824: DIED LONDON DEC[r] 31st 1893

Description: A head and shoulders portrait in three-quarter profile, in a circular recess decorated with polychrome mosaic. The surrounding tablet is in the Early Renaissance style.

Sources
Glasgow University Magazine, 25 November 1896, pp.43–4; HAG, Francis Sandford object file; Williamson *et al.*, p.339.

South end of West Range

Lion and Unicorn Staircase
Sculptor: William Riddel

Architect: original architect not known; reconstruction by John James Burnet
Date: *c.*1689
Material: sandstone
Dimensions: lion 1.07m high; unicorn 1.04m high; bases 39cm × 39cm
Listed status: category A (15 December 1970)
Owner: University of Glasgow

Description: The animals are sejant on square bases at the dog-leg turn in the two-stage staircase, with the unicorn on the left and the lion on the right. The crude but vigorous characterisation is stylistically in keeping with the bulbous forms of the balusters, their decorative effect enhanced by the use of gold paint on the unicorn's horn and other key details. A grotesque mask on the front of the lion's pedestal (and which it clutches with its claws) also closely resembles the masks on Pearce Lodge (q.v., University Avenue).

Discussion: The staircase originally formed part of the outer quadrangle of the Old College on the High Street, and was moved to its present position in 1872 to serve as an entrance to the West Range from Professors' Square. At this time the upper level turned to the right, but this was reversed in 1929 after the completion of the War Memorial Chapel.

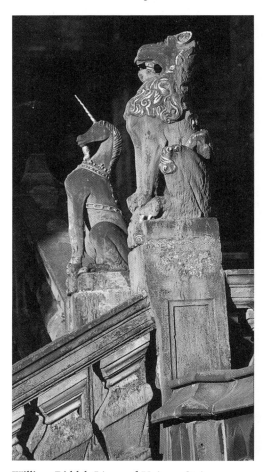

William Riddel, *Lion and Unicorn Staircase*

A drawing of the staircase in its original location was published by R.W. Billings, who also quotes the following passage from 'Affairs relating to the College of Glasgow' by Principal Fall:

June 20th 1690.—The great stair which caryes up to the Fore Common Hall, and my house, &c., wanting a raile, made that Hall useless. So upon the day forsaid an agreement was made with William Riddel, mason for putting up a raill of ston ballusters about it, with a lyon and unicorne upon the first turn, for all which he was to have for workmanship twelve pound sterling, the College furnishing stone, lyme, and all other materialls. The worke was begune the last day of June, and was finished the 15th day of August of the same year.[1]

Condition: A detailed report was written by Professor Arthur E. Truman *c.*1941, who noted various signs of deterioration, particularly in the right foreleg of the unicorn, concluding, however, that the stone work was 'generally… in quite good condition' and that there was 'no reason, other than the exposed situation, for the signs of decay'. He recommended several applications of paint thinned with linseed oil as a further protection.[2] No conservation measures appear to have been taken in the meantime, and the surface of the animals remains marred by unevenly worn paint and a light green deposit overall.

Notes
[1] R.W. Billings, *Baronial and ecclesiastical antiquities of Scotland.* Edinburgh, 1845–52, vol.2, quoted in Johnstone. [2] GUABRC, 'Lion and Unicorn Staircase', DC8/679.

Other sources
Gomme and Walker, p.45 (incl. ill.); Williamson *et al.*, p.340; McKean *et al.*, pp.11, 180 (incl. ills); McKenzie, pp.95, 97 (ill.).

On the west façade of the West Range, including War Memorial Chapel

Figurative Corbels, University Arms and Related Decorative Carving
Sculptor: Archibald Dawson, possibly assisted by Andrew Willison

Architect: Sir John James Burnet
Builders: Bruce & Hay
Material: yellow sandstone
Date: 1923–9
Dimensions: lower corbels approx. 49cm across, upper corbels 66cm; St Mungo approx. 2.5m high
Inscriptions: see below
Listed status: category A (15 December 1970)
Owner: University of Glasgow

Description: An extensive programme of decorative carving, mostly very modest in scale, but distributed over all parts of the west façade. The scheme is divided into three sections, with the projecting entrance block of the University War Memorial Chapel in the centre. The various components of each section are described here in ascending order and from left to right, in many cases with only a representative sample of the contents noted in detail:

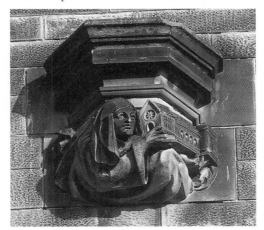

1. North Wing
Corbels in cornice above the basement: imagery includes a bird, a squirrel, a Green Man, a serpent. *Three niche corbels above basement*: a male figure (St Michael?) fighting a serpent; a chorister (St Cecilia?) singing from an open book; a soldier (St George?) in combat with a dragon. *Three niche corbels above third floor*: an architect holding a model of a Gothic church; a pair of entwined dragons; a bricklayer holding a trowel and a brick. The canopies above them are carved with flowers, including a fleur-de-lis, a thistle and a rose. *Attic cornice*: a squirrel with acorns, the head of a monkey, a fish with a ring in its mouth, a bell, a knight's helmet, a bishop's mitre, a tree, a sun with face and radial beams, a comic and a tragic mask, a pair of dividers and a set square, a tree with an apple (pomegranite?) inscribed IN 1727, a winged wheel, a wheatsheaf and sickle, a crescent moon with stars, oak leaves, a leek, a sailing ship, a big cat, a bird and a pair of demons.

(below) Archibald Dawson, *Bricklayer*

(left) Archibald Dawson, *Architect*

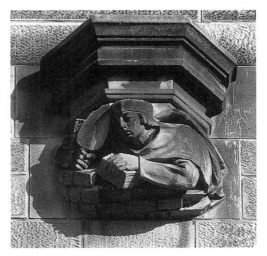

2. Chapel Entrance Block

a) North Face. *Panel above basement door*: polychrome relief of University arms (Faculty of Arts version; see Appendix C, Coats of Arms). *Attic cornice*: a series of natural forms inscribed with letters – a mushroom (A), a leaf (N), a rose (N), birds of prey (O), a tree (D), a thistle (O), a Celtic strapwork motif (M).

b) West Face. *Cornice above left entrance*: a suspended shield bearing a double-headed eagle (symbol of Glottiana). *Capitals flanking left entrance*: birds preening wings and eating strawberries, a squirrel eating a nut. *Cornice above right entrance*: a suspended shield bearing a galleon in full sail. *Capitals and corbels flanking right entrance*: a male head, a stag's head with a cross entwined with a saltire, a knight holding a mace over a dragon, a dog's head, a stag's head, a spider in foliage, an owl in foliage, birds pecking wheat, a harp. *Central cornice above basement*: a male mask, a serpent, a demon head, an eagle, a bird with berries, all entwined in foliage. *Central buttress above basement*: inscription in raised letters: IN / REMEMBRANCE / 1914–1918 / 1939–1945. *Corbel below main west window*: a pelican in a nest feeding her young ('in her piety'). *Cornice above main west window*: the arms of Glasgow University (common seal version; see Appendix C, Coats of Arms) including full-length St Mungo with right hand raised in benediction and the vesica inscribed: UNIVERSITAS GLASGUENSIS / SIGILLUM COMMUNE (trans.: 'the common seal of Glasgow University'). The canopy is surmounted by a half-length hooded figure and a bull and an eagle (both winged and in profile) and flanked by angels holding a fish and a book. *Attic cornice*: corbels with flowers and the symbols of the four Evangelists (an angel, a lion, an ox and an eagle).

c) South Face. *Attic cornice*: natural forms inscribed with Roman numerals – a flower (M), leaves (C), leaves (M), a Celtic motif (X), leaves

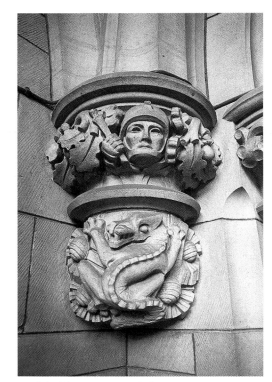

Archibald Dawson, *Corbel* [RM]

(X), a pair of frogs (V), an eagle (II, in its beak).

3. South Wing

Corbels in cornice above the basement: imagery includes an owl and other birds, grotesque masks (including a Green Man, with foliage moustache), fish, bells and foliage. *Three niche corbels above basement*: a fisherman in a boat holding a net and a fish; a male figure reading and pointing to his head; a medieval knight holding a sword and a shield bearing a set of scales. *Three niche corbels above third floor*: a carpenter sawing wood beside a scaffold; a pair of dragons(?); a stonemason carving a stiff leaf capital. *Attic cornice*: flowers and vegetables, an

oil lamp and scroll, a cross in a thorn bush, an hour-glass in a snake biting its tail, a Green Man mask, a wheel with projecting arrows, a bowl of flowers, a mace entwined with a serpent, a tree, a mortar and pestle, a chameleon, an owl, a set of scales with a sword, an open book, a lighted oil lamp, some berries, a pear and a profile head with distended cheeks.

The interior of the Chapel also contains an extensive body of carver work in wood by Dawson, including numerous misericords and poppyheads on the choir stalls decorated with animals, grotesques and incidents from the legend of St Mungo.

Discussion: The generous provision of decorative carving on the Chapel and West Range stands in sharp contrast to the comparative dearth of sculpture on the rest of the main building, and suggests that Burnet was deliberately compensating for Gilbert Scott's apparent parsimony in this aspect of his design. In Dawson he found a sculptor entirely in sympathy with the spirit of the project, and whose ability to move freely between medieval naturalism and a more modish Art Deco idiom was well suited to the self-consciously anachronistic historicism of the structure. Dawson's characteristic humour, and the astonishing fertility of his imagination, were given full rein in this commission.

Condition: Good. The Pollock Hammond Partnership carried out some restoration work on the exterior masonry of the West Range in 1999. This involved the replacement of some of the carvings, including the symbols of the Evangelists on the upper cornice of the Chapel block.

Sources
Williamson *et al.*, p.340; Anon., *Glasgow University Chapel*, 1990 (leaflet); Hamish Dawson, 'The Man Behind the Chapel Carvings', *Avenue*, no.19, January 1996, pp.8 (ills), 9; McKenzie, pp.96, 97 (ill.); conversation with Hamish Dawson, 7 December 2000.

In the West Quadrangle

Three Squares Giratory
Sculptor: George Rickey

Fabricators: McCall, Munro & Co. Ltd, East Kilbride
Material: stainless steel
Date: 1971–3
Dimensions: whole work 4.9m high; each square 1.53m × 1.53m × 13cm
Inscription: on plaque attached to base – GEORGE RICKEY / THREE SQUARES GIRATORY / 1972
Listed status: quadrangle listed category A (15 December 1970)
Owner: University of Glasgow

George Rickey, *Three Squares Giratory*

Description: The work consists of three steel planes mounted asymmetrically on spindles which branch outwards from a central bearing at the top of a square-sectioned vertical post. Each square is thus able to rotate on two axes simultaneously: horizontally, as an independent form, and in unison with the other two on the common vertical axis. A slight differential in the internal weighting of the three squares causes them to respond differently to surrounding air currents, and thus rotate at varying speeds. The main post is mounted with bolts on a square stone base.

Discussion: The University of Glasgow was awarded a government grant of £1,000 through the Royal Scottish Museum, and £1,100 from the SAC's fund for commissioning modern sculpture in public places to purchase this work, the total cost of which was approximately £3,000. In a uniquely 'unselfish gesture', the artist waived his own fee, so that the only costs incurred were those of fabricating and erecting the sculpture. The University's intention was that the work should be installed in the sculpture court of the Hunterian Art Gallery, at that time in the process of construction, siting it in the West Quad only as a temporary measure.[1] On its removal to the Hunterian in 1980, however, the court was found to be too windy, and it was reinstated in its original location. The present base is a replacement of the concrete one which the sculpture stood on when it was first erected, and which was described by Emilio Coia as a 'disturbing factor'. He went on to explain that the original plan was to 'sink the steel post straight into the ground to convey the impression that it has grown up like a tree'.[2]

Condition: Good.

Notes
[1] Roger Billcliffe, unpublished press information sheet, HAG. [2] Emilio Coia, 'Sculpture', *Scottish Field*, December 1972, p.70.

Other sources
Information provided by HAG staff; McKenzie, pp.94 (ill.), 95.

On the Hunter Memorial, immediately south of the main entrance, University Avenue

Portrait Medallions of William and John Hunter
Sculptor: George Henry Paulin

Architect: John James Burnet
Date of unveiling: 24 June 1925
Materials: bronze (medallions); sandstone (memorial)
Dimensions: medallions 36cm diameter
Inscriptions: on either side of the portrait medallions – JOHN / HUNTER 1728 / 1793; 1718 / 1783 WILLIAM / HUNTER; on the coat of arms (west) – CONJURAT AMICE / NON VIVERE SINE[?] VALERE (trans.: 'He swears willingly not to live without thriving'); on the coat of arms (east) – QUAE PROSUNT / OMNIBUS ARTES (trans.: 'Arts that benefit everyone'); below the University arms – IN GRATAM MEMORIAM / FRATRUM / DE SCIENTIA NATURALI ET MEDENDI ARTE / OPTIME MERITORUM / GULIELMI ET JOHANNIS HUNTER / 1718–1783 1728–1793 / QUORUM UTERQUE FAMAE VENATOR AETERNAE / HIC COLLEGIUM CHIRURGORUM LONDINI REGIUM / ILLE GLASGUAE ALUMNUS IDEM ET DITATOR / MATREM STUDIORUM UNIVERSITATEM / MUSAEO CONDITO ORNAVIT (trans.: In grateful memory of the brothers William and John Hunter, 1718–1783, 1728–1793, highly meritorious in natural science and the art of healing, each of whom was a seeker of eternal fame. The latter adorned the Royal College of Surgeons in London, the former as both pupil and benefactor adorned the University of Glasgow, mother of his [?] studies, each by

George Henry Paulin, *John Hunter* [RM]

George Henry Paulin, *William Hunter* [RM]

founding a museum'); on the rear face of the obelisk – UNVEILED BY / MRS GEORGE R. MATHER / 24th JUNE 1925
Listed status: category B (6 February 1989)
Owner: University of Glasgow

William Hunter (1718–83), pioneer obstetrician, teacher of anatomy and writer on medical subjects. He studied in Glasgow from 1731 to 1736, and later in Edinburgh and London, where he went on to become physician to Queen Charlotte. In his house in Great Windmill Street he assembled a vast collection of books, anatomical objects and works of art, which he donated to the University, together with £8,000 for the erection of a building to contain them. The Hunterian Museum still holds his scientific collection, but the paintings, including his portrait by Sir Joshua Reynolds, were transferred to the Hunterian Art Gallery in 1980.[1]

John Hunter (1728–93), pioneer surgeon. Followed his elder brother to London, where he was elected Fellow of the Royal Society in 1767 and appointed surgeon-extraordinary to

the King in 1776. His collection of anatomical objects was bought by the government and placed in the Royal College of Surgeons, London.[2]

Description: The design of the Memorial follows the pattern established by Burnet in his slightly earlier Cenotaph in George Square (q.v.), and consists of a low, U-shaped wall enclosing three sides of a paved central area raised on a short flight of steps. In the centre of the rear wall is a long, horizontal sarcophagus intersected vertically by a truncated obelisk. The portrait medallions are on the inside (north) faces of the sarcophagus, with William Hunter on the right. Additional sculptural work includes a relief carving of the arms of Glasgow University on the front face of the obelisk, and a pair of bronze armorial devices on the end walls of the sarcophagus; these are the arms of the Royal Faculty of Physicians and Surgeons of Glasgow (west) and the Royal College of Surgeons of England. The Memorial is sited to the north of the apse of the Hunterian Museum.

Discussion: The plan to erect a memorial to the Hunter brothers was first proposed in 1893 by their biographer Dr George Mather, who argued for the educational benefits of reminding Glaswegians – 'especially… the younger portion of the community' – of the achievements of the two great pioneer surgeons.[3] Mather himself died shortly afterwards, but the idea was revived in February 1897, when the Faculty of Physicians and Surgeons approached Glasgow Corporation for assistance,[4] followed by a public meeting in the City Chambers in the following June.[5] Mather's widow had by this time 'got a sum of £850' as a first step towards raising the estimated £3,000 to £4,000 to cover the cost not only of the Glasgow monument, but also a memorial in East Kilbride.[6] The implementation of the project was delayed 'in consequence of a difficulty in arranging for a suitable site within the University grounds at Gilmorehill and subsequently by the outbreak of War'.[7] The scheme was revived in the 1920s, however, when a triumvirate consisting of the city council, the Faculty of Physicians and Surgeons in Glasgow and the University was formed to carry it to completion.

Burnet initially planned to award the sculpture commission to the expatriate Glaswegian, John Tweed, who declined the invitation. 'I deeply regret', he wrote in a letter to Burnet,

> … that I cannot see my way to accepting your offer to do the bronze reliefs. I feel that the design exhibits your capable management of architectural style, but I fail to see its suitability as a worthy monument to the memory of John Hunter, one of the greatest names in science. The cenotaph with his works engraved on it is hardly a symbol of one whose work is still being carried on. I trust you appreciate my reasons for refusing the commission.[8]

Condition: Good.

Notes
[1] GCA, OCH 68, pp.167–8; Anne Ross, 'Glasgow 800 and the University's Famous Ten', GH, 3 May 1975, p.8. [2] GCA, OCH 68, pp.167–8. [3] David Murray, *The Hunterian Museum in the Old College of Glasgow*, Glasgow, 1925, p.13. [4] GCA, C1/3/24, p.254. [5] 'Proposed Memorial of John and William Hunter', GH, 30 June 1897, p.10. [6] *Ibid.* [7] Murray, *op. cit.*, p.15. [8] Tweed (1936), pp.184–5.

Additional source
McKenzie, pp.94 (ill.), 95.

On the north wall of the Inorganic Chemistry Building, University Place

Joseph Black Memorial Tablet

Sculptor: Benno Schotz

Architects: Alexander Wright & Kay
Date: 1952–4
Material: sandstone
Dimensions: whole tablet approx. 5.5m high × 3.2m wide; portrait 1.6m high × 80cm wide
Inscription: on main tablet – 1728 1799 / JOSEPH BLACK M.D. / PIONEER / OF MODERN CHEMISTRY / HE WAS LECTURER IN / CHEMISTRY 1756–1766 / PROFESSOR OF ANATOMY / AND BOTANY 1756–1757 / PROFESSOR OF PRACTICE / OF MEDICINE 1757–1766 / IN THIS UNIVERSITY; on base – 1953
Listed status: category A (15 January 1985)
Owner: University of Glasgow

Joseph Black (1728–99), chemist and doctor. Following Lavoisier, his experimental proof that air could be combined with and removed from solids repudiated Georg Ernst Stahl's theory which proposed that objects became hot by absorbing 'phlogiston', defined as a 'negative oxygen'. He also developed the theory of latent heat, which proved useful in the work of his colleague James Watt.[1]

Description: The head and shoulders of the subject are represented in profile in a rectangular panel at the top of the tablet. The carving is in very low relief, with the features defined in a sharp, angular style and the profile emphasised by a thin raised fillet. The main part of the tablet is undecorated apart from a pair of small, stylized owls on the lower corners.

Discussion: Debate about the inclusion of a memorial tablet began in June 1951, during the architects' consultation with the Works Committee over suggested amendments to the exterior of the department's Lecture Theatre,[2] and by the end of the year the architects had forwarded Schotz's name for consideration as the sculptor.[3] After examining photographs of portraits of Black by Henry Raeburn, David Martin and James Tassie, it was decided that a profile portrait should be made, based on the plaster medallion by James Tassie in the Scottish National Portrait Gallery, and that any accompanying ornamentation should be 'in the Eighteenth Century spirit' of Tassie's work.[4] Schotz was required to produce a plaster model for approval by the committee; it was also suggested that 'a full size mock-up be erected on the building so that the [University] Court would be in a position to judge of the actual scale and general arrangement of the proposed plaque'.[5] Whether this was carried out is not known. The committee's proposal that the portrait and the inscription be carved by different sculptors was challenged by Schotz, who argued that 'the whole plaque, sculpture and lettering, was a single work', and that it 'could not be satisfactorily done by two people'.[6] The cost of the work was originally estimated at £150, but eventually rose to £464, including an excess cost of £22, 'due to the cutting of wider lettering than originally intended'.[7]

Related work: A smaller relief medallion portrait of *Joseph Priestley* by an unknown sculptor is located on the north-east corner of the neighbouring Organic Chemistry Building. More naturalistic in style than Schotz's work, the portrait is enclosed by palm branches and carries the inscription '1733 1804 / JOSEPH PRIESTLEY'. The portrait is slightly larger than life-size.

Condition: Good.

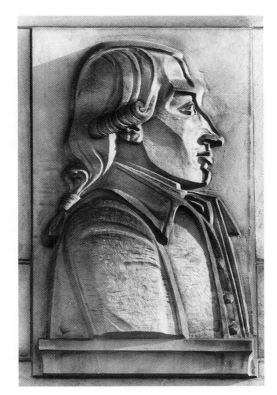

Benno Schotz, *Joseph Black*

Notes
[1] Fisher, p.389. [2] GUABRC, *Glasgow University Court Minutes*, C1/1/58, p.245. [3] *Minutes*, C1/1/59, p.164. [4] *Ibid.* [5] *Ibid.* [6] *Ibid.* [7] *Minutes*, C1/1/61, p.278.

Additional source
Williamson *et al.*, p.342.

On the south elevation of the James Watt Building (South)

The Progress of Science

Sculptors: Eric Kennington, assisted by Eric Stanford and Archibald Robertson

Architects: John Keppie & Henderson & J.L.
 Gleave
Date: 1957–8
Material: Portland stone
Dimensions: approx. 10.8m high × 3.6m wide
Inscriptions: on various parts of the relief, in
 ascending order – PER MARE / PER TERRAS;
 SCIENTIA / ET / INGENIO; DISCE DOCE (trans.:
 'Through sea and land; by science and
 genius; learn, teach'); PROGRESS
Listed status: not listed
Owner: University of Glasgow

Description: The work is in the form of a
vertical relief panel inserted in the centre of the
otherwise undecorated ashlar surface of the
south wall of the Electrical Engineering wing of
the Engineering Department. The subject is a
free interpretation of the development of
science and technology, combining figures
engaged in technical activities accompanied by
an array of instruments and objects associated
with science and industry. The figures are
mostly mythological, and include Vulcan, Zeus
and Hermes, accompanied by the winged horse
Pegasus; among the objects are a ship, a
governor mechanism, a pulley with chains, a
parachute and a number of scientific and
agricultural tools. Woven into the design are
also several references to the natural world –
including a whale and a shoal of fish swimming
through stylized waves at the base of the design
and a sunburst at the top – as well as a number
of mottoes taken from the crests of various
engineering societies[1] (see Inscriptions, above).
The specific association of technology with
Glasgow University is indicated by the

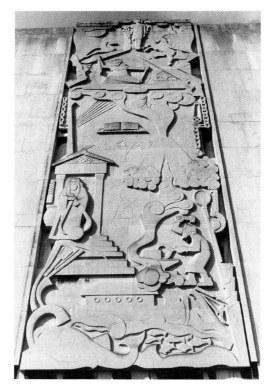

Eric Kennington, *The Progress of Science*

inclusion of a tiny replica of the University's
distinctive spire in the top right corner of the
panel. The depth of the cutting varies between
'flush, minus 3", minus 6" and minus 8" as the
maximum cutback'.[2]

Discussion: The architects intended from the
beginning that a relief sculpture of some kind
should form an integral part of the design of the
building, and in an early report to the
University authorities specified the
'architectural design factors' they regarded as
desirable for such a work. It was to be 'rich in
overall texture to fulfil its primary purpose of
matching with the Scott Gothic of the
University Main Building'; 'Deep in Relief', in

order 'to "carry" as texture' when seen from a
distance; a 'unified composition of small units'
in order to remain in scale with the 'details such
as windows etc., of the new building'.[3] They go
on to suggest that the subject should be 'the
development of engineering relative to the
University', accompanying the report with a
sketch plan outlining a 'deliberately tentative'
design. At this stage their intention was to use a
basically abstract image, inscribed with various
relevant names and dates ascending in
chronological order. Estimating the cost of the
work at about £3,000, they recommend that a
'non-Scottish sculptor' should be asked to carry
out the work, nominating Kennington as the
'British sculptor most likely to make an
outstanding job of the panel'.[4]

It is clear from the surviving correspondence
that the Amenities Committee, which
represented the University Court and to whom
the architects were expected to report, were
deeply unhappy with many aspects of the
proposal. There were, for example, regular
complaints about what they perceived to be a
lack of proper consultation, with many crucial
decisions being presented as *faits accompli*, and
the 'rather insulting omission' of the committee
from the discussion of several key points.[5] The
problem was aggravated by the fact that
opinion within the Committee itself was very
much divided as to the aesthetic merits of the
scheme. This is indicated in a somewhat fraught
letter from Professor A.D. Gibb to the
University Principal, in which he states that 'the
matter is rather controversial and I fear I cannot
testify to a unanimity which does not exist'. He
took the opportunity, nevertheless, of
expressing the personal opinion that a 'more
classical form for the panel' should be
considered, with 'names and dates and suitable
ornamentation rather than formalised
representations of e.g. pithead machinery'.[6] The
most detailed critique, however, is provided by
a confidential letter to Gibb himself from J.C.
Wingate, Assistant Secretary to the University

Court, who complained that the

> ... shape of the proposed vertical panel, the position of an entrance below it (and of exactly the same width), and above it, the lack of any moulding, cornice or band, all these features cannot now be changed. I am aware that the projecting roof lantern will, from certain angles of vision, form a 'hat' for the plaque – but hardly an appropriate one. All seem to me defects which might well have been modified to advantage, had we been consulted earlier.

He goes on to predict that the panel 'will look like the edge of a rather thick lantern slide inserted in an odd kind of stone holder', drawing the conclusion that it would therefore 'do nothing to "tie" the New to the Old, as claimed' by the architects. Under cover of the confidentiality of the document the writer was also able to express a more personal reservation about J.L. Gleave, who appears to have been the partner most closely involved in development of the scheme:

> While admiring much of the work of Gleave, I am reminded only too forcibly in this present connection that he does not believe in the superaddition of decoration to a functional building. I have myself heard him maintain this point of view – and I am therefore not prepared to trust his judgement on such a matter... Personally I consider the plaque is unlikely to seem a good £3000 worth...

Finally, the letter records the more general disquiet among the committee members that the architects favoured Kennington in preference to a Scottish sculptor: 'If the proposal is adopted, I would still be regretful if no consideration of sculptors, Scottish, or resident in Scotland were given. What about either Hew Lorimer or Benno Schotz?'[7]

The architects themselves responded immediately with a detailed, point by point rebuttal of the committee's objections, conceding only the most minor of issues. On the question of Kennington's appointment, for example, they were quite adamant:

> We are glad that the names of two Scottish sculptors, Hew Lorimer and Benno Schotz were raised as it gives us the opportunity of saying that we know them and their work very well, and, for some other types of sculpture, would have been only too pleased to suggest their names. You will appreciate that before submitting Eric Kennington's name, Mr Henderson and Mr Gleave thought and talked over the nomination at great length. The point of supporting local sculptors in order that they might not miss this rather magnificent opportunity was very much in their minds and also, the implications of suggesting another name. As, however, it became clear that they sincerely believed that Eric Kennington was the most likely to turn out a brilliant piece of sculpture of the type envisaged on the building, they felt they had no option but to give that opinion regardless of any other factors.[8]

By this time they appear to have won the support of the Assistant Secretary, who stoutly defended the decision to include the cost of the relief within 'prime costs' of the building when this was queried by H.J. Oram, of the University Grants Committee. Quoting from the architects' own earlier report, he pointed out that the £3,000 allocated for the sculpture was

> ... less than ½% of the total cost of the building work and below the percentage, which we have always understood, is generally allowed on government financed buildings for the encouragement of the plastic arts.[9]

In his view this in turn demonstrated the wisdom of the design, with the 'concentration of a richer texture at one point' proving to be thus 'an economy measure rather than an extravagance'.[10] Oram remained unconvinced, arguing that the UGC had 'hitherto always taken the line that the cost of sculpture etc. should be met by the University and not from public funds'.[11] Despite this, however, he was prepared to 'leave matters as they stand', and allow the funding to go ahead.

Acceptance of Kennington's design was formally ratified at a meeting of the committee on 22 April 1958, during which a number of small modifications were agreed. These included the deletion of the word 'Progress' from the top of the panel, and a reconsideration of the narrow fillet surrounding the work as a whole. In the event, the word 'Progress' was reinstated and the fillet retained.

Kennington estimated that he would require 'at least twelve months to complete his work', but a delay in the delivery of the stone from the suppliers Shaw & Campbell, together with the University's desire that it should be completed by September 1959, in time for the official opening of the new building, meant that the carving had to be executed much more quickly than expected.[12] 'Preliminary stone cutting' was completed by mid-April 1959, allowing the building contractors to erect a barricade around the site and begin placing the cut blocks in position with a crane.[13] A further setback occurred in July, when Kennington became seriously ill and had to 'go South to have a rather serious operation'. Arrangements were made 'for carrying on the work by Mr. Kennington's two assistants, who [had] been working with [him] on it for approximately two months'.[14] Kennington died before the work was completed.[15]

Condition: Good.

Notes
[1] GUABRC, BE 13/4, 'Minute of sub-committee', 22 April 1958. [2] *Ibid.*, 'Notes on Bas-Relief Sculptural Panel', 19 April 1957, p.1. [3] *Ibid.* [4] *Ibid.*, p.2. [5] *Ibid.* 13/4, copies of correspondence,

20 May 1957, pp.2, 4. [6] *Ibid.*, p.2. [7] *Ibid.*, p.4. [8] *Ibid.*, letter from John Keppie & Henderson & J.L. Gleave to J.C. Wingate, 22 May 1957, p.4. [9] *Ibid.*, letter to H.J. Oram, 28 June 1957, p.1. [10] *Ibid.* [11] *Ibid.*, letter from D.R.W. Williams to J.C. Wingate, 24 July 1957. [12] *Ibid.*, letter from Keppie Henderson & Partners to John Laing & Son Ltd, 12 March 1959. [13] *Ibid.*, letter from Keppie Henderson & Partners to J.C. Wingate, 17 April 1959. [14] *Ibid.*, letter from Keppie Henderson & Partners to Secretary of the University Court, 10 July 1959. [15] Williamson *et al.*, p.338.

Additional source
McKenzie, pp.93, 94 (ill.).

University of Strathclyde TOWNHEAD

Although Glasgow's second university did not receive its charter until as recently as 1964, its history may be traced back to 1796, and the founding of Anderson's Institution (often referred to as Anderson's University). This was the creation of John Anderson, Professor of Natural Philosophy at Glasgow University (see entry for *Prometheus*, below), who bequeathed his fortune, library and collection of scientific instruments for the formation of a college which would foster 'intelligence, knowledge and skill among the classes who would most benefit from the turning of these possessions to account in the business of their lives'.[1] It was the first college in Britain to admit women students, and provided a model for George Birkbeck in the establishment of the Mechanics' Institutes.[2] In 1887 it was united with three other colleges to become the Glasgow and West of Scotland Technical College, with premises on George Street, later merging with the Scottish College of Commerce, before achieving full University status.[3] In addition to the three main works listed below, the University has a number of sculptures in its collection, including two important pieces in the foyer of the former Royal College, 204 George Street:

Statue of James Watt, 1823–4, sandstone, by John Greenshields. (For biographical information on Watt, see *Monument to James Watt*, George Square, above.) Dimensions: 2.34m high on a 15cm plinth. Commissioned by the Mechanics' Institute and Technical College of Science as a result of an 'agitation for the erection of a statue to the memory of James Watt', with £30 raised by charging one shilling admission to public lectures on the workings of the steam engine.[4] (Members also contributed £30 towards the erection of Chantrey's later monument in George Square.) The first statue of Watt in Glasgow, it originally stood on the attic of the Institute's building at 38 Bath Street,[5] and like Grassby's portrait of *c*.1864 (q.v., McPhun Park), shows the inventor leaning on a steam cylinder.

Notes
[1] *Burgh Records*, 9 June 1796, quoted in Eyre-Todd, vol.3, p.377. [2] *Ibid.*, pp.377–8. [3] Williamson *et al.*, pp.147–9. [4] A. Humboldt Sexton, 'The First Technical College' A Sketch of 'The Andersonian' and the Institution Descended from it: 1796–1894, London, 1894, p.73. [5] *Ibid.*, p.78.

War Memorial, by T.L. Watson, 1921, with life-size male and female workers in bronze by William Kellock Brown, and a winged Victory extending a wreath in the broken pediment. In the Collins Gallery there are also portrait medallions of John Anderson by James Tassie and Thomas Graham (q.v., George Square) by J.W. Minton. The three exterior sculptures on the University campus are catalogued here in chronological order.

In the John Anderson Campus, north of the Department of Architecture and Building Science

Callanish
Sculptor: Gerald Ogilvie Laing

Installed: January 1974
Unveiled: June 1977
Material: corten steel
Dimensions: each pillar 4.88m high
Owner: University of Strathclyde

Description: The work consists of sixteen free-standing steel abstract pillars, often referred to as 'monoliths', distributed over a gently undulating area of grass in an arrangement recalling, but not duplicating, the circle of prehistoric standing stones at Callanish on the Hebridean island of Lewis. In total, the work occupies an area of approximately half an acre. Though the pillars are of uniform height, and all have battered bases, there are variations in their design. Some are shaped like the blade of a knife, with straight, parallel sides, while others have one edge cut away and are grouped in pairs to create an impression not unlike the eye of an enormous needle with its point buried deep in the ground. Dominant among them, however, is a cluster of four pieces with much wider bases and projecting upper sections, and which have the appearance of stylized hooded figures. There is an understated anthropomorphism pervading the entire work,

with a suggestion of ritualistic meaning in the axial symmetry of the overall distribution, and the placement of one pair of pillars in isolation from the main group. Each pillar is erected on a buried concrete base, with a narrow recess at the junction creating the illusion that they are suspended a few inches above the ground.

Discussion: After receiving its charter, the University embarked on a massive programme of building work which was to continue more or less unabated throughout the late 1960s and early 1970s. Recognising, however, that no provision had been made within this for works of art, a series of tripartite meetings between the University, the SAC and Gerald Laing were held in the early part of 1971 to discuss proposals for introducing an 'imaginative and exciting' artistic project into the scheme. Despite a prevailing climate of financial stringency, the University and the SAC agreed to allocate £14,000 (on a 'roughly 50–50 basis') towards the procurement of a major sculpture.[1] *Callanish* was commissioned as a result.

The realisation of the project was very much bound up with the wider pattern of architectural developments occurring at the time and of which *Callanish* was intended to form a part. Initially, the plan was to site the work on a flat roof extending between the John Anderson Building (Physics) and the Wolfson Centre (Bio-engineering), both then under construction. The decision to bring it down to ground level and place it in the centre of the campus – the University's 'favoured site' – entailed some modifications in the design, as well as a slight reduction in the cost.[2] It also led to a delay of more than three years between the installation of the pillars and their formal inauguration on completion of the landscaping in June 1977.[3]

Laing's use of the title *Callanish*, and the immediately recognisable formal references to the standing stones of Lewis, raise interesting questions concerning the relationship between late twentieth-century art practice and the achievements of ancient cultures. According to

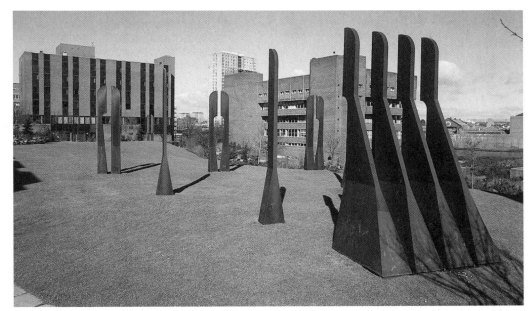

Gerald Ogilvie Laing, *Callanish*

one critic writing in the *Stornoway Gazette*, the work was an 'attempt to restate in contemporary terms the values which Laing believed ought to be preserved in Scotland', going on to note the sculptor's apparent belief that there was 'a real danger of Scotland surrendering its cultural identity, of losing the very elements which once produced the Callanish Stones'. The implicitly 'New Age' tendency in critical approaches of this kind is revealed in the same writer's claim that in more 'philosophical' terms:

> ... the pattern of the pillars is seen as a link between, on the one hand, the great aesthetic and spiritual awareness of Megalithic Man, his great mathematical skills, capacity for civil engineering and social organisation (all as shown by stone circle construction) and, on the other hand, the need of a modern technological university to rediscover spiritual values.[4]

The University was a little more cautious in its claims for the work, expressing only the hope that by accommodating such a group, Strathclyde might:

> ... help remind scientists that society has a continuing need for the contemplative while demonstrating for arts students that art itself must use modern scientific materials and scales if it intends to remain relevant.[5]

For his own part, Laing described his intentions in equally generalised terms, asserting that the work was 'not symbolic', and that it was designed to appeal to the 'very basic instinct rooted in mankind from earliest times to erect monuments bigger than himself'.[6] What appears to have attracted the sculptor was the 'quiet authority of standing stones in the middle of fields, ploughed around by generations of farmers who did not understand them, yet did not destroy them', and it was this which

suggested 'the manner in which [he] approached the task'.[7] Curiously, an advertising photograph used frequently in the 1970s by the landscaping company Border Square Builders Ltd shows the pillars *in situ* before the area around them was grassed.[8] The roughness of the surrounding topsoil provides a remarkable match for Laing's description of the ploughed fields of the original Callanish monument.

In retrospect, the University's prediction that *Callanish* might come to be regarded as 'the most important twentieth century sculpture erected anywhere in the British Isles'[9] seems somewhat over-ambitious, and like many conspicuous works of public art in the 1970s, particularly those in a radically abstract idiom, attracted its own share of ridicule. Described variously as a collection of 'washing tongs' and the 'tail-ends of gondolas', the work eventually came to be referred to by the student body as 'Steelhenge', a nickname which the University somewhat defensively pointed out was based on a mistaken association with Stonehenge in Wiltshire, and which thus overlooked its specifically Celtic pedigree. The site was also criticised, with one writer perceptively claiming that the work would be more successfully located 'on a wild ridge, rather than dwarfed by educational skyscrapers and hedged in by rather fussy landscaping'.[10]

Related work: Among the numerous variations on the theme of the divided 'monolith' by Laing in Scotland are *Bilith III*, 1971, King's College, Aberdeen, *Alness Pyramid*, 1971, Alness Academy, Alness, *Tunnels and Pyramids* 1971, Glenshee Sculpture Park, Tayside, and *Pyramid*, 1971, in the SNGMA.

Condition: The pillars have acquired an even patina of rust, and are in good condition.

Notes

[1] John C. Eaton, 'Major Sculpture Group acquisition may shortly Transform the Central Campus'. *University of Strathclyde Gazette*, vol.6, no.3, April 1971, pp.22–3. [2] *Ibid.* [3] Gerald Ponting, '"Callanish"

in Glasgow', *Stornoway Gazette*, 27 August 1983, p.35. [4] *Ibid.* [5] Eaton, *op. cit.* [6] Strathclyde University Archive, press release, quoted in unpublished letter from James McGrath, University Archivist, to H.W.T. Pepper, 18 May 1982. [7] Ponting, *op. cit.* [8] See, for example, *West End News*, 30 August 1974, p.14. [9] Ponting, *op. cit.* [10] *Ibid.*

Other sources

Strachan, pp.220, 231, 233 (incl. ills); Williamson *et al.*, p.151; Pearson, pp.112, 121, 175 (incl. ills); McKenzie, pp.6 (ill.), 7.

At the junction of Taylor Street and Rottenrow

Prometheus: The Gift of Science to Liberty
Sculptor: Jack Sloan
Fabricator: Hector McGarva

Installed: September 1994
Date of unveiling: 14 December 1994
Material: galvanised steel
Dimensions: whole work 6m high; figure approx. life-size
Inscriptions: on plaque – THE GIFT OF SCIENCE TO LIBERTY / JACK SLOAN 1994 / '*And fire has proved for men / A teacher in every art, their grand resource*' / Aeschylus, Prometheus Bound
Listed status: not listed
Owner: University of Strathclyde

Description: The work consists of a tower-like arrangement of geometric forms raised on a stylized representation of a primitive wheeled vehicle. The upper part of the structure is dominated by the figure of Prometheus, who strides forward with arms extended on a small platform. Three alternative forms of the figure are shown in the space behind it. These consist of a negative shape cut from a flat rectangular plane, a free-standing silhouette and an open linear outline. The foremost version of the figure, which is composed of a complex mass of interlocking planes, thus appears to be

undergoing a process of development, as if emerging from, or discarding, more elemental embodiments of itself. Much of the work is constructed of standard industrial steel units, including a series of I-beams, placed in a cross-wise formation, articulating the transition from the base to the superstructure. The figure is fabricated from 4mm plate.

Discussion: Commissioned jointly by the University of Strathclyde and the GDA, the sculpture was part of a package of environmental improvements in the University campus costing £860,000. Preliminary discussions began shortly after the completion of the Chancellors Hall Student Residence Building at the east end of the campus in November 1992. It would appear that one of the planning requirements of this building was the commissioning of an associated artwork.

In its competition brief the University emphasised the importance of the proposed site, and made it clear that the sculpture would be expected to function as an effective landmark within the surrounding architectural context. The work was to be located at the convergence of the two principal cross-walks of the University precinct: the east-west route from the Cathedral to the John Anderson Campus, which carries the general flow of student traffic; and the north-south route along Taylor Street, much used by the general public en route from George Street to Cathedral Street. The work was thus intended to contribute to the amenities of the City generally as well as providing an enhancement of University life. In addition to these environmental considerations, it was also a requirement that the work should reflect the philosophical outlook of the funding organisations, though there were no further guidelines as to how this should be achieved.

The selection process began with an open competition, which attracted a total of 39 portfolios. A panel of judges composed of representatives from the University, the GDA and the Scottish Sculpture Trust chose a

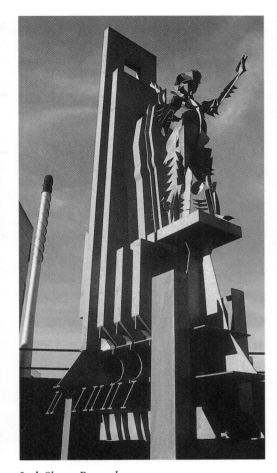

Jack Sloan, *Prometheus*

shortlist of six competitors, who were invited to submit more detailed proposals by 14 June 1993. The selected artists were Stan Bonnar, Shona Kinloch, Jamie McCullough, Tim Pomeroy, Jack Sloan and George Wyllie, each of whom submitted a scale model, a set of sketches and a detailed statement of intent. A second panel of judges met two days later and unanimously selected Jack Sloan's entry as the one which most effectively satisfied the conditions of the commission. As well as being impressed by its 'philosophical content' – which generated much debate – the panel was also pleased with the powerful verticality of the design, and the enhanced visibility achieved by the simple tactic of positioning the work at an angle of 45° to the two main cross-axes. The runners up were each paid a premium of £750, and their maquettes were displayed in the Collins Gallery in the following July.

Thematically, *Prometheus* is a complex and multi-layered conception, combining aspects of mythology and the history of science with an erudite reflection on the University's educational mission. The principal point of reference is the work of the scientist John Anderson (1726–96), the founder of the institution from which the University eventually grew (see above). Professor of Natural Philosophy at Glasgow University, Anderson was by all accounts an inspiring teacher, whose 'fiery temperament' earned him the nickname 'Jolly Jack Phosphorus' from his students. The derivation of the word 'phosphorus' via Latin from the Greek 'light-bringing' provides Sloan with the link to Prometheus, the character in Greek mythology who stole fire from the gods and who, as the prototypical teacher and benefactor of mankind, is presented by Sloan as the 'personification of the University'. In his written statement, Sloan noted the Promethean nature of steel, which requires fire in order to be cut, formed and joined. He also intended the flame-like treatment of many of the planes of the body to suggest that the figure, the bringer of fire, is simultaneously being consumed by flames.

A related aspect of Anderson's career was a 'predilection for the military art', acquired while helping, at the age of nineteen, to raise a regiment to defend Stirling during the Jacobite Rebellion of 1745. He published a book of *Essays on War and Military Instruments* and invented a field gun capable of absorbing its own recoil through the condensation of air in the gun carriage. After being rejected by the British government, his design was accepted by the revolutionary National Convention in Paris, who exhibited it in the Hall of Assembly under the title 'The Gift of Science to Liberty'. This dimension of Anderson's achievement is celebrated not only in the title of the work, but also its form, the lower half of which is intended to resemble 'some great siege machine, or gun carriage'. The tiny thunderbolt attached to the plate behind the figure is a further variation on this theme, as well as an additional link between Anderson and Prometheus. It is also a reminder that Anderson erected a lightning conductor on the College Steeple in the High Street, the first on any building in Glasgow. In his background research, Sloan also discovered a more recent Glasgow scientist with the name John Anderson (1893–1962). By an extraordinary coincidence, he too appears to have had a volatile temperament, basing his approach to education on the belief that it is 'through conflict… that we learn what our ends and purposes are'.

As part of his attempt to relate the sculpture to its surroundings, Sloan incorporated a number of large vertical abstract shapes designed as an acknowledgement, albeit oblique, of Gerald Laing's earlier work *Callanish*, which occupies the central area of the campus immediately to the west (see above). In *Prometheus*, however, the abstract background serves to reinforce the function of the figure as an embodiment of 'Liberty', and as a metaphor of the 'forward movement' of Glasgow's current cultural development.

The budget for the commission was £35,000, shared equally between the University and the GDA, with £25,000 allocated directly to the design, fabrication and installation of the sculpture. The original intention that it should be installed before Christmas 1993 proved optimistic, and it was not until September of the following year that it was finally erected, with the formal unveiling taking place three months

later. The University authorities were well pleased with the outcome, and as a result expressed an intention to commission further sculptures in the future.

Condition: Good.

Sources
Eyre-Todd, vol.3, pp.373–8; miscellaneous unpublished documents, including artist's statement, in file provided by Collins Gallery; McKenzie, pp.6 (ill.), 7.

On the west wall of the Chancellors Hall, Taylor Street

The Pursuit of...
Sculptor: Shona Kinloch

Founder: Powderhall Bronze
Date of installation: 21 November 1996
Date of unveiling: 28 November 1996
Material: bronze
Dimensions: dog 1.22m long and fastened 1.83m from ground; cat 91cm long and fastened 2.44m from ground; birds 61cm long and fastened 3m and 4.2m from ground
Inscription: on plaque – 'The Pursuit of . . ' / by Shona Kinloch / 1996 / commissioned to mark *200 Years of Useful Learning* / funded by the / University of Strathclyde Cultural Trust / with assistance from the GDA'
Listed status: not listed
Owner: University of Strathclyde

Description: The sculpture consists of a dog, a cat and two birds in low relief, each animal fastened separately to the brick wall and arranged in a sequence suggestive of a chase. The dog, cat and first bird form an arc over a window, while the second bird is 'slightly detached, broken free from the main chase, yet still in pursuit of something'.[1] There is very little surface detail, and the birds are treated almost as silhouettes. On the dog, however, there are a number of spirals scored on the surface to suggest a 'curly mongrel sort of coat', while the crosses incised on the cat are intended to recall the 'magical sparks of fire produced

when old fairy tale witches, such as Baba Yaga, stroke their cats'.[2] The bronze is finished with a green/blue patina.

Discussion: Kinloch was invited to make the work as a result of her shortlisted submission for an open competition organised by the University in 1993, which was ultimately won by Jack Sloan (see *Prometheus*, above). Her design for this was rejected because 'at just under 3 metres tall' it was not sufficiently visible from the upper pedestrian level which formed the approach to it from the rear. The panel of judges, however, were so impressed by the quality of the entry that they 'suggested that the artist could be asked to produce a sculpture for another occasion'.[3] The occasion arose three years later, with the bicentenary celebration of the founding of the Anderson Institution, the college from which the University is descended (see above). The subtly caricatured treatment of the animals suggests that they are intended as a playful satire on the '200 years of Useful

Shona Kinloch, *The Pursuit of ...* [RM]

Learning' celebrated by the anniversary, though the artist herself described the sculpture as a metaphor not only of the striving for academic excellence and knowledge, but also, more generally, of the 'pursuit of happiness and freedom of choice'.[4] The work was funded jointly by the University's Cultural Trust Fund and the Glasgow Development Agency Artwork Fund, and cost £5,500.

Condition: Good.

Notes
[1] Artist's statement, unpublished press release, Collins Gallery. [2] *Ibid.* [3] Unpublished typescript, 'Sculpture for University of Strathclyde (John Anderson Campus)', 23 June 1963, Strathclyde University Archive. [4] Press release.

Other sources
Scotsman, 29 November 1996; McKenzie, pp.6 (ill.), 7.

Victoria Park SCOTSTOUN

A short distance north of the Victoria Park Drive South entrance, beside the boating pool

Partick and Whiteinch War Memorial

Sculptor: Francis William Doyle Jones

Date: 1922
Materials: bronze figure on a pink granite cenotaph
Dimensions: figure approx. 2.5m high; cenotaph approx. 5.2m high
Signature: on the left side of the plinth – F.W. DOYLE JONES 1922
Inscriptions: on the cenotaph – OUR / BELOVED DEAD / TO THE GLORY OF GOD / AND IN / GRATEFUL & EVERLASTING / REMEMBRANCE / OF THE MEN OF / PARTICK & WHITEINCH / WHO FELL IN THE GREAT WAR / 1914–1918 / 1939–1945; on the base – WE WILL REMEMBER THEM
Listed status: not listed
Owner: Glasgow City Council

Description: The monument consists of a female figure with outspread wings standing on a globe and holding out a wreath with both hands. A symbol of *Peace Crowning the Heroes*, she is dressed in an elaborate, windswept chiton, the lower part of which flutters energetically behind; only her feet and shoulders are exposed. The cenotaph is designed as a tall, slender obelisk with projecting side piers and a pulvinated roll on the upper stage, and with a sword entwined with a wreath carved on the topmost block on the front (east) face. The wreath is identical to the one held by the figure.

Discussion: On 29 April 1921, the council received a letter from James Arthur, secretary of the Partick Joint-Wards War Memorial Committee, requesting permission to erect a monument in Victoria Park, and shortly afterwards 'received and heard' a delegation from the committee itself.[1] A site on the west side of the model yacht pond was granted, subject to the design being approved.[2] A little over a year later approval of the design itself was granted, subject this time to the work of erection being carried out satisfactorily, and the construction of an iron railing round it.[3] The railing, if it was erected, has now been removed.

Related work: The pose of the figure is very similar to that of *Peace* on Doyle's *South African War Memorial* in Saltwell Park, Gateshead, of 1905. Here, however, the draperies are more static, and fall in regular, vertical folds onto the plinth.

Condition: Good.

Notes
[1] GCA, C1/3/65, p.1498. [2] *Ibid.*, p.1956. [3] *Ibid.*, C1/3/67, p.2012.

Other sources
Johnstone; Williamson *et al.*, p.380; Bill Spalding, *Bygone Partick*, Glasgow, 1992, pp.33, 40 (ills); Usherwood *et al.*, pp.70–1 (incl. ill.).

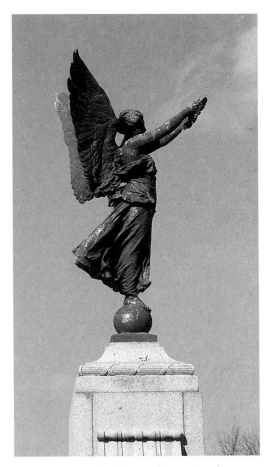

Francis William Doyle Jones, *Partick and Whiteinch War Memorial* [RM]

Waterloo Street CITY CENTRE

Waterloo Chambers, 15–23 Waterloo Street

Seated Female Figures
Sculptors: McGilvray & Ferris

Architect: John James Burnet
Date: 1898–1900
Material: red sandstone
Dimensions: figures life-size
Inscriptions: on the fascia above the entrance –
 WATERLOO CHAMBERS; on lead panel above
 entrance – 1899
Listed status: category B (15 December 1970)
Owner: The *Catholic Herald* and others

Description: A seven-storey commercial
building with a pair of female figures seated on
the first-floor cornice on either side of the main
entrance. Both figures are dressed in capes,
which billow out from their shoulders, partly
concealing the windows behind them. The
figure on the right holds a scroll and a pen.
Minor decorative details include blind
cartouches inserted in the broken pediments
and swags on the sills of the second- and third-
floor aedicule windows. A wooden version of
the cartouche appears in the window
immediately above the central doorway.

Discussion: One of the first of Burnet's
American-inspired 'elevator' blocks, its
enormous scale provoked objections from
adjacent property owners, who tried
unsuccessfully to limit its height to 52 feet.[1] The
façade is composed of much the same
architectural elements as the contemporary
Atlantic Chambers (q.v., 43–7 Hope Street) –
including aedicule and canted oriel windows,
projecting cornices and numerous balconies –
but with a more dramatic use of advancing and
receding planes and a greater monumentality
provided by pairs of giant Corinthian columns.
Like the Hope Street building it also confirms
the waning of Burnet's enthusiasm for
architectural sculpture since the heyday of
buildings such as Charing Cross Mansions
(q.v., 540–6 Sauchiehall Street) of a decade
earlier. The figures here, however, are slightly
more dynamically conceived than their
counterparts on Atlantic Chambers. Their
relationship with the surrounding architecture
is also less 'additive', with the angled recesses at
the ends of the first-floor balconies allowing
them to be more closely integrated with the
fabric of the façade, and the adjacent cornices
providing a surface on which to rest their
elbows.
Condition: Fair.

Note
[1] BJ, 10 August 1898, p.11.

Other sources
BJ, 10 August 1898; AA, 1899[1], pp.104, 115 (ills);
GAPC, 27 June 1899, n.p.; Young and Doak, no.124
(incl. ill.); Williamson *et al.*, p.247; McKean *et al.*,
p.136 (incl. ill.); McKenzie, pp.70 (ill.), 71.

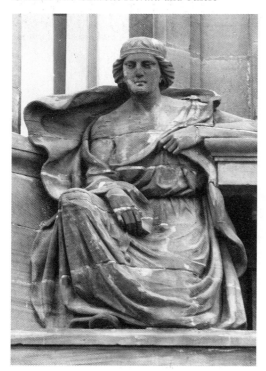

McGilvray & Ferris, *Seated Figure*

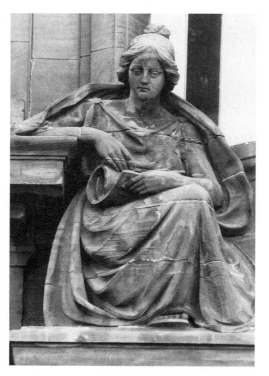

McGilvray & Ferris, *Seated Figure*

Roderick Dhu, James Fitz-James, Ellen Douglas and Associated Decorative Carving

Sculptor: Richard Ferris (attrib.)

Architect: James Chalmers
Date: 1898–1900
Material: red Locharbriggs sandstone
Dimensions: figures approx. 2.1m high
Inscription: on the frieze between the first and
 second floors – UNITED DISTILLERS plc
Listed status: category B (21 July 1988)
Owner: The COLTAS Group

Description: An eclectic mixture of
Renaissance and Tudor styles, combining a
three-storey main block with a fortified
baronial tower (originally domed) rising to five
storeys on the south-east corner. The main
sculpture programme consists of three free-
standing statues representing characters from
Sir Walter Scott's narrative poem *The Lady of
the Lake*, first published in 1810.[1] *Roderick
Dhu* stands at the left of the entablature above
the Waterloo Street entrance and is shown
dressed in Highland costume, including a kilt
and sporran, and with his right hand placed on
the hilt of a sword. On the opposite side, his
rival *James Fitz-James* is depicted in a short
tunic, knee-length boots and huntsman's hat
and with a horn hanging from a chain round his
shoulder. Both figures have pieces of natural-
istically carved rock at their feet, suggestive of
the rugged landscape of the Trossachs in which
the poem is set. The poem's heroine, *Ellen
Douglas*, stands on a rock above an oriel
window projecting from the first floor of the
tower. Described by a contemporary reviewer
as having been 'secured to give the required
suggestion of Loch Katrine',[2] she has a paddle
resting on her left arm, and with her free hand
she lifts the hem of her dress, as if in the act of
stepping over the small waterfall at her feet.

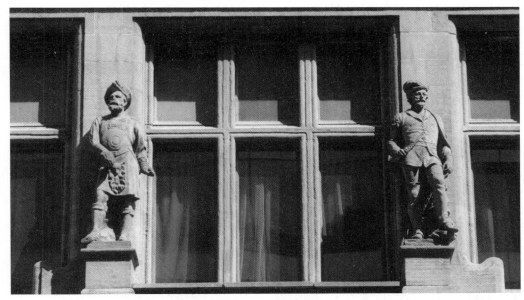

Richard Ferris (attrib.), *Roderick Dhu* and *James Fitz-James*

The building is rich with subsidiary
decorative carving, much of it combining
aquatic imagery recalling the poem's lake-side
location with references to wine-making and
distilling, but also incorporating a range of
more generalised neo-medieval details. On the
corner turret there is a line of corbel heads
terminating the window labels on the first-floor
oriel, with the space between the central
window on this floor and the statue of *Ellen*
filled with a fruit-laden vine branch. The
windows behind *Ellen* are surmounted by
cartouches filled with a small head of a unicorn
(second floor) and stylized griffins (third floor).
On the main Wellington Street frontage there
are numerous mythical beasts, including a
winged lion and a griffin attacking a stook of
corn in the small triangular pediment above the
triplet window at the left, a dragon eating its tail
and a winged monster in the corbels of the
second-storey windows. The pilasters flanking
the entrance are decorated with female masks
surrounded by vine leaves, and the capitals in
the ground-floor windows are enriched
variously with cherub and lion masks and a
small shield with a boar's head. The most
distinctive feature of the building, however, is
the series of *trompe l'oeil* gun barrels projecting
from the *baldacchini* and flattened bartizans of
the corner tower, with the reference to military
ordnance continued in the rings of cannon balls
attached to the wall below the parapet on the
main façade.

Discussion: The building was erected for the
wholesale wine and spirit merchants Wright &
Greig Ltd, whose most popular product,
'Roderick Dhu Old Highland Whisky',
provided the pretext for the main sculpture
programme. The depiction of Roderick himself
corresponds closely to the woodcut illustration
of him used frequently in the company's
advertisements, including such details as the

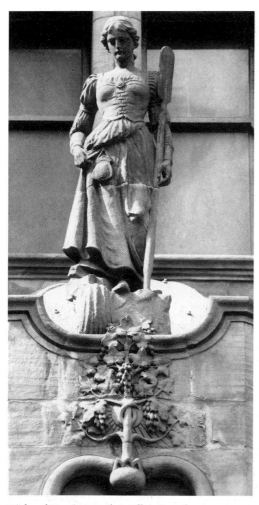

Richard Ferris (attrib.), *Ellen Douglas*

fox's head on his sporran and the decorative designs on his singlet.[3] A number of modern commentators have described the paddle on Ellen's arm as a malt shovel.[4] It seems more likely, however, to be the 'hasty oar' with which she rowed ashore from Ellen's Isle in the poem.[5] Drawings submitted by Chalmers to the Dean of Guild Court show additional figures symbolising the four seasons in the *baldacchini* on the corner tower.[6] Framed by extravagant barley-sugar columns, these were perhaps intended to rival Francis Derwent Wood's slightly earlier figure of *Mercury* on the façade of the nearby Mercantile Chambers (q.v., 35–69 Bothwell Street). The military references in the tower do not appear to have any relevance to the poem, and may be merely an acknowledgement of the name of the street in which the building is situated.

The attribution here of the work to Richard Ferris is based on the resemblance between *Ellen* and the female figure on the former Kingston Public Halls (q.v., 330–46 Paisley Road), particularly in the treatment of the sleeves. (See also Glasgow District Court, 54 Turnbull Street.) It is also relevant to note that Ferris's commercial partner, Robert A. McGilvray, was responsible for the building's plaster work.[7]

Related work: An earlier interpretation of *The Lady of the Lake*, including a full-size statue of Ellen Douglas, is to be found on the Stewart Memorial Fountain, Kelvingrove Park (q.v.), 1872.

Condition: Generally weather-worn, and the blade of Roderick's sword and the feather on his cap are missing. A curved pediment enclosing a coat of arms has also been removed from the main doorcase.[8]

Notes
[1] Sir Walter Scott, *Poetical Works*, Edinburgh, 1871, pp.243–344. [2] BI, 15 February 1900, p.168. [3] See, for example, *Bailie*, 22 May 1895, p.2. [4] Teggin *et al.*, p.54; Williamson *et al.*, p.246. [5] Scott, *op. cit.*, Canto I, verse 20. [6] GCA, TD 1309/A494. [7] GAPC, 15 November 1898, n.p. [8] AA, 1900¹, p.107.

Other sources
BI, 15 February 1900, p.169 (ill.); ET, 8 January 1983; Worsdall (1982), p.70 (incl. ill.); McKean *et al.*, pp.136, 141 (ill.); McKenzie, pp.70 (ill.), 71.

Merchants' House Buildings, 7 West George Street / 30 George Square

Caryatids, Atlantes, Pediment Figures and Associated Decorative Carving

Sculptor: James Young

Architect: John Burnet
Builders: Morrison & Mason Ltd
Date: 1875–7
Material: yellow sandstone
Dimensions: caryatids and atlantes approx. 2.14m in length
Inscriptions: under and round the globes in the first-floor pediments on West George Street – TOTIES REDEUNTES EODEM (trans.: 'always returning to the same place'); on either side of the Glasgow arms above the George Square entrance – M and H
Listed status: category A (15 December 1970)
Owner: Shipventure Ltd

a) Exterior work

Description: A five-storey public building, largely Italian Renaissance in style but with a more Baroque treatment in the north elevation and the domed corner tower. The principal sculptures are the three pairs of caryatids and atlantes supporting the first-floor oriel windows on the north and east faces of the corner tower, and at the west end of the West George Street frontage. These are semi-naked, and project horizontally from brackets decorated with acanthus scrolls, rosettes, draperies and shields bearing the arms of Glasgow. In the broken segmental pediment above the central window on the first floor of the West George Street frontage are two seated female figures flanking the arms of the

Merchants' House (a globe supported by palm branches and surmounted by a sailing ship). The figure on the left wears a crown and raises a set of scales (missing) in her right hand, while her companion wields a sword. Minor carvings on West George Street include a pair of similar globes in the flanking pediments and a bearded male mask in the keystone over the main entrance. On the George Square frontage there is a sequence of six alternating male and female masks in the keystones of the ground-floor windows, a Glasgow coat of arms superimposed on a globe (with a set of scales on the diagonal band) in the pediment over the entrance, a pair of cherub masks on side brackets in the recess above the lintel and a set

of lion masks on the brackets in the upper cornice. High up on the Anchor Lane elevation are six roundels with projecting heads. There is also some decorative ironwork, possibly by William McGeoch & Co.,[1] including a merchant ship in full sail on the dome (modelled on the Merchants' Steeple in Bridgegate), and pairs of wrought iron gates in the George Square and West George Street entrances, which incorporate oval plates inscribed with the monogram 'MH' (gilded and entwined).

Discussion: John Burnet was awarded the commission to design the building following his victory in a select competition in 1873, which stipulated that the elevation to George Square should 'be consistent or harmonise with' the existing Bank of Scotland by J.T. Rochead at the south end of George Square (1869, see 2 St Vincent Place).[2] As part of the same

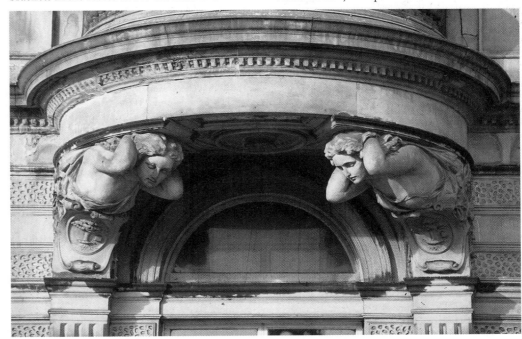

James Young, *Caryatids* [RM]

development, James Sellars designed the intervening block (also for the Bank of Scotland) so that the three buildings together formed a unified three-storey *palazzo*. By and large, Burnet adhered to the Rochead prototype in the overall design and the treatment of detail, including the keystone masks on the ground-floor windows and the lion masks in the cornice, which are very nearly identical to those on the earlier building. The symmetry of the arrangement was compromised by the inclusion of the six-storey tower at the junction with West George Street, though this was tall enough, and sufficiently distinct stylistically, not to upset the balance of the three main sections. John Tweed described the three buildings as 'together [forming] one of the most beautiful architectural ornaments of the city'.[3] The coherence of the block was more seriously disturbed, however, when Burnet's son, John James Burnet, was commissioned in 1907 to remodel the interior of the Merchants' House and add two further storeys to the attic.[4] With their giant Corinthian columns, these are not only much more boldly designed, but the increased height of the building lends the block as a whole a curiously additive quality, as if ascending in a series of step-wise increments from left to right. The remodelling also involved making alterations to the tower, including the removal of six roundels from the spandrels on the third floor, and their relocation on Anchor Lane (see above).[5]

Tenders for the sculpture work were received from J. & G. Mossman (£1,538 11s.), William Mossman (£1,538 11s.), Charles Grassby (£826 4s.) and W.J. Maxwell (£529 11s.), as well as James Young, whose estimate of £491 11s. was the lowest by a very clear margin.[6] From the surviving documentation it is not entirely clear what agreement was made between Young and Burnet, but there appears to have been some negotiation before the sculptor's fee was finalised. In a letter to Burnet dated 30 November 1875, for example, we find Young claiming to have

… gone carefully over the prices for the carving of the Merchants' House – and I find that to allow me the means of giving you the satisfaction I would like – also credit to myself in the work – it would require the sum of £812–0–0 as the nearest sum I can bring it to – I shall be glad to give you a copy of the prices if you desire.[7]

The following April, Burnet consulted William Hill, the agent for the building, on the matter:

Mr. Young has sent me the enclosed letter which is as you will see an application for an increase to his estimate for the carving on the new buildings on the ground of the stone being of a harder character than he was aware of and from his inability to give the work that time and study which it requires. I think he should, at least, have understood the nature of the stone but I have great doubts of his ability to do the work at his original price. He is an excellent workman and artist and should be helped a little and I would recommend an increase of £160. 10., which is the [average?] of his original estimate and the amount he applies for making the total £651. 10. and somewhat less than the cost would be were Mr. Mossman employed to do the same important parts of the work, which he might not consent to seeing his estimate for the whole was £1538. 11.[8]

This compromise appears to have been accepted, though the exact sum that eventually appeared on the report by the measurers Henry Herbertson & Co. after the work was completed was £649 1s. 3d.[9] The report itself is an extremely thorough document, and reveals that such details as the keystone masks were carved for thirty shillings each, while the six oriel figures were priced together at £96. After the completion of the work in the summer of

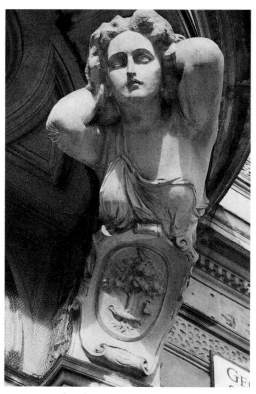

James Young, *Caryatid*

1877, Burnet expressed the view that the scheme had been 'executed in a most satisfactory manner'.[10]

Condition: In 1909, following J.J. Burnet's alterations, the exterior stonework was treated with '"Duresco" silicate petrifying liquid', which not only gave the masonry an 'exquisite soft grey stone shade', but also enabled it to fight 'stoutly against the natural tendency to decay'.[11] The building has been cleaned recently, and the condition of the sculptures is good.

b) Interior work

On the staircase inside the George Square entrance

Statue of Kirkman Finlay
Sculptor: John Gibson

Date: *c*.1842–4
Material: marble
Dimensions: statue 2.05m high
Inscriptions: on left side of plinth – JOHN GIBSON. SCULPT; on front of plinth – KIRKMAN FINLAY, OF CASTLE TOWARD / MERCHANT, GLASGOW. / BORN 10TH APRIL 1777, DIED 4TH MARCH 1842

Kirkman Finlay (1777–1842), cotton merchant and politician. He played an important part in the development of international commerce in Glasgow during the decades when the tobacco trade was in decline and cotton was in the ascendant. A vocal opponent of the monopoly of the East India Company, he was one of the first Scottish merchants to trade with India. He also organised a system for circumventing Napoleon's blockade of Britain during the Napoleonic Wars by establishing a network of depots and agencies both inside and outside French lines. He was Governor of the Forth and Clyde Navigation Company and of the Glasgow Chamber of Commerce (eight times), Lord Provost of Glasgow, Rector of Glasgow University and the Member of Parliament for Glasgow from 1812 to 1818. His election was greeted with popular celebrations, and medals inscribed 'FAITH, HONOUR, INDUSTRY, INDEPENDENCE. – FINLAY, 1812' were struck in his honour. In 1815, however, his support for a controversial corn bill provoked a street mob to smash the windows of his house in Queen Street. His connection with the arts included his membership of the committee of subscribers for the erection of Flaxman's *Monument to Sir John Moore* in George Square (q.v.) and his personal friendship with the painter Sir David Wilkie,

whom he entertained both in Glasgow and at a rented castle on the Isle of Bute. His own estate was at Auchenwillan, on the Cowal peninsula in Argyll, where he built Castle Toward in 1821 and planted an estimated 5,000,000 trees. He died at home and is buried in the Blacader Aisle of Glasgow Cathedral.[12]

Description: The subject wears a classical toga and is shown in a contrapposto stance with the left foot in advance of the right, in the manner of a Roman senator. A large mass of draperies is gathered in his left arm, while in his right hand he holds a scroll. The idealisation of the pose and costume extends to the treatment of the head. The eyes, for example are without pupils and the hair, unlike in the oil portrait by John Graham Gilbert (see below), is brushed forward over his temples.

Discussion: In November 1842, seven months after Kirkman Finlay's death, Robert Finlay[13] announced to a meeting of the Merchants' House that a subscription had been opened in Glasgow for a marble statue to 'the late distinguished Citizen', proposing that 'the most appropriate situation in which it could be placed was the Hall of the Merchants' House, now in the course of erection'.[14] (See former City and County Buildings, 40–50 Wilson Street.) The proposal was accepted, although it was necessary for the architects of the new building, Clarke & Bell, to strengthen the floor of the hall with iron beams at an extra cost of £10.[15]

Recollecting the commission at a later date, Gibson gave a detailed account of his visit to Glasgow at the time of the statue's installation:

I had been applied to by a committee at Glasgow to execute a statue of the late Mr Kirkman Finlay to be placed in the Merchants' Hall in that town. When the statue arrived there during my stay in England in 1844 I visited Scotland for the first time and witnessed the placing of the statue, which met with the approbation of

the sons of Mr. Finlay and of his friends. The principal gentlemen of Glasgow did me the honour to invite me to a public dinner, when Mr. [Archibald] Alison was in the chair, and I was much gratified by the kindness which he and the other gentlemen showed me on that occasion.[16]

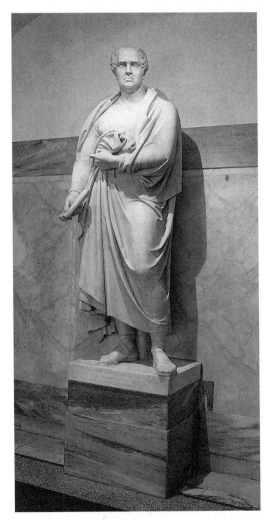

John Gibson, *Kirkman Finlay* [RM]

Gibson's biographers have often tended to present the sculptor as a paradoxical figure who, despite his sophistication as an artist, never entirely outgrew his humble origins as a Welsh market gardener's son. Referring to the public dinner, Grant Allen, for example, claimed that 'the simple-minded sculptor, unaccustomed to such honours, hardly knew how to bear his blushes upon him'.[17] He does go on to note, however, that one of the results of his visit was a commission to execute a statue of Queen Victoria.

During his brief sojourn in Glasgow, Gibson was 'surprised to see so many public monuments erected, and all by the best sculptors'.[18] He described the statues of Sir John Moore by Flaxman and James Watt by Chantrey (qq.v., George Square) as among their best works, and the treatment of the horse in Marochetti's *Equestrian Monument to The Duke of Wellington* (q.v., Royal Exchange Square) as being 'very clever'.

In his 1881 account of Finlay's life, George Stewart described the statue as having 'a fitting place in the vestibule of the Merchants' House', going on to speculate how many among those who 'troop past it' were aware 'how much the Glasgow they live by owes to Kirkman Finlay'.[19] His reference to the 'vestibule' of the Merchants' House suggests that the statue had already been moved from the Hutcheson Street building by this time.

Related work: Gibson recorded that when he was in Glasgow he stayed at the house of the painter John Graham Gilbert (1794–1866), who took the opportunity to paint his portrait. This was exhibited at the RSA in 1849 (cat. no.2), and subsequently donated to the Academy.[20] *Condition:* Good.

Above the door to the Director's Room (West George Street staircase)

Relief Panel of Sailing Ship
Sculptor: not known

Material: sandstone (painted gold)
Date: c.1659(?)
Dimensions: 71cm × 71cm

The ship is the emblem of the Merchants' House, and the panel was made for the original building on the Bridgegate (demolished).

A companion piece depicting three elderly men is above the inside of the same door. These have been identified as representing inmates from Hutchesons' Hospital (q.v., 158 Ingram Street) but are more probably retired merchants living on the charity of the Merchants' House.[21] Other works in the Director's Room include: a Flaxmanesque marble panel (c.1809?, 64cm × 1.08m) of Archibald Ingram (Dean of Guild 1757–8 and 1761–2) kneeling to receive a wreath from an allegorical figure; a decorative stone block (24cm × 33cm × 23cm) carved with a sailing ship, the Glasgow arms and the number '4' (Masonic reference to the Merchants' House) almost certainly salvaged from the Bridgegate building; a marble bust of *James Ewing of Strathleven* (1775–1853) by James Fillans; a marble bust of *James Buchanan* (1785–1853) by William Brodie. (Buchanan was Brodie's benefactor, and financed his study trip to Rome.)

Notes
[1] A receipt in the Merchants' House archive, dated 11 December 1877, records a payment of £377 to McGeoch for 'ironmongery'. [2] GCA, T-MH 53/3/2, 'Memoranda by the Merchants [*sic*] House', 7 January 1874. [3] Tweed (*Guide*), p.6. See also Hume and Jackson, pl.5. [4] 'Glasgow Merchants' House', B, 2 March 1907, p.272. [5] There were at least two other roundels on the west tower on West George Street. [6] GCA, T-MH 53/3/2, 'Merchants House. Estimates for Slater, Plumber, and Stone Carver Work'. [7] *Ibid.*, T-MH 53/3/1. [8]*Ibid.* [9]*Ibid.*, T-MH 53/3/2, 'Measurement of Stone Carvers Work', 31 July 1877. [10]*Ibid.*, T-MH 53/3/2, 'Report by

John Burnet', 2 August 1877. [11] BI, 16 August 1909, pp.66–7. [12] James Gourlay (ed.), *The Provosts of Glasgow, from 1609 to 1832*, Glasgow, 1842, pp.118–19; Allan Cunningham, *The Life of Sir David Wilkie*, 3 vols, London, 1843, vol.1, pp.463–9; George Stewart, *Curiosities of Glasgow Citizenship*, Glasgow, 1881, pp.207–9; DNB, vol.19, p.32. [13] Probably a nephew; Finlay's fourth son, Robert Finlay, died in Bombay in 1830. [14] GCA, T-MH 1/6, Minute Book, 1838–1853, p.125. [15] *Ibid.*, pp.129, 154. [16] T. Mathews, *The Biography of John Gibson, R.A., Sculptor, Rome*, London, 1911, p.109. [17] Grant Allen, 'John Gibson, Sculptor', ch.3 in *Biographies of Working Men*, London, 1888. [18] Mathews, *op. cit.*, p.109. [19] Stewart, *op. cit.*, p.208. [20] *Ibid.*; Laperriere, vol.2, p.178. [21] Cowan, pp.98–100; Graham, pp.112–14.

Other sources
BN, 5 June 1874, p.611, 4 September 1874, p.298, 6 April 1877, p.351; B, 3 October 1874, p.826, 17 February 1877, p.148; BI, 16 August 1909, pp.66–7; Gomme and Walker, pp.157–8; Worsdall (1982), p.59 (incl. ill.), (1988), p.43 (incl. ill.); Nisbet, 'City of Sculpture'; McKean *et al.*, p.85 (incl. ill.); Williamson *et al.*, pp.176–7; McKenzie, pp. 57, 65 (ill.); LBI, Ward 25, pp.62–3.

Connal's Building, 34–8 West George Street / 1–1a Dundas Street

Portraits Roundels, Industrial Scenes and Associated Decorative Carving
Sculptor: James Young

Architect: James Thomson
Builders: Alexander Muir & Sons
Date: 1898–1900
Material: red Locharbriggs freestone
Dimensions: portrait heads and terms approx. life-size
Inscriptions: on entablature above the entrance, from the left – LET GLASGOW FLOURISH (on Glasgow arms); W, 1900 (entwined) and C (in roundels); ERIMUS (on escutcheon); see also below
Listed status: category B (4 September 1989)
Owner: The Meadowflat Property Co. Ltd

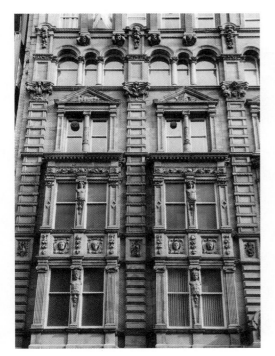

James Young, *Sculpture Scheme* [RM]

Description: Modelled loosely on the Ritter Inn in Heidelberg,[1] this six-storey commercial building is one of the most idiosyncratic in Glasgow, and one of the most extravagant in its use of sculptural ornamentation. The design is dominated by a series of giant, ladder-like pilasters spanning the first and third floors, above which the roofline is articulated by a medley of scrolled gables, ornate dormer windows and an octagonal corner dome. A particularly distinctive feature of the building is the treatment of its fenestration, with window surrounds ranging from pedimented aedicules to miniature colonnades. As well as being entirely asymmetrical, the façade also contains numerous eccentricities, such as the triplet arcades on the fourth floor, where the smallest arches are placed in the centre of each group and the spacing fails to align with the bays above.

The architect's approach to the use of carved ornamentation is characterised by the same playful lack of reverence for conventional notions of propriety, in the process creating rich opportunities for the sculptor to exploit his own powers of invention in the reworking of familiar ornamental themes. There is in fact such a plenitude of decorative devices, and in some cases such apparent illogicality in their distribution over the building, that it is not possible to describe them all in detail here. This entry will therefore confine itself only to the most prominent features on each façade.

On West George Street there is a line of seven cartouches with projecting portrait heads above the lintels of the first-floor windows. The three on the right are inscribed with the surnames of their subjects, as follows:

NEILSON – James Beaumont Neilson (1792–1865), inventor of the 'hot blast' smelting process which reduced the cost of iron manufacture and allowed Scotland to become the 'lowest-cost iron-producing region in Britain'.[2] His portrait is recognisable by the slight disfigurement beside his left eye.

BAIRD – possibly William Baird (1796–1864) one of eight brothers who established the Gartsherrie Ironworks in 1830, the largest manufacturers of pig-iron in Scotland.

DIXON – William Dixon (1788–1859), proprietor of the Govan Iron Works, popularly known as 'Dixon's Blazes'.[3]

The four heads on the left are without inscriptions, but the identity of the first, which has the distinct character of a portrait, has been a subject of speculation for many years. James Cowan, for example, noted the oddity of the omission in an essay of 1934 entitled 'Glasgow's Sculptured Faces', concluding that 'it would be

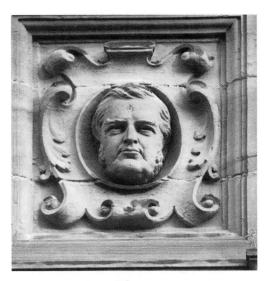

James Young, *James Thomson* [RM]

satisfactory to have the blank name space on the West George Street façade filled in'.[4] Although there are no plans to add an inscription, it is now known that the head is a portrait of the building's architect, James Thomson (1835–1905), and is identical with portrait masks on three other buildings in Glasgow known to have been designed by him: Cambridge Buildings (8–12 Cambridge Street); Pearl Assurance Building (137 West George Street); Liverpool London & Globe Insurance Building (112–18 Hope Street) (qq.v.).[5] Of the three remaining heads, the two females do not appear to be portraits of specific individuals, and the bearded male has a mallet and a pair of tongs crossed below. Above the windows on the third storey are five pediments carved with images celebrating the Victorian iron industry. From the left these are: a steam train emerging from a railway tunnel; a still life group comprising a furnace, a cannon, a cog-wheel, a governor mechanism and a propeller; a steamship on the open sea; the fourth and fifth

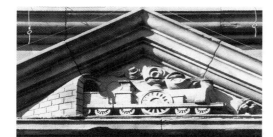

James Young, *Industrial Scene* [RM]

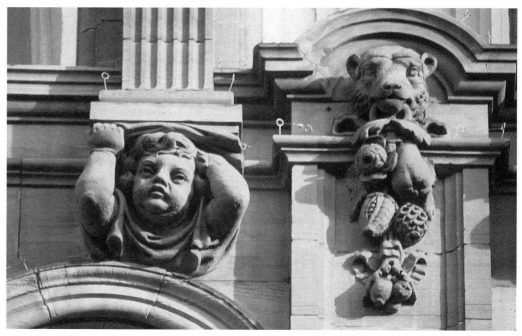

James Young, *Corbel Figure and Decorative Carving* [RM]

pediments repeat the first two.

On the top storey, immediately below the gable on the left, is a group of four corbels carved in the form of elderly men and children with their heads, shoulders and elbows protruding from the wall. A witty variation on the traditional form of the caryatid, they have every appearance of being trapped in the process of trying to free themselves from the surrounding masonry, the anguished expressions on their faces suggesting the mental and physical exertion involved in bearing the weight of the pilasters above. Other minor carvings on this façade include: male and female terms on the mullions of several first-, second- and fifth-floor windows; margents suspended from hands emerging from the wall (between the second-floor portraits) and from the mouths of animals (beside the corbels); a number of griffins, grotesques and ships' prows in the capitals of the giant pilasters and a lion acroterion on the main gable.

With minor variations the Dundas Street façade repeats all the elements of West George Street, though in this case there are only three portrait heads on the first floor. These are all inscribed, as follows:

DONALDSON – W.A. Donaldson (fl.1900), ironmaster and member of the Scottish Pig Iron Association.[6]

WATT – James Watt (1736–1819), pioneer of steam technology (for biographical details see *Monument to James Watt*, George Square).

CONNAL – William Connal (1789–1856), iron merchant and warehouseman, founder of Connal & Co., whose Clydeside yards were capable of providing storage space for over a million tons of pig iron; great uncle of William Connal, the commissioner of the building.[7]

An interesting additional detail is the colossal bee – a quotation from the Connal family arms[8]– in the gable at the extreme right.

Discussion: The carvings executed by Young differ in a number of important details from the programme indicated by Thomson on the plans he submitted to the Dean of Guild Court.[9] For example the third-floor pediments in the drawing for the West George Street elevation are all different, and include images of the Forth Rail Bridge and a domed building. In general, however, the drawings are much less elaborate than the finished work, with many of the figurative elements on the building, such as the corbels and portrait heads either omitted or shown as simple floral decoration.

Related work: A marble bust of William Connal by John Mossman is in GAGM (S.52).[10]

Condition: Good.

Notes
[1] Anon., 'Glasgow Buildings: a Victorian Example', GCCJ, no.9, September 1957, p.257. [2] Daiches, p.187. [3] *Memoirs and Portraits of One Hundred Glasgow Men*, vol.1, Glasgow, 1886, ill. facing p.103. [4] Cowan, pp.166. [5] For confirmation of Thomson's likeness, see entry for Cambridge Buildings. [6] C.A. Oakley, *Connal & Co. Ltd. 1722–1946*, Glasgow, 1946, ill. facing p.12. [7] Slaven

and Checkland, vol.2, p.357. [8] Anon., *op. cit.*, p.258. [9] GCA, B4/12/1/6791. [10] See illustration in Oakley, *op. cit.*, opp. p.5.

Other sources
GAPC, 25 April 1899, n.p. (incl. ill.); Gomme and Walker (1987), pp.258, 260 (ill.); Nisbet, 'City of Sculpture'; McKean *et al.*, p.123 (incl. ill.); Jack House, 'Ask Jack', ET, 16 December 1989; Williamson *et al.*, p.248; Teggin *et al.*, p.29 (incl. ill); McKenzie, pp.56 (ill.), 57; LBI, Ward 25, p.170.

Pearl Assurance Building, 133–7 West George Street / 39–45 Renfield Street

Keystone Portrait and Associated Decorative Carving
Sculptor: James Young (attrib.)

Architect: James Thomson
Date: 1896–9
Material: red Locharbriggs sandstone
Dimensions: portrait head life-size
Inscriptions: on Renfield Street – PEARL
 ASSURANCE BUILDINGS (first-floor frieze);
 PAB (entwined, in attic pediment); L
 (entwined in acanthus scrolls in five first-
 floor balcony panels); on West George Street
 façade – L (entwined in acanthus scrolls in
 two second-floor balcony panels)
Listed status: category B (21 July 1988)
Owner: Pearl Assurance PLC

Description: The building is of interest chiefly for the portrait of its architect, James Thomson, in the keystone over the West George Street entrance, and it is on the basis of the frequent use of this device by James Young that the carver work is attributed to him here (see Related work, below). Despite the scale of the building, and its elaborate German Renaissance style, the remainder of the sculpture programme is relatively modest, and consists of a number of male and female masks, many of them grotesque, distributed with the architect's customary disregard for regularity, over the second-floor balcony panels on both

façades. There are also four grotesque masks terminating the brackets supporting the balcony beside the West George Street entrance.

Discussion: The building was erected for the Lancashire Insurance Company, whose name was originally inscribed on the friezes of both façades. These, together with the company's armorial shield above the entrance, were removed during alterations carried out by Thomas Tait in 1935.[1] Evidence of the identity of the original owners remains, however, in the decorative use of the letter 'L' in various balcony panels.

Related work: For a discussion of the Thomson portrait, see Cambridge Buildings (8–12 Cambridge Street). Other buildings on which it appears are Liverpool London and Globe Insurance Building (112–18 Hope Street) and Connal's Building (34–8 West George Street).

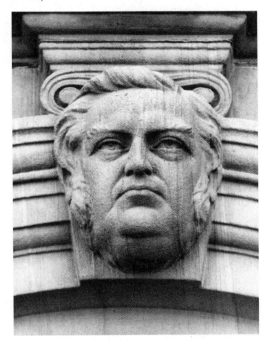

James Young (attrib.), *James Thomson*

Condition: The keystone portrait is perfect, and the remainder of the programme is good, with the exception of the right hand mask below the West George Street balcony, which has been badly damaged.

Note
[1] See plans by James Thomson, GCA, B4/12/1/4276; LBI, Ward 18, pp.212–13.

Other sources
Nisbet, 'City of Sculpture'; Williamson *et al.*, p.251; McKean *et al.*, p.126.

James Sellars House, 144–6 West George Street

Spandrel Figures and Associated Decorative Carving
Sculptor: William Mossman Junior

Architect: James Sellars (of Campbell, Douglas
 & Sellars)
Date: 1877–80
Material: yellow sandstone
Dimensions: figures approx. life-size
Listed status: category A (15 December 1970)
Owner: London Transport Pension Fund
 Trustee Co. Ltd

Description: A five-storey building, ornately French Renaissance in style, with distinctive oval portholes on the ground floor and pavilion-roofed wings. The spandrels are over the arch in the asymmetrically placed entrance, and show reclining female figures symbolising *Summer* (left, with scythe and corn-stalks) and *Autumn* (grapes and pitcher). Between them is a male keystone mask wearing a winged helmet. Subsidiary carving includes an acanthus scroll in the entablature above the figures, a pair of bas-relief candelabra panels on the front faces of the entrance piers, and an arabesque frieze running between the second-floor windows. The ground-floor windows in the middle bays are also separated by consoles heavily carved

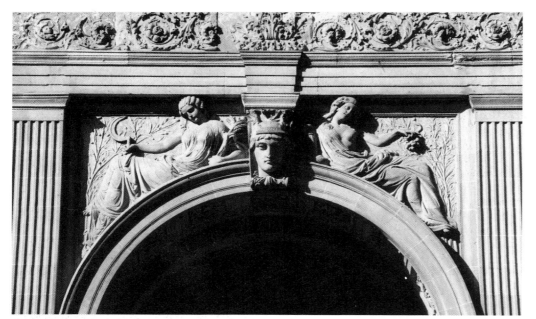

William Mossman Junior, *Spandrel Figures*

Ocean Chambers, 188–94 West George Street

Poseidon, Amphitrite and Associated Decorative Carving
Sculptor: not known

Architect: Robert A. Bryden
Builder: George Barlas & Co.
Date: *c*.1901
Material: red sandstone
Dimensions: figures approx. 1.9m; walruses approx. 1.5m high
Listed status: category B (21 July 1988)
Owner: Britannia Life Ltd (?)

Description: Commissioned by the London-based Ocean Accident and Guarantee Corporation, this six-storey freestyle office block was described at the time of its erection as 'among the latest contributions to the list of palatial insurance buildings' in Glasgow,[1] and a 'distinct advance in what might be called the re-building of the city'.[2] Its extravagant vocabulary of scrolled pediments, pierced balconies and oriel windows provides ample scope for inventive decorative carving, but the specifically maritime imagery associated with the company's business concerns is chiefly concentrated in the central bay. Above the main door is a massive escutcheon decorated with a lighthouse flanked on either side by galleons and a pair of vividly characterised walruses. Above this, in a broken pediment over the third-storey window, are reclining figures of *Poseidon* and *Amphitrite*, the former holding a gilded trident. Modern commentators have criticised the ugliness and vulgarity of the building as a whole, and in *The Buildings of Scotland: Glasgow* the two main figures are described as being 'badly carved'.[3]

Condition: The building was restored in 1999/2000, but much of the sculpture is weathered, and the walrus on the left has lost a tusk.

with leaf forms, and have wrought iron balconies by Adam Patrick.

Discussion: The building was erected as the New Club at a cost of about £35,000 and was formally inaugurated on 6 February 1880.[1] It was reported that the architect visited 'nearly every club of importance in London' before drawing up his plans, in order to 'embody the most recent improvements, and render the accommodation as luxurious and complete as possible'.[2] This may well account for the radical shift in style in Sellars' work, which until this time had adhered rigorously to the precepts of the Greek Revival. Many modern commentators find the results less than satisfactory. Gomme and Walker, for example, describe the façade as confused and undisciplined, singling out the 'pointless asymmetry' of the entrance bay for particular censure.[3] The quality of Mossman's carving,

however, is widely admired.[4]

In 1979 the building was extensively refurbished and its name changed from Cornhill House to James Sellars House, after its architect. Much important decorative work was lost at this time, including interior fittings and external cast-iron lamp standards by Walter Macfarlane & Co.

Condition: Good, though with minor damage to the keystone mask.

Notes
[1] 'New Club Buildings in Glasgow', B, 7 February 1880, p.171. [2] 'Building Intelligence', BN, 30 March 1877, p.330; 'Glasgow New Club Buildings', B, 14 April 1877, p.372. [3] Gomme and Walker, p.155. [4] See, for example, Worsdall (1982), p.147.

Other sources
T. Raffles Davison, 'Rambling Sketches: No.81. – The New Club, Glasgow', BA, 22 September 1882, p.453 (plus ills); BN, 21 December 1883, p.1000 (plus ill.); Young and Doak, no.92 (incl. ill.); Worsdall (1988), p.46 (incl. ill.); McKean *et al.*, pp.126 (ill.). 127; Williamson *et al.*, p.251; McKenzie, pp.74 (ill.), 75; LBI, Ward 18, p.223.

Notes
[1] GAPC, 3 April 1900, n.p. [2] BI, 16 April 1900, p.3. [3] Williamson *et al.*, p.252.

Other sources
GCA, B4/12/1/7061; BA, 16 March 1900, p.183 (incl. ill.); BI, 16 April 1900, p.9 (ill.); Gomme and Walker (1987), p.258; McKean *et al.* p.127; Teggin *et al.*, p.46 (ill.).

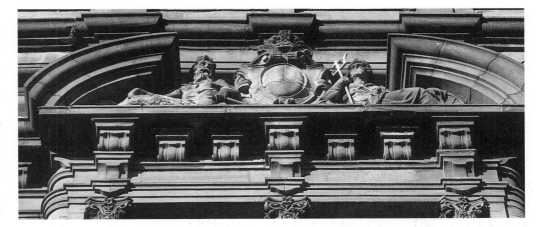

Anon., *Poseidon* and *Amphitrite*

West Graham Street GARNETHILL

Above the entrance of the former Sick Children's Dispensary, 9–13 West Graham Street

Mother and Child
Sculptor: not known

Architect: James Sellars
Building opened: October 1888
Material: red sandstone
Dimensions: figure approx. life-size
Inscriptions: on a frieze over the ground-floor
windows – SICK CHILDREN'S HOSPITAL
DISPENSARY; in a panel on the east corner
tower – ERECTED / FROM THE PROCEEDS OF /
A FANCY FAIR / HELD IN GLASGOW / IN 1884
UNDER THE / AUSPICES OF HER GRACE / THE
DUCHESS / OF MONTROSE
Listed status: category B (15 December 1970)
Owner: Glasgow School of Art

Description: A relief of a half-length mother with a child in her arms is shown in a medallion on the gable above the (now defunct) entrance in the east corner tower. The building also has a street lamp attached to it incorporating one of the *Chookie Burdies* by Shona Kinloch (Appendix B, Minor Works, see Garnethill Lighting Project, Buccleuch Street).

Discussion: The building was erected to provide an out-patients' department and dispensary for the Sick Children's Hospital on Scott Street (q.v.), which has an almost identical relief on its east façade. The two works were almost certainly executed by the same sculptor. Sellars produced the design after winning a limited competition between Campbell Douglas & Sellars, Baird & Thomson and John Burnet & Son, though the accepted scheme proved too expensive to build and had to be modified. One of the hospital's leading surgeons, James Nichol, described the advantage of a dispensary as lying in the fact that sick children could be brought to the hospital and carried home again 'in their mothers' arms',[1] a sentiment which may be reflected in the carving.

The building now forms part of the Barnes

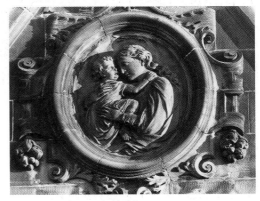

Anon., *Mother and Child*

Building of Glasgow School of Art, and houses the Department of Sculpture and Environmental Art.

Condition: Good, but very blackened.

Note
[1] Edna Robertson, *The Yorkhill Story: the History of the Royal Hospital for Sick Children, Glasgow*, Glasgow, 1972, p.61.

Other sources
B, 9 July 1898, p.27; Gomme and Walker, p.298; Robertson, *op. cit.*, pp.52–64 (incl. ill.); Williamson *et al.*, p.271.

West Princes Street WOODLANDS

On the north side of West Princes Street, between Rupert Street and Dunearn Street

As the Crow Flies
Sculptor: Shona Kinloch

Founders: Powderhall Bronze
Date: 1990
Installed: February 1993
Material: bronze
Dimensions: bird and pedestal 1.22m high; bird alone 36cm high; pedestal 26cm × 25cm at base
Inscriptions: see below
Listed status: not listed
Owner: Woodlands Community Development Trust(?)

Description: In this work the artist has responded to the concept of sculpture as waymarker by creating a hybrid from two familiar forms of signage: the weather-vane and the type of multiple signpost found in many famous geographical locations such as Land's End, which indicate directions and distances 'as the crow flies' to remote and exotic parts of the world. A specialist in animal sculpture, Kinloch presents a literal, albeit mildly caricatured crow perched on a tall, tapered pedestal clutching an arrow in its right claw. It is typical of Kinloch's humorous approach to the representation of animals that the bird has its head turned in the opposite direction from the arrow, and that the stepped treatment of the plinth imitates the 'crow-stepped' gables found on many Glasgow buildings. The inscriptions on the pedestal form an integral part of the work, and provide a complex body of information which may be summarised as follows:

1. The upper stage of the plinth is inscribed with a compass (top surface) and the date 1990 (front side face).

2. The lower stage of the plinth has GLASGOW / SCOTLAND / WEST PRINCES STREET / WOODLANDS inscribed upside down on the upper surfaces and AS THE CROW FLIES on the front. This, like many of the place names below, is given in English and a variety of non-European languages, including Chinese, Bengali and Urdu, to reflect the multi-cultural diversity of the area.

3. The main part of the pedestal is divided into a series of narrow horizontal bands inscribed with the names of other parts of the world accompanied by an indication of their distance, in miles, from the site. These range from neighbouring suburbs in Glasgow to stars in other parts of the universe. It is not possible to reproduce all the names here, but the following gives the nearest and furthest sites inscribed on the west, north, east and south faces respectively: GOVAN (1½ miles) – BUENOS AIRES (11140 miles); PARTICK (1 mile) – AUCKLAND (11852 miles); STRATOSPHERE (31 miles) – NEAREST GALAXY (55000m miles); GEORGE SQUARE (1½ miles); SYDNEY (10915 miles). In some cases the place names are accompanied or replaced by pictograms.

Discussion: The work was commissioned by the Festival Committee of the Woodlands Community Development Trust and was one of seven 'Glasgow Milestones' created under the aegis of the Glasgow Sculpture Studios between 1991 and 1995. For a full discussion of this project, see *Calvay Milestone*, Barlanark Road.

Condition: Good, though with some light graffiti. In 1995 the entire sculpture was coated in silver paint by vandals, but this was removed without damage to the surface.

Related work: Other works in the 'Glasgow Milestones' project are *Milestone* (Cromwell Court), *Milestone* (Duke Street), *Rosebud* (East Garscadden Road), *Govan Milestone* (Govan Road), *The Works* (Springburn Way).

Sources
Rae and Woolaston, p.32; Location map, *Milestones*, Glasgow Milestones, n.d. (1994); McKenzie, pp.98 (ill.), 99.

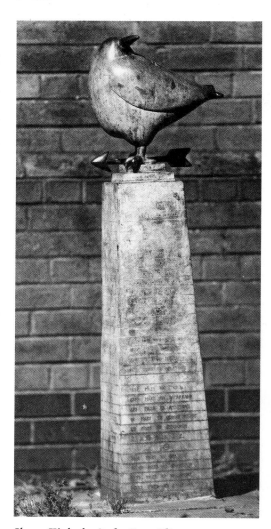

Shona Kinloch, *As the Crow Flies*

West Regent Street BLYTHSWOOD

On the former Masonic Halls, 98–104 West Regent Street

Statues of Saint John the Baptist and Saint John the Evangelist, Sun and Associated Decorative Carving

Sculptor: not known

Architect: J.L. Cowan
Date: 1895–6
Material: red sandstone
Dimensions: figures approx. 1.9m high
Listed status: category B (21 July 1988)
Owner: Portfolio Holdings

Description: In the design of this four-storey building the architect has adopted a 'free treatment of the English Renaissance style of architecture',[1] incorporating decorated gables, corner turrets and a varied vocabulary of ornamentation. The two statues are in canopied niches on the second floor, on either side of the main oriel window. On the left, *Saint John the Baptist* holds a lamb and is shown wearing an animal skin and a long cloak; he is bearded. *Saint John the Evangelist* is clean-shaven, wears a Roman toga and holds a chalice. In the large gable above them is a decorated roundel filled with a stylized personification of the sun in low relief. Minor decorative carving includes a set of three panels in the canted faces of the first-floor balcony showing a stylized flower, a coat of arms (lion rampant and three castles) and a crescent moon encircled by stars. The capitals on the pilasters at the entrance (no.100) are also carved with lion and grotesque masks.

Discussion: Erected at a cost of £16,000 by the Masonic Halls Company Limited, the building was designed as a temple and meeting room combined with commercial offices for rent. The company was formed by the Lodge of

Glasgow St John 3 *bis* – 'possibly the oldest institution in the City of Glasgow' – specifically to build a replacement of its existing premises on Buchanan Street.[2] Masonic symbolism is

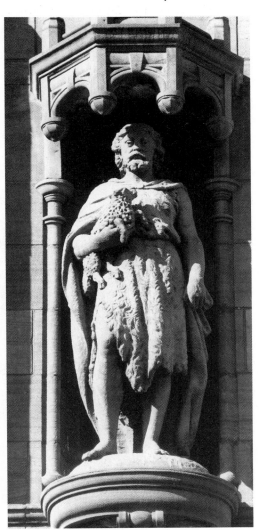

often complex and obscure, and the interpretation of the sculpture programme here has led to some wayward speculation in the past. Williamson *et al.*, for example, tentatively identify the two main figures as *The Good Shepherd* and *St Margaret*.[3] However, in view

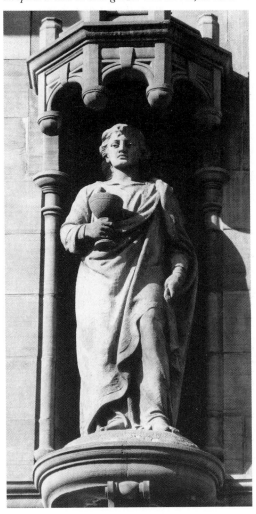

Anon., *St John the Evangelist*

(left) **Anon.,** *St John the Baptist*

of the nominal association of the St Johns with the Glasgow Lodge, which is recorded as having 'carefully observed' the celebration of the festivals of both saints throughout the nineteenth century,[4] it seems more reasonable to assume that the figure with the lamb is in fact the Baptist rather than Christ, and that the companion figure, which is quite clearly male, represents the Evangelist. It is worth noting also that the chalice in the Evangelist's hand has a small projection visible above the rim. Though it is difficult to decipher clearly, it may well be the head of a snake, an attribute often associated with the Evangelist.[5] According to American usage, the Baptist and the Evangelist signify mid-summer and mid-winter respectively, and thus between them embody the 'Law of Duality'.[6] Masonic cosmology demands in turn that duality is resolved ultimately through its 'Divine Source', which is possibly represented here by the sun, or 'Blazing Star', in the gable. Local scholars have also suggested references to Masonic iconography in details such as the grotesque figure beside the door, which may be a traditional 'Green Man', placed at the entrance to ward off evil, and the numerous empty niches and small blind arches on the façade, most of which appear in groups of three.[7]

Significantly, none of these details, or the main statues, appear on Cowan's plans, and the imagery may therefore have been chosen by the sculptor.[8] The identity of the sculptor himself is not known, but in the list of Masters appended to his history of the Lodge, Ephraim Lawrie includes Robert A. McGilvray (1892–3), as well as the building's architect, James Cowan (1896).[9]

Related work: A bust of the architect David Hamilton is recorded as having belonged to the Lodge, but appears to have been lost in the move from Buchanan Street.[10] This may have been the bust of Hamilton 'taken in later life' by William Mossman Senior, which is also lost.[11]

Condition: Good.

Notes
[1] 'Glasgow Masonic Hall', ACR, 9 April 1897, p.246. [2] 'Glasgow Masonic Temple: Laying of Memorial Stone: Imposing Masonic Ceremonial', *Scottish Freemason*, vol.2, no.6, November 1895, p.125; Bro. Ephraim S. Lawrie, P.M., *The Lodge of Glasgow 'St. John', No. 3 Bis, with notes on the Incorporation of Masons in Glasgow*, Glasgow, 1827, pp.47–8. [3] Williamson *et al.*, pp.254–5. [4] Lawrie, *op. cit.*, p.57. [5] Hall, p.175. [6] W. Kirk MacNulty, *Freemasonry: a Journey through Ritual and Symbol*, London, 1991, p.18. [7] Conversation with Chris Adams, researcher 'Secrets in Stone'. [8] GCA, B4/12/1/395. [9] Lawrie, *op. cit.*, p.86. [10] *Ibid.*, p.69. [11] BN, 7 February 1868, p.91; Johnstone.

Other sources
BI, 15 June 1895, p.44, 15 November 1895, p.124; BJ, 18 June 1895, p.301; BA, 1 November 1895, p.321; B, 2 November 1895, p.318; McKenzie, pp.75, 77 (ill.); LBI, Ward 18, pp.240–4.

Sovereign House, 158 West Regent Street / West Campbell Street

Relief of Christ Healing the Deaf and Dumb Man

Sculptor: not known

Architect: Robert Duncan
Date: 1893–5
Material: red freestone
Dimensions: tympanum 1.12m high × 2.24m wide
Inscriptions: on tablet in south gable – SOVEREIGN HOUSE; above the relief, in the apex of the tympanum – EPHPHATHA
Listed status: category B (15 December 1970)
Owner: Whitbread Pension Fund (Trustees) Ltd

Description: The relief is in a semi-circular tympanum on the first floor above the entrance

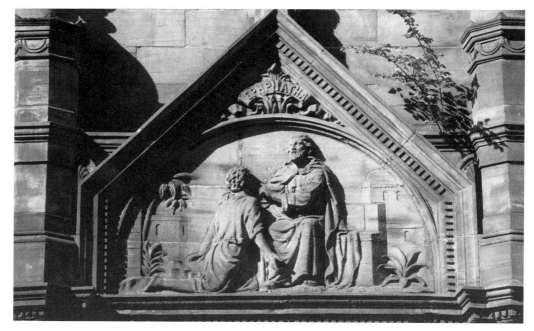

Anon., *Christ Healing the Deaf and Dumb Man*

to the building, which is designed in an Arts and Crafts Gothic idiom. Christ is shown seated on a throne with the index finger of his left hand touching the lips of a man kneeling with his arms outstretched, and his right hand on his shoulder. The scene is set in the landscape of the Holy Land, with palm trees and a domed building in the background.

Discussion: The building was erected by the Glasgow Mission for the Deaf and Dumb as the Glasgow Institute for the Adult Deaf and Dumb, using the proceeds of a bazaar held in 1891 to acquire the site. In 1897, Queen Victoria sent a donation of £50 to the Institute, and directed that it should be known as the Royal Glasgow Institute.[1]

The scene depicted in the relief refers to a passage in the Gospel of St Mark describing Christ's return to the Sea of Galilee:

> And they bring unto him one that was deaf, and had an impediment in his speech; and they beseech him to put his hand upon him. And he took him aside from the multitude, and put his fingers into his ears, and he spit, and touched his tongue; And looking up to heaven, he sighed, and saith unto him, Ephphatha, that is, Be opened.[2]

'Ephphatha' is believed to be an Aramaic imperative transliterated into Greek.[3]

The name of the sculptor is not recorded, but the style of the work is similar to James Pittendrigh Macgillivray's tympanum relief on the Anderson College of Medicine (q.v., 56 Dumbarton Road).

Condition: Good.

Notes
[1] 'The John Ross Memorial Church', information leaflet by Keppie Design Ltd, Glasgow, n.d. [2] *The Holy Bible*, Mark 7.32–4. [3] J.D. Douglas (ed.) and N. Hillyer (revision ed.), *New Bible Dictionary*, Leicester, 1982 (2nd edn), p.338.

Other sources
GCA, B4/12/1/2685; McKean *et al.*, p.123 (incl. ill.); Williamson *et al.*, p.255; McKenzie, pp.76, 77 (ill.).

Former John Ross Memorial Church, 160 West Regent Street

Agnus Dei and Other Carved Animals

Sculptor: Archibald Dawson

Architect: Norman A. Dick
Date: 1921–31
Material: red freestone
Dimensions: various; Agnus Dei approx. 25cm high
Inscription: above door – IHS (entwined) (monogram derived from Greek for 'Jesus')
Listed status: category B (15 December 1970)
Owner: Whitbread Pension Fund (Trustees) Ltd

Description: The *Agnus Dei* is in the keystone of the relieving arch over the entrance, and the remaining animals are principally in the corbels and imposts below. Among them are a pair of dragons, and a menagerie of mice, lizards and snails. The voussoirs in the arch are also decorated with corn-stalks, which, like the animals, are carved in a flat, graphic style reminiscent of the work of contemporary Scottish wood engravers such as John Farleigh. The interior contains much equally distinguished work, including carved pews, decorative corbels and a low-relief frieze of corn inhabited by dragonflies, birds and other wildlife running intermittently between the windows in the nave.

Discussion: Originally the John Ross Memorial Church for the Deaf and Dumb, the building was erected as an extension to the neighbouring Institute for the Deaf and Dumb (see above), and was intended to allow 'the Religious and Social work of the Mission to proceed in a wider sense than has hitherto been possible'.[1] The bulk of the funding was provided by John Ross, but the members of the Institute also contributed £600, which they raised through a bazaar in 1929.[2]

The reliefs as executed, though very fine, are a much reduced version of the programme indicated on the plans Dick submitted to the Dean of Guild in 1929, which show full-size figures in niches in the side turrets and a free-standing statue silhouetted against a rose window.[3] These were presumably omitted for reasons of cost. Keppie Design Ltd made extensive alterations to the interior in 1995 when the building was converted for use by them as a design and architectural office.

Condition: Good.

Notes
[1] 'The John Ross Memorial Church', information leaflet by Keppie Design Ltd, Glasgow, n.d. [2] *Ibid.* [3] GCA, B4/12/1929/232.

Other sources
McKean *et al.*, p.123 (incl. ill.); Williamson *et al.*, p.255; Johnstone; McKenzie, pp.76, 77 (ill.).

Archibald Dawson, *Agnus Dei*

Whitevale Street DENNISTOUN

In the front garden of South Dennistoun Neighbourhood Centre, 13 Whitevale Street

The Community

Sculptor: Stanley Bonnar

Date: *c.*1980
Materials: fibreglass statue on a red brick base
Dimensions: figures 1.62m high; base 35cm × 1.34m × 1.34m
Signature: in cursive script incised on the upper surface of the statue plinth – STAN BONNAR
Owner: Reidvale Housing Association

Description: A group of four naked figures, including an adolescent girl, an old man and a couple in their prime standing in a small circle, back to back. The group stands on its own plinth, which is bolted to the brick base.

Discussion: The work was commissioned in 1979 by the Reidvale Housing Association as part of a refurbishment of its new premises on Whitevale Street. Funding for the refurbishment was provided by GEAR (Glasgow Eastern Area Renewal), and Bonnar was selected to make the work on the recommendation of the architect, who was familiar with the sculptor's earlier work. A proposal from Bonnar was accepted by the housing association, which formed a committee to liaise with him in the early stages of the design. The sculpture is intended to symbolise the local community, with the arrangement of the figures expressing unity and social optimism. It was also a personal response on the part of the artist to the growth of feminism as a global movement, which is reflected in the dominance of the female figures. The old man is described by the artist as a 'large brute being destabilised by the women – he is wise and has a long way to go'. The sculpture was cast by hand by Bonnar in his studio at Strathaven, and cost approximately £1,200 to make.

Condition: There is some graffiti and the eyes of the figures have had chewing gum pressed into them. Structural damage includes the loss of the staff of the old man's walking stick and the tip of one finger on the girl's right hand. Several small holes have also appeared elsewhere on the surface, exposing the fibres.

Sources
Williamson *et al.*, p.448; information provided by Reidvale and Molendinar Park Housing Associations; letter from Stan Bonnar to the author, n.d. (July 2000).

Stan Bonnar, *The Community* [RM]

Former City and County Buildings, 40–50 Wilson Street / 70–4 Hutcheson Street / 117 Brunswick Street

Narrative Friezes and Associated Decorative Carving

Sculptors: Walter Buchan and John Mossman

Architects: Clarke & Bell
Dates: 1842–4 (extension 1871–4 and 1892)
Material: yellow sandstone
Listed status: category B (15 December 1970)
Owner: Glasgow Development Agency

Description: This large Greek Revival block occupies the rectangle bounded by Ingram, Wilson, Hutcheson and Brunswick Streets, and was designed to bring together the Glasgow and Lanarkshire County Council offices, the Sheriff Court and the Merchants' House in a single building. Clarke & Bell's original design stretched from Wilson Street to Garth Street, following their victory in a competition of 1841. The memorial stone was laid on 18 November 1842, and the building was opened two years later. In 1871–4 it was extended to Ingram Street to provide offices for the Town Council and more space for the Courts. This development included the purchase of a section belonging to the Merchants' House, which was converted for use as a Small Debts Court.[1] By this time the Merchants' House had moved to temporary accommodation in Virginia Street, before the construction of its present premises on West George Street (q.v.). Further changes were made in 1892 when the Council moved to the City Chambers on George Square (q.v.), and the Ingram Street section was demolished and rebuilt in its present form.
Condition: The building has been empty since 1984 and was cleaned in 1994–5 by Hunter & Clarke using aluminium oxide in an innovative micro-particle system.[2] A plan in 1996 to site a new Museum of Scottish art, architecture and design in the building came to nothing, as did a later proposal to convert it to a leisure centre.[3]

On the entablature of Hutcheson Street façade

International Commerce

Sculptor: Walter Buchan

Date: 1843
Dimensions: approx. 75cm high × 24.5m long

One of the stipulations of the architectural competition was that the Merchants' House should 'by breaks in the plane of the wall… be easily distinguished as a separate building'.[4] In the event the architects gave the Merchants' House a clear visual dominance by the use of a giant Corinthian colonnade surmounted by a richly sculpted frieze, and by its alignment with the axis of Garth Street. The frieze consists of approximately fifty figures, arranged in a sequence of fifteen discrete narrative groups, and with the composition as a whole falling into two halves divided and framed by carved representations of small walls. The subject matter reflects the Merchants' House policy of encouraging the expansion of trade with 'countries which, notwithstanding their distance from each other, seemed destined to reciprocate the advantages of Commerce'.[5] A detailed and colourful description of the frieze was published in the *Glasgow Courier* in 1843, shortly after it was completed:

> The centre figure represents Neptune, with his trident, seated behind his finny coursers; to the right and left of the monarch of the deep are two groups, the one allegorical of a large river – the Clyde, of course – the other shipping and manufacturing interest – being a boat in which are seated three cotton lords, with bails, it is to be presumed, of the same material. The other figures are illustrative of active traffic over the globe; the elephant and lions speak of climes which pour forth their treasures to the enterprising merchant. Some of the figures are engaged in friendly intercourse – one points to a globe. These speak of the effects of commerce in

Walter Buchan, *International Commerce* **(detail)** [RM]

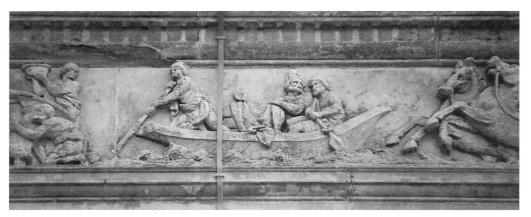

Walter Buchan, *International Commerce* (detail) [RM]

Trial by Jury
Sculptor: Walter Buchan

Date: 1844
Dimensions: 1.37m high × 12m long

Description: This frieze contains 22 classically draped figures, arranged in a series of five discrete groups, including a man in chains, a murder victim with a mourning woman and various court officials, all 'emblematic of the course and functions of Justice'.[13] At either end of the relief there is shield containing a mask surrounded by snakes, and there is a series of classical profile heads in medallions inserted into the acanthus frieze in the upper entablature.

Discussion: Although this part of the building included a 'small Court-House, which is generally used by the Dean of Guild' and the offices of the County Sheriff,[14] its main purpose was to provide accommodation for the Town Council, and thus allow it to vacate its cramped premises at the foot of the Saltmarket. (See City Chambers, George Square, for a fuller discussion.) As a result of the move the Saltmarket building was to become the main Justiciary Court, incorporating two minor court rooms, one of which was for 'Jury Trials'.[15] Buchan's choice of subject for the frieze, which is identified in his obituary

promoting amity and advancing science. At one extremity [right] is the allegorical representation of home, beside which is a group of girls strewing flowers to welcome the return of the travellers, &c. &c.[6]

It is interesting to note the presence of elephants and lions on the frieze, as the main hall was used in the 1860s as a circus.[7] The correspondent goes on to note that

… as the sculptures of this frieze are chiefly adaptations from works of Flaxman and Thorwaldsen, it does not pretend to that unity of design which might have been expected had it been an entirely new composition.[8]

In fact most of the figures are not so much adapted as copied directly from Thorwaldsen's frieze of the *Triumphal Entry of Alexander into Babylon* in the Salone of the Villa Carlotta in Tremezzo, Italy (*c.*1826), the groups merely rearranged to suit the requirements of the new narrative.[9] The writer describes the execution, however, as 'very able and spirited', and expresses the hope that 'the example set here will be followed in future public buildings'.[10] Buchan was paid £56 1s. 4d. for the frieze on 22 August 1843.[11]

Condition: The frieze was cleaned in 1994–5 by Jackson & Cox, under the supervision of conservation specialists from the Burrell Collection.[12] It is, however, very worn and has suffered from recent rain penetration in the masonry above.

Walter Buchan, *Trial by Jury* [RM]

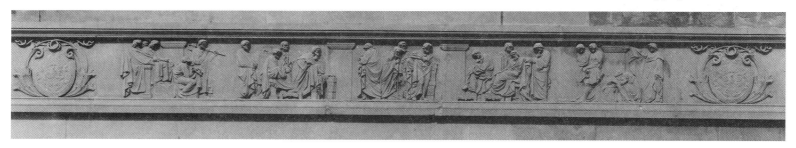

specifically as 'Trial by Jury',[16] appears, therefore, to be more relevant to the earlier building. The obituarist describes this early work by Buchan as the 'most important of his works in Glasgow'.[17]

Related work: A full-size copy of the frieze was installed in the Justiciary Court shortly after its completion. This was destroyed when the building was modified in 1911, but a plaster replica was made by Archibald Macfarlane Shannan after 'getting wind of the "vandalism"'.[18] Composed of five sections, this remains in the court-house today.

Condition: The frieze was cleaned in 1994–5 by Conservation Specialists Ltd, under the supervision of the conservation staff of the Burrell Collection.[19]

Walter Buchan, *Trial by Jury* (detail)

On the north end of the Brunswick Street façade

Series of masks
Sculptor: John Mossman

Date: 1871–4
Dimensions: approx. life-size

The six male and female masks are in roundels below the first-floor windows. They are mostly very plain, though the first (from the left) is enclosed in wings, the third is helmeted and the fourth wears an exceptionally large moustache. These are the only survivors of the extensive sculpture programme which formed part of the Council Chambers building erected in 1871–4, but which was remodelled in 1892 as the Sheriff Court following the removal of the council to the City Chambers on George Square. By this time the exterior stonework had deteriorated to such an extent that the entire Ingram Street façade had to be replaced.[20] Among the sculptures lost in the process were six free-standing allegorical attic figures by John and William Mossman, as well as a seventh mask on the end bay.[21] (See former Municipal Buildings, Ingram Street, Appendix A, 'Lost Works'.)

Condition: Cleaned in 1994–5, but very worn.

Notes
[1] Anon., 'Merchants' House Buildings', GCCJ, December 1967, pp.736–7. [2] Information provided by GCC Planning Department. [3] Ruth Wishart, 'Sheriff Court back in frame for gallery', H, 24 February 1997, pp.1–2. [4] GCA, D-TC 13/463A, 'Plan of proposed City & County Buildings, also housing Merchants' House'. [5] Anon. [John Buchanan, Andrew Scott and William Henry Hill], *The Merchants' House of Glasgow*, Glasgow, 1866, p.443. [6] Quoted in Anon., 'The Merchants' House, Glasgow', B, 16 September 1843, p.383. [7] GCCJ, December 1967, pp.736–7. [8] B, 16 September 1843, p.383. [9] Elena di Majo *et al.*, *Bertel Thorwaldsen, 1770–1844, scultore danese a Roma*, Rome, 1989, pp.120–4. [10] B, 16 September 1843, p.383. [11] GCA, T-MH.6/7, Merchants' House Ledgers, 1836–48, p.96. [12] Information provided by GCC Planning Department. [13] Tweed (*Guide*), p.13. [14] Tweed, (*Glasgow Ancient and Modern*), p.1074. [15] *Ibid.* [16] A, 13 April 1878, p.230. [17] *Ibid.* [18] Anon., 'Sculpture', GH, 8 July 1911, p.36. [19] Information provided by GCC Planning Department. [20] G. Linwood, 'The New Municipal Buildings for Glasgow', B, 26 August 1882, p.289. For a fuller discussion, see City Chambers, George Square, 'Condition'. [21] GCA, D-TC 13/487 K-T; Stevenson (1914), ill. opp. p.29; Anon., 'The New Municipal Buildings', GH, 17 September 1873, p.7; Anon., 'The New Municipal Buildings at Glasgow', B, 16 May 1874, p.414.

Other sources
Pagan, p.145; BN, 6 March 1868, p.160, 19 May 1871, p.393, 28 July 1871, p.76, 21 January 1876, p.80, 26 February 1892, p.xiv; Anon., 'Men You Know – No. 105', *Bailie*, no.105, 21 October 1874, pp.1, 2; B, 27 February 1892, p.167; Gildard (1892), pp.2, 10; BJ, 18 June 1895, p.301, 10 March 1896, p.69; Hitchcock, vol.1, p.312; Gomme and Walker, pp.104–5 (incl. ills); Worsdall (1982), pp.57, 73 (ills), (1988), p.74; Nisbet, p.522; Williamson *et al.*, pp.165–6; ET, 17 September 1999, p.11; McKenzie, pp.44 (ill.), 45.

Woodlands Road WEST END

At the junction of Woodlands Road and Woodlands Gate

Lobey Dosser

Sculptors: Tony Morrow and Nick Gillon

Founder: Powderhall Bronze
Date: 1992
Material: bronze
Dimensions: statue 1.49m high; pedestal 52cm high × 1.27m × 1.27m
Inscriptions: on granite plaque on upper surface of pedestal- STATUE ERECTED BY PUBLIC SUBSCRIPTION / ON MAY 1, 1992, TO THE MEMORY OF / BUD NEILL / 1911–1970 / CARTOONIST & POET / CREATOR OF LOBEY DOSSER, SHERIFF OF CALTON CREEK, HIS TRUSTY STEED EL FIDELDO, RESIDENT VILLAIN RANK BAJIN, / AND MANY OTHER CHARACTERS; on the horse's rump – LD (entwined)
Listed status: not listed
Owner: not known

Description: Lobey Dosser is the creation of the cartoonist Bud Neill, whose popular comic strip appeared regularly in the Glasgow newspaper, the *Evening Times*, in the 1950s. The fictive marshal is shown here with his adversary Rank Bajin seated on the horse El Fideldo ('Elfie'). In addition to its other comic attributes, the statue has the distinction of being the world's only two-legged equestrian monument. A portrait of Bud Neill is engraved on the plaque.

Discussion: The idea of commemorating the achievement of Bud Neill with a three-dimensional realisation of his most famous character was first proposed in the early part of 1990 by the artist Calum MacKenzie. It immediately won the support of the journalist Tom Shields, whose appeal in the *Herald* 'Diary' column raised £10,000 within two months. The intention was that the work should be ready for unveiling on Fair Friday, Glasgow's traditional mid-July public holiday, as a contribution to the European City of Culture celebrations. It quickly became evident, however, that the organisers had underestimated the cost of producing a statue in bronze, and that the funds did not include an artist's fee. In the event the modelling work was undertaken 'for the challenge' by Tony Morrow and Nick Gillon, both final year students at Duncan of Jordanstone College of Art, Dundee, who completed their fibreglass model within three months of being awarded the commission. After a further appeal in the *Guardian* newspaper, as well as substantial subventions from the Clydesdale Bank, the SAC and Glasgow District (now City) Council, the project achieved its target of £15,000 and was able to commission Powderhall Bronze to cast the work. Help was also given by Hewcon Contractors, who provided landscaping and transport services, and the architect Judy Keith, who dealt with planning formalities. The plaque was supplied by Co-operative Memorial Services.

The unveiling ceremony took place on 1 May 1992, and included the 'swearing-in as deputies of everyone who donated to the cause'. A 'birthday' celebration is held annually for the sculpture by the patrons of the Halt Bar, a nearby public house in which much of the planning of the commission was conducted.

Condition: Good.

Sources
All quotations from Tom Shields, *Tom Shields Too: More Tom Shields Diary*, Edinburgh and London, 1993; John Calcutt, 'Seriously Kitsch: Kenny Hunter's *Cherub*', in Guest and McKenzie, p.62; McKenzie, pp.84 (ill.), 85.

Tony Morrow and Nick Gillon, *Lobey Dosser*
[GN]

APPENDIX A *Lost Works* *by* GARY NISBET, *edited by* RAY McKENZIE

Argyle Street ANDERSTON

Anderston House (Neptune Building), 470 Argyle Street / 45–7 Pitt Street

Neptune, Salacia and Dolphins

Sculptor: not known

Seven-storey bank and warehouse, 1906, in red sandstone by Peter MacGregor Chalmers, incorporating seven large vertical relief panels on the first floor. *Neptune* and his female counterpart *Salacia* were adjacent to each other on the Argyle Street / Pitt Street corner; the remaining panels had dolphins. The corbels of the arched ground-floor windows were carved with seashells. Vintage photographs show that the carving was executed *in situ*, after the main structure was completed. The building later became the Pitt Street Common Lodging House, a notorious 'model' (or working men's) hostel, and was demolished to make way for the city's first Holiday Inn in 1966.

Sources
BJ, 28 November 1906; Gomme and Walker; Stewart; VM: C4062; information provided by David McLaughlin.

Balornock Road BALORNOCK

Stobhill Hospital, Administration and Staff Accommodation Building

Allegorical Figures

Sculptor: not known

Built in 1900–4 as a Poor Law Hospital to a design by Thomson & Sandilands. The Administration and Staff Accommodation Building originally had two draped female allegorical figures seated above the entrance

portico; these were possibly removed in 1931 when Thomas Somers converted the building to a nurses' home.

Sources
BN, 6 July 1900; Stuart (1994); Williamson *et al.*

Bath Street CITY CENTRE

Copland & Lye Ltd, 122–30 Bath Street / Wellington Street

Allegorical Figures, Medallion and Ornamental Clock

Sculptors: James Alexander Ewing and William Vickers

Designed in the French Renaissance style by Donald Bruce (of Bruce & Hay), and built in 1896 as an extension to the company's Caledonian House at 128–36 Sauchiehall Street, this was one of the city's leading department stores. The corner dome was surmounted by a draped female figure, while another stood at the apex of the attic window at the west end of Bath Street, the tympanum of which contained a medallion of an anonymous profile head. The sculpture was executed in sandstone and the façades were richly modelled with Corinthian pilasters and shell tympana above the third-storey windows, all carved by Vickers. The statues were removed after 1935, possibly as a safety measure during the Second World War. An ornamental clock, salvaged from the turret on the north-east corner of Caledonian House (built 1878–80) when the turret was removed, *c.*1950, was modified and remounted on the corner between the first and second floors. This was later bought by Raymond Gillies, Chairman of the Hard of Hearing Group, and re-erected at Milngavie Cross after the entire block was demolished, *c.*1971.

Sources
BJ, 14 April 1896; GAPC, 7 April 1896; VM: C5475, C2057, C4751; GCCJ, January 1971; GH, 10 April 1971; Harris (1994); Kenna.

Bellahouston Park BELLAHOUSTON

Empire Exhibition, 1938

Sculptors: Douglas Bisset, Archibald Dawson, Andrew Dods, Benno Elkan, Charles d'Orville Pilkington Jackson, Jack Mortimer, Alexander Proudfoot, Benno Schotz, Scott Sutherland, Thomas Whalen

The British Empire Exhibition at Bellahouston Park opened on 3 May 1938, and closed after a hugely successful run on 29 October. Designed in the Modernist style by Thomas Tait, the project's Architect-in-Chief, the exhibition incorporated figurative sculpture and coats of arms as a prominent feature throughout the grounds and as part of the design of many individual pavilions. Documented examples include:

Catholic Pavilion: Architect: Jack Coia; sculptor: Jack Mortimer. The pavilion had a central tower with a Crucifixion on its front.

Jungle Family: Sculptor: Benno Elkan (1877–1960). Site not known. A two-figure group in lead, comprising a female orang-utan with her baby in her arms, seated on a square pedestal inscribed: JUNGLE FAMILY / BENNO ELKAN / THIS GROUP IS EXHIBITED BY / MESSRS STOVER & SAUNDERS LTD. / LEAD CASTERS – LONDON. The plinth was signed: BENNO ELKAN LONDON.

Scottish Pavilion South: Architect: Basil Spence; sculptors: Archibald Dawson, Jack

Mortimer and Andrew Dods (1895–1976). Inside the entrance was a plaster figure of *St Andrew as a Youth*, standing semi-naked on the prow of an ancient galley. This was 7.6m high and was placed in front of a window painted with a crucified figure of St Andrew. The sculpture's armature was regarded as a work of art in itself. Dawson died suddenly while working on the figure and it was completed by Jack Mortimer. The sculpture, which had become Dawson's memorial for the duration of the exhibition, was later destroyed. Another sculpture within the pavilion was *Youth and Health*, by Andrew Dods: a crouching, naked male figure emerging from a block of stone, mounted on a square pedestal incised with a naked female figure playing tennis.

Scottish Pavilion North: Architect: Basil Spence; sculptors: Thomas Whalen (1903–75), Scott Sutherland (1910–84) and Douglas Bisset. The entrance hall was dominated by a colossal, seated female figure representing *Service*, shown holding the Torch of Knowledge in her right hand and the Staff of Health in her left. The pedestal featured a relief of a naked girl standing in a vesica-shaped letter O, flanked by a stylized A and I. The building's exterior incorporated statues of great Scots: Robert Burns, Sir Walter Scott, Thomas Carlyle, David Livingstone and James Watt, the latter two by Douglas Bisset.

United Kingdom Pavilion: Architect: Herbert Rowse; sculptor: not known. There were two gilded bronze lions flanking the main entrance and a tall relief of *Britannia* over the door. Directly above this were three standing, draped and semi-draped allegorical figures, one male (holding a hammer) and two female. The interior featured a colossal family group (a semi-naked male and female, with a naked boy) striding over a globe under a pointed arch. The globe, emerging from clouds, had a band carved with Zodiac signs, and was studded with stars.

Wool Pavilion: Sculptor: not known. At one end of the building was a tall tower surmounted by a colossal, gilded representation of *Jacob's Ram*, while the main façade featured a frieze of five rams emerging in procession from left to right towards the tower. There were more ram reliefs on at least two other façades.

In the centre of a circular pool in front of the **Concert Hall** there was also a bronze fountain group by Charles d'Orville Pilkington Jackson (1887–1943) entitled *Foam*. The group consisted of a full-length, naked female figure in a dancing pose, with her head thrown back and her (webbed) hands outstretched. Standing on one foot on a stylized wave, and with her free leg extended behind her, she was surrounded by three leaping, horse-headed dolphins, also on stylized waves, and three waterspouts, which sprayed water over the entire ensemble. Since the exhibition, the fountain has led a peripatetic existence. According to a contemporary source the dolphins were sold off after the exhibition closed, and the central figure was moved to the sculptor's garden, where it remained, mounted on a stone, until 1985. It was then presented to the National Trust For Scotland, by Jackson's widow, and re-erected, without the dolphins, as an ornament in the garden of Greenbank House, near Glasgow, in 1986. The following year, the figure was re-erected at the centre of the garden's pool, where it worked again as a fountain for the first time since 1938. In 1988, however, the fountain was temporarily transferred to Govan as the centrepiece of the Trust's display at the Glasgow Garden Festival. *Foam* has also lost the webbing from between her fingers and toes, alterations probably made by Jackson himself, *c.*1939, in response to the figure's change of function from a water sprite to a garden nymph.

The model for the complete fountain was exhibited at the RGIFA (cat. 93) and RSA in 1931 (cat. 78), and in the exhibition's Palace of Arts (cat. 727). Among the other works shown

at the latter exhibition were Gilbert Bayes' relief panel *Contentment* (no.696) from the series on the former Commercial Bank of Scotland, 30 Bothwell Street (q.v., main catalogue).

Sources
Anon., *Illustrated Souvenir of the Palace of Arts*, Glasgow, 1938; *Daily Record* and GH, various dates, May-October 1938; Worsdall (1981); Crampsey; Kinchin and Kinchin; Dawson; VM: Bellahouston Park; GCCJ, July 1983; Hartley; Glendinning *et al.*; information provided by Jim May, Head Gardener, Greenbank House.

Berkeley Street WOODLANDS
Glasgow Eye Infirmary, 170–4 Berkeley Street

Statue and Portrait Medallions
Sculptor: George Edwin Ewing

Established in the east end of Glasgow in 1824, the Eye Infirmary moved to the west end in the 1870s, with a new Gothic Revival building by John Burnet. It opened on 4 May 1874. According to Wright Thomson, there was above the main entrance a canopied niche occupied by a figure of 'a young girl with eyes closed, stretching her arms out for help or guidance'; he also recorded that this 'took a long time to sculpt and cost £100 guineas'. Above the main windows of the two pavilions were projecting portrait heads of Harry Rainy, the Infirmary's founder, and William Mackenzie, a long-serving medical officer and Surgeon Oculist to Queen Victoria. By 1962 the medallions had become 'somewhat affected by the ravages of eighty years of Glasgow weather', and the building was demolished in the 1970s. Ewing exhibited a posthumous bust of Mackenzie at the RGIFA in 1869, and one of Harry Rainy in 1875.

Sources
GWH, 2 May 1874; John J. Rae, *The Ministers of*

Glasgow and their Churches, Glasgow, 1899; GH, 28 July 1923; Wright Thomson, *The History of the Glasgow Eye Infirmary*, Glasgow, 1963; Billcliffe.

Bothwell Street CITY CENTRE

YMCA, 64–100 Bothwell Street

Statues, Portrait Medallions and Carver Work

Sculptors: not known (1878–80); James Charles Young (1895–8)

A massive Gothic fantasy built in three stages, and costing £57,000 in total. The centre section was built first, as the Christian Institute, 1878–80, designed by John McLeod, and the east and west wings, for the Bible Training Institute and YMCA, 1895–8, by Robert A. Bryden, of Clarke & Bell. The centre section had statues of *John Knox* and *William Tyndale* in canopied niches above the entrance, and two unidentified figures in niches below the east and west gables. These latter figures were not included in the elevation drawing published in 1880 in the *Architect*. There were also portrait heads in high relief projecting from medallions in the spandrels of the second-floor windows, representing Zwingli, Calvin, Melcanthor, Luther, Wishart, Cranmer and Wycliffe. A further pair of medallions flanked the main entrance, each with a half-length angel holding a harp and a pipe organ. In the second phase of building, sculpture was restricted to gargoyles on the east tower and carver work around the entrances. The building was demolished in the summer of 1980.

Sources
GH, 3 May 1879; A, 6 November 1880; Groome; BA, 20 March 1896; B, 21 March 1896; GAPC, 16 August 1898; AA, 1896[II]; GCCJ, May 1972; Ward; Nisbet, 'City of Sculpture' (photograph, June 1980); Worsdall (1981); NMRS, W/3359, W/3362-3, W/3372-3; information provided by Tom McAllister, GCC Land Services.

Bridge Street HUTCHESONTOWN

Kinning Park Co-operative Society Ltd, 47–61 Bridge Street

Allegorical Statues and Decorative Carving

Sculptor: not known

Built 1902, by Donald Bruce, with sculpture including two standing female figures with attributes, possibly representing *Agriculture* and *Commerce* on curved pediments at either end of the main (west) façade. There was also some ornamental floral carving above and below the windows and human masks and cherub heads at the base of the oriels. The statues were removed some time in the 1960s, before the building's demolition in the 1970s.

Sources
Eunson (1996); Kenna.

Brown Street ANDERSTON

Seamen's Chapel, 9 Brown Street

Hope Leaning on an Anchor

Sculptor: John Crawford

Designed by John Burnet and opened in May 1861, the building was described at the time as being 'neat and commodious' and a 'marked contrast to the [chapel] whose place it occupies' (GG). The entrance was formed by two arched openings between which was an alcove containing a figure of *Hope Leaning on an Anchor*. Concealed beneath the alcove was 'a bottle with relics from the foundation stone laying in 1860, including a list of contractors and descriptions of the interior and exterior of the building' (GH). The figure was removed when the alcove was filled in during alterations in 1926, and the building itself was demolished in the 1970s. (See also former Seamen's Institute, 9 Brown Street, main catalogue.)

Sources
GG, 4 May 1861; GH, 13 February 1861, 28 December 1926; NMRS, Brown Street.

Buchanan Street CITY CENTRE

Concept of Kentigern

Sculptor: Neil Livingstone

Bronze sculpture on cyclopean sandstone pedestal, 5m high. The theme of the work was 'the bird that never flew' from the Glasgow arms (see Appendix C, Coats of Arms), and referred to the miracle performed by St Kentigern in bringing a headless bird back to life. In March 1973, the former Highways Committee of Glasgow Corporation agreed to the principle of installing a 'special feature' in the proposed Buchanan Street pedestrian precinct. A competition was launched in November 1974, by the Depute Director of Museums, George Buchanan, in association

Neil Livingstone, *Concept of Kentigern*, Buchanan Street [RM]

with the Civic Amenities Committee. The competition was open to all sculptors working in Scotland and from the initial 29 entries a shortlist of three was selected. The panel of selectors included Michael Clark (President, Royal Bank of Scotland), James S. Morris (SAC), James H. Rae (Director of Planning) and Trevor A. Walden (Director, GAGM). The sum available for promoting the competition and commissioning the winning design was £6,000, of which £3,000 was provided by the then Highways Committee, and £3,000 by the SAC. The three shortlisted sculptors were each paid £250 for producing a maquette, and £5,000 was made available for the realisation of the winning design. The finished work was unveiled by Lord Provost David Hodge on 8 October 1977, and the plaster maquette was presented by the promoters of the Buchanan Street Precinct Sculpture Competition to GAGM in 1977 (no.S.325). After more than twenty years as one of the most controversial pieces of public art in Glasgow, it was finally removed, amid much hostile media coverage, in the spring of 2000 during a refurbishment of Buchanan Street. It is now in a council store on Lochburn Road, Maryhill. Neil Peter Livingstone (b.1954) studied at Duncan of Jordanstone College of Art, Dundee, and now lives and works in Arbroath.

Sources
GH, 9 November 1972, 18 July 1973, 25 September, 24 October 1975, 3 March, 30 December 1976, 25 March, 25 August 1977; leaflet 'Buchanan Street Sculpture', SRC, 8 October 1977; Strachan; Williamson et al.; McKenzie; Scotsman, 4 February 2000.

Warner Brothers Studio Store, 71 Buchanan Street

Wile E. Coyote and Taz

Manufacturers: Penwal Industries, Inc.

The two cartoon characters, each 2.1m high and made of fibreglass on welded steel armatures,

Penwal Industries, Inc., *Wile E. Coyote* and *Taz*, Buchanan Street [RM]

were mounted on a canopy projecting over the entrance to the Glasgow outlet of the Warner Bros' retail chain; between them was a Warner Bros shield rising from a parodic acanthus scroll acroterion. The figures were similar to many others used on Warner Bros shops throughout the world, all of which incorporate a cultural reference appropriate to the location; in this case kilts, bagpipes and thistles. Manufactured in the USA, and installed in 1994, the group was removed for re-erection at another Warner Bros store in Braehead on 29 January 2001.

Sources
Correspondence with Warner Bros Worldwide Retail, 21 November 1995, and Penwal Industries, Inc., 29 November 1995.

Scottish Widow's Fund Life Assurance Society, 141 Buchanan Street

Allegorical Group

Sculptor: John Steell

Designed by an unknown architect and erected c.1860, the building was in an Italian *palazzo* style, typical of many mid-nineteenth-century commercial buildings in Glasgow. In early June 1860, the *Glasgow Gazette* noticed that the front of the building had just been adorned with a group of statuary

> … embodying an allegorical representation of the object of the institution in providing for the relief of families bereaved of their natural protectors. On one side is a widow surrounded by her helpless orphans; on the other, Ceres bearing a cornucopia, and accompanied by a rustic youth. The work which has hitherto been in Edinburgh, possesses an interest as having been the first commission of the now eminent sculptor, John Steel [sic] RSA.

The building was demolished c.1970. John Steell (1804–91) was an Edinburgh-based sculptor of portrait busts and public monuments, most notably *Alexander and Bucephalus* (plaster 1833; bronze cast 1884, St Andrew Square) and *Equestrian Monument to the Duke of Wellington* (1852, Princes Street). Work in Glasgow includes *Banner Monument* (1859) and *93rd Highlanders Monument* (1869), both in Glasgow Cathedral.

Sources
GG, 9 June 1860; GCCJ, July 1980; Lyall; Johnstone.

Cadogan Street CITY CENTRE

Dominion Rubber Company, 42–50 Cadogan Street

Portrait Heads

Sculptor: not known

Designed in a Gothic style by an unknown architect, the building had fourteen portrait heads under the cornice, with gargoyles and organic carving on the two first-floor arched windows. In 1933, the *Glasgow Citizen* noted that

> … it was built in 1874 as a warehouse for Messrs Leslie & Hall, general metal and tinplate merchants. The initials J.A.L. and

J.H. on shields above the doorway being those of the partners... John Adam Leslie and John Hall... Their likenesses are portrayed on the two stone plaques [at the entrance] and we understand that the fourteen faces represent famous inventors and workers among iron.

The building was demolished in the 1970s.

Sources
Glasgow Citizen, 28 October 1933 (MLG, Glasgow Scrapbook, no.17); VM: C2403.

Castle Street TOWNHEAD

Townhead District Library, 188–92 Castle Street

Allegorical Figures of Literature and Learning, and Coat of Arms
Sculptor: James Charles Young

A single-storey building in the Baroque style, designed by John Fairweather and erected 1905–7. There was a colossal relief of the Glasgow arms with palm fronds in the pediment at the north end of the west façade, and figures representing *Literature* and *Learning* in aedicules with twisted Corinthian columns above the entrances. Subsidiary details included blind escutcheons and winged cherub heads below the statues. Young's tender for the carving was £201 12s. The statues and pedimented niches were rescued by Retrouvius Architectural Reclamation, London, when the building was demolished in March 1998, and stored at Taymouth Architectural Antiques, Dundee. They were then sold to an American businessman, Addison Kimball of Woodstock, Illinois, for £12,500. However, due to the prohibitive cost of shipping them to the USA, the statues were submitted for re-auction at Christie's in London on 26 September 2000 (lot 54; attributed to William Birnie Rhind), with an estimate of £10–15,000, but withdrawn on the day of the sale.

James Charles Young, *Allegorical Figures*, Townhead Library, Castle Street. From *Descriptive Hand-Book of the Glasgow Corporation Public Libraries*. [ML]

Sources
GCA, C1/3/33, p.2736; AA, 1906; *Descriptive Hand-Book of the Glasgow Corporation Public Libraries*, Glasgow, 1907; NMRS: C16837–45 CN (photos dated 28 June 1994); Nisbet, 'City of Sculpture'; Scottish Civic Trust, *Buildings at Risk Register*, May 1998; H, 15 June 1999; *Garden Sculpture*, Sotheby's South sale catalogue, 26 September 2000.

Cranston Street CRANSTONHILL

Cranstonhill Police Station, 55 Cranston Street

Figurative Sculpture and Keystone Heads

Sculptor: not known

Designed by City Architect John Carrick, and erected in 1857, this two-storey building in yellow sandstone was designed in an Italian *palazzo* style to house the Western District Police Office, its court and fire station. The sculpture was concentrated at the centre of the façade, and included two draped female figures, one holding a fasces, above the portico. Behind them, on the arch of the centre window, was a bearded male keystone head, and directly above this, at attic level, was an escutcheon bearing the city arms. There were also a number of tiny lion heads above the ground-floor windows, several blind escutcheons and an elaborate rinceau frieze below the cornice. The building was demolished c.1971 as part of the comprehensive redevelopment of the area. Detailed photographs of the building are in the collection of David McLaughlin, at his business premises, 1/7 Derby Street.

Sources
Worsdall (1981); information provided by David
McLaughlin; *Recreation Roundup*, 1970; MLG.
Glasgow Scrapbook, no.25.

Dunlop Street CITY CENTRE

Theatre Royal

Statues of William Shakespeare, David Garrick, John Henry Alexander, Thalia and Melpomene

Sculptors: not known (1764); John Mossman (1839–40)

The statue of William Shakespeare was taken from the Alston Theatre, Alston Street (built 1764, now the site of Central Station), when the theatre was gutted by fire, and placed on the first theatre on the Dunlop Street site in 1782. The royal arms were carved shortly afterwards when the theatre received letters-patent to stage drama and style itself 'Theatre Royal'. William Burn rebuilt the theatre in 1829 with a Roman Doric façade, which he altered again in 1839–40, when John Mossman was commissioned by its proprietor, John Henry Alexander, to execute statues of himself, David Garrick and the muses Thalia and Melpomene. The muses occupied niches flanking the centre of the façade, and the statues of Alexander and Garrick stood at attic level at the south and north ends respectively. The statue of Shakespeare was modelled on Peter Scheemakers' *Monument to William Shakespeare* in Westminster Abbey (1740), and stood on a small pediment at attic level over the centre of the façade until 1863, when further alterations necessitated the enclosing of the portrait figures in niches across the new third floor, and the shifting of the royal arms to the centre of the attic above *Shakespeare*. John Henry Alexander (1796–1851) was the manager of the theatre until a disaster in the auditorium, killing 65 people, hastened his early death. Ever a showman and self-promoter, he was ridiculed in the press for erecting a statue of himself amongst such illustrious theatrical company. An unidentified periodical of *c*.1840 published a cartoon depicting his statue being hoisted onto the building, watched by a jeering, missile-throwing crowd, and with the other statues looking on, clearly enjoying the comedy. Shakespeare's manuscript is inscribed 'ALL THE WORLD'S A STAGE' (as is the statue itself), while Alexander's pedestal bears the legend 'BLOCK' (MLG, Young Scrapbooks). The theatre closed on 28 May 1869, and was demolished the following year. *Shakespeare* appears to have been the only statue to have been rescued from the building. It was sold to the owner of The Craigs, near Carmunnock, in 1870, and has stood in the garden ever since. The head has been stolen and replaced, but the left hand has long been missing.

Sources
Glasgow Courier, 17 December 1829; GH, 2 February 1863; Tweed (*Guide*); *Bailie*, 21 October 1874; BJ, 20 August 1895; Groome; GAPC, 22 April 1902; Worsdall (1981); *Scots Magazine*, July 1988; GCA, P1935 (photograph, 1855); Peter.

Eglinton Street KINGSTON

British Linen Company Bank, 1 Eglinton Street

Minerva and Royal Arms

Sculptor: Charles Benham Grassby

Designed *c*.1870–1, by Salmon, Son & Ritchie as a bank and tenement in the Italian Gothic style, and built for £10,000. The main entrance on the Eglinton Street / Norfolk Street corner was flanked by Corinthian columns supporting an elaborately carved entablature. Standing above this was a figure of *Minerva*, and directly above her, at attic level, was a royal coat of arms, reputedly the largest in the city. The building was demolished in the 1970s.

Sources
GCA, D-OPW 18/2, 26 May 1871, no.37; BN, 20 December 1872; Tweed (*Guide*); Groome; Eunson, 1996.

Gallowgate CALTON

Saracen Lane

Saracen Fountain

Sculptor: not known

Erected in the late nineteenth century by Walter Macfarlane & Co. to commemorate the original location of their Saracen Foundry in Saracen Lane. A three-tiered ornamental cast-iron fountain, with free-standing birds and foliage around its base and middle tier, and surmounted by a standing female figure, the fountain stood in the back court of the Saracen Head Inn adjacent to the ancient St Mungo's Well. Photographs of both of these appeared in the press in the late 1950s and show the fountain in various states of dereliction. According to one report, after the gates to the yard were removed vandals attacked the fountain with a sledgehammer; by the time the fountain was finally removed the birds and foliage had already disappeared. It was demolished *c*.1959, despite an appeal by Councillor John Rennie for Glasgow Corporation to restore it, together with the Saracen Head tenement, as a tourist attraction.

Sources
'Sightseers Glasgow', 18 June 1957, unidentified newspaper article in MLG, Glasgow Scrapbook no.19; 'When Glasgow Hauls Down History with Slums', unidentified newspaper article in MLG, Glasgow Scrapbook no.24.

George Square CITY CENTRE

General Post Office, 1–7 George Square

Royal Arms

Sculptor: Alexander McGaw

The building was erected in 1856 by HM Office of Public Works for Scotland. The arms were carved in yellow freestone and put into position above the main entrance during the last week of October 1856. The *Citizen* newspaper (quoted

in the *Glasgow Gazette*) greeted their arrival with less than enthusiasm:

> As a work of art it represents no remarkable feature. The helmet above the shield is perhaps somewhat small and out of proportion; but this is evidently the result of a wish not to interfere with the window immediately adjacent. On the whole the work has been executed in a respectful manner.

The *Glasgow Gazette* itself described the building as an 'abortion', but was sympathetic towards the sculptor: 'We believe that Mr McGaw [c.1820–62/68] has made the very most of them "according to order", but if his own genius had been left to play [we would] have an emblem worthy of Royalty and worthy of Glasgow'. The arms were removed c.1875–8 when the building was enlarged and reconstructed, and a new coat of arms was placed at attic level. The replacement was accepted by the press without complaint. Both sets of arms can be seen in photographs of George Square taken at different times by George Washington Wilson.

Sources
GG, 1 November 1856; Lyall; Johnstone.

Glasgow Cross CITY CENTRE

Warehouse, on the north-east corner of Gallowgate and High Street

Britannia and Putti

Sculptor: John Crawford

The statue of *Britannia* was approximately 2.5m high and stood on a parapet inscribed JOHN MCINTYRE CORNER over the canted attic of a four-storey warehouse dating from the early 1850s. Holding a trident and agricultural produce, she was flanked on both sides by lion heads and pairs of standing, naked putti with stooks of corn. There were also tiny human masks above the second-floor windows. The sculpture disappeared when the building (one of the first iron-frame structures in Glasgow) was reduced to a single storey, c.1949. The site was landscaped in 1981, and originally featured two large *Red Robins* in concrete.

Sources
GH, 13 December 1861, 23 January 1981; Gomme and Walker; Mozley; *Scots Magazine*, April 1982; I.G.M. Stewart, *The Glasgow Tramcar*, Glasgow, 1983 (rev. 1994).

Gordon Street CITY CENTRE

Scottish Life Assurance Building, 18 Gordon Street

Figurative Relief

Sculptor: Alexander Carrick

Built 1939–40, to a plain classical design by T. Aikman Swan. On the canted corner at West Nile Street was a relief featuring a standing, draped female figure with her hands resting on the shoulders of two naked children who faced each other holding what appears to have been the model of a building. The relief was between the first and second storeys and was in a stylized Art Deco idiom. A half-size working model of the work was exhibited at the RSA in 1940, and the finished relief was removed some time after 1952. Alexander Carrick (1882–1966) trained under William Birnie Rhind and at the ECA and RCA. Chiefly an architectural sculptor, his work includes figures in the Scottish National War Memorial (1924–7).

Sources
Harris; Laperriere; Johnstone; Fiona Pearson, in Guest and McKenzie.

Grosvenor Restaurant, 74 Gordon Street

Marble Staircase, Marble Relief Panels and Atlantes

Sculptors: Galbraith & Winton; Albert Hemstock Hodge

An opulent Edwardian refurbishment of Alexander 'Greek' Thomson's Grosvenor Building (1865), by J.H. Craigie (of Clarke &

Albert Hemstock Hodge, *Science and Art*, **Grosvenor Restaurant, Gordon Street.** *Academy Architecture, 1907*[1]. [GSA]

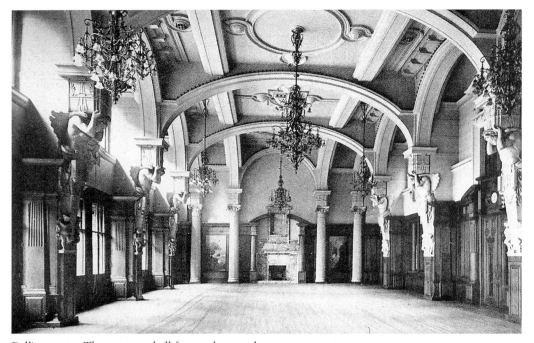

Albert Hemstock Hodge, *Atlantes*, Grosvenor Restaurant, Gordon Street. *Academy Architecture*, 1907[1]. [GSA]

Bell), 1904–7. The entrance hall featured a grand marble staircase with a winged lion at its foot, by Galbraith & Winton, its curved wall inset with five marble relief panels illustrating the *Arts* and *Science* by Albert Hodge. This led to a ballroom with plasterwork including half-length winged atlantes rising from term columns, each with a pair of naked putti standing at their base. The atlantes were modelled in plaster by Hodge and each carried a square capital, which rested on their shoulders and upturned hands to support the vaulted ceiling above. A panel entitled *Science and Art* was exhibited at the RA in 1904, and photographs of the entrance hall and atlantes were displayed at the RGIFA in 1907. The building was gutted by fire in 1963, when the interior work was completely destroyed.

Sources
B, 24 September 1904, 22 June 1907; AA, 1907[1]; Worsdall (1981); Stewart (1997).

Hope Street CITY CENTRE
Corn Exchange, 81 Hope Street

Figures of Sowing and Reaping
Sculptor: James Young

Built 1894–6, to a French Renaissance design by W.F. McGibbon, with a pair of colossal male and female figures standing above the two-storey Doric portico in the centre of the east façade. Carved in sandstone, they held agricultural attributes and were dressed in rustic medieval costume. McGibbon's published perspective drawing reveals that he initially intended the figures to be naked and sitting back to back on either side of an escutcheon

within a broken segmental pediment. The building was demolished in 1963 to make way for a plain office block.

Sources
GCA, B4/12/1/3856, DOPW 37/3; BN, 2 August 1895; B, 4 January 1896; Gomme and Walker; Worsdall (1981); NMRS; VM: C3394.

Ingram Street MERCHANT CITY
Bank of Scotland, 174–6 Ingram Street

Arms of the Bank of Scotland
Sculptor: Alexander Handyside Ritchie

The building was erected in 1828 to a plain design by William Burn, but the massive coat of arms was not added until October 1849. These were designed by Burn and carved by Ritchie in Edinburgh. The shield was 3.35m high, and the supporters – *Justice*, holding a sword and scales, and *Plenty*, holding a cornucopia and a fasces – were 2.46m high. The group was carved from three blocks of freestone from the Binnie Craig quarry near Edinburgh and cost 30 guineas. Such was their size that they each required six horses to transport them to Ritchie's studio. The *Glasgow Gazette* (quoting the *Citizen*) commented on the group while it was still being carved:

> The magnificent group of statuary which is intended to adorn the front of the Bank of Scotland's branch establishment in this city, is now considerably advanced... [the] figures, which are about a half larger than life, are completed and are executed in a style which does credit to the genius of the sculptor. From the excellent situation of the Bank of Scotland, fronting Glassford Street, the beautiful group will be seen to great advantage, and will form an additional and prominent adornment to Ingram Street, which is already the richest in architectural display in the city.

The group was erected by builder William York, who had brought it from Edinburgh himself. It was removed when the bank relocated to new offices at 2 St Vincent Place (q.v., main catalogue), c.1870, and their former position is now occupied by Alexander Stoddart's *Italia* (Italian Centre, John Street, q.v., main catalogue).

Sources
GG, 24 February, 20 October 1849; Groome; VM: C1827.

Former Municipal Buildings

Allegorical Statues, Coat of Arms, Relief Panels

Sculptors: John and William Mossman Junior

Roman classical building by Clarke & Bell, erected 1874–6. According to the *Building News* the statues and coat of arms were put into position early in January 1876:

Last week there was placed on pedestals over the entablature towards Ingram Street... a series of representational statues by John and William Mossman... The statues are about 8ft high, and are of 'Britannia,' 'The Town Clerk,' 'The Lord Provost,' 'The City Architect,' 'The Finisher of the Law,' and 'Glasgow'. Over the principal doorway and by the same sculptors, is the civic escutcheon, the dexter-side of the shield supported by a male figure, representing the iron industry of the city, and the sinister by a female representative of the textile.

These can be seen in a perspective drawing published by D.M. Stevenson in *Municipal Glasgow* (1914) which also shows figurative relief panels and fasces above the windows on the east façade. By August 1882, the building's stonework was already 'undergoing a continuous process of decay', and had apparently become 'a sorry sight'. The north façade was eventually rebuilt in 1892, but without the sculpture. The reason for and precise date of their removal are not known, although it seems likely that they were taken down when the Town Council moved into the newly built City Chambers in 1889 (George Square, q.v., main catalogue), and the old building was converted for use as the Sheriff Court.

Sources
B, 16 May 1874, 26 August 1882, 27 February 1892; BN, 21 January 1876; Groome; Bell and Paton; Stevenson (1914).

Kelvingrove Park WEST END

Park Terrace entrance

Henry Drummond Memorial Drinking Fountain

Sculptor: James Pittendrigh Macgillivray

Erected on the west face of the central gate pillar, the fountain was composed of a circular bronze medallion bearing a profile portrait of Professor Henry Drummond enclosed in a wreath of ivy. Below this was a bronze tablet inscribed: THERE IS A RIVER, THE STREAMS WHEREOF MAKE GLAD THE CITY OF GOD. The water spouted from the centre of an ornamental basin attached to the pillar. Henry Drummond (1851–97) was Professor of Natural Science at the nearby Free Church College, and a noted theologian, traveller and author. The fountain was donated to the city in 1899 by the Countess of Aberdeen, whose offer reveals that the fountain was to be paid for by the 'proceeds arising from the sale of the little children's book of Professor Drummond's, "The Monkey that would not Kill," which he wrote for a little magazine of [hers]'. Her original intention was that William Hamo Thornycroft was to design and sculpt the fountain. The offer was graciously accepted and the fountain was unveiled by the Countess on the fifth anniversary of Drummond's death, on 11 March 1902, but with Macgillivray as its sculptor. It was removed in the late twentieth century for reasons that are not known, though traces of its outline and fixtures can still be seen on the pillar. Macgillivray later produced a marble medallion of Drummond for the Free Church College (exhibited at the RSA in 1905).

Sources
GH, 12 March 1897, 12 March 1902; ET, 12 March 1902; GCA, C1/3/26; Laperriere.

To the east of the present Art Gallery and Museum

Kelvingrove International Exhibition Buildings (1901)

Sculptors: Albert Hemstock Hodge; 'Dimsy' of Doulton & Co., Lambeth

Architect: James Miller. The largest and most exotic of the temporary structures was the Industrial Hall. Its golden domes, the main entrance and the pediments of its east and west wings were surmounted by gilded angels holding torches and standing on one toe. The figure on the main dome represented *Light*. The interior of the dome featured spandrels filled with four colossal female groups representing *The Triumph of Navigation*. Each group consisted of a pair of naked, trumpet-blowing figures flanking a winged figure holding a torch, and hovered above the bows of ancient galleys which, in turn, were supported by naked cherubs. Directly beneath the dome stood a 5.5m plaster statue of King Edward VII, the first statue erected to the new, but as yet, uncrowned King. It was much derided by the critics. Other sculptural decorations on the building included a Parian ware panel in the tympanum above the entrance by 'Dimsy', an unidentified artist working for Doulton & Co. None of the sculpture programme seems to

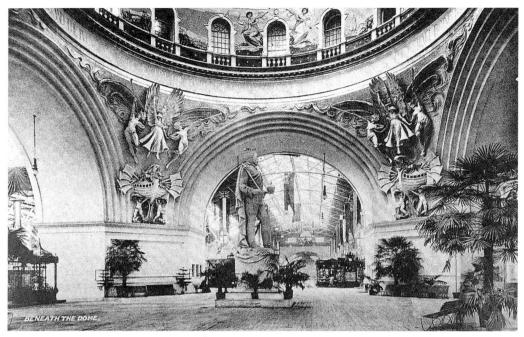

BENEATH THE DOME.

Albert Hemstock Hodge, *Edward VII* and *Spandrel Figures*, **Kelvingrove International Exhibition Buildings.** [JK]

have survived beyond the exhibition, although it has been claimed that one figure was relocated to the tower of Miller's Municipal Buildings at Clydebank (1902).

Sources
RIBAJ, 28 September 1901; Kinchin and Kinchin; Harris.

On the former Kelvingrove Mansion Museum
Minerva, City Arms and Keystone Masks

Sculptor: not known

The museum was built in 1874–6, as an eastward extension to the south end of Kelvingrove House (1782, attributed to Robert Adam). Designed by City Architect, John Carrick, and built in yellow sandstone, the building cost £10,000. It is described by Groome as being a 'plain massive building in the Doric style'. He goes on to say that the 'pediment is surmounted by a huge but ill-designed and ill-proportioned figure of [Minerva]'. Draped, helmeted and standing on a stepped pedestal above the east façade, she held a spear in her right hand and rested her other hand on a shield. Also at her right side was a snake, which was modelled in the round and wriggled up to her right hip. Early photographs show the building before and after the statue was erected, but a photograph of *c.*1908, published by 'Noremac', shows the statue in detail (when the building housed the Jeffrey Reference Library), and reveals that it was actually quite an impressive work. Also shown are two large, male keystone heads on the east and north façades. One was above a lunette over the east door (which contained a carved city arms); the other was above the north-east door and resembled one of the 'Tontine Faces' (see St Nicholas Garden, Castle Street, main catalogue). The mansion was demolished for the 1901 Kelvingrove International Exhibition but the museum was retained for use as the Japanese pavilion and not demolished until *c.*1910.

Sources
GWH, 22 April 1876; Groome; 'Noremac'; Worsdall (1981); Lyall; Urquart.

In the east section of the Park

La Innocenza

Sculptor: Boschetti

Erected in 1879, this figurative group stood approximately 300 yards to the north-west of the Stewart Memorial Fountain. It is described by Groome in the following terms:

> Close by [the Kennedy Monument] is a small bronze group of a girl playing with a dog, and is intended to illustrate the lines from Coleridge 'He prayeth best who loveth best / All things both great and small, / For the dear God who loveth us / He made and loveth all'.

The group was gifted to the city by James Walker McGrigor in March 1879, 'in memoriam of a niece of his', with the condition that it was sited in Kelvingrove Park. The Parks Committee discussed the offer on 10 March 1879 and, after studying a photograph (untraced) of the sculpture, accepted the gift. The group was erected soon afterwards without official comment. The sculptor is identified in McGrigor's letter, though little is known of Boschetti other than that he was a nineteenth-century Italian sculptor based in Rome. For almost a century the group was overlooked by commentators and photographers until its

destruction on 29 July 1953, when the *Glasgow Herald* reported that

> The police are looking for the vandals who damaged the statue 'La Innocenza' in Kelvingrove Park during the night. The statue, which is a bronze figure of a girl holding a dove, with a dog sitting at her feet, was pushed from its plinth, carried about 300 yards over a lawn and left lying on a path. The head, an arm, and other parts were broken off. The statue, which weighs 1cwt, was erected in 1879 and has for years been one of the main attractions of one of the walks adjoining the Stewart fountain.

All trace of the group has now been lost although an unidentified bronze right arm which was found on the nearby river bank in 1995 may have belonged to the girl (see Kelvin Way Bridge, Kelvingrove Park, main catalogue).

Sources
GCA, C1/3/9, pp.2158–9; Groome; GH, July 1953; *Daily Record*, 25 August 1995.

Maxwell Park POLLOKSHIELDS

Hamilton Fountain

Sculptor: Doulton & Co.

Designed by Frank Burnet (of Burnet & Boston) in 1907, the fountain was French Renaissance in style and built in white Carrara stoneware. The base and column were 10.75m high and the outer basin was 12.2m in diameter. It stood at the rear of the (former) Pollokshields Burgh Hall, 72 Glencairn Drive, on the east side of the park (see Appendix B, Minor Works). The fountain and its unveiling ceremony, on 11 March 1908, were described by 'Noremac' as follows:

> From the centre of [the outer basin] rises the fountain itself in four stages, on the second of which are modelled panels, these being

occupied by the Glasgow, Hamilton and Poloc [*sic*] Coat of Arms, whilst the fourth bears the inscription 'Hamilton Memorial Fountain, 1907' and a portrait bust in mefizo relievo [*sic*]. The upper stage forms the pedestal for the life-size statue of a sportsman in the [shooting] attire of the mid-nineteenth century. The unveiling ceremony was performed by Lady McOnie, after which Lady Ure Primrose turned on the water. On behalf of the donors, Sir John Ure Primrose, Bart., handed the monument over to the custody of the Parks Department. Quite a large and interesting gathering of those interested and of the general public were present at the unveiling ceremony.

The statue was of Thomas Hamilton (d.1904), a local baker, victualler and grain merchant, who used to hunt in the area before the park was created (1890), and the portrait medallion was of his son John, a storekeeper in Hamilton, Larkhall and Newton. The other decorative details included lion head masks on the upper basins and four dolphins at its base. The fountain was the gift of Elizabeth Miller Hamilton and Christina Brown Primrose Hamilton to commemorate their father and brother. It was renovated in 1953, together with other fountains in the city, to have them working and floodlit 'in time for the coronation', but by the 1980s the structure was

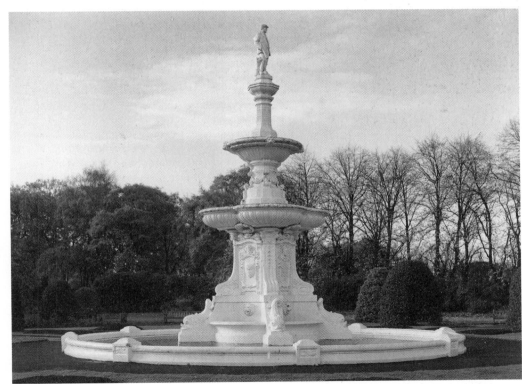

Doulton & Co., *Hamilton Fountain* [CIA]

derelict. Years of vandalism and neglect necessitated it being 'encased in timber hoarding to prevent youngsters from using it as a climbing frame' which 'caused the carreraware [sic] glazed tiles to crack'. Despite appeals for its renovation, the fountain was dismantled in the late 1980s, with only the outer basin remaining *in situ* as a flowerbed.

Sources
GH, 13 February 1907, 11 April 1908, 18 March 1953; B, 25 April 1908; 'Noremac'; GCA, P267; MLG, Glasgow Scrapbook no.26 (Doris Black, 'The Hamilton Memorial Fountain', 1975); *Bulletin*, July/August 1984; *South Side News*, 3 August 1984; *Pollokshields Guardian*, February 1986, October 1987; Atterbury and Irvine; Read and Ward-Jackson.

McIntyre Street ANDERSTON

Anderston Public Library, 18 McIntyre Street

Putti and Glasgow Arms

Sculptor: not known

The building was designed in 1902 by Stewart & Paterson, and included two standing putti supporting an escutcheon bearing the Glasgow arms in a segmental pediment at attic level, directly above its main entrance. Two of the ground-floor windows also had grotesque keystone masks. The building was demolished *c*.1970 as part of the redevelopment of the area.

Sources
GCA: C1/3/29 *passim*.; POD, 1905; Stevenson (1914); VM: C3881, C3466; information provided by David McLaughlin.

McNeil Street GORBALS

United Co-operative Baking Society, 12 McNeil Street

Portrait Medallion of Duncan McCulloch

Sculptor: not known

French Renaissance-style commercial building by Bruce & Hay, erected 1885–7. According to the *Glasgow Herald*: 'over the doorway to the engine room [was] a fine sculptured bust of the late Mr Duncan McCulloch, who was for some years chairman of the Society and a Clyde Trust official'. The building was demolished in the late 1970s.

Sources
GH, 23 July 1923; Worsdall (1981).

McPhun Park CALTON

John Pollock McPhun Memorial Drinking Fountain

Sculptors: Scott & Rae

Erected in 1906, the fountain was approximately 3m high, and consisted of a truncated, grey granite obelisk on a square basin, pedestal and step. Affixed to the south-east face of the obelisk was a square, bronze portrait and inscription panel. McPhun, a quarrymaster, builder and timber merchant, was a member of the town council from 1889 to 1899 and a magistrate from 1893 to 1897. The fountain was formally presented to the city by McPhun's son, Peter, at a ceremony on 12 September 1906. The obelisk and panel were removed some years ago but the pedestal, inscribed: SCOTT & RAE, on the north-west face of its step, is now used as a planter. It has been much vandalised. The firm of Scott & Rae was established in 1881 by George Scott (1845–1903) and Robert Rae (1845–1910), specialising in monumental masonry, and since 1971 has been trading under the name Scott Rae Stevenson Ltd.

Sources
GCA, AGN 233; GH, 13 September 1906; Morgan; Eunson.

Miller Street CITY CENTRE

Anderson Company Warehouse, 37–51 Miller Street

Figurative Sculpture and Keystone Masks

Sculptor: not known

Venetian Renaissance-style commercial building, designed 1854–6 by Alexander Kirkland, with large recessed central forecourt. The figurative sculpture was concentrated at the centre of the west façade and featured, on a pedestal at attic level, a larger than life-size female figure, probably *Cybele*, seated on a throne or plough; she held agricultural produce and had a couchant lion at her right side. Directly below her, the spandrels of the first-floor window were filled by two crouching female figures, and the spandrels of the main doorway were filled with two smaller females reclining against an arch. Additional carved details included 15 large, bearded, male keystone masks above the entrance and ground-floor Palladian window bays, all powerfully modelled in yellow or grey sandstone, together with 30 small female heads protruding from foliage above the arched windows on the second floor. The building was destroyed amid controversy in 1969.

Sources
Gomme and Walker; Worsdall (1981).

Walter Stirling's House, 62(?) Miller Street

Colossal Bust of a Man

Sculptor: not known

The present Stirling's Library was built on the site of the former dwelling house of Walter Stirling, whose collection of 804 books, bequeathed to the city on his death in 1791,

formed the basis of the first free public library in Scotland. At the right side of the two-storey villa was an arched entrance with a free-standing bust of a man, possibly Homer, on the attic. It was probably removed in 1863–5, when the new premises were built.

Sources
Cowan; Williamson *et al.*

Necropolis TOWNHEAD

Peter Lawrence Memorial

Sculptor: John Mossman

Located in the Gamma division, at the head of the walkway to the west of the *Monument to William McGavin* (q.v., main catalogue), this life-size, naked seraph in sandstone dates from around 1845 (possible as early as 1840) and may have been John Mossman's first major work. The figure was apparently a favourite target for local hooligans, who finally succeeded in bringing it to the ground in the mid-1990s. With nothing remaining of it on the pedestal except a small fragment of drapery and the bowl of an inverted torch, the figure itself now lies in fragments, and with its head missing, in a council store in Kelvingrove Park. For George Blair it was one of the 'most exquisite pieces of sculpture in the Necropolis'. He went on to say that the

> ... attitude, form and expression of the cherub, are all alike faultless, and the statue is worthy of the best ages of Greek sculpture. It certainly reflects great credit on the late Mr. [William] Mossman, from whose studio it proceeded. The countenance of the figure expresses subdued sadness, chastened by calm resignation, and mingled with that celestial beauty which points to a region of immortality and everlasting youth.

Peter Lawrence (1795/6–1839) was himself a sculptor of some note.

Sources
Blair; Berry; Williamson *et al.*; Johnstone.

Prince's Dock GOVAN

Glasgow Garden Festival, 1988

Four 'L' Eccentric

Sculptor: George Rickey

Following a successful exhibition of his work in Glasgow in 1982, Rickey gifted this kinetic sculpture to the city for display in the Garden Festival. However, unlike his earlier *Two Lines Up Eccentric VI* (1977), which was purchased by the Scottish National Gallery of Modern Art in 1984, and which can now be seen in the grounds of their premises on Belford Road, Edinburgh, the Glasgow sculpture has become a source of acute embarrassment to the city council, and the focus of much disquiet among Rickey's admirers in Scotland. According to press reports, because the sculpture was found to have been vandalised within 24 hours of its installation in the Festival Park, it was immediately designated as 'unsafe for children' and removed to a council depot in the east end. This was regarded as not only an act of disrespect to a major international artist, but also an inappropriate way of treating a kinetic sculpture, which, like any mechanical object requiring maintenance, is 'more easily damaged in store than in the open, where [it is] at home'. The question of its fate remained unresolved for many years, and in June 1994, Rickey wrote to the *Herald* from his home in East Chatham, New York State, reporting that a friend had recently returned from Scotland with the news that the sculpture was 'dismembered and stacked... in a muddy, fenced enclosure with no padding or protection'. In an act of extraordinary generosity, Rickey offered to give the city a new work if the old one were returned to him, covering the freight and installation costs himself. The council does not

appear to have made a response. Six months later, the film maker Murray Grigor, together with the sculptor George Wyllie, broadcast a short film entitled *Fakelore*, which included interviews with the leader of the city council, Pat Lally, and the controversial Director of Glasgow Museums and Art Galleries, Julian Spalding. It emerged that Spalding had earlier approached Rickey for a piece to be included in the newly-opened Glasgow Gallery of Modern Art, but this too appears to have come to nothing. Recent attempts to determine the whereabouts of *Four 'L' Eccentric*, at one point involving police detectives, have been unsuccessful, and it is rumoured that the sculpture has in fact been disposed of as scrap metal.

Source
H, 22 June 1995, *Arts* supplement.

Queen Street CITY CENTRE

British Linen Company Bank, 110 Queen Street

Allegorical Figures and Doorcase Group

Sculptors: Johan Keller (figures); Richard Ferris and George Gregory (doorcase group)

The building was erected in 1839 by David Hamilton, with a Mannerist attic added 1903–5 by James Salmon and John Gaff Gillespie. The additions included figurative sculpture by Johan Keller comprising three standing, draped female figures representing *Agriculture* (plough), *Industry* (tool and flywheel) and *Britannia* (trident and shield), the former pair flanking the dome on the Queen Street corner, the latter over the east end, on Ingram Street. Also added was an extra bay to the north, on Queen Street, which featured a doorcase group by Richard Ferris and George Gregory. This incorporated a

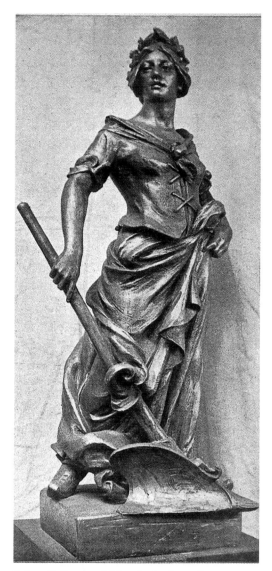

Johan Keller, model for *Agriculture*. From *Academy Architecture*, 1905[1] [GSA]

pair of standing chimeras supporting an entablature with their wings; in their mouths were garlands attached to an escutcheon bearing the bank's arms, crested with a tiny, seated *Britannia*. The models of *Industry* and *Agriculture* were exhibited at the RGIFA in 1905; *Britannia* in 1906. The building was demolished in stages after 1956, with the dome and statues disappearing first, and the lower storeys *c.*1967.

Sources
AA, 1905[1]; BJ, 28 November 1906; Gomme and Walker; Worsdall (1981); Billcliffe.

Renfield Street CITY CENTRE

City of Glasgow Life Assurance Building, 28–36 Renfield Street

Statues of St Andrew and St Mungo and Decorative Carving

Sculptors: George Edwin Ewing, William Brodie and Charles Benham Grassby

The building was designed by Peddie & Kinnear in 1872, and the larger than life-size, yellow sandstone statues of *St Andrew* (by Brodie) and *St Mungo* (by Ewing) were in pedimented niches at the north and south ends of the façade respectively. The carver work, by Grassby, consisted mainly of Greek ornament on the pediments over the niches, around the entrance and windows and on the capitals of the first-floor columns. The fate of the statues after the building was demolished in 1929 is not known.

Sources
GCA, D-OPW, 25 April 1872, no.40; BN, 22 March 1872; Groome; GH, 25 January 1929; Tweed (*Guide*); Lyall.

John Mossman, William Mossman Junior and James Young, *Figurative Programme*, Fine Art Institute, Sauchiehall Street. From the *Architect*, 1 July 1887. [GSA]

Sauchiehall Street CITY CENTRE

Fine Art Institute, 175 Sauchiehall Street

Sculpture Group, Figurative Reliefs and Decorative Carving

Sculptors: John Mossman and William Mossman Junior (figures); James Young (carver work)

Built 1878–9, to a competition-winning Beaux-Arts design by J.J. Burnet (of John Burnet & Son). The sculpture scheme consisted of a standing figure of *Minerva* with three putti at her feet on the central attic pediment, and two figurative friezes, modelled by the Mossmans but carved by Young, illustrating the arts, industry and science high on the east and west wings. Over the arched main door was a

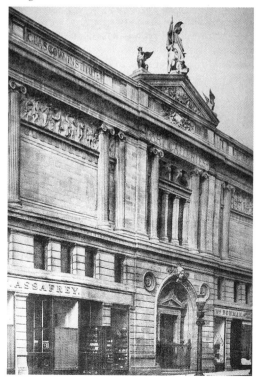

helmeted, female keystone mask, and there were two medallions of unidentified profile heads on either side of the entrance. Minor decorative details included a pair of griffin acroteria on the pediment, a mass of floral carving in the central tympanum and a short frieze below this incorporating a painter's palette. The ground floor, including the ornate entrance, was destroyed in the 1930s when new shopfronts were inserted after the building had become part of Pettigrew & Stephens' department store (see below). According to a local commentator, parts of the friezes were placed in storage in a mason's yard in Stirling after the building was demolished in 1967. The site was eventually cleared in 1973.

Sources
GCA, AGN 108; A, 20 July 1878, 4 November 1882, 1 July 1887; BA, 18 August 1878; BN, 6 February 1880; B, 22 April 1882, 21 March 1896; Groome; Gomme and Walker; GCCJ, January 1968, July 1973; Worsdall (1981); Service; information provided by Michael Donnelly.

Pettigrew & Stephens (Manchester House), 191 Sauchiehall Street

Allegorical Figures, Carver Work and Coats of Arms

Sculptors: Albert Hodge, Aniza McGeehan, Alexander Proudfoot, William Shirreffs and Benno Schotz

Built 1895–6, to a design by John Keppie, with later additions to its Bath Street frontage in the 1920s. The sculpture was on the north façade, and included a seated female figure representing *Justice* in a niche on the dome, with four standing male and female figures symbolising *Weaving, Building, Industry* and *Agriculture* between the fifth-floor windows. Above the three central windows of the third and fourth storeys were reliefs featuring seated cherubs among ship's prows and machine components. The Honeyman & Keppie Job Book for 1900

records that payments totalling £700 were paid to Albert Hodge for unspecified sculpture for the building. Woodward attributes the work to Aniza McGeehan (1874–1962), although in fact she was responsible only for a group of six relief panels and four figurative corbels (one of which survives in HAG) on the third and fourth storeys. The standing figures were removed before demolition and reputedly shipped to the USA. William Shirreffs was also employed to carve seated putti around a small clock face above a dormer window on the west façade, receiving £95 6s. for these on 29 March 1900.

Hodge was employed again in 1915, and was paid £200 to provide 'two figures at door'. Further extensions were added on Bath Street in the 1920s, with bronzework at its two entrances by Benno Schotz, including two shields supported by naked male and female figures above a bronze escutcheon bearing the store's name. The store, together with Copland & Lye's (which had itself been absorbed by Pettigrew & Stephens) at the east corner of the block (see above), closed its doors on 8 January 1971, and its demolition shortly afterwards was photographed by the NMRS. The four standing figures and Schotz's bronzes were apparently sold to an American buyer, but the statue of *Justice* and the corbel figures were destroyed. The building's cupola, however, was regarded as its most important feature and was saved. This (together with the dome) had been designed by Charles Rennie Mackintosh and was relocated to the garden of his Hill House in Helensburgh, where it was used as a gazebo. It was transferred back to Glasgow in 1988 as an exhibit at the Glasgow Garden Festival, and is now in the sculpture courtyard at the HAG.

Sources
GCA, AGN 108; GAPC, 7 April 1896; BN, 18 April 1899; BI, 5 November 1899; HAG, Honeyman & Keppie Job Books 1899–1905, 1908–2; NMRS, GW/1094–100, GW/2165; GCCJ, February 97, July 1973; GH, 10 April 1971, March 1988; Woodward;

Worsdall, (1981); I.G.M. Stewart, *The Glasgow Tramcar*, Glasgow, 1983 (rev. 1994); GUABRC, HF 43/1/1–3, 43/71/; Elma MacDonald, 'The McGeehan Family from Raywards, Airdrie', unpublished research, Monklands Heritage Society.

St Vincent Street CITY CENTRE

Former Scottish Provident Institution For Life Assurance, 67–79 St Vincent Street / 19–25 West Nile Street

Allegorical Figures and Portrait Heads

Sculptor: not known

Designed by J.J. Stevenson and erected c.1875–8, the building had at least two standing, draped female figures and ten portrait heads distributed over both façades. The figures were carved in yellow sandstone and stood in the segmental attic pediments flanking the West Nile Street corner, above the Corinthian columns, which rise through the centre of the second floor; the points where they were attached to the walls are still clearly visible. The portrait heads projected from above the ground-floor windows and each portrayed a famous Scot, including, on the West Nile Street side, David Livingstone, James Watt and Thomas Carlyle. On St Vincent Street there were at least two portraits, possibly Joseph Lister and William Simpson. The heads, and probably the statues, were removed when new shop fronts were inserted in the 930s.

Sources
VM: C3996, C8597, C8888; Cowan; Gomme and Walker; Williamson, *et al.*; I.G.M. Stewart, *The Glasgow Tramcar*, Glasgow, 1983 (rev. 994).

West Campbell Street CITY CENTRE

McGeoch's Warehouse, 28 West Campbell Street

Figures of Industry and Science

Sculptors: Phyllis Archibald (modeller); Holmes & Jackson (carvers)

A massive six-storey corner block commissioned by ironmongers William McGeoch & Co. Ltd, designed by J.J. Burnet in 1905. The sculpture consisted of a pair of figures reclining on a segmental pediment over the Cadogan Street entrance (west façade), representing *Science* (female, holding dividers and plans), and *Industry* (male, holding a hammer and pincers). There were also grotesque lion masks on the corbels below the pediment. Standing on the north-west corner, between the third-storey windows, was a winged figure representing *Art*. It is not known whether Archibald modelled all the carved details (escutcheons, lion masks, wreaths, urns, seashells, shields with entwined numerals and monograms), as well as the statues. The building was demolished in 1971.

Sources
BJ, 28 November 1906; GCCJ, April 1978; Worsdall (1981); NMRS, GW/1656–8; Service.

West George Street CITY CENTRE

Alliance Building, 147–51 West George Street

Figurative Group

Sculptor: not known

A six-bay, three-storey commercial *palazzo*, built *c*.1882, by an unknown architect. Sculpture included a three-figure classical group on a pedestal in the attic balustrade, the standing, helmeted figure in the centre probably representing *Britannia*. The building was demolished *c*.1980.

Source
NMRS, GW/769 (photograph dated 1969.

West Scotland Street KINNING PARK

Kinning Park Burgh Chambers, Public Hall and Library, 116–22 West Scotland Street / 60 Stanley Street

The Goddess of Harmony, Portrait of William Mair and Caryatids

Sculptor: not known

Erected in phases between 1901–7 by Donald Bruce (of Bruce & Hay), the Burgh Surveyor, the buildings were of red sandstone and in a hybrid Romanesque and French Renaissance style. A full-length statue of the *Goddess of Harmony* stood in a niche at attic level, directly above the entrance to the Burgh Halls. Over the entrance to the Public Hall was a roundel carved with the portrait of William Mair, a former Lord Provost of the burgh. The caryatids were small and draped, and supported an entablature over the library entrance. The buildings were destroyed to make way for the M8 motorway, *c*.1971.

Sources
GCA, P556; B, 13 July 1901, 29 March 1902; BI, 15 April 1902; GH, 6 August 1907, 23 July 1923; Stevenson (1914); VM: C394.

APPENDIX B *Minor Works*

INTRODUCTION

Every researcher in the field of public sculpture will be familiar with the often painful dilemma of having to decide where the boundary lies between those objects that are unequivocally sculptural and those that just as definitely are not. This is no mere exercise in sterile semantics; rather it is an acknowledgement of an important aspect of the situation in which public sculpture is actually encountered. There is in fact no branch of sculptural activity – from the great figurative monuments of the Victorian period to the site-specific works of more recent times – that is not embedded in a penumbra of related activities that clearly share some of its concerns while at the same time conforming to other, sometimes very different agendas. Where does one draw the line?

The problems are especially acute in the case of architectural sculpture. Here the range of possibilities stretches from the creation of artistically ambitious statues, many of which can be appreciated as unique works of art in their own right, to the more or less mechanical reproduction of pattern-book designs for capitals and other decorative accessories which scarcely vary from one building to the next. Yet to dismiss the latter as irrelevant to the purposes of 'real' sculpture would be to perpetuate the dubious, and now rather discredited notion that ornament is an intrinsically inferior branch of art.[1] More importantly, it would also deprive us of the opportunity to consider an entire category of work which, on examination, not only often turns out to be of great formal and imaginative interest, but which can also do much to aid our understanding of how sculptors actually went about doing their work. To put it bluntly, ornamental work is something that many sculptors *had* to do in order to earn their living, and if we divorce this from their ostensibly more creative output we run the risk of seriously misrepresenting the historical forces which determined the way the profession developed over time. What is true of architectural decoration also applies to many other tangentially sculptural forms, such as street furniture and ornamental ironwork, as well as a variety of contemporary idioms which require the skills of a modeller or carver, such as the text-based works of Ian Hamilton Finlay (see, for example, Clyde Street, below). To omit such works in a survey of this kind on the grounds that they are not truly works of sculpture would be to give at best only a partial account of the subject.

All this, however, must be weighed against the equally important matter of numbers. There are more than three hundred entries in the main catalogue, many of which are sub-divided further into several distinct components. To add to this already substantial body of work the many scores of buildings with unusual or interesting carved ornamental details would put an impossible strain on the editorial process, swelling the text to unmanageable proportions. The compromise adopted here is to present this material as an annotated list (with a separate list for coats of arms; see Appendix C), in the hope that this will enable readers to form a better idea of the larger context in which the major works were made, and to show that not even the detailed discussions presented in the main catalogue can do justice to the true wealth of sculptural work to be found in Glasgow. It should be added that for practical reasons even this list cannot be comprehensive or complete.

The reference to the work of Ian Hamilton Finlay above should also alert the reader to the fact that the word 'minor' is being used here in a wholly non-evaluative way. Certainly there are many pieces in the list below which can be described as minor in the straightforward sense that they are both small in scale and relatively modest in their artistic ambition, but this is not always so. In some cases the work is of great intrinsic importance, conforming to standards of excellence that are as rigorous as anything to be found in the entire range of historic and contemporary art. These have been excluded from the main catalogue only because they stand in a slightly oblique relation to mainstream practice, not because they are judged to be of lesser merit.

Note
[1] See, for example, two key texts on this subject by David Brett: *C.R. Mackintosh: The Poetics of Workmanship*, London, 1992, and *On Decoration*, London, 1992.

CATALOGUE

a) Secular Works

129–31 Abbotsford Place / Devon Street, former Abbotsford Primary School, *c.*1879, architects H. & D. Barclay. Four portrait roundels of 'eminent Scots', approximately life-size, in yellow sandstone by an unknown sculptor, flanking the front and rear entrances. The subjects include John Knox and David Livingstone on Devon Street, but those on the main front are worn beyond recognition. Condition: very poor.

Adelphi Street, at the junction with Commercial Road, geometric abstract sculpture in concrete by an unknown sculptor; 1.78m high. Condition: fair.

Adelphi Street, on the north-east corner of Florence Street, former Adelphi Terrace Public School (now Glasgow College of Building and Printing Annexe), 1894, by T.L. Watson. Classical building in red sandstone, with Pharaonic and Elizabethan masks and acanthus scrolls by an unknown carver in tympana. Condition: good.

646–54 Argyle Street, yellow sandstone tenement building, 1869, with a panel containing Masonic insignia on the first floor, a series of five busts set in foliage under the second-floor windows, a deer's head on the third floor and the motto of the Belsches family FULGET VIRTUS INTAMINATA (trans.: 'unspotted virtue shines bright'). Condition: masks weathered.

179 Ayr Street, Springburn Public Library and Museum, red sandstone, 1902–6 by W.B. Whitie; rich ornamental carving at entrance. Condition: good.

436–60 Ballater Street, red sandstone tenement block, 1903, built for workers in former United Co-operative Bakery on nearby McNeil Street, with Co-op emblem of hands clasped in friendship and monogram 'U Co. B S' in separate panels. Condition: good.

Bellahouston Park, House for an Art Lover, 1990–6. A modern realisation by G.D. Lodge & Partners (main consultant Andy McMillan) of Charles Rennie Mackintosh's unexecuted competition design of 1901, including a 'Tree of Life' relief panel in yellow sandstone on the south elevation, carved by Jack Kennedy. The working drawings were prepared by Graham Robinson, who creatively enlarged the 'postage stamp size illustrations' on Mackintosh's original plans. Smaller carved variations on the Tree of Life theme, combined with Mackintosh's favourite roseball motif, appear at various other points on the exterior. Condition: good.

Bell Street, red sandstone former Fruit Market by A.B. McDonald, 1907, now Merchant Square, east of junction with Candleriggs. Decorative carving includes six Bacchic keystone masks in the side arches and Athena over the entrance. Condition: good.

9–17 and 10–16 Benny Lynch Court, bronze fir-cone reliefs, 90cm × 60cm, by Liz Peden (b.1955) and Cath Keay (fl.1997–8), above doors of houses built in 1997 as part of the first phase of the Crown Street Regeneration Project in Gorbals. Species include Scots Pine, Douglas Fir, Larch and Sequoia. Condition: good.

71–7 Bothwell Street, red sandstone commercial building by Robert Ewan, 1893, with carved maritime imagery, possibly by MacGilvray & Ferris, including: bearded male mask with turban in entrance keystone; ship's prow with writhing sea monsters in pediment; prodigious quantities of fruit and flowers in gable scrolls; monogram 'GS&S' (George Smith & Sons). Condition: good.

Liz Peden and Cath Keay, *Fir Cone Relief*, Benny Lynch Court [RM]

20–2 Bridge Street, former Commercial Bank of Scotland, 1884, by Bruce & Hay, with bearded, crowned male keystone head over corner entrance, and unidentified male portrait mask over no.20. Condition: good.

63–7 Bridge Street, mid-nineteenth-century commercial building, with first floor recast in 1888 by John Gordon as Glasgow Savings Bank. Four relief panels, approximately 45cm square, between windows, are carved with scales and sword; distaff, spinning wheel and inverted cornucopia; globe and thistles; lamp, and books framed by flowers. Condition: good, but coated with off-white paint.

52 Broomfield Road, Balgray (Breeze's) Tower. 'Tudor Gothick' belvedere, built *c.*1820 by Moses McCulloch, with a series of human masks, possibly portraits, in cornices below the

battlements. There are eleven masks in all, seven on the main tower and four on the adjoining turret. Condition: fair.

Buccleuch Street, and neighbouring streets in Garnethill, 'Chookie Burdies', 1993, by Shona Kinloch. Pairs of aluminium pigeons placed on lamp-posts (over 150 in all) as part of the Garnethill Lighting Project by Page & Park. Condition: good.

Shona Kinloch, *Chookie Burdies*, Buccleuch Street [RM]

92–100 Buchanan Street / Royal Bank Place / Exchange Place, former Royal Bank of Scotland (now Borders bookshop), 1850–1 by Charles Wilson, incorporates 19 bearded male masks on lintels of first-floor windows on all three façades. Condition: poor. Above the side entrance on Royal Bank Place is a sandstone relief panel of 'Medieval Masons at Work', 40cm × 1.2m, commissioned *c.*1998 by the Incorporation of Masons of Glasgow. Condition: good.

106–12 Buchanan Street / Royal Bank Place, former Royal Insurance Company building, 1894–8, by Thomson & Sandilands. Decoration includes inscribed bronze shield, plus heraldic devices, cherub friezes and male and female masks in yellow sandstone by an unknown sculptor. Condition: good.

116–28 Buchanan Street / 41 St Vincent Place, St Vincent Chambers, 1902, by Baird & Thomson; red sandstone commercial building with relief of a rider on horseback in the gable on Buchanan Street, plus the motto of the Craig family 'VIVE DEO UT VIVAS' (trans.: 'live to God that you may live'). Condition: poor.

164a–8 Buchanan Street, Britannia Building (former Dundas House), architect John A. Campbell, 1888–9. Sculpture by unknown artist includes pair of seated griffins flanking gable and seated lion in small niche on fourth floor; much decorative work elsewhere. Condition: good.

99 Calder Street, on the façade of Calder Street Public Baths and Wash-house. Bronze inscription plaque with medallion portrait of Lord Provost Sir Daniel Macaulay Stevenson, who laid the foundation stone of the building on 3 July 1914. Sculptor not known; founders Elkington & Co. Ltd. Condition: good.

60–82 Candleriggs, colossal yellow sandstone sculpture of a bowl of fruit on south-west attic corner of City Halls, designed by John Carrick, 1886. Condition: fair.

Cathedral Square, St Mungo Museum of Religious Life and Art, 1992, by Ian Begg, has steel window grilles designed by Jack Sloan and fabricated by Hector McGarva. These incorporate imagery from the Glasgow arms (bird, bell, tree, fish), astronomical symbols (stars, crescent moon) and plant forms (thistles, holly). On the north tower there is also a

foundation stone framed by two 28cm-square sandstone panels carved with a Scottish lion and St Mungo, both painted. Condition: good.

Cathedral Square, at the north-west and south-east corners of St Mungo Museum are two identical circular bronze relief maps of Townhead, 50cm diameter on a 95cm-high steel pedestal, designed by Page & Park and cast by Powderhall Bronze. A third copy is on Macleod Street, a little to the west of St Nicholas Garden. Condition: good.

Clyde Street, on eastern piers of former (first) Caledonian Railway Bridge, inscription by Ian Hamilton Finlay, assisted by Brenda Berman and Annet Stirling, 'ALL GREATNESS / STANDS FIRM IN / THE STORM', 1990, commissioned by TWSA Four Cities Project. (Inscriptions also in Greek.) Rodger (p.30) describes the text as 'a rewording, after Heidegger, of a line from the sixth book of Plato's *Republic*', suggesting that a more accurate (and appropriate) translation would be 'all great things are precarious'. The piers are of Dalbeattie granite and were erected in 1876–8 by B.H. Blyth. Condition: good.

Coplaw Street, decorative gates by Veronica Connachie, *c.*1998, opposite Govanhill Housing Association (no.151), with cut-out footprint, shoes and boots. Condition: good.

8–12 Cranworth Street, Western Baths, 1876–81, by Clarke & Bell, with a pair of carved yellow sandstone female heads in the entrance spandrels. Condition: fair.

Dalnair Street, beside the west entrance of the Outpatients' Department of the Queen Mother's Hospital, 'Spirits of the Forest', 1991 by Gennady Viknyanski; wooden sculpture group consisting of a series of benches (one originally a see-saw) accompanied by a gnome (1.46m high), a cat, a chicken, a crocodile and a beaver. Condition: good.

Elder Park, beside Govan Road entrance, *K-13 Memorial*, 1922 by Robert Gray. Granite drinking fountain in the form of a dome-capped pillar with crown finial, commemorating the fatal sinking of the K-13 submarine in the Gareloch, 29 January 1917. Condition: good.

38 Elmbank Crescent, Quaker House. Decorative railings and sign in mild steel by John Creed, c.1996. Condition: good.

39 Elmbank Crescent, former premises of the Institute of Engineers and Shipbuilders in Scotland (now Scottish Opera Rehearsal Rooms), 1907–8, by John Bennie Wilson & Son, with decorative cartouches and trophies in Blackpasture stone by Holmes & Jackson. In the entrance hall is a marble tablet commemorating the sinking of the *Titanic*, with bronze frame capped by a pair of reclining figures by William Kellock Brown. Condition: good.

26 Florence Street, in the foyer of the Community Services Day Hospital, *Fragments*, 1992–3, wall-mounted cement reliefs cast from everyday objects by Lucy Byatt and Anne Bevan, with Hospital attenders; keys in entrance arch. (Access only during hospital opening hours, 8am to 5pm.) Condition: good.

24 George Square, former Bank of Scotland, 1874, yellow sandstone *palazzo* designed by James Sellars as an extension to J.T. Rochead's bank building next door (see 2 St Vincent Place, main catalogue). The single keystone mask in the entrance arch may be by William Mossman Junior. Condition: good.

Glasgow Green, in the centre of the north-west division, *Lord Nelson Obelisk*, 1806, sandstone, 44m high, designed by David Hamilton and built by A. Brocket. The first public monument to Nelson in the British Isles, erected at a cost of £2,075; rebuilt after being partially destroyed by lightning in August 1810. Condition: fair.

Glasgow Green, south of People's Palace, *Hugh MacDonald Fountain*, 1872, with cement profile portrait (a botched replacement of John Mossman's bronze original). Originally erected at Gleniffer Braes, Paisley, was removed to Glasgow Green in 1881 because of vandalism. Hugh MacDonald (1817–60) was a popular poet and journalist, and author of *Rambles Round Glasgow* (1910, ed. Rev. G.H. Morrison). Condition: good (fountain); poor (portrait).

Glasgow Green, on the Green, a short distance from the People's Palace, *Bailie James Martin Memorial Fountain*, 1893, designed and manufactured by Walter Macfarlane & Co. Octagonal cast-iron canopy on slender colonettes, with river scenes, inscriptions and Glasgow arms in exterior lunettes, garden birds in dome scrollwork and eagle finial. Interior fountain in the form of a squat octagonal column on cabriole legs, originally supporting a bust of Martin (removed 1974, whereabouts not known) by James Alexander Ewing. Condition: good.

61–5 Glassford Street / Wilson Street, red sandstone commercial building, erected 1908–9 by Robertson & Dobbie as a warehouse for Messrs Gordon Brothers. W.P. Gordon's monogram is on the shield on the corner, flanked by a sea monster and a griffin, and with a grotesque mask below. Two versions of the Green Man appear on the first floor, at either end of the two façades. Condition: good.

70–2 Glencairn Drive, Pollokshields Burgh Hall, red freestone, designed 1888–90 by H.E. Clifford. The building included a meeting hall for the local Freemasons (lodge 772), and the exterior has numerous panels carved with Masonic symbols and a pair of lions sejant over the entrance. Some details were recarved c.1920. Condition: good.

Gorbals Park, Gates and Bandstand, 1998, painted steel by Jack Sloan, fabricated by Hector McGarva. The gates are in the north, south, east and west entrances, and explore the theme of the four seasons, with a wild Scottish rose appearing in various stages of growth accompanied by insects active at different times of the year: dragonfly (east); bee (south); snail (west); grasshopper (north). The regeneration of Gorbals is symbolised by a Phoenix rising from flames at the apex of the suspended conical roof on the bandstand. Condition: good.

162–70 Gorbals Street, former British Linen Company Bank, 1900, by James Salmon Junior. Glasgow Style building with lively decorative carving, including cherub masks, a miniature Britannia and the royal arms in the pediment. In 1999, artist Lisa Gallacher pierced the walls and roof with a huge needle and thread to create *Sewing Machine*, a temporary artwork that won the Bulkhead Prize for experimental urban art. Condition: building derelict.

Govan Road, at the junction with Pacific Drive, Prince's Dock Hydraulic Pumping Station Chimney, 1894, by J.J. Burnet and John A. Campbell. Inspired by the Tower of the Winds in Athens, the architects have included sandstone relief panels by an unknown sculptor of the four winds, alternating with ships battling against the tempest. Condition: good.

Govan Road, at Govan Cross, *John Aitken Memorial Fountain*, 1884, painted cast iron, by Cruikshank & Co. Ltd. Delicately ornamented hexagonal canopy on slender colonettes, similar in many details to fountain on Alexandra Parade (q.v., main catalogue), including central cherub (now removed). Aitken was a much-respected local doctor. Condition: good.

801–5 Govan Road, red sandstone tenement building, 1894, with enigmatic carved cat crawling downwards from string course, and

sinister horned creature twisting back on itself in impost beside entrance. Condition: fair.

840 Govan Road, Pearce Institute, 1902–6, yellow sandstone, by Sir Robert Rowand Anderson. Carved ornaments include a dragon water-spout, a dolphin over the oriel window and a group of escutcheons, as well as a three-masted galleon made from copper by local shipyard workers on the gable. Condition: good.

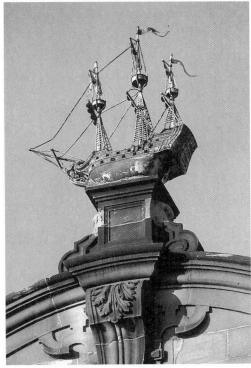

Anon., *Galleon*, 840 Govan Road

Govan Road, at entrance to Old Parish Church, War Memorial by Robert Gray, with carved soldiers' heads on the cornice. Condition: fair.

Great Western Road, 10 Lowther Terrace (Baxter House), yellow sandstone, 1904–6, by James Miller, with two profile medallions by William Vickers flanking oriel window. The medallions were originally located above the oriel, but were moved to their present position when a second storey was added in 1909. The neighbouring building at no.9, by A.G. Sydney Mitchell, has a series of Jacobean dormer heads carved with a complex (and obscure) iconography of winged cherub masks, crossed scythes entwined with shamrocks, a bunch of grapes on the vine and a group of three crowns surmounted by a five-pointed star. Condition: fair.

Highburgh Road, cast-iron drinking fountain and decorative lamp standard by Walter Macfarlane, *c*.1903, in the centre of Dowanhill Park. Only the lower stage, consisting of four bowls supported by cabriole legs, has survived, the lamp column having been removed some years ago. Condition: the bowls are currently used as planters.

252–84 High Street / 1–31 Duke Street, red sandstone tenement building, 1899–1903, by Burnet, Boston & Carruthers, built for the City Improvement Trust. Relief carving includes a rich vocabulary of floral decoration and numerous animals (see especially the lion, bird of prey, snake and sheep in the line of ground-floor keystones on Duke Street). Condition: mostly good, but the keystone animals are very worn.

High Street, in traffic island at Glasgow Cross, Tolbooth Steeple, sandstone, *c*.1625, designed by John Boyd. A seven-storey square clock-tower in the Scots Renaissance style, with balustraded crown cupola, built as part of the Tolbooth (main building redesigned by David Hamilton, 1814; demolished 1921) shortly after the Union of the Crowns. Carver work includes historically interesting strapwork on window labels on north, south and east façades, variously interwoven with crowns, thistles, roses, royal monograms (CR) and the Glasgow arms. Condition: very weathered.

Hillhead Street, set at irregular angles on the upper and middle terraces in front of student refectory, University of Glasgow, *Section Extending (Two Cast In-Situ)*, 1996, by Zeyad Dajani and Robin Lee. The work consists of two vertical concrete slabs, 2.3m × 1.9m × 40cm and 2.03m × 5.5m × 12cm, rising directly from pavement, not unlike the mysterious monolith in Stanley Kubrick's *2001: a Space Odyssey*. Funded by Blue Circle Industries plc and other construction companies, with support from SAC and GCC. Condition: good but with some graffiti.

127 Hope Street / 125–7 St Vincent Street, former Norwich Union Chambers, 1892–8, red sandstone, by John Hutcheson. There are various keystone and corbel decorations, including lion heads, amorino masks, griffins and grotesques on Hope Street, with more substantial amorini holding trumpets over the main St Vincent Street entrance. Condition: fair.

157–67 Hope Street / 169–75 West George Street, red sandstone commercial building, 1902–5, designed by John A. Campbell for the West George Street Property Co. Anonymous carving includes putti holding money-bags and writing in a ledger above main Hope Street entrance; on West George Street a mask of Fortune and a group of harpies. Condition: good. *Illustration overleaf.*

23–33 Ingram Street, former Central Fire Station, 1898–1900, designed by A.B. McDonald. Carved details in red sandstone

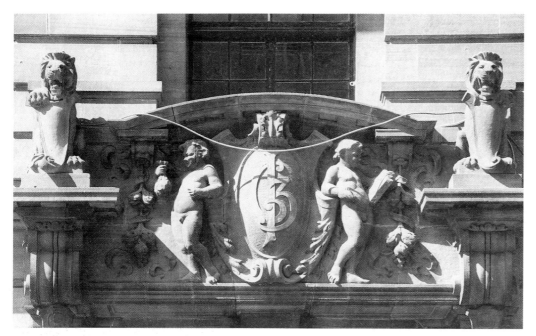

Anon., *Putti*, 157–67 Hope Street

include wreaths with firefighters' tools and helmets, masks with windswept hair and much floral work. Condition: weathered in places.

42–4 Jamaica Street / 5–9 Midland Street, MacSorley's Bar, red sandstone commercial building by George Bell II, 1898, with six portrait roundels by James Young above the second-floor windows, together with a pair of sea monsters in the pediment and much decorative scrollwork elsewhere. The carving is exceptionally fine, and the subjects are probably members of the family of the publican Philip Macsorley (*sic*) who commissioned the building. Condition: good, but with some wear on the sea monsters.

7 James Street, at the junction with Greenhead Street, former Logan and Johnstone School of Domestic Economy, 1893, by James Thomson, red sandstone. Decorative carving includes a beehive panel above ground-floor bay window. Condition: derelict.

69 James Watt Street, c.1848, possibly by John Stephen. Yellow sandstone former grain store, with relief of a keg, an anchor and three bales in the pediment, with a colossal acanthus acroterion above, both approximately 1.8m high. Condition: good.

Kelvingrove Park, a little to the east of the Stewart Memorial Fountain, large *Bear*, c.1998–9, carved by Philip Benson from a storm-damaged tree. Condition: unfinished.

2–4 Kirk Road, eighteenth-century terraced cottage, restored in 1974 by David Miller, with modern sandstone relief panels carved by his father, Keith Miller, who used his grandchildren as models. *Tree of Life*, 70cm ×

56cm, fills a former window opening on the street frontage; *Weather Vane*, 76cm × 46cm, is on the garden front and was carved from stone salvaged from the site. Condition: good.

Laurieston Road, at the south end of St Ninian's Terrace, *Welder*, wall-mounted figure fabricated from steel wire, 1996, by Andy Scott. The earliest public artwork commissioned by the Crown Street Regeneration Project as part of its comprehensive redevelopment of Gorbals. Condition: good.

517 Lawmoor Street, at the entrance to Cosmo Ceramics Ltd, 5.5m bronze copy of Michelangelo's *David* (marble, 1501–4, Accademia, Florence), by Fabio Pazzi.

Philip Benson, *Bear*, Kelvingrove Park

Keith Miller, *Tree of Life*, Kirk Road [RM]

Commissioned by Rodolfo Benacci, managing director of Cosmo Ceramics, at a cost of £80,000, the monument was intended as a contribution to the regeneration of Gorbals, and an acknowledgement of his own roots in La Spezia, a small town near the Carrara Mountains in Italy where the marble for Michelangelo's original was quarried. The work was unveiled on 26 June 2000, by Frank Macaveety, MSP, who paid tribute to the contribution the Italian community had made to the recent Gorbals 'renaissance'. The work was cast in three pieces in Pazzi's workshop in Milan, and is raised on a 6.4m steel arch. Condition: good.

(right) Fabio Pazzi, copy of Michelangelo's *David*, Lawmoor Street [RM]

Lilybank Gardens, at entrance to Geology Department building, University of Glasgow, colossal fragment of xenolithic Ballachulish granite salvaged from a demolished railway bridge, presented 1977 by Amalgamated Quarries of Stirling. Condition: good

Maitland Street, on the south façade of St Andrew's House, 48 Milton Street, oval panel with relief figure of St Andrew superimposed on a saltire, yellow sandstone, *c.*1958, by an unknown sculptor. Originally located on the St Andrew's Ambulance Association headquarters in North Street, the relief was moved to its present location in 1970 when the building was demolished. Condition: good.

1513 Maryhill Road, Burgh Halls, yellow sandstone public building in the French Renaissance style, 1876–8, by Duncan McNaughtan. Anonymous carving includes series of keystone masks on the north façade, some of which are either unfinished or extremely perfunctory in their treatment of detail. Condition: fair.

1 Maxwell Road / Pollockshaws Road, former Southern Christian Institute, 1896–7, red sandstone, by Robert Miller. Mason work by Alexander Stewart includes a panel over the entrance with an open book, a tree, a torch and a lamp. Condition: good.

McNeil Street, at various points on the pavement, group of bronze Pine Cone Bollards,

(above) Liz Peden and Cath Keay, *Pine Cone Bollard*, McNeil Street

1998, by Liz Peden (b.1955) and Cath Keay (fl.1997–8), with members of Gorbals Arts Project, cast by Powderhall Bronze. Designed as part of a traffic-calming system, the group consists of eight bollards on McNeil Street, two on McNeil Gardens and two on Turnlaw Street, each 1m high × approx. 56cm diameter. Condition: good.

53–9 Miller Street, yellow sandstone commercial building in a mixed Renaissance and Tudor style, 1874, by an unknown architect, with complex and unusual capitals and pediment decoration on the first floor and a line of rosettes on the ground floor. Condition: very worn.

61 Miller Street, yellow sandstone commercial building in the Renaissance style, 1854, by John Burnet. Over the two central second-floor windows is a Mercury mask superimposed on a horizontal caduceus, with a ribbon inscribed 'MAY' and '+' and with 'COMMERCE' below. Condition: good.

60–76 Mitchell Street / Mitchell Lane, former Glasgow Herald Building, 1894–6, by Charles Rennie Mackintosh, with carved ornamentation by James Young and McGilvray & Ferris. Details include organic window heads, possibly representing plant forms undergoing a growth cycle as they ascend, and corner shields elongated to resemble elephant trunks. Converted by Page & Park in 1999 to The Lighthouse, Scotland's Centre for Architecture and Design, incorporating exterior signage by Javier Mariscal, glass screen sculpture by Alexander Beleschenko and three-panel gates by Andy Scott which, when aligned, reveal a portrait of Margaret Macdonald Mackintosh. Condition: good.

54 Nelson Mandela Place, former Liberal Club (now Town House Hotel), red sandstone, 1907–9, by A.N. Paterson, with particularly

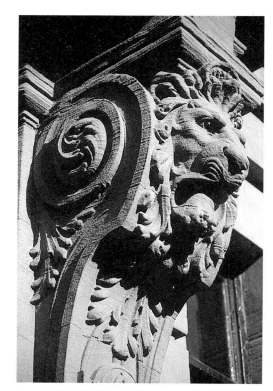

Anon., *Lion Mask*, **54 Nelson Mandela Place** [RM]

Anon., *Wheatsheaf*, **Old Dumbarton Road** [RM]

imposing lion masks by an unknown carver in corbels flanking entrance and much floral decoration elsewhere. Condition: good.

77–81 Nelson Mandela Place, yellow sandstone commercial building in the Venetian Renaissance style, 1875, by James Boucher, has a pair of winged griffins seated a either end of the second-floor balcony. Very crudely executed by an anonymous carver, they are repeated on West Nile Street frontage. Condition: fair.

206–12 Old Dumbarton Road, former Bishop

Mills building, 1839 and c.1853, architect and sculptor not known, now private flats; freestanding wheatsheaf in yellow sandstone, approx. 2m high, at the apex of each gable. Condition: good.

187 Old Rutherglen Road , former Twomax Building (now Gorbals Neighbourhood Housing Office), *Smokestack*, 1994, by Adrian Russell Lamb. Fibreglass and stainless steel rotating sculpture of a cloud of smoke on the chimney at the north end of Commercial Street frontage, approx. 3.6m long, based on an idea by designer Rita McGurn. Condition: good.

Adrian Russell Lamb, *Smokestack*, Old Rutherglen Road [RM]

71 Oxford Street, Strathclyde Police Training Centre, 1892–5, by A.B. McDonald; pink-painted *palazzo* with blindfold Justice in central keystone and pairs of *fasces* crossed with swords in outer panels. Condition: good.

Pollok Country Park, on north side of Haggs Road exit, carved wooden *Woodpecker*, 1996, by Gordon Joss, an employee of Glasgow Parks Department. This work, like the *Cormorant* in the Wildlife Garden, was carved by Joss on his own initiative. Condition: fair.

56 Prospecthill Road, former Institution for the Deaf and Dumb (now Langside College),

yellow sandstone Venetian Gothic building, 1866–8, by Salmon, Son & Ritchie. Among numerous small carved details are bat and owl corbels, a series of gargoyle drainpipe heads and a pair of fine portrait busts flanking the main entrance. Condition: good.

20 Queen Margaret Drive, BBC Scotland, designed 1869–72 as Northpark House by J.T. Rochead, yellow sandstone. Includes two male keystone heads by Stewart & Campbell in side windows of west façade and head of Michelangelo by Charles Grassby over the door. The building was extended by Charles Rennie Mackintosh in 1894–5, incorporating a further five masks by McGilvray & Ferris and an iron finial by George Adam & Son. This part of the building is now enclosed by later additions. Condition: fair.

Queen's Crescent, four-stage octagonal fountain, *c.*1870, in the centre of a private residents' park, reputedly built to cap a disused mine-shaft. The main structure is approximately 6m high, and is made of faience or sandstone, with cast-iron details, including a group of entwined dolphins on the upper stage. It was originally surmounted by a figure. Condition: dilapidated and very worn.

121 Renfield Street / Renfrew Street, Pavilion Theatre, 1902–4, by Bertie Crewe. Yellow terracotta ornamentation includes numerous panels, friezes, capitals and pediments filled with riotous combinations of cherubs, musical instruments, theatre masks and grotesques, mostly entwined in arabesques. A statue of Minerva originally stood on the pediment. Condition: good.

Renfield Street, at the north end, in front of Scottish Media Group building, William Annan Fountain, 1915, by Scott & Rae (attrib.). Grey granite drinking fountain in the form of a traditional Scots market cross (see, for example,

Mercat Cross, 1 Saltmarket, main catalogue) with unicorn finial and inscription plaque, coat of arms and lion masks in bronze. Commissioned by local business man and philanthropist William Annan, and resited (1999) from its original location on Cowcaddens Road.

71–5 Robertson Street, red sandstone commercial building, 1899–1901, designed by John A. Campbell for the tea merchants Robert Balloch & Co. On the corner with Robertson Lane is a ship's prow with a cherub and two dolphin heads; the main façade is decorated with male console masks, lion heads and a fruity cartouche. Condition: very worn and with some damage.

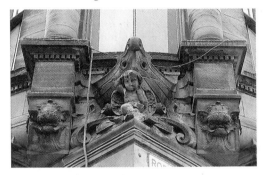

Anon., *Decorative Carving*, 71–5 Robertson Street [RM]

Royal Exchange Square, Glasgow Gallery of Modern Art (former Royal Exchange), 1827–32, by David Hamilton; particularly magnificent capitals by James Fillans, working for Hall McLatchie, on the giant Corinthian columns and pilasters on all four façades. Condition: good. In the pediment there is also a mosaic of coloured and reflective glass by Niki de Saint-Phalle (b.1930) incorporating semi-abstract interpretations of the components of the Glasgow arms (bell, fish, bird, tree and St Mungo). Commissioned in 1996 to coincide

with the opening of the Gallery of Modern Art, and measuring approximately 2.5m × 14m, it was intended by the then Director Julian Spalding to temper the severity of the building with an element of 'fun'. Condition: good.

Saltmarket, High Court of the Justiciary, 1809–14, by William Stark. Entrance balcony carries 1m × 35m inscription frieze, hand-carved on Portuguese limestone by Gary Breeze, commissioned in 1997 by Scottish Court Service through Art in Partnership. Three texts representing The Law, The Word of Man and The Word of God are drawn from the writings of David Hume and the Old Testament, each passage cut in a different lettering style. Condition: good.

147–59 Sauchiehall Street, former Photo Playhouse Cinema, 1912–13, designed by Neil C. Duff, includes a pair of putti, a garland and a bucranium on the north-west attic. The spandrels of the arch above the door were originally filled with reclining female figures. Condition: good.

901–3 Sauchiehall Street / Kelvingrove Street, yellow sandstone tenement building, 1853, by Charles Wilson, with thirteen crowned male masks under the first-floor window consoles and lion heads in scrollwork frieze. Also two pairs of royal masks at entrances of adjacent tenement, 3–9 Kelvingrove Street. Condition: fair, though some masks are very worn.

Sandiefield Road, concrete sculpture in the form of a 'French Fry', 1.73m high, in south-west corner of play park adjacent to Cumberland Street; sculptor not known. Condition: good.

225 Scotland Street, former Scotland Street Secondary School, 1904–6, by Charles Rennie Mackintosh, red sandstone. The front and rear elevations are replete with low-relief Art Deco ornament carved by McGilvray & Ferris, including interlocking flutes, zigzags, and checkerboards, often verging on neo-Egyptian. The ironwork in the gates is equally distinctive. Condition: good.

Shields Road, on the east side of Trinity Square, red sandstone entrance arch with square panels carved with biblical reliefs, Old Testament subjects on the left, New Testament right, and with a free-standing infant Jesus in a tabernacle in the centre. The arch was salvaged from Trinity United Presbyterian Church (1891, gutted by fire in 1988) and re-erected as an ornamental feature of the Trinity Square housing development c.1997. Condition: good.

48 St Andrew's Square, former Tanning Building, 1876, has a finely carved colossal bull's head keystone over the entrance. Condition: good.

St Enoch Square, in the centre of the Square, St Enoch Travel Centre, 1896, by James Miller. Dimunitive red sandstone Jacobean-cum-Baronial style subway station, converted to its present use in 1978. A wealth of finely carved details, including numerous grotesque masks, animate the exterior of one of the city's architectural gems. Condition: good.

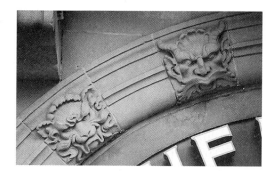

Anon., *Grotesque Masks*, St Enoch Travel Centre [RM]

38–44 St Enoch Square, yellow sandstone commercial building, c.1870, by Robert Thomson, with head of Athena wearing a plumed helmet decorated with a lion mask in the central pediment, and male and female masks in cartouches in first-floor quoin stones. Condition: good.

63–89 St George's Road / 10–28 Woodlands Road, St George's Mansions, red sandstone City Improvement Trust tenement by Burnet & Boston, 1900–2, with three pairs of winged cherubs by James Sheriff in the attic spandrels, each pair holding a shield decorated with the emblems of the arms of Glasgow (bell, tree and bird). The central clock-face is surrounded by a copper repoussé panel with two standing female figures. Condition: good.

509 St George's Road, former fire station by John Carrick, 1887, with yellow sandstone relief panels showing mirror images of a fireman's helmet, hose and axe flanking first-floor windows. Condition: good.

40 Stockwell Street / Osborne Street, Argos catalogue store. On either side of the entrance is a pair of wall-mounted sculptures, c.1992, by Andy Scott on the theme of the elements; steel plate, wire and mesh, coated with micaceous oxide paint. Both are approximately 2.8m high and depict a sea-horse riding on waves with whales below and a clock-face (without movement) and a group of stars above (Stockwell Street); Pegasus above a cloud with birds below and a globe and wind rose (mariner's compass) above (Osborne Street). Condition: the paint has begun to deteriorate, causing the steel to rust in places.

24 St Vincent Place, red sandstone Franco-Flemish commercial building, 1885–9, designed by T.L. Watson as the premises for the *Evening Citizen*. Carved details by James Hendry include a frieze of roundels separated by tiny

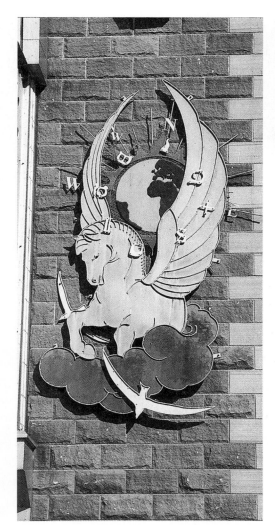

Andy Scott, *Pegasus,* **40 Stockwell Street** [RM]

James Hendry, *Decorative Lettering,* **24 St Vincent Place** [RM]

balusters, the right hand section containing the inscription 'CITIZEN OFFICE' in elaborate Celtic letters; a second-floor frieze of floral work interwoven with fantastic snarling animals; numerous arabesques and lion masks. Condition: good.

84–94 St Vincent Street, tall commercial building in Portland Stone, 1909, by John A. Campbell & A.D. Hislop; chained dolphins on cornice above the door. Condition: fair.

140–2 St Vincent Street / Hope Street, former Royal Bank Chambers, red sandstone, 1899–1900, by Burnet, Boston & Carruthers. Numerous putti and amorini by William Vickers, mostly in sill panels, supporting inscriptions, shields, etc. Those in the attic on Hope Street are larger, more deeply modelled and more energetic than the others. Condition: good.

142a-4 St Vincent Street, 'The Hatrack', 1899–1902, red sandstone commercial building in the Art Nouveau style by James Salmon Junior. Carvings by Francis Derwent Wood include goat-head keystones over the entrance arches and, on corbels on the first floor, a pair of decorative motifs consisting of a winged figure, a sunburst and a tiny aedicule, all carved with exceptional fluency. Condition: good.

7–27 Thistle Terrace, at the junctions with Cumberland Street and Alexander Crescent, corner features, 1998, by Adrian Russell Lamb and Jules Gosse, designed in collaboration with architect Neil Paterson; abstract sculptures made from fibreglass faced with copper and aluminium, combining various references to popular culture (e.g., the crown on the Statue of Liberty) with the function of a traditional architectural cupola. Condition: good.

120–36 Union Street / 41–55 Gordon Street, Ca d'Oro, 1872, by John Honeyman. The façade is mostly of cast iron, and incorporates numerous small female masks and a variety of floral ornaments. Honeyman originally intended to place standing female figures in the attic storey. Condition: good.

University of Glasgow, Organic Chemistry building, 1936–9, by T. Harold Hughes and D.S.R. Waugh, completed 1950–4 by Alexander Wright & Kay. On the south-east corner is an incised frieze depicting the origin of the species, said to have been added to mollify the professor of zoology whose view was blocked by the erection of the building. Condition: poor.

University of Glasgow, on grass bank in front of the east end of the south façade of the main building, sandstone sundial, 1.45 m high, believed to have been made by Lord Kelvin (q.v., Kelvingrove Park). Condition: very worn with broken pointers.

42 Virginia Street, three-storey High Renaissance *palazzo* designed by R.G. Melvin and William Leiper, 1866–7, for the Glasgow Gas-light Company; the colossal canopy over the entrance has a pair of crowned male heads with large moustaches in the acanthus brackets and a female keystone mask over the door. Condition: good; painted off-white.

74 Waterloo Street / Blythswood Street, Fortune House, 1925–7, by J. Taylor Thomson; animal masks in yellow sandstone by Phyllis Bone in the cornice, including a lion, an owl and a ram. Condition: good.

40–60 Wellington Street / 3 Cadogan Street, Baltic Chambers, commercial building in Locharbriggs sandstone, 1897–1900, by Duncan McNaughtan, with ornamental details by William Vickers. These include broken pediments filled with ships' prows, a ship in full sail in the entrance keystone, a series of grotesque sea monsters in the ground floor capitals and much lively decorative work elsewhere. Condition: fair.

21 West George Street, Royal Bank of Scotland, includes a yellow sandstone cat by Callum Sinclair, added during alterations made in 1990 to conceal misalignment of stone courses. The cat is at the end of the pediment over the main entrance, and playfully stretches its paw down to a stone ball. Condition: good.

92–8 West George Street, James Miller House (former Commercial Bank), 1930–7, by James Miller. The building is of Portland stone and has Art Deco details carved by Gilbert Bayes, including neo-Egyptian capitals, corner panels with stylized cornucopias and cast-iron abstract in-fill panels. Condition: good.

112–14 West George Street / 46–50 Renfield Street, yellow sandstone commercial building in the Venetian Renaissance style by David Bryce, designed 1868–71 for the Scottish Widows Fund Assurance Society and the Junior Conservative Club, with eight keystone masks by Charles Grassby in the ground-floor windows. The masks are all stern bearded males, almost identical in design, but with some variations in the headgear which includes crowns and maritime imagery. Six masks on the Renfield Street frontage were lost when the building was altered in the late 1950s. Condition: fair.

163 Wilton Street, group of eight fibreglass lion masks and fasces, 1995, by Edward Taylor; masks 60cm diameter; fasces 1.2m high. The building dates from the 1860s and is thought to be by Charles Wilson. Condition: good.

164 Woodlands Road / West End Park Street, pair of carved cats in yellow sandstone, c.1988, by Hugh Pritchard (Stonemason) Ltd. The cats are approx. 55cm high and are seated on the cornice of the corner tower at second-floor level. Condition: good.

74 York Street, red sandstone warehouse, c.1910, by Neil C. Duff, with extensive decorative scheme by an unknown sculptor. Details include heraldic devices, corbel masks with swags emerging from their mouths, nautical and maritime panels, cornucopias, griffins and the Glasgow arms. Of particular interest is the small but finely modelled Egyptian keystone head in bronze above the main door. Condition: good.

b) The Necropolis

Esther Ritchie Cooper of Ballindalloch Monument, Grecian structure in sandstone, c.1851, with life-size angels by John Mossman. Condition: good. Signed, lower right plinth: 'MOSSMAN'. Location: beta. (For location terminology, see Necropolis, *Introduction*, main catalogue.)

Aitken of Dalmoak Mausoleum, large Graeco-Roman building designed by James Hamilton, 1875, with colossal angel dividing central bays and wings filling spandrels; sculptor not known. Condition: the head is missing. Location: gamma.

John Graham Gilbert Monument, marble portrait medallion by Wiliam Brodie, n.d. Gilbert was a distinguished portrait painter and member of the RSA, but is better known today as a collector of Old Master paintings (including works by Rembrandt and Rubens), many of which he bequeathed to GAGM. He was also a co-founder of the RGIFA. Condition: very worn. Location: delta.

Mrs Lockhart Memorial, elaborate sandstone tabernacle in the Gothic style, 1842, designed by the subject's brother, with carvings by J. & G. Mossman. Condition: very poor. Location: delta.

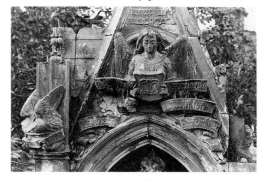

J. & G. Mossman, *Mrs Lockhart Memorial* (detail), Necropolis [RM]

Duncan Turner Monument, bronze portrait medallion of a Glasgow merchant by John Mossman, c.1878. Signed on the neck: 'J. MOSSMAN. sc./1878'. Condition: good. Location: delta.

John McDonald Monument, Celtic cross, c.1857, attributed to J. & G. Mossman, with reliefs of the Ascension, the Assumption of the

Virgin and the Evangelists in the arms, with much zoomorphic imagery and knotwork elsewhere. Condition: good. Location: epsilon.

Thomas Andrew Miller Monument, bronze panel in a granite stele, *c.*1922, by William Kellock Brown, depicting an angel beckoning a semi-naked figure seated in a cloister with an open book in his lap. The composition is reminiscent both of Renaissance representations of the Annunciation, and of medieval images of the Evangelists writing in their studies, though in this case the seated figure appears to be pointing in the same direction as the angel, rather than writing. The angel is modelled almost in the round. Signed at the bottom edge of the panel: 'KELLOCK BROWN RSS'. Condition: good, but very stained. Location: epsilon.

Peter Stewart Monument, bronze panel (1.33m × 7.4m), modelled by James Pittendrich MacGillivray in 1887, combining a three-quarter profile of the deceased with an allegorical representation of a Greek classical figure placing a laurel branch on a sarcophagus. Signed in cursive script at the bottom of the panel: 'J.P. Macgillivray Sc 1889'. Condition: good. Location: epsilon.

John Henry Alexander Monument, elaborate cylindrical structure with *trompe l'oeil* curtained proscenium, niche figures representing Comedy and Tragedy, portrait medallion, cherubs and numerous theatrical allusions. Designed in 1851 by James Hamilton to commemorate the actor-manager John Henry Alexander, the proprietor of the Theatre Royal, Dunlop Street (q.v., Appendix A, Lost Works), with sculpture by Alexander Handyside Ritchie, who was awarded the commission after the death of James Fillans, the architect's first choice. Condition: fair, but the figure of Tragedy is missing. Location: omega.

Pastor William Black Memorial, sandstone sarcophagus with reliefs in side panels and marble effigy on the lid, *c.*1851, designed by J.T. Emmet and carved by John Mossman. The subjects of the reliefs are the Entombment (north), the Resurrection (south), 'Noli Me Tangere' (west) and Christ on the Road to Emmaus (east). This is the remnant of a much larger structure, which originally included a tall Gothic canopy decorated with numerous reliefs. Condition: very worn. Location: omega.

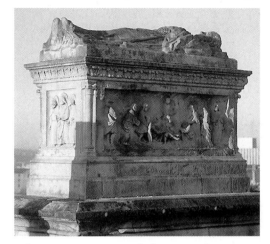

John Mossman, *Pastor Black Memorial*, Necropolis [RM]

Duncan Macfarlan Monument, bronze profile portrait by William Brodie, *c.*1860, attached without a surrounding medallion to a Binny stone tower designed by J.A. Bell. Condition: good. Location: omega.

Margaret McNee Monument, bronze relief panel, *c.*1847, by an unknown sculptor, showing a Grecian female figure crouched in mourning. The deceased was the wife of the painter Daniel McNee, RSA. Condition: good. Location: omega.

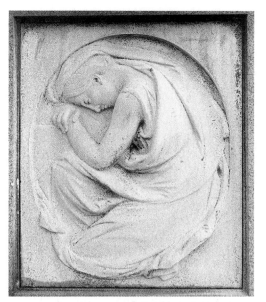

Anon., *Margaret McNee Monument* (detail), Necropolis [RM]

Dugald Moore Monument, colossal marble portrait bust, *c.*1841, by James Fillans, of a distinguished poet and bookseller. Condition: fair. Location: omega.

George Mason Monument, bronze portrait panel, *c.*1901, by Archibald Macfarlane Shannan, set in a red sandstone Mannerist aedicule. Signed, bottom right, 'A. McF. SHANNAN, ARSA / SCULPTOR'. Condition: good. Location: quartus. *Illustrated overleaf.*

David Miller Monument, colossal (almost twice life-size) portrait bust in marble, *c.*1862, by George Edwin Ewing on a monumental Greek pedestal. Condition: very worn. Location: quartus.

Thomas Gildard Monument, bronze portrait panel, 1896, by William Shirreffs set within an aedicule of Peterhead granite. Gildard was an

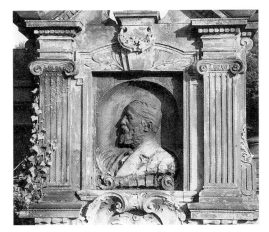

Archibald Macfarlane Shannan, *George Mason,*
Necropolis [RM]

important architect and commentator, whose
memoir of John Mossman is a key source of
information on the sculptor's life and work.
The memorial was designed by his nephew R.J.
Gildard, and constructed by Peter Smith.
Condition: good (panel); surrounding
stonework badly damaged. Location: sextus.

James Jamieson Monument, seated female
mourner in marble, *c.*1861, by George Edwin
Ewing. Signed on the front right of the base:
'G.E. EWING, / SCULPTOR / GLASGOW'. Condition:
worn and damaged. Location: sigma.

Rev. Ralph Wardlaw Memorial, colossal marble
portrait bust, 1853, by John Mossman.
Condition: fair. Location: sigma.

Alexander McCall Monument, fibreglass replica
of a bronze portrait and inscription plaque,
*c.*1888, by James Pittendrigh MacGillivray, set
in a granite cross designed by Charles Rennie
Mackintosh and constructed by Peter Smith.
The monument is signed, bottom right, by
Peter Smith, and the panel carries
MacGillivray's Greek palmette device.
Condition: good. Location: theta.

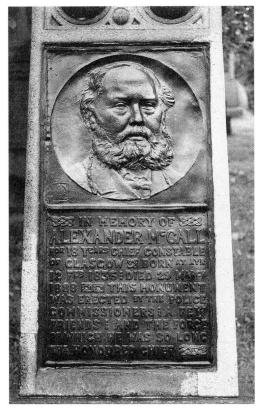

James Pittendrigh Macgillivray, *Alexander
McCall,* **Necropolis** [RM]

Alexander McKenzie Tomb, cast-iron structure,
*c.*1875, by George Smith & Co., in the form of a
Gothic reliquary with half-length angels holding
crowns in the gables of all four sides. Signed,
bottom right: 'GEO. SMITH & CO. / PATENT / SUN
FOUNDRY / GLASGOW'. Condition: extremely
rusty overall, with some advanced deterioration
in the main fabric. Location: upsilon.

Sheridan Knowles Monument, sandstone
sarcophagus, 1866, with corner pilasters incorp-
orating portraits by John Mossman of characters
from the playwright's works. Signed on the

front right of the base: 'MOSSMAN'. Condition:
very worn and damaged. Location: zeta.

Walter Macfarlane Tomb, rectangular bronze
panel, 1896, modelled by Bertram MacKennal
and cast by Hollinshead & Burton, with a
portrait of the proprietor of the renowned
Saracen Foundry (see Biographies). Under the
portrait is a miniature sarcophagus, its front
face decorated with a relief of a female figure
pouring water from a vase into the sea, and with
a pair of female masks enclosed by clusters of
birds' wings supporting it from below. Signed
in cursive script in the lower panel: 'Bertram
MacKennal / London 1896'; the founder's mark
is in the bottom right corner. Condition: good.
Location: zeta.

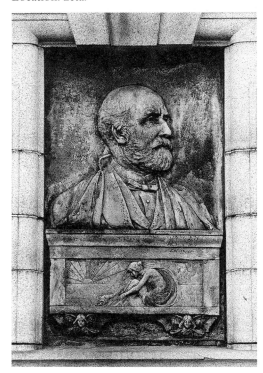

Bertram MacKennal, *Walter Macfarlane,*
Necropolis [RM]

APPENDIX C *Coats of Arms*

INTRODUCTION

In the context of this survey, coats of arms present the same difficulties as the minor works listed in Appendix B. On the one hand, they are too commonplace (and too repetitive) to justify full descriptive entries, and have only been included in the main catalogue when they appear as part of a larger architectural programme. On the other hand, even when they exist in isolation they are much too interesting to be omitted altogether. Not only were many coats of arms produced by sculptors of note, but in several cases the standard of the modelling and carving is as high as anything to be found in the major figurative schemes. More important than any individual example, however, is the collective role coats of arms have played in determining the appearance of the city. Their very ubiquity testifies to the degree of significance attached to them by architects and sculptors in their attempts to articulate the city's unique historical identity. Paradoxically, it is the fact that they *are* so commonplace, that confirms their relevance to this study. The only practical solution to this dilemma is to present the information in the form of an annotated list of the more significant examples, which will hopefully prove useful as a starting point for those who wish to explore this aspect of the city's sculpture in the depth it properly deserves.

The study of heraldry constitutes a distinct branch of scholarship, and is supported by a substantial body of specialist literature, much of it extremely erudite. No attempt is made here to enter into a detailed discussion of the forms and iconography of heraldic devices, but it may be helpful to preface the list with a few general remarks about the rules and language of blazonry, together with a brief analysis of the three principal examples to be found in Glasgow.

The main component of a coat of arms is the *shield* or *escutcheon*, upon which the various designs, or *charges*, are inscribed. Among the different areas of the shield are the *fess* (the centre), the *chief* (the upper division) and the *base*, each of which divides vertically into the *dexter*, or left, side (i.e., the right side from the point of view of the bearer of the shield) and the *sinister* side. All other components of the design are referred to as *accessories*, the main elements of which are as follows: the *helmet*, directly above the shield; the *crest*, a decorative device above the helmet; the *supporters* (in Scotland sometimes *bearers*), usually a pair of animals or human figures on either side of the shield; the *motto* or *mottoes*, consisting of brief texts, usually, though not always, in Latin, inscribed on a ribbon-like *escrol* (sometimes *escroll*) above the crest and/or below the shield. A number of specialist terms are also used to describe the precise postures in which heraldic animals are presented, the most common of which are: *couchant*, lying down; *sejant*, sitting upright with forelegs raised; *passant*, walking; *rampant*, raised on hind legs; *rampant guardant*, the same with face turned towards the viewer; *reguardant*, looking back; *affrontée*, facing forward. Various parts of the arms are often coloured, or *tinctured*, and among the most common terms used to indicate colour are *or* (gold), *argent* (silver), *vert* (green) and *proper* (coloured naturally). In combination, the shield and accessories are referred to as the *achievement*, and in Scotland the adoption of an achievement by an individual, family, city or institution must be officially approved by the Lyon Court, under the jurisdiction of the Lord Lyon King at Arms.[1]

In Glasgow, the three most frequently used coats of arms are the following:

The arms of the city of Glasgow. This derives from episcopal seals in use in Glasgow since 1270.[2] However, it was not until 1866 that the Corporation of Glasgow applied to the Lord Lyon to have the design officially ratified, or 'fixed', as the official symbol of the city. It is described in the Lord Lyon's patent as follows:

> Argent, on a Mount in base vert an Oak Tree proper, the stem at the base thereof surmounted by a Salmon on its back also proper, with a Signet Ring in its mouth, Or; on the top of the tree a Red-breast, and in the sinister fess point an ancient Hand Bell, both also proper; above the Shield is placed a suitable Helmet, with a Mantling Gules [red] doubled Argent, and, issuing out of a Wreath of the proper Liveries, is set for Crest the half-length figure of St. Kentigern affrontée, vested and mitred, his right hand raised in the act of benediction, and having in his left hand a Crozier, all proper; in a compartment below the Shield are placed for Supporters Two Salmon proper, each holding in its mouth a Signet Ring, Or; and in an Escrol entwined with the compartment this Motto, 'Let Glasgow Flourish.'[3]

The elements of the design are associated with the legend of St Kentigern (also known as St Mungo), the founder of the sixth-century ecclesiastical community which was later to grow into the city of Glasgow. The tree is probably an oblique reference to the hazel branch with which he magically rekindled a fire to light the church at night; the robin is the bird he miraculously brought back to life; the salmon is the fish which swallowed the ring of the Queen of Strathclyde, and which he recovered from the River Clyde. The bell is thought to be an example of the 'curious quadrangular type common to those which

figure among Celtic ecclesiastical antiquities', and which Kentigern may have hung from an oak tree on the banks of the Molendinar burn as a makeshift belfry in the early days of his ministry.[4] A more familiar version of the legend is enshrined in the popular Glasgow rhyme:

This is the bird that never flew,
This is the tree that never grew,
This is the bell that never rang,
This is the fish that never swam.

It should also be noted that the motto on the arms is an abbreviation of the prayer 'Lord, let Glasgow flourish by the preaching of Thy Word and praising of Thy Name', reputedly St Mungo's last words.[5]

The royal arms of Britain. As officially used in Scotland, this derives from a woodcut of 1541.[6] The shield is quartered, with the divisions charged with the symbols of the King of England (three leopards) and Scotland (lion rampant) and the harp of Ireland. The helmet is that of a sovereign (full-face, with six vertical bars), and the crest consists of an imperial crown (decorated with crosses and fleurs-de-lis) surmounted by a lion sejant affrontée holding a sceptre and a sword in its paws. The supporters are a lion rampant guardant (sinister) and a unicorn rampant, both crowned, holding the standards of England (cross of St George) and Scotland (saltire), and the motto IN DEFENCE (sometimes IN DEFENS; possibly a contraction of 'In my defence God me defend') is invariably

placed above the crest. The accessories are usually liberally decorated with thistles.

Arms of the King of Scotland. This is very similar to the royal arms of Britain, but is not to be confused with it.[7] The shield is occupied entirely by a lion rampant and the supporters are both unicorns, which in Scotland have the body of a horse, the legs of a stag, the horn of a narwhal and the tail of a lion. These are often crowned and the standards they bear are the saltire and the Scottish lion. Below the shield is the additional motto: NEMO ME IMPUNE LACESSIT (trans.: 'No-one provokes me with impunity'). This was incorporated into the arms by Charles II and is associated with the Order of the Thistle.[8] An idiomatic rendering of it is found in the popular Scottish proverb: 'Ye maunna' tramp on the Scots thistle, laddie'.

More local or specialised coats of arms (such as Govan, the University of Glasgow, etc.) are described in their appropriate entries below.

Notes
[1] Chambers Encyclopædia, vol.5, pp.658–9.
[2] Andrew Macgeorge, *An Inquiry as to The Armorial Insignia of the City of Glasgow*, Glasgow, 1866, pp.18ff. [3] *Ibid.*, pp.187–8. [4] John Marquess of Bute, K.T., J.R.N. Macphail and H.W. Lonsdale, *The Arms of the Royal and Parliamentary Burghs of Scotland*, Edinburgh, 1897, pp.162–5. [5] *Ibid.*, p.165. [6] William M'Millan, *Scottish Symbols: royal, national, & ecclesiastical their history and heraldic significance*, Pailsey, n.d. (1916), p.174. See also illustration, p.150. [7] See illustration, *ibid.*, p.180. [8] *Ibid.*, p.183.

CATALOGUE

Argyle Street / Bunhouse Road / Blantyre Street, Kelvin Hall, 1926–7, red sandstone, by Thomas Somers. Glasgow arms in attic above main enrance; St Mungo's crozier in bronze. Condition: good.

46 Bath Street, Tara House, 1850, by John Baird II, with doorpiece added 1904 by A.B. McDonald. Includes Glasgow arms in yellow sandstone above door, and separate panels of birds and bells in architrave and reliefs of St Mungo in consoles. Condition: good.

56–68 Bell Street, yellow sandstone City Improvement Trust tenement by A.B. McDonald, 1895–6; Glasgow arms in gable. Condition: poor.

40 Bridgeton Cross / Landressy Street, former Glasgow Savings Bank, 1894, red sandstone, by D.B. Dobson; royal arms of Scotland on the second storey. Condition: good.

656 Cathcart Road / Dixon Avenue, Dixon Halls, 1878–9, yellow sandstone, by Frank Stirrat. Unidentified coat of arms above entrance; also various heraldic lions, female keystone masks and five substantial female medallion heads in tympana over windows. Condition: good.

298–306 Clyde Street, former Custom House (now Procurator Fiscal's office), yellow sandstone, designed in 1840 by George Ledwell Taylor; free-standing royal arms of Britain on the attic. Shortly after the completion of the building, a correspondent in the *Glasgow Gazette* noted that

… some years ago, when the miserable, puny coat of arms was set upon the roof of the Custom House, some wag or other in those days got upon the roof and stuck a tobacco

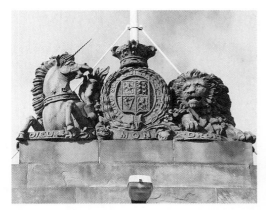

Anon., *Royal Arms of Britain,* **298–306 Clyde Street** [GN]

pipe in the mouth of the would-be rampant lion. This excited such roars of laughter, and turned the whole thing into such derision, that the Lords of the Treasury were soon after graciously pleased to order a new coat of arms on a more exalted scale to be placed over the Custom House.[1]

It is not known if the replacement was carried out, or if present sculpture is the original. Condition: fair.

29 College Street, former telephone exchange, yellow sandstone, *c.*1922; royal arms of Britain, approx. 2m high, above the main entrance. Condition: good.

305 Dumbarton Road, Partick Library, 1925, yellow sandstone building in the Renaissance style, designed by the Office of Public Works and built by the Scottish Building Guild; Glasgow arms on each corner of the main bay window; also a pair of lion masks on stringcourse of the rear extension. Condition: good.

Elder Park, Elder (former Free) Library, 1903 by J.J. Burnet; Govan arms by Holmes & Jackson over main entrance. Derived from the

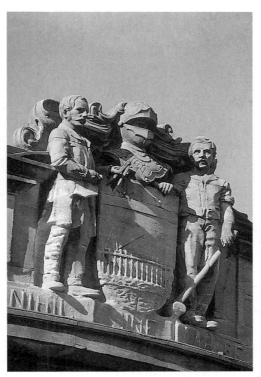

Holmes & Jackson, *Govan Arms,* **Elder Library**

arms of Mrs Rowan of Holmfauldhead, the Govan arms consists of a shield charged with a ship on the stocks, with a carpenter and an engineer for supporters; the crest is a salmon crossed with a stook of corn. Condition: good.

1–7 George Square, former General Post Office, yellow sandstone Italianate building erected in three stages between 1875 and 1916 by various architects from HM Office of Public Works. The royal arms of Britain in the attic replaced the one carved by Alexander McGaw for the original Post Office building of 1856 (see George Square, Appendix A, Lost Works). Condition: fair.

99 Glassford Street, Italianate bank building of 1866 by John Burnet, remodelled 1894 by J.J. Burnet, includes royal arms of Britain above entrance, with a sailing ship and a beehive in panels on the second floor. Condition: arms a little worn.

705–7 Govan Road / Broomloan Road, former Glasgow (now Trustee) Savings Bank, 1906, by E.A. Sutherland; a large royal arms of Britain in red sandstone by Richard Ferris on each façade. Condition: good.

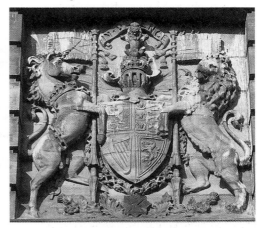

Richard Ferris, *Royal Arms of Britain,* **705–7 Govan Road** [GN]

115–29 High Street, red sandstone tenement block, 1898–1900, by A.B. McDonald; Glasgow arms enclosed by elaborate ribbon work in central gable. Condition: good.

235–87 High Street / 6 George Street, red sandstone City Improvement Trust tenement, 1899–1901, by Burnet, Boston & Carruthers. Carved decorations repeat many of the details on the same architects' tenement opposite (see 252–84 High Street, Appendix B, Minor Works), with the addition of a Glasgow arms beside the corner turret. Condition: good.

Appendix C: Coats of Arms 463

307–35 Hope Street / 91 Cowcaddens Road, red sandstone tenement, 1906–8, built by Honeyman, Keppie & Mackintosh for the City Improvement Department (formerly Trust); includes four colossal examples of the Glasgow arms by Holmes & Jackson. Condition: good.

41–5 James Watt Street, former tobacco warehouse, built in 1854 by John Baird I, reconstructed 1911; royal arms of Britain in yellow sandstone by John Mossman above pediment. Condition: very worn and damaged.

Jocelyn Square, 1997 extension to High Court of the Justiciary by TPS Consult; yellow sandstone royal arms of Britain by Stirling Stone. (See also Saltmarket, Appendix B, Minor Works.) Condition: good.

Killermont Street / Buchanan Street, Glasgow Royal Concert Hall, 1990, by Sir Leslie Martin & Partners. Glasgow arms in fibreglass moulded from wooden originals by M.W. Stephens, Heraldic Woodcarvers, of Blairgowrie; two copies, each 3m high, attached to north and south walls. Condition: good.

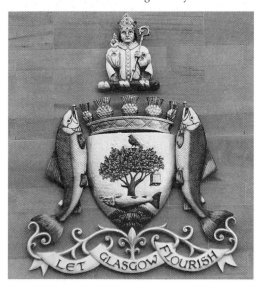

M.W. Stephens, *Glasgow Arms*, Killermont Street [RM]

30 Leslie Street / Kenmure Street, Pollokshields Library, 1905–7, red sandstone, by Thomas Gilmore. Glasgow arms above the main (Leslie Street) entrance; also pairs of cherubs in decorative inscription panels on both façades and numerous blind cartouches. Condition: good.

McAlpine Street, former Marine Police Office, 1882, yellow sandstone, by John Carrick; painted Glasgow arms over entrance, with a fasces and a sword entwined with a serpent in separate panels flanking the central window on the second floor. Condition: poor.

Old Rutherglen Road, at the junction with Lauriston Road, free interpretation of the Glasgow arms in steel wire, 1996, by Andy Scott, surrounded by topographical references to Glasgow and images of contemporary workers. Commissioned by Crown Street Regeneration Project. Condition: good, but with some letters missing from the motto.

1110 Pollokshaws Road / 4 Moss-side Road, Trustee Savings Bank, 1905–6, by Neil C. Duff; masons, George Barlas & Co. Red sandstone royal arms of Britain in pediment over main entrance, with medallions of Saints George and Andrew below. Condition: good.

91 Port Dundas Road, Strathclyde Fire Brigade Command Headquarters, 1984. Glasgow arms in painted sandstone, approx. 1.7m × 2.1m, and set in a decorative brick surround on the grass in front of the entrance. Condition: good.

69–71 Queen Street, red sandstone warehouse, 1899–1907, designed by George S. Kenneth for the merchant Charles Buchanan. Above the second-floor windows is the Buchanan arms: a

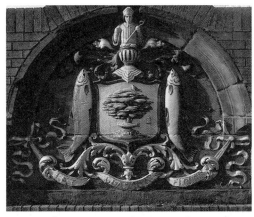

Anon., *Glasgow Arms*, 91 Port Dundas Road [RM]

lion rampant with shield; crest: a dexter hand holding a ducal cap, tufted on top with a rose enclosed by laurel branches; supporters: two falcons, armed, jessed and belled. Inscribed above and below are the Buchanan mottoes: AUDACES JUVO (trans.: 'I assist the bold'); CLARIOR HINC HONOS ('hence the brighter honour'). Buchanan's monogram is on the third floor. Condition: fair. (See also 69 Queen Street, main catalogue.)

74–98 Saltmarket, yellow sandstone tenement, 1895, built by A.B. McDonald for the City Improvement Trust. Glasgow arms below chimney-stack; rose, thistle and shamrock(?) acroteria on gables. Condition: fair.

137–47 Sauchiehall Street, red sandstone commercial building, 1903–6, by Honeyman, Keppie & Mackintosh; royal arms of Britain by William Kellock Brown in the pediment above the central first-floor window, with sovereign's helmets above the adjacent windows. Condition: good.

43 Shamrock Street / West Graham Street, Stow College, 1929–32, by Whyte & Galloway;

Glasgow arms in yellow sandstone over main entrance. Condition: good.

Springburn Road / 7 Keppochhill Road, former fire station, *c*.1893, in yellow sandstone; large Glasgow arms in gable. Condition: good.

1 St Andrew's Square, St Andrew's Parish Church, 1739–56, yellow sandstone, designed by Allan Dreghorn and built by Mungo Naismith; the Glasgow arms in the pediment may have been carved by David Cation or Naismith himself. Condition: worn.

Anon., *Glasgow Arms*, **St Andrew's Parish Church** [GN]

47 St Vincent Street / 131–7 Buchanan Street, former National Bank Chambers, 1898–1900, by John Dick Peddie; a particularly magnificent example of the royal arms of Scotland, believed by some to be by Albert Hodge, is above the entrance on St Vincent Street. Condition: good.

124 St Vincent Street, former Edinburgh Life Assurance Company building, 1904–6, yellow sandstone, by John A. Campbell. The arms of Glasgow and Edinburgh (maiden and unicorn flanking a triple-towered castle with anchor; motto: NISI DOMINUS FRUSTRA, trans.: 'Except the Lord [keep the city, the watchman waketh

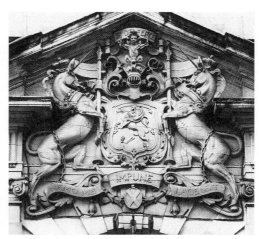

Albert Hemstock Hodge(?), *Royal Arms of Scotland*, **47 St Vincent Street** [RM]

but] in vain') by H.H. Martyn & Co. are in large shields over the entrance, with a relief of a castle in the keystone. Nameplates by the Bromsgrove Guild. Condition: good.

145 St Vincent Street, red sandstone commercial building, 1931–2, by Burnet & Boston. Large unidentified coat of arms, possibly painted metal, above entrance, the shield including: a pair of castles flanking a crown in the fess; wings in the base and three birds in flight in the chief; motto: PER CURAM PLACEBIMUS (trans.: 'Through our care we will please you'). The red granite entrance piers are carved with griffins (passant). Condition: good.

1 Stanley Street / Paisley Road West, royal arms of Britain, approximately 1.8m high, in painted stone on the cornice between the first-floor corner windows. Condition: fair, but with flaking paint.

143–55 Stockwell Street / 138 Bridgegate, red sandstone tenement, 1905, built by A.B. McDonald for the City Improvement

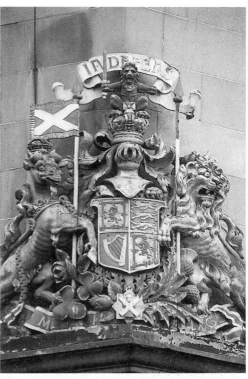

Anon., *Royal Arms of Britain*, **1 Stanley Street** [RM]

Department; Glasgow arms in aedicule rising from central gable. Condition: good.

92 Tobago Street, former Eastern District Police Buildings, 1868–9, yellow sandstone, by John Carrick; Glasgow arms over the entrance. Condition: good.

5–39 Trongate / 2–6 Saltmarket / 5 Chisolm Street, yellow sandstone tenement, 1889–1900, built by A.B. McDonald for the City Improvement Trust; Glasgow arms in central attic window. Condition: good.

62–80 Trongate / Albion Street, yellow

sandstone commercial building, designed 1855 by J.T. Rochead for the City of Glasgow Bank. Unidentified armorial device on the Trongate gable. Condition: fair.

73 Trongate, two-storey commercial building, 1857–8, in the Flemish style by John Carrick; painted Glasgow arms in gable. Condition: good.

79–89 Trongate / 5–11 King Street, hybrid Flemish and Scots Baronial tenement in yellow sandstone, built 1896 by A.B. McDonald for the City Improvement Trust; Glasgow arms in crow-step gables of both façades. Other carver work includes thistle acroteria, a gable relief with a ribbon flowing from the mouth of a grotesque male mask and a seated lion on the corner gable. Condition: fair.

97 – 101 Trongate / King Street, former warehouse, 1849, designed by J.T. Rochead for the Buchanan Society. Painted Glasgow arms enclosed by inverted cornucopias on the corner attic. Condition: fair.

103 Trongate, Dutch-style former warehouse in red sandstone, 1901–2, by J.T. Rochead; Glasgow arms in gable. Condition: good.

University of Glasgow. Coats of arms and related armorial devices are used extensively on the buildings of the Gilmorehill campus and form an integral part of the University's historical identity. In addition to the Glasgow and royal arms, there are also some carved examples of the University's own coat of arms, which appears in two versions, both based on seals introduced in the mid-fifteenth century. Stevenson and Wood provide descriptions of seven variants on the design, of which the third and sixth are probably derived from the seal of the Arts Faculty of 1455 and the 'common seal' of 1453 respectively:

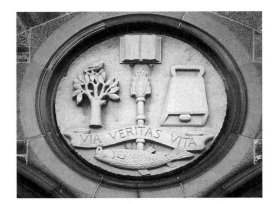

Anon., *Arms of the Faculty of Arts, University of Glasgow* [RM]

Third Seal. A crowned mace in pale [vertical], with an open book above it, and over that an escroll bearing the motto VIA VERITAS VITA [trans.: 'the way, the truth and the light'], beneath a salmon, embowed [curved] on its back to sinister with ring, on dexter flank a tree with bird perched on topmost bough, on sinister flank a hand bell.

Sixth Seal. Under a triple canopy the figure of a bishop standing on a bracket in rich vestments, with mitre and nimbus, his right hand raised in benediction, his left holding a crozier. On dexter a hand holding up an open book and on the sinister a salmon hauriant [in pale with head uppermost as if rising for air], with ring.[2]

Working westwards from Pearce Lodge (q.v., main catalogue, University Avenue) the most notable examples of sculpted arms are on the following buildings:

1. *Engineering Building*, 1901, by John James Burnet and J. Oldrid Scott; large royal arms of Britain in yellow sandstone in the east gable. Condition: good. Also University arms (common seal version) on arch adjoining Pearce Lodge. Condition: very worn.

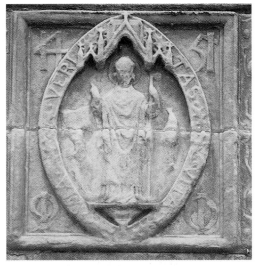

Anon., *Common Seal, University of Glasgow* [RM]

2. *Main Building*, 1864–70, Sir George Gilbert Scott; at the entrance in the south façade, two roundels, approx. 90cm diameter flanking the arch and one, approx. 1.5m diameter above, all yellow sandstone and not carved until the 1950s. The lower left roundel is inscribed 1451 and has a bull on the shield with a bishop's mitre as a crest (the reference is to Bishop Turnbull, the founder of the University in 1451); the right roundel has a shield charged with three shells and is dated 1870, while the upper has the arms of the Faculty of Arts. Condition: good.

3. Above the entrance to the Bute Hall, large royal arms of Britain in polychrome high relief. Condition: good.

4. *Main Gates* (east of John McIntyre Building, q.v., main catalogue, University Avenue), 1951–2, designed by A. Graham Henderson, with yellow sandstone pillars built by Thaw & Campbell and wrought-iron work by Thomas

Hadden, Edinburgh. The gates incorporate names of outstanding historical figures associated with the University, with the 'meeting styles' modelled in the form of the University's mace. The University motto, together with a lion rampant and a saltire are carved in relief on the pillars, which are in turn surmounted by a free-standing lion and unicorn modelled by Charles d'Orville Pilkington Jackson (1887–1973) and fabricated by Charles Henshaw & Sons, Edinburgh. Condition: good.

5. *Reading Room*, 1939–40, by T. Harold Hughes and D.S.R. Waugh; yellow sandstone arms of the Faculty of Arts above entrance arch. Condition: good.

6. *Main Entrance* (west of John McIntyre Building), date and architect not known; arms of the Faculty of Arts in yellow sandstone in centre of the arch. Condition: fair. Common seal on inner face. Condition: very worn.

7. *Bower Building* (Department of Botany), 1903–7, by James Miller; yellow sandstone arms of the Faculty of Arts above entrance. Condition: good.

8. *Kelvin Building* (Natural Philosophy), 1906, by James Miller; yellow sandstone arms of the

Faculty of Arts above first-floor windows. Condition: good. Beside the entrance to the north extension, 1947–52, by Basil Spence & Partners, is a yellow sandstone roundel carved with a snake biting its tail enclosing a six-pointed star in a triangle. Condition: good.

Vulcan Street, Kenmuir Lodge No.570, two-storey Masonic building in red sandstone; Glasgow arms superimposed with Masonic symbols in escutcheon enclosed by thistles over door. Architect and carver not known. Condition: fair; partly painted.

50 Waterloo Street / 36–48 Wellington Street / 54 West Campbell Street, former GPO parcels office, 1903–5, yellow Northumberland freestone, by W.T. Oldrieve. Carver work by Holmes & Jackson, including the royal arms of Britain over Wellington Street entrance and lion masks in Diocletian windows on all three façades. Condition: good.

79 West Regent Street, mid-century office block, redesigned 1903–4 by James Salmon Junior, with beaten copper panels on the oriel windows incorporating Glasgow Style interpretations of the Glasgow arms and the

banner of the King of Scotland, Masonic devices and various monograms. Uniquely inventive in their form, they may have been made by Albert Hodge. Condition: good.

76–84 Wilson Street / 58–68 Virginia Street, former Scottish Legal Life Assurance Society building, red sandstone, 1884–9, by Alexander Skirving. Colossal royal arms of Scotland in the attic, with bronze details (horns on unicorns; sword on lion crest). Additional decoration includes nine female keystone heads in second-floor windows and lavish ornamental work in capitals, spandrels, window heads and architraves, all carved with exceptional finesse. Condition: good.

52–68 Woodlands Road / Baliol Street, red sandstone tenement, 1902–4, designed by Burnet & Boston for the Glasgow Corporation Police Department; Glasgow arms on Baliol Street, with bird, fish and bell carved separately on Woodlands Road. Condition: good.

Notes
[1] GG, 1 November 1856, p.4. [2] Stevenson and Wood, vol.1, p.166; see also John Durkan and James Kirk, *The University of Glasgow 1451–1577*, Glasgow, 1977, pp.75, 167.

Glossary

In the following glossary, italicised words indicate cross-references.

abacus: the flat slab on top of the *capital* of a *column*.

acanthus: an architectural ornament, derived from the Mediterranean plant of the same name, found mainly on *capitals*, *friezes* and *mouldings* of the *Corinthian order*.

accessories: in heraldry, the components of a coat of arms other than the *escutcheon*.

accretion: the accumulation of extraneous materials on the surface of a sculpture, for example, salt, dirt, pollutants or guano.

acroterion (plural: **acroteria**): an ornamental block on the apex and at the lower angles of a *pediment*, bearing a statue or a carved *finial*.

aedicule: a statue *niche* framed by *columns* or *pilasters* and crowned with an *entablature* and *pediment*; also a window or door framed in the same manner.

allegory: a conventional depiction of a subject in the guise of another, usually using figures from mythology or history to personify abstract concepts.

amorino (plural: **amorini**): diminutive of Amor, the god of love, also identified with Eros; often depicted as cupids or cherubs, and unlike *putti* have wings.

antae (sing.: **anta**): *piers* or *pilasters* placed at the ends of the short projecting walls of a *portico*; when *columns* are between the antae they are called *in antis*.

apse: a semi-circular or semi-polygonal termination to a building, usually vaulted; hence **apsidal**.

arabesque: intricate and fanciful surface decoration using combinations of symmetrical flowing lines, tendrils and *volutes*, etc., often including small vases, sphinxes, etc.

arcade: a range of *arches* carried on *piers* or *columns*, either *free-standing* or attached to a wall (i.e., 'a blind arcade').

arch: a curved structure, which may be a *monument* itself, e.g., a Triumphal Arch, or an architectural or decorative element within a monumental structure.

architrave: the main beam above a range of *columns*; the lowest member of an *entablature*. Also the *moulding* around a door or window.

armature: the skeleton or framework upon which a modelled *sculpture* is built up and which provides an internal support.

arms, or **coat of arms**: heraldic device of cities, families or individuals.

Art Nouveau: a decorative style that flourished in all fields of design in Europe and America *c.*1890–1910, characterised by asymmetry and sinuous lines.

ashlar: masonry cut into smooth square or rectangular blocks and laid in regular courses. May be 'banded' (with narrow horizontal projections) or 'channelled' (with deep grooves in the joints).

astragal: a small *classical moulding*, circular in section, often decorated with alternating bead and reel shapes.

astylar: of a building, without *columns* or *pilasters*.

atlantes (sing. **atlas**): supports in the form of full- or half-length male figures, sculptured in the round or in *relief*. See also *caryatid*.

attic course / attic storey: the course or storey immediately above the *entablature*, less high than the lower storeys.

attribute: a symbolic object by which an *allegorical* or sacred personage is conventionally identifiable.

baldachin / baldacchino: in monumental architecture, a *canopy* carried on *columns* or *piers*.

baluster: one of a series of short posts carrying a railing or coping, forming a balustrade.

base: the lowest part of a structure; that part on which the *shaft* rests in a *column* or on which the *dado* rests in a *pedestal*.

basement: the lowest storey of a building or architectural *monument*, sometimes partly, sometimes wholly below ground level. If wholly above ground level, the basement storey is of less height than the storey above.

bas-relief: see *relief*.

battered: of a wall, inclined inwards.

bay: a vertical division of a building or architectural *monument*, marked by supporting members such as *pilasters*, *buttresses*, *engaged columns*, etc.

biriga: a chariot drawn by two horses.

boss: a block of wood or *keystone* which masks the junction of vaulting ribs in exposed roof spaces.

bronze: alloy of copper and tin, with traces of metals which affect the surface *patination* as the sculptural work weathers. A very responsive, strong and enduring substance, it is easily handled and has become one of the most common materials for *sculpture*. Usually *cast* to shape, but can also be *forged*.

buttress: a mass of masonry or brickwork projecting from a wall, or set at an angle against it, to give additional strength.

caduceus: attribute of Hermes and Mercury, messenger of the Gods. A staff, culminating in a pair of intertwined snakes, surmounted by two wings. As an emblem on its own, in post-Renaissance secular *iconography* it is a symbol of peace, justice, art or commerce. See also *staff of Asclepius*.

candelabrum: stand to support lamps or candles, consisting of a central upright and branches. 'Candelabra form' refers to a decorative motif based on the classical

candelabrum, used in vertical *panels*, e.g., in *pilasters*; symmetrical and incorporating curvaceous forms.

canopy: a hood or roof-like structure, projecting over a *niche*, or carried on *columns* or *piers* over a *monument* or sculpture, etc.

capital: the head of a *column* or *pillar*.

cartouche: an ornamental *panel* in the form of a scroll or sheet of paper with curling edges, often oval and usually bearing an inscription or emblem. Without inscription or emblem known as 'blind'.

caryatid: a sculptured female figure, used in place of a *column* or *pier* as an architectural support. See also *atlantes*.

cast iron: see *iron*.

cast: to reproduce an object by making a negative mould or moulds of it and then pouring material (e.g., liquid plaster, molten metal) into the moulds. A cast is an object made by casting. An 'after-cast' or 'recast' is a subsequent cast taken from moulds, not of the original object, but of the first, or even later, cast (and often not authorised by the artist). A metal after-cast is inevitably slightly smaller than its original since metal shrinks on cooling.

castellated: fortified with battlements. By extension, the term is descriptive of something that is ornamented with a battlement-like pattern, e.g., a castellated crown.

cenotaph: a *monument* which commemorates a person or persons whose bodies are elsewhere; a form of First World War memorial popularised by Sir Edwin Lutyens' precedent at Whitehall, London.

ciment fondu: a cement-like material which is easily moulded and can be coloured.

cire perdue (Fr. 'lost wax'): metal *casting* technique used by sculptors, in which a thin layer of wax carrying all the fine modelling and details of the sculpture is laid over a fire-proof clay core and then invested within a rigid, fire-proof outer casing. The wax is then melted and drained away ('lost') through vents, and replaced with molten metal.

classical: in its strictest sense, the art and architecture of ancient Greece and Rome, especially that of Greece in the fourth and fifth centuries BC and later Roman work copying it or deriving from it. By extension, any post-antique work that conforms to these models. *Neo-classical* describes work of this sort produced across Europe from the mid-eighteenth to the mid-nineteenth centuries.

colonnade: a range of *columns* supporting an *entablature*.

colonnette: a small, usually ornamental, *column*.

column: upright structural member with a *shaft*, topped by a *capital* and usually rising from a *base*. Whatever the shape of the *capital* or *base*, the *shaft* is usually round or octagonal in plan. In classical usage columns generally conform to five main types, or *orders*. An **engaged column** is one which appears to be partly embedded in a wall – also called an attached, applied, or half-column.

Composite order: see *order*.

console: a decorative bracket with a compound curved outline, resembling a figure 'S' and usually taller than its projection.

contrapposto (It. 'set against', 'opposed'): a way of representing the human body so as to suggest flexibility and a potential for movement. The weight is borne on one leg, while the other is relaxed. Consequently the weight-bearing hip is higher than the relaxed hip. This is balanced by the chest and shoulders which are tilted in the opposite direction.

coping: a protective capping or covering to a wall, *parapet*, etc., often sloping to shed water.

copper: a naturally occurring red-coloured metal. Characteristically malleable, it is often used for *repoussé* work. As an alloy, it is the main constituent of *brass* and *bronze*.

corbel: a brick or stone which projects from a wall and supports a feature on its horizontal surface.

corbel-table: row of corbels supporting a *parapet* or *cornice*.

corbie-steps: Scottish 'crow-steps'; steps up the slope of a *gable*. The top stone of a gable is the 'crowstone'.

Corinthian order: see *order*.

cornice: (i) the overhanging *moulding* which crowns a *façade*; (ii) the uppermost division of an *entablature*; (iii) the uppermost division of a *pedestal*. The sloping mouldings of a *pediment* are called raking cornices.

cornucopia (plural: **cornucopiæ**): the 'horn of plenty'; a goat's horn overflowing with fruit, flowers, wheat or money.

corrosion: gradual deterioration of a material through chemical reaction with acids, salts or other agents. It is accelerated by the presence of moisture.

corten steel: a trade term for a type of *steel* which naturally forms a very tough protective, evenly-coloured layer of rust over its surface. Once this has formed the process stops and there is no further oxidization and *corrosion*.

couchant: heraldic term indicating a quadruped lying on its belly with its head raised.

crocket: in *Gothic* architecture, an upward-pointing ornamental spur sculptured into a vegetal form. Found in series on the angles of spires, pinnacles, *gables*, *canopies*, etc.

cupola: a small dome.

cusp: in *Gothic tracery*, a projecting point at the meeting of two *foils*.

dado / die: on a *pedestal*, the middle division above the *plinth* and below the *cornice*.

dentils (from Fr. *dentilles*, 'little teeth'): small square blocks used in series on *cornices* of the Ionic, Corinthian and Composite (rarely in the Doric) *orders* of architecture.

dexter: in heraldry, on the left side of the *escutcheon* (i.e., the right side from the point of view of the bearer).

Diocletian window: see *thermal window*.

Doric: see *order*.

dormer: vertical-faced structure situated on a sloping roof, sometimes housing a window.

dressed: of masonry, worked to a desired shape, with the exposed face brought to a finish, whether polished, left matt, or moulded.

drum: (i) a cylindrical *pedestal*, supporting a *monument* or sculpture; (ii) a vertical wall, circular in plan, supporting a dome; (iii) one of the cylindrical stone blocks making up the *shaft* of a *column*.

egg and tongue (or **egg and dart**): classical moulding of alternated egg and arrow-head shapes.

engaged column: see *column*.

entablature: in *classical* architecture, the superstructure carried by the *columns*, divided horizontally into the *architrave*, *frieze* and *cornice*.

erosion: the gradual wearing away of one material by the action of another or by, e.g., water, ice, wind, etc.

escrol (or **escroll**): in heraldry, the ribbon-like form on which a *motto* is inscribed.

escutcheon: in heraldry, the main shield upon which the armoreal devices or 'charges' are inscribed.

fabrication: cold assembly of metal parts by cutting and joining methods such as welding or rivetting.

façade: external face or elevation of a building or *monument*, especially the principal *frontage*.

faience (Fr. name for Faenza in Italy): earthenware with a tin glaze.

fasces: originally a bundle of rods tied around an axe, a symbol of a Roman magistrate's authority. In architecture, a decorative motif derived from this.

festoon: a sculptured ornament representing a garland of flowers, leaves, fruit, etc., suspended between two points and tied with ribbons. See also *swag*.

fibreglass: a material made of resin embedded with fine strands or fibres of glass woven together to give it added strength. As it does not shrink or stretch, has high impact strength and can withstand high temperatures, it has become a popular material for modern sculpture.

finial: an ornament which finishes a vertical projection such as a spire or *gable*.

fluting, flutes: concave grooves of semi-circular section, especially those running longitudinally on the *shafts* of *columns*, *pilasters*, etc.

foil: leaf-shaped lobe created by *cusp*.

foliate: decorated with leaf designs or *foils*.

forged: shaped by hammer blows, utilising the malleability and ductility of metal, either hot or cold.

forged iron: see *iron*

founder's mark: a sign or stamp on a sculpture, denoting the firm/individual responsible for its *casting*.

free-standing: of a *monument* or sculpture, standing independently.

freestone: any *limestone* or *sandstone* which is sufficiently homogeneous and fine-grained to be cut or sawn 'freely' in any direction.

frieze: the middle horizontal division of a *classical entablature*, above the *architrave* and below the *cornice*, often decorated with *relief* sculpture. The term is also applied to any band of sculptured decoration.

frontage: the front face of a building.

gable: triangular upper part of a wall, normally at the end of a ridged roof. Some gables have a series of steps up the side, known as crow-steps or corbie-steps. Often capped with a *finial*.

galvanise: to immerse a metal in molten zinc to give it a protective coating against rust.

gargoyle: a spout in the form of a carved *grotesque* human or animal head, projecting from the top of a wall to throw off rainwater.

giant order: an *order* whose *columns* or *pilasters* rise through two or more storeys. Also called a colossal order.

Giffnock sandstone: yellow/cream-coloured sandstone of the Carboniferous Age from Giffnock, Renfrewshire, south of Glasgow, used from the mid-nineteenth century.

gilding, gilt: to gild is to cover a surface with a thin layer of gold, or with a gold-coloured pigment; gilding is the golden surface itself.

Glasgow Style: distinctive form of *Art Nouveau* developed by architects and designers in Glasgow in the early twentieth century, principally among the associates of Charles Rennie Mackintosh (q.v.). Characteristic motifs include elegantly attenuated abstract and natural forms and emaciated human figures.

Gothic: a style of medieval art and architecture that predominated in Europe *c.*1200 – *c.*1450. In architecture it is characterised by the pointed *arch* and an overall structure based on a system of ribbed cross vaulting supported by clustered *columns* and flying *buttresses*, giving a general lightness to the building. In sculpture the figure is generally treated with naturalistic detail, but is often given an exaggerated elegance through elongation and the use of an S curve. During the Renaissance the Gothic went out of favour. In the eighteenth century, however, there was revival of interest in medieval forms, an interest which in the next century gradually grew more serious and scholarly.

Gothic Revival: a revival of the forms of Gothic art and architecture, beginning in the mid-eighteenth and lasting throughout the nineteenth centuries.

graffiti: unauthorised lettering, drawing, or scribbling applied to or scratched or carved into the surface of a building, *monument* or sculpture.

granite: an extremely hard crystalline igneous rock consisting of feldspar, mica and quartz. It has a characteristically speckled

appearance and may be left either in its rough state ('axed') or given a high polish. It occurs in a wide variety of colours including black, red, pink, grey-green. In buildings and monuments in Glasgow the most common granites are from Creetown, Dalbeattie (both Kirkcudbrightshire), Peterhead and Rubislaw (both Aberdeenshire).

grotesque: a form of decoration composed of fanciful animal and human forms, fruit, flowers, etc.

guano: bird excrement.

guilloche: a running pattern formed by two or more bands which interweave like a plait to form circular openings sometimes filled with circular ornaments.

herm: see *term*.

high relief: see *relief*.

Hopton Wood stone: a limestone from Derbyshire, occurring in light cream and grey. In common with other polishable limestones it is sometimes referred to incorrectly as *marble*.

iconography: the visual conventions by which traditional themes are depicted in art under changing historical and cultural conditions.

impost: the point of junction between an *arch* and its support.

in antis: see *antae*.

in situ (literally 'in place'): a term used to denote the original location of a work of art for which it was first intended.

Ionic order: see *order*.

iron: a naturally occurring metal, silver-white in its pure state, but more likely to be mixed with carbon and thus appearing dark grey. Very prone to rust (taking on a characteristic reddish-brown colour), it is usually coated with several layers of paint when used for outdoor *sculptures* and *monuments*. As a sculptural material it may be: (i) **cast** – run into a mould in a molten state and allowed to cool and harden; (ii) **wrought** – heated, made malleable, and hammered or worked into shape before being welded to other pieces. Strictly refers to pure iron mixed with slag, but often incorrectly used to describe modern decorative work made with mild steel; (iii) **forged** – fashioned in such a way that every surface of the stock material is modified by compressive force.

jamb: one of the vertical sides of a door, window, or archway.

keystone: the wedge-shaped stone at the summit of an *arch*, or a similar element crowning a window or doorway.

lantern: a small circular or polygonal windowed turret, surmounting a dome, *cupola* or *canopy*.

lettering: characters which comprise the *inscription*. The following types are commonly found. **Applied:** metal letters stuck or nailed. **Incised:** letters carved into stone or etched in metal. **Relief:** low-*relief* letters. **Raised:** high-*relief* letters.

lintel: horizontal beam or slab spanning a door or window, supporting the wall above.

Locharbriggs sandstone: red sandstone of the Permo-Trias Age from quarries in Locharbriggs, Dumfriesshire, used from *c.*1890.

lunette: semi-circular surface on, or opening in, a wall, framed by an *arch* or vault.

margent: strip of floral or foliate forms hanging downwards from a mask or a ring, and often emphasising the sides of windows.

maquette (Fr. 'model'): in sculpture, a small three-dimensional preliminary sketch, usually roughly finished.

marble: in the strictest sense, limestone that has been recrystallised under the influence of heat, pressure, and aqueous solutions; in the broadest sense, any stone (particularly limestone that has not undergone such a metamorphosis) that can take a polish.

mask: decorative motif representing a face or head in *relief*, of humans, gods or animals; sometimes portraits, often *grotesque*.

medallion: a circular frame shaped like a large medal.

memorial: see *monument*.

mild steel: *steel* containing only a small percentage – up to 0.15% by weight – of carbon. Mild steel is noted for its strength and toughness.

monolithic: of a large sculpture, *pillar*, *column*, etc., made from a single stone.

monument: a structure with architectural and / or sculptural elements, intended to commemorate a person, event, or action. The term is used interchangeably with 'memorial'.

mosaic: a design comprising small, coloured, pieces of glass, *marble*, stone, tile, etc., cemented to a surface.

motto: in heraldry, a brief text, often in Latin, inscribed on the *escrol* above or below the *escutcheon*.

moulding: a projecting or recessed band used to ornament a wall or other surface.

mullion: one of the vertical stone or timber members dividing a window into lights.

Muses: ancient Greek goddesses who preside over specific arts and sciences. They are the daughters of Zeus and the Titaness Mnemosyne ('Memory'), are nine in number, and live with Apollo on Mount Parnassus. Each has her own sphere of influence. Clio is the Muse of history, Euterpe of music and lyric poetry, Thalia of comedy and pastoral poetry, Melpomene of tragedy, Terpsichore of dancing and song, Erato of lyric and love poetry, Urania of astronomy, Calliope of epic poetry, and Polyhymnia of heroic hymns.

Neo-classicism (adj. **Neo-classical**): artistic style and aesthetic movement which spread across Europe from the second half of the eighteenth century. It drew upon a renewed interest in antique art, sculpture and particularly architecture.

niche: a recess in a wall used as a setting for a statue, bust or ornament.

obelisk: tapering upright *pillar* with rectangular or square section, ending pyramidally, usually *free-standing*.

oculus: a circular opening or window.

ogee: a line with a double curve resembling a letter 'S'; descriptive of a *moulding* with such a shape. An ogee *arch* is one with lower concave and upper convex curves meeting at a point.

open-work: any kind of decorative work which is pierced through from one side to the other.

order: in classical architecture, an arrangement of *columns* and *entablature* conforming to a certain set of rules. The Greek orders are (i) **Doric**, characterised by stout columns without *bases*, simple cushion-shaped *capitals*, and an entablature with a plain *architrave* and a *frieze* divided into triglyphs and metopes; (ii) **Ionic**, characterised by slender columns with bases, capitals decorated with *volutes*, and an entablature whose architrave is divided horizontally into fasciae and whose frieze is continuous; and (iii) **Corinthian**, characterised by relatively slenderer columns, and bell-shaped capitals decorated with *acanthus* leaves. The Romans added **Tuscan**, similar to the Greek Doric, but with a plain frieze and bases to the columns; **Roman Doric**, in which the columns have bases and occasionally *pedestals*, while the echinus is sometimes decorated with an egg and tongue moulding; and **Composite**, an enriched form of Corinthian with large *volutes* as well as acanthus leaves in the capital.

oriel window: a bay window projecting on *corbels* (i.e., 'corbelled out') from the wall of an upper storey.

palazzo (It. 'palace'): grand civic building or town house derived from the Italian Renaissance, usually consisting of a *base* (or 'basement'), *piano nobile* and attic, with prominent *cornice* and frequently with *pedimented* central section.

palmette: an ornament, somewhat resembling the splayed fingers of a hand, derived from a palm leaf.

panel: a distinct part of a surface, either framed, recessed, or projecting, often bearing a sculptured decoration or an inscription.

parapet: a wall bordering the edge of a high roof, or bridge, etc.

passant: heraldic term indicating an quadruped walking with three paws on the ground and one foreleg raised.

patina: surface coloration of metal caused by chemical changes which may occur either naturally, due to exposure for example, or by processes employed at a foundry.

pavilion: a turret, small building, or wing of a larger structure. In a large building, prominent parts, such as the centrepiece and terminating features, given special importance by means of height, enrichment, etc.

pedestal: the *base* supporting a sculpture or *column*, consisting of a *plinth*, a *dado* (or die) and a *cornice*.

pediment: in *classical* architecture, a low-pitched gable, framed by a *cornice* (the uppermost member of an *entablature*) and by two raking cornices. Originally triangular, pediments may also be segmental. Also, a pediment may be open at the apex (i.e., an open-topped or broken-apex pediment) or open in the middle of the horizontal cornice (an open-bed or broken-bed pediment). The ornamental surface framed by the pediment and sometimes decorated with sculpture is called the *tympanum*.

personification: a representation of an abstract idea, moral quality, or actual thing, by an imaginary person.

piano nobile: main, usually first, storey of a large public building, town house or *palazzo*.

pier: in architecture, a free-standing support, of rectangular, square or composite section. It may also be embedded in a wall as a *buttress*.

pilaster: a shallow *pier* projecting only slightly from a wall.

pillar: a free-standing vertical support which, unlike a *column*, need not be circular in section.

pits / pitting: small holes and other faults in a metal surface caused either by imperfections in the *casting* process or by *corrosion*.

plaque: a *panel*, usually of metal, fixed to a wall or *pedestal*, bearing sculptured decoration and/or an inscription.

plaster: a range of materials ideal for *casting*. The type most often used by sculptors is specifically known as plaster of Paris, a mixture of dehydrated gypsum and water. It is mixed together as a liquid and may be poured into negative moulds (which themselves may be made of plaster) to make positive casts of a fragile clay model, or as a studio record of a finished work.

Plean sandstone: yellow/cream-coloured sandstone of the Carboniferous Age from quarries in Plean, near Bannockburn, Stirlingshire.

plinth: (i) the lowest horizontal division of a *pedestal*; (ii) a low plain *base* (also called a *socle*); (iii) the projecting base of a wall.

portico: a porch consisting of a roof supported by *columns*.

Portland stone: a limestone from Dorset, characterised by its bleached white appearance when exposed to the elements.

putto (plural: **putti**): a small boy or chubby male baby; unlike *amorini* they have no wings.

pylon: strictly, the monumental gateway to an ancient Egyptian temple, consisting of a pair of rectangular, tapered towers connected by a lower architectural member containing the gate; more loosely, a tapering tower resembling one of the towers from such a gateway.

quadriga: a chariot drawn by four horses abreast.

raking cornice: see *cornice*.

rampant: heraldic term indicating a quadruped raised on hind legs

relief: a sculptural composition with some or all areas projecting from a flat surface. There are several different types, graded according to the degree of their projection. The most common are (i) **bas-relief**, or low relief, in which the figures project up to less than half their notional depth from the surface; and (ii) **high relief**, in which the main parts of the design are almost detached from the surface. Many reliefs combine these two extremes in one design.

repoussé (Fr. 'pushed back'): *relief* design on metal, produced by hammering from the back.

rinceau: classical ornament, usually on a *frieze*, of leafy scrolls branching alternately to left and right.

Rococo: the elegantly decorative style which predominated in France in the eighteenth century during the reign of Louis XV, characterised by asymmetry; shell, rock, and plant motifs; and the use of S-curves and C-scrolls. The term is used to describe any later work which embodies those characteristics.

Roman Doric: see *order*.

rosette: a rose-shaped decorative motif.

rotunda: a circular building, usually domed. May also be a cylindrical projection from the *façade* of a building.

roundel: a circular decorative *panel*.

rustication: stonework cut in massive blocks, separated from each other by deep joints. The surfaces are often left rough to suggest strength or impregnability. A rusticated *column* has a *shaft* comprising alternated rough (or textured) and smooth *drums*.

sandstone: a sedimentary rock composed principally of particles of quartz, sometimes with small quantities of mica and feldspar, bound together in a cementing bed of silica, calcite, dolomite, oxide of iron, or clay. The nature of the bed determines the hardness of the stone, silica being the hardest. In Glasgow the most commonly used sandstones for building and sculpture are from Blackpasture (England), Blaxter (England), Binnie (West Lothian), Closeburn (Dumfriesshire), Dunmore (Perthshire), *Giffnock*, *Locharbriggs*, Mauchline (Ayrshire) and *Plean*, as well as numerous quarries in Glasgow itself which have now been built over.

scroll: a spiral architectural ornament, either one of a series, or acting as a terminal, as in the *volute* of an *Ionic capital*.

sejant: heraldic term indicating a quadruped sitting upright with its forelegs raised.

Serlian window: triple window with arched central opening and narrower sides. Also known as a Venetian or Palladian window.

shaft: main section of a *column*, between the *capital* and the *base*.

sinister: in heraldry, on the right side of the shield or *escutcheon* (i.e., the left side from the point of view of the bearer).

socle: a low undecorated *base* or *plinth*.

spalling: the splitting away of the surface layers of stone or brick parallel to the surface. Sometimes called delamination.

spandrel: the surface, roughly triangular in shape, formed by the outer curves of two adjoining *arches* and a horizontal line connecting their crowns. Also the surface, half this area, between an arch and a corner.

staff of Asclepius: staff with serpents coiled round it, representing the opposing forces of sickness and health, used as a symbol of medicine. Similar to, but not to be confused with a *caduceus*

stainless steel: a chromium-*steel* alloy. The alloy is rendered stainless because its high chromium content – usually between 12–25% – protects its surface with a *corrosion*-resistant chromium oxide film.

steel: an alloy of *iron* and carbon, the chief advantages over iron being greater hardness and elasticity.

string course: a continuous horizontal band projecting from or recessed into a *façade*.

stylobate: substructure supporting a colonnade, sometimes carrying a *relief*.

supporter: in heraldry, one of a pair of figures or animals flanking the *escutcheon*. In Scotland sometimes 'bearer'.

swag: like a *festoon* but consisting of cloth.

tablet: stone panel, often inscribed.

tempietto: a small temple-like structure, especially of an ornamental character, set in a garden.

term: male or female bust, usually armless, surmounting a pillar or pedestal which tapers towards the base, deriving from boundary posts carved with a head of Hermes. Also known as a terminal figure or *herm*.

terracotta (It. 'baked earth'): clay that has been fired at a very high temperature and which is usually unglazed. It is notable for its hardness and was much used for architectural ornament in the second half of the nineteenth century.

thermal window: a semi-circular window divided by *mullions* into three lights. Also known as a Diocletian window.

trophy: a sculptured group of arms or armour commonly found on military *monuments* and war memorials.

triptych: tablet or picture in three divisions; a set of three carved *panels*.

turret: small tower, usually attached to a building.

Tuscan order: see *order*.

tympanum: a section over a door or window which is often enclosed by a *pediment*. It has no structural function and so is usually filled with decoration or *relief* sculpture.

urn: vase with lid originally made to receive ashes of the dead, but in sculpture, usually decorative.

vesica: oval compartment with pointed top and bottom, like a rugby ball.

Virtuvian scroll: running ornament with curly waves, also known as a 'running dog'.

volute: a spiral *scroll*, especially on an Ionic or Composite *capital*.

voussoir: wedge-shaped stones used in *arch* construction.

wrought iron: see *iron*.

Zephyr: wind-god (from Greek 'Zephuros', god of the west wind).

Selected Biographies *by* GARY NISBET, *edited by* RAY McKENZIE

George Adam & Son (1873–1909)
Firm of Glasgow blacksmiths, specialising in gates, railings and architectural ornamentation. The earliest reference to the firm in the Glasgow Post Office Directories occurs in 1873, when George Adam is listed as a smith, with a workshop in Orchard Street, Partick. In 1896, after several changes of premises, the company was renamed George Adam & Son and began trading as 'Art Metal Workers'. The company appears to have been wound up in 1909, after the completion of its work on the main building of Glasgow School of Art (q.v., Renfrew Street, main catalogue).
Source: POD, 1873–1909.

Michael Dan Archer (b.1955)
Born in Glasgow, he studied sculpture at Coventry School of Art, 1975–9, after which he lived and worked in Japan and Spain. He has exhibited widely in the UK, including a solo show at the Yorkshire Sculpture Park, and has made sculptures at international symposia in Italy, Japan, South Korea and Germany. In 1999 he made a 15–ton granite work as a stipendiat at KKV-B in Sweden. He now has a studio in Lincolnshire and works as a part-time lecturer at Loughborough University School of Art and Design.
Source: information provided by the artist.

Phyllis Muriel Cowan Archibald (1880–1947)
Born in Tunbridge Wells, the daughter of a designer, she studied at GSA, winning her diploma in 1908. She resided at 20 Kew Gardens and 13 Highburgh Terrace, married Charles Clay, *c.*1906, and later moved to London and then Grasmere, Westmoreland. Among her many exhibits at the RSA were a bronze relief portrait of *Lady Archibald* (1908), *The Pillar of Salt* (1920), *Demeter* (1925) and

David Dancing Before the Ark (1933). Other recorded commissions include the memorial tablet to A.H. Charteris at Kirk O' Field, incorporating a low relief portrait bust, and the figures for the choirstall in the Congregational Church, Whitchurch (1910).
Sources: McEwan; Laperriere.

William Aumonier (1841–1914)
Architectural sculptor and carver in wood and brick, born in London, of Huguenot stock. He operated from premises at New Inn Yard, Tottenham Court Road, London, from 1880, with his sons William and Percy as assistants. Important commissions by them include the New Victoria Law Courts, Birmingham (1886) and Bath Municipal Buildings (1891). They also executed wood carving for the steamships *Austral* and *Ophir*.
Sources: BJ, 10 February, 1897; RIBAJ, 14 February 1914 (obit.).

Lucy Baird (b.1959)
Born in Malawi, she attended ECA, 1980–5, gaining a BA Hons in Sculpture and a postgraduate diploma. She was the winner of the Andrew Grant Scholarship Award in 1984 and an RSA Travelling Scholarship to Florence in the following year. Commissioned as a student to produce *Mining* (1984) for Irvine Development Corporation, she was appointed Artist in Residence for Irvine New Town, 1990, in which capacity she executed *Birds* (1992). She has exhibited in Glasgow, Birmingham and Munich.
Source: information provided by the artist.

Harry Bates (1850–99)
Born in Stevenage, Hertfordshire. After working as an architect's clerk he became an apprentice stone carver with Farmer & Brindley

(q.v.). In 1883 he won a travelling scholarship from the RA Schools, which enabled him to study in Paris under Dalou and Rodin. He was a key figure in the New Sculpture movement, a good illustration of which is his bronze *Aeneid* triptych in GAGM (1883). Major public works include relief panels for John Belcher's Institute of Chartered Accountants, London (1899) and the *Monument to Queen Victoria*, Dundee (1890). He was elected ARA in 1892.
Sources: BN, 3 February 1899, p.160 (obit.); Beattie, p.240; Mackay.

Gilbert Bayes (1872–1953)
London-born sculptor, he was the son of the painter and etcher Alfred Walter Bayes, and the brother of the painter Walter John Bayes. He studied at the City and Guilds College, Finsbury, and at the RA Schools, 1896–9, where he was taught by George Frampton and Harry Bates (qq.v.). After winning the Gold Medal and Travelling Scholarship in 1899, he spent three months in Italy and nine months in Paris, where he exhibited at the 1900 Exposition Universelle. He specialised in poetic and romantic subjects taken from the classics and Wagner's operas, but also executed the statues of Sir William Chambers and Sir Charles Barry on the V&A. For J.J. Burnet's London practice he carved a statue of Joseph Priestly at the Institute of Chemistry, Russell Square (1914), and the bronze group at the entrance to Selfridge's, Oxford Street (1928). Elected HRI in 1918, he was awarded the RBS medal in 1935, and served as PRBS, 1939–44.
Sources: Spielmann, pp.143–4; Grant: Waters; Gray.

Beltane Studios (1996–)
Foundry and sculpture fabrication workshop established by three brothers Ruaraig, Iomhar

and Njord Maciver in a converted water-mill building in Peebles. In addition to casting bronze work by artists such as Allison Bell, Vincent Butler and Scott Associates (qq.v.), the firm also undertakes independent sculptural commissions, a recent example of which is the replacement of the full-size bronze figure (itself copied from Alexander Carrick's war memorial at Blairgowrie) which had been stolen from the Walkerburn War Memorial in 1997. Current projects include a Millennium Fountain for the proposed Eastgate Theatre in Peebles.

Source: information provided by the company.

Philip Benson (b.1950)
Self-taught sculptor, who took up wood carving for therapeutic reasons in 1990, and who has since made a speciality out of carving large animals from storm-damaged trees in the west end of Glasgow.

Source: Eddie Toal, 'Wood you believe it', ET, 5 June 1995, p.3.

Douglas Bisset (1908–2000)
Born in Strichen, Aberdeenshire, he left school at the age of fourteen and did not begin attending art classes until he became involved in a charitable foundation at Christchurch, in the east end of Glasgow in the late 1920s. He then became an apprentice with Holmes & Jackson (q.v.), and began attending sculpture classes as a part-time student under Archibald Dawson (q.v.) at GSA, where he also later worked as a pupil-teacher. In 1932 he won the Keppie Scholarship, which allowed him to travel to Copenhagen, where he continued his studies under the Danish Neo-classicist Einar Utzon-Frank (1888–1955). As the winner of the Prix de Rome he travelled to Italy in 1939, but his strongly anti-Fascist views forced him to transfer to Athens, where he worked at the British School of Archaeology. After the Second World War he was Head of Sculpture at Leeds School of Art and the City and Guilds

School of Art, London, and in 1980 he moved to Mexico for health reasons, not returning to Glasgow until 1995. He produced mainly portrait busts and female nudes for private collectors, very rarely exhibiting his work. There are two bronze busts by him in GAGM and a plaster portrait of William Stewart, produced on May Day, 1930, in the People's Palace Museum.

Sources: Johnstone; recorded interview with Ian Harrison, 13 January 1980.

Sir Joseph Edgar Boehm (1834–90)
Born in Vienna, he settled in London in 1862, becoming naturalised in 1866. He studied in London, Vienna and Paris. His portrait busts and equestrian studies endeared him to Queen Victoria, who commissioned bronze statuettes of her family and statues of herself and her father for Windsor Castle; she appointed him Sculptor in Ordinary in 1881. Among his public works are the monuments to John Bunyon, Bedford (1874), Thomas Carlyle, Chelsea (1882), The Duke of Wellington, Hyde Park Corner (1889) and Sir Francis Drake, Plymouth Hoe (1885). A sculptor of medals and medallions, he modelled the head of Queen Victoria for the 1887 Jubilee coinage. He exhibited at the RA from 1882, was elected RA and made a baronet in 1889.

Source: Grant.

Stanley Bonnar (b.1948)
Brought up in Leith, he studied sculpture at Duncan of Jordanstone College of Art, Dundee, 1968–72, and was Town Artist at Glenrothes New Town, 1973, where he produced *The Witty Parade of Hippos*, and at East Kilbride and Stonehaven New Town, 1974–7. After working as a scenic artist at the Royal Lyceum Theatre, Edinburgh, he joined Blackness Public Arts Project, Dundee, 1981–4, then became a part-time tutor in the Department of Environmental Art, GSA,

1985–92. Winner of an SAC Award in 1994, his recent public work includes *The Leith House*, Edinburgh (1996). He is currently collaborating with Mark Bonnar on film work.

Sources: Pride, pp.82–3; Gooding and Guest, project no.5; information provided by the artist.

Edward George Bramwell (1865–1944)
Born in London, he studied at the City and Guilds School of Art, London, winning a silver medal for sculpture and a travelling scholarship. Working under George Frampton, W.S. Frith (qq.v.) and T. Stirling Lee, he produced statuettes and small groups. He taught modelling at Westminster School of Art, and exhibited at the RA from 1898.

Source: Mackay.

John Broad (1873?–1919)
Principally a modeller of figures, monuments and terracotta ware with Doulton & Co., of Lambeth (q.v.), he also executed statues of General Gordon and Queen Victoria, Gravesend, and a number of portrait medallions. Examples of his ceramics were exhibited at the Arts and Crafts Exhibition, London, 1891, the Chicago World's Fair, 1893, and the RA, 1890–1900.

Sources: Bergesen, p.95; Darke, p.87.

Stephen Broadbent (b.1961)
Liverpool-based sculptor, but born in Wroughton, he trained with Arthur Dooley (q.v.), 1979–83. His first one-man show was held at the Aberbach Gallery, London, 1982. Public works by him include the bronze relief panels of *The Trades and Professions of Edinburgh*, Saltire Court, Edinburgh (1991), and *Challenge*, at Capital House, Chester (1993).

Source: Cavanagh, p.323.

William Brodie (1815–81)
The son of a Banff shipmaster, and brother of

the sculptor Alexander Brodie, he worked first as a plumber in Aberdeen while teaching himself sculpture. In 1847 he moved to Edinburgh to study at the Trustee's School of Design until *c.*1851, then visited Rome in 1853 to study under Lawrence MacDonald. Returning to Edinburgh, he established a large practice specialising in portrait busts and statues, many of which were exhibited at the RA, the RSA and the RGIFA. He executed the *Monument to John Graham Gilbert*, Necropolis (*c.*1863), the *71st Highland Light Infantry Memorial*, Glasgow Cathedral (1863), and the *93rd Sutherland Highlanders Memorial*, St Giles Cathedral, Edinburgh (1864). Elected ARSA in 1857, and RSA in 1859, he was the Academy's secretary, 1876–81. Most of his public work is in Edinburgh, including the famous tourist attraction *Greyfriars Bobby* (1872).

Sources: *Scotsman*, 31 October 1881, p.4 (obit.); Gunnis; Johnstone.

Bromsgrove Guild (fl.1895–1965)

Late-Victorian offshoot of the Arts and Crafts movement, founded by Walter Gilbert. They produced craft work in a wide range of materials – such as wood, metal, glass, embroidery and plaster – for public and private commissions throughout Britain, their most prestigious work being the gates of Buckingham Palace. Among their commissions in Glasgow were plasterwork in the Central Station Hotel (1900–8), and at Averley, 996 Great Western Road, as well as stained glass (designed by H.J. Payne and Mary Newill) at Stoneleigh, 48 Cleveden Drive (1900–6).

Sources: Williamson *et al.*, pp.210, 314, 321; Cavanagh, p.324.

William Kellock Brown (1856–1934)

Born in Glasgow, the son of a metal worker and brother of the painter Alexander Kellock Brown, he trained under his father and attended sculpture classes at GSA. After winning a

scholarship he moved to London to study at the RCA and RA Schools under Edouard Lantéri (1848–1917). Among the commissions he executed in London were the balconies on the Savoy Hotel (1888). A member of Mackmurdo's Century Guild (briefly its chief metal worker), the Art Workers Guild, the Scottish Guild of Handicrafts and the Scottish Society of Art Workers, he returned to Glasgow to teach modelling, metal work and *repoussé* at GSA, 1888–98. His students included Albert Hodge, J.P. Main and J.H. Mackinnon (qq.v.), who benefited from the improvements he introduced in the life class. An independent artist from 1892, he carried out numerous commissions for architectural sculpture and monuments in Glasgow and the west of Scotland, including the *John Watson Memorial Fountain*, Hamilton (1893), the *Monument to David Livingstone*, Blantyre (1913) and the *John Robertson Cenotaph*, Southern Necropolis (1912). After the First World War he executed war memorials for Penpont (1920), Inverary (1922), Largs (1922), and Johnstone (1924). He exhibited regularly at the RA, the RSA, and the RGIFA from 1887, showing genre works, busts and Burns subjects, including an unsuccessful model for the Paisley Burns statue competition of 1893. He died of heart failure in Cambridge Street, leaving a colossal statue of Burns unfinished.

Sources: GH, 12 May 1924, p.5, 21 February 1934, p.15 (obit.); *Southern Necropolis Newsletter*, December 1988; Blench, *et al.*, pp.13–14.

Michelle de Bruin (b.1967)

An art and design graduate from Lincoln College of Art, she also studied sculpture at GSA, 1986–9. In 1988, she showed work at student exhibitions in GSA and the Christmas Show, Compass Gallery, and participated in the Sandstone Sculpture Project, College Lands, Glasgow. She is a frequent collaborator with Callum Sinclair (q.v.).

Source: Scott, p.30.

Walter Buchan (fl.1837–78)

Little is known of Buchan's life and career other than the fact that he trained under William Mossman Senior (q.v.), assisted John Mossman (q.v.) and was employed as a carver by Cuthbert Brodrick on Leeds Town Hall (1853–8) and by John Thomas (q.v.) at the Houses of Parliament, London. Work by him is rare but distinguished, and was much admired by Archibald Macfarlane Shannan (q.v.), who exhibited a plaster copy of his *Trial by Jury* frieze at the Corporation Galleries in 1911. He died obscure and in poverty in London, too late to benefit from John Mossman's attempts to alleviate his plight.

Sources: A, 13 April 1878 (obit.), 26 September 1890; Gildard, pp.4–8.

Jim Buckley (b.1957)

Born in Cork, Eire, he studied sculpture at Crawford's School of Art, Cork, 1975–80. He has contributed to international conferences on sculpture and has shown work at group and solo exhibitions throughout Europe, the USA and Japan, including *Jim Buckley*, at the Kyoni Gallery, Tokyo (1994). Winner of the Benno Schotz Prize in 1984, he has collected awards from a variety of sponsors and arts organisations, including an SAC Travel Award, 1984, and the Royal Bank of Scotland Prize, 1987. In 1988 he exhibited *Red Gates* at the Glasgow Garden Festival. He is a co-founder and co-director of Glasgow Sculpture Studios Ltd, and is represented in many major private and public collections.

Sources: Scott, pp.46–7; Murray, pp.32–3; Euan McArthur and Jim Buckley, *Jim Buckley*, Aberdeen, 1994 (ex. cat.).

John Burnet & Son (1882–6)

Architectural partnership formed in 1882 between John Burnet (1814–1901) and his son John James Burnet (1857–1938), later becoming Burnet, Son & Campbell, 1886–97, with John Archibald Campbell (1859–1909). Burnet

Senior was the first Glasgow architect to use sculpture on a grand scale, often employing the Mossmans and James Young (qq.v.). After returning from the École des Beaux-Arts, Paris in 1878, Burnet Junior continued the trend throughout his Beaux-Arts and American Neo-classical phases, with Albert Hodge (q.v.) a frequent contributor to his Glasgow and London buildings. Burnet set up a London office in 1905, and was knighted for his King Edward VII Gallery, London (1903–14), which incorporates lions by Sir George Frampton (q.v.). The firm's other important buildings providing opportunities for sculptors include Forsyth's, Edinburgh (1906), with work by William Birnie Rhind and William Reid Dick (qq.v.). The firm continued as Burnet, Tait & Lorne, designing the Empire Exhibition, Glasgow, 1938 (see Bellahouston Park, Appendix A, Lost Works), the flagship of architectural Modernism in Scotland.

Sources: Gomme and Walker, pp.266–9; Service, pp.192–215; Gray; ET, 25 February 2000, pp.8–9.

John James Burnet See John Burnet & Son

Jamie Burroughs (b.1961)
English sculptor, studied at Wimbledon School of Art, currently living in Hong Kong.

Vincent Butler (b.1933)
Manchester-born sculptor of figures, animals and portraits in bronze, he trained at Manchester School of Art and ECA, completing his studies in Milan under Marino Marini and Giacomo Manzù, 1955–7. After working in Italy he taught sculpture in Nigeria, 1960–3, then joined the staff of ECA. Casting most of his work himself, he has held several one-man shows and has exhibited at the RSA and the RGIFA since 1963, including a bust of Benno Schotz (q.v.) (1978, SNPG), *Mother and Child* (1986) and *Primogenito* (1988). His commissions include the *Stations of the Cross*, St Mark's RC Church, Oxgangs Avenue,

Edinburgh (1959) and a cross for St Paul's RC Church, Pennywell Road, Edinburgh (1968). Winner of the Benno Schotz prize for portraiture in 1969, he was elected ARSA in 1972, and RSA in 1977.

Sources: Spalding; Billcliffe; McEwan.

Auguste-Nicolas Cain (1822–94)
Born in Paris, he worked as a joiner before studying sculpture under François Rude, Alexandre Guionnet and Pierre Mene, becoming a sculptor of monumental statuary, wax groups, and small animals and birds in bronze. His best-known public work is the equestrian *Monument to Duke Charles of Brunswick*, Geneva (1879). He exhibited at the Paris Salon from 1846, and won medals for his work in 1851 and 1863, and at the Exposition Universelle, Paris, 1867. A pair of stone lions by Cain outside the town hall of Oran, Algeria, is discussed, in slightly disparaging terms, by Albert Camus in his essay 'Minotaur or the Halt at Oran'.

Sources: S. Larni, *Dictionnaire de sculpteurs de l'école francaise au dix-neuvième siécle*, 1914–21, vol.1; Mackay; Albert Camus, *Summer*, Harmondsworth, n.d. (Penguin 60s), pp.20–2.

David Cation (fl.1740–56?)
Mason and carver known chiefly in connection with his work on the first phase of Glasgow Town Hall (1737–42), and who, together with Mungo Naismith (q.v.), probably carved the keystone masks known as the 'Tontine Faces' (see Castle Street, St Nicholas Garden, main catalogue). A Council minute of 1741 records that he was paid half a crown per day for a little over a year, with one shilling a day for his apprentice, but the document does not specify which parts of the building they were working on; a further payment of £3 2s. was made in 1742 for carving the jambs and hearthstones of the chimney-piece. He may also have been responsible for the capitals and other passages of decorative carving on St Andrew's Parish

Church (1739–56), again in collaboration with Naismith.

Source: Cowan, pp.434–5.

Kathleen Chambers (b.1942)
A graduate of the Department of Sculpture at GSA, she has taught in Scotland, Canada and Ireland, and exhibited work at the Pearce Institute, Govan, 1988, and the City Chambers, Glasgow, 1989. She participated in adult education with the Govan Environment Project, 1988–90, and has been Exhibitions Co-ordinator at GSA since 1990.

Source: information provided by the artist.

Sir Francis Leggatt Chantrey (1781–1841)
Born in Norton, Derbyshire. He trained as a wood-carver before taking up portrait painting, but became a full-time sculptor after his marriage to a rich cousin enabled him to build his own studio. After achieving major success with a bust of the radical reformer John Horne Took (1811), he received commissions for busts, monuments and full-length portrait statues, including *George Washington*, Boston, USA (1826), *William IV*, Trafalgar Square (1829) and *Sir Thomas Munro*, Madras (1838). Although he 'never received an hour's instruction from any sculptor in his life' (Gunnis), he was one of the most successful and prolific sculptors of his day, building a foundry to maintain his own exacting standards in bronze casting. Elected ARA in 1815 and RA in 1818, he exhibited at the RA from 1804 to 1842, and was knighted in 1835. His marble portrait of Sir Walter Scott in Abbotsford is generally regarded as his finest bust.

Sources: Gunnis; Cavanagh, p.325.

Giovanni Ciniselli (1832–83)
Italian sculptor, born in Novate near Milan, he studied at the Brera Academy and also in Magni's studio. In 1856 he settled in Rome, specialising in portraits, mythological subjects

and figures from the Old Testament, and exhibiting in both Europe and Australia. He died in Rome.

Source: Stevenson (n.d.).

Thomas John Clapperton (1879–1962)
Born in Galashiels, the son of a photographer, he studied at Galashiels Mechanics' Institute, 1896, GSA, 1899–1901, Kennington School of Art and the RA Schools, 1904–5, where he was student assistant to Sir William Goscombe John (q.v.). He later studied in Paris and Rome on a travelling scholarship. Returning to London, he set up studios at Chelsea and St John's Wood, receiving commissions for the *Mungo Park Memorial* and *Flodden Memorial* in Selkirk (1913), and allegorical figures on the National Museum of Wales, Cardiff (1914–37). After war service in India, he executed war memorials at Canonbie (1919), Minto (1921) and Galashiels (1925). He executed a colossal frieze for Liberty's store in London (1926), and in 1929 produced the statue of Robert the Bruce, at the portcullis, Edinburgh Castle. He also made work in New Zealand, Canada and California. His last important work was the *49th West Riding Reconnaissance Memorial*, Wakefield Cathedral (1947). Elected ARBS in 1923 and FRBS in 1938, he exhibited at the RGIFA from 1915 to 1951. He died at Upper Beeching, Sussex.

Source: Parker, *passim*.

Philip Lindsey Clark (1889–1977)
Son of the sculptor Robert Lindsey Clark, he studied in Cheltenham, 1905–10, the City and Guilds School, Kensington, 1910–14, and at the RA Schools after serving in the First World War. He exhibited at the RA from 1920 and at the Salon des Artistes, Paris from 1921. His output included war memorials, sculptures for churches and cathedrals, and the *Monument to William Dennis*, the 'Potato King', at Kirton, Lincolnshire (1930).

Sources: Waters; Mackay.

John Clinch (1934–2001)
Born in Folkstone, Kent, he studied fine art at Kingston School of Art, 1951–5, and sculpture at the RCA, 1957–61. A regular participant in group exhibitions since 1960, he held his first solo show in 1982. He has received several prestigious awards, including the Sir Richard Sainsbury Scholarship (1962), an ACGB Major Award (1979) and a Welsh Arts Council Travel Award (1989). His multi-figure, polychrome group in glass reinforced polyester, *Wish You Were Here*, was commissioned for the International Garden Festival at Liverpool in 1984. He was an ARBS and ARCA.

Source: Cavanagh, pp. 325–6.

Doug Cocker (b.1945)
Born in Perthshire, he studied at Duncan of Jordanstone College of Art, Dundee. In 1982 he was appointed Lecturer in Sculpture at Gray's School of Art, Aberdeen, but resigned in 1990 to become a full-time practitioner. He works on a colossal scale, combining formal simplicity with a concern for weighty social issues, but almost invariably leavening the political critique with a vein of ironic humour. Among his best works is *State of a Nation* (1985, destroyed), a Greek temple mounted on rockers, the entire exterior surface faced with tree bark. He is also a prolific draughtsman, and has developed a distinctive form of multi-compartment box construction to accommodate, in miniature, the prodigious outpouring of ideas for sculptures that would otherwise remain as two-dimensional designs on paper. A good example is *2 Tribes/40 Shades* (1989, private collection). He was elected ARSA in 1984, and in 1992 he was awarded a Wingate Scholarship.

Sources: Christopher Carrell *et al.*, *Doug Cocker: sculpture and related works 1976–1986*, (ex. cat.), Glasgow, 1986; Pearson, pp.113, 126; Patrizio, pp.44–9, 145.

Richard Coley (b.1938)
Sculptor in metal and fibreglass. Among the works he has exhibited at the RGIFA are *Solar* (1970), *Cathedral* (1971), *Saturn's Cradle* (1972) and *Pyramus* (1975); the latter two were also exhibited at the RSA.

Sources: Laperriere; Billcliffe; McEwan.

James Colquhoun (fl.1641–83)
Little is known about Colquhoun's life, and the two statues listed in the main catalogue are the only surviving works that can be attributed to him. It is recorded, however, that he repaired and gilded the clock on the original Hutchesons' Hospital (1683), and he is also credited with inventing Glasgow's first fire engine – an 'ingyne for slockening of fyre'. A wright by trade, he was something of a polymath, and has been described as 'a man of singular knowledge and skill in all mechanical arts and sciences'. He was, at different times, the Town Treasurer, Crafts Bailie and the Master of Works.

Sources: David Murray, 'Early Art in Glasgow', *Scottish Art and Letters*, vol.1, no.1, November 1901–January 1902, pp.13–14.)

Frank Cossell (fl.1965–7)
English sculptor about whom little is known other than that he lived at Herne Bay, Kent, and worked for the Architectural Department of British Rail. Recorded works by him include a statue of St Christopher at the railway station and a relief mural on the Tannery Buildings, Northampton.

Source: Johnstone.

John Crawford (1830–61)
Taken as a boy apprentice into the Mossman firm after his precocious talents were noticed by William Mossman Junior (q.v.), he became the workshop's 'favourite pupil'. A frequent prizewinner at GSA, he received press attention in 1848 when the art patron A.S. Dalglish

awarded him £5 for his copy of a statue of *Niobe*. In 1856, after completing his studies, he set up on his own at 28 Mason Street, producing work for John Thomas (q.v.) on the Houses of Parliament, London, and for John Honeyman on a monument in Bothwell (1856). He died with his wife and children in the typhus epidemic of 1861 and is buried in Sighthill Cemetery. A surviving son, John M. Crawford, became an architect.

Sources: GG, 8 July 1848, p.2; GH 13 December 1861(obit.); Eyre-Todd (1909), p.51.

John Creed (b.1938)
Sculptor in iron and steel. Born Heswall, Cheshire, he studied at Liverpool College of Art, 1955–9, and Liverpool University, gaining an Art Teacher's Diploma. He taught in the Department of Silversmithing and Jewellery at GSA, 1971–95, and became a professional blacksmith in 1988, establishing a forge at Milton of Campsie, East Dunbartonshire. Among his recent commissions are a set of sliding gates for the main entrance of Borders Regional Council Headquarters, Newton St Boswells (1990); internal double doors for the Royal Museum of Scotland (1995); *Constellation* (1997); and *Benchmark*, a series of sculptural seating units at Norrie Miller Park, Perth (1998). He exhibits widely and is represented in major public collections throughout the UK.

Source: information provided by the artist.

Cruikshank & Co. Ltd (1863–1985)
Decorative cast iron manufacturers and general ironfounders, based at the Denny Works, Stirlingshire. Very little is known about the company, and the fact that its products are rarely referred to in recent literature on ornamental ironwork suggests that it was much smaller than many of its contemporary rivals, such as Walter Macfarlane & Co. (q.v.). Nevertheless, examples of its ornate drinking fountains can be found in many Scottish towns, including Dundee and Newcraighall, Midlothian. Most of the company's records were destroyed in a fire in the 1980s, though some surviving documentation is now in Falkirk Museum Archive.

Source: Falkirk Museum.

Alan Dawson (b.1947)
Artist blacksmith, specialising in architectural metalwork, site specific street furniture and monumental free-standing sculptures. He was born in Whitehaven, Cumbria, and initially studied woodwork at Loughborough College of Art. After teaching metalwork for three years in a secondary school, he moved to a craft village near Cape Wrath, in the far north of Scotland, where he ran a candlemaking business. After participating in the inaugural conference of the British Artist Blacksmiths Association in 1978, he began to specialise in hand-forged work, later establishing Alan Dawson Associates Ltd in Workington, Cumbria. In addition to his numerous public commissions in Britain, including an activated sculpture based on a typewriter mechanism in the *Daily Express* building in London (1990) and *Delius Leaf* in Bradford, he has also executed a pair of Peacock Gates for the Sultan of Brunei and the entrance gates to Disneyworld in Paris.

Sources: Chatwin, pp.92–103; information provided by the artist.

Archibald C. Dawson (1892–1938)
Born in Hamilton, the son of an architectural carver, Mathew Dawson, with whom he initially trained. He studied at GSA, winning Haldane Trust awards between 1911–13. After war service in the Highland Light Infantry he returned to GSA, succeeding William Vickers (q.v.) as teacher of stone carving, 1920–38, with Alexander Proudfoot (q.v.) and James Gray as colleagues. He became Head of Modelling and Sculpture in 1929, and taught design, decorative art and figure pottery at the School of Architecture. He worked for the architectural carvers James Young & Son (q.v.) (later Dawson & Young), specialising in commercial and ecclesiastical buildings, among which were the early churches of Jack Coia. For the Russell Institute, Paisley (1924–7), he provided bronze groups using his wife and sons as models. He exhibited at the RGIFA, 1914–38, showing genre pieces and portrait busts, including *J.M. Groundwater* (1931) and *Jack Coia* (1933). A member of the Glasgow Art Club, he executed their *War Memorial* in 1922. He died at a friend's house at 81 Nithsdale Drive, and is buried in an unmarked grave in the Necropolis. Elected ARSA in 1936, his work is represented in private and public collections, including HAG and GAGM.

Sources: GH, 18 April 1938, p.13 (obit.); Dawson.

Helen Denerley (b.1956)
Born in Roslin, Midlothian, she studied at Gray's School of Art, Aberdeen, 1973–7, becoming a sculptor utilising farming implements, industrial machinery and scrap metal. Her early commissions include *Musical Play Sculpture*, for Aberdeen City Council (1977), *Sundial in Steel and Granite*, Sheltered Housing Complex, Inverurie (1991) and sculpture for the Princess Royal Trust Carers' Centre, Aberdeen (1994). A founder member of Aberdeen Community Arts Association, 1982, she was Director of Upper Donside Community Trust and Strathfest, 1989–94. She has exhibited regularly since the late 1970s, and her recent work, *Millie* (1999), modelled on her own horse and symbolising the working relationship between humans and animals over the past 1,000 years, was shown at the West of England Art Fair, Bath, 1999.

Sources: *Scotsman*, 12 May 1999, p.26; information provided by the artist.

Sir William Reid Dick (1879–1961)
Glasgow-born sculptor of figures, portraits and public monuments who lived for most of his working life in London. He served an apprenticeship with James C. Young and James Harrison Mackinnon (qq.v.) before receiving formal training at GSA and the City and Guilds School of Art, London. A regular exhibitor at the RGIFA, the RSA and the RA from 1912, he was elected RA in 1928 and president of the RBS in 1915. Major works include the equestrian group *Controlled Energy* on Unilever House, London and *Godiva* in Coventry, as well as studio pieces such as *Androdus* (1919) and *Dawn* (1921) in the Tate Britain Gallery. He was knighted in 1935, was King's Sculptor in Ordinary from 1938 and Queen's Sculptor from 1952.

Source: Buckman

Arthur Dooley (1929–94)
Liverpool-born sculptor of mainly religious subjects. Before studying sculpture he was an apprentice welder at Birkenhead Shipyards, a heavyweight boxing champion in the Irish Guards, a factory worker and a cleaner at St Martin's School of Art, London. He trained at the School from 1953, and began exhibiting in 1962 with a solo show at St Martin's Gallery. He worked mostly in bronze or scrap metal, receiving commissions from churches in England, Spain and Latin America. He was a Roman Catholic and a Communist, but also a passionate admirer of the Beatles, whom he commemorated with *Four Lads Who Shook the World* in Mathew Street, Liverpool (1974).

Source: Cavanagh, p.327.

Doulton & Co. (1815–)
Established as a pottery by John Doulton in 1815 at Vauxhall, London, the firm became Henry Doulton & Co., of Lambeth, in 1858. They patented improvements in the production of stoneware, earthenware and china, and won medals for their work at major international exhibitions. The firm flourished when terracotta was adopted by architects as a durable and easily produced building material, showcase examples being Alfred Waterhouse's Natural History Museum, London (1873–81) and the firm's own Lambeth headquarters. They produced statues, medallions, busts and other ornamental work from studios staffed by male and female crafts workers and students from the London art schools, all of whom were supervised by the chief designer A.E. Pearce and chief modeller George Tinwoth (qq.v.). Their work in Scotland includes a series of tiles of *Famous Inventors* in the Café Royal, Edinburgh (1901). The Lambeth works closed in 1956, but the company continues today at Burslem, Staffordshire (est. 1882).

Sources: Atterbury and Irvine, *passim*; Godden, pp.192–6.

Herbert Ellis (c.1877– c.1910)
An artist and modeller in stoneware and terracotta employed by Doulton & Co., of Lambeth (q.v.). In 1889 he won a prize in the Art Workmanship competition of the Society of Arts for a modelled ewer in silicon with a Bacchanalian subject.

Source: Bergesen, p.99.

George Edwin Ewing (1828–84)
Born in Birmingham, he worked as a sculptor in Liverpool and London, and briefly studied with John Gibson (q.v.) in Rome. In 1859 he established a successful practice in Glasgow as a portrait sculptor, producing busts of prominent Scots and the royal family, with Lord Clyde and the painter Thomas Faed among his sitters. His architectural and public work is rare, and his monuments to James Jamieson (1861) and David Miller (c.1862) in the Necropolis are at risk. Joined by his brother James Alexander Ewing (q.v.) in 1875, he lived and worked at various addresses in the city before he moved to the USA, c.1882, working in Philadelphia and New York, where he died. He exhibited at the RA, 1862–79.

Sources: *Bailie*, 1 April 1874; POD, 1859–82.

James Alexander Ewing (1843–1900)
Born in Carlisle, he received art training in England, but moved to Glasgow in 1875, where he remained for his entire career. He worked at first in collaboration with his brother George Edwin Ewing (q.v.), then independently with John Tweed as his assistant. Though chiefly a portraitist working in marble and bronze, he produced architectural sculpture for the Scottish Co-operative Wholesale Society and the figure of *Justice* on Dunbeth Municipal Buildings (1894). Among the many busts he produced are *Alexander Duff Robertson* (1880), *Alexander Smollet* (1882), *Ellen Terry* (1885, from a sketch by G.E. Ewing, lent by Sir Henry Irving) and *Sir Michael Connal* (1894). He also exhibited genre pieces at the RGIFA, including *Comin' thro' the Rye* (1878) and *Bonny Meg* (1879). His work is represented in GAGM and other public collections.

Sources: Woodward, pp.114–17; Billcliffe.

Aristide Fabbrucci (fl.1880–1903)
An architectural sculptor, born in Florence, but resident in London. He is an elusive figure, who may be identical with the sculptor known as Fabruzzi who introduced G.F Watts to the technique known as 'gesso grosso'. He is listed in Grant as a regular exhibitor at the RA from 1880 to 1903, showing portrait busts and imaginitive pieces such as *Federica Cockerell* (1882), *The ball player* (1883) and *First love* (1885), and with an address at 14a Hollywood Road, London. Walkley, however, cites '?Aristide Louis Fabbrucci' as the proprietor of a now demolished suite of studios at 454a Fulham Road, where his tenants included J.A.M. Whistler, Walter Sickert, Alfred Drury, Paul Raphael Montford and Henri Gaudier-Brzeska.

Sources: Grant; Read, p.285; Mackay; Giles Walkley, *Artists' Houses in London 1764–1914*, Aldershot, 1994, p.238.

Farmer & Brindley (fl.1860–1929)
London firm of architectural sculptors, decorators and church furnishers founded by William Farmer and William Brindley. Their work in Scotland includes a reredos in St Mary's Episcopal Cathedral, Glasgow (c.1874), furnishings in St Mary's Episcopal Cathedral, Edinburgh (1878) and a chimney-piece at 3 Rothsay Terrace, Edinburgh (1883). The firm amalgamated with another company after the partners' deaths.

Sources: Gifford, *et al.*, p.365; Cavanagh, p.328.

Richard Ferris (fl.1886–1915)
The son of a plasterer, he attended GSA, 1879–87, training under John Mossman and Francis Leslie (qq.v.). In 1886 his work was noticed by Robert A. McGilvray (1849–1914), who awarded him a cash prize for ornamental design and offered him a partnership in his firm. With their studio at 129 West Regent Street, they were responsible for the decorative carving on many Glasgow Style buildings and the plasterwork in several others, including Norwich Union Chambers (1898) and the plaster panels in the Willow Tea Rooms (1903) by C.R. Mackintosh (q.v.). For Honeyman & Keppie they executed carving on the Canal Boatmen's Institute (1891, demolished 1966), Queen Margaret College (1894) and a memorial tablet at Bellahouston Dispensary (1900). Ferris operated independently as a sculptor, exhibiting portraits at the RGIFA from 1885. He later taught modelling to evening students at the Glasgow and West of Scotland Technical College. The firm amalgamated with George Rome & Co. after McGilvray's death in 1914.

Sources: HAG, Honeyman & Keppie Job Books, 1890–1909; GSA Reports, 1879–87; GAPC, 1898–1903; GH 2 October 1914, p.4 (obit., McGilvray); Billcliffe.

James Fillans (1808–52)
Born in Wilsontown, a mining village in Lanarkshire. A self-taught sculptor and painter, he was apprenticed first as a handloom weaver in Paisley then as a stonemason with Hall McLatchie. He set up a studio in Paisley specialising in portrait busts, moving to Glasgow, c.1830, and finally settling at 8 High Holborn in London in 1835. His Scottish patrons remained faithful, commissioning wax portraits of William Motherwell (1835) and James Ewing of Strathleven (1845), a marble bust of architect John Burnet (1840) and the statue of Sir James Shaw, Kilmarnock (1848). Among his public monuments are *James Dick*, Old Kirkyard, Ayr (1840), *Jacobus Brown*, Necropolis (1846) and the model for *Grief*, or *Rachel Weeping For Her Lost Children* (1852). Originally intended for his father's grave in Woodside Cemetery, Paisley, *Grief* was completed in marble by John Mossman (q.v.) and placed over Fillans' own grave in Woodside in 1854. His work was exhibited at the RA, 1837–50, and posthumously at the RSA, 1916 and 1926.

Sources: Paterson; Gunnis.

Margaret Cross Primrose Findlay (1902–68)
A Glasgow-born sculptor, she was a pupil of Archibald Dawson (q.v.) at GSA, where she won the Guthrie Award enabling her to study in Italy. She exhibited at the RGIFA, 1925–35, and the RSA, 1928–34, showing mainly genre pieces including *Blind* (1925), *The Bathers* (1926), *Dorothy* (1928) and *Morning Song* (1935). She was an expressive modeller of small animals and also produced lead garden ornaments. Her career, however, was principally as an art teacher at Sir John Maxwell School, Hillhead High School, and King's Park Primary School. She lived at 30 Falkland Mansions, Hyndland, and retired in 1966.

Sources: GH, 1 February 1968, p.10 (obit.); Billcliffe.

Mark Firth (b.1952)
He trained as an engineer before studying fine art at Camberwell School of Art and sculpture at the Slade School of Art. His interest in engineering remains evident in many of his public commissions, including work for Marconi Radar Systems, the Chicago Research and Trading Company, as well as collaborative projects with British Airports Authority at Heathrow, IBM and British Rail Freight.

Source: Art in Partnership information sheet.

John Flaxman (1755–1826)
Born in York, he was the son of a caster and model maker who worked for the leading sculptors of the mid-eighteenth century. By 1767 Flaxman began to exhibit plaster models of classical figures at the Society of Arts, and in 1769 entered the RA Schools, where he befriended William Blake. Working with his father for Matthew Boulton in Birmingham and the Wedgwood factory, he designed cameos and made wax models of classical friezes and portrait medallions, which helped develop his linear style. In 1787 he visited Rome, where he remained for seven years, making monuments and producing his first book of illustrations, while also working as the Director of Josiah Wedgwood's pottery. His funerary works, such as the *Monument to Lord Nelson*, St Paul's Cathedral (1808–18), are considered his finest achievements. Public sculptures by Flaxman are rare in Scotland, but among them are *Christ Blessing Little Children*, St Cuthbert's Parish Church, Edinburgh (1802), and the statue of Robert Burns, SNPG (1822). He is also reputed to have modelled plaster reliefs for the Assembly Rooms, Glasgow (1796, demolished 1890).

Sources: Gunnis; Irwin; Noszlopy, p.191.

John Henry Foley (1818–74)
Born in Dublin, he was educated at the Royal Dublin Society Schools, 1833, and was admitted

to the RA Schools in 1835. He exhibited there from 1839, and in 1844 received the first of many commissions for statues of historical and contemporary political figures, including John Hampden, Palace of Westminster (1844), and the equestrian *Monument to Viscount Hardinge*, Calcutta (1858). His most famous work is the seated figure of the Prince Consort in the Albert Memorial, London, for which he also produced the representative group *Asia*. The commission was awarded to him after the death of Marochetti (q.v.), but Foley himself died before it was finished, and the statue was completed by his studio assistant Thomas Brock. He executed numerous portrait busts of society figures and monuments in churches throughout Britain, Ireland and India; he also designed the Great Seal of the Confederate States of America and the *Stonewall Jackson Monument*, Virginia (1874). He was elected ARA in 1849, and RA in 1858.

Sources: BN, 4 September 1874, p.283; Gunnis; Cavanagh, p.328; Brooks, pp.189–97.

Edward Onslow Ford (1852–1901)
Born in Islington, London, he originally studied painting at Antwerp Academy, 1870, but turned to sculpture while studying in Munich, 1871–4. A close associate of Alfred Gilbert (1854–1934), and a contributor to the New Sculpture movement, his many public commissions include statues of General Gordon, Chatham (1890, repeated at Khartoum, 1904) and Queen Victoria, Manchester (1901). He exhibited busts, statuettes and genre pieces at the RA from 1875, many of them with exotic subject matter drawn from Egyptian archaeology, such as *The Singer* (1889) and *Applause* (1893). He was elected ARA in 1888, and RA in 1895.

Sources: Spielmann, pp.51–63; Waters; Beattie, p.242; Mackay.

Robert Forrest (1791–1852)
A stonemason and self-taught sculptor, he was born in Carluke, Lanarkshire, near the Clydesdale quarries where he worked until being 'discovered' by an army officer named Colonel Gordon. His first commission was for a life-size *Highland Chieftain*, followed by *William Wallace*, for Lanark (1817). As a full-time sculptor he produced statues of literary and historical figures, and completed Chantrey's (q.v.) *Monument to Lord Melville*, St Andrew Square, Edinburgh (1822). Despite his secure reputation as a sculptor, in 1823 he began attending classes in drawing, modelling and anatomy in various private studios and schools, including the Trustees' Academy in Edinburgh and Warren's Academy in Glasgow. His education was continued in 1837 when he visited France and Italy. In 1832 he was given permission to set up a temporary exhibition hall beside the National Monument on Calton Hill, Edinburgh, to display four colossal equestrian statues of historical figures, including Robert the Bruce and Mary, Queen of Scots, each carved from a single block of sandstone weighing approximately twenty tons. The collection was subsequently extended to about thirty groups. Although the exhibition was well received, and did much to enhance his reputation as Scotland's 'national sculptor', it was not a financial success, and eventually proved ruinous. His most ambitious project was the design for a statue of the Duke of Wellington, commissioned by Lord Elgin for the summit of Arthur's Seat, Edinburgh. This was to be eighty feet tall, but remained unexecuted after Lord Elgin's death in 1841.

Sources: Anon., 'The Lanarkshire Sculptor', *Chambers Edinburgh Journal*, no.1 (1832), pp.357–8; *Descriptive Catalogue of Statuary from the Chisel of Mr Robert Forrest*, Edinburgh, 1835; *Scottish Reformers Gazette*, 4 April 1840, p.2; Robert Forrest, *Descriptive Account of Exhibition of Statues, National Monument, Calton Hill, Edinburgh*, Edinburgh, 1846.

Sir George James Frampton (1860–1928)
Born in London, he trained as an architect, then studied sculpture at Lambeth School of Art, under W.S. Frith (q.v.), and at the RA Schools, winning the Gold Medal and a travelling scholarship to Paris in 1887. A central figure in the New Sculpture movement, he produced ideal work, busts in marble and bronze, and received many commissions for architectural and public sculpture throughout the UK. These include terracotta decoration on the Constitutional Club, London (1883–6), the *Sailingship* and *Steamship* bronzes on Lloyds Registry, London (1902), the lions at the Edward VII Galleries, British Museum, for J.J. Burnet's London practice (1903–14) and sculpture on the façade of the V&A (1899–1908). His public monuments include statues of William Rathbone, Liverpool (1899), Queen Victoria, Newcastle (1901) and the W.S. Gilbert Memorial, Victoria Embankment, London (1915). Frampton's most popular work, however, is *Peter Pan* in Kensington Gardens, London (1912). After the First World War he executed the *Pearl Insurance War Memorial*, High Holborn, London (c.1918), and the *Edith Cavell Memorial*, St Martin's Place, London (1920). He exhibited at the RA from 1884, was elected ARA in 1894, RA in 1902, and served as PRBS, 1911–12. He was knighted in 1908.

Sources: Waters; Beattie, pp.243–4; Gray.

William Silver Frith (1850–1924)
A graduate of Lambeth School of Art and the RA Schools, he succeeded Jules Dalou as modelling master at SLTAS, 1880–95, and became 'one of the most successful instructors who ever worked in England' (Spielmann). As a student he won premiums for his entries in the Blackfriars Bridge competition (1884), for which he submitted an equestrian *Boadicea*, and the competition for the relief panels on St George's Hall, Liverpool. Principally an architectural sculptor, much of his work was in terracotta, including a figure of *Justice* on the

Victoria Law Courts, Birmingham (1887–91). A founder member of the RBS, he also produced decorative metalwork, as well as public monuments such as *King Edward VII*, Whitechapel.

Sources: Spielmann, pp.95–6; Beattie, p.244; Noszlopy, p.192.

Galbraith & Winton (1846–c.1970)

Firm of marble cutters, sculptors and stone engravers, established by William Galbraith in 1846 with a workshop at Kelvin Street and a showroom at 350 Argyle Street. In 1854, David Winton joined the firm, which remained active throughout the remainder of the nineteenth century, adding mosaic work to its range of practices and undertaking contract work for steamships. In 1913 the firm converted its steam power works at Kelvin Street to electricity, and continued to flourish until after the post-war period. In 1968 the firm moved to Hillington, and probably ceased to trade shortly afterwards.

Source: POD, 1846–1968.

Hans (sometimes Hanns) Gasser (1817–68)

Austrian painter, sculptor and collector, he was born in Eisentratten and learnt painting and carving from his father, a cabinet-maker and wood-carver. In 1838 he moved to Vienna to study at the Akademie, earning his living by painting portraits. He produced some architectural sculpture, but was most renowned for his portrait busts, as well as his work on unusual commissions, such as the figures on a bookcase presented in 1851 to Queen Victoria by the Emperor Franz Joseph. Among his best known works are a *Self Portrait* (1855) and the monument for Mozart's tomb in Vienna (1859). He died in Pest, Hungary, from a festering wound he received while carving.

Sources: HAG, GLAHA 44315, unpublished letter from Walter Krausse to Martin Hopkinson, 23 July 1981; Turner, vol.12, p.172.

John Gibson (1790–1866)

Born in Wales, he moved at the age of nine with his family to Liverpool. In about 1806, while apprenticed to a wood-carver, he met F.A. Legé, who brought him to the notice of his employers, Messrs Franceys, the Liverpool statuaries, who paid to cancel Gibson's existing indentures so that he might take an apprenticeship with them. His work there attracted the attention of William Roscoe, who supplied him with commissions, contacts and access to his collection of antique sculpture. In 1817, Gibson moved to London, but in the same year left for Rome, where he trained under Canova and Thorvaldsen. Apart from occasional visits to the UK, he remained in Rome for the rest of his life, undertaking lucrative commissions from wealthy English visitors. He was a friend and professional associate of the Scottish photographer Robert Macpherson, who photographed many of his statues. His most prestigious patron was Queen Victoria, upon whose statue he first introduced touches of colour, as Canova had done before him, in accordance with ancient Greek practice. The culmination of his experiments in polychromy is *The Tinted Venus*, in the Walker Art Gallery, Liverpool. He was elected ARA in 1833 and RA in 1838, exhibiting at the RA from 1816 until 1864.

Source: Cavanagh, p.329.

Ernest Gillick (1874–1951)

Born in Bradford, he studied at the RCA, later receiving commissions for public monuments and architectural sculpture throughout Britain and abroad. In London he carved statues of J.M.W. Turner and Richard Cosway for the façade of the V&A (1899–1908) and the *Britannia* group on the former National Provincial Bank, Princes Street, London. In 1909 he executed the memorial drinking fountain to the novelist Ouida (Marie Louise Ramé) at Bury St Edmunds, the *Monument to*

Sir Francis Sharp Powell, Wigan (1910) and monuments in India and New Zealand. After the First World War he executed the memorial to *The Missing*, Vis-en-Artois, France. A member of the Art Workers' Guild, he executed the medallion portrait of fellow Guild member Sir George Frampton (q.v.) for St Paul's Cathedral (1928). He was elected ARA in 1935.

Sources: Grant; Waters; Gray.

Nicholas John Gillon (b.1967)

A Scottish sculptor, he was educated at St Thomas Aquinas High School, Edinburgh and Duncan of Jordanstone College of Art, where he graduated with a BFA Hons in sculpture in 1991. He then became the Head of the Mould Making and Casting Departments at Wildtrack Wildlife Art Ltd in Perth (1991–3), and taught life drawing at Telford College of Further Education (1994–5). He has participated in group exhibitions since 1990, and his public commissions include four low relief panels for the Abbey Gate Development, Forfar (1992) and a replica statue of St Roland for Historic Scotland in Orkney (1994). He is currently based in Wigan.

Source: information provided by the artist.

Edward Good (fl.1888–1923?)

Architectural carver and sculptor based in the west end of Glasgow. His name first appears in the Post Office Directories in 1888, with an address at 376 Lansdowne Terrace, and later at 259 St Vincent Street, but disappears between 1891 and 1895, only to reappear for a year at 96 Napiershall Street in 1896. In 1889 he submitted an unsuccessful tender for the carver work at Anderson College of Medicine (56 Dumbarton Road, q.v.). His few recorded works include the Egyptian-style *Monument to James Sellars*, Lambhill Cemetery, designed by John Keppie (1890).

Sources: POD, 1888–96.; HAG, Honeyman & Keppie Job Book, 1881–94.

Douglas Gordon (b.1966)
Born in Glasgow, he studied with David
Harding in the Department of Environmental
Art at GSA, 1984–8, and attended the Slade
School of Art, London, 1988–90. He won the
Turner Prize in 1996, the Premio 2000 at the
1997 Venice Biennale, and the prestigious Hugo
Boss Award, New York, in 1998. Working in a
variety of media ranging across video, film,
photography and text, his installations include
24 Hour Psycho (1993) and *Déjà-vu* (2000). His
work was also included in *Between Cinema and
a Hard Place*, the inaugural exhibition at Tate
Modern, London, in 2000. A teacher as well as
an independent artist, he is a titular professor of
Fine Art at GSA.

Sources: H, 29 December 1997; Patrizio, pp.149–52.

Julian (Jules) John Gosse (b.1967)
A Scottish sculptor, he studied Fine Art at
Gray's School of Art, Aberdeen from 1986 to
1990, and is currently a lecturer in Product
Design at Glasgow College of Building and
Printing. He has participated in group
exhibitions, including *Benchmarks* at the House
for an Art Lover, Bellahouston Park, Glasgow
(1999–2000), in addition to undertaking
commissions for interior design work for
numerous private and public clients. He also
designed and fabricated a group of kinetic
'inventions' for the film *My Life So Far*,
directed by David Puttnam.

Source: information provided by the artist.

Edward Graham See Mortimer, Willison &
Graham

**Charles Benham (sometimes Blenkarn)
Grassby** (1834–1910)
A figurative sculptor from Hull, he worked in
London before establishing a career in Glasgow
spanning 48 years. He executed the carver work
on many churches and schools by John
Honeyman, including Methven UP Church

(1867) and Partick Free High Church (1869,
demolished). In 1865 he executed the memorial
to the stained glass artist David Keir in
Glasgow Cathedral burial ground. Outwith
Glasgow he worked on the Church Schools,
Aberfoyle (1870), Free West Church, Perth
(1872) and the Sailors' Home, Dundee (1881),
as well as many banks, municipal buildings,
private houses and commercial premises. His
Reformers' Monument ('Statue of Liberty') in
Kay Park, Kilmarnock (1885), was blown down
in a storm in 1936, and his gothic angel on the
Leiper Family Monument in Sighthill Cemetery
(c.1864) is now lost. He exhibited at the
RGIFA, mostly religious subjects, including
Christ in the Temple (1878) and *Blind Girl
Reading*. He occupied addresses at 139
Wellington Lane, 170 Pitt Street, and 40 Apsley
Street, Partick, where he died on 17 December
1910.

Sources: HAG, Honeyman & Keppie Job Books,
1861–94; POD, 1862–1911; GH, 20 December 1910,
p.6 (obit.); CI, 1911, p.246; GCA: AGN 1194; Tweed
(*Guide*), pp.37, 51; Eunson, p.25.

Robert Gray (fl.1850–)
Firm of monumental sculptors established at 44
York Street, and listed in the Post Office
Directories from 1857. They moved to 40
Bothwell Street in 1858, though by the late
twentieth century they were trading from 167
Clarence Drive. They operated workshops at
Sighthill Cemetery and the Western Necropolis
in Glasgow, as well as in Helensburgh, Largs,
Renfrew and Lochgilphead. The firm latterly
amalgamated with J. & G. Mossman (q.v.).

Sources: POD 1850–1978; Morgan.

John Greenshields (1797–1835)
Born in Lesmahagow, and apprenticed as a
mason, he became interested in sculpture while
employed by Robert Forrest (q.v.) in 1822, after
which he set up a studio in Milton, near
Carluke, Lanarkshire. He carved the pediment
of Hamilton Palace (c.1822, demolished 1926)

and a statue of *Robert Burns* for Australia. His
statues of George Canning (1827) and the Duke
of York (1828) received critical acclaim and his
statue of *King George IV* so impressed Sir
Walter Scott that he visited him in his cottage in
1829. Numerous portraits of Scott followed,
including the *sic sedebat* statue in Parliament
House, Edinburgh, the plaster model of which
is in Abbotsford. His last completed work was
The Jolly Beggars (1835).

Sources: Anon. (Daniel Reid Rankin), pp.302–24;
Gunnis; Pearson, p.156.

Paul Grime (b.1956)
Born in Stockport, Cheshire, now based near
Kelso as a multi-media artist producing murals,
mosaic and metalwork. He was a contributor to
the establishment of Dundee Public Art
Programme and in 1998 was appointed Artist in
Residence at Barrow, executing architectural
glass, metalwork, silkscreen prints and
landscape design projects for Barrow Borough
Council.

Sources: Castlemilk Environment Trust; information
provided by the artist.

Sybille von Halem (b.1963)
Born in West Germany, she moved to Britain in
1975, studying sculpture at GSA, 1981–5, and
Birmingham Polytechnic, 1985–6. Among the
group exhibitions she has participated in are the
Scottish Sculpture Open, Aberdeenshire (1987),
Sculpture from Scotland, Economist Plaza,
London (1988) and *New Sculpture in Scotland*,
Edinburgh (1988). A co-founder of Glasgow
Sculpture Studios, she was Artist in Residence
at the 1988 Glasgow Garden Festival, and in
1994 collaborated with Mike Osborne on
environmental improvement projects in Irvine
New Town.

Source: Scott, p. 38.

Albert Hemstock Hodge (1875–1917)
Born on Islay, he originally trained as an
architect in the office of William Leiper and at

GSA, where he regularly won local and national prizes for modelling and architectural design. His skill in modelling architectural details at Leiper's office persuaded him to turn to sculpture. He worked with the architects James Salmon and J. Gaff Gillespie (see Salmon, Son & Gillespie) and the sculptor Johan Keller (q.v.) on wood-carving at 22 Park Circus (1897–1900), but came to prominence with his temporary work on the Industrial Hall, designed by James Miller (q.v.) for the International Exhibition in Kelvingrove Park in 1901 (see Kelvingrove Park, Appendix A, Lost Works). He went on to produce colossal groups for Beaux-Arts buildings by Miller and J.J. Burnet (q.v.) in Glasgow and many major buildings in England, Wales and Canada. Moving to London in 1900, he was commissioned to make *The Daughters of Neptune* for the Guildhall, Hull (1907), *Navigation and Mining* for Mid-Glamorgan County Hall, Cardiff (1910) and pediment groups for the Parliament Buildings, Winnipeg (1916–19). Other commissions in Scotland include sculptures on Clydebank Municipal Buildings (1902). He also produced genre pieces and portraits, which he exhibited regularly at the RSA, 1897–1913, as well as public sculptures, such as the *Monument to Robert Burns* in Stirling (1914) and the *Monument to Captain Scott*, Mount Wise, Devonport (1914–25). He was a Fellow of the RBS.

Sources: A, 11 January 1918, p.16 (obit.); Beattie, p.245; Gray; Baker, pp.82–4.

Holmes & Jackson Ltd (fl.1892–1963)
Firm of sculptors, modellers and plasterers in partnership from 1892, becoming a limited company in 1929, and outlasting their rivals until 1963. They were very prolific at the turn of the century, winning many tenders for carver work on buildings by Honeyman & Keppie, including, Mackintosh's Queen's Cross Church (1899), a chimney-piece at Broughton House, Kirkcudbright, for the artist E.A. Hornel

(1908), the *Robert M. Mann Memorial*, Busby (1910), and the gateposts and sundial at Dineiddwg, Milngavie (1912). After the First World War War they executed the *War Memorial* for Lenzie UF Church (1920), and the carver work on Bank of Scotland, Glasgow Cross (1925). Both John Holmes and Mathew Jackson trained at GSA, and exhibited portraits and genre works concurrently with their commercial activities. Operating from premises at 61 Jane Street, 1892–1930, and 373 West Regent Street, 1930–62, they undertook commissions for decorative work on buildings throughout the city, but with the decline of architectural carving in the 1950s, they relied on contracts such as the plaster and roughcast work at Greenfield Primary School (1951). Jackson's son operated his own firm of carvers as Mathew Jackson & Co., 44 Jane Street, 1924–40.

Sources: HAG, Honeyman & Keppie Job Books, 1899–1963; POD, 1892–1963; Billcliffe.

Kenny Hunter (b.1962)
Born in Edinburgh, he studied at GSA, 1983–7, and has exhibited widely in the UK, France and Scandinavia, including the major shows *Hyperboreans*, Glasgow (1992) and *Work 1995–1998*, Bristol (1998). Winner of the Benno and Millie Schotz Award in 1991, his public work outside Glasgow includes *Four Youths*, Hamilton (1998) and *Interalia Stevenson Trail*, Sunderland (1995). His most recent commission, a full-size statue of Christ entitled *Man Walks Among Us* (2000), was awarded by Glasgow City Council to mark the Christian Millennium. His work is represented in the collections of the SAC, the British School in Athens, the SNPG, and GOMA.

Sources: Grant and Maver, pp.40–6; Kenny Hunter, *Work: 1995–1998* (ex. cat.), Arnolfini, Bristol, 1998, p.32.

Sir William Goscombe John (1860–1952)
The son of a Cardiff stone carver and sculptor

to the Marquess of Bute, he trained with his father and at Cardiff School of Art before moving to London in 1882. Here he became an assistant to the architectural sculptor William Nicholls, and studied at Lambeth School of Art under W.S. Frith (q.v.) and the RA Schools. After winning a gold medal and a travelling scholarship in 1889, he completed his studies in the Paris studio of Antonin Mercié, 1890–1. He produced ideal bronzes and portrait busts, and received many public commissions, particularly in his native Wales, including *David Lloyd George*, Caernarvon (1921) and at least fourteen other commemorative bronzes. In 1905, he executed memorials to the King's Liverpool Regiment, Liverpool, the Royal Army Medical Corps, Aldershot, and the Coldstream Guards, St Paul's Cathedral. Also for Liverpool, he executed an equestrian *Monument to King Edward VII* (1916), the *Engine Room Heroes Memorial* (1916) and statues of King George V and Queen Mary on the Mersey Tunnel (1939). A member of the Art Workers' Guild, he was elected ARA in 1899 and RA in 1909. He was knighted in 1911 and was awarded the RBS Gold Medal in 1924.

Sources: Spielmann, pp129–32; Gray; Fiona Pearson, *Goscombe John at the National Museum of Wales*, (ex. cat.), Cardiff, 1979; Beattie, p.245; Cavanagh, p.330–1; Stevenson (n.d.).

Francis (sometimes Franklin) William Doyle Jones (1873–1938)
A London-based sculptor, he trained with Édouard Lantèri and specialised in war memorials and portrait busts. His South African War memorials include those for Middlesbrough (1904), West Hartlepool (1905) and Penrith (1906). Other public works include several monuments: *Captain Webb* at Dover (1910), *Robert Burns* at Galashiels (1914), *T.P. O'Connor*, Fleet Street (1934) and *Edgar Wallace*, Ludgate Circus (1934). He exhibited at the RA 1903–36.

Source: Usherwood *et al*.

Johan Keller (1863–1944)

Born in The Hague, he was able, through the success of his father's novels, to study there and in Rotterdam, and to travel widely before settling in Glasgow as Professor of Sculpture at GSA, 1898. A key exponent of the Glasgow Style, he produced portraits and architectural sculpture, often in collaboration with Albert Hodge (q.v.) and the architects James Salmon Junior and J. Gaff Gillespie (see Salmon, Son & Gillespie). His statue of Dr John Gorman, Rutherglen (1901) represents a return to a more conventional style. He lived at Albany Chambers, Sauchiehall Street, 1898, and The Glen, Helensburgh, 1915, before returning to Holland where he spent the latter part of his life. He exhibited at the RGIFA, 1898–1915, and the RSA, 1899–1911.

Sources: GSA Reports, 1898–1911; AA 1905[1], p.120; Eyre-Todd (1909), pp.104–5; Mackay; Billcliffe.

Brian Kelly (b.1958)

Born in Paisley, he studied painting at GSA, 1976–80, and was awarded a postgraduate diploma in 1981. He has been involved with public art projects since 1979, and produced several gable end murals in and near Glasgow in the early 1980s, as well as interior and exterior work for a variety of commercial and community organisations. He was one of six Glasgow artists collaborating on the *Easterhouse Mosaic* (1982–4), a serpentine wall decoration commissioned by the Easterhouse Festival Society and measuring 3.5m × 61m. More recent murals include a series of six panels in Antonine Park, Dalmuir (1992) and a commission for Clydebank, 1994–5, combining three mosaic panels with six bronze sculptures. In addition to his public work, he has also contributed regularly to group exhibitions at various galleries in Scotland, including Transmission, Glasgow (1985 and 1987), and the Smith Museum, Stirling (1978, 1985 and 1986). He has worked as a part-time tutor at GSA, Duncan of Jordanstone College of Art,

Dundee and Chelsea School of Art, and since 1990 has been a full-time lecturer at GSA.

Sources: Carrell, p.11; Ray McKenzie, *The Eye of the Storm*, Stirling, 1986 (ex. cat.), p.16; Guest and Smith, p.18; information provided by the artist.

Jake Kempsell (b.1940)

Scottish sculptor and teacher, born in Dumfries and educated at Edinburgh College of Art, where he graduated with a postgraduate diploma in 1965. He had his first solo show at the Richard Demarco Gallery, Edinburgh, in 1970, and was represented at the British Art Show in 1979–80. Since then he has exhibited widely in Scotland, England and Wales and undertaken numerous public commissions. He was a founder member of the Scottish Sculpture Trust and a director of Workshops and Artists' Studio Provision Scotland (Wasps) until 1983. In 1982 he was invited to join the Faculty of Sculpture at the British School in Rome, and was Faculty Visitor there in 1985. He was Director of Sculpture at Duncan of Jordanstone College of Art, Dundee, from 1975 to 2000.

Sources: Jake Kempsell, *Voids and Constellations*, Dundee, 1997 (ex. cat.); information provided by the artist.

Eric Henri Kennington (1888–1960)

Born in Chelsea, London, son of the painter T.B. Kennington, he studied at Lambeth School of Art and at the City and Guilds School of Art, London, becoming a painter and sculptor of portraits and ideal work. He served in the First World War, 1914–15, and became an Official War Artist, 1916–19, and again in 1940–3. A friend and travelling companion of T.E. Lawrence, he executed his effigy at Wareham Church, Hants, and exhibited a bust of Lawrence at the Empire Exhibition, Glasgow, 1938 (no.224a). He also executed sculpture at the Shakespeare Memorial Theatre, Stratford-upon-Avon (1928) and the *Monument to Thomas Hardy* at Dorchester, Dorset (1931). He exhibited at the RA from 1908, and the RSA

from 1948. Elected ARA in 1951, and RA in 1959.

Sources: Darke, pp.96–7, 160; Mackay; Nairne and Serota, p.255.

Shona Kinloch (b.1962)

Born in Glasgow, she studied sculpture at GSA, 1980–5, and now specialises in animal and figure sculptures. The winner of the Benno and Millie Schotz Award in 1985, and a Saltire Society Award in 1992, her work is represented in numerous public collections, including GAGM and the Lillie Art Gallery, Milngavie. In addition to her public works in Glasgow, she has work in Edinburgh, Kilmarnock, Loughborough and East Kilbride, where she lives. Among her most recent commissions is *The Square Stars*, Hamilton (1998). She has exhibited regularly throughout the UK since 1984, and her *Seven Glasgow Dogs* was a popular feature at the Glasgow Garden Festival in 1988.

Sources: Murray, pp.62–3; information provided by the artist.

Rick Kirby (b.1952)

Born in Gillingham, Kent, Kirby is a London-based figurative sculptor working mainly in metal. His commissions include the large-scale work *Cross the Divide* (2000), on the south bank, London.

Source: Castlemilk Environment Trust.

Gerald Ogilvie Laing (b.1936)

Born in Newcastle, he trained as an officer at Sandhurst, 1953–5, then as a sculptor at St Martin's School of Art, 1960–4. He lived in New York until 1969, later moving to Kinkell Castle, Dingwall (receiving the 1971 Civic Trust Award for its restoration). In 1971 he produced a number of large abstract 'monoliths' for outdoor sites in the north of Scotland, including *Division* in the Highland Sculpture Park, Carrbridge, and in 1979 he was commissioned

by Standard Life Assurance, George Street, Edinburgh, to execute a bronze relief of *The Wise and Foolish Virgins*, a modern re-interpretation of the building's pediment group by Sir John Steell, of 1839 (see also Standard Buildings, 82–92 Gordon Street). Recent commissions include *The Fountain of Sabrina*, Bristol (1981), a bronze *Cricketer*, for Sir Paul Getty (1998), *Stone Dragon*, for Bluewater Shopping Centre, Dartford (1999), and *In Memory* (2000), for Creag Bunuillidh, Helmsdale, to commemorate victims of the Highland Clearances.

Sources: Strachan, pp.220, 224, 263; H, 30 April 1998, p.11; *Scotsman*, 24 February 1999, p.8, 3 June 2000, p.12.

Adrian Russell Lamb (b.1964)
Born in Sedgefield, Co. Durham, he trained at Middlesex Polytechnic, 1982–3, Chelsea School of Art, 1983–6, and the RCA, 1986–8. He later studied landscape and architecture in France and Italy on a Travel Bursary from Northumberland Council. A freelance artist since 1988, he taught at the École D'Arts Plastiques, Monaco, before settling in Glasgow. He is now based at Glasgow Sculpture Studios, where he has acted as technical assistant to Iain McColl and Kenny Hunter (q.v.), in addition to working on independent projects such as a commission for work at an architectural development in Newmacher, Aberdeen.

Source: information provided by the artist.

George Anderson Lawson (1832–1904)
Edinburgh-born sculptor of imaginative figures and groups illustrative of literary subjects. He trained under A.H. Ritchie (q.v.) and Robert Scott Lauder at the Trustees' School of Design before setting up a studio at 36 St George's Place, Glasgow, in 1860. After visiting Rome he settled in Liverpool, where he won the *Wellington Monument* competition with his architect brother Andrew Lawson (1864). From 1866 he lived in London but maintained contact with artists and patrons in Scotland. He executed figures of *Robert The Bruce*, *Baillie Nicol Jarvie* and *Diana Vernon* on the Scott Monument, Edinburgh (1874), the statues of *Lord Cochrane*, Valparaiso (1874), *Joseph Pease*, Darlington (1875), and monuments to Robert Burns in Ayr (1891), Belfast (1893), Halifax, Nova Scotia, and Melbourne, Australia (1904). Among his portrait busts and narrative works are *George MacDonald* (1887), *Jeanie Deans* (n.d.) and *Motherless* (1901). His architectural sculpture, which is rare, includes a bronze relief representing *The Arts* on Aberdeen Art Gallery (1905). Elected HRSA in 1884, he exhibited at the RA, 1862–93, the RSA, 1860–92 and the RGIFA, 1870–92. He died in Richmond, Surrey.

Sources: BN, 9 May 1890. p.672; Spielmann, pp.20–1; Woodward, pp.114–16; Cavanagh, p. 332.

Francis Leslie (1833–94)
Born in Glasgow, he trained at GSA, where he won a prize for figure modelling, 1850, and taught modelling, 1885–8. He also worked in London with J.H. Foley and G.A. Lawson (qq.v.), 1870–5, before returning to Glasgow to assist G.E. Ewing (q.v.) and John Mossman on many Glasgow monuments, as well as architectural commissions such as Greenock Municipal Buildings (1879–86). An active member of the Glasgow Art Club, he executed portrait busts and exhibited at RGIFA, 1863–92, and at the International Exhibition, Kelvingrove Park, 1888. He occupied addresses at 87 Abercromby Street, 1861, 7 Park Place, 1871, and 79 Grove Street, 1881, before moving to Edinburgh, c.1890.

Sources: GSA Reports, 1885–8; Billcliffe; McEwan.

Alexander Beith MacDonald (1847–1915)
Born in Stirling, he was City Engineer in Glasgow from 1890 to 1914, during which time he was responsible for planning and designing most of Glasgow Corporation's public buildings and works. He was apprenticed to the Glasgow civil engineers Smith & McWharrie in 1862, and studied engineering, natural philosophy and mathematics at Glasgow University. He joined the City Architect's office in 1870, assisting in the work of the City Improvement Trust, and in the erection of tenements, baths, washhouses, markets, police offices and fire stations. He used statuary sparingly, but most of his buildings are distinguished by splendid armorial bearings affirming the power and authority of the Corporation and revealing the adaptability of the city's arms to imaginative sculptural treatment. He died after falling from a tram in Sauchiehall Street, and is buried in the Western Necropolis.

Sources: *Bailie*, 25 November 1896, 4 May 1910; GH, 2 November 1915, p.10 (obit.); BN, 10 November 1915, p.296 (obit.).

Walter Macfarlane & Co. (1849–1965)
Also known as the Saracen Foundry, Macfarlane's was the most important manufacturer of ornamental ironwork in Scotland, producing drinking fountains, bandstands, lamp standards, prefabricated buildings and architectural features for a client base stretching from Australia to the Amazon. Founded by Walter Macfarlane (1817–85) in 1849, in Saracen Lane, off the Gallowgate, the firm moved to a purpose-built foundry at 73 Hawthorn Street, on Sir Archibald Alison's former Possil Estate in 1872, creating the suburb of Possilpark to house the firm's vast workforce. With the emphasis on artistic utility, the firm mass produced patterns designed by the architects James Boucher, James Sellars (q.v.), John Burnet and Alexander 'Greek' Thomson, and employed sculptors such as James A. Ewing (q.v.) to craft the commemorative busts and other interchangeable sculptural features incorporated into the designs as required. They also produced Glasgow's earliest police phone boxes

(1889). Though little of their free-standing work survives in Britain, and vast quantities of their architectural crestings and railings were removed during the Second World War, many examples of their castings survive elsewhere as evidence of the firm's importance on the global market and the elegance and durability of their products. In the inter-war years the firm produced cast-iron panels for commercial buildings, including the former Union Bank, 110–20 St Vincent Street (1924–7) and Selfridges, London (1928). A fine example of their surviving commemorative work is the *Queen Victoria Diamond Jubilee Drinking Fountain*, Overnewton Park, Rutherglen (1897), which, until recently, incorporated a bust of the Queen. In 1965 Macfarlane's was taken over by Allied Founders, which was itself absorbed by Glynwed Ltd; the Possilpark works were demolished two years later. In recent years the firm's patterns, and those of its competitors, have been revived and reproduced by Glasgow-based Heritage Engineering.

Sources: GCA TD 299/2/2: *Macfarlane's Castings*, vols 1 and 2; *Stratton's Glasgow and its Environment*, pp.98–9; Slaven and Checkland, vol.1, pp.125–7; Williamson *et al.*, p.495.

James Pittendrigh Macgillivray (1856–1938)
Born in Inverurie, son of the sculptor William Ewan Macgillivray, he trained in the Edinburgh studio of William Brodie (q.v.) from the age of thirteen and in Glasgow with the ornamental plasterer James Steel (q.v.), for whom he executed the interior decoration and carved elephant on the Scotia Theatre, Stockwell Street. He later assisted John Mossman (q.v.) before becoming an independent sculptor. Occupying a studio at 112 Bath Street, he produced portrait busts of Joseph Crawhall (1881) and Thomas Carlyle (1889), monuments in the Necropolis to Peter Stewart (1887), Annie Greenhill (1889) and Sir James Robertson (1889), the *Margaret and Annie Brown Monument*, Cathcart Cemetery (1888)

and the *James Sellars Monument*, Lambhill Cemetery (1890). A painter, philosopher, musician and distinguished poet as well as a sculptor, he was a close associate of the group of artists known as the 'Glasgow Boys' and a co-founder of the *Scottish Art Review*. Moving to Edinburgh in 1894, he produced numerous busts and medallions for Edinburgh patrons, as well as funerary works such as the *Monument to Peter Lowe*, Glasgow Cathedral (1893). He also produced a report for the Scottish Education Department, which contributed to the establishment of Edinburgh College of Art, and became Sculptor Royal in 1921. His small-scale pieces are well represented in collections in Glasgow and Edinburgh, though his public works are rare. The most important of these are the *Monument to Robert Burns*, Irvine (1895) and a multi-figure *Monument to William Ewart Gladstone*, Edinburgh (1899–1917). His architectural work outside Glasgow includes sculpture on Dumfries Public Library (1904).

Sources: Spielmann, p.151; GH, 30 April 1938, p.13 (obit.); NLS, MS. Acc. 3501, nos.1–38; Melville, *passim*.

David Mach (b.1956)
Born in Methil, Fife, he studied at Duncan of Jordanstone College of Art, Dundee, 1974–9, and at the RCA, London. He usually works on a colossal scale, using waste products, consumer durables and multiples such as newsapers, bricks, containers, toys and tyres to produce both temporary and permanent installations. His first public work, *Rolls Royce*, was created from thousands of old books, and his *Temple at Tyre*, Leith Docks, Edinburgh (1994), was built using discarded car tyres. His work has been exhibited in Britain, Europe and the USA, and is represented in major international collections. His best known recent work is *Train*, Darlington (1997), a simulated steam railway engine constructed from 200,000 engineering bricks.

Sources: McEwan; Guest and McKenzie, pp.24–5;

Hartley, pp.86–7; Usherwood *et al.*, p.329.

James Harrison Mackinnon (1867–1954)
Scottish sculptor of architectural decoration and small figures, born in Pollockshaws, Glasgow. After beginning his career as an ornamental mason, he later become a sculptor and a teacher of carving at GSA (1891–8). He also trained a number of younger sculptors as apprentices, including Sir William Reid Dick (q.v.). In addition to his contribution to the decorative programmes of numerous major public buildings in Glasgow, he also undertook many important restoration commissions, including 'the delicate task of recutting about eighty figures' in Paisley Abbey. Among his other major public works were the Mercat Cross in Perth and the city's coat of arms.

Sources: Anon., 'Architectural Sculptor', GH, 8 November 1954, p.9 (obit.); Billcliffe; McEwan.

Charles Rennie Mackintosh (1868–1928)
Born in Glasgow, the son of a police superintendent, he trained with John Hutchison in 1884, and attended architecture and modelling classes at GSA, winning a prize for modelling and the Alexander Thomson Travelling Scholarship in 1890. He joined the architectural firm of Honeyman & Keppie as a draughtsman in 1889, becoming a partner in 1904. He collaborated with his wife, Margaret Macdonald (1860–1933), on *repoussé*, gesso panels and the models for the sculptural details on his buildings. His designs for architectural sculpture were rarely executed, but the necessity for practical features in wrought iron, such as railings and gates, provided an outlet for his sculptural imagination, with plant forms, insects, birds and the regeneration of nature and the human spirit as recurrent symbolic themes. He also designed the *Monument to A.O. Johnston*, MacDuff Cemetery, East Wemyss (1905). After a disastrous attempt to pursue an independent practice in London he settled in Port Vendres, France, as a painter but returned

to London after being diagnosed with cancer. He has since become recognised as Glasgow's most important designer.

Sources: Gray; Blench, *et al.*, pp.32–5.

John P. Main (fl.1896–1928)
A Glasgow-born sculptor and painter, resident at Pollokshields and Clarkston. He studied at GSA in the 1890s under William Kellock Brown and Francis Derwent Wood (qq.v.), winning national competitions, 1893–8, including a bronze medal for *Fighting Gladiator*, 1895, which received high praise from examiners W.H. Thornycroft (q.v.), Thomas Brock, E.O. Ford (q.v.) and H.H. Armstead. He executed portrait busts, decorative panels and statuettes, but was more productive as a painter of landscapes and subjects relating to the River Clyde. Among the many works he exhibited at the at RGIFA were *Architectural Panel* (1897), *The Song* (1902) and *The Young Highland Chieftain* (1907).

Sources: GSA Reports, 1893–8; Billcliffe; Pearson, p.149.

Baron Carlo Marochetti of Vaux (1805–67)
Born in Turin, his family settled in Paris and became naturalised French citizens when Piedmont was ceded to Italy in 1814. He studied under Baron François Boscio at the École des Beaux-Arts, Paris, and exhibited work at the Salon of 1827. He worked on genre groups in marble and plaster, but became celebrated for his bronze equestrian statues; in Turin, *Emanuel Filiberto* (1833); in Paris, *The Duke of Orleans*, and in London *Richard Coeur de Lion* (1860). A darling of the French and Italian courts, his urbane personality and brilliant sculptural style quickly endeared him to the British *cognoscenti* after he fled Paris in the revolution of 1848. Executing portraits of the British establishment and middle class increased his celebrity, but his rivals criticised his public work as being flashy and theatrical,

citing the *Monument to the Duke of Wellington* in Glasgow, as a typical example. He also executed the *Crimean War Memorials* at Scutari and St Paul's Cathedral. Among the international honours bestowed upon him were a Baronetcy of the Italian Kingdom (for which he took the name of his father's château) and the French Légion d'honneur. He was elected ARA in 1861, and RA in 1867, having exhibited at the RA from 1851.

Sources: DNB; Mackay.

H.H. Martyn & Co. Ltd (fl.1906–25)
Firm of sculptors, carvers and modellers producing architectural sculpture, metalwork, ornamental plasterwork and joinery, with reproductions of Grinling Gibbons' carvings a speciality. Founded in London, the company also had studios in Cheltenham and Birmingham. Their Glasgow studio opened in 1909 and operated from a variety of premises (including 30 George Square and 93 West George Street) until 1925. They provided metalwork for the former Union Bank, 110–20 St Vincent Street (1924–7).

Sources: AA, 1906; POD, 1909–25.

John McArthur (b.1941)
Born in Glasgow, he worked as a boilermaker and plater at the Fairfield Shipyard, becoming Training Centre Manager and assisting apprentices in producing *Sunburst, Cloud and Rain* for Irving New Town Shopping Centre. On retiring he joined the Govan Reminiscence Group, and was a founder member of Govan Practical and Historical Art Group, 1991, collaborating on relief panels for Fairfield's and a model of Govan (1913–45), exhibited at Govan Library, 2000.

Source: information provided by the artist.

Keith McCarter (b.1936)
Born in Scotland, he served in the Royal Artillery before entering ECA in 1956. He was

the winner of the Andrew Grant Scholarship in 1960, which enabled him to travel in Europe, and after a further period of travel in the USA he joined the staff of Hornsey College of Art as a visiting lecturer. After his first solo show in Burleighfield in 1978, he began to receive commissions for large outdoor abstract sculptures, usually in bronze, including *La Primavera*, in Copthorne, East Sussex (1978) and *Ridrich*, in Aldgate, London (1980). Since 1966 he has also produced many sculptures for buildings.

Source: Strachan, pp.33, 89, 144, 265.

Hector McGarva (b.1944)
Metal fabricator trading under the name of his father's firm, Samuel McGarva & Son. A frequent collaborator with Jack Sloan (q.v.) he has also worked on commissions with the architects Page & Park (q.v.) and the engineer Jim Gilchrist.

Source: information provided by the artist.

Robert A. McGilvray (1849–1914) and **McGilvray & Ferris** See Richard Ferris

James Miller (1860–1947)
Born in Auchtergaven, Perthshire, he trained with local architect Andrew Heiton, then in various offices in Edinburgh. In 1888 he became staff architect for the Caledonian Railway Company, designing stations and hotels in the west of Scotland, the finest of which were at Botanic Gardens, Glasgow (1894, demolished 1970), and Wemyss Bay (1903–4). He established his Glasgow practice in 1893, producing churches, tenements and houses throughout the city and elsewhere in Scotland. Winning the competition for the buildings of the 1901 International Exhibition, Kelvingrove Park, he became associated with Albert Hodge (q.v.), employing him on sculpture and plasterwork for the Industrial Hall (see Kelvingrove Park, Appendix A, Lost Works).

This was to make both their reputations and further collaborations followed, including Clydebank Municipal Buildings in 1902. Miller is chiefly remembered for his massive, American-style mercantile buildings in Glasgow, of which the former Union Bank, 110–20 St Vincent Street (1924–7) is a notable example. Among his buildings outside Scotland are the Prince of Wales Museum of Art, Bombay (1908) and the Institute of Civil Engineers, Westminster (1912). A little-known Glasgow work is the *Monument to David Younger*, Cathcart Cemetery (1904), with bronzes by William Kellock Brown (q.v.).

Sources: GH, 1 December 1947, p.4 (obit.); Gomme and Walker, p.275; Gray.

Dhruva Mistry (b.1957)
Born in Kanjari, Gujarat, India, he studied at the University of Baroda, and at the RCA, 1981–3. He become a Fellow and Artist in Residence at Churchill College, Cambridge, in 1984 and Artist in Residence at the V&A in 1988. He held his first solo exhibitions in Delhi (1981), and at the Walker Art Gallery, Liverpool (1986), and contributed work to the garden festivals at Liverpool, 1984 (*Sitting Bull*), Stoke-on-Trent, 1986, and Glasgow, 1988 (*Reclining Woman*). He has also received commissions for public works in Japan (1987), Wales (1990), Birmingham (1992) and London (1992), and represented Britain at the third Rodin Grand Prize, 1990. He was elected RA in 1991.

Sources: Murray, pp.76–7; Cavanagh, pp.61, 333.

Paul Raphael Montford (1868–1938)
Son of the London sculptor Horace Montford, with whom he trained before studying at Lambeth School of Art, and the RA Schools, where he won three painter's and seven sculptor's prizes, including a gold medal in 1893; he was also awarded the Landseer Scholarship and a Travelling Scholarship in

1891. He taught modelling at Chelsea Polytechnic from 1898, and produced much architectural sculpture, including reliefs on Battersea Town Hall (1892), Cardiff City Hall (1901–5) and figures of Caxton and George Heriot on the V&A. His work at this time was described as: 'Vigorous in style, excellent in drawing, and though a little academic and not strikingly original, it is decorative in character and vigorous in conception and handling' (Spielmann). He later executed bronze busts of Sir Henry Campbell-Bannerman, Westminster Abbey (1908) and Sir William Randall Cramer, Geoffrye Museum (1908). After the First World War he moved to Melbourne, Australia, where he executed the *War Memorial* (1922) and other public statues.

Sources: Spielmann, pp.151–2; B, 28 January 1938, p.196 (obit.); Gray; Makay.

Anthony Morrow (b.1954)
A Scottish sculptor and teacher, he studied Fine Art at Duncan of Jordanstone College of Art, Dundee (where he won the Mitchell Prize for the best First Year student in 1988), and Art Therapy at Hertfordshire College of Art (1991–2). In 1996 he won the Brenda Clauston Award for Sculpture. His work has been exhibited widely in Scotland, and as a partner in Gilmor Sculptures since 1993 has undertaken numerous public commissions, including a bronze *Dragon* in Murraygate, Dundee (1994) and the restoration of the bronze statue of *Peter Pan* in Kirriemuir (1994). He has been Head of Sculpture at Dundee College since 1997, and is currently producing a pair of colossal bronze statues of the cartoon characters *Desperate Dan* and *Minnie the Minx* for the City Square, Dundee.

Source: information provided by the artist.

Mortimer, Willison & Graham
(fl.1938–*c*.1961)
John (Jack) Mortimer (1912–61), Andrew

Willison (d.1944?) and Edward Graham (b.1914) trained as carvers with James C. Young and Archibald Dawson (qq.v.) in the 1920s, while studying stone carving at GSA; Willison also taught carving at the school, 1934–8. As apprentices they worked on several buildings in Glasgow (e.g., 200 St Vincent Street, 1927, q.v., main catalogue) alongside apprentices from Italy and New Zealand. Becoming partners in 1938, they produced sculpture for the Empire Exhibition, Bellahouston Park (see Appendix A, Lost Works), and several Roman Catholic churches by Jack Coia, such as St Columbkille's, Rutherglen (1940) and St Paul's, Shettleston (1958), with Mortimer making the main contribution. Mortimer also executed the *St Aloysius College War Memorial*, (1948). The firm was wound up after Mortimer's death in 1961.

Sources: GH, 10 October 1953, p.5; GUABRC, IP6/1/38 (unidentified newspaper cutting, n.d., dated by hand 10 October 1955); Rogerson, p.117; information provided by Edward Graham.)

J. & G. Mossman (fl.1816–)
Firm of architectural sculptors and monumental masons founded in Leith by William Mossman Senior (q.v.), with sons John (q.v.), George and William (q.v.) as successors. They moved to Glasgow, *c*.1828, later taking advantage of the newly opened Necropolis to establish themselves as Glasgow's most successful firm of monumental masons. They also produced much of Glasgow's architectural sculpture in the second half of the nineteenth century and trained several sculptors of note. Relying on their monumental business during building slumps, they acquired a granite quarry in Creetown, Kirkcudbrightshire, and appointed former assistant Peter Smith (d.1911) as manager of their granite workshop in Glasgow. Smith later worked independently as a rival from 1875, then purchased the firm in 1890 after John Mossman's death. Continuing to operate under the firm's original name, he concentrated on monuments and later

diversified into building shopfronts. The firm passed to his descendants, the Pollock Smiths, who later amalgamated with Robert Gray. It is still trading today, with premises at 284 High Street.

Sources: GCA, AGN 255; Morgan, p.15; Stoddart (1980).

John Mossman (1817–90)

Born in London when his father, William Mossman Senior (q.v.), was working for Francis Chantrey (q.v.), he was the brother of George (1823–63) and William Junior (q.v.), and father of a third William Mossman (1843–77). He studied under his father and with Baron Marochetti (q.v.), and later with Sir William Allan at the RSA in 1838. He moved to Glasgow c.1828, working in his father's firm of monumental masons, and made his name with the *Peter Lawrence Memorial*, Necropolis (c.1840; see Appendix A, Lost Works). A prolific society portraitist, his many busts include *William Connal* (1856), *The Duke of Hamilton* (1864) and *Alexander 'Greek' Thomson* (1877). As an architectural sculptor he worked for the most important architects of his day in Glasgow, dominating the scene until his retirement in 1886. He was the most important maker of statues of his generation in the west of Scotland, providing Paisley with monuments to Patrick Brewster (1863), Alexander Wilson (1874) and George A. Clarke (1885), but also executing work for overseas, such as the *Viscount Ormiston Monument* for Bombay. One of the founders of GSA in 1844, he taught modelling there, and served as visiting master and member of the Committee of Management until 1890. At his workshop he trained Walter Buchan, James Young, James Pittendrigh Macgillivray and Francis Leslie (qq.v.) amongst others, and with his brother George he ran the family firm of J. & G. Mossman (q.v.). He exhibited at the RA, 1868–79, and the RSA, 1840–86, and was elected HRSA in 1885. He died at Port Bannatyne, and is buried at Sighthill Cemetery, Springburn.

Sources: *Bailie*, 21 October 1874; GH, 26 September 1890 (obit.); Gildard; Stoddart (1980) *passim*.

William Mossman Senior (1793–1851)

Glasgow-born carver and monumental sculptor, and founder of the firm J. & G. Mossman (q.v.) which dominated public sculpture in Glasgow for most of the nineteenth century. A descendant of James Mossman, goldsmith to Mary, Queen of Scots, he was the father of John Mossman (q.v.), George Mossman (1823–63) and William Mossman Junior (q.v.). After spending time as a pupil of Francis Chantrey (q.v.) in London, he moved to Leith, c.1821, to set up as a monumental sculptor. Towards the end of the decade he moved his family to Glasgow, and became the manager of David and James Hamilton's marble business. As an architectural sculptor he carved details on several of Hamilton's buildings, including St Paul's Church, John Street (1836, demolished 1906) and Mosesfield, Springburn (1838). He also executed death-masks, chimney-pieces for steamboats, and the gothic *Monument to Lord Cathcart*, Paisley Abbey (1848). He attempted to establish himself as a portraitist with busts of James Cleland (1831, reputedly the first marble bust executed in Glasgow), David Hamilton, and Thomas Muir of Huntershill (1831), but failed to impress the critics. However, with the opening of the Necropolis in 1833 his success as a monumental sculptor was assured. Thereafter he concentrated on training his sons in the family business. He exhibited at the RGIFA, 1829–33.

Sources: POD, 1830–51; Gildard; GCA: TD 110; Gunnis.

William Mossman Junior (1824–84)

Born in London, the youngest son of William Mossman Senior, and brother of John Mossman (qq.v.) and George Mossman (1823–63). He trained in the family firm and in the London studios of Marochetti (q.v.), William Behnes, and John Thomas (q.v.), for whom he produced carving work on the Houses of Parliament, London. He collaborated with his brother John on several important sculpture schemes in Glasgow, but also worked independently as an architectural sculptor. He taught modelling at GSA, 1869–71, where his pupils included William Shirreffs (q.v.), and exhibited portrait busts and wax medallions at the RGIFA, 1862–84, the latter including the architect John Honeyman and his wife (1877). He was also busy as a monumental sculptor, working with his brothers and on his own, and later formed the partnership Mossman & Wishart (1880–4) in Aberdeen. The firm continued as William Mossman & Co. until 1898.

Sources: GSA, Governors' Minute Books, 1854–69; POD 1854–98; GH, 8 April 1884, p.4 (obit.); A, 12 April 1884, p.232 (obit.); Gildard, pp.5–6.

Edwin Roscoe Mullins (1848–1907)

Born in London, he studied at Lambeth School of Art, the RA Schools under Birnie Philip and in Munich under Professor Wagmüller. From 1870 he shared a studio with E.O. Ford (q.v.), producing portraits and 'fancy' figure groups, which he exhibited at the Grosvenor and New Galleries, as well as at the RA. He also produced monuments, such as *General Barrow* (1882), in Lucknow, and several major architectural schemes, including the pediment group on the Harris Museum and Art Gallery, Preston, (c.1882–93). Work by him in the GAGM collection includes *Isaac and Esau* (1904). He also wrote a *Primer of Sculpture* (London, Paris and Melbourne, 1890).

Sources: Spielmann, pp.48–50; Read, pp.52–5, 351, 369; Stevenson (n.d.).

Mungo Naismith (1730–70)

A master mason, builder and sculptor, his 'Tontine Faces' (see St Nicholas Garden, Castle Street, main catalogue) are the only recorded sculptures that can be attributed to him with any certainty. As a mason he achieved celebrity

status for his repairs to the spire of Glasgow Cathedral after it was struck by lightning in 1756, and his innovative construction of the portico of St Andrew's Parish Church (completed 1756), for which he was accorded the Freedom of the City. He occupied a studio in Parnie Street and is buried in the Merchant City at St David's Churchyard, Ingram Street. One of his grandsons, James Naismith, was an important figure in the YMCA, and reputedly invented the game of Basketball in 1891.

Sources: 'Senex', vol.1, pp.128, 270, vol.2, p.241; GH, 27 July 1923, p.8; House, p.55; Fisher, pp.37, 380.

Page & Park Architects (fl.1981–)
Founded by GSA graduates David Page (b.1957) and Brian Park (b.1956), and based in Glasgow's Merchant City, the firm has been involved in numerous prestigious urban design, redevelopment and conservation projects as architects, project leaders and consultants. Commissions have included the Royal Mile Traffic Calming and Environmental Enhancement programme, Edinburgh (1995–7), St Francis Church and Friary, Glasgow (1996) and Municipal Building, Port Glasgow (1996–7). Among the major awards they have received are the Scottish Civic Award Scheme (1990) and the RIBA Award (1995). Page is a lecturer in the Department of Architecture and Building Science at the University of Strathclyde, and was responsible for the redesign of the interior of the Glasgow Centre for Contemporary Arts on Sauchiehall Street (2000–1), which links Alexander 'Greek' Thomson's Grecian Building with several neighbouring structures.

Sources: Kenneth Powell, 'The best of British', *Perspectives on Architecture*, no.21, February/March 1996, p.47; Grant and Maver, p.47.

Patric Park (1811–55)
The son and grandson of masons and sculptors in Glasgow, he served his apprenticeship on the building of Hamilton Palace (1822–6), carving the coat of arms above the north entrance. He studied with Thorvaldsen in Rome, 1831–3, returning to Scotland as a sculptor, and was employed on carving work at Murthly House (built 1831–8). Despite criticism of his models for the *Nelson Monument*, London (1839), the scandal caused by *Modesty Unveiled* (1846) and indifference to his *William Wallace*, for Edinburgh (1850), he became a successful and prolific portraitist in marble, producing busts of artists, literary figures and politicians, among whom were Charles Dickens (1842), Horatio McCulloch (1849), and Napoleon III (1854). He was also commissioned to carve twenty figures for the Scott Monument, Edinburgh (built 1840–6), but these were never carried out. He moved to Manchester in 1852, and died after bursting a blood vessel while helping a porter at Warrington station. He exhibited at the RA from 1836, the British Institution from 1837 and the RSA from 1839. He was elected ARSA in 1849, and RSA in 1851.

Sources: Gunnis; Gifford *et al.*, p.316; Johnstone.

George G. Parsonage See Glasgow Green, Introduction, main catalogue

George Henry Paulin (1888–1962)
Born in Muckhart, Clackmannanshire, the son of the minister of Muckhart Parish Church. He was educated at Dollar Academy, and later studied sculpture under Percy Portsmouth at ECA, winning a travelling scholarship which enabled him to study in Paris, Rome, Naples and Florence, where he set up a studio, 1912–16. During the First World War he served with the Lothian and Borders Light Horse, and later with the Royal Flying Corps in Italy. He worked in Glasgow, 1917–25, producing portrait busts, genre pieces and the war memorials at Kirkcudbright (1920), Dollar Academy (1920), Denny (1921), Rutherglen (1924), Milngavie (1924) and Beaumont Hamel

(1924). In 1925 he moved to London where he executed the statue of Anna Pavlova in the London Garden of Remembrance (c.1932). An active member of the Glasgow Art Club, he exhibited at the RSA, 1909–63, and the RGIFA, 1915–59. He died in Watchfield, Swindon.

Sources: *Bailie*, 3 October, 1923; GH, 12 July 1962, p.10 (obit.); Laperriere.

Arthur E. Pearce (fl.1873–1934)
A modeller and designer of ceramics and terracotta with Doulton & Co.'s Lambeth studios, he studied at South Kensington Art School and at Julien's studio in Paris. As well as being a gifted painter and printmaker, he also designed large-scale works in terracotta, including the firm's pavilion for the Chicago Exhibition of 1891. He is credited with introducing the firm's Morrisian ware.

Sources: Eyles, pp.30, 42; Bergesen, p.105.

Frederick William Pomeroy (1856–1924)
The descendant of a family of artist-craftsmen, he was born in London, and trained there as an architectural carver, possibly with Farmer & Brindley (q.v.); he later attended the SLTAS and RA Schools before studying with Dalou in Paris. He executed much important architectural sculpture but is best known for *Justice* on the Old Bailey, London (1900–7). Prolific in ideal work and portraiture, he also executed public monuments, including the *Monument to Robert Burns*, Paisley (1893). He was elected ARA in 1906, and RA in 1917.

Sources: Spielmann, pp.114–18; Beattie, p.248; Gray.

Tim Pomeroy (b.1957)
Sculptor, painter and poet, he was born in Hamilton, and studied at Gray's School of Art, Aberdeen, from 1976 to 1981. Since then he has held solo shows and participated in group exhibitions throughout the UK. His public commissions include *Of Arms and the Man*, Cadzow Arcade, Hamilton (1985) and *A Tree*

of People, Cadzow Glen, Hamilton (1996). A recent private commission was for a gravestone for Lady Jane Fford, on the island of Arran (1999). Winner of the Benno Schotz Prize in 1983, he has exhibited paintings and sculpture at the Fine Art Society, the RGI, Royal Society of Watercolourists and the Scottish Society of Artists. His work is represented in collections in the UK, USA, Italy, Holland and New Zealand. He published his first anthology of poetry, *Caught in the Shrapnel*, in 1982, and has contributed poetry and illustrations to the *New Edinburgh Review* and the *New Arcadian Journal*. He lives on Arran.

Sources: *Sunday Mail*, 18 April 1999, p.15; information provided by the artist.

Henry Poole (1873–1928)

Born in Westminster, London, he was the son and grandson of masons and sculptors working on churches by William Butterfield and on the restoration of Westminster Abbey. He trained at Lambeth School of Art, 1888, and at the RA Schools, 1892–7, before serving apprenticeships with Harry Bates (q.v.) and G.F. Watts. He became a prolific architectural sculptor, producing work for town halls at West Ham, Deptford, Rotherhithe and Cardiff, and restoring the statuary on St Paul's Cathedral. His public work includes *Physical Energy*, Kensington Gardens (after G.F. Watts), and the *Monument to Captain Albert Ball*, Nottingham (1919). A member of the Art Workers' Guild, he was a Trustee of the NPG and Master of Sculpture at RA Schools, exhibiting ideal work and portraits at the RA in 1912 and 1927. He was elected ARA in 1920, and RA in 1927.

Sources: Beattie; Gray; Spalding; Mackay.

Powderhall Bronze (1989–)

Foundry established in Edinburgh by husband and wife team Brian and Kerry Caster, after studying together at ECA, as a studio for producing their own bronze sculptures. They were immediately inundated with commissions to cast other sculptors' work, and by 1997 had to move to larger premises in Leith to cope with increased production and to accommodate a gallery for their own work. Employing several assistants, the firm currently provides a service for around forty Scottish sculptors, including Kathy Chambers, Kenny Hunter, Shona Kinloch and Alexander Stoddart (qq.v.).

Source: Harry Conroy, 'Sculptors are fired up', H, 6 January 1997.

Walter Pritchard (1905–77)

Scottish stained glass artist, mural painter and sculptor. He was Head of the Department of Murals and Stained Glass at GSA, and exhibited *Summer* at the RSA in 1941, and the aluminium and copper *Annunciation* at the RGIFA in 1961. He designed a lamp for St Charles Church, Kelvinside and painted the ceiling of the Sacred Heart Chapel in St Columbkille's RC Church, Rutherglen, for Gillespie Kidd & Coia (1934–40).

Sources: Rogerson, p.117; Schotz, p.168; Laperriere; Billcliffe.

Alexander Proudfoot (1879–1957)

Liverpool-born sculptor, associated with Archibald Dawson and Benno Schotz (qq.v.) throughout the inter-war years as the most important sculptors of their generation in the west of Scotland. He studied modelling and stone carving at GSA, winning the Haldane Travelling Scholarship in 1908, and becoming Head of Sculpture in 1912. He was busy throughout 1914, working on carving for the Dunfermline Carnegie Library, gavels for the Trades House and Old Deacons Club, as well as exhibiting various portrait busts and reliefs. His output was interrupted, however, by the First World War, in which he served as a sergeant in the Artists Rifles, during which time he invented a protractor for the Vickers machine gun. Even so he managed to exhibit *Charon* at RGIFA in 1915. After the war he continued as an independent sculptor, with a prodigious output of portrait busts and ideal work, and remained Head of Sculpture at GSA until 1928. He also secured commissions for war memorials at Bearsden (1924), and Greenock (1924). He was elected ARSA in 1921, RSA in 1932, and FRSBS in 1938, and was President of Glasgow Art Club three times between 1924 and 1939. Two years before his death he married his assistant, Ivy Gardner.

Sources: GSA Reports, 1911–28; GH, 11 July 1957, p.9 (obit.); McEwan.

John Rhind (1828–92)

Born in Banff, the son of a master mason, he was the father of William Birnie Rhind (q.v.) and J. Massey Rhind. A pupil of Alexander Handyside Ritchie (q.v.), he carried out numerous schemes of architectural sculpture in Edinburgh, including the portrait heads on the Royal Scottish Museum (1859), and figurative work on the Bank of Scotland, Bridge Street (1864–70), Fettes Aademy (1864–70) and the SNPG (1891). He also executed the *Monument to Sir William Chambers*, Princes Street (1888–91), assisted by William Shirreffs (q.v.). Outside Edinburgh he executed the *Biggar Memorial Fountain*, Banff (1878), and the *Agriculture* and *Shipbuilding* reliefs on New County Hall, Paisley (1892). He exhibited at the RSA, 1857–92, the RA and the RGIFA, and died a few days after his election as ARSA in 1892.

Sources: BN, 24 October 1890, p.572; McEwan.

William Birnie Rhind (1853–1933)

Born in Edinburgh, and best known for his war memorials there, including *Royal Scots Greys* (1905), *Black Watch* (1908) and *King's Own Scottish Borderers* (1919), but principally an architectural sculptor, with most of his important work also in Edinburgh. The eldest son of John Rhind (q.v.), with whom he trained before attending the School of Design and the

RSA, he established a studio in Glasgow at 217 West George Street in 1885 with his sculptor brother, J. Massey Rhind, but settled permanently in Edinburgh two years later. He produced numerous figures for buildings such as the SNPG (1898), the Scotsman Building (1900), the Professional & Civil Service Supply Association, George Street (1903–7), and Jenner's, Princes Street (1893–1903). Outside Scotland he executed sculpture for Wakefield County Council Offices (1897), Liverpool Cotton Exchange (1905–6) and Winnipeg Parliament Building, Canada (1916–19). His public monuments include statues to William Johnston, St Anne's (1888), Sir Peter and Thomas Coates, Paisley (1893–8), and the equestrian *Monument to the Marquis of Linlithgow*, Melbourne, Australia (1908). He exhibited regularly at the RSA from 1878 to 1934, showing portrait busts and models for many of his public and architectural sculptures; his work was also often seen at the RGIFA and the RA. He was elected ARSA in 1893, and RSA in 1905.

Sources: Spielmann, pp.127–9; GH, 11 July 1933, p.11 (obit.); Gray; Laperierre; McEwan; Cavanagh, p.336.

Edwin Alfred Rickards (1872–1920)
English architect who, with partners H.V. Lanchester and James Stewart built a number of major public buildings in an exuberant Edwardian Baroque style, often in collaboration with architectural sculptors such as Henry Poole and Albert Hodge (qq.v.). Major buildings include Cardiff City Hall (1897) and Deptford Town Hall, London (1908), both with sculpture programmes by Poole.

Sources: Beattie, p.131; Curl.

George Rickey (b.1907)
American-born sculptor of kinetic work in metal, inspired by Clydeside machinery and engineering. He emigrated with his parents from Indiana, USA, to Craigendoran, Scotland, in 1913, and went on to study at Balliol College and the Ruskin School of Drawing, Oxford, before war service in the RAF and US Air Corps. His experience of engineering work during this period led him to take up sculpture, producing his first kinetic works while in military service in 1945. After the war he taught fine art at colleges and universities in various American cities, including Bloomington, Indiana, and New Orleans, and served on the board of Massachusetts Institute of Technology. The author of an important historical survey of early twentieth-century sculpture, *Constructivism: Origins and Evolution* (London, 1968), he has received honorary degrees from universities around the world, as well as the John Simon Guggenheim Memorial Fellowship (1960; renewed 1961). His work in Scotland includes *Two Lines Up Eccentric VI* (1977), in the grounds of the Scottish National Gallery of Modern Art, Belford Road, Edinburgh, and *Three Right Angles Horizontal*, Highland Sculpture Park (1982). Rickey currently lives at East Chatham, New York State.

Sources: Rosenthal, pp.201–2; Strachan, pp.225, 271; Clare Henry, 'Scrappy way to handle great art', H, 22 June 1995, *Arts* supplement, p.18.

William Riddel (fl.1690)
A local stone mason about whom few facts have survived other than that he was responsible for the *Lion and Unicorn Staircase* in the quadrangle of the Old College on the High Street.

Source: Johnstone.

Alexander Handyside Ritchie (1804–70)
Born in Musselburgh, he was the son of a brickmaker and ornamental plasterer, and the grandson of a fisherman and self-taught sculptor. He studied art, architecture and anatomy at Edinburgh School of Arts, under Samuel Joseph, 1823, then attended the Trustees' School of Design before studying with Thorvaldsen in Rome, 1826–30. He returned to Musselburgh in 1830, then opened a studio at 92 Princes Street, Edinburgh, in 1842. Assisted by his brother John Ritchie (q.v.), he executed portrait busts for wealthy patrons, and statuary on the Central Public Library (1837), the Royal College of Physicians, Queen Street (1844) and Commercial Bank, George Street (1847). He worked for John Thomas on the Houses of Parliament, London, executing marble statues of Eustace de Vesci and William de Mowbray, and in 1852 produced sculpture for the Hamilton Mausoleum. For the Valley Cemetery, Stirling, he executed the *Monument to Agnes and Margaret Wilson* (1850), and five statues, including *John Knox* and *Ebenezer Erskine* (1858). Among his public monuments elsewhere in Scotland are *Sir Walter Scott*, Selkirk (1839), *Sir Robert Peel*, Montrose (1852), *The Fisherman's Monument*, Dunbar (1856), *Hugh Miller*, Cromarty (1858) and *Sir William Wallace*, Lanark (1859). He exhibited regularly at the RSA, 1831–71, and the RA, 1830–68, and was elected ARSA in 1846. Despite considerable artistic success and aristocratic patronage he died virtually penniless, leaving an estate valued at £6 10s. 6d.

Sources: Gunnis; Johnstone.

John Ritchie (1809–50)
Largely self-taught, he assisted his elder brother, Alexander Handyside Ritchie (q.v.), with numerous portrait busts and architectural sculpture schemes in Edinburgh. He exhibited fancy pieces and narrative works at the RSA, 1832–50, and carved *The Last Minstrel* on the Scott Monument, Edinburgh (1846). A commission to enlarge his earlier plaster group, *The Flood* (exhibited at the RA 1840) in marble, enabled him to visit Rome in 1850, where he intended to complete it, but he died of malaria two months after arriving.

Sources: Gunnis; Johnstone.

Antonio Rossetti (fl.1819–70)
Born in Milan, he studied and later worked in Rome, where his marble statues and 'fancy' figure groups earned him an international reputation.

Source: Stevenson (n.d.).

Saracen Foundry See Walter Macfarlane & Co.

Salmon, Son & Gillespie (fl.1892–1913)
Architectural firm founded by James Salmon Senior (fl.*c*.1825–88). The firm passed to his son, William Forrest Salmon (1843–1911) then to grandson James Salmon Junior (1873–1924) and their former assistant James Gaff Gillespie (1870–1926) in 1898. Their Glasgow Style buildings and interiors provided early opportunities to Albert Hodge, Johan Keller and Francis Derwent Wood (qq.v.), but they often produced their own decorative work such as *repoussé*, stained glass and sculpture. (Gillespie modelled the sculpture for their Stirling Municipal Buildings, 1907–14.) They later pioneered the use of reinforced concrete for building frames and façades. Their successors, Gillespie Kidd & Coia, are noted for their churches throughout Scotland, several incorporating sculpture by Archibald Dawson, Alexander Proudfoot and Benno Schotz (qq.v.).

Sources: Service, pp.236–49; Blench *et al.*, pp.45–6; Gray; Rogerson, pp.2–73.)

Benno Schotz (1891–1984)
Born in Arensburg, on the Estonian island of Oesel, he studied engineering at Darmstadt, then joined his brother in Glasgow in 1912. He continued his studies at Glasgow Royal Technical College, 1912–14, and, while working as a draughtsman at John Brown's shipyard, attended evening classes at GSA. He exhibited sculpture at the RGIFA in 1917, became President of the Society of Sculptors and Painters, Glasgow, in 1920, and established himself as a professional sculptor in 1923. A protégé of the architect John Keppie, and influenced by Rodin and Epstein, he executed many portrait busts, including one of Keppie in 1923. Among his many ideal works and public commissions are the Partick Camera Club Trophy (1925), the *Keir Hardy Monument*, Old Cumnock (1939), *Ex Terra*, Glenrothes (1965), and several cycles of *The Stations of the Cross* for churches by Jack Coia. He succeeded Archibald Dawson (q.v.) as Head of the Department of Sculpture and Ceramics at GSA in 1938 and remained in the post until 1961. Exhibiting widely throughout Britain, Israel and the USA, he was elected ARSA in 1933, and RSA in 1937. In 1963 he was appointed Her Majesty's Sculptor in Ordinary for Scotland. He also received an HLLD from Strathclyde University in 1969, and was accorded the Freedom of the City of Glasgow in 1981. His *Moses the Sculptor* (1949, originally shown in Kelvingrove Park), was exhibited as a posthumous tribute at the 1988 Glasgow Garden Festival.

Sources: HAG, Honeyman & Keppie Job Book, 1920–8; *West End News and Partick Advertiser*, 16 November 1973, p.14, 29 March 1974, p.5, 12 July 1974, p.4; GH, 12 October 1984, p.3 (obit.); Schotz, *passim.*; Halliday and Bruce, p.xi; SAC, *Benno Schotz Retrospective Exhibition*, Edinburgh, 1971 (ex. cat.); GAGM, *Benno Schotz Portrait Sculpture*, Glasgow, 1978 (ex. cat.); Murray, pp.98–9; Mackay; McEwan.

Andy Scott See Scott Associates Sculpture & Design Ltd

William Scott (b.1935)
Born in Moniaive, Dumfriesshire, he graduated from ECA in 1958 and went on to study at the École des Beaux Arts, Paris, 1959–60. His early work was mostly in metal, with constructivist pieces such as *Rig and Platform* (1978–85) paying tribute to the engineering achievements of the North Sea oil industry. His more recent work in wood places a greater emphasis on craft skill and shows a preoccupation with the forms of 'primitive' sculpture. His ongoing series of 'Monuments' and 'Markers' explore the nature of human rituals, and the relationship between society and the environment. He has exhibited extensively in Britain, Scandinavia and Japan, and has works in public collections throughout Scotland. He was elected RSA in 1984, and was Head of the School of Sculpture, ECA, from 1990 to 1997.

Source: Patrizio, pp.122–7, 159.

Scott Associates Sculpture and Design (1999–)
Glasgow-based firm of sculptors, interior designers and fabricators founded by Andy Scott (b.1964) and five other former members of the Glasgow Sculpture Studios: Simon Hopkins, Derek Cunningham, Kenneth Mackay, Pat Moran and Ewan Hunter, with Wilma Eaton as education and outreach officer. In addition to their regular work as designers and fabricators of studio props for television broadcasts, and their collaborations with architects and engineers, they have produced numerous works of permanent public art. These include a bronze statue of the footballer Davie Cooper, Hamilton (1999), *The Heavy Horse*, Easterhouse (1999) and the *Carmyle Heron*, Carmyle (2000). Their most prestigious commission to date is for a sculpture for Thanksgiving Square, Belfast (1999).

Sources: H, 18 May 2000, p.8; information provided by Scott Associates.

James Sellars (1843–88)
The son of a Glasgow house factor, he trained as an architect under Hugh Barclay, 1857–64, and with James Hamilton Junior, then entered into partnership with Campbell Douglas in 1872, executing commissions for buildings of every type and style throughout the country. Renowned for his diligence at the drawing board, he designed every detail of his buildings, including interior fittings and exterior railings and lamps (cast and mass produced by Macfarlane & Co., q.v.) while rarely missing an

opportunity to deploy sculpture on his façades. He competed unsuccessfully for the City Chambers commission (1880–1), but won the competitions for the Victoria Infirmary (1882), and the 1888 International Exhibition in Kelvingrove Park. He died of gangrene after injuring a foot on the exhibition construction site and was buried in Lambhill Cemetery. His monument, designed by his assistant John Keppie and executed by Edward Good (qq.v.), formerly incorporated a bronze portrait panel by J.P. Macgillivray (q.v.) (1890).

Sources: HAG, Honeyman & Keppie Job Book, 1881–94, p.95; SAR, vol.2, 1888, pp.191–2 (obit.); Gomme and Walker, p.278.

James Shanks (c.1825–c.1872)

An architectural carver, he trained under William Mossman Senior (q.v.), and is listed in the POD as trading at 346 Parliamentary Road, 1855–64, but was active in the 1840s. His recorded work includes the *Buchanan of Dowanhill Monument* (designed by James Brown, 1844), and the stonework for the *Duncan Macfarlan Monument* (1861), both in the Necropolis, as well as the carver work on many churches by John Honeyman. These include the Free Churches at Greenock (1862) and Dumbarton (1863), and Lansdowne Church in Glasgow (1863).

Source: POD, 1855–64.

Archibald Macfarlane Shannan (1850–1915)

Educated at Glasgow University, and apprenticed to his father, the builder Peter Shannan, he began as an architect superintending the construction of sanatoria in the Cameroons, West Africa, and the state buildings, Texas, USA, later switching to a successful career as a sculptor. He trained at NATS, then studied in Paris from 1885–94. His early work was fanciful, with titles such as *The Arcadian Shepherd's Dream*, but he soon established a reputation for portraiture and monumental statuary. He produced several

bronze medallions of local academics and clerics, including the *Ross Taylor Memorial*, Kelvinside UF Church (1909). His work outside Glasgow includes a bust to Phillip Baudains, St Helier, Jersey (1897), the *Memorial to William Nicholson*, Kirkcudbright (1901) and the statue of John Barbour on the SNPG (1905). He produced a number of important works in Paisley, including the *Christopher North Plaque* (1905), the *Dunn Memorial Fountain* (1910) and a memorial to Lord Provost Cochran (1906). A member of the Glasgow Art Club, he was elected ARSA in 1902, and exhibited regularly at the RA, RSA and RGIFA. He died of injuries sustained in an accident involving a cyclist.

Sources: GH, 29 September 1915, p.8 (obit.); Cowan, pp.422–4; Billcliffe; Laperriere; Mackay; McEwan.

James Milne Sherriff (fl.1890–1904)

An architectural sculptor, who, after studying at GSA under Francis Leslie (q.v.) in the 1880s, formed the partnership Dawson & Sherriff, 1890–4, at 20 Canning Place. They worked on St Ninian's Wynd Free Church, Crown Street (1888, demolished), and Cathcart UP Church (1894), both for W.G. Rowan. Working on his own from 1895, Sherriff executed carving on a church in Clydebank (1895). He moved to a studio at 5 Dalhousie Lane, Garnethill, in 1900, and lived nearby with his wife at 83 Hill Street. He died on 19 September 1904.

Sources: GSA General Register (Alpha), 1881–92; POD, 1890–1904; BN, 18 May 1894, p.673; BJ, 22 October, 1895, p.174; CI, 1905, p.551; Worsdall (1982) pp.17, 29.

William Shirreffs (1846–1902)

Born in Huntly, Aberdeenshire, a relative of the bronze-founder Charles G. Shirreffs, he moved to Glasgow in 1870 to study sculpture under William Mossman Junior (q.v.) at GSA, where he won the Queen's Prize in 1871 and a free studentship in the following year. He opened a studio at 108 West Regent Street in 1877,

moving to 261 West George Street ten years later, establishing a *cire-perdue* foundry where he cast the reliefs on the *Monument to Sir William Chambers*, Edinburgh, 1891, for John Rhind (q.v.). For J.J. Burnet he made copper reliefs of *Christ*, *St John* and *St Cecilia* (after Donatello) for a fireplace in Nunholme, Dowanside (1888). He produced portrait busts, including *J.L. O'Toole* (1895) and *Robert Phillips* (1896), as well as public statues such as the *Monument to William Barbour*, Royal Alexandra Infirmary, Paisley (c.1899). Outside Glasgow he worked on the General Accident and Assurance Company Offices, Perth, and the Sugar Exchange, Greenock, while in Edinburgh he carved figures of *Diana Vernon* and *Gurth the Swineherd* for the Scott Monument (1882). He also briefly assisted James Pittendrigh Macgillivray (q.v.) on the *Monument to William Ewart Gladstone*. Of his architectural sculpture in Glasgow little has survived. He exhibited at the RGIFA, 1883–1900, the RA in 1896, and at the 1888 International Exhibition in Kelvingrove Park. He died at Lochwinnoch.

Sources: GSA Annual Reports, 1871–2; HAG, Honeyman & Keppie Job Books, 1894–1905; *Bailie*, 5 December 1896; GH, 26 June 1902, p.11 (obit.).

Callum S.G. Sinclair (b.1966)

Born in Glasgow, he studied at GSA, 1983–7, becoming a professional sculptor on graduating. After working as an assistant to Sjord Buisman at the 1988 Glasgow Garden Festival, he received commissions for a stone sculpture for the Royal Botanic Gardens, Dunoon (1990), stone carving and landscaping at Perth Royal Infirmary (1991), and a joint commission with Greg White for landscaping and sculpture at a Safeway store in Suffolk (1992). A frequent collaborator with Michelle de Bruin (q.v.), he also contributes to group exhibitions and workshops for children. He is a co-founder of Glasgow Sculpture Studios, and has served as its vice-chair since 1994. His work is

represented in private collections throughout Britain.

Sources: Scott, p.27; information provided by artist.

Stephen Skrynka (b.1962)
Born in London, he studied at Manchester University until 1983 and Glasgow University until 1991; he has lived and worked in Scotland since 1989. His work in Glasgow includes an installation utilising radiator parts at 187 Old Rutherglen Road, and a collaboration with Peter McCaughey entitled *Borrowed Light*, 1990, which consisted of a series of pavement installations rehabilitating basement skylights at various locations in the city centre. His most ambitious work to date has been *Tunnel*, a temporary 'soundwalk' combining coloured light with recorded dialogue in the Clyde pedestrian and cycle tunnel in May/June 2000.

Sources: Guest and Smith, pp.10–11, 20; Alex Hetherington, 'Perfect City', *Sculpture Matters*, no.8, June 2000, p.11.

Jack Faulds Sloan (b.1950)
Born in Motherwell, he studied interior design at GSA, 1967–72, winning the Sam Mavor Bequest in 1971, later working as a set designer for the BBC and as a community artist in Lanarkshire in the 1970s. A lecturer in Art and Design at Central College of Commerce since 1977, he received commissions for public work throughout the 1980s and 1990s, including *Commemorative Gates*, Colinton Parish Church, Edinburgh, and the Civic Trust Award-winning *Apotheosis*, Kilmarnock (both 1995). Among the works he has exhibited at the RGIFA since 1980 are *The Fruiterer* (1980), *Tractor Study* (1981), *Sphinx for Oedipus* (1982) and *Cadzow Oak* (1987). He lives in Hamilton.

Source: information provided by the artist.

Michael Alan Snowden (b.1930)
Sculptor of figures and portraits in bronze. Born in Leicestershire, he trained as an art teacher in York before studying sculpture under Karel Vogel at Camberwell School of Art. He taught there until 1962 and joined the staff of ECA in 1964. He began exhibiting ideal works and mythological subjects at the RSA in 1966, and held his first solo show in Leicester in 1971. Commissions include sculpture in Southwark Cathedral and Livingstone New Town, a *Mother and Child* group for Cumbernauld, and *Baptized Christ* for Craiglockhart College, Edinburgh (1968). He was elected ARSA in 1974, and RSA in 1985.

Source: McEwan.

James Steel (1818/19–1878)
There are two minor sculptors by the name of James Steel who are known to have lived in Glasgow in the mid-nineteenth century, both of whom were born in Dundee. The artist recorded in the catalogue as the carver of the Royal Faculty of Procurators (q.v., Nelson Mandela Place, main catalogue) is probably the modeller and plasterer residing at 4 Grafton Place in 1871. He died in Glasgow on 16 October 1878.

Source: Johnstone.

David Watson Stevenson (1842–1904)
Born in Ratho, Midlothian, he was the brother of the sculptor William Grant Stevenson (1849–1919) with whom he often worked in the partnership D.W. & G. Stevenson. He studied modelling at the Trustees' Schools, Edinburgh, whilst serving an eight-year apprenticeship in the studio of William Brodie (q.v.). During this time he was the winner of the South Kensington National Prize for a statuette of the *Venus de Milo*. After further study in Rome, he assisted Sir John Steell on the *Monument to Prince Albert*, Edinburgh, executing the *Science* and *Learning* groups himself (1865–76). He produced busts in marble and bronze, classical groups and genre pieces, but is best known for his statue of William Wallace on the National Wallace Monument, Stirling (1859–69). His other public works include the figures of *Mary, Queen of Scots*, *Halbert Glendinning* and *James VI* on the Scott Monument, Edinburgh (1874), the *Monument to Robert Tannahill*, Paisley (1884) and *Highland Mary*, Dunoon (1896). He also executed a multi-figure *Monument to John Platt, M.P.*, Oldham (1876) and the *H.F. Bocklow Monument*, Middlesbrough (1881). He exhibited at the RA, RSA and RGIFA from 1859.

Sources: Spielmann, pp.33–4; Grant; Mackay; Billcliffe; McEwan.

Alexander Stoddart (b.1959)
Born in Edinburgh, he studied at GSA, 1976–80, under Cliff Bowen, writing his undergraduate thesis on the life and work of John Mossman (q.v.). After a brief period as a postgraduate student at the University of Glasgow, he collaborated with Ian Hamilton Finlay (b. 1925) at his garden Little Sparta, in Lanarkshire. Though employing a very different sculptural idiom, he shares with Finlay a desire to combine his practice as a creative artist with a critical reflection on contemporary art and society, producing work that often combines formal and intellectual elegance with a sharply satirical edge. Works in this vein include *Biederlally* (1992), in the Glasgow Gallery of Modern Art, and *Heroic Bust: Henry More, OM (1898–1986)* (1990), in the SNGMA. A vocal, and often polemical, advocate of Neo-classical monumentalism, he has contributed to historical research on Glasgow sculpture, particularly the work of John Mossman, frequently courting controversy in his own attempts to reassert the values of the classical tradition in a contemporary context. His colossal *Monument to David Hume*, installed on the pavement of the Royal Mile, Edinburgh, in 1997, provoked much discussion, with his presentation of the Enlightenment philosopher dressed in a classical toga attracting extensive coverage in the Scottish press. In 1999, he

received a joint commission from the Universities of Paisley and Princeton for bronze statues of Rev. Dr John Witherspoon, to be erected in 2001. He lives and works in Paisley.

Sources: Pearson, p.174 (ill.); McEwan; *Scotsman*, 16 December, 1999, p.6; Gilles Robel, 'Liking Hume but not his statue', *Sculpture Matters*, no.10, December 2000, pp.16–17; information provided by the artist.

Scipione Tadolini (1822–92)
Born in Rome, of a family of sculptors, he studied under his father, Adamo (1788–1868), who in turn had studied under Canova. After establishing his reputation with his *Nymph Fishing* (1846), he became a fashionable sculptor of marble figures, portraits and copies of work by Canova. He also executed some work for churches in Rome.

Source: Stevenson (n.d.).

Sean Taylor (b.1959)
Born in Cork, he studied at Crawford College of Art and Design, Cork, 1979–82, and was awarded an MFA from the University of Ulster, Belfast, in 1983; he later spent a year studying at the Kunstenacademie in Rotterdam, Holland. He has had solo exhibitions in Cork, Berlin, Stockholm, Mexico City and Celje in Slovenia, and has contributed to many important group exhibitions, including the Irish Pavillion at EXPO 2000, Hanover. In 2000 he also participated in *Bliain le Baisteach* ('A year with Rain'), a live webcast multi-media event with the Irish Chamber Orchestra, Limerick. He is currently Course Director of Sculpture at Limerick School of Art and Design.

Source: information provided by the artist.

John Thomas (1813–62)
A prolific sculptor and architect, born in Chalford, Gloucester. After serving an apprenticeship as a stonemason he joined his architect brother in Birmingham, where he was noticed by (Sir) Charles Barry and immediately employed by him as a stone carver on his Birmingham Grammar School, and later as supervising carver on his Palace of Westminster. His workshop there was to become the training ground of a generation of British carvers, exerting a profound influence on the quality of the architectural sculpture of the period. Prolific and versatile, he worked in every genre of sculpture, producing reliefs for Balmoral Castle, statues for Windsor and Euston stations, the monuments to Thomas Attwood, Birmingham (1859), and Queen Victoria, Maidstone (1863). As an architect he designed Headington House, Oxford, Somerleyton Hall and extensions to Windsor Castle. He exhibited at the RA, 1842–61, the British Institution in 1850, and the Great Exhibition of 1851. A dispute over his colossal statue of Shakespeare for the 1862 International Exhibition hastened his death in April 1862.

Sources: Gunnis; Read, *passim*.

James Thomson (1835–1905)
A Glasgow architect, he trained with James Brown (1813–78), and worked as a draughtsman for John Baird I (1798–1859) from *c*.1848, before forming the partnership of Baird & Thomson (fl.1856–1905). After Baird's death he produced many of Glasgow's finest Italianate buildings, but it was not until his sons James Baird Thomson (d.1917) and William Aitken Thomson (*c*.1871–1947) joined him in the 1890s that sculpture became a significant feature of the firm's designs, with James Young (q.v.) and his son James C. Young as their preferred artists. They produced little of significance after their German Renaissance commercial buildings of 1895–1902.

Sources: Gomme and Walker, p.282; Glendinning *et al.*, p.553.

Sir William Hamo Thornycroft (1850–1925)
Son of the sculptors Thomas and Mary Thornycroft, he trained in his father's London studio and assisted him on the *Commerce* group for the Albert Memorial and the *Park Lane Fountain*, London. Entering the RA Schools in 1869, he won the gold medal in 1875, later receiving many commissions for public monuments, including *General Gordon*, Victoria Embankment, London and Melbourne, Australia (1888), *Oliver Cromwell*, Westminster (1899), *Peter Denny*, Dumbarton (1898–1902), *King Alfred*, Winchester (1901) and *King Edward VII*, Karachi (1915). His best-known work, *Boadicea* on Westminster Bridge (1901) was completed from a model by his father. He executed sculpture on J. Belcher's Hall of the Institute of Chartered Accountants, London (1899), and regularly exhibited portrait busts and genre pieces at the RA from 1872, and the RGIFA from 1880. A founder member of the Art Workers' Guild, he was elected ARA in 1881, and RA in 1888, knighted in 1917 and awarded the RIBA Gold Medal in 1923.

Sources: Spielmann, pp.36–45; Manning, *passim*.; Gray.

George Tinworth (1843–1913)
The son of a wheelwright, he enrolled at Lambeth School of Art in 1861, and the RA schools in 1864. From 1867 he spent his entire career working for Doulton & Co., of Lambeth (q.v.), becoming chief modeller, and producing decorative tiles, animal groups and terracotta reliefs. This included decorations on Doulton's own buildings, where an exhibition of his work was held in 1895. He also accepted independent commissions for work in churches and cathedrals, executing several panels for the Guards' Chapel, Wellington Barracks, London (1878), a reredos for York Minster (1876–9) and the *Henry Fawcett Monument*, London (destroyed). He exhibited at the RA from 1866.

Sources: Gosse, *passim*.; BJ, 26 November 1895, p.243; Spielmann, pp.22–4; Grant; Atterbury and Irvine, p.486; Read, pp.311–13; Mackay.

William Vickers (d.1922)
Founder of the Glasgow-based firm of architectural carvers, William Vickers Ltd (fl.1892–1940). He studied at GSA under William Kellock Brown (q.v.), winning the Haldane Bursary in 1898, the year of his graduation, after which he was appointed teacher of design, decorative art and stone carving. He worked independently as a carver from 1892, with premises first at 99 Grant Street, and later at 221 West Regent Street. In 1899 he executed the marble and alabaster work on the reredos, St Ninian's Episcopal Church, Pollokshields, and in 1900 carved the lettering and symbols of the Agnus Dei and the Evangelists on the Reredos in Burnet's Barony Church, Cathedral Square. His most important commission was for the High Altar and other carved work in St Aloysius Church, Rose Street (1908–10). Among his other works are several monuments in St Peter's Cemetery, including one designed by Pugin (c.1894), the models for the figures on the Roseberry Mace of the City of Glasgow, and the mace of University College, Dundee (c.1912). The firm became a limited company in 1926 and moved to 124 Cambridge Street, where it remained until closing in 1940.

Sources: POD, 1890–1940; GSA Annual Reports 1898–1913, Press Cuttings 1907–17, pp.167, 182; Johnstone.

William Warren (fl.1790–1828?)
Little is known of Warren's connections with Glasgow, other than his well-documented involvement with the *Monument to John Knox* in the Necropolis (q.v., main catalogue), which was carved by Robert Forrest (q.v.) to his design. There is no mention of him in any of the standard reference works, such as Thieme and Becker, Bénézit, etc., but Gunnis lists a William Warren of Hitchin who repaired statues for Countess de Grey and carved the piers for the gates of her estate at Wrest Park in Bedfordshire. He may also have been the proprietor of 'Warren's Academy' in Glasgow, which Robert Forrest is known to have attended.

Source: Gunnis.

Lucinda C. Wilkinson (b.1961)
An English sculptor, she studied Fine Art at Wimbledon School of Art, 1982–5, and was awarded a postgraduate diploma in sculpture at GSA in 1987. She has contributed to group exhibitions since 1983 and worked as an artist in residence at GAGM and the Botanic Gardens, Glasgow, in 1990. Her first solo show was in Bilbao, Spain, in 1992. A founder member of Glasgow Sculpture Studios, she currently works as a part-time lecturer in art and design at James Watt College, Greenock.

Source: information provided by the artist.

Andrew Willison See Mortimer, Willison & Graham

Francis Derwent Wood (1871–1926)
Born in Keswick, Cumbria, of American and Australian parents, he trained at Karlsruhe, at the NATS under Lantéri and at the RA Schools, 1894. As Visiting Director of Modelling at GSA, 1897–1900, he was in close touch with many Glasgow Style architects, producing his finest architectural sculpture for their buildings, including models of allegorical figures for an unexecuted low level station in Glasgow by J.J. Burnet (1899). He settled in London in 1901, and became Professor of Sculpture at the RCA in 1918. He assisted Thomas Brock on the *National Queen Victoria Memorial*, London (1900–11), and the *Liverpool Cotton Exchange War Memorial* (1921). Strongly influenced by Alfred Gilbert, his best-known post-war work is the *Machine Gun Corps Memorial*, Hyde Park Corner (1925). A member of the Art Workers' Guild, he exhibited at the RSA from 1905 to 1925, was elected ARA in 1910 and RA in 1920.

Sources: Spielmann, pp.153–5; Beattie, p.252; Gray.

John Warrington Wood (1839–86)
A pupil at the School of Art at Warrington, he interpolated the name of his birthplace into his name to distinguish himself from two other students called John Wood. After art school he moved to Rome, where he studied with John Gibson and became a member of the Guild of St Luke in 1877. He produced mainly ideal statues, including *Eve* (1871). This was purchased by Sir Andrew Barclay Walker, the founder of the Walker Art Gallery, Liverpool (1874–7), which also commissioned Wood to make statues of Michelangelo and Raphael, as well as the colossal *Allegorical Statue of Liverpool*, which formerly sat on the roof. Although he remained in Rome, he exhibited regularly at the RA between 1868 and 1884.

Source: Cavanagh, pp.296–7, 341–2.

George Wyllie (b.1921)
Sculptor, writer and performer, he was born in Glasgow but has been resident in Gourock since 1959. He worked as a Post Office engineer until undertaking war service in the Royal Navy, after which he became a Customs Officer in Ireland and on the west coast of Scotland. Inspired by Italian metal sculpture, he attended welding classes at the Royal Technical College, and studied part-time at GSA, becoming a full-time artist in 1979. He specialises in mixed media, kinetic, installation and performance art, and has developed a distinctive form of 'Social Scul?ure', humorously exploring Joseph Beuys' assertion that 'all art is questionable'. He has exhibited regularly throughout the UK since the 1960s, and his work is represented in major private and public collections, including GAGM, the University of Stirling and the SAC. Among his many contributions to Glasgow's annual Mayfest are the *Straw Locomotive* (1987, see Introduction) and *Just In Case*, a colossal safety pin in the manner of Claes Oldenberg, installed at Glasgow Cross (1995). For the 1988 Glasgow

Garden Festival he produced *Arrivals and Sailings*. An artist of international stature, his Gulbenkian Prize-winning *Paper Boat* sailed down the Clyde, Sheldt and Hudson rivers in 1990; the newspaper *Scotland on Sunday* now presents 'Paper Boat Awards' to artists producing work of distinction. His latest venture, a giant *Crystal Ship* (2000), has been proposed as a permanent feature of the rejuvenated Govan dry dock.

Sources: Murray, pp.110–11; Nairne and Arefin; Patrizio, pp.138–9, 162; *Sunday Times*, 9 April 2000, p.15.

James Young (fl.1872–*c.*1900)
Founder of the family firm of architectural sculptors (fl.1872–1936) which emerged towards the end of the nineteenth century to dominate Glasgow for a time after the death of John Mossman (q.v.) in 1890. From his studio at 68 Bothwell Street he was to carry out several important tenders in the 1870s and 1880s, executing carver work on John Honeyman's Cameron Street School (1877), and Coates Observatory, Paisley (1882–3). He also carved the font at Lochgilphead Parish Church (1884), and the figures of *St Mungo* and *St Ninian* on the Calderwood Reredos, Glasgow Cathedral (1893). His most important commissions were

for the carver work and allegorical figures of *The Seasons* on the George A. Clarke Town Hall, Paisley (1879–82), and the statue of *Vulcan* on Dunbeth Municipal Buildings (1894). Throughout the 1890s he trained his son James Charles Young (d.1923) as his successor, and from *c.*1896 much of the work credited to the firm may be attributed to him. After James Young's retirement or death in 1900, the firm continued to trade under his name, executing work on Brechin Cathedral (1900–1) and at Holy Trinity Church, St Andrews (1907–9). In 1910, James Charles Young was joined by his own son, James Andrew Young, to form the partnership James Young & Son, which later became James A. Young on his father's death. The *Madonna and Child* on St Anne's Church, Corstorphine, Edinburgh, dates from this period. Archibald Dawson (q.v.) later became a partner, and the firm traded as Dawson & Young until it closed in 1936.

Sources: POD, 1872–1936; CI, 1923, p.Y4; Johnstone; information provided by Edward Graham.

James Charles Young See James Young

Paul Zunterstein (1921–68)
Born in Vienna, he came to Scotland in 1938, and studied sculpture as a day student from 1946 to 1950. The winner of a post-diploma scholarship in 1950, he was later invited to join the School's teaching staff. He produced mostly small figure groups, often with abstract or mythological subjects such as *The Dream* (1957) and *Euridice* (1964), and using a variety of materials, including wood, concrete, *ciment fondu* and terracotta. Music and dance were also major preoccupations in his work, and in 1957 he contributed to the exhibition *Painting, Sculpture, Music* at the McLellan Galleries. The poet Sydney Goodsir Smith described his *Girl Standing* (1960) as 'amusing and attractive, and sculpturally truly elegant in her dumpy way'. For most of his working life he lived at 155 Hill Street, Glasgow, but moved to Kilmacolm shortly before his death, which Benno Schotz (q.v.) described as a 'grievous loss' to Scottish sculpture. He exhibited regularly at the RSA and the RGIFA from 1950 to 1968 (including posthumously) and was an associate of the RBS.

Sources: GSA General Register (Alpha) 1933–49, 1949–59; Sydney Goodsir Smith, 'Choice Sculpture at the RSA', GH, 22 April 1961; Benno Schotz, 'Death of Paul Zunterstein', GH, 25 June 1968.

Bibliography

1. Works of General Reference

Anderson, William, *The Scottish nation: or the surnames, families, literature, honours, and biographical history of the people of Scotland*, Edinburgh, 1863.

Bénézit, E., *Dictionnaire critique et documentaire des peintres sculpteurs dessinateurs et graveurs ...* , Paris 1911–23, new edition 1999, 14 vols.

Billcliffe, Roger, *The Royal Glasgow Institute of the Fine Arts 1861–1989: A Dictionary of Exhibitors at the Annual Exhibitions etc.*, 4 vols, Glasgow, 1992.

Buckman, David, *Dictionary of Artists in Britain since 1945*, Bristol, 1998.

Chambers' Encyclopædia: a Dictionary of Universal Knowledge, 10 vols, London and Edinburgh, 1891.

Curl, James Stevens, *A Dictionary of Architecture*, Oxford, 1999.

Daiches, David (ed.), *A Companion Guide to Scottish Culture*, London, 1981.

Dictionary of National Biography, 63 vols, London, 1885–1900. *Supplement*, 3 vols, London, 1901. *Second Supplement*, 3 vols, London, 1912.

Donaldson, Gordon and Morpeth, Robert, *A Dictionary of Scottish Social History*, Edinburgh, 1877.

——, *Who's Who in Scottish History*, Oxford, 1973.

Eadie, John, D.D., LL.D., *A New and Complete Concordance to the Holy Scriptures, on the Basis of Cruden*, London, 1875 (48th edition).

Elvin, C. N., *A Hand-Book of Mottoes Borne by the Nobility, Gentry, Cities, Public Companies etc.*, London, 1963 (reproduced from the original edition of 1860).

Encyclopædia Britannica, The New, 30 vols, 15th edition, Chicago, London, Toronto, etc., 1943–73, 1973–4, including *Micropædia* vols I–X and *Macropædia* vols 1–19.

Evans, Ivor H. (ed.), *The Wordsworth Dictionary of Phrase & Fable*, London, 1959.

Fisher, Joe, *The Glasgow Encyclopedia*, Edinburgh, 1994.

Fleming, John, Honor, Hugh and Pevsner, Nikolaus, *The Penguin Dictionary of Architecture*, Harmondsworth, Baltimore and Victoria, 1966.

Glossary of Terms used in Grecian, Roman, Italian and Gothic Architecture, 3 vols, Oxford, fifth edition, 1850.

Grant, Col. Maurice H., *A Dictionary of British Sculptors from the 13th Century to the 20th Century*, London, 1953.

Graves, Algernon, *The Royal Academy of Arts: a complete dictionary of contributors and their work from its foundation in 1796 to 1904*, 8 vols, London, 1904.

Gray, A. Stuart, *Edwardian Architecture: a Biographical Dictionary*, London, 1985.

Groome, Francis H. (ed.), *Ordnance Gazeteer of Scotland: a survey of Scottish topography, statistical, biographical and historical*, 6 vols, London, n.d. [1895?].

Gunnis, Rupert, *The Dictionary of British Sculptors, 1660–1851*, London, 1953.

Hall, James, *Dictionary of Subjects and Symbols in Art*, London, 1974.

The Holy Bible, containing the Old and New Testaments, London, Edinburgh and New York, n.d.

'Hunterian Art Gallery: Sculpture', unpublished handlist of sculpture in HAG, 23 November 1995.

Hutchison Dictionary of Abbreviations, London, 1994.

Irving, Joseph, *The Book of Scotsmen, eminent for achievements in arms and arts, church and state, law, legislation, and literature, commerce, science, travel, and philanthropy*, Paisley, 1881.

Johnstone, W.T., *Dictionary of Scottish Sculptors*, MS Word for Windows 1.1, Livingston, 1993–5.

Laperriere, Charles Baile de (ed.), *The Royal Scottish Academy Exhibitors 1829–1990: A dictionary of artists and their work in the Annual Exhibitions etc.*, 4 vols, Wiltshire, 1991.

Lewis, Philippa and Darley, Gillian, *Dictionary of Ornament*, London, 1986.

Mackay, James, *The Dictionary of Sculptors in Bronze*, Woodbridge, 1977, revised 1992 and 1995.

Mallett, Lee (ed.), *New Architects: a guide to Britain's best young architectural practices*, London, 1998.

McEwan, Peter J.M., *Dictionary of Scottish Art and Architecture*, London, 1994.

Radice, Betty, *Who's Who in the Ancient World: a Handbook to the Survivors of the Greek and Roman Classics*, London, 1971.

Simpson, John A. (ed.), *The Concise Oxford Dictionary of Proverbs*, Oxford, 1982.

Slaven, Anthony and Checkland, Sydney (eds), *A Dictionary of Scottish Business Biography, 1860–1960*: vol.1, *The Staple Industries*, Aberdeen, 1986; vol.2, *Processing, Distribution, Services*, Aberdeen, 1990.

Smailes, Helen, *The Concise Catalogue of the Scottish National Portrait Gallery*, Edinburgh, 1990.

Spalding, Frances, *Twentieth Century Painters and Sculptors* (Dictionary of British Art, vol. 6), Woodbridge, 1990.

Stevenson, Hugh, unpublished 'Catalogue of Sculpture', GAGM, n.d.

Thieme, Ulrich and Becker, Felix, *Algemeines Lexikon der Bildenden Künstler von der*

Antike bis zur Gegenwart, Leipzig, 1907–50, 37 vols.

Turner, Joan (ed.), *The Dictionary of Art*, London, 1996, 34 vols.

Warrington, John, *Everyman's Classical Dictionary*, London, revised ed., 1969.

Waters, Grant M., *Dictionary of British Artists Working 1900–1950*, Eastbourne, 1975

2. Books, catalogues and articles

Alloway, Lawrence, 'The Public Sculpture Problem', *Studio International*, (184), October 1972, pp.123–4.

Annan, Thomas (photographer and publisher), *Illustrated catalogue of the exhibition of portraits on loan in the new Galleries of Art, Corporation building, Sauchiehall Street, Glasgow*, Glasgow, 1868.

Anon. [Daniel Reid Rankin], *Notices Historical, Statistical, & Biographical, relating to the Parish of Carluke from 1288 till 1874*, Glasgow, 1874. (Includes essays: 'Robert Forrest (Sculptor.)', pp.295–301 and 'John Greenshields (The Clydesdale Sculptor.)', pp.302–24.).

—— [J.O. Mitchell, J. Guthrie Smith and others], *Memoirs and Portraits of One Hundred Glasgow Men*, 2 vols, Glasgow, 1886.

'The Architecture of Our Large Provincial Towns. XVI. - Glasgow', *Builder*, 9 July 1898, pp.21–30, plus ills.

Armitage, Harold, *Francis Chantrey: Donkey Boy and Sculptor*, London, 1915.

Association for the Promotion of Art and Music in the City of Glasgow, Kelvingrove Art Gallery and Museum: Selected Designs, Glasgow, 1893.

Atterbury, Paul and Irvine, Louise, *The Doulton Story* (ex. cat.), London, 1979.

Aumonier, W., *Modern Architectural Sculpture*, London and New York, 1930.

Baker, Marilyn, *Manitoba's Third Legislative Building: Symbol in Stone: the Art and Politics of a Public Building*, Manitoba, 1986.

Baldry, A.L., 'The Art of 1900', *Studio*, vol.XX, no.87, June 1900, pp.3–20.

Barnard, Julian, *The Decorative Tradition*, London, 1973.

Barr, William W., *Glaswegiana: a miscellany of stories of Glasgow past and present*, Glasgow, 1973.

Beattie, Susan, *The New Sculpture*, Newhaven and London, 1983.

Bell, Sir James and Paton, James, *Glasgow: Its Municipal Organisation and Administration*, Glasgow, 1896.

Bergesen, Victoria, *Encyclopaedia of British Art Pottery 1870–1920*, London, 1991.

Berry, James J., *The Glasgow Necropolis Heritage Trail*, Glasgow, 1985.

Bett, Norman M., *Civic Bronze: the Memorials and Statues of Central Glasgow*, Edinburgh, 1983.

Biographical Sketches of the Hon. the Lord Provosts of Glasgow, Glasgow, 1883.

Black, Jimmy, *The Glasgow Graveyard Guide*, Edinburgh, 1992.

Blair, George, *Biographical and Descriptive Sketches of the Glasgow Necropolis*, Glasgow, 1857.

Blench, Brian J.R. *et al.*, *The Glasgow Style 1890–1920*, Glasgow, 1984.

Bliss, Douglas Percy, 'Sculpture in Glasgow', *Glasgow Herald*, 20 February 1954, p.3.

Borenius, Tancred, *Forty London Statues and Public Monuments*, with photographs by E.O. Hoppé, London, 1926.

Bowes, Christopher, 'J.G. Gillespie and the Lion Chambers', unpublished dissertation, GSA, 1989.

Brotchie, T.C.F., *The History of Govan*, Glasgow, 1905.

Brown, A.L. and Moss, Michael, *The University Of Glasgow: 1451–1996*, Edinburgh, 1996.

Buchanan, William (ed.), *Mackintosh's Masterwork: the Glasgow School of Art*, Glasgow, 1989.

Burnett, Charles J. and Dennis, Mark D., *Scotland's Heraldic Heritage: The Lion Rejoicing*, Edinburgh, 1997.

Bute, John Marquess of, K.T., Macphail, J.R.N. and Lonsdale, H.W., *The Arms of the Royal and Parliamentary Burghs of Scotland*, Edinburgh, 1897.

Carrell, Christopher (ed), *The Visual Arts in Glasgow: Tradition and Transformation*, Glasgow, 1985.

Cavanagh, Terry, *Public Sculpture of Liverpool*, Liverpool, 1997.

Chalmers, Peter M., *Art in Our City: Glasgow 1896*, Glasgow, 1896.

Chatwin, Amina, *Into the New Iron Age: Modern British Blacksmiths*, Cheltenham, 1995.

Crampsey, Robert A., *The Empire Exhibition of 1938: the last Durbar*, Edinburgh, 1988.

Cowan, James, ('Peter Prowler'), *From Glasgow's Treasure Chest*, Glasgow, 1951.

Craig, Archibald, *The Elder Park, Govan: an account of the gift of the Elder Park and the erection and unveiling of the statue of John Elder*, Glasgow, 1891.

Curtis, Penelope, *Sculpture 1900–1945*, Oxford, 1999.

Darby, Elisabeth and Smith, Nicola, *The Cult of the Prince Consort*, New Haven and London, 1983.

Darke, Jo, *The Monument Guide To England And Wales: A National Portrait in Bronze and Stone*, London, 1991.

Dawson, Hamish, 'The Man Behind the Chapel Carvings', *Avenue*, no.19, January 1996, pp.8–10.

Dibdin, Thomas Frognall, *A bibliographical, antiquarian and picturesque tour in the northern counties of England and in Scotland*, London, 1838.

Dobson, Zuleika (ed.), *Built in Scotland: work by ten sculptors*, (ex. cat.), Glasgow, n.d. (1983).

Duff, David, *Victoria in the Highlands*, London, 1968.

Dunkerley, Samuel, *Francis Chantrey Sculptor: from Norton to Knighthood*, Sheffield, 1995.

Durkan, John and Kirk, James, *The University of Glasgow 1451–1577*, Glasgow, 1977.

E.B.S., 'Afternoons in the studios: a chat with Mr. George Frampton, A.R.A.', *Studio*, vol.VI, no.34, January 1896, pp.205–13.

Empire exhibition, Scotland, 1938, Palace of Arts (Glasgow): illustrated souvenir, (Glasgow) 1938.

Eunson, Eric, *The Gorbals: an Illustrated History*, Ochiltree, 1996.

——, *Old Bridgeton and Calton*, Ochiltree, 1997.

Eyles, Desmond, *The Doulton Burslem Wares*, London, 1980.

Eyre-Todd, George, *Who's Who in Glasgow in 1909*, Glasgow and London, 1909.

——, *History of Glasgow*, vol.2, Glasgow, 1931, vol.3, Glasgow, 1934 (see also Renwick and Lindsay).

Frampton, George, A.R.A., 'The Art of Wood-Carving: Part I', *Studio*, vol.XII, no.55, October 1897, pp.43–7; 'The Art of Wood-Carving: Part II' *Studio*, vol.XII, no.57, December 1897, pp.155–62.

Frew, Brian J., 'The Commercial Architecture of James Miller', unpublished dissertation, GSA, 1988

Gibb, Andrew, *Glasgow: the Making of a City*, London, 1983.

Gifford, John, McWilliam, Colin and Walker, David, *Edinburgh*, The Buildings of Scotland, London, 1984, revised 1988.

——, *Highland and Islands*, The Buildings of Scotland, London, 1992.

Gildard, Thomas, 'On the late John Mossman, Hon. Royal Scottish Academician', *Proceedings of the Philosophical Society of Glasgow*, vol.XXIII, 1892, pp.291–302. (Note: text citations refer to MLG offprint, B118434, pp.1–12).

Glasgow and Lanarkshire illustrated, Hamilton, n.d. (1904?).

Glasgow contemporaries at the dawn of the XXth Century, Glasgow, n.d. (1901).

Glaves-Smith, John *et al.*, *Reverie, Myth, Sensuality: Sculpture in Britain 1880–1910* (ex. cat.), Stoke-on-Trent, 1992.

Glazier, Richard, *A Manual of Historic Ornament*, London 1899, revised edition 1948.

Glendinning, Miles, MacInnes, Ranald and MacKechnie, Aonghus, *A History of Scottish Architecture from the Renaissance to the Present Day*, Edinburgh, 1996.

Godden, Geoffrey A., *Jewitt's Ceramic Art of Great Britain 1800–1900*, London, 1972 (revised edition).

Goldscheider, Ludwig, *Michelangelo: Paintings, Sculptures, Architecture*, London and New York, 1953 (4th edition 1962, revised 1967).

Gomme, Andor and Walker, David, *The Architecture of Glasgow*, London, 1968, revised edition 1987. (Note: unless otherwise stated, text citations refer to the first edition.).

Gooding, Mel and Guest, Andrew, *The City is a Work of Art: Edinburgh*, Edinburgh, 1996.

Gordon, J.F.S. (ed.) and McUre, John, *Glasghu facies: a view of the city of Glasgow … By John M'Ure, alias Campbell, Glasgow MDCCXXXVI. Comprising also every history hitherto published. Edited by J.F.S. Gordon, D.D.*, Glasgow, 1873. (See also McUre.).

Gosse, Edmund, *A critical essay on the life and works of George Tinworth*, London, 1883.

Gourlay, Charles, 'Some notable Glasgow Buildings', *Architects' Journal and Architectural Engineer*, 15 October 1919, pp.471–8, 507.

Graham, William, 'Inscribed and sculptured stones in and around Glasgow. With limelight illustrations', paper no.6, read to the Old Glasgow Club, 21 February 1910, *Old Glasgow Club Transactions*, vol.2, 1908–13, pp.112–14.

Grant, Simon and Maver, Irene, *Five Spaces: new urban landscapes for Glasgow*, Glasgow, 1999.

Guest, Andrew and Smith, Helena, *The city is a work of art: 1., Glasgow*, Glasgow and Stirling, 1989.

—— and McKenzie, Ray (eds), *Dangerous Ground: Sculpture in the City*, Edinburgh, 1999, and www.sstq.demon.co.uk/dang_ground/index.htm.

Halliday, T.S. and Bruce, George, *Scottish Sculpture: a record of twenty years*, Dundee, 1946.

Harding, David, *Decadent: Public Art: Contentious Term and Contested Practice*, Glasgow, 1997.

Harris, Paul, *Glasgow Since 1900*, Edinburgh, 1989 (revised 1994).

Hartley, Keith, *Scottish Art Since 1900* (ex. cat.), Edinburgh and London, 1989.

Hill, William H., *History of the Hospital and School in Glasgow Founded by George and Thomas Hutcheson of Lambhill, A.D. 1639–41*, Glasgow, 1881.

Hitchcock, Henry Russell, *Early Victorian Architecture in Britain*, 2 vols, London and New Haven, 1954.

Honeyman, Tom, *Art and Audacity*, Glasgow, 1971.

House, Jack, *The Heart of Glasgow*, Glasgow, 1965 and 1978.

Howarth, Thomas, *Charles Rennie Mackintosh and the Modern Movement*, London, 1952 and 1990.

Hume, John R., *The Industrial Archæology of Glasgow*, Glasgow, 1974.

—— and Jackson, Tessa, *George Washington Wilson and Victorian Glasgow*, Aberdeen, 1983.

Hunter, Stanley, *International Exhibition of Industry, Science and Art, Glasgow, 1888*, Glasgow, 1990.

Irvine, Ian, *Edinburgh, Glasgow & Southern Scotland*, London, 1985.

Irvine, Louise, 'The Architectural Sculpture of Gilbert Bayes', *Journal of the Decorative Arts Society*, no.4, 1980, pp.5–11.

—— and Atterbury, Paul, *Gilbert Bayes*

Sculptor 1872–1953, London, 1998.

Irwin, David, *John Flaxman 1755–1826: sculptor, illustrator, designer*, London, 1979.

Jackson, Tessa and Guest, Andrew (eds), *The Visual Arts in Glasgow Cultural Capital of Europe 1990: a platform for partnership*, Glasgow, 1991.

Jezzard, Andrew, 'The Sculptor Sir George Frampton', 2 vols, unpublished PhD thesis, University of Leeds, 1999.

Keelie, G., *The Wee Glasgow Facts Book*, Glasgow, 1989.

Kenna, Rudolph, *Old Glasgow Shops*, Glasgow, 1996.

Kinchin, Perilla, *Tea and Taste: the Glasgow Tea Rooms, 1875–1975*, Oxon, 1991.

—— and Kinchin, Juliet, *Glasgow's Great Exhibitions: 1888, 1901, 1911, 1938, 1988*, Oxon, n.d. (1988).

King, David, *The Complete Works of Robert and James Adam*, Oxford, 1991.

Lacey, Suzanne (ed.), *Mapping the Terrain: New Genre Public Art*, Seattle, 1995.

Lawson, Judith, *Building Stones of Glasgow*, Glasgow, 1981.

Leighton, John M., *Select Views of Glasgow and its Environs*, with engravings by Joseph Swan, Glasgow, 1828.

——, *Strath-Clutha: or the Beauties of the Clyde etc.*, with engravings by Joseph Swan, Glasgow, n.d. (c.1839).

Lindsay, Maurice, *Victorian and Edwardian Glasgow from Old Photographs*, London, 1987.

——, *An Illustrated Guide to Glasgow, 1837*, London, 1989.

The Lord Provosts of Glasgow from 1833 to 1902: Biographical Sketches, Glasgow, 1902.

Lyall, Heather F.C., *Vanishing Glasgow*, Aberdeen, 1991.

MacDonald, Hugh, *Rambles Round Glasgow*, ed. Rev. G.H. Morrison, Glasgow, 1910. Reprinted as *Rambles Round Glasgow in the 1850's*, Newtongrange, 1982.

Macdonald, Murdo, *Scottish Art*, London and New York, 2000.

Macgeorge, Andrew, *An Inquiry as to the Armorial Insignia of the City of Glasgow*, Glasgow, 1866.

Mallett, Lee (ed.), *New Architects: a Guide to Britain's Best Young Architectural Practices*, London, 1998.

Manning, Elfrida, *Marble & Bronze: the Art and Life of Hamo Thornycroft*, London and New Jersey, 1982.

McFarlane, James, *George Square: Its History, Statues and Environs*, Glasgow, 1922 (GCA, Miscellaneous Pamphlets, vol.2, PA11/2.).

McKean, Charles, *The Scottish thirties: an architectural introduction*, Edinburgh, 1987.

——, Walker, David and Walker, Frank, *Central Glasgow: an Illustrated Architectural Guide*, Edinburgh, 1993.

McKenzie, Ray, *Sculpture in Glasgow: an illustrated handbook*, Glasgow, 1999.

McLellan, Duncan, *Glasgow Public Parks*, Glasgow, 1894.

McMillan, William, *Scottish Symbols: royal, national, & ecclesiastical their history and heraldic significance*, Pailsey, n.d. (1916).

McUre, John, *The History of Glasgow*, Glasgow, 1830 (new edition). (See also Gordon).

Melville, Jennifer, *Pittendrigh Macgillivray* (ex. cat.), Aberdeen, 1988.

Morgan, Nicholas J., 'Pavement, Glasgow': Scott Rae Stevenson Ltd 1838–1988*, Glasgow, 1988.

Mozley, Anita Ventura, *Thomas Annan: Photographs of the Old Closes and Streets of Glasgow 1868/1877*, New York, 1977.

Murray, Graeme (ed.), *Art in the Garden: Installations, Glasgow Garden Festival*, Edinburgh, 1988.

Nairne, Andrew and Arefin, Tony (eds), *George Wyllie Scul?ture Jubilee 1966–1991*, Glasgow, 1991.

Nairne, Sandy and Serota, Nicholas, *British Sculpture in the Twentieth Century* (ex. cat.), London, 1981.

Nisbet, Gary, 'City of Sculpture', *Scots Magazine*, vol.133, no.5, August 1990, pp. 520–5 (incl. ills).

'Noremac' (ed.), *The Public Parks of Glasgow: Historical and Descriptive Articles*, with photographs by William Cameron, Glasgow, 1908.

Noszlopy, George T., edited by Jeremy Beach, *Public Sculpture of Birmingham*, Liverpool, 1998.

Oakley, C. A., *The Second City*, London and Glasgow, 1946.

——, *Our Illustrious Forbears*, Glasgow, 1980.

Pagan, James, *Sketches of the History of Glasgow*, Glasgow, 1847.

Paterson, James, *Memoir of the Late James Fillans, Sculptor, Paisley*, Paisley, 1854.

Patrizio, Andrew, *Contemporary Sculpture in Scotland*, Sydney, 1999.

Parker, W.M., *A Great Scottish Sculptor* (Thomas John Clapperton), Guernsey, n.d.

Pearson, Fiona (ed.), *Virtue and Vision: Sculpture in Scotland, 1540–1990* (ex. cat.), Edinburgh, 1991.

Peter, Bruce, *Scotland's Splendid Theatres*, Edinburgh, 1999.

Pride, Glen L., *The Kingdom of Fife: an Illustrated Architectural Guide*, Edinburgh, 1990.

Rae, Alison and Woolaston, Graeme (eds), *Milestones for Scotland Handbook*, Glasgow, 1997.

Rankin, Daniel Reid, see Anon., above.

Read, Benedict, *Victorian Sculpture*, Yale, 1982.

Read, Ben (ed.) and Ward-Jackson, Philip, *Courtauld Institute Illustration Archives: Archive 4, Late 18th and 19th Century Sculpture in the British Isles, Part II, Glasgow*, London, 1984.

Read, Benedict and Skipworth, Peyton, *Sculpture in Britain Between the Wars* (ex. cat.), London, 1986.

Redstone, Louise G., *Public Art, New Directions*, New York, 1981.

Reed, Peter (ed.), *Glasgow: the Forming of the*

City, Edinburgh, 1993.

Reiach, Alan and Hurd, Robert, *Building Scotland: a cautionary Guide*, Glasgow, n.d. (c.1950).

Renwick, Robert (ed.), *Extracts from the Records of the Burgh of Glasgow*, 11 vols, Glasgow, 1909–16.

—— and Lindsay, Sir John, *History of Glasgow*, vol.1, Glasgow, 1921. (See also Eyre-Todd.).

Riches, John, McKee, Francis and Hunter, Kenny, *Man Walks Among Us*, Glasgow, 2000.

Rodger, Johnny, *Contemporary Glasgow: The Architecture of the 1990s*, Edinburgh, 1999.

Rogerson, Robert W.K.C., *Jack Coia C.B.E., F.R.I.B.A., P.P.R.I.A.S., R.S.A., Queen's Royal Gold Medalist for Architecture His Life and Work*, Glasgow, 1986.

Rosenberg, Eugene, *Architect's Choice: Art and Architecture in Britain since 1945*, London, 1992.

Rosenthal, Nan, *George Rickey*, New York, 1977.

Schotz, Benno, *Bronze in my Blood*, Edinburgh, 1991.

Scott, Susan (ed.), *Sculpture in Springburn Towards Glasgow 1990*, Glasgow, 1988.

'Senex' (Robert Reid), *Glasgow: past and present*, 3 vols, Glasgow, 1884.

Service, Alastair, *Edwardian Architecture and its Origins*, London, 1975.

Sinclair, Fiona J. (ed.), *Charles Wilson Architect, 1810–1863: A Question of Style*, Glasgow, 1995.

Sloan, Audrey with Murray, Gordon, *James Miller 1860–1947*, Edinburgh, 1993.

Smailes, Helen, *A Portrait Gallery for Scotland: the Foundation, Architecture and Mural Decoration of the Scottish National Portrait Gallery 1882–1906*, Edinburgh, 1985.

Smart, Aileen, *Villages of Glasgow*, vol.2, Edinburgh, 1996.

Smith, George Fairfull, 'Lanarkshire House, Glasgow: the Evolution and Regeneration of a "Merchant City" Landmark', *Architectural History*, vol.42, 1999, pp.293–306.

Smith, Michael, 'A menagerie in stone', *Scots Magazine*, December 1999, pp.618–21.

Smith, Ronald, *The Gorbals: Historical Guide and Heritage Walk*, Glasgow, 1999.

Smith, Tracy, 'Elusive Sculptors: sources for identifying and accrediting architectural sculpture'. *Scottish Archives: The Journal of the Scottish Records Association*, vol. 5, 1999, pp.107–14.

Smout, T.C., *A Century of the Scottish People, 1830–1950*, London 1986 and 1987.

Somerville, Thomas, *George Square, Glasgow and the Lives of Those Whom its Statues Commemorate*, Glasgow, 1891.

Sparrow, Walter Shaw, see W.S.S., below.

Spielmann, M.H., *British Sculpture and Sculptors of To-day*, London, Paris, New York and Melbourne, 1901.

Stamp, Gavin, *Alexander Thomson: The Unknown Genius*, Glasgow, 1999.

—— and McKinstry, Sam (eds), *'Greek' Thomson*, Edinburgh, 1994.

Steuart, W.O., 'A Man Called Greenshields', *Scots Magazine*, vol.57, no.1, April 1952.

Stevenson, D.M. *et al.*, *Municipal Glasgow; its Environs and Enterprises*, Glasgow, 1914.

Stevenson, John Horne, K.C. and Wood, Marguerite, Ph.D., *Scottish Heraldic Seals: royal, official, ecclesiastical, collegiate, burghal, personal*, 3 vols, Glasgow, 1940.

Stewart, Peter, *Central Glasgow*, Stroud, 1997.

Stoddart, Alexander J., 'John Mossman, Sculptor: 1817–1890', unpublished dissertation, GSA, 1980.

——, 'Thomson, Mossman and Architectural Sculpture' in Stamp and McKinstry, pp.80–93.

——, '"A refined sense of Beauty in Architectural Adornment": Figure-sculpture on Charles Wilson buildings', in Sinclair, pp.13–15.

Stothers' Glasgow, Lanarkshire and Renfrewshire Xmas and New Year Annual, 1911–1912, Hamilton, 1911.

Strachan, W.J., *Open Air Sculpture in Britain*, London, 1984.

Stratten's Glasgow and its Environs: a Literary, Commercial, and Social Review Past and Present, London, 1891.

Stuart, Andrew, *More Old Springburn*, Ochiltree, 1994.

——, *Old Dennistoun*, Ochiltree, 1995.

——, *North Glasgow*, Stroud, 1998.

Swan, Joseph (engraver and publisher), see John M. Leighton.

Teggin, Harry, Samuel, Ian, Stewart, Alan and Leslie, David, *Glasgow Revealed: a Celebration of Glasgow's Architectural Carving and Sculpture*, Glasgow, 1988.

Tweed, John, *Tweed's Guide to Glasgow and the Clyde*, Glasgow, 1872. Reprinted as *Glasgow a hundred years ago*, Molindinar Press, Glasgow, 1972.

——, *Glasgow Ancient and Modern*, 4 vols, Glasgow, 1872.

Tweed, Lendal, *John Tweed, Sculptor: a Memoir*, London, 1936.

Urquhart, Gordon R., *Along Great Western Road : an illustrated history of Glasgow's West End*, Ochiltree, 2000.

Urquhart, R.M., *Scottish Burgh and County Heraldry*, London, 1973.

Usherwood, Paul, Beach, Jeremy and Morris, Catherine, *Public Sculpture of North-east England*, Liverpool, 2000.

Ward, Robin, *Glasgow Drawings*, Glasgow, 1975.

Warner, Marina, *Monuments and Maidens: The Allegory of the Female Form*, London, 1985.

Warring, J.B., *Masterpieces of Industrial Art and Sculpture at the International Exhibition, 1862*, with lithographs by W.R. Tymms *et al.*, 3 vols, London, 1863.

West, W.K., 'The Work of F. Derwent Wood', *Studio*, vol.XXXIII, no.142, January 1905, pp.297–306.

Whinney, Margaret (revised John Physick), *Sculpture in Britain 1530–1830*,

Harmondsworth, 1988.

Williamson, Elizabeth, Riches, Ann and Higgs, Malcolm, *Glasgow*, The Buildings of Scotland, London, 1990.

Woodward, Robin Lee, 'Nineteenth Century Scottish Sculpture', unpublished PhD thesis, University of Edinburgh, 1977.

Worsdall, Frank, *The Tenement: a way of life*, Edinburgh, 1979.

——, *The City That Disappeared: Glasgow's Demolished Architecture*, Glasgow, 1981.

——, *Victorian City*, Glasgow, 1982.

——, *Victorian City*, Glasgow, 1988.

W.S.S. (Walter Shaw Sparrow), 'Mr. George Frampton A.R.A., and his work for the Glasgow Art Gallery', *Studio*, vol.XXII, no.95, February 1901, pp.14–18.

Yarwood, Doreen, *Robert Adam*, London. 1970.

Young, Andrew McLaren and Doak, A.M., *Glasgow at a Glance*, Glasgow, 1965, revised 1971.

Young, William, *The Municipal Buildings of Glasgow*, Glasgow, 1890.

3. Archives and Manuscript Sources

Glasgow School of Art
General Register (Alpha) 1881–.
Governors' Correspondence Books, 1853–92.
Governors' Minute Books, 1847–1906.
Prospectuses, 1900–14.
Reports, 1854–1938.

Hunterian Art Gallery
Honeyman & Keppie Job Books, 1849–67, 1861–76, 1874–81, 1881–94, 1894–5, 1894–1905, 1902–8, 1908–21, 1920–8, 1926–37, 1934–57.

Glasgow University Archive and Business Record Centre
Illustrated Catalogue of Macfarlane's Castings, Glasgow, n.d. (*c*.1885) sixth edition vols 1 and 2.

Mitchell Library, Glasgow (Glasgow Room)
Calendar of Confirmations and Inventories Granted and Given up in the Several Commissariots of Scotland, HMSO, 1876–1936.
Post Office Glasgow Directory, 1787–1978.
Virtual Mitchell <http://ww.mitchelllibrary.org/vm>
Glasgow Scrapbooks, vols 1–31.
Young Scrapbooks, vols 1–39.

Glasgow City Archive
Administrative and General Notes (AGN).
Buildings of Special Architectural or Historic Interest. Combined Statutory and Descriptive List (LBI).
Dean of Guild Court plans (B4/12/-).
Glasgow Corporation Minutes (C1/3/-).
Jot Book of William Mossman, 1835–39, TD 110.
Miscellaneous Prints (M.P.).

National Monuments Record of Scotland
Photographic Collection, Glasgow (A-Z).

National Library of Scotland
Macgillivray MSS.

Other Unpublished Sources
'City of Sculpture', private research archive and visual documentation compiled by Gary Nisbet, 1988–2001.

4. Newspapers and Periodicals

Academy Architecture.
Architect.
Architect and Building News.
Architect and Contract Reporter.
Architects' and Builders' Journal.
Architects' Journal and Architectural Engineer.
Avenue: the Magazine for Graduates and Friends of the University of Glasgow.
Bailie.
Builder.
British Architect.
Building Chronicle.
Building Industries and Scottish Architect.
Builders' Journal.
Builders' Journal and Architectural Record.
Builders' Journal and Architectural Engineer.
Building News.
Bulletin.
Evening Citizen.
Evening Times.
Glasgow Advertiser and Property Circular.
Glasgow Chamber of Commerce Journal.
Glasgow Courier.
Glasgow Gazette.
Glasgow Herald.
Glasgow Weekly Herald.
Govan Press.
Herald.
Illustrated London News.
Inverness Courier.
Journal of Decorative Art.
North British Daily Mail.
Northern Looking Glass.
Pollokshields Guardian.
Pollokshields Monthly.
Royal Institute of British Architects' Journal.
Scots Magazine.
Scottish Archives: The Journal of the Scottish Records Association.
Scottish Art Review.
Sculpture Matters.
Southern Necropolis Newsletter.
South Side News.
Studio.
West End News and Partick Advertiser.

Index

Notes: titles of works are in italics. References to illustrations are in bold. Monuments and sculptures are indexed in two ways: (i) by the title, followed by location, then maker's surname in brackets, and (ii) by maker, followed by title.

A. & J. Main & Co. Ltd 228
A. MacDonald & Co. Ltd 303
AA Brothers Ltd 29
Abbey National PLC 323
Abbotsford Primary School, Abbotsford Place 448
Abundance, personifications
 Bank of Scotland Building (W. Mossman Jr) 365
 Bank of Scotland Chambers (Unknown) 371, **371**
 Bank of Scotland (Crawford) 28
 St Vincent Street (Unknown) 372, **372**
Academy Architecture (periodical) 35, 333, 336, 360
ADAC Engineering Services 50
Adam, George *see* George Adam & Son
Adam, James 164, 165, 173, 174, 380, 381
Adam, Robert xii, 164, 165, 173, 174, 279
Adam, Stephen 335
Adelphi Terrace Public School, Adelphi Street 448
Adventure, personification, Royal Bank of Scotland (Archibald and Ferris) 360, **360**
Africa, personification, Renfield Street (W.B. Rhind) 322
Agnus Dei and Other Carved Animals, John Ross Memorial Church (Dawson) 425, **425**
Agriculture, personifications
 British Linen Company Bank (Keller) 443–4, **444**
 Corinthian (J. Mossman) 212
 Stock Exchange (J. Mossman) 43

Aitken of Dalmoak Mausoleum, Necropolis (Hamilton) 458
Aitken, John, Memorial Fountain, Govan Road (Unknown) 450
Aitken, Margaret Carlyle 235
Albany Chambers, Sauchiehall Street 349
Albert Bridge, Saltmarket/Laurieston Road 342–3
Albert, Prince 128
 and Queen Victoria, Medallion Portraits of, Albert Bridge (Ewing) 342–3, **342, 343**
 Equestrian Monument to, George Square (Marochetti) 115, 116, 130, 134–6, **135**, 148
Alberti, Leon Battista 270
Albion (formerly Nelson) Street 1
Alexander, James 88
Alexander, John Henry
 Monument, Necropolis (Ritchie) 459
 Statue of, Theatre Royal (J. Mossman) 436
Alexander Macdonald & Co. 96
Alexander Muir & Sons 198, 331, 360, 382, 416
Alexander Thomson & Son 286
Alexander Turnbull Building, George Street 162–3
Alexander Wright & Kay 401, 457
Alexandra Parade 2–4
Alexandra Park 2–4, **2**
Alfred, Duke of Edinburgh 135
Alison, Archibald 127–8, 337, 338–9, 415
Allan, Alexander 298
 and Family, Tomb of, Necropolis (Macgillivray) 303–4, **304**
Allen, E.J. Milner 247, 248, **248**, 249–50, **249**, 255, 264, 266
Allen, Grant 416
Alliance Building, West George Street 446
Alloway, Lawrence xviii
Allscot Plastics Ltd 290, 318, 357
Alston, John 298
Amphitrite
 Ocean Chambers (Unknown) 420–1, **421**

with a Pair of Seahorses, Clydeport Building (Hodge) xiv, 333, **333**
Anchor Line Building, St Vincent Place 366
Anchor Line Steamship Company 366
Ancient Arts, personification, Mitchell Theatre (J. Mossman and Fergusson) 191
Anderson & Henderson 44
Anderson College of Medicine, Dumbarton Road 90–1
Anderson Company Warehouse, Miller Street 442
Anderson, David 353
Anderson, James 128
Anderson, John 404, 407
Anderson, Robert Rowand 59, 451
Anderston 7–8, 29–30, 190–5, 310–13, 431, 433, 442
Anderston House, Argyle Street 431
Anderston Public Library, McIntyre Street 442
Anderston Savings Bank, Argyle Street 7–8
Angel, Angel Building, Paisley Road West (Unknown) 317–18, **317**
Angel, J. 159
Annan, James Craig 347
Annan, Thomas 346
Annan, William, Fountain, Renfield Street (Scott & Rae) 455
Apollo
 Mitchell Theatre (J. Mossman and Fergusson) 191
 Renfield Street (W.B. Rhind) 323–4, **323**
Arch Bronze Foundry 197
Archer, Michael Dan 476
 Gateway 110–11, **110**
Archibald, Phyllis Muriel Cowan 476
 Figures of Industry and Science 445–6
 Symbolic Figures and Associated Decorative Carving 360, **360**
Archibald Young (Brassfounders) Ltd, Kirkintilloch 89, 104
Architect (periodical) 335, 379, 433

Architects' and Builders' Journal 370
Architecture, personifications
 Glasgow Art Gallery and Museum
 (Wood) 253, 259
 Govan Town Hall (Young) 180
 Mitchell Theatre (J. Mossman, W.
 Mossman Jr and Fergusson) 191
 Relief Panels of the History of, Naburn Gate
 (Scott and Scott Associates Sculpture and
 Design) 290, **290**
Architecture (periodical) 260
Argos catalogue store, Stockwell Street 456
Argyle Street 4–8, 249, 431, 448, 462
Argyll Chambers, Buchanan Street 34–5
Argyll, Duke of 276
Aristotle, portrait roundel of, Ladywell School
 (Crawford) 88
Armitage Associates 86
Armitage, Joseph 23
Art and Museum Fund 240
Art in Partnership xvii, 284, 361, 456
Art, personifications
 Bridgeton District Library (Brown) 272, **272**,
 273
 Grosvenor Restaurant (Hodge) 437–8, **437**
 Stock Exchange (J. Mossman) 43, 44
Art Union 338
Arthur & Co. Ltd 66
Arthur & McNaughtan 387
Arthur, James 409
 Monument to, Castle Square (Lawson) 65–6,
 65
Arts and Humanities Research Board v
Arts Pay Homage to Minerva, Hindu Temple
 (J. Mossman) **271**
Arts of Peace, The City Chambers (J. Mossman)
 159, **159**
Arts, the, personifications
 Glasgow Art Gallery and Museum
 (Wood) 259–60, **259**
 Notre Dame High School (Unknown) 314
 People's Palace Museum (Brown and
 Mackinnon) 171
Artworks for Glasgow scheme 78, 91, 284, 361
As the Crow Flies, West Princes Street

(Kinloch) 422, **422**
As Proud As..., Springfield Court (Kinloch) 359,
 359
Ashgill Road 8–9
Ashley Street 10–11
Assaye, Battle of, Royal Exchange Square
 (Marochetti) 337
Association for the Promotion of Art and
 Music in the City of Glasgow 248
Athena
 Bothwell Street (McGilvray & Ferris) 25–6
 Castle Chambers (Brown) 324–5, **325**
 Gordon Street (Unknown) 178, **178**
 Mitchell Theatre (J. Mossman and
 Fergusson) 191
 Profile Reliefs of, Kelvinside Academy
 (Unknown) 16, **16**
Athenaeum, Nelson Mandela Place 305–6
Athenaeum Theatre, Buchanan Street 44–5
Atherton, Barry 30
Atlantes
 *Allegorical Female Figures and Associated
 Decorative Carving*, Bank of Scotland
 Building (W. Mossman Jr) 365–6, **365**
 Caledonian Chambers (Hodge) 385
 Fraser's Department Store (Vickers) 6–7, **6**
 Grosvenor Restaurant (Hodge) 437–8, **438**
 Merchants' House Buildings (Young) 413–14
 Mitchell Theatre (W. Mossman Jr) 190, 191,
 193, 194
 Trustee Savings Bank (Frampton and
 Shirreffs) 208–9, **209**
Atlantic Chambers, Hope Street 198–9, 410
*Atlas, Allegorical Pediment Relief and
 Associated Decorative Carvings*, Standard
 Buildings (J. Young) xiv, 179–80, **179**
Atlas Square 11–12
Aumonier, William 252, 254, 476
*Aurora, Apollo, Allegorical Figures of Night and
 Morning and Related Decorative Carving*,
 Renfield Street (W.B. Rhind) 323–4, **323**
Australia, personifications
 Doulton Fountain (Pomeroy) 167
 Renfield Street (W.B. Rhind) 322
Ayr Street 448

B. & W. Anderson 201
Bacon, John, the Younger 122
Bailie (periodical) 142, 368
Baillie, Joanna 204
Baily, Edward Hodges 144
Baird & Stevenson 17
Baird & Thomson 449
Baird, John 36, 48, 464
Baird, Lucy 476
 Untitled 389–90, **389**
Baird, Robert 270
Baird, Susan 198
Baird, William, portrait roundel of, Connal's
 Building (J. Young) 417
Balfour & Stewart 371, 386
Balfour, A.J. 230
Balgray Tower, Broomfield Road 448–9
Balgrayhill Council 11
Ballater Street 448
*Ballindalloch, Esther Ritchie Cooper of,
 Monument*, Necropolis (J. Mossman) 458
Balornock Primary School 358
Balornock Road 431
Baltic Chambers, Wellington Street 458
Bank of Scotland
 Bridge Street 28, **28**
 George Square 450
 Govan Road 183, **183**
 Ingram Street 438–9
 St Vincent Place 365–6
 Sauchiehall Street 344–5
Bank of Scotland Chambers, St Vincent Street
 371
Bannatyne, Andrew 138, 139
Barbedienne, F. 221
Barlanark Road 12–13
Barlas, George 340
Barnes, H. Jefferson 328, 329, 330
Barrett, Francis Thornton, Memorial Tablet to,
 Mitchell Library (Paulin) 312–13
Barrie, Councillor 238
Barrie, J.M. 204
Barry, Charles 150
Basil Spence & Partners 467
Bass Leisure Retail 205, 371

Bates, Harry 232–3, 234, 476
 Monument to Field Marshall Earl Roberts 231–4, **231**
Bates, Mrs 232, 233
Bath Street 13–14, **14**, 87, 431, 462
Battle Place 14–15
'Battle of the Styles' xiii
Baxter House, Great Western Road 451
Bayes, Gilbert 432, 458, 476
 Six Allegorical Relief Panels 22–3, **22**
BBA Group Pensions Trustees Ltd 370
BBC Scotland, Queen Margaret Drive 455
Beattie, Susan 232, 234
Beethoven, Ludwig van
 Bust of, Sauchiehall Street (Ewing) 348, **348**
 Portrait Profile Medallion of, King's Theatre (Unknown) 13, **14**
Begg, Ian 449
Beleschenko, Alexander 454
Belfast 79
Bell & Miller 342
Bell, Alison, *Ibrox Disaster Memorial* 93–4, **93**
Bell, David xiv, 270, 271–2
Bell, George, II 178, 339, 340, 452
Bell, Glassford 144
Bell, Henry, *Statue of*, Clydeport Building (Hodge) **334**, 335
Bell, J.A. 459
Bell, James 355
Bell, Robert 196
Bell, Sheriff 62
Bell Street 448, 462
Bellahouston Park 431–2, 448
Bellarmine Arts Association 282
Bellshaugh Road 16
Beltane Studios 477
Bemersyde, Earl Haig of 244
Benacci, Rodolfo 453
Bengal Tigress, Kelvingrove Park (Cain) 220, 221–2, **221**
Benny Lynch Court 448
Benson, Philip 452, **452**, 477
 Big Bluey 267–8, **267**
Berger, John 189–90
Berkeley Street 432–3

Berman, Brenda 449
Bernard Reinhold Trust 211
Best Practice Award, British Urban Regeneration Association 215
Best, W.T. 194
Bevan, Anne, *Fragments* 450
Bevan, Peter 12
Big Bluey, Big Blue diner (Benson) 267–8, **267**
Billings, R.W. 397
Bilsland Drive 17
Bilsland, William 228, 229
Bird and Fish Panels, Errol Gardens (Gosse and Doyle) 109–10, **109**
Birkbeck, George 404
Birmingham Guild 27
Birrell, Augustine xiv, 230
Birrell, Ross, *Working Class Hero* 117–18, **118**
Bishop Mills building, Old Dumbarton Road 454, **454**
Bishop's Palace Memorial Pillar, Castle Square (Gray) 66–7, **66**
Bisset, Douglas 431, 432, 477
 Reaper 276, **277**
Black, J. Buyers 220, 235
Black, James 119, 265
Black, Joseph, Memorial Tablet, University of Glasgow (Schotz) 401, **401**
Black, Pastor William, Memorial, Necropolis (J. Mossman) 459, **459**
Black, William George 203, 340–1
Blair of Avontoun, Lord, *Keystone Portrait of*, Royal Faculty of Procurators (A.H. Ritchie and Steel) 307
Blair, George 295, 296, 297, 298, 299, 300, 301, 302, 443
Blake, William 320
Blessings of Peace, Royal Exchange Square (Marochetti) 337
Bliss, Douglas Percy xv, 9, 70, 236
Blouët, Paul 116
Blue Circle Industries PLC 451
Blyth, B.H. 449
Blythswood 107–9, 423–5
Blythswood, Lord 149
Blythswood Street 27, 345

Boase, Alan M. 391–2
Boehm, Joseph Edgar 235, 236, 477
 Monument to John Elder 96–100, **97**
Bon Accord Granite Company Ltd 51
Bonheur, Rosa 222
Bonnar, Stanley 477
 The Community 426, **426**
Border Square Builders Ltd 405
Borglum, Gutzon 235
Boschetti, *La Innocenza* 440–1
Botanic Gardens 17–22
Bothwell Street 22–7, 433, 448
Boucher & Cousland 322
Boucher, James 454
Bowen, Clifford 30
Boyd, James Davidson 55
Boyd, John 451
Boyd, Zachary 388
Bradford and Bingley Building Society 40
Braehead Shopping Centre, King's Inch Road 269
Bramwell, Edward George 247, 477
 Seated Female Figure Symbolising Literature 253, **253**, 260–1
Breen, Robert 268
Breeze, Gary 456
Bridewell Studios 79
Bridge Street 28, 433, 448
Bridgegate Trust 227
Bridgeman, R. 396
Bridgeton 195, 272–3, 282–4
Bridgeton Cross 462
Bridgeton District Library, Landressy Street 272–3
Bridie, James 204
 Portrait of, Citizen's Theatre (Schotz) 175
Briggait, Clyde Street 75
Bringer, Springburn Way (Scott) 357, **357**
Bristol & West PLC 386
Britain, royal arms of 462
Britannia Building, Buchanan Street 449
Britannia Life Assurance Ltd 25, 420
Britannia, personifications
 Albany Chambers (Unknown) 349, **349**
 Atlantic Chambers (McGilvray & Ferris)

198–9, **199**
Corinthian (J. Mossman) 212
Glasgow Cross (Crawford) 437
Jeffrey Reference Library 219
British & Italian Mosaic Company 7
British Architect (periodical) 37, 40, 43, 170,
200, 253, 254–5, 260, 261
British Linen Company 183, 196–7
 bank, Eglinton Street 436
 bank, Gorbals Street 450
 bank, Queen Street 443–4
British Urban Regeneration Association 215
Broad & Sons 184
Broad, John 166, 477
 India 167–8
 Queen Victoria 168–71, **168, 169**
Broadbent, Stephen 477
 Reconciliation 79–80, **80**
Brock, Thomas 146
Brocket, A. 450
Brodie, William 416, 478
 Duncan Macfarlan Monument 459
 John Graham Gilbert Monument 458
 The Mathematician 195, **195**
 Monument to Graham Thomas 139–40, **139**
 Statues of St Andrew and St Mungo and
 Decorative Carving 444
Bromhead, Horatio Kelson 6, 81
Bromsgrove Guild of Applied Arts 465, 478
 Phoenix Trophies 370–1, **370**
Broomfield Road 448–9
Brougham and Vaux, Lord, *Keystone Portrait*
 of, Royal Faculty of Procurators (A.H.
 Ritchie and Steel) 307, **307**
Brown, Andrew 311
Brown, Crum 230
Brown, Smith & Co. 33
Brown Street 29–30, 433
Brown, William Kellock 102, 243, 404, 450, 464,
478
 Figurative Programme, Bridgeton District
 Library 272–3, **272**
 Figurative Programme, Dennistoun Public
 Library 80–1, **80, 81**
 Figurative Programme, Gorbals Economic

and Training Centre 280–1, **280, 281**
Figurative Programme, Govanhill and
 Crosshill Public Library 274–5, **275**
Figurative Programme, Maryhill Public
 Library 280, **280**
Figurative Programme, Parkhead Public
 Library 378–9, **379**
Figurative Programme, Woodside Public
 Library 363, **363**
Four Allegorical Female Figures, Athena and
 Related Decorative Carving 324–5, **324,**
 325
Hygieia 286–7, **287**
Monument to John Stewart 86–7, **86**
Monument to Thomas Carlyle 234–6, **235**
Nine Allegorical Figures 171–3, **172**
Pallas Athena, Muses, Wind Gods and Putti
 44–5, **45**
Thomas Andrew Miller Monument 459
Browne, George Washington 40
Bruce & Hay 84, 287, 317, 348, 397, 442, 448
 see also Bruce, Donald
Bruce, Donald 431, 433, 446
 see also Bruce & Hay
Bruin, Michelle de 478
 Illuminated Wall Sculpture 47–8, **47**
 Milestone 83, **83**
Brunswick Lane 31–2
Bryce, David 297, 458
Bryden, Robert Alexander 351, 352, 420, 433
Bryson, William, Semi-abstract Figure of, St
 Nicholas Garden (Sloan) 57–8
Buccleuch Street 449
Buchan, George 433–4
Buchan, Walter 109, 478
 Narrative Friezes and Associated Decorative
 Carving 427–9, **427, 428, 429**
 Narrative Friezes, Portraits, Trophies and
 Associated Decorative Carving 270–2, **270,**
 271
Buchanan, Charles 464
Buchanan, Dr 152
Buchanan, James 195
Buchanan Street 5, 6, 32–46, **33**, 55, 433–4, 449
Buchanan, Walter 118, 133

Buchanan, William 30, 328
Buckley, Jim 478
 Dennistoun Milestone 89, **89**
Buck's Head Building, Argyle Street 4–5
Budden, Lionel 4
Builder (periodical) x, 22–3, 23, 69–70, 131, 133,
 137–8, 142, 152, 160, 194, 210, 248–9, 271,
 274, 278, 304, 311, 339, 343, 388
Builders' Journal 8, 38, 210, 255
Building Chronicle (periodical) 129–30
Building Design Partnership 174
Building Industries (periodical) 26, 179, 311,
 350–1
Building News (periodical) 42, 43, 60, 116, 118,
 137, 139, 141, 144, 198, 226, 310, 360, 366,
 368, 439
Building, personification, Stock Exchange (J.
 Mossman) 43
Bulkhead public art prize xvii
Burford Investment Co. Ltd 41
Burford Midland Group PLC 344
Burges, William 43–4
Burgh Hall Street 47
Burgh Halls, Maryhill Road 453
Burgher Street 113
Burke, Bernard 46
Burke, Ian 318
Burleighfield Foundry, High Wycombe 11
Burn, William 436, 438
Burnet & Boston 456, 465, 467
Burnet, Boston & Carruthers 346, 451, 457, 463
Burnet, Frank 441
Burnet, John v, 26, 28, 43, 88, 109, 175, 210,
 212, 214, 413–14, 432, 433, 454, 463
Burnet, John James 44, 87, 103, 116, 147, 198,
 210, 230, 305, 321, 322, 324, 331, 335, 336,
 349, 350, 351, 367–8, 374, 375, 380, 390, 396,
 397, 398, 399, 400, 410, 414, 444, 446, 450,
 463, 466
Burnet, Son & Campbell 208, 210, 349, 478
Burns, Robert 271
 Monument to, George Square (G.E. Ewing,
 Leslie and J.A. Ewing) xiii, 140–3, **140**
 Statue of, Citizen's Theatre (J. Mossman)
 174–6

Burrell Collection 428, 429
Burroughs, Jamie 479
 Surf City **16**, 17
Burton, A.B. 236, 239–40
Bushe, Fred 30
Butler, Vincent 479
 Springburn Heritage and Hope 11–12, **11**
Byatt, Lucy, *Fragments* 450
Byres Road 47–8

Cadogan Street 434–5, 446
Caged Peacock, Queen Street (Wyllie) 320, **320**
Cain, Auguste-Nicolas 479
 Bengal Tigress 220, 221–2, **221**
Cain, Kibble Palace (Mullins) 18, **18**
Caird, Very Reverend Principal 72
Calcutt, John 31–2
Calder Street Public Baths and Wash-house,
 Calder Street 449
Caledonian Chambers, Union Street 385
Caledonian Railway Bridge, Clyde Street 449
Calf, Graham Square (Hunter) 189–90, **189**
Callanish, University of Strathclyde (Laing)
 404–6, **405**
Calton 88, 163–73, 205, 377–8, 384, 436, 442
Calvay Housing Co-operative 12–13
Calvay Milestone, Barlanark Road (Skrynka)
 12–13, **13**
Cambridge Buildings, Cambridge Street 48
*Cameron, Charles, Portrait Medallions of, and
 Associated Decorative Work*, Cameron
 Memorial Fountain (Tinworth) 351–2, **352**
Cameron, Hector 243
Cameron, Lady 352
Cameron Memorial Fountain, Sauchiehall
 Street 351–2
Cameronians (Scottish Rifles) War Memorial,
 Kelvingrove Park (Clark) 243–4, **244**
Campbell, Alexander 98, 183
Campbell, Colen 383
Campbell Douglas 174, 175
Campbell Douglas & Sellars 37, 62
Campbell Douglas & Stevenson 368, 369
Campbell, James 137
Campbell, James A. 72, 144

Campbell, John A. 370, 449, 450, 451, 455, 457,
 465
Campbell, Mungo Nutter 123
Campbell, Thomas 125, 141, 196
 Monument to, George Square (J. Mossman
 and MacGillivray) 143–4, **143**
Canada, representations
 Doulton Fountain (Frith) 167, **167**
 Renfield Street (W.B. Rhind) 322
Candleriggs 449
Canning, Viscount 128
Cant & Lindsay 67, 68
Capital Shopping Centres 269
Carlisle Memorial Centre 79
Carlton George Hotel, Dundas Lane 91
Carlton Place 49
Carlyle, Thomas, Monument to, Kelvingrove
 Park (Brown) 220, 234–6, **235**
Carmichael, ex-Bailie 183
Carmichael, James 294
Carmunnock Road 50–1
Carnarvon Street 10
Carnegie, Andrew 81, 311–12, 316
Carnegie, Samuel Chisolm 81
Carrick, Alexander, *Figurative Relief* 437
Carrick, John 70, 115, 141, 150, 164, 169, 190,
 341, 381, 435, 440, 449, 456, 464, 465, 466
Carruthers, James 325
Carter's Hitch, Carlton George Hotel
 (Hutchison) 91, **91**
Castle Chambers, Renfield Street 324–5
Castle Street 52–60, 435
Castlemilk 50–1, 51–2, 110–11
Castlemilk Drive 51–2
Castlemilk Environment Trust 50, 51, 110
Castlemilk Women's Group 110
Castlemilk Writer's Group 111
Cathcart Road 462
Cathedral Square 61–7, 449
Cathedral Square Gardens 67–72
Catholic Herald (periodical) 410
Cation, David 465, 479
 *Thirteen Keystone Masks, including nine
 'Tontine Faces'* 52–6, **54**
Cavanagh, Terry xiii

*Caxton, William, Statue of, Narrative Relief
 Panels and Associated Decorative Carving*,
 Glasgow Herald Building (Grassby and J.
 Mossman) 38–40, **39**
Cenotaph, George Square (Gillick) 116, 147–9,
 147
Central Fire Station, Ingram Street 451–2
Central Springburn Council 11
Central Standard Buildings Ltd 179
Centre Street 73
Ceres and Neptune, Trongate (Unknown)
 381–2, **382**
Cesar, Josef 395
Chalmers, James 411
Chalmers, Peter MacGregor 431
Chambers, Kathleen 479
 Relief Map of the West End of Glasgow
 246–7, **247**
 Topographical Relief Map 42, **42**
Chantrey, Francis Leggatt 338, 339, 416, 479
 Monument to James Watt 115, 122–4, **123**
 Statue of James Watt 393–4, **393**
Charing Cross 13–14, **14**, 106–7, 349–52
Charing Cross Mansions, Sauchiehall Street
 349–51
Charity, personifications
 The City Chambers (Lawson) 153
 Garnethill Convent Nursery (Unknown)
 353–4, **353**
 Houldsworth Family Mausoleum,
 Necropolis (Thomas) 302, **303**
Charles Henshaw & Sons 467
Charlie, Bonnie Prince 163
Cheltenham & Gloucester PLC 370
Cherub/Skull, Tron Theatre (Hunter) 380–1,
 380
Children of Glasgow Fountain, Kelvingrove
 Park (Snowden) 246, **246**
China Town Investments Ltd 308
Chinatown, New City Road 308–9
Chirnsyde Primary School, Ashgill Road 8–9
Chookie Burdies, Buccleuch Street (Kinloch)
 449, **449**
Christ
 Feeding the Multitude, Church of St

George's in the Fields (W.B. Rhind) 363–4, **364**

Healing a Blind Boy, Royal Asylum for the Blind (Grassby) 60, **60**

Healing the Deaf and Dumb Man, Relief of, Sovereign House (Unknown) 424–5, **424**

Chthonic Columns, St Enoch Underground Station (Firth) 360–1, **361**

Church of St George's in the Fields, St George's Road 363–4

Church Street 73–4

Cicero, Statue of, Strathclyde House (Unknown) 107–9, **108**

Ciniselli, Giovanni 480

Ruth 19–20, **20**

Citizen's Theatre, Gorbals Street 174–6

City Centre 6–7, 22–7, 32–46, 48, 86–7, 91, 114–63, 177–80, 198–203, 305–8, 320–5, 331–9, 344–9, 360–1, 365–76, 385–6, 410–21, 431, 433–8, 442–6

City Chambers, George Square 148, 149–61, **158, 161**

City and County Buildings, Wilson Street 427–9

City of Culture Festival, Glasgow 1990 36

City of Glasgow Friendly Society 87

Douglas Street 86–7

City of Glasgow Life Assurance Building, Renfield Street 444

City and Guild of London Institute Technical Art School, Kensington 166

City and Guilds Institute 170

City Improvement Department 382, 464, 465

see also City Improvement Trust

City Improvement Trust 72, 451, 456, 462, 463, 464, 465, 466

see also City Improvement Department

City Site Investments Ltd 373

Civil Engineer and Architect's Journal 178

Clapperton, Thomas John 173, 480

Allegorical Figure of Literature 310–12, **310, 311**

'Springtime' Pedestal 283–4, **284**

Clark, Lynn, *Topographical Scenes at Partick Cross* 106, **106**

Clark, Philip Lindsey 480

Cameronians (Scottish Rifles) War Memorial 243–4, **244**

Clark, Sheriff 63

Clark, Thomas 68–9

Clarke & Bell 75, 178, 352, 415, 427, 449

Classical House Ltd 215

Clayton, Thomas 211

Cleland, James 46, 70, 163, 294, 298

Cleland Testimonial, Buchanan Street 46

Clifford, H.E. 59, 450

Clifton Street 270, 271

Clinch, John 480

Wincher's Stance 268, **268**

Clouston, Peter 134, 135

Clubb, Alex 298

Clyde Clock, Concert Square (Wyllie) 78, **78**

Clyde, Father

Clydeport Bank (Grassby) 367, **368**

Clydeport Building (J. Mossman) 332

Clyde, Field Marshall Lord, Monument to, George Square (Foley) 136–9, **136**

Clyde Navigation Trust 335

Clyde Street 75–7, 449, 462–3

Clydeport Building, Robertson Street 331–6

Clydeport PLC 331

Clydesdale Bank Pension Fund 368

Clydesdale Bank PLC 366, 367, 430

Brunswick Lane 31–2

St Vincent Place 367–8

Co-operative Funeral Service 105

Co-operative House, Morrison Street 287–9

Co-operative Memorial Services 430

Cobden Road 77

Cochrane Street 151, 160, 216–18

Cockburn, Lord, Royal Faculty of Procurators (A.H. Ritchie and Steel) 306

Cocker, Doug 480

On the Up and Up 50–1, **51**

Rosebud 92, **92**

Coia, Emilio 399

Coia, Jack 203, 431

Coley, Richard 480

Abstract Sculpture xv, 214–15, **214**

College Street 463

Collins, Sir William, Memorial Fountain, Glasgow Green (J. Mossman) 165–6, **166**

Colquhoun, James 341, 480

Statues of George and Thomas Hutcheson xii, 205–8, **205, 206**

COLTAS Group 411

Columbia, Britannia and Associated Decorative Carving, Atlantic Chambers (McGilvray & Ferris) 198–9, **199**

Colvin, William 20

Commerce, personifications

Argyll Chambers (Sherriff) 34, **34**

Bridgeton District Library (Brown) 272

Clydesdale Bank (W. Mossman Jr) 367, **367**

Commercial Bank of Scotland (Bayes) 22–3, **22**

Corinthian (J. Mossman) 212, **212**

Glasgow Art Gallery and Museum (Fabbrucci) 253, **253**, 260

Gordon Street (Thomas and Ritchie) 177

Govan Town Hall (Young) 180

Kelvin Way Bridge (Montford) 236, 238, **241**

Langside Public Halls (Thomas) 273–4

New City Road (Unknown) 309, **309**

Stock Exchange (J. Mossman) 43

Trustee Savings Bank (Frampton and Shirreffs) 209, **210**

Commercial Bank of Scotland 41

Bothwell Street 22–3

Bridge Street 448

Commercial Union Building, St Vincent Street 374–6

The Community, Whitevale Street (Bonnar) 426, **426**

Community Services Day Hospital, Florence Street 450

Concept of Kentigern, Buchanan Street (Livingstone) xvii, 433–4, **433**

Concert Square 78

Connachie, Veronica 449

Connal, William 298

Portrait Roundel of, Connal's Building (Young) 418

Connal's Building, West George Street 416–19

Connaught, Duke of 228

Conservation Specialists Ltd 429
Copland & Lye Ltd, Bath Street 431
Coplaw Street 449
Cordiner, Thomas S. 313
Corinthian, Ingram Street 212–14
Corn Exchange, Hope Street 438
Corporation Galleries (now McLellan
 Galleries) 253, 266, 352
Corrie, Joe 204
Corson, George 150
Cosgrove, Paul 377
Cosmo Ceramics Ltd, Lawmoor Street 452–3
Cossar, Jane White, Portrait Medallion of,
 Govan Press Building (Unknown) 182, 182
Cossar, John, Portrait Medallion of, Govan
 Press Building (Unknown) 182–3, 182
Cossell, Frank 480
 Locomotion 318, 318
Couchant Buck, Buck's Head Building (J.
 Mossman) 4–5, 4
Courage, personification, Scottish Legal Life
 Assurance Society Building (Dawson and
 Young) 27
Cousland, James 17
Cowan, James 53, 55, 165, 175, 214, 302, 333, 417
Cowan, J.L. 109, 423, 424
Cowcaddens 78, 268, 308–9, 318
Cowglen Road 79–80
Cox & Sons 62, 63, 140, 141, 143, 144
Craig, Archibald 97, 103
Craig, John 120
Craigie, J.H. 437–8
Craigie, Laurence 265
Craigpark 80–2
Cranston, Catherine 40–1
Cranston Street 435–6
Cranston, Stuart 34–5, 40
Cranstonhill Police Station, Cranston Street
 435–6
Cranworth Street 449
Crawford, John 29, 371, 480–1
 Armorial Bearings with Allegorical Figures
 28, 28
 Britannia and Putti 437
 Hope Leaning on an Anchor 433

Six Portrait Roundels 88, 88
Creed, John 481
 Roof Sculpture and Entrance Gate 86, 86
 Transition 321, 321
Crewe, Bertie 455
Cromwell Court 83
Cromwell Properties 22
Cross, Deacon James 53
Crosshill 319–20
Crown Street 83
Crown Street Regeneration Project 110, 204,
 315, 448, 452, 464
Cruikshank & Co. Ltd xv, 2, 227, 346, 450, 481
Cumming & Smith 344
Cunningham, John 192
Currie, D. 241
Curtis, Eric 18
Custom House, Clyde Street 462–3, 463
Custom House Quay, Clyde Street 75–7
Cuthbertson, Sir David, Portrait Medallion of,
 Royal Infirmary (Laing) 60
Cybele, Co-operative House (Ewing) 287

Daily Record (newspaper) 275
Dajani, Zeyad 451
Dalhousie, Earl of 343
Dalintober Street 84
Dalnair Street 449
Dalrymple, James, Keystone Portrait of, Royal
 Faculty of Procurators (A.H. Ritchie and
 Steel) 307
Dan-Tan Investments Ltd 198, 199
Dante
 Statue of, Gaelic Primary School (Unknown)
 10–11, 11
 Statue of, Mitchell Theatre (J. Mossman, W.
 Mossman Jr and Fergusson) 190, 191, 192
Darnley Street 85
David, Lawmoor Street (Pazzi) 452–3, 453
Dawson & Young, Unicorn and Associated
 Decorative Carving 340–2, 340
Dawson, Alan 320, 481
 Peacock, Gates, Balustrades and Associated
 Decorative Ironwork 35–6, 35
 Tree of Life 372–3, 373

Dawson, Archibald xiv, xv, 431–2, 481
 Agnus Dei and Other Carved Animals 425,
 425
 Allegorical Figures of Night and Day and
 Associated Decorative Carving 73–4, 74
 Figurative Corbels, University Arms and
 Related Decorative Carving 397–8, 397,
 398
 Relief Panels of Virtues, Royal Arms of
 Scotland and Associated Decorative
 Carving 26–7, 27
 St Andrew, Allegorical Figures and
 Associated Decorative Carving 374–6, 374
 Six Allegorical Figures and Associated
 Decorative Carving 277–9, 278
Dawson, Hamish 376
Day and Night, Allegorical Figures of, and
 Associated Decorative Carving, Tennent
 Memorial Building (Dawson) 73–4, 74
de Braux (founder) 336
Demeter/Europa Leading a Bull, Clydeport
 Building (Hodge) 333, 333, 336
Denerley, Helen 481
 Govan Milestone 186–7, 187
Dennistoun 2–4, 80–2, 89, 189–90, 426
Dennistoun Community Council 89
Dennistoun Conservation Association 89
Dennistoun Milestone, Duke Street (Buckley)
 89, 89
Dennistoun Public Library, Craigpark 80–2
Department of Environmental Health,
 Montrose Street 286–7
Derby, Earl of 233
Design Limited, Shipbuilders 269, 269
Dessurne, Mark B.A. 266
Diagram of an Object, Hunterian Art Gallery
 (Mistry) 197–8, 197
Dibdin, T.F. 125, 295–6, 298, 394
Dick, Norman A. 73, 425
Dick, William Reid 247, 261, 279, 482
Dickson, Alan 380
'Dimsy' 439–40
Disraeli, Benjamin 17
Ditchfield, John 36
Dixon Halls, Cathcart Road 462

Dobson, D.B. 85, 462
Dods, Andrew 431, 432
Dominion Rubber Company, Cadogan Street
 434–5
Donaldson, W.A., Portrait Roundel of, Connal's
 Building (Young) 418
Dooley, Arthur 482
 *La Pasionaria (Monument to Dolores
 Ibarruri)* 75–7, **76**
Douglas, Campbell 192
Douglas, Ellen
 and Associated Decorative Carving, United
 Distillers (Ferris) 411–12, **412**
 statue of, Kelvingrove Park (J. Mossman)
 224, **224**
Douglas Street 86–7
Doulton & Co. 166, 168, 169, 170, 352, 355,
 366, 482
 Hamilton Fountain 441–2, **441**
 Kelvingrove International Exhibition
 Buildings 439–40
Doulton Fountain, Glasgow Green (Pearce et
 al.) 164, 166–71, **166–9**, 219–20
 *Four Allegorical Groups Representing the
 Colonies in the Eastern and Western
 Hemispheres* 167–8, **167**
 Four Female Water Carriers 168, **168**, 169, 170
 Four Servicemen 168, **168**
 Queen Victoria 168–71, **168**, **169**
Doulton, Henry 169, 170
Dowanhill 313–15
Doyle, Alison, *Bird and Fish Panels* 109–10, **109**
Dragon Gate and Lions, Chinatown (various)
 308–9, **308**
Dreghorn, Allan 211, 465
Drumchapel 92
Drumchapel Community Organisations
 Council Public Arts Team 92
*Drummond, Henry, Memorial Drinking
 Fountain*, Kelvingrove Park (Macgillivray)
 439
Drumoyne Drive 87–8
Duff, John 71
Duff, Neil C. 309, 456, 458, 464
Duke Street 88, 89

Dumbarton Football Club 104
Dumbarton Road 90–1, 463
Duncan, Ebenezer 276
Duncan, Henry 7–8
Duncan, Robert 424
Dundas Lane 91
Dundas Street 418
Dunlop, Nathaniel 232–3
Dunlop Street 4, 436

Eadie, Alexander 37
Eardley, Joan, Semi-abstract Figure of, St
 Nicholas Garden (Sloan) 58
East End Partnership 88
East Garscadden Road 92
Easterhouse 376–7
Eastern District Police Buildings, Tobago Street
 465
Edinburgh Evening Post (newspaper) 129
Edinburgh Life Assurance Company, St
 Vincent Street 465
Edminston Drive 92–4
Edward VII, King of England
 Relief Medallion of, National Bank of
 Scotland (Unknown) 386
 Statue of, Kelvingrove International
 Exhibition Buildings (Hodge) 439–40, **440**
Eglinton Street 436
Eight Allegorical Female Figures, The City
 Chambers (J. Rhind) 155, **155**
Eight Keystone Masks, Argyle Street (Shannan)
 5, **5**
EK Metal Fabricators 166
Elder Cottage Hospital 87–8
Elder Library, Elder Park 463, **463**
Elder Park 450, 463
Elf, Kibble Palace (John) 20–1, **21**
Elie Street 106
Elkan, Benno 431
Elkington & Co. 136, 449
Ellis, Herbert 166, 482
 South Africa 167
Elmbank Crescent 450
Elmbank Lane 106–7
Elmbank Street 13–14, 107–9

Elmvale Primary School 358
Emmet, J.T. 459
Empire, Clydesdale Bank (Gordon) xvii, 31–2,
 31
Empire Exhibition, Glasgow 23, 431–2
Empire Salutes Glasgow, Glasgow Art Gallery
 and Museum (Frampton and Shirreffs) 257–8,
 258
*Engineer, Shipwright and Associated Decorative
 Carving*, Kvaerner-Govan Yard Offices
 (Macgillivray and McGilvray & Ferris) 187–8,
 188
Engineering, personifications
 People's Palace Museum (Brown and
 Mackinnon) 171
 Stock Exchange (J. Mossman) 43
Errol Gardens 109–10
Erskin, Robert 388
Erskine, John, of Carnock, Keystone Portrait of,
 Royal Faculty of Procurators (A.H. Ritchie
 and Steel) 307
Erskine, Lord Henry, Keystone Portrait of,
 Royal Faculty of Procurators (A.H. Ritchie
 and Steel) 307
Eve, Kibble Palace (Tadolini) 19, **19**
Evening Citizen (Glasgow newspaper) 282–3,
 312, 436–7
Evening News (Glasgow newspaper) 169
Evening Times (Glasgow newspaper) x, 339,
 430
Ewan, Robert 448
Ewing, George Edwin 139, 287, 482
 David Miller Monument 459
 James Jamieson Monument 460
 *Medallion Portraits of Queen Victoria and
 Prince Albert* 342–3, **342**, **343**
 Monument to Robert Burns 140–3, **140**
 Statue and Portrait Medallions 432–3
 *Statues of St Andrew and St Mungo and
 Decorative Carving* 444
Ewing, James Alexander 149, 287, 482
 *Acroterion Group of Liberty, Riches and
 Honour* 157
 *Allegorical Figures, Medallion and
 Ornamental Clock* 431

Jubilee Pediment 152, 156–7, **156**
Monument to Robert Burns 140–3, **140**
Pediment Group with Acroterion Figure 287–9, **288**
Two Caryatids, Allegorical Figure of Harmony and Colossal Bust of Beethoven 348, **348**
Ewing, T.A. 348
Exchange, personification, Royal Bank of Scotland (Archibald and Ferris) 360
Eyre-Todd, George 266, 296

Fabbrucci, Aristide 247, 482–3
Seated Female Figure Symbolising Commerce 253, **253**, 260
Fairweather, James 348
Fairweather, John 435
Faith, personifications
The City Chambers (Lawson) 153
Houldsworth Family Mausoleum, Necropolis (Thomas) 302
Scottish Temperance League Building (Ferris) 200–1, **200**
Fame, Glasgow Art Gallery and Museum (Shannan) 266
Farmer & Brindley 149, 151, 483
Fergusson, Alex 269
Fergusson, Daniel McGregor, *Figurative Programme* 190–6, **191**, **192**, **193**
Fergusson, Provost 185, 186
Fernhill Road 110–11
Ferrie, Robert 125
Ferrigan, James 289
Ferris, Richard 483
Allegorical Figure of Learning and Three Portrait Medallions 316–17, **316**
Allegorical Figures and Doorcase Group 443–4
Law and Justice and Associated Decorative Carving 384, **384**
Roderick Dhu, James Fitz-James, Ellen Douglas and Associated Decorative Carving 411–12, **411**, **412**
Royal Arms of Britain 463, **463**
Statues of Faith, Fortitude and Temperance,

Relief Medallions, Putti and Masks 200–1, **200**
Symbolic Figures and Associated Decorative Carving 360, **360**
Zephyrs, Figurative Capitals and Associated Carving 183, **183**
Festival of Architecture and Design 1999 ix, 286
Fields, Emily 377, **377**
Fillans, James 416, 455, 483
William Motherwell Memorial 301–2, **301**
Findlay, Margaret Cross Primrose 483
Unicorn and Associated Decorative Carving 340–2, **340**
Fine Art Commission 30
Fine Art Institute, Sauchiehall Street 444–5
Finlay, Ian Hamilton 449
Finlay, Kirkman 265
Statue of, Merchants' House Buildings (Gibson) 415–16, **415**
Finlay, Robert 415
Fir Cone Relief, Benny Lynch Court (Peden and Keay) 448, **448**
Firth, Mark 483
Chthonic Columns 360–1, **361**
Fish with the Chi-rho Monogram, Notre Dame High School (Unknown) 313
Fisher, Gareth 30
Fitz-James, James and Associated Decorative Carving, United Distillers (Ferris) 411–12, **411**
Five Oaks Project Ltd 381
Flanagan, Joseph 63–4
Flaxman, John 271, 483–4
Athenaeum (J. Mossman and Mackinnon) 305, **305**
Monument to Sir John Moore xii, 114, 119–22, **119**, 137, 416
Statue of William Pitt the Younger 264–6, **264**
Fleming, James 146
Flemington Street 111–12
Fletcher, Sir Banister 292
Florence Street 450
Foam, Bellahouston Park (Pilkington Jackson) 432

Foley, John Henry 484
Monument to Field Marshall Lord Clyde 136–9, **136**
Font, St Nicholas Garden (T. Pomeroy) 56–7, **56**
Forbes, Duncan, of Culloden, Keystone Portrait of, Royal Faculty of Procurators (A.H. Ritchie and Steel) 307
Ford, Edward Onslow 484
Monument to Sir William Pearce 184–6, **185**
Forrest, Robert 122, 484
Monument to John Knox 293–7, **294**, 298
Monument to William McGavin 297–9, **297**
Forsyth, Bill x
Forsyth, R.W. 322
Fortitude, personification, Scottish Temperance League Building (Ferris) 200–1, **200**
Fortune House, Waterloo Street 458
Fortune, personification, The Mercantile Chambers (Wood, Young and McGilvray & Ferris) 23–5
Foulis, Robert, *Semi-abstract Figure of*, St Nicholas Garden (Sloan) 58
Foundation for Sports and the Arts 358
Four 'L' Eccentric, Glasgow Garden Festival 1998 (Rickey) 443
Four Muses, Statue of, Citizen's Theatre (J. Mossman) 174–6, **175**
Four Seasons, The City Chambers (Unknown) 157, **157**
'Four, The' 326–7
Fragments, Community Services Day Hospital (Byatt and Bevan) 450
Frampton, Sir George 232–3, 234, 237, 240, 484
Glasgow Art Gallery and Museum 247, 250–1, 252, 253, 254, 255, 256–9, **256**, **258**, 261
Masks of 'The Great Trio of Greek Art' 259
Reliefs Representing Music, Literature and Manufacturing Arts 257–9, **258**
St Mungo, Atlantes, Allegorical Figures and Related Decorative Carving 208–9, **209**
St Mungo as the Patron of Art and Music 250–1, 255, 256–7, **256**
Frank Burnet & Boston 162, 321, 324, 325, 368, 369, 373, 381

Frank Lafferty & Co. 152
Fraser, Hugh 55
Fraser, Sons & Co. 33, 55
Fraser's Department Store
 Argyle Street 6–7
 Buchanan Street 37, **37**
 see also House of Fraser Ltd
Friends of Glasgow West Society 18
Frith, William Silver 166, 484–5
 Canada 167, **167**
Fuseli, Henry 120

G. & J. MacLachlan 325
Gaelic Primary School (formerly Albany
 Academy), Ashley Street 10–11
Galbraith & Winton 485
 Marble Staircase, Marble Relief Panels and
 Atlantes 437–8
Galbraith, Andrew 225
Galileo, Statue of, Strathclyde House (J.
 Mossman) 107, **108**
Gallacher, Lisa 450
Galleon, Pearce Institute (Unknown) 451, **451**
Galloway, W. & J. 170
Gallowgate 113, 436
Gandon Pender 87
Garbe, Richard 237
Garnethill 326–31, 353–4, 421
Garnethill Convent Nursery, Scott Street 353–4
Garnethill Lighting Project 449
Garrick, David, Statue of, Theatre Royal (J.
 Mossman) 436
Gasser, Hans 485
 Statue of Adam Smith 394–5, **395**
Gateway, Fernhill Road (Archer) 110–11, **110**
Gateways, Castlemilk Drive (Grime) 51–2, **52**
'Gateways and Landmarks' project 50, 51, 110,
 111
G.D. Lodge & Partners 448
GEAR (Glasgow Eastern Area Renewal) 426
General Post Office, George Square 436–7, 463
Geography, personifications
 Govanhill and Crosshill Public Library
 (Brown) 274
 Notre Dame High School (Unknown) 314

George Adam & Son xii, 8, 149, 154, 208, 210,
 326, 327, 328, 329, 330, 455, 476
George Barlas & Co. 420, 455, 464
George Edward & Sons 99
George Rome & Co. 335
George Smith & Co., Alexander McKenzie
 Tomb 460
George Square x, xii, xv, 63–4, 114–61, **114, 115,**
 117, 220, 230, 436–7, 450, 463
George Street 159–60, 162–3
George V, King 59
 Relief Medallion of, National Bank of
 Scotland (Unknown) 386
Gibb, A.D. 402–3
Gibson, Catharine 68
Gibson, John 273, 485
 Statue of Kirkman Finlay 415–16, **415**
Gilbert, John Graham 415, 416
 Monument, Necropolis (Brodie) 458
Gildard, R.J. 460
Gildard, Thomas 61, 62, 71–2, 133, 178, 194,
 366, 368, 369
 Monument, Necropolis (Shirreffs) 459–60
Gillespie, John Gaff 7, 183, 203, 443
Gillick, Ernest 325, 485
 cenotaph 147–9, **147**
Gillies, Raymond 431
Gillon, Nicholas John 485
 Lobey Dosser 430, **430**
Gilmore, Thomas 392–404, 464
Gilmorehill 197–8, 391–2, 397–91
Giovanazzi, Sandro 267
Gladstone National Memorial Fund 145, 146
Gladstone, William Ewart 17
 Monument to, George Square (Thornycroft)
 116, 144–6, **145,** 148, 149
Glasgow 1999 Festival Partnership Fund 17
Glasgow Academy 108–9
Glasgow Archaeological Society 70
Glasgow Arms 461–2
 The City Chambers (Unknown) 160
Glasgow Art Gallery and Museum, 18, 19, 20,
 21, 22, 100, 124, 144, 236, 241, 266, 355, 418,
 434, 458
 Kelvingrove Park 18, 146, 171, 219–20, 230,

235, 247–67, **248, 249,** 440
 Sculpture Programme 247–67
 decorative carving 261–4
 figurative work 256–61
 interior sculptures independent of the
 building 264–6
 lost sculptures 266–7
Glasgow Athenaeum Company Ltd 44
Glasgow Boys' Brigade 232
Glasgow Building Preservation Trust 42, 189,
 203
Glasgow Chambers of Commerce Journal 117
Glasgow Citizen (newspaper) 134, 226, 434–5
Glasgow City Archive 14, 32, 35, 172, 335
Glasgow City Council v, xix, 163, 215, 279, 313,
 373, 376, 427
 Anderston works 190, 310
 Blythswood works 107
 Bridgeton works 195, 272, 282, 283
 Calton works 88, 164, 165, 166, 169, 171, 384
 Castlemilk works 50, 51, 110, 111
 Charing Cross works 13, 351
 City Centre works 42, 119, 123, 124, 126,
 130, 131, 132, 134, 136, 139, 140, 143, 144,
 147, 149, 152, 162, 336, 346, 374
 Cowcaddens works 78
 Dennistoun works 2, 80
 Education Committee 8–9
 Glasgow Cross works 277
 Glasgow Green works 342
 Gorbals works 174, 176, 281, 342
 Govan works 97, 100, 104, 180, 182, 184
 Govanhill works 274, 275
 Ibrox works 92
 Kelvingrove Park works 219, 220, 221, 222,
 223, 227, 229, 231, 234, 235, 236, 238, 239,
 240, 242, 243, 244, 245, 246, 247, 250, 252,
 253, 254–5, 264, 265
 Kingston works 73
 Kinning Park works 316
 Langside works 14–15
 Maryhill works 280
 Merchant City works 1, 75, 76, 286, 380, 381
 Milton works 8
 Partick works 47

People's Palace Museum 171–2
Pollok works 79
Saltmarket works 340, 341
Scotstoun works 409
Shawlands works 273
Sighthill works 77
Springburn works 11, 285, 286, 354, 355, 356, 357
Tollcross works 378
Townhead works 52, 57, 61, 62, 64, 65, 66, 68, 70, 71, 72, 294, 297, 299, 300, 301, 302, 303
Woodlands works 10, 362, 363
see also Glasgow District Council
Glasgow City Council Departments of Architecture and Related Services 1
Glasgow Corporation 14, 15, 17, 80, 115–16, 148, 149, 155, 194, 235, 237, 240, 248, 251, 254–5, 281, 282, 283, 285, 296, 316, 354, 363, 378, 400, 436
Glasgow Corporation Fire Department 73
Glasgow Corporation former Highways Committee 433, 434
Glasgow Corporation Police Department 467
Glasgow Council for Voluntary Services 79
Glasgow County Council 451
Glasgow Courier (newspaper) 129, 427–8
Glasgow Cross 277–9, 340–2, 437
Glasgow Development Agency (GDA) 32, 46, 48, 52, 78, 91, 186, 204, 215, 247, 268, 279, 376, 406, 407, 408, 427
Glasgow District Court, Turnbull Street 384
Glasgow District (now City) Council 11, 42, 105, 198, 247, 358, 362, 430
Glasgow Evening News Building, Hope Street 199–200, **199**
Glasgow Eye Infirmary, Berkeley Street 432–3
Glasgow from Knox's Monument (Swan) 291, **291**
Glasgow Gallery of Modern Art, Royal Exchange Square 455–6
Glasgow Garden Festival, Prince's Dock 1998 443
Glasgow Gazette (newspaper) 61, 62, 271, 434, 437, 438, 462–3

Glasgow Green 163–73, 220, 282, 283, 342–3, 450
Glasgow Herald Building
 Buchanan Street 38–40
 Mitchell Street 454
Glasgow Herald (newspaper) xv, 9, 54–5, 56, 63, 69, 76, 77, 99, 116, 118, 123, 125, 132–3, 134, 136, 137, 138, 141, 142, 145, 146, 148, 149, 150, 151, 170, 213, 226, 232, 234, 235, 240, 254, 319, 335, 430, 441, 442, 443
Glasgow High School 109
Glasgow Humane Society 163
Glasgow Institute of Architects 165
Glasgow International Exhibitions 219
 1888 19, 96, 168, 170, 230, 236, 248
 1901 3, 18, 20, 219, 234, 236, 254, 264, 346, 439–40
 1911 236
Glasgow Mechanics' Institute and Technical College of Science 123
Glasgow Mercury (newspaper) 69
'Glasgow Milestones' 12–13, 83, 89, 92, 187, 358, 422
Glasgow Museums Service 167
Glasgow Parish Council Chambers, George Street 162–3
Glasgow, personifications
 Corinthian (J. Mossman) 212
 Kelvingrove Park (J. Mossman and Young) 224, **224**, 225
Glasgow Public Halls Company 192
Glasgow Rangers Football Club PLC 93, 98, 104
Glasgow Royal Concert Hall, Killermont Street 464, **464**
Glasgow Savings Bank
 Bridgeton Cross 462
 Govan Road 463, **463**
Glasgow School of Art, Renfrew Street v, 30, 326–31, 421
 Department of Sculpture and Environmental Art, *Untitled* 376–7, **377**
Glasgow Sculpture Studios 12, 89, 187, 315, 357, 358, 380, 422
Glasgow Seamen's Institute 29

Glasgow Town Council 149–50
Glasgow Tree Lovers' Society 245
Glasgow University Archaeological Research Division 171
Glasgow Water Company 123
Glasgow Weekly Herald (newspaper) 230
Glasgow West Convention Trust 48
Glasgow West Housing Association 47
Glasgow West Preservation Society 247
Glassford Street 173–4, 209–10, 216, 382, 450, 463
Glasworks 320
Gleave, J.L. 403
Glencairn Drive 450
Glendinning, M. 197
Gleniffer Braes 450
Glory, personification, The City Chambers (Lawson) 153
Godwin, E.W. 43
Gomme, A. ix, xii, 368, 375, 420
Good, Edward 149, 151, 485–6
Gorbals 49, 83, 109–10, 174–6, 204, 280–2, 290, 315, 342–3, 442
Gorbals Arts Project
 Pine Cone Bollards 453–4, **453**
 Three Dancing Muses 281–2, **281**
Gorbals Economic and Training Centre, McNeil Street 280–2
Gorbals Park 450
Gorbals Street 174–6, 450
Gordon Brothers 450
Gordon, Douglas 486
 Empire xvii, 31–2, **31**
Gordon, John 205, 448
Gordon Street 177–80, 437
Gosse, Jules 457, 486
 Bird and Fish Panels 109–10, **109**
 Topographical Relief Panels 315, **315**
Gourlay, Charles 194
Gourlay, James 225
Govan 96–105, 180–8, 443
Govan Chronicle (Newspaper) 182
Govan Fair Committee 105
Govan Housing Association 186, 187
Govan, James 124

Govan Milestone, Govan Road (Denerley) 186–7, **187**

Govan Police Commissioners 180

Govan Practical and Historical Art Group 104

Govan Press Building, Govan Road 182–3

Govan Press (newspaper) 96, 100, 103, 104, 182, 184, 185, 186

Govan Road 180–8, 450–1, 463

Govan Town Hall, Govan Road 180–2

Govanhill 274–5

Govanhill and Crosshill Public Library, Langside Road 274–5

Governors of Glasgow School of Art 326

Gow, Leonard, Esq. 19

Graham, Edward *see* Mortimer, Willison & Graham

Graham Square 189–90

Graham, Thomas 404

 Monument to, George Square (Brodie) 139–40, **139**, 230

Grand Orange Lodge of Scotland 70

Granville, Earl 128

Granville Street 190–5

Grapes and the Wheat, Notre Dame High School (Unknown) 313

Grasp the Thistle, Ingram Street (Sloan) 211

Grassby, Charles Benham 124, 149, 151, 362, 455, 458, 486

 Allegorical Figures, Coats of Arms and Associated Decorative Carving 367–8, **368**

 Christ Healing a Blind Boy 60, **60**

 James Watt 282–3, **282**

 Minerva and Royal Arms 436

 Statues of Caxton and Gutenberg, Narrative Relief Panels and Associated Decorative Carving 38–40, **39**

 Statues of St Andrew and St Mungo and Decorative Carving 444

Gray, Robert 450, 451, 486

 Bishop's Palace Memorial Pillar 66–7, **66**

Great Western Road 451

Greater Easterhouse Partnership Management Board 376

Greenfield Farms Ltd 321

Greenhead Street 195

Greenshields, John 124, 283, 486

 Monument to Sir Walter Scott 124–6, **124**

 Statue of James Watt 404

Greenview School, Greenhead Street 195

Greggs, Paul 79

Gregory, George, *Allegorical Figures and Doorcase Group* 443–4

Greig, John 93, **93**

Griffin Panels, Trades House (Unknown) 173–4, **173**

Grigor, Murray 443

GRIM 163

Grime, Paul 486

 Gateways 51–2, **52**

Grinneal 117

Groome, F.H. 440

Grosvener Buchanan PLC 305

Grosvenor Restaurant, Gordon Street 437–8

Guardian (newspaper) 430

Guardian Royal Exchange 36, 320

Guardians and Mythological Figures, Italian Centre (Sloan) 216–18, **217**

Gunnis, Rupert v

Gutenberg, Johannes, Statue of, Glasgow Herald Building (Grassby and J. Mossman) 38–40, **39**

Guthrie, James 229

Guthrie, Lord 234–5

Guthrie, Sheriff 203

H. & D. Barclay 10, 25, 26, 344, 363, 448

H. Pringle & Co. 222

Hadden, Thomas 467

Haig & Low 72

Haig, Earl 149

Halem, Sibylle von 486–7

 Springburn Milestone 'The Works' 357–8, **358**

Hall, John 435

Hamilton, Christina Brown Primrose 441

Hamilton, David 46, 175, 205, 207, 211, 213, 271, 443, 450, 455

Hamilton, Duke of 337

Hamilton, Elizabeth Miller 441

Hamilton Fountain, Maxwell Park (Doulton & Co.) 441–2, **441**

Hamilton, James 46, 458, 459

Hamilton, John 441

Hamilton, Thomas 293, 294, 441

Hamish Allen Centre, Centre Street 73

Handel, George Frideric 271

Hanna, Donald & Wilson 342

Hannan, James 225

Harle, Fraser 47

Harley, ex-Bailie 181–2

Harmony

 Allegorical Figure of, Sauchiehall Street (Ewing) 348, **348**

 Goddess of, Kinning Park Burgh Chambers (Unknown) 446

Harvey, Jake 30

Harvey, Jim, *Fountain with Relief Panels* 176, **176**

Hastie, Alexander 128

'The Hatrack', St Vincent Street 457

Hedderwicke, James 141

Heisenberg 286

Helenvale Street 378

Helios Award 42

Henderson, A. Graham 277, 344, 467

Henderson Brothers Ltd 366

Henderson, Francis 67

Henderson, Joseph 352

Henderson, Michael 389

Hendry, James 456–7, **457**

Henry Boot Ltd 211

Henry, Clare 187

Henry Herbertson & Co. 414

Henry Moore Foundation v, 12

Henshaw, Charles 27

Henson, Laurence x

Heraldic Woodcarvers 464

Heritage Lottery Fund v, 164

 see also SAC

Hermes and Clerical Medical 36

Hernes Property Management Ltd 46

Herries, Michael 246

Hewcon Contractors 430

H.H. Martyn & Co. 466, 491

Decorative Masks and Associated Carving
366, **366**
High Court of the Justiciary, Saltmarket 456,
464
High Street 196–7, 451, 463
Highburgh Road 451
Highland Light Infantry Memorial,
Kelvingrove Park (Rhind) 220, 227–8, **228**
Hilight/Emap Construct Award 52
Hill Samuel Life Assurance Ltd 372
Hill, William 55, 414
Hill, William H. 206, 207
Hillhead 47–8, 339–40
Hillhead Housing Association 47–8
Hillhead Street 197–8, 451
Hindu Temple, La Belle Place 270–2
Hislop, Alexander D. 370, 457
History, personification, Notre Dame High
School (Unknown) 314
History of Scottish Theatre, Hospital Street
(Sloan) 204, **204**
HM Office of Public Works for Scotland 436,
463
Hodge, Albert Hemstock xiv, 124, 219, 254,
372, 467, 487
Allegorical Female Figures of Speed and
Science, with Associated Decorative
Carving, Flemington Street 111–12, **112**
Allegorical Figures, Carver Work and Coats
of Arms, Sauchiehall Street 445
Caryatids, Atlantes and Associated
Decorative Carving, Union Street 385, **385**
Figurines, Angels and Associated Decorative
Carving, Argyle Street 7–8, **7**
Kelvingrove International Exhibition
Buildings 439–40, **440**
Marble Staircase, Marble Relief Panels and
Atlantes, Gordon Street 437–8, **437**, **438**
Monument to Queen Victoria, Castle Street
58–60, **59**
Mythological and Historical Figure
*Programme*Robertson Street 331, 332–5,
333, **334**, 335, 336
Royal Arms of Scotland, St Vincent Street
465, **465**

Hodge, David 434
Holland Street 108, 109
Hollinshead & Burton 460
Holmes & Jackson Ltd 96, 277, 278, 326, 327,
450, 464, 467, 487
Decorative Carvings, Parkhead 113
Figures of Industry and Science, West
Campbell Street 446
Govan Arms 463, **463**
Pediment Group and Associated Decorative
Carving, Albion Street 1, **1**
Home, John 204
Homer
Gaelic Primary School (Unknown) 10–11, **11**
Ladywell School (Crawford) 88
Statue of, Mitchell Theatre (J. Mossman, W.
Mossman Jr and Fergusson) 190, **192**
Statue of, Strathclyde House (J. Mossman)
107–8, **108**, 109
Honeyman, John 96, 457
Honeyman & Keppie 278, 326, 341, 347, 445
Honeyman, Keppie & Mackintosh 113, 346, 464
Honeyman, Tom 18, 221, 245, 267
Honour, personifications
The City Chambers (J. Mossman) 159
The City Chambers (Lawson and Ewing)
157
Hope, personifications
Leaning on an Anchor, Seamen's Chapel
(Crawford) 433
The City Chambers (Lawson) 153
Houldsworth Family Mausoleum (Thomas)
302, 303
Hope Street 179, 198–203, 438, 451, 464
Hopkinson, Martin 395
Horn, R.W. 316
Hospital Street 204
Houghton, Lord 142
Houldsworth Family Mausoleum, Necropolis
(Thomas) 302–3, **303**
House for an Art Lover, Bellahouston Park
(C.R. Mackintosh) 448
House of Fraser Ltd 6, 37
see also Fraser's Department Store
House, Jack 14, 236

Howard & Wyndham Ltd 14
Hugh Martin Partnership 35, 36, 259
Hugh Pritchard (Stonemason) Ltd 458
Hughes, Edith Burnet 279, 340
Hughes, T. Harold 457, 467
Hunter & Clarke 427
Hunter, John, Portrait Medallion of, Hunter
Memorial (Paulin) 399–401, **400**
Hunter, Kenny 487
Calf 189–90, **189**
Cherub/Skull 380–1, **380**
King of the Castle 111, **111**
Hunter Memorial, University of Glasgow
399–401
Hunter, Ross 32
Hunter Street 205
Hunter, William
Portrait Medallion of, Hunter Memorial
(Paulin) 399–401, **400**
Portrait of, Hunterian Museum (Unknown)
393
Hunterian Art Gallery, Hillhead Street 140,
144, 197–8, 445
Hunterian Museum, University of Glasgow
393–5, 399
Hurd, Robert xv
Hutcheson, George, Statue of, Hutchesons' Hall
(Colquhoun) xii, 205–8, **205**
Hutcheson, John 451
Hutcheson, Thomas, Statue of, Hutchesons'
Hall (Colquhoun) xii, 205–8, **206**
Hutchesons' Hall, Ingram Street 205–8
Hutchesons' Hospital trustees 15
Hutchesontown 28, 433
Hutchesontown Library 82
Hutchison, Robert 270, 271
Carter's Hitch 91, **91**
Hygieia, Department of Environmental Health
(Brown) 286–7, **287**
Hypostyle Architects 109

Ibarruri, Dolores 75–7, **76**
Ibrox 92–4
Ibrox Disaster Memorial, Edminston Drive
(Scott and Bell) 93–4, **93**

Illustrated London News (newspaper) **128**, 130, 274

Immortality, Glasgow Art Gallery and Museum (Shannan) 266

India, represetnations
 Doulton Fountain (Broad) 167–8
 Renfield Street (Rhind, W.B.) 322

Industrial Hall (temporary structure), Kelvingrove Park (Miller) 219, 254, 439

Industries of Glasgow at the Court of Mercy, Glasgow Art Gallery and Museum (Frampton and Shirreffs) 258

Industry, personifications
 Argyll Chambers (Sherriff) 34, **34**
 Bridgeton District Library (Brown) 272
 Clydesdale Bank (J. Mossman) 367, **367**
 Commercial Bank of Scotland (Bayes) **22**
 Corinthian (J. Mossman) 212
 Kelvin Way Bridge (Montford) 236, 238, 239, 240, **241**
 McGeoch's Warehouse (Archibald and Holmes & Jackson) 445–6
 Mercantile Chambers (Wood and J. Young) 23–5
 Mercat Building (Dawson) 277, 279
 Scottish Legal Life Assurance Society Building (Dawson and Young) 26, **27**
 Stock Exchange (J. Mossman) 43
 Trustee Savings Bank (Frampton and Shirreffs) 209, 210

Ingram, Archibald 416

Ingram Hotel, Ingram Street 214–15, **214**

Ingram Street 205–15, 438–9, 451–2

Innes, Robert, Monument to, Robert Innes Memorial Garden (Unknown) 356, **356**

Inspiration, personification, Kelvin Way Bridge (Montford) 236, **238**, 239, 241

Institute for the Deaf and Dumb, Prospecthill Road 455

Institute of Engineers and Shipbuilders in Scotland Building, Elmbank Crescent 450

International Brigade Association in Scotland (IBAS) 76, 77

International Commerce, City and County Buildings (Buchan) 427–8, **427**, **428**

International Exhibitions, *see also* Glasgow International Exhibitions; Paris International Exhibition

International Festival of Sand Sculpture, George Square, 2000 117, **117**

Inverclyde, Lord 230

Irwin, D. 266

Italia, Italian Centre (Stoddart) 215–16, **215**

J. & A. McArthur 205

J. & G. Mossman 66, 131, 146, 149, 214, 296–7, 492–3
 John McDonald Monument 458–9
 Mrs Lockhart Memorial 458, **458**
 St George and the Dragon 362, **362**

J. & W. Beardmore 98

Jackson & Cox 428

Jaeger Company's Shops Ltd 37

Jamaica Street 452

James Cunning Young & Partners 52

James II, King 163

James Miller House, West George Street 458

James Moore of Thames Ditton 71, 96

James Ritchie & Co. 352

James Salmon & Son 23, 25, 183

James Sellars House, West George Street 419–20

James Street 452

James Watt Street 454, 464

Jamieson, James, Monument, Necropolis (G.E. Ewing) 460

J.C. Wilson & Co. 140

Jeffrey, Lord, Keystone Portrait of, Royal Faculty of Procurators (A.H. Ritchie and Steel) 306, 307

Jeffrey Reference Library, Kelvingrove Park 219

Jocelyn Square 464

John Baird & James Thomson 48

John Bennie Wilson & Son 450

John Black & Son 322

John Burnet & Son 478–9

John Elder & Co. 98

John Emery & Sons 147, 149, 236, 267, 274

John McCormick and Co. Ltd 85

John McIntyre Building, University Avenue 390–1

John Porter & Sons 80, 272, 363

John Ross Memorial Church, West Regent Street 425, **425**

John Street 160, 161, 215, 215–18

John Watson & David Salmond 161

John, William Goscombe 487
 The Elf 20–1, **21**
 Monument to James Reid of Auchterarder 354–5, **355**

Johnson, Gary 52, 56

Johnstone, Ninian 8

Johnstone, W.T. 362

Jones, Francis William Doyle 487–8
 Partick and Whiteinch War Memorial 409, **409**

Jones, George 123

Joss, Gordon, *Woodpecker* 455

Jubilee Pediment, The City Chambers (Lawson, J.A. Ewing and Tweed) 152, 156–7, **156**

Judges, Busts of, Armorial Shield and Associated Ornaments, Lion Chambers (Unknown) 203, **203**

Junk Sculpture, Glasgow Green (Parsonage) 163–4, **164**

Justice, personifications
 Bank of Scotland Building (W. Mossman Jr) 365
 Bank of Scotland Chambers (Unknown) 371, **371**
 Bank of Scotland (Crawford) 28
 Buchanan Street (Unknown) 37, **38**
 The City Chambers (J. Mossman) 159
 Co-operative House (Ewing) 287
 Corinthian (J. Mossman) 212
 Glasgow City Council Departments of Architecture and Related Services (Holmes & Jackson) 1, **1**
 Glasgow District Court (Ferris) 384, **384**
 Partick Burgh Hall (W. Mossman Jr) 47
 St Vincent Street (Unknown) 373, **373**
 Scottish Co-operative Wholesale Society warehouse (J.A. Ewing) 84, **84**

J.W. Singer & Sons 100, 229, 231, 233, 360

Kames, Lord, Keystone Portrait of, Royal
 Faculty of Procurators (A.H. Ritchie and
 Steel) 307, **307**
Keay, Cath 282
 Fir Cone Relief 448, **448**
 Pine Cone Bollards 453–4, **453**
Keith, Judy 430
Keller, Johan 8, 60, 247, 488
 Allegorical Figures and Doorcase Group
 443–4, **444**
 Allegorical Figures of Wisdom and Literature
 310–12, **310**, **311**
 Seated Female Figure Symbolising Religion
 253, **253**, 260, **260**
 Zephyrs, Figurative Capitals and Associated
 Carving 183, **183**
Kelly, Brian 106, 488
 Four Relief Panels (The Modern Myth) 95,
 95
Kelly, John D. 86
Kelly, Mike 76
Kelvin Hall, Argyle Street 462
Kelvin, Lord 185, 186, 229, 457
 Monument to, Kelvingrove Park (Shannan)
 xiv, 220, 229–31, **229**
Kelvin Walkway 267–8
Kelvin Way Bridge, Kelvingrove Park xv, 220,
 221, 236–42
Kelvinbridge 267–8
Kelvingrove 270–2
Kelvingrove International Exhibition Buildings
 (1901), Kelvingrove Park 439–40, **440**
Kelvingrove Park 3, 168–9, 219–67, 439–41, 452
Kelvinside Academy, Bellshaugh Road 16, **16**
Kelvinside Academy War Memorial Trust 16
Kemp, Jonathan 189
Kempsell, Jake 30, 488
 Symbolic Relief 49, **49**
Kenmuir, Lodge, Vulcan Street 467
Kennedy, Jack 448
Kennedy, John Stewart 222
Kennedy, Thomas 222
Kenneth, George S. 320, 464
Kennington, Eric 488
 Progress of Science 402–4, **402**

Kentigern House, Brown Street 29–30, **30**
Keppie & Henderson & J.L. Gleave 402
Keppie Design Ltd 373, 425
Keppie Henderson & Partners 30, 49, 86, 87,
 345, 389
Keppie, John 86, 87, 90, 187, 188, 279, 310, 345,
 445
Kerr, Tom 8
Kibble, John 17
Kibble Palace, Botanic Gardens 17–22
Killermont Street 268, 464
Kimball, Addison 435
King of the Castle, Fernhill Road (Hunter) 111,
 111
King City Leisure Ltd 212, 214
King, James 65, 66
King's Inch Road 269
King's Theatre, Bath Street 13–14, **14**, 106–7
Kingston 73, 84, 287–9, 317–18, 436
Kinloch, Shona 36, 421, 488
 As the Crow Flies 422, **422**
 As Proud As... 359, **359**
 Chookie Burdies 449, **449**
 The Pursuit of... 408, **408**
 Thinking of Bella 218, **218**
Kinning Park 316–17, 446
Kinning Park Burgh Chambers, West Scotland
 Street 446
Kinning Park Co-operative Society Ltd, Bridge
 Street 433
Kirby, Rick 488
 Southern Arch 50, **50**
Kirk Road 452
Kirkland, Alexander 442
Kirklee 16
Kirkwood, James 180, **180**
Kirkwood, John 7
Knowledge, personifications
 The City Chambers (J. Mossman) 159
 University Gardens (Pritchard) 391–2, **391**
Knowles, Sheridan, Monument, Necropolis (J.
 Mossman) 460
Knox, John 433
 Monument to, Necropolis (Warren and
 Forrest) 291, 293–7, **294**, 298

Kvaerner-Govan Yard Offices, Govan Road
 187–8
Kwik Save supermarket, Crown Street 83, **84**

La Belle Place 270–2, **270**, **271**
La Fiorentine 317
La Innocenza, Kelvingrove Park (Boschetti)
 440–1
La Pasionaria (Monument to Dolores Ibarruri),
 Custom House Quay (Dooley) 75–7, **76**
Lacey, Susanne xvii
Lady of the Lake, Kelvingrove Park (J.
 Mossman and J. Young) **224**, 225, 226
Ladywell School 88
Laing, Gerald Ogilvie 30, 60, 180, 489
 Callanish 404–6, **405**
Laing, R.D. 275
Lally, Pat 443
Lamb, Adrian Russell 457, 489
 Smokestack 454, **455**
Lamb, Helen A. 342
Lambeth School of Art 166, 170
Lanarkshire County Council 214
Landless, William 60
Landressy Street 272–3
Langside 14–15
Langside Avenue 273–4
Langside Battlefield Memorial, Battle Place (J.
 Young) 14–15, **14**
Langside Library 81
Langside Public Halls, Langside Avenue 273–4
Langside Road 274–5, 276
Lark, James H. 177
Lauder, James 306
The Launch, Elder Park (Wyllie) 105, **105**
Laurieston Road 342–3, 452
Law, personifications
 Glasgow City Council Departments of
 Architecture and Related Services (Holmes
 & Jackson) 1, **1**
 Glasgow District Court (Ferris) 384, **384**
Lawmoor Street 452–3
Lawrence, Peter, Memorial, Necropolis (J.
 Mossman) 443
Lawrence, Thomas 121

Lawrie, Ephraim 424
Lawson, George Anderson 149, 151, 252, 254, 489
 Acroterion Group of Liberty, Riches and Honour 157
 Allegorical Frieze 153–4, **153**, **154**
 Jubilee Pediment 152, 156–7, **156**
 Monument to James Arthur 65–6, **65**
Learning, personifications
 Bridgeton District Library (Brown) 272
 Govanhill and Crosshill Public Library (Brown) 274
 Talbot Centre (Ferris) 316–17, **316**
 Townhead District Library (Young) 435, **435**
Lee, Robin 451
Leeway Forbes, Edinburgh 389
Leighton, John 116
Leiper, William 47, 323–4, 351, 377, 378, 458
Leonardo da Vinci 191
Leslie, Francis 149, 489
 Monument to David Livingstone 62–4, **63**
 Monument to James White of Overtoun 64–5, **64**
 Monument to Robert Burns 140–3, **140**
Leslie, John Adam 435
Leslie Street 464
Lethaby, W.R. 327
Liberal Club, Nelson Mandela Place 454, **454**
Liberty, personifications
 and Corbel Figures, Queen's Drive (Unknown) 319–20, **319**
 Riches and Honour, Acroterion Group of, The City Chambers (Lawson and J.A. Ewing) 157
The Lighthouse, Mitchell Street 454
Lilies, Notre Dame High School (Unknown) 313
Lilybank Gardens 453
Lim, Maurice 308
Lindsay, David 204
Linthouse Housing Association 87
Lion Chambers, Hope Street 203
Lion and Unicorn Staircase, University of Glasgow (Riddle) 396–7, **396**
Lister, Joseph, Lord

Monument to, Kelvingrove Park (Paulin) 220, 242–3, **242**
 Royal Infirmary (Keller) 60
 Royal Infirmary (Unknown) 59–60
Litany of Loretto, Nine Panels with Inscriptions from, Notre Dame High School (Unknown) 314
Literary Education, personification, Athenaeum (J. Mossman and Mackinnon) 305
Literature, personifications
 Glasgow Art Gallery and Museum (Bramwell) 253, **253**, 260–1
 Mercat Building (Proudfoot) 277–8, 279
 Mitchell Library (Clapperton) 310–12, **310**, **311**
 Mitchell Theatre (J. Mossman and Fergusson) 190–1, **192**
 Notre Dame High School (Unknown) 314
 Townhead District Library (J.C. Young) 435, **435**
Liverpool 79
Liverpool, London and Globe Insurance Building, Hope Street 201–2
Liverpool Victoria Friendly Society Ltd 178
Livingstone, David, Monument to, Cathedral Square (J. Mossman, Leslie and Macgillivray) 62–4, **63**
Livingstone, Neil, *Concept of Kentigern* 433–4, **433**
Lobey Dosser, Woodlands Road (Morrow and Gillon) 430, **430**
Lockhart, Mrs, Memorial, Necropolis (J. & G. Mossman) 458, **458**
Locomotion, Port Dundas Road (Cossell) 318, **318**
Lofthus Signs 31
Logan and Johnstone School of Domestic Economy, James Street 452
London Geographical Society 63
London Road 277–9
London Transport Pension Fund Trustee Co. 419
Longden & Co. 208, 210
Lothian, Lord 99
Lottery Sports Fund 376

Love Teaching Harmony to the Arts, Glasgow Art Gallery and Museum (Frampton and Shirreffs) 258
Low, D.P. 72
Lowe, Peter 90–1
Lumsden, James 125
 Monument to, Cathedral Square (J. Mossman) 61–2, **61**

MacAlister, Principal 230
McAlpine Street 464
McArthur, John 188, 491
 SS Daphne Memorial 104–5, **104**
MacArthur, Mary 292, 300
Macaveety, Frank 453
McCaig and Watson 109
McCall, Alexander, Monument, Necropolis (Macgillivray) 460, **460**
McCall, Munro & Co. Ltd 399
McCarter, Keith 491
 Abstract Wall Relief 106–7, **107**
McClafferty, Maria 36
McConnell, Eddie x
McCormick House, Darnley Street 85
McCulloch, Duncan, Portrait Medallion of, United Co-operative Baking Society (Unknown) 442
McCulloch, Moses 448–9
McDonald & Cresswick 242, 243
McDonald, Alexander Beith 73, 152, 171, 172, 236, 237, 240, 273, 278, 286, 287, 310, 346, 384, 448, 451, 455, 462, 463, 464, 465, 466, 489
McDonald, Calum 17
MacDonald, Hugh, Fountain, Glasgow Green (Unknown) 450
McDonald, John, Monument, Necropolis (J. & G. Mossman) 458–9
McDowall Steven & Co. 170
McEwan, Thomas 250
McEwan, William 64, 66
Macewen, Sir William, Royal Infirmary (Proudfoot) 60
McFadden, Bailie Jean 76–7
Macfarlan, Duncan, Monument, Necropolis (Brodie) 459

McFarlane, James 116, 125
McFarlane Masonry Ltd 51
McFarlane, Patrick 295
Macfarlane, Walter
 Tomb, Necropolis (MacKennal) 460, **460**
 see also Walter Macfarlane & Co.
McGarva, Hector 57, 77, 91, 204, 449, 450, 491
McGavin, William 294, 295
 Monument to, Necropolis (Forrest) 297–9,
 297
McGaw, Alexander, *Royal Arms* 436–7, 463
McGeehan, Aniza, *Allegorical Figures, Carver*
 Work and Coats of Arms 445
McGeoch's Warehouse, West Campbell Street
 445–6
McGibbon, Alexander 210
McGibbon, W.F. 438
MacGill, Rev. Stevenson 294–5, 296
Macgillivray, James Pittendrigh 88, 146, 149,
 307, 490
 Alexander McCall Monument 460, **460**
 Engineer and Shipwright 187–8, **188**
 Female Spandrel Figures **158**, 159
 Henry Drummond Memorial Drinking
 Fountain 439
 Monument to David Livingstone 62–4, **63**
 Monument to Thomas Campbell 143–4, **143**
 Narrative Tympanum Relief and Two
 Winged Figures 90–1, **90**
 Peter Stewart Monument 459
 Tomb of Alexander Allan and Family 303–4,
 304
McGilvray & Ferris 14, 91, 172, 247, 262, 311,
 448, 454, 455, 456
 Columbia, Britannia and Associated
 Decorative Carving 198–9, **199**
 Decorative Carving, Bothwell Street 23–5,
 23, **24**, **25**
 Decorative Carving, Govan Road 187–8, **188**
 Profile heads of Athena and Mercury, Masks
 Representing Different Nations and
 Associated Decorative Carving 25–6, **26**
 Seated Female Figures 410, **410**
 Two Seated Michelangelesque Figures 346–7,
 347

McGilvray, Robert 210, 335, 412, 424
McGrath, John 204
McGrigor, James Walker 440
McGurn, Logan, Duncan & Opfer 10
McGurn, Rita 454
Mach, David xvii, 361, 490
 Some of the People 284–5, **284**
McIntyre, Anne 390
McIntyre, John 390
McIntyre Street 442
Mackay, Kenny, *Shipbuilders* 269, **269**
Mackay, Ross 76
McKean, C. 8, 197
MacKenna, Tracy 380
MacKennal, Bertram, *Walter Macfarlane Tomb*
 460, **460**
McKenzie, Alexander, Tomb, Necropolis
 (George Smith & Co.) 460
MacKenzie, Calum 430
MacKenzie, William 432
Mackinnon, James Harrison 149, 151, 247, 261,
 392, 490
 Foundation Stone 264
 Nine Allegorical Figures 171–3, **172**
 Portrait Statues and Allegorical Figure
 Groups 305–6, **305**
 Puma and Coats of Arms 276, **276**
Mackintosh, Charles Rennie 40–1, 58, 248, 290,
 347, 351, 445, 448, 454, 455, 456, 460, 490–1
 Keystone Relief and Decorative Ironwork
 326–31, **326**, **327**, **329**, **330**
Mackintosh, Margaret Macdonald 454
McKissock & Gardner 1
McLaughlin, David 435
McLaughlin of Irvine, Councillor 301
McLean & Co., Metal Window and Door
 Makers 339
McLellan, Archibald 294, 298, 338, 346
McLellan Galleries, Sauchiehall Street 237, 266,
 346
McLennan, James 164
McLennan, John D. 9
McLennan, Robert 204
McLeod, John 433
Macleod, Reverend Dr Norman, Monument to,

Cathedral Square Gardens (J. Mossman and
 Fergusson) x, **xi**, 71–2, **72**
McMorran, Ebenezar 1
McNab, James 301
McNaughtan, Duncan 453, 458
McNee, Daniel 459
McNee, Margaret, Monument, Necropolis
 (Unknown) 459, **459**
McNeil Street 280–2, 442, 453–4
McOnie, Lady 441
McPhail, Dugald 195
McPhun, John Pollock 282
 Memorial Drinking Fountain, McPhun Park
 (Scott & Rae) 442
McPhun Park 282–4, 442
McPhun, Peter 442
MacQuarrie, Stuart 94
Macrae, James 68
Macsorley, Philip 452
MacSorley's Bar, Jamaica Street 452
McUre, John 68, 206
McVeigh, Sam 282
Main, John P. 491
 James Wilson Memorial Fountain 92–3, **93**
Mair, William 446
Maitland Street 453
Manenti, M. 243
Mansfield, 1st Earl of, Keystone Portrait of,
 Royal Faculty of Procurators (A.H. Ritchie
 and Steel) 307, **307**
Marine Police Office, McAlpine Street 464
Mariscal, Javier 454
Marochetti, Baron Carlo 307, 416, 491
 Equestrian Monument to the Duke of
 Wellington x, **xi**, xiv, 129–30, 336–9, **336**
 Equestrian Monument to Prince Albert 115,
 130, 134–6, **135**
 Equestrian Monument to Queen Victoria
 115, 126–31, **126**, **127**, **128**
 Monument to James Oswald 131–2, **131**
Marr, John 100–1, 102, 180, **180**, 182
Marshall, John 28
 Semi-abstract Figure of, St Nicholas Gardens
 (Sloan) 58
Martin & Partners 318

Martin, Bailie James, Memorial Fountain, Glasgow Green (Walter Macfarlane & Co.) 450
Martin, N. 32
Marwick, Thomas P. 382
Mary, Martha and Jesus, Relief Panel of, Notre Dame High School (Unknown) 314–15, 314
Mary Queen of Scots 15
 Semi-abstract Figure of, St Nicholas Gardens (Sloan) 57
Maryhill Housing Association 17
Maryhill Public Library, Maryhill Road 280
Maryhill Road 280, 453
Mason, George, Monument, Necropolis (Shannan) 459, 460
Mason, Thomas 55, 146
Masonic Halls, West Regent Street 423–4
Masonic Halls Company Limited 423
Matcham, Frank 13
Mathematician, the, Greenview School (Brodie) 195, 195
Mathematics, personifications
 Notre Dame High School (Unknown) 314
 People's Palace Museum (Brown) 171
Mather, George 400
Mathieson, Kenneth 205
Maxwell Park 441–2
Maxwell Road 453
M'Crie, Dr 295
Meadowflat Property Co. Ltd 416
Mechanics' Institute and Technical College of Science 404
Mechanics, personification, Corinthian (J. Mossman) 212
Meek, David 214
Meldrum Brothers, Dumfries 140
Melpomene, Theatre Royal (J. Mossman) 436
Melvin, R.G. 458
Menzies, Colin 34
Mercantile Chambers, Bothwell Street 23–5
Mercat Building, London Road 277–9
Mercat Cross, Saltmarket 340–2
Merchant City 1, 4–5, 31–2, 75–7, 173–4, 205–18, 286–7, 359, 380–3, 427–9, 438–9
Merchant City Civic Society 31, 32

Merchants' House Buildings, West George Street 413–16
Merchants' House of Glasgow 292, 294
Mercurial, Italian Centre (Stoddart) 216, 216
Mercury
 Anchor Line Building (H.H. Martyn & Co.) 366, 366
 and Mercurius, Italian Centre (Stoddart) 216, 216
 Bothwell Street (McGilvray & Ferris) 25–6
 Castle Chambers (Brown) 325
 Mercantile Chambers (Wood and J. Young) 23–5, 23, 24, 25
 Trongate (Unknown) 381, 382
Mercy, personification, Partick Burgh Hall (W. Mossman Jr) 47, 47
Meridian, M.S. 50
Merkland Street 284–5
Merryland Street 181
Michelangelo 351
 Figurative Programme, Mitchell Theatre (J. Mossman and Fergusson) 191
 Portrait Roundel of, Ladywell School (Crawford) 88, 88
Milestone, Cromwell Court (Sinclair and de Bruin) 83, 83
Millarbank Street 285–6
'Millennium Spaces' 189
Miller & Lang 85
Miller, Andy 380
Miller, David 452
 Monument, Necropolis (G.E. Ewing) 459
Miller Developments 289
Miller Homes 290
Miller, James 22, 58, 59, 62, 66, 111, 112, 219, 254, 366, 385, 439, 440, 451, 456, 458, 467, 491–2
Miller, John, Keystone Portrait of, Royal Faculty of Procurators (A.H. Ritchie and Steel) 307
Miller, Keith 452, 453
Miller, Robert 453
Miller Street 442–3, 454
Miller, Thomas Andrew, Monument, Necropolis (Brown) 459

Milton (district) 8–9
Milton, John, Portrait Roundel of, Ladywell School (Crawford) 88
Minerva
 and Royal Arms, British Linen Bank (Grassby) 436
 City Arms and Keystone Masks, Kelvingrove Mansion Museum (Unknown) 440
 Fine Art Institute (J. Mossman, W. Mossman Jr and J. Young) 444
 Hindu Temple (J. Mossman) 270–1, 271
 sand sculpture, George Square (Grinneal) 117, 117
Mining, personification, Stock Exchange (J. Mossman) 43, 44
Ministry of Defence 29, 30
Minton, J.W. 140, 404
Mistry, Dhruva 492
 Diagram of an Object 197–8, 197
Mitchell, A. Sydney 41, 451
Mitchell, Councillor 228
Mitchell Library, North Street 310–13
Mitchell, Rosslyn 148
Mitchell, Stephen, Portrait Bust of, Mitchell Library (J. Mossman) 312
Mitchell Street 6, 454
Mitchell Theatre, Granville Street 190–5
Modern Languages Building, University Gardens 391–2
Modern Myth, Edzell Street (Kelly) 95, 95
Molendiner Park Housing Association 189
Moncrieff, Hope Margaret 300
Moncrieff, Lord, Keystone Portrait of, Royal Faculty of Procurators (A.H. Ritchie and Steel) 307
Monk, George 341
Montague Burton Ltd 32
Monteith, Henry 294
Montford, Paul Raphael xv, 220
 Allegorical Figure Groups 236–42, 237, 238, 239, 241
Montrose, Duchess of 96, 103
Montrose Street 286–7
Moore, Sir John
 memorial fund xii

Monument to, George Square (Flaxman) xii, xiv, 114, 115, **115**, 118, 119–22, **119**, 137, 138
Moore Taggart & Co. 53
Morning, personification, Renfield Street (W.B. Rhind) 323–4, **323**
Morris & Hunter 66
Morris Singer Company of Walthamstow 240
Morrison & Mason 13, 14, 25, 33, 43, 55, 149, 150, 151, 154, 155, 247, 324, 331, 413
Morrison & Muir 171, 316
Morrison, James 38
Morrison, Lynn 88
Morrison Street 287–9
Morrocco, Alberto 30
Morrow, Tony 492
Lobey Dosser 430, **430**
Mortimer, Jack xiv, 375–6, **375**, 431–2
Mortimer, Willison & Graham 492
Seafarer and Seafarer's Wife and Associated Decorative Carving, St Vincent Street 374–6, **374**, **375**, **376**
Morton, W.G. 85
Mossman, John 2, 65, 116, 118, 124, 149, 151, 172–3, 307, 371, 418, 460, 464, 493
Allegorical Figure Groups, Putti and Associated Decorative Carvings, George Square 159–60, **159**
Allegorical Figures, Coats of Arms and Associated Decorative Carving, St Vincent Place 367–8
Allegorical Statues, Coat of Arms, Relief Panels, Ingram Street 439
Allegorical Statues, Narrative Tympana And Associated Decorative Carving, Ingram Street 212–14, **212**, **213**
Allegorical Statues, Roundels and Capital Figures, Buchanan Street 43–4, **43**
Bust of Queen Victoria 346, **346**
Couchant Buck 4–5, **4**
Duncan Turner Monument 458
Esther Ritchie Cooper of Ballindalloch Monument, Granville Street 458
Figurative Programme 190–6, **192**
Monument to David Livingstone 62–4, **63**

Monument to James Lumsden 61–2, **61**
Monument to the Reverend Dr Norman Macleod xi, 71–2, **72**
Monument to Sir Robert Peel 118, 132–3, **132**
Monument to Thomas Campbell 143–4, **143**
Mythological and Historical Figure Programme, Robertson Street 331–2, **332**, **334**, **335**
Narrative Friezes and Associated Decorative Carving, Wilson Street 427, 429
Narrative Friezes, Portraits, Trophies and Associated Decorative Carving, La Belle Place 270–2, **270**, **271**
Pastor William Black Memorial 459, **459**
Peter Lawrence Memorial 443
Portrait Bust of Stephen Mitchell 312
Portrait Statues and Allegorical Figure Groups, Nelson Mandela Place 305–6, **305**
Rev Ralph Wardlaw Memorial 460
Sculpture Group, Figurative Reliefs and Decorative Carving, Sauchiehall Street 444–5, **444**
Series of Masks, Wilson Street 429
Sheridan Knowles Monument 460
Sir William Collins Memorial Fountain 165–6, **166**
Statues of Caxton and Gutenberg 38–40, **39**
Statues of Galileo, James Watt and Homer 107–9, **108**
Statues of David Garrick, John Henry Alexander, Thalia and Melpomene 436
Stewart Memorial Fountain 222–7, **223**, **224**, **225**
Trades and Industries of Glasgow, George Square 154–5, **155**
Two Pairs of Symbolic Caryatids, George Square 158–9, **158**
Mossman, William, Junior 141, 429, 493
Allegorical Female Figures, Putti and Associated Decorative Carving, St Vincent Place 368–9, **369**
Allegorical Figures, Coats of Arms and Associated Decorative Carving, St Vincent Place 367–8, **367**
Allegorical Roundels, Burgh Hall Street 47, **47**

Allegorical Statues, Coat of Arms, Relief Panels, Ingram Street 439
Atlantes, Arms of the Bank of Scotland and Associated Decorative Carving, St Vincent Place 365–6, **365**
Figurative Programme, Grenville Street 6, 190–6, **191**, **193**
Sculpture Group, Figurative Reliefs and Decorative Carving, Sauchiehall Street 444–5, **444**
Spandrel Figures and Associated Decorative Carving, West George Street 419–20, **420**
Mossman, William, Senior 493
Coat of Arms 46, **46**
Monument to Sir Walter Scott 124–6, **124**
Mother and Child
Chirnsyde Primary School (Zunterstein) xv, **xvi**, 8–9, **9**
Elder Cottage Hospital (Unknown) 87–8, **87**
West Graham Street (Unknown) 421, **421**
Motherwell, William, Memorial, Necropolis (Fillans) 301–2, **301**
Mozart, Wolfgang Amadeus, King's Theatre (Unknown) 13
Muir, Alexander 152
Muirhead, Bishop Andrew, Semi-abstract Figure of, St Nicholas Garden (Sloan) 57
Muirsheil, Right Hon. Viscount 30
Mullan, Nigel 389
Mullins, Edwin Roscoe 493
Cain 18, **18**
Municipal Buildings, Ingram Street 439
Munro, Neil 116
Murray, David 94
Murray, G. 23
Muses
Athenaeum Theatre (Brown) 44–5, **45**
Citizen's Theatre (J. Mossman) 174–6, **175**
Gorbals Economic and Training Centre (Members of Gorbals Arts Project) 281–2, 281
Mitchell Theatre (J. Mossman, W. Mossman Jr and Fergusson) 191
Theatre Royal (Unknown and J. Mossman) 436

Music, personifications
 Glasgow Art Gallery and Museum (Wood)
 253, 259, **259**, 260
 Mitchell Theatre (J. Mossman, W. Mossman
 Jr and Fergusson) 191
Mylne, George 292

Naburn Gate 290
Nairn, Andrew 9
Naismith, Mungo 211, 465, 494
 'Tontine Faces' 52–6, **54**
Napier, Robert 128
Nasmyth, Alexander 142
National Bank Chambers, St Vincent Street
 465, **465**
National Bank of Scotland, Union Street 386
National Lottery 17
 see also Heritage Lottery Fund; SAC
National Trust for Scotland 205, 432
Navigation, personifications
 Corinthian (J. Mossman) 212, **212**
 Kelvin Way Bridge (Montford) 236, 238, **239**
Neat, Timothy 328, 329
Necropolis 291–304, 443, 458–60
Neill, Bud 430
Neilson, James Beaumont, Portrait Roundel of,
 Connal's Building (Young) 417
Nelson, Lord, Obelisk, Glasgow Green
 (Hamilton) 450
Nelson Mandela Place 305–8, 454
Neptune
 Anchor Line Building (H.H. Martyn & Co.)
 366
 and Ceres, Trongate (Unknown) 381–2, **382**
 Kvaerner-Govan Yard Offices (McGilvray
 & Ferris) 187–8
 Salacia and Dolphins, Anderston House
 (Unknown) 431
New City Road 308–9
New Gorbals Housing Association 109, 315
Newbery, Francis H. 330
Nichol, James 421
Nichol, John 144
Nicholas Street 196
Nicol, James 145

Night
 Allegorical Figure of, Renfield Street (W.B.
 Rhind) 323–4, **323**
 *and Day, Allegorical Figures of, and
 Associated Decorative Carving*, Tennent
 Memorial Building (Dawson) 73–4, **74**
Nightingale, Florence, Royal Infirmary
 (Unknown) 60
Nisbet, Gary ix
Nollekens, Joseph 121
North British Daily Mail (newspaper) 98, 151,
 155, 157
North British Locomotive Company xiv, 112
North British Rubber Company Ltd 38
North Glasgow College, Flemington Street
 111–12
North Glasgow University Hospital NHS
 Trust 58, 60, 73
North Kelvinside, Botanic Gardens 17–22
North Street 310–13
Northern Lights 376
Norwich Union Chambers, Hope Street 451
Notre Dame High School, Observatory Road
 313–15
Nubian Slave, Kibble Palace (Rossetti) 20, **20**

Observatory Road 313–15
Ocean Accident and Guarantee Corporation 420
Ocean Chambers, West George Street 420–1,
 421
Office of Public Works 436, 463
Old Dumbarton Road 454
Old Parish Church, Govan Road 451
Old Rutherglen Road 315, 454, 464
Oldrieve, W.T. 467
On the Up and Up, Carmunnock Road
 (Cocker) 50–1, **51**
Oram, H.J. 403
Order of Notre Dame 313
Orpheus, Relief Panel of, Glasgow Green
 (Unknown) 164–5, **165**
Orr, Andrew 225
Oswald, James 125
 Monument to, George Square (Marochetti)
 131–2, **131**, 133

Oswald, R.A. 131
Oxford Street 455

P. & W. Anderson Ltd 6, 23, 111, 310, 385
Page & Park 117, 189, 211, 215, 246, 449, 454,
 494
Painting, personifications
 Glasgow Art Gallery and Museum (Wood)
 253, 259
 Mercat Building (Schotz) 277, 279
 People's Palace Museum (Brown and
 Mackinnon) 171
Paisley Road 316–17
Paisley Road West 317–18
Pallas Athena, Muses, Wind Gods and Putti,
 Athenaeum Theatre (Brown) 44–5, **45**
Parable of the Wise and Foolish Virgins,
 Standard Buildings (J. Young) 179, **179**
Paris International Exhibition 1900 324
Park, Patric 307, 494
 Charles Tennant Memorial 300, **300**
Parkhead 113
Parkhead Public Library, Tollcross Road 82,
 378–9
Parkhead Savings Bank, Gallowgate 113
Parks Committee 63, 148, 222, 235, 440
Parks Sub-Committee 233
Parnie Street 380
Parsonage, George G. 494
 Junk Sculpture 163–4, **164**
Partick 47, 73–4, 90–1, 106, 284–5
Partick Burgh Hall, Burgh Hall Street 47
Partick Housing Association 106
Partick Library, Dumbarton Road 463
Partick Underground Station, Merkland Street
 284–5
Partick and Whiteinch War Memorial, Victoria
 Park (Jones) 409, **409**
PAT (Pensions) Ltd 370
Paterson, A.N. 360, 454
Paterson, James 302
Paterson, Neil 457
Patrick, Adam 420
Patrizio, Andrew 189
Pattison, Lieutenant-Colonel Alexander Hope,

Monument to, Necropolis (Ritchie) 299–300, **299**

Paul Mellon Centre for Studies in British Art v

Paulin, George Henry 494
 King Robert of Sicily 19, **19**
 Memorial Tablet to Francis Thornton Barrett 312–13
 Monument to Lord Lister 242–3, **242**
 Portrait Medallions of William and John Hunter 399–401, **400**
 Sir William Ramsay Memorial Plaque 395

Pavilion Theatre, Renfield Street 455

Paxton, Joseph 219

Paxton, Thomas 148

Pazzi, Fabio, *David* 453, **453**

Peace, personifications
 Corinthian (J. Mossman) 212
 Kelvin Way Bridge (Montford) 236, **237**, 240

Peacock, Gates, Balustrades and Associated Decorative Ironwork, Princes Square (Dawson) 35–6, **35**

Pearce, Arthur Edward 494
 Doulton Fountain 166–71, **166–9**

Pearce Institute, Govan Road 451

Pearce, Lady 185

Pearce Lodge, University Avenue 387–8

Pearce, Sir William 98, 188, 388
 Monument to, Govan Road (Ford) 184–6, **185**

Pearce, Sir William George 188

Pearl Assurance Building, West George Street 419

Peddie & Kinnear 444

Peddie, John Dick 465

Peden, Liz
 Fir Cone Relief 448, **448**
 Pine Cone Bollards 453–4, **453**

Peel, Sir Robert 131, 271
 Monument to, George Square (J. Mossman) 118, 132–3, **132**

Pegasus, Argus catalogue store (Scott) 456, **457**

Pelican, Notre Dame High School (Unknown) 313

Pentecostal Dove, Notre Dame High School (Unknown) 313

Penwal Industries, Inc., *Wile E. Coyote and Taz* 434, **434**

People's Palace Museum, Glasgow Green 55, 56, 164, 171–3, **172**, 257, 283

Persimmon Developments Ltd 84, 287

Peter McKissock & Son 247, 254, 264

Petershill Community Council 11

Pettigrew & Stephens, Sauchiehall Street 445

Phillips, Henry W. 139

Philosophy, personification, Kelvin Way Bridge (Montford) 236, **238**, 239, 241

Phoenix Assurance Company 370

Phoenix Trophies, St Vincent Street (Bromsgrove Guild of Applied Arts) 370–1, **370**

Photo Playhouse Cinema, Sauchiehall Street 456

Photocast of Liverpool 94

Pierce, R.I. 32

Pilkington Jackson, Charles d'Orville 431, 432, 467

Pine Cone Bollards, McNeil Street (Peden and Keay) 453–4, **453**

Piranesi, Gianbattista 279

Pitt, William (Pitt the Younger), Statue of, Glasgow Art Gallery and Museum (Flaxman) 264–6, **264**

Plean Pre-cast 106

Plenty, Allegorical Figure of
 Langside Public Halls (Thomas) 273–4
 Scottish Co-operative Wholesale Society warehouse (Unknown) 289, **289**

Pollock County Park 455

Pollock Hammond Partnership 398

Pollock, Robert 318

Pollok 79–80

Pollokshaws Road 464

Pollokshields 85, 441–2

Pollokshields Burgh Hall, Glencairn Drive 450

Pollokshields Library, Leslie Street 464

Pomegranate, Notre Dame High School (Unknown) 313

Pomeroy, Frederick William 166, 167, 494

Pomeroy, Tim 494–5
 Carved Pavement Plaques 57

Font 56–7, **56**

Poole, Henry 495
 Monument to Field Marshall Earl Roberts 231–4, **231**

Port Dundas Road 318, 464

Portfolio Holdings Company PLC 44, 365, 423

Poseidon
 Amphitrite and Associated Decorative Carving, Ocean Chambers (Unknown) 420–1, **421**
 and Triton, Clydeport Building (J. Mossman) 332, **332**

Powderhall Bronze 218, 246, 359, 380, 408, 422, 430, 449, 454, 495

Power, personification, The City Chambers (J. Mossman) 159

Powers, Hiram 97, 100

Prince of Wales Bridge, Kelvingrove Park 220, 235

Prince's Dock 443
 Hydraulic Pumping Station Chimney 450

Princes Square, Buchanan Street 35–6

Princes Square Consortium 35, 320, 359

Pritchard, Walter 495
 Knowledge and Inspiration 391–2, **391**

Progress of Humanity, Hindu Temple (J. Mossman) **270**

Progress, personification, People's Palace Museum (Brown) 171

Progress of Science, University of Glasgow (Kennington, Stanford and Robertson) 402–4, **402**

Prometheus: The Gift of Science to Liberty, University of Strathclyde (Sloan) 406–8, **407**

Property Services Agency (PSA) 29, 30, 49

Prospecthill Road 455

Prosperity, personification, Mercantile Chambers (Wood and J. Young) 23–5

Protestant, The (periodical) 298

Proudfoot, Alexander 60, 237, 243, 431, 495
 Allegorical Figures, Carver Work and Coats of Arms, Sauchiehall Street 445
 Allegorical Figures of Literature and Science 277–9, **278**

Prudence, personifications
 Mercantile Chambers (Wood and J. Young)
 23–5
 Royal Bank of Scotland (Archibald and
 Ferris) 360, **360**
 Scottish Legal Life Assurance Society
 Building (Dawson and J.A. Young) 26
 Strangling Want, Parkhead Savings Bank
 (Shannan) 113, **113**
Prudential Assurance Co. Ltd 32, 33, 34
Psalmist, Tom Honeyman Memorial Garden
 (Schotz) 245–6, **245**
Public Monuments and Sculpture Association
 v, 291
Puma and Coats of Arms, Victoria Infirmary
 (Mackinnon) 276, **276**
Puma, Ruthven Lane (Unknown) 339–40, **340**
Purcell, Henry, Athenaeum (J. Mossman and
 Mackinnon) 305
The Pursuit of..., University of Strathclyde
 (Kinloch) 408, **408**
Putti
 Anchor Line Building (H.H. Martyn & Co.)
 366
 Anderston Public Library (Unknown) 442
 Athenaeum Theatre (Brown) 44–5, **45**
 Buchanan Street (Unknown) 40–1, **40**
 Charing Cross Mansions (W.B. Rhind) 349
 The City Chambers (J. Mossman) 159–60
 The City Chambers (Unknown) 160–1
 Clydeport Building (J. Mossman) 332, 335
 Glasgow Cross (Crawford) 437
 Govan Town Hall (Shannan) 180, 181, **181**,
 182
 Hope Street (Unknown) 451, **452**
 Maryhill Public Library (Brown) 280, **280**
 New City Road (Unknown) 309, **309**
 Parkhead Public Library (Brown) 379
 Renfield Street (W.B. Rhind) 321–2, **322**
 St Vincent Place (W. Mossman Jr) 368–9, **369**
 St Vincent Street (Unknown) 370–1, **370**
 Scottish Temperance League Building
 (Ferris) 200–1, **200**
 Springbank Public Halls (Sheriff) 285
 Trustee Savings Bank (Frampton and

Shirreffs) 209–10, **209**

Quadriga, Renfield Street (W.B. Rhind) 321–2,
 322
Queen Margaret Drive 455
Queen Mother's Hospital, Dalnair Street 449
Queen Street 320–1, 443–4, 464
Queen's Crescent 455
Queen's Drive 319–20
Queen's Park 276
Quiz (magazine) 116

R. Masefield & Co.139
R.A. Bryden & Robertson 29
Rabvend Ltd 203
Radio Clyde 78
Rae, David 177
Rae, Robert 442
Railtrack PLC 318
Railtrack Property 385
Rainy, Harry 432
Rait, Robert 175
Ramsay, Allan 204
Ramsay, Sir William, Memorial Plaque,
 University of Glasgow (Paulin) 395
Ramsay, W.N.W. 391
Randolph, Charles 188
Rankin, Daniel Reid 125, 295
Rankine Building, University Avenue 389–90
Rankine, John 103
Raphael, Portrait of, Mitchell Theatre (J.
 Mossman and Fergusson) 191
Raymond, Stanley 318
Read, Ben ix
Reaper, Victoria Infirmary (Bisset) 276, **277**
Reconciliation, Cowglen Road (Broadbent)
 79–80, **80**
Reddie, James, Keystone Portrait of, Royal
 Faculty of Procurators (A.H. Ritchie and
 Steel) 307
Reeve, Peter 30
Regent Quay Development Company Ltd 309
Reiach, Alan xv
Reid Family 285
Reid, Hugh 354, 356

Reid, James, of Auchterarder, Monument to,
 Springburn Park (John) 354–5, **355**
Reid, Robert 68
Reid, William 207, 293, 298
Reidvale Housing Association 426
Relief Map of the West End of Glasgow
 (Chambers) 246–70, **247**
Religion, Seated Female Figure Symbolising,
 Kelvingrove Art Gallery and Museum
 (Keller) 253, **253**, 260, **260**
Religious and Moral Education, personification,
 Notre Dame High School (Unknown) 314
Renfield Street 321–5, 371, 444, 455
Renfrew Street 326–31
Rennie, John 436
Retrouvius Architectural Reclamation, London
 435
Reynolds, Joshua 271, 400
 Statue of, Athenaeum (J. Mossman) 305
RGI Kelly Gallery, Douglas Street 86
Rhind, David 124, 125, 177, 178, 370
Rhind, James R. 80, 81–2, 272, 273, 274, 275,
 280, 281, 363, 378, 379
Rhind, John 149, 253, 255, 495
 Eight Allegorical Female Figures 155, **155**
Rhind, William Birnie xiv, 247, 495–6
 Allegorical Female Figures, Quadriga, Putti
 and Related Decorative Carving, Renfield
 Street 321–2, **322**
 Aurora, Apollo, Allegorical Figures of Night
 and Morning and Related Decorative
 Carving, Renfield Street 323–4, **323**
 Christ Feeding the Multitude 363–4, **364**
 Figurative Programme, Sauchiehall Street
 349–51, **350**
 Highland Light Infantry Memorial 227–8,
 228
 Seated Male and Female Attic Figures and
 Associated Decorative Carving, Trongate
 382–3, **383**
 Seated Male Figure Symbolising Science,
 Kelvingrove Park 253, 261, **261**
 Ten Allegorical Figures and Associated
 Carving, Sauchiehall Street 344, **344**
Richard Murphy Architects 189

Richard Seifert Co-Partnership 106
Riches, personification, The City Chambers
 (Lawson and J.A. Ewing) 157
Richmond, David 145
Rickards, Edwin Alfred 496
 Monument to Field Marshall Earl Roberts
 231–4, **231**
Rickey, George 496
 Four 'L' Eccentric 443
 Three Squares Giratory 399, **399**
Riddell, James xii
Riddle, William 496
 Lion and Unicorn Staircase 396–7, **396**
Ritchie, Alexander Handyside 496
 Arms of the Bank of Scotland 438–9
 John Henry Alexander Monument 459
 Keystone Portraits, Nelson Mandela Place
 306–8
 *Narrative and Allegorical Reliefs of Children
 and Associated Decorative Carving*,
 Gordon Street 177–8, **177**
Ritchie, John 496–7
 *Monument to Lieutenant-Colonel Alexander
 Hope Pattison* 299–300, **299**
 Monument to Sir Walter Scott 124–6, **124**
RMJM Associates 380
Robert Innes Memorial Garden, Springburn
 Park 356
Robert, King of Sicily, Kibble Palace (Paulin)
 19, **19**
Robert Lawson, Aberdeen 184
Robert McCord & Son 37, 368
Roberts, Dowager Countess 232, 233, 234
Roberts, Field Marshal Earl, Monument to,
 Kelvingrove Park (Bates, Rickards and Poole)
 220, 221, 231–4, **231**
Roberts, Lady 233
Robertson & Dobbie 450
Robertson, Archibald, *Progress of Science*
 402–4, **402**
Robertson, James 222
Robertson Street 331–6, 455, **455**
Robinson & Cottam 132
Robinson, Graham 448
Rochead, J.J. 365, 413, 450, 455, 466

*Roderick Dhu and Associated Decorative
 Carving*, United Distillers (Ferris) 411–12,
 411
Rodger, J. 449
Rodger, W.K. 244
Rodin, Auguste 235
Romano Wines Ltd 348
Rosa Associates (Delaware) LP 370
Roscoe, Ingrid 68
Rose, Notre Dame High School (Unknown)
 313
Rosebery, Earl of 96, 112, 146, 172, 312
Rosebery, Lord 233
Rosebud, East Garscadden Road (Cocker) 92,
 92
Ross, John 425
Rossetti, Antonio 497
 The Nubian Slave 20, **20**
Rossi, John Charles 121
Rowse, Herbert 432
Royal Academy (RA) 20, 21, 22, 22–3, 122, 123,
 210, 239, 300, 394, 438
Royal Arms of Scotland, Scottish Legal Life
 Assurance Society Building (Dawson and J.A.
 Young) 26–7, **27**
Royal Asylum for the Blind, Castle Street 60
Royal Bank Chambers, St Vincent Street 457
Royal Bank of Scotland 41, 177, 246, 360, 382
 Buchanan Street 449
 St Enoch Square 360
 West George Street 458
Royal College of Surgeons 242–3
Royal Exchange House, Queen Street 321
Royal Exchange Square 336–9, 455–6
Royal Faculty of Physicians and Surgeons in
 Glasgow 400
Royal Faculty of Procurators, Nelson Mandela
 Place 306–8
Royal Glasgow Institute of Fine Art (RGIFA)
 8, 19, 21, 25, 55, 65, 86, 93, 103, 182, 183,
 208, 230, 266, 311, 324, 325, 432, 438, 444, 458
Royal Highland Fusiliers Museum, Sauchiehall
 Street 346–7
Royal Infirmary, Castle Street 58–60, 61, 62, 67,
 242, 243

Royal Institute British Architects 43, 274
Royal Insurance Company Building, Buchanan
 Street 449
Royal Liver Assurance Ltd 34
Royal Scottish Academy (RSA) 19, 103, 113,
 122, 139, 230, 383, 416, 432, 437
 exhibition 1904 228
Royal Scottish Museum 399
Royal Society of Surgeons 242–3
Ruchill 17
Russell, Richard 180, 181, 182
Ruth, Kibble Palace (Ciniselli) 19–20, **20**
Rutherford, Lord, Keystone Portrait of, Royal
 Faculty of Procurators (A.H. Ritchie and
 Steel) 306
Ruthven Lane 339–40

St Aloysius College 353
St Andrew
 Allegorical Figure of, Commercial Union
 Building (Dawson) 374–6, **374, 375, 376**
 Argyle Street (Hodge) 7
 St Andrew's House (Unknown) 453
 Statue of, City of Glasgow Life Assurance
 Building (Brodie) 444
 as a Youth, Bellahouston Park (Dawson and
 Mortimer) 432
St Andrew's House, Maitland Street 453
St Andrew's Parish Church, St Andrew's
 Square 465, **465**
St Andrew's Square 456, 465
St Cecilia, Statue of, Notre Dame High School
 (Unknown) 314, 315
St Enoch Square 360–1, 456
St Enoch Travel Centre, St Andrew's Square
 456, **456**
St Enoch Underground Station 360–1
St Francis Primary School 282
St George and the Dragon, St George's Cross
 (J. & G. Mossman) 362, **362**
St George's Cross 362
St George's Mansions, St George's Road 456
St George's Road 363–4, 456
*Saint John the Baptist and Saint John the
 Evangelist, Statues of*, Masonic Halls

(Unknown) 423–4, **423**
St Kentigern 461
 and Symbols of the Four Nations, John
 McIntyre Building (Unknown) 390–1, **390**
 and Symbols of the Four Nations, University
 of Glasgow Students' Union (Unknown)
 387, **387**
 Symbols of, Kentigern House (Scott) 29–30,
 30
 see also Concept of Kentigern
St Mungo
 Argyle Street (Hodge) 7
 as Patron of Art and Music, Glasgow Art
 Gallery and Museum (Frampton) 250–1,
 255, 256–7, **256**
 Cenotaph (Gillick) 148
 Charing Cross Mansions (W.B. Rhind) 349,
 351
 Doulton Fountain (Pearce) 166
 Statue of, City of Glasgow Life Assurance
 Building (G.E. Ewing) 444
 Statue of, Trustee Savings Bank (Frampton
 and Shirreffs) 208–9, **209**
 with Female Figures, Gorbals Economic and
 Training Centre (Brown) 281, **281**
St Mungo Museum of Religious Life and Art,
 Cathedral Square 449
St Nicholas Garden, Castle Street 52–8
St Nicholas, Semi-abstract Figure of, St
 Nicholas Garden (Sloan) 57
St Rollox Monument, Cobden Road (Sloan) 77,
 77
St Vincent Chambers, Buchanan Street 449
St Vincent Place 365–9, 456–7
St Vincent Street 202, 370–6, 445, 457, 465
Saint-Phalle, Niki de 455
Salacia, Anderston House (Unknown) 431
Salmon, James, Junior 7, 8, 203, 450, 457, 467
Salmon, James, Senior 141, 144, 212, 213–14,
 443
Salmon, Son & Gillespie 196, 200, 203, 455, 497
Salmon, Son & Ritchie 436
Salmon, William Forrest, *Commemorative
 Plaque* 196, **196**
Salmond & Gray 109

Saltmarket 340–3, 456, 464
Sandford, Francis, Memorial Tablet, University
 of Glasgow (Unknown) 396
Sandiefield Road 456
Saracen Foundry 16, 192, 460, 497
 see also Walter Macfarlane & Co.
Saracen Fountain, Alexandra Park (Stevenson)
 2–4, **3**
Saracen Fountain, Saracen Lane (Unknown)
 436
Saracen Lane, Gallowgate 436
Sauchiehall Street 344–52, 444–5, 456, 464
Savoy Centre, Sauchiehall Street 344
Scheemakers, Peter 68, 436
Schotz, Benno xv, 175, 240, 335, 371, 431, 497
 *Allegorical Figures, Carver Work and Coats
 of Arms*, Sauchiehall Street 445
 Joseph Black Memorial Tablet 401, **401**
 Painting and Sculpture, Mercat Building
 277–9, **278**
 The Psalmist 245–6, **245**
 *Two Allegorical Figures, Armorial Shield and
 Associated Decorative Reliefs*, Sauchiehall
 Street 344–5, **345**
Science, personifications
 Glasgow Art Gallery and Museum (W.B.
 Rhind) 253, 261, **261**
 Govan Town Hall, Govan Road (Young)
 180
 Grosvenor Restaurant (Hodge) 437–8, **437**
 McGeoch's Warehouse (Archibald and
 Holmes & Jackson) 445–6
 Mercat Building (Proudfoot) 278, **278**, 279
 North Glasgow College (Hodge) 111–12,
 112
 Notre Dame High School (Unknown) 314
 People's Palace Museum (Brown and
 Mackinnon) 171
 Stock Exchange (J. Mossman) 43, **43**
Scientific Education, personification,
 Athenaeum (J. Mossman and Mackinnon) 305
Scobie, Isobel 241
Scotland, arms of the King of 462
Scotland Street Secondary School, Scotland
 Street 456

Scotstoun 409
Scott & Rae
 *John Pollock McPhun Memorial Drinking
 Fountain* 442
 William Annan Fountain 455
Scott, Andy 318, 454, 456, 464, 497
 Bringer 357, **357**
 Ibrox Disaster Memorial 93–4, **93**
 Pegasus 456, **457**
 Relief Panels of the History of Architecture
 290, **290**
 Shipbuilders 269, **269**
 Welder 452
Scott Associates Sculpture and Design 94, 269,
 269, 497
 Relief Panels of the History of Architecture
 290, **290**
Scott, George 136, 442
Scott, George Gilbert 388, 392, 398, 466
Scott, J. Oldrid 396, 466
Scott, Sir Walter 224, 225, 411
 King's Theatre (Unknown) 13
 Monument to, George Square (Greenshields,
 J. Ritchie and W. Mossman) 115, 116,
 124–6, **124**
Scott Street 353–4
Scott, William 497
 The Symbols of St Kentigern 29–30, **30**
Scottish Art Review (periodical) 151, 158,
 159–60
Scottish Arts Council 30, 32, 50, 358, 389, 399,
 405, 430, 434, 451
 see also Heritage Lottery Fund
Scottish Building Guild 463
Scottish Co-operative Wholesale Society 288,
 289, 362
 warehouse
 Dalintober Street 84
 Morrison Street 289
Scottish Court Service 456
Scottish Development Agency 362
Scottish Enterprise Glasgow 377
Scottish Exhibition of Arts and Manufacturers
 Connected with Architecture 133
Scottish Homes 48, 186, 376

Scottish Legal Life Assurance Society Building
 Bothwell Street 26–7
 Wilson Street 467
Scottish Life Assurance Building, Gordon
 Street 437
Scottish Metropolitan PLC 43, 44, 321
Scottish Mutual Assurance PLC 200, 372
Scottish Natural Heritage Environmental
 Regeneration Award 52
Scottish Natural Portrait Gallery xiii
Scottish Office 50
Scottish Provident Institution for Life
 Assurance, St Vincent Street 445
Scottish Sculpture Trust 406
Scottish Stock Exchange Association 44
Scottish Temperance League Building 200–1
Scottish Widows Fund and Life Assurance
 Society 38, 458
 Buchanan Street 434
Scougal, George 208
Sculpture in the Open Air exhibition 1949 283
Sculpture, personifications
 Glasgow Art Gallery and Museum (Wood)
 253, 259
 Mercat Building (Proudfoot) 277, **278**, 279
 Mitchell Theatre (J. Mossman and
 Fergusson) 191
 People's Palace Museum (Brown) 171
Sea Horses and Portraits of Queen Victoria,
 Clyde Street (Unknown) 75, **75**
Seafarer and Wife, Commercial Union Building
 (Mortimer, Willison & Graham) **374**, 375,
 375, 376
Seamen's Chapel, Brown Street 433
Seamen's Institute, Brown Street 29, **29**
Second World War 240
Section Extending, University of Glasgow
 (Dajani and Lee) 451
Security, personifications
 Royal Bank of Scotland (Archibald and
 Ferris) 360
 St Vincent Street (Unknown) 372, **372**
Sellars, James 16, 38, 90, 174, 190, 192–3, 222,
 226, 276, 353, 414, 419, 420, 421, 450, 497–8
Sewing Machine, British Linen Company Bank

(Gallacher) 450
Shakespeare, William
 Figure of (J. Mossman and Fergusson) 190–1,
 192
 Portrait Roundel of, Ladywell School
 (Crawford) 88
 Profile Portrait Medallion of, King's Theatre
 (Unknown) 13, 14
 Statue of, Citizen's Theatre (J. Mossman)
 174–6, **175**
 Statue of, Theatre Royal (Unknown) 436
Shamrock Street 464–5
Shanks, James 498
 *Keystone Portraits and Associated Decorative
 Carving*, Nelson Mandela Place 306–8
Shannan, Archibald Macfarlane 208, 247, 253–4,
 255, 266–7, 429, 498
 Eight Keystone Masks, Argyle Street 5, **5**
 George Mason Monument 459, **460**
 Monument to Isabella Ure (Mrs John Elder)
 100–4, **101**
 Monument to Lord Kelvin 229–31, **229**
 *Portrait Roundels, Portrait Keystone and
 Procession of Putti* 180–2, **180**, **181**
 Prudence Strangling Want 113, **113**
 Success 266–7, **266**
 Keystone Masks, St Nicholas Garden 52–6,
 54
Shannan, Peter 5, 33, 54, 55
Sharp, Joseph 174
Shaw & Campbell 113, 403
Shawlands 273–4
Shepley Dawson Architectural Engineering Ltd
 35, 36
Sheriff Court of Glasgow and Strathkelvin,
 Carlton Place 49
Sherriff, James Milne 247, 262, 456, 498
 Pair of Allegorical Female Figures, Buchanan
 Street 34–5, **34**
 *Two Allegorical Figures and Related
 Decorative Carvings*, Millarbank Street
 285–6, **285, 286**
Shields Road 456
Shields, Tom 430
Shipbuilders, Braehead Shopping Centre (Scott

and Mackay) 269
Shipbuilding, personifications
 Kelvin Way Bridge (Montford) 236, 238,
 239, **239**, 240
 Mercat Building (Dawson) 277, 279
 New City Road (Unknown) 309, **309**
 People's Palace Museum (Brown) 171
Shipventure Ltd 413
*Shipwright, Engineer and Associated Decorative
 Carving*, Kvaerner-Govan Yard Offices
 (Macgillivray and McGilvray & Ferris) 187–8,
 188
Shirreffs, William 85, 247, 250, 255, 261, 498
 *Allegorical Figures, Carver Work and Coats
 of Arms*, Sauchiehall Street 445
 Masks of 'The Great Trio of Greek Art',
 Glasgow Art Gallery and Museum 259
 *Reliefs Representing Music, Literature and
 Manufacturing Arts*, Glasgow Art Gallery
 and Museum 257–9, **258**
 *St Mungo, Atlantes, Allegorical Figures and
 Related Decorative Carving*, Trustee
 Savings Bank 208–9, **209**
 Thomas Gildard Monument 459–60
Shopping Baskets, Kwik Save supermarket
 (Sloan) 83, **84**
Sighthill 77
Sillars, A.L. 50
Simister Monaghan, Architects 95
Simpson, J.W., Glasgow Art Gallery and
 Museum 247, 248, **248**, 249–50, **249**, 253, 255,
 259, 264, 266
Simpson, Robert 350
Sinclair, Archie 57, 216
Sinclair, Callum 458, 498–9
 Illuminated Wall Sculpture 47–8, **47**
 Milestone 83, **83**
Singer, J.W. 100, 229, 231, 233
 see also J.W. Singer & Sons
Singer, Morris 216
Sir Frank Mears & Partners 194
Sir Leslie Martin & Partners 464
Sisters of Bethany, Kibble Palace (Wood) 21–2,
 21
Skirving, Alexander 14, 15, 174, 467

Skirving, Archibald 142
Skrynka, Stephen 499
 Calvay Milestone 12–13, **13**
Slater, Peter 307
Slezer, Captain 292
Sloan, A. 23
Sloan, Jack 408, 449, 450, 499
 *Decorative Gates and Railings with Eight
 Semi-abstract Figures* 57–8, **58**
 Grasp the Thistle 211–12, **212**
 Guardians and Mythological Figures 216–18,
 217
 History of Scottish Theatre 204, **204**
 Prometheus: The Gift of Science to Liberty
 406–8, **407**
 St Rollox Monument 77, **77**
 Shopping Baskets 83, **84**
SM PH LP 23
Smart, Henry 194
Smith, Adam, Statue of, Hunterian Museum
 (Gasser) 394–5, **395**
Smith, Alexander 234–5
Smith, George 98
Smith, James 336, 346
Smith, Peter 362, 460
Smith, Tracy ix
Smokestack, Twomax Building (Lamb) 454, **455**
Snowden, Michael Alan 499
 Children of Glasgow Fountain 246, **246**
Soldier's Return, Royal Exchange Square
 (Marochetti) 337, **337**
Some of the People, Partick Underground
 Station (Mach) 284–5, **284**
Somers, Thomas 431, 462
Somerville, John 139
Sorley, R. & W. 352
South Africa, Doulton Fountain, Glasgow
 Green (Ellis) 167
Southern Arch, Carmunnock Road (Kirby) 50,
 50
Southern Christian Institute, Maxwell Road 453
Southorn, Frank 372
Sovereign House, West Regent Street 424–5
Sowing and Reaping, Figures of, Corn
 Exchange (J. Young) 438

Soyer 336, 338
Spalding, Julian 339, 443, 456
Sparrow, Walter Shaw 257, 258–9, 260
Speed and Science, North Glasgow College
 (Hodge) 111–12, **112**
Spence, Basil 431–2
Spence, William 5, 6, 33
Spielmann, M.H. 260, 324
Spirits of the Forest, Queen Mother's Hospital
 (Viknyanski) 449
Springbank Public Halls, Millarbank Street
 285–6
Springburn 11–12, 111–12, 285–6, 354–6, 357–8
Springburn & Possilpark Housing Association
 Ltd 358
Springburn Heritage and Hope, Atlas Square
 (Butler) 11–12, **11**
Springburn Milestone 'The Works', Springburn
 Way (von Halem) 357–8, **358**
Springburn Museum Trust 286, 358
Springburn Park 354–6
Springburn Public Library and Museum, Ayr
 Street 448
Springburn Road 465
Springburn Way 357–8
Springfield Court 320, 359
'Springtime' Pedestal, McPhun Park
 (Clapperton) 283–4, **284**
SPTE 284
SS Daphne Memorial, Elder Park (McArthur)
 104–5, **104**
Stakis Hotels 214
Stakis PLC 349
Stallan, Paul 380
Standard Buildings, Gordon Street 179–80
Standard Life Insurance Company 179, 180
Stanford, Eric, *Progress of Science* 402–4, **402**
Stanley Street 465, **465**
Stark, William 121, 456
Starkie, Gardner & Co. 149, 160
Statute Labour Committee 67
Steel, James 499
 Decorative Carving, Royal Faculty of
 Procurators 306–8
Steell, John 179

Allegorical Group, Buchanan Street 434
Stepford Road Sports Pavilion, Stepford Road
 376–7
Stepford Road Sports Trust 376–7
Stephen, John 452
Stephens, M.W., *Glasgow Arms* 464, **464**
Stepping Stones, Kibble Palace (Thornycroft)
 21, **21**
Stevenson Dalglish, Mr 271
Stevenson, David Watson 499
 Saracen Fountain 2–4, **3**
Stevenson, D.M. 439, 449
Stevenson, J.J. 445
Stevenson, John Horne 466
Stewart & Campbell 455
Stewart & Paterson 442
Stewart, Alexander 453
Stewart, George 416
Stewart, James Watson 148
Stewart, John, Monument to, City of Glasgow
 Friendly Society Building (Brown) 86–7, **86**
Stewart Memorial Fountain, Kelvingrove Park
 (J. Mossman and J. Young) 222–7, **223**, **224**,
 225, 227
Stewart, Peter, Monument, Necropolis
 (MacGillivray) 459
Stewart, Robert *see Stewart Memorial Fountain*
Stewart, William 394
Stirling, Annet 449
Stirling, Walter 442–3
Stirrat, Frank 462
Stobhill Hospital, Balornock Road 431
Stock Exchange, Buchanan Street 43–4
Stockweld Ltd 376
Stockwell Street 456, 465
Stoddart, Alexander 4–5, 109, 117, 190–1, 279,
 499–500
 Italia 215–16, **215**
 Mercurial 216, **216**
 Mercury and Mercurius 216, **216**
 Sculpture Scheme, Ingram Street 211–12, **212**
Stone, Stirling 464
Stornoway Gazette (newspaper) 405
Strang, John 55–6
Strathclyde Fire Brigade Command

Headquarters, Port Dundas Road 464, **464**
Strathclyde House, Elmbank Street 107–9
Strathclyde Passenger Transport Executive
 (SPTE) 268, 284, 361
Strathclyde Police Training Centre, Oxford
 Street 455
Strathclyde Regional Council 42, 52, 109, 187,
 247, 358
Strong, Rebecca 60
Stuart and Macdonald 6
Studio (magazine) 41, 257, 258, 260, 304
Success, Glasgow Art Gallery and Museum
 (Shannan) 266–7, **266**
Summer, personification, Renfield Street (W.B.
 Rhind) 322, **322**
Surf City, Bilsland Drive (Wilkinson and
 Burroughs) **16**, 17
Sutherland, E.A. 463
Sutherland, Scott 431, 432
Swan, Joseph **114**, 115, **115**, 291, **291**
Swan, T. Aikman 437
Symbols of St Kentigern, Kentigern House
 (Scott) 29–30, **30**

T. & R. Annan & Sons 99, 170, 346, 348
Tadolini, Scipione 500
 Eve 19, **19**
Tait, Thomas 419, 431
Talbot Centre, Paisley Road 316–17
Tara House, Bath Street 462
Tassie, James 395, 401, 404
Taylor, Edward 458
Taylor, George Ledwell 462–3
Taylor, Sean 500
 Untitled (Woodlands Men) 10, **10**
T.C. Lewis & Co. 193–4
Teesland Developments 36
Teesland Investment Co. Ltd 48
Teggin, H. 375–6
Telephone exchange, College Street 463
Telford, Thomas, *Historical Portrait*, Clydeport
 Building (Hodge) 332, 334, **334**, 336
Temperance, personification, Scottish
 Temperance League Building (Ferris) 200–1,
 200

Templeton Business Centre, Templeton Street
 377–8
Templeton, John Stewart 378
Templeton Street 377–8
Tennant, Charles, Memorial, Necropolis (Park)
 300, **300**
Tennent, Gavin Paterson 74
Tennent Memorial Building, Church Street
 73–4
Textile industry, personifications
 Govan Town Hall, Govan Road (J. Young)
 180
 People's Palace Museum (Brown) 171
 Templeton Business Centre (Unknown) 377,
 377
TGI Friday's Restaurant, Buchanan Street 41–2
Thalia, Theatre Royal (J. Mossman) 436
Thaw & Campbell 26, 34, 200, 340, 366, 370,
 467
Theatre Royal, Dunlop Street 436
Thinking of Bella, Italian Centre (Kinloch) 218,
 218
Thistle Terrace 457
Thomas, John 214, 500
 *Allegorical Figures of Commerce and Plenty
 and Related Decorative Carving* 273–4, **273**
 Houldsworth Family Mausoleum 302–3, **303**
 *Narrative and Allegorical Reliefs of Children
 and Associated Decorative Carving* 177–8,
 177
Thompson, John 392
Thomson & Sandilands 1, 162, 180, 431, 449
Thomson, Alexander 4, 133, 134, 192–3, 387,
 388, 392, 437
Thomson, David 109
Thomson, J. Taylor 458
Thomson, James 33, 201, 202, 416, 418, 419,
 452, 500
 Portrait Roundel of, Connal's Building (J.
 Young) 417, **417**
 Relief Head of, Cambridge Buildings (J.
 Young) 48, **48**
Thomson, John 179
Thomson, Robert 37, 199, 456
Thomson, William *see* Kelvin, Lord

Thornycroft, William Hamo 439, 500
 Monument to William Ewart Gladstone
 144–6, **145**
 Stepping Stones 21, **21**
Thorwaldsen, Bertel 428
Three Graces, Relief Panel of, Glasgow Green
 (Unknown) 164–5, **165**
Three Squares Giratory, University of Glasgow
 (Rickey) 399, **399**
Thrift, personification, Scottish Legal Life
 Assurance Society Building (Dawson and J.A.
 Young) 26–7, **27**
Tinworth, George 169, 170, 500–1
 *Portrait Medallions of Charles Cameron and
 Associated Decorative Work*, Sauchiehall
 Street 351–2, **352**
T.M. Miller & Partners 214
Tobago Street 465
Toft, William 186
Tolbooth Steeple 278, 451
Tollcross Road 378–9
Tom Honeyman Memorial Garden,
 Kelvingrove Park 245–6
Tominey Estates Ltd 324
'Tontine Faces' xii, 1, 5, 33
 St Nicholas Garden (Cation and Naismith)
 52–6, **54**
Tontine Hotel, Trongate 52, 53, 54
Tontine Society 53
Topographical Relief Map, Buchanan Street
 (Chambers) 42, **42**
Topographical Relief Panels, Old Rutherglen
 Road (Gosse) 315, **315**
Topographical Scenes at Partick Cross, Elie
 Street (Clark) 106, **106**
Townhead 52–72, 196–7, 291–304, 435, 443
Townhead District Library, Castle Street 81, 82,
 435
TPS Consult 464
Trades Hall of Glasgow Charitable Trust 173
Trades House, Glassford Street 173–4, **173**
Trades and Industries of Glasgow, The City
 Chambers (J. Mossman) 154–5, **155**
Transition, Royal Exchange House (Creed) 321,
 321

Tree of Life
 Kirk Road (Miller) 452, **453**
 St Vincent Street (Dawson) 372–3, **373**
Trial by Jury, City and County Buildings
 (Buchan) 428–9, **428**
Trinity Square housing development, Shields
 Road 456
Triton and Poseidon, Clydeport Building (J.
 Mossman) 332, **332**
Tron Steeple, Trongate 380, 381
Tron Theatre, Trongate 380–1
Trongate x, 1, 68, 69, 70, 266, 380–3, 465–6
Trophies and Coats of Arms, The City
 Chambers (Unknown) 161, **161**
*Trophy of Agricultural Implements and
 Produce*, Hunter Street (Unknown) 203, **205**
Truman, Arthur E. 397
Trustee Savings Bank of Scotland PLC 113, 208
 Ingram Street 208–9
 Pollokshaws Road 464
Trustees of Hindu Mandir 270
Truth, personifications
 Buchanan Street (Unknown) 37–8, **38**
 The City Chambers (Lawson) 153
 Partick Burgh Hall (W. Mossman, Jr) 47
Turnbull Street 384
Turnbull, William 163
Turner, Duncan, Monument, Necropolis (J.
 Mossman) 458
Tweed, John 53, 118, 149, 178, 341, 365, 400,
 414
 Jubilee Pediment 152, 156–7, **156**
Twelvetrees, W.N. 203
Twomax Building, Old Rutherglen Road 454
TWSA Four Cities Project 449
TWSA-3D xvii
Tyndale, William 433

UK City of Design and Architecture Festival,
 Glasgow 1999 189
Unicorn and Associated Decorative Carving,
 Mercat Cross (Findlay, Dawson & Young)
 340–2, **340**
Union Bank of Scotland 212, 213
Union Street 385–6, 457

United Co-operative Baking Society, McNeil
 Street 442
United Distillers, Waterloo Street 411–12
University Avenue 397–91
University Gardens 391–2
University of Glasgow xii, 90, 197, 387, 388,
 389, 390, 391, 392–404, 451, 453, 457
 coats of arms 466–7, **466**
 Hunter Memorial 399–401
 Hunterian Museum 393–5, 399
 Inorganic Chemistry Building 401
 James Watt Building 402–4
 Main Building 392–3
 Organic Chemistry building 457
 Students' Union, University Avenue 387
 War Memorial Chapel 397–8
 West Quadrangle 399
 West Range 396–8
University of Strathclyde 162, 404–8
 John Anderson Campus 404–6
Ure, Andrew 157
Ure, Bailie 67
Ure, Isabella (Mrs John Elder), Monument to,
 Elder Park (Shannan) 100–4, **101**
Ure, John xiv, 65, 102, 150
Ure Primrose, John 203, 441
Ure Primrose, Lady 441
Utzen, Jøern 290

van Dyck, Anthony 207–8
Varleys of St Helens 79
Veitch, John, *Memorial Tablet*, University of
 Glasgow (Unknown) 396
Vickers, William 247, 261, **263**, 451, 457, 458,
 501
 *Allegorical Figures, Medallion and
 Ornamental Clock*, Bath Street 431
 *Pair of Atlantes, Narrative Tympanum and
 Decorative Masks*, Fraser's Department
 Store 6–7, **6**
Victoria Infirmary, Langside Road 276
Victoria NHS Trust 276
Victoria Park 409
Victoria, Queen 136, 150, 156–7, 166, 276, 338,
 416, 425

and Prince Albert, Medallion Portraits of,
 Albert Bridge (Ewing) 342–3, **342, 343**
Bust of, McLellan Galleries (J. Mossman)
 346, **346**
Doulton Fountain, Glasgow Green (Broad)
 168–71, **168, 169**
Equestrian Monument to, George Square
 (Marochetti) 115, 116, 126–31, **126, 127,
 128**, 134, 135, 148, 338, 339
Monument to, Royal Infirmary (Hodge)
 58–60, **59**
Relief Medallion of, National Bank of
 Scotland (Unknown) 386
Sea Horses and Portraits of, Clyde Street
 (Unknown) 75, **75**
Victorious (or Paschal) Lamb of God, Notre
 Dame High School (Unknown) 313
Victory, personifications
 Buchanan Street (Unknown) 38, **38**
 The City Chambers (Lawson) 153
 Kelvingrove Park (Bates, Rickards and
 Poole) 232
 St Vincent Street (Unknown) 372
Viking Sea God, Kvaerner-Govan Yard Offices
 (Macgillivray and McGilvray & Ferris) 187
Viknyanski, Gennady, *Spirits of the Forest* 449
Virgin and Child, Statue of, Notre Dame High
 School (Unknown) 314
Virginia Place 209, 210, 213
Virginia Street 458
Virtue, personification, The City Chambers (J.
 Mossman) 159
*Virtues, Royal Arms of Scotland, and Associated
 Decorative Carving, Relief Panels of*, Scottish
 Legal Life Assurance Society Building
 (Dawson and J.A. Young) 26–7, **27**
Visual Art Projects (VAP) xvii, 31, 189, 380
Visual Arts, personification, Mitchell Theatre
 (J. Mossman and Fergusson) 191
Vulcan Street 467

W. & J. Martin 282
W. & J. Taylor 280
Walden, Richard, portrait of, Citizen's Theatre
 (Unknown) 175

Walker, D. ix, xii, 183, 368, 375, 420
Walker, E.E. 99
Walker, Tom 290, 315
Walker, W.B. 98
Wallace, Captain 21
Wallace Street 73
Wallacewell Council 11
Walter Macfarlane & Co. 2, 154, 192, 420, 436, 451, 489–90 *see also* Saracen Factory
 Bailie James Martin Memorial Fountain 450
Walter Stirling's House, Miller Street 442–3
Walton, George 40–1
Walton, John 18
Want, personification, Parkhead Savings Bank (Shannan) 113, **113**
War Damage Commission 240
War Memorials
 Cameronians (Scottish Rifles) War Memorial, Kelvingrove Park (Clark) 243–4, **244**
 Old Parish Church (Gray) 451
 Partick and Whiteinch War Memorial, Victoria Park (Jones) 409, **409**
 University of Strathclyde (Watson) 404
War, personifications
 Kelvin Way Bridge (Montford) 236, **237**, 239, 240
 Kelvingrove Park (Bates, Rickards and Poole) 232
Ward-Jackson, Philip ix
Wardlaw, Rev. Ralph, Memorial, Necropolis (J. Mossman) 460
Warner Brothers Studio Store, Buchanan Street 434
Warren, William 501
 Monument to John Knox 293–7, **294**
Warrington Borough Council 4
Water Row 183
Waterhouse, Alfred 248, 254, 255, 266
Waterloo, Battle of, Royal Exchange Square (Marochetti) 337
Waterloo Chambers, Waterloo Street 410
Waterloo Street 410–12, 458, 467
Watson, Arthur 30
Watson, James 190
Watson, T.L. 448, 456

War Memorial 404
Watson, William 138, 139
Watt, James 120–1, 163, 271
 Monument to, George Square (Chantrey) 114, 115, 122–4, **123**
 Portrait of, Athenaeum (J. Mossman and Mackinnon) 305
 Portrait of, Clydeport Building (Hodge) 332, 334–5, **334**, 336
 Portrait Roundel of, Connal's Building (J. Young) 418
 Statue of, Hunterian Museum (Chantrey) 393–4, **393**
 Statue of, McPhun Park (Grassby) 282–3, **282**
 Statue of, Strathclyde House (J. Mossman) 107, **108**
 Statue of, University of Strathclyde (Greenshields) 404
Watt, James, Junior 393
Watts, G.F. 234
Waugh, D.S.R. 457, 467
W.D. & H.O. Wills 89
Wealth, personification, Corinthian (J. Mossman) 212, **212**
Weather Vane, Kirk Road (Miller) 452
Welder, Lauriston Road (Scott) 452
Wellington, Duke of, Equestrian Monument to, Royal Exchange Square (Marochetti) x, **xi**, **xiii**, xiv, 129–30, 336–9, **336**
Wellington Street 22, 25–6, 458
Welsh, James 284
West Campbell Street 26, 27, 445–6
West End 219–67, 430, 439–41
 Relief Map of the, Kelvingrove Park (Chambers) 246–7, **247**
West George Street 413–21, 446, 458
West Graham Street 421
West Princes Street 422
West Regent Street 423–5, 467
West Scotland Street 446
Western Baths, Cranworth Street 449
Westmacott, Richard 121
Whalen, Thomas 431, 432
Whinney, Margaret 68

Whistler, J.A.M. 235
Whitbread Pension Fund Ltd 424, 425
White, Douglas 19, 22
White, Gleeson 41
White, James, of Overtoun 63
 Monument to, Castle Square (Leslie) 64–5, **64**
Whiteinch & Scotstoun Housing Association 95
Whitelaw, Mathew, Semi-abstract Figure of, St Nicholas Garden (Sloan) 58
Whitevale Street 426
Whitie, William B. 285, 310, 311, 448
Whyte & Galloway 464–5
Whyte, John 297
Whyte, William M. 320
 Corbel Figure of, Queen's Drive (Unknown) 319
Wile E. Coyote and Taz, Warner Brothers Studio Store (Penwal Industries, Inc.) 434, **434**
Wilkinson, Lucinda C. 501
 Surf City **16**, 17
William, Dixon, Portrait Roundel of, Connal's Building (Young) 417
William Douglas & Co. 42
William III, King, Equestrian Monument to, Cathedral Square Gardens (Unknown) x, **x**, xii, 67–71, **69**
William IV, King, Relief Medallion of, National Bank of Scotland (Unknown) 386
William McGeoch & Co. 413, 446
William Morgan & Young 1
William Potts & Sons 78
William Shaw & Son 162
William Steven & Son 384
Williams, Dave 79
Williams, John 30
Williamson, Bailie 100, 103
Williamson, E. 197, 276, 423
Willison, Andrew 397
 see also Mortimer, Willison & Graham
Willox, David 313
Wilson, Charles 107, 108, 109, 195, 211, 219, 247, 270–1, 303, 306, 449, 456, 458
Wilson, Harry 32
Wilson, Hubert F. 63

Wilson, Hugh, Corbel Figure of, Queen's Drive (Unknown) 319
Wilson, James, Memorial Fountain, Edminston Drive (Main) 92–3, **93**
Wilson Street 427–9, 467
Wilson, Walter 104
Wilson, William 141
Wilton Street 458
Wincher's Stance, Killermont Street (Clinch) 268, **268**
Wind Gods, Athenaeum Theatre (Brown) 44–5, **45**
Wingate, J.C. 402–3
Winter, personification, Renfield Street (W.B. Rhind) 322, **322**
Wisdom, personifications
 Mitchell Library (Keller) 310–12, **310**, **311**
 St Vincent Street (Unknown) 372
Wood, Francis Derwent 247, 253, 412, 457, 501
 Four Seated Female Figures Symbolising the Arts 259–60, **259**
 Mercury, Allegorical Figures of Industry, Prudence, Prosperity and Fortune, Mercantile Chambers 23–5, **23**, **24**, **25**
 Zephyrs, Govan Road 183, **183**
Wood, John Warrington 501
 Sisters of Bethany 21–2, **21**
Wood, Marguerite 466
Woodlands 10–11, 362, 363–4, 422, 432–3
Woodlands Community Development Trust Ltd 10, 422
Woodlands Men, 20 Ashley Street (Taylor) 10, **10**
Woodlands Road 430, 458, 467
Woodpecker, Pollock County Park (Joss) 455
Woodside 83
Woodside Place 243
Woodside Public Library, St George's Road 363
Woodward, Robin Lee 445
Wordie Property Company 91

Working Class Hero, George Square (Birrell) 117–18, **118**
Worsdall, F. 344
Wren, Sir Christopher, Portrait of, Athenaeum (J. Mossman and Mackinnon) 305
Wright, Daphne 380
Wright, Frank Lloyd 290
Wright, Richard 380
Wylie & Lochhead 37, 135
Wylie, E.G. 26
Wyllie, George 171, 359, 389, 443, 501–2
 Caged Peacock 320, **320**
 Clyde Clock 78, **78**
 The Launch 105, **105**
 The Straw Locomotive xvii–xviii, **xviii**
Wylson, James 133

Yellowlees, John 30
YMCA, Bothwell Street 433
York Street 458
York, William 439
Yorkshire Hennebique Constructing Co. Ltd 203
Young, J. (councillor) 76
Young, James (industrialist) 62, 63, 140
Young, James 96, 124, 188, 502
 Allegorical Statue, Figurative Reliefs and Associated Decorative Carving, Hope Street 201–2, **201**, **202**
 Atlas, Allegorical Pediment Relief and Associated Decorative Carvings, Standard Buildings 179–80, **179**
 Caryatids, Atlantes, Pediment Figures and Associated Decorative Carving, Merchants House, West George Street 413–14, **413**, **414**
 Figures of Sowing and Reaping, Corn Exchange, Hope Street 438
 Keystone Portrait and Associated Decorative Carving, Pearl Assurance, West George Street 419, **419**

Langside Battlefield Memorial 14–15, **14**
Mercury, Allegorical Figures of Industry, Prudence, Prosperity and Fortune and Associated Decorative Carving, Mercantile Chambers, Bothwell Street 23–5, **23**, **24**, **25**
Portrait Roundels, Industrial Scene and Associated Decorative Carving, Connal's Building, West George Street 416–19, **417**, **418**
Sculpture Group, Figurative Reliefs and Decorative Carving, Fine Art Institute, Sauchiehall Street 444–5, **444**
Seven High Relief Heads and Associated Decorative Sculpture, Cambridge Buuildings, Cambridge Street 48, **48**
Stewart Memorial Fountain 222–7, **223**, **224**, **225**
Young, James A. 452, 454
 Relief Panels of Virtues, Royal Arms of Scotland and Associated Decorative Carving 26–7, **27**
Young, James Charles 247, 259, 261, **262**, 502
 Allegorical Figures of Literature and Learning and Coat of Arms 435, **435**
 Allegorical Spandrel Figures and Related Decorative Carving 180, **181**, 182
 Spandrel Figures 162–3, **162**
 Statues, Portrait Medallions and Carver Work 433
Young, William 149, 150, 151, 152, 153, 155, 156–7, 158, 160, 161
Youth and Health, Bellahouston Park (Dods) 432
Yule, Ainslie 30
Yunann Corporation 308

Zephyrs, Figurative Capitals and Associated Carving, Bank of Scotland (Wood, Keller and Ferris) 183, **183**
Zunterstein, Paul xv, **xvi**, 502
 Mother and Child 8–9, **9**